FROM DAWN
TO DECADENCE

OTHER BOOKS BY JACQUES BARZUN

Race: A Study in Superstition
Darwin Marx Wagner
Classic Romantic and Modern
Berlioz and the Romantic Century
The Energies of Art
The House of Intellect
Science the Glorious Entertainment
The Use and Abuse of Art
Clio and the Doctors
Critical Questions
A Stroll with William James
The Culture We Deserve

FROM DAWN TO DECADENCE

500 Years of Western
Cultural Life

1500 to the Present

JACQUES BARZUN

HarperCollins*Publishers*

HarperCollins books may be purchased for educational, business, or sales promotional use. For information please write: Special Markets Department, HarperCollins Publishers Inc., 10 East 53rd Street, New York, NY 10022.

FIRST EDITION

Designed by Nancy B. Field

Printed on acid-free paper

Library of Congress Cataloging-in-Publication Data has been applied for.

ISBN 0-06-017586-9

00 01 02 03 04 ❖/RRD 10

To All

Whom

It May Concern

Contents

Author's Note

IT TAKES ONLY a look at the numbers to see that the 20th century is coming to an end. A wider and deeper scrutiny is needed to see that in the West the culture of the last 500 years is ending at the same time. Believing this to be true, I have thought it the right moment to review in sequence the great achievements and the sorry failures of our half millennium.

This undertaking has also given me a chance to describe at first hand for any interested posterity some aspects of present decadence that may have escaped notice, and to show how they relate to others generally acknowledged. But the lively and positive predominate: this book is for people who like to read about art and thought, manners, morals, and religion, and the social setting in which these activities have been and are taking place. I have assumed that such readers prefer discourse to be selective and critical rather than neutral and encyclopedic. And guessing further at their preference, I have tried to write as I might speak, with only a touch of pedantry here and there to show that I understand modern tastes.

Because the plan of the work is new, and thus unlike that of excellent histories that might be named, special care has been given to the ordering of the parts. Linking is particularly important in cultural history, because culture is a web of many strands; none is spun by itself, nor is any cut off at a fixed date like wars and regimes. Events that are commonly said to mark novelty in thought or change of direction in culture are but emphatic signposts, not boundary walls. I punctuate the course of my narrative with events of that kind, but the divisions do not hang upon them. Rather, the chapter divisions suggested themselves after rethinking the given past to find in it the clearest patterns. They are framed by the four great revolutions—the religious, monarchical, liberal, and social roughly a hundred years apart—whose aims and passions still govern our minds and behavior.

*
* *

During the writing of this book I was frequently asked by friends and col-leagues how long its preparation had taken. I could only answer: a lifetime. My studies of separate periods and figures, which began in the late 1920s, disclosed unexpected vistas and led to conclusions at variance with a number of accepted judgments. After further study and a review of what I had published, it seemed possible to shape my findings into a continuous tale. In it, as will appear, figures worth knowing emerge from obscurity and new features appear in others. Familiar ideas are reassessed, particularly the notions in vogue today as to where in the past our present merits and troubles come from.

I do not expect the reader to be steadily grateful. Nobody likes to hear a rooted opinion challenged, and even less to see good reasons offered for a principle or policy once in force and now universally condemned—for exam-ple, the divine right of kings or religious persecution. Our age is so tolerant, so broad-minded and disinclined to violence in its ideologies, that to find a case made out for the temper of the 16th or 17th century is bound to affront the righteous. Yet without exposure to this annoyance, one's understanding of our modern thoughts and virtues is incomplete.

Not that I am in favor of royal masters or persecution or any other evil supposedly outgrown. I cite these examples as a hint that I have not consulted current prejudices. My own are enough to keep me busy as I aim at the histo-rian's detachment and sympathy. For if, as Ranke said, every period stands jus-tified in the sight of God, it deserves at least sympathy in the sight of Man.*

Claiming detachment need not raise the issue of objectivity. It is waste of breath to point out that every observer is in some way biased. It does not fol-low that bias cannot be guarded against, that all biases distort equally, or that controlled bias remains as bad as propaganda. In dealing with the arts, for example, it is being "objective" to detect one's blind spots—step one in detach-ment. The second is to refrain from downgrading what one does not respond to. One has then the duty to report the informed judgment of others.

Since some events and figures in our lengthy past strike me as different from what they have seemed before, I must occasionally speak in my own name and give reasons to justify the heresy. I can only hope that this account-ability will not tempt some reviewers to label the work "a very personal book." I would ask them, What book worth reading is not? If Henry Adams were the echo of Gibbon, we would not greatly value the pastiche.

On this point of personality, William James concluded after reflection that philosophers do not give us transcripts but visions of the world. Similarly, historians give visions of the past. The good ones are not merely

* "Man" is used throughout in the sense of human being(s) of either sex, except when the con-text makes it clear that the secondary sense of male is intended. The scholarly reasons that war-rant adhering to this literary usage are set out on pages 82–85.

plausible; they rest on a solid base of facts that nobody disputes. There is nothing personal about facts, but there is about choosing and grouping them. It is by the patterning and the meanings ascribed that the vision is conveyed. And this, if anything, is what each historian adds to the general understanding. Read more than one historian and the chances are good that you will come closer and closer to the full complexity. Whoever wants an absolute copy of what happened must gain access to the mind of God.

Speaking of meanings, I must say a word about the devices and symbols used in the text; and first about the role of the quotations in the margins. They are meant to supply the "real self and voice" of the persons in the drama. In form, these extracts resemble the familiar "pull-outs" in magazines—sentences lifted out of the article to lure the reader. In this book they are not pull-outs but "add-ins." Their insertion without preamble helps to shorten the text by dispensing with the usual: "As Erasmus wrote to Henry VIII, . . ." "As Mark Twain said about Joan of Arc, . . ."; after which, more words are needed to sew up the cut. This small innovation also permits juxtaposition for contrast or emphasis. By the end, the reader may find that he has been treated to an anthology of choice morsels.

Likewise for brevity, I use the formula 16C, 19C, and so on for the quick recognition of centuries. The indications *early*, *mid*, or *late* next to these specify times more closely. There are as few multi-digit dates as possible, because persons, works, and events do not modify culture the moment they enter it. Readers who wish precise limits to the lives of culture-makers will find the birth-and-death dates opposite the names in the Index of Persons.

Another device that calls for comment is my use of THEMES, that is, ideas or purposes that I find recurring throughout the era. The ideas are expressed, the purposes are implied in the event or tendency I describe. I shall say more about the nature and scope of themes on a later page.

As an additional help to seeing wholes, the mark (<) or (>) with a number attached directs the reader to a page where the topic is carried forward or has been introduced. For further light from other minds, I insert from time to time: "The book to read is . . ." such and such. These are almost always short books. When the phrase is: "The book to browse in is . . ." it indicates a longer work which is worth sampling. These referrals seem to me more likely to be serviceable than the usual list of titles at the back "for further reading." A good many of these books are not of recent date, which does not make them any less informative and pleasant to read. It is a false analogy with science that makes one think latest is best. No footnotes will be found except the one above. Source references (when needed) are in the backnotes, marked (°) in the text.

*
* *

Although in the usual author-fashion I speak possessively of what this book contains, it is in truth the product of a vast collaboration. When I think of all that I have garnered from other minds in my extended sojourn, of what I owe to reading, to my teachers, to conversation with students, colleagues, friends, and strangers; to travel, to the artists who have exercised my wits and delighted my soul since infancy, I am overwhelmed by the size of the debt. To list the names of these helpers would amount to a directory, but again and again as I wrote I vividly recalled my obligation.

Chance has also aided the enterprise: family, time, and place of birth gave shape and direction to effort; insomnia and longevity—sheer accidents— helped to crystallize fleeting insights by obsessive recurrence. A student of cultural history is the last person who can believe he is self-made or the sole begetter of his most original idea. To quote from William James: "Every thought and act owes its complexion to the acts of your dead and living brothers." He addressed this reminder to himself; it defines both the situation of the candid author and the principle of a work of history.

PROLOGUE

From Current Concerns to the Subject of This Book

LOOKING AT the phrase "our past" or "our culture" the reader is entitled to ask: "Who is *we*?" That is for each person to decide. It is a sign of present disarray that nobody can tell which individuals or groups see themselves as part of the evolution described in these pages.

This state of affairs has its source in that very evolution. Our culture is in that recurrent phase when, for good reasons, many feel the urge to build a wall against the past. It is a revulsion from things in the present that seem a curse from our forebears. Others attack or ignore selected periods. In this latter mood, national, religious, or cultural ancestry becomes a matter of choice; people who feel the need "dig for roots" wherever they fancy. The storehouse of traditions and creeds offers an over-abundance, because the culture is old and unraveling.

This passion to break away explains also why many feel that the West has to be denounced. But we are not told what should or could replace it as a whole. Anyhow, the notion of western culture as a solid block having but one meaning is contrary to fact. The West has been an endless series of opposites—in religion, politics, art, morals, and manners, most of them persistent beyond their time of first conflict. To denounce does not free the self from what it hates, any more than ignoring the past shuts off its influence. Look at the youth walking the street with ears plugged to a portable radio: he is tied to the lives of Marconi and of the composer being broadcast. The museum visitor gazing at a Rembrandt is getting a message from the 17C. And the ardent follower of Martin Luther King might well pause over his leader's given names, which evoke ideas from the Protestant Reformation and link the 20C to the 16th.

On the workaday plane, anyone receiving some form of social security here or abroad is the beneficiary of a long line of theorists and activists along which are found such disparates as Florence Nightingale, the Comte de Saint-Simon, Bismarck, and Bernard Shaw. The political refugee who finds his host nation evidently more congenial than the one he fled from can now breathe

freely thanks to the heroic efforts of thousands of thinkers and doers, famous or obscure, martyrs or ordinary folk, embattled in the cause of political freedom—though often enemies when so engaged.

If the new-minted citizen then turns critic of his adopted country, attacking policies and politicians with impunity, he enjoys this privileged pastime because of the likes of Voltaire, who also had to skip across frontiers to escape persecution and keep dissenting. Even the terrorist who drives a car filled with dynamite toward a building in some hated nation is part of what he would destroy: his weapon is the work of Alfred Nobel and the inventors of the internal combustion engine. His very cause has been argued for him by such proponents of national self-determination as President Wilson and such rationalizers of violence as Georges Sorel and Bakunin, the Russian anarchist.

Mankind does nothing save through initiatives on the part of inventors, great or small, and imitation by the rest of us. Individuals show the way, set the patterns. The rivalry of the patterns is the history of the world.

—WILLIAM JAMES (1908)

To see these connections is also to see that the fruits of western culture—human rights, social benefits, machinery—have not sprouted out of the ground like weeds; they are the work of innumerable hands and heads.

I have cited famous names, but they had predecessors now forgotten, and then followers who harped on one idea until it was made actual at last by the consent of the multitude. The enduring force of these deeds is what is meant by the living past; they form the substance of what is now called "the culture."

Culture—what a word! Up to a few years ago it meant two or three related things easy to grasp and keep apart. Now it is a piece of all-purpose jargon that covers a hodge-podge of overlapping things. People speak and write about the culture of almost any segment of society: the counterculture, to begin with, and the many subcultures: ethnic cultures, corporate cultures, teenage culture, and popular culture. An editorial in *The New York Times* discusses the culture of the city's police department,° and an article in the travel section distinguishes the culture of plane travel from the bus culture.° On a par with these, recall the split between the "two cultures" of science and the humanities, which is to be deplored—like the man-and-wife "culture clash," which causes divorce. Artists feel the lure—no, the duty—of joining an adversary culture; for the artist is by nature "the enemy of his culture," just as he is (on another page of the same journal) "a product of his culture." In education, the latest fad is multiculturalism, and in entertainment the highest praise goes to a "cross-cultural event." On the world scene, the experts warn of the culture wars that are brewing.°

At the bottom of the pile, "culture," meaning the well-furnished mind, barely survives. Four thousand cultural facts in dictionary form have recently been laid on the coffee table,° but it may be doubted whether this bonanza

will by itself cultivate the fallow mind, lift it out of day-to-day interests, and scrape it free of provincialism. A wise man has said: "Culture is what is left after you have forgotten all you have definitely set out to learn."° How did culture in this sense—a simple metaphor from agri-culture—lose its authority and get burdened with meanings for which there were other good words? These mini-cultures created on the spur of the moment are obviously fictitious. But again, they express the separatism already mentioned. It arises from too much jostling with too many people—nothing but constraint at every turn, because the stranger, the machine, the bureaucrat's rule impose their will. Hence the desire to huddle in small groups whose ways are congenial.

The hope of relief is utopian; for these small groups are not independent. Their "culture" consists only of local customs and traditions, individual or institutional habits, class manners and prejudices, language or dialect, upbringing or profession, creed, attitudes, usages, fashions, and superstitions; or, at the narrowest, temperament. If a word is wanted for the various pairings of such elements, there is *ethos*. The press—not to say the media—with their love of new terms from the Greek, could quickly make it commonplace.

* * *

But what are the contents of the overarching culture? By tracing in broad outline the evolution of art, science, religion, philosophy, and social thought during the last 500 years, I hope to show that during this span the peoples of the West offered the world a set of ideas and institutions not found earlier or elsewhere. As already remarked, it has been a unity combined with enormous diversity. Borrowing widely from other lands, thriving on dissent and originality, the West has been the mongrel civilization par excellence. But in spite of patchwork and conflict it has pursued characteristic purposes—that is its unity—and now these purposes, carried out to their utmost possibility, are bringing about its demise. This ending is shown by the deadlocks of our time: for and against nationalism, for and against individualism, for and against the high arts, for and against strict morals and religious belief.

The now full-blown individual wields a panoply of rights, including the right to do "his own thing" without hindrance from authority. And any right is owed to all that lives: illegal immigrants, school children, criminals, babies, plants, and animals. This universal independence, achieved after many battles, is a distinctive feature of the West. EMANCIPATION is one of the cultural themes of the era, perhaps the most characteristic of all. And of course it requires more and more limitations in order to prevent my right from infringing yours.

A parallel theme is PRIMITIVISM. The longing to shuffle off the complex arrangements of an advanced culture recurs again and again. It is a main motive of the Protestant Reformation, it reappears as the cult of the Noble

Savage, long before Rousseau, its supposed inventor. The savage with his simple creed is healthy, highly moral, and serene, a worthier being than the civilized man, who must intrigue and deceive to prosper. The late 18C returns to this utopian hope; the late 19C voices it in Edward Carpenter's *Civilization: Its Cause and Cure*; and the 1960s of the 20C experience it in the revolt of the young, who seek the simple life in communes, or who as "Flower People" are convinced that love is an all-sufficient social bond.

Our five centuries present some ten or twelve such themes. They are not historical "forces" or "causes," but names for the desires, attitudes, purposes behind the events or movements, some embodied in lasting institutions. Pointing out this thematic unity and continuity is not to propose a new philosophy of history in the tradition of Marx, Spengler, or Toynbee. They saw history as moved by a single force toward a single goal. I remain an historian, that is, a storyteller who tries to unfold the intricate plot woven by the actions of men, women, and teenagers (these last must not be forgotten), whose desires are the motive power of history. Material conditions interfere, results are unexpected, and there can be no single outcome.

The story accordingly deals not only with events and tendencies but also with personalities. The recital is studded with pen portraits—some of the presumably well-known, but more often of others too often overlooked. We meet of course Luther and Leonardo, Rabelais and Rubens, but also Marguerite of Navarre, Marie de Gournay, Christina of Sweden, and their peers down the ages. They appear as persons, not merely as actors, for history is above all concrete and particular, not general and abstract. It is for convenient remembering only that in the retelling of many facts the historian offers generalities and gives names to "periods" and "themes." The stuff itself is the thoughts and deeds of once living beings.

But why should the story come to an end? It doesn't, of course, in the literal sense of stoppage or total ruin. All that is meant by Decadence is "falling off." It implies in those who live in such a time no loss of energy or talent or moral sense. On the contrary, it is a very active time, full of deep concerns, but peculiarly restless, for it sees no clear lines of advance. The loss it faces is that of Possibility. The forms of art as of life seem exhausted, the stages of development have been run through. Institutions function painfully. Repetition and frustration are the intolerable result. Boredom and fatigue are great historical forces.

It will be asked, how does the historian know when Decadence sets in? By the open confessions of malaise, by the search in all directions for a new faith or faiths. Dozens of cults have latterly arisen in the Christian West: Buddhism, Islam, Yoga, Transcendental Meditation, Dr. Moon's Unification Church, and a large collection of others, some dedicated to group suicide. To secular minds, the old ideals look outworn or hopeless and practical aims are

made into creeds sustained by violent acts: fighting nuclear power, global warming, and abortion; saving from use the environment with its fauna and flora ("Bring back the wolf!"); promoting organic against processed foods, and proclaiming disaffection from science and technology. The impulse to PRIMITIVISM animates all these negatives.

Such causes serve to concentrate the desire for action in a stalled society; for in every town, county, or nation, it is seen that most of what government sets out to do for the public good is resisted as soon as proposed. Not two, but three or four groups, organized or impromptu, are ready with contrary reasons as sensible as those behind the project. The upshot is a floating hostility to things as they are. It inspires the repeated use of the dismissive prefixes *anti-* and *post-* (anti-art, post-modernism) and the promise to *reinvent* this or that institution. The hope is that getting rid of what is will by itself generate the new life.

<p align="center">*</p>
<p align="center">* *</p>

Granted for the sake of argument that "our culture" may be ending, why the slice of 500 years? What makes it a unity? The starting date 1500 follows usage: textbooks from time immemorial have called it the beginning of the Modern Era. Good reasons for so doing will be found on nearly every page of the first half-dozen chapters. The reader will note in passing that *era* is used here to mean stretches of 500 years or more—time enough for an evolving culture to work out its possibilities; *period* or *age* denotes the shorter distinctive spans within an era.

Strictness on this point helps to clear up the confusion by which "modern" has been made to cover both the era since the Middle Ages and the ill-defined periods when "modernism" is said to begin—in 1880 or 1900 or 1920 (>713). The divisions within the modern era will be seen to differ from those in college texts, whose subject is general history. The cultural perspective requires a different patterning. Three spans, each of approximately 125 years, take us, roughly speaking, from Luther to Newton, from Louis XIV to the guillotine, and from Goethe to the New York Armory Show. The fourth and last span deals with the rest of our century.

If this periodizing had to be justified, it could be said that the first period—1500–1660—was dominated by the issue of what to believe in religion; the second—1661–1789—by what to do about the status of the individual and the mode of government; the third—1790–1920—by what means to achieve social and economic equality. The rest is the mixed consequence of all these efforts.

What then marks a new age? The appearance or disappearance of particular embodiments of a given purpose. Look out of the window: where is the town crier?° where are the idlers watching the bear-baiting or laughing at the gates of Bedlam, the madhouse? Again, does anyone now use "noble" to

praise a person or, like Ruskin, to classify types of art? Turn to the dedication of a new book: why are there not three or four pages of convoluted flattery addressed to a lord? Each of these items now lacking is the token of a change in: technology, moral attitudes, social hierarchy, and the support of literature.

With such things in mind, newspapers are fond of referring to the "dustbin of history," a notion they borrow not from Karl Marx, as they think, but from an English writer and member of Parliament, Augustine Birrell.° On inspection the bin is much less full than is commonly believed. The repeats and returns in the last five centuries have been frequent. To cite an example, one need only note the present resurgence of intellectual interest in the text of the Bible and the life of Jesus. Or consider another survival that could qualify for the dustbin but has been overlooked: the newspaper column on astrology. The rivalry of patterns rarely ends in a complete victory; the defeated survive and keep fighting; there is a perpetual counterpoint.

Having said all this on the strength of the western experience—its reckless inclusion of peoples, outreach for exotic novelties, endless internal conflict of leading philosophies, repeated changes deep enough to produce distinct ages— it may seem contradictory to speak of one culture flourishing from end to end of our half millennium. There is in fact no inconsistency. Unity does not mean uniformity, and identity is compatible with change. Nobody doubts the unity of the person from babyhood to old age. Again, in a civil war, though all political and social bonds are broken, the cultural web is tough and it still links the two sides together. Both speak the same language, fight over one set of issues, and remember a common past, full of wrongs for one side, seen as rights by the other. Both live at the same level of civilization. Family, type of government, moral standards remain alike in both. Both use the same weapons, lead their armies in similar fashion, wear the same sort of uniform, and in naming ranks and carrying flags show that the practice has but a common meaning.

One last question: do ideas really exert force? Skepticism about their influence in history has always appealed to certain temperaments. Says the skeptic: "Art and thought should be kept in their proper place. Elizabeth I did more to shape the everyday life of a modern Englishman than Shakespeare."° With a firmer grasp on his example, the critic might have seen that one of Elizabeth's chief troubles was how to cope with the threat of ideas, those of her newly Protestant subjects, embattled against their Catholic compatriots, also acting on ideas.

Again, if the last five centuries present the spectacle of a single culture, it is also because of the tenacious memory, aided by the practice of obsessive record-keeping. Our distinctive attitude toward history, our habit of arguing from it, turns events into ideas charged with power. And this use of the past dates precisely from the years that usher in what is called modern times.

PART I
From Luther's Ninety-five Theses to Boyle's "Invisible College"

The West Torn Apart

The New Life

The Good Letters

The "Artist" Is Born

CROSS SECTION:
The View from Madrid Around 1540

The Eutopians

Epic & Comic, Lyric & Music, Critic & Public

CROSS SECTION:
The View from Venice Around 1650

The Invisible College

The West Torn Apart

THE MODERN ERA BEGINS, characteristically, with a revolution. It is commonly called the Protestant Reformation, but the train of events starting early in the 16C and ending—if indeed it has ended—more than a century later has all the features of a revolution. I take these to be: the violent transfer of power and property in the name of an idea.

We have got into the habit of calling too many things revolutions. Given a new device or practice that changes our homely habits, we exclaim: "revolutionary!" But revolutions change more than personal habits or a widespread practice. They give culture a new face. Between the great upheaval of the 1500s and the present, only three later ones are of the same order. True, the history books give the name to a dozen or more such violent events, but in these uprisings it was only the violence that was great. They were but local aftershocks of one or other of the four main quakes: the 16C religious revolution; the 17C monarchical revolution; the liberal, individualist "French" revolution that straddles the 18th and 19th; and the 20C "Russian," social and collectivist.

The quotation marks around French and Russian are meant to show that those names are only conventional. The whole western world was brooding over the Idea of each before it exploded into war, and the usual dates 1789 and 1917 mark only the trigger incidents. It took decades for the four to work out their first intention and side effects—and their ruling ideas have not ceased to act.

One must speak of *the West* as being torn apart in the 16C because *Europe* would be inexact. Europe is the peninsula that juts out from the great mass of Asia without a break and is ridiculously called a continent. In the 16C revolution only the westernmost part of that peninsula was affected: from Germany, Poland, Austria, and Italy to the Atlantic Ocean. The Balkans belonged to the Moslem Turks and Russia was Orthodox Christian, not Catholic. For the West, in this clearly defined sense, it would be convenient to say "the Occident."

To call the first of the four revolutions religious is also inadequate. It did indeed cause millions to change the forms of their worship and the conception of their destiny. But it did much besides. It posed the issue of diversity of opinion as well as of faith. It fostered new feelings of nationhood. It raised the status of the vernacular languages. It changed attitudes toward work, art, and human failings. It deprived the West of its ancestral sense of unity and common descent. Lastly but less immediately, by emigration to the new world overseas, it brought an extraordinary enlargement of the meaning of West and the power of its civilization.

*

*　　*

When the miner's son from Saxony, Luther, Lhuder, Lutter, or Lotharius as he was variously known, posted his 95 propositions on the door of All Saints' church at Wittenberg on October 31, 1517, the last thing he wanted to do was to break up his church, the Catholic (= "universal"), and divide his world into warring camps.

Nor was he performing an unusual act. He was a monk and professor of theology at the newly founded university of Wittenberg (where Hamlet later studied), and it was common practice for clerics to start a debate in this fashion. The equivalent today would be to publish a provocative article in a learned journal. A German scholar has recently argued that Luther never posted his theses. Whether he did or not, they circulated quickly; he had made copies and sent them to friends, who recopied and passed them on. Soon, Luther had the uneasy surprise of receiving them back from South Germany, *printed*.

This little fact is telling. Luther's hope of reform might have foundered like many others of the previous 200 years, had it not been for the invention of printing. Gutenberg's movable type, already in use for some 40 years, was the physical instrument that tore the West asunder. But one point about the new techne° is worth noting: the printing press by itself was not enough: better paper, a modified ink, and a body of experienced craftsmen were also needed to make type a power. Pamphlets could now be produced quickly, accurately, in quantity, and, compared to manuscript copies, cheaply.

Many of the Protestant tracts were illustrated with woodcuts, by Cranach, Dürer, and other leading artists, which helped propaganda by attracting the illiterate: their friends read them the text. No longer always in Latin for clerics only, but in one of the common tongues, the 16C literature of biblical argument and foul invective began what we now call the popularization of ideas through the first of the mass media.

Some notion of the force wielded by this new artifact, "the book," may be gathered from the estimate that by the first year of the 16C, 40,000 sepa-

rate editions of all kinds of works had been issued—roughly nine million volumes from more than a hundred presses. During the Protestant struggle some towns had half a dozen firms working day and night, their messengers leaving every few hours with batches of sheets under their cloaks, the ink hardly dry, for delivery to safe distributors—the first underground press. [The book to browse in is: *The Coming of the Book* by Lucien Febvre and Jean Martin.]

If Luther had no thought of setting off a revolution, what was his aim? He "only wanted to elicit the truth about the sacrament of penance." An innocent question, but timely, because of the current sale of "indulgences." These were a sort of certified check drawn by the pope on the "treasury of merit accumulated by the saints." In popular belief, buying one enabled the holder to finesse penance and shorten his or her time in Purgatory—or that of a friend or relative. Luther wanted to know whether any substitute for true remorse and active penance could be bought in the open market. He thought the only treasure of the church was the gospel.

> An indulgence can never remit guilt; the Pope himself cannot do such a thing; God has kept that in His own hand.
>
> It can have no efficacy for souls in Purgatory; penalties imposed by the church can only refer to the living. What the Pope can do for souls in Purgatory is by prayer.
>
> The Christian who has true repentance has already received pardon from God, altogether apart from an indulgence, and so does not need one.
>
> —FROM LUTHER'S "NINETY-FIVE THESES"

Many besides Luther had felt true piety and wanted to worship sincerely, not buy their way into heaven. One form of awakened faith was significantly called *devotio moderna*. The formation of groups like the Brothers of the Common Life, the founding of new grammar schools, works such as *The Imitation of Christ* by Thomas à Kempis, and the spontaneous attitude of ordinary folk showed that the work of earlier reformers was bearing fruit.

These reformers had been many. From Wycliff in 14th-century England to John Huss in Bohemia in the 15th, heroic attempts had been made to "go back to the primitive church," the humble early Christians, whose only church was their elected overseers. For them the gospel had been enough—and so it should still be.

Even before Wycliff, who was later called "The Morning Star of the Reformation," a whole region around the southern French town of Albi had in the 13C achieved this simplification. The Albigenses were exterminated. Later movers of heresy were burned at

> So many pointed caps
> Laced with double flaps
> And so many felted hats
> Saw I never.
>
> So many good lessons,
> So many good sermons,
> And so few devotions,
> Saw I never.
>
> —JOHN SKELTON (c. 1500)

the stake. Within the church hierarchy itself, repeated demands had been heard for "reform of the head and members"; but institutional self-reform is rare; the conscience is willing, but the culture is tough.

In this setting, Luther's downright assertions proved explosive. He had sent the text to the Archbishop of Mainz, a gross and greedy young man who could not help taking an interest, since he was to get one-third of the proceeds of this indulgence sale as reimbursement for the cost of the bishopric he had just bought. Getting no reply, Luther sent another copy to the pope and pursued his meditations.

Now 34 years old, he was not a young hothead. For seven years he had lived in anguish, often in despair, about the state of his soul. He had fought the urgings of the flesh—not only desire but also hatred and envy—and he had always lost the battle. How could he hope to be saved? Then one day, when a brother monk was reciting the Creed, the words "I believe in the forgiveness of sins" struck him as a revelation. "I felt as if I were born anew." Faith had suddenly descended into him without his doing anything to deserve it. His divided self or "sick soul," as William James called the typical state, was mysteriously healed. The mystery was God's bestowal of grace. Lacking it, the sinner cannot have faith and walk in the path of salvation. Such is the substance not merely of the Protestant idea, but of the Protestant experience.

Seeing how thick and fast the response came when Luther proclaimed his discovery, it is plain that fellow sufferers could be numbered by the thousand. Sensitive souls could be found among poor peasants at the plow, stolid merchants in the free cities, ambitious princes, impoverished knights in their crumbling castles, and sincere priests at the altar. To the pope, who at the time was the esthetic voluptuary Leo X, Luther's outburst was just another little monk's showing off his learning. The document was handed over to clerical bureaucrats who took three years to pick out the heresies.

But Luther was not waiting. His revelation of grace, coupled with the memory of his visit to Rome half a dozen years earlier as an envoy of his order, brought him to another simplifying idea: every man is a priest. He is far from being "another Christ," as the Catholic ordination of priests puts it, but he does not need the Roman hierarchy as middleman; he has direct access to God. That top-heavy apparatus, a burden throughout the West, is useless. To make the proposition absolute, Luther added the principle he called Christian liberty: "A Christian man is a perfectly free lord, subject to none."

This proclamation—every man a priest, a free lord, and no church— broadcast to the Germans in German, could only mean a new way of life. But Luther had no mind to manufacture anarchists and he stated the counterpart of the claim to liberty: "A Christian man is a perfectly dutiful servant of all, subject to all"; that is, to the secular society ruled by princes.

This reassured the lay authorities and marked out Luther's course. Side-

stepping quite unconsciously the dangerous role of religious prophet, he was taking on the popular role of anti-clerical. It rallies many interests. Pope-bashing had long been a high-toned enterprise, doubling as a form of black-mail. By it, kings got political concessions; others, cardinal's hats. It had done nothing to reform the church, which, many agreed, must be rid of abuses, but everyone stood firm—yes, but not *my* privileges.

The incipient revolution had defined the enemy: not the Catholic religion and its faithful, but the pontiff, his employees, and their hocus-pocus, that is, the trappings of worship. When the pope's bull condemning 41 of the 95 the-ses arrived in Wittenberg, it gave Luther an opportunity for a demonstration: he burned it publicly, to the great delight, naturally, of the university students crowding around him. For good measure he threw in some rescripts, the de-cretals of Clement VI, the *Summa Angelica,* and a few books by a colleague who championed the pope, Johann von Eck. "It is an old custom," said Luther, "to burn bad books."

<p style="text-align:center">*</p>
<p style="text-align:center">* *</p>

How a revolution erupts from a commonplace event—tidal wave from a ripple—is cause for endless astonishment. Neither Luther in 1517 nor the men who gathered at Versailles in 1789 intended at first what they produced at last. Even less did the Russian Liberals who made the revolution of 1917 foresee what followed. All were as ignorant as everybody else of how much was about to be destroyed. Nor could they guess what feverish feelings, what strange behavior ensue when revolution, great or short-lived, is in the air.

First, a piece of news about something said or done travels quickly, more so than usual, because it is uniquely apt; it fits a half-conscious mood or caps a situation: a monk questions indulgences, and he does it not just out of the blue—they are being sold again on a large scale. The fact and the challenger's name generate rumor, exaggeration, misunderstanding, falsehood. People ask each other what is true and what it means. The atmosphere becomes elec-tric, the sense of time changes, grows rapid; a vague future seems nearer.

On impulse, perhaps to snap the tension, somebody shouts in church, throws a stone through a window, which provokes a fight—it happened so at Wittenberg—and clearly it is no ordinary breach of the peace. Another unknown harangues a crowd, urging it to stay calm—or not to stand there gaping but *do* something. As further news spreads, various types of people become aroused for or against the thing now upsetting everybody's daily life. But what is that thing? Concretely: ardent youths full of hope as they catch the drift of the idea, rowdies looking for fun, and characters with a grudge. Cranks and tolerated lunatics come out of houses, criminals out of hideouts, and all assert themselves.

Manners are flouted and customs broken. Foul language and direct insult become normal, in keeping with the rest of the excitement, buildings defaced, images destroyed, shops looted. Printed sheets pass from hand to hand and are read with delight or outrage—Listen to this! Angry debates multiply about things long since settled: talk of free love, of priests marrying and monks breaking their vows, of property and wives in common, of sweeping out all evils, all corruption, all at once—all things new for a blissful life on earth.

Immortal God! What a century do I see beginning!
If only it were possible to be young again!

—ERASMUS TO GUILLAUME BUDÉ (1517)

Bliss was it in that dawn to be alive,
But to be young was very heaven.

—WORDSWORTH REMEMBERING THE
FRENCH REVOLUTION (1805)

A curious leveling takes place: the common people learn words and ideas hitherto not familiar and not interesting and discuss them like intellectuals, while others neglect their usual concerns—art, philosophy, scholarship—because there is only one compelling topic, the revolutionary Idea. The well-to-do and the "right-thinking," full of fear, come together to defend their possessions and habits. But counsels are divided and many see their young "taking the wrong side." The powers that be wonder and keep watch, with fleeting thoughts of advantage to be had from the confusion. Leaders of opinion try to put together some of the ideas afloat into a position which they mean to fight for. They will reassure others, or preach boldness, and anyhow head the movement.

Voices grow shrill, parties form and adopt names or are tagged with them in derision and contempt. Again and again comes the shock of broken friendships, broken families. As time goes on, "betraying the cause" is an incessant charge, and there are indeed turncoats. Authorities are bewildered, heads of institutions try threats and concessions by turns, hoping the surge of subversion will collapse like previous ones. But none of this holds back that transfer of power and property which is the mark of revolution and which in the end establishes the Idea.

The seizure by Henry VIII of England's abbeys and priories, openly in the name of reform and morality, is notorious. But this secularizing of church property went on during the 16C in every other country except Italy and Spain. During this transfer, treaties were made every few years to confirm or reverse the grab, as the fortunes of war dictated. To the distant observer the course of events is a rushing flood; to those inside it is a whirlpool.

Such is, roughly, how revolutions "feel." The gains and the deeds of blood vary in detail from one time to the next, but the motives are the usual mix: hope, ambition, greed, fear, lust, envy, hatred of order and of art, fanatic fervor, heroic devotion, and love of destruction.

Chance also plays its capricious role. Henry VIII, sincerely convinced that

his marriage to Queen Catherine was incestuous and prevented his begetting a male heir, asked the pope for an annulment at a time when Lutheran ideas were spreading. The king had previously attacked Luther in a learned tract, for which the pope had named Henry "Defender of the Faith." Now the defender had to break with a pope

When Love could teach a monarch to be wise

And Gospel light first dawned from Bullen's eyes.

[Bullen is Anne Boleyn.]

—"ON THE PLEASURES OF VICISSITUDE," "ELEGY" GRAY ON HENRY VIII'S PREDICAMENT

who dared not grant the divorce, because Emperor Charles V would not hear of it: Catherine was his aunt. Out of this operatic plot came a new church, the Anglican, headed by the king, not a cleric, and forever independent of Rome.

In fact, the king was working for himself, for royal power. His theology was unchanged, but his taking the church lands was a step in the silent march of the next revolution (239>).

*

*　　*

One may wonder why Frederick, Elector of Saxony, did not discipline Luther and his followers as the pope requested—a request accompanied by a high honor, the Golden Rose, to make it persuasive. Frederick was Luther's sovereign as well as his employer, having set up and staffed the University of Wittenberg. And he was a pious Catholic who collected saintly relics; he seems to have owned 8,000, including straw from Jesus's crib. Yet all his life he kept protecting the monk-professor who burned papal bulls.

In this and other signs of resistance to the pope one detects the feelings of secular rulers against the religious, the antagonism of local authority toward central, and now a heightened sense of German nationhood that fretted at "foreign" demands. For in the conflict with the pope and his Roman hierarchy, the feeling that "those Italians" were interfering in "our affairs" would seem natural to some. Others would also find cause for national pride—though there was really no German nation—in the little tract entitled *Germania,* by the ancient Roman historian Tacitus. He portrayed Rome as decadent and slavish and the German tribes as nobly moral and free. Frederick of Saxony may not have taken by this doubtful parallel, but in his defense of Luther a private emotion came into play: he was offended that a faculty member of his cherished university should be called to account by Vatican officials.

The pope, still combating heresy, not as yet secession, enlisted the aid of the recently elected emperor, the chivalric teenager Charles V, who agreed to try the Wittenberg trouble-maker at the next imperial congress, the now famous Diet of Worms. The strategy was to alternate threats and entreaty.

But the defendant's heroic stubbornness on the second day, after a momentary weakening on the first—a touch worthy of the tragic stage—made Frederick fear the worst. He had Luther kidnapped and hidden in a castle that is now a tourist attraction, the Wartburg.

Luther's life and the fate of his doctrine everywhere thus depended on the secular arm being exerted in support, and in many places at once. A revolutionary idea succeeds only if it can rally strong "irrelevant" interests, and only the military can make it safe.

At the Wartburg, despite the rude noises that the Devil kept making to thwart him, Luther translated the New Testament into German, choosing the dialect most likely to reach the greatest number.° The gospels, if read by everybody, would prove him right. Hence the name of Evangelicals. It preceded and long prevailed over the accidental name of Protestants, which arose when some delegates protested against a tentative agreement with the Catholic partisans.

From his unexpected sabbatical onward, Luther kept addressing the Germans on every issue of religious, moral, political, and social importance. Pamphlets, books, letters to individuals that were "given to the press" by the recipients, biblical commentaries, sermons, and hymns kept streaming from his inkwell. Disciples made Latin translations of what was in German and vice versa. It was an unexampled barrage of propaganda to pose a country-wide issue. Opponents retorted, confrontations were staged at universities and written up. A torrent of black-on-white wordage about the true faith and the good society poured over Christian heads. It did not cease for 350 years: 1900 was the first year in which religious works (at least in England) did not outnumber all other publications.

The late 20C has resumed the battle. Fundamentalism is Luther's Biblicism in a new phase (>40; 261), and throughout the West, sects multiply as they did 450 years ago—there are 172 such groups registered in France alone, most of them Christian. And the results of this renewed search for faith are the same now as then. The modern stirrings are of course less root-and-branch efforts than those of the 16C. They demanded a full-scale return to the conditions of the early church, sounding the theme of PRIMITIVISM— Back to the basics! When people feel that accretions and complications have buried the original purpose of an institution, when all arguments for reform have been heard and have failed, the most thoughtful and active decide that they want to be "cured of civilization." Needless to add, Luther's "Christian liberty" was also the first blast heralding that highly conspicuous theme of the modern era, EMANCIPATION.

*

*　　*

What were in fact the things in the church's "head and me
people wanted to be rid of? First, the familiar "corruptions"—g
monks in affluent abbeys, absentee bishops, priests with concubines, and so
on. But moral turpitude concealed a deeper trouble: the meaning of the roles
had been lost. The priest, instead of being a teacher, was ignorant; the monk,
instead of helping to save the world by his piety, was an idle profiteer; the
bishop, instead of supervising the care of souls in his diocese was a politician
and businessman. One of them here or there might be pious and a scholar—
he showed that goodness was not impossible. But too often the bishop was a
boy of twelve, his influential family having provided early for his future hap-
piness. The system was rotten. This had been said over and over; yet the old
hulk was immovable. When people accept futility and the absurd as normal,
the culture is decadent. The term is not a slur; it is a technical label. A deca-
dent culture offers opportunities chiefly to the satirist, and the turn of the
15C had a good many, one of them a great one:

Erasmus

The well-known portrait by Dürer shows him with eyelids modestly,
thoughtfully down, the face smooth-featured and serene. Later portraits—in
words—often make him out a cautious, middle-of-the-road academic charac-
ter who, in the battle of his time, took the line of compromise. Luther was the
strong man, Erasmus the intellectual; therefore the good that came out of
rebellion we owe to the strong man.

No summary could be falser. Erasmus was a courageous, independent
fighter, as easily roused to anger—if anger is a revolutionary virtue—as Luther
himself. He was impetuous in pushing his cause well before Luther thought of
having one. Erasmus was the greater scholar, had more wit, and a different kind
of literary genius. From his earliest days
he denounced the monks, discredited
the saints, and declared "almost all
Christians wretchedly enslaved by
blindness and ignorance."

He was himself a monk, made into
one against his will by his guardian; for
though not abandoned by his father,
he was illegitimate, and had been
trapped into his vows. He had no
thought of a career in religion, any
more than Luther and Calvin, who
both chose the law. Luckily, by the spe-
cial favor of a friendly bishop, Eramus

The air is soft and delicious. The men are
sensible and intelligent. Many of them are
learned. They know their classics, and so
accurately that I have lost little in not going to
Italy. The English girls are divinely pretty
and they have one custom which cannot be
too much admired. When you go anywhere
on a visit, the girls all kiss you. They kiss you
when you arrive. They kiss you when you go
away. They kiss you when you return. Once
you have tasted how soft and fragrant those
lips are, you would spend your life here.

—ERASMUS ON ENGLAND IN 1497

was exempted from residence, permanently—another sign of clerical laxity. The young monk was able to lead the life of a Renaissance Humanist (74>).

His mastery of Greek, then a new accomplishment, made him a favorite of princes eager for learning, and he became the oracle of the enlightened on all subjects of timely interest. Popes consulted him and offered him bishoprics and (twice) a cardinal's hat. Universities wanted him on their faculty, Henry VIII tried to keep him at his court, Charles V took his advice, Luther begged for his support—and turned vindictive when it was refused. In between these flattering gestures he was reviled—by the monks in loud chorus, or censured by the pope when Rome's policy wavered, or cold-shouldered by erstwhile friends when he wrote a letter they disagreed with: before and during the revolution, much public argument was carried on in correspondence. Seeing the effect of his writings, Erasmus rightly judged that his power lay in his pen, not in titles or partisan activism.

Erasmus had welcomed the Evangelical movement and he contributed to it both by his edition of the Greek text of the New Testament and by a variety of popular works. He was the first Humanist to earn his living by his writings, which is a measure of his influence. Nothing like his sway over the minds of his contemporaries has been seen since; not even Voltaire or Bernard Shaw approached it; for by their time Protestantism itself, in making the clergy and men of letters two distinct social groups, had broken the link between the thinker and the bulk of the people. Erasmus was called many hard names but never "highbrow," as he would be today.

Difference of generation plays a large part in the battle of ideas. Given his age—Erasmus was Luther's elder by nearly 20 years—he could not become an Evangelical. He was a good Christian, but he did not experience faith as a passion. As a scholar, too, he read scripture differently; he gave credence to the message but not to all the sayings and events—many were poetic statements, fables, allegories. And when he read the ancient classics he found figures of such near-Christian piety that he could exclaim only half-humorously, "Saint Socrates, pray for us!"

To Luther this was blasphemous frivolity. The Evangelicals despised the Humanists, even though some Humanists had long discarded the superstitions that Protestantism still attacked. When Erasmus would not accept Luther's denial of free will, the break was complete: Erasmus must be an atheist. The sectarians used that word to mean: disbeliever in *my* belief.

Erasmus was among other things a humorist, which to the earnest means one who trifles with serious things. But Erasmus was serious enough when he refuted Luther's doctrine that most of mankind was damned from all eternity, only a few being saved, and these not for leading a good life but, unaccountably, by God's grace. When this last phrase is used today, only a vague notion of chance or mischance is in the speaker's mind. Not so when John Bradford

on seeing a criminal led to the gallows exclaimed: "There but for the grace of God goes John Bradford." He felt it in his bones that God had from the beginning settled the outcome of the two men's lives. This was Predestination. The belief is still strong today and not among Protestants or religious believers alone (>29).

While Luther thought this mystery central to Christianity, and indeed "comforting," Erasmus rejected it as against reason. In his satirical skits depicting the life around him, he saw the interplay of wills free enough to choose good or bad, wise or foolish actions. These immensely popular *Colloquies,* dialogues between ordinary people, dealt with their petty predicaments—the soldier's troubles in civilian life, the wrangles of married folk, the tricks of an alchemist, the traveler's shabby treatment in German inns as compared with the French.

Though often poor and ailing, Erasmus loved travel and the good things of life, including the rapid, flashing conversation of learned friends in Paris, Oxford, and (at the end) in Basel, where he had his favorite printer-publisher. [The book to read is James Anthony Froude's *Life and Letters of Erasmus*.]

Erasmus summed up his criticism of life in one great work, *The Praise of Folly*. His friend Holbein the Younger liked it so well that he made in his copy pen-and-ink illustrations that have been often reproduced in modern editions. Folly, speaking for herself, shows how people of every rank and occupation prefer her to common sense, yet they give her a bad name, especially the worst fools. She at least is honest—no pretences—anybody can see what she is like. Her father was Plutus, the god of riches, by whom everything in the world is governed. (Denouncers of the current "materialistic culture," as if ours were the first of the kind, should take note.) Folly concludes that, all in all, the greater the madness, the greater the happiness.

By the author's art this entertaining paradox is expanded into a panorama of the times. The fiction is not strained. Unfortunately, the second half of the book, though still effective in its way, abandons "story" and drops into a direct attack against clerical and other abuses. The vivid reality is still there, but art has succumbed to political passion. This verbal assault against the hierarchy came a good while before Luther felt doubts about his church or even about his soul. Eight years elapsed between *The Praise of Folly* and the 95 Theses.

—Let me tell you: I've been on a visit to St. James of Compostello. —From curiosity, I suppose? —No, for the sake of religion. My wife's mother bound herself by a vow that if her daughter should give birth to a live male child, I, her son-in-law, should go to St. James in person and thank him for it. —Did you salute the Saint in your name or your mother-in-law's? —In the name of the whole family. —And what answer did you get? —Not a syllable. Upon handing over my present, he seemed to smile and gave me a gentle nod. —A most gracious saint, both in hospitality and midwifery!

—ERASMUS, *COLLOQUIES*

*
* *

By the time Luther and his followers had launched their onslaught, not seeing that it must lead to violence—or not caring—sober men on both sides kept seeking compromise. The Erasmian outlook did not vanish because Luther thundered. More than one bishop and cardinal was eager for reform and found the Evangelical vision congenial. Some Protestants also were ready to accept a halfway house if it was free of corruption and "superstition." After the open break, Melanchthon, Luther's young protégé and spokesman, drafted a statement meant to reconcile and reunite the church; it was rejected by both parties. Still, the best minds, including the emperor, viewed a civil war with horror. When a courtier spoke to Charles of "heads rolling," he replied: "No, my dear lord, no heads." And the elector Frederick would say: "It is easy to take a life, but who can give it back again?"

Among the high clergy there were conciliators also. Cardinal Contarini spent his life trying to regain the loyalty of the Lutheran seceders while correcting the abuses of his own church. So outspoken was he on these points that he was suspected of being a crypto-Protestant. But he was a superb diplomat, highly esteemed as statesman and political theorist in his native Venice and ever welcome at Charles's imperial court; so he survived, though he failed to recapture the straying flock.

An idea newly grasped stirs the blood to aggressiveness. From safe corners such as universities and monasteries, force was called for, and many laymen were not afraid to use it. They quoted Luther: "One must fight for the truth." When possessions were at stake, whether simply threatened or taken over by the Protestants, armed conflict was inevitable. Pulpits, churches, and other religious houses, town offices, and the privileges that went with all of these changed hands—and more than once. Local sentiment, coupled with power, decided ownership.

Again it was chance that Emperor Charles V did not quickly give armed support to the Catholic princes and put an end to the revolution. But he was at war on another, even more endangered front. The armies of Islam—the Turks—held the Balkans, and their fleet, aided by accomplished pirates, the Mediterranean. Vienna, gateway to the West, was forever being threatened. Charles had to fight in North Africa as well as in Central Europe, while he must also defend his lands in Italy and the Netherlands against France and the heretics. There seemed no way he could finish off the Protestant usurpers at one stroke on the field of battle.

Civil war broke out when the imperial knights, an independent, poverty-stricken order, tried to recoup their fortunes under cover of the general unrest. Their leader, Götz von Berlichingen, became a German national hero, further glorified later in a play by Goethe. The knights were defeated, but a

satire written by another of them, Ulrich von Hutten, *Letters from Obscure Men*, so inflamed the monks, whom he held up to hatred, ridicule, and contempt, that the war fever became unquenchable.

Two years after the knights, the peasants rose up, with far better excuse. Luther at once approved their twelve demands, one of which was the right to choose their own ministers. The other articles begged for relief from the princes' pitiless exploitation. When the petition was rebuffed, thousands under the lead of Thomas Münzer took to pillage and killing. Luther back-tracked and in his most vituperative vein called on the princes to destroy them. The end was massacre or exile for some 30,000 families.

Münzer had won their allegiance by proclaiming that all men were created equal and should remain so. An impossible idea, but how suggestive! Gospel simplicity, self-rule, faith unencumbered by authorities—PRIMITIVISM. These sentiments traveled wide. At Münster in 1534, a tailor known as John of Leyden set up with his Anabaptist followers the Kingdom of Zion. They terrorized the rest of the citizens, also in the name of equality but equal under John the despot, who kept a harem. The kingdom satisfied one of the recurrent dreams of the occidental mind: community of goods and of women.

It is interesting to note that when East Germany was under Soviet rule Münzer was a hero, and called so again in a *New York Times* article of recent date.° As for John of Leyden, he could point to the New Testament on sharing goods and to the Old on plural wives. He was overthrown after a year, and in the usual fashion of this evangelical time put to death as horribly as it could be contrived. His reign furnished the matter for Meyerbeer's grand opera *Le Prophète* (1849).

Violent events were to be typical of European life till the middle of the 17C. Riot, combat, sieges and sacks of towns, burnings at the stake, and escape by self-exile repeat without letup. In Germany, 23 years of war, with breathing spells, kept in the field two unstable leagues of princes, Protestant and Catholic. In the Netherlands, the seesaw went on for a somewhat shorter time; likewise in the Swiss cantons, where the capable leader Huldreich Zwingli, by combining theology with economic reform, provoked the war in which he met his death. In France the last 30 years of the century were devoted to eight bouts of civil

Antwerp, 2nd May 1581

Eight days ago the soldiery and the Calvinists mutilated all the pictures and altars in the churches and cloisters of Belgium. The clergy and nearly 500 Catholic citizens were driven out and several cast in prison. Thus an end has been made of the Catholic faith in Brussels.

Antwerp, 6 May 1581

Four ships were laden with sculptured and carved statues, bells, brass and stone effigies of saints, candlesticks and other such-like ornaments from the churches. All are to be despatched to Narva and Moscow. The consigners hope to do good business with them.

—FUGGER NEWSLETTERS

war, with ambush, assassination, and massacre in between, including the famous one on the feast day of St. Bartholomew. The English Civil War, also impelled by sectarian passions, was reserved for the next century (>263). Luther admitted with his usual honesty that "he had never meant to go as far as he did."

Erasmus had remained a reformer and it is his temper that has prevailed until very recently. The faith of most Christians in the centuries after him gradually became less literal, mystical, hellfired, and sectarian. The leading churches grew resigned to toleration and adopted the social gospel of doing good to others, while the expanding secular knowledge came to be seen as compatible with scripture. The interesting fact is that the great initiator of sectarian attitudes was himself not a sectarian through and through. This observation refers to

Luther

The image that the mindless jade Posterity retains of him is of the rough-hewn peasant, ready with blind courage and foul language to rout all opponents—"typically German," some will say. It is true that according to Luther himself he did his best work in anger, and by a reverse snobbery he kept stressing his peasant origins, although he was the son of an artisan. But his need of that internal tonic rather suggests a character more complicated than the legend.

His achievement puts him in the class of great defiers and self-made rulers—Caesar, Cromwell, Napoleon, Bismarck—and like them he is only half understood if one ignores his imagination and sensibility. Certainly, Luther's anxiety about his soul bespeaks not simply self-consciousness but also imagination; nor must his aggressiveness blind one to the passionate warmth of his affections and the rich variety of his gifts. Fortunately, his *Table Talk,* a work that ought to be as popular as Boswell's *Johnson,* gives us the whole man. [A good version to read is that edited by Preserved Smith.°]

After the break with Rome, Luther turned his house into a kind of student hostel. Fellow preachers, disciples, scholars, refugees—mostly young—came from all over, unannounced, and used and abused his hospitality. At the big downstairs table in the Black Cloister, which was a wing of his former monastery, he would hold forth on the creed, on current events, on people and life at large. He was often poor and his wife, Kathie, would complain about the number of free boarders eating their heads off. He would then do some manual labor for cash or sell a silver drinking cup. Eight of his hangers-on, aided by two secretaries, have paid their debt by noting down and verifying one another's reports of "the doctor's" conversation. It tells us at the same time what the eager young wondered and argued about.

Luther alone among the Reformers stands beside Erasmus for range of mind. Well might he say, in spite of his humility, that "God could not do without wise men." The daily side of him is all common sense and tender feelings. He married, not for love but from conscience, a plain-looking nun made homeless by having followed his teachings. He grew to value her loyal help and to love her dearly. And friendship was with him a cult. In his 50th year—old age then—he found himself bewailing the loss of one friend after another. The death of the closest, Haussmann, left him weeping distractedly for two days.

The soft-spoken Melanchthon, his early disciple and fourteen years his junior, he treated like a son and prized as his superior: "he is concise, he argues, instructs. I am garrulous and rhetorical." Melanchthon, he adds, is a master of Greek and Latin; his own Latin vocabulary is insufficient and lacks elegance. But the young Humanist's pamphlets are bitter. "I prefer to hit out like a boy." This meant that the "boy" used an adult vocabulary of abuse. His antisemitic utterances are sheer vituperation. In the 16C and for a good 200 years more, insult was the accepted seasoning of intellectual debate. The solemn Milton, the sons of the Age of Reason, the aristocratic reviewers of Keats and Shelley used it freely. The mildest of Luther's jibes was to call Dr. Eck, his chief antagonist, Dr. Geck (Dr. Goose). Yet Luther deplored the roughness of German manners and named it *Grobiana,* pseudo Latin from the German *grob,* which means coarse, boorish, uncouth. He inveighed against its frequent cause, drunkenness, "a filthy, scurvy vice."

But Luther was no prude; his common sense shines in his repeated references to sexuality. He knew its power: as a monk he had tortured himself to fight desire, slept on stones, and found this treatment only making it worse. As he said, it is thoughts of "rosy cheeks and white legs" that drive young men to get engaged. "Early love is fervid and drunken, blinds us and leads us on." So it is cruelty to young people to bind them to celibacy as priests, monks, or nuns. Even in marriage it is hard to be chaste. No fierce penalty ought to be visited on those who yield to a force of nature divinely ordained for the begetting of children.

A difficult case in point was put to him by his strong ally among the princes, Philip of Hesse, who, already married, wanted to marry a second wife. The first one was uncongenial and he was devoutly opposed to keeping a mistress. Luther of course wanted to save a good Evangelical from transgressing, and he found among the patriarchs of the Old Testament full justification for bigamy. He gave Philip citations and a caution: "Go ahead, but keep it quiet." It could not be kept quiet. Protestants denounced the crime; Catholics gained a fine argument.

Even so, no one could accuse Luther of kow-towing to the great. He (and later Calvin and Knox) had a habit of addressing princes and princesses as if

they were naughty boys and girls. Clearly, the revolution did not stop one from playing the old role of priest—was he not called "father" for his exercise of moral authority? In the same spirit, with his prime defender the Elector Frederick, whom he never met but dealt with through a majordomo, Luther behaved like an intimate friend, not hesitating to reproach him with neglect.

After all, Luther was the head of a powerful party. Some called him the Protestant Pope, whose ruling must be sought on all questions. This he found an appalling chore. "Princes," he said, thinking also of himself, "are gods burdened and tempted, whereas the people are blessed and without temptation." He admired his political foe Charles V for shouldering such painful duties quietly and steadily. For 28 years Luther preached three or four sermons every Sunday, in addition to writing the innumerable tracts, Bible commentaries, translations, and the letters already mentioned. They come to 55 volumes in the standard English edition. It is no wonder that he left money matters and other domesticana to Kathie.

For relief from heroic deskwork he relied on the sights of nature. He had an intense love of living things and became something of a naturalist. He played the flute and the guitar, composing or adapting tunes to his own words. Some 40 hymns are attributed to him, including the superb *Ein feste Burg ist unser Gott.* Contemporaries said that these hymns did as much for the cause as his books. Indeed, the place of music was for Luther "next to theology. The Devil hates music because it drives away temptation and evil thoughts." In the schools for boys and girls that Luther wanted to see established he would allow no man to teach who could not sing, "nor would I let him preach, either."

I don't understand this wretched malady at all. I take it that it is made up, first, of the ordinary weakness of advanced age; second, of the result of my labors and habitual tension of thought; third and above all, of the blows of Satan. If so, there is no medicine in the world that will cure me.

—LUTHER (1543)

Alternating with passionate work were bouts of deep depression, illness ("the stone"), plus the self-discipline required by his faith. He must force his expansive heart-and-mind to obey the commands he found in the Bible. He read it through twice a year and thought it perfection, but concluded: "If one consults reason alone, one cannot assent to the articles of our faith." It was full of mysteries; "we are fools to try to explain them." This makes preaching Christianity not only a hard task but also dangerous. "Had I known, I should never have been a preacher."

This avowal from the rediscoverer of the gospel distinguishes him from most of his followers—one cannot imagine Calvin or Knox making such admissions—and brings him nearer to Erasmus than he knew. But one thing he did know: he was not "one of the prophets." He "heard no voice"; he did

not even think himself "justified," meaning saved. Yet here he was, doing God's work, in part against the grain. "I smote the peasants; all their blood is on my head; the Lord God ordered it."; some of his early books he found offensive. In touch with the unseen, he kept arguing with the Devil, and he was sure that witches must be put to death, quickly, to prevent great harm. Magistrates must not be squeamish. "Consider how harsh is the law of God the merciful when he says: 'He that curseth his father or mother shall be put to death.'"

<div align="center">*
* *</div>

This unhappy reflection of Luther's brings out one trait that marked the age. Once literal biblicism had taken hold, all imaginable acts of cruelty, moral, social, and political, found their warrant somewhere in scripture. And this, even though the two Testaments were at odds—harsh and merciful, as Luther observes. As in later secular ideologies that command total submission—say, Marxism—much depends on which part of which scripture is invoked. In the Protestant revolution, the Old or the New dominates one generation, one place, one leader or another. Or again, both are followed, inconsistently, and the interpreter alternately forgives like Christ and punishes like Jehovah. For merciful souls, piety can amount to a sacrifice of natural feeling in obedience to righteousness; to punish becomes a painful "work" in the Catholic sense.

Characteristically, Luther's zeal in punishing was reserved for criminals and those in league with demons. Others, he thought, should not suffer for their opinions as he saw that they did in Geneva under Calvin. Luther also saw Melanchthon working at astrology and continually predicting the emperor's death; this was idolatry: "the stars have nothing to do with us." But astrologers and alchemists were not to be punished or even badgered. Copernicus with his sun-centered astronomy was a fool exploiting a crazy point of view—let him alone. Humanists such as Erasmus were atheists and would be taken care of hereafter. It does not do to be grim about "big things without remedy."

A strong sense of humor kept Luther (like Erasmus and unlike almost every other Reformer) from fretting about human weaknesses. He knew he shared them, and in keeping with the gospel, he preferred the repentant sinner to the self-righteous. In fact, he burst out several times against "the merely good man." This antagonism between faith and moral conduct has been repeatedly manifested in western culture. A latter-day form of it appears in the scorn of "the bourgeois and his values." Respectability seems dull and cowardly compared to sin and crime. It was in this mood that Luther prepared himself to give a sermon about Noah, the patriarch noted for his

drunkenness: writing it the night before, Luther "laughed as he took a big swig of beer."

But then comes the difficulty. To hold the true faith, Scripture is the only guide: every word of it is "a precious fruit," of plain meaning, not to be turned into allegory. Doing so was what made atheists. Luther mocked the breed: "I'll write them a few allegories myself." At the same time, a man of intelligence and honesty such as Luther cannot be blind to the many contradictions in the divinely inspired text. He must have suffered when, on Old Testament authority, he recommended bigamy (and secrecy) to Philip of Hesse, knowing that St. John and St. Paul, his favorite apostles, would never have condoned that solution. Again, he had to dismiss St. James as "a gospel of straw," because it called for good works as an earnest of faith.

At the end as at the beginning in his monastic days, he confessed how feelings and belief struggled within him. His favorite daughter had died, and he cried out: "Darling Lena, it is well for you. I am happy in spirit, but the flesh is sorrowful." Every passing year added to his unhappiness—defections from the new teachings; the lessening of his influence; increasing greed everywhere ("the princes are profiteers"). The world was "ungrateful for the gospel"; the Turks were "invincible"; the emperor kept making gains against the Protestant League; in short, his life's work was unraveling. Surely the end of the world was near. People were seeing visions—blood, figures, and fiery crosses in the sky. It could not last; the finish was at hand.

His own end came not quite 30 years after the posting of the theses, in 1546. The next year Wittenberg was besieged and the then Elector of Saxony captured and dispossessed. Luther's revolution was doomed. Another eight years of struggle had to pass before peace within Germany was concluded. It recognized the independence of the new sect, but collectively. Every German prince could go the Evangelical or the Catholic way (likewise every town), but his subjects would be bound by his choice; they could leave freely; self-exile would be the lot of the recalcitrants. In this last provision INDIVIDUALISM was implied and partly actual. Nothing had been achieved universally, but the revolution was a fait accompli and for large portions of the occident life had radically changed.

The New Life

IN HIS *JUDGMENTS ON HISTORY,* Burckhardt summarizes the Reformation as an escape from discipline. EMANCIPATION is indeed the immediate appeal of all revolutions. They inflame the feeling that life in society is perpetual constraint, the eternal cause of Freud's "discontents."° This feeling goes with another, that the ancestral scheme of things is a heavy routine, not sufficiently relieved by the free play of Erasmian "folly." Again, boredom and fatigue.

Burckhardt's verdict reminds us that the thick crust of custom that broke in the early 16C did not consist solely of abuses; nor did the revolution benefit in a material way only the princes. It threw off Everyman's shoulders a set of duties that had become intolerable burdens. The "works" denounced by the Evangelicals took a daily expenditure of cash, time, and trouble. The service of the Mass had been free, but celebrating the other milestones of life— a child's christening and first communion, a couple's marriage, and the final rites at bedside and gravesite—cost money. Penance after confession of sin might entail a pilgrimage to a shrine or some other tangible sacrifice and, latterly, the purchase of an indulgence.

The good Christian must give alms regularly and pay for votive candles or special masses for the sick or the dead. Then would come the "Gatherer of Peter's Pence," to help the pope rebuild St. Peter's in Rome; and next, the begging friar knocking at the door. To carry a body across town to the cemetery the fee was one noble (about six shillings), the price of 20 prayers for the departed. In certain predicaments a dispensation was required, an expensive necessity. It was galling, too, to see one's tithes (the 10 percent church tax on land) going not to the poor parish priest but to the prosperous monks nearby, who did little or nothing toward saving the souls of the taxpayers.

The demands on time and effort included confession, fast days, and taking part in processions on the many holidays. Some of the pious rich might feel obliged to establish a chantry, an endowment for singing masses in perpetuity for the dead. Others, at death's door, would bequeath their goods and land to the church, thus depriving their heirs and shrinking the supply on the market.

These good deeds created the clerical interest—and the anti-clerical opposition. Princes saw their territories nibbled away when large estates were handed over to bishops already heads of provinces. Merchants and artisans in the free cities lost gainful working days as more and more saints' days were declared feast days. And since bishops had to pay their first year's revenue to the pope, while the people's pence took the same route, secular rulers felt alarm at the drainage of coin Romewards.

How much more anxiety than solace resulted from the incessant formal devotion cannot of course be gauged. A pilgrimage to far-off St. James of Compostella in the extreme west of Spain, or a trip to worship relics in the large town nearby, might gladden some sinners as a welcome break in routine, and so could the feasts and processions. Taking ritual trouble regularly was like our precautions for keeping up bodily fitness; prayer, confession, and fish on Friday were akin to jogging and counting calories; the distant shrine was the Mayo clinic. These analogies hold only for those who lacked fervor— always the greater number; but all knew that to fail in care about one's soul meant perdition. Regular exercises buttressed faith in sound psychological fashion until the system was denounced as a crude scheme of debits (sins) and credits (works) to be totted up on Judgment Day. When this banking operation collapsed, Luther could exclaim, "We have found the Savior again!"

To invoke the Savior in the place of works was to change reality; that is, to reshape culture and individual behavior. Worshipping the saints had been a kind of polytheism: they were the powers to entreat. Every living person, every activity and institution, every town and village was dedicated to a patron saint, and aware of living under his or her protection. Many Catholics in Europe still celebrate not one's birthday, but the day of the saint after whom one is named. Travelers would rely on St. Christopher, sailors on St. Elmo, old maids on St. Catherine. One prayed to St. Germain for sick children, to St. Sythe for lost keys, and to St. Wilgefortis for getting rid of detested husbands. Those in hopeless trouble beseeched St. Jude.

This distributed worship had come into being when the early church converted the pagan populations of the West. To make the new creed intelligible and congenial, Christian rites and holidays were adapted to existing customs. Saints took the place of local deities; Christmas, Easter, Rogations (the springtime blessing of the fields) re-enacted the original pagan festivals. Hence the Puritan hostility to Christmas, forbidden by law for 22 years in 17C Massachusetts and, in our day, by the Truth Tabernacle in South Carolina (125 members), who hanged a Santa Claus in 1982 to make the point clear.

Luther was induced by overwhelming tradition to condone the worship of the Virgin Mary. The late Middle Ages, thinking of mercy as peculiarly maternal had made her, not Christ, the intercessor in forgiveness. Luther recalled that in his youth to mention Christ in a sermon was considered

"effeminate." But Luther did not allow prayers to the Virgin's mother, St. Anne, or to the rest of the blessed troop.

These details of the new life after Luther point to something easily over-looked: the revolution was strictly speaking not religious but theological. Christianity was not replaced by another *religion*. The Occident continued to believe in the same revelation of the divine events described in the old Scriptures. Everybody still moved about not only in fields and streets but in an unseen world full of dangers, though ruled by a Power righteous and eternal, who governed every event and took note of every motion of the spirit within the individual soul.

The overturn, then, was in the slowly built-up system of ideas surrounding the faith, which is to say ideology. The more modern term makes it easier to understand the fury unleashed among the multiplying sects, each differently revisionist. It also explains the moral paradox of "wars of religion" in the name of a Christ who preached the brotherhood of man. On that injunction there seemed to be a meeting of minds; it meant: "Be my brother or I will kill you."

*
* *

To understand the feelings that kept up the sectarian bloodshed, it is not enough to cite material interests. These did lead to war, but the passion was for more than winning back possessions or exacting revenge. What makes it hard to recapture the quality of religious beliefs in the 16C is that so much has happened since to draw the human mind and heart away from the goal of saving one's soul. The meaning of faith has changed, its native quantity has been divided, its quality diluted. People blithely speak of someone's (or their own) religious *preference*—as if it were something like a taste in food or sport.

The change has come about not simply because, for the majority in the Occident, physical science has usurped the place of "our best hope and trust." It has come about because every believer is surrounded by a host of non-believers, as well as by believers in many different creeds. All being tolerated, all must be worthy of belief, all are in some way "right." In the 16C and earlier too, there were some atheists, but Disbelief is one thing—it can be explained away as perverse wickedness. *Un*belief is something else, far more unsettling to the believer, especially when it becomes the norm. When faith loses its singleness, its central role in life fades away, and with it the feeling that comes from knowing one's view of the world universally shared. When all around take fundamental ideas for granted, these must be the truth. For most minds there is no comfort like it.

This is not to say that the Protestant Revolution ended by destroying all belief. Millions of church-goers today, hundreds of sects, prove its vigorous survival (<10; 28>). Indeed, in the 1990s the believers' attacks on what they

call "secular Humanism" are so vehement that after a long slump religion has regained an important place in public debate (40>). But Protestantism did destroy in the West the possibility of that ancient solace, single truth and unanimous belief.

Religion defined, Middle Ages and Early Modern Times:

—A monastic order. —A reference to outward signs rather than inward faith. *Root meanings, various:* —To collect, bring together. —To tie back, to bind. —To read over. —Tradition. —To reverence from fear. —Scrupulous attention, to re-collect oneself.

—FROM DICTIONARIES IN SEVERAL
 LANGUAGES

Not that in what is called "the ages of faith" everybody understood the one faith alike or with the same degree of devotion. To some, as always, salvation meant only personal safety, or even less: mere conformity. The point is that in earlier times people rarely thought of themselves as "having" or "belonging to" a religion. The word itself had various uses. Everybody "had" a soul, but did not "have a God," for God and all that pertained to Him was simply *what is,* just as today nobody has "a physics"; there is only one and it is automatically taken to be the transcript of reality.

The 20C obviously needed a new word to recharge *belief* with its full meaning. Hemingway in his book on Spain tried to do this by saying: "It was not something he believed in. It was his Belief." With a like intent, some modern theologians call belief "the interruption of faith"—virtually a heresy—because belief implies a statement or thought "about" the object of faith, which distracts the mind from being suffused by its reality. This view in fact dates back to St. Augustine in the 5C.

Catholicism has a conception of the Christian ideal: to become nothing in this world. Protestantism is worldliness from beginning to end.

—KIERKEGAARD (A 19C PROTESTANT)

The Reformation was the scraping of a little rust off the chains which still bind the mind. … Darwinism is the New Reformation.

—T. H. HUXLEY (A 19C AGNOSTIC)

Whether more or less faithful, people before, during, and after the revolution never doubted that they needed God's help from moment to moment. In their letters they invariably call for God's blessing on the recipient, on the sinful age, on the writer's next trip or project. Merchants opening a new ledger dedicate it on the first page: "In the name of God and profits." Striking incidents are divine warnings or commands, as when young Luther, terrified by a thunderstorm on his way to law school, felt his fright as a sign of God's will that he should serve Him. Then and there the youth took a vow to become a monk.

Prayers were in order several times a day, like our hygienic ablutions,

because the Devil and his minions were as ubiquitous as our viruses. Satan went up and down the earth like a campaigning politician making promises. During his own travels Luther found him in woods, thick clouds, and waste places. He knew that the Devil's interference accounted for the varying fortunes of the Evangelical cause. Witches close at hand were a menace too, even when they offered to cure ailments and did so. Catholics of course could counteract Satanic intentions by calling on saints or relics for help. Practical Christianity for both groups resembled the eastern heresy called Manichean: two powers run the world, the evil one must be fought and the good placated.

These vicissitudes were a reminder of the worth of salvation. To gain it puts an end to all troubles and the assurance of it is the greatest boon—hence the "comfort" that Luther found in predestination. By it salvation is guaranteed to the elect. They have grace, a free gift that no deed can obtain. Even so, the best of Christians might feel anxious when ill or on the point of death: was he or she really destined for eternal life? Salvation in the 16C and long after was understood as "resurrection of the flesh." The promise of the gospel was literal: the body would come into being again. As the learned told those who asked, St. Augustine had explained that the hair shed in life and the fingernails cut would be restored in full, though invisibly, in the new heavenly body.°

The different phrase now in use, "immortality of the soul," promises something less definite, a faceless, disembodied bliss. It had no wide currency till later centuries. As a Catholic dogma, it dates only from 1513 and it was not then addressed to the people, but to the learned. It was intended to refute certain philosophers who had talked about a "unity of the intellect," meaning by it a

> The Turks tell their People of a Heaven where there is a sensible Pleasure, but of a Hell where they shall suffer they don't know what. The Christians quite invert this order; they tell us of a Hell where we shall feel sensible Pain, but of a Heaven where we shall enjoy we can't tell what.
>
> —JOHN SELDEN, C. 1650

fund of spirit emanating from God, out of which the soul is fashioned and to which it returns. These philosophers' notion anticipated 19C European and American Idealism with its Absolute as both God and reservoir of soul-substance.° The prospect of individuality lost in a merger with others would have been intolerable to Evangelicals and Catholics alike, particularly the former, whom William James called "the unsocial Protestants" for their insistence on having each what one might call today his "hot line" to God.

So important did some 16C believers consider individuality that they declared each soul separately created. Others were content with a collective origin. The former were called Creationists. The name now refers to those who attack Evolution and believe that the whole human race was created in and through Adam and Eve.

*
* *

So much for ideology. The revolution also changed other parts of cultural reality. The Protestant church, the building itself, was no longer the town hall for public business, the banquet hall on feast days, and the theater for moral dramas. Nor were any burlesques put on there, no Feast of Fools, run by a "lord of misrule" for the annual saturnalia that afforded a relaxation of discipline. If newly built, the Protestant "meeting house" could not serve like the cathedrals as a refuge for women and children in wartime, and certainly not as a sanctuary for criminals; its central and civic role was gone.

With each new sectarian reform, the houses of worship became more and more bare of ornament. Luther did not object to flowers, nor did he, like some zealots, want to break the stained glass of the ancient churches or vandalize the sculptures. But pictures and altar cloths, candles and relics, and the crucifix must go, incense too, and the priests' vestments, of which the Roman church had a profusion. Color and cloth, shape of hat or stole, gold or silver ornament or piping went with rank or occasion and made up an impressive show. It was, said the English Puritans and Presbyterians, "idolatry dressed up." Significantly, for those on whom the pull of religion is partly sensuous, Catholicism has remained their church; it has recaptured them in each generation. For the rest, the age-old association of the church with art was broken forever.

In the new church the minister, probably a married man with children, officiated in ordinary clothes. The parson was none other than the *person* appointed to serve the rest, though he was still expected to have some learning and to be more or less formally ordained. The congregation acting as an independent body had chosen him; and as dissident sects multiplied, the congregations more and more assumed the support of their leader and their activities. The Lutherans still employed bishops, sometimes elected, and paid by the state. The Anglicans retained the hierarchy; other churches used laymen as deacons or elders. The thoroughgoing souls at last took Luther literally—"everyone a priest"—the Pietists and the Quakers "minister" to themselves.

Protestants of all types became self-sufficient also during the musical part of the service. No choir, no clerics sang on the congregation's behalf the praise of the Lord. All the faithful gathered together sing, inexpertly but sincerely, simple words and tunes. The hymns, composed perhaps by Luther, are based on a psalm or a gospel idea versified, uttering threat or promise: "Whatever, Lord, we lend to Thee, Repaid a thousandfold will be." No one kneels or confesses. Everybody partakes of communion "in both kinds," meaning that each receives bread and wine—and it is real bread, a bit stale, not a consecrated wafer. Formerly, only the priest drank the wine, lest a layman should accidentally spill the blood of Christ. Clerics who did had their thumbs cut off.

Another discard: the mumbling in Latin to uncomprehending ears by an absentminded priest. Clear words in everyday language carried the homily, now called sermon. It has shrunk in size over the years, but when it first became the main part of the Evangelical service, and particularly when it celebrated public events, it could last three hours. Well into the 19C the "lesson" expounding a sentence or two from the Bible still needed an hour, and attendance at two services on one day was no uncommon habit. "The English Sunday" came to signify a peculiar division of human time.° Lacking relics and images, Protestants go to church only for services (children for Sunday school), instead of at any hour of the day for prayer or recollection, as Catholics still do.

The Evangelicals made the sacraments less awesome. No rites for the dying, and the others ceremonial rather than magical. Communion—earlier, the Eucharist—was celebrated less often than the Mass had been; Luther thought four times a year was enough; and it could no longer help the dead or relatives and friends. Other emancipations: a Protestant could marry a first cousin and, if really "advanced," could refuse to take oaths or serve as magistrate.

The change of greatest consequence, a cultural step comparable to Mohammed's gift of the Koran to his people, was making the new life find its mental and spiritual food in the Bible. Luther had never seen a Bible until he was twenty. His very thorough religious education had been based on a selection from the church Fathers. But more than one thinker before him had wanted to bring the word of God to the people and a dozen translations into the common tongues had been made. Once again, it was Luther who compounded these efforts and made the Bible The Book for all Protestants (bible *means* book) and even forced it into the Catholic consciousness.

The results for Protestants were remarkable. To start with, it gave whole populations a common background of knowledge, a common culture in the high sense of the term. A 19C incident makes the point vivid: when Coleridge was lecturing in London on the great English writers, he happened to mention Dr. Johnson's finding on his way home one night a woman of the streets ill or drunk in a gutter. Johnson carried her on his broad back to his own poor lodging for food and shelter. Coleridge's fashionable audience tittered and murmured, the men sneering, the women shocked. Coleridge paused and said: "I remind you of the parable of the Good Samaritan" and all were hushed. No amount of moralizing could have done the work of rebuke and edification with such speed and finality.

The Bible was a whole literature, a library. It was an anthology of poetry and short stories. It taught history, biography, biology, geography, philosophy, political science, psychology,

Bibles laid open, millions of surprises!
—GEORGE HERBERT, "SIN" (1633)

hygiene, and sociology (statistical at that), in addition to cosmogony, ethics, and theology. What gives the Bible so strong a hold on the minds that once grow familiar with its content is its dramatic reporting of human affairs. For all its piety, it presents a worldly panorama, and with particulars so varied that it is hard to think of a domestic or social situation without a biblical example to match and turn to moral ends.

With the Bible most often the only book in the house, kept in a place of honor, and with its first blank page containing the family records—names, dates of birth, marriage, and death—came the practice of family prayers three or four times a day, besides grace at meals. It was natural that if father or grandfather read a story from scripture to the assembled clan, servants included, the feelings aroused should be summed up in the Lord's Prayer or some other appropriate to the moment. When secularism came to prevail, Bible reading disappeared among the majority, and with it the background of ideas and allusion common to all. In this role, the only ecumenical replacement one can think of is the daily newspaper's comic strip.

<p align="center">*</p>
<p align="center">* *</p>

During the modern era dozens, scores, hundreds of Protestant sects have grown out of the first Evangelicism—the count at present is around 325 and unstable. Inner light, coupled with brooding over scripture, has been the efficient cause. Dissent has kept arising about details of practice as often as about articles of belief or the authenticity of the new prophets. Differences might be small but symbolic. The Amish reject machinery and the Mennonites buttons. The unbalanced but charismatic George Fox, to equalize ranks, made the Friends (the Quakers) use (misuse) *thee* instead of *you* and not take off their hats to anyone. The Mormons favor polygamy in obedience to an additional latter-day scripture; and by a still more recent prophecy, the Christian Scientists deny pain and, quite logically, medicine. Reserved to our own time are the cults in which salvation is reached by group suicide.°

The longest, most violent—and indeed blood-spattered—clashes were about the Eucharist, the Trinity, baptism, grace and merit, and predestination. The one tenet common to the Evangelicals was abhorrence of the Catholic church, the "whore of Babylon." Only one group centered at Strasbourg and led by two able thinkers, Martin Bucer and Oecolampadius (Johann Huszgen), pleaded for agreement on the fundamentals and an end to lethal hair-splitting. They were called Fundamentalists, or even better, *Adiaphorists,* which means anti-destructionists. They were hated by all the others, excepting a scattering of thoughtful scholars or statesmen. Mildness and wisdom did not suit the times. Today, in Islam as in Christian lands, Fundamentalism means the opposite of the Strasbourgers' temper and its expression is expectably violent.

Were these issues matters of moment to their time only? Not if one makes some effort to see the cultural continuity between two modes of interpreting human experience. Granted the differences of language and social environment, the parallels will show the path we have traveled.

Let us drop these diabolical words, these party names, these factional, seditious terms—Lutheran, Huguenot, Papist—let us not change the name of Christian.

—CHANCELLOR MICHEL DE L'HOPITAL AT THE OPENING OF THE ESTATES GENERAL OF 1560

To the first Reformers, the Eucharist, which means thanksgiving and commemorates Christ's Last Supper with the Apostles, was the central sacrament, as it was to the Catholics. But the Protestants balked at the notion of the priest as a miracle-worker who transformed the bread and wine into Christ's flesh and blood—transubstantiation. Lutherans believed in consubstantiation: the blood and flesh side by side with the ordinary materials. This was called the Real Presence, a mystery, but not a magical act done by a man in a cassock. The Calvinists took the bread and wine as symbols only, simple reminders of the Last Supper. When Calvin was questioned about the Real Presence, he said that Christ was everywhere and hence present at the sacrament also. The mystery was removed to a distance.

The Calvinist thus edges a little closer to seeing poetic meaning and psychological truth in periodic thanksgiving to lessen pride and ego. The naturalistic interpreter goes the whole way and sees that it is the sinner, cleansed of sin and grateful for pardon, who has undergone a wondrous transformation: his spirit is now as Jesus would have it. Is this a mystery or not? No answer seems conclusive if we ponder any important change in ourselves—for example, how our bodies cure themselves, sometimes nudged by "miracle" drugs; sometimes by placebos in the form of bread pills; occasionally by an emotional shock. Again, when our minds undergo sudden, profound alterations—in opinion or belief, in love, or in what is called artistic inspiration—what is the ultimate cause? We see the results, but grasp the chain of reasoning at a link well below the hook from which it hangs.

Next, consider Predestination, which states that individual merit does not ensure salvation and that man has no free will. This has been the most widely held Protestant dogma. When an idea possesses so many minds and such good ones, it is foolish to write it off as fantasy; one must look for the experience on which it rests. Luther supplies it: his seven years of helplessness till lifted up by grace. It was said earlier that predestination was still maintained by a good many non-believers (<12); they might be surprised to hear it; they do not, indeed, believe that eternal damnation is decreed for the many, including unbaptized infants. But they do believe in scientific determinism—the unbreakable sequence of cause and effect, and that is predestination. It is the assumption all laboratory workers make and it rules out free will. Any

present state of fact, any action taken, is the inevitable outcome of a series of events going back to the Big Bang that produced the universe.

Social scientists and common folk who babble about genes or the Unconscious or "man a chemical machine" similarly account for others' actions and their own as did Luther and Calvin. The road taken was set from all eternity, with no choice at any moment: will is an illusion. The sense of being driven by a power not ourselves is not uncommon, especially among great doers and creators. Some temperaments seem born worshippers of Necessity—Frederick the Great for instance, who outgrew his Calvinist upbringing but remained a fierce determinist. Modern criminology is rooted in this conviction and public opinion in the main agrees: the criminal is not responsible for his acts; he is "conditioned." Grace (the right heredity or environment) has been denied him.

Other root beliefs of the 16C also have their present counterparts. Luther's agonizing about sin is matched by the Existentialist preoccupation with *Angst*, or despair at "the human condition." Unaccountable "guilt" may be said to be popular today, notably among the many sufferers of depression. It is sometimes cured, as Luther's was, by introspection, on the analyst's couch and by acceptance of what is thus revealed. Catholic confession was a summary form of the therapy.

Nor has the word *sin* disappeared from the vocabulary of the enlightened. More than one modern novelist, poet, or social theorist has attributed the horrors of our time to original sin, although its definition is left vague. It presupposes that human nature is fatally flawed. This is a more ruthless belief than the theologian's, since it does not include a Redeemer from sin or the efficacy of baptism. In the 16C both together lifted that terrible burden. For some in our day what redeems "scientifically" is political revolution, after which history will stop and society will know happiness without laws—in other words, the Kingdom of the Saints fought for by the Anabaptists and others for 100 years (<15; 265>).

Keeping in mind the endless translation of ancestral thoughts and feelings effected by evolving culture, we can follow with sympathy the Reformers' arguments and the choices among the mysteries that they confronted. Luther said of the Trinity that he did not so much believe it as find it true in experience. What could he have meant? In the present century that excellent scholar and fine critical mind Dorothy Sayers affirmed the same thing and explained it (742>): the Father, the Son, and the Holy Spirit preside over all acts of creation, artistic and other, each Person playing a distinct part. [The book to read—hers—is *The Mind of the Maker.*] It is true that she allegorizes in the way Luther reproved, but can he have done anything else if it was experience and not faith alone that made him a Trinitarian?

Some of his contemporaries clamored instead for Unity. Servetus, a

Spanish physician, paid with his life at the hands of Calvin for disbelieving that three could simultaneously be one. He has been called "a martyr to truth," but it is only fair to say that he was just as rabidly bent on persecution as his opponents, and he did much to provoke Calvin in secular ways before the reluctant decision was taken to put him to death. Again about the Trinity, the Sozzini, uncle and nephew, Italian refugees in Poland, argued that rejecting polytheism and the worship of the saints must mean one God and not three. Their adherents, first called Socinians, have been the Unitarians, notably influential in the thought and literature of New England (505>). Logically, the existence of only one God must mean that all religions are one. Innumerable thinkers, from Voltaire and Victor Hugo to Bernard Shaw and Gandhi, have said so, without much effect on western religious institutions.

The minister and his lay visitor, both Protestants, had talked over amiably the differences between their creeds. It was a beautiful lesson in toleration, which the minister neatly summed up: "Yes, we both worship the same God, you in your way and I in His."

—TRADITIONAL IN NEW ENGLAND

The point of drawing parallels between 16C conceptions and the latter-day naturalism, which has obscured but not abolished them, is to show the persistence of meanings within altered expressions of life's mysteries. It is an abstract continuity, for likeness is not sameness. In history everything observed wears its own dress and raises images peculiar to itself. Protestants and Catholics 500 years ago were not "for all practical purposes" our doubles who happened to talk poetically instead of scientifically. The Socinian's God was not "the principle of unity"; he was Christ the Lord saving sinners. The likeness in these similars is in the human motive: the idea of worshipping one God is akin to the scientific hope of bringing all phenomena under one law.

* \
* *

Juniors are impatient. In any movement, the second generation is likely to be dissatisfied with what it has inherited, including the confused state of affairs produced by the pioneers. The urgent duty is to create a system, a single doctrine, that will exclude the new dissenters, rally the uncertain, and make one flock of the faithful.

For this kind of task, ambition is the agent that selects the leaders. There is no "legitimacy" in revolution; power belongs to whoever can seize it; and the newcomer is most apt to gain it who is most "pure," strict, and systematic. John Calvin was such a man. With a politician's eye and a lawyer's mind, he saw that Luther's piecemeal polemics, coupled with everybody's access to the Bible, endangered Reform. Anybody who could read might think himself "called" to found the true church of God. Extreme views encouraged crackpots and rabble rousers, and the Adiaphorists of Strasbourg were compro-

misers, too broad to be right. Some Catholic priests who had turned Protestant ministers went so far in diversity as to keep offering Mass to their old flock and the Lutheran service to others.

So in 1534 Calvin issued his first book, a small one. It was the germ of Calvin*ism,* which brought about the division of the Protestants into two main bodies. The book was *The Institutes of the Christian Religion* (institutes then meaning teachings), a work often compared to Aquinas's *Summa Theologica*. It cannot compare. The *Institutes* as we have it grew by periodic additions to what was no more than an essay, and though in its final form it is coherent enough, it is not a comprehensive philosophical system. It simply organizes the several evangelical beliefs and anchors them in scripture; it is in fact and purpose a textbook. Its effect on ordinary minds was powerful, but it did not put an end to all innovations. The fertility of the western intellect is great.

For example, Agricola, a good theoretical mind, preached a kind of early Quakerism. He argued that Luther's repudiation of "works" forbade doing anything at all to express belief; if one had genuine faith, one could choose the rules one would obey. Martin Bucer, mentioned earlier, had a vision of the cosmos that was widely adopted, 200 years later, under the name of Deism: God endowed the world that He created with laws to make it endure and He does not intervene in their working. With Providence thus eliminated, the interpretation of events as signs of divine displeasure goes by the board and the importance of prayer and ritual is nil.

In this galaxy the figure of Sebastian Castellio is particularly attractive. He was born in French Burgundy, his original name being Châteillon. His humanistic studies at Lyon soon led him to Protestantism and so to Strasbourg, where he met Calvin. Called by him to Geneva, Castellio was made rector of the academy at the age of 25. But in his biblical studies—he was a master of Latin, Greek, and Hebrew—he interpreted texts in a spirit too liberal to suit his patron and he was refused ordination as minister. He moved to Basel and suffered poverty, but was at last appointed professor of Greek at the university.

Like his colleagues everywhere, he had to argue about predestination and the Trinity and over this latter issue he condemned the Calvinists' execution of Servetus. Out of this debate came what is the first appearance in print of the momentous question: "Whether Heretics Should be Persecuted." Castellio argued the negative. The date was 1554. His translation of the entire Bible, first into classical Latin, then into lively vernacular French, did not keep him from being persecuted and he ended his life poor and a wanderer. His merits were known to a kindred spirit, Montaigne, who has a warm word for him in the *Essays*.

A few others arrived at Castellio's position on heretics: Conrad Mutian, a Deist in the sense given above, believed that all religions are one and thus

could see no point in persecution. Tyndale, another translator of the Bible, argued that to make a belief prevail by fear was wrong and contrary to Christ's word (though "Compel them to come in" could be instanced on the side of force). These solitary Tolerationists were regarded with horror: they simply did not understand the reasons, religious and secular, that justify the drive to uniformity (271>).

Yet another innovator, Carlstadt, once Luther's good friend, took it into his head that as a preacher he must live like the lowest of the low, in shabby clothes, "acting the peasant on his dunghill" (so Luther jeered). Carlstadt denied the Real Presence of Christ at communion, which made him a kind of Calvinist in the Lutheran fold.

The gentlest among dissenters from dissent came to be known, with the usual mocking intent, as Pietists. Their prophet was Jacob Boehme, a shoe-maker. He carried Luther's simplification as far as it could go. God, he said, knows whether one's piety is genuine. If it is, that is enough—no need of min-isters or deacons, of church buildings and services, not even of a name to define a group. In quiet sessions at home or anywhere convenient, pious friends come together to pray and meditate on divine truths. Did not the gospel say that the Lord was wherever two or three are gathered together? Pietism had a lasting influence. It inspired several cohesive sects, such as the Moravian Brothers still extant in Pennsylvania, the Familists (who emulate the Holy Family), the Society of Friends (Quakers), and a quickly suppressed outburst of Catholic mysticism in France, which pitted in controversy two of the greatest writers of the age (298>).

In the Netherlands, Jacob Hermansz, known as Arminius, put forth a doc-trine unwelcome to the tough-minded: Redemption through Christ was for all souls, predestination was not absolute but conditional. Everyone can by his efforts cooperate in attaining grace and be saved—there is free will after all. Akin to the Catholics' "natural grace," this view was soon condemned by all parties, but it quietly found favor among Anglicans and was adopted in the 18C by John Wesley and his Methodists.

> We have a Calvinist creed, a Popish liturgy, and an Arminian clergy.
>
> —WILLIAM PITT, EARL OF CHATHAM (C. 1760)

A last eccentric who should not be forgotten is the German Kaspar Schwenkfeld. If, he said, each soul has a unique destiny, then each man and woman may frame his or her creed within the common Christian religion. They deserve to have faith custom-tailored to their needs. Today, when Individualism has turned from a fitful theme to a political and social right, this seer deserves to rank as the Reformer with the greatest following—millions are Schwenkfeldians *sans le savoir*. A suitable name for their one-man church would be Privatist, if its very character did not forbid its having any name at all.

There remains to look into the work of the pre-eminent ideologist of the 16C, the reformer of Reform,

Calvin

His achievement was to combine in practice Luther's two statements about the Christian's liberty: individual salvation through faith, and subjection to society as antidote to anarchy. The second clause means the control of morals and manners by the state, a system that Calvin brought about without any planning. A provincial French lawyer and humanist scholar, he had gone to Paris and picked up Lutheran ideas. The Sorbonne, keeper of Catholic orthodoxy, reprimanded him and he went to Strasbourg, then the center of Protestant polemics. A bit later, by the age of 32, he was governing souls and behavior in Geneva, one might say, through no fault of his own: in passing through the city he was urged to stay and help out a Reformist minority struggling with the city fathers.

Contrary to common belief, Calvin was not fond of power. Generally in poor health, he preferred study and he did not repine when, in the local struggle, Geneva expelled him. He was soon called back, after which his life was that of a prime minister fighting the crown—the municipal government. Calvin guided, threatened, and conciliated by turns to keep Protestantism in being. Under such conditions no practical detail was too trivial for his attention, just as no backsliding seemed a trifle to his moral sense. But unlike most martinets and bureaucrats, he also had large ideas which he knew how to set forth persuasively. His *Institutes,* now a classic in Latin and French, grew to full length from 1535 to 1559 as the needs of instruction increased with the flood of students pouring into Geneva to hear him. He made the town a second Wittenberg.

The two oracles respected each other, warily. Luther, who had only five years to live when Calvin's fame began to spread, was not best pleased to see so many new recruits differing from his theology only in details and yet bearing a new name. But Calvin—a sort of Lenin to Luther's Marx—may well have saved Protestantism when it was at a low ebb. In Germany after Luther's death, Charles V was winning the war. While Wittenberg and the Elector of Saxony were vanquished, Calvinism was flourishing to the north and west.

Its pulling power was not due to a book alone. The Academy or college that Calvin founded to train ministers and that was to become the city university, made Geneva a European center of learning. The latest converts, the young seekers, the lost souls went there, listened, and more often than not came out missionaries. John Knox, for instance, who a few years earlier had been a galley slave in the Mediterranean, got his training at the Academy before "conquering" Edinburgh. Once there, he sent promising young Scots

to the source of light in Geneva. The place was buzzing with foreigners of all ages and origins. It was a Mecca for the enthusiasts, a city of refuge for exiles.

To talk of Calvin and Knox inevitably brings to mind the label Puritan. It belongs to England and New England rather than Switzerland and Scotland, and like other nicknames it is made to cover too much (262>). Only one feature properly connects it to Calvin: the desirability of self-restraint, in itself not a strange idea. Revolutions paradoxically begin by promising freedom and then turn coercive and "puritanical," to save themselves from both discredit and reaction (428>). Creating a purer life requires that people forget other aims; therefore public and private conduct must be regimented. That is why the theme applicable to revolution is EMANCIPATION and not Freedom. Old shackles are thrown off, tossed high in the air, but come down again as moral duty well enforced.

In Geneva under Calvin people must go to church twice daily. When a truant from services, an adulterer, or a blasphemer was reported by the vigilant elders, someone was sent at once to the erring brother or sister to admonish gently and plead rather than scold.

> **The Church has no punishment but withholding the Lord's Supper. It has no sword to punish or restrain, no empire to command, no prison, no other pains.**
>
> —CALVIN, *INSTITUTES* (1536)

But there was also "the Discipline." If stubborn and persistent in sin, the dear soul must be turned over to the civil authorities. Adultery might mean death, quite as if Jesus had not dealt rather differently with the woman taken in adultery. Blasphemy, that curious crime of "damaging God by bringing Him into ill-repute," was even more unforgivable. Sometimes, alas, for political reasons, a culprit in Geneva might be spared, but social pressure was intense, and the threat of hellfire ever present. Besides, by withholding communion, that is, by excommunication, Calvin could cut off a person from all social intercourse whatever.

Calvinism, it has been said, makes every man the enemy of every other, as well as his own. Certainly its rigor accounts for the agonizing fear of sin that has been recorded in many lives—

Hell's Flames Avoided and Heaven's Felicities Enjoyed

by John Hayward, D.D., 10th Edition, 1696, 33rd Edition, 1733

Bunyan's two years of terror; the poet Cowper's repeated plunge into wild despair when he *knew* that his soul was lost; Byron's lifelong conviction, born of his harsh Calvinist rearing, that everything he found good would turn to evil because *wrong*. Still more surprising, Rousseau's Genevan birth and upbringing influenced his philosophy of life and of the state. The number of plain people, especially adolescents, whose minds were tortured by Calvinist sermons in England and America may be imagined.

In theory at least, Calvin himself was not the extinguisher of pleasure that

There is no middle way between these two things: either the earth must be worth nothing to us, or keep us fettered by an intemperate love of it. ¶ The contempt which believers should train themselves to feel for the present life must not beget hatred of it or ingratitude to God. It has many enticements, a great show of delight, grace, and sweetness. We ought to have such fondness for it that we regard it as one of the gifts of divine goodness which are by no means to be despised. ¶ If heaven be our country, what can earth be but a place of exile? Let us long for death and constantly meditate upon it.

—Calvin, "Of Meditating on
 the Future Life"

Calvinism has come to suggest. In Geneva, playing cards and other recreations were not forbidden. As for enjoyment in general, it was a point on which he and Luther were as Box and Cox: Luther wrote that "the Christian man is dead to the world," yet, as we saw, he granted a large place to instinct and nature; he relished life (<17). The ailing Calvin was not a relisher; his advice is contradictory and leaves nature a rather narrow crack through which to manifest God's goodness.

*
*　　*

When the two great sects are taken as wholes, the geographical lines of demarcation at the end of the 16C are clear, though not exact. The German states were generally Lutheran, part of France and of the N. :herlands were Calvinist. Sweden and its neighboring dependencies were Lutheran, Switzerland two-thirds Calvinist. England made a creed of its own more antipapal than thoroughly reformed. Scotland was Calvinist. But everywhere enclaves of heresy and rash individuals occupied the persecutors for nine generations.

Self-repression for the sake of freeing the spirit had other than strictly religious consequences. It resembles the ethos of the ancient Stoics, and we shall not be surprised to find their doctrine adopted as a living philosophy by many humanists in Calvin's day and the century following (52>). Clearly it was not his influence alone but something in the common temper that made discipline congenial. After the expansiveness of rebellion and the excitement of a new turn in culture, there is savor in austere deportment and sober expectations. Oddly enough, these ways of dealing with the self have in our day been believed to throw light on a complex economic question: the rise of Capitalism. Thanks to repetition, the thesis proposed by two scholars, one German, the other English, has become a thought-cliché: the Capitalist system owes its birth and success to the moral teachings of the Reformers. The Protestant "work ethic" created the entrepreneur, the economic man as we know him under capitalism.

But was the God-fearing Protestant—anxious soul—really predestined to be a capitalist? The sociologist Max Weber and the socialist R. H. Tawney wrote quasi classic books that give complementary accounts of this supposed cultural connection. It pleased the modern critics of Capitalism by linking

that system and its evils to a "straitlaced morality" and "a discredited theology," at the same time as it vexed the strict Marxists by substituting a spiritual for a materialistic agency in the march of history.

Weber and Tawney based their thesis on social and psychological grounds: Protestantism, by leaving the believer in doubt about his salvation, yet holding out the chance of grace, encourages him to act as if already an elect—sober, earnest, hardworking. His moral code makes him *calculating* at every turn—the ideal man of business. On earth and beyond, he faces risk with fortitude while taking all thoughtful precautions. The Catholic, by comparison, is easy-going, pays his way spiritually by symbolic "works," most of which have no practical effects on earth. Far from praising real work, he sees it as Adam's curse. His church condemns as usury any demand for interest on loans. And the model man is not the one who achieves material success; on the contrary, poor and humble is the mark of sanctity.

These two studies brought out some interesting cases of moralizing about life and work, ranging from the Puritan Baxter to Benjamin Franklin and his canny Poor Richard. But neither Weber's nor Tawney's somewhat different demonstrations has stood up to criticism. For one thing, Weber's notion of Puritan "asceticism" is an exaggeration, both verbal and factual (262>); and more important, Capitalism long antedates the Protestant revolution and hence must have had a "spirit" at that earlier time. Permitting usury and trade by means of capital were argued for in the late Middle Ages—and practiced. Medieval abbots lent their surplus funds at interest, and if the rate was no higher than ten percent, they received dispensation from the guilt of usury.

Again, large-scale banking thrived early in Italy—the Medici are the outstanding example—and so it was not the child of Protestantism. When it occurred, it was in Italy that it made the least headway. Facts from the Protestant side itself refute the thesis: both Luther and Calvin attacked profit-making and deplored "the materialism of the age." (Every age is "materialistic" and fit for deploring.) Calvin reluctantly agreed to allow charging five percent interest in certain narrowly defined cases. He urged his flock to live as modestly as possible, so as to always leave something for charity. Whoever went in for Capitalist enterprise in the 16C was not spurred on by Calvin's teaching or Luther's. And throughout the 17th, preachers everywhere kept denouncing usury and lust for gain.

Besides, the newly Protestant countries did not lead Europe in economic progress. Catholic France outstripped all others till its costly wars in the late 17C set back its prosperity. As for the great towns of north Germany, the Netherlands, and the Baltic, their trade was flourishing long before the Reformers' ideas reached them. A final point, which incidentally shows how poorly knowledge percolates in our "age of communication": Weber in his

argument lists the Protestant ethic as only one element, which further study must relate to half a dozen others before it can be known how far "the Protestant ethic" promoted "the spirit of capitalism."°

*

* *

The cultural predicament after a revolution is how to reinstate community, how to live with those you have execrated and fought against with all imaginable cruelty. Here and there, to be sure, compromisers still existed after three decades of violence and abuse, and as late as the year before Luther's death the Protestants were invited to send delegates to a Council of the church that was to meet at Trent to review Catholic teaching and practice. The opportunity was declined.

The Protestant Reformation being a revolution, it would seem logical that the Catholic Counter-Reformation devised at Trent should be called a counter-revolution. In fact, the theological and administrative decisions taken by the Council were not revolution but reform, the only reform of the century—a deliberate large-scale change without violence. The bishops were certainly deliberate: they took 18 years, in three bouts of discussion to reach a consensus. It was a providential schedule: old resisters could be gradually argued into their graves.

The English cardinal delegate Reginald Pole tells us what the Council aimed at: "the uprooting of heresies, the reform of ecclesiastical discipline and of morals, and lastly, the eternal peace of the whole church. These we must see to, or rather, untiringly pray that by God's mercy they may be done."°

One of the means was to restate things clearly and require them strictly: the creed, the catechism and missal, the exclusive use of the Vulgate version of the Bible, and the guidelines governing the Index of Prohibited Books. The Roman Inquisition was revitalized and assisted by the bishops' visitations; seminaries were established in Rome, one for each nation, and a mission given to designated orders, chiefly the recently founded Oratorians and the Jesuits. An interesting coincidence: the order founded by Loyola as The Society of Jesus to reconquer the countries lost to Protestantism came into action within a few months of Calvin's parallel Discipline for those who would go forth to make Protestant converts.

To counter the Evangelicals' PRIMITIVISM, Cardinal Baronius wrote a history of the early church, a classic that gained topical interest from the discovery of the catacombs, the underground passages in Rome in which the earliest persecuted Christians took refuge. The traces of their presence reinvigorated the worship of relics and strengthened the papacy by reminding the faithful that the church triumphed thanks to its first martyrs, including St. Peter, *at Rome*.

The resolve sealed at Trent recaptured a good deal of territory, notably

Poland. It succeeded because it was in large measure organized against INDIVIDUALISM. It enlisted the minds of men as zealous and capable as the first Evangelicals and readier than they to work in teams on a common plan. One of these, Ignacio de Loyola, a Spanish soldier, self-converted, who had a genius for administration, united a small band of seven (later ten) for a pilgrimage to the Holy Land. When war on the Mediterranean with the Turks made this impossible, he thought of creating an active society for re-awakening faith and he began writing his *Spiritual Exercises*—rules for meditation and discipline. The *Exercises* are a masterpiece of applied psychology. Unlike earlier guides— indeed, contrary to their teaching—the rules called for the user to picture the topic of his thought or prayer, to see the incidents of Christ's life, and at times to form an image of the self at these tasks. This "application of the senses" formed a group of missionaries at once spiritualized and in touch with the imaginings of common folk.

The popes after Trent were similarly zealous "gospel men" with large ideas. The Jesuit Order having been recognized at last by the Vatican, its members soon spread beyond the confines of Europe and began making Catholics of the people of the New World and the Far East, defending them, often, against the greed of their conquerors. At home, the cultural split in the new life was tangible: the Catholic effort to regain ground produced new works of architecture and the fine arts; the Protestant effort produced literature and large works of doctrine. The Calvinist courts in particular favored learning and Scotland

> Perform the acts of faith and faith will come.
>
> —LOYOLA, *EXERCISES* (1548)

> Assume a virtue, if you have it not, . . .
> For use can almost change the stamp
> of nature
>
> —HAMLET TO HIS MOTHER (1602)

> So with faith, if it does not lead to action, it is in itself a lifeless thing.
>
> —THE GOSPEL ACCORDING TO ST. JAMES

> Only act in cold blood as if the thing in question were real and it will become so knit with habit and emotion that our interests in it will be those which characterize belief.
>
> —WILLIAM JAMES, *PRINCIPLES OF PSYCHOLOGY* (1890)

started popular education. The Catholics put up or restored churches, commissioned altar pieces and paintings and sculptures of the Virgin and the saints—witness the abundance of Baroque art. The Protestants contributed *Pilgrim's Progress*, the poems of Milton and Marvell, Jeremy Taylor's *Holy Living and Dying* and (as will appear) a spate of tracts, many of them in favor of rule by the people (265>).

At the same time as it cleansed and refurbished the ancestral fabric, the Council of Trent tied reform to narrow views; in this respect, it too went PRIMITIVE. The aim was to oppose Protestant errors: the result was to freeze Catholic beliefs at the point that European ideas had reached by 1500 or even earlier. Doing this was to go against tradition. The very meaning of that word

for the church had been that teachings not central to the faith changed over time, unhampered by the Bible, which was not yet in the hands of the people. The clergy being the only literates, they were the active, thoughtful public opinion whose debates and conclusions were the march of the Occidental mind.

This give-and-take maintained a common ground in large matters, but not close uniformity. Henry Adams's view of the happy 13C undisturbed by diversity is a Utopian retrospect. Adams ignored or forgot that Thomas Aquinas, the great synthesizer, was nearly excommunicated twice. An accusation of heresy was a way of starting an argument, and knowledge made headway.

Heretics are given us so that we might not remain in infancy. They question, there is discussion, and definitions are arrived at to make an organized faith.

—St. Augustine

The ideas in the heads of 16C bishops were obviously well in advance of those held as true by the contemporaries of Charlemagne in the 9th. Now in the 16th, instead of an intellectual free-for-all and gradual enlightenment, the church decided to arrest the current of thought. This stand was in effect dictated by their Protestant enemies. One could say that in roundabout fashion, it was these Bible-ridden revolutionists who got Galileo condemned for his astronomy. If the literalism of the Word had not been adopted at Trent to show that Catholics too revered Scripture, there would have been no need to make science conform to Genesis. By commanding belief in matters not essentially religious or moral, Trent laid the ground for that "warfare of science and religion" which is still being waged.° It has kept making unbelievers, or rather—since it forces a choice—it has deprived many of the chance to believe.

The widespread discontent among western Catholics as our century ends—the public wrangling among bishops, the desertion of clerics and lagging recruitment of priests, the "liberal" doctrines sprung up in South America or taught at Catholic universities in defiance of papal decrees—all have their ultimate source in the success of the Tridentine reforms. Yet it would be a mistake to think that these actions and reactions are part of a continued trend toward a secular world ruled by science. On the contrary, divisions within the churches suggest a renewed search for the transcendent. Though today in the West the schools and governments, the press and the habits of public life, are no longer blended with religion, more and more demands are expressed that they should do so once again.

And more than demands: efforts to reconquer souls and institutions. Fundamentalisms are vocal everywhere; religious issues and personalities occupy the media as never before. Noting headlines at random, one learns that Protestantism is making converts in Brazil and in France; that the Church of England, now outnumbered by the English Catholics, has redefined Hell to eliminate its "sadistic tortures"; that the Reverend Sun Myung

Moon is touring Europe lecturing on Evolution, and has married 36,000 couples in Seoul; that Satanism is a fad among the young in more than one country, while other cults, meditative, Eastern, televised, or self-immolating proliferate.

Meantime, the Virgin Mary appears in sophisticated American suburbs and crowds gather to await her second appearance. More orthodox events also attract notice. The annual appeal of the Taizé order of monks in Poland brings together some 70,000 young people from all over Europe to "restore a soul to the mechanized world." The pope's visits are attended by hundreds of thousands, new translations of the Bible are published, and science is attacked on intellectual grounds by writers free of religious motives. Lastly, Islam—or part of it—is again fighting the West, and where it conquers it is much more intolerant than it was in the 16C. It is plain that the Protestant revolution has not ended in diffuse indifference to faith, nor has the Catholic self-reformation settled doctrine with finality.

Popular interest in matters spiritual, so much a feature of life in the 1990s, has provided publishers with a ready audience for all sorts of books about angels, miracles, and visions of an afterlife. It has meant a market for more serious works, too, like studies of Jesus and most lately of the Virgin Mary.

—*THE NEW YORK TIMES*, AUGUST 17, 1996

* * *

The Jesuits' activity impinged on culture in other ways than the strictly devotional. In undertaking to deal with the young, the stubborn, and the hesitant souls, the Order developed casuistry, penetrated domestic life, and acquired a virtual monopoly of education. "Casuistry" and "Jesuitical" have become synonyms for deviousness, thus obscuring an important subject. The famous casuists of the 16C, such as the Spanish Mariana and the Anglican Jeremy Taylor, were men of high moral and intellectual caliber. Casuistry is the theory of *cases*: the casuist shows how to apply the general rules that govern conduct to the particular moral problem—exactly what the judge does with a statute when he decides a case. All the recent codes of conduct for lawyers, physicians, and other professionals require casuistry for their application. Casuistry is also the mental operation of the moral person when he or she faces an ethical dilemma. It is a difficult art.

The sad fate of Jesuit casuistry came about when in the course of making the old faith attractive once more, some writers set down ingenious ways of evading plain but painful duties. Such books, full of tantalizing, often sexual, cases (as in psychoanalytic literature) became popular as guides to *mis*conduct. Before psychiatrists and magazine articles on psychology, counselors were needed and easily found among the Jesuits. The well-disciplined Order supplied father confessors who found a permanent role in great houses. In

more modest settings, as "directors of conscience," they were regularly con-
sulted by the members of the family, most often the women. Molière's *Tartuffe*
depicts the arrangement. In time, it led to such abuses that it was denounced
on both moral and intellectual grounds (219; 345>).

Meanwhile, by care and thought and continually revised methods, the
Jesuits shone as schoolmasters—unsurpassed in the history of education.
They taught secular subjects as well as church doctrine and did so with unex-
ampled understanding and kindness toward their pupils. Their success was
due to the most efficient form of teacher-training ever seen. They knew that
born teachers are as scarce as true poets and that the next best cannot be
made casually out of indifferent materials, so they devised a preparation that
included exhaustive learning and a severe winnowing of the unfit at every
phase of a long apprenticeship.

The University of Paris opposed the Jesuits
not merely because they were from abroad
but because they competed with those in
salaried posts at the University by offering
education free. It is not hard for firmly
united, clever, and courageous men to do
great things in the world. Ten such men
affect 100,000.

—Burckhardt, *Judgments on History*°

The Jesuits set up schools by the
score. In mid-17C Europe there were
more schools and pupils than in the
mid-19C. Indeed, there soon was com-
plaint of too many schools for the pop-
ulation. All likely youths, rich or poor,
were given the means to attend, and the
merits of the system were shortly seen
in the galaxy of brilliant minds that it
produced. From Descartes to Voltaire
and beyond, a good many philosophers
and scientists were educated by the Jesuits. Some of these bright pupils went
on to undermine the dogmas they had so well learned; they became leaders of
the 18C Enlightenment, to whom the church was the "infamous thing" they
must crush (361>).

The Good Letters

SO FAR IN THIS STORY, events and ideas have suggested three themes: PRIM-ITIVISM, INDIVIDUALISM, and EMANCIPATION. The first and last, audible in Luther's proffer of Christian liberty and based on what might be called the churchlessness of the gospels, succeeded in putting an end to the West's unity of belief. It also foreshadowed the third theme, INDIVIDUALISM, not as a political or social right, but as an assumption behind the proliferation of sects, themselves a result of the individual's untrammeled relation to God.

Side by side with this revolutionary idea, another of equal power was also at work strengthening the awareness and the claims of the individual. This was Humanism, to which passing reference has been made in characterizing figures important in the revolution. Humanism, too, grew out of concern with the past, but not a primitive past; on the contrary, a civilized one, the recovery of which came to mean not a purer religion but a more secular world.

The name Humanist has a familiar aura but commonly conveys no well-defined affiliation. We heard Luther call Erasmus an atheist because he was a humanist and condemn humanist pursuits as frivolous, while he himself regretted his lack of proficiency in classical Latin, which his protégé Melanchthon had mastered like any good humanist. And Calvin, we saw, was trained humanistically without turning atheist. The appellation obviously had several connotations at the dawn of our era and has acquired more since. Various adjectives have been added to it: secular, theistic, naturalistic, and even esthetic Humanism.°

To make things more complicated, the name is associated with that of Renaissance, which is also an elastic term. One meets the latter in reading about many things—painting, diplomacy, or the geniuses who possess more than one talent—Renaissance men. And both its meaning and its date are in permanent dispute. But this confusion is not hopeless. If one is willing to go back to origins, one sees the usual growth of a new cultural interest, a change of direction in purposes and feelings. Those origins take us back some 150 years before the Modern Era.

Oh century! Oh letters! It is a joy to be alive.

—Ulrich von Hutten to Pirckheimer,
Secretary to the Emperor (1518)

The term *humanist* was first applied by German scholars of the early 19C to writers who in the 14C and 15C rejected parts of the immediate past in favor of the culture they perceived in the classics of ancient Rome. They were particularly keen about the Latin style of these classics.

The label Humanism is odd—the *ism* of being human—but it is not arbitrary: it originally described the style of the ancients: *litterae humaniores,* the more human letters, meaning a literature less abstract than medieval philosophy and expressed in a more elegant grammar and concise vocabulary. These qualities defined what the humanists liked to call the "good letters." By comparison, the prose of the medieval scholastics was barbaric and fit only for discussing theology. It was far from ignoring Man, but it was logic-chopping and it linked all human concerns to the hereafter. Such was the animus of certain gifted writers born in Italy in the first third of the 14C, notably Petrarch, Salutati, and Boccaccio, whose disciples made humanism the culture of the next centuries.

Their negative view was unfair; the Humanists owed more to the past than they knew or acknowledged—the typical attitude of innovators. But since their positive views have shaped western thought and action to this day, the conception of *humanitas* that came out of the preoccupation with style wants looking at. We still speak of "the humanities" and keep trembling at the danger they are in, apparently their permanent condition. But we are not always sure of what they are or why so called. Are they just college subjects or something besides?

For the original Humanists, the ancient classics depicted a civilization that dealt with the affairs of the world in a man-centered way. Those books—poems and plays, histories and biographies, moral and social philosophy—were for the ancients guides to life, important in themselves, rather than subordinate to an overriding scheme that put off human happiness to the day of judgment. The theme of SECULARISM emerges from this outlook.

Humanitas, that is, the studies it involved, opened a vista on the goals that could be reached on earth: individual self-development, action rather than pious passivity, a life in which reason and will can be used both to improve worldly conditions and to observe the lessons that nature holds for the thoughtful. The Humanists were scholars, but they had no use for an ivory tower. With this vision in mind, it is not surprising that Cicero became the humanists' culture hero. A writer of superb prose, an orator and statesman, a moral philosopher, and the last defender of Republican Rome, he had all the virtues and talents of the ideal Humanist, except that of able warrior. His "imperishable fame" perished only when physical science began to drive Latin out of the curriculum around 1890. Until then, which is to say for 500 years,

ideas and catchphrases from Cicero's speeches and writings, together with the works of other Romans, filled the minds of educated western man and woman after bedeviling the young in school. The structure of thought and argument in the western languages has been influenced by Cicero, and the oration long flourished as a literary form (51>).

The new degree of Bachelor of Science does not guarantee that the holder knows any science. It does guarantee that he does not know any Latin.

—DEAN BRIGGS OF HARVARD COLLEGE (C. 1900)

Besides Cicero's works, Livy's patriotic history of Rome and its wars with Carthage; the *Annals* and *Germania* of Tacitus (<9); the tragedies and moral essays of Seneca; the comedies of Plautus and Terence; the poems of Virgil, Ovid, Lucretius, Catullus, and Horace; and—lone specimen—Pliny's encyclopedic natural history—made up the portrait of a complete culture that seemed to its 14C devotees grander and far more highly civilized than the one they lived in.

Why no mention of the Greeks? To be sure, Plato and Aristotle, long used by the Scholastics in their speculations, were important to the humanists, and Homer, Thucydides, and Demosthenes as well. But learning Greek in order to read these authors came late—hardly before the Turks captured Constantinople, capital of the Greek-speaking Byzantine Empire at the midpoint of the 15C. It was then that learned refugees from that city came to Rome and made a living by teaching Greek. But reading Greek was never so general an accomplishment. Humanism as the common possession of the intellectual class meant old Rome—witness a custom of the English Parliament: a member could quote a Latin tag to round out an argument and he was laughed at if he uttered a false quantity; but to quote Greek was a faux pas—it might not be understood by everybody, Whig or Tory.

Humanists saw Greece through Roman eyes anyway. The vivid awareness and worship of Greece—the Parthenon, Pericles, the Venus of Milo—came later in our era (514>), and different conceptions of Greece have flourished in successive periods. But throughout, the highly educated were supposed to have mastered both the ancient languages, and the clergy must know Hebrew in addition. It is a noteworthy feature of 20C culture that for the first time in over a thousand years its educated class is not expected to be at least bilingual.°

*
* *

The path between the onset of the good letters and the modern Humanist as freethinker or simply as scholar is circuitous but unbroken. If we look for what is common to the Humanists over the centuries we find two things: a body of accepted authors and a method of carrying on study and

debate. The two go together with the belief that the best guides to the good life are Reason and Nature. Finding this assumption all-important, some moderns have carped at the early Humanists for fussing over grammar and words, but it is hard to see how they could have produced scholarly editions of the ancient works that they valued so highly without first mastering the minutiae of language. In any case, what is the point of saying about innovators that they should have done what later comers were able to do after the ground had been cleared for them?

As for the Humanist method, it is the one still in universal use. Its conventions are commonplace everywhere: in government, business, the weekly magazines, and even in schoolwork—who has escaped "research"? who dares ignore exact quotation and date, consulting previous work, citing sources, listing bibliography, and sporting that badge of candor, the footnote?°

The accepted authors have not been as stable, though drawn from the same pool. Cicero's rise and fall has been mentioned; with every shift of mood new names emerge from relative neglect or oust others from the top places. The new choices point to a recurrent cultural need that can be described as "elements that are wanted," because lacking at that moment. The freshly admired figures correspond to that felt need. The passing of a generation usually ends a battle and installs those who urged new heroes, who deserve what is amusingly called lasting fame. Today, the whole Occidental canon is under attack by many people who find it out of tune, useless, although they could not readily say who is in it.

In the 15th and 16C the continuing enthusiasm for the ancients was reinforced by the feeling that the inherited culture was dissolving and here was a storehouse of ideas and attitudes with which to rebuild. It was like going up to the attic and polishing up semi-discarded treasures. The names of authors, the titles of their books, the topics treated were fresh, not the old bores; they formed a field of discovery all untouched, a mine to exploit for those ambitious of literary fame. Hence the passionate search for old manuscripts to save from loss, to compare and edit. Scholars traveled widely to ransack castles and monasteries; wealthy amateurs sent agents to buy in Constantinople and the Greek cities. The monks had copied and recopied the old texts and housed them for a millennium, but they had regarded them in another light. To be sure, as early as the 12C when Frederick II of Hohenstaufen had held court at Naples, he had shown a true humanist interest, extending even to Arabic works, but he was a lone exception.

To explain the curious fact that the Middle Ages valued the ancients enough to keep their works copied but did not breed Humanists calls for a Theory of Aspect. It would state than an object or idea is rarely seen in the

round. Like a mountain, it presents a variety of faces. Moved by an ulterior purpose, observers take a few of these for the whole. This is a cultural generality. It accounts for the surprising differences in the value put on the same artist or thinker at different times and for the different pasts depicted by different historians. This partiality should not be surprising; it is a familiar fact of life: each individual "takes" only some elements of experience, and that spontaneous choice governs tastes, career, estimates of worth, and the feel of life itself.

For the early Humanists, the aspects that shone out in the works of antiquity were the beauty of the language and the novel features of a vanished civilization. Both gave rise to a new sense, the sense of history, which may be defined as the simultaneous perception of difference and similarity between past and present. But had the medievals no historical awareness? They thought of themselves as descendants of the Roman Empire; they venerated the first Christian emperor, Constantine, and his feudal inheritor Charlemagne. They read Virgil and thought that one or another of the Trojan heroes in his poem had founded this or that western nation. That same poem was also used as a means of foretelling the future, by opening it at random and reading some one line on the page. For Virgil had been a magician. All this is a clue to the Middle Ages' attitude toward history. They merged time and space indiscriminately. They mingled fact and legend and miracle, and being preoccupied with eternity, they "took" sameness and continuity as more real than development and change—hence, no history in the modern sense (234>).

With the usual pride of advanced thinkers, the Humanists saw their repossession of a great past as a Renaissance—a rebirth of civilization itself. The immediate past was "Gothic" in language, thought, and sensibility. This boast of rebirth was accepted without demur until our own century. When contrary-minded researchers, tired of hearing praises of Renaissance Humanism, tackled the Middle Ages with gusto, they unearthed evidence to show that many of the achievements credited to the Renaissance had a root in the previous period, including certain scientific ideas. So if any renaissance ever did occur, it was in the 12C, leading to the high medieval civilization of the 13th.°

The dispute is not one of those that can be settled; judgment depends on how the viewer takes the unquestioned facts. But it can also be held that there is no need to "take" sides. In the first place, the traditional Renaissance is like a movable feast. The Italian Petrarch in the 14C is deemed the first full-blooded Humanist. "Renaissance" painting is the great achievement of the 15C. Erasmus, Ariosto, Tasso, Rabelais, Montaigne, Shakespeare, and the *Pléiade* poets in France are all labeled Renaissance writers, and they belong to the 16C. So does Renaissance music. As we saw, Erasmus, arriving in England in 1497,

was glad to find that English scholars were now abreast of "the good letters." In short, the cultural features of the so-called Renaissance moved north and west from Italy during a cultural lag of some two and a half centuries.

These dates can serve to calm the dispute: since the Modern Era is seen as beginning around 1500 and Petrarch is seen as the earliest Humanist, the Renaissance is a going concern in the 14C and 15C, which is to say before the Modern Era, and thus part of the medieval, its germs present in the late Middle Ages, its fruitfulness intensified in the early modern era. So viewed, the black-and-white contrast between eras disappears: it was an illusion of the innovators, serviceable to them as self-encouragement. To us, it is tenable only if we make comparisons over a wide gap, say between 1250 and 1550— Aquinas with Erasmus, or the two towers of Chartres cathedral, built 200 years apart. In this perspective, the inquiring reader can safely enjoy both Burckhardt's *History of Civilization in the Renaissance* and his challenger Huizinga's *Waning of the Middle Ages*°—two masterpieces of cultural history, two visions that complement each other in spite of partial disagreement.

Since the passage of time always brings on difference, "the" Humanist is an abstract figure that must be made concrete by examples. Nuances in an evolving ideal and the turbulent culture then appear together as they should. One must obviously begin with the veneration for the ancients and their language as recorded in the life and work of

Petrarch

The son of a Florentine notary, young Francesco, born in 1304, began by studying law, but being left impoverished after his father's political exile to southern France, he became a priest. By his 30th year he was famous as a poet—so famous that in a revival of the ancient custom of crowning a hero with laurel leaves, a Roman senator crowned him "poet laureate." Petrarch gave thanks in a Latin oration on a text by Virgil. But this Latinity was only part of his renown. Petrarch's name today evokes that of Laura, to whom the poet wrote sonnets and odes for years, and these were in Italian. Incidentally, he made no attempts at intimacy; indeed, so varied was the purely literary tribute that some scholars classify the poems as pro-Laura, anti-Laura, and neutral— deconstruction with a vengeance.

> **Think you, if Laura had been Petrarch's wife,**
> **He would have written sonnets all his life?**
> —BYRON IN *DON JUAN*

This early Humanist ritual of laureateship, somewhat dimmed, is still with us. As everybody knows, it persists in England, where it is a lifetime post whose holder is expected to celebrate great events in verse. The harvest of poetry has been small. In the United States since 1985 a series of incumbents

have held the title for one year each, with the modest expectation that their elevation will publicize the importance of literature. Petrarch's celebration at Rome signifies much more: it means that the aura of the Roman past was in the air, intimations of what was to come. It is in his combining "elements that were wanted" and adding one or two that Petrarch is a new man, who inspired imitation without end.

The one thing of monetary value that he inherited from his father was a manuscript of Cicero. The work filled his mind with ancient facts and ideas; a trip to Rome fixed his vision. For there he saw and marveled at the antiquities, tangible remains of a culture once alive and complete. It may have helped the vision that the city just then was no longer papal Rome: a schism in the church had exiled the popes to Avignon, where Petrarch grew up. The pope's court there gave the young man a distaste for intrigue, which made him refuse official posts—even university rectorships—all his life.

Instead, he set himself to earn his keep as a writer, though not, of course, by the sale of his works. He was at first part of the household of the Colonna family; then, when famous, he served as envoy to various princes. Diplomacy in his day was occasional, not a permanent exchange of resident ambassadors, as it became in the 16C. In the mid-14th, someone with a ready choice of words—Latin words—was despatched to make a formal speech on the matter at issue. Petrarch excelled in the required rhetoric, and though his speeches rarely produced results, his distinguished presence flattered the recipient prince and his words were appreciated by an invited audience as high entertainment.

To earn a more than passing repute as a poet, Petrarch started an epic in Latin on the deeds of the Roman hero Scipio, the commander-in-chief in the second war against Carthage—hence the title *Africa* for the epic. It was never finished, partly because Petrarch never gained ease in handling the classic metres—any more than he mastered Greek, though he tried more than once. This falling short of the later Humanists' panoply accounts for one modern scholar's quaint description of him as only "the vanguard of the changed emphasis."°

During a wide tour of Europe, Petrarch found another manuscript of Cicero—the letters to his friends. This familiar style he did master and popularized. At the same time, his poems in Italian—by no means all sonnets or all addressed to Laura—he fashioned into a shapely quasi narrative work, a kind of allusive autobiography. This was new. And it was also an expression of his intense interest in himself: "I am unlike anybody I know." He declared that art is an individual matter, not something within the reach of all professionals. "Everyone should write in his own style." The theme to note here is SELF-CONSCIOUSNESS. It is allied to INDIVIDUALISM but it differs from it in being not a social and political condition but a mental state. One can be in prison,

individuality all but submerged, and yet be acutely self-conscious. Individualism has limits imposed by the coexistence of many other individuals; self-consciousness has none. Over the centuries it has dug ever deeper into the ego, with no boundary in sight.

Another singularity in Petrarch's life was that he climbed a high hill in southern France in order to admire the view.° If it was done before him, it was not recorded. Nature had been endlessly discussed, but as a generality, not as *this* landscape. As for Petrarch's nurture of his unique self, it included changing his name, for a purpose that can only be called esthetic. Petrarch was born Francesco di Petracco, but with a poet's ear he decided that it was not a euphonious run of syllables. Cutting a *c*, adding an *r* to lengthen the middle *a*, and changing *o* to *a* at the end to make *Petrarca* (in Latin *poeta* ends in *a*) was as deft a piece of work as making a good verse.

> Whether we wish to leave some memory of ourselves to Posterity by thinking or writing something and thus to arrest the flight of days and extend this short span of life, we must flee and spend the little time that is left us in solitude.
>
> —PETRARCH, ON THE SOLITARY LIFE

Nearly the whole of Petrach's verse and prose is in effect autobiography. He wrote an explicit one entitled *Letter to Posterity*, and his letters to friends recount what he has done, while his poems tell what he has thought and felt. Introspection followed by self-portraiture is linked in Petrarch with another novelty, the express desire for eternal fame. It too is a revival of an ancient habit, and not the kind of passion that one would readily confess to in an age that still desired eternal bliss. Since Petrarch, every poet has followed him (and Horace) by appealing to Posterity and promising eternal renown to the patron of the work through its being tied to the author's own.

<div align="center">*
 * *</div>

Although in the Laura poems Petrarch strikes the personal note, and the emotions are fresh and vividly described, we are not given the kind of detail that brings out a unique character such as we find (say) in Meredith's *Modern Love*. "Character" is a later invention (135; 140>). It was no doubt Petrarch's simpler notion of self that made him so imitable. After him and without end, Europe has been flooded with lovelornery in sonnet form. The species that we owe to Petrarch is now regarded as if the command: "thou shalt stop at fourteen lines" had been uttered on Mount Sinai. But it was a happy turn of practice that established it; no ancient model existed, and in Petrarch's day sonnets—verses to be *sounded*, to be sung—were of various lengths. The now traditional length is just right for a small oration—exposition, development, and conclusion. And that classical form, so closely studied and practiced by

the Humanists, has remained a pattern that governs western creations, from public speaking to poetry, drama, prose, and the symphony (419>).

True, the span of fourteen lines does not suit all languages equally well, which is why (for instance) French poets have used the form sparingly. But sonnet sequences like Petrarch's or Shakespeare's make possible a narrative-by-episode; the poet need not versify any connective matter as he must in an epic. Rather, he anticipates by five or six hundred years the technique of film and television. Meredith found he needed sixteen lines for the sonnets of *Modern Love* and his great story is none the worse for this return to the freedom of choice abolished by Petrarch.

The imitators, with their exaggerated sighs of love and cries of despair addressed to an idol in female shape have repeatedly brought the love lyric into disrepute. Germany at one time went Petrarch-mad and during such high tides of production Petrarchist became a term of abuse. But the genre always rebounded, and not solely to express love; it has conveyed passion allied to descriptions of nature or to moral reflections and political opinions.

Petrarch himself showed that a poet bent on the contemplative life could, at the shock of an event, turn political. A commoner named Cola di Rienzi led an uprising in 1347 and "restored the Roman republic"—for a few months. (Wagner's early opera uses his name and story.) Petrarch, then in his early forties, was overjoyed at this revival of another classical institution, though he did not give up hobnobbing with the tyrants who ruled the several Italian cities; his ideal remained untouched by the facts. Like his predecessor Dante and other writers yet to come, he longed for a united Italy. His "Ode to Italy" and other pieces foretold glories of the kind he read about in Livy.

This utopian wish was another Humanist departure: educated men and women began to revere the Roman republic instead of the empire that had so deeply stirred the Middle Ages. Cicero fighting to save a free government became the model citizen, even to the loyal subjects of 16C princes. Caesar was the hated usurper and Brutus a hero for killing him—witness Shakespeare's *Julius Caesar*. Like the value put on the judgment of Posterity, this excitement about political ideals shows the importance that the Humanist temper attached to worldly things.

But one must not overlook opposites and contradictions. Humanists were not indifferent to religion or wanting to replace Christianity with paganism. Those called Humanists today may rule out the divine and make Man the measure of all things, but Petrarch, for one, remained deeply religious. All secular works, he said, took second place to the gospel; he had a cult for Saint Augustine and late in life wrote a tract on Contempt for the World. It was a sort of confession of sins paralleling the anti-Laura poems. He even attacked the followers of Averroës, the Arab physician-philosopher, for being materialists and infidels. One can imagine Petrarch in old age retiring to a Humanist

convent, had there been such a thing. All he wanted to do then was cultivate the good letters so as to "shut out the reality of my own times."

What may mislead about the Humanists' genuine faith is that, after Petrarch, writers of all tendencies mingle the pagan mythology, history, and geography with the Christian. Milton, the firm believer, is a prime example: his poems are filled with nymphs and ancient myths. Poets took pleasure in using a set of fresh words; the names of the gods, heroes, places, and deeds formed a treasury of new images and sounds. Humanists freely refer to the "divine Plato," the "divine Seneca"; some use Jove to mean God or Jehovah, or call it Providence when a god in Homer protects a warrior—all this without a thought of being freethinkers, heretics, or atheists. From reading the ancients the conviction grew that some of them, by their thoughts and lives, were almost Christians. We saw Erasmus invoking "Saint Socrates." Many believed that Plato failed to be a Christian only because Revelation had not yet occurred. Seneca the Roman Stoic was revered for his austere ethics and his conception of a universe obedient to a single god, remote though Seneca thought him.

After this merger of traditions it is not surprising to see the Renaissance Humanists followed in the 17C by thinkers who professed themselves Stoics without abandoning their equal claim to being Christians. These things being so, it seems bad history to keep referring today to "our Judaeo-Christian heritage." Pagan or Graeco-Roman ought to be added to the phrase, not to mark a separate strand but as a fused element like the other two. To cite but one item, the endless effort to change society for the better, which is a characteristic of the last five centuries, comes from the Graeco-Roman tradition. To say this is to point again to the presence of Humanism throughout the Modern Era.

*

* *

Between Petrarch and Erasmus the development of Humanist knowledge and taste took place mainly in Italy. Its great cities and universities were magnets that drew adventurous minds from other countries, just as Wittenberg and Lyon, Strasbourg and Geneva successively drew partisans of the new creeds. Nor was it learning and atmosphere alone that brought the talented young and the inquisitive tourist: the new painting and sculpture and their amazing new methods, the ancient ruins and the new churches and palaces were also powerful attractions. Still other minds felt the pull of Italy's advanced ideas in science, law, and business methods, to which may be added a new regard for elegance in cookery and table manners (183>).

Returning home, the visitor spread the news of this many-sided civilizing influence, which other countries acknowledged in the catchphrase "Italy the

mother of the arts." It should have been: "Italy the mother of all high culture." This dominant role is recorded in the vocabulary we still use about the arts, to say nothing of all the Italian names in the plays of Shakespeare and his contemporaries, English and foreign. What would we do without such technical terms as sonata, rondo, aria da capo, folio, octavo, impasto, chiaroscuro, terza rima, intermezzo, solo, tremolo, 'cello, prima donna, bravo, and many more? Italian remained the obligatory language for men of letters down to fairly recent times: they must read Boccaccio, Tasso, and Ariosto in the original, part of "the canon" and inspirers of operas, the genre itself being an Italian invention and for a time a monopoly (159; 174>).

> They have no concern for music or rhetoric or the metrical art. Oratory and poetry are almost unknown. For them, all study in logic is futile disputation. You rarely find anyone who owns the works of Aristotle and other philosophers. The students at the new university devote themselves largely to pleasure and are avid for food and wine, nor are they restrained by any discipline. Day and night they roam about inflicting injuries on citizens and their heads are completely turned by the shameless women.
>
> —POPE PIUS II ABOUT VIENNA, C. 1458

For all these reasons, during the 17th and 18C the young well-to-do from elsewhere must make the Grand Tour, of which the peak experience was to enjoy, under a tutor's informed guidance, the art and easy life of Rome and Florence, possibly of Naples and Venice. Milton's tour was decisive for his vocation, and it has been plausibly suggested that *Paradise Lost* owes much to the Italian author of *Adamo Caduto* (The Fall of Adam).° As for those aspiring to be artists, it was imperative that they go and "finish" themselves at the source, Italy. France and the United States still maintain for them under the name of Academy residences in Rome.

That the rest of Europe freely conceded its own barbarism and praised Italy was not a wholly poised judgment. It partook of the social climber's repudiation of his origins and eagerness for acquiring abroad the right tastes and behavior. To be fashionable in some particular foreign way has been a recurrent phenomenon in the west. After Italy, it was Spain that radiated light; then France imposed its ways and later went Anglophile, not once but twice (361; 498>). After a short-lived Germanism in England and France, the Orient, and last the United States have been the irresistible model, followed even when denounced.

Almost always, though not in that first Italian example, these fads come in the wake of the political or economic might of the admired nation. This is curious, since it is artists and intellectuals, noted for being above such mundane realities, who generate these cultural infatuations.

At the beginning of the successive "ages of the Renaissance" north and west of Italy, when Italian poetry, drama, and prose fiction were taken as models, together with the Humanist scholarly methods, attention to the writ-

ten word affected enlightened opinion on law, history, politics, and religion. Establishing a text by comparing sources, verifying dates, weighing evidence and witnesses' credibility, while also analyzing usage, impressed on the European mind the effect of the passage of time: documents began to be read critically; oral traditions lost authority unless confirmed. The age of indispensable literacy had begun. The first fruit of this organized skepticism was the demonstration by Lorenzo Valla that the Donation of Constantine was a forgery. This document, purporting to be from the hand of the first Christian emperor, gave the popes their territorial possessions, thus adding the worldly to the spiritual power. Valla showed that the language and allusions belonged to a later age than the emperor's.

This proof gave comfort to the Reformers: their enemy the pope was a usurper on earth as he was in heaven. And although the Evangelicals looked down on the Humanists' pursuit of the telltale word, pious students of Scripture had to use that same method themselves. The many new editions and translations of the Bible could not have been made without it. These works embodied the primary criticism of Scripture. Soon followed what is known as the "higher criticism" of the Testaments: questioning the substance after questioning the words (359>). This discipline is still at work today, though with a freedom that would have petrified the pioneers. The specialized journals discuss such questions as whether King David ever existed and "Did Sarah Have a Seminal Emission?"° In general, 16C scholarship strengthened the Protestant idea that the gospel, not the church, was the fount of doctrine. It is a Humanist principle that if you want to know the truth, go to the sources, not the commentators. In short, Humanism and Reform, without being allies, converged in one point toward the same goal. This fact would seem enough to justify the usual phrase "Renaissance and Reformation" to label the culture of the 16C.

*

* *

The leading Humanists did not, of course, share the Evangelical passion. The Renaissance popes, Humanists by taste if not by works, despised the Protestants as bigots and heretics. Were the Humanists in fact atheists? If not, what was their faith? Erasmus, we know, was sure he was a good Christian. Petrarch went from faithful to devout, first wooing the world then wanting to give it up. The difference between these two representative positions is one of theology, of ideology. Each is based on different parts of the gospel: Christ came to forgive sins as a spur to living the right life; this is a moral and social concern. He also preached giving up the world, a prerequisite to the soul's salvation. Can one follow both commands?

The truth that religion and morality are at odds with each other is rarely acknowledged, probably because the two desires are equally strong in the human breast, reflecting there the respective demands of society and of the self. The dogma that a repentant sinner—say, the Prodigal Son—is to be cherished ahead of the merely moral character has great appeal. Like Luther, popular opinion prefers the rogue, once he is tamed, to those dull clods who have resisted temptation. But if adopted by most people as a rule of life, the sentiment would make for anything but a peaceful society.

> **May not a man be a Christian who cannot explain how the nativity of the Son differs from the procession of the Holy Spirit? If I believe in the Trinity in Unity, I want no arguments. If I do not believe, I shall not be convinced by reason. The sum of religion is peace, which can only be when definitions are as few as possible and opinion is left free on many subjects. Our present problems are said to be waiting for the next Ecumenical Council. Better let them wait till we see God face to face.**
>
> **—ERASMUS (1522)**

The Italian Humanists witnessed one fit of Evangelical zeal and it was enough. Toward the end of the 15C the monk Girolamo Savonarola roused the Florentines to a high pitch of devotion that led to the famous "bonfire of the vanities." Such a high ideal tension cannot be sustained by a whole community for very long, and when this one broke, the prophet was declared a heretic and burned at the stake with public approval. Savonarola had been too literal—too Evangelical—in using the words of Christ to convert the masses.

Good Christian Humanists were moral beings of the conventional sort, but their trained minds wanted something more: a metaphysics that would reformulate or at least parallel in classical terms the Catholic theology. Most of them found it in Plato. He had taught that human beings are in a cave with their backs to the entrance and looking at the inner wall, which reflects dimly the reality outside. Interpreted, this means that the senses give an imperfect copy of the eternal forms of Being. These are the proper object of human attention. By steady effort, the individual can raise his sight from the love of earthly things to the love of eternal beauty, which consists of those pure forms. Such is the Platonist's grace and salvation.

Perhaps because this prospect is somewhat dry and abstract, a number of these Neo-Platonists added to it various beliefs from the Cabbala and the traditions of "white magic." Plato, thus turned into a theologian, had the advantage of getting rid of Aristotle, the great buttress of scholastic theology, now rejected. Aristotle was a physicist, biologist, social scientist, and aesthetician. His system gave matter basic importance. He taught that wealth, friends, and comfort were part of the good life and prerequisites of virtue; for every ideal possibility rests on a natural (material) base. Though Plato's ladder to eternal forms was closer to Christian aspiration, a minority among Humanists,

attracted by the new findings of science, still adhered to the Aristotelian philosophy, especially after it became known in its original texts, another fruit of the new scholarship.

From then on, the two parties—are they temperaments?—have carried on this same debate over Matter and Idea, but not on equal terms. In successive periods one outlook tends to predominate and to permeate every intellectual activity, including natural science itself, where the opposite of Materialism takes the name Vitalism (665>). This seesaw has been greatly productive; the stimulating effect of toppling the orthodoxy is a cultural constant. [The book to read is *Renaissance Thought* by Paul Oskar Kristeller.]

For natures inclined to mysticism, Plato (and his later expounder Porphyry, who showed how to lift one's gaze from sensuous to abstract beauty) satisfied a strong desire akin to the Reformers' for a pure faith. Michelangelo, for example, whose hand was subdued to matter like any ditch digger's, valued his works not for their artistic merit, as we do, but for the ideal beauty that he put into them and that, for him, made their materiality disappear. His love sonnets worship the same ineffable entity in a woman, Vittoria Colonna, to whom they are addressed.

No mortal thing enthrall these longing eyes
When perfect peace in thy fair face I found;
But far within, where all is holy ground,
My soul felt Love, her comrade of the skies

—Michelangelo, from *Sonnet 52*

To all this the materialist opposition says that the ideal does not exist apart from the natural, the abstract from the concrete. It is too bad that in popular use "Platonic love" means only absence of sexual relations. That typical reduction of an important idea prevents one from using the term conveniently to denote a recurrent striving in occidental culture, the longing for the Pure. Individuals and movements, not all rooted in religion or metaphysics, have repeatedly proclaimed their pursuit or their achievement of pure love, pure thought, pure form in art (622; 639–40>). It is a yearning akin to PRIMITIVISM.

*
* *

The Humanist fusion of faith and philosophy had a by-product which deserves to be called "toleration by absentmindedness." A church hierarchy thoroughly Humanistified is able to appreciate the varieties of religious experience and, short of extremes such as Savonarola's, tends to permit variations. After all, a good many of those ardent Platonists were in holy orders and felt easy about their role. Lorenzo Valla provides a good example: when he exposed the Donation of Constantine, he feared sanctions in Rome and fled to Naples, where like a true Humanist he opened a school of oratory. But even at that early date, the pope forgave him and found him a secretaryship.

Favoring neither Plato nor Aristotle, Valla has even been classed among Luther's forerunners.° His chief interest, history, led him to translate Herodotus and Thucydides into Latin, for most readers were as yet unable to read Greek. This reminds us that for a good while after the Humanist awakening, half the ancient world and its fund of wisdom were still a vague or secondhand reality. The entry of Greek into minds overflowing with Cicero's Latin was a dramatic event and another Italian scoop. With Greek came Plato in the guise just described, and through the career and works of Valla's contemporary

Marsilio Ficino

we see at close range how lives and culture mesh. Chief mover of the Florentine Academy, inspirer of poets and statesmen, teacher of the legendary Pico della Mirandola, Ficino was acclaimed in his time as supreme. Then he was unread for a long time and he remains largely untranslated.

He was six years old about the mid-15C when the Byzantine emperor came to Rome with one of his scholars, the 80-year-old Geminthus Pletho. They were seeking an alliance against the Turks, who were advancing upon Constantinople, the Byzantine capital. A reconciliation of the Greek with the Roman church might also be discussed but it was not concluded. Pletho lectured in Rome and startled his hearers by showing a firsthand knowledge of Plato, who was still generally thought an infidel. The Byzantines themselves were deemed schismatics: they did not accept the Holy Ghost as an equal member of the Trinity, they celebrated Easter on the wrong date, and gave other signs of wrong-headedness.

Accordingly, when Pletho talked Plato, the lecturer was suspected of being the Devil come to seduce the faithful. But Cosimo de' Medici, the wealthiest banker and political boss of Florence, took a chance and invited Pletho to dinner. At the end of it Cosimo decided to found a school of Greek thought. The idea simmered a while, and four years after the fall of Constantinople in 1453 the school opened. Cosimo called it *Accademia* in honor of the place where Plato had taught in Athens, a grove honoring the hero Academos. Hence the modern term for schools, universities, and official guardians of learning, while "academic" has had a checkered career in fine art and social opinion. (But Acad*eme* is not a synonym of academy: it is a variant spelling of *Academos*.) Cosimo's institution was a self-selected group of scholars who met regularly to keep abreast of one another's findings. It needed a director, and Cosimo appointed to the post the son of his own son's physician: Giovanni de' Medici and Marsilio Ficino were close friends. Though Marsilio was only 25, he was already a fine Latinist. He had also a passion for music and a boundless curiosity.

About that time, another Byzantine, a refugee from the Turks named

Argyropoulos, was trying to earn a living by lecturing. He adopted the title of Public Explainer of Aristotle, but on getting pressing requests he altered course and talked about Plato, while also teaching Greek in its ancient form. Ficino, who had accepted the traditional Aristotelian creed, took these language lessons, heard the lectures on Plato, and suffered a crisis of conscience. He was losing his Christian faith and here he was in training for the priesthood. He confessed. The head of his seminary forbade his attending lectures and sent him home. At home, Marsilio was found reading the Epicurean materialist Lucretius, so his father packed him off to Bologna to study law. At that point Cosimo intervened, telling the father: "You doctor bodies; he will doctor souls."

As a "domestic" in Cosimo's Villa Careggi, Ficino decorated the walls in fresco with astrological images and the figures of Democritus and Heraclitus, the rival Greek philosophers of nature, the one (says tradition) always laughing, the other weeping. Aristotle was nowhere to be seen. Next, Marsilio began to translate Plato, gathered around him students, artists, bankers, and politicians, and conducted what we should call seminars on Platonic and post-Platonic ideas—Porphyry, Plotinus, and also Hermes Trismegistus, the master magician. The prevailing mood was the mystical; Cosimo on his deathbed asked his young protégé to read to him from these works. When Marsilio shortly completed his commentary, *The Platonic Theology,* he had provided his fellow Humanists with a system that enabled them to replace the Catholic orthodoxy by Platonic mysticism while remaining good Christians.

The naturalistic strain in Marsilio had not vanished in Platonic mists. His *Book of Life* is a treatise of physical and mental hygiene for thinkers and writers. Its three parts are entitled: On Caring for the Health of Students; How to Prolong Your Life; and On Making Your Life Agree with the Heavens. In practicing judicial astrology, Ficino was no different from many other Humanists; to them it was a science, not a superstition, for it was based on observation and calculation and it enabled one to predict. This view was long held by scientists such as Copernicus, Kepler, and their contemporaries.

The advice given brain workers in *The Book of Life* is not out-of-date: eat and drink in moderation, sleep well, laugh and be merry as often as you can; do not repress sexual desire or overindulge it. All these precepts are needed,

Someone will say: "Is not Marsilio a priest? What do priests have to do with medicine? And furthermore, what business of his is astrology? What does a Christian have to do with magic and images?"

"But come, tell us what you condemn in the use of the stars? That it takes away free will and goes against the worship of one God? Well, I condemn and detest the same things you do. Nor is Ficino talking about the magic that is the cult of demons, but the natural kind that seizes from the heavenly bodies through natural things benefits for one's health."

—FICINO, *THE BOOK OF LIFE*

says Ficino, because intellectuals are prone to depression (then called melancholy), "a body-and-soul destroying disease" (222>).

As Cosimo had predicted, Ficino also doctored souls. He studied theology anew, was ordained a priest, and although still residing at the Villa Careggi, was appointed rector of a church at Nacoli, without duties, of course. It was this Humanist phase of Catholicism which, as the 15C ended, gave a good ground for the Protestant revolution about to come: the quiet attachment to Christian belief was offset by an open delight in the here-and-now; and an approving church hierarchy was giving these intellectuals support as non-resident priests, at the expense of pastoral care.

> Now may every thoughtful mind thank God for having been allowed to be born in this new age, so full of hope and promise, which already rejoices in a greater array of noble and gifted souls than the world has seen in the last thousand years.
>
> —MATTEO PALMIERI, ON CIVIC LIFE (1440)

If anything showed that this blend of human and divine was widely accepted, it is the fame accorded in his day to Pico della Mirandola. He was a Count who had been a child prodigy destined for the church. Appointed by way of encouragement to a papal office at the age of ten, he studied the good letters at the universities of Bologna, Padua, and Florence, and Hebrew and Arabic on his own. At the age of 23 he set down 900 theses, of which the pope condemned seven and murmured about six more. Pico unwisely published a defense and had to take refuge in Paris, where he was imprisoned. But several Italian noblemen pulled strings and had him released, after which he lived and wrote and consorted with the "academicians" in Florence until his early death at 31.

His name is preserved—or used to be—by the curious tradition in Latin Europe of holding him up as a model to lycée students: he was represented as a walking encyclopedia whom they should emulate. (In my time, this ideal of becoming "a veritable Pic"—the French for Pico—was accepted very unevenly as between teachers and students.) What distinguished Pico, apart from erudition, was the originality of his faith, Humanist and Christian, but not limited to the gospel and the fashionable Plato. He did reject much of Aristotle, but as he explained in poetry and prose and summed up in his oration "On the Dignity of Man," all theologians and philosophers had seen a portion of the truth; he would reconcile the two well-known Greeks, the neo-Platonic mystics, Thomas Aquinas, the Jewish authors of the Cabbala, and the Persian Zoroaster as well.

This breadth of view suggested to some the danger of knowing too many languages. Today, we agree with him though knowing hardly any. Pico argued that this "dignity" of man lay in the scope which God had bestowed on Adam before the Fall and which redemption had restored. A Humanist would also think of the ancient maxim of Plautus the playwright: "I am a man. Nothing

O sublime generosity of God the Father! O highest and most wonderful felicity of Man! To him it was granted to be what he wills. The Father endowed him with all kinds of seeds and with the germs of every way of life. Whatever seeds each man cultivates will grow and bear fruit in him.

Who then will not wonder at this chameleon, Man, who was said by Asclepius of Athens able to transform his own nature owing to his mutability, and who is symbolized in the mysteries as Prometheus?

—PICO, "ON THE DIGNITY OF MAN" (1486)

human is alien to me." The word *dignity* can of course be interpreted as flouting the gospel's call to humility and denying the reality of sin. Humanism is accordingly charged with inverting the relation between man and God, with atheism and the secularizing of society.

What humanism at its fullest did reject, by implication as much as directly, was the ascetic ideal of physical and mental repression. Asceticism is often called inhuman, but it is just as much a human tendency as its opposite. The ascetic is often a sensualist who has reached the limit of his capacity. In any case, we play fast and loose with the words *human* and *inhuman*, flattering ourselves by making *human* mean only the good things in our makeup or simply what we approve. The historian cannot subscribe to this policy, knowing as he does that cruelty, murder, and massacre are among the most characteristic human acts.

In declining the ascetic life and even the milder forms of self-reproach, the Humanists liberated the impulses that fuel INDIVIDUALISM, the desire that goes beyond the awareness of one's talents and demands room to develop them. The good society fosters Pico's sense of endless possibility. Individualism thus works toward EMANCIPATION, the modern theme par excellence.

*

* *

Anything that can be said about the good letters implies the book, the printed book. To be sure, new ideas and discoveries did spread among the clerisy before its advent, but the diffusion of manuscripts is chancy and slow. Copying by hand is the mother of error, and circulation is limited by cost. As was noted earlier, print made a revolution out of a heresy (<4). Speed in the propagation of ideas generates a heightened excitement. Besides, the handwritten roll or sheaf (codex), on vellum or primitive paper, makes for awkward reading and for clumsy handling and storing. Indexing, too, was long absent or unsatisfactory, because the medieval mind rejected the alphabetical order—it was "artificial," "irrational," since no principle governs the sequence a, b, c, d, and the rest. To the modern lover of books, the product of the press is an object that arouses deep feelings, and looking at Dürer's charcoal drawing of hands holding a book, one likes to think the artist felt the same attach-

ment. The book, like the bicycle, is a perfect form.

With multiple copies of works available and new works rapidly coming out, the incentive to learning to read was increased. The one drawback to print is that the uniform finality of black on white leads the innocent to believe that every word so enshrined is true. And when these truths diverge from book to book (for the incentive to write and publish is also increased), the intellectual life is changed. From being more or less a duel, it becomes a free-for-all. The scrimmage makes for a blur of ideas, now accepted as a constant and fondly believed to be, like the free market, the ideal method for sifting truth.

Italy was a pioneer in that transformation also. In Venice at the end of the 15C an inventive printer-Humanist who called himself Aldus Manutius (from Aldo Manuzio or Manucci) founded a house which for a century issued the Greek and Latin classics in the best form. An Aldine edition meant excellence and is now for collectors to hoard. Aldus designed simpler forms and styles of letters, notably the italic, which tradition says was based on Petrarch's handwriting.° The regular font is, again by apt tradition, called roman, without capital *r*. Before these now familiar fonts printers had imitated in metal the latest form of the copyists' handwriting, thereby producing the "black letter" volumes, now even more precious to collectors. There were ligatures between pairs of letters and special forms of the same letter for use when next to another. One font is known to have numbered 240 characters. The page was beautiful but not easy to read, especially for the recently illiterate. A modified black letter remained in German books until nearly the mid-20C.

Aldus was not the only great printer-designer. Every country could boast several of comparable genius, such as the Estienne brothers in France and the Elzevirs in Holland. To them collectively we owe several conveniences: punctuation, accents in the Romance languages, the spacing that makes words, sentences, and paragraphs stand out as units of meaning, with capital letters adding to this clarity. The first call for uniform spelling was also of that time and had the same purpose.

Another potent publisher was William Caxton. Starting out in life as a merchant and becoming wealthy, Caxton turned his thoughts to literature and began translating and writing out by hand a popular work. His "pen grew weary," as he tells it, so he learned printing, set up a press in Cologne, and after two years as publisher there returned to England. From then on, unlike his colleagues abroad, he kept translating and publishing works only in the vernacular. First and last, he brought out nearly all the best extant in English, notably Chaucer's *Canterbury Tales* and Malory's *Morte d'Arthur*. Caxton's own

prose is not fluent, but his choice of one English dialect and his steady output for a public of lords, gentry, and clerics contributed to the eventual standardization of the language.°

This first generation of international publishers did not merely make and sell books; they were scholars and patrons who translated the classics, nurtured their authors, and wrote original works. Their continual redesigning of letter forms gave rise to the new art of typography. Dozens of fine artists since 1500 have created typefaces for every kind of use without making the earliest ones obsolete. Books have a period look to the connoisseur; he can spot the date by the typeface, except that new books are still printed in Caslon, Jenson, Garamond, and other fonts made and named after these early printers. It is only very recently that an ugly, bastard alphabet (and numbers as on printed checks), has been contrived under silent pressure from non-human "readers."

As a whole, the early printed book of good quality was a work of art. The page was a composition—whence the name compositor for the typesetter. Margins, space between lines, indents, capital letters—everything was in studied proportion, and the woodcut illustrations were by master hands—Holbein, Dürer, Cranach among the most prolific. This regard for beauty was not new; it continued the medieval tradition and was in one respect inferior to it: it lacked illuminated initials. It made up for it by a handsome title page, which named and often described the author: "Marsilio Ficino, Florentine and Celebrated Doctor and Philosopher"; to which was added the rudimentary blurb: "On caring for the health of students or those who work in Letters, taking care of their good health." Next came the dedication to a patron, chief source of the author's income. It was an ingenious device: in praising expectantly or uttering gratitude for past gifts, it gained a protector and, thanks to print, it might indeed bestow "immortal fame." Both parties had an equal chance of profiting from the bargain. (Speaking of profit, the late 15C also saw the faint outline of the thought of copyright.)

As a physical object, the Humanist book differed in several respects from those that now overcrowd the city dweller's shelves. To 16C scholars our usual octavo volume, although another Aldine invention, seemed miniaturized. Theirs was a thick and heavy folio measuring 12 by 15 inches or more. *Folio* means that the large printer's sheet of thick rag paper was folded once to provide four pages. These were bound in leather- or vellum-covered boards—real boards, of wood, held shut by a metal clasp at midpoint of the vertical; cloth binding is only 175 years old. Often, a chain was attached to the book for safekeeping; it might be stolen—strange idea! As late as the 1750s, one such book, a folio Shakespeare, could be found moored to a lectern in the library at Yale. A notice specified that it was for the students' "diversion" from the less frivolous reading of the real classics elsewhere in the room.

The *use* of the book in the modern era was marked by several other inno-

vations. People were now reading silently and alone.° The monk in the gallery of the refectory reading to his brothers at mealtime was becoming a memory; likewise the university lecturer, insofar as his title means only "reader." Medieval students had not been able to own the expensive hand copies of the learned works and libraries were rarely nearby or open to them; medieval disputation was a by-product of that scarcity. When the press made the pamphlet commonplace, in the 17C, one could contradict a colleague by rushing into print.

Printers and booksellers, as friends, confidants, and protectors of literary men, were often led to publish daring books that would sell because they were scandalous. They suffered for it in various ways. Among them, Etienne Dolet had the distinction of being burnt at the stake along with his works—"a martyr of the Book." Originally a writer, he was a passionate admirer of Cicero but not a humane Humanist; on the contrary, brutal and unbalanced, he was known to have killed a man in a brawl, like Ben Jonson. Books, books everywhere, like home computers today; yet a shadow of the old oral habits lingered: it is seen in the Humanists' partiality for the dialogue form to argue a case in print. It is an imitation of the ancients and an echo of the medieval *sic et non* (pro and con) oral disputing. The genre seems fair, but shows the author-character always winning. The oration, more often printed than delivered, was an equally popular Humanist genre, also modeled on the ancient classics, its tone based on the spoken word.

From these various aspects of the book important results may be deduced: print brought a greater exactness to the scholarly exchange of ideas—all copies are alike; a page reference can kill an argument by confounding one's opponent out of his own words. A price is paid for this convenience: the book has weakened the memory, individual and collective, and divided the House of Intellect into many small flats, the multiplying specialties. In the flood of material within even one field, the scholar is overwhelmed. The time is gone when the classical scholar could be sure that he had "covered the literature" of his subject, the sources being finite in number. That is why E. M. Forster used to call "pseudo scholarship" anything not relating to the ancient classics—a rather harsh way to acknowledge the modern predicament. Lastly, in reading classical texts and Renaissance publications, one becomes aware of the ambiguity that has overtaken the word *book*. In the 16C and for a good while after, works carry titles that state the number of "books" within; for example, Jean Bodin's *Six Books About the Commonwealth* (245>). Using "book" for "part," and "chapter" for a short section, reminds us that the parchment roll or sheaf that was a book could not be very long or thick without being unwieldy, whence several "books" in one work.

<center>*
 * *</center>

Humanists were not all professional bookmen. Among the most passionate were popes, beginning in the mid-15C with Nicholas V, a sincere Christian who made his court an art center and engaged the architect Alberti to draw plans for rebuilding not only the Vatican but also the shabby basilica of St. Peter's. This had not been the papal church, but it stood on the site of the oldest Christian cemetery, where the apostle named by Christ to head the church was presumably buried. In this rebuilding of St. Peter's, for which people to the north gave so many pence, the Humanist historical spirit was at work.

After a gap of a few years came another Humanist pope and author of a remarkable autobiography, Pius II, who wanted to be called Aeneas after *pius aeneas,* the hero of Virgil's epic. Similarly, Alexander VI took his name not from a saint, but from Alexander the Great. In between reigned one anti-Humanist pope, but his negative program failed. Apart from their varying moral caliber, the "Renaissance popes" are best known for their legacy in stone and paint, but they also relished poetry and music, plays, philosophical arguments, and exotic animals for their zoo.° They paid lavishly for this princely display and set the pattern of the cultivated court.

By the third quarter of the century Julius II was on the throne—famed as fisherman and soldier, and victorious in wars that recovered papal territory. He was one of the ablest judges of artists and their works. It was he who actually started the reconstruction of St. Peter's. At the Vatican he created a sculpture garden around the "supreme statue," the *Apollo Belvedere,* and the no less famous Laocöon group, unearthed in 1506. Julius was bent on making Rome once again a beautiful city, using Bramante and Michelangelo as his designers. Julius also devised the indulgence scheme that recoiled on his successor Leo X, the connoisseur to whom Raphael owed his greatest commissions.

Such was the scene that revolted the young Luther. Viewed with his eyes, humanism was only a name for worldliness. The low morals of high churchmen often justified his verdict, yet on the whole, the Humanists were perhaps more truly Christian than the run-of-the mill priests and monks or the fanatic Evangelicals who lived by violence yet deemed themselves saved by faith. For one thing, in filling their minds with the facts of the two ancient civilizations, the Humanists were forced to settle the perennial questions that precede religious belief: What is life for? What is man's duty and destiny? What is the significance of death?

The "Artist" Is Born

EAGER FOR NOVELTY in all things, confident of possessing vast quantities of new knowledge, proud of their scholarly and other fresh methods, the Humanist generations, armed with print, set about educating the world in all the arts and sciences. From anatomy to arithmetic and from painting to metallurgy, the presses kept issuing treatises, treatises. The later the date, the less likely were they to be in Latin; the common language of each country was easier for the printer, and the reading public was no longer exclusively clerical.

None of this means that the Middle Ages had failed to diffuse advances in practical knowledge, but this effort was restricted by their institutions. The guilds of artisans kept the tricks of the trade secret; they were valuable property, as are today patents and copyrights. By an unconscious pun, the French for craft—*métier*—was thought (erroneously) to be derived from *mistère* (= mystery). The men of science—alchemists and astrologers—also used to compete in secret for gainful ends. From the late 15C on, moved by a nascent INDIVIDUALISM and the decline of the guild spirit, all these brain workers relied more on talent than on secrets to protect the value of their services. Benefiting themselves from others' inventions, they publicized their own in manuals that gave the latest news on technique.

One of the first to feel the urge to teach was the sculptor Ghiberti in the mid-15C. He was also the first to believe that an artist's life was important to record for its lessons in craftsmanship. In this view of handiwork lay the germ of a new social type, the Artist. He or she was no longer a common performer of established manual tasks, no longer ruled by group rules, but an *un*common individual free to innovate. The treatises kept the artist class up to date about these innovations.

After Ghiberti's, the deluge. His greatest, most prolific successor was Leone Battista Alberti, the 15C architect, who considered his art one with sculpture and painting and wrote on them—or it—accordingly. New buildings needed to be decorated, old ones restored, with additional figures in the round, and on the walls scenes in color, more impressively lifelike than ever.

Like most of his fellow theorists, Alberti was also a practitioner. He drew up the plans which, with some alterations, were carried out by Bramante, Michelangelo, Maderno, and Bernini to create the grandest monument of modern Rome, St. Peter's. This undertaking has been thought to mark the "rebirth of Rome," in parallel with the much questioned rebirth of the western mind (<47). A true polymath, Alberti expounded for painters the rules of perspective, and for businessmen those of computation and bookkeeping. His treatise on architecture, in Latin, was translated into French, Italian, Spanish, and English. We see here again the immense benefit of print.

Another Italian, Giorgio Vasari, impelled by the unexampled artistic outburst of his time, divided his energies between his profession of painter and builder in Florence and biographer of the modern masters in the three great arts of design. His huge collection of *Lives,* which is a delight to read as well as a unique source of cultural history, was an amazing performance in an age that lacked organized means of research—no interlibrary loan or union catalogue of books, much less the habit of interviewing, tape recorder in hand.

We who cast figures often call in the help of ordinance founders, but their insufficient experience and want of care may lead to terrible misfortunes, as nearly happened to my Perseus, a figure more than five cubits high, in a difficult pose, and with much rich detail. I therefore made a great number of air vents and many flow-in mouths, all diverging from the main one down the back. All these little hints are part of the craft. But because my methods were different from the usual ones, they neglected the furnace, the metal began to curdle, and none knew a remedy for the blunder.

—Benvenuto Cellini, *Two Treatises on Goldsmithing and Sculpture*

Vasari wanted to record more than facts and dates and anecdotes about the commissioning of great works and their execution. He describes techniques and discusses their merits and difficulties, adding to his estimates a theory of place, climate, and milieu that proves Rome unhealthy for men and works (the bad air ages both prematurely). Florence was ideal in all respects. Throughout, Vasari makes sure that his reader will appreciate the enhanced human powers shown in the works that he calls "good painting" in parallel with "good letters."

That so much light could be shed on method and achievement through books created the temptation that has ever since accompanied every technical advance: the oversupply of guides, manuals, and instructive "lives." The exuberant output of the Renaissance, besides Alberti's writings, included works now classic: Benvenuto Cellini's autobiography and a pair of monographs on small-scale sculpture and the goldsmith's art,° Palladio's treatise on building, Piero della Francesca's on design, Dürer's outline on painting and human proportions, and Leonardo's wide-ranging *Notebooks.*

Among other artist-theorists are names that raise but a faint echo today:

Serlio, Filarete, Lomazzo, Zuccaro, Ammanati, Van Mander, Von Sandrart—all dealing with the same topics, almost all describing the new science of perspective, several giving its geometrical rules in great detail, and along the way, much miscellaneous advice, ranging from the best way to grind pigments to the proper handling of apprentices.

What would strike a modern textbook publisher is the space given in these works to the importance for artists to have true faith and strict morals. Virtue is inseparable from good art. It is taken for granted that a work reveals the artist's soul as well as his mind. But what is more important, the work of art must by its order mirror the hierarchical order of the world, which is a moral order. Whether by intuition or by convention, the artist must know how to convey this reality. Hence the (to us) irrelevant injunctions in the treatises. For example, in his *Notebooks* [which is a book to read],° Leonardo makes excuses for not being a writer, but he nonetheless shows himself a moral philosopher, a psychologist, and a creator of semi-mystical parables. That all art must be moral is the rule until the 19C, when it cuts loose from moral significance, from regard for virtue in the maker's character, and from the expectations of the public (474; 616>).

<div align="center">*
* *</div>

The sheer number of Renaissance treatises tells us something about the nature of a cultural movement. One tends to think of what goes by that name as comprising a handful of geniuses with a group of admirers, patrons, and articulate supporters whose names appear (so to speak) as footnotes in smaller type. Actually, it is a large crowd of highly gifted people—the mass is indispensable. This is a generality. And these many co-workers must be great talents, not duffers. They may be incomplete or unlucky as creators, their names may remain or turn dim, but in retrospect we see that this one or that contributed an original idea, was the first to make use of a device. Together, by what they do and say, they help to keep stirred up the productive excitement; they stimulate the genius in their midst; they are the necessary mulch for the period's exceptional growths.

This reflection goes some way toward answering our question when we wonder what conditions bring about great artistic periods, seemingly at random, here or there, and for a relatively short time. It is not, as some have thought, prosperity, or wise government support, or a spell of peace and quiet—Florence at its height was in perpetual conflict inside and outside. The first requisite is surely the clustering of eager minds in one place. They may not be on the spot to begin with; they come mysteriously from all over, when some striking cultural event bruited abroad, some decisive advance in technical means, draws them to its place of origin. Like the spread of the revolu-

tionary temper, the feverish interest, the opposition, and the rivalry among artists working, comparing, and arguing, generate the heat that raises performance beyond the norm. It takes hundreds of the gifted to make half a dozen of the great. The late-discovered genius who by mischance had to work alone in a remote spot is a sad survivor of solitude and is often maimed by it.

In the best periods practice precedes theory—works before notions. But, again in the best periods, the theories derived from practice tell us something (not all) about the intentions of the leading artists and the criteria applicable to their work. These commonplaces hold for 400 years and should not be laughed out of court to please late-20C critics whose own intention is to discount artistic intention (621; 757>). The Renaissance treatises declare that apart from his moral mission, the artist's duty (and thereby his intention) is to imitate nature. He must minutely observe "God's footstool"; it is a way to worship Him. This discipline parallels the scientist's, and more than one artist of the period thinks of himself as a "natural philosopher." No "two cultures" as yet divide the best minds.

> I saw behind the King's house at Brussels the fountain, maze, and beast garden; anything more beautiful and pleasing to me, and more like a paradise, I have never seen.
>
> Erasmus is the name of the little man who wrote out my supplication at Herr Jacob de Bannisis' house. I took [made] a portrait at night, by candlelight, and drew Doctor Lamparter's son in charcoal, also the hostess.
>
> —Dürer, *Travel Diary* (1520)

Although in the Middle Ages natural forms served graphic artists as starting points, they felt no obligation to copy them faithfully. The different Humanist intention rests on the more concrete interest in nature that reading the ancients encouraged. Horace's *Art of Poetry* states the ideal of imitating life in literature and draws an analogy with painting. The same principle fitted the other arts, as anybody could see. The ancient figure sculpture that survived looked more lifelike, *humanior,* than the stylized saints lining the porches of Gothic cathedrals. The Greeks had no scruples about portraying their gods and goddesses in the guise of perfect human bodies. To the Humanist, the broken pieces of statuary discovered while digging the foundations of new buildings in Rome were golden hints of "nature."

It was a prime instance of familiar things being "taken" in a new way. The ancient temples, the Coliseum, the great memorial arches had been in plain sight for centuries, but now they were no longer pitiable remnants of paganism; they were majestic creations to be studied and copied. The architecture of northern Europe, which must now be called Gothic to stamp it as barbaric, had never been dominant in Italy. The climate favored wide windows, round arches, and interior spaces unlike those suited to the gray wintry north; so that when the desire for change arose in Petrarch's time, the mid-14C, there were elements at hand for a new style. The Certosa at Pavia, built not as a copy but

making an original use of classical features, shows the transition from old to new as if designed to serve the cultural historian.

The same need for change in painting Vasari explains by saying that the good art had been obscured and forgotten in wars and tumults, leaving only the "crude manner of the Greeks" (meaning the Byzantines), whose medieval mosaics in the eastern Italian cities were never meant to look "natural."° The accepted story of the turnabout in painting is that in the late 13C the Florentine Cimabue, after some works in the rigid tradition, depicted a Virgin in softer lines "approaching the modern manner—nobody had seen anything so beautiful." Vasari goes on to tell how the people of Florence carried the painting in a triumphal march from the painter's house to the church of Santa Maria Novella for which it had been commissioned.

Cimabue's protégé, Giotto, took the next step by basing himself on what Vasari calls "the true human form" and reproducing it as closely as he could. Nature entered in a further way through a Petrarchan interest in rocks and trees as settings: Giotto's St. Francis receives the stigmata not against a neutral background but in the countryside.

This new style is sometimes described as "realistic." This adjective and its opposite have become not only critical terms in the several arts, but also the commonest retort in the arguments of daily life: "That's unrealistic."—"Be realistic!" In all uses it is a regrettable pair of words. It begs the difficult question, what *is* the reality? Artists and ordinary people alike spend much of their time trying to find out—what do I perceive? what are the facts? If Renaissance painting gives us "the real world at last," why does it look so blindingly different in Michelangelo and in Raphael? And it goes on diverging: is nature—is reality—in Rubens or in Rembrandt? Reynolds or Blake? Copley or Allston? Manet or Monet?

True, all these artists present features of the world that are recognizable, in addition to common features of the art of painting itself. But the total effects differ; they correspond to the different visions of reality that dwell in the minds of different individuals, whether painters or not. Reflecting on the evidence, one would venture the generality that reality is to be seen in all of them and in others too. All styles of art are "realistic." They point to varied aspects and conceivings of experience, all of which possess reality, or they would not command the artist's interest in the first place and would not spark any response in the beholder. The variety of the Real confirms the importance of "taking" as a factor in life. Realism (with its implication of Truth) is one of the great western words, like Reason and Nature, that defy stable definition. It will come up again for discussion (552>). Here it is enough to question the term, and if one is needed to mark the difference between works that "resemble" rather than "symbolize," the word *naturalistic* is the less misleading of the two—perhaps.

Whatever may be the right word, the Renaissance artists believed that they had found the only true goal in art, and this for a "scientific" reason shortly to be told. But reason or no reason, the artists who count, in any school at any time, *know* that they are aiming at the right goal; it is the normal and necessary conviction for good work.

As for the terms *nature* and *imitation,* one must ask, how much do time and place, which is to say the surrounding culture, come between the object and its representation? To some extent, but not entirely. Artists tend to imitate other artists; a style or mood once adopted for its technical interest, or emotional value, or because it is in demand, becomes "nature" for both artist and viewer. The Venetian painter shows "Sacred and Profane Love"° glowing in primary colors, even though the climate he works in is not invariably sunnier than that of Rome or Florence. In the north, the Flemings created an altogether different feeling about nature by showing in muted tones but fine detail quiet interiors, civic scenes, and tall ships. In between, the Germans retained a dark "Gothic" line and spirit in their recording of persons and places.

The various kinds of paint give a different appearance to equally faithful imitations, nor can pigments ever reach the brightness of light. The painter creates his illusion by favoring some colors and proportioning their intensities to match those in what he likes to look at; and there are many ways of accomplishing this relativism. He further creates emphasis by so-called functional lines, not dictated by strict perspective; or he distorts in other subtle ways for drama, as in Leonardo's *Last Supper,* combining the effects of two points of view in place of one; or having the light come from two directions, as often in Rubens. Perspective is not "scientific"; it is an art of *calculated* illusion. In clever hands it can create *trompe l'oeil* pictures so "real" that one stretches one's hand out to test its objects by touch; or again, so neatly foreshortened that a ceiling seen from far below shows Tiepolo's figures adequately lifelike.°

In the Renaissance it was assumed that the graphic arts must treat of clear subjects—indeed, must "tell" something, in addition to pleasing the eye and the sense of composition while also observing the rules of perspective. Classical myths naturally had a great appeal, but Christian subjects did not lose ground, especially after the Catholic counter-revolution, which promoted the decoration of new churches and the renovation of old ones.

Religious and moral edification moved, so to speak, from the windows and porches of the church building to its interior walls, altars, and ceilings: the medieval "sermons in stone" now sermons in paint.

I look upon a picture with no less pleasure than I read a good history. They are indeed both pictures, one done with words, the other with paint.

—ALBERTI, *ON ARCHITECTURE* (1452)

The Bible and the lives of the saints supplied the figures and scenes as before, but in many ways secularized: the Virgin looked like a peasant girl, the costumes were contemporary, the scenery local. Veronese went too far. When he put some drunkards and a dog in his *Last Supper,* he was summoned for sacrilege but after a long grilling got off rather lightly (76>).

*
* *

With the artist becoming independent, a dedicated being, art itself begins to be an entity distinct from work, thought, faith, and social purpose. In the 16C it had not yet sworn off morality or ignored existing tastes, but the roots of autonomy were there. When a mural or altar piece came to be judged not for its pious effulgence and fitness for the spot in need of decoration, but instead for what we now call its aesthetic merit, art for art's sake was just below the horizon. Aesthetic appreciation is something more than spontaneous liking; a good eye for accurate representation is not enough; one must be able to judge and *talk about* style, technique, and originality. This demand gives rise to a new public character: the critic. The future professional begins by being simply the gifted art lover who compares, sees fine points, and works up a vocabulary for his perceptions. He and his kind are not theorists but connoisseurs and ultimately experts.

This rise in status ultimately led to the split between the knowing and the ignorant, who only "know what they like." We are told that the division did not yet exist in Renaissance Florence—everybody was a born appreciator—as in ancient Athens. In both cases this is a mere belief—or hope. Elsewhere in the 16C the two groups of beholders were at peace because they shared the same view about the role of art in society. Together they dictated fashion and taste, by purchase or utterance. From then on to the end of the 18C common opinion held that religious and history painting were the highest genres. The one edified, the other reminded; both decorated. Portraits came next, landscapes lagged behind. For nature was not yet loved for itself alone. In the early Renaissance it served as background only, and even then it was "humanized" by the presence of temples, columns, or other architectural fragments, along with actual figures. In the late 16C, other subjects made up the oddly named "genre painting"—aspects of day-to-day existence and bits of "still life," the less-than-natural assemblage of a dead bird, a hunting horn, and crockery.

As time went on, secular subjects gained in importance, in part because of a new technique: painting on canvas with pigments carried in oils. Michelangelo scorned this new trick "fit only for women and children," because the amateur or the inept professional could so easily correct a mistake—scrape it off and try again. Before oils, pigments dissolved in pure or lime water were applied to a wall which the artist himself had plastered; or

again, the colors were mixed with egg yolk and water, to a panel of poplar or other wood. To paint, one must have an infallible hand and a far-seeing mind; each stroke was final, as in watercolor today.

But the oil painting had a merit all its own: it was portable; it domesticated art. By the 17C the well-to-do citizen who was devout or fond of his own likeness could order or buy ready-made a canvas of modest dimensions and with it enliven a room. The work might depict a sacred subject or a familiar scene—the harbor and its fishing fleet, a girl sewing, the peasantry roistering on a holiday, or the night watch on its rounds. When "personalized," it showed the members of the town council, complacent in their finery, or the purchaser himself, his wife and children, with a dog and sometimes a book. These uses of art anticipated the camera and its extravagant output of faces and places, but with one difference: early portraits do not seem to flatter the subject—witness Holbein's *Henry VIII*. In the 16C no airbrush fix by a fashionable photographer revised nature.

Two other arts gained impetus from the general taste for reproducing "life": book illustration—the woodcut with its thick lines matching the heavy type of the page at first, then the steel engraving, better suited to go with the finer fonts. Equally popular was the art of tapestry, in demand as much for wall insulation in cold climates as for decorative effect.

Faithful imitation implied an indefatigable study of human anatomy and the shape and texture of inanimate objects. The nude thereby became a regular part of subject matter and schooling. Still, a painting is art only if it is an organized whole. For composition and harmony and even more for dramatic force, nature must be rearranged. Some distortion in the figures themselves, their placement, and in the relations marked by light, shade, and color is called for, in addition to the use of conventional symbols that designate the saint or hint at the burgher's occupation. In short, the painter must think.

> Painting is a thing of the mind [*cosa mentale*]. The painter who draws by practice and judgment of the eye without the use of reason is like a mirror, which reproduces in itself all the objects placed before it, with no knowledge of what they are.
>
> —LEONARDO, *NOTEBOOKS*°

Such was the meaning of the dictum that imitation must not be slavish. That warning opened the door to every imaginative possibility. It meant that the artist's goal could be beauty, that "divine attribute." And beauty being a preconceived idea, it requires compromise with what nature gives us in the raw state. Michelangelo explicitly rejects the copying of externals. Platonists like him drew out of each natural object its more perfect, transcendent model, while Aristotelians saw in the ideal form the fulfillment that matter must reach in order to become reality. Both philosophies led to the same plastic ends.

Stoics and Epicureans, for their part, also regarded nature as supplying

the ideal pattern that human life must try to attain. But knowing that nature continually destroys and re-creates individual things, they placed a modest value on the imitation of transitory objects. If undertaken, let it be done soberly. Such ideas about Nature—nature as model and yardstick—long antedated the Renaissance. They have not ceased to mold belief and behavior in many departments of life; "follow nature and you cannot go wrong" has been reiterated with unblushing confidence. But what Nature includes or what its dictates are remains in debate. Still more often, the word *natural* is simply invoked as self-evident proof of whatever is being urged.

The grand innovation that made Renaissance painters certain that theirs was the only right path for art was the laws of perspective. The discovery made them as proud as the men of letters after *their* discovery of the true path. For some Nature had been rediscovered; for the others, civilization had been restored. Perspective is based on the fact that we have two eyes. We therefore see objects as defined by two lines of light that converge at a distance, the painter's "vanishing point" on the horizon. Since those two lines form an acute angle, plane geometry can show the size and place that an object at any distance must be given in the painting to make it appear as it looks in life.

Another way to grasp the situation is to imagine a pyramid with its point at the spot where the lines from the eyes come together and its base touching one's nose. Then a slice made anywhere across the pyramid will show the relative size that distant objects and figures must have on the canvas to look "real." Or again, when the jet plane is about to land and one looks down, the size of the cars on the highway gets larger as the plane gets nearer the ground, because one is pushing forward (so to speak) the base of the pyramid. This relativism of size according to distance when figures and things are seen against a flat surface is exact. Hence the statement in an early Renaissance treatise that painting consists of three parts: drawing, measurement, and color.° One of the uses of color is to create "aerial perspective." A light blue-gray makes distant objects in the painting look hazy, as they appear to the eye owing to the thickness of the atmosphere. Combined, the two perspectives create the illusion of depth, the three-dimensional "reality" on a flat surface. Our seeing objects "in depth" is itself an illusion, for without the sense of touch to make us aware of solids and the habitual expectation thus created, what we see from the jet plane would be as flat as the patterns of wall paper. But early in life we associate the findings of hands and eyes and reconstruct the world from the signs that imply three dimensions.

<p style="text-align:center">*</p>
<p style="text-align:center">* *</p>

In any art a new technical power leads to uses and ideas not suspected at first. With lifelikeness, painting gained more and more autonomy from social

use as illustration of religious ideas. It could stand by itself, whatever it showed. The viewer needed less imagination to make out the intention, thus enlarging subject matter indefinitely and giving interest to things in and for themselves. With so much knowledge written down and disseminated and so many ardent workers and eager patrons conspiring to produce the new, it was inevitable that technique and style should gradually turn from successful trial and error to foolproof recipe. The close study of antique remains, especially in architecture, turned these sources of inspiration into models to copy. The result was frigidity—or at best cool elegance. It is a cultural generality that going back to the past is most fruitful at the beginning, when the Idea and not the technique is the point of interest. As knowledge grows more exact, originality grows less; perfection increases as inspiration decreases.

In painting, this downward curve of artistic intensity is called by the suggestive name of Mannerism. It is applicable at more than one moment in the history of the arts. The Mannerist is not to be despised, even though his high competence is secondhand, learned from others instead of worked out for himself. His art need not lack individual character, and to some connoisseurs it gives the pleasure of virtuosity, the exercise of power on demand, but for the critic it poses an enigma: why should the pleasure be greater when the power is in the making rather than on tap? There may be no answer, but a useful corollary is that perfection is not a necessary characteristic of the greatest art.

To anyone in the mid-16C who looked back to Petrarch or Giotto or Wycliffe and thought of recent work in literature and the graphic arts or scholarship and religious thought, it must seem evident that the accumulation of desirable changes meant Progress. The word and a theory about it arose° and provided a new standard of judgment: are we improving? Change came to be judged a move forward or backward, the latter being pointless. This in time generated the familiar labels progressive, conservative, and reactionary. The doctrine of progress was thus no foolish fantasy of the 18C philosophes, as is generally believed, which the 19C made into a creed certified by the forward march of industry. Now that the notion is generally decried—"the arts do not progress, nor does the moral character of man"—a look at its 16C origins makes clear how reasonable, how irresistible, how useful the new cultural yardstick was.

First was the conviction at the heart of Humanism—"more human," therefore better than the medieval outlook, behavior, and language. Next, the awareness of techniques obviously "advanced"—perspective in painting, polyphony in music (158>), improvements in the practical arts and the sciences. Finally, a sense of refinement in manners and the consciousness of religion purified, for both churches, by the Evangelical revolution. Ramus (Pierre La Ramée), who perished in the massacre of the St. Bartholomew, was confident that in the century just past greater advances had been made "in man and

works" than in the preceding fourteen hundred years. Another observer, Guillaume Postel, who had traveled to the Orient, foresaw continual progress and world unity, unless the wars and plagues that Providence might decree destroyed all the knowledge stored in books.° Otherwise, latest was best.

> The whole world is full of learned people, learned teachers, and large libraries, and it's my belief that neither in Plato's time nor Cicero's were there so many facilities for study as now.
>
> —RABELAIS, LETTER TO PANTAGRUEL FROM *HIS FATHER GARGANTUA* (1532)

To be aware of progress means being also aware of who has done the new thing, who is campaigning for the new idea. The individual gains in value: so-and-so is the talent to employ, to talk about and praise—or attack from a rival's point of view. Renaissance enthusiasm thereby built up the artist into a figure destined to be more and more extra-ordinary, more and more exempt from convention and the law. His predecessor, the *artisan*—any man who worked with his hands—now rose in status if he worked in one of the *fine* arts, again a new distinction. It was not established all at once; for the people at large, the taint of the grubby hand persisted. It was no doubt to placate the other servants, including the paymaster, that Philip IV of Spain put Velasquez on the payroll as an upholsterer. [The book to read is *Artist and Craftsman* by H. Ruhemann.]

The marks of the new type were none the less clear. The artist was no longer anonymous as he had almost always been in the Middle Ages (in contradistinction to the author, whose hand was not grubby). The builder, sculptor, painter now signed his work or was credited in print. Again, he chose his patron as often as his patron chose him. Cities and burghers hired his services only for the specified task; he traveled where money and fame awaited him, or at least were held out as bait, for payment was often hard to collect. The great are lavish in words but stingy or impecunious in cash (334>). This footloose practice enabled the artist to serve simultaneously two patrons who might be at war with each other. It even made artists useful as ambassadors from one court to another if they had the right personality. Rubens is the great example of the artist as statesman, supreme in both roles (334>).

Clearest sign of independence, the patron (or his majordomo) who tries to inject his ideas into the design is told not to meddle in matters which he does not understand. In time it became impossible for the patron to coerce or even direct "his" artist.

The artist is occasionally a writer as well. He describes his work and his views, he tells of his struggles, publishes his grievances, gives good and bad marks to his employers—Cellini

> And further, if I am to do any work for Your Holiness, I beg that none may be set in authority over me in matters touching my art. I beg that full trust may be placed in me and that I may be given a free hand.
>
> —MICHELANGELO, SCULPTOR, FLORENCE (1524)

It is a duty incumbent on upright and credi-
ble men of all ranks who have performed any
thing noble or praiseworthy to record in their
own words the events of their lives. But they
should not undertake this honorable task
until they are past the age of forty.

—Benvenuto Cellini, Opening
 Sentence of His Autobiography
 (c. 1558)

flunked Clement VII—and like Petrarch
appealed to Posterity. [The book to
browse in is Cellini's autobiography.]

*

* *

After the Council of Trent, when
every form of religious opinion was
more or less under surveillance by
church authorities, works of art were
liable to censorship. The case mentioned earlier of Veronese's *Last Supper* is
notorious. His interrogatory shows the painter confident that in the exercise
of their art artists are free agents. The tribunal pressed hard but did not shake
him. Asked first about his trade, the accused said: "I paint and compose fig-
ures." The quizzing goes on:

Q. Do you know why you have been summoned?
A. I can well imagine. Your Lordships had ordered the Prior of the Convent
 to have a Magdalen painted in the picture [of the Lord's Last Supper]
 instead of the dog. I told him that I would do anything for my honor and
 that of the painting, but that I did not see how a figure of Magdalen
 would be suitable there.
Q. Have you painted other Suppers besides this one?
A. Yes, my lords. [He mentions five.]
Q. What is the significance of the man whose nose is bleeding? And those
 armed men dressed as Germans?
A. I intended to represent a servant whose nose is bleeding because of some
 accident. We painters take the same license as poets and I have repre-
 sented two soldiers, one drinking and the other eating on the stairs,
 because I have been told that the owner of the house was rich and would
 have such servants.
Q. What is Saint Peter doing?
A. Carving the lamb to pass it to the other end of the table.
Q. And the one next to him?
A. He has a toothpick and cleans his teeth.
Q. Did anyone commission you to paint Germans, buffoons, and similar
 things in your picture?
A. No, my lords, but to decorate the space.
Q. Are not the added decorations to be suitable?
A. I paint pictures as I see fit and as well as my talent permits.
Q. Do you not know that in Germany and other places infected with heresy,

pictures mock and scorn the things of the Holy Catholic Church in order to teach bad doctrine to the ignorant?

A. Yes, that is wrong, but I repeat that I am bound to follow what my superiors in art have done.

Q. What have they done?

A. Michelangelo in Rome painted the Lord, His Mother, the Saints, and the Heavenly Host in the nude—even the Virgin Mary.

The Illustrious Judges decreed that the painting must be corrected within three months, at the expense of the painter. In the end, he changed nothing except the title of the work.

It should not be thought that in becoming artists, painters and their kind ceased to be artisans in the physical sense. Painter and sculptor, engraver and architect did not throw off their smock and keep their hands clean like the writer at his desk. The graphic arts are rooted in matter and the least competence requires skill and knowledge about pigments, oils, glue, wood, wax, plaster—and how to handle raw eggs. [The book to browse in is *The Artist's Handbook* by Ralph Mayer.] The sculptor is equally a workman, his hands roughened by chipping stone and his hair full of plaster dust; the architect oversees the masons and bricklayers as one familiar with their routines, and he scampers up scaffoldings—like the painter of frescoes.

The painter's ad hoc chemistry has to be learned, and in the Renaissance and for two centuries more, the training of artists was by the apprentice system inherited from the medieval guilds. It would have been folly in the 16C to transfer the teaching of art to the universities or to special schools as we have done. The 16C artist needed a group of trainees to help him in the routine manual tasks and the "filler" portions of the very large works commissioned for churches and city halls. This system was so effective that it is the cause of present-day puzzles that bedevil museum curators and art dealers: Is this a Rembrandt? Or is it a superb piece by So-and-so, known to have been one of his best assistants? The master's teaching imparted the master touch. And in doing so well, the "ghost" Rembrandt was unwittingly carrying out the medieval principle, which was that the good artisan reproduces the model

My beard turns up to heaven; my nape
 falls in,
Stuck to my spine. My breastbone visibly
Grows into a harp; a rich decoration
Adorns my face with paint drops thick and
 thin.
My loins into my paunch like pistons grind,
My buttocks like a saddle bear my weight.
My feet unguided wander to and fro;
Crosswise I strain, bending like a bow.
Come, Giovanni
Help save my pictures and good name,
Since I'm so badly off and painting is my
 shame.
—MICHELANGELO, "ON PAINTING
 THE SISTINE CHAPEL"

exactly, whether it is a picture for the guild hall or a felt hat for the Lord Mayor. The artist does the opposite: he follows his bent, creates his own style, as Petrarch recommended. In the course of time, he *must* be original altogether if he is not to be deemed academic, worthless. But even before the cult of the new (160>), the users of new techniques advertised their *ars nova, dolce stil nuovo,* or *via moderna.*

Contract for the *Pietà,* August 7, 1498

... the Most Reverend Cardinal di San Dinizio has agreed that Maestro Michelangelo, statuary of Florence, shall make a *Pietà* of marble, a draped figure of the Virgin Mary with the dead Christ in her arms, the figures being life-size, for 450 ducats, 150 to be paid before the work is begun. And I, Jacopo Gallo, promise that the said Michelangelo will complete the work within a year and that it shall be more beautiful than any work in marble to be seen in Rome today.

—GALLO, A COLLECTOR OF ANTIQUES,
 ACTING AS AGENT FOR THE SCULPTOR

Emancipated from guild rules, the artist becomes an independent contractor. He deals with any member of the public on his own terms; willy-nilly he is a businessman, not always a congenial role. For as usual with EMANCIPATION, hard conditions limit the new freedom. If to win recognition the artist must show a distinctive style, the command may strain his fund of originality at the same time as he faces vicious competition. To gain the favor of the rich he must cultivate their taste and earn the applause of critics fronting for the public, not to mention the speculative eye of the art dealer, who also first appears in the 16C. Society meanwhile, though a willing customer in a general way, fumbles at that insoluble problem, the patronage of art (338>).

*
* *

By a pleasant custom dating back to the last century, a noted brain-surgeon who plays the violin, can sail a boat, and keeps up with new books is known among his friends as a Renaissance man. He deserves credit, certainly, for battling against the force of SPECIALISM, but his qualifications for the honorific title fall a little short when he is compared with, say, Alberti, who not only painted and built and theorized, but was also a poet and playwright, a musician (organist), and a writer on theology and philosophy.

What Pico thought man could develop in himself and what Castiglione was to describe as the perfect creature of a civilized court (85>) excluded no faculty of the mind—hence the label *uomo universale.* But it called for at least the basis of Humanism, "the good letters"; and this is why the figure so often cited nowadays as *the* Renaissance man, Leonardo da Vinci, does not deserve the title. He has obviously been chosen to flatter our dominant interests: art and science. Towering as a painter, he was also preoccupied with civil engi-

neering, aviation, and scientific observation generally. His machines did not work, but his sketches and calculations for them are remarkable. The combination of the "two cultures" is to us striking and so is his persevering "research." Yet of all the men of his period he is the outstanding case of the genius who was not a Renaissance man in the intended sense: he lacked the good letters. He speaks of this limitation himself. He cared nothing about Latin and Greek. He never wrote poems or orations. He had little to say about philosophy and theology. He took no interest in history; to paint a mural in the Governors' Palace in Florence, he had to borrow Machiavelli's notes on a famous battle. Nor was he an architect or a sculptor. Worst of all, he had no use for music, which (he said) had two great faults—one mortal, in that music ceased to exist as soon as the piece was over; and one he called "wasting": its continual repetition, which made it "contemptible."

A close ranking of candidates would place Luther higher than Leonardo, for Luther was a great writer and orator (though not a great classicist), a musician, a theologian, a practiced observer of nature and (as we saw) a willing partaker of the life of the senses (<17). To Leonardo, a picture was more fully expressive than the products of any other art, and even in painting his output was small. The point of this comparison is not to disparage Leonardo, whose genius is beyond question, or to replace him in the hall of fame with Alberti, the encyclopedic talent. It is only to restore the proper meaning of the honorific title now bandied about heedlessly. A once popular book that used the phrase Renaissance man as a title offered Machiavelli, Castiglione, Aretino, and Savonarola as representatives.° They are not the best that might be chosen, but they suggest the interdisciplinary mind, a cultural type more wondered at today than truly appreciated. In a genuine instance, the murmur "jack-of-all-trades" is likely to be heard.

> If you [poets] call painting "dumb poetry," then the painter may say of the poet that his art is "blind painting." Consider which is the more grievous affliction, to be blind or dumb?
>
> —LEONARDO, *NOTEBOOKS*

Actually, the true Renaissance man should not be defined by genius, which is rare, or even by the numerous performing talents of an Alberti. It is best defined by variety a of interests and their cultivation as a proficient amateur. A Renaissance man *or woman* has the skill to fashion verses and accompany or sing them; a taste for good letters and good paintings, for Roman antiquities and the new architecture; and some familiarity with the rival philosophies. To all this must be added the latest refinements in manners as practiced in the princely courts, where men and women were expected to talk agreeably, to dance gracefully, to act in masques, and improvise other at-home theatricals. Social life for them was a species of serious work for mutual pleasure, one motive being to

fend off boredom. The men must be soldiers; both sexes could be adept at politics. In short, it is the exact opposite of our intellectual and social specialisms, the reverse of our prefabricated hobbies and entertainments.

It was of course easier in the 16C and 17C than now to be a generalist in the arts and to some extent in science (191>). These subjects were not so much accessible as manifest, and the lines between them were hardly drawn. One might say that life itself was general. Under colorful differences, similar cultural attitudes and arrangements prevailed in Rome, Florence, Venice, and Padua; in Paris and London, in Antwerp and Lisbon. A sizable group from the upper classes accepted the talented; the latter being "domestics" in the residential sense. All as it were "practiced high culture" in the newest forms that had reached the place, all were ready to follow the latest whims of taste as these were wafted from whichever was then the most active center of innovation.

Seconding this movement of ideas was the astonishing amount of traveling done, despite hardships and hazards. The switchabout of scholars between universities, the tide of artists to the liveliest spot and of gentlemen and ladies to the capital cities—none of this organized—was incessant. It went with a polyglot frame of mind; the nation-state had not yet concentrated mind-and-heart on one country and one language. In Rome and Paris the very beggars made their pitch in several languages as the stranger approached.

> Travel in the younger sort is part of Education; in the elder, a part of Experience. He that travels into a country before he has some entrance into the language goes to school and not to travel. The things to be seen are: the courts of princes, the courts of justice, the churches, the monuments, walls, and fortifications, harbors, antiquities, ruins, and libraries, colleges, shipping and navies, houses and gardens, armories and arsenals, exchanges, warehouses, exercises of horsemanship, fencing, and training of soldiers, comedies of the better sort, treasuries of jewels, robes, and rarities, as well as triumphs, masques, feasts, weddings, and capital executions.
>
> —BACON, "Of Travel" (1626)

Because this group of globe-trotters belonged to the upper orders (and were not as yet too numerous), they could count on being received abroad by one of their peers without previous notice or acquaintance, even in a small town. Word would come from the innkeeper to the burgomaster or to the squire that a person of quality had arrived, and an invitation would follow. [The travel book to read is Montaigne's *Diary of 1580–81*.]° Artists, unless famous, would carry letters of introduction.

The prerequisite for these activities was leisure. Nobles and their kept artists, not being workers captive to the nine-to-five, enjoyed freedom not at stated times but in scattered fragments throughout the day. Artists are envied now for the same reason. But leisure is not the simple thing it seems. The people who supported 16C culture were embroiled in politics, love intrigues, and vendettas; they fought in wars, and bore the usual burden of managing

their estates and of adding to them by complicated marriages and long-drawn-out negotiations. They were not idlers or free of worries. Yet they did things that appear impossible without casual *far niente*. The paradox has only one explanation: leisure is a state of mind, and one that the modes of society must favor and approve. When common routines and public approval foster only Work, leisure becomes the exception, an escape to be contrived over and over. It is then an individual privilege, not a custom, and it breeds the specialized recreations and addictions of our time.

As for the artists in the noble palace, they too were kept busy at other things than their art. They must devise the frequent elaborate entertainments and also serve in humbler ways. Velasquez "the upholsterer" had to supervise King Philip's house staff. But these arrangements, usual in the 16th and 17C for living a hundred or more under one roof, facilitated the pleasurable activities. The palaceful of retainers afforded quick communication and direct execution. Planning a ball or a masque went from my lord to the poet, the musician, and the carpenter without the deliberations of a committee. Besides, living and working together softened the distinctions of rank. Antagonism, if any, was individual rather than class-inspired, though arrogance at the top and envy at various levels below found its opportunities. Not a family and not a clan, the "house" was nevertheless a protective institution. All within the group had a role and a living, regardless of status, talent, or schooling; and as the master's "people," wearing his livery, they could count on his support inside and defense outside. It was a society in little. [The book to read is *The Marriage of Figaro*— Beaumarchais' play,° not Da Ponte's opera libretto.]

It is a temptation to credit the Renaissance with another new social type, the journalist. But that would be playing with the word *type*: the age produced one specimen, not a type: Aretino, and he proved a sample of the kind not much in favor with the conscientious writer for the press today. The son of a cobbler and entirely self-educated, Aretino used his extraordinary narrative style in the vernacular tongue to purvey news in *avisi* (broadsheets) and letters that everybody wanted to read, because they were often scandalous. The persons and politics of the highly placed were his target, and it has been thought that sometimes he used his information for blackmail. He could praise as well as ridicule and would receive propitiatory gifts, one from the French king, Francis I. The poet Ariosto put Aretino in his epic (147>) under a nickname that has stuck: "the scourge of princes." Nowadays it takes a staff of paid informers among the fashionable to keep a scandal sheet going. Being a Renaissance man, he did it alone.

Aretino attached himself to various princes, rarely for very long until mid-career, when he settled in Venice and periodically published collections of his letters. He wrote plays and dialogues that are esteemed as high-class erotica. He was loyal to the friends he made among the painters, notably

Titian, and led in their appreciation by the public. He closed his career, predictably, with two works of devotion.

* * *

The suggestion made about the term *Renaissance man* coupled it with *woman* in italics. This was no afterthought but a heralding of the truth that 16C society was molded and directed by a host of women as brilliant as the men and sometimes more powerful (85>). On an earlier page I said that in this book I would adhere to the long use of *man* as a word that means human being—*people*—men and women alike, whenever there is no need to distinguish them. Why then make a point of Renaissance women if already included in Renaissance man? First, to emphasize the presence in the group being discussed of the women we are about to meet, and secondarily for a chance to discuss the usage of *man* followed in these pages. Here, then, is

A Digression on a Word

The reasons in favor of prolonging that usage are four: etymology, convenience, the unsuspected incompleteness of "man and woman," and literary tradition.

To begin with the last, it is unwise to give up a long-established practice, familiar to all, without reviewing the purpose it has served. In Genesis we read: "And God created Man, male and female." Plainly, in 1611 and long before, *man* meant human being. For centuries zoologists have spoken of the species Man; "Man inhabits all the climatic zones." Logicians have said "Man is mortal," and philosophers have boasted of "Man's unconquerable mind." The poet Webster writes: "And man does flourish but his time." In all these uses *man* cannot possibly mean *male* only. The coupling of *woman* to those statements would add nothing and sound absurd. The word *man* has, like many others, two related meanings, which context makes clear.

Nor is the inclusive sense of human being an arbitrary convention. The Sanskrit root *man, manu,* denotes nothing but the human being and does so par excellence, since it is cognate with the word for "I think." In the compounds that have been regarded as invidious—*spokesman, chairman,* and the like—*man* retains that original sense of human being, as is proved by the word *woman,* which is etymologically the "wife-human being." The *wo* (shortened from *waef*) ought to make *woman* doubly unacceptable to zealots, but the word as it stands seems irreplaceable. In a like manner, the proper name Carman is made up of *car,* which meant male, and *man,* which has its usual *human being* application. *Car,* originally *carl* or *kerl,* was the lowest order of freeman, often a rustic. (*Carl* has further given us *Charles* and *churlish.*)

In English, words denoting human beings of various ages and occupations have changed sex over time or lost it altogether. Thus at first *girl* referred to small children of either sex, likewise *maid*, which meant simply "grown-up," and the ending *-ster,* as in *spinster* and *webster,* designated women. It is no longer so in *gangster* and *roadster.* Implications have shifted too. In Latin, *homo* was the human being and *vir* the male, so that *virtue* meant courage in battle; in English it long stood for chastity in women. The message of this mixed-up past is that it is best to let alone what one understands quite well and not insist on a one-sided interpretation of a word in common use.

Some may brush aside this lesson from usage old and new with a "Never mind. Nobody knows or thinks about the past and *man* remains objectionable." At this point the reformer must face practical needs. To repeat at frequent intervals "man and woman" and follow it with the compulsory "his and her" is clumsy. It destroys sentence rhythm and smoothness, besides creating emphasis where it is not wanted. Where *man* is most often used, it is the quick neutral word that good prose requires. It is unfortunate that English no longer has a special term for the job like French *on.* But *on* is only the slimmed down form of *hom(me)*—man again.

For the same neutral use German has *man,* true to the Sanskrit and meaning people. English had the identical word for the purpose until about 1100. German has also *Mensch* with the sense of human being. So at bottom both French and German carry on the same double meaning of *man* as English, just more visibly; it is the only convenient generic term when it is not perversely interpreted. There is after all an obligation to write decent prose and it rules out recurrent oddity or overinsistence on detail, such as is necessary (for example) in legal writing. Besides, the would-be reformers of usage utter contradictory orders. They want *woman* featured when men are mentioned but they also call for a ban on feminine designations such as *actress.*

The truth is that any sex-conscious practice defeats itself by sidetracking the thought from the matter in hand to a social issue—an important one, without question. And on that issue, it is hardly plausible to think that tinkering with words will do anything to enhance respect for women among people who do not feel any, or increase women's authority and earnings in places where prejudice is entrenched.

Finally, the thought occurs that if fairness to all divisions of humanity requires their separate mention when referred to in the mass, then the listing must not read simply "men and women", it must include *teenagers.* They have played a large role in the world and they are not clearly distinguished in the phrase "men and women." Reflection further shows that mention should be given to yet another group: children. The child prodigy in music is a small category. But one must not forget the far larger group of 8-, 10-, and 12-year-olds: boys (and sometimes girls in disguise) who in the armies and navies of

the West have served in fife-and-drum corps or as cabin boys. Columbus's ships had a large contingent; all the great explorers of the New World relied on sizable teams of these hard-worked crew members. Manet's painting of the small fife player and one by Eva Gonzales remind us of the continued use of these little waifs past the mid-19C. Perhaps the last child to be so memorialized is to be seen in Eastman Johnson's "The Wounded Drummer Boy,"° portrayed at the height of the American Civil War.

Western culture is also indebted to children in a less cruel way, through the age-old institution of the boys' choir in church. In Renaissance England the "Boy Players" were actors, not amateurish as in the modern school play, but professionals and organized in companies. One of these was a serious competitor of Shakespeare's troupe.

The teenagers' cultural contribution is more varied and better recorded, and the thought it brings to mind is the marked difference between earlier times and our own in the feeling about age. When the 19C novelist George Sand at 28 declared herself too old to marry (by custom she had been an old maid since 25) or when Richard II, 14 years old, alone in a large field, faced Wat Tyler's massed rebels and pacified them with a speech, attitudes were taken for granted that are hard for us to imagine. Nearly to the beginning of the present century, society accorded teenagers roles of social responsibility. Rossini first conducted an orchestra at 14 and led the Bologna Philharmonic at 18. Weber was even younger in a comparable position.

In war and government, posts of command were won early. Alexander Hamilton, also at 14, set the rules for captains who traded with the firm that employed him on St. Croix Island, and he was 19 when Washington made him aide-de-camp. Pitt the Younger was prime minister at 23. Lagrange was professor of mathematics at the Turin School of Artillery at 19. And in Castiglione's manual of Renaissance manners, *The Courtier* (85>), one of the engaging figures is Francesco della Rovere, nephew of the pope, Lord General at 17, and soon to be "General of Rome." In the book he has just lost a battle but not the respect of his friends. His rank, his charm, and his mind ensure his being listened to as if he were a mature philosopher. Teenagers could lead armies in battle, for an older warrior's young page might be made a knight at 12 and there was no ladder of ranks between the first signs of talent and the top—witness several of Napoleon's marshals.

Cultural expectations were based on early mortality and spurred the young to live up to them. Melanchthon wrote an acceptable play when not quite 14 and Pascal's essay on conic sections, written at the age of 15, won the praise of Leibniz and other mathematicians. Halley—later famous for his comet—was a serious astronomer at the age of 10. The same often held good of the women. Catherine de' Medici was married early to her husband Henry, heir to the throne of France. She was 14 (a little older than Shakespeare's

Juliet) and he a few weeks older than his wife. The marriage had been arranged by the pope as part of a complex political scheme, and to make it secure it was imperative that Catherine should produce a son in short order. When Henry proved unequal to the work, the pope challenged Catherine with the words: "A clever girl surely knows how to get pregnant somehow or other." We shall shortly meet this great stateswoman in her prime (86>).

<p style="text-align:center">*
 * *</p>

In that same book of *The Courtier,* which is nearly contemporaneous with Luther's *Ninety-Five Theses,* one soon notices that two of the characters, Gaspar and Octavian, are declared enemies of women and that they are steadily refuted by the rest. The majority opinion is that women are equal to men in understanding, virtue, and ability, including at times physical prowess. They are shown to be great rulers, poets, and conversationalists. Two of the four women in the dialogue are the moderators, and their decisions show them to be as well informed as the men about the topics being discussed. That (still in this portrayal) women's wish to preserve tenderness in their conduct may lead them to use different ways of doing what men do is true, but the result is nonetheless excellent. Men, although benefiting from women's civilizing influence, should not lose through refinement the robust aggressive qualities they are born with and need for their special tasks.

The vindication of women was not a mere notion of Castiglione's. The evidence for his assertions was all around him. The 16C was full of women who exerted their talents like men for all to see and judge. The Vatican under the Renaissance popes was crowded with women politicians—nieces or sisters-in-law of the reigning power and others less closely related, who struggled among themselves for the exercise of that power. One or two of them remained the ultimate decision-maker for years. Their world of court intrigue brought out abilities that in another setting would have successfully ruled a modern nation.

That setting did exist and was well occupied. Isabella of Castile, as will appear (98>), was again and again Ferdinand's *better* half in governing Spain at a critical time in the making of the nation. Later in the century, Philip II had Spain well in hand but was beset by an over-extended empire, and needed a deputy to govern the unruly Netherlands. He appointed as governor his illegitimate sister, Margaret of Parma. In the nine years of her authority over a growling rebellion, her skillful efforts to achieve reconciliation postponed the outbreak. She has not been celebrated because she was "on the wrong side," and because her successor, the Duke of Alva used cruel means of repression. Modern Liberal feeling cheers for the Dutch and condemns all who tried to prevent their emancipation. But the cause and outcome of a struggle give no measure of the ability displayed by either side. Fair judgment should follow

the model that has made a hero of General Robert E. Lee although he lost a war fought to preserve slavery.

Another 16C stateswoman, well worth notice, is Louise of Savoy (also a 14-year-old bride), without whom her son Francis would very likely not have been King of France, the line of succession being in dispute. She adored that vain and self-indulgent youth and she deployed her diplomatic genius to such affect that he did gain the throne and once on it performed not badly. Why is Louise not listed among history's king-makers? Or mentioned as the negotiator of the Treaty of Cambrai that ended France's War with Spain in 1529 and was soon known as the *Paix des Dames,* because the other contracting party was Margaret of Austria, aunt of Charles V. Elizabeth of England has received her due and there is no need to rehearse her superior arts of delay and defusion. But she should also be remembered as one of the most learned minds of her time, a character of the type traditionally called manly, and an expert organizer of public relations.

Elizabeth I of England

She assigned Thursday as bear-baiting day and decreed that the giving of plays on that day was "a great hurt to this and other pastimes which are maintained for Her Majesty's pleasure." The Master of the Bears requisitioned bears and dogs anywhere for her entertainment. (1565)

A good many other leading women in 16C politics could be mentioned. One more will suffice: the Catherine whose teenage marriage was mentioned above. She also has suffered in reputation from serving interests not to our taste. But as queen and queen mother of France she guided policies that upheld the royal prerogative and the integrity of the kingdom. She faced ruthless factions, including the Protestant Huguenot party. She is blamed for the massacre of the St. Bartholomew, but it is not clear that the responsibility is hers—and we never hear about the "Michelade," when the Huguenots massacred Catholics on St. Michael's day. [The book to read is Balzac's semi-fictional *Catherine de Médicis.*]

The many Italians who found a post at Catherine's court were resented as foreigners, but their influence under her leadership brought into French life many of the refinements from their homeland. (One odd trace of their presence is embalmed in the French language. Apparently in imitation of their speech, it became fashionable to pronounce *r*'s as *s*'s; so the French word for chair, originally and sensibly *chaire,* turned into present-day *chaise.*)

Turning to the gentler sort, we encounter another "pearl," Marguerite of Navarre (also d'Angoulême), sister of Francis I and protector of Rabelais. At her court in southwestern France she entertained a coterie of writers and thinkers of all persuasions, including for a time Calvin. She encouraged local trade and art, wrote poetry, and tried to reconcile Catholics and Huguenots. Her great work, *The Heptameron,* is a collection of 72 tales patterned after Boccaccio's *Decameron,* but original in mood and different from his by the

change in manners over two and a half centuries. It has been called "a masterpiece of pornography" and it is certainly erotic: all are stories about the tricks and turns of love affairs, mostly illicit. But the porn-monger of today would look in vain for the physical exploits that have become commonplace in high and low fiction.

Marguerite's contemporaries thought her "as good as she was beautiful and as brilliant as she was good," and her stories praise in all sincerity honorable love and chastity. The tales in which adultery, murder, or clerical concubinage are features of the entertainment are not fantasy for titillation; they could have been documented by the author from contemporary life. And when her tone is serious and the case is one of grave sin, retribution follows. Toward the end of the unfinished series—it was planned to number 100—she verges on a somber naturalism in which love is still a force but the erotic disappears. Her prose is among the best of its day, simple—there is no occasion for philosophical abstractions—and it is therefore lucid.

Marie de Gournay, the adopt*ive* daughter of Montaigne (*she* adopted *him*), did go in for philosophy. She was a woman of prodigious erudition, hobnobbing in Paris with all the leading celebrities. She edited two enlarged editions of Montaigne's *Essays,* wrote a *Defense of Poetry,* a discourse *On the French Language,* a tract *On the Small Value of Noble Rank.* Most important, she wrote *The Equality of Men and Women.* In this, it must be added, she had the support of others, who were men, notably the German Cornelius Agrippa, who defended the "superexcellence of women."° Marie tested her self-reliance by traveling across France alone to visit Montaigne's family and "console them" after his death.

No less striking is the personality of another 16C artist, Louise Labé, poet and musician, adept at horsemanship and other sports, who mastered several languages—all this after serving in the army with her father at the age of 16. Most remarkable at the time, she was of bourgeois origins and perhaps the first woman who gathered around her poets and artists to form a *salon,* the bourgeois equivalent of a court. Her writings include sonnets and elegies still anthologized and an unusual prose work, *The Debate Between Folly and Love.*

Louise Labé's counterpart in England, Lady Pembroke, has been duly celebrated. Edmund Spenser named her among the great contemporary poets. Known as Urania (the muse of astronomy), she was a patron of poets and playwrights. With her brother Philip Sidney she versified the Psalms and is thought to have introduced a note of feminism in his noble *Arcadia* (155>), as well as changed passages that were "too free."

Because all but one of these women belonged to the nobility it should not be supposed that artistic talent and managerial ability in women existed or had a chance to come into play only at the top of the social scale. There were—there always have been—hundreds of women in all ranks who were in

fact rulers—sometimes tyrants—of their entourage, as well as hundreds of others who wrote, sang to their own accompaniment, or practiced one or another of the ornamental crafts. The notion that talent and personality in women were suppressed at all times during our half millennium except the last fifty years is an illusion. Nor were all women previously denied an education or opportunities for self-development. Wealth and position were prerequisite, to be sure, and they still tend to be. The truth is that matters of freedom can never be settled in all-or-none fashion and any judgment must be comparative. Individual cases moreover show that what happens in a culture always differs in some degree from what is supposed to happen; possibilities are always greater than custom would dictate.

One standard for judging the status of women is the contemporary status of men. In the hierarchical society of the 16C and later, they too were deprived—of education, of openings for talent, of the means to leave the narrow space where they toiled—hence there was little or no lateral mobility, let alone vertical. In the Renaissance this constriction was greater than before because of the diminished prestige of the clergy. The Middle Ages had offered the humblest boy a chance to be educated and to rise to high posts in church and state. After the Reformation, laymen more and more filled these places. What John Stuart Mill in the 19C chose to call the subjection of women was thus matched for a long time by the subjection of men. And since Mill had in mind his own day, in which a good many women did emerge into public notice and power, a second mode of comparison might well be to measure their status against that of women in Mohammedan countries.

The cultural point here is not to condone the presence of obstacles to self-development, at any time, against anybody. It is to mark a difference between social norms and cultural actualities. If we see "the artist" emerge in the Renaissance as a self-directing individual who can say to his employer: "Hand's off. Be quiet. I know my business better than you," it implies that formerly he suffered "subjection"—to the employer *and* the guild. Nor did subjection completely disappear: the agent, the patron, and the public have continued to this day to limit and hinder artistic free will.

This is to say that cultural absolutes do not exist, pro or con. Nobody in the Renaissance circles so far looked at was shocked by the rise to eminence of the women whose mention here is far from closing the roster. The names of others are known and their lives recorded in detail; their deaths memorialized in poems, letters, and other expressions of praise and grief. The debate in *The Courtier* suggests that the reality was ahead of the stereotype and this fact was the spur to the arguments in defense of equality for the sexes.

Over our five centuries, the changes in social structure, economic life, and cultural expectations have worked fairly steadily toward EMANCIPATION and made INDIVIDUALISM a common form of SELF-CONSCIOUSNESS. The artist is

the conspicuous and congenial example. But free play for the self is still a goal to be achieved and not a gift. Under any system, whoever wants self-fulfillment must exert willpower over a long stretch of time, besides possessing talent and knowing how to manage it. And as is plain from daily experience, many who make this effort fail nonetheless and complain of "subjection." Meanwhile, the great majority feel no wish for public fame or self-expression, which does not mean that they are denied respect or some scope for their modest powers. The society in which everybody finds his or her proper level and due recognition has yet to be designed and made to work.

CROSS SECTION

The View from Madrid Around 1540

IN THIS FIRST and later "Cross Sections" the aim is to survey events and ideas of mixed kinds as they might be noted or heard about by an alert observer at a given time and place. A wide-awake youngster "of good family" (however defined) begins to be aware of the wide world in his or her early teens. By then, knowledge of the recent past has also been absorbed automatically: it was "the present" for the parents, who keep referring to it. Its striking events and startling notions come through this hearsay to seem part of the youth's own experience, so that with this headstart his mind keeps abreast of developments; that mind is in fact the place—or one of the places—where culture has its being. Given a life expectancy of forty years— a generous allowance for the 16C—such a viewer commands a panorama of at least half a century—thirty years of direct knowledge and twenty or so of gatherings from the collective memory of his milieu, which may on certain points stretch back indefinitely into the past.

The cities from which such viewings will be taken have been chosen for their timely connection with the cultural topics discussed up to that point. These were set out in roughly consecutive patterns for the sake of clarity. But life actually lived, as Hazlitt reminds us, is "a miscellany," a jumble of apparently unrelated incidents and tendencies, so many daily cross sections of the world. For this tutti-frutti of impressions one must simulate the casual conjunction of significant items, adding only background for clear portrayal.

First, a word about the center from which this first survey is to take place. Madrid, like a good many of the things so far looked at, was a 16C innovation. Before the Modern Era it was the merest village in central Spain, perched on

a plateau some 600 feet high, 2,100 above sea level. Not until 1540 did it seem possible that it would enlarge into a European capital. In that year, Charles V, just turned 40 and suffering from gout and perhaps malaria, repaired to this spot, thinking that its brisk air, which he remembered from two previous visits, would do him good.

The place was otherwise unattractive and remained so for a good many years. It had poor soil, few trees, and not enough water. Its adobe houses were mean in size and looks, the streets a blend of mud and garbage along which pigs ran wild, protected by their local patron saint. Its very name had a doubtful meaning. In its Arabic form it stood for "place of winds" or "running waters" or perhaps simply "fortress." The population of about 3,000 did not grow or prosper until the site was made the capital of the realm by fiat. This last feature is but one of the curious parallels between Spain and Russia, the two appendages of the Occident.

Not being on a river but on a stream likely to vanish in summer heat, Madrid lacks easy communication with the rest of the country. When it started growing to 30,000 in half a century, food had to be brought up by endless trains of mules. The Spanish and foreign "immigrants" who came there did so only because the town had been decreed the "sole court, loyal and crowned." And yet in 1543 a visitor described some amenities—a pleasant park where well-dressed women and their escorts promenaded and, the brothel having been removed, some handsome houses and public buildings to be admired. Others among the newcomers thought of Madrid as "nine months of winter, three of hell."

So much for the site. Nobody had been looking for a new capital; the country had a surplus of them: Valladolid, Toledo, Saragossa, and Seville— evidence of the lack of integration that has characterized Spanish history from the beginning. With these details in mind, what might a Madrid resident, new or old, think of most often as the 16C neared the midpoint? First and foremost, surely, it would be the creator of Madrid himself,

Charles V

By 1540 the Spanish had become used to him. When he first came to the place as king and emperor two decades earlier, he was an unknown quantity, a foreigner barely out of his teens, a Fleming who did not speak Spanish. He brought a Burgundian adviser and Flemish hangers-on: he could hardly be a popular sovereign. But he was a conscientious youth and he learned fast. He had been well brought up on a mixture of modern knowledge and medieval ethics, that is to say, the chivalric ideals of faith in God, honor on earth, and scorn of greed and cunning.

Yet as the grandson of that gifted pair, Isabella of Castile and Ferdinand

of Aragon, whose union and hard work had made a start on unifying the peninsula, he had worldly duties as well as spiritual. But his position was difficult: he was not King of Spain; there was no such entity. He ruled four kingdoms—Navarre, Valencia, Aragon-Castile, and Catalonia, each with an assembly and claims to some form of independence. To this day, Catalonia is still at odds with central authority, and the Basques of Navarre are rebels and terrorists. Nor was Charles technically the sovereign; his mother Joanna was. But she was mad and confined. [The book to read is *Through Spain with Don Quixote* by Rupert Croft-Cooke.]

> I was not invested with the imperial crown in order to take over yet more territories, but to ensure the peace of Christendom and so to unite all forces against the Turks for the glory of the Christian faith.
>
> —CHARLES V IN 1521

The young man was made aware of his uneasy role at his coronation in Aragon, where the assembly declared that it was a republic with an elective king. It served notice that "we who are as good as you, make you, who are no better than we, our king. And we will bear true allegiance if you observe our laws and customs; if not, not." No wonder that for many years after Charles's reign, the well-informed in Europe spoke of "the Spains" as they did of "the Germanies."

Yet by 1540 from Madrid, Charles's person, his realms, and his authority over them formed a grandiose prospect. He was the head of an empire that stretched from Italy in the south to the Netherlands in the North and from Spain to Mexico and Peru, including dozens of islands in the Mediterranean, the overlordship of the Germanies, and measureless areas of the Western Hemisphere. The extent was twenty times the size of the ancient Roman Empire; it prompted the first use of the boast that "on our lands the sun never sets." It made Spain the leading power in Europe. Never mind the mud of Madrid or the arrogance of the Aragonese: the countries thus assembled by inheritance gave reason to hope that Charlemagne's empire might be re-created and Dante's dream of "universal monarchy" fulfilled.

But so much power and territory in Europe meant perpetual war, the issue being: which king shall dominate the Continent. One must say king, not nation, because that political creation was not yet a clear or firm reality. The feeling that came to be called nationalism was mainly negative—resentment of foreign advisers at the royal court. That they could be there holding office shows how limited the idea of nation was. Except for commanders and staff, the armies that fought each other for the kings of France and Spain were neither French nor Spanish but German and Swiss (95>).

Another detail that did not surprise the Madrid observer of Charles's mission was that the battles—none conclusive—were mostly fought in Italy, though the object of the campaigns was the control of Burgundy, the duchy that Charles's ancestors had nearly made into the Middle Kingdom of

Europe. His enemy Francis I of France laid claim to portions of it, for a very practical reason: if Charles held them, Francis's kingdom would be encircled. That stretch along both sides of the Rhine—Flanders, Alsace, Lorraine, and Burgundy proper—has in fact been the stake of the repetitious European wars. It is prosperous and strategic, and it is no accident that today it is the active center of the European Union; its chief agencies sit in Brussels and Strasbourg.

In the 16C the theater of war was Italy, because it was the traditional battlefield (as Germany later became) because its cut-up condition provided allies—the pope, the republic of Venice, the duchy of Milan, and so on, who varied their alliances. Intermarriage among rulers being the basis of possession and diplomacy, it created overlapping rights to this or that province, and the muddle, complicated by unexpected deaths and births, was the occasion of these ever-renewable wars.

The degree to which the conflict was felt as personal, in addition to dynastic and strategic, is shown by a little drama that mid-century Madrid dwellers well remembered. In 1525, Charles V defeated Francis I in a great battle at Pavia, in Italy, and by accident Francis was taken prisoner. The French king wrote to his political mother, Louise of Savoy: "All is lost save life and honor."° Charles, embarrassed by this loot in human form, had him sent to the Alcazar, the castle-prison of Madrid, to be treated there as a distinguished guest.

What honor could survive defeat and capture is now hard to see, but as mentioned earlier, the medieval ideas still had influence, especially on Charles's mind. The feudal notion of war as a contest between two knights aided by their friends and servitors went with the feeling that if well fought, the battle and its outcome left honor intact. The loser goes home to bind up his wounds and start again. Although both warriors have been fighting for property, they think rather that it was for the (legal) right; neither imagines that he represents a nation, which is another reason why defeat is not disgrace.

The Spanish shared this outlook. When Charles first came among them they greeted him with a tournament in which he took part and which ended in many wounds and broken bones. At a crisis later than Pavia he offered to fight Francis in single combat and thus avoid another expensive war. Nor is it surprising that Charles quickly learned to enjoy the favorite Spanish sport of bullfighting and went into the ring himself to enjoy it even more. [The book to read is *Wars of Ideas in Spain* by José Castillejo.]

The Pavia situation seemed to him another instance of these one-to-one encounters. He went to visit his prisoner and found him in bed. Francis struggled to his feet. Charles took off his hat and embraced him. Francis said: "Sir, you see I am your slave." Charles replied: "No, you are my good brother and

free friend." "No," repeated the other; "I am your slave." And again Charles called Francis "my free friend and brother." Charles had in fact the greatest respect for "The House of France" and had given orders that the king be shown every courtesy. But Francis, as his behavior soon showed, seems to have had inklings of a more modern, more national conception of war, and he was despondent. He was kept from suicide by his guardian, Alarcón, the head of the Spanish armies, but he kept worrying: what would be the terms of his release?

The medieval solution would have been the payment of a ransom. Francis's sister, the brilliant Marguerite, whose court was a center of art and letters (<86), pleaded with Charles to let her brother go, as if the war had been a tournament. When the plea failed, Francis, although he had given his word to stay put, decided to escape "disguised as a negro slave"—whatever costuming this may have meant. Clearly, Francis did feel like a slave and not a knight. He was caught escaping, Charles was shocked, unbelieving. How could a Christian gentleman who had given his word act like a varlet? The transition from princely conduct to raison d'état, from knight to head of state, from medieval to modern was painful.

The ensuing Peace of Madrid proved it again: Francis gave his two sons as hostages for his good faith in renouncing all claims in Italy and Burgundy. But once home he denounced these terms as having been obtained under duress. War resumed for another two years. At the height of it an event occurred that outraged all Christendom: Charles's army sacked Rome. The looting and savaging of the people was fearful and prolonged. Neither Charles nor the leader of the forces, the Constable of Bourbon, condoned the action. The troops were uncontrollable; they had been unpaid for too long. Here again are signs of the times: first, the mercenary army and then the Constable from Southern France fighting against a "French" army that had hardly any French in the ranks.

It was during this campaign that Bayard, "the knight without fear or reproach," who *was* French and who lay dying, supposedly admonished the Constable for betraying his country. The anecdote implies loyalty to nation at a time when it was hardly felt, even by the most honorable. For another 300 years, soldiers and statesmen could without blame serve a king and country other than their own. Where whole provinces kept changing hands every few years, there was no fully defined nation, no "citizenship," only "subjects" who were traded about according to the chances of war.

That same campaign was concluded in unusual fashion: negotiations for the terms of peace were carried on by two women: Francis's mother Louise and Charles's aunt Margaret. As we saw (<86), the treaty was at once dubbed the Ladies' Peace. Francis got his two boys back unharmed and Charles, ten years after his election, was at last crowned emperor by the pope.

That election had also been secured with the aid of a woman. The other Margaret, Charles's sister, had helped to distribute the bribes—one million gold ecus borrowed from the amiable Fuggers (<15), half the sum going direct to the seven electors, the rest to such princes as might interfere. Margaret later helped Charles again as regent of the Netherlands: he could not be everywhere. Nor was the semi-permanent war with Francis his only preoccupation. He had the indefatigable Turks to contend with. To the east his brother Ferdinand would hold the gates of Vienna and Hungary against them, but the infidels were also a menace at sea, allied as they were with an outstanding pirate named Barbarossa, based in Algiers. To dispose of him Charles planned to conquer North Africa and was partly successful, but the menace to trade and travel was not abated until the American navy destroyed the "Barbary pirates" in the early 19C.

Seeing Charles's manifold activities the Madrid observer might won-der—and worry—about the emperor's apparent neglect of Germany, where the heretics flouted the true faith with impunity. Charles was devout but not narrow. In religious matters he consulted and followed Erasmus. Luther's rebellious words at Worms and later did not change Charles's tolerant temper, which was reinforced by his impression that in practice the Evangelicals did not differ very much from the moderate Catholics. Reconciliation, a return to the one church, seemed to him possible for a long time. The primacy of the pope proved to be the only immovable barrier. But there was also the ques-tion of who owned and ruled which of the German states. It must be settled. Near the mid-century, with the support of Philip of Hesse, betrayer of the Protestant cause, Charles nearly extinguished it by a decisive battle at Mühlberg. Not long after, the agreement by which the princes could choose either religion and rule the like-minded populations put an end to Charles's sympathetic stand (<20). He was revolted by the number of princes who became converts in each direction for the sake of grabbing land.

<center>*
*　*</center>

The people of Madrid—and many other places—knew Charles V as something other than the head of a great empire. He had the knack of the politician who can speak to everybody in a way easy for both parties. He learned Spanish, Italian, and French and adapted his Flemish to German forms so that he could seem homegrown throughout his realm. He was well built and dignified in bearing, but not handsome. The Habsburg jaw (which Titian por-trays without flattery) gave the face an equine look that failed to show intelli-gence. No matter. Charles's prowess in field sports and his courtly accomplish-ments (<92; 97>) made him popular; his rectitude was felt and respected even where he was the persistent enemy: Luther's admiration—and, on one occa-

sion, defense—of his sovereign is indicative. At the beginning of his reign he had been faced by a rebellion in Spain that paralleled the Peasants' Revolt in Germany (<15) and similar outbreaks elsewhere. The Spanish Comuneros were put down like the rest, but Charles deplored the executions that took place in his absence. They haunted him for years, because he understood the reasons for the uprising.

Charles had two love affairs, one early and long-lasting, with a Flemish noblewoman who bore him a daughter; the other with an Austrian bourgeoise who bore him a son. These children, Margaret (of Parma) and Don John (of Austria) proved abler and dearer to the father than his heir, the later Philip II. Philip was the conscientious, bigoted soul and born bureaucrat under whom the Great Armada was built and Spain began her decline.

Though none could foresee it at the time, the imperial kind of state that Charles felt it his mission to make solid in Europe (he had scruples about ruling unknown lands overseas) was no longer workable. It was yet another medieval longing, inherited from Rome and Charlemagne. The new idea of the nation-state glimmered in royal minds, though still confused with the hope of empire, which seemed more practical—the pieces were there in plain sight, and the old rights of towns and provinces were compatible with it, not with nation. One clear hint of national reasoning was given in Charles's time when at mid-century a treaty gave France the bishoprics of Metz, Toul, and Verdun, "because French is the language spoken there." Such an argument would break up any empire.

Charles's polyglot realm was impossible not only to defend but to govern. He had a good network of agents and a fair system of communication, but administration and war were too expensive. It was money troubles that led to his abdication. To meet his costs he had to borrow from two to four million ducats a year. Taxation was unavoidably haphazard, the amount having to be haggled over, time and again, separately, with each town and district. After half a dozen years of deficit, unlike 20C presidents, Charles had a nervous collapse. Thirty-five years of toiling and immense self-control brought him down. He felt death coming; he abdicated. He recovered quickly once he had shuffled off the burden. He left Spain and New Spain to his son Philip and central Europe, with the imperial title, to his brother Ferdinand, from whom it descended to the Austrian Habsburgs exclusively.

The news of his retirement caused consternation, and much weeping when he reviewed before a Brussels audience the main points of his stewardship. His remarks (and a "political testament" written shortly before) constitute, with his letters, an important addition to the literature of practical politics.

In his three years of retreat at the monastery of Yuste (St. Just, near Toledo), Charles did not lead a monastic existence. He relished the quiet life that he filled with his favorite recreations—gardening and field sports, enjoy-

ment of the fine arts—he was proficient in music—and good conversation. He had gathered about him a select company that shared his tastes. Looking back, one thinks of him as a somewhat less ascetic counterpart of another dutiful emperor and man of thought, Marcus Aurelius.

*
* *

To say that empire in Europe ended with Charles seems contradicted by the continued presence of Spain in America. And it may seem to make the Madrileño unobservant that there has been no mention till now of that continent's discovery. Columbus made his four voyages as the 15C ended and one supposes that the cultural consequences must have been felt soon after. It was not so. The delay in this narrative reflects the delay in fact. Although the seafaring crowd in Europe were excited at once, the general public were slow to take in what happened when Columbus landed on a Caribbean island° on October 12, 1492. For one thing, it was not till 1513, when Balboa (not Cortez as in Keats's sonnet) first beheld the Pacific Ocean, that anyone could know a continent lay between Europe and the Far East. And it was not till 1522—a full generation after Columbus—that Magellan's circling the globe disclosed its size and the place of its land masses. Until then America was India; Cuba or California was Japan.

"Jesus!" I said, "is there a New World?"
—Rabelais, *Pantagruel* (1532)

It is idle to discuss the landings of earlier discoverers than Columbus; there are a dozen plausible and implausible ones.° None was the discovery of a new world by *Europe,* by the whole West. Explorers had been sailing down the African coast and westward to the Azores for many decades—ever since Prince Henry of Portugal (called the Navigator though he never left dry land) had set up a research center at Sagres in 1415. Much knowledge and many maps accumulated there till they inspired the great feats at the century's end. It had been known since the Greeks that the world was round, but its girth was greatly underestimated by Columbus—luckily. The error encouraged the obsession that sustained him through the incredible rebuffs and delays at the hands of the Portuguese and the French authorities. The Spanish queen Isabella is rightly credited with sponsoring him, but not till she had turned him down several times like all the others, while committees argued: he was a braggart, a bore, and a bit cracked. God would not have hidden land for so long if He had meant it to be found.

Yet the prelates consulted were more favorable than the laymen (in one case two Jewish physicians), because Columbus was so obviously candid and pious. His speech and dignity impressed. Anyhow, he was not looking for the lost Atlantis; he wanted to reach the Far East, trade with the natives, convert

them, and—who knows?—perhaps find the legendary Christian kingdom of Prester John and encircle the infidels. Finally, the queen's private treasurer pointed out that this sailor's request amounted to less than the cost of entertaining a royal visitor and he urged her to give the money.

The man Columbo, Colombo, Columbus, Colomb was without question competent and experienced. He came of well-to-do Genoese stock, and had first gone to sea at age 10. He looked hardy. Once, having fallen overboard, he floated and swam six miles to shore. He was married to one of the leading Portuguese families, worked at mapmaking with the Sagres experts, and had even persuaded a Spanish Count–shipowner to subsidize his plan. But the queen insisted that if the attempt was made it must be a crown enterprise. Hence an ultimate delay of six years out of the twelve.

The preparations for the voyage were level with the state of the art. The type of ship chosen, the caravel, was swift, easily maneuvered, and reliable. Oddly enough, no plan or sunken hull of the type was found until recently. The crew was both professional and aristocratic. The "gromets," ship's boys paid about $4.60 a month, were recruited to say the Lord's Prayer and sing religious songs when turning the hourglass: "Five is past and Sixth followeth, More shall flow if God willeth." There were a surgeon and an Arabic translator for bartering with the natives of China and Japan, some convicted felons, and a few expelled Jews—in all a complement just short of 100. [The book to read is *Christopher Columbus, Mariner,* by Samuel Eliot Morison.]

The whole saga, including the sailors' distrust and their leader's deliberate deception;° the success and the mistake at the heart of it; the glorification followed by the disgrace during and after the second voyage (the hero led back home in chains); the persistence and the final neglect and poverty—every feature of his career is part of a typical pattern. Not all, but many of the great achievements of western man have followed this tortuous course, visiting more or less harsh punishment on the doers. This "tradition" is not the result of perversity. It is not the clash of stupid men opposing an intelligent one: Columbus's interviewers were right to question his calculation of the distance to India: he made it 2,400 miles short of the actual 10,600. And it is true that the promoters of the really new more often than not look and talk like cranks and mis-state or mistake their goal. Their behavior is often arrogant or seems so from their impatience with cautious minds. The upshot—humiliation and penury—is disproportionate to the offense, but it expresses the culture's need to defend its rational ways, to ward off the genuine cranks, and to avoid moving too fast into the untried. There is no evidence that the present system of subsidizing innovations—government and foundation grants—works any better than that of the kings and queens of earlier times: the same committee is always sitting at the gate.

The outcry in the United States denouncing Columbus during his 500th

I am the voice of Christ saying to you that you are all in a state of mortal sin for your cruelty and oppression in your treatment of this innocent people. Are these Indians not human beings? Have they not a soul and the use of reason?

—The monk Antonio de Montesinos (1511)

anniversary year takes us back to Madrid around 1540;° for contrary to common opinion, the concern about the exploitation of the natives dates almost from the beginning of Spanish colonization. Queen Isabella herself condemned the abuse and issued edicts against it; so did Charles V. The strongest of the protesters, Bartolomé de Las Casas, had continual access to the emperor and aroused the public by his vehement writings. In "New Spain" itself, the clergy and the religious orders, Dominican and Jesuit, were active opponents of the evils of forced labor and lawless brutality. By Charles's legislation these were crimes with definite penalties attached; enforcement was the difficulty: it depended on the character of the officials on the spot. Preaching the truth that these "Indians" were not red devils but fellow men loved by God even though they were not Christians could influence but few. The men and women who left the homeland for America were a mixed lot with mixed motives; on Columbus's second voyage were "ten convicted murderers and two Gypsy women."

The conquistadors' impelling goals have been summarized as "Gold, Glory, and the Gospel."° At any time, neither Gold nor Glory is a respecter of persons, and Gospel occasionally sins; together they do their worst when the scene is vast and sparsely populated, when communication is slow and policing haphazard. If we think back to the western frontier of the United States down to 1890, we find not exactly anarchy but free-wheeling crime and violence that took its toll of lives and goods, and sent not a few venturers scuttling back to the relatively civil order of the Midwest.

The Spanish colonists committed atrocities from greed and racist contempt that nothing can palliate or excuse. But to blame Columbus is a piece of retrospective lynching; he was not the master criminal inspiring all the rest. It is moreover a mistake to think that because the native peoples were the sufferers, all of them were peaceable innocents. The Caribs whom Columbus first encountered had fought and displaced the Anawaks who occupied the islands. The Aztecs whom Cortez conquered had originally descended from the north and destroyed the previous civilization. To the north and east many of the tribes lived in perpetual warfare, the strong exploiting the weak, and several— notably the Iroquois—had slaves. In short, what happened on the newfound hemisphere in early modern times continued the practice of the old: in ancient Greece alien tribes marching in from the north; likewise in the making of the Roman Empire, in the peopling of the British Isles by Romans, Angles, Saxons, Jutes, Danes, and Normans; in France, Italy, and Spain by Franks, Normans,

Lombards, Visigoths, Ostrogoths, and later by Arabs. Everywhere the story is one of invasion, killing, rape, and plunder and occupation of the land that belonged to the vanquished. Today, this fusion or dispersion of peoples and cultures by means of death and destruction is abhorred in principle but flourishing in fact. Africa, the Middle and Far East, and South Central Europe are still theaters of conquest and massacre. And Columbus is not the responsible party.

<p style="text-align:center">*
* *</p>

Parallel to the migration of persons westward was the migration of food eastward. It was accompanied by the transfer both ways of plants and animals. One of the aims of the Portuguese and Spanish in going west was to reach the source of spices, silks, and gems—the Far East—more quickly and easily than by the traditional caravans on land. The new route would also break the Venetian monopoly of trade in these goods. It is often said that this land route had been cut off when the Turks captured Constantinople in the mid-15C. An American scholar riddled that notion 80 years ago.° The Turks had more sense than to stop it when they could tax it.

Apropos of food, it remains a mystery why in earlier times spices should have been so much in demand as to impel merchants and sailors across deserts and oceans. It is said that a note on an old map, close to the spot marked Calicut, inspired Vasco da Gama to be one of those. The note read: "This is where pepper is born." The usual explanation—that spices concealed the bad taste of spoiled meat and gave variety to dull foods too often served—seems unconvincing. Though we are told that dishes in 16C Madrid were few and unappetizing, pepper on everything would be tiresome too and the fancier spices inappropriate—cinnamon on cabbage? Besides, Europe had many herbs of its own and we do not hear about them.

The cookbooks that might enlighten us did not yet exist; the "revolution in cuisine" often attributed to the 16C belongs in fact to the next (183>). But it is likely that the imports from America gave it a great push. The advent of potatoes, tomatoes, squash, beans (white, kidney, and lima), vanilla, avocadoes, pineapples, "wild rice," and maize (U.S. corn) began to enlarge agreeably the 17C menu. The bird misnamed *turkey* (in French *d'inde* = from India and for a while in Britain *Indian fowl*) also made its appearance, these names being another indication of the long ignorance about America.

The strange foods were not accepted at once in all places. France resisted potatoes as poisonous because they are of the nightshade family. Other vegetables remained luxuries. The first novelties to be popular, though dissent lasted a while, were the drinks tea, coffee, and chocolate. All were addictive in a genteel way, but how was life possible without them? And they brought in

Don't talk of chocolate!
Don't talk of tea!—
Medicines made—ye gods'—as you see
Are no medicines for me.

I'd sooner take poison
Than a single cup lay eyes on
Of that bitter stuff ye
Talk of called coffee

—Francesco Redi (mid-17C)

another insidious tyrant: sugar—needed in these bitter drinks, sugar in solid foods, sugar in everything. The sugar cane had been taken by Irish colonists to Montserrat in the West Indies; there it grew larger and more quickly and was carried to the other islands. The products, rum and sugar, were cheap and profitable. Sugar not only seduced the palate, undermining teeth and encouraging slavery, but as a modern scholar has shown, its trade corrupted politics.°

Best (or worst) of all these sophistications was tobacco. It made its way first in pipes—the Indians' pipe of peace and meditation—and only gradually multiplied its forms of intake, each curiously dominant at a particular time: where are the 18C snuff-takers today? Tobacco was also the earliest lucrative export from South America, and from the first it aroused in Europe strong feelings of opposite kinds. It was extolled and denounced in poetry and prose.°

Tobacco, Nectar, or the Thespian spring.
Are all but Luther's beer, to this I sing.
Of this we will sup free, but moderately.

—Ben Jonson, "Inviting a Friend
 to Supper"

It is a custom loathsome to the eye, hateful to the nose, harmful to the brain, dangerous to the lungs; and the black, stinking fumes thereof nearest resembling the horrible stygian smoke of the pit that is bottomless.

—James I of England (1604)

These cultural changes in Europe were matched by their like in the New World. The "Indies" had few domestic animals besides dogs and cats. Wild pigs and bison frisked about in the north, and in the south the llama and vicuña had been tamed. But cattle were unknown. The first horse arrived with Columbus. And as everybody (perhaps) remembers, it was Cortez's horses that frightened the Mexicans into believing the invaders a species of god. Pizarro had the same advantage against the Incas of Peru.

Without the importation of many more animals and plants, the Spanish could not have established their authority and culture so quickly and extensively in both halves of the western continent. Cattle, swine, mules, sheep, goats, rabbits, and European dogs peopled the new landscapes, making them home to the colonists. Plants were more difficult to carry across the ocean and adapt to a climate that was often tropical. But wheat, the grape vine, the sugar cane, olives, lemons, oranges sweet and sour, bananas, and in hopes of making silk, the mulberry tree, successfully took root in America. Some few of these could have been found already there in wild species, but they were not at once usable.

These domestic details make clear that the Spanish were not merely exploiters but true colonists, settlers. Theirs was the first European civilization in the newfound land. After them the continual interchange of goods and habits made old world and new more and more alike, mingling hemispheric specialties to the point where western culture means what is found on either or both sides of the Atlantic.

*
* *

The great to-and-fro of courtiers and prelates, of colonial governors and literati at Charles's Spanish court kept supplying it with news and rumors of life in New Spain, of the Portuguese "factories" (trading posts) in India, Malaysia, and Japan, and of the nascent efforts of other countries to join in what has been called the Expansion of Europe. But what was fact or fiction in the common mind it would be difficult to sort out. The same holds true of the effects produced by the seemingly sounder means of information, books. From about the middle of the century the works in the vernacular that finally established the genre "travel book" began to be popular. [The essay to read is *English Maritime Writing from Hakluyt to Cook*, by Oliver Warner.°] The first samples were pretty well confined to the regions of their language, but the great *Universal Cosmography* by Sebastian Münster, first published in 1544, turned after its reissue of 1550 into a best-seller translated into six languages and running into 36 editions before the end of the century. [For an amusing description of the work, read Dorothy Sayers' short story "The Adventure of Uncle Meleager's Will."] The *Cosmography* contained fact and fantasy in liberal amounts; the careful and comprehensive accounts came later and correct ideas filtered slowly.

The most famous source, Richard Hakluyt's *Divers Voyages* of 1584, was enlarged into three folios in the next decade, as if it were for Shakespeare to read. But that voracious learner made small use of the work in his plays. For him and his audience in 1596, over a century after Columbus, it is still *The Merchant of Venice*, not of Cadiz or London or Rotterdam. A few years earlier, in *The Comedy of Errors*, the words "America, the Indies" form an exclamation, followed by a lush but fanciful definition: ". . . all o'er embellished with rubies, carbuncles, sapphires, declining that rich aspect to the hot breath of Spain, who sent whole armadoes to be ballast at her nose."° It is not till *The Tempest*, two decades farther on, that we find the famous reference to "the brave new world," coupled with the "still-vexed" (stormy) Bermudas and a scene making fun of utopias (124>).

From this haphazard spread of information a long and permanent confusion in names and places was to be expected. Columbus's error begot "the Indies" and "West Indies," with the surviving appellation Indian for the

inhabitants. (The general use of the anthropologists' *Amerind* is long over-due.) The Venetian printer of Vespucci's fourth report coined the unusual term *new world* as a title for it; Columbus had called it "other world." As for "America," from Amerigo (Vespucci), it was the mapmaker Waldseemüller's mistake about who made the first landing. Vespucci a few years later adopted the printer's "New World," gave the first (questionable) news of cannibalism, and by the success of his work—30 editions before the end of the century—made the use of any other name than America unlikely.°

It is surely the appropriate name. Columbus, though by far the greater navigator, the true hero and sole pioneer, never knew what he had found. Vespucci knew first and at firsthand that the Brazilian shoreline was that of a continent as yet unexplored. Let it be added that "American" as noun and adjective referring to the United States is a usage born of necessity, not a culpable confiscation. The citizens of Canada, Mexico, and other Latin-American countries would not give up "Canadian," "Mexican," "Peruvian," and the rest, even if the United States adopted some other designation. In the early 19C, when Columbus's name had gained currency owing to the first anniversary celebration in 1792, some wanted to glorify him and depose Vespucci. Washington Irving was one of the fervent admirers who argued for Columbus and for Columbia as the continental name. The debate was hot but conclusive. When a little later Signora America Vespucci, the explorer's direct descendant, came to petition Congress for a monetary award in recognition of her ancestor's gift of his name, she was politely turned down.

<div align="center">*</div>
<div align="center">* *</div>

The glorious empire, the pestiferous Turk and his North African pirates, the brash King of France cooped up right there in Madrid, the shameful Sack of Rome and the Ladies' Peace—these images afloat in the mind of Madrid residents in the second half of the 16C were surely coupled with pride in the success of Spanish arms. Two victories stood out in particular, the one on land against the heretical Protestant League, at Mühlberg in 1543, the other on the sea at Lepanto in 1571; the former led by Emperor Charles, the latter by his beloved bastard son, Don John of Austria.

The Spanish infantry was famous everywhere, its pre-eminence due to another innovation of the century: the foot soldier supplanting the horseman as the decisive force in battle. (Note the meaning of *infant*—small foot soldier—in infantry.) Cavalry and chivalry, cognate in sense and medieval in character, declined together. The new tacticians were the Swiss—of necessity, since their terrain is discouraging to the horse. They devised the discipline and the use of the new army, though the first form of "infantry," *infantera,* is Spanish. Soon the North German *landsknecht* rivaled the Swiss as mercenar-

ies. The new battle formation was the tight square of men wielding extraordinarily long lances to break up the formerly decisive cavalry charge. [For a vivid impression of the lancer, look at Velazquez's painting of "The Surrender at Breda."]

To this return of the ancient Greek phalanx, the 16C added firearms. Gunpowder had been known and used for 200 years, but it was not really effective until this second half of the great century. Now a couple of dozen field pieces could breach the walls of a castle, as happened at Metz in 1552, and the pistol enabled the horseman to kill more handily than with sword or lance. So armed, the light cavalry found a new use in the opening clash of battle and as protectors of the infantry's flanks. Artillery compelled towns and provinces to rebuild their strongholds, enlisting for the purpose engineers who were often artists or mathematicians able to apply the latest findings of the science (243; 313>). Leonardo was their forerunner in this new professional specialty.

The emperor's victories naturally led to the Spanish officers' being regarded as "born soldiers" and invincible. This is a roving title: The French inherited it a century later and the Germans in the next but one after. "Born" is a figure of speech. Changing conditions—and ambitions—stimulate a capacity common to all, as shown in our century by the warlike Israelis, once thought "born merchants," with the merchant's timidity and bent for compromise. The conditions and ambitions that energized the 16C Spanish went back a long time: the people of the center and north of the peninsula were at war for 800 years; sometimes among themselves, more often against their enemies to the south: the Moors, Islamic in religion and North African or Arabian in origin (not black as mistakenly in *Othello*).

A final "Reconquista" against the highly civilized Moorish kingdom of Granada took place in the same year as Columbus's landing far to the west. The Spaniard's fighting spirit was thus rooted in a religious hatred that included the Jews, who were numerous, tolerated, and influential among the Arabs. The vanquished of either faith could become converts—*Moriscos* or Christians—but they kept being

> Gentle river, gentle river
> Lo, thy streams are stained with gore
> Many a brave and noble captain
> Floats along thy willowed shore.
>
> All beside thy limpid waters
> All beside thy sands so bright
> Moorish chiefs and Christian warriors
> Joined in fierce and mortal fight
>
> —SPANISH BALLAD

persecuted on suspicion of having only feigned conversion; they were ultimately expelled or executed after "inquisition." Meanwhile, there had been a good deal of intermarriage and some of the highest and proudest of Spanish families perforce numbered Moorish or Jewish ancestors.

A long tradition develops a cultural type that looks genetically produced:

the *hidalgo,* which is said to mean "son of something"; the Spanish peasant, not a fighter, is presumably son of nothing. Hidalgos embody the warlike spirit, which in private life bristles at a hint and ends in dueling. Among them some were *grandees,* distinguished not by any emoluments but solely by the privilege of keeping one's hat on in the presence of royalty. It is an uncommon trait to be content with style and no substance. The hidalgo as grandee found compensation in being haughty, austere, and reconciled to being poor—sometimes visibly underfed. He was poor because inflation due to the flow of gold and silver from New Spain cut down the value of his rents (107>), or because his estate had been lost through indifferent management or the mischance of local war.

Part of the ethos of this class was to despise work and practicality, one could only choose between two careers: soldier or priest, the red and the black or their variants—explorer or civil servant, the one being a kind of soldier, the other a kind of "cleric", that is, able to read and write. This mighty aloofness from worldly goals offers the spectacle, unique in the west, of a society at least partly "anti-materialistic." Again like old Russia ("Muscovy" in the 16C), it lacked a bustling middle class and was thus bound to resist new ideas, since these often travel as by-products of trade and are put forward as advantageous. Denouncers of "bourgeois values" should meditate on Spain and its long isolation from mainstream European developments. Not until the turn of the 19C, when the Spanish-American War put an end to the pride of empire, did Spain begin to prosper again and seek modernity. [The book to read is *Invertebrate Spain* by José Ortega y Gasset.]

In 16C Spain the common people did, of course, work for their living, and some magnates could be found who drew wealth from the country's main industry: raising sheep to export wool. The "Mesta" was a huge guild of sheep-owners, large and small, who took part in the semi-annual trek from the central plateau, where the animals summered, to the less wintry south 400 miles away, and back again. The wool, made into cloth in Flanders, was then re-imported. However large, this commerce together with the slender output of other goods did not keep up with the amount of precious metals being coined out of the intake from America. The inevitable result was inflation.

What created the silver flood was the discovery made at Potosí in 1545. While chasing a goat, some natives of Upper Peru, now Bolivia, ran into a mountain of silver ore. It proved richer than the fabled El Dorado, the golden king, who had been sought in vain that he might be robbed at leisure. Potosí became an instant mining town, a boom city of over 150,000. News of the miraculous process just discovered in Germany, which used mercury to extract the silver, brought to Potosí an international population of prospectors, gamblers, thieves, prostitutes, and slave-drivers, unmatched until the mining frenzy of the mid-19C in the far-west United States. Only, at Potosí

the natives were maimed and killed by forced labor. Potosí today is a museum town protected by Unesco. Silver is still mined on a modest scale, but raising coca is a better source of livelihood.

In Madrid, the safe return of the Silver Fleet was a cause for regular rejoicing. For although the English pirates boasted of their frequent captures, and ventured close enough to the coast to "singe the King of Spain's beard," the great convoy failed to arrive only twice during the half century. The crown's annual revenue from this source—some four million pounds—amounted to 16 times that of Queen Elizabeth. The real disaster was the spread of inflation to the rest of Europe. The long spell of high prices impoverished all those on fixed incomes, not all the landlords, but all workers and artisans.

Their protracted plight stimulated economic thought. Some argued that an excess of exports, others that declining population, or luxury, or debased coinage was the cause of the depression. Two Spaniards, Martin de Novarro and the friar Tomás de Mercado, had glimpses of the truth. At last a French jurist who will be met again (245>), Jean Bodin, made unmistakable the relation between the amount of goods and that of money in circulation. He thus laid the ground for the "quantity theory of money" which, refined over the years, still rules central banks in their fight against inflation by the exquisite tuning of interest rates. Yet another effect of the sudden increase in precious metals was the final replacement of barter by money, which in turn led nations in the 17C to adopt the principle of Mercantilism; it is the merchant's outlook extended to the whole nation (292>). Tariffs and export bounties are its modern descendants, still debated and debatable.

<p style="text-align:center">*</p>
<p style="text-align:center">* *</p>

Out of the battle over souls and bodies that Las Casas and others waged in Madrid and New Spain to protect the mistreated natives came the revival of an ancient idea. The Roman Tacitus, it will be remembered, had portrayed the Germanic tribes of the first century in such a way as to shame the citizens of Rome (<9). The Germans led the simple life, in which candor, truthfulness, courage, and loyalty are as normal as falsehood, deceit, treachery, and a cowardly fear of death are in civilization. This contrast was exemplified for the 16C by a number of the American tribes—at least as they seemed to observers 3,000 miles away. Thus arose the figure of the Noble Savage, which has ever since reinvigorated the successive PRIMITIVISMS.

Note that it dates back virtually to Columbus, who gives a hint of the natives' simple life in his earliest report.

Further facts of the sort inspired all the Utopias beginning with Thomas More's in the first decade of the 16C (117>). These things being so, one

I sent two of our men. They traveled for three days and found people and houses without number, but they were small and without government; therefore they returned.

—CHRISTOPHER COLUMBUS, FIRST LETTER FROM THE NEW WORLD (MARCH 14, 1493)

should try to cut the Noble Savage loose from the name of Rousseau, who flourished 200 years later and who did not cherish this imaginary figure anyway (384>).

The fine barbarians in Tacitus were used as models in Luther's Germany to stimulate resentment against the foreign authority of Rome, and these two attitudes, favoring the Indian and the German, combined to change the western peoples' notion of their origins. For a thousand years they had been the sons and daughters of the ancient Romans. Now the idea of different "races" replaced that of a single, common lineage. The bearing of this shift is clear: it parallels the end of empire and the rise of nations. Race unites and separates: We and They. Thus the English in the 16C began to nurse the fetish of Anglo-Saxonism, which unites them with the Germanic and separates them from the Roman past. [The brief book to read is *Racial Myth in English History* by Hugh A. MacDougal.] We shall see how a similar notion influenced politics in France up to and beyond the 1789 Revolution (247; 295>).°

From the changed outlook a new group of words came into prominence: not only German, Saxon, and Angle, but also Jute and Dane, Gaul, Celt, and Frank, Norman, Lombard, and Goth (Ostro = eastern and Visi = western). The conviction moreover grew that the character of a people is inborn and unchangeable. If their traits appear odd or hateful, the theory of race justifies perpetual enmity. We thus arrive at some of the familiar prejudices and hostilities of our time. "Race" added the secular idea of inborn difference to the theological one of infidel and Christian.

In the popular mind Spain and Inquisition are so closely tied together as to suggest that the search for heretics and their despatch to a better world existed nowhere else. That is contrary to fact. It is true that, as we saw, the Spanish inquisitors had special groups to suspect—the converted Moors and Jews who might be shamming their change of faith, as some were. It is also true that the ill-famed auto-da-fé—action of faith in Portuguese—at which the condemned suffered, took on the form of a public drama, a popular entertainment. But inquisition with a small *i* was active throughout Europe. In Protestant Scotland and Geneva, it was called the Discipline and it too relied on the secular arm to punish offenders such as Servetus (<30–1). England had its burnings, in good number, of Protestants and Catholics by turns during three reigns, all legalized by one statute: *De haeretico comburerendo* "On the Duty to Burn the Heretic."

In France it was the University of Paris, the Sorbonne, that persecuted; the Humanist printer Etienne Dolet was one victim of its inquisition. As for Italy, where the Inquisition was created as a department of the church gov-

ernment, the vigor of its pursuit varied with the city. Stern but inefficient in Rome, it was tempered in Venice, where it was content with remonstrance; the governors felt no wish to bother foreign traders, often from Protestant countries; their continued presence mattered to the commercial republic.

Inquisition as such, that is, apart from methods and severity of results, has remained a live institution. The many dictatorships of the 20C have relied on it and in free countries it thrives ad hoc—hunting down German sympathizers during the First World War, interning Japanese-Americans during the second, and pursuing Communist fellow-travelers during the Cold War. In the United States at the present time the workings of "political correctness" in universities and the speech police that punishes persons and corporations for words on certain topics quaintly called "sensitive" are manifestations of the permanent spirit of inquisition.

<p style="text-align:center">*
* *</p>

How many in Madrid thought of other things than religion, empire, and high prices is beyond conjecture; but as always there must have been a good few who cared for literature and the arts. This we know, because the second half of the century saw the beginning of what the Spanish have called their Golden Age of culture. Unfortunately, the names of its great figures other than painters have not spread beyond the ranks of scholar-specialists. The main cause lies in Spain's isolation when its imperial glory faded.

But neglect of this kind has not been limited to works produced in Spain. It is a mistake to believe that "anything really good" will cross frontiers and find its due place. Such countries as Portugal, Scandinavia, the Netherlands, Hungary, Poland, and other parts of Slavic Europe cherish classics that are still confined to home ground. The prime 16C example is the poem about Europe's expansion westward, the epic *Lusiads* by the Portuguese Camoëns, himself an explorer and Humanist (153>). Why is fame so capricious a goddess? In any country its favor depends on attention by one group of critics rather than another, or again by the fanatical devotion that goes to the right man at the right time. Some element in the work must chime in with some concern of the moment.

And for literary works the right translator must be there. The loss of Latin made the 16C a great age of vernacular translations, but what is or is not translated depends on casual preferences. Some masterpieces fail to be exported and are thus not read in the five leading languages. And then, like certain wines, there are books that do not travel well. In effect, Goethe's conception of "world literature," like the label Great Books or "the canon," is an ideal only part-fulfilled. When our century keeps urging a global view that would enlarge the list of classics by adding the contributions of the Far East

and the Third World, it is worth remembering that Europe itself has not yet discovered all that it has produced.

Spain's cultural achievements in the 16C consist of the poetry of Garcilaso, Boscán, and Montemayor; the political theory of Vives and Vitoria; and the early poetic dramas of Lope de Vega. Theater continued to flourish in the ensuing age, influencing writers in France and England; and in that same later time painting and music reached new heights (334>). These last two arts cross frontiers more easily than literature and obtain recognition accordingly.

Garcilaso, who died at 36 fighting in Provence, has been called the greatest poet of his age.° Whether the age cited here embraces all Europe or is limited to Spain, the encomium suffices to mark pre-eminence. With his friend Boscán he published a collection of the popular Spanish ballads, a rich poetic heritage that has inspired the poets of Spain down to Lorca in our time. Simplicity and pathos mixed with angry resentment are the notes struck, as they are also in that other Spanish genre, the flamenco, which is song and dance expressing popular feeling.

Juan Luis Vives was a disciple of Erasmus, who among other works wrote a treatise promoting the education of women. He had been tutor to Henry VIII's daughter Mary before that unhappy woman earned for her persecutions the title of Bloody. Vives' other writings dealt with the good life, international peace, and the relief of the poor. Of special interest today is his attack on the philosophers at the University of Paris. They spent too much time (according to Vives) on analyzing the meaning of meaning and the process of inference, and some were trying to quantify phenomena. What Vives objected to was not these topics as such, but the exclusive attention paid to them. This narrowness, apparently due to the influence of a Scot named John Major, left untouched the great philosophical questions that puzzle the thoughtful in every age. One finds in Vives more than a touch of the future Baconian spirit of science. He urged more observation of nature and more self-confidence; and he disputed the philosophers' cliché of the time that said the present generation were "dwarfs standing on the shoulders of giants."

Vives' exact contemporary, Francisco de Vitoria, was the long-unrecognized pioneer in the study of international law. A Dominican from the Basque country, he studied in Paris, edited Thomas Aquinas, and ended his career holding the most coveted chair at the newly reformed University of Salamanca. (The term *reformed* has here the sense of adopting the Humanist outlook and methods.) In that setting Vitoria helped Charles V to frame laws for the colonies and formed a host of disciples. It is they who after Vitoria's death published their lecture notes about government in general and war and peace in particular. On this last topic his ideas are those also found in the work of Hugo Grotius 75 years later. It is not a case of plagiarism, but if pri-

ority and fullness of treatment establish the title of founder, it belongs to Vives. The Dutch Grotius Association acknowledged the fact in 1926 by presenting a gold medal in honor of Vitoria to the University of Salamanca.

International law sounds like a contradiction in terms: who is to enforce law on powers that boast of their independence and act as they please? The United Nations agree on some principles—in principle—but find it hard to live up to them. Vitoria as a proponent of Natural Law asserts that society is not an agreement or convention, but a set of necessary relations which, under God, protect the rights of all individuals equally. His application of that doctrine is universally accepted—again, in principle: international society has the same structure of rights and duties as the national—the right of states to exist as independent equals, unless unable to govern themselves. The duty of equals is to maintain free communication and trade. Interfering with these is just cause for war, as is also intervention to save a people from a tyrant or give help to one wantonly attacked by a stronger neighbor. But war is always a last resort; and when waged, its ends must not outweigh the good aimed at. Defensive war is always justified, and all means to victory are allowable. The victor should then act with Christian moderation. Little progress in enforcing these "laws" has been made since Vitoria (and Grotius), although many western thinkers have proposed plans, and a number of courts, leagues, and tribunals have been established (672; 758>). [The book to read is *Peace Games* by Theodore Caplow.]

<p style="text-align:center">*
* *</p>

It was another Spanish writer of the period who gave the first sketch of a new genre: the novel. He was not Cervantes, as some critics assert, but the anonymous author of *La Vida de Lazarillo de Tormes*. Why Cervantes's masterpiece is not a novel will appear in a moment. And in any case *Don Quixote* belongs to a later generation than *Lazarillo*. His is the story of a friendless waif who becomes the servant successively of half a dozen common social types—friar, priest, squire, a seller of indulgences, and so on. At each move, the foibles of the master and the defects of society emerge from the incidents, mostly painful to Lazarillo, yet spurs to his growth in cunning and self-help. He ends up as a town crier. What makes the work, though short, a true novel is this double subject: character and social scene, both treated matter-of-factly and by inference critically. [The translation to read is that by W. S. Merwin.] *Don Quixote* does indeed contain elements of what is the distinctive subject matter of the novel, but it merges them with allegory and philosophy. It is not bound by the plausible, whereas the novel pretends to be genuine history, full of real people and places (153; 352>).

Lazarillo inaugurates at the same time a subgenre, the picaresque, so

called from the *picaro* (root of the later *Figaro*), the youth without prospects who makes his way by his wits, and as he goes sheds light on human relations as they are, not as convention supposes them to be. In later centuries the picaresque becomes the "novel of education" (*Bildungsroman*), in which an able but naive and not necessarily poor young man learns about the world through trial and error—Tom Jones or Pierre in Tolstoy's *War and Peace.*

Another kind of 16C story—fact plus fantasy—reached a wider public than this first novel, and it caused a shiver of fear or a glow of righteousness wherever it was heard. It told of a German named Dr. Faust, half sage, half charlatan, who came to a violent death precisely in 1540—and deservedly so: he had sold his soul to the Devil, a creditor who is strict in his accounts. Why was the bargain made? For three things, the first of which every 16C creature could readily understand: to eat his fill. It was not only in Spain that poverty prevailed, although on more favored soils it could alternate with plenty. But everywhere famine recurred at frequent intervals; so hauntingly, in fact, that a modern scholar has put forward the idea that in the 16C most people lived in a state of perpetual hunger that gave them hallucinations.°

Faust wanted more than food: enough money to buy good clothes and the power "to fly among the stars"; the doctor evidently had aspirations beyond physical well-being. It is noteworthy that in the original story there is no hint of making love to a beautiful woman—Gretchen or Helen of Troy; these variants came after the story got into print at the end of the century. As everybody knows, the Faustian bargain has had a long and rich career. It is not solely an emblem of Humanist pride, it is a great western myth. To "fly among the stars" stands for the restless discontent with mere humanness and for any aspiration so lofty that to fulfill it Man is willing to barter his most precious possession. Marlowe's play at the end of the 16C is but the first philosophic embroidering of the myth; it has been worked and reworked in poetry, drama, music, paint, and the dance.° In Fielding's England it appeared as a puppet show competing with his own satirical comedies, and it was in this same attenuated form that it first aroused Goethe's youthful imagination (479>).

*
* *

The observer scanning the scene beyond the borders of Spain found it full of novelties other than this edifying tale from Germany. A few deserve a quick glance now as affording contrast with Spain's resistance to the new. Next door, over the Pyrenees, Francis I seemed not too engrossed in war and court frivolities to indulge his genuine taste for art and thought. He imported Italian artists with a free hand, among them Benvenuto Cellini, Primaticcio, and Leonardo, the last-named died at his royal patron's favorite residence, Fontainebleau.

Francis renovated the Louvre, and built grand châteaux, including the magnif-
icent Chambord on the Loire. An "advanced" mind in the Humanist manner,
he supported scholars such as Guillaume Budé and made the wisely liberal
Lefèvre d'Etaples his chancellor. To offset the intolerance of the Sorbonne he
founded the Collège de France, which has remained a forum for the presenta-
tion of unofficial thought.

Like his sister Marguerite, Francis wanted to tolerate the Protestants, but
the sect were not content with being let alone. Their attacks were so fierce
and so crude—as on the Day of the Posters, when Paris was placarded with
gross insults against church and pope—that their provocation could not be
overlooked. (Calvin naively thought that it would be.) Severe punishments
followed and toleration lost its supporters.

In administration too Francis was a modernizer. Besides tightening his
control over his agents in the provinces—one more step toward the mon-
archs' revolution, he ordered the law courts to render their decisions no
longer in Latin but in the vernacular. Again, aware of the increased number
and mobility of the population, he decreed that every person take or be given
a surname. About the same time Henry VIII did likewise for his English sub-
jects. This expansion of the self by a double name has interesting social impli-
cations. It raises the common man nearer the noble lord, fully tagged and dis-
tinguished by a coat of arms. Today the tendency is to revert to the tribal
simplicity of Ben, son of Thomas; strangers now call each other Susan and
John ten seconds after meeting, and public figures are ashamed of their full
double names. To be popular, heads of state and other politicians must be
Jimmy and Betsy and Bill.

In the 16C the surname was a consequence of cutting loose from one's
native soil. Many late medieval and Renaissance poets and artists were and are
still known by their first names: Raphael, Leonardo, Michelangelo; Dante is
even a nickname, the short form of Durante. When confusion with another
had to be avoided, the place name supplied it: Raphael da Urbino, Leonardo
da Vinci. The peasant or artisan, the monk or midwife were content with a
baptismal name as long as they kept to their usual narrow orbit. But with
travel (and exile) more frequent, with the needs of stricter tax collecting and
religious conformity, rulers at every level wanted to register their subjects
unmistakably. In Spain no edict was needed. The long conflict (and intermar-
riage) with the Moors and Jews had made descent a matter of uncommon
pride and at times a claim to privilege. From this came the practice of double
and sometimes multiple surnames, showing father, mother, title, and place of
origin—Miguel de Cervantes y Saavedra—and the longer the better: Maria
Teresa Velez del Hoyo y Sotomayor.

In other countries, after the call for verbal ID, the question was, where to
look for a good tag. Four main kinds were hit upon: the nickname given by the

—What was your father's name? Grig? That's Gregory—oh no, we've got a Gregory already. We'll call you Samuel Grigson.

—What do you do? Thank you, then: William Chapman

—The parish official under Henry VIII, carrying out the royal demand for surnames°

neighbors—Bright, Stout; the dwelling place: Hill, Woods; the trade or office: Smith, Marshall; and paternity: John(son) or MacShane, which also means John's son. That this last leads to the contradiction of *Mary* John*son* only shows how words can defy their derivation. [The book to read is: *Is Thy Name Wart?* by James Pennethorne Hughes.]

It is not stretching things too far to see in this demand for clear naming an early instance of a trend in western culture that has itself no name: it might be called "the sharpening of identification." The feudal lord, probably illiterate, used visual symbols, his heraldic shield, to make himself known. The modern commoner, who can spell, has been using two names and a middle initial; exact designation goes with heightened INDIVIDUALISM. But with vast populations and multiplied roles and wants, names are proving insufficient, especially with literacy in decline. To remain distinct within the mass we must be branded with a series of numbers and must recite them to be known and served and allowed to pursue one's life.

The identifying habit applies to things as well. Art, techne, science, and industry have gradually labeled and numbered every object from star to lawn mower and canvases in a series of paintings. The 16C, rich in discoveries and inventions, was already busy at the game. For example, at the University of Padua, long dedicated to medicine, the two anatomists Eustachio and Fallopio described and gave their names to a pair of important tubes of the human body. Their work owed much to the pioneering effort of Vesalius, who had struggled against church authorities and popular prejudice to make dissection a recognized part of medical training (199>). In the next century, Rembrandt could paint the solemn "Anatomy Lesson" without shocking any but bigots. Meanwhile in physics, astronomy, botany, and practical arts such as metallurgy, workers were contributing new words that are still part of the present terminology and nomenclature.

Like physicians at the present time, their 16C predecessors were suddenly faced with a new and appalling plague. The familiar one (bubonic), which decimated towns every few years, was bad enough, being untreatable. The new was first called the French evil by the Italians and the Italian evil by the French, both logical names since it was first noted during a late-15C invasion of Italy by the French. The soldiers were the first sufferers and carried it abroad. Its full character and horror were first celebrated—if that is the right word—by the poet-physician Fracastoro. His epic in three cantos, full of striking images and elegant Latin versifying, he named after the hero, Syphilus (= swine lover). His name did not replace the insulting national nicknames;

the poet himself used the subtitle *de morbo gallico* ("about the French disease"). Girolamo Fracastoro was a gifted man, or rather teenager, since he began teaching at Padua in his 18th year. He practiced medicine besides, came to be First Physician to Pope Paul III, and was later sent as medical adviser to the bishops in council at Trent. Among his writings are works of philosophy and cosmography and a treatise on the cure for rabies.

Science may lessen superstition but does not abolish it. Beyond the reach of the Padua scientists, a work called *Centuries and Presages,* by a Frenchman who called himself Nostradamus, was a perennial bestseller. It is a book of prophecies, still in print in several languages. In a recent biography of the author that quotes many of the forecasts and applies them to past and present events, hardly a doubt is voiced about their validity.° Nostradamus wrote his pseudo poetic quatrains in a mixture of French, Italian, Latin, and Greek and by his own admission used "cloudy, twisted sentences" so as "not to shock people" by the horrors in store for them. The interpreting, still lively among his devotees, shows how the lines can be made to fit events time after time. The urge to know the future and the love of mystery are thus jointly satisfied.

Nostradamus was no mere prophet; he was also a physician, an almanac-maker, a magician and occultist scholar, a psychic, and a beautician: his first book, published at mid-century, was a *Treatise on Make-Up,* which for good measure includes recipes for love potions and jam. The compounding of makeup and skin creams was as serious a business in the Renaissance as it is today. For strange as it may seem, humanism, for all its love of the natural, did nothing to keep the human face from being heavily painted. Some men and all self-respecting women other than the lowly or rural applied thick coats of color and varnish to their features. Elizabeth of England and her ladies in waiting (we are told) put on a mixture of mashed apples (whence the word *pomade*), rose water, and hog's fat. But as the queen wanted her face to be perfectly white, it would seem that chalk was used as the overriding ingredient of the compost. She could test its effect with the aid of a new device, the mirror as we know it, made of clear glass with a backing. She completed her improvement on nature by dying her hair red (later wearing a wig to the same effect), and plucking her eyebrows out of existence: nobody could catch her looking surprised—it was her permanent expression, and no doubt an asset to any ruler and especially to one trying to be absolute.

> The unhappy marriage will be celebrated
> Amid great rejoicing, but will remain
> unhappy.
> Mary and her mother-in-law will detest
> each another
> Phybe once dead, the in-law shall be more
> piteous.
>
> —NOSTRADAMUS, SUPPOSEDLY ON THE FATE
> OF MARY QUEEN OF SCOTS (1555)

The Eutopians

THE TITLE OF THIS CHAPTER will cause the open-eyed reader to think: "a misprint," or worse: "a misspelling." It is neither. The slight shock is intended to fix in the memory a point of interpretation that has a cultural bearing and is moreover a piece of literary criticism.

The first user of the word *Utopia* was Sir Thomas More, in the well-known book that he wrote and published just a year before Luther's 95 Theses. He coined the name from the Greek roots meaning "no place," and the term has since meant, in all languages, a work describing an ideal state. The adjective *utopian* has acquired the further meaning of "unworkable"; but that implication has not kept writers since More from designing happy societies (593>). Writing utopias is a western tradition, and it is found in other genres than explicit accounts of imaginary countries. All extended discussions of social justice, from Plato to Marx and down to Rawls's treatises of our own day° are of similar bearing. Why not call them Eutopian, the Greek prefix altered to mean the *good* place? "Eutopias for Euphoria" might be the motto of all these writers, including some novelists, as we shall see (124>).

Literature is my Utopia.

—HELEN KELLER (1908)

In the Renaissance, the three overt and famous Eutopias are those by Thomas More, Tommaso Campanella (*The City of the Sun*), and Francis Bacon (*The New Atlantis*). A gap of about a hundred years separates the pioneer from the other pair, of whom Campanella needs a word of identification. He was a poet whose sonnets were good enough to be translated by John Addington Symonds and published by him together with those of Michelangelo. Campanella was also one of the new scientists. He wrote a defense of Galileo and a treatise on physiology and psychology combined. This work has left a trace in American literature: Poe quotes him in "The Purloined Letter," though not from having read him: the reference is lifted from Burke's *Essay on the Sublime and Beautiful* (417>), where presumably it came direct from the source.

As theater-goers know from Robert Bolt's play, *A Man for All Seasons,* More was Lord Chancellor of England under Henry VIII. It was during a diplomatic mission in Antwerp that remembering the account of Amerigo Vespucci's *Fourth Voyage,* and full of ideas about present discontents, More began writing in Latin what is now Part II of the work that he called *The Truly Golden Book About the Best Condition of a Commonwealth and About the New Island of Utopia.* More showed his work in progress to friends, and they, familiar like More with Plato's *Republic,* were so enthusiastic about the modern parallel that nine of them, with Erasmus most prominent, contributed letters or poems for inclusion at some convenient point in the story.

Utopia is thus in a very full sense a Renaissance book. Four editions quickly appeared in different cities. But Part I, which introduces the explorer-narrator and his new island, was so severe a description of social and economic evils in England that it could not be published there until fifteen years after the author's death, forty after it was written. It is now an English classic in Ralph Robinson's engaging translation.

More's thesis is simple and straightforward: everywhere "a certain conspiracy of the rich" works against the poor and makes it absurd to call the state a *common*wealth. (We have heard this somewhere more recently.) It follows from the indictment that a good society must rest on holding goods in common. Communism is also the basis of Campanella's *City of the Sun,* which lies below the equator in Africa. Bacon, intent upon making his "Bensalem Island" a vast research institute, says nothing about property, but from the general peace and quiet of "that happy land," one infers that it is free of poverty and class struggle.

By inference all utopias tell us about what is deemed good in the present state. The three 16C Eutopias are intensely religious communities, governed ethically by the Christian revelation, either obtained in miraculous fashion or paralleled by local inspiration. Like More, Campanella is broad-minded about other religions; their prophets seem to preach much the same creed, and it is the Christian Apostles whose example justifies communism in Campanella as in More. At the same time, Campanella does not believe that the world was created from nothing or that it is eternal: the scientist peeps out in this way from time to time.

Does communism in goods mean wives in common too, as in Plato? Campanella brings up the controversy of the early church between St. Clement, who answered Yes, and Tertullian, who said: "all in common, except wives." Being in favor of eugenic breeding, Campanella reports that the Citizens of the Sun side with St. Clement (like the first Anabaptists), but he hedges by adding that they misunderstood the argument.

More is for monogamy, but like Campanella and Bacon, he treats marriage as an economic concern of the state. Seeing in England the devastating

effects of the enclosure of farming land for the raising of sheep, which made landowners rich and tenant farmers homeless, More comes to wonder whether there is such a thing as overpopulation. In a time of high mortality, large families were a blessing—youthful hands help with the work and when adult, support their old parents. In *Utopia* the average household numbers twenty, which is low, given the presence of servants, apprentices, and three generations of kindred. It makes the total population of the 54 cities six and a half million, about a million more than England's in the 16C. Since trade—the wool trade—seems unavoidable, More's solution for justice to all classes is state regulation of all business.

As for the individual aspect of marriage, an institution that all three authors regard as causing painful restraint, More wants to make it more attractive by having the intending bride and groom see each other naked, very gravely, in separate sessions presided over by an older relative. Bacon, a century later, had read *Utopia* and calls this custom cruel when one or the other party refuses the match "after so intimate an encounter." Since its only purpose is to detect disease or malformation, Bacon suggests that a friend of each party view the other swimming naked in a pool. Campanella cannot leave an entirely free choice to those who will ensure the continuance of the race in marriage. They must be fit. But he foresees difficulties: suppose a young pair fall in love: well, they can meet and talk freely, but not go any farther. And what about the greater attraction of beautiful women? There aren't enough to satisfy the demand. High-minded deception must be practiced to prevent disappointment and jealousy. Besides, nobody in the City of the Sun is ill-favored. Such are the tangles that beset the creators of new institutions. As for contentment in marriage, the parties must take a chance. Divorce is a last resort. It is granted after a long investigation by a magistrate, adultery being a valid cause, to which More compassionately adds radical incompatibility.

Details of this sort, as well as the reasons given for them, are composite indications. They tell us something about the cultural norms of the time and they also express the critic's own quirks. To make existence better, which for these three Humanists means not more godly, but happier, each drives at a main goal. More wants justice through democratic equality; Bacon wants progress through scien-

> There is not under heaven so chaste a nation as this. It is the virgin of the world. There are no stews, no dissolute houses, no courtesans, nor anything of that kind. Nay, they wonder, with detestation, at you in Europe who permit such things. And therefore there are found among you infinite men that marry not, but choose rather a libertine and impure single life than to be yoked in marriage; and many that do marry, marry late, and what is marriage to them but a bargain, wherein is sought alliance or portion or reputation, with some desire (almost indifferent) of issue and not the faithful nuptial union of man and wife that was first instituted.
>
> —BACON, *THE NEW ATLANTIS* (C. 1624)

tific research; Campanella wants permanent peace, health, and plenty through rational thought, brotherly love, and eugenics. All agree on a principle that the West adopted late: everybody must work. When that happens, Campanella estimates that four hours a day will be enough to create prosperity for all, leaving ample leisure for (he suggests) attending lectures.

He alone holds enlarged views about women. They are fit to do everything that men do. (In More, they can be priests.) In Campanella they can even train for armed combat, being especially good at throwing fireballs. No men are unfit until old, when they may become government spies. But all Eutopians find war detestable, except in self-defense or (in one case) to liberate an oppressed people. For Campanella, trade being a cause of war, it should be limited to absolute needs. The ideal is *autarky*—total self-sufficiency, which means: *no money*.

Eutopian laws are invariably few, plain, and posted for all to know. Lawyers are unknown; everyone pleads his own cause. In treating crime, the three evince great tenderness. Reproach and advice are the first measures taken; then hard labor, death in very few cases. Yet prisoners of war automatically become slaves. It is an odd harking back to ancient times, for slavery had long disappeared in western Europe. The Eutopians soften it by making the slaves' children, also automatically, free citizens. The vagary reminds us that in writing their works these Humanists kept an eye on Plato's *Republic,* which contains several of the proposed institutions—communism, eugenics with wives in common, and an end to poverty and class envy, though not to permanent class duties and distinctions.

On teaching the young, the note struck is the one that resounds again and again in our half millennium: schooling should be about things, not words, and it must be made attractive. In Campanella the whole city is designed as an exhibit of all the arts and sciences, so that it helps to instruct as it were by environmental force. It anticipates in this the famous work of the school reformer Comenius (180>).

In Bacon, thinking about science is the aim of life, and delightful it is. Only Campanella cares for machinery—wagons moved by "sails and gears" and ships by "a marvellous contrivance," unspecified. (Aristotle had the farseeing idea that there would be no need for slaves if one had the requisite machines.)

As for moral education, in all Eutopias elaborate religious and civic ceremonies provide it, while they also

On the interior wall of the first circuit all the mathematical figures are conspicuously painted, marked symbolically and with the explanations neatly written each in a little verse. There are definitions, propositions, and the like. On the exterior wall is first an immense drawing of the whole earth, given in one view; then tablets that set forth for every country the curious customs, public and private, the laws, the origins and power of the peoples and their different alphabets, displayed above that of the City of the Sun.

—CAMPANELLA, *THE CITY OF THE SUN* (1623)

unite the people through patriotic emotions. In our day, celebrations with significant phrases and music have become obsolete; and the words *pomp* and *patriotism* invite ridicule. But for centuries such public reminders of community proved indispensable as popular spectacle and conveyor of tradition.

Indeed, the use of music in the 16C Eutopias is a striking feature carried over from the life of the times. Music was always in the air (155>), at home, in church, in the street, on feast days and at guild functions, at burials and weddings; and again on special occasions such as the arrival in town of princes, officials, or ambassadors. Voices, trumpets, and drums dialogued with speeches.° Music was not the frill it later became and to a certain extent remains, divided into separate species for separate groups and enjoyed at one's choice when convenient.

Just as the Eutopians take pleasure in lavishly describing houses, temples, clothing, and domestic customs, so they all delight in telling us how healthy their people are, how handsome, kindly, and completely reasonable. For example, they work briskly and faithfully, because they have figured out that slacking on the job will reduce the common stock of goods and everyone will have less. Soviet experience showed that this intricate reasoning does not always take place.

Again, although the citizens are a priori healthy and wise, the spectre of European plague could not be forgotten. Campanella is curiously worried about epilepsy, and he is the only one who mentions washing the body often and at the behest of physicians. Eutopias cannot avoid having free public hospitals and physicians who continually search for new drugs and make up artificial ones. Bacon alone is not much interested in workaday arrangements; he merely posits that the "pious and humane" people of "that happy place" have organized life so that "everything is well kept and without disorder."

In Naples there exists 70,000 souls and of these scarcely ten or fifteen thousand do any work, and they are always lean from overwork. The rest become a prey to idleness, avarice, ill-health, lasciviousness, usury, and other vices, and corrupt many families by holding them to servitude for their own use. But in the City of the Sun, as duty and work are distributed among all, it falls to each one to work about four hours a day. The remaining hours are spent in learning joyously, in debating, reading, writing, reciting, in walking and exercising mind and body, and in play, but in no game that is played while sitting.

—CAMPANELLA, *THE CITY OF THE SUN* (1623)

It is the assumption of ready compliance with rational demands that makes Eutopias utopian. True, the absence of the blind struggle among the many for a bare livelihood and among the few for wealth and honors is a plausible cause of social amity and amenity. The authors make sure that merit is recognized; fame and rewards are plentiful for every kind of service; so that, fed and praised, the people are content and loyal to the government. But they are strangely free of those likes and dislikes in small matters that bring on

neighbors' quarrels, family feuds, and racial hatred. Custom may create consent to some measure of uniform behavior, but is there no grumbling or resistance against taking all meals at the common table with its eutopian menu, or against having to attend all state ceremonies ready to sing with unfeigned joy? In the 300 pages of the three Eutopias, there is only one touch of psychology: the young in the City of the Sun do not mind waiting on their elders, but "it is alas unwillingly" that they wait on one another.

<p style="text-align:center">*</p>
<p style="text-align:center">* *</p>

In reading Eutopias one must take care to distinguish, as suggested, between the living conditions of the author's time that are implied by their Eutopian opposites and the quirks of the particular author. Thus More suggests that if fools, that is, lunatics, are treated kindly there is no harm in their being used to entertain the people by "their foolish sayings and ridiculous actions." It will ensure their being valued and well taken care of. In the 16C, clever fools—jesters—were often supported by kings and nobles for the way they acted and spoke—freely—(302>), but except in a village with only one "Natural" (idiot), the ordinary mental cases, whether at large or herded in a "bedlam," were subjected to baiting, jeering, and abuse. More's benevolence here landed him in callousness.

And looking at his career one wonders how he reconciled his Eutopian rule of religious toleration with his willing persecution of heretics when he was in power. Nor is this all. His reputation as a great and good man was given a fine start by his son-in-law's biography; it was furthered by martyrdom for his faith and ultimate canonization. The modern play about him confirms it all. Thus most readers are hardly aware of a disturbing fact: More either invented, or allowed himself to propagate in a work of his own, the "big lie" in favor of the Tudors under whom he served—the lie that Richard III, the king whom the Tudor Henry VII overthrew, was a deformed monster who murdered his nephews, the young princes in the Tower. Ever since Horace Walpole in the late 18C raised doubts, a number of scholars have come to believe that Richard was the very opposite of the legend—handsome, able, and innocent of blood. It is not remembered, either, that the phrase "a man for all seasons," now applied to More as a compliment, was used in the past to mean an opportunist.

Incidentally, Walpole's work created a great stir on the Continent and had the distinction of being translated into French, then the universal language, by no less a scribe than Louis XVI. [The book to read is Josephine Tey's fictional account, *The Daughter of Time;* and for the present state of the case, *Richard III,* by Charles Ross.] Of course, Shakespeare's great melodrama has made a reversal of common opinion impossible. And that too is cultural history.

*
* *

In pictures of perfect states and less formally, as we shall see in Rabelais, Montaigne, Shakespeare, Swift, and others, the theme of EMANCIPATION from present hardships is the author's main motive; but there is at least one other timely reason to account for the 16C cluster of such works. For the generation after Columbus, knowledge of the New World and its inhabitants began to modify the western mind about its own culture. The explorers' voyages had become a literary form, which the Eutopians imitate minutely. They describe the ship's going off course, the remote island, the natives' treatment of the foreign crew, touchy at first, then friendly. Eutopia must always be isolated, to account for its being so long unknown and to prevent its being corrupted by the bad customs of the rest of the world—which incidentally suggests how fragile a good commonwealth is expected to be.

Now, new knowledge about alien customs creates SELF-CONSCIOUSNESS. This is a fact and a theme: as soon as comparisons are made, one's own customs no longer seem inevitable. To be sure, the neighboring people, the enemy,

> We then sailed for three days without discovering anything.
>
> —[RABELAIS' DIG AT EXPLORERS]
> PANTAGRUEL (1532)

has always behaved differently from us, but he is simply wrong-headed. It is when two or three cultures far-off provide large contrasts that the question thrusts itself on the mind: If others can do common things differently, why shouldn't we? The idea of deliberate change is born, social engineering is around the corner and begins to find expression in literature.

It was remarked above that other genres than imaginary travels were eutopias. Castiglione's living-room debate about "the Courtier" (<85) is imaginary in large part, portraying as it does an ideal type which, as always, owes much to what may already exist, though not in perfect form. If only there were enough courtiers on this model, society would be vastly improved: the book is a Eutopia on a limited scale. Again, in Rabelais' prose epic and in Montaigne's Essays, the messy real world is shown without disguise or softening, but the ideal one runs alongside in the author's comments, and in both authors this shadow is supplemented by a small, explicit Eutopia (126; 139>).

> Here enter you—and welcome from our
> hearts—
> All noble sparks endowed with gallant
> parts.
> This is the glorious place which nobly shall
> Afford sufficient to content you all.
> Here enter Ladies all, of high degree,
> Of goodly shape, of humor gay and free;
> This bower is fashioned by a gentle knight,
> Ladies, for you and innocent delight.
>
> —RABELAIS, FROM THE INSCRIPTION ON THE
> GATE OF THE ABBEY OF THÉLEME (1562)

Don Quixote also breathes the same air. Cervantes divides his fiction in two by means of his characters, the knight continually acting out of the noblest feelings, and the squire not ignobly but in the crude way of the world. The folly of Don Quixote's actions does not contaminate his principles; they are reasonable and just, as one can see if one listens carefully to his precepts and reproofs, especially when he collects them into little harangues in the wonderful second part of the work. They define the perfectly ethical man, both virtues recorded in the word *quixotic*, which does not mean crazy but idealistic—Eutopian. It would not be hard to go through a list of the great novels from *Tom Jones* down to the works of Dickens, George Eliot, Tolstoy, and Hardy, and still further to D. H. Lawrence, Gide, Joyce, and Fitzgerald, and point out the Eutopian features sketched or implied in the depiction of what is.

Shakespeare too, at the end of his playwriting life, makes in *The Tempest* a clean sweep of all but one of the evils he had so faithfully reproduced in all his other plays. Speaking for him (with some irony), Gonzalo declares:

> *I' the commonwealth I would by contraries*
> *Execute all things; for no kind of traffic*
> *Would I admit; no name of magistrate;*
> *Letters should not be known; riches, poverty,*
> *And use of service, none. . . .*
> *No occupation; all men idle, all;*
> *And women too, but innocent and pure;*
> *No sovereignty—*

but the dramatist in Shakespeare never sleeps and another speaker breaks in:

> *—Yet he would be king on't;*

after which Gonzalo, unfazed, pursues his dream, decreeing all things in common, no marrying, and all abundance. At which all cry: "Long live Gonzalo!"°

It is a paradox that in most Eutopias (Rabelais' is an exception) the common good is achieved by enforcing a uniformity of behavior that seems tighter than any that is felt in the bad societies. The better state aims at relieving the body of hunger and the mind of anxiety; it does not promise freedom for society in the abstract, but only from the concrete privileges of the upper orders. All the battles for social justice have been fought against the tyranny of poverty and class. How do the Eutopias deal with their possible recurrence? They rely on the force of good habits. But they also recognize that the magistrates must occasionally step in to prevent abuses, and at times one

senses the presence of a dictator at the top to run all things right, an anticipation of the 18C Enlightened Despot.

The great argument used to sustain right conduct is: "Live according to Nature. Nature is never wrong and we err by forgetting it." Nature here replaces God's commandments, but although Nature is His handiwork, His commandments are a good deal clearer than Her dictates. Throughout western history the appeal to natural law resounds as the great absolute, but its guidelines vary with each interpreter, and in Eutopia as elsewhere social life is in the hands of a ruling group. True, the magistrates are elected from among the elderly and wise, and there are periodic assemblies of the whole people to settle policies; but these purely political rights do not cover civil whim or eccentricity, the violence of the bloody-minded, the vagaries of genius or of adolescence. Significantly, in none of our three Eutopians is there any mention of laughter—except once, in derision at a custom of the West.

Despite the hints of regimentation, INDIVIDUALISM is also a motive behind the literature of complaint, so often bitter against nobles and clergy. By the mid-16C the human being who not only bewails but resents his lot and his master has attained that SELF-CONSCIOUSNESS, which is one part of individuality. It is also the prerequisite for the amazing self-control and rationality ascribed to the Eutopian populations. At the same time, the early Eutopias are a literature of longing. In the decaying 15C and the ensuing 150 years of sectarian wars, the Eutopias in their several ways express the occidental passion for unity. The west Europeans could no longer think of themselves as the progeny of the Christianized Roman Empire, and the comfort of the unified nation-state was not yet in plain sight (239>). Third and last motive: the Humanist attachment to the here and now that made vaguer the reality of heaven, while scholarship discredited the belief in a Golden Age in the past. The Modern Era was to be one of plans and proposals, which is to say futurist to the point of bigotry.

<p style="text-align:center">*
* *</p>

When this change of expectations occurred in the late Renaissance, it began to reverse the original creed of the Renaissance itself: thou shalt ape and worship the ancients. The cluster of ideas that make up the later, revised outlook has been called the Counter-Renaissance.° The ancients were now antiquated and the word *modern*, besides the meaning of "present-day," acquired the connotation of total praise. "Progress," "the latest science," "advanced ideas," "up to date" are the perennial markers of this cultural shift. It did not take place without opposition. For a century and a half—say, down to the time of Voltaire—there was all over Europe a "battle of the ancients

and the moderns." It affected literature, made a tangle of religion and philosophy, and often determined the fate of particular works and authors (204; 348>). Only in natural science was it firmly settled by the 17C that latest is truest.

By an unconscious play on words, the dogma that "science is the best truth" became fused with the idea just cited of "living according to nature"; for men of science undoubtedly were trying to read the meanings that Nature held for Man. This progressive revelation gave the word *natural* the same authority that clings to *modern*: natural foods are the most healthful, natural behavior is more agreeable than affectation, the natural environment and its fauna and flora are primary treasures, natural law is the test of man-made law and government.

In the 16C, the tales about the inhabitants of the New World chimed in with this preconception. Those peoples were remarkably free of western vices and complexities; they were wonderfully natural; hence they have much to teach us. The Eutopia in Montaigne is a description of such a tribe, and its title "Of Cannibals" does not detract from the admiration we should feel. Here and in other accounts of the time we meet that western creation mentioned earlier: the Noble Savage. He acquired that name a little later but his portrait was complete from the first. He is fearless, healthy in his unspoiled habitat, devout in the spontaneous worship of the one god of nature. He may be cruel to his enemies, but he is altogether moral in his relations to kin and enemy alike. Knowing nothing of kings and courts, popes and churches, he needs no improving tracts like Castiglione's for his manners to be impeccable. He attracts, because an old encrusted culture likes to think that a simple existence means an easy life. Tacitus, as we saw, believed it in late Roman times. The Germanic tribes were to him what the "wild Indians" were to Montaigne—or the Apostles to Luther and Thomas More. PRIMITIVISM takes many forms.

*

* *

Eutopias were flawed by taking it for granted that under fair conditions people would be sensible; they are in fact so sensible that they would make any system work. But more must be said about this obvious criticism. The common impression that eutopias have been useless pipe dreams is contrary to fact. In letting wish and fancy roam, this galaxy of writers have imagined institutions that *are* workable. The modern program of welfare and "social security" is a Eutopia in little. The guidelines for its application by the bureaucracy remind one of the details Eutopian authors like to multiply for lifelike effect, and the 20C efforts to ensure universal contentment by means not only of laws governing health, livelihood, education, and equity but also of incessant unof-

ficial advice carries out the central idea of Eutopia. It is the opposite of charity to the sick and the poor, seen as being always with us, and its upward-pulling power has been constant through the centuries. Whether modern societies are happier because of it or chafe under rules that do not fully secure their ends is not an answerable question. The social-bliss meter for comparing periods has not been invented.

If we ask what the eutopian legacy has been, it may be summed up in five points: social equality is more humane than hierarchy. (In this the Counter-Renaissance men diverge radically from Plato.) Next, everybody must work and *earn* his living or his honors. Then, rulers should be chosen by the people: it fosters a more willing obedience. In addition, marriage and divorce need accommodation to actual experience: adultery is not the sole cause of hopeless disunion. Finally, the existing order is not fixed forever by divine fiat and doomed to be evil by original sin. Clear thought and strong wills can improve the human lot. Humanism takes it for granted that this worldly aim is legitimate.

On reflection, one must add communism to the list of contributions from the Eutopians, since our century has seen that system established for a time over fairly large areas, though with a difference: The Eutopians had of course no inkling of machine industry; their peoples were farmers, to whom Providence in the form of droughts and flood, pests and soil erosion, was more vivid than it became as control of natural processes increased. Prayer and righteousness were still pillars of society for the Eutopians. The idea of an atheist state did not occur to them as a possibility—nor even the idea of a secular government indifferent to all creeds. The related conviction that social order required religion to buttress the force of law died hard in western culture, if indeed it has died altogether.

Eutopian morals show how mistaken are modern critics who keep complaining that science has made great progress in improving material life but has lagged in doing the same for the ethical. There was no progress to make. Men have known the principles of justice, decency, tolerance, magnanimity from an early date. Acting on them is another matter—nor does it seem easier for us to act on our best scientific conclusions when we deal with bodily matters: an age that has made war on smoking and given up the use of the common towel and the common cup should prohibit shaking hands.

A word ought to be said about the Eutopian writers' effort to make their

> There is a great number of noblemen among you that are themselves as idle as drones, that subsist on other men's labor, on the labor of their tenants, whom, to raise their own resources they pare to the quick. Besides this, they carry about with them a great number of idle fellows, who never learned any trade by which they may gain a living, and these, as soon as their lord dies, are turned out of doors. Those turned thus out of doors grow keen and they rob no less keenly, for what else can they do?
>
> —THE TRAVELER TALKING TO MORE IN *UTOPIA* (1516)

tales plausible—it is one more difference from Plato's *Republic*. After telling us how the ship went off course, the moderns describe the geography of the new-found land, with its cities, architecture, and—most important—fortifications. But it is the smaller details that suggest the actual; we hear much about trivial things: "They use linen cloth more than wool and they value cloth only by the whiteness of the linen or the cleanness of the wool, without regard to the fineness of the thread." The color and savor of a fruit ("a little sweeter than our own"), the size of common objects, the idioms, garments, and gestures used on various occasions add verisimilitude to what would otherwise be an unconvincing narrative. For examples one need only turn to the adventures in

Rabelais

The world has made the adjective *Rabelaisian* stand for something conspicuous on the surface of the text, but contrary, almost, to its message. It is not for bawdiness and scatology that Rabelais claims serious attention. The young who are tempted by the common misconception to look for the naughty passages find them not very titillating. Still, the impression persists that in Rabelais grossness is all, and the man himself a sort of Falstaff of literature. A look at the one portrait we have is a swift antidote. It may have been painted from tradition rather than from life, but that makes it all the better as an index of the author's mind. What we see is a somewhat narrow rectangular face, well-proportioned features, bright eyes that suggest inner amusement, matching the shadow of a smile on the lips—no coarseness of flesh or spirit anywhere.

It is also helpful to remember that Rabelais was not solely an author and that like many other notable men, he had an uncommon history. He was an unwanted child who, as happened to Erasmus, was forced into a monastery: the family would then not have to share the property into one more part; young François would be "dead under the civil law." Thanks to influential outside help he was able to study medicine and he soon became a leader in the profession. He made public dissections of human bodies when it was still a dangerous innovation; he became a specialist in the new disease, syphilis, and in hysteria; he taught at Lyon, then the cultural center of France, as professor of medicine and astrology, and published both almanacs and scientific papers. He also invented devices for the treatment of hernia and fractured bones.

In addition, he mastered Latin, Greek, and Hebrew, and read widely in history, geography, and general literature. Competent in jurisprudence, he was an attendant of the powerful family of du Bellay in political and other capacities. He was, in short, one of the most learned men of his time and he happened besides to be a literary genius. In his ardor about social and moral issues, he set forth one of the broadest world views of the Modern Era.

He evidently thought that putting his ideas in a treatise would be neither safe nor likely to reach a large audience. Instead, he worked up a narrative about giants and explorations, interspersed with vulgar anecdotes. These three appetizers drew on the common stock: Gargantua had a model, "voyages" were current fare, and bawdy jokes are ever welcome adaptations of earlier ones. It is in the descriptions of persons between the events of the leisurely tale and in the Prologues full of verse and wit that Rabelais insinuates his radical opinions. At other times he speaks straight out, and just as often he makes a point through the purpose or outcome of actions and incidents. Thus the great debate between Panurge and the Englishman Thaumast (= Thomas More) is carried on entirely by signs and gestures; the point is: words fail to express all that can be thought and felt in human life. But when Rabelais attacks the monks or the theological faculty at the Sorbonne, he does not mince words: "Reason? We never use it here."

The voyage that the admirable Pantagruel, son of Gargantua, grandson of Grandgousier, undertakes is in search of an oracle, that of "the Holy Bottle." This, like the repeated injunction "Drink!" and the author's frequent reference to "his beloved topers," are symbols that may puzzle or mislead.

> Hundreds of absurd stories have been made up about the author of *Pantagruel,* one of the finest books in French literature. Rabelais, a sober man who drank nothing but water, is thought of as a lover of food and drink and a confirmed tippler.
>
> —BALZAC (1840)

Like the giants' meals, for which thousands of cattle must be killed, the repeated references to bodily functions and their satisfaction mean only one thing: the basis of human life—and therefore of all higher endeavors—is physical. This "grossness" is part of Rabelais' attack on the ascetic ideal of the monk—the ideal, for the monastic reality (as we saw through Erasmus and Luther) was very different. But ideals take a good deal of killing even after the fact has fled—hence Rabelais' repeated blows. The moral of the physical is that human nature is good, not corrupt. (Calvin vituperated the author of such a heresy, and no wonder.) For if Man were hopelessly bad and in continual need of divine help, civic education and social reform would be useless, and Rabelais is full of ideas under both these headings.

Whereas Gargantua's education is monkish like Rabelais' own, Pantagruel's begins with the development of a healthy body by exercise and games; it goes on with the observation of things—all things. Nature supplies endless object lessons, and the creations of man are to be examined in an inquiring way. It is again the pedagogy of "things, not words," independent thought, not ready-made opinions. The great revolution, which, in Rabelais' story, pits the Papefigues (Protestants) against the Papimanes (Catholics) is proof of the harm done by fierce and doubtful opinion. The physician-author is in tune with the spirit of the new science and it is by concrete details that he

utters his own "Live according to nature." What is more, it includes laughter, for to him is due the maxim "To laugh is natural to man."

The philosophic outlook that has acquired the clumsy name of Pantagruelism does not spring fully formed at some point in the story. It develops little by little in Book III, The Heroic Deeds and Sayings of the Worthy Pantagruel. Rabelais published this part for the first time under his own name when he had become well-known by common report. In exchange for his inordinate praise of Francis I as patron of culture, Rabelais received a royal privilege (= copyright) for ten years. The work is dedicated to the king's sister Margaret of Navarre who was Rabelais friend and protector (<86).

Pantagruelism is rooted in a noble quality of mind: to take nothing in bad part. Rabelais ascribes this power symbolically to a plant, pantagruelion, which, as its made-up Greek name suggests, is the giver of all good things—knowledge, self-improvement, space travel, and above all: contentment.

> The plant Pantagruelion will give perfect assurance, incredible liberation for everything that men look, work, sail, and fight for.
>
> —*PANTAGRUEL* (1532)

Pantagruel's actions and comments during the dazzling variety of adventures that befall the travelers in search of the Holy Bottle are, again, as many concrete demonstrations of the Rabelaisian philosophy. The persistent "Drink!" is the symbolic invitation to perfect oneself by quaffing from the right source. Rabelais chooses to cite Pandora's bottle (in place of *box*), which is inexhaustible. Her name means "all gifts" and modern usage remembers only the bad, but Rabelais' bottle is a barrelful of good ones. It contains wisdom on every subject, salted with wit and floated on laughter.

Even when his philosophy takes the form of definite precepts, it must remain a free choice and its adherents must never become fanatical. "Drink, but do not souse or carouse German-fashion." There are no formulas for the good life, nor can Rabelais be called an optimist or a pessimist. He knows how difficult it is for man to live up to the principles they most believe in, and rigidity in principle defeats its own end. From Book III onward, the figure of Panurge becomes the center of attention as the living proof of that truth. His name means "all-action," restless impulse, thoughtless energy. He does think, but after the act. He cares only about himself. He cheats, lies, plays ugly tricks on others, and is a coward. But he is no fool and he is often engaging, as such people can be, by his buoyancy and cleverness in getting in and out of scrapes, which is why Pantagruel tolerates and helps him. For him he is also an object of study. It is the Panurge in everyone of us who must be molded into a Pantagruel.

By this point the giant features of the narrative have disappeared and the doings are altogether of and about men, although exaggeration for satire—or simply out of high spirits—continues. Rabelais measures everything in high

figures. Pantagruel when a student in Paris had posted 9,764 Theses. Distance in travel and estimates of population when discovering new lands, heroic deeds and casualties in the armed encounters, are astronomical. This exuberance is Rabelais' way of showing life as it really is—bursting out multiform all over the globe, chaotic, resistless, seeking only its own perpetuation. Hence his insistence that Sir Gaster—the stomach—is the ultimate power and source of all that matters—society, the arts, poetry, and war. (*His* wars, by the way, are moralizers—the decent spared and helped, the brutish or tyrannical put down.)

Parallel with nature's opulence, Rabelais' huge lists of things, such as the marvelous contents of the Library of St. Victor, depict the endless works of Man. The flood of synonyms for ideas, sensations, or parts of the body; and the creation of unheard-of compounds of Greek, Latin, and French all spell abundance—and resurgent appetite. It is a unique literary method of conjuring up a conception of the world.

But to contemplate this "hippocervus buzzing in a void" is not an end in itself. It arouses the will to tame it, precisely through social order, poetry, science, and the arts. And social order depends on the Pantagruelian virtues. They reach their sublime goal in the Abbey of Thélème, whose single commandment is, "Do as you wish" (↖123). This is Rabelais' Eutopia, four pages long. It is an abbey, so as to shame the existing orders of monks and nuns, and for the same reason it houses men and women together. Their life there is notable for courtesy and mutual respect. Elegance of setting is matched by elegance of behavior, which means that beyond conversation in the mode of Castiglione's courtier the relations must be of perfect decency, not necessarily chastity. That is what makes the life of the senses "pure" and "innocent," and not abstention from it as the ascetics preach. The monks (and the Calvinists), looking at life through peepholes, hate it; Rabelais hates them in return.

There is deep feeling about men and women in his description of ideal human relations, as there is also in his account of Gargantua's love for his son Pantagruel and the son's reciprocal devotion. Rabelais lost his own son, Théodule, when the boy was only two years old. Like the world of giants and verbal exaggeration, the ideal existence at Thélème is not isolated from the actual 16C; it is surrounded by contemporary persons and events and real places, named and described with marked affection or criticized in overt polemics. The quarrels he discusses—the cake-peddlers', for instance—are patterned on well-known facts. Panurge's going about for advice whether to marry or not is inspired by the long *Querelle des Dames* between critics and defenders of women. And factual also are a host of small incidents of the day. True or made up, the various details give us the world as we find it in the modern newspaper and the modern novel. A judicious critic has said that Rabelais

foreshadows the whole of French literature, meaning that he supplies brilliant examples of all the forms, from fable and epigram to dramatic dialogue and satire. This last element is often distilled in phrases three words long, tacked on to the end of an otherwise harmless sentence. What the critic did not point out is that Rabelais' five books show up the cliché about the French genius consisting exclusively in classical order and symmetry—as if the cathedrals did not visibly refute it also.

Rabelais' influence has been repeatedly felt abroad. Swift's *Gulliver*, Sterne's *Tristram Shandy,* and Peacock's delightful "novels" (564>) come to mind among works by writers who have sat down "to laugh and shake in Rabelais' easy chair." Jean-Paul Richter in Germany owed more to Rabelaisian technique than to substance, but Balzac took up both and even produced a set of pastiche tales in something like Rabelais' idiom, the *Contes Drôlatiques*. One wonders why James Joyce in *Ulysses* made Molly Bloom say she disliked Rabelais; *Ulysses* itself at times suggests a sort of Rabelais in low spirits, exposing the grubbiest corners of society, parodying the professions, and insisting tonelessly on the body's needs and acts; all this besides the would-be Rabelaisian play with language. The contrasts of course outweigh the likenesses. Rabelais leaves one exhilarated, as one is after seeing a Greek tragedy; *Ulysses* leaves one depressed, as one is after seeing a modern play like *Death of a Salesman*. It is the difference between the 16C and the 20th, between the dawn of a new culture and its close in disenchantment.

Typical of that contrast is the treatment of the body and especially of sexuality. In Joyce with Bloom, Molly, and Mulligan as its representatives, the body is mean, furtive, unfulfilled, and disgusting, the main reason being that its importance is exhibited seriously. It is observed as a naturalist looks at other animals and judged in the light of higher things. This is to Joyce's credit as an interpreter of his age: we have a "problem" of sexuality and of pornography. We try to define obscenity—helplessly—and argue for and against its exploitation in life and in films. We misuse the word *sex*, saying we "have sex" when we mean coupling, quite as if everybody did not *have sex* day and night by being either male or female. Our confusion is part of the excess of ideas typical of old civilizations. Joyce's poet Stephen Daedalus can only stand aside from the maze, not above it like Pantagruel.

Rabelais, we know, sees the physical as the power that spurs man to all achievements. But once these are in being—society, the arts, and the felicity of Thélème—then Sir Gaster (and Madam Lust) look comical and not degrading. The antics we go through to satisfy the belly and the bollocks are ridiculous, hilarious, excruciatingly funny. The funniest aspect is perhaps the fact that we go on repeating those acts even after seeing how ludicrous they are—gobbling three meals a day, with the known consequence, and re-enacting the beast with two backs ad libitum.

It may seem a paradox—but it is not—that the Rabelaisian view upholds the dignity of man. By keeping the sense of proportion continually awake, it makes clear that the natural does not contaminate the spiritual. It may even, by relaxing tension through laughter, soothe the anxiety that the sexual emotions occasion in certain souls, confusing it with the guilt of real sin.

Rabelais' intent to reform man rather than the state did not amuse everybody equally. The monks who had plotted against Erasmus were still powerful and they succeeded at least once in their machinations against Rabelais; he had to take refuge in Metz, from which his patron and friend Cardinal du Bellay rescued him. But there was no general outcry against the book, thanks to the garniture that concealed from the common reader the writer's outrageous ideas and insane proposals, such as softening the laws of marriage and accepting religion without theological barriers. Rabelais ended his life peacefully as the vicar of Meudon, near Paris, no longer writing or practicing medicine, but teaching plainsong to the young.

His great work is in five "books" and the authenticity of the fifth has been questioned because it was published posthumously. That any forger could have imitated style and thought and carried out the indicated scheme as perfectly as we find it done is not credible. Writing is not like painting, an art in which mechanical skill can deceive. Of all the translations of Rabelais into English, the first, by Urqhart and Motteux, should be at least browsed in. It is not altogether faithful, but it is the only one that re-creates the atmosphere of verbal exuberance. [The book to read is *A Journey Into Rabelais' France* by Albert Jay Nock;° but note that the author's naming one of Rabelais' characters John of the Funnels is a mistake. The name *Jean des Entommeurs* is not *des Entonnoirs*: substitute John the Hacker.]

<center>*
 * *</center>

Next in order of time but not second in importance to Rabelais is

Montaigne

All of us readers are slaves to spelling, and whether speakers of French or not, we pronounce this well-known name with the *ai* sounding *eh,* as in *mais* or *j'ai.* The fact is that the name is but the common word *montagne,* meaning mountain, and it was so pronounced in the author's time, when it and many other words sported an *ai* where today the single vowel is found.

Storing away that small fact, one likes to think of him as the wise old man of the mountain and to describe his *Essays* as mountainous—a chain of uneven peaks which, like Rabelais' work, defy the regularity of form that is believed to limit the genius of the French. The very title *Essays,* coined by

Montaigne, refutes the idea of a prescribed form. Its ordinary meaning, at the heart of Montaigne's intention, is *attempts*. *Essayer* in French means to try; the word is cognate with English *assay*, to test and weigh in order to judge quality. What was Montaigne essaying to do? What did his assaying show?

One has only to read the first page of "To the Reader" to get the answer: "Himself." But the book is not an autobiography. It is such only over short stretches along the self-exhibition, which uses the confession of faults, the recital of opinions, tastes, and emotions, and the quoting of events from ancient and modern history to describe one specimen of the human being in society. This undertaking is the first of its kind, in more than one respect, for unlike, say, the *Confessions* of St. Augustine or Bunyan's autobiography, it has no purpose beyond the description itself. Those other books were written to show through what mental travails the author went before reaching "the truth." The truth in Montaigne is the portrait of the writer.

But was he not a skeptic whose motto, *Que sçais-je?*—What do I know?—denies the possibility of truth? The debate on that question is a piece of futility. Turn the pages and read: the book contains a thousand positive assertions. Besides the big subjects—creeds, love, poetry, experience, politics, education, history, old age, and death—that Montaigne exhaustively treats in varied contexts, he sheds glancing lights on a multitude of incidental topics—houses, Caesar, cats, poisons, the island of Cea, "and more," as modern sales catalogues like to say.

Montaigne, then, is not "a skeptic" in the sense of a shoulder-shrugging philosopher who looks at the world with tolerant amusement; he is *skeptical* in the sense of the reader who does not believe without evidence and the scholar who does not take any particular truth as final. This outlook in no way prevents having rooted convictions. To name only one, Montaigne is sure that people ought not to be burnt alive for their beliefs.

Montaigne lived in an age full of people who knew that they, and they alone, had the truth, direct from God—and these truth-bearers all disagreed. Reflecting on a far wider set of facts and with greater self-knowledge, Montaigne was at pains to make the point that Cromwell later phrased so superbly: "By the bowels of Christ, bethink ye that ye may be mistaken."°

The *Essays* have been called the ideal bedside book—it invites browsing. But a greater and subtler pleasure rewards the reader who begins at the beginning and follows the self-portraiture to the end. For what the full course shows is the evolution of a mind from a negative to a positive philosophy. As a good Humanist, Montaigne starts out believing that "to philosophize is to learn how to die." The stoics—Seneca, Epictetus—had said so and the Renaissance thinkers who were not devout found in these ancients a sober moral philosophy that was consistent with Christianity, without requiring that one "die to the world" before life was over. Instead, one lived in obedience to nature and its

God, resigned to any ills that Fortune might bring, but free of the Evangelical anxiety for grace.

So things stood with Montaigne when he began his exploration. Gradually, without any upheaval of feeling such as accompanies sudden conversion, he came to see that to philosophize is to learn how to live. One can only speculate about what brought on the change: it seems reasonable to suppose that the turn came from the increasingly vivid sense of the inmost self and its frequent independence from the intellect. To learn to die is a mental project born of worldly observation; to learn to live is also a project, but it takes in that "depth and variety," that "weakness" to which Montaigne attributes the temper of his opinions, and indeed of his experience as a whole.

> I, who make no other profession, find in myself such infinite depth and variety, that what I have learned bears no other fruit than to make me realize how much I still have to learn. To my weakness, so often perceived, I owe my inclination to coolness in my opinions and any hatred for that aggressiveness and quarrelsome arrogance that believes and trusts wholly in itself, a mortal enemy of discipline and truth.
>
> —MONTAIGNE, "OF EXPERIENCE" (1588)

The theme of SELF-CONSCIOUSNESS can never be more manifest than here, and its embodiment in the *Essays* has a cultural import that has hardly been recognized: Montaigne discovered Character. I mean by this that when he calls Man *ondoyant et divers,* a phrase so precise that it is difficult to translate—"wavelike and varying" will have to do—he replaced one conception of the individual by another, deeper and richer.

Before him, the accepted idea of personality was that it was ruled by one of the body's "humors." A man, woman, or child was choleric, sanguine, phlegmatic, or melancholic. All acts, attitudes, and moods depended on the given disposition. The system, as will appear in Burton's masterpiece (223>), was well worked out to allow for temporary deviations and it fitted pretty well the impression that one gets from our own neighbors: they always tend in one direction while responding to the way we tend toward them. And in the family, habit creates this same sense of uniformity—"there he (she) goes again." This sameness is broken only by occasional vagaries that are explained away as "not being oneself."

This psychology of the humors, also called the ruling passion, kept its ancient authority for a long time. In the 17C Ben Jonson based on it two of his plays *Every Man in His Humor* and *Every Man Out of His Humor,* and Pope versified it as late as the early 18th. To this day, the suppliers of popular novels are incapable of anything better, which is good enough for ordinary consumption.

Meanwhile, in the essay "Of the Inconsistency of Our Actions," Montaigne points out the elements that make the difference between a type and a character. The type may exhibit all kinds of tricks and tastes and gestures that make him different, recognizable, but his "stance" is unchanging,

"typical." Not so in the Character. He is, as we say, many-sided ("mountainous"), which is why we also speak of seeing someone "in the round." For practical purposes, the character exists only in literature, because nobody has the time or the opportunity to look as roundly at anybody else as Montaigne looked at himself.

This contrast between type and character as we meet them in life and in fiction explains why so many biographers declare the subject of their book "a bundle of contradictions." This misleading cliché occurs to them when, on surveying the life of the man or woman, they find the variations that belong to character: he or she was generous to strangers and public charities and stingy with the family. Contradiction! Not at all, *inconsistency;* a contradiction kills its opposite; inconsistencies exist side by side, in response to different situations. How could an unbending self survive in a variable world? In winter, hot soup; in summer, cool drinks. And when the need is less apparent, as in the shift from open-handed to stingy, it is real enough to the doer: he has come to dislike his family, or they fail to give him the praise he gets from strangers, or some other point of contact with reality alters the posture of the "wavelike and varying self."

This disparity between logic and action enables Montaigne to understand history, of which he is so eager a student. Character (in his sense) and history are two facets of one reality: becoming. As he declares: "I do not portray being but passing." The mass of observations in the *Essays* is backed up by telling facts from history and biography. The quotations from the ancient Greek and Roman writers that pepper his text increased in number with each edition he published; they are evidence piling up about what he calls the "human condition." Our modern use of the phrase to mean man's sad lot is quite wrong; it means only the power of circumstance—for evil *or* for good. Acting together with character, circumstance accounts for the chaos of history and its unpredictable twists and turns, which cannot always be referred to motives. When asked the reason for his close friendship with La Boëtie, the answer was no list of traits in the abstract; it was: "because he was he, because I was I." The complexity of things, the plurality of minds and wills, and the uncertainty of outcomes form the grounds for keeping one's opinions ever subject to revision.

*
* *

Montaigne, unlike Erasmus or Rabelais, had a pleasant childhood and a good start in life: nobody forced him into a monastery. His father, to whom he was devoted, taught and reared him with tender care—he would have a servant play the flute to wake him gently. The family estate in southwestern France could have afforded young Michel Eyquem the easy life of the lesser

nobility, living on his rents and never to be heard of again. But his temper was active, his curiosity intense; he despised idleness and felt his responsibilities.

There is nothing so inimical to my health as boredom and idleness. Melancholy is the death of me and my irritability.

—MONTAIGNE, *TRAVEL DIARY* (1580)

Not only did he serve two terms as mayor of Bordeaux, a post he did not seek—he was ordered to accept it by Henry III—but he also served the king with advice and help in negotiation. At the same time he admired the Huguenot Henry of Navarre, who by war and religious conversion gained the throne as Henry IV. The introspective mind was also competent in worldly affairs. If classed at all, Montaigne should be seen as a *politique,* that is, a sympathizer of the party that earned the name for wanting an end to the religious wars and a re-united France. During those wars, Montaigne refused to be a partisan, which was almost as dangerous as being one. When he met on the road a roving detachment of armed "gentlemen" and told them the truth about his indifference, it seemed to them very strange. He escaped murder, but he would not dissemble. He proved his courage again by remaining at the post of mayor during the plague.

This rare combination of active strength and love of meditation made not only for balanced views but also for the kindliness of the strong, the Pantagruelist. It also guarantees the truthfulness of the self-revelations; in his circumstances, what had Montaigne to fear from "telling all"? And how conducive to sincerity for a writer not to have to sell books, worry about reviews, and keep the public favorable to his "image." [The book to read is the brief diary of Montaigne's travels, in which, among other surprises, the reader will find the account of a homosexual marriage in Rome.]

Critics in his day charged him with vanity for talking so much about himself and with triviality for paying attention to intimate and workaday details. Who cares, they said, whether when he is ill he is most comfortable on horseback? Ethical opinion in our day, while recognizing his genius and originality, has been disconcerted to find a skeptic with strong convictions and a radical with conservative leanings. It has failed to grasp the nature of the double mind—the ability to see both sides of the mountain at once. Thinkers of this type are few: Diderot, Walter Bagehot, William James, spring to mind as examples. They are not to be written off as undecided or vacillating. Their minds are simply multilinear and perspectivist: when Montaigne was playing with his cat, he wondered whether the cat was not perhaps playing with him.

For a more consequential example, one thinks of the longest of the *Essays,* the "Apology for Raymond Sebond," a Spanish theologian who gave a start to "Natural religion," the creed that Man can know God by seeing Him in His handiwork. Montaigne had been asked by his father to translate the work, and then by a Valois princess to defend the thesis of the book.

In truth, knowledge is a great and very useful quality; those who despise it give evidence enough of their stupidity. Yet I do not set its value at that extreme measure that some attribute to it, such as the philosopher Herillus, who find in it the sovereign good and think it has the power to make us wise and happy.

—MONTAIGNE, FROM THE "APOLOGY
 FOR RAYMOND SEBOND" (1569)

Montaigne's defense turns out to be a grudging admission that Sebond's ideas may do religion some good at the present time, when people are rabid sectarians and not truly religious. But on the whole Sebond is shown as misguided; the "Apology" leaves him behind and goes on to discuss the conceit of human reason, the limited value of human knowledge. The attitude is the one that Rabelais expressed in hit-and-run fashion. It raises the great question whether knowledge leads to virtue and thereby to happiness.

Our century possesses an amount of knowledge immeasurably greater than that Montaigne or Rabelais could gain access to. Are we proportionately wiser and happier? There is today a body of opinion that ascribes our unhappiness precisely to the knowledge we have. What has been called here the double mind can logically desire more knowledge, like any touter of Progress, and at the same time recognize that getting it will not necessarily improve the quality of life. The knowledge of atomic fission and genetic interference is double-edged. Montaigne had a shrewd foreboding about gunpowder.

Still, he devoted fifty pages to the education of children. In that essay he anticipates Rousseau by insisting on the need of a tutor, and he acknowledges the daunting challenge of teacher training by declining to say what the tutor's qualifications should be. But as Nature is the best guide; teaching must be the development of natural inclinations, for which purpose the tutor must watch his pupil and listen to him, not continually "bawl words into his ears as if pouring water into a funnel." Good teaching will come from "a mind well-made rather than well-filled."

For the learner, no more memorizing and regurgitation. The pupil being a young nobleman whose mother had requested the advice, he is to be made fit for governing, not for dialectical argument. But there must be serious study. Solid learning is "a wonderfully serviceable tool" and philosophy a liberating art, although now (says Montaigne) it has become "empty quibbling, a thing of no use or value." As might be expected, after arming the mind with superior common sense, the plan ensures the health and strength of the body by exercise, martial arts, games, riding—and dancing. In a well-conducted education, everything teaches, and if the good is to last, practice—habitual use—must be kept up. But the harsh discipline of common masters is sure to make the pupil reject as soon as possible all he has been taught. The right course is to use, in double-minded fashion, "a severe gentleness."

The Eutopia in Montaigne is not imaginary. It summarizes the report of

an explorer who has studied the manners and institutions of "the cannibals." It is of course fanciful at many points, but its lesson is clear: ways of life vastly different from our own have merit. Their simplicity in this particular case allows the natural virtues free play; ours are repressed by the need to overcome the barriers and complications of an old society. We plot and lie and cheat our way through them and are as cruel, and with less excuse, as the peoples we call savages. Again and again in this essay, Montaigne interrupts to castigate the western way of life.

> When the vines freeze in my village, my priest infers that the wrath of God is upon the human race. Seeing our civil wars, who does not exclaim that the system is topsy turvy and judgment is at hand, not reflecting that many worse things have happened and that 10,000 parts of the world to our one are having a jolly time.
>
> —MONTAIGNE, "ON EDUCATING CHILDREN" (1588)

Montaigne is far from recommending that Europe imitate the wild men overseas. In the uncertainty of our knowledge and the extreme difficulty of persuading others of our point of view, it is wisest to conform to established usages in morals and government. Custom is an enormous force that makes for peace and order; yet there should be checks to a king's power and social ranks are hard to justify—men are equal by their very diversity; they cannot be measured and hence cannot be ranked. In spirit, Montaigne is a true cosmopolite, opposed to national boasting. He loves his country and is loyal to his king and his church; they are the supports of such liberty as can be had. Before the violent Evangelical revolution, the laws maintained the public peace and the custom of Christianity was the adequate corrector of morals.

> I should like to say to Plato: "here is a nation that has no kind of trade, no knowledge of letters, no science of numbers, no word for magistrate or statesman, no use for slaves, neither wealth nor poverty, no contracts, no inheritance, no occupation but to be idle, only a general respect for parents, no clothing, no agriculture, no metals, no use for wine or wheat. The very words for falsehood, treachery, deceit, avarice, envy, detraction, and pardon are unheard of. How far from this perfection would he find the Republic he imagined!"
>
> —MONTAIGNE, "ABOUT THE CANNIBALS" (1588)

Montaigne and Rabelais are Eutopians and Humanists whose reliance on history and the bearing of contemporary events issues into philosophic Pragmatism (666>). But one external difference separates their work. Montaigne can be read by the educated French citizen of today, with only an occasional footnote to define an obsolete word. Rabelais needs much more assistance to make clear his vocabulary and constructions, especially because he often invents words out of Latin, Greek, and Hebrew that are not found in any other author. The prose of Montaigne is not yet limpid, rhythmical, elegant as it became half a century later (219>). His sentences bear the Humanist marks of the Latin syntax, and he affected a certain carelessness,

making fun of "some men so stupid that they go a mile to chase after a fine word." Even so, he wanted to "fit words to things" and he did revise. When he is difficult to follow, it is often the jump that he makes by sudden association, and it is this very jump that makes him inexhaustibly re-readable; spontaneous novelty does not fade.

<p style="text-align:center">*</p>
<p style="text-align:center">* *</p>

Montaigne settles for himself so many live questions *in passing* that the *Essays* are the equivalent of some other philosophers' complete works—ethics, aesthetics, sociology, and the rest. As a result, his influence has been great but hard to trace. Montesquieu, Voltaire, and the philosophes in general owe much to him; his closest beneficiaries are Pascal, as we shall see, and

Shakespeare

The lines quoted above from *The Tempest* suggest that the poet did not take detailed Eutopias very seriously. Yet as pointed out, the whole play is eutopian, in form and atmosphere. It begins with a shipwreck that allows the survivors to land on a favored isle, and everything that ensues comes out happily with a minimum of thwarted will. But it is all the work of magic, not human contrivance. The quoted remark about the "still-vexed Bermoothes" (Bermudas) is a sign that the playwright linked happy lives with the New World. It is his only exact reference to it (<124).°

The traces of Montaigne in the play are unconcealed. Some dozen lines from the essay on cannibals are reproduced almost word for word in Act II, scene i, and the name of the gross Caliban is a spoonerism for cannibal, no doubt intentional. The human link between the two writers is John Florio, whose translation of the *Essays* made Montaigne known quickly in England; and it may well be that something of Shakespeare's lack of a positive creed, for which Bernard Shaw reproved him, was due to the *Essays*. Shakespeare at any rate found in Montaigne a kindred temperament. [The book to read is *Shakespeare and Montaigne,* by Jacob Feis, a hostile work that blames the latter for perverting the former's mind.]

The strongest evidence of the kinship lies in their identical (and doubtless independent) invention of "character." Montaigne, as we saw, pioneered in viewing man as *ondoyant et divers,* the variable sport of self and circumstance (<135). Making character a category of thought yielded nothing less than a rival to the physiology of the humors, namely psychology. The cognate fact is that in the drama before Shakespeare there are no characters, only types. Literature presented great figures made distinct from one another by a well-marked trait or two, but not rendered unique by complexity.

This is not to say that before Shakespeare the persons in the drama were unlifelike "cardboard." They were by no means abstractions as in the medieval plays, where "the Vice" is one of the actors. But they were single-tracked in their headlong roles, the shifts in their actions being due to the actions of others, who were similarly conditioned by mutual buffeting. This conflict enabled the playwright to portray the human passions in their variety and fatal consequences. This was enough for ancient Greek drama, the Elizabethan, and the French classical to hold the spectator breathless. But we cannot say that we know Oedipus or Phèdre as we know King Lear or Lady Macbeth. The latter are as various as we feel ourselves to be, the others not; in types there are (so to speak) no irrelevancies.

How does Shakespeare create the roundness of character? By throwing light on new aspects of the person in successive relations. Polonius as a courtier is obsequious, as a royal adviser overconfident, as a father to his daughter callously blind, as a father to his son, endearingly wise. The grand result of this method, this multi-dimensional mapping, is that since Montaigne and Shakespeare, plays, novels, and biographies have filled the western mind with a galaxy of characters whom we know better than our-selves and our neighbors. We say: she is a Jane Eyre or a Madame Bovary; he is a touching Billy Budd, or a regular Pecksniff. Note that although the world understands what Freud meant by the Oedipus complex, nobody has the slightest notion of how Oedipus felt when he killed his father and married his mother. His later sense of guilt is general, not particular. Note also that in dis-cussing Greek tragedy, Aristotle says that the action, the plot, is all-important; never mind the characters. In short, the full theme of INDIVIDUALISM had not yet resounded.

<p style="text-align:center">*
* *</p>

The Montaigne-Shakespeare link calls for the mention here that in the story of western culture Shakespeare belongs at two points quite distant from each other. He is a different figure in the two centuries, 16th and 19th. In the first, he is a Renaissance man in the fullest sense of the word: concerned with everything in the universe. He is also a semi-Eutopian, negatively: he depicts every species of infamy. Then he is quasi forgotten, only to reappear in full (516>) near the beginning of the 19C as the bard, the Shakespeare who now lives in the textbooks, supplies actors with good material to cut from, and is so handy in advertising as the symbol of excellence.

The one who lived two-thirds of his life in the 16C was a popular and profitable playwright, who was the object of much admiration and some jeal-ousy among his colleagues, and who earned the friendship of one of his rivals, Ben Jonson. The sincerest praise he received was as the author of the "sweet

poems" *Venus and Adonis,* and *The Rape of Lucrece;* and later for some "sugared sonnets." There was fine poetry in the plays too, but it is not clear that his plays—or writing plays at all—had then the towering importance we now attach to such works. The craft carried with it a hint of pot-boiling; being a professional author was not a gentlemanly pursuit.° Gentlemen—in palaces or at Oxford—wrote verse as a pastime, as a form of letter-writing or as compliments and small gifts, never for money. Besides, plays were rough-hewn things, fiddled with by the actors, directors, and printers, not polished works of art. Shakespeare's had the further demerit of not observing the classical rules. Ben Jonson was more conscientious and rated higher.

These facts, limiting Shakespeare's contemporary fame and enhancing his friend's, are reflected in the references of the next century to their respective works. The comments about them have been tabulated:° not only is Ben Jonson rated the first great English dramatist, but his name appears three times as often as that of his inferior rival. Shakespeare performances after his death were few and we shall see on what grounds this low estimate was based (356>).

Ben Jonson himself, in his retrospective words of praise and of love for his departed friend, utters the often-quoted wish that Shakespeare had "blotted a thousand lines." It might be an amusing parlor game to sit around a table with the text and match wits over which lines to blot. For despite what has been well-named bardolatry, readers since its start in the 19C have found much in Shakespeare that they wished away, but did not dare condemn openly. R. H. Hutton justified his own courage: if he was qualified to admire the great things in the bard, he was also qualified to reprove the bad—and not just fallings-off from sublimity, but the dreadfully bad.

Among these would be the playing on words that spoils the mood, as in the song that ends: "boys and girls, like chimney sweepers, must come to dust." Again, crude comments, like the one about Ophelia drowned: "too much of water hast thou," or silly conceits: "the fringed curtains of thine eye advance," to mean shut your eyes. One also finds passages that defy sense— enough of them to suggest that they cannot all be attributed to printer's errors following bad stage copies. Finally, there are the "horrors" that made even an admirer like Voltaire, who knew the works in the original, call him a barbaric mind—the putting out of Gloucester's eyes on stage, for example, or "Exit, pursued by a bear."

Bringing out the objections that the first Shakespeare was long liable to is a reminder of an easily forgotten fact of cultural history, and also a striking example of an important recurrence in that history: the radical, white-to-black, up-and-then-down variations in the periodic estimates of men and works. This has been aptly called "the whirligig of taste," the phrase itself alluding to one of Shakespeare's.° To the Renaissance, Cicero was the

supreme man of letters; today he has been banished even from the classroom. Until the 1920s, John Donne was a name encountered in passing, mainly in the writings of other poets, such as Coleridge. Then Donne became a great poet, deemed by the New Critics, finer than Shakespeare because more philosophical and "better structured." The same Montaigne-like inconsistency occurs about periods: After 150 years of contempt, the Baroque, especially its music, has become a valued acquisition. And so on ad infinitum.

Epic & Comic, Lyric & Music,
Critic & Public

A WIDELY READ NOVELIST of the 20C who had a talent for crime-and-spy
fiction and occasionally wrote in that genre called those tales "entertainments."
His novels dealt seriously with moral and religious issues. This unusual double
role mirrors the literary situation of the late medieval and early Modern Era:
writers then—poets for the most part—wrote to entertain a circle of friends or
a princely or royal court, or else went in for moral edification, hoping to save
the unregenerate and possibly produce literature with a large *L*.

But there is a difference between Graham Greene and the Renaissance
poets: today, the entertainments—by him or anybody else—are considered a
lower sort of production, even when they are excellent in their kind. In the
early Modern Era there was no such discrimination. For centuries, poetry and
storytelling had no purpose but to entertain. There were no other means of
spending leisure time, of chasing away boredom, than to sing, recite, or listen.
This pastime itself became a device of fiction: in Boccaccio's *Decameron*, the
famous set of erotic tales, these are presented to the reader as having been
told to entertain a group of Florentines who fled their city to escape the
plague. Marguerite of Navarre 200 years later used the framework again for
her *Heptameron* (<86).

But contemporary with Boccaccio, Petrarch wrote his Italian sonnets to
"express himself" and a Latin epic to establish his fame in the way of the
ancients. Thus entertainer and amateur slipped into professional. The recog-
nized names: poet, playwright, essayist, novelist suggest the theme of SPE-
CIALISM, then at the start of its career. Humanist awareness of the ancients
gave this transformation a strong push. The Greeks and Romans, the
ancients, had a literature in the formal sense and the moderns must build one
too, a set of works that would reach beyond one's friends or fellow courtiers;
Literature was for all time.

The older role did not yield at once—or in full—to the new. Down to the

19C one finds the poet writing for his circle, which may be the members and retainers of his patron's family (whence "occasional verse" = for an occasion) and also the royal poet laureate. The amateur survived too, especially the nobleman, who must affect nonchalance, tossing off sonnets and madrigals by virtue of his blue blood. Lord Byron was the last of the breed, though he tossed off larger fruit than the sonnet. Neither poet nor musician could as yet rely on publishing to earn a livelihood. There was nothing like the modern maze of agents and editors, royalties, and reprint rights, although a kind of copyright was beginning to take shape: obtaining a "royal privilege" gave the possessor the exclusive right to print and sell a work, usually for ten years (<130). The scheme served censorship as well. The author sold this right and his text to the publisher for a single flat sum. Milton's *Paradise Lost*, late in the 17C, when the practice had become usual but not regular, went for 10 pounds.

These arrangements explain why until recent times authors could claim, as they brought out their works, that a manuscript copy had got into print without their knowledge or consent—it was full of mistakes and now here was the work as it should be. The enduring practice of circulating hand-written copies of verses among friends, or even of philosophic and scientific papers, was a constant temptation to the pirate printer or the false friend.

In short, at the start of the Modern Era we see only the rough outline of organized authorship and publishing and of similar institutions for the other arts. Yet the passage from the patron to legally protected public sale and yearly support by governments and foundations has not turned the artist into a certified professional whose license and abilities permit him to expect a reasonable livelihood.

*

* *

The Humanists believed that of all the literary forms, the epic was the highest. Being longer, it is hard to keep at a high level. This difficulty challenged Petrarch, but his Latin proved unequal to the task (<49). The ancients offered but few models—Homer and Virgil were the outstanding pair, and Aristotle supplied virtually no rules for the genre. He only said that a true hero was essential, meaning that incidents and scenic details were not enough to sustain interest.

Lacking or ignoring the many heroic poems of the early Middle Ages, from the *Song of Roland* to the Germanic and Icelandic sagas, the chief Renaissance epics were a peculiar blend, created by four Italian poets: Boiardo, Pulci, Ariosto, and Tasso. The first two belong to the 15C, the other pair to the 16th. Once as familiar throughout the West as Shakespeare and Goethe are now, those four names and their glory survive only in their country of origin. When the gondoliers of Venice sing for the tourist, it may well

be bits of Tasso's epic. As late as the beginning of the 19C, Ariosto and Tasso were read, quoted, and enjoyed by educated Europeans. At the same time, Dante's *Divine Comedy,* also an epic adventure and now one of the "great books," was looked down on as "Gothic," a piece of medieval obscurantism. What is the "more human" subject of the other four Italian epics? The first three in the list take up some aspect of the legendary tale about Charlemagne's paladins or chosen knights whose mission in life is to fight the infidel Saracens. They are betrayed by the villain Gan (in French, Ganelon) and are defeated at the famous battle of Roncesvalles in the Pyrenees. The early medieval *Song of Roland,* in Old French, gives the details in stark matter-of-fact language. Boiardo, Pulci, and Ariosto add the element of love, and with it the intervention of magic. Instead of the old epic's warriorlike sober sadness, they provide for the sophisticated Humanists and courtiers the excitement of love-making and of what has been called "The Marvelous," the miraculous, performed by black or white magic.

The wizards and goblins and enchantresses are not meant to be believed in; they entertain by their unexpected powers and their malicious tricks, and they come to a bad end. It is wild fantasy: in Ariosto's *Orlando Furioso,* the wizard survives decapitation. In Pulci, the giant Morgante dies from laughing too much on seeing a monkey put on a pair of boots. In Tasso, one of the paladins sets out to clear a wood occupied by the forces of evil, and his dead mistress appears: she has been one of the trees. Women of great moral and physical strength play a large part in these adventures, especially the Valiant Amazon who occurs in the popular ballads and is here turned into a heroine and lover. Even the enchanting Armida, who helped the infidel, wins our admiring regard when she is converted by love.

All this at first sight seems alien to the Renaissance rejection of medieval superstition in favor of the human and lifelike. In effect, those epic magicians fill the role of the gods and goddesses in the ancient Greek and Roman epics, while the paladins represent and behave like the gentlemanly courtiers in Castiglione's book of etiquette. Warfare between Christian and infidel, it must be remembered, was still going on in the 16C, medieval Saracen being replaced by modern Turk: Ariosto's *Orlando Furioso* ends with the hero's killing the King of Algiers—precisely what Charles V had been trying to do.

Love against anger rose, and their dispute
Proved that her flame still glowed, though
 hid from view;
Three times her arms she stretched abroad
 to shoot,
Three times took aim and thrice her arm
 withdrew;
Disclaim at length prevailed: again the yew
She with an eager and unshrinking arm
Bent, and the bowstring twanged. The shaft
 outflew—
Out flew the shaft, but with the shaft this
 charm:
She the next moment breathed: "God grant
 it do no harm!"

—ARMIDA FIGHTING RINALDO IN TASSO'S
JERUSALEM DELIVERED (1581)

In three of the four poems—Boiardo's *Orlando in Love,* Pulci's *Morgan the Great,* and Ariosto's sequel to Boiardo, *Orlando's Madness*—the hero pursues several goals, but each comes to a different end. The name Orlando, by the way, is a metathesis for Roland. His madness is only fitful and is due to jealousy in love. But what matters is not the plot but the charm and variety of the episodes.

Tasso, a generation after Ariosto, chose a new theme in his *Jerusalem Delivered,* but it still combines religious zeal and love. His hero is the historical leader of the first Crusade, Godfrey of Bouillon, and the climax is the equally historical capture of the holy city. All the crusaders except Godfrey are in love; he is content to be kindness personified, quite unlike the real Godfrey. The others' amorous diversions are skillfully interwoven into the martial plot, so that the goal of the expedition is not lost sight of, only delayed.

It is of course this unbusinesslike concern with lovemaking, together with the battle pieces, alienates the 20C reader. But to judge the poems fairly one must remember their audience. After the advent of the book, the pleasure it afforded could still take the form of reading aloud to a group. The modern habit of silent and solitary intake was not yet ingrained, let alone the addiction to reading in bed, dependent as it is on central heating and a good steady light. In an epic tale, interest is best kept up by variations on the familiar. No large array of entertainments had trained the mind, as ours is, to accept the wholly unexpected and unconventional. In the Italian poems, separate stories and digressions are inserted at intervals; these and the long speeches did not destroy suspense, on the contrary. In fact, the story-within-story device persisted as late as Dickens. As for love—or rather courtship—it is the pastime of the idle in any age, just as fighting is the diversion of the well-born as long as rank has any meaning. Denizens of courts never tired of either in their literature.

In the light of these facts, the Italian epics must be seen as thoroughly up to date for their time. Their immense popularity, immediate or nearly so in all four cases, is the best proof. The poets' contemporaries in high places praised the works as masterpieces and used them as founts of truth; that is what epics are for. Galileo, for one, knew Ariosto by heart and loved it so much that he said mean things about that upstart,

Tasso

Socially, the poet was no upstart: he sprang from a large clan of nobles in Lombardy that had branches all over Europe, notably the Taxis family in Germany. In Latin, *taxus* means badger or yew-tree. The Tasso coat of arms sports the animal; but the poet preferred the tree, and his life makes this emblem of sadness appropriate. Among the Renaissance poets, he is the one

whose destiny has evoked lasting inter-
est and been taken as typical of the artist
mistreated by society. Because he was
confined to a lunatic asylum for seven
years by his patron, the Duke of Ferrara,
the poet has been pitied by other poets,
and the patron and "society" pilloried.
Goethe wrote a play suggesting that the
duke was punishing the impudence of
the genius for winning the love of the
duke's sister. After visiting the "prison
cell" Byron wrote a poem that depicted
the victim's mental torture. Liszt composed a symphonic vindication in two
movements, the first entitled "Lament," the second, "Triumph."

> ... I make
> **A future temple of my present cell,**
> **Which nations yet shall visit for my sake.**
> **While thou, Ferrara, when no longer dwell**
> **The ducal chiefs within thee, shalt fall
> down,**
> **And crumbling piecemeal view thy
> heartless halls—**
> **A poet's wreath shall be thine only crown,**
> **A poet's dungeon thy most far renown.**
>
> —BYRON, "THE LAMENT OF TASSO" (1817)

The legend should not be accepted uncritically. The quasi dungeon shown
to the tourist is not where Tasso spent those seven years. In his actual apart-
ment he wrote poems and essays and endless letters and he received visitors
(including Montaigne), as well as gifts and praise from other writers and titled
amateurs. What his life and undoubted misery exemplify is one kind of relation
between genius and patron. Duke Alfonso was a show-off, touchy, ever con-
scious of his rank. Torquato Tasso was a manic-depressive inclined to paranoia,
and so restless that his seven years' confinement was his longest period in one
place after his first decade at Ferrara. His upbringing had bred him to wander-
lust. His father, a poet of renown in his own time, was poor and feckless. He
sought and held posts here and there, taking with him his son, the youngest
child, and leaving his wife at home. She died when the boy was 13. Torquato did
not resent this broken-family existence and—like Montaigne, Mozart, and
Berlioz—loved and admired his father all his life.

Shortly after his 16th birthday the youth was sent to the University of
Padua to study law. There he wrote a verse romance, *Rinaldo,* which was soon
published in Venice; at 19, he began his epic, *Jerusalem Delivered.* In Padua also
he joined the Academy of the Ethereals founded by his friend Scipio
Gonzaga, later a famous cardinal and Tasso's rescuer-friend. Academies then
were informal groups of amateurs, mostly young, who met to discuss the
intellectual and religious issues of the day. They studied Plato, and read for
comment each other's productions in verse and prose. Every self-respecting
Italian city had at least one academy, each labeled with an evocative title.
Imitated abroad, these gatherings grew into the formal king-sponsored
academies of the 17th and 18C, which in turn became the specialized learned
societies of the 19th.

For the Ethereals Tasso wrote three essays on the heroic poem as a
genre—theory a bit ahead of practice. By then the father was resigned to his

son's neglect of the law and Torquato went to Bologna to study "the good let-
ters." Noticed for his talents and his tall, handsome bearing, he was taken into
the retinue of Cardinal d'Este, to whom *Rinaldo* was dedicated. This appoint-
ment (after a year's illness spent in Mantua) brought the youth of 21 to
Ferrara, seat of the house of Este, the rabid enemies of the Medici. Alfonso's
two sisters at once befriended the young poet, who saw in the duke his own
epic hero: Alfonso was ready to help the emperor against the Turks with 300
knights appareled in velvet and gold.

Tasso, who had left a first love in Padua, now fell for a second, the beau-
tiful Lucrezia Benedidio. But she did not respond to his suit and married
Machiavelli instead. Tasso's loves were plentiful, a by-product no doubt of his
restless moves from place to place; novelty of setting included the appeal of a
fresh conquest. It would seem that a good number of these amours were lit-
erary rather than passionate. A few fine sonnets recording the new ardor suf-
ficed to fulfill the desire. Such was the fashion of the day—languishing in
verse, suffering lyric despair, and sharpening the quill to besiege the next
inamorata. Young Tasso, giddy and vain, wrote in praise of all the princesses
around and took part in a pseudo debate three days long on "Fifty
Conclusions About Love," a mixture of logic-chopping and erotic utterances.
It made many jealous men and women.

At one point, Cardinal d'Este took Tasso with him on a diplomatic visit
to Charles IX of France. The king was a good judge of poetry and gratified
Tasso's thirst for praise. But the poet made a tactless remark about the sur-
prising toleration of Protestants at the French court. The cardinal dropped
him and from that moment on (though not cause and effect) Tasso's troubles
began. He could not be happy in spite of honors, affection, and praise.
Everything seemed to him false. In a pastoral play, *Aminta,* which he wrote at
that time and which was performed to everybody's delight both at Ferrara
and a neighboring town, he denounces courtly life: it is "the House of Idle
Talk" where "one sees things as they are not."

He had become suspicious of his very success. The more compliments
he received the more he imagined he had enemies who were denying him the
genuine praise he deserved. He was also worried about the orthodoxy of his
Jerusalem epic and, wanting a papal license, he submitted it to the Vatican,
where niggling censors took two years to riddle the work with objections. The
edicts of Trent were being applied. Tasso grew wildly irritable, demanding
attention, challenging criticism. He had a scuffle in public over an insulting
word, feared assassins, and then bragged that he had scattered a squad of
them. This tale was long believed outside Ferrara, so plausible was the
sequence of events. But Tasso's truly grave offense was that he negotiated
secretly with the aid of his friend Gonzaga for an invitation to Rome by the
house of Medici, the D'Este's enemies.

The offer he obtained was so generous that it raised all his apprehensions: Was it for him really and truly, or against the D'Estes? He turned down the Roman welcome, went back to Ferrara, fell in love with a newly arrived beauty, believed the duke would burn his great poem not quite finished, and attacked a servant with a knife. Alfonso used the mildest means to have him confined to his apartment and treated by a physician. Tasso wrote to some friends that he was being taken care of like a brother, and to other friends, "treated like a criminal." The duke meanwhile was doing all he could to keep the epic poem from being pirated in other cities.

It would be tedious to recount all that followed Tasso's first move away from Ferrara. The pattern goes something like this: he entreats friends to receive him in another town; they comply. In two months, he moves again. As with D. H. Lawrence in our century, the first few weeks' stay satisfies every wish; then: "This place is no good." Tasso yearns to go back to Ferrara. The duke is willing to forgive—and does so more than once. Tasso takes to a convent and resolves to become a friar. Then he flees to his widowed sister in Naples. He comes dressed as a shepherd for security in traveling alone and arrives so haggard that she does not recognize him. She lavishes tender care, but it is no good. He must go to Rome, and the round begins again: a few months each at Rome, Mantua, Naples, Florence, Turin, Urbino, Ferrara. There, at last, at the age of 35, he thinks he will be able to put the finishing touches to the grand story of the Crusaders' capture of Jerusalem.

Unfortunately, the duke is getting married for the third time and he and his entourage are too busy to pay as much attention to the returning prodigal as he is entitled to. He goes frantic and shouts curses and invectives in public. Alfonso and his court are a crowd of ungrateful debauchees and cowards. Tasso is taken to the hospital of St. Anne for the poor and lunatic. The blow is unexpected. He implores the duke to set him free, but he suffers delusions and hallucinations. He sees the Virgin Mary, he eats and drinks too much "so that he can sleep"; he begs his physician to make the medicine less bitter. But he also writes sonnets and answers rationally, learnedly, the reviews of his work. For his *Jerusalem* has at last been printed, though in a garbled edition, and he reads avidly all the comments it evokes. The pope was ready to honor him with the laurel crown in Rome when the poet died in 1595.

*
* *

Like its three predecessors, *Jerusalem Delivered* combines holy war and love affairs, lifelike adventure and magic spells. The duels and battles are vigorous and convincing; there is a talking bird and a wizard who walks on water; the Devil appears, complete with horns and tail, and as mentioned earlier, at the very end the lovely witch Armida, whose evil enchantments

have helped the infidels, is converted by love for her dedicated foe. Orlando himself is shrewd and touching by turns, and the "marvels" are so well done that when one is in the mood they produce the effect that modern taste finds in science fiction.

The work has been aptly called an epic for lovers. Charlemagne's paladins would have been disgusted with it, and the ancients would have called it a romance, not an epic. The Italians' side dishes of the erotic and the marvelous are so good of their kind that they have furnished characters and plots for innumerable grand operas, from the inception of the genre (174>) through the centuries up to the rise of opera, that is, from Monteverdi, Handel, Gluck, and Rossini to Meyerbeer (498; 499>).

If, as critics seem to agree, *epic* means heroic, the Italian attempts at the genre must be called failures, or else classified under some other rubric. [The book to read is W. P. Ker's *Epic and Romance*.] Their authors knew but disregarded or misunderstood Aristotle's dictum that the source of interest in epic is character in the sense of "person of character." The hero must be firm in danger and undeviating from the line of duty. Achilles' defection at the opening of the *Iliad* is part of a struggle for power; and Aeneas is not afraid to boast: "I am the faithful Aeneas," meaning faithful to his mission— and therefore unfaithful to Dido. This artistic principle excludes the self-indulgence of the lovelorn. To be sure, there are love passages in the *Odyssey* and the *Aeneid,* but they are few, brief, and shown as hindrances, not priorities. In the 8C *Song of Roland,* the only mention of a woman in love—Roland's betrothed Aude—is half a stanza about her death from grief at his being killed. In the Italians' would-be epics the women are finer, stronger characters than the men—another sign that the tone of the poems was up to date.

But whatever misdirected intentions may be listed as flaws in these works, we know that they exerted their charm on the best judges down to the first quarter of the 19C, partly for a cultural reason now forgotten: Italian was the language, next to French, that the educated must know: the mother of the arts dare not be ignored; and so we find—to name a few others than Byron and Goethe—Voltaire, Landor, and Thomas Love Peacock quoting the Italian poets from memory and exclaiming at the beauties that now lie buried there. Shelley was also a devotee, who in his "Defence of Poetry" credited Tasso with being the first to call a poet a creator. Tasso scholars have not found that bold comparison, now a cliché.

Reasons for the eclipse of a classic are not easy to find. The retreat of Tasso and Ariosto within their native frontiers coincided with the West's discovery of German culture, which required the literate to learn German and possibly to visit Germany, but this conjunction in time may be accidental. A more plausible reason is that the merits of Tasso and his predecessors were literary rather than intellectual and moral. They have never been satisfactorily

translated, whereas Dante with his system of ideas keeps inciting foreigners to translate him.

Again, there is the ever-watchful Boredom, ready to pounce and destroy what has been too often tasted and touted. And when the really new is abundant, as it was in the Romanticist period, it swamps the old by sheer weight of numbers. Finally, there is the pressure of social evolution. The sequence of dominant genres during our half millennium has paralleled the march of the Individual toward equality; it runs: epic, tragedy, the lyric speaking for the self, and the novel and the play in prose criticizing life. This is to say that it goes from the hero of a whole people to the great hero of tragedy, to the common-man hero, to the anti-hero.

<p style="text-align:center">*
* *</p>

While Tasso was garnering praise for his work, another poet in another southern land was composing a true epic. If the name of Camoëns and the title *Lusiads* do not at once evoke recognition, the reason is again that of language: Portuguese is not widely read or studied outside its native limits in Europe and America. Camoëns chose a subject more factual than the paladins and had a more useful experience than the Italians for epic work. He was a soldier and sailor. He fought the Moors in north Africa, lost his right eye in battle and was invalided, re-enlisted to find adventure in the Indies, and there became an official in charge of a trading post. Accused of embezzlement and put in prison, he managed to get free and sail home. There, like everybody who could hold a pen, he wrote plays and sonnets and began the epic that made him the great national poet—indeed, a great poet *tout court*.

His subject was contemporary: the conquest of the ocean sea by the Portuguese. And his ostensible hero was a recent, historical character, Vasco da Gama. The actual hero is the Portuguese people, "the illustrious heart of Lusitania"; the name of the ancient Roman province that recurs in the title *Lusiads*. The adventures of the hero as man and people are the real and allegorical events of the explorer's voyage home from the East. What there is of the marvelous in the incidents is due not to magic but to the well-known gods and goddesses of the ancients. Thus in the great episode of the Isle of Love, the domain of Venus, where the sailors take the Nereids, nymphs of the sea, as brides, Gama is the lover of their queen, Thetis, hitherto unattainable. Gama succeeds in his wooing after the repulsive giant Adamastor, typifying the enemies of the Portuguese, has failed. The union of godly beauty with human courage is to produce the future heroes of Portugal. In Greek mythology, when Thetis is subdued by Love, her offspring is the dauntless Achilles.

This sample episode from *The Lusiads* is enough to show that it is a Humanist epic. Women other than goddesses play important parts in several

of the main scenes. Among these is the story, told with lyrical tenderness, of Iñes de Castro, the historical mistress of Prince Pedro of Portugal, whose close advisers compelled him to have her put to death. In tone and conception, the poem is equidistant from the popular ballad and the learned pastiche. Camoëns has been blamed for mixing the pagan myths with Christian, but it is standard Humanist practice (<52). It is not sacrilege but spiritual synonymy. In *The Lusiads* the allegorical and the historical planes are traversed by physical action, told with unabating vigor and vivid detail. It came naturally to one who, though writing on terra firma, had spent many days on the deck of a ship. The fervor with which Camoëns celebrates the conquest, first of the sea by rounding the Cape of Storms at the tip of Africa,° and then of the natives and the trade of the southeast Indies, makes his poem the first and last national epic—this at a time when the nations of the West were not so much made as in the making. The work withstands comparison with Virgil's imperial *Aeneid*. Using a longer line than the Italians, Camoëns was able to achieve grandeur more easily, especially in the speeches. And he shares with the ancients and the writers of sagas something one might call epic pessimism. He is also considered Portugal's greatest lyric poet, as well as the man whose writings fixed the Portuguese language.

Os Lusiadas has been translated four times into English, the latest version being in prose. [The one to read is Leonard Bacon's, in verse.] But there is another means of access that is strongly recommended to anyone who knows Spanish: it is to study in a comparative grammar the forms that differ regularly in Spanish and Portuguese and then to plunge into the poem with a dictionary at hand.

In their own explorations the Spanish had as good materials as Camoëns, but their one effort, Ercilla's *Araucana,* took a South American locale for its events and is said by good judges to contain only one passage of epic quality: the natives' resistance to the colonists.° In France, poems in that genre were attempted in the next two centuries, with the same intent as Camoëns's—to glorify the nation, now full fledged. But they failed to an even worse degree than the Italians and Spanish. Germany meanwhile could show only folk ballads and the comic adventures of *Till Eulenspiegel;* which leaves the Elizabethans to be accounted for. They knew their Ariosto at least and were variously influenced by him, perhaps to their detriment. Spenser's *Faerie Queene* is a long narrative poem in praise of Queen Elizabeth, but no national emotion emerges from the allegory. The pleasure lies in the superb poetry that conveys rich scenery and high morality, with no immediacy in what purports to be epic adventure; it has even been said that its language is not genuine English, meaning vernacular and contemporary. But admirers of Keats should read his master if they do not already know him.

More vivid and more varied, Sir Philip Sidney's *Arcadia* might be called "epical." It is made up of verse and prose and offers, despite its pastoral title drawn from an Italian work by Sannazaro, strong characters and good plotting. It has the distinction of embodying passages by the author's sister, the learned charmer and intellectual Lady Pembroke. Sidney did not at first regard it as an epic on classical lines, he thought it a romance. But as he added adventures the heroic element increased, only to be overborne by debates on politics and morals, discussions of beauty and suicide and the existence of God. The work is imbued with the chivalric spirit of its creator, truly a "perfect, gentle knight," who died of his wounds in battle: he had taken off his leg armor when he saw another captain refusing to put on anything as strong as his own.

*
* *

It was not until the advent of the long-playing disk in the mid-20C that the general public had, or could have, any idea of the richness and beauty of Renaissance music. In the mid-19C Victor Hugo wrote a long poem entitled: "That Music Dates from the Sixteenth Century." This proposition states all that was known on the subject then and later. In its flat assurance the statement is of course wrong. It should have said *modern* music. The poem in fact tells us very little about music—Hugo was no musician°—and much about 16C art and artists. To complicate matters, there is disagreement about the degree of novelty in Renaissance music as there is about the period as a whole° (<47). This need not cause surprise: the many-facetedness of written music and the fluid testimony of the ear make for contradiction. Besides, as shown earlier, antecedents can be found for nearly any innovation. What may properly be called new is any work or artistic practice that is not isolated in its originality, but visible and potent.

On this premise, several points may safely be made: the first is: the Renaissance found new programs for music. "Programs" is used here advisedly and for a critical purpose that will emerge later on (639>). All music has a program, a formal plan that must also be functional. A composer puts sounds together for a purpose—to fit the steps of a dance, the words of a song, the character of each part of a religious service, or any other goal that may fire his imagination. It may be an outward demand or event or simply a private thought or memory—the range is unlimited. That is what makes music an art on a par with the rest.

In the late 15C and thereafter, the programs were increasingly secular, in keeping with the importance that the period attached to human actions and feelings. These programs—as noticed earlier (<121)—arose out of the activities of courts, the cities' love of festivals, the demand for entertainment in

All their music, both vocal and instrumental, is adapted to imitate and express the passions and is so happily suited to every occasion that whether the subject of the hymn be cheerful or formed to soothe or trouble the mind, or to express grief or remorse, the music takes the impression of whatever is represented, affects and kindles the passions, and works the sentiments deep into the hearts of the hearers.

—THOMAS MORE IN *UTOPIA* (1516)

large and small households, the abundant production of poetry (including a widespread revival of Petrarch's), and the Humanists' passion for emulating the ancient Greeks, whose writings ascribed to music a leading role in life.

The courtly round included weddings, official receptions, funerals, tournaments, and wars. We find Jannequin, for example, composing a choral work entitled "The Battle of Marignan," as well as pieces on workaday subjects such as "The Hunt" and "Paris Shouts and Cries." A sizable group of choristers singing in parts suggested such imitative effects of ordered confusion. With its shadings by means of voice combinations, its variety of dynamics (volume) and rhythmic and harmonic possibilities, the 16C chorus prefigures not the orchestra as such but its effects—dialogue between sections, variety of tone-color, and physical impact.

The period was one of musical expansion—larger choirs in churches, bigger and better organs, larger "families" of instruments and more numerous players in town bands—all encouraged by more patrons of the art. Castiglione in his *Courtier* had required the gentleman and lady to be practicing musicians and he set the scene for the pastime: when close friends of both sexes were together it was to be an interlude during conversation. Others argued platonically that the art was conducive to order and harmony in private life and the state. Certainly the men and women in the half-dozen Italian towns where the new music developed with the help of a duke or a learned lady were bent on more than casual pleasure. In Rome, Florence, Venice, Ferrara, Mantua, Urbino, and Naples, poets, musicians, and mathematicians debated what music should be. They worked at devising new forms and techniques, wrote theories, and tried their innovations on the amateurs who gathered in academies like the scholars and philosophers.

The resulting works were of various kinds. The resident poet at court would write a pastoral or allegorical story in episodes that called for music, lyrical or dramatic and interspersed with dances. Petrarch, once again in favor, had given the model of a sequence of poems on one subject. The Renaissance composers followed suit. They set groups of madrigals treating of one theme or unfolding a tale. Vecchi entitled such a sequence *commedia harmonica*. One thinks at once of Schuman and Schubert, masters of the song cycle. In 16C Italy the numerous patternings of poetry and music were forerunners of the later forms, cantata and oratorio, plus one other easy to guess and soon to be named.

The church service itself, which had always used music to heighten the devotional mood, was reformed in the interest of musical appropriateness. The Mass had for some time been used by composers simply as a chance to give a concert; now it was to be set so that the music of each section was in keeping with the words. And care must be taken to avoid breaking those words in half or distorting their accentuation.

The Protestants managed this very well with their hymns and chorales sung by the congregation in unison. These changes of practice can be summed up as a universal effort to achieve expression in music, expression through music. The tendency is itself an expression of the modern temper in the arts, which aims at the particular in place of the general and concentrates all means and devices on portraying what is unique, that is to say INDIVIDUAL.

In college or monastery it is still the same: music, nothing but music. Words nowadays mean nothing. They are mere sounds striking upon the ear, and men are to leave their work and go to church to listen to worse noises than were ever heard in Greek or Roman theater. Money must be raised to buy organs and train boys to squeal.

—ERASMUS (1513)

*

* *

A full understanding of the musical means newly devised in the Renaissance would naturally require the use of technical terms and illustrations in notes. But a skeletal idea of the significant change may be given in words alone if a brief retrospect is first supplied.

For most of the Middle Ages, church music consisted of the so-called Gregorian chant—one line of melody attached to the words of the service. And of course the large repertory of popular and domestic music was also melodic—one voice. In the 12C flowering of art and thought it was found that two or more melodies could be combined agreeably, though this blurred the words. In the next two centuries the *ars nova* (new technique), as it was called by its first theorist, Philippe de Vitry, added voices and tempted composers in northern France, Belgium, and the Netherlands (called for short the Flemish School) to play with the technique for the sole pleasure of exploring its possibilities. This complex art developed luxuriantly to the detriment of expressiveness. Zeal for discovery rather than use is a repeated occurrence in all the arts.

Vitry also devised the symbols for noting music and showing its measure by means of numbers (binary time and so on). Armed with all these, the Flemish School had the great merit of demonstrating the resources and establishing the rules of the style called polyphony. By an obvious image it is called horizontal: the composer writes melodic lines that move forward along four, six, or more paths simultaneously. In these combinations, the notes sound together pleasantly most of the time—hence the other name, counterpoint:

There is a certain hidden power in the thoughts underlying the words themselves, so that as one meditates and constantly and seriously considers them, the right notes in some inexplicable fashion suggest themselves spontaneously.

—William Byrd, Preface to *Gradualia* (1607)

one point or note jammed *against* another. But this piling up occasionally proves harsh or intolerable. Out of this predicament comes the idea of composing "vertically," that is, taking care about the collisions that occur between horizontal lines. This musical style bears the other obvious name of harmony. It offers the listener a melody visualized as being on top (though all notes are equidistant from the center of the earth) and having "below" a group of notes (a chord) so chosen as not to shock the ear—or if they do, to do it in a passing way, quickly "resolved" into harmoniousness. Both styles, polyphony and harmony, are equally capable of expressiveness, although harmony is better suited to the lyrical, individual voice and its nuances of feeling. The seesaw in the history of music between harmony and polyphony is a characteristic instance of response to external demands, coupled with fatigue-and-boredom prompting change.

The technical innovation of the 16C was to combine elements of the two musical styles, the polyphonic and the harmonic. This merger produced a number of new forms, both for voice alone and for voice accompanied by instruments. Chief of these was the madrigal, a verse form more flexible than those sung by the troubadours—the minstrels—in the Middle Ages: ballade, sestina, and others. Like the popular songs that continued to be written and sung, the 16C lyrics dealt with the eternal subjects—love, sorrow, death, the springtime, and drinking. The music of a madrigal could vary from stanza to stanza and, as we have seen, a series of such poems could be made into a quasi dramatic work; there was no refrain or lines repeated word for word to halt the forward motion of the idea. The madrigal originated in Italy and was cultivated there by many gifted hands, but it also inspired in England a school of brilliant composers (161>) who flourished from the mid-16C to the early part of the next. Though long ignored, they have come in our century to be ranked among the master musicians.

It would not be fitting to use a sad harmony and a slow rhythm with a gay text or a gay harmony and quick lightfooted rhythm to a tragic matter full of tears. [The composer] must set each word to music in such a way that where it denotes hardness, cruelty, etc. the music must be similar to it, without offending.

—Zarlino of Venice, *Harmonic Principles* (1558)

Other 16C forms such as the pastoral, the masquerade, and the *ballet* (the speech-and-dance ancestor of what we know under that name) embodied the same intention. Whether the subject was the loves of shepherds and shepherdesses in the pastoral or pagan gods and goddesses in the ballet or masquerade (in English, the masque), the emotions to be under-

lined by music were worldly, not the familiar religious ones. A set of rules must therefore be devised to ensure a comparable fitness.

Another problem to solve came from the Humanist devotion to the ancients, which urged that some form be devised to emulate Greek drama. Those plays, as everybody knew, were musicals—dialogue, song, and dance. The word *tragedy* means "goat song," a reminder of the animistic and musical origin of the genre. To re-create it after a thousand years, modern music must be at once expressive and transparent: it must leave the words of the play intelligible.

With so many purposes to fulfill, battle was joined among theorists and practitioners. The main conflict was between the lyricist, who cherished his expressive words, and the lover of musical complexity, who reveled in counterpoint of 4 and up to 16 different voices and who argued that a vocal ensemble was fully expressive. The masses and secular works of Orlando Lasso, Josquin des Prés, Palestrina, and Victoria are there to prove the contention. The 16C gave the world the richest legacy of purely vocal music, polyphonic and expressive in character.

The attackers of polyphony won out. They had in mind not only the elegant playlike forms of the court but also the public occasions cited earlier. Any gain in clear expression would improve all festive uses. The lyricist sided with them because his role too had changed. He had, figuratively speaking, dropped the lyre. Formerly, the troubadour-minstrel sang his own song to his own strumming, or if accompanied by one or two *jongleurs* (players) to pluck the strings, the work performed was still the entire product of his mind—as it is again today in pop, rock, rap, and other explosive musics. The new, words-only poet still hankered after performance and when his poem was set to music he wanted its verbal beauties appreciated—hence no polyphony.

Better than arguments was the actual creation of various attempts at music drama and the setting of poems and church ritual in a manner that has been called word-painting (an unfortunate term since the effect is not visual but visceral; 640>). Thus Vincenzo

> **The melody must not depict mere graphic details in the text but must interpret the feeling of the whole passage.**
>
> —GIULIO CACCINI (1601)

Galilei, father of Galileo the astronomer, set Ugolino's monologue from Dante's *Inferno*; others took passages from Tasso; still others—in France—invented the vaudeville, a storytelling song in many stanzas; while the English school of madrigalists produced, as mentioned earlier, a body of work of the first magnitude in both amount and quality. In short, the single voice, fully expressive, survived side by side with the relentless search for the perfect form of dramatic music, the search that ended with the century itself in a new genre: the opera (174>).

<center>*</center>
<center>* *</center>

The divorce between the poet, who is content to write and publish words by themselves, and the musician, who sets the verses he happens to like, is now an irreversible division of labor. The terms we use mirror the facts: when we refer to the lyrics of a musical, we mean the words only; and we call accompaniment the music that goes, like a *jongleur,* with the utterance. A second implied theme is EMANCIPATION. Sixteenth-century music freed itself from the rigidities of the Flemish polyphony. It gave poet and musician greater scope by separating their functions; it added to the choral registers the bass voice, not commonly included before; it ventured into chromaticism ("color" by means of notes foreign to the scale being used; here the uninhibited Gesualdo was a pioneer); it made the playing of instruments alone seem natural: the creation of the orchestra is plausibly dated 1470;° and it inaugurated the grand music festival: the two Gabrielis, uncle and nephew, made San Marco in Venice resound with compositions for masses of players and singers in dramatic exchanges across an open space. A new term, *concerti* (striving together), indicated instrumental combinations of various types and sizes. And of course the rampant expressionism had to find expression marks for the score to decree speed and mood: the familiar *adagio, allegro, tremolo,* and so on—technical terms for which the Italian language seemed predestined.

The Italian musicians were fully aware of their advances upon new ground. The title pages of their published works bear the words *new music* or some equivalent. A curious, possibly related fact: in the city of Lyon, then a buzzing center of occidental culture, a printer who specialized in music publishing brought out a notable work in the new style, *Musicque de Joye.* His name was Jacques Moderne. Was it his real name or a deft piece of advertising? In any case, the "cult of the new" attributed to recent times° has a history that goes back at least to Philippe de Vitry—700 years.

As might be said again, not all the new ways became universal at once. Some styles and usages died out slowly. Polyphony was indestructible. And the poet-musician and the musician-poet survived, especially among amateurs, who exercised their double gift nobly like the Englishman Thomas Campion, or mechanically, like the German cobbler Hans Sachs, who turned out products in bulk and at top speed: 4,275 songs, 1,700 poems, 208 plays.

It is only fair to add that music in the Renaissance had its enemies, some merely censorious, some radical. Among the latter, Savonarola was prince. His bonfire reduced to ashes all the instruments he could collect. In the north, a similar opinion, but less effective, inspired Hieronymus Bosch (anticipating Bernard Shaw) to put musical instruments in two of his panoramas of Hell. These attitudes are consistent with an undercurrent of Renaissance culture that may be called its dark thoughts. Gesualdo's lyrics often invoke death.

The melancholic and the moralists, as well as the devout, read the times as wicked and bound for perdition. Endless wars, recurrent plague, the new curse syphilis, the readiness to murder for gain or revenge—all these frequently depicted in the Dance of Death—justified gloom. In any period it is hard to believe in the maxim *Emollit musica mores*—music makes behavior gentler. Among the censors were the bishops at Trent, who edicted rules for religious music, thus ensuring an unstoppable controversy: is music that dramatizes the service acceptable, or does piety require, even when facing the Last Judgment, the unbroken calm of prayer—the Requiem of Berlioz or that of Fauré?

The bishops had reasons for their crackdown. Some of the early polyphonists did not scruple to use popular tunes—often linked to obscene words—as themes for their church compositions. The faithful were upset; recognizing the tune made the service a burlesque. But purism went further: some said that only vocal music *a cappella* (no accompanying instruments) was fit for worship. The basilica of St Peter's in Rome held to that view, though the pope's own chapel tolerated organ accompaniment. Philip II of Spain banned all styles but Gregorian chant. Beyond excluding the tune of vulgar songs, no citing of reasons can settle the issue.

> Many evil and depraved men misuse music as an excitant in order to plunge into earthly delights, instead of raising themselves by means of it to the contemplation of God and to praise His glories.
>
> —VICTORIA [GREATEST OF SPANISH 16C COMPOSERS, WHOSE WORKS ARE UNCOMMONLY EXCITING]. (1581)

One further fact about Renaissance music is notable: it was not only boldly inventive and in some genres unsurpassable, it was also international. Much came from Italy, but England, the Netherlands, France, Spain, and Portugal could boast great masters. To take but one illustration, the English madrigalists Dowland, Byrd, Tallis, Morley, Gibbons, Weelkes, and their kind, who set poems by Ariosto, Ben Jonson, Spenser, Sir Philip Sidney, John Donne, and Sir Walter Raleigh, form a galaxy of artists whose eminence is acknowledged by all qualified judges. [For the amateur musician the practical guide to read is *The English Madrigal School* by Edmund H. Fellows.] There is still need to correct the general impression that the Germans have at all times been *the* musical people, especially the contingent living in and around Vienna. In the early Modern Era the Germanies were certainly not in the vanguard, and their output of folk songs has been meager compared to that of other peoples. Why should humankind everywhere be obliged to shine steadily in all the arts? The spirit bloweth where it listeth.

*
* *

One has only to look at the songs scattered through Shakespeare's plays to see what the Renaissance poet felt free to do. Whether or not he had a tune in mind, he was emancipated from the medieval stanzas shaped for music. The result was a great outpouring of passionate verse, particularly fine in England and France. The harvest of the English Renaissance is so abundant and so well known that it is only necessary to mention it, although from Sidney's eloquent *Defence of Poetrie* one gathers that the art was appreciated only by the elect. In any event, from Wyatt and Surrey to Jonson and Donne, the list of great names is continuous and long in relation to the span of years. Sonnets, singly and in sequences, odes, madrigals, narratives retelling classical myths flooded the court, the universities, the theater, the great houses—and correspondence; for one of the genres now almost extinct was the letter or message in verse, sent to a friend or patron on the occasion of a birth or wedding, an invitation to dine or simply a topic under discussion. Anybody and everybody was likely to produce these improvisations. Some might be no more than an exclamation on the spot.

Oh, Fortune! How thy restless wavering
 state
Hath fraught with cares my troubled wit!
Witness this present prison, whither fate
Could bear me, and the joys I quit.

—Queen Elizabeth when prisoner at
 Woodstock, written with charcoal
 on a shutter° (1554)

The love sonnet and other love lyrics outnumbered all other forms and subjects and established conventions about feeling and courtship so narrow that it is a wonder they lasted so long. For 300 years the poet wooed a reluctant mistress by turns indifferent, hard-hearted, coquettish, cruel, and faithless. This state of affairs was self-perpetuating: mutual love generates no extensive riming. The beloved's features too were standardized in certain adjectives of color and shape and likened to natural objects, fruit and flowers especially. As a result, ingenuity in finding fresh ways to follow the pattern was required in addition to actual poetic powers. The challenge was great and it accounts for the quantity of verbal lovemaking in the blue, addressed to the remote or non-existent tribes of Celias and Delias.

This last detail need not lower the value of the poetry, though readers prefer what seem to them the cries really wrung from the soul, the genuine pangs of jealousy in Shakespeare's sonnets or the desperate calm of Chidiock Tichborne awaiting execution. [The book to read is the anthology, *The English Poets*, Volume II: *Marlowe to Marvell*, edited by W. H. Auden and Norman Holmes Pearson.]

*
* *

The comparable French poets, a smaller group, were perhaps the first anywhere who thought of themselves as a "school." At their beginnings they

called themselves a brigade; then, their fame increasing and their numbers decreasing, they took the name of Pléïade, in English Pleiades, after the Greek myth of the seven stars and the constellation so named by the astronomers. The 20C publisher of well-edited French classics took the label again for his series, to suggest their excellence on a par with the poets'. But this implication is relatively recent. The seven, so much admired in their own day, were eclipsed at the turn of the 16C for reasons that mark an epoch in French politics and society (187>).

As we see in the poems they addressed to one another, the seven saw themselves as revolutionaries bent on making all things new in poetry. In their exuberant awareness of novelty and mastery of form they knew they were the *avant-garde,* a metaphor, as it happens, first used by their contemporary, the social historian Etienne Pasquier.° For a time, some of the group tried to revive the ancient meters, scanning the verse not by accent but by quantity—the length of the vowel and syllable. Jacques de la Taille supplied a theory, while independently in England and Italy similar attempts were made. The modern languages refused to cooperate; under the pressure of accent their syllables are indeterminate.

Innovation in language and meter was nonetheless the merit of the Pléïade, manifested most fully in the work of its chief, Ronsard. He faced a great difficulty: the enthusiasm of the early Humanists had borne hard on the French vocabulary. Its neat, brisk old words had been replaced by new ones made up of Greek and Latin roots. For example, the people of the early Middle Ages had taken the Latin *potionem* and whittled and polished it down into *poison.* The Renaissance re-introduced *potion.* This must be considered a gain because the two words mean different things; but in a multitude of other cases the new displaced the old. (English experienced a similar influx that doubled its share of words: *motherhood, maternity.*) In French, moreover, as Rabelais' diction shows, a flood of long Greco-Roman hybrids had swollen literary diction and made it pedantic, abstract, ridiculous, and vague. English owes to the same source its use of *ph, th,* and *y* in words formerly content to use *f, t,* and *i* or *u.*

One of the stars of the Pléïade, Du Bellay, wrote a *Defense of the French Language* to make clear that trying to rival the ancients in Latin was *passé;* the vernacular was rich enough for all needs. To make it so, Ronsard and his fellows established a balance among the new and old elements of the current tongue; they produced a body of work in what begins to be modern French. The bulk of it is by Ronsard. He outlived his peers and cultivated every genre: odes, sonnets, elegies, love lyrics, epistles, and epigrams. Coming after the fluent, lighthearted, Italianate Clément Marot, he gave the models of the grand style in his long poems, notably the *Hymnes.*

It was for these works that he rescued and improved the line called *alexandrine* after a medieval poem on Alexander the Great. The meter had

been long abandoned. Ronsard gave it a majestic ring and showed how it could serve the many subjects dear to the Pléiade: love, of course, but also nature, history, faith, and all that belongs to the seven ages of man. For the next three centuries the alexandrine, though subjected to stricter rules than the Pléiade's, remained dominant in French poetry.

The verse is 12-syllables long with a pause in the middle and it rimes in successive pairs of lines. [The book to read is *An Essay on French Verse for Readers of English Poetry* by Jacques Barzun.] It is interesting to note that about the same time poets in England settled on the 10-syllable blank verse as the line best suited to great subjects and convenient equally for rapid dialogue and long speeches in plays. Marlowe was the poet who, in *Tamburlaine,* gave it the speed and cadence that distinguish it from the alexandrine and from its 18C English counterpart, the heroic couplet rimed like the French (356>).

The earlier history of these two main lines is circuitous. The underlying type originated among the Provençal troubadours in the 12C. It traveled to Italy, where it established the 10-syllable line used by Dante, Petrarch, and others, and also to northern France, where it acquired two extra syllables. Meanwhile, the Italian line was taken up in England and served Chaucer, still riming. Then the needs of playwriting turned it into the rimeless instrument that has served the diverse aims and temperaments of Shakespeare, Milton, and Wordsworth.

*
* *

The status of drama in the 16C and the quality of the works in the genre are hard to account for. As everybody knows, English plays in the latter part of the 16C were numerous, full of passion and poetry, and popular with all ranks of society. The best of the Elizabethans are still performed. In Spain, Lope de Vega was then at the start of his amazing output. Elsewhere, the showing was a perpetual disappointment. In Italy the pastoral play prevailed over other kinds. The shepherds' loves happy or unhappy but touching had an irresistible appeal, and no wonder. The idyllic state of Arcadia was a change from the civil and foreign wars that beset Florence and its turbulent sister cities. The pastoral served as a therapeutic PRIMITIVISM. In France, for decades, playwrights translated Italian comedies or dutifully wrote tragedies on ancient themes, supplying conscientious effort instead of art.

It should be recalled that in the Renaissance and occasionally later, the word *comedy* meant any sort of play—drama in general. In French to this day *comédien* means simply an actor. And nobody supposes that Dante's *Divine Comedy* is comedy in the laughter-provoking sense. This usage tells us that before the rise of the modern theater there was no fixed nomenclature. Plays in the previous era had been religious stories or folk scenes, the ones moral-

istic, the others farcical. In the 16C, with its liking for clear-cut genres, comedy begins to mean fairly elaborate predicaments that portray ordinary people and end more or less happily. The one masterpiece of this sort comes early: it is Machiavelli's *Mandragola,* a play of intrigue that makes one think of *Dangerous Liaisons* (a recent film based on a cynical French novel of the 18C).

La Mandragola was "modern," like Machiavelli's *Prince* (256>). Other authors of comedies tried in vain to make something new by imitating the Romans Plautus and Terence, who themselves had imitated the still older Greek Menander. The copies of copies of copies were bound to be faint. What remained vigorous in Italy was the *commedia dell'arte,* the slapstick comic play with traditional characters, improvised on the stage along predictable lines. It led in the 18C to the brilliant comedies of Goldoni, who made masterworks by adapting this popular art form to the uses of high comedy.

Another form of the comic was the burlesquing of serious genres. The epic lends itself to it most readily, being often close to burlesque as it is. Already in Pulci there are intentionally light moments. But it was the 16C Italian Berni who in parodying Boiardo showed how to ridicule the heroic and combine it with serious reflection. Later, Scarron in France used the recipe and made a popular success of his *Virgile Travesti.* We may infer that readers in the neo-classical age were not humorless. The best product of Berni's technique was the farthest in time and place: Byron learned from the Italian model and, having studied Tasso and Ariosto, and translated a part of Pulci's poem, tried his hand at the satirical epic in a short work called *Beppo.* It was the rehearsal (as it were) for his masterpiece *Don Juan* (486>).

All the while, poets and critics had been discussing the rules that tragic poets must obey in order to succeed. These rules came from Aristotle's *Poetics* and Horace's *Technique of Poetry.* The one had made a survey of Greek drama, the other had expatiated on vividness and sincerity in poetry as antidotes to the permanent threat of boredom. The preoccupation with Aristotle's rules was paradoxical: more than one theorist was clear-minded enough to reject one or another of them as unnecessary or misunderstood. Some even said that not all that were current could be found in the *Poetics.* Yet writers by the score kept arguing these points for generations—a vast library of comment on a very short treatise. After a time, play-goers themselves began to babble about "the three unities" and to pass judgment on playwrights accordingly as they respected or violated "the rules."

What did Aristotle say? That a tragedy must show a hero whose downfall is brought about by some false step in his behavior. The action, the plot, is all-important, not the persons in conflict. To be effective, this action must be single and straightforward—no subplots. This is unity number one of the later theorists. Given the hero's headlong course toward destruction, the spectators during performance are moved to pity for him and fear for them-

I venture to say that such plays, simply acted by intelligent actors who recite in a language not smacking of Latin, not pedantic, but direct, and fearless in pronunciation, would be the most pleasant of pastimes for the great when they come to the city for rest after their hawking and hunting.

—JEAN DE LA TAILLE (1548)

Those battles or sieges that are fought out in two hours do not please me, nor is it the part of a discreet poet to pass from Delphi to Athens in a moment of time.

—JULIUS CAESAR SÇALIGER (1561)

Whoever studies with care the works of the greatest of the ancients will discover that the action of the dramatic poem takes place in a day—or is never prolonged beyond two.

—ANTONIO SEBASTIANO MINTURNO (1563)

The time of action should never exceed the limit of twelve hours.

—LODVICO CASTELVETRO (1570)

What can be more absurd than the introduction in the first scene of a child in swaddling clothes, who in the second appears as a bearded man?

—CERVANTES, DON QUIXOTE (1603)

Tragedy mixed with comedy—Terence with Seneca—will cause much delight. Nature gives us the example, being through such variety beautiful.

—LOPE DE VEGA (1609)

selves, after which purging of their anxieties they come away emotionally on an even keel. It is a fact of experience that a true tragedy—not just a sad play—is exhilarating.

The critics also debated the notion that a tragedy must take place on one spot on one day—opinions wavered between 12 and 24 hours. The argument was that these two other unities were necessary to foster belief; somehow three hours in the theater could seem equal to 24 but not to 36 and never to 10 days. That the English and Spanish audiences swallowed with pleasure works that broke every one of the unities, including that of tone, mixing as they did tragic and comic scenes, did not figure in the debates outside those two countries.

The determination to follow the ancients—or what was taken to be their practice—apparently did not include the demand for the song-and-dance part of Greek drama. This omission certainly made plays more lifelike, an appeal that proved as strong as formal correctness. The moderns wanted plausible plots; so the historical were better than the mythical. They wanted human beings on the stage, instead of biblical figures or the medieval abstractions— Truth, Goodness, The Vice.

The other literary lawgiver, Horace, had made a fundamental assertion: "poetry is like a picture." It followed that the dramatic poet must present real situations. But on the stage what is real? The play-goer, to be sure, knows that the actors are not kings and queens or young lovers and scamps, yet (answered the critics) the good dramatist creates complete illusion. He does so by taking advantage of the ancients' experience and going by the rules. When one is tempted today to permit oneself an impatient word or two about this dogma, one ought to remember that in its 16C beginnings "the play" needed to persuade spectators of its merit by its

truthfulness. Centuries later, we are sophisticated and believe in Art. Aesthetics, which is our Scripture, makes us accept as important and truthful anything offered as such. The question of rules does not occur; on the contrary, breaking rules has become a test of true art.

<p style="text-align:center">*
* *</p>

The first modern critics did not spend all their time discussing tragedy. Other forms of poetry enjoyed their minute attention, most often in the light of Horace's precepts. Applying such pre-existing standards was the very definition of criticism until the 19C. The process was analytic and judicial. A sort of stencil was laid over the work and the places noted where the right features showed through the holes. The more points scored, the better the work. [The book to read is *Literary Criticism in the Renaissance* by J. E. Spingarn.]°

Now, ANALYSIS, the breaking of wholes into parts, is fundamental to science, but for judging works of art, the procedure is more uncertain: what are the natural parts of a story, a sonnet, a painting? The maker's aim is to project his vision by creating not a machine made up of parts but the impression of seamless unity that belongs to a living thing. Looking at an early example of systematic criticism by analysis—say, Dante's comments on his sonnet sequence *La Vita Nuova*—one sees that the best he can do is to tell again in prose what the first two lines mean, then the next three, and so on in little chunks through the entire work. We may understand somewhat better his intention here and there, but at the same time we vaguely feel that the exercise was superfluous and inappropriate. Reflection tells us why: those notations taken together do not add up to the meaning of the several poems. In three words: analysis is reductive. Since its patent success in the natural sciences, ANALYSIS has become a universal mode of dealing not merely with what is unknown or difficult, but also with all interesting things *as if* they were difficult. Accordingly, ANALYSIS is a theme. Depending on the particulars of its effect, it can also be designated REDUCTIVISM.

In the arts other than literature, the professional, specialized critic did not come into being until late, say, the mid-18C. Until then, qualified criticism came from fellow practitioners, sometimes aided by amateurs of the art when a quarrel over style was raging, or by journalists, who might take up the cause of a particular artist.

CROSS SECTION

The View from Venice Around 1650

AS THE AMERICAN HUMORIST Robert Benchley found out on his first visit to Venice, and thought so remarkable that he cabled the news to his friends in New York, the streets there are full of water. The lagoon on which the great city is built was the shelter for refugees from the mainland when north Italy was overrun by Germanic invaders in the 5C. Up to that time, Venice was but a village. It grew into a center of trade by sea with the Near East, and by 1400 was the vast channel for the goods that Europeans to the north and the west (England included) wanted as part of their increasingly luxurious life.

The medieval Crusades had shown the westerners the amenities of life in the Levant, and through the pilgrims who came back from these mass movements had inspired in the barbarous Occident a widespread desire for gold and silver cloth, cotton, silk, and muslin (from Mosul in Iraq); for glassware, porcelain, and swords of Damacus steel; for oranges, apricots, figs, and wine from Cyprus grapes; for rugs, gems, drugs, pepper, incense, and perfume. Venice at the head of the Adriatic Sea had the geographical advantage over Genoa, which had tried to share this many-sided trade from the opposite side of Italy. Even after the Portuguese had found an ocean route to the east (<103) and Venice was no longer sole trader, it retained a monopoly in some of those expensive goods. It was envy of its wealth that had stimulated Portuguese exploration; it was a Genoese sailor, Columbus, whose westward longings led him to the King of Portugal for help in fulfilling them. By 1650, Venice was on the slope of decline, but slowly. Its manufactures were still profitable and its naval power unbroken. The inhabitants of the city and of the territory it ruled on the mainland were aware of change only as increased

Oh Venice! Venice! When thy marble walls
Are level with the waters, there shall be
A cry of nations o'er thy sunken halls,
A loud lament along thy sweeping sea! . . .
Oh agony! That centuries should reap
No mellower harvest! Thirteen hundred
 years
Of wrath and glory turned to dust and
 tears . . .

—Byron, "Ode on Venice" (1815)

competition. They knew that they were still the wonder of the world. One such reason was the Venetian government, unique in form and amazing in efficiency.

Everybody has heard about the Doge, the head of the state, who each year went through the ceremony of throwing his ring into the sea as a symbol of the wedding of Venice with the element that gave it life. But long before the mid-17C the Doge had become a figurehead, a constitutional monarch whose only power was that of personal influence if he chanced to have it through character and brains. The governing was done by a system of interlocking councils, all in the hands of the patrician families, a nobility of merchants. As in no other European society, the Venetian gentleman lived by trade and governed too.

The Great Council at the base of the state pyramid was a self-renewing body made up of patricians 25 years old or over. It elected or appointed the other officials: the Senators; the "Ten Men"; the Procurators of St. Mark, the city's patron saint; the justices; some special committees; and a College of Sages—altogether some 300 who met on Sunday to do the choosing of persons but not to discuss policy except in grave emergencies.

So far there is nothing extraordinary about these arrangements. What was so is the rules and customs these officials observed. The Ten—the executive branch elected for one year—was a policing and a defense department. It dealt with morals, public decency, rebels, and foreign enemies. Readers of Casanova's memoirs remember how he began his libertine adventures by escaping from the prison in Venice, called "The Leads," because it was under the roof of a building next to the Ducal Palace. Casanova's high-colored story and the legend to the effect that an anonymous note dropped through the mouth of the Lion of St. Mark's on one dark night ensured that the next day the person named was heard of no more have given the Ten the reputation of arbitrary and merciless enforcers of the law.

The legend is pure legend; the "Bridge of Sighs" is real but no warrant for melodrama. Venice had eleven courts of first instance and two of appeals; no juries, but the accused was allowed counsel centuries before the English and other systems of criminal law adopted the practice. The courts tried patricians as well as commoners and the Ten were popular. The people could petition them and were protected from oppression. Justice was quick—trial within one month of offense—and by contemporary standards not severe: the death penalty for grievous felonies; for forgery loss of one hand; one hand and one

eye for rape and adultery; and five modes of execution in capital cases, which meant drowning for ordinary criminals. Torture for confession was practiced as elsewhere, but the law—whether observed or not, it is hard to say—specified strict limits.

For their multifarious work the Ten chose three as leaders who served alternately for one month each. Other departments had a head for one day. During his term, the "Capo" was forbidden to go into the city or talk to any citizen. This quarantine carried out the resolve to keep the people entirely unpolitical. To that end also the Ten used detectives to help nip subversion in the bud. Whereas all the other Italian states lived through incessant plotting and treason, exile and assassination, the tyrants and their kindred taking turns at massacring one another, Venice remained free of "times of trouble" for five centuries.

Among other political devices, Venice used one intended to ensure faithful service, at least from the Doge, whose wealth made him a suitable subject: the review of his tenure of office after his death. If the report was adverse, his heirs were fined or otherwise punished. He dared not appoint any relative to a government post. In life, the Doge's six Ducal Councillors watched him all day, especially when he opened letters.

More important, all offices were filled by men who had been trained in the most direct way. A young patrician who showed talent was enlisted as a teenager, watched the Great Council at work, and as soon as eligible was tested in successive posts. Nobody could refuse or resign office. With the short terms of power, rotation was rapid and the men at the top knew the work of every bureau. The pleasures of feuding among departments were much reduced. Vigilance behind a stiff façade could be the defining formula for the Venetian Republic. It resembles the principle that made the early Roman one great. Both have been admired but never again imitated. By comparison, other states—and modern democracies especially—look as if they did not take government seriously enough to run their affairs with rigor and gravity.

Taken all in all, Venice was the nearest approach ever made to Plato's system of rulers by duty and dedication who govern soberly. The commons are excluded but happy to consent. Not that the Venetians read *The Republic;* their inspiration was Trade, coupled with being vulnerable on a small island perch. But unlike Plato's utopia, Venice was neither isolated nor intolerant. It allowed foreigners their ways and their places of worship—Greek Orthodox, Protestant, Armenian, Slavonian, Albanian, and Jewish—and at the same time resisted any clerical interference with the city's laws. Papal officers must be approved by the Doge and report their proceedings to him. The Inquisition, reluctantly established, could try only Catholics. All in all, it was a clear case of Trade broadening the mind.

But the means of trade, and at the same time the well-being of the citi-

zens, were closely regulated. There were inspectors of weights and measures and of the Mint; arbitrators of commercial disputes and of servants and apprentices' grievances; censors of shop signs and taverns and of poor workmanship; wage setters and tax leviers, consuls to help creditors collect their due; and a congeries of marine officials. The population, being host to sailors from all over the Mediterranean, required a vigilant board of health, as did the houses of resort, for the excellence of which Venice became noted. All the bureaucrats were trained as carefully as the senators and councillors and every act was checked and rechecked as by a firm of accountants.

Two great institutions—the Mint and the Arsenal—were famous throughout Europe for the quality of their output. For centuries the gold ducat, first struck in 1284, circulated everywhere at par value—it was the "Euro" of its day, to be succeeded for a short time only by the English gold sovereign in the 19C. Even earlier, in the 12th, Venice created a public debt, which helped to make its taxation the lightest in Europe. The popes invested in these highly rated bonds, but the Senate could deny some undesirable applicants the right to purchase them. In the mid-16C the city established the first state bank. The products of the Arsenal were ships and their armaments and munitions of all kinds. The long galleys, built to convoy the "round" cargo ships, could carry 250 soldiers, and by way of obbligato a group of musicians. The traditional enemies, other than the onetime trade rival Genoa, were the Turks and the pirates.

Well ahead of the other states, Venice pioneered in legal theory. For its own needs, it developed a body of marine law, and by acting as patron to the University of Padua, it taught students from other countries the Roman and other systems of civil law. Regrettably, one must mention a breach of the city's own law by some of its citizens—those who engaged in the prohibited trade in slaves. Men and women were brought from southern Russia and Slavic Europe (the name Slav means slave), the men being sold in Egypt and the women in the West. Prisoners of war were also goods for sale, but all this had come to an end by the 17C.

In keeping with its desire to maintain peace for trade, Venice had a large corps of ambassadors. As we saw, when Petrarch served as envoy in the 14C, diplomacy was carried on by orators. They had to be handsome; they entertained the target court and then went home. The resident ambassador with his instructions and immunities, his cipher code and his order of precedence, became the rule spottily and after many backtrackings. [The book to read is *Diplomacy* by Harold Nicolson.]° By the 17C the institution was fairly solid. One result was that the Venetian ambassadors' daily reports (*Relazioni*) form one of the fullest sources for the history of the times.

In the years here surveyed, Venice was embroiled in a 25-year war that was not the cause but one of the signs of its decline. The Republic had lost

Cyprus, its eastern outpost in 1571; in 1645 a pirate crew based in Malta captured a Turkish vessel coming from Algiers and carrying 30 members of the Sultan's harem, including (it is said) his favorite wife. The Turks made this a pretext for an attack on Crete, the island that was to Venice what Cuba is

In and out of these glittering strands of development ran the homely worsted of the mercantile conception of diplomacy governed by the reasonable bargaining of man with man. Sound diplomacy was the invention of middle-class citizens.

—HAROLD NICOLSON (1939)

to the United States, a place the enemy must not occupy. The city was hard pressed. It had lost much of its revenue to the traders on the Atlantic and the treasury was short of money. To raise the means of defending Crete the government took the unheard-of step of selling state offices. Worse, it sold the rank of patrician for cash. As the war showed, courage and ability were still plentiful; as late as the end of the 17C Venice was besieging Athens, but by the end of the prolonged wars Crete had been lost and the republic's decay through the next 125 years proved irreversible.

*

* *

As the Venetians who lived around 1650 could see for themselves or heard from visitors and their own ambassadors, the world outside was full of novelties other than westward explorations for trade. In that rising country, France, the great canal of Briare had opened, connecting the central region with the north, and the Mediterranean was joined to the Atlantic by the Canal du Midi. In Paris, the new Pont Royal was another sign of revival in French civil engineering. But the heads of state, Louis XIII and his minister Richelieu, had recently died and a confused struggle of parties, mainly in Paris, threatened the royal succession. The heir, Louis XIV, was a teenager and not ready for ostentation, but much building was going on, and a resourceful architect, Mansart, revived the kind of roof now known by his name.

Science and mathematics were flourishing everywhere. Pascal in France had invented a calculating machine, and several other devices and discoveries excited an international group of searchers (207>) who corresponded regularly. These activities drew attention to the deaths of Galileo and Descartes. But that Newton was born on the same day—or was it the same year?—as Galileo died passed unnoticed until somewhat later. The confusion was natural: England had refused to adopt the Gregorian calendar, so that errors in matching the continental dates with the English, 11 days behindhand, was frequent. It was said that the kingdom was on the verge of civil war; at the same time, Dutch workmen had been imported to drain the fen country.

In the New World, the small English colony of Massachusetts Bay was

likewise divided on the politico-religious question that agitated the mother country. The governor, John Winthrop, argued vehemently against moves to make his government more democratic: there was no warrant for it in Scripture. In that same year the colony (and Virginia to the south) passed laws establishing schools to teach the true religion and promote Bible reading. The first book published in New England, the Bay Psalm Book of 1640, was an encouragement to the same end.

But these remote affairs, like the discovery of Tasmania in the South Pacific, probably reached the Adriatic city after some delay. The belief that contemporaries are aware of what history records as significant is not well-founded, which is why history has on the whole a more balanced view of the past than the past had of itself. At any time the amount of general knowledge about any important subject, past or present, varies with fashion and shrinks or widens at the whim of accident. Who now thinks of Venice as a supreme creator in political science? The name raises only aesthetic ideas and even these are incomplete: Venetian painting and architecture—the collective memory stops there. They are solild, visible, much written about—Ruskin's *Stones of Venice* is a monument itself. But Venice in its prime made no contribution to world literature—a curious fact since Ferrara, the home of Tasso and Ariosto (<151), was only a day's journey away; and this lack may account for the forgetfulness about what Venice did contribute, because it is poems, tales, and plays, rather than paintings, that carry to posterity the details of life.

Venice did produce one fine historian, Paolo Sarpi, but his main subject was the Council of Trent; and the two great comic writers of the 18C, Goldoni and Gozzi, wrote in the Venetian dialect, which even other Italians find a virtually foreign tongue. Thus not only the statesmen and ambassadors, but also the first great printer-publishers—Jenson, Aldus Manutius, Wendelin, who created type and layouts for all subsequent makers of books (<61)—might as well never have existed. For public opinion "the book" means Gutenberg alone, that is to say, from the Bible to the paperback with little in between.

The collective memory has done even worse: it has forgotten the cradle of opera. It was the love and nurture of opera in Venice that made it a genre of endless possibilities. Forgotten with it are the other Venetian innovations in music referred to earlier (<160). It is true that the first operas of which the music has survived were composed and performed in Florence. They were the work of amateurs who followed a theory derived from the cult of antiquity and aiming at re-creating Greek tragedy (<159). These works were justly criticized in their own day for being monotonous. The wish to make the play understood word for word limited the music to a few solos, the rest being recitative. True opera is a kind of music rather than a kind of play—no one reads a libretto as a source of pleasure—and to express drama, the music

must be composed by a master of many talents. Claudio Monteverdi is thus rightly regarded as the founder of the genre.

His first opera, *Orfeo*, was first performed in Mantua in the early years of the 17C. But he was soon appointed choirmaster of St. Mark's in Venice and there spent the rest of his life. After *Orfeo* he produced 18 other works in the new dramatic genre, two of which, *The Return of Ulysses* and *The Crowning of Poppea,* written near the mid-century, are masterpieces on a par with the familiar works in the repertoire of modern capitals.

The same cannot be said of the numerous "court operas" that proliferated after *Orfeo*, especially in Rome. These were domesticated pieces, produced for the entertainment and glorification of noble families, and they would not withstand revival. So to Venice must go the credit of producing publicly, supporting, and appreciating the singular creation. Incidentally, the word *opera* is not, as one might suppose, the plural of *opus*, Latin for work. It is another Latin word, *opera*, plural *operae*, which means *willing* work instead of the necessary or forced labor implied by *opus*. By extension, *opera* was used by the ancient Romans for any elaborate undertaking, just as we say "a production." The word certainly fits the reality of staging one of these works as it is described in the history of the great opera houses: a battle with wounded and vanquished before roles and wills are subdued into temporary unity.

Monteverdi's genius lay in finding the means to express character and situation while fulfilling the musical requirements of form. In all such forms—recitative, aria, or choral ensembles—the composer conveys the fitting significance by melody to begin with, and next by shifts in harmony, long held notes, cadences, sequences, and other musical devices, all supported by a rich instrumentation.

Audiences today are getting used to certain features of 17C music, thanks to the efforts of several scholar-conductors—the use, for example, of the high male voice called counter-tenor, which in earlier periods was obtained by the mutilation of gifted youths, the castrati. The liking for the sounds of the top register was due to familiarity with the voices of choirboys in church. The Monteverdian orchestra included a good number of chord-playing stringed instruments, only a few winds, and no percussion. The "tinny" sound that results is disconcerting until the ear gets accustomed to the nuances actually there—another proof that music is not a homogeneous substance for all good ears to enjoy as soon as heard.

This observation applies to the operatic genre itself. Until about the mid-20C, people who regarded themselves as devotees of music looked down on opera-goers; and these, it is true, often showed no interest in music other than operatic. The long-playing disc had the effect of an Act of Toleration, compelling both parties to recognize the obvious: operas on disc, without staging, are pure music too, while other genres can also be dramatic music, as full of

thrills as opera. The subjects chosen for the genre doubtless contributed to its former discredit. Born of the classical temper of the Renaissance, the early operas used the ancient myths and a sprinkling of pastoral subjects. Then for freshness came events drawn from history, ancient and modern; next in the 18C, fantasy was added, followed in the 19th by history once more; after which any topic or period, any contemporary play or novel might be adapted to exhibit the twin staples of opera: Vanity and Violence.

To name these staples is to say that the literary side of opera is melodrama, not tragedy, not social criticism or the play of ideas, all of which require words to make the intellectual and moral distinctions cross the footlights. Tolstoy wrote a withering description of opera showing it to be inherently absurd.° In dialogue and action operatic relationships are etched in crude or dull lines that inspire the familiar mode of acting and delivery—violent denial, stalking, turning the back, snatching the letter, struggling over the poisoned cup, singing with emphatic repetition words of contempt, anger, and hate. And the singing—in duets, trios, and so on up to septets—rises to what is often—alas—shouting. A contemporary singer candidly describes her loud top notes as "a controlled scream." Besides, the situations of conflict tend to be complex, legalistic, and arbitrarily insoluble: hero, heroine, ruler, rival never give in, and the reasons adduced usually show this to be personal or official ego, that is, vanity. When the ballet was introduced into opera late in the 17C, it added to the spectacular element, but one suspects that it also provided relief from turmoil, although at times the librettist made the dancers represent the fiends of hell already invoked by the chief antagonists.

But what of love? and what of comic opera? The comic genre parodies the predicaments of the serious genre. Equally make-believe obstacles to peace and bliss hold up the denouement, which is happy instead of mortal. As for love in grand opera, it is indeed celebrated in an aria or two, but its role is really to incite jealousy and intrigue. These standard features, which could be regarded as defining the least honored of literary forms, have not prevented the great operas from being as diverse as the works in any other genre. When one thinks successively of Monteverdi's *Poppea*, Rameau's *Indes Galantes*, Handel's *Xerxes*, Gluck's two *Iphigeneias*, Mozart's half dozen, Beethoven's *Fidelio*, Spontini's *Vestale*, Weber's *Freyschütz*, Berlioz's *Les Troyens*, Rossini's *Comte Ory*, Wagner's *Tristan,* Verdi's *Otello*, Moussorgsky's *Boris Godunov*, Chabrier's *Gwendolyn*, and Benjamin Britten's *Billy Budd*, one must admit that the art of opera has lodged in the western mind a set of images and emotions that no possessor would willingly give up. And the revivals today of totally forgotten works and their composers show us that the riches of the genre are still imperfectly known.

It is true that a kind of seesaw is noticeable as one or another of the three components of opera dominates the other two—words, music, or scenic

effects. But the force of the images—of the mythology created by opera—has been the work of the musician who, inspired diversely by the repetitious framework of the genre, endowed the frigid ideas and inane words with the warmth and the nuances of life—all this from the earliest flowering in Monte-

It is sad to think that so much beauty lies buried in the silence of the past, that all these things which so mightily pleased our forefathers have become things of yesterday.

—DONALD GROUT, FROM THE LAST PARAGRAPH IN HIS *HISTORY OF OPERA* (1965)

verdi's Venice, at the Theater of St. John and St. Paul, where *The Crowning of Poppea* was first performed in the autumn of 1642.

* * *

The Venetians who looked abroad in that decade could follow the fortunes of several other wars besides their own with the Turks. In Germany, the struggle that had begun more than two decades earlier was in its final phase. In a few years more it would qualify for the title of Thirty Years' War. In England, civil war had at last broken out, and in France the partisans of royal power faced various enemies in violent incidents verging on civil war also (296>). Meanwhile, French soldiers were skirmishing on the Spanish frontier. One of them was D'Artagnan, later glorified in *The Three Musketeers*, who was defending his native Gascony.°

The war in Germany began as a religious sequel to the conflicts between the parties created by the Protestant Revolution. It ended as a dynastic war for domination in central Europe. The imperial house of Austria, the Habsburgs, found itself pitted against unexpected allies, Protestant Sweden and Catholic France, both bent on territorial gains. Sweden had risen to the status of great power, owning provinces in north Germany and wanting more. Cardinal Richelieu's policy for France was to make its eastern frontier the Rhine. Each side nearly succeeded, which might have brought back the Germanies to one religion. But the opposing commanders were equally brilliant and kept the balance even until King Gustavus Adolphus of Sweden was killed in battle and the Czech Wallenstein was assassinated a year later by his officers: He was about to go over to the Swedish side. In the outcome, some of the lands that had been lost to the Protestants in the Reformation were regained by the Catholics, to the benefit of Austria.

One piece of literature that came out some time after the war tells us about it at firsthand. This was the picaresque novel *Simplicissimus* by Grimmelshausen. It is the tale, told by himself, of a young boy of humble birth and no education whatever—hence his title designation of "simple to the utmost"—who is set adrift in the world when the soldiery plunder his village and burn down his home. He flees to the nearby woods, where he finds

shelter with a forester in his hut. From him the boy learns something of the big world, into which he has to plunge when his rescuer dies. His next savior is a state official who turns him into his court jester, his fool. The role develops the boy's wits, but his tenure is not long. Soldiers again break into his life and this time carry him off. After more vicissitudes he becomes a soldier himself and goes through a variety of adventures that depict, amid the horrors of war, the coarsening of the individual's moral fiber, the misery endured by all classes, and the dulling of the mind by the fighting, which, when prolonged, makes the contenders forget what it is about.

The work had great success, which induced Grimmelshausen to add a sixth book to the original five, and this is the reason why it cannot be called a masterpiece: the latter portions were written under the spell of the contemporary romances. Simplicissimus turns hero in the literal sense; he wins honors and travels as far as Turkey, losing along the way his appealing character and our interest.

Nearly at the end of the war the French defeated the invincible Spanish infantry. France was now the largest, richest, most populous, and most warlike country in Europe. It was following the traditional top-dog policy called universal monarchy; that is, trying to dominate the entire Continent. The Thirty Years' War proved fruitless in the end. More significant, indeed momentous, were the treaty concluded at mid-century and the cultural consequences of the war.

The battles, the sieges, the marches and countermarches devastated large parts of Germany, depopulating villages, reducing towns to poverty and the numerous states to perpetual weakness. The upshot was that for the next two centuries the disunited Germanies were the theater of war, the indicated playground for the European powers to fight out their dynastic rivalries. The Germans were the people without a country. To others they seemed—and partly were—dull, patient, defenseless drudges, their heads full of fanciful dreams and murky philosophy, and their art, language, and manners backward and coarse. A time came when the memory of this long humiliation strengthened the resolve to show the world the opposite of all these sheeplike traits; the docility imposed in the 17C and 18C generated the self-discipline, civic duty, and military might of the 19th and 20th.

The Thirty Years' War, the last of the "wars of religion," had turned during its own course into the monarchic type. The treaty that ended it implicitly recognized the national idea by declaring the Netherlands and Switzerland, two mainly Protestant countries, independent. That word means sovereign, which means in turn that the interests of the state come first, ahead of any religious allegiance to the papacy or to a state church. For the same reason—raison d'état—an alliance with a country of opposite religion incurs no blame. The Venetians at one point had begged the Turks to aid them against a great

league headed by the pope, who at another time had done the same and had received subsidies from the infidel. In short, by the mid-17C and the close of the war, the West had taken a great step in secularizing public life.

With this decisive parting from the ancestral idea of the community of Europe, the Continent became a group of distinct societies, each wanting to go its own way in language and laws, in manners and the arts. The danger of anarchy prevailing among these separate and equal sovereignties was so evident that it stimulated thought about law and order through some overarching rule. The example of the Italian states was disheartening. They never ceased battling each other, undeterred by a common religion. Venice had to contend incessantly with four neighboring powers, including the papacy. Hugo Grotius (de Groot), pondering the recent past in his newborn Dutch nation, set down the principles of international law. He had been preceded by the Spanish scholar Vitoria, whom few had heard of (<110). Both had to face a question without answer: the sovereign—man or state—is by definition not subject to law. There is God's moral law, but who is to enforce it? To obey it can only be agreed upon, out of self-interest. Grotius's work *On the Laws of War and Peace* ranks as the first attempt to make public such an agreement; the latest is the charter of the United Nations.

The other war observable from Venice at the same time was the civil war in England. It combined religion and politics, that is, dissent from the national church and limits to the exercise of sovereign power at home were the issues fought about. The seven years of bloodshed with a lull midway did not settle either question, but they brought out others, social and economic, that made the struggle far more fruitful than the three decades of mutual harassment in the Germanies.

In counterpoint to the English and the German wars there occurred the first wild speculation ending in a crash of international scope: the tulip mania. The flower, an import from the Near East, had first been seen in Europe around the mid-16C and had been especially prized in Central Europe and the Netherlands. Bypassing Venice, it continued to be sent direct from Constantinople to its fanciers. Owning a gardenful became a status symbol and the desire to buy and grow tulips spread among the Dutch of every rank. By 1635 the demand had raised prices to vertiginous heights; a Haarlem merchant was reported to have given half his assets for a single bulb—not to resell but to show off.

Some shrewd minds began to see that trading might be even better than owning, and soon the stolid Dutch were buying and selling bulbs like company shares. Exchange markets were set up in several cities; brokers ("tulip notaries") quoted varying prices according to the name, color, and weight of each bulb; and selling short and trading in futures developed and flourished. Fortunes were quickly made, the poor grew rich overnight. At one point an

The tulip next appeared, all over gay,
But wanton, full of pride and full of play;
The world can't show a dye but here has
 place—
Nay, by new mixtures she can change her
 face. . . .
Her only study is to please the eye
And to outshine the rest in finery.

—ABRAHAM COWLEY (1656)

"Admiral Lifskin" was worth 4,400 florins or "44 times the price of a bed complete with bedding." For two years the fever raged, with London and Paris as suburbs showing a lesser degree of heat. When the Dutch regained their senses and the market collapsed, the government and the courts tried to find fair solutions to the tangle of troubles—buyers defaulting, vendors suing, and bankrupts groaning in jail. Months of debate and reams of decisions were in vain. Given the character of the adventure, nothing seemed just or enforceable.

*

* *

A quite different cultural offshoot of the selfsame war was the work of a man who twice suffered the looting and burning of his house and manuscripts by the soldiery, the Czech thinker

John Amos Comenius (Jan Komensky)

Born into a Moravian family, he was pious, but it was not religious devotion that made him oppose the highly successful practice of the Jesuit teachers (<42). A lifelong refugee, his wanderings took him to Poland, where he established a school on a model of his own; then to Sweden, and finally to England, where his ideas spurred thought in the minds of Milton and Locke. While there he received an invitation from John Winthrop to head Harvard College.

Of the many books that he managed to write, the most famous is *Orbis Sensualium Pictus*—the world portrayed to the senses, published at the exact mid-century point. Others of his school texts were widely used and translated into a dozen languages, including Arabic, Persian, Turkish, and Mongolian. Despite Luther's early appeal for free public schools to teach Protestant children, few were founded and none had a philosophy of education to match the Jesuits'. Comenius supplied it. He was another in the long line of school reformers who, with interesting variations, always say the same thing; it is their fated role. The nature of a school being to ossify, it must be periodically galvanized into life. The reason for the loss of vitality is that the school is a government on the small scale; it aims at forming a common mind as government aims at a common will. Both need periodic overhaul, a re-injection of the original idea that got lost in routine.

At this point anyone who has had much to do with education or has dipped into its history can guess what Comenius said: things, not words— hence the *Sensualium* of the textbook. Change school from a prison to a *scholae ludus* (play site), where curiosity is aroused and satisfied. Stop beatings. Reduce rote learning and engage the child's interest through music and games and through handling objects, through posing problems (the project method), stirring the imagination by dramatic accounts of the big world. The *Orbis Pictus* teaches objects and places, simultaneously with words, by means of pictures to be studied and talked about, a first hint of the audiovisual in education. Comenius would also teach a universal religion compatible with modern science, "*Pansophia*." All children should be schooled at state expense, starting very early in affectionate surroundings: nursery school for the four- to six-year-olds. He added the substance of the 20C thought-cliché: education goes on as long as life.

This program aroused the enthusiasm of Samuel Hartlib in England, who took steps to publish it but was delayed by the Civil War. It saw the light in the 1660s and competed successfully with current notions of school reform put forward by men who were—or would be—scientists. It was then that Milton wrote his "Letter to Samuel Hartlib." In part obscure, it ranks as a notable tract on education by reason of its authorship rather than its merits. Milton wanted towns to set up a sort of barracks for 120 boys, who between the ages of 12 and 21 would learn through books about things and through these things would attain knowledge of God and likeness to God. That, said Milton, is the aim of education. By it a man performs justly and skillfully all the duties of private and public life, including war. Hartlib cannot have felt encouraged in his crusade.

Comenius did not limit himself to school reform. He was a feminist and a pacifist, a political scientist and a philanthropist. He recommended pre-natal clinics, marriage counseling, and geriatrics. He believed that men could be improved and, like Bayle and the 18C Encyclopedists (360>), that "light" would bring about peace and concord. The spectacle of war during his whole adult life (said Comenius) had moved him to promote these ideas. The school reformer went on to practice what he preached, which is more than can be said about most educationists. Wherever he went Comenius set up schools and taught in them. No less invariably he received bids to go elsewhere and repeat his success. His methods were adopted, and some of his textbooks were used down to the mid-19C. In an essay of 1957, Jean Piaget asserted the

I began to concentrate my designs upon an endeavor to reconcile the whole human race. If men were shown what their complete and real good is, they would be drawn to it. Were they, moreover, shown the right means for its achievement, an all-inclusive and all-satisfying philosophy, religion, and statecraft would be finally attained.

—COMENIUS (C. 1660)

rightness of his great predecessor on all important points. But fame has bypassed Comenius, as it has Lichtenberg and some others of the same caliber (440>). Time, place, and nationality have the power to confer or withhold renown.

<div align="center">*
* *</div>

This generality takes us from the public realm to the private. The late 16C observer saw changes in manners and domestic life—not all on the lagoon, but here and there throughout Europe. Italy was again a Mother, this time of refinements. Venice apart, the big prosperous cities—London, Paris, Amsterdam, Strasbourg, Geneva—were by modern standards little better than mud holes crisscrossed by row houses. Narrow streets, ill- or unpaved, served as sewers for the waste dumped into them from the upper stories that overhung and nearly touched above the way. Venice had a board of health, but in other capitals nobody inspected the turbid, foul-smelling stream that ran through all passageways except one or two main thoroughfares.

The houses of the great had grounds around them for protection, yet the spacious ones that survive to amaze the tourist were in fact crowded, filled not only by a fully extended family but also by dozens of servants and hangers-on—protégés, tutors, scribblers—among them possibly a great artist earning his livelihood by a special kind of servitude. A palace housed a clan; the word *house* designated both the members of the family and those who were owned and fed by it.

Inside, whether palace or bourgeois dwelling, the rooms in the mid-17C were more numerous than before; the all-purpose big hall had been cut up, by curtains at least, and several chimneys let out the smoke instead of one. But windows remained few, narrow, not always glazed, and in some places highly taxed as luxuries. A large chamber was still the center of work, rest, and pleasure, as well as the site of birth and death. Its furnishings had improved: the chairs had arms, higher backs, and a fixed cushion; and chests that had been mere boxes tended to turn into chests of drawers.

In this main room, ladies received while dressing or still in bed, though there might be an alcove to one side for the bed. When some men and women friends became habitués, the *ruelle* or space between bed and wall became a regular meeting-place for conversation; it was the germ of the *salon*. The master likewise carried on his business affairs in the chamber—whence the survival of that word (rather than *office*) in many phrases: judge in chambers, the chamber of commerce, the chamber of deputies.

This mode of home life implies a sense of self in relation to others that differs from ours. Consider the bed. It was large, high off the floor, curtained all around to keep off drafts, and topped by a ceiling cloth to cover the sleep-

ers—sleepers in the plural, for it might serve several members of the family, sleeping naked but wrapped in some incomprehensible way in a single sheet under the coverlet. The elderly wore a gown and nightcap. At times, a visiting friend would be offered a place with the rest of the crowd. Similarly, the ailing poor in hospitals and travelers at the inn must expect to share the bed. This practice lasted for a long time in America, as we learn from a letter of Lincoln's.

People ate in the kitchen or the chamber on a removable trestle table, on which—except in Italy—there might be no plates and certainly no forks. These effeminate innovations became common only toward the end of the century, and even then the forks were used only to convey a portion for oneself, not to eat it with: what were fingers for? The spoons were large ones for serving; one brought one's own knife for the meat, which one put on a thick piece of bread called in French *tranchoir*. This means cutting board and has given us the word *trencherman* to denote the hearty eater. For drinks there were cups of various metals to pass around and for foods other than meat, wooden bowls, generally one for two persons. The sole touch of refinement in dining was the customary washing of hands before and after the meal.

As to diet, literature has made familiar the great feasts at which an extraordinary number of dishes were heaped up. These banquets, required at public ceremonies, were not frequent at home. They marked the good harvest and served as a palpable offset to the remembered famine. Not all the diners partook of all the dishes. Footmen in livery stood at a sideboard and carried the dish called for by his master at the table. Leftovers were eaten by the servants or given to the poor. We know less about regular meals, but in good bourgeois houses they seem to have run to eight courses, beginning with soup, then several meats, custardlike preparations, fish, fruit, and sweets. The 1650s rarely saw a vegetable, never a vegetarian. The authority on the subject, J. F. Revel, says that the period was about to see the passage from cookery to cuisine—gastronomy.° Maybe there was a cultural link between gourmet menus and the bel canto of opera being developed at Venice.

That washing of the hands at meal times was the one recurrent act of hygiene in the whole of life. The body was washed at birth, before marriage, and after death. The century that laid down the fundamentals of science is the one that got rid of public baths and of the very idea of regular bathing. In the Middle Ages and the Renaissance even small towns had bathhouses. Lyon had 28. They were shut down throughout Europe out of a moral concern probably heightened by syphilis: to control prostitution and other misconduct. We blame the Puritans in England for this raid on the "stews," but the Continent had no Puritans as such; it was the Zeitgeist that took action there. Even when used, baths had not stopped the plague; it was carried by rats and fleas, striking every 15 or 20 years to decimate townspeople and send refugees

to the countryside. By plague was meant the killing fever that took one of three forms, the most common being the bubonic, indicated by the ring of *bubos* or red swellings. The outbreak in London that Defoe described in his *Journal of the Plague Year* was no extraordinary event, any more than the one in Milan in 1630, both devastating.

The other recurrent catastrophe was fire. Control or escape were equally difficult in towns laid out in the huddled way described above. The London fire of 1666 drove 200,000 from their homes; they encamped in neighboring fields during the five days that it raged. But instances are on record of the population's making no effort to save themselves or their household goods, particularly when some Mother Shipton or other had predicted the calamity as a punishment from God. By chance, 15 of the 20 years being reviewed here passed untouched.

Clothing, in thick layers and uncleanable, was not healthful either. Dress has of course never been rational, except in Tahiti. Even the Roman toga, which looks so comfortably loose, took two helpers to put on and was formal dress for ceremonial occasions only. Around 1650 garments for either sex could still express individual fancy, but the previous exuberance was gone; bright colors gave way to black, dun, and dark green. Women continued to wear stomachers, now of whalebone instead of metal, but the skirts were less puffed out. Clothes for gala evenings were garnished with gold or silver braid or elaborate lace or precious stones attached to the cloth itself. Men's legs no longer showed up in tights but were hidden in knee breeches of the cut now called plus-fours. The rather indecent Spanish invention for carrying odds and ends, the masculine codpiece, had vanished, but is making a reappearance in 1997.° Its equivalent for women, the broad belt to hang things from, had narrowed and become only an ornament. Men needed theirs to trundle the inevitable sword.

Both sexes had given up ruffs in favor of the flat Vandyke type of collar. Shoes and boots had turned sober also—no long points, though some women began to teeter on high heels. Boots for outdoors came up high for protection against mud and filth. They were a necessity in any case, because the horse was the only means of rapid transit. At mid-century two innovations, less for speed than comfort, were taking hold. One was the *chaise*—an armchair fitted with a pair of poles at the sides for a servant fore and aft to lift and carry the sitter. The other was the coach, adapted from the rural cart, but not yet hung on straps or springs to soften the ride. Even so, it was denounced as weakening the moral fiber, and in Germany it was prohibited outright and in vain.

At all times hair has carried significance. It shows rank, or sophistication, or rebelliousness. Its dressing varies frequently and sometimes mere chance alters the fashion. Louis XIII, being at loose ends while Richelieu was at the

helm, decided that the royal officer guard should shave. Soon, the previous full or rounded beard was everywhere replaced by a mustache and a little tuft on the chin. Hair from the head was allowed to grow long, straight or curled, depending on the degree of vanity and youth. This style continued until about 1660 when for dubious reasons wigs of many sizes and shapes crept in and grew into a combination headgear and picture frame for the face. The French king's whim had distant repercussions: when later in the century Peter of Russia decided to modernize his country, he levied a tax on beards. Meanwhile, women's hair (not yet pulled up high off the forehead and built into complex structures) was simply arranged to show a fringe over the forehead, with a shower of curls hanging on each side, often wired in a fan shape. When frizzed instead of curled, the head was called *à la moutonne,* meaning like wool on a sheep.

<center>*
* *</center>

Given these various tastes and physical limitations, it is not surprising that social behavior was simultaneously crude and elaborate. Letter writing, for example, aimed at formal elegance by a mixture of conventional and improvised compliments. The tone blended humility with devotion: "Your obedient servant." The feeling involved in the old feudal relation of lord and vassal had not yet turned into the pure formality that makes us start our letters with *Dear* and end them with *Yours*. From the courtesy books of the period we also learn that what we would call the ordinary physical decencies of social intercourse were rarely practiced. For the sorry details, go to the gossipy memoirs of the day° or infer them from the fact that in 1600 the King of France owned only five handkerchiefs, the queen three, and his mistress two. We get another hint when we see in museums the collections of small, decorated perfume bottles that people carried defensively in crowded gatherings.

Disregard of bodily offense went with extreme sensitiveness to every other kind—hence the prevalence of dueling. To be sure, it was an improvement on the family feud, which goes on for generations. Still, as wise heads argued, how can skill in fencing be the rule of justice? For the touchy ego—or the bully—the "point of honor" was so delicate that a duel could be triggered by a mere look. In the *Memoirs* that the Duke of Sully, chief minister under Henry IV, published in 1638, he estimates that some 8,000 gentlemen were killed in duels during the previous dozen years—over 12 each week. His successor, Richelieu, enforced the royal prohibition with severity, but the practice did not stop. Once again, read *The Three Musketeers*—or even more telling, because evidence from the period itself, read Corneille's tragedy *Le Cid,* in which there are two duels justified for our admiration. Honor takes priority over love. Duels, of course, often grew out of rivalry over a woman,

who might encourage it from vanity; but the result was self-defeating all around: one man killed, the other forced to flee the country; the woman deprived and left as fair game for other admirers.

<div align="center">*
* *</div>

In those same years, other excellent arguments were heard on another subject, also not heeded and not new: equality between the sexes. The 16C had seen a galaxy of great women—rulers such as Queen Elizabeth, Louise of Savoy, and Margaret of Parma, poets and novelists like Louise Labé and Margaret of Navarre, to say nothing of the Italian stateswomen who made policy at the Vatican (<85). These examples spurred reflection, and in the 1640s several women and two clerics wrote books about the injustice of treating women as inferior and denying them education. As we saw, the most vehement and best argued was by Marie de Gournay, the "daughter" of Montaigne and posthumous editor of his *Essays* (<134). She and those who agreed with her faced one grave difficulty: the dogma, based on precedent as old as the Garden of Eden, of female mental and moral weakness. How could a faithful Christian question and oppose Scripture? Marie and also a broad-minded priest, who wrote the longest and most learned plea for women's rights, managed to get around the theological bar.°

And so, apparently, did the universities of Padua and Bologna. Padua conferred an honorary degree on the famous Anna von Schurman, the most learned woman of her time, master of seven languages, including Syriac, Chaldean, and Ethiopian; and Bologna gave her a lectureship. She too argued for women's rights, in 15 irresistible propositions. One other woman compelled recognition for her intellectual stature: Queen Christina of Sweden. Even before she abdicated in 1650 to devote herself to study, she was known as a serious thinker (208>). Earlier, another woman, the Princess Palatine Elizabeth, had elicited from the scientist-philosopher Descartes his most serious reflections on certain philosophical issues. His letters to her form a volume to which one must refer for answers to some of the points not covered elsewhere in his works.

Far away from Sweden and the Palatinate, in rugged New England, yet another woman was asserting her right to compete with men on their own ground. Anne Hutchinson was a preacher with liberal views on religion that threatened to split the Massachusetts Bay Colony, a fiercely theological population. She was finally declared guilty of 80 erroneous opinions and banished. She went to Providence, founded not long before by Roger Williams after *his* banishment, and later to Hellgate, New York, where she was killed by the Indians.

It was women's ideas and influence that in the mid-century effected in

France a notable change in manners. The Marquise de Rambouillet gathered around her a group of like-minded friends (including a few men), who by their conversations, well publicized, made it fashionable to aim at precise speech, to use language free of grossness, and to behave in society—and in marriage—with considerateness for one another's feelings. This choice company legislated on grammar and vocabulary, the formulas of love-making and amiability, and it made compliance the basis of self-respect. What Castiglione's *Courtier* (<85) urged in book form was here put into practice, with improvements suggested by the passage of time and the imagination of the participants.

This circle will be recognized as the Précieuses whom Molière later made fun of as *Ridicules,* thereby giving to preciosity its unfavorable meaning. But Molière came when the refining movement had done its good work, and exaggeration among late followers had turned delicacy into—preciosity. Excess had led to absurdity: avoiding crude talk had become false shame about calling ordinary things—door, table, chair—by their right names; some far-fetched euphemism had to be found. But this tailing off should not obscure the truth that the Chateau de Rambouillet was the site of rehearsals for the civility that ruled the court of Louis XIV. And in the three ensuing centuries, whether in courts or salons or family drawing rooms, it was women and their tastes that determined proper speech and deportment.

By an odd but perhaps significant coincidence, while the Précieuses were at their good work, a group in Hamburg led by Philip von Zesen was reaching ridicule at one bound. They were bent on purifying the German language in a manner pathetically national: for all foreign words or of foreign derivation, even though long accepted, a roundabout substitute must be coined. Thus for *Natur,* the phrase "nurturing mother." All the Greek and Roman deities must be renamed. Venus was to be *Lustinne*—that is, *Pleasuress.* The mid-17C was indefatigably laboring at self-improvement.

Besides these lofty pastimes, plain athletic ones existed, one of which was growing less popular, at least in France: the game of royal tennis. It is played on indoor courts whose complex arrangement of walls and ceilings has a role in the volleys and in the scoring. Originally the ball was hit with the palm of the hand; the racquet was invented in the late 1500s. About that time there were 250 tennis courts in Paris. Half a century later only 114 were left. But as it declined in France it spread across Europe.

Tennis—the king of games and the game of kings—was mentioned by Chaucer two hundred years before Shakespeare put the game on the literary map; Erasmus devoted a colloquy to it, Rabelais made Pantagruel play tennis at Orleans, and people playing tennis were a feature of Swedenborg's vision of Heaven. A print shows Charles IX of France at the age of two with a tennis racket already in his hand.

—JEREMY POTTER, *HAZARD CHASE* (1964)

Dutch skating was also popular, together with its related game, something like ice hockey. When the ice was gone, the game moved to grassy lawns where the *kolf* (Dutch for *club*) was used to strike a ball rather than a puck. In this form the sport was taken up by princes and deemed royal also. The common people in rural places enjoyed other games of various vintages that required an animal skin blown up, to be thrown, kicked, or carried to a goal. Once a year they organized the May Festival, in which a lord and lady of the May lead a semi-dramatic pageant with dialogue, song, and dance around the Maypole. Everybody had a role in it, from the milkmaid, who was always pretty and merry, to the chimney sweep, who was always black-faced and comic.

The indoor equivalent was the upper-class masque, a series of verses recited, sung, and danced, the whole hung on a slender thread of story—a classical myth, or a pastoral love affair, always quite moral. [The sample to read is Milton's "Comus."] The sets and costumes were elaborate and expensive; the words and the music were written and composed by the noble family's talented pensioners, and sometimes by the lord and lady themselves, who in any case sang and acted in the event. At other times, dancing filled the leisure hour. The choice of steps was large, though one or another might suddenly become the raging fashion: the others were boring.

Of the new ones, the minuet reached Paris in 1650 and long prevailed. It was derived from a brawl of Poitou and got its new name from the small steps that were thought to make it graceful, dignified, and stately—in a word, monarchical. Louis XIV's court musician Lully composed minuets, Molière used them as interludes in his plays, and the musical form later became part of the classical symphony. Other dances—the coranto, galliard, jig, pavane, branle (brawl), Bergamask (from the Venetian town of Bergamo)—each had its heyday. In some parts of Europe every trade had its special dance; the German brewers, for instance, appropriated the waltz in this same century, with the tune "Ach, du lieber Augustin"; it remained local for 200 years (500>). In Spain, the grandees consented to dance only the slow and grave; the lively dances, such as the gallega with castanet accompaniment, were for the lower orders, whose dignity survived going wild as the pace grew faster and faster.

People of all ranks went to plays (344>), where they more or less jostled one another, made one by the common pleasure. But ladies protected their identity by wearing masks, and gentlemen might do the like, unless they chose to show off their face and finery by sitting on the stage; it was their right as noble patrons. Much has been said against the English Puritans for closing the theaters in 1642, a ban that lasted two decades, until the Stuart kings were restored. The motive was not hostility to plays, they continued to be written

and acted by dons and students in the universities and by lawyers at the Inns of Court. It was the theater as a place of assignation and the players as disreputable characters that were aimed at. And yet, shortly before the closure, when the highly moral Charles I and his French queen were still on the throne, a troupe of French actors was invited to London, where it presented works with the women's roles played by women, instead of boys as the English custom was. They were not hissed off the stage, as happened earlier when a native troupe included actresses.

It should be added that the 1640s of the century saw the fall of Shakespeare and his works into disrepute and neglect, Ben Jonson being by far preferred (<142). Waller emerged as the first of poets.

The fit of morality that made an end of theaters and baths was no affectation. It was pervasive and may be seen in the more subdued clothing, the toning down of rhetoric, the more rigorous good manners; perhaps also in Hobbes's joyless vision of man and in the chiaroscuro of Rembandt's later works. At any rate, the fashionable philosophy was Stoicism. Christina of Sweden was a Stoic before her conversion to Catholicism; Pascal had been one before the accident that made him a fervent Christian; many others, without reading Stoic doctrine in Epictetus, fell in with the mood of its sober expectations.

These changes may be attributed to the normal swing of social attitudes—the "whirligig of taste"—or in other words, fatigue and boredom. Warring in Central Europe for a whole generation, then further wars in which England, France, Spain, and Venice took part after the mid-century point, had some dampening effect on the spirit. The long struggle over religion had not put an end to fervent faith; the number of sects and of shades of belief within them kept growing; and by division these yearnings lessened public hope, the hope of overcoming others' errors and of seeing the fulfillment of God's plan.

In addition, the public mind was affected by the tone of the natural philosophers. A universe of mindless, colorless matter in motion is not a cheering sight. Nor is there much gaiety in mathematics—geometry looks bare and algebra is even one more step away from the familiar, friendly numbers. Stoicism is abstract like algebra and unarousing. It sees a fixed order in the universe, in which it is best not to resist or repine—whatever is, is right. God or Providence governs wisely and does not interfere with its own laws, nor does it reward or punish in this world. The question of another, it leaves untouched, so that apart from the hope of immortality, a Christian may be a Stoic without feeling heretical. Stoicism does teach that to make the best of life, moral conduct is imperative; it causes the least trouble and leaves the fewest regrets. In the face of life the goal is composure.

What were you taught to call exile, slander, prison, and death? —Externals, indifferent things. —How do you define indifferent things? —Those that are not dependent upon our Will. —What is the inference from that statement? —Things independent of our Will are nothing to us. —Upon what does the good of Man depend? —Upon the rectitude of his Will and an understanding of those things that are external to us. —What is your goal in life? —To follow God.

—Epictetus the Stoic (1C a.d.)

But the practice of Stoicism uses up energy to coerce the natural impulses; and among these it denies the urge to explore the world. Stoic and scientist is not a likely combination. True, Newton thought that studying the ways of Nature was trivial compared with interpreting Revelation; but other natural philosophers were neither true Christians nor old Stoics; they were Epicureans, which does not mean pursuers of pleasure, but believers in the importance of the sensory world. Among them were some who earned the name of Libertines—again, not loose-livers, but freethinkers. This intellectual EMANCIPATION did not simply facilitate the scientific enterprise; it also revived the hopeful vision of Man as capable of improvement and creator of Progress.

The Invisible College

WHEN WE SPEAK of 17C science and scientists we are committing an anachronism. At that time the word *science* had not been narrowed down to one kind of knowledge; it meant whatever was known, and men of learning were still able to possess most of it. Those who spent much of their time in investigating nature were called natural philosophers; what they used in their work were "philosophical instruments." The mathematician was generally called a geometer, by reference to the then most advanced branch of mathematics. Calculations on paper were still a relatively recent innovation (199; 200); the word *scientist* dates from 1840.°

These distinctions are important, because they show that science in the modern sense had its source not solely in the new facts brought out by Copernicus and Galileo, but in a large pool of ideas dating back to the Middle Ages and beyond. Astrology, alchemy, and magic were serious enterprises, and the physics and biology of Aristotle, the medicine and physiology of Galen, the astronomy of Ptolemy, were highly developed systems grounded in solid reasoning—too solid, as Whitehead pointed out long ago. Not until the systems were revised and simplified, while made to accommodate newly observed facts, did the "march of science" as a concentrated effort begin all over Europe.

It is thus misleading to see in the 17C a scientific *revolution,* not because it is best to keep the word *revolution* for vast changes in power and property, but because the new conception of the cosmos was rather an evolution, with stumbles and backtrackings along the way. Points in Aristotle's physics were refuted at the University of Paris as early as 1300, others soon after at Oxford. The dismantling of the reigning systems went on bit by bit in halting fashion, speeding up in the 16C and taking another fifty years or more to make an end.

That Galileo, Kepler, Bacon, Jung, Pascal, and Descartes—all men of the 17C—are better known than their elders in science is the kind of wrong that happens repeatedly in all fields of culture. The pioneers, the first who struggle out of the established systems and who form new and useful conceptions,

Science has never shaken off the impress of its origin in the historical revolt of the later Renaissance.

—WHITEHEAD, *SCIENCE AND THE MODERN WORLD* (1925)

appear only half right, incomplete; and their names stay remote. But they are perhaps more to be cherished than those who come after, who clear off the debris and offer a neater, more full-blown view.

In any case, the 16C must not be left out of the supposed revolution. It is the century of Copernicus, Kepler, Tycho Brahe, Paracelsus, Paré, Vesalius, and the less noted Telesio, whose work of 1565, *On Nature*, led Bacon to call him "the first of the moderns."° It is to the point that the best short account of the growth of modern science, by H. T. Pledge, is called *Science Since 1500*, not 1600.°

The road to the present was hard and long because the old systems were good. They had consistency and completeness; only at a few points did contrary facts or gaps in explanation threaten their validity. One such fact was the odd behavior of the planets, especially Mars, which at times went backward instead of forward. Another ill-explained phenomenon was that of horizontal motion: what keeps an arrow flying so far and no farther? Does the push of the bowstring put something into the arrow? Or, as some thought, does the air get displaced around the head and keep propelling it? Lastly, why do these forces give out?

The larger picture was this: in the heavens, with Earth at the center, were several huge spheres, one within the next, each made of finer and finer stuff, and all revolving and emitting the "music of the spheres." The planets, then the stars, studded the two nearest spheres, the rest being the dwelling place of angels and other spirits in the service of God the Creator, the Unmoved Mover at the farthest boundary. Sphere and circle, the two perfect figures, were essential to this perfect movement; it was unconscionable on the part of Mars that it should retrogress. Other irregularities were taken care of by old Ptolemy's epicycles, circular paths around the point where the errant body should be.

It made a very complex structure, and at last the mind rebelled at more and more contortions. William of Occam's principle of economy, that the best explanation is the one that calls for the least number of assumptions, was an argument against Ptolemy, in addition to the awkward facts. It impelled Copernicus to revise—not destroy—the system, by supposing the sun to be the center instead of the Earth. He was thereby able to reduce the epicycles from 84 to 30. But even his scheme is not quite sun-centered. His work, published in the mid-16C after his death, proposed an important change indeed, but it was not the shattering blow it is commonly taken for; it raised new difficulties, and those who rejected it were not simply diehards refusing evidence.

Kopernik (to use his proper name) was a devoted admirer of the ancients and obsessed with the perfection of circles and spheres. Such notions (and several others) had to be abandoned before the modern planetary system could be suggested and tested; he did not bring this about single-handed. And another thing he did not do is what the textbooks would have us believe: "Science has cut Man down to size and broken his pride: Copernicus removed him from the center of the universe; Darwin reduced him to the status of animal; and Freud dethroned his intellect and put instinct in its place."

The last two of these claims will be dealt with later (571; 662>). The first betrays absentmindedness: what pride was felt when men thought of themselves as miserable sinners fearful of an angry God, who visited on them the punishment of plague, famine, and earthquakes? When Satan was free to "roam the world in great wrath" and doom his victims to eternal fire? When it took endless pains and costs to pray in aid from the saints and their relics, from pilgrimages, and from self-abasement? True, the Humanists felt the dignity of the human being, because his powers were achieving wonders, but it was not because of his cosmic location. He was still under God, no matter what Ptolemy or Kopernik might say. Montaigne himself found no cause for men to be proud. The notion of medieval or early modern man saying to himself: "I am at the center of the universe and what a glorious thing it is!" is an invention of SCIENTISM centuries later.

<p style="text-align:center">*
* *</p>

The Middle Ages did not "neglect observation." They examined the heavens minutely (mostly for astrological prediction) and the earth eagerly for what it could yield of food, medicines, materials, and elemental power for use in machines (230>). But observation is rarely neutral; it rests on pre-conceptions and pre-perceptions; and it was these that had to change. In fact, close observation can be a hindrance to scientific thought if it fastens too hard on outward appearances. A better way of observing consists in overlooking visible details, in *neglecting* observation (to put it rather strongly) and in viewing objects in geometrical fashion—seeing the Rabelaisian quintessence (<130). It is the method used in Picasso's bull: in the series of sketches he starts lifelike—massive, glossy, beautifully drawn in every part. Then, in a dozen or so of gradual reductions, he loses one characteristic after another until, at the last, he is the bare outline of what he was at first. He is the abstract bull, the bull, so to speak, of science.

For centuries, movement was studied by thinking of the arrow in flight or the cart drawn by a horse—it was push or pull by an unknown force. But what about falling bodies? After Galileo and Newton, by abstraction, motion no longer raised images of *movement*; it was defined geometrically as change from

place to place, its rule being that it will continue forever until something stops it—an obstacle or the friction of the air. Similarly, an object at rest stays put until a force is applied to it. The two statements make up the law of inertia. It is a law not because objects "obey" it—that again is a skewed interpretation; the law is only a statement of regularity in behavior.

It is clear why science is closely allied to mathematics, but the link is not solely with numbers, so as to count and measure. Mathematics includes geometry, the science of figures and their relations. As one can count only exact similars—not apples and oranges, but "fruit" or "things," so measuring the relations of objects requires the use of their geometrical forms. In both cases, abstraction is the stripping away of the qualities that make a thing distinct, useful, rough or smooth, friendly or hostile. This reduction is the work of the geometrical mind (216>). It sees the piece of wood of triangular shape that holds together the balls on the pool table not as a triangle; its measurements would not give the answers that the triangle of geometry supplies. Even the printed figure in the textbook is not the triangle of geometry; it is only a reminder of the definition of triangle and the properties deducible from it.

In other words, for science to arise from previous speculations, a strange idea had to become clear and fully accepted—the idea of body as such, the purely physical, devoid of qualities so as to be capable of quantity. Earlier conceptions were not sufficiently geometrical; their truth was pictorial and poetic. They mirrored the universe clearly but symbolically, which is to say full of meanings; whereas the purely physical has no meaning; it just is. The transitional outlook—a little of both worlds—is exemplified in one of the prime contributors to 16C scientific thought,

Giordano Bruno

He believed the cosmos to be infinite and full of inhabited worlds. He agreed with Kopernik about the sun-centered galaxy of planets. He espoused the atomic hypothesis of the ancient thinkers Democritus and Lucretius, but his atoms were animated units—"monads" (366>), so that everything that exists is alive. He was an able psychologist who wrote on memory, on the imagination, and on the religious impulse as the source of cosmologies. Long protected by princes and cities for his skill in magic, Bruno was at last accused of heresy by the Inquisition. He recanted, was imprisoned for eight years, and then re-examined. This time he did not recant and was burned alive in the year 1600.

Thinkers in every succeeding period have claimed Bruno as a great forerunner—in the 18C, of Deism; in the 19th, of German *Naturphilosophie* (Coleridge was much taken with his "polar logic and dynamic psychology");

in the early 20C, of Vitalism. The two terms *atom* and *monad* stand for matter *versus* units of the "life force"; the debate between Bruno and his 16C peers was thus the first of the conflicts between physicists and biologists, most of whom may be found in one or the other of the two camps—Materialists and Vitalists (365>).

Both atom and monad are concepts that reduce the visible world to "simple natures," fundamental things that are all alike and do not change. The common-sense look of things is not to be trusted; it is too variable. The human aspect of the world and human use of objects must be ignored by the student of nature. In this purging of variety the importance of words is considerable: it helps to keep the geometrical idea in mind. Thus *mass* is better than *weight*, which suggests a burden pulling at one's arms. *Force* also seems to imply our own exertion, and *energy* does not—or not so much. The abstract word *gravitation* conceals "heavy" very nicely. Again, references to *spirit* or *principle* to account for what happens are too vague and suggest unseen "powers." As for the biological sciences, they must use a system of words—nomenclature, which is names, and terminology, which designates parts and functions. To sum up, any "anthropomorphic"—manlike—view of things is wrong in principle and will mislead. Especially wrong is the belief that anything in nature fulfills a purpose. Aristotle's physics relied on a doctrine of ends, of final purposes and meanings. The reverse assumption yields the truth of science, not movement toward goals but purposeless push or pull that need not end.

It goes without saying that the cultural consequences, the effect on human lives, of this shift in outlook have been profound. To begin with, as success in "natural philosophy" became evident in one realm after another, scientists, as we now call them, came to be regarded as "those who really know." This in turn meant that reality was split—scientific fact and human experience, no longer one and often contradictory. If the one was real, the other must be illusion.

> There is inherent in Nature's works no prudence, no artifices, no intelligence, but these only appear to our thinking to be there because we judge of the divine things of Nature according to our special faculties and peculiar manners of thought.
>
> —WILLIAM HARVEY (1649)

The only way out of the contradiction was to regard Man as not part of Nature. He confronted it as an enemy. The search for knowledge began to be spoken of as the "conquest of nature," the hostile cosmos being regarded as "blind"; for once man was excluded from it, it had no consciousness. Next, man himself must be regarded as nursing a fantasy when he thought he was pursuing a purpose. Being made of matter, he was a thing too, possessing no free will, only the illusion of it. The chain of causes determined his every act. He was predestined, as Luther and Calvin had said, though they said it for a different reason (<6).

A further consequence of re-thinking nature geometrically was to make ABSTRACTION an obsessive habit of mind. Ever enlarging its scope, it has become so infectious that it ranks as a theme. For the moment, consider abstraction as the urge to disregard the features that lie on the surface of things, in hopes of finding the kernel within that does not change and is therefore felt to be *the* reality. This urge has always existed; it makes experience orderly. But the scientific use of abstraction has modified the very feeling of life on a scale unexampled, as will appear in the sequel.

<p style="text-align:center">*
* *</p>

The great advantage for science of an aimless universe is that it frees the imagination. Since there are no preconceived "ends" that things must "reach," anything is possible. Thus Galileo could assert that the earth moved, when obviously it didn't.° His assertion could be true for reasons that outweigh direct sensation, provided he could explain why people and their houses did not fly off in all directions. Circles are perfect, as anybody can see, but Kepler could assert that planets moved in ellipses, because he had calculated on that basis their actual positions. Numbers had the last word.

But that freedom of imagination was not achieved all at once in the 17C. Obstacles crumbled only after much hesitation and long debate. The minds of the 16C philosophers, both the traditionalists and the radicals, were full of ideas inherited from antiquity. They were Humanists who knew Pliny's large *Natural History*, a work of mixed observation and fantasy. The physicians, as we saw, knew their Galen, the Greek who had made a system of what the ancients knew about disease. In addition, the medieval Arab scholars who had transmitted Greek learning had tacked on their own speculations. There was, besides, an occult tradition comprising the Jewish Cabbala, works on magic highly esteemed by those called Rosicrucians (still an active sect), and ideas that Ficino among others attributed to Egyptian wisdom. Some of these ideas also entered into the doctrine of the nascent "Freemasons," whose later political influence is recorded on the back of the U.S. one-dollar bill in the green pyramid and mottoes.

Add to this massive background the well-rooted theory and practice of astrology and alchemy and it is obvious that the new notions that we perceive as budding science had a thick armor to penetrate. New ideas do not battle so much with ignorance as with solid knowledge. Nor was the battle confined to individual opponents; it went on inside the head of each thinker; hardly any was totally "a modern." Kepler was a practicing astrologist, Newton a dedicated alchemist. [The book to read is *The Alchemists* by F. Sherwood Taylor.] We saw Bruno leaping forward to an unheard-of vision of the cosmos but still working magic. Vesalius came to think his dissecting human bodies was sin-

ful, and Philip II, his patron, persuaded him to atone for it by a pilgrimage to Jerusalem. On the return journey he died. Van Helmont, Boerhaave, and other true innovators continued to believe that "directive spirits" were at work in the phenomena they observed and saw the operation of male and female principles in chemical reactions. Cardano, who was sound in his geology and brilliant in mathematics, had the further gift of prophecy and predicted the date of his own death, with fatal accuracy. A last example: Newton virtually gave up science during the last third of his life and spent his time studying the book of Daniel to find the truth about Armaggedon and the end of the world.

Among these early seekers the ones little known today were figures of European reputation, continually moving from court to court and university to university. The courts wanted magic and predictions, the universities polemical teaching. It was a hard way to earn a living and an easy one for making enemies. These traveling salesmen in ideas were not philosophers in the sense of pale meditators tied to a desk, yet they managed to write an incredible number of books, often not published till after their death but widely circulated in manuscript. This was the case of the most extraordinary character of the first half of the 16C:

Paracelsus

The extraordinary in him begins with his real name: Philippus Aureolus Theophrastus Bombastus von Hohenheim. His Latin moniker means either "higher than Celsus," the ancient Roman encyclopedist, or is meant to translate Hohenheim (high homestead), a place in Switzerland. From his physician father he learned the principles of natural philosophy, which led him to study botany, mineralogy, and metallurgy. He actually worked in the mines owned by the Fugger cartel.

Next, he qualified as a military surgeon and used this traveling opportunity to search for works on medicine—mainly to refute them. His outspoken opinions ("the ravings of a monomaniac" said the city fathers of Basel) caused him to be fired from more than one lucrative post. Hot with anger against authority, he coolly proclaimed that the whole world should listen and follow him. This very egotism brought him innumerable adherents. In the end, they became a kind of international, semi-secret society, disturbing to the medical and alchemical establishment and helping to shake up conventional ideas at large. Nothing quite like it appeared in the West until the spread of Freudian psychoanalysis in the 1920s.

Paracelsus thought of himself as a fighter against Evil with a capital E. Thinking in symbols and using astrology, he was at the same time a naturalistic researcher and practitioner. He treated syphilis with guiacum and distin-

guished the congenital from other causes. He urged the unviolent treatment of wounds and ulcers. He was the first to diagnose silicosis in miners and to connect tuberculosis with occupation. He gave a medical account of chorea (St. Vitus' dance), described the symptoms of hysteria, including blindness, and saw that goiter and cretinism were endemic owing to minerals in the drinking water. All this went against the ruling doctrine of the "balance of humors" (223>). Instead, he saw disease as externally caused and localized in some part of the body. Hence specific drugs, preferably chemical and not "simples" from the garden.

In pure chemistry, Paracelsus described some new products of combining metals, he concentrated alcohol by freezing it, found a new way to make aqua fortis (nitric acid), and gave more than a hint of the system of elements, defined by their behavior in given processes. His *Handbook of Chemistry* went through many editions. His restless imagination brought him to the verge of the modern conception of the purely physical.

He and his fellow natural philosophers were nonetheless believers in God and immortality. They reconciled Christianity with semi-materialistic science by what is called Fideism—"faith-ism." In the words of one of its early expounders, Pomponazzi, "I believe as a Christian what I cannot believe as a philosopher." In this latter guise he tried to give natural explanations of miracles and argued that the soul is immortal, "but not in the usual sense of the word." Pico, Rabelais, Montaigne, Bacon, Pascal, Sir Thomas Browne, like many 20C Catholic men of science, have been fideists.

The doctrine—or perhaps it is only an attitude—exposes its adherents to being called either hypocrites or heretics. Pomponazzi, who taught at Padua, the center for new ideas, was accused of heresy but escaped condemnation, partly because in him and others Fideism is ambiguous: it may mean a "double truth," with a contradiction between the two halves, so that half the believer is *not* a Christian. Or it may mean—and this is the argument for the defense—that the human mind is unable to grasp why God's Revelation differs from Reason and must take them as equally true without reconcilement.

*

* *

What did these pioneers of the 16C and 17C find that has stood the test of time?

—in physics and astronomy, that the planets, including Earth, circle about the sun in elliptical orbits (Kopernik, Kepler, Galileo); that motion and acceleration occur in the same way and in regular fashion for all bodies, these being subject to the pull of a force known as gravitation. This force ties together the planetary system, the power exerted being directly proportional

to the masses involved and inversely so to the distances between them (Hooke, Newton); that air exerts pressure and does this with greater force on the surface of the earth than on top of a mountain, because there is a smaller mass of it bearing down as one goes up into it (Toricelli, Pascal; the barometer); that light occurs in waves, is reflected and refracted according to formula, and that colors result from the different frequencies of these waves (Descartes, Newton); and, most generally, that everything hangs together like clockwork, because everything is matter, a uniform, invisible substance that underlies all appearances. The things we see and touch do not belong to different realms governed by different rules. In a word, the cosmos is a machine.

—in medicine, that the human body is also like a machine (Vesalius), part of it being a pump that keeps the blood circulating (Harvey). The body is also a vessel in which chemical reactions take place; accordingly not only plants but minerals can cure disease (Paracelsus); that wounds can be better treated with a dressing than by red-hot iron; that the blood vessels should be tied to prevent bleeding during amputation; that the skull may be trepanned for relieving pressure on the brain; that difficult births should be aided by instruments (Paré); that upbringing and culture play a role in mental illness (Burton).

—in botany (despite much error in ascribing functions to parts of plants), much good description of various species, acute comparisons of forms, and a systematic arrangement in kinds, based on accurate observation (Caesalpino); improved classifications by Joachim Jung, Vegetius, Grew, and Ray, all leading to the famous synthesis of Linnaeus in the 18C.

—in chemistry, that substances showing active properties, such as salt, sulfur, mercury, quick lime, and the various acids—all used for centuries by the alchemists—are not in fact activated by a spirit or principle within, but interact mechanically (Boyle). Equally important, the idea of a gas and the law of its behavior (Van Helmont, Boyle). Van Helmont coined the ugly word, probably from the German *Gäscht,* which is the foam that occurs in fermentation. He also showed by quantitative methods that substances persist in their compounds.

—in geology, that fossils are evidence of the sea's having covered the hills in earlier times (Cardan). The definitive descriptions of many minerals, their color, luster, weight, cleavage, and crystalline form (Agricola = Georg Bauer); the suggestion that the strata of rocks are formed of sediments such as would be deposited by turbid waters (Nicolas Steno).

—in mathematics, the shift from machine calculation (with the abacus or computing table) to arithmetic on paper (Treviso and others) soon leading to the use of decimals and later of logarithms (Napier), the invention of calculus (Leibniz and Newton), of a calculating machine (Pascal), and the combining of algebra and geometry into analytical aeometry by

Let me see. Every wether tods;
Every tod yields pound and odd shilling;
Fifteen hundred shorn, what comes wool to?
I can't do it without counters.

—SHAKESPEARE, *THE WINTER'S TALE* (1610?)

To multiply one number by itself or by
another number is to find a third number
which contains one of these numbers as
many times as there are units in the other.
This is done by . . . [etc.]

—TREVISO, *ARITHMETIC* (1478)

Descartes

He has been made the cause of many
things—of ruining French education
down to the present, of having exerted
the greatest influence on Newton's intel-
lectual development, of being the father
of German philosophy, of having pre-
ceded Adam Smith in seeing "the invis-
ible hand" of the free market at work.°
In our day, he has inspired the linguistics
of the Transformationist school and the
music of a ballet with spoken text. It
takes a great genius to do so many right and wrong things.

Descartes was a soldier, educated by the Jesuits, who in the 1630s, during
one of the more desultory campaigns of the Thirty Years' War, was in winter
quarters near Ulm in southern Germany. He found there the leisure to phi-
losophize. He wanted to put an end to the doubts created by the rival systems
in current debate—the old Aristotelianism and new Stoicism, Epicureanism,
atheism, and Pyrrhonism, the complete skepticism that went so far as to deny
one's own existence. To settle his own mind, he had to sweep out of it all that
he had ever learned. This once done, his first conclusion was the famous *cog-
ito, ergo sum*: I think, therefore I am. The test of this or any truth was its being
a "clear and distinct idea." By *distinct* he meant unmixed with any other idea.
This is what a born mathematician would assume from his specialty: a circle
is not a square.

The next clear distinction is that between thought and what it thinks
about—things regarded as essentially matter. Matter is bulk—what occupies
space; in philosophical language, it has *extension*. Mind is impalpable, without
extension. In this respect it is akin to God, who created Man and endowed
him with a mind or soul. God exists because the human mind thinks of Him
as in all ways perfect, and the idea of perfection can only have come to man's
mind from a perfect Being, who is God. Mind and matter are thus the two
constituents of reality and they are distinct.

True or not, this simple system was ideally suited to the needs of 17C sci-
ence. It left a place for God and thereby averted the charge that dropping spirit
and taking everything as matter must make atheists; and it separated mind and
matter, so that the several sciences could forget what impresses the mind so
forcibly: qualities, meanings, and purposes. Those things were in the mind and
not in matter, which is entirely neutral stuff. Such is the view of the man in the
lab today.

Descartes had cleared the ground. It seemed to him covered by an accu-

mulation of rubbish. A curious psychological fact is that his first impulse to build a system came to him in a dream, or rather a nightmare. In it he was possessed by a genius and overcome by a dazzling light that suggested to him that he would be given answers to the questions he had been wrestling with. There followed three dreams full of disparate images—of an exotic fruit, of a noisy storm and lightning in his room, then of silence and a book of poetry at hand, followed by a conversation with a man about verses ending with a line of his own that said: "What path shall I follow in Life?" Still in the dream, all this struck him as supernatural and he at once prayed to the Virgin Mary and vowed to go on a pilgrimage on foot.

The answer Descartes gave to the question in his dream was: unify all knowledge by the use of exact reasoning, the kind used in geometry—the world mathematicized. During nearly twenty years he worked productively at various sciences, including biology and psychology, in preparation of *The World, Or a Treatise on Light*. But news of the vigilance exercised by the Inquisition made him abandon the work. Instead, urged by friends, he published a small book entitled *Discourse on the Method of Rightly Using the Mind in Seeking Truth in the Sciences*.

It is an epoch-making work in more than one way. It is in French, not Latin, and it tells in simple words how the author discovered his method; that is, the book is a piece of intellectual autobiography addressed to the general public. It tells how the root idea came while the philosopher was lying in one of those huge porcelain stoves, common in northern and central Europe,

> Now that we have studied them all [the passions] we see that we have much less reason to fear them than before. For we see that they are all good by nature and all we need do is avoid their excess or bad uses. And these can be cured by separating in oneself the motions of the blood and spirits from the ideas they are usually linked with.
>
> —DESCARTES, *TREATISE ON THE PASSIONS*

that provide a shelf or recess for the householder to lie on and keep warm. Lastly, the book flatters the reader by telling him that all the method takes is a faculty that almost all people have enough of for the purpose: common sense.

What is the method? It is to look long and hard at any question or problem and break it down into as many parts as make it up; then deal with each part separately—a much easier task than trying to solve the whole—and finally, to re-assemble the parts, making sure to count them so that none is left out. The method, in short, is ANALYSIS—Greek for "breaking down." It is the ideal method for science not only because it is standardized, but also because it takes for granted that the thing studied is made up of parts—is a mechanism: the kitchen clock once taken to pieces, the function of each wheel and pinion can be clearly seen, the lot is put together again, and the analyst understands the whole. ANALYSIS is a theme, the twin of ABSTRACTION, as will appear.

A less obvious cultural influence of the Cartesian philosophy and its method has been to promote faith in Reason. Mankind has always used reason*ing*—argument went on in cave, tent, or prairie hut—but the Cartesian or scientific reason is of a particular kind. Like geometry, it starts from clear and distinct ideas that are abstract and assumed to be true. Faith in this type of reason is a creed, often passionate, called Rationalism. It differs from the workaday use of our wits by its claim that *analytical* reasoning is the sole avenue to truth.

This conviction is one that is being questioned today, and not for the first time. Unfortunately, the combatants on both sides keep arguing whether the modern mind is harmed—some say victimized—by "too much reason," the attackers holding that science and numbers are not the only truth; the defenders retorting that if reason is given up, intellectual anarchy and wild superstition will reign. The latter are right about reason as an activity—reason*ing*; the former are right about Rationalism, the dominance of a particular form of reason and its encroachment where it does not belong.

In the 17C itself, this misapplication of "reason" was exposed, as we shall see, and this by a scientist and philosopher of equal stature with Descartes (219>). Still earlier, as we saw in Rabelais and Montaigne, the caution was given: do not reduce all experience to formulas by reason: leave room for impulse and intuition, those acts of the whole being that are often called "nature," or again, "the heart," both by contrast with "the mind." Wisdom lies not in choosing between them, but in knowing their place and limits.

That is the great difficulty. The more science proves its worth, the harder it is for "nature" or "the heart" to feel free. Reason should guide—all moralists agree—but, as others point out, mind is not separate from heart. The astute Chinese have a character for heart-and-mind.° They perceived that the urge to reason is itself a drive from the heart, which explains why rationalists are often fanatics. The arbitrary distinction may be unavoidable for denizens of a well-developed culture, where the result is SELF-CONSCIOUSNESS.

<div style="text-align:center">*
* *</div>

Whether Descartes used his method to arrive at the scheme that underlies analytic geometry may be questioned. After all, his vocation was revealed to him in a series of dreams, they were not the workings of pure reason. Great ideas come to men of science as to poets, all at once, after long internal incubation. But Descartes' new mathematical tool deserves its epithet analytic, because it expresses spatial relations in algebraic terms and conversely: numerical relations in visual fashion. It does this by coordinates along which related entities are measured off, producing the familiar graph. The curve or jagged line or other figure represents—analyzes—the relation between time

and crime, or higher education and divorce, or locality and lung cancer. We lead today a compulsively graphic existence (535>).

ANALYSIS is a form of ABSTRACTION in that it takes every object of study as being fundamentally a clock, made up of parts, and identical with every other object of its kind. To take the examples above, all crimes, all divorces, all residents, all lung cancers are identical units. Analysis by abstraction has turned into an ordinary habit of thought. It governs not only the newspaper graphics and all the "studies" of everything under the sun, but also the stock market, conversation, political debate, advertising, the Olympics, education, literary criticism—nothing has escaped it.

> In 1594, being then seventeen years of age, I finished my courses of philosophy and was struck with the mockery of taking a degree in arts. I therefore thought it more profitable to examine myself and I perceived that I really knew nothing worth knowing. I had only to talk and wrangle and therefore refused the title of master of arts, there being nothing sound or true that I was master of. I turned my thoughts to medicine and learned the emptiness of books. I went abroad and found everywhere the same deep-rooted ignorance.
>
> —VAN HELMONT (1648)

This handling of life by numbers, together with all the "marvels" of engineering science, are so familiar and so glorious a proof of human ability that any account of the history of science is almost sure to suggest a triumphal procession. The troops with their banners look small at the 16C horizon, but they swell steadily and approach to full size in the present. This is a pleasant illusion. The march of mind that is often equated with the progress of science has not been in a straight line, even though it is true that the results of scientific work accumulate and many remain valid over time. Between the 16C dawn and the 20C high noon, many external battles had to be fought, quite aside from those within the body of searchers, about the place, role, worth, and harm of science. Battles is of course a metaphor; they were propaganda campaigns aimed at established opinion, the first important one being that led by

Bacon

The titles he gave his works tell of his aim and effect: *The Advancement of Learning, The Great Instauration* (= renovation), *The Novum Organum* (= the new tool). Bacon, a judge, Lord Chancellor of England like Thomas More, and guilty of taking bribes when he ought to have taken only presents, made it his true business to serve as both prosecutor in the case against the ancients' modes of knowledge and as defender of the moderns. In so doing he formulated all the clichés about the merit of investigating nature and the usefulness of physical science.

The ancients, he pointed out, can no longer be invoked as authority, because we know more than they did. *We* are the ancient and wise, they were

the young and ignorant. Besides, authority is worthless. The notion that something is true because a wise man said it is a bad principle. Is the thing true in fact, tested by observation? The new tool consists in applying this test. Observe closely, record findings exactly, and frame generalities that cover the facts, without coloring from myth, poetry, or other preconceived idea. "Go to the earth and it shall teach thee." The lessons will enable you to predict without fail the future behavior of things and thereby guide action with assurance and wisdom. Knowledge is power.

For my name and memory, I leave it to men's charitable speeches, to foreign nations, and to the next ages.

—FROM BACON'S WILL (1621)

This pleading was set forth so ably, the message was so simple and direct, that Bacon soon became the hero of the scientific militants. By the mid-18C, the Age of Reason, Bacon was what Aristotle had been for so long, "the master of those who know."

In recent times, Bacon has been ungratefully debunked. Historians of science have pointed out with scorn that Bacon did nothing for science since he never devised or carried out experiments; and they cry up Gilbert, who worked diligently on magnets. Bacon is said to have frozen a chicken to see if it would keep fresh, but that would not earn a Nobel Prize. Bacon has also been accused of not understanding how scientists work, because he recommends observation free of preconceived ideas. He said "Do not anticipate Nature," and his critics point out that all great advances are made by framing a possible view of what happens and then testing it; so Bacon was wrong. But surely he had good reasons for ruling out anticipation, in the sense of ideas such as the perfection of circles, to explain how nature works. And to say that science proceeds only by means of new conceptions is to generalize beyond the facts. Sheer observation by Tycho Brahe sitting at his telescope enabled Kepler to reach his conclusion about the planets. Only observation could discover the way dew forms, and at what temperature; observation, again, is the mainstay in the study of plants, insects, the earth, and human life.

On all scores Bacon's critics err by considering him and his work in a vacuum. They do not see that the progress of science needed all the help it could get from the general culture. They write indignantly about Galileo's condemnation by the church, but they fail to note that his noble and clerical patrons defended him as long as they could. The rest of the public were against *them*. His was—so to speak—a defeat at the polls. Had the public, the culture, not been taught to think differently, the work of science would have continued risky and its advancement been more often retarded than it was. Hence any effort to change opinion was a contribution to science, and Bacon was, in his own words, the trumpeter who called the troops to battle. In sober history Bacon remains a hero.

*
* *

Science should not be credited alone with all the material advantages that modern man is said to enjoy. Technology, or more exactly *techne,* the practical arts, not their ology, came earlier and was for a long time the foster mother of science. The working inventions of the mechanic, who fiddles to improve his tools, accumulate into large aids to science. We are now used to the reverse effect: so-called pure science finds some new principle and applied science— engineering—embodies it in a device for industry or domestic use. That is why industry devotes part of its profits to Research and Development, an innovation that dates only from 1890 (601>).

Techne preceded science in another way. Inventors made machines before anybody could explain why they worked—the pump, for instance. The vacuum was known but not why the water gushed. All that could be said was: "Nature abhors a vacuum, therefore fills it up—but not above 32 feet." The pressure of the air was invisible until the day when Toricelli and Pascal measured it and devised the barometer. Again, Bolton and Watt made a good steam engine in the late 18C, but it was a generation before Joule in the 1840s made clear the mechanical equivalent of heat. Under engineering comes the development of cannon and other machines for war. This sequence of practice before theory has its parallel in literature and the fine arts, which says something important about the workings of the human mind and the essence of culture.

Pure science, moreover, with the one exception of theoretical physics, is not so pure as it thinks it is. Experimenting requires equipment. Many great scientists—Faraday, the wizard of electricity comes to mind—could not have got their results without the ingenuity to build one instrument after another. The cyclotron is a piece of engineering as well as of pure thought aided by numbers. In the 17C the instrument needed to observe the heavens more accurately— the telescope—had to be invented and then improved. These steps required better glassblowing and metalworking. Glass was a Venetian specialty, metal a German. The two combined made for perfected instruments—not only the telescope but the microscope that soon followed (essential to biology), as well as the balance and the aids to navigation—compass, quadrant, and sextant, to which the superior clock or chronometer was later added. Without it the sailor could not determine his longitude, or westward distance from Europe, no matter how certain he was of his latitude or distance above or below the equator. [The book to read is *Longitude* by Dava Sobel.]

The sailors' crisscrossing the globe ever more often spurred mapmaking, which soon made use of geometry (the Mercator projection) and popularized the mathematical turn of mind. Seventeenth-century artisans, tradesmen, even butchers grew excited by what numbers could do. Hobbes, picking up a

work of geometry and browsing in it exclaimed, "By God, that can't be true!" then went on to learn the science. Newton, aware of the vogue, was persuaded to write his *Principia* in mathematical form. One may regard Spinoza as doubly emblematic of his time: he offered his *Ethics* as "geometrically demonstrated" and he earned his modest living in Amsterdam by grinding lenses. Geometry (as we saw) had already proved its value to artists who used perspective. It made its way into architecture and the design of fortifications. Palladio, the builder of elegant classical mansions in Italy and England, invented the truss, and the building of large bridges and canals in 17C France relied on novel calculations that led in turn to advances in mechanics and hydrostatics.

> When the laboratory had been kept warm for some months, and they expected the golden fruit and there was not so much as one grain of gold in the Vessels (for the Chemist had wasted all that too), another obstacle was found out: the glass they used was not of the right temper—for every glass will not make gold.
>
> —Erasmus, "The Alchymist,"
> *Colloquies* (1525)

Public opinion took a good while to connect science with practical benefits such as bridges and machines and to disconnect it from the useless experiments of alchemists and astrologers. But as mentioned earlier, some of the findings and calculations of these investigators had value; and looking back one can see that the habits of the merchant or banker also proved helpful to scientific workers. The niggling attention to detail, the respect for small numbers, and the demand for exact information were not aristocratic traits; they were the lowly tradesman's. As we saw from the Fugger Letters, international trade had long been capitalist, based on credit, protected by insurance, and ruled by rigorous accounting. As early as the dawn of the 16C, the leading treatise on arithmetic, algebra, and geometry, by Pietro Pacioli, contained a section on double-entry bookkeeping (*doppia scrittura*), the first description of the system in print. Thanks to it, this "method of Venice" was shortly available in other countries. Pacioli at one time was a traveling companion of Leonardo's and it was Leonardo who drew the solid figures in several of his friend's works. These included books on the golden section (for artists and builders) and arithmetical problems offered as pastime.

Double-entry bookkeeping is quasi scientific in two ways: it supplies a test of accuracy and it rests on equations: at the bottom line (now a famous metaphor) the figures must match to the last penny. Further, in the body of the account, the line items are abstractions from common-sense reality. That is why to learn accounting is not quick or easy—or obvious: in given circumstances, a merchant who exports gold as part of a transaction must put it down as a debit.° Trade also contributed to mathematics the idea of negative numbers, essential to algebra. The minus quantity appears to have arisen when bales of goods for shipment varied a little in weight. To be fair to buyer

and seller alike, they would be marked in chalk plus or minus the standard weight. Parenthetically, the present symbols, including *a, b, c* and *x, y, z*, but not the equal sign, were fixed for all users by Descartes; his = sign was ∞, which now stands for infinity. From these parallels between science and trade one might say without much exaggeration that the scientist at work is a prime exemplar of the bourgeois virtues.

*
* *

To grow rapidly and flourish, science needed one more type of cultural assistance: communication. The alchemist worked in secret, for the excellent reason that if he did find the "philosopher's stone" (a magic powder) and transmuted lead into gold, or distilled the "elixir of life" and contrived immortality, he did not want to share the glory or the profits. The physician likewise kept his means and methods to himself. A common trick was to note one's findings in anagrams—a series of figures and letters, such as IT2NNOWE to mean "Newton," himself a user of this device for his early work. The 17C man of science and geometer began to think and act in the opposite way. Experience had taught him that a great truth is discovered bit by bit (Bacon pointed this out) and that mutual review and correction benefit every worker. Fame will not be denied to anyone who helps to build "the great edifice of science."

The free exchange of ideas and results corrects error and speeds up discovery. In the formative period print was of course available and put to use, as shown by the works of Kopernik, Galileo, Bacon, Descartes, Boyle, and the rest; but it is remarkable how much of the new thought was conveyed in private letters between congenial minds; or again, between a person of scientific tastes and a cluster of thinkers. Father Mersenne, a classmate of Descartes', served as a kind of post office or clearinghouse for the scientists of Europe. People of rank might get in touch with a particular celebrity of the new kind. Thus Descartes came to write a book-length batch of letters to Elizabeth, the Princess Palatine, and it is in them alone that we learn his belief—not clear from his other works—that the will, which connects the mind with the body and directs its actions, is lodged in the pineal gland of the brain.

Another crowned head had the same wish to learn from Descartes, but not by letter, face-to-face. He was also to help her found an academy of science. This fatal invitation came from

Christina of Sweden

She was a virgin queen like Elizabeth of England and a political intriguer like Mary Queen of Scots, but in variety of interests and cultural influence,

superior to both. As she herself said, she thanked God that she had a man's soul in a female body. She was in fact uncommonly strong, loved hunting and riding unruly horses, wore low-heeled shoes, and had a voice that went from girlish to mannish without modulation. At birth she had been taken for a boy, her whole body being covered with hair. She viewed women with contempt, especially as rulers; and in this scorn she included herself.

As the daughter of Gustavus Adolphus, the hero of the Thirty Years' War, she found herself at 18 the responsible head of a European power that dominated the whole Baltic area. She had been brought up a Lutheran and a Humanist, both, which is to say that her creed was Christian stoicism. Her tolerance was wide and her intellectual curiosity boundless. She spoke Latin and four modern languages, her fluency in French punctuated by swear words. By the age of 20 she had a European reputation as the "Minerva of the North" for her patronage of thinkers and scientists. Grotius, Saumaise, and Voss had been previous tutors at her court when she invited Descartes to come and teach her philosophy. He kept refusing but she prevailed. Daily at 5 A.M. he had to expound the rules and results of his method. Although her prime minister, the wise Oxenstierna, judged her intelligence "extraordinarily brilliant," Descartes thought it unsuited to philosophy. This view of Christina's powers did not stop Pascal from dedicating to her, in a long letter of eulogy, the calculating machine he had just invented. Under the strain of teaching a mind of the wrong type, the early hours, and the cold of Stockholm, Descartes fell ill with pneumonia and died in a few days in the middle year of the century.

Christina, defying the traditions of royalty, refused to marry. She says in her autobiography that she did not lack normal desire—indeed, she thought that if she had been a man, she would have been a rake; but she could not bear the idea of pregnancy and of losing her independence. She began to be unpopular on this account, though she handled affairs of state with judgment, balancing the claims of the nobility by an alliance with the middle class and using in crises the good old method of deceit and delay that had served Elizabeth so well in England. Finally, the lack of an heir, criticism at home, and false rumors abroad about her lovers induced her to give up the throne to her cousin. She was 28.

From that moment on, Christina was the object of vicious slander that lasted until fairly recently. Three French playwrights, including Dumas, have depicted her titillating misbehavior. Adoration turned to contumely, partly because she had yielded her post of duty, partly because she was brilliant and still a power in her retreat. She had 35 years of life ahead of her, and she filled them with political ventures and cultural extravaganzas.

All this took place in Rome, after some travel in Germany and France. The papal city found her court a welcome addition to its pleasures. It was crowded with poets and musicians, thinkers and talkers, who enjoyed the

round of dinners, dances, plays, masques, ballets, and conversations that she devised for her own pleasure. The successive popes approved and partook. In the papal atmosphere Christina was drawn to the Catholic faith. Earlier, in Sweden, she had gone through a period of doubt, induced in part by her interest in science. Disbelief in miracles and in the resurrection of the body had left only faith in some supreme being. The Protestant theologians disagreed with one another—none of them was right. When Stoicism went out of fashion, she was left without any system by which to interpret the universe. But in Rome she found Catholicism seductive, more tolerant than any sect and intellectually coherent. She became a Catholic "in her own way." She read theology with renewed interest, side by side with mathematics and literature.

She also came to view her abdication as a sign of wisdom and promise of fame: she would be compared to the great emperors Diocletian and Charles V. Yet in other ways (she thought) she was unique and known to be such, a faultless creature who had been a representative of God on earth. Pride, she later recorded, was her besetting sin. Others thought that her ordering the execution of an upper servant who had betrayed her secrets was a greater sin. But her act was within the law; Italian political customs were still merciless, and the judgments passed on her by writers of the Enlightenment for what took place a century earlier are wrongheaded.

Christina's efforts to find a role in the world, other than as a patron of thought and culture, began in Sweden while she thought of abdication. She would be Queen of Zeeland in the Low Countries if Cromwell would conquer the province for her. In Rome, she wanted to be Queen of Naples, where a ruler was wanted. And in a more steady fashion she took part in papal politics, then often in the hands of powerful women relatives of the incumbent. The practice of religion itself was chaotic; it swung from processions of penitents, whose bare backs were whipped by their servants, to occasions where refreshments consisted of pastries depicting the crucifixion. And as usual, there were sincere souls, mostly noblewomen, who led pious lives or renounced the world altogether. It was in Rome also that Christina found at last a man to love, Cardinal Azzolino, a worldly, cultivated cleric and ladies' man who helped her in her practical undertakings but who did not return her passionate feelings. She kept them under control, except in the many letters she wrote him, in which she calls herself his slave forever.

Christina's many exertions brought her in touch with the great Baroque sculptor Bernini, who designed a carriage for her, and with Mazarin, the French king's maker of policy, which she wanted more favorable to the pope.

She took singing lessons and commissioned music from her resident

> The world is threatened with peace and quiet.
> I love storm and dread it when the wind abates.
>
> —CHRISTINA OF SWEDEN (n.d.)

composers, Corelli and Alessandro Scarlatti; she organized archaeological excavations, filled her palace with objets d'art and her library with classical and oriental manuscripts. She kept up with French literature and wanted to put on Molière's *Tartuffe* as soon as she heard what a scandal it had created, but Louis XIV would not permit the export of the play. She founded three academies for art and science that sponsored lectures and discussions; she had an observatory and a "distillery"—a laboratory (her adored father having been something of an experimenter)—and she illustrated a work on chemical problems.

If this incomplete list of her doings may be called picturesque, the details of each enterprise deserve to be called fantastic—and representative of the crosscurrents that marked her age: Baroque exuberance and neo-classic severity; the Jesuits' casuistry and Puritan morals; preciosity side by side with grossness in manners; restraint and extravagance in literature; the conscientious persecution of witches and the new science.

*
* *

While noble heads were poring over Descartes' little book on method or "distilling" in palace laboratories, and serious searchers were writing to Mersenne about their latest calculation, a group of like-minded persons began in 1645 to meet weekly in London to discuss points in the "new philosophy." Three years later at Oxford, a similar group founded a society with the same purpose. After a dozen years the groups combined, and Robert Boyle, the "Skeptical Chemist,"° wrote a detailed memorandum sketching the plan of a formal organization. In the document he referred to the company of searchers as the Invisible College. It was soon to be the Royal Society of London for Improving Natural Knowledge.

Having started with some 80 members, the groups that joined came to feel the need for selectivity. When in 1660 a royal charter was requested, Charles II approved the statutes, and the number of members was set at 35, divided into classes: physicians, professors of physics and of mathematics, and barons. Titled patronage was desirable even if it was of the lowest rank. Learned dukes were too few or less committed to experimentation.

Even with the downsizing, the Royal Society was a rather motley assemblage. Sir Robert Moray (= Murray) was the baron-president. Others were: Christopher Wren, a budding chemist, not yet an architect; John Evelyn, an expert on trees and later a famous diarist; Sir William Petty, the initiator of social statistics; Samuel Pepys, a civil servant and secret diarist; and thirty other, less familiar names. Two secretaries were appointed, of whom one, Henry Oldenburg, a German fluent in several languages, became like Mersenne a live center of European scientific correspondence. The academy's *Journal* recorded

the members' lectures and discussions and two series of *Transactions*—A for physics and mathematics, B for biology—enshrined selected papers. Foreign corresponding members—"the Ingenuous from many considerable parts of the world"—were eagerly recruited.

Such was the model of the innumerable professional associations now in being. It took the first step in SPECIALIZATION after the original, Humanistic academies. A French Academy of Science soon followed the English, then a Spanish, and so on. Later in Philadelphia, Benjamin Franklin founded the American Philosophical Society; at Schweinfurt in Franconia, the Leopoldine issued the first medical journal, dated 1670.˚ The usefulness of association for testing new ideas at meetings and publishing reports was implanted, with the result that nearly every trade has re-acquired the medieval guild spirit— bankers, realtors, and cake-decorating artists have their annual gathering and, at the very least, a newsletter.

Some are better than others. When Bishop Sprat came to write the history of the Royal Society, he complained that his fellow members wrote badly. This deficiency was the start of a tradition. It is explained partly by the convenience of numbers and fixed technical terms to tell colleagues exactly what one has found: correct syntax looks inessential; it may be safely left to the intuitive, who really need it. In truth, science needs it too, and today one finds many specialized journals outfitted with busy re-write editors. Bad writing harms science even more seriously at another place, the textbooks that instruct the next generation of workers. The faults that escape author and publisher are frequent and little remarked on; they seem as invisible as Boyle's college.

*

* *

It is hard to erase from the imagination all that now fills our secular culture when it thinks of "science" and equates it with the Only Real. One can more easily picture the street without cars or the desk without a computer, because these are concrete objects of fairly recent birth, than recapture the 17C mixture of new science and revivified magic. Failing to do so, one entertains a biased view of that century's scientific progress as crowded with definite outcomes when much was but the germ of later triumphs.

The Cartesian-Newtonian view of matter filtered slowly into the well-read mind. It was not easy to conceive a uniform substance, invisible yet measurable, when the senses show us color, texture, smell, which science disregards. It not only ignores these "secondary qualities," but by abstraction it reduces the world to the testimony of the eye—on the pointer of a balance, on a yardstick, or on the shape of an equation. But when everything is matter, on earth and beyond, it spurs speculation about the origin of the universe.

Everybody (roughly speaking) becomes a cosmogonist. A poor Italian miller named Menocchio was put to death, just a year before Bruno, because he maintained that out of original chaos a solid lump developed like cheese out of milk, then a worm appeared in it, which was the first angel. His analogy was not bad; it has points of resemblance with our Big Bang Theory, followed by Evolution. What grew more and more evident as time went on was that motion is everywhere and rest is the unusual state. The upshot was that in place of the age-old static world the new was what is called dynamic.

Needless to say, the source of truth likewise shifted, from settled revelation to restless experiment; truth itself was no longer static. Science took pride in having the courage to discard its own views. Why, then, should it be trusted, a platform moving underfoot? Because the method was sure and the results covered an ever-wider area of the previously unknown or misknown. Someday all the truths would have been won and they would form a coherent system, for Nature is regular and uniform.

At this point comes the paradox already hinted at: the age of the new method and the new revelations (in the plural and without capital letter) saw a resurgence of superstition, most violently expressed in the persecution of witches (213>). Yet it should be no surprise that when novel ideas set minds wondering and tongues wagging, strong minds with well thought out convictions should resist and defend the intellectual status quo. Not everybody has the mental elasticity to be a fideist, believe in Genesis and in Galileo at the same time. There is always a conservative party, and by a kind of Newtonian law of the mind, action is matched by an equal reaction; one branch of the conservative party turns reactionary and clings more intensely to the old convictions.

In the 17C there were also some who accepted both science and witchcraft and whose acts and writings fostered the two alike—such men as Joseph Glanvill and Sir Thomas Browne, the former a good astronomer and the latter an experimental physician and biologist. Their posture is not that of the fideist with his mind working on two levels; it is a fusion of systems incompatible on the surface but that may have common elements. It is reasonable in a period of challenge to established truths to be skeptical and to test any new proposition by seeing whether it is consistent with the great body of established truth. Browne considered the witch question carefully and concluded that to disbelieve would violate the cosmic hierarchy of beings—God at the summit, then angels of various grades, Man, and at the bottom evil spirits, the minions of Satan, who by their doings also carry out the divine plan. They account for the temptation of men as well as for a host of otherwise unexplained mishaps in daily life. To remove them from the orderly scheme would make God responsible for Evil and bring man down to the lowest level of spirits. The world would no longer be the battlefield on

which souls are tested by the continual assaults of the Devil. Witches, in short, were necessary to the system called The Great Chain of Being, the hierarchy of living things.

This reasoned conclusion did not conflict with another of Browne's reasonings, his exhaustive book on Vulgar Errors, in which he discredited a great many superstitions in a manner that still makes good reading. It could not be expected that "the new method" would immediately get rid of them all. As for Glanvill, a productive scientist, member of the Royal Society, who turned propagandist against witchcraft, that mysterious power of certain women (and fewer men, called wizards) seemed no more unlikely to him than the equally mysterious powers that natural philosophy was discovering; only, the witches' power, known as "fascination," was of evil origin, even when it cured cattle or people.

Besides, the existence of witches is not a clear-cut issue. There is no doubt that old women—and often enough, young girls—acted in odd ways that conformed to the definition of witch. They themselves believed in their craft and power, they confessed or boasted about it. Some must have been insane, others subject to hysteria, and still others sought the egotistical satisfaction that criminals enjoy—of being conspicuous and of having done evil. At any rate, the witch-hunting that flourished in the midst of science and is typified by the trials in Salem, Massachusetts, was rooted in the work of reason upon fragments of experience, like all great errors of the human mind.

*
* *

The two themes ABSTRACTION and ANALYSIS here singled out as characterizing the task and method of the natural philosopher have aspects that call for attention if they are to help in understanding the Modern Era. From early childhood, ABSTRACTION serves to organize the world: from *this* red apple we learn to think of all red apples in general, then of apples regardless of color; then come fruit, things, and finally the largest, the thinnest category: Being. Climbing the ladder of abstraction enables one to deal with large groups of things or ideas on the basis of their common features. The law is a good example. If it states that first offenders shall receive lenient sentences, the individual traits of this offender are irrelevant; he may be thin or fat, black or white, Christian or Buddhist, he is solely a first offender—a category, not a description.

ABSTRACTION is a calculated departure from experience, from what is seen and felt as the real, which goes by the opposite name of *concrete*. The Modern Era has endowed the world with more abstractions than any other culture on record; our ubiquitous use of numbers is a sign of it: THP-35R is not a car that you can drive; but the formula stands for it at the bureau of

motor vehicles and the insurance company; it is "real" in both places at once. In the 20C we may be said to be living a largely abstract life; and we suffer concretely from it when for lack of a classifying number on a piece of cardboard, our desires are balked, our rights denied, our identity doubted. Your declaration and even your presence have become worthless as proof under the reign of ABSTRACTION.

The other operation, ANALYSIS, distorts reality in a different but related way. To follow Descartes is to split into fragments the subject of one's interest. An idea, a thing, or a human being lies disintegrated like the kitchen clock. The modern phrase is apt: "find out what makes him tick." The abstracting that underlies analysis consists in regarding anything whatever as a thing made up of parts. We keep subdividing downward, expecting that we shall reach a unit that refuses to be broken—an atom (= uncuttable)—but the uncuttable within the atom still eludes us. Meanwhile we divide and subdivide, taking it for granted that when we put the pieces together again we have the original whole.

That is a useful assumption, but is it always true? When we carefully fit the pieces of a jigsaw puzzle together, we have obeyed Descartes' last rule, but we also see that the pretty picture was spoiled when it was cut up. Analysis and abstraction are indispensable. If the mind were incapable of either, there would be no such thing as physical science, medicine, law, education, criticism, or the moral conscience. But it is also possible that the utility of the two A's has limits and that their indiscriminate use is full of danger. In the 17C one man at least was aware of the error, if not of the danger. That man was

Pascal

He is generally thought of as a mystic who was also a mathematician. Some few remember that he conducted experiments that led to the barometer and that he invented the first calculating machine, La Pascaline. (To help his father's staff of tax accountants, he had 50 made, only to see them rejected by the stubborn quill-driving clerks.) At his death Pascal left a large collection of notes for a work defending Christianity against freethinkers. These notes were published by his family under the modest title of *Thoughts,* but they are often referred to in English in the original French *Pensées*. Readers such as T. S. Eliot admire them for their originality and wisdom, quite apart from their religious intention.

These few facts give no hint that Pascal, in his *Pensées* and other writings, set forth a philosophy of man and society that throws a critical light on what has happened in western culture since his day. In the conventional judgment, Pascal's mathematics and scientific work atone for the Christian apologetics and passionate "mysticism," both of which are ascribed to his desperate ill

health—he died at 39—and as the observations of one remote from the world of normal actions and feelings.

That judgment is at fault and nothing more is wanted to disprove it than Pascal's essay on love. It is the fruit of the two years he spent in the world, the fashionable world of conversation, gambling, gossip, and lovemaking. There is a rumor that his heart, if not his hand, was engaged—and disappointed—but there is no doubt that he shone in society by his manners and his wit. Gambling, whether it entertained him or not, fixed his attention and he made contributions to the theory of probability.

"On the Passion of Love" is a piece of psychology worthy to be compared to Stendhal's "On Love" (475>),° and although much briefer it is in its way more thorough, because Pascal begins by considering the passions as thoughts coupled with feelings and occasioned by the body. This is the important notion of heart-and-mind (<202; 453>). The more mind, the greater the passion, says Pascal, particularly in the two "adult passions"—Love and Ambition. They contradict and weaken each other; a life is therefore happy when it begins with love and ends with ambition. It would be Pascal's choice, given man's short span, its length to be measured from the age of reason—say, 12 years old.

> **Does one need to love? Don't ask—feel it.**
>
> —PASCAL, "ON THE PASSION OF LOVE"

Next come some typically Pascalian insights into character and society: a tumultuous life pleases great minds; for it keeps feelings astir and action continuous. Man at rest is unhappy, bored (as we say) to death. Pascal understands what rationalists do not, which is that the body and its feelings are primary, not mind and reason. As to the mind by itself, Pascal sets down here the distinction he develops in *Thoughts,* between two types: the one, rigid, inflexible; the other, supple and born with the impulse to love, especially what is beautiful. When both minds are combined in one, what great pleasure arises from love! One has within oneself the image of that Other whom one seeks in order to complete oneself. Here our psychologist notes the phenomenon of projection—painting the desired image on a person whom it does not fit; he thinks women very liable to this self-deception. A passage about loving above one's station has suggested a factual origin for the essay. Scholars have named Mademoiselle de Roannez, of a ducal family, as the person alluded to. What follows is a series of astute comments about the vicissitudes of love in society, the fashions and pretenses it inspires; all this interspersed with subtle remarks on the emotions and the sense of beauty.

Pascal was not a mystic. It is a misuse of the term to apply it to his religious fervor. A mystic is one who seeks union with God. Catholic dogma frowns on mysticism, because it makes God a Being that a human soul can

consort with, overlooking Christ and blurring the relation of creator and creature. Pascal, on the contrary, sees God's majesty as so far removed from earth, and His designs as so incomprehensible, that mortal man has no connection with Him *except* through Christ, who was both man and God. And what Pascal sought in Christ was love. If one wants to psychologize Pascal's faith, one can attribute it to some childhood deprivation of love or his unhappy attachment to Mlle de Roannez. Or again, one may say like Voltaire in his retrospective attack: "Pascal, you are sick."

He *was* sick, but his religion is so rationally tied to his science that it is best to judge it as if he had been in robust health. The truth is, Pascal was kin to the modern existentialist—to Kierkegaard or Gabriel Marcel, both ardent believers. When Pascal wrote his famous *Pensée*: "the eternal silence of this infinite space frightens me," he was seeing the cosmos like the existentialist—empty, bleak, and meaningless. How had all these rotating spheres come to be? Why all this void? And how absurd was that enigma, Man! To repeat: God's design was inscrutable. Christ was the sole link with Meaning, and Christ's message was forgiveness and love. The divine was no abstract essence in which to merge for the ecstasy of forgetting self; it was the living God. His miracles were all humane in purpose, and the miracle and mystery of His existence mediated for man the mystery of the infinite space and silence of creation.

*

*　*

The distinction that Pascal touched on in writing about love, the contrast between two types of mind, is for our time his most pregnant idea. In the *Thoughts* it is fully expounded as the difference between the geometrical and the intuitive temperaments (*esprit géométrique, esprit de finesse*). By geometrical, Pascal means the mind when it works with exact definitions and abstractions in science or mathematics; by intuitive, the mind when it works with ideas and perceptions not capable of exact definition. A right-angle triangle or gravitation is a perfectly definite idea; poetry or love or good government is not definable. And this lack of definition is not due to lack of correct information; it comes from the very nature of the subject.

"Geometrical" matters are handled by all good minds without any argument over their interconnections, and mistakes in reasoning are quickly

In the spirit of geometry, the principles are obvious but remote from common understanding, so that it is hard to turn one's mind in that direction—from lack of the habit. In the intuitive spirit, the principles are in common use and in front of everybody's eyes—no need to turn the mind and do violence to habit. But the principles are so many and subtle that it is almost impossible not to overlook some. All geometers would be intuitive if their eyesight was good and the intuitive would be geometers if they could bend their attention to unfamiliar principles.

—PASCAL, *PENSÉES*

noticed and readily admitted by the culprit; whereas in matters of intuition, of *finesse,* the details to take in are so numerous and fugitive that reasoning about them is chancy and good minds arrive in all honesty at different conclusions. Pascal might have added that this large number of elements rules out the use of Descartes' method: one can never be sure of having found all the parts of the problem or of having put back all those one thinks one has found—no complete analysis is possible of Love or Ambition.

It is from this incapacity that the belief in science and mathematics as the only forms of truth has arisen. Such has been the faith of most scientists and mathematicians, who in turn have persuaded the people that apart from their experimental findings and deducings all is mere opinion, error, and fantasy. Even so, in every generation, thinkers—including some notable scientists— have maintained that the geometrical spirit and the method of Descartes do not apply to everything. Truths of a different order are attainable by finesse, even if consensus is lacking. The language itself recognizes the source of the distinction: to know and to know about express the difference between inti- mate awareness and things learned. Some languages in fact use different words for the contrast: *wissen* and *kennen, savoir* and *connaître.* Man as scientist has come to know a great deal, but as human being knows and feels intuitively love and ambition, poetry and music. The heart-and-mind reaches deeper than the power of reason alone.

Longing for unanimity in belief is understandable (<23). The bloody conflicts of the world have their source in the realm of finesse, and to deplore the fact leads to such skepticism as Montaigne's. It is also the best argument for toleration. But although the realm of finesse does not yield unshakable conclusions, it is not alone in variability. Science is continually revising its dec- larations and at no time do its practitioners fully agree with one another. The unbroken confidence in it rests on the fixity of the objects defined, which makes every worker talk about the same thing and deal with it in the same way, thanks to numbers. But not even this admirable rigor ensures eternity to the results of its application. Still, when by a combination of science and finesse, useful inventions are created and benefit the common life, the public is doubly convinced that science has a monopoly of truth.

The two "minds" that Pascal describes do not constitute two species of individuals. They are but two directions that the one human mind can take. Pascal himself is proof that one can be a great geometer and a profound intu- iter. And in fact any good mind properly taught can think like Euclid and like Walt Whitman. The Renaissance, as we saw, was full of such minds, equally competent as poets and as engineers. The modern notion of "the two cul- tures," incompatible under one skull, comes solely from the proliferation of specialties in science; but these also divide scientists into groups that do not understand one another, the cause being the sheer mass of detail and the

diverse terminologies. In essence the human mind remains one, not 2 or 60 different organs.

What, then, is the importance of Pascal's distinction? It is as an axiom for the critic and a warning against SCIENT*ISM*. Ten succinct paragraphs of the *Pensées* state it with finality. Scientism is the fallacy of believing that the method of science must be used on all forms of experience and, given time, will settle every issue. Again and again, the bright thought has occurred, "If we can only define our terms, if we can only find the basic unit, if we can spot the right 'indicators,' we can then measure and reason flawlessly, we shall have created one more science." And nearly as often, the shout has been heard: "Eureka! We are scientists," the new science being some portion of the desired Science of Man—history, sociology, psychology, archaeology, linguistics, and other more or less short-lived ologies. This hope and this pretension began to be heard in a mild way early in the 18C, before Newton's death; Vico's *New Science,* for example, is an important theory of history (314>), but no more a science than its many successors with the same confident title.

The motives behind scientism are culturally significant. They have been mixed, as usual: genuine curiosity in search of truth; the rage for certainty and for unity; and the snobbish desire to earn the label scientist when that became a high social and intellectual rank. But these efforts, even though vain, have not been without harm, to the inventors and to the world at large. The "findings" have inspired policies affecting daily life that were enforced with the same absolute assurance as earlier ones based on religion. At the same time, the workers in the realm of intuition, the gifted finessers—artists, moralists, philosophers, historians, political theorists, and theologians—were either diverted from their proper task, while others were looking on them with disdain as dabblers in the suburbs of Truth. The case of Karl Marx is typical. Infatuated with the kudos of science, he persuaded himself and his millions of followers in and out of the Soviet Union that he had at last formulated the mechanics of history and could predict the future scientifically. (One can find Marx and Lenin in the otherwise admirable *Dictionary of Scientific Biography.*° They were included under pressure, not by the free choice of the editors.)

<div align="center">*
* *</div>

The clue to the fallacy of SCIENTISM is this: geometry (in all senses of the term) is an ABSTRACTION from experience; it could not exist without the work of the human mind on what it encounters in the world. Hence the realm of abstraction, useful and far from unreal, is thin and bare and poorer than the world it is drawn from. It is therefore an idle dream to think of someday getting along without direct dealings with what abstraction leaves untouched. The meaning of this contrast is that the enterprise of science has its limits.

Pascal does not stop at showing the difference between the two distinct grips that the human mind has on the world. In a widely quoted passage he adds: "The heart has its reasons that the reason does not know." The heart here is not merely the seat of the affections; it is desire in general, the impulses to action, and Reason is the discriminating servant that carries out some of them. Note that the word *reason* in the dictum is used in two senses: the reasons of the heart—its needs and motives—are not products of reason*ing,* or there would be no spontaneity in conduct, no sympathy, friendship, or love in the world. Throughout the *Pensées* one hears Montaigne speaking. Pascal's mentor is present in many of the observations on custom, law, and social life; the disciple echoes, refines, or disputes passages in the *Essays*. At times, Pascal argues with Montaigne as if face-to-face with him. At other times he turns a sentence of the master's into an epigram: "Whoever tries to turn angel turns beast," punning on *bête,* which also means stupid. Or again: "Truth on this side of the Pyrenees [is] error on the other side." These are "mountainous thoughts" compressed in Pascal's characteristic way. Montaigne never had a better reader than Pascal.

It may seem strange that the skeptic should be so congenial to the religious enthusiast in a work that urges total belief. But for Pascal it is precisely the uncertainty arising from human truths that requires taking refuge in the bosom of God. Pascal, we are told, was converted by the Jansenists of Port-Royal, a famous retreat of disciples of Jansen, an Augustinian theologian. They were men and women of great piety and learning, who represent at the heart of Catholic France the Puritan passion then rousing England to Civil War (263>).

So convinced a recruit was Pascal that he employed his genius in a public defense of his friends' austere outlook against their all-powerful enemies, the Jesuits. A conscious literary artist, Pascal in his Jansenist polemic created the model of classical French prose (353>). Colloquial, eloquent, satirical, and witty by turns, these *Letters from a Provincial to a Friend of His* had immediate success with the public and made "casuistry" and "jesuitical" forever terms of reproach. All this is familiar French history, but it has not been sufficiently noted that in the *Pensées,* the status of man differs from the Jansenist-Puritan image of the miserable sinner. For Pascal, man is miserable *and great.* On the scale of the universe, he is puny—"a drop of water can kill him; he is a feeble reed." But he is "a thinking reed." The blind universe destroys him and all his works, but he is conscious—he *knows* that which is stronger than he; that is why the silence of space frightens him. Yet Thought (and here one includes science) remains master of that which does not know its own size and power.

In this vision of human greatness Pascal differs not only from the Puritan *and* the Existentialist, but also from most men of science since the 19C. These last sided with the universe; they enjoyed telling their audience that man was a

negligible accident and that in the future they had mapped, earth and man would be bits of cold matter whirling pointlessly as if they had never been (570>). As a true believer, Pascal had no need to revel in destruction; he was fond enough of his fellow men to want them saved, on any terms—hence "Pascal's Wager." He pleads with the increasing number of freethinkers, atheists, who had been "freed" by science and who were the first to be called Libertines—Mersenne thought there were 2,000 in Paris. Pascal says to them: "If you disbelieve in God, you have no eternal life—you yourselves say there is none. But if you believe, you have at least one chance out of two; for if there is no God, you are where you were before; and if there is, your have won salvation."

What is faith but a kind of betting or speculation after all? It should be: "I bet my Redeemer liveth."

—SAMUEL BUTLER, *NOTEBOOKS* (LATE 19C)

To some judges the wager seems so cold-blooded as to cast shame on Pascal's religion. But his mathematics of probability went with the psychology of a good Augustinian: make-believe after a time generates true belief (<39). Besides, as a Catholic Pascal did not espouse predestination or the need of special grace to obtain faith. This leaves the question, was Pascal a fideist? He probably was early in life; later there are grounds for saying No. He did not live to work out his system, but the elements given do not demand the split-level mind. God being All-mystery and All-encompassing, His will and the searchings of humankind into His cosmos cannot be in conflict—any more than the geometrical and the intuitive minds are in conflict when rightly understood. In people like Pascal, the two capacities interpenetrate. When very young, he came upon Euclid by chance and was at once a geometer: at fifteen he wrote a paper on conic sections that the great Leibniz found useful. In manhood, besides love, society, and science, he experienced revelation—the night of vision and possession by the divine that enhanced his power to think and manifest his genius.

Digression on a Word

Like ideas and styles of art, certain words belong to a given period. The word *genius,* in the sense in which it is now used, belongs to the 19C (474>). *Esprit,* as in Pascal, is the special property of the neo-classical age; a look into its meanings is therefore in order. Of course, no words of this kind are the creations of their time, only their special usage.

Esprit, as Pascal uses it, is slightly ambiguous. It means mind when he talks about the two intellectual types; it also means direction, tendency, and even realm. In English, *spirit* is not so apt for this second meaning. We do say: "Please take this in the spirit in which it is offered"; but the title of Montesquieu's book *L'Esprit des lois* is poorly conveyed when translated *The Spirit of the*

Laws. One wants to add the notions of *essence, bearing, purpose, intention-and-results.*

The trouble is that *esprit* has several applications, only loosely related. It can characterize a person: an *esprit éclairé, juste, faux, profond,* which mean respectively an enlightened, fair, twisted, or deep intellect. The *faux* kind is an interesting category, unknown in English. *Faux* here means twisted but not in the sense of deceitful; such a mind is *unreliable,* because it's "out of alignment," like a damaged device.

Next, *esprit* means wit, and this again in a double sense. When Dryden wrote "Great wits are oft to madness near allied," he did not mean witty persons; he meant great minds—geniuses. Likewise, in French, *un homme d'esprit* is a fine mind, but *un trait d'esprit* (a stroke) is a witty remark. This ambiguity in both languages is still with us: a nitwit has no brains, while a wit keeps the company amused. The Germanic root *wissen,* meaning to see, to know, has branched out in two directions, giving us *wise* and *wit.*

Esprit had a different origin, with the meaning *breath,* leading to *inspiration, aspire, expire,* and so on. The highest decoration awarded by the French kings in the 17C was the *Saint-Esprit*—the Holy Ghost, who is both spiritual and intellectual, thus giving the award super-eminence. With us, *ghost* and *spirit* designate the souls of the dead who revisit this world, and the notions of thin and pure account for *spirits of wine,* alcohol. It should be added that *esprit de corps*—another 17C usage—is not in French the admirable "team spirit" that it conveys in English. It denotes instead the selfish sticking together of a profession or government bureau against the legitimate claims of the public. The German for ghost or spirit—*Geist*—again conveys ambiguously the ideas attached to *esprit* and *wit. Geist* is mind; *geistvoll, geistreich* = intelligent or witty; and by a later invention, *Zeitgeist,* the Spirit of the Age.

Spirit, finally, has in English the additional sense of liveliness and even of courage; and in the plural it means mood, high or low. This meaning, developed out of the original *breath,* is a survival of the fully developed physiology of ancient and medieval times—the theory of the four humors, the four elements, and the several spirits. A good introduction to the system with its cultural importance is to browse in the famous *Anatomy of Melancholy* by

Robert Burton

who called himself *Democritus Junior.°* He was an Oxford don, who by the first third of the 17C, when he published his book, had read everything that contained the slightest reference to his subject: not medicine alone, but ancient and modern literature (poets included), biography, alchemy, astrology, botany, and the biological sciences generally. His subject, moreover, is con-

ceived so broadly as to become virtually man's fate on earth. Love and the other emotions, the ranks and customs of societies, the endless vicissitudes of social inequality are treated or glanced at. Burton has a darting mind and he comments freely on his own time and state. He repeats himself, but the matter follows a fine logical scheme that is graphically displayed at the head of his work. The work itself inspired an American poet to compare it to a cathedral.°

Anyone who starts reading the *Anatomy* anywhere comes upon entertaining anecdotes, surprising facts, and a mind full of imagination and verbal felicities. The conversational style reminds one of Rabelais at times, at other times of Sir Thomas Browne, a near-contemporary of Burton's. Both were rediscovered by Charles Lamb, who drew on them for a good deal of his own contrived quaintness in the *Essays of Elia*. Although Burton does not figure in the vast *Dictionary of Scientific Biography* and is fitfully mentioned in general histories of science, he deserves to figure there, for he was the first systematic psychiatrist, an extraordinary collector of widely scattered case histories. In its own time the book had a wide audience—it was a perennial best-seller—and in ours it has impressed a qualified student of mental science. [The book to read is *The Psychiatry of Robert Burton* by Bergen Evans.]°

What did Burton contribute? And first of all, why this elaborate study of melancholy—the "black choler," the condition now known as manic-depressive illness? Burton was subject to it, and all around him he saw fellow sufferers. He decided to learn everything that was known about it. He amassed descriptions and diagnoses going back to the Middle Ages, when the affliction was much noticed. The *Anatomy* contains what is surely the largest "literature" ever gathered for a scientific inquiry. It is handled critically, even though one may smile occasionally at what Burton is willing to accept. Far ahead of his contemporaries on more than one topic, he coud not avoid sharing their ignorance on some others. Burton's originality begins with his view that mental cases should be treated with tender sympathy. A century and a half elapsed before this view was officially adopted by the French physician Pinel, who ordered the manacles taken off the lunatics at La Salpêtrière hospital in Paris and who has been duly credited with the reversal of an age-old attitude. If priority matters, Burton was the (unheeded) initiator.

He also perceived that melancholy was linked to the deepest feelings, including the sexual. Lack of affection in childhood, such as he himself experienced, could never be compensated for, and it might so warp the character that the person could not feel proper love for himself or others. Hence the round of depression and excitement. Burton also notes that melancholy tends to attack the more gifted, an observation as old as Aristotle, yet recently put forth as quite fresh by a physician at Johns Hopkins.° The melancholy individual is the plaything of opposite forces; he despises himself and then

acts arrogantly; he is envious of others and knows he is undeserving; he wants friends and lovers but does not know how to make the right approach and he alienates those who begin to feel affection for him. Yet the cause of this perpetual mismatch is not entirely within him. The structure of society exacerbates the disharmony. Burton again and again lashes out at the ways the upper ranks behave toward the lower, without conscience and without reproof.

It follows from this analysis that the cure of melancholy—or rather its alleviation, for there is no cure—can only come from a good regimen, aided by certain drugs and more surely by the patient's acknowledging of what he really wants and by his becoming aware of the circumstances that led to his twisted feelings. To gain this SELF-CONSCIOUSNESS and deal with its revelations he must talk things out with someone who has sympathy and who understands the pattern of melancholic causes and behavior.

To Burton and the people of his time, "black choler" was a substance like blood, part of the body's normal components. A reader of Burton's *Anatomy* becomes familiar with the long-accepted theory of temperament and illness based on the four humors: black and yellow choler (= bile), phlegm, and blood. It ruled the western mind until the mid-18C, explaining character and actions; we still use the familiar terms *melancholic, phlegmatic, choleric,* and *sanguine.*

The origin of this physiology goes back to the Greek physician Hippocrates, whose views were amplified and systematized by Galen, his successor and chief authority for 1,000 years. In the 16C, as we saw, Paracelsus and others disputed Galen on important points (<198), but not on the four humors. It was the four elements of ancient physics—earth, air, fire, and water—that had suggested the system, their qualities being seen as reproduced throughout nature: weight, lightness, heat, and moisture. Add that absence of heat is cold, that flames go upward and weights downward, and you have the makings of a scheme applicable to the human body. In the various central organs one or another humor resides and may produce too much heat or cold or moisture. Subtler elements called spirits emanate from certain parts and move about as the body seeks to maintain that equilibrium among humors which is health. Suitably recast, this scheme still holds, the endocrine glands doing the work of the humors. (And by the way, the phrase "animal spirits," which we use to suggest a doglike friskiness, are really the spirits of the *anima* or soul, and should therefore mean liveliness of mind rather than of limb.)

Now, perfect health is rare and balance easily upset. At the best of times, individual character tips in one direction under the pressure of one of the humors—hence the names listed above, which designate human types: sanguine, from too much blood, and so on. Burton believes that the melancholic is the most prevalent; and he seems borne out by the historical record and the present-day multitudes of the depressed.

The detailed workings of the humors and spirits were seen to be com-

plex, and being subject to debate they filled volumes of argumentative medi-
cal literature. Burton tells without partisanship what his army of authorities
variously say. But he is also sure that ideas, occupations, modes of life, and
kinds of reading matter will help the melancholic, whom he cares for so ener-
getically because he is one himself. His self-examination, as relentless as that
of Montaigne, leads him even farther: he believes that contemporary culture
could be a cause of "his" disease. He has hard words against the people in
place, public indifference to merit, and the hypocrisy of clerics and moraliz-
ers. The worst melancholy, though, is that caused by love—worst because it is
the hardest to avoid or overcome. The chapters on the subject are as eloquent
and introspective as Shakespeare's sonnets and—at times—as humorous as
Rabelais in their enumeration of antics and sensations.

Burton has sometimes been dismissed by modern psychiatrists because,
in accepting the orthodox physiology, he failed to develop an "independent
view" of the mind. Again, he "lacked a dynamic psychology" such as Freud's.
These unhistorical critiques may be dismissed. It could be argued that Burton
at least did not separate mind and body; that he was alive to cultural influ-
ences in mental illness; and that in digging for causes he came close here and
there to positing the unconscious. Today, the phrase psychosomatic medicine
continues to imply a separation, as if any physician had ever seen a soma enter
his office without a psyche, or the psychiatrist a psyche without a soma. The
latest psychiatric practice uses drugs together with talking-out by the patient,
which is a departure from Freud in the direction of Burton.

An Interlude

The omission of Burton's *Anatomy* from general accounts of 17C science
is without excuse. Because he took the humors as sound physiology, his
sound psychiatry is ignored. Such eclipses of a source of light by some dark
matter in the surroundings are familiar to the student of cultural history. They
are the cause of stereotypes; one trait alone stands out in a figure or a period
and that is all that is remembered. The mind is an impressionable organ rather
than a recording instrument.

Since one aim of this book has been to show the Modern Era as a unit
distinct in many ways from its predecessor, the amount of evidence offered
may have produced or confirmed a stereotype of large dimensions. Cautions
given here and there, reminders of important starts before 1500, may have
failed of their effect and thus the existing impression of the Middle Ages as
"dark" may have been reinforced. To dispel it from at least the minds of pre-
sent readers calls for a brief interlude in the main narrative.

The name Middle Ages is a modern usage. It was hardly known until the

late 17C.° The wish to set off that era from antiquity on one side and from modernity on the other probably expressed pride—men of science and free-thinkers generally wanted to separate themselves from the "centuries of igno-rance." Soon the 18C made that consciousness of superiority explicit and convinced posterity that "Gothic" art, scholastic thought, and pious behavior were barbarism incarnate. The residue of that conviction is the use of "medieval" in journalism and common talk to condemn anything felt as out-dated and crude. Everybody knows that the Middle Ages were brutal, brutish, and superstitious in every way.

The truth is that during the 1,000 years before 1500 a new civilization grew from beginnings that were uncommonly difficult. The breakup of the Roman empire in the 5C had left a few towns and many isolated settlements to fend for themselves against outer anarchy. But the Middle Ages, as the plu-ral indicates, were several ages. Their varied achievements include creating institutions, reforming others (more than once), and—according to some—showing the world two renaissances before the one that has monopolized the name. The latest view is that instead of two such flowerings, there was only one great one, from 1050 to 1250. Much earlier, it is true, the intellectual and political activity during the time of Charlemagne in the 8th and early 9C had been remarkable. But this burst of genius was limited to his court, and then swamped by a fresh wave of Germanic invaders—Franks, Vandals, and Goths of all stripes; while from the south Arabs and Berbers, lumped under the name Saracens, attacked and though repulsed were not eliminated.

While the occidental populations were being re-formed out of these ele-ments, monks in Ireland worked to preserve the treasures of high culture by copying manuscripts and compiling books. St. Patrick and his followers did more than rid the island of snakes. On the Continent, from the latter half of the 9C to the middle of the 11C, practical life-or-death concerns were paramount and the period may be called dark° if it gives anybody pleasure. Later, its application is absurd. Far from scared or gloomy, the mood por-trayed in much of the popular literature of the Middle Ages is jollity; contin-ual danger can lift the spirits and energize action. Even during the worst times strong traditions endured. Neither the Roman code nor the canon (church) law faded away, and the Germanic invaders brought a type of custom law that some later thinkers have credited with the idea of individual freedom.°

The use of descriptive terms in speaking of the medieval era is always a delicate task. Within any one period, any one region or town, there was great diversity in language, law, government, and other components of culture. As Agubard wrote to Ludwig the Pious in the 9C: "One frequently sees convers-ing together five persons no two of whom are governed by the same law." The situation resembles that of ancient Greece; it is the modern habit to say

"Greek drama," when "Athenian" would be the proper word, while other city-states should be named in describing some one work of architecture or history or lyric poetry.

Accordingly, though the term *Feudalism* springs to mind when the word *medieval* is uttered, it is best forgotten unless one wants to study the period in detail.° In its place, one should put the idea of loyalty between man and man, the strong feeling backed by an oath that bound a vassal to his lord for military service and other aid. This bond was the practical means of defense against threats to life and sustenance from whatever quarter they might come. Vassalage did not necessarily imply a fief, that is, the possession of land by the vassal, but it did imply the moral force that held society together. It underlies the familiar stories and traditions, from King Arthur's Round Table to Wagner's operas.

Below the fighting man and his knights were the serfs and in the next town the artisans. The serfs, bound to the soil, supplied the food and the artisans the handmade goods. But as in all ages, the system was unsystematic and anything but fixed in its ways for all time. Upward mobility was a fact; a serf could run away or buy his freedom; a poor boy could become priest and even pope. When lords came to need help in managing their increasingly large domains, they employed serfs, and the privileges attached were so envied that some freemen wangled the status of serf so as to qualify for the post.° In short, medieval society was no tyranny; it was layered and less than rational, like all societies.

In a fitful way it had one principle, which it found in Aristotle and which is returning to favor: no rule was held valid if not approved by those it affected. A large institution, of course, could not function under such a constraint; but in the medieval university, as we shall see, students were in a good position to enforce it, and when the machinery of consent failed to work, strikes and riots ensued. To the extent that generalities inform, the medieval personality, molded by extremely harsh and variable conditions, tended to be impetuous and violent.° Different laws, claims, and rights arising from overlapping sources—marriage, inheritance, promise, gift, ransom—encouraged the kind of temper that now inspires instant rage, immediate litigation, and summary dismissal. The endless local wars were not, as is believed, the doing of "robber barons": almost invariably they could show a legal right. When William the Conqueror crossed the Channel to make England his own, he had three substantial claims to the kingship. Land being the main form of wealth and the only source of a meager and chancy subsistence, owning more or less of it was not solely a question of pride or greed.

War, moreover, had some civilized features—it was a game. The rules were strict. The word of honor, courtesy between foes, the captured knight deemed a "friend and brother" until ransomed (<94–95)—the full code must be

observed if the accusation of foul *play* was to be avoided. "In 1415 the English and the French heralds watched the battle together from a high place. When the French had fled, King Henry [V] waited anxiously until the principal French herald confirmed that the English were the victors. And it was also for him to name the battle. He named it Agincourt."°

More than a game, the Feast of Fools was a kind of mental health measure that indicates the attitude of medieval man to his church, as distinguished from his faith. The Feast was staged in the church itself, where, after electing a "king of revels," the forms of worship were mocked by parody. The brothers in abbeys chose a "lord of misrule" to conduct the same sort of organized relief from rigor, something that our time conspicuously lacks. The model for both gaieties was the pagan saturnalia enriched by the Christian mythology. It was the Protestant Revolution, obsessed with the difficulties of salvation, that introduced into the idea of churchgoing the hushed voice and tiptoe solemnity.

Neither of these was dreamt of in the boisterous fervor that led to the Crusades in the 11C. These did serve the desire to gain spiritual merit, to do penance for repented sin, to obtain a relic for use as protection; but also: to find adventure, escape home drudgery, partake of the famed luxuries of the East, and enjoy a good fight with the paynim. One more motive was trade. In the end it produced the account of Marco Polo's 17 years in China. Marco went with his merchant uncle for that reason and remained there to become the adviser of the last Mogol emperor, Kubla Khan, the inspirer of Coleridge's poem.° Marco's visits to Indochina, Japan, Malaysia, and India made known to the West the extent of the East. It now seems that his was not the first venture. Three who preceded him in the mid-13th and 14C also wrote accounts. [The book that reprints them in translation is: *The Contemporaries of Marco Polo*, ed. Manuel Komroff.]

Like earlier times and ours, the Middle Ages entertained many superstitions. Theirs were the more picturesque and some were beliefs about natural phenomena that were not fanciful. The collective folly frequently cited as typically medieval is the great fear that the world would end in the year 1000. It has been mentioned again as we approach the year 2000. It never happened. An American scholar long ago showed that the story is a fabrication contrary on many points to medieval habits of thought.° The date itself is suspect: tens, hundreds, and thousands meant little compared to threes, sevens, and twelves. Besides, the year began in different months in different places, which would make the panic somewhat straggling. The end of the world had been frequently predicted—and still is. In the enlightened, secular, and Protestant 17C it was a reflex action following calamities.

The supernatural did play a role in medieval justice. Since God directs all events, trial by ordeal and later by combat was the infallible way to prove one's

case. Those who today believe in the same premise ought to call for a return to the custom. Anglo-Saxon law provided a simpler, more practical means. It defined crime literally as breaking the peace; it could therefore be repaired with money. *Murther* was the name of a fine before denoting one type of killing; the payment "bought back" the peace; one notes in passing that the moral sense is not always engraved on the human heart in exactly the same terms. The English jury, also at first, was a group of 12 whose position as neighbors enabled them to testify to the facts at first hand. They rendered no verdict but told what they knew of the parties and the place.

A third procedure, combat (*duellum*), was instituted by William the Conqueror for both criminal and civil cases. It followed fairly sensible guidelines: a professional could be hired for the day and he fought with specified weapons less than deadly. If by nightfall either combatant had cried "craven," the losing party to the suit was deemed a perjurer and was fined. If the issue was felony, he was hanged. Championship was a recognized profession and local courts kept on a yearly retainer one such qualified man to defend itself against potential claimants.

*
* *

Two medieval institutions remembered today with respect are the university and its arts curriculum. The Sorbonne, Oxford, and Cambridge live in the memory together with the cathedrals and pretty well make up the sum of merit accorded the era. The cathedral is known fairly accurately, being still extant. Not so *Universitas,* which means corporation and refers to the group of teachers in the cathedral school who set up with a few students a place for higher education. These early teaching firms dating from the 11C were self-governing like a guild.

As for the arts curriculum, its meaning also differed from what we know under the name. Art meant know-how, techne, as in our "mechanical arts." The "liberal" ones were for free men and prerequisite to teaching, to serving the government, or simply to leading the life of the mind. There was a growing body of "intellectuals" who were not in the church or the professions.° The arts they studied were seven—four and three: arithmetic, geometry, astronomy, and music; grammar, logic, and rhetoric. *Bachelor, master,* and *doctor* expressed the degree of qualification attained. In the separate grouping of subjects the primacy of science is already evident. From the mix came the modern notion, now in decline, that the liberal arts provide any future leader in civilian life or government with what his duties will

I would there were no age between sixteen and three-and-twenty; for there is nothing the between but getting wenches with child, wronging the ancientry, stealing, fighting, drinking.

—SHAKESPEARE, *THE WINTER'S TALE*

require. After changing some of the contents to keep up-to-date, England as nation and empire thrived for a century and a half on that understanding.

Medieval undergraduates were unruly and some had a better right than later comers to dictate to their teachers, namely when students were officially the administration of the university. At Oxford, the faculty was in charge, but in Paris, those enrolled paid their teachers direct and could complain of the way the courses were given—as well as of anything else not to their taste. Representatives from the four "nations" (not national but mixed) rotated rapidly by law, while factional struggles ensured a steady round of grievances, disputes, riots, and wounds. The townsmen were fair game for mugging and murder with impunity.° As for town life itself, its setting is familiar to present-day travelers and its crowded, unhygienic conditions fairly known from literature. [For greater detail, read *The Medieval Town* by John H. Mundy and Peter Riesenberg.]

> King Henry III of England to the masters and students of the University of Paris, greeting. Because of the many tribulations and difficulties you have undergone under the evil law of Paris, we desire out of reverence for God and the holy church to aid you in restoring your condition to its due liberty. If it pleases you to come to our kingdom of England and make it your permanent center of students, whatever cities, boroughs or towns you choose we shall assign to you.
>
> (JULY 16, 1229)

The outlook of the developing class referred to above as intellectuals appealed to students even before graduation—they had entered at 13 or 14— and they joined this subversive element, which was united not by doctrine but by temperament and habit; they were not advocates of reform or revolution but practitioners of anarchy. The ballades of François Villon give without reticence an insider's view of the life and its perils. Graduates, students, vagrants, criminals together, they roamed the countryside in bands, unwelcome to villagers, but by now much admired for their songs of love and sadness and drink. Among many collections, a choice of some found in a German abbey form the text of Carl Orff's popular cantata *Carmina Burana.*° Not until early modern times were the lawless students of Europe put down by the royal heads of the budding nations.

<p style="text-align: center;">*
* *</p>

In science and techne the Middle Ages progressed well beyond the Romans and Greeks. Aristotle supplied the framework of Thomas Aquinas's theology, but the Stagirite's physics were refuted at the University of Paris. The first of the Bacons, Roger, practiced experiment, produced results in optics—he was credited with inventing eyeglasses—and promoted the idea that the test of truth is not authority or logic but experience. Toward the end of the period the versatile Cardinal Nicholas of Cusa ranged over physics,

mathematics (he suggested infinitesimals), astronomy, and geography (he commissioned the first map of Central Europe). He wrote on philosophy and jurisprudence and fruitfully advanced these disciplines. He gave up the Scholastics' way of settling questions by formal debate pro and con, and before Copernicus and Kepler, he intimated doubts of the circular motion of the planets and the earth's fixity at the center of the universe. Today, Cusa is honored by cosmologists for having conceived the cosmos as continuous, instead of divided into spheres of different materials. His ideas were not adequately followed up; he is a prime example of the truth that before science could prosper it had to become an institution. At the same time, to be fair to the Scholastics, one must heed Whitehead's reminder that by their logic-chopping they contributed to science the habit of asking what a statement implies and of not being satisfied with merely plausible answers.

Logic as an antidote to loose inference was helped in the Middle Ages by the use of the international language, not Latin, but *Medieval* Latin, a medium of exact expression, simplified in syntax and enriched in vocabulary. The modern tongues owe to it the subject-verb-predicate form of sentence and most of the abstract terms used in science, philosophy, government, business, and daily intercourse. By the end of the era, searchers after truth were well supplied also with "philosophical instruments" and machines: various types of measuring and drafting tools; and the compass and the astrolabe, supplemented by charts, to guide sailors on their way. Tacking (sailing against the wind) probably dates from the 15C if not earlier. And a comprehensive treatise on magnets served more than one purpose in science and daily life. Technicians could boast a vast experience in building, mining, and manufacturing, and a tradition of seeking the new.

The invention and utility of machinery depend on a source of power stronger than man's right arm. Before steam that power was water. The mill was the medieval machine par excellence; it served grinding, fulling, and other industrial needs. Using metal forged into exact shapes for gears and shafts, the mill was sturdy and its action continuous. The metallic ores mined in Germany were treated in new ways for durability and strength. In France steel was first made by some Carthusians monks well before their brothers in the Alps invented Chartreuse. [The book to read is *The Medieval Machine* by Jean Gimpel.] There is no need to point out the solidity and sound design of the bridges, houses, and churches that still stand to show their workmanship. The stone dressing and carving and the stained glass that we cannot duplicate are duly recognized, together with the priority of the cathedral as a skyscraper: it was the first building which, to attain height, is a frame and not a pile. The walls fill in the sides, they do not support the fabric.

Hardly remembered are the smaller artifacts—utensils, jewelry, ornaments, and the plate and chainmail armor, all of which presuppose refined

methods and high individual skill. [The book to read is *The Fate of Medieval Art* by G. G. Coulton.] Still more virtuosity went into the first mechanical clocks, which date from the last quarter of the 13C. The reliable watch came two centuries later. The importance attached to Time in the West is a distinctive trait: Swift's Gulliver looks at his watch so often that his hosts the Brobdingnagians think he is consulting his god. [The book to consult is *A Revolution in Time* by David S. Landes.]

Nor should it be forgotten that it was by medieval techne that firearms and movable type were first made. Muskets and cannon changed the tactics of war and the meaning of the word *artillery*, which gave the infantry superiority over the cavalry, thereby socially demoting the knight. As to movable type, now that it seems no longer needed thanks to the ubiquitous digitals, the moderns must not imagine that they invented it and built the machine that begot the book. Even the use of small letters in place of capitals throughout is due to a scribe contemporary with Charlemagne.

<div align="center">*</div>

<div align="center">* *</div>

When a book was a scroll or a codex (fastened sheets) it was expensive and rare, yet if one could have counted the number of separate titles, one would have found a good many about, including those that were compilations of the knowledge in the other books. Encyclopedias make their start with Isidore of Seville's in the 8C and reach the 15th with that of Bartholomeus Anglicus. From Spain, where (as we saw) a high Arab civilization lasted for those same 800 years, a great deal of scientific and philosophical knowledge flowed into northern parts, matching the goods and refinements, also of eastern make, that the crusaders brought back.

By oral tradition ultimately written down, the Middle Ages enjoyed a vast literature, so vast that it has not yet been entirely studied and ticketed. The cycle of stories about King Arthur and his knights has already been mentioned. Other figures and legends have likewise fed the modern imagination after filling the medieval: Roland and Oliver, Tristan and Isolde, Parsifal, the Nibelungen, Beowulf, Burnt Njal, and other characters in the Icelandic sagas. Huge epics about Alexander the Great or *The Romance of the Rose* or *Bertha Bigfoot* need for their appreciation a different training from that on the market today. The shorter works of poets were in strict forms meant to be sung; of these the ballade has remained in steady use. By the side of this output we have their poems in Latin and mainly on religious themes, the first in the West to use rime. The modern listener to a *Te Deum* or *Requiem* who reads the text samples the style. [A selection to read is in *Medieval Latin Lyrics,* translated by Helen Waddell.]

The cargo of poetry and wisdom in those and other than popular works

may be gauged from the summary statement that Chaucer in the 14C found
in the literature of the Continent "a wealth of romances, lives of saints, *contes,
fabliaux,*° drama, history, biography, all of great interest and importance."°
Chaucer's own output in the 14C forms a kind of anthology of high medieval
literature. Reflected in it is the place women occupied in the culture and life
of the time, a mirroring that as always must be adjusted by what appears in the
histories and official records. During the crusades women necessarily had a
hand in the management of households and estates. As widows or regents
they ruled counties and dukedoms and sometimes kingdoms, for example:
Matilda of England, Eleanor of Aquitaine, Blanche of Castille, Isabel of
Spain. [The book to read for the lives of outstanding figures, including two
women is *Medieval Lives* by Norman Cantor.] The world for obvious reasons
remembers most vividly Héloïse and Joan of Arc (properly *Darc* and no *of*).°

In the *fabliaux,* popular pieces in the vulgarest comic vein that criticize
every habit, class, custom, and institution of their day, it is possible to find
hostility to women. But given the other subjects that are equally attacked, this
testimony needs interpreting.° The vicissitudes of marriage expose the
women to satire—and the men as fornicators, the jokes being the eternal
ones on the subject. Nobody has ever believed that they apply to all men,
women, and married couples. [The book to read is *The Fifteen Joys of Marriage,*
translated by Richard Aldington.] By the 14C the literary and other evidence
shows women as men's social and intellectual partners. The good society as it
is then conceived and shown in practice could not exist without them. In that
very time we meet a witness who is also a professional writer,

Christine de Pisan

Christine was the daughter of a Venetian who held office in France. He
educated her and provided a husband with good prospects at court. But soon
the king died, the father lost his post and died too, followed not long after by
the husband. He left Christine with three children to rear. Knowing Latin and
Italian, besides French literature and the manners of high society, she put this
capital to use in a stream of works in verse and prose—manuals of etiquette,
ballades, rondeaus, virelais, and other pieces for special occasions, all graced
by fulsome dedicatory epistles.

Christine missed no chance to defend women and their rights, notably in
her *Epistle to the God of Love.* The cause was taken up by another poet, Martin
LeFranc in *Le Champion des Dames,* and the issue became a free-for-all known
as "*la querelle des femmes*" (<131). This episode makes clear a point in the per-
during "woman question," namely, that there is a difference in the status of
women, which has varied from free in the Renaissance to depressed in
Victorian times, and different again in law, in custom, and in common talk. It

is a difference which, with variations, applies likewise to the status and rights of men and of children too. Society hardly ever follows its blueprint, a fact that makes comparisons extremely difficult and judgments more than usually fallible.

At the origin of the woman question in modern times is a medieval novelty called courtly love. It probably accounts for Christine's addressing her book to the god of love. The troubadours and *jongleurs,* the poet's accompanist on the lute, invented romance. While it lasts, it is a state of being like no other—out of bounds in relation to society and yet in many ways conventional. It has nothing to do with marriage, which is a means of cementing alliances and redistributing wealth among families. A marriage may be contracted for, rather than by, a boy and a girl before their teens; nor does the institution shy at pairing an old widower with a young girl, complete strangers to each other. Arranged marriages still obtain in many parts of the world; and where obsolete as in the West, members of the family still interfere as of right. Romance re-installs the state of nature and re-asserts the individual will.

This medieval institution is called courtly, because it is grafted on the ideal and ritual of chivalry—the ethos of the warrior on horseback. When 12 years old, the page, in order to become a knight, goes through a long night's vigil in prayer, and he vows to fight only for pure causes, such as aiding the weak and distressed. Channeling the adolescent emotions, this program includes Woman—not just attractive women—but Woman as a sex. The beloved must be married, not a young girl still at home, and the marriage vow must be respected, both on religious grounds and to ensure the legitimacy of offspring. Notwithstanding the bold words amid the sighs, poems, and tender messages, the passion must remain ideal, often no doubt, in the teeth of temptation. The lecherous Dante's worship of the nine-year-old Beatrice, Petrarch's distant devotion to Laura were romances of courtly love. [The anthology to read is *Medieval Lyrics of Europe,* translated by Willard R. Trask.]

> Fair, sweet lover, why did I not do all that you asked of me? The churls whom I feared hindered me so that I could never reward you for your service.
>
> —DUCHESS OF LORRAINE, "ELEGY" (13C)

In parallel fashion, the mystics such as St. Teresa of Avila direct their pure love to God. That they use the language and imagery of earthly lovers does not debase their attachment; it only shows the common ideality of the two desires. Conversely, modern romantic love makes free use of the religious idiom. The beloved is an "angel," her nature "divine"; the lover declares he is in heaven in her presence. It is foolish to laugh or even to smile; much of the best poetry of the world has sprung from this adoration, as it has from the religious passion. It is easy to see how the ideal can degenerate into mawkishness, and equally easy to sympathize with women's irritation at being worshipped—"put on a

pedestal." It makes either staying there or jumping off risky and ridiculous. Still, by depicting woman as a being instead of an object of political, economic, and marital utility, courtly love established in theory the rights and privileges that women deserve and that many have enjoyed in reality, beginning with respect of their person and admiration of their qualities.

For to suppose that from antiquity they have been uniformly oppressed, used as drudges by their husbands, as chattel by their lords, is to accept a stereotype and forget their possession of the very qualities women want to vindicate: intelligence, self-respect, and resourcefulness in exerting their native powers. There have always been brutes, of either sex, for the reasons stated earlier. Until late in the Middle Ages men were doubtless more bestial than in imperial Rome or the 18C salons of Europe; and it is plausible to think that courtly love was a softening influence. Still in the comparative mode, it must be pointed out that the brutish type fills the daily news today, when we have no courtly love to bring to bear on their rugosities. Romance exists, and it is a refugee from the reign of the sexual, to which "courtly" does not apply.

<p style="text-align:center">*
* *</p>

One more topic needs attention before this interlude comes to a close. The Middle Ages were far from indifferent to the past, but their way of looking upon it was not the same as our "sense of history"; or to be more exact, the sense developed in the 19C and which is fast fading (775>). The Middle Ages welcomed any books and traditions that told them about the Roman empire; and the learning transmitted by Arab and Jewish scholars (<231). But what medieval writers themselves produced in the way of history was of a different cast.

They compiled chronicles, a day-by-day recital of events, into which might be interwoven hearsay about previous or remote incidents. These works are valuable for their firsthand factual reports, but in these and other types of medieval literature the unhistorical mind is betrayed by the authors' failure to perceive differences of time and place: under Providence life has been the same as we see it to be; the past is uniform with the present. What interests the medieval writer is the details of visions and miracles, of sin and repentance, which explain events and individual lives. Medieval biography follows a like moralistic and theological interpretation of earthly doings, the lives of the saints being rich in lessons and miracles. Some are nonetheless informative, pleasant to read, and models of the narrative art. Toward the end of the Middle Ages, the accounts by Villehardouin, Froissart, and Commines of their own deeds contain much about their times and their travels, but without evincing that perpetual awareness of time and change that has become congenital since their day.

And yet it is a fact, a stupendous fact, that a whole literature has come down to us from the ancient world thanks to the tireless activity of the medieval scribes. They copied and recopied the texts, apparently without noticing Difference in what that literature portrayed. This is one of the great paradoxes of history. For if we suppose that this blindness came from contempt for pagan society, why spend time preserving its records? Enough minds must have been in some way captivated if certain parts of Cicero or Tacitus were among those that the delegated Brother read aloud at meals. And then, for lack of cultural context (so to speak), that interest had no sequel. In any event, the modern world must remain grateful to the medieval copyist for copying, not only the local chronicler's exciting pages but also the scattered remnants of the previous civilization.

Careful with your fingers! Don't touch writing! You don't know what it is to write. It's a crushing task; it bends your spine, blurs your eyesight, creases your stomach, and cracks your ribs.

—LATE MEDIEVAL MANUSCRIPT

PART II

From the Bog and Sand of Versailles to the Tennis Court

The Monarchs' Revolution

Puritans as Democrats

The Reign of Etiquette

CROSS SECTION:
The View from London Around 1715

The Opulent Eye

The Encyclopedic Century

CROSS SECTION:
The View from Weimar Around 1790

The Forgotten Troop

The Monarchs' Revolution

ONE REVOLUTION calls forth another. When the Protestant Revolution of the 16C had done its best and its worst while destroying unified Christendom, its worst—namely the protracted war of sects—hastened the Monarchical Revolution of the 17th. Its twofold Idea was "monarch-and-nation" and its double goal was stability and peace. The sects had challenged or broken authority everywhere; some means must be found to restore order through a new loyalty and a new symbol.

The symbol was *monarch,* not king. There had been kings in Western Europe for a thousand years, but no matter what their ambition had been, they had remained "first among equals" rather than "one and only." Their peers, the great nobles, had endlessly challenged or infringed their authority, fought to usurp their title, and ruled like kings large parts of the country. Each was the legitimate force in his own county or dukedom. As a result boundaries were always shifting. What was France? Burgundy? Italy? Austria? Savoy? Wholes or parts, they were at the mercy of rulers seeking wealth and power by conquering provinces not only nearby but far afield. France and Spain fought in Italy to annex some piece of it, just as the English had done in France for centuries. Indeed, for 400 years after their departure, the English in their coronation service continued to claim France as part of the king's realm and to sport the lilies of France on the English coat of arms. Within each country, strong nobles kept enlisting the aid of some foreign king to dislodge their own and take his place. The idea of a *nation,* a continuous, stable territory with an increasingly homogeneous population, was hardly clear in theory, let alone in practice.

Nation implies the nation-state, the one source of authority, just as *monarch* when compared to *king* means undisputed rule by one alone. This double development—king into monarch, realm into nation—is the mark of the revolution, in keeping with the definition given earlier (<3): a violent transfer of power and property in the name of an idea.

This change in the meaning of kingship and country did not take place all

at once throughout Europe. Local traditions and the chances of war and of character in kings account for the variations of speed and of phase that made this revolution take about 200 years. If this seems odd for "a revolution," remember that revolution is a process not an event. We think of the French Revolution in capsule form—1789 to '94, but what occurred then had antecedents in polemics and practice, and the Idea of the outbreak—the rights of man, equality, suffrage, and "no king"—took 100 years to be finally accepted, either in France or among the other western nations (548; 587>). As for the idea of the nation-state, it is still in the future for some peoples in various parts of the world. Their struggles are a remote consequence of the revolutionary monarch-and-nation idea, as well as a paradox in our time, when kings are few and the nation as a form is falling apart in the countries that first made it a reality (774-776>).

The story of that accomplishment is long and complicated and need not occupy us at length. A reminder of a few facts will suffice to show the pattern. In 15C Spain, the union of the kingdoms of Aragon and Castile through the marriage of Ferdinand and Isabella was enhanced by the conquest of Granada and the expulsion or assimilation of the Moors and the Jews. The local assemblies were gradually subdued to the central power, the very test of monarchy. In the 16C Portugal came under Spanish rule but broke away after a half century, making two nations in the peninsula.

In England, again in the late 15C, the Wars of the Roses (coalitions of great lords) came to an end, also by a marriage and a victory, and the first two Tudors ruled almost as monarchs. Henry VIII had to face one rebellion, and by Elizabeth's time internal troubles returned and weakened autocratic rule. Tried again by Charles I it collapsed in the Civil Wars (263>). Not until the Glorious Revolution of 1688 (no revolution but a glorious compromise) was the English monarchy a solid institution. Two failed attempts to overthrow it in the 18C showed its strength. Note in passing that after 1066 the English never had a line of *English* kings: William the Conqueror was Norman; the Plantagenets were French; the Tudors were Welsh; the Stuarts were Scots, and the Hanoverians, German. These shifts and turns no doubt helped Parliament to retain powers that a sustained monarchy might well have extinguished.

In Sweden, the Vasa family succeeded early in governing the entire Scandinavian region, and did not falter, despite the death of Gustavus Adolphus in the Thirty Years' War and the abdication of the wondrous Christina (<207). Poland in the late 16C was a nation in spirit and seemed to have a sole ruler, but unhappily he was an elective monarch, and one particularly hamstrung, because the nobles who chose him enjoyed each a veto on the acts of the law-making body. It was institutional anarchy and contradiction. The two semi-nations, Netherlands and Switzerland, created by the

comprehensive treaty that ended the Thirty Years' War, managed their affairs without a monarch by schemes as composite as their group of provinces. Two larger, indefinite regions, known as Germany and Italy, were unable to overcome their past and seize the benefits of the revolution. They remained divided into small units for another 200 years, suffering the harm of division and causing harm to others by their tempting weakness.

<center>*

* *</center>

On hearing the words *absolute monarchy,* one is likely to think of France and of Louis XIV in particular. There is truth and error in this association of ideas (284>). What is true is that for the concrete details of the monarch-and-nation scheme, 17C France is the place to look; it supplies them most fully, and well before Louis XIV. The French kings and their ministers from the 15C onward worked to control the nobles, to round out the territory, and by being careful about money to become independent. This last is the all-important requisite. A king is a monarch when he holds the monopoly of war, and this means money for a standing army. Money also confers the monopoly of justice, taxation, and coinage—all this made secure by a legion of civil servants to enforce the rules. These indispensables presuppose direction from a center. Monarchy implies centralization. Without it, the well-defined region called nation could not be a nation-*state.* Its agents replace local authorities and govern as uniformly as possible. Thus bureaucracy is born or at least greatly expanded.

The mastermind who set up such a system in France was Cardinal Richelieu, minister to Louis XIII for a quarter century. He did it in the teeth of plotting nobles and clerics bent on thwarting him. Dumas' *Three Musketeers* gives a good idea of Richelieu's corps of henchmen and spies and the hatred he and they incurred. Under his rule the nation solidified—foreign powers were kept at arms' length, the dissident Huguenots restricted to specified towns, and the nobles cowed by conspicuous and unexampled executions as lawbreakers.

One peculiar measure that was also needed had to do with an ancient cultural institution, the duel. Its prohibition goes back to the previous reign, when the annual toll of casualties in the pastime was high enough to alarm the Duke of Sully (<185). One might suppose that a king aiming at monarchy would rejoice. The bumptious and braggart who go in for dueling as a sport might as well dispose of one another. But of course, that breed might make up only half the participants, the other half being decent, peaceable subjects forced into fighting by the code of honor. And these, if killed or maimed, would be a loss to the country. Richelieu's severity did not put a stop to the custom or the needs that it served.

Conflicting interests were at stake: if monarchy promises law and order, all types of brawl must be forbidden, all disputes settled in court. But dueling exists because it settles matters that courts cannot take notice of—insults, offenses against dignity or against women or elders in one's family. When pride is high by reason of rank, honor can be compromised in a thousand ways and tolerating affronts is either cowardice or lack of self-respect. Besides, a duel settles matters between individuals and is thus more rational than the blood feud that keeps two families (those of Romeo and Juliet come to mind) killing each other off after the original offense. With dueling not only is there an end, but the wiping out of the insult is accomplished not by stealth or ambush but according to rules under the supervision of seconds.

Despite these advantages, dueling is seen today as not quite rational enough, although there are occasions—say, of unpunishable cruelty or injustice—that make one long for redress through single combat. Our enlightened century has in fact witnessed a return to a kind of blood feud. Instead of the family, it is the local clan or gang or sect. Schoolchildren are keen for it, and so are criminals, the Mafia, the inhabitants of Northern Ireland, Lebanon, Corsica, and other places at present known to all.

This vendetta-style warfare gives a measure of the force that monarchy tried to repress. It succeeded to some extent, but appeal to sword or pistol kept playing a part in political and cultural history. It killed Galois, the young mathematical genius; Pushkin, the first among Russian poets; Alexander Hamilton, the leading statesman of his generation. In modern France, from Armand Carrel, the political theorist of the 1820s, down to Clemenceau, the head of state a century later, duels put at risk the lives of a large number of statesmen and writers. It lasted democratically in the American West, later proving a boon to the movie industry.

The desire for self-vindication is deeply ingrained in western man. In the 17C it was called "the point of honor." Its moral force derived from medieval chivalry, which regarded the knight as the champion of all that is noble and fair and as an independent judge in his own cause. No monarch wanted his subjects to lose all of these qualities, and the ethos persisted. When Montesquieu classified forms of government in the 18C, he assigned honor as the mainspring of monarchy. It implies loyalty, honesty, and courage, which remove or reduce the need for inspectors and written codes of ethics.

One also sees in the triumph of monarchism under Louis XIV the shift that Burckhardt pointed out, of the thirst for honor into "honors"—titles,

The sense of honor is of so fine and delicate a nature that it is only to be met with in minds which are naturally noble or cultivated by good examples and a refined education.

—Sir Richard Steele (1713)

Honor lies in honest toil.

—Grover Cleveland, accepting the
Presidential Nomination (1892)

decorations, favors slight in themselves but of infinite value, such as being spoken to by the king before anyone else among a cluster of courtiers. Topping all these, honor for the nation was served by glorious action in war. Though muted in the late 20C, the popular response to a victorious general (or woman prime minister) is still the same. As for the love of titles and decorations, it has become the rage in the democracies—prizes for everything and everyone. Montesquieu miscalculated when he made virtue the mainspring of republics.

<center>*
 * *</center>

No king wanting to be monarch could succeed by means of soldiers and bureaucrats alone. Mere coercion would only produce a tyranny, and with tardy means of communication it could not last long. There must be wide consent, tangibly expressed in the form of money paid into the treasury. By the 17C the cost of war had greatly increased: cannon and firearms were more expensive than bows and arrows, and national defense was now based on enormous fortresses built on scientific lines (>313). The great sums required gave the edge to rulers of large territories that included prosperous cities. The artisans and merchants who lived there were the future monarch's natural allies in his rise to centralized power.

They had every reason to support him. The nobles were their natural enemies and humiliators, and as anti-national warlords they were lawless disturbers of trade and ravagers of towns. Besides, the bourgeoisie supplied the king's best servants for administering the realm in a systematic, businesslike way. An aristocrat conquers and commands; he does not record and report in ignoble paperwork. Under the illiterate kings of the Middle Ages, the clergy had been their aides; the enlarging demands for able bureaucrats installed the bourgeoisie as the main agency of monarchical rule.

The name bourgeoisie has been put to so many uses since the vogue of Marxism and sociology, that it needs a moment's attention. One of the dullest clichés one encounters in books is: "the rising bourgeoisie." Most often it is represented as emerging in 19C England as a class made up of manufacturers. The phrase also serves to explain various reform movements in England and revolutions abroad; it is made to account for improved police organization and the popularity of the novel. The rising bourgeoisie resembles a perpetual soufflé. For Karl Marx, the bourgeois were the masters of a stage in history, as if aristocrats and peasants no longer exerted any power. After him, novelists and critics used the name as a term of abuse denoting stuffy moralism and philistine tastes.

To begin with, the chronology is wrong. The time of the rising bourgeoisie is not the 19C but the 12th. It was then that after much travail the

towns of Europe began to revive, roads improved, and trade flourished again beyond the town walls. By the beginning of the Modern Era, this trade was inter-European and soon global. The people who carried it on got the name of bourgeois from being inhabitants of the *burg* or town; they were burghers or, in the early American assemblies, burgesses. They were well-to-do; as early as the 14C they were lending money to kings and replacing the clergy as government officials, for they knew how to read and write and especially to count. By the time of Louis XIV they occupied the most important posts and were being ennobled right and left for their services. So the bourgeoisie was not rising 200 years later in the days of Queen Victoria. It was fully risen.

A further error is to regard the bourgeoisie—or any class—as a solid mass of people moving up or down the centuries in concert. If the bourgeoisie (or middle class) is made up of the medieval and later town dwellers, it is clear that at any given time some were wealthy patricians ruling the town; others were ordinary tradesmen, others lawyers, builders, artists and writers, still others shopkeepers, makers of hats and shoes; and some, the shabby genteel, lived on charity. And these categories were occupied by ever-shifting groups. Long before Louis XIV, many French bourgeois had bought themselves a title by buying a piece of land or an office.° Lawyers and the judiciary were such buyers and were known as the nobility of the robe. In England, a merchant's daughter entered the aristocracy by marriage and produced a succession of noblemen and -women whose bourgeois ancestors evidently had finished rising.

Similar results occurred from distinguished service to the state. The Duke of Marlborough was plain John Churchill to start with.° His descendant Winston was content with a knighthood. Generally speaking, the titles of noble families in Europe do not go back much farther than the 15C and a good number were at some point fradulent.° It follows that their stock was originally peasant or bourgeois, there being no other human material that could rise. Besides, within the bourgeoisie as within the aristocracy there are gradations determined by wealth or occupation, by talent, manners, or simple tradition. It is therefore idle to speak of *the* bourgeoisie or *the* middle class or even the petty bourgeoisie as if one knew what one was talking about. One must make clear in any given context what kind of bourgeois is invoked, specifying the distinguishing marks of riches, education, or profession. In the monarchical recruitment from that mixed group, it is obviously the literate and well reared who qualified for service.

In that revolution we accordingly detect the theme of EMANCIPATION. The king is finally rid of his restless rivals scheming to supplant him, and the capable among the bourgeois are now free to exert power over their former oppressors, who feel, if not actually oppressed, deeply offended. The Duke

of St. Simon at the court of Louis XIV resents this topsy-turvy development and writes in his memoirs: "This has been a century of vile bourgeoisie."°

<p style="text-align:center">*</p>
<p style="text-align:center">* *</p>

Like all revolutions, the monarchical looks like a mainly political and economic change, but its origins and effects were cultural to an equal degree. Literature and the arts, philosophy and commonplace states of mind were affected (333>). For example, the word *noble* turned from simply denoting a person (= knowable, worth knowing) to naming an abstract quality that even became a label for certain words (355>). Again, through the idea of nation, the revolution enlarged the scope of one's attachment to the place of one's birth. The words a *native of Italy* would have meant nothing to a 16C beggar in Naples: he was a Neapolitan, if not a son of some neighboring hamlet still closer to his heart. This expansion of citizenship made less personal, more abstract, the feeling of obedience, no longer to the local lord but to the distant king, and finally to the wholly abstract state. ABSTRACTION is another theme implicit in monarchy.

And by way of unexpected effect, the rapprochement between kings and the bourgeoisie led to an amalgam of chivalric ideals and mercantile rigor in material things that became the code of civilized manners for 300 years. This code improved the personality of both noble and commoner, making the one considerate instead of arrogant and the other dignified instead of obsequious. The code lasted about halfway into the 20C.

To find the beginnings of monarchical theory one must go back to the contemporaries of Montaigne and the *politiques* in the late 1500s who wanted an end to civil war in France. Earlier in that century, Machiavelli also qualifies as a forerunner, for reasons that will appear (> 256). But the most direct theorist of the revolution was the French jurist Jean Bodin. His work *On the Republic* (= the state) was no humanist utopia, but a historian's study of governments in ancient and modern times, aimed at defining a government fit for the immediate present. For Bodin, the new system should embody all the good provisions of previous and foreign laws and should be closely tailored to fit the nation—not any nation, but the one in view. This demand was meant to counter the worship of Roman law as the source of all wisdom in political theory; comparative history is the true source (he said) and it shows that the fundamental question for the political scientist is: where in the state is power to be lodged?

For France, Bodin is sure that a division of powers, a so-called mixed government, will not work. Sovereignty is not divisible, though he admits that in some situations a difference may exist between the form of the govern-

It is necessary for the wise government of a people to understand fully its humors and nature before it can expect anything from changes in the state or the laws. For the main foundation of a commonwealth lies in the adaptation of the state to the nature of the citizens, and the edicts and ordinances to the nature of the place, the persons, and the times.

—BODIN, *ON THE REPUBLIC* (1576)°

ment and the type of state—a democracy may be run not by the people but by their delegates. In France, a monarch is necessary. The clashing interests and groups (he is thinking of the Huguenot power and the ambitious nobles) require a power above them all, able to balance their claims in the interests of the whole, the republic or commonwealth.

The only check on monarchy that Bodin would retain was the Estates General, the irregularly summoned assembly that voted new taxes; Bodin was their secretary in the year his book was published. The Estates represented the three orders—clergy, nobles, and commoners—and sat and voted as units after the separate orders had conferred among themselves. Once the monarchy began to prosper under Henry IV, they met only once until 1789, when they took on unknowingly the opposite task of destroying it (423>).

Bodin's *Republic* was widely read in France, influential also in England, and reissued at frequent intervals; all of which shows that the public mind was prepared by other influences to find it good. A thoroughly new idea gets no response. One element of the book's success was that the proposals were shown as practical inferences from history. Bodin had previously urged the value of thinking historically in his *Method for the Easy Understanding of History*. In it he anticipates Montesquieu's idea that climate and soil and their joint products condition forms of government, and that in framing laws these conditions should be taken into account—experience before theory. This belief that history has a present use when properly read is a mark of the modern temper (482>); whole periods and peoples have done quite well without it (<234). Now we take it for granted that the physician is wise to take the patient's history and that the chairman of the board must review the past year in his annual report. To have not only the knowledge but the sense of history is deemed an asset in practical life. This sense detects likeness and difference under the facade and the names of things. To take a crude example, someone who "sees" the same objects when he reads the words *coat, hat,* and *shoe* in a book about ancient Greece and again in a book about colonial America lacks the sense of history.

Its acquisition is not automatic—hence Bodin's *Method*, which sums up what the Renaissance scholars were the first to make clear. Not until Valla, Budé, and others studied texts comparatively did it dawn on them that an author's meaning depended in part on the time when he wrote. The relation was also true in reverse: an author can be dated by his phrasing. Out of verbal

analysis came the notions of "an age," of "period style," and of their trans-
formation into something different. The feeling of fixity, of permanence
under eternal law, which characterized the religious view of life gave way to
the secular view of its ceaseless evolution. Comparative history promotes
SECULARISM.

A little before Bodin, another lawyer, François Baudouin, had suggested
that jurisprudence should be taught historically, so that its rules should
appear not as abstract notions but as practical devices. He wanted men
trained for public office by a combined course of history and legal reasoning.
Infectious history finally persuaded those influential men, the doctors of the
Roman Law, that the first kings of Rome were a different kind of prince from
the emperors in the years of decline. The ruler of modern times (they argued)
should be a composite of early king and late emperor, close to his people like
the former; revered as quasi divine like the latter. These theorists were
preaching to the converted. Most people—lawyers, *politiques,* bourgeois, and
kings too—wanted a central power at once strong and popular.

But there was a minority view. What might be called the native and con-
servative tradition was expounded by the well-named François Hotman in a
book called *Franco-Gallia,* also a best-seller. A master of polemics, Hotman
inveighed against all appeals to the Roman Law that could serve the monar-
chical idea. He urged a limited kingship. The "liberties" of France must not
be wiped out; the town charters, the local and general assemblies, the special
privileges won or bought from lords and kings—this was a heritage not to be
given up: security lay in these, not in a monarch who was bound to be uncon-
trollable.

The title of Hotman's book alludes to the Franks, a free German tribe,
and the Gauls, a free people until the hateful Romans came. This formula for
the racial origins of the nation and its classes was destined to survive its first
use. It played a role under Louis XIV, in the French Revolution of 1789, and
in 19C Liberal politics (295>). Finally, reinforced by other elements, it
formed the core of the murderous 20C theories of race (748>).°

<center>*
* *</center>

With the metamorphosis of king into monarch and of realm into nation,
religion also shifted its position in culture. Laymen, as we saw, replaced clerics
in government, while the longing for a strong central power came out of weari-
ness with sectarian fighting. Religious faith as such did not weaken, but many
saw its ideologies as interfering with governance. What weight, if any, should
they have in the conduct of state affairs? A striking event gave one answer. In
1593, Henry, king of Navarre and a Protestant, was at war to make good his
claim to the throne of France; he needed to win over the Parisians, who were

staunch Catholics. He gave up his Huguenot faith, saying: "Paris is well worth a Mass." Similarly, and about the same time, the future James I of England, a Protestant king of Scotland, was promising to turn Catholic if the leaders of that party would help him to secure the English throne. And during the Thirty Years' War (as we saw), Cardinal Richelieu, believing the national interest to lie on the Protestants side, allied himself to Lutheran Sweden.

Yet the monarch could not be an altogether secular ruler. The separation of church and state was far in the future and indeed has never been complete. In the 17C no monarch could do without the support of the church, Protestant or Catholic. Each had wealth and numbers and the clergy were permanent leaders of public opinion. The devout and the conventional believers were equally firm Christians; for Christianity gave the plainest picture of moral and physical reality. It followed that the consent of the governed was identical with the people's double loyalty to God and king. When James I got his throne he recorded his conviction that "No bishop, no king."

On its side, a national church feels it at once a duty and an act of self-interest to support the legitimate government. The church served the people and the state in ways we have forgotten. The humble parish priest, parson, or minister was the best instrument of telecommunication. In a period that had no press and no wide literacy, the daily sermon was a news bulletin with editorial comment. The people were kept in line not only morally but also politically by the main device of propaganda, repetition. The church moreover was the dispenser of what we know as social services—teaching, taking care of the poor, the sick, and the troubled, and by its recurrent occasions of gathering the people it sustained the sense of community.

Monarchs made one other use of religion: they reasserted the divine right of kings. Much derided in later centuries, because misunderstood, this doctrine was a pillar of the system, metaphysically and practically. At the Estates General of 1614, the bourgeois order made it Article I of their petition; they wanted the king's right to oppose papal interference and to put down the lords made explicit. A decade earlier, James I again, the scholarly king, had published two important works on the subject: *The True Law of Free Monarchies* and *Basilikon Doron* (the royal gift). Both gave offense to some groups, but the dogma proved stronger than the critics. Note the phrase *Free* Monarchies.

As for the people, they needed the comfort of divine right to replace the former means of protection against tyranny—local assemblies, customary privileges, and the like, which under monarchy were neutralized or swept away. Security was now to be found in the renewed scriptural assurance that

And shall the figure of God's majesty,
His captain, steward, deputy elect,
Anointed, crowned, planted many years,
Be judged by subject and inferior breath?

—SHAKESPEARE, *RICHARD II* (1594)

the monarch, though absolute, reigned by the grace of God and exercised power under His watchful eye. St. Paul had said it: God gives his assent to the choice of ruler. Kings had claimed divine authority from earliest times

> **Let him go, Gertrude, do not fear our person:**
> **There's such divinity doth hedge a king**
> **That treason can but peep to what it would.**
>
> —SHAKESPEARE, *HAMLET* (1602)

because it reinforces obedience. The Roman Emperors had done likewise, and the Middle Ages knew that Providence allowed or brought about the events ascribed to this or that ruler. The monarchical revolution made systematic and public a traditional assumption. Divine sanction thus made the monarch right in reason, and not merely by might; his power was in every way legitimate.

At the same time, the theory imposed terms: the king must feel the deepest awe in the face of his responsibilities. If he governs badly, he will suffer. On the other hand, if he does govern badly and the people suffer, it is because they have sinned and are being punished. If the repentant people pray for relief and it is deserved, God will grant it. The king is no ordinary human being: he is "the father of his people"; he does not represent, he embodies them, which is why in his edicts he says We, not I.° The entire scheme is made believable by the fact that Christianity too is an absolute monarchy. Every story and precept in the Bible shows God, the king of kings, ruling the universe according to His will. Prayer is to our Lord, petition to our lord the king. Monarchy and monotheism go together; in heaven there are no struggles such as one sees among the pagan gods and goddesses.

> **Though not known to you, Sire, he feels love for you and sees God in your person.**
>
> —FÉNELON, REFERRING TO HIMSELF IN HIS "LETTER TO LOUIS XIV" (1714)
>
> **Kings, you are gods.**
>
> —BOSSUET, SERMON IN THE LOUVRE (1662)

To the atheist these are empty imaginings, but the atheist should not fall into his own imagining that "no sensible man" ever trusted this guarantee of right with perfect sincerity. When thinkers and populace agree in an interpretation of the world, it is foolish to suppose that they have lost their reason. One has only to observe how believers in, say, Marxism or Islam feel about their teachings. Like these, the 17C divine-rightists found practical evidence of the system's final validity. Consider Mark Twain. He declared that "Monarchy is nothing but piracy"; and in his journal of travels abroad he keeps ranting in the same vein. His dogmatic conviction helps us to understand how most people in the 17C felt about their king and his divine right: like Mark Twain, they knew that the current system and its rationale were the only tenable ones; all others are absurd and wicked.

*

 * *

The thought occurs, why theories of government at all? The forms and devices have varied greatly with times and places, changing with needs and with the push-pull of interests and the ups and downs of armed combat. To find a logical or metaphysical basis for each of these turns of the wheel seems wasted effort, especially since no actual government matches its theory exactly.

The answer is that the western mind has steadily wanted to stand off from its experiences, label them, and put them in a communicable order. There must be reasons other than chance and convenience for what we do or endure. Only by stating principles can argument go on, and argument is unavoidable among people who accumulate traditions and have some degree of SELF-CONSCIOUSNESS. From rationalizing past and present experience it is but a step to promoting change by the same method: propose to the world a new rationale or metaphysics. It works in all fields: art, manners, science—a hypothesis is a projection of what might be—and as in divine-right theory, the new system embodies pieces of the old.

In assessing that theory one should not forget that the more recent dogma of popular sovereignty is but a transfer of monarchical absolutism from the One to the Many. As the king is divinely right, so the voice of the people is the voice of God.° This republican maxim expresses the fact that there is no way of finding on earth a warrant for the topmost authority, the sovereign. The British parliament is as absolute as the worst dictator; the king's possible decline into tyranny is matched by the potential tyranny of the majority.

The comparison should also remind us that absolute does not mean arbitrary. Monarchs from the 17C on ruled more freely than before, as the people wished, but none with total freedom. At least one historian has concluded that France from 1500 to 1789 was a limited monarchy.° Quite apart from the usual pressures of economic interests and influential persons—ministers, favorites, mistresses, confessors—monarchs had to observe not just one code of civil and criminal law, but several sets of custom law and a good many special rights. Some had been accorded by their predecessors, others by their own sales of privileges or grants or charters for revenue. That fact alone was enough to prevent absolutism in the textbook sense.

How do these facts square with that part of the theory which says that the king can do no wrong? That principle is a logical inference from sovereignty itself: the ultimate source of law cannot be charged with making a wrong law or giving a wrong command. Modern democracies follow the same logic when they give their lawmakers immunity for anything said or done in the exercise of their duty; they are members of the sovereign power. Constitutions, it is true, limit lawmaking; but the sovereign people can change the

constitution. There is no appeal against the acts of the sovereign unless the sovereign allows, as when it is provided that citizens can sue the state.

Of course, the monarch can do wrong in another sense—in a couple of senses. He can add up a sum and get a wrong total and he can commit a wrongful act morally speaking—cheating at cards or killing his brother. To make clear the distinction between sovereign and human being, theorists developed quite early the doctrine that "the king has two bodies";° as a man he is fallible, as king he is not. Similarly in elective governments, a distinction is made between the civil servant acting in his official capacity and as a private citizen. Whether a monarch or a president would be prosecuted for a non-capital crime is doubtful; it might seem a danger to the state and the authority of the office. For high crimes and misdemeanors the president of certain nations must be impeached—a laborious process workable only when the head of state is elected for a term and the people is used to frequent new faces. It would not suit a monarchy, of which the root idea is permanence.

So permanent is the monarch that at his crowning the chief prelate wishes him to live forever—and in one sense he does: in the ritual exclamation "The king is dead, long live the king!" it is the same king*ship* (one of the two bodies) that is wished a long life. Stability through continuity is the reason why monarchy is vested in the eldest son of the one family known to all. It was not always so in the Middle Ages. Later, by this device of primogeniture the West has guarded against what has happened from time immemorial in the East: one son killing his brothers (or sisters) to gain the throne, and occasionally the king killing his son or sons to prevent their killing him for the same elevated end. Since such acts may lead to civil war, primogeniture is politically sound and humane to boot. And it contains a lesson of political science: a feature of government must be judged good when for a given purpose it uses the force of convention instead of physical force and its evil chances.

*
* *

Convention is in truth too weak a word when applied to monarchy. Ritual is the more appropriate term; one has only to think of a royal court and what antics it makes people perform.° The acme of ritual is seen at the coronation—in French *le sacre* or the "making sacred" of the new holder of an undying sovereignty. Its pageantry makes such a strong impression on the populace that Napoleon did not disdain it when he sought to establish a line of emperors. Here is a description, abridged, of the crowning of the last of the Bourbons, Louis XVI, in 1774. In symbolism and drama it is no less elaborate and effective than the enthronement of the Venetian doge or the Vicar of Christ at the Vatican.

The *sacre* takes place at the Cathedral of Reims, where it is supposed that

in 496 the Germanic chieftain Clovis was baptized a Christian with his 3,000 warriors and accepted as the first king of a region called France. The Clovis story is pure legend, but so potent that the anniversary of that event was officially celebrated in France in 1996 and sanctified by the presence of the pope (776>). Reims is the chosen place because the holy oil (or chrism), which came from heaven to anoint Clovis, is kept there for all time. It is indispensable to making the king sacred. By it he becomes another person. (Similarly, the king of Madagascar changes his name on gaining the throne.) In 1774, for Louis XVI, the canons of the cathedral went to it at dawn, soon followed by the higher clergy, who set the scene. The archbishop put on the altar the crown, the spurs, the "hand of justice," and the garments of purple silk embroidered in gold and of priestly cut.

By then, all the high orders—civil, military, and religious—have been mustered and arrive in procession to attend mass and witness the unction (anointing) of the king. He is not yet in sight. He has to be fetched from behind a closed door by a delegation of notables. They knock on the door. "What do you want?" asks the king's chamberlain without opening. "We want the king." "The king is asleep." Challenge and response are gone through twice again—in vain. The highest ecclesiastical peer then calls for the particular king: "We want Louis XVI whom God has given us as king."

The door opens and the king is borne in on a litter richly draped. The prelate then delivers a harangue: "Almighty and eternal God, who hast raised Thy servant Louis to be king, grant that he shall secure the good of his subjects and that he shall never stray from the path of justice and truth." The king is lifted bodily by two bishops and brought into the main aisle of the church, the choir all the while singing prayers. He is led toward a group of lay lords whom the king has appointed to hold the ampulla of oil. They have sworn on their lives, and vowed moreover to be hostages, to ensure that no harm shall come to that holy vessel until its present use is over.

Before Louis can receive the ointment, he must swear to protect the church and to exterminate heretics. Thereupon he is presented to the assembly and asks for its consent to the act that will make him king. This is given by a moment of silence. The primate hands the king the Holy Scriptures for him to take the oath of office. The words state particulars such as enforcing the prohibition of dueling. Sworn in, he is handed the sword of Charlemagne. Prayers follow, calling for prosperity to reach all classes of the nation during the reign. For the seven unctions administered to the king, he lies facedown toward the altar; one drop of the holy oil has been mixed with the ordinary kind. He is anointed on the chest, shoulders, top of the head, middle of the back, and inside each elbow.

During and between the main phases of the ceremony, choral music resounds. There follows another harangue by the archbishop, who enjoins on

the king charity to the poor, a good example to the rich, and the will to keep the nation at peace. Yet he also recommends that the king not give up his claims to "various kingdoms of the north." Last comes the clothing of the king, from the shirt to the coat of purple velvet lined with ermine. He is then led to the throne. The archbishop doffs his mitre, bows, and kisses the sovereign, exclaiming in Latin, "May he live forever!" The doors of the church open and the people rush in.

So far, the clergy has been conferring the elements of power. Now it is the role of the nobility to perform the concurring rite. The Keeper of the Seals of France goes to the altar and summons the peers of the realm one by one to participate in the solemn act. They come forward, the archbishop takes from the altar the crown of Charlemagne and places it on the king's head, and the peers raise a hand to touch it in a gesture symbolic of their support. Then a sort of petition to the Almighty that varies each time is recited. On one occasion the wish was made that "the king, with the strength of a rhinoceros, may scatter enemy nations to the ends of the earth."°

In this collection of symbols and vows it is easy to see the layers of historical memory and the practical intentions. These last are akin to the presidential inaugurals in democracies—the promise of prosperity, respect for the laws, regard for the poor, justice for all, and a firm foreign policy.

The visual and musical dressing up under monarchy was in keeping with the tastes of a time when holy days, processions, public prayers, and hymns to the Almighty saturated the daily life of the people with religious feeling. There was entertainment in worship, and nothing else was so well organized as to compete with it. The secular world of today entertains itself in other ways, not less mass-designed, and feels it can afford to do without lavish public rituals. Besides, its desire for government is not the same, less deferent, more greedy. Nothing in any case warrants Mark Twain's imputation that kingly ritual was "hypocritical mumbo jumbo." At the death of a good king the people wailed and wept—at home, in church, in the streets. They prayed between their bouts of grief. The loss was personal and intense and charged with anxiety about the future. Today, such a collective emotion about rulers is felt only after certain assassinations.

*

* *

Except among those whose education has been in the minimalist style, it is understood that hasty moral judgments about people in the past are a form of injustice. But one may forget that hasty intellectual judgments are equally deplorable. On the evidence given above, it is plain that the tenets of monarchical theory answered a need of the century that gave them birth. One has only to read Elizabethan drama or a sampling of Shakespeare to be sure of the

Our moral criticism of past ages can easily be mistaken. It transfers present-day desiderata to the past. It views personalities according to set principles and makes too little allowance for the urgencies of the moment.

—Burckhardt, *Judgments on History*
(1865–85)

fact. Of his 37 plays, the 10 based on English history are about kingship and its duties, legitimacy, and the challenges to it from noble lords. Among his other plays, the greatest deal with the right or wrong claims and ensuing acts of monarchs and princes: *Hamlet, King Lear, Macbeth, Julius Caesar, Coriolanus.*

The same theme enters into *Antony and Cleopatra, Titus Andronicus, Troilus and Cressida,* and *Timon of Athens;* and a number of the comedies down to the last—*The Tempest*—use as framework the familiar feature of usurpation and exile, coupled with the woes of rulers. If one did not know from our specialist scholars that Shakespeare had a perfectly balanced mind, one would say that he was obsessed with "the problem of kingship" and his audience also.

The failure to understand these facts and feelings accounts for a blunder in literary history which is worth a moment's attention. The common notion of Hamlet is that he vacillates. In Olivier's film, the play is called "the tragedy of a man who could not make up his mind." That the play is first and foremost political is ignored. Everybody since Coleridge has concentrated on Hamlet's character and forgotten his situation. It is true that his character is finer than that of his entourage; he has a conscience and does not kill first and think afterward. Killing a king accepted by the populace is not a bagatelle. Laertes is the impetuous boy, put in to make the contrast clear. Hamlet *has* to think and watch, because from the outset he is in danger, a threat to the usurper and his aides; all conspire against him, including, though unwittingly, his betrothed. And he has his mother to consider. His soliloquies show him superior to his barbaric times, but what he thinks must not be taken for what he does. He wipes out the hired killers sent with him to England; he comes back resolved but wary and fails only by treachery.

Two further facts reinforce the corrective view. One is what the warrior Fortinbras says about Hamlet at his burial: he would have been a great king. This forecast would sound ridiculous if through five acts the hero had shown nothing but indecision. The other is the conclusion of a modern playwright that the text of *Hamlet* transposes scenes which, in a different order, would make the action go straight and fast. To appreciate the argument and the result, read *Shakespeare's Game* by William Gibson.

In treating of kingship, Shakespeare has much to say about honor. He uses the word 692 times. The idea can attach itself to many things. Being the apanage of the nobleman, the sign not only of his superiority to the commoner but of his independence from most mundane constraints, honor resents and resists monarchy on two counts: it creates a superior over equals—all are equally subjects of the king. Next, the king can subdue the noble lords but can-

not abolish them; so the conflict between central authority and local power continues. It is what makes the theory of monarchy still interesting; it deals with a permanent issue: local liberties *versus* centralization, unlimited power *versus* limited. The terms differ over time, but not the struggle of interests: states' rights resist federalism, central planning leads to calls for decentralization. Also perennial is the complaint against bureaucracy, the monarchical institution par excellence, because it works with ABSTRACTIONS—rules that impose from the center a uniform law that often fails to fit. And to resist these onenesses is to challenge the very idea of nation, twin of the monarchical.

The ups and downs of this struggle are manifest in events so important that they have been given names—the English Civil War (263>), the American Revolution (397>), the Jacobin phase of the French Revolution (434>), out of which have come the slogans and doctrines of today. The parties are still in conflict, because they express the opposite demands of INDIVIDUALISM and of social cohesion. The cultural aspects are literacy for all, universal suffrage, religious toleration, the opportunity to rise in the world and to participate in government, *plus* all the modes of social security and protection against harm now summed up under the label of natural or human rights (430>).

One result of the union between monarch and nation remains a problem for theorists of government. The king takes a vow of justice and peace as God's chosen steward. Yet as head of the nation he takes away ancestral rights and pursues selfish interests by the deceit of diplomacy and the immoral acts of war. How reconcile the divine sanction with behavior admittedly unjust? (This last issue is called today ethics in foreign affairs.) The contradiction is supposedly taken care of by the phrase *raison d'état*. The reasoning in the *raison* goes something like this: human beings in groups do as they please unless prevented by stronger groups. Observe how, within the nation itself, peace and justice cannot exist without the threat and use of force. It would be unsafe to expect that self-restraint, which fails to control crime in each nation, will deter entire foreign nations whose interests clash with ours and one another's.

Such is the first lesson of political science. It may best be read in the work of its founder,

Machiavelli

The name evokes self-righteous horror; intellectuals tend to want villains so as to show moral sensitivity and Machiavelli ranks highest in that abhorred group. Yet with few exceptions, the great minds in the 16C and since have acknowledged his genius and the moral value of his teaching. The reason for this estimate, as for the others' hissing, is the small book entitled *The Prince*.

He wrote it in retired old age after a career in the politics of Florence,

A principality is created either by the people or by the nobles. He who obtains sovereignty by the assistance of the nobles maintains himself with more difficulty than he who comes to it by the aid of the people, because the former finds many around him who consider themselves his equal, and he cannot rule or manage them. But he who reaches sovereignty by popular favor has none or few who are not prepared to obey him. You cannot satisfy the nobles without hurt to others, because their object is to oppress. You can satisfy the people, for their only desire is: not to be oppressed.

—Machiavelli, *The Prince* (1513)

mainly as ambassador, which had been cut short by a violent change of factions. Suspected of treason, he had suffered imprisonment and torture and finally exile. Seeing with detachment the fate of his city, then the cultural center of the peninsula, and reflecting on its history and that of ancient times, Machiavelli distilled in quick, plain words his direct and vicarious political experience. He thought the time was ripe for "a new prince," who would establish peace and order and even unify Italy. Machiavelli in effect drew the picture of a monarch.

So far the teaching raises no hackles. It is the means Machiavelli proposes for achieving princehood and staying in power that have caused the furor. These ways have given rise to the epithet Machiavellian, which now implies the quintessence of fiendish conduct. (In the vast register of unpublished dissertations there is one entitled *Machiavellianism Among Hotel Employees*. I have never looked it up, preferring to speculate freely about the path of influence from *The Prince* to chambermaids and concierges.) In youth, before coming to the throne of Prussia, Frederick II wrote an *Anti-Machiavel* (a common form of the name in Europe). It is an able argument and no wonder, since Voltaire licked it into shape. It denounces deceit and broken promises in statecraft and condemns unjust war and the elimination of enemies by violence, all of which Machiavelli is presumed to have recommended as the ideal ruler's guide to success.

The truth is rather different and calls for judgment with appropriate nuances. It is best arrived at by recalling the condition of Italy in the early 16C when Machiavelli wrote—divided into numerous towns and city-states, all but one (<171) subject to death-dealing factions, *coup d'états,* assassinations, aggression and defeat in war. For the details, one may read Machiavelli's own *Florentine History*. It was that spectacle, clearly unending, that posed for Machiavelli the question: is there a way or a device for making an end? The facts showed a total absence of moral principle; worse still, the immorality produced no visible good—no peace and quiet for individuals, no stability for the city and its leaders. Yet all of them professed the Christian ethics. Only, they interpreted the "do unto others" as: "I must kill you who killed my first cousin."

Machiavelli's program rests on the conviction that since one must start from the present state of things, one can work only with the material at hand.

It is useless to say, only be good and you will all find life better. The human material at hand (he saw and said) was bad: "Italians are cowards, poor, and vain." This badness must be used to create not good conditions but tolerable ones; both morality and immorality must contribute. The prince must be honest and decent as far as he can and he must certainly uphold the precepts of Christian ethics. He must be just and if possible popular. But he had better be feared than loved. He dare not let ethics keep him from doing whatever evil must be done to preserve himself and the state.

This making the best of both worlds is not a surefire recipe. Machiavelli as historian is alive to the role of chance—fortune, as he calls it. No prince can command it, but if a prince has *virtù*, that is, courage and foresight, and if fortune favors his plans, he can be the new prince that the times call for; he may even unify Italy. One might say that *The Prince* is a utopia that has abandoned ideal measures for possibly workable ones.

Hostile critics fasten on two points. One is that—to put it briefly—Machiavelli gives the show away. Everybody knows that Christian ethics are violated right and left, in plain sight—business, government, private life are riddled with immorality. Christianity says so in the one word *sin*. But these critics think nonetheless that institutions should not be stripped of their façade. If you proclaim that bad faith may serve a state purpose, it will make for more bad faith everywhere. The rejoinder is: unless political theory shows the truth about the occasional utility of evil, the existing forms of evil will continue undiminished and useless besides.

The second criticism rests on an oversight. It is easy to forget that Machiavelli is describing a prince who has to get into the saddle before he can rule wisely. There was in Italy no legitimate line of kings out of which to make a monarch. Lacking legitimacy, the new prince has to do many more indelicate things. His descendant can be more fastidious. In fact, every royal line in Europe had its origin in force. Reading *The Prince* without noting this difference leads to the belief that Machiavelli urges established monarchs to continue being—in his famous metaphor—fox or lion on all occasions.

The ruler's ambiguous moral character makes one see that he cannot behave like a private person—the king has two bodies. As ruler he is trustee for his whole people's interests, mingled with his own. He may not indulge his sentiments, generous *or* vindictive. He cannot give away a province, though a liberal response to others' claims is a virtue; for what would the inhabitants say to being deprived of their nationality? Again, he may disavow an envoy as he would not disavow a friend. "He" throughout is not the king alone, but his chief minister or council or power behind the throne—it is the state, acting on the reason of state.

When young Frederick of Hohenzollern was writing against *The Prince* he no doubt imbibed from it ideas which, contrary to his thesis, helped him later

to make Prussia a power and, later still, to defeat the coalition that intended to crush it. At the partition of Poland with other monarchs he noticed Maria Theresia weeping and he remarked afterward: "She wept, but she took." The words sum up the paradox of government—doing the unjust thing as the way to do the best for the state, perhaps on quite mistaken lines. Hence the ways of the eternal politician, who breaks promises, conceals, palliates, distorts facts to maintain the show of rightness, the rightness aimed at even when not reached.

*
* *

In the five centuries since *The Prince* was written, enough scholars have read it closely to clear the author (at least among the learned) of the character of moral monster. If he were, a long list of thinkers, from Plato (advocate of the "big lie") and Aristotle through St. Augustine and St. Thomas down to John Adams, Lipsius, Montesquieu, Hume, Tasso the poet, Sir Walter Raleigh, Montaigne, Bacon, Pascal, Spinoza, Gracían, Bodin, Herder, Coleridge, Shelley, Leopardi, Dostoevsky, and most historians (including the peaceful and religious Ranke) would form a legion of fellow immoralists. They have advised, approved, or borrowed Machiavellian maxims. The view in which they concur with Machiavelli is that the state is not immoral but *a*moral; half of it exists outside morality.

To this it has been objected that for political theory to base itself exclusively on "things as they are" is to discourage the improvement of mankind; it is "pessimistic," "cynical," a bar to progress. It does not seem to have done so. A good many evils, legal and political, have been got rid of in our half millennium—and Machiavelli wrote at its dawn. As a Renaissance man he found a disparity between the buoyant new arts and letters and the political morass; it called for a remedy. He did not choose half measures, nor did he want them used in perpetuity. In another work, the *Discourses on Livy* the Roman historian, he showed how admirable a republic with liberties can be. On a trip to Germany, he wrote a letter that gives a utopian view of the free cities there, free (among other things) of Florentine plotting and fighting. After his death, the *Discourses* excited some Florentine shopkeepers to such a degree that they called on the government to install tribunes of the people in place of the nobles and other officials.

But again, when he portrayed his contemporaries in the comedy *La Mandragola,* he found no cause to flatter them. The play is witty, vulgar, full of puns and wisecracks that point up the ways in which people are devious, gullible, corrupt, and greedy. The plot makes one think of Restoration comedy and of the later novel by Laclos, *Les Liaisons Dangereuses,* in which the cunning cajole or coerce others into serving the intriguers' own ends.

In his other works, Machiavelli shows himself a true Humanist in taste and style. He translated Roman plays, borrowed from Vegetius when writing *The Art of War,* and wrote verse and prose that show him a lover of women. It was his opinion that they were as fit for rule as men, and he referred to "heroic examples" of their *virtù* and capacity. In spite of his exile, he had a wide circle of friends and admirers to whom he wrote unbuttoned letters. In the most famous of these, to Francesco Vettori,° we glimpse his addiction to hobnobbing with simple people over cards and drinks at the tavern. When in the late afternoon he is through with that recreation, he goes home, dresses in handsome garments, and converses with the ancients, "asking" them about their lives and actions. During these four studious hours he is never bored; he forgets his poverty and disgrace, and does not fear death.

*
* *

The prince or monarch and the nation-state reached their flowering in the 17C, fulfilling the intent of the era's second revolution and implanting ideas that have not lost their power. But simultaneously another set of ideas and another form of government were highly visible facts of the age. The republic of Venice was that conspicuous form (<170); and the Civil War in England was the carrier of those other ideas. Republican Venice, as a stable, orderly city-state, kept fascinating Europe while monarchy and nation became the dominant mode of governance. As for the drama in three acts played out in England between absolutism and its opponents, it had ambiguous results and its lessons were forgotten. When the buried ideas emerged again, ultimately to set off a third revolution, they were attributed to another set of historical deeds, and the name Puritan kept only the narrowest of meanings.

Puritans as Democrats

THE HISTORY OF IDEAS is a string of nicknames. They may start as a crude insult, or again they may carry a fairly definite meaning; even so, they will soon degenerate. Throughout western culture the image aroused by the name Puritan is that of the killjoy. In the United States he is the thin-lipped New Englander who passed "blue laws" against all innocent pleasures, his only pastime being to hang witches. In England, he wore pointed hats, spoke through his nose, sported names like Praisegod Barebones, and after killing the king ruled a country deprived of gaiety. As usual we can turn to Shakespeare for an early snapshot: the Puritan is Malvolio in *Twelfth Night*, who thinks that because he is righteous there will be no more cakes and ale.

The trouble with this portrayal is that it omits much, takes one feature for the whole set, and yields a caricature. What brought the false face into being is perhaps that in England the Puritan regime of Cromwell and his army petered out and was repudiated after a dozen years. Defeat, unless it is dramatic and poignant, blots out the memory of things accomplished. Dim in England, the collective idea of the historical Puritans is contradictory in the United States. There the Puritan settlers, condemned for their ethos, are nevertheless admired as the Pilgrim Fathers—and credited with much that they did not do.

It is not merely concern with historical accuracy that warrants a review of the word and the movement it denotes. Social prophets today are warning against the onset of a new Puritanism. They see it in the so-called fundamentalism of certain religious groups and in the secular animus against smoking. Alcohol is threatened with the same hostility, and the outcry against sexual freedom, "obscene art," and "godlessness" is gaining volume. The violent conflict about abortion is related to these issues. Does this late 20C outbreak of moralism reproduce the Puritan of the 17th? And equally important, were the Puritans of history exercised only about individual behavior? They did not prohibit drink or tobacco, and when they shut down the theaters, they did it (as we saw) to suppress not plays but seduction and prostitution, a policy

that was also enforced by other, non-Puritan states of Europe, when they shut down public baths (<183).

The *pure* in *Puritan* refers to religious institutions and to the political reforms needed to do the purifying, the same effort as Luther's with his Evangelicals: get rid of the bishops and their train of officials; omit the trimmings in the services—candles, crucifix, vestments, and the rest: simplify worship, back to the gospel. It is PRIMITIVISM coupled with a quasi scientific feeling against "Romish superstition" and "popery."

That the gospel rule enjoins good behavior and a consciously moral attitude to life is true, but to infer from this stripping of worship and arousal of conscience that the Puritans outlawed pleasure and the arts goes against the evidence. England and New England were not turned into places of systematic dullness and hypocrisy. Fifty years ago an English scholar delved into the records on both sides of the Atlantic and his findings explode the myth of the Puritan constipated in faith and thought.

The massive book, though called *The Puritans and Music*,° covers the full range of cultural activity. One discovery in it is that the "blue laws" of Connecticut never existed; the reference to them is a fabrication by an overzealous minister. As for the use of music, poetry, and the other arts, not only did the Puritans not reprove them, they cultivated and relished them. This generality of course applies to the self-selected group that in any culture finds pleasure in art and intellect. In mid-17C England the taste for music was widespread, with poetry as its twin. The English school of madrigalists and keyboard composers was numerous—like its audience—and remains one of the peaks in the history of the art (<161). The two poets of like eminence, Milton, who wrote in praise of music and dance and "jollity," and Marvell, who urged his "coy mistress" to yield, were highly regarded. Cromwell employed them to serve the state as writers of sound views and ready pens.

Milton's performance is peculiarly telling. He was a propagandist for the regime but also an independent critic of it. His tract in favor of divorce outlined the qualities of mind that a wife should have to be a good companion. His political sonnets offered comments on the party line, and he inveighed against the censorship of printing. The strongest passage of his *Areopagitica* has been quoted threadbare, but in that same essay his linking freedom of thought with art and pleasure has been overlooked.

His words testify not to his tastes alone, but to those of the whole country. At the same time, Milton served the

If we think to regulate Printing, thereby to rectify manners, we must regulate all recreations and pastimes, all that is delightful to man. No music shall be heard, no song be set or sung, but what is grave and Doric. And who shall silence all the airs and madrigals that whisper softness in chambers? It will ask more than twenty licenses to examine all the lutes, the violins, the guitars in every house.

—MILTON, *AREOPAGITICA* (1644)

Council of State as censor and editorial supervisor of the *Mercurius Politicus,* the leading newspaper of the Commonwealth. This inconsistency with *Areopagitica* is on the surface. Milton and his fellow Puritans never doubted that writers were accountable for the possible danger of their ideas. *Areopagitica* ends with praise of the law requiring authors' names on all publications. If "mischievous," those responsible might incur the "remedy of fire and the executioner."

During the violent reaction against the Puritan regime, under the restored Stuart Charles II, Milton's head was at risk. He had to go into hiding, and in obscurity he wrote the two-part epic *Paradise Lost* and *Paradise Regained,* and the drama *Samson Agonistes,* this last not for the stage but, like the epic, a treatise on morals and politics. Sovereignty; the rule of law; obedience and revolt; truth and its attainment through debate; science, nature, and pleasure; reason and revelation, justice and mercy—all these find their assessment somewhere in the poems. Add the prose works, which are political journalism, and Milton becomes the living embodiment of the battle of ideas in his time. Thousands of pamphlets and sermons record the intensity of the struggle and its thoroughness. Those ideas still agitate the western mind, and the contradictory merits of that mid-17C debate suggest that resolving the conflict is impossible, not because of human ignorance or perversity, but because of the nature of human needs and the hopes that call forth ideas and systems.

<p style="text-align:center">*
* *</p>

The political aim of the parties in the English Civil War was to settle the question, who is sovereign in England? In effect this was to test the strength of the monarchs' revolution. When Charles I tried to overawe the nation's elected representatives and to keep on ruling alone as he had done for 11 years, he only made their resistance more stubborn. The monarch by definition is he who holds the monopoly of taxation and war (<241). Parliament's demands were, first, that the militia and all fortified places be put under the command of officers appointed by Parliament. The second similarly denied the king sole authority: recently made peers could be unseated by the Commons; even the royal children's guardians must be appointed by Parliament. The king would cease to be a monarch. He would hardly be a king, old style, but a figurehead. Evidently, the representatives of the English people in the mid-17C had a vision of the country as it came to be ruled 250 years later; or conversely, as it would have been ruled 300 years earlier if Simon de Montfort's program had been carried out when the king's Great Council was first called Parliament. That early hope failed, and by the 1640s the royal tradition was so strong that in the half dozen years of the civil struggle, Charles was nine times offered a chance to keep his throne; he only had

to accept some modified form of the original 19 demands. When he agreed to the last approach, but with further modifications of his own, it was too late.

The English Civil War was not clear-cut like the one that split the United States in the 19C. England's closest neighbors were messily involved: Ireland gave the king troops; the Scots were divided and fought on both sides, their concern more tribal and religious than constitutional. Parliament was largely Presbyterian, the army under Cromwell was Independent—Puritan. The London mobs that periodically staged protests were unpredictable. The royal forces won the first battles; their ultimate defeat showed that Cromwell had in fact trained a model army. But the conventional picture of Cavaliers (Royalists) with long hair and floppy hats against close-trimmed Roundheads is a fiction. There were lords and gentlemen on the parliamentary side who continued to wear their usual "cavalier" dress and there were Puritans whose tenets required long hair.

Out of these motley elements a republic—the Commonwealth—emerged: the two words translate each other. Then, when the republic became ungovernable, a Protectorate followed, with Cromwell as Lord Protector. In the midst of these events, Charles was tried and executed, an Irish rebellion was fearsomely put down, the Scots were semi-pacified, Parliament, showing great elasticity, was purged and restored and re-purged; and England had her first and only written constitution. A demand for one is being heard as this 20C ends.

The notion of some historians that the conflict arose because English agriculture was backward and landholders suffered in the expanding international trade, thereby setting them at odds with the merchant class, requires one to believe that a whole generation argued, preached, published, denounced, condemned, went to prison or to the block in a state of pure illusion as to their real motives. They were moved (according to the class warfare view) not even by economic self-interest but by their diverse relation to the means of production. It is the tectonic-plate theory of earthquakes applied to human affairs.

That the English wrapped up every idea and attitude in religious language and used precedents from Scripture as their best authority gives the period the aura of a struggle about obsolete causes. But these causes were double, and the ideas hidden by the pious language were, as is foolishly said, "ahead of their time," meaning pregnant for the future. The sects and leaders classed as Puritans, Presbyterians, Independents, were social and political reformers. They differed mainly in the degree of their radicalism.

Now, social reform must appeal to some accepted standard. In our day it is the general welfare, or the needs of a neglected group, or the desirability of more trade for employment and a better standard of living—in a word, utility of a material kind. The Puritans, many of whom were called Levellers, agi-

tated for equality of rights and condi-
tions. Soldiers and officers serving in
the army demanded a decent living for
all. Allowing for inevitable deviations
by individuals and using modern words
to suggest rather than define tenden-
cies, the Anabaptists were commu-
nists, the Ranters were anarchists, the
Diggers were collectivists, and the
Fifth Monarchy men were utopians
awaiting the Second Coming of Christ and the absolutist rule of the saints.

Sir, I see that it is impossible to have liberty but all property must be taken away. If it be laid down for a rule and if you will say it, it must be so. But I would fain know what the soldier has fought for all this while. He hath fought to enslave himself, to give power to men of riches, men of estates, to make him a perpetual slave.

—COLONEL THOMAS RAINBOROW, M.P. (1647)

Still others, such as George Fox and his disciples, the Friends (later
Quakers), who would not take off their hats to anybody, were egalitarians too.
The Millenarians worked to establish the New Jerusalem, the reign of the
saints on earth. The Familists, emulating the Holy Family, taught that love
inspired by faith sufficed to maintain society—no need of laws or ranks. This
type of anarchism is perennial in the West—witness the Flower People of
1968.

The drive toward something close to democracy came from these
Christian sects which, by later accepting the status quo, are not remembered
as revolutionary. The Anabaptists were still political, though no longer favor-
ing communism and polygamy as they had been under John of Leyden (<15).
And the groups bearing the Dickensian names of Muggletonians and
Brownists showed how readily a headstrong preacher or pamphleteer could
gather around him a crowd of followers demanding a better world. All were
certain that it consisted in one or another overhaul of the present church and
state.

It had to be church *and* state, for no people had ever lived in a state with-
out a church, and any reform in the one must affect the other. After all, it was
the Evangelicals, with their doctrine of EMANCIPATION from the Roman
hierarchy, who had started the whole unrest. The steps to greater freedom
followed logically: why lords and gentry? When every congregation was inde-
pendent and elected its minister, the whole people should be politically
empowered through the vote. The religious parallel was decisive: if a purer
religion, close to the one depicted in the gospel, was attainable by getting rid
of superiors in the church, a better social and economic life, close to the life
depicted in the gospels, would follow from getting rid of social and political
superiors.

The monarchs themselves had recognized the analogy. Charles I's father,
James I, had said that without bishops the king would not last long. The
clergy as a whole sustained royal authority by exerting theirs directly: from the
pulpit they spoke every day to every man, woman, and child. Monarchism had

prospered on the Continent only when both nobility and assemblies were neutralized. The position in England differed: Parliament, of which the lower house—the Commons—had stood up to the king more than once, was accustomed to lawmaking. But now the spread of proposed reforms split the body that had been at one against the king, and with an army in being that held militant political views, orderly legislation by majority rule succumbed. Trying to remake the whole state led to dictatorship.

To follow the parliamentary history of the Civil War would not add any ideas to those so far mentioned. It is the vast pamphlet literature that shows the full variety of the period's original and constructive thought. In the clamor of economic proposals and biblical quotations the common man must have found it hard to decide who was right. Every amateur thinker had a scheme of his own.° The professional resorted to a type of argument characteristic of western culture, the appeal to things that all parties must acknowledge as real and potent. These were the familiar pair of backstops: Reason and Nature. As pointed out earlier, although they sound universal and compelling (<69), they only seem to be sturdier than other props.

The Puritans who appealed to reason in support of popular rights pointed out that human institutions were a matter of choice designed for a purpose and maintained by custom. They should be changed when the purpose was no longer served. Mere length of time—custom—is arbitrary, not in itself a reason. Consciously or not, some of the Puritans shared the scientists' trust in experience, in results, in utility. With these tests one could condemn any part of the status quo. The great lawyer of the period, Sir Edward Coke, made it a maxim that the common law was the embodiment of reason; it followed that judges must not only give reasons for their decisions, but must use reason to iron out the kinks created by bad cases. Coke himself did a piece of rationalizing when in one of the early parliamentary scuffles before the Civil War he seized on Magna Carta, which was then unremembered, and smuggled into the lore about the document rights that the 13C barons had not dreamed of. (*Magna,* by the way, meant that the charter was long, not necessarily great.)

Nature is the twin of reason in that both are *given*: man is the reasoning animal by nature, and nature is what man finds ready-made to be reasoned about. It acts apart from his will and wishes. Many Puritans thought that God was to be known in and through nature. Natural law and natural rights seem plain when one argues about fundamentals; for instance, that every human being has a right to live unmolested, that government is needed to ensure that right, and that man-made laws must serve and not defeat natural rights. If any civil law does work against a natural right, the law of nature warrants disobeying the law and even overthrowing the government.

These reasonings are familiar to those who remember the preamble to

the Declaration of Independence and who read current debates about the contents of social justice.° The 17C produced two great works on what the polity should be. The best known, Hobbes's *Leviathan,* set forth with finality one line of reasoning on this ever-open question. It is written in splendid prose, yet the author's contemporaries were not sure which camp Hobbes belonged to. He was praised and pelted equally by Puritans, Presbyterians, and Royalists. Another point of interest is that the opening chapters form a little treatise on psychology. It is plain that government must be based on Nature—the nature of man. But as soon as that nature is defined, political theorists disagree. Hobbes saw man in the state of nature as an aggressor; man is a wolf to man. Unless controlled, he and his fellows live a life that is "solitary, poor, nasty, brutish, and short." From these premises reason concludes that government must be strong, its laws emphatic and rigorously enforced to prevent outbreaks of wolfish nature against other men.

Hobbes saw how England had drifted from repeated acts of lawlessness to civil war, a type of war that is always brutish—and not short. No compromise could reunite men under arms, who were doing "God's work," and other men, who were bent on saving king and church, law and order, tradition and property. In that war, worse than the battles were the sieges of towns; most casualties took place there—starvation and plague, often followed by massacres that did not spare women and children. At Leicester the Royalists' plunder and killing knew no bounds. Revenge was meted out by the Puritans at Naseby, where the enemy's camp followers—servants, hostlers, and mistresses—were slaughtered with a will. From near the beginning, the war brought penury to artisans, drovers, and others who lost their employment, and sent beggars and cripples and marauders over the land. The lives snuffed out is estimated at 200,000 or two and a half to three percent of the population.

Long years of such a spectacle stirs the mind to reflection on the makeup of state and church. For Hobbes, the only viable state is one headed by an absolute ruler and lawgiver. The title of his book *Leviathan* and the frontispiece illustrate its theme: it is a monster whose body is made up of the bodies of all the citizens of the state—under one massive head. Their individual strengths are fused in the sovereign, and this union is the fruit of a contract not subject to revision.

At first sight, Hobbes looks like a partisan of the monarchs' revolution and one wonders why the Royalists did not embrace him. But the absolute that he argues for is a sovereign; he does not say a king, much less *the* king-in-waiting, Prince Charles Stuart. The members of the Commons could therefore find in *The Leviathan* the justification for an absolute Parliament. As pointed out earlier, that is exactly what England is ruled by now. It is an elective Leviathan with royalty like a dab of whipped cream on top.

The second work of the period, which surpasses all but Hobbes's by its

orginality and foresight, is *The Commonwealth of Oceana* by James Harrington. Although it describes the ideal state, it does not belong to the utopia class. Harrington, born of noble stock, was from early life a republican. He nonetheless earned the regard of Charles I and failed at first to win Cromwell's. In fact, *Oceana* was seized midway in its publication during the Commonwealth and came out only later, at the urging of Cromwell's daughter.

Oceana is a republic whose instigator resigns after he sees it well established. It has a written constitution, a legislature of two houses, rotation in office, and a president elected indirectly, as in the later Constitution of the United States, by a secret-ballot vote of all citizens. To ensure stability, Harrington is at pains to demonstrate that the political power and the economic must be in agreement. Where the two are at odds, there is trouble and soon revolution. This acknowledgment of the power of wealth was previously made by Aristotle in his *Politics,*° and it is the basis of the modern commonplace that for democracy to be born and survive there must be a large middle class flanked by as few rich and as few poor as possible. This need justifies the legal and populist resistance to cartels, trusts, and big business when it gets too big. It also explains the 20C collapse of democracy into dictatorship in Central and Eastern Europe, in South America and the many new 20C nations of the Third World, and elsewhere: no middle class means no habits of self-restraint and compromise such as are generated by trade.

Clearly, Harrington was a political mind of the statesman type rather than the theoretical, and it is a pity that, as in his own time, his views and fame have filtered mainly through specialists—except in the United States, where Jefferson and other democrats read his work with care and profit. After 1660, Harrington suffered the odium of being a republican and of having a cousin who was a regicide. Excluded from the general amnesty, he was imprisoned and released only when ailing in body and in mind.

*
* *

To grasp the tenor of Puritan politics one should wade through all the pamphlets—a life's work. The next best thing is to read *The Rise of Puritanism: The Way to the New Jerusalem* by William Haller. Strange and wonderful characters emerge from the mass, including vigorous women preachers. We have already met Milton as the literary representative of the myriad debaters. For the activist role, the agitator who risked his head, the obvious choice is

John Lilburne

He was the son of a gentleman from Durham, but for some reason he was apprenticed at the age of 12 to a clothing merchant in London. There,

while still in his teens, he showed his lifelong trait of rebelling against things as they are. He was full of ideas, which he urged as aggressively as he could. Having decided that the Church of England was the Church of AntiChrist

I dare not hold my peace, but speak unto you the things which the Lord in mercy hath made known unto my soul, come life, come death.

—LILBURNE, SPEAKING TO THE CROWD (1638)

(being then 24), he fell foul of the Court of Star Chamber for importing and circulating subversive tracts, notably some by the anti-bishop sectarian William Prynne, to whom Lilburne had become law clerk. Lilburne was sentenced to be publicly whipped over a long stretch of London streets, and at the end put in the pillory for two hours. He was then to be jailed until he paid a fine of 500 pounds.

The event made him a public figure and popular with the mob. During his two years behind bars, he wrote blasts at large and detailed petitions to the House of Commons. One of these was the occasion of Cromwell's first recorded speech, supporting the request. Lilburne was freed and the next year was granted 3,000 pounds in compensation. To be a victim of Star Chamber was a certificate of righteousness. Lilburne next enlisted in the army, was captured, tried as a rebel, and would have been executed by the Royalists but for the threat by Parliament to retaliate. He was exchanged and returned to the field, rising to lieutenant-colonel. Still dissatisfied—the army was too full of Presbyterian moderates for a radical Puritan—he resigned his commission and devoted himself to collecting his back pay by means of another petition to Parliament. In carrying out this difficult task he used such insulting words about the Speaker and members of the House that he was jailed again, but let out three months later.

He now supported the Levellers and aimed demands and accusations at persons and institutions alike. When he attacked Cromwell in 1647, Lilburne was sent to the Tower but released once more. He clearly belonged to that rare species, which can put its head in the lion's mouth again and again and survive to die of natural causes. Prison was a tonic to the man. His pamphlets became even more personal while expressing his *Apprehensions of a Part of the People on Behalf of the Commonwealth*. He declared *England's New Chains Discovered* (in two parts), and saw himself and four followers as "five small beagles hunting the foxes from Newmarket and Triploe to Westminster," the seat of Parliament. Cromwell and his aides were the foxes. Their misconduct was endangering the army and the Commonwealth. England was groaning under the dominion of the Council of State.

This broadside earned Lilburne another stay in the Tower, but his trial on charges of sedition and scandal ended in his acquittal. Another kind of freedom then engaged his attention: monopolies and chartered companies were unjustly privileged; trade must be free. The reasoning, again, had a biblical

base—the parable of the talents, which must be put to use. An argument from Scripture was hard to counter; no prison term ensued. But an outburst against a powerful guild, which Lilburne believed had done an injustice to his uncle George, proved more damaging to the rebel than all his assaults on Cromwell and Parliament. Lilburne was fined 7,000 pounds and banished from the Commonwealth, under pain of death if he returned. This was in 1652. In 1653 he returned. He had gone to Holland, which was then the asylum country for political and other refugees as England became in the 19C.

In the dock once more, Lilburne, after an unusually long trial, was acquitted; he was the saint and hero of the London populace. At the same time he received a left-handed tribute from the state: he was to be kept captive "for the peace of the nation." In the Channel Islands, and at last in Dover, he simmered down and was finally set free. He turned Quaker and preached that quietest of doctrines until his death at 43.

> Christ doth not choose many rich, nor many wise, but the fools, idiots, base and contemptible poor men and women in the esteem of the world.
>
> —Lilburne (1645)

Lilburne deserves more fame than he has been granted by posterity. Plumb in the middle of the 17C here is a writer who declares and demands the rights of man. His program was the one that has made the glory of the 18C theorists and his behavior has become standard policy for revolutionists down to the present. His handicap is that although at times he invokes the law of nature, his argument is full of biblicisms.

What Lilburne carried whole in his mind, dozens of his fellow Puritan pamphleteers advocated piecemeal. Many called for a republic; the vote for all; the abolition of rank and privilege; equality before the law; free trade and a better distribution of property. Few urged toleration. Again, because these goals were justified out of Scripture, the substance of Puritan political thought has been eclipsed. Later historians' secular minds prefer to read about free trade in Adam Smith than in Lilburne and his parable of the talents. It is easier to credit John Locke than some obscure Anabaptist preacher for the thought that all men are born free and equal. The preacher quoted St. Paul, who said that God has "no respect of persons" and that there is "no difference between Jew and Gentile." Others insisted that God's grace is free—all share in it as they share in Adam's sin. Hence superior rank has no warrant; the only superiority is of the spirit. To rationalists this was no way to argue. Nor did the plea for freedom seem sincere when many of its proponents, Cromwell included, thought that they were close to the end of the world.

This failure of understanding and sympathy marks a great divide in the Modern Era. It takes place neatly around 1750, the midpoint of the 500 years. Religion, it is true, did not disappear along with the Puritans themselves; but

the progress of science made Nature more and more convincing than Revelation as a source of truth. God went into respected retirement; His works (if one happened to remember that they had an author), formed a sufficient reference to buttress one's rationalist arguments about society and the state.

The Puritan democrats did not wrangle only among themselves; they had opponents who defended the old institutions root and branch, notably the spokesmen of the Anglican church. These reactionaries made fun of the new pieties, of the worried souls and grave looks, and especially of the riffraff with their Bibles talking and writing as if they were intellectuals. The most picturesque of these satirists was John Taylor, called the Water Poet, because he was for a time a waterman on the Thames, famous for having once rowed up the river in a boat made of brown wrapping paper. His verses preceded by a generation the like-minded work of Samuel Butler, whose comic epic *Hudibras* delighted the Restoration Court of Charles II (355>).

> **When women preach and cobblers pray, The fiends in Hell make holiday.**
>
> —JOHN TAYLOR (C. 1640)

* * *

Conscience, which is SELF-CONSCIOUSNESS about morals, brings on the issue of Toleration. For conscience implies INDIVIDUALISM, and its exercise threatens perpetual dissent. Paradoxically, the Puritan legacy of libertarian ideas helps us to understand Persecution a little better; one almost comes to sympathize with it, as Dostoevsky did with the Grand Inquisitor in his novel (769>). Singly or by sects, the Puritans were ready to devour one another. Lilburne embodies the prevailing animus.

What is the reasoning behind exclusion and persecution? The keener the individual conscience, the sharper is its judgment of human beliefs and behavior, its own included. In proportion to its "love of truth and hatred of sin," it develops suspicion of others' faith and morals. The smallest divergence from the absolute is grave error and wickedness. From there it is a short step to declaring war on the misbelievers. When faith is both intellectual and visceral, the overwhelming justification is that heresy imperils other souls. If the erring sheep will not recant, he or she becomes a source of error in others. (That was the argument of the 20C scientists who caused the publisher of Velikovsky's works to suppress them and fire their editor: The author had put forth gross errors in cosmogony as science. Later, some of the errors were proved facts.) Earlier miscreants were seduced by the Devil and

> **If the world were emptied of all but John Lilburne, Lilburne would quarrel with John, and John with Lilburne.**
>
> —HARRY MARTEN, A FELLOW LEVELLER AND REGICIDE (n.d.)

must be rescued from his toils. Nowadays the so-called whistle-blower, he who denounces falsehood or fraud in his workplace, is similarly persecuted for the good of the firm, and the Devil is not even blamed. In other words, religious persecution is a health measure that stops the spread of an infectious disease—all the more necessary that souls matter more than bodies. Since God expects his faithful to defend every detail of His revelation, persecution is a duty; as well as self-defense against a spiritual invasion; it is the domestic form of religious war.

When this outlook is aggressive it is a crusade, as in the religious and political fundamentalisms of our century.° It is a mistake to say that because fundamentalists suppress free thought they are anti-intellectual. On the contrary, they over-intellectualize, like all literalists; they interpret a text as a judge does a statute. In Soviet Russia, deviationists (as the West learned to call them) were condemned for straying from the sense of some sentence by Marx or Lenin.

These latter-day holy writs were political, not religious, which raises the question why governments in nations formerly permeated by liberal and scientific thought came to adopt a method once justified more plausibly by a supernatural religion. Extreme diversity of opinion makes certain individuals uncomfortable; it affronts their own opinions. Then this discontent brings together a group that opposes pluralism in the name of some absolute such as moral or national unity. This opposition to freedom of thought must, according to that very thought, be tolerated, thus creating a general lack of direction that a dictator will supply.

What is curious about 20C dictatorships is that with their powerful means of repression they fear the slightest murmur of dissent. A careless word, a mistimed joke is enough to suggest heresy. This remains true under present-day "political correctness," but so far the penalties have been mild—opprobrium, loss of employment, and virtual exclusion from the profession. Any form of persecution implies an amazing belief in the power of ideas, indeed of mere words casually spoken. How this consorts with the Marxist dogma that the only true causes of events are material is not clear. The Catholic Inquisition had a better estimate of what was harmful and why. At any rate, governments in all parts of the world today keep killing and exiling for the sake of uniformity. The collective zeal that helped monarchs to forge the ultimately pluralist nation-state seems dormant in the nearly 200 new nations born of anti-colonial EMANCIPATION.

To succeed as a model, the monarch's nation-state had to rely on the enlargement of local patriotism into the feeling of national pride, the satisfaction of belonging to a very large and distinguished group. Being secular, it aimed at unity rather than at the former religious Unanimity—except in time of war. But the monarch as God's anointed needed the benefits of agreement

in religion and had a duty to promote it. He therefore aided the established church in persecuting or at least in discriminating against dissenters. This policy increased the division that it wanted to prevent. Thoughtful observers notice that it solidifies dissent and also contradicts the idea of nation; they argue for a smoother unity not achievable (they say) by repression; they plead for tolerance.

> Experience teaches us that sword and fire, exile and persecution are more likely to exacerbate our ills than to cure them.
>
> —CHANCELLOR DE THOU, *UNIVERSAL HISTORY* (1604)

Unfortunately, neither persecuting nor tolerating ensures the expected result. Toleration does not guarantee social peace, and persecution may be effective. Repression got rid of the 14C English Lollards, the French Albigenses, and the Czech Hussites, which is why it took two centuries for their reforms to triumph in Luther's day. As for toleration, it may induce a permanent soreness among believers. They see it as a lack of moral authority in their government. Secularists meanwhile keep fighting these "religious bigots," and exclude them from schools by law and from official posts by pressure of opinion.

> A *right* to toleration seems to me a contradiction in terms. Some criterion must in any case be adopted by the state; otherwise it might be compelled to admit whatever hideous doctrines and practice any man might assert.
>
> The only true argument for a discriminating toleration is that it is of no use to stop heresy by persecution, unless, perhaps, it be conducted upon the plan for direct warfare and massacre.
>
> —COLERIDGE, *TABLE TALK* (1834)

Toleration—allowing freedom of expression—has no logical limits. In religion it includes ritual, which is action as well as words. But does it include burning the country's flag? Law in the United States says yes. What of behavior onstage that many consider obscene? Or sacrificing animals for a ritual purpose? Facing such questions, reason shrinks back and is mute. Nor is this all. The facts compel us to make a distinction between Toleration, a public policy useful to the secular nation, and tolerance, the very rare individual state of mind that "lives and lets live." When found it is decried as "lukewarm," "latitudinarian," "Laodicean," "lacking in principle." Words beginning with *l* seem indicated for the charge; the human intellect is imperialist. In spite of the occasional, perfunctory "I may be wrong," all assertors defend their position like wolverines their cubs. And they can defend the defense by saying that all social progress depends on the aggressive promotion of right ideas, theirs.

> For of what use freedom of thought if it does not produce freedom of action?
>
> —SWIFT, "ON ABOLISHING CHRISTIANITY" (1708)

> We are none of us tolerant in what concerns us deeply and entirely.
>
> —COLERIDGE (1836)

It is moreover a common trait of innovators that they are rude, noisy, rambunctious: Lilburne, Servetus, Roger Bacon, George Fox, William Lloyd Garrison—the list is endless, and it includes saints, artists, and scientists. Tact and reasonableness, loyalty and fair play are foreign to their genius, and it is no wonder that persecutors feel offended twice over, by the heresy and by the heretic. These things being so, the character and career of a promoter of Toleration who was also tolerant merit attention, especially since he was also a dedicated Puritan, namely

Oliver Cromwell

His life and mind put one in mind of Julius Caesar—not Shakespeare's Caesar, the bugbear of republicans, but the man who in middle life turned himself into a soldier with outstanding success and used his military authority to guide his countrymen's return to a settled state. Each of the pair was offered a crown, which was refused, while the people they led also refused to agree among themselves and make their own innovations work. Only the leader's armed power and skill maintained any social peace. With his death— Caesar's by assassination, Cromwell's from natural causes—the new and improved order ended in confusion.

The essential likeness between these two solider-statesmen may be seen in a trait that is often noted with surprise—their clemency. But this readiness to welcome and make use of former enemies is the clearest mark of the statesman: he understands that what he has to govern is the whole country, not just his own party and good friends. The mere politician talks about the public good but acts only for a portion of it.

Given the kaleidoscope of religious and political aims of the Puritans and the hatred aroused in the Royalists and Anglicans by the rebels' radicalism, anybody willing and able to rule England needed uncommon talents. They germed and blossomed in Cromwell. A country gentleman of modest means, he had no ambition of greatness. By chance, his early teacher was a Puritan, and at Cambridge his college was known for its Puritan leanings. Young Cromwell did not distinguish himself academically, but is said to have been good at mathematics and a keen reader of history; Raleigh's *History of the World* was his favorite book. These two studies he urged on his son Richard, because "they fit for public services for which a man is born." (If Richard took the advice, it did not help him when he succeeded his father. He fell from power and is best known for his subsequent fame on pub signs as "Tumble-down Dick.")

Cromwell made a happy marriage with Elisabeth Bourchier. She wrote to him: "My life is but half a life in your absence"; and he to her: "Thou art dearer to me than any creature." His occupation for a dozen years was farm-

ing the land he had inherited. Though capably done, it yielded but a small income. Nonetheless his neighbors sent him to represent them in Parliament at the very time when it began to quarrel with the king over "ship money"— a tax not authorized by law—and other abuses of royal power. Though Charles granted a Petition of Right that let go some of his powers, he went on to rule without a Parliament for 11 years, nullifying the rights. Little is known about Cromwell's life during that decade; presumably it was a round of farming until he sold his fields and rented some grazing land nearby.

> For neither didst thou from the first apply
> Thy sober spirit unto things too high;
> But in thine own fields exercising long
> A healthful mind within a body strong.
>
> —ANDREW MARVELL, "ODE ON OLIVER CROMWELL" (1650)

The Thirty Years' War was then in its Swedish period (<177) and Cromwell, anxious like others about its bearing on Protestantism in Europe, apparently read accounts of Gustavus Adolphus's military methods, for his own later command of troops was based on them. But before war was thought of, he showed his resistance to royal authority in small ways. He refused the ritual of knighthood and was fined 10 pounds; he stood up against his fellow local officials when they tried to infringe the rights of the poorer users of common land. Cromwell was jailed, released after trial, then reconciled with the mayor who had impugned him.

A believable tradition has it that Cromwell had at one point considered emigrating to New England. The home country, under the king's last minister, seemed drifting toward permanent repression of conscience. Troubled also inwardly, Cromwell underwent a conversion to Calvinism in its fullest form. A deep depression followed, as in Bunyan later. The torturing thought was: Have I the divine grace that certifies faith and opens the way to salvation? (<6). Both men, like many since Luther, believed themselves "chief of sinners."

When such an attack of SELF-CONSCIOUSNESS was relieved by the sense of grace bestowed, it was logical to regard events as also expressing the will of God. The Puritans could believe that He willed the king and the lords to be overthrown. Providence, like predestination, lifts the burden of responsibility from the individual, as does their equivalent today: scientific and psychological determinism eliminates responsibility for behavior, crime included. But Cromwell's and Bunyan's torment beforehand seems a stage that 20C people skip, unless it is the guilt without cause that many people labor under.

Having God in their hearts, Cromwell's soldiers were sure that He was on their side, but Cromwell was not an ordinary believer. Though confident that "faith will answer all difficulties," he also knew that "we are very apt, all of us,

> Oh, I lived and loved darkness and hated light. I hated Godliness, yet God had mercy on me.
>
> —CROMWELL, TO HIS COUSIN MRS. ST. JOHN (1638)

> Sir, the state, in choosing men to serve it, takes no notice of their opinions; if they be willing to serve it, that satisfies. I advised you formerly to bear with minds of different men from yourself. Take heed of being sharp against those to whom you can object little but that they square not with you in matters of religion.
>
> —Cromwell, to Major General Crawford (1643)

to call that faith which perhaps may be but carnal imagination and carnal reasoning." *Carnal* then meant human and fallible. It will be remembered how he besought his opponents to entertain the idea that they might be mistaken (<134). This possibility reinforced Cromwell's political sense about toleration. He found some of his officers creating trouble by making military judgment depend on a kind of religious test.

Diversity, inside or outside his army, could not be reduced. Cromwell's toleration was of course not complete—nobody's has ever been or ought to be: the most tolerant mind cannot tolerate cruelty; the most liberal state punishes incitement to riot or treason. To all but the Catholic minority in England, the church of Rome was intolerable. Popery was not simply superstition, the word designated a power in the world that was hostile to England and its faith. The Catholic nations—Spain, France, Austria, often instigated by the pope—kept plotting in Ireland and Scotland when they were planning to invade England or to seduce the Stuart kings. Anti-popery lasted in England until the first third of the 19C. It had the quality of the 20C Cold War against Communism. Both fears were partly justified and partly exaggerated. Cromwell's fierce putting down of the Irish rebellion was, again, partly foreign policy and partly traditional English contempt for the Irish. It did not affect his domestic policy of toleration.

Under his rule the Catholics and the Anglicans were somewhat better off than before; he had wanted to pardon a Catholic priest who in 1654 was put to death for his zeal. The verdict on Cromwell himself is that he was not the cruel, tyrannical ruler nor the narrow-gauge Puritan of legend.

> I desire from my heart—I have prayed for—I have waited for the day to see—union and right understanding between the Godly people—Scots, English, Jews, Gentiles, Presbyterians, Anabaptists, and all.
>
> —Cromwell, after the religious war in Scotland (1648)

His policies made England prosperous. By "navigation acts," he increased trade in English ships; he favored the colonies and furthered colonization; he may be called the founder of the British Empire. These actions brought on a trade war with the Dutch in which their fleets, though ably led, were defeated by the naval hero of the age, Robert Blake. In the Elizabethan tradition, Spain's treasure cargo was seized off Cadiz; and for safe shipping, the Mediterranean pirates were got rid of. (Lloyd's insurance reports today that their professional descendants now flourish in the Far Eastern waters.)

On land, Cromwell's effort to form a league of Protestant states failed like other grand alliances (299>). Nation-states rarely see their interests as steadily convergent, but his views were nonetheless global: "God's interest in the world is more extensive than all the people of these three nations," meaning England, Scotland, and Ireland, then bound together by common lawmaking. This union, too, came apart after Cromwell's death in 1658. He had contracted malaria in Ireland and died of it, aged 59.

His dictatorship during the latter half of his tenure as head of state came about because the army and Parliament could not agree. Cromwell later blamed himself for the purge of Parliament that led to his Protectorate, entailing censorship and local government by army officers. He described it as "wickedness and folly," though it is hard to see what other choice he had. In the first half of his governance he had behaved like a model monarch, that is, a king who is a good administrator and obeys the law. His successor Charles II had different concerns: staying in power, doing without Parliament by accepting periodic bribes from Louis XIV, and enjoying himself. After a long exile such as Charles endured, this mode of existence is understandable. But within half a dozen years, according to Pepys, many people remembered "Oliver" with a sense of longing.°

<center>*
 * *</center>

The fact without precedent about Puritanism is that it was the first radical movement to have representatives in America. Noteworthy also is that they began their adventure on this soil by writing down a social contract. Earlier English colonists, in Virginia, had carried with them their orthodox Anglicanism, scarcely troubled by a scattering of Quakers and other eccentrics. The French, north and west, like the Spanish in Mexico and South America, were Catholics who felt no qualms about bishops, the Eucharist, and the Inquisition. And the wide-ranging Jesuit missionaries had no thought of mixing reform politics with their promotion of Christianity.

The hardy band honored as the Pilgrim Fathers were one offshoot of the earliest 17C agitation to purify the church. James I, seeing the growing number of these dissenters, swore that he would "harry them out of the land." They did not wait, and here they were in 1620, perched on the edge of the wilderness, facing Indians and starvation just so they might live without bishops. There was then no cultural lag. Men, ideas, and passions traveled back and forth between England and New England, creating the same doubts and divisions and individual calamities.

As one reflects on the narrow meaning of *Puritan,* which unfairly colors the movement as a whole, one is tempted to think that without its American branch the attitude to life that it stands for might have left little or no trace in

the public memory. In the United States the New England adventure has been unforgettable: the *Mayflower,* the Thanksgiving holiday, the witch trials in Salem, and the story of Hester Prynne wearing her scarlet *A* for adultery make up the popular picture of the country's beginnings. For there is a general impression that the Pilgrims were the first English-speaking colonists in North America and that they brought with them the doctrine of freedom for all. This error does not rob Jefferson, Samuel Adams, or Patrick Henry of their contributions to that ideal, yet the New England images, more picturesque, remain the core of the national myth.

As for the equation of Puritan with killjoy, the English scholar cited earlier who showed its falsity blames Hawthorne's *Scarlet Letter* and his gray-tinted short stories for making it take root. The charge is fair enough, but it is also true that the New England Puritans were more strait-laced than those they left behind, and understandably so: they were in a foreign country and beset by dangers. Rules had to be strict and relaxation limited. The settlers were a very small group too—about 100 to start with—which makes deviation difficult: everybody's behavior is common knowledge, and social pressure to conform is great. Hence little room for original ideas and even less for toleration. Besides, in those early days there was no need to argue in favor of leveling ranks or sharing goods: the American situation by itself established the arrangement. Things changed when land was parceled out and hamlets grew into towns. The issue then was whether the governor and top officials should make policy or the General Court, the Assembly. But nobody questioned that the civil magistrates ought to ensure religious unanimity.

On this point, as we saw, England differed. Cromwell and the independent sects° found themselves feeling like the earlier French *politiques* (<137): after prolonged religious war, they yearned for peace, which required some degree of toleration. By contrast, in Massachusetts Bay Colony, "sectarians" were given short shrift. As noted earlier, the woman preacher Anne Hutchinson, guilty of 80 heresies, was expelled. Also banished, Roger Williams founded Providence in Rhode Island. Others, less iron-willed, were admonished into silence; religious "wars" continued in Massachusetts to 1780 at least and full toleration had to wait another 50 years.

Toleration of all upon pretence of conscience I thank God my soul abhors it. The godly in former times never fought for the liberty of consciences by pleading for liberty for all.

—THOMAS SHEPARD OF NEWTOWN
 (CAMBRIDGE), TO HUGH PETER OF SALEM
 (1645)

The governors, though chosen by vote, tended toward authoritarian rule, although one of them, John Winthrop, was elected for his one-year term because of his tolerant, amiable character. Yet being hard-pressed by his councillors, he resisted all popular demands to share in making policy. The fear of

"anarchy" must have been great, since after a defeat or two he was re-elected again and again. At the end of his life he regretted having yielded principle and inclination to fear.

Toward freedom as represented by toleration on the one hand and democratic rule on the other, the Puritans in America appear to have been driven into ambivalence—and such the country has remained. Nothing could show more precisely the difference between EMANCIPATION and freedom: the oppressed demand *their* freedom, which will surely not upset society; but how dangerous it would be to accord it to others! The popular belief in the Pilgrims' devotion to liberty rests on this confusion of ideas. Among the principal actors in the founding of the colonies, only two were thorough liberty-men: Roger Williams and William Penn°—and Roger Williams himself showed a small flaw: he wanted any dissenter to earn his freedom by first denouncing the Church of England.

> It were better to be of no church than to be bitter for any.
>
> —WILLIAM PENN (n.d.)

On the score of conduct in daily life, the Puritan record in New England is also ambiguous. The moral atmosphere varied at different times under the influence of crises and outside events. One is surprised to see Christmas outlawed for 22 years, then re-accepted, and to find civil marriage required in addition to the religious. How to treat the Indians also divided ethical minds. But the morally precarious device of bundling was made into an ordinary custom (280>). A little-known aspect of moralism comes to light in the case of Robert Keayne, and the witch trials at Salem were not exactly what they have come to seem.

To get to know Robert Keayne it is only necessary to read his will, a document which he spent five months in composing—50,000 words of justification for his alleged misdeeds.° He was a Boston merchant who began life in England as a poor butcher boy. In America he grew wealthy and aroused among his competitors suspicion flavored with envy. The General Court and the church, alike intent on economic morality, accused him of taking too high a profit on bridles, nails, and gold buttons; for example, one penny on 100 sixpenny nails, two on the sevenpenny variety, and eight on a dozen gold buttons. It was tantamount to usury. The General Court had not read Max Weber on *The Protestant Ethic and the Spirit of Capitalism* (<36–37).

The Court's "unchristian, uncharitable, and unjust slanders" caused Keayne both acute and chronic suffering. His church also conducted an "exquisite search" into his behavior, and he was reproved for "dishonoring God's name." He had to repent. Against the Court he fought back with desperation, his innocence and piety affronted beyond endurance.

The result of his appeal was to split the Court, physically: the disagreeing legislators sat apart, thereby making Keayne if not the father, then the occasion

I renounce all manner of known errors, all Popish and prelatical superstitions, all anabaptical enthusiasms and familistical delusions, with all other feigned devices and all old and new upstart opinions, unsound and blasphemous errors, and other high imaginations against the honor and truth of God.

—ROBERT KEAYNE, 2ND PARAGRAPH OF HIS WILL ("6:1:1653 COMMONLY CALLED AUGUST")

of a bicameral legislature in Massachusetts. Besides the recital of his grievances, his encyclopedic will details the half a dozen public institutions to be built with money from his estate. If Boston will not have them, the sum goes to Harvard College. The rest of the piece describes the testator's dealings with relatives and friends and explains why they do or do not get a legacy. This accounting is not egotism but deference to the Puritan principle of the stewardship of wealth. Andrew Carnegie and John D. Rockefeller consciously acted as heirs of this tradition.

*

* *

In the late 1620s present-day Quincy, a suburb of Boston, enjoyed under the name of Merry Mount, a reputation exactly opposite to that of its surroundings. It was founded by Thomas Morton, who came over to be a fur trader and was a strong believer in the free-and-easy life. His character and the temper of the town furnished Hawthorne with matter for a short story and John Lothrop Motley with enough more for two novels, *Merry Mount* and *Morton's Hope*. Morton offended Massachusetts by his festive life (characterized as wild), by celebrating the pagan May first with its sacrilegious May queen, and by selling guns to the Indians. He was arrested three times and shipped back to England twice. There he gave rein to his revenge by publishing a scathing denunciation of his American neighbors' ideas and comportment, including what he thought excesses in religious purity; he cited their seeing in the use of a ring in marriage a relic of popery. How dissolute he may have been, it is hard to say. What is clear is that the means and extent of his pastimes went beyond the limits considered legitimate by Puritans not wholly averse to recreation, and certainly not ignorant of human instincts and emotions: witness Bundling.

This ingenious custom is defined as "sleeping together with the clothes on, especially applied to lovers." It was an ancient means of comfort in Wales and other rural districts of the British Isles, as well as in Switzerland and parts of India. Its convenience is plain: lack of heating in winter and of room and furniture at any time is obviated in the simplest way. [The book to read is *Bundling* by Henry Reed Stiles.]

When the practice was resorted to, not to accommodate visitors but for courtship, the theory was that the young people would adopt it for acquaintance stopping short of all tempting familiarities. Experience showed the diffi-

culty of restraint and, sexuality regularly prevailing, the rule was made absolute that pregnancy after bundling imposed marriage. When this untoward result ensued it had to be confessed by the parties in front of the congregation. So frequent was this occurrence that the church records repeatedly show the abbreviation FBM—fornication before marriage. What happened when no pregnancy disclosed what may yet have taken place is not known, but the realities of the bundling life were certainly known and condoned.

"Mr. Ensign," says she, "our Jonathan and I will sleep in this, and our Jemima and you shall sleep in that." I was astonished and offered to sit up all night, when Jonathan immediately replied, "Oh, la! Mr. Ensign, you won't be the first man our Jemima has bundled with, will it Jemima?" She was a very pretty, black-eyed girl of about sixteen or seventeen, who archly replied, "No, father, not by many, but it will be with the first Britainer."

—LETTER FROM LT. ANBURY FROM CAMBRIDGE, MASS. (1777)

*
* *

What remains to be told is often regarded as the one unfortunate blot on the Pilgrim Fathers' just fame—the witch trials at Salem. There again the facts are partly misconceived. The witches were not burnt but hanged, some were self-confessed; and most important, the belief in witchcraft did not prevail among Puritans alone, much less the New England contingent alone. It gripped the whole West, Catholic and Protestant. Nor was it sheer old-style medieval ignorance; it was tied closely to the new concerns of the scientists. Witchcraft is mentioned in the Bible, but it was not until the end of the 13C— an age of enlightenment—that it took hold of the best minds by its connection with the several magics or "-mancies": geo-, hydro-, aero, pyro-, necro- and chiro-; that is, divination by means of earth, water, air, fire, the dead, and the hand. These powers may be used for good or evil, depending on the reason for invoking the "mystery." The choice is like the modern physician's prescribing of a narcotic. When the magic is for "carnal lust," it is witchcraft; exercised for doing evil to others, it is "fascination," but even when it performs cures, it abets the Devil and is the "mystery of iniquity."

How this system of ideas was compatible with the rise of science is shown in the career of

Joseph Glanvill

We saw how his contemporary, the physician and naturalist Sir Thomas Browne, accepted as fact the existence of witches: they fitted the hierarchical scheme of created beings (<212). Knowledge and reasoning supported the belief. Glanvill was an early member of the Royal Society and took part in its

work with papers on natural history and the mining of lead. But his great contribution was to defend science and the Society against its attackers. He argued the utility, the harmlessness, the modernity of science. One gains knowledge, he said, by first admitting ignorance; causes may remain unknown, but mathematics gives certainty. Glanvill was in effect a philosopher of science and one of its first historians.

In matters of faith he was a broad-church Anglican who favored the use of reason in religion. Ordained at 23, he wrote at 24 a long essay on "The Vanity of Dogmatizing," which depicts nature as an object of contemplation that heightens admiration of the Divine Architect. Glanvill's worldly heroes were "Galilaeo [*sic*], Gassendi, Harvey, and [Des] Cartes." When the attacks on the Royal Society did not stop but rather increased after its favorable history was published by Bishop Sprat, Glanvill was urged to further defense. He wrote *Plus Ultra,* in which, while explaining "deep research," he boasted that more knowledge had been garnered in the recent past than in all the years "since Aristotle opened his shop in Greece."

Such was the man who by reasoning arrived at the conviction that he must combat skepticism about witches. His early books on the subject bear on the title page his designation as Fellow of the Royal Society. Since all phenomena must be studied, he proposed that the Society investigate the facts of the spirit world.

Millions of spiritual beings unseen
Walk the earth up and down.

—MILTON, *PARADISE LOST* (1667)

Facts depend on witnesses, and the testimony about "Satanic work" were abundant. When we recall that Newton worked at alchemy and the prospect of the world's end and that others, like John Wilkins, the prolific writer on mechanics, thought that the mission of the Royal Society was to promote the teachings of the Rosicrucians, one can judge how difficult it was then to achieve a totally naturalistic view of science.

That view, indeed, was not only not wanted but must be resisted; for its triumph would mean that only matter existed, that atheism was the truth, that Hobbism (as they called Hobbes's mechanical psychology) was correct. In short, the believers in spirits foresaw the state of mind that now dominates and that disquiets not merely the devout but many freethinking Humanists and some scientists. In the 17C conception of spirit (or mind) versus matter, it was logical that witches should figure among real beings.

The New Englanders who tried and hanged some of them—35 in all—could hardly doubt that they had reason and evidence on their side. Some of the adolescent girls actually said they were witches—proud of the fact or glad of being the center of attention. Once started, the notion took on the character of crowd hysteria and had to run its course like a disease. Later in life the

persecuters saw their error and felt repentance—too late, like John Winthrop regretting his different but no less high-minded political persecution.

The Puritan legacy as a whole is mixed: toleration of the individual conscience, linked to the democratic right of participation in government and the demand for social justice. These co-exist with the hounding of dissenters and the extermination of witches. Mixed again is the welcome to the full enjoyment of life, art, and pleasures of the body, coupled with a strain of asceticism, born of a high sense of duty. Of these components, the narrow moralism and the social repression of dissent were to affect the future United States for a long time and more deeply than their opposites.

The Reign of Etiquette

Louis XIV was much too clever to have said, "The State? I am the State." If he ever did, it was not meant in the sense that it is quoted for. In any case it was not true. His own words, deliberately written for the guidance of his son and heir, say the exact opposite. His hold on the throne, and even more on the court, depended on Regularity. The last thing he wanted was to be thought arbitrary; he would not boast of behaving as the nobles did in their domains.

Centuries later, De Gaulle may have remembered the cliché when he said of his role in the Second World War: "I was France, the state, the government. I was the independence and sovereignty of France—a quite untenable position."°

The other cliché about Louis XIV—his title of Sun King—is also misinterpreted. It does not refer to the golden glory he coveted in his ruinous wars, nor was he the first to be so called. His father was: Louis XIII was described by that phrase, because thanks to Richelieu he had become the sole center of power—like the sun.° The sun's rays—authority—radiated to all parts of France unopposed—or almost. Under Louis XIV this figure of speech became blended with that of military might and its more important meaning was forgotten. At the same time, the principle of sovereignty was misconstrued as personal rule—despotism—which is the error embodied in *L'état, c'est moi.*

> The interests of the state come first. When one gives these priority, one labors for one's own good. The advantage to the state redounds to one's glory.
>
> —LOUIS XIV, "REFLECTIONS ON THE BUSINESS OF KINGS," *MEMOIRS* (n.d.)°

As monarch, Louis XIV made it his business to carry on two distinct activities. He worked daily, faithfully, like a top civil servant, sitting in council with his four secretaries of state; and in parallel he ran the court on a plan that he had devised for political stability. Both duties were anchored in his makeup, were implanted there by his childhood experiences. One could say in modern jargon that he came from a troubled family. He was brought up by a single parent, having lost his father at the age of five. His mother, the queen

regent, soon contracted a secret marriage with the chief minister, Cardinal Mazarin, who was a foreigner—an Italian surrounded by Italian dependents. Extremely able at devious diplomacy, Mazarin took pains to instruct the child-king in the role of monarch, and the lessons took.

But Mazarin's unpopularity, combined with the infancy of the king, gave the nobles and others an opening for revolts that amounted to a civil war. It began just after the Thirty Years' War had ended, at mid-century, lasted four and a half years, and coinciding in time with the rise of the English Commonwealth, it also aped some of the features of that republic. The turmoil forced Mazarin and his queen to flee Paris with the young princes. At one point, the mob rushed into the little king's room while he was in bed. Twice Mazarin went into exile, and during one of his absences the queen had to surrender the children to one of the warring parties. She pleaded for the maintenance of the monarchy. The outright battles were few but bloody, and the leaders switched sides so erratically that the situation ought perhaps to be called anarchy rather than civil war. This perpetual insecurity that Louis lived through between the ages of 10 and 15 he never forgot. It taught him the necessity of taming the nobles and it explains the extraordinary self-mastery that he developed to make etiquette serve as an anti-revolutionary force.

Before looking at the ways in which this was done, a word or two are in order about the rebels of those four years. They were of three kinds—first, ambitious nobles who thought that Richelieu's work, the triumph of monarchism, could be undone; next, the Paris Parlement, a body of 200 lawyers, not legislators, who thought that like the true Parliament which they saw governing England they could make the French king share power with them; and last, the Paris mob which like its London counterpart vaguely thought that some measure of democracy could be won out of the confusion. The Parlement alone had definite plans—a written constitution in 27 articles providing for such things as the granting of taxes, the abolition of Richelieu's provincial agents, the intendants (<241), the cessation of arbitrary imprisonment by *lettres de cachet,* and a form of habeas corpus.

Nobody got his wish. The nobles, divided into unstable factions, tried to get foreign help and thus ensured their unpopularity. The Parlement suffered from inept leaders, and the Paris mob had no single goal or head. The contemporaries found the fitful fighting so capricious that they nicknamed the whole operation *la Fronde*—"the sling"—suggesting children at play with stones and catapults. The outbreak ended up being neither a parallel to the English overthrow of royalty nor a foretaste of the French revolution of 1789. It was the last attempt of some nobles to bring the king back to his position of first among equals (<239). But one circumstance matched the state of affairs just before the actual revolution of 1789: the state was bankrupt. That condition too Louis

kept in mind, though unfortunately not as long as he did the nobles' ambition to demote him.

Life at the court of Louis XIV was a daily drama in which he played the lead. He was also its director and producer, and he built his own theater for it as soon as he was of age and fully king: the palace at Versailles. It was wise to move the court out of Paris, away from the restless populace and the intellectuals. When the château 11 miles away was completed, the show, underwritten by the vanity of the nobles themselves, put them at the mercy of the Grand Monarch. Every hour of every day they wanted his favor, his glance—a nod was enough reward, a blessing. By watching one another, making little plots, and getting in each other's way, the mischief-makers of the Fronde were kept amused and tamed.

> In the presence of the absolute monarch the great became the small. It was with veneration that the courtiers approached a king who was the sole object of their respect and the sole arbiter of their fortunes. Those who had been the little tyrants of their province were now nothing more than their tutors. To obtain favors from *them,* it was no longer necessary to bluster or to fawn.
>
> —ANTONY HAMILTON, *MEMOIRS OF GRAMONT* (1704)

To stay out of the production was impossible. Louis, with the memory of a politician, knew everybody and noted at once the absentees. "Where is So-and-so?" Any relative who was present was rebuked by the question alone, thus compelling attendance from whoever had stayed away out of sulks or love of country life. By this simple device potential rebels were under permanent surveillance. It was an automatic "Divide and rule," because the competition for favors made each courtier the enemy of every other, and not in a trivial way. For in addition to the short-lived joys of vanity, there were real plums to be got—posts of high honor, titles affording privileges, decorations and favors giving access to his majesty and thus to other benefits—gifts of land or cash, appointments and promotions in the army and the church. Incidentally, one decoration created in Louis's reign, though not by him, has had a circuitous history. The period was one of marked advances in cookery, in which some women distinguished themselves. To honor their talents, the blue ribbon of the highest state medal was chosen as appropriate. The connection with the Medal of the Holy Ghost has been forgotten and the ribbon is now freely bestowed on male chefs, restaurants, and grand juries.

The fulfillment of desire hung on first obtaining the favor of a word or a smile. It was in this way that the monarch was absolute and arbitrary. An earlier Louis, the eleventh, had coined the formula "For such is my pleasure...," which might better be rendered "such is my whim"—not a compliment but notice served that luck, not merit, secured the boon. Besides tossing around *whims,* the later Louis had to keep inventing new pastimes to keep his huge retinue diverted; it was a feat of high imagination. To go with him on a hunt

or a country outing or be a guest at camp during war required special desig-
nation beforehand. He chose the group in the light of recent remarks, atti-
tudes, costume, or facial expressions. Everyone was on tenterhooks. If at the
appointed place a room had the magic word *Pour* (for), followed by the name,
this touch doubled the delight. Permission to keep one's hat on at various
times was another honor, which the king's call: "Hats, gentlemen!" made vis-
ible to all. He, by the way, always raised his hat in passing by a woman or an
upper servant.

To provide such lures, the royal master of ceremonies thought up enter-
tainments without cease—rides, balls, masques, ballets, plays, banquets,
games—and made the most of birthdays, christenings, receptions of foreign
notables, all this besides the feast days of the church, his days of taking
medicine (purge), and whatever little circumstance in the life of his family,
legitimate or "natural," gave excuse for some form of pageantry. His
resourcefulness in this domain kept the crowd continually busy—getting new
clothes, wondering and arguing about the moves to make, the words to say if
this person or that was to be the center of attention, and worrying about
precedence—one's place on the ladder that reached the sun. The fuss, the
frenzy can readily be conceived if one thinks of such lesser models of court
life as Washington, D.C., or Hollywood in its prime. A court under any clime
is a mass of resourceful people with only one aim in life.

At Versailles what one might call the fusion of revelry and rivalry was an
instrument of government, expensive but efficient—no need of any army of
spies throughout the country as Richelieu had needed, or of soldiers to fight
coalitions of nobles. They fought each other, without bloodshed, under their
king's eye and over such things as footstools and "bonnets" (caps), these
being the cause of famous quarrels too involved to go into. Louis looked on
impassively like a teacher in the playground at recess time.

His Majesty's meals shall be brought in thus:
two of the guards will walk in first, then the
doorkeeper, the maître d'hôtel carrying his
staff, the gentleman who serves bread, the
controller-general, the controller's clerk, the
squire of the kitchen, and the keeper of table
settings.

—LOUIS XIV, HOUSE RULES, ARTICLE 21
 (REVISED 1681)

At other moments, each day, he
sacrificed his privacy to the good of the
state: rising and going to bed, at meals
and at stool, he occupied center stage.
He chose what noble fingers should
hand him his shirt or who should sit
opposite him across the table or per-
form some other rite. These privileged
beings shone in rotation as did the
select crew allowed to stand near the
chamber door and feast their eyes on
the daily spectacle. But none in the audience ever saw him without his wig:
Louis had lumps—sebaceous cysts—on his scalp.

The words just used—audience, show, spectacle, pageant—suggest the resuming word *facade*. It is the means of ruling by keeping the mind entranced through the eye. Facade imparts grandeur, brilliance, power. It is the contrary of another artifice of government, the calculated mystery of dictatorships. The western world today wants the opposite of both facade and mystery, destroying them as soon as suspicion of either arises. We speak of the importance of "image," and the kind desired is one of anti-facade. It must dispel, not create, the aura of grandeur and power and even of dignity. Heads of state insist on being Tony or Jimmy; they grow in popularity when they are inarticulate. The plain man with the boyish, rather helpless look is the figure congenial to a democratic society (785>).

It might be thought that there was a likeness between the sun king's self-display in the bedroom and the photographs of our leaders jogging or the diagram of their organs after surgery.° But Louis's exhibitionism fostered no intimacy; it was solemn and stylized; it implied that majesty permeated the least action, making it different from its analogue in you and me. The fact is that far from these antics making him (in our favorite phrase) "more human," they set him apart from the rest of mankind. The king has two bodies (<253) and the one on show was at all times the royal being.

The proof is that from his accession to his death, Louis terrified all who came near him. No source of pride or strength—great estates or wealth, fame as a soldier or genius as an artist—helped anybody to withstand his glance; all were reduced to humility. Physically, Louis was well designed for his role; he was of medium height and sturdy build. His features were regular, the mouth firm and eyebrows strongly marked over a wide-open glance. And as we see in the standard full-length portrait by Rigaud, which obviously makes a point of it, Louis had an athlete's legs. Nor did Louis achieve this mastery by any form of thunder—he was said to have lost his temper only twice. He dominated by his stance and his gaze, his self-control and his vigilance about the minutest infraction of what he regarded as his due. This peculiar power is well illustrated by a remark on record: "I was almost kept waiting." It was part of his grand strategy to mention with a shudder his escape from that catastrophe.

Not without dread do I approach the subject—I mean the monarch at whose court I spent the best and most numerous days of my life, imbued with the most religious respect, a being who created and fostered in me the most justified admiration, a prince who was more a master than any other whom one can remember, even by recourse to books, who was such for a long time abroad as he was at home and whose aura of terror persists owing to the impression it once made.

—SAINT-SIMON, *MEMOIRS* (n.d.)

*
* *

Plentiful as were the king's expensive entertainments, they did not fill every moment of the day or night. The hours left over were occupied by two other pastimes—gambling and lovemaking.

Gambling propels itself, an excellent time filler and a mode of excitement without strain on the muscles. The Versaillese used cards and dice (especially in tric-trac = backgammon), unaware of its cultural by-product: Pascal, who enjoyed it in his worldly period, was led by it to work on probability theory and then to his theological "wager" (<220).

It is a fact of nature that people who are well-fed and idle in the sense of free from steady work feel a restlessness that inevitably turns amorous. That is why for chastity monks and nuns give themselves a full schedule of "works." But love at court would also grow tedious if it were merely what people who labor tend to make it—finding sexual opportunities and satisfactions. The courtier, male and female, dresses up everything, from their bodies to their ways of speech, and sexuality is no exception; for them lovemaking is a ritual with tactical moves, progressive phases, fulfillment, and retreat. This explains why one of La Rochefoucauld's maxims asserts that nobody would fall in love if one hadn't heard about it (350>). Obviously, the sexual impulse as such needs no previous notice to make its demands; its plain urge marks its distinction from love, which means whatever a period may fancy to embellish lust.

This is not to say that the men and women at Versailles were all ingenious and delicate amorists who made the affair a work of art. Still, many differed radically from those who today haunt bars for "singles" on the prowl. Married or unmarried, the courtiers' opportunities were at hand and in readiness, a perpetual stimulus to the verbal imagination as well as the physical, everybody picturesquely poised in a kind of sensual Eden. Marriage did not hinder, because it was almost always an alliance of material interests and nothing more. But discretion and tact must be used in violating the formal vows, and again in disengaging from a liaison. Some liaisons moreover were lifelong attachments and praised by all, every move in the pairings being commonly known and the details handed down to posterity in letters and memoirs (477>).

The one disdainer of this minuet was the king himself. Acting this time in his proper person, he obtained his successive mistresses without the use of tactics. Some offered themselves and any who were summoned were obliged to surrender. Unlike recent times, when the sexual relations of public figures are leaked out and in some quarters carry a little discredit, a 17C monarch's love passages were rather a sign of his lofty role and virility—his two bodies manifest at once. Secrecy was difficult but could last a little while, after which the title of official mistress (*maîtresse en titre*) might be earned and made public. A good indication of the state of fact was the set of persons—relatives and friends of the mistress—who bore off the bounty from on high.

One of the women whom the king favored obtained her post by means unique in modern times. On the road from Paris to Orleans stood a château in the chapel of which a priest named Guibourg officiated from time to time. His notion of the service was peculiar. On a certain day near the mid-century the altar in that chapel, covered with a black cloth, supported the semi-naked body of a woman in her twenties. The priest placed the chalice on her midriff and intoned the black mass, winding up with the ritual kiss bestowed on Satan's new recruit. Then came the sacrifice of a live offering to the lord of Evil, to ensure the fulfillment of a petition shortly to be made. The live victim this time was unusual: an infant who had been bought for a few francs. And the petition was also out of the common: "I want the king's affection so that he will do everything I ask for myself and I want him to give up La Vallière and look with favor on my relatives, my servants, and my retainers." The infant's heart was set aside to be burnt and reduced to powder "for the king's use."°

The woman on the altar was Athénais de Mortemart, Marquise de Montespan. She became lady-in-waiting to the queen and acknowledged mistress of the king at 27. Her reign lasted 14 years.

During that time she was eulogized in verse by many, and notably by Racine and La Fontaine. They did not know, of course, any more than the king, the unorthodox means by which she had made her way to the foot of the throne. She produced eight children and managed to get two legitimized, inevitably creating permanent dissension between partisans of the true line and of the bastards. Before being supplanted by the formidable (and pious) Mme de Maintenon, Montespan had been converted by Bishop Bossuet—or so he believed—but she still showed a restless spirit and nursed the ambition of recapturing her long-forgotten husband—in vain. He was one of the few who kept away from the circus at Versailles.

The king's and others' adventures in love, by being open and continual, made observant minds reflect on the human emotions. Their interplay in heart-and-mind, their consequences in society, and their role in history, became a subject of study by French playwrights, tragic and comic, and especially by essayists of the kind called *politique et moraliste*. We shall shortly meet some of them and the genres they cultivated (342.ff>).

<center>*</center>
<center>* *</center>

The monarch, meaning his supra-human body, came to the direction of affairs at the same time as he ordered work begun on the building of Versailles, in the sixth decade of the century. Labor in both proved arduous. The site of the château was a sandy and boggy flat ill supplied with fresh water (337>). Louis' daily meetings with his ministers and domestics were perhaps no less dry and swampy by turns, but he listened patiently and

gravely to their reports and advice. He insisted on reading all documents; he would not sign any that he did not understand. He was a reading man, although his spelling was capricious like everybody else's.

An early decision shocked the court: the Superintendent of Finance, Nicolas Fouquet, was in disgrace, arrested, and to be tried for corruption. He was the wealthiest man in France, popular among those he favored with gifts of money from the public treasury, and he had just given the king several days' magnificent entertainment at Vaux-le-Vicomte, his stupendous garden-estate. He was condemned to banishment, which the king interpreted as prison, in various towns. Fouquet's peculations had been tracked down by a man named Colbert, a bourgeois, who wanted the superintendent's post; he meant to put order in the nation's economy. The king was eager to crush Fouquet for a second reason: the man had bought and fortified an island off the coast as a safe retreat if need arose: Louis scented the spirit of the Fronde.

Colbert's plan was in effect a reform of the whole administration of the kingdom. It must be made efficient and profitable. Finances in disarray, high officials keen only about taking and giving bribes, their departments neglecting their mission and keeping no records—such a state of affairs was intolerable to a bourgeois mind. To reverse the headlong march to bankruptcy, Colbert's first move was to trim outlays and accumulate cash. Taxes would keep flowing only if the country was prosperous; therefore exports must be spurred and imports reduced. This was Mercantilism, the economic theory in vogue since the previous century.

To carry out his scheme, Colbert devised "maxims of order" to replace what he termed "maxims of confusion." He and his growing body of agents were bourgeois who put into practice a conception of the state as a business enterprise. The class as a whole had long supported the monarchy in its struggle against the nobles; now under Louis XIV the bourgeoisie was virtually in power; the king's reading and initialing memos made him in part a bourgeois king. Before his day, collecting and spending the revenue was—even when honest—a haphazard operation. Colbert with his tireless eye looked over everybody's shoulder, wanting to see records, receipts, minutes, audits, and figures so as to guide action. He began by ordering a survey of the country's resources and products of all kinds. Consciously scientific, he promoted "government by inquiry."

At the head of the treasury was the Controller-General—Colbert—with his bookkeepers. Each department had a Register—a large book of specified format and number of pages, the first 25 of which were to be left blank for an index. The rest were subdivided for each type of transaction. Nothing could be ordered, no payment made without an order signed by Colbert and immediately entered in the daybook, to be summed up with others in the Register. Each month the Register was totaled up, verified, brought to the king in

Council. Each page was re-verified by him; he said *Bon* if the figures tallied and his initials were affixed. Bureaucratic ways are a form of etiquette.

The value of centralization through bureaus was soon proved. France became the workshop of Europe. That role was won not by dumping but by producing high-quality goods—linens, lace, silks, wines, pottery, tapestries, clocks, and other artifacts of wood and metal. Colbert's innumerable officials—new and old civil servants—were punctilious: a bolt of cloth an inch too short was stopped at the border and destroyed. These men did not so much displace as take over the duties of the nobility that had governed locally. To

Bureau. The wise man will set everything down on his bureau to weigh it in the balance.

—RABELAIS (1573)

Bureau. A chest of drawers with a writing board.

—RICHARDSON'S *PAMELA* (1740), QUOTED IN THE *OXFORD ENGLISH DICTIONARY*

Bureaucratique. Power exercised by the bureaus. A hardly correct neologism, but made necessary by the wide influence that government exerts on all undertakings.

—LITTRÉ DICTIONARY (1889)

Bureaucracy. "The inexpediency of concentrating in a dominant bureaucracy all the power of organized action. . . ."

—JOHN STUART MILL (1848)

them and to certain landowners and tradesmen, Colbert was a menace; they found the new regulations oppressive and often absurd, for the drawbacks of centralization showed up as promptly as its great merits. To this day, *Colbertisme* is a term of praise and dispraise in French political debate.° But as the king himself noted in his jottings for the Dauphin, the local governors had often been little tyrants.

Meantime, there is no doubt that the aim was to promote the general welfare. Colbert felt concern about the poor, whether artisan or peasant, and he used his officials to gather statistics for remedial action. He had roads repaired, swamps drained, canals built, and took measures to lighten burdens such as tolls and other levies. Had it not been for the king's ambition to be a hero in war as well as a paternalistic monarch, the history of the reign might have been a worldwide lesson in political economy. The lavishness of Versailles and the patronage of art would not have bankrupted the country. But another man's ambition interfered with the peaceful plan: Colbert had in Louvois, the minister of war, a rival for the supreme power. Louvois fed the king's dreams of glory and cut Colbert's influence in half using his own to help bring

Not one provincial governor but commits some injustice, no body of troops but lead dissolute lives, no gentleman but acts the tyrant toward his peasants, no tax collector, no delegate, no common sergeant but performs his role with insolence. These crimes are the worse for being committed in the name of the king. Even the upright among officials get corrupted, unable as they are to go against the current. Instead of a single ruler that the people ought to have, they have a thousand.

—LOUIS XIV, *MEMOIRS* (n.d.)

about the four costly struggles that made France the warmonger nation for over a century and a half.

The continued presence of lesser nobles and others in their old places, but without clear duties to perform, created friction and added to the confusion caused by rigid and complex rules. Besides, paperwork made for slowness, and as always, some officials were arbitrary and arrogant. Half a dozen years after the start of Colbert's system, the export tariff bewildered even the government agents, and honest merchants were forced to pay whatever they were asked.°

The central bureaus were not indifferent to complaints; they applied remedies when made aware. But from the outset protests were heard about more than Colbert's plan. Attacks were aimed at the monarchical idea itself. They grew in volume and intensity as the years passed, their expression ranging from lists of grievances to theories of government and economics. Pamphlets, books, verses, and epigrams fed a public controversy, centered at first on the long trial of the disgraced Fouquet. Men and women of letters took sides, divided as deeply—so says the leading authority—as intellectuals were again by the Dreyfus case in the early 20C.°

In the opposition to the monarchy, some bourgeois and nobles found themselves making common cause. Their cries of pain or anger, it should be noted, were not suppressed: there existed a genuine public opinion in word and print. Among its views were some heard as far back as the 16C. Merchants objected to high tariffs; aristocrats to the loss of "liberties." When Colbert put pressure on mercantile wealth to invest in state trading companies, more protests ensued; but well-to-do nobles jumped at the chance, because doing so was declared no breach of the rule that an aristocrat "derogates"—loses his status—if he engages in trade. In the noble tradition only land is clean.

Colbert also caused irritation by conducting an inquiry into titles, so as to ascertain who was truly exempt from taxation. Some of the verifiers collected bribes, the unavoidable accompaniment of inspection. The results threw doubt on the classification. With a bourgeois fortune one could buy an office that carried a title. All magistrates, forming "the nobility of the robe," owed their rank to that practice—and the title was inherited: such was the Baron de Montesquieu's. Again, some portions of land on the market carried a *de* but it implied no title—for example, the Seigneurie de Barzun in the Pyrenees, was for resale as late as this century.° In addition, kings and ministers had distributed titles for special services, or for cash, or to ennoble royal bastards. For service, Colbert's son became Marquis de Seignelay. Saint-Simon's peerage was of very recent creation, his father being the first duke. Finally, people of note, writers especially, assumed an implicit title by means of a *de*: Jean *de* Racine, François *de* Voltaire, Caron *de* Beaumarchais. Annexing the particle

was for convenience: these men had aristocratic friends; when calling on them, the visitor must give his name, and without the *de* he might be refused entrance or treated with contempt by the snob in charge of the front door. To sum up: in the 17C a *de* or even an explicit title was no sure sign that one's ancestor had fought by the side of Charlemagne.°

Among those who felt oppressed by the two-headed monarchical system—by Louis at Versailles and by Colbert everywhere else—were the adherents of a theory that expressed a corporate sense of wrong. Saint-Simon's outburst about "a century of vile bourgeoisie" (<245) was consigned to his secret memoirs (355>); but the Comte Henri de Boulainvilliers published a theory of race superiority that later played a part in the politics of nationalism and ultimately of National Socialism (671>).

Race as the word was then understood meant family descent. In common usage the kings of the Capet family were the "third race" of French kings. The great noble clans were each a race, and when all these were thought of together they formed the aristocratic race, distinct "by blood" from the bourgeois and the peasant races. The nobility was obviously the superior one: they had come out of the German forests and conquered the mixed race of "Gallo-Romans" who peopled France; they had remained fighters, masters, leaders of crusades, and had enjoyed power until the kings, betraying their own race, had made the kingdom a monarchy.°

In the process—the argument ran on—the liberties of the people had perished. The local assemblies had disappeared; the Estates General of the realm were no longer convened, the last dating back half a century (<246). Likewise, the privileges accorded to individuals by rank and to provinces and towns by charter had been eliminated. In a word, the constitution of France had been subverted. Every so-called reform, every regulation made plain the march of tyranny. A far-seeing thinker of the preceding century, François Hotman, had given warning in his *Franco-Gallia* (<247), though with different details and little stress on the idea of race. What was carried over was the dogma that the Germanic element in France is the bearer of liberty (>482).

That the historical fiction was not buried with its obscure author may cause surprise. Two sources contributed to its survival and its spread beyond the dwindling circle of resentful aristocrats. For one, Montesquieu devoted many pages to it at the end of his *Esprit des Lois,* the influential rationale of constitutions. Published in the mid-18C, the book was in the hands of every well-read person in Europe and America. Earlier, Pierre Bayle had given Hotman favorable notice in his *Dictionary* (360>). In addition there was behind the "German race equals freedom" doctrine the indestructible Tacitus and his *Germania* (<9). Note in conclusion that Saint-Simon's "vile" bourgeoisie meant only that it was low, not vicious. The Gallo-Roman inhabitant of the *villa,* or settlement, started the "villain," on his downward course.

*
* *

Moved by anger, ambition, and hard times in the mid-1670s, a Chevalier de Rohan in Normandy organized an uprising with the aim of seceding from the realm and establishing an independent state. It was to be an aristocratic republic. The organizers grouped themselves into two classes, the nobility and the people, who jointly swore not to lay down their arms until they had won the power to enact new laws, especially regarding taxation. The program was not exclusive: Protestants could be elected to assemblies and preside over them.

Seeing the hardships and pitiable state of the people, to which the cruelty and greed of the partisans [meaning Colbert and his aides] have brought the kingdom internally and by evil or heedless counsel have created many enemies externally, the nobility and the people of Normandy have pledged each other never to separate their interests, but to sacrifice their goods and their lives for the common welfare.

—PLACARD OF THE REPUBLICAN
CONSPIRATORS (C. 1672)

The revolt was put down and the leaders tried and executed. The king was at that time undertaking his second war of annexation in the midst of poor harvests, low prices, and a level of taxation above the people's capacity to pay. In these circumstances, taxation did not cause unrest in Normandy alone. It spurred a debate that brought into question all the current ideas about economics. Why, for example, should the nobles' ancestral tax exemption be continued in a rational economy? Some writers put forward statistics; others tried to find fixed relations between the sources of wealth and the regulations of trade. These gropings pointed the way to the discipline that was first called political economy and later economics. The original name might well be revived now that the state is once more partner and regulator in business.

What was surely unexpected by the monarchy was that men of strong religious views should enter the debate and side with the opposition. Yet it was not unreasonable for devout moralists to object to the increasing SECULARISM and to the behavior of a court whose confessors were the flexible Jesuits. This opposition, moreover, included thinkers who argued once again in the light of Reason and Nature.

The religious who took this high ground were a group of solitaries named Jansenists, after the Dutch theologian Cornelis Jansen, bishop of Ypres and author of a learned tome on St. Augustine. Their retreat was at Port-Royal, near Paris, where a convent for titled ladies was headed by a remarkable woman, Mère Angélique. She persuaded her son, Antoine Arnauld, to settle in the vicinity for meditation. Others joined him, and their friends, including Pascal, Fénelon, and Racine, became regular visitors, thus forming without prearrangement a group embattled against the political and religious orthodoxy. Inspired

by their talks, Pascal's devastating tract *Letters from a Provincial* summed up the Jansenist attack on the morals condoned by the Jesuits (<219), while Arnauld's polemics blasted the Sorbonne. This was only a beginning. In 135 volumes Arnauld set the world straight on theology, ethics, grammar and style, logic, and geometry. The good fight kept him alive to the then uncommon age of 82.

Port-Royal thus became a significant institution in French history. The 19C critic Sainte-Beuve devoted years of research and eight volumes to delineating its character and achievements. Flaubert ridiculed him and the coterie by remarking how odd it was that a group of men who lived in common for 30 years called each other Monsieur to the end. But that period style was in keeping with the tone of their creed. Like their master Jansen, they disbelieved in free will, were convinced of predestination like Luther, and like him trusted in efficient grace for their salvation. But despite these Protestant ideas and personal austerity they professed fidelity to Catholic dogma. They were nonetheless declared heretics by the pope. Some modern scholars have seen in their animus the start of the political dissent that split the country permanently into "two Frances," this, long before the radical division caused by the revolution of 1789 (432>).

The link between Jansenist thought and that of the 18C philosophes is the cult of reason. The Jansenists regarded it as divine in origin and superior to prayer. Further, they took utility as a test of value. They believed that natural science led to important truths, since the laws of nature are an expression of God's will. Accordingly, the study of geometry trains the mind to reach the ultimate verities. This forward-looking blend of faith and science was recommended by Arnauld, Lamy, and—some Jansenists affirmed—by St. Augustine.

Complications do not end there. A dissenting branch of the movement took a different tack. Pascal, as we saw, imbued with the thought of Montaigne,

> Going into a bookseller's shop, I asked for Montaigne's *Essays*; he told me he had it not. A young fellow standing by presently said: "I have it at home." He told me he loved Montaigne's *Essays* because they were so like St. Augustine's *Confessions*. I kissed his hands and made an end of the story.
>
> —SIR WILLIAM TEMPLE (1652)

deemed human reason wavering and fallible and urged unquestioning reliance on God, whose ways were unfathomable. Geometry was useful, of course, but its method stopped short at the mundane.

These skeptical warnings, supported by arguments and references to the radical diversity of human opinion, were plainly another way of invoking Reason and Nature. The two Jansenisms illustrate to perfection the elastic strength of these twin ultimates of western debate. But of all the attacks on monarchism by men of religion the most direct (and ineffectual) was launched by

Fénelon

Of noble lineage, an intellectual in holy orders, an eloquent preacher and writer, he served Louis XIV as tutor to his grandson and heir, the Duc de Bourgogne. For his instruction Fénelon wrote some fables and a series of *Dialogues of the Dead,* and for a girl's school a treatise on women's education. In middle life he met a Mme Guyon, a mystic who made converts to her Quietism, the religion of pure piety, free of ritual and clergy, that Boehme had initiated in Germany during the Protestant Revolution and there called Pietism (<33). Fénelon, a fervent soul, was attracted by the doctrine and defended its author.

Sire: For thirty years your ministers have violated all the ancient laws of the state so as to enhance your power. They have increased your revenue and your expenditures to the infinite and impoverished all of France for the sake of your luxury at court. They have made your name odious.

For twenty years they have made the French nation intolerable to its neighbors by bloody wars. We have no allies because we only wanted slaves. Meanwhile, your people are starving. Sedition is spreading and you are reduced to either letting it spread unpunished or resorting to massacring the people that you have driven to desperation.

—FÉNELON TO LOUIS XIV (C. 1694)

That act of loyalty was the beginning of his misfortunes. His friend, Bossuet, also a renowned preacher and writer, turned on him and worked at court and at Rome to have Fénelon condemned and disgraced. It took some time, for Fénelon had friends and the king thought him the "subtlest and most inspired thinker in the kingdom." On his part, Fénelon revered Louis, yet reprobated his conduct, public and private. About the time when Bossuet was forcing his heretical friend to recant, the friend was composing a "Letter to Louis XIV" denouncing his character and policies.

It was anonymous, but the author of the unsparing words as of a father confessor must have been guessed. Fénelon was already renowned as one of the leading prose writers of the age. To his surprise, no doubt, the king's retaliation was to make Fénelon Archbishop of Cambrai. But that did not stop the conspiracy against him, and by a mischance it succeeded: a secretary who was copying a new work of Fénelon's gave it out to his employer's enemies. The work was *Télémaque,* a fiction based on Homer. It contrasted the behavior of an upright prince—Odysseus's son Telemachus—with the various agents of evil surrounding him. The work became a best-seller, being read as a satire on the court and the king. Fénelon was doomed.

Since it would have been difficult to try him like a layman, he was confined to his bishopric. There he devoted his time and resources to the relief of the poor and the comfort of the afflicted. On the edge of the war zone, he did

so much good to both armies that the enemy generals gave orders to prevent their troops from foraging or otherwise harming the territory.

Télémaque is a classic, which until lately French schoolchildren were made to read. The *Dialogues of the Dead* is an early example of that genre, in which famous men and women are made to discuss perennial questions of morals, politics, and literature. But these two works do not give the full measure of Fénelon's remarkable mind. In his voluminous works—sermons, treatises, "letters" that are really essays—he draws a picture of the government he thought France should have: a limited monarchy with a written constitution, representative assemblies, and a strong aristocracy discharging important duties. There should be equality before the law, public education, the mutual independence of church and state; the liberation of agriculture and trade from oppressive burdens, and due respect to all who work—in shops, fields, or the lower ranks of the clergy and government service.

Fénelon died in his place of exile a few months before the king died at Versailles. The next year a final "Letter" of Fénelon's came out, also radical in purpose. It was addressed to the Academy and dealt ostensibly with the question proposed by that body to its members: what should they be working at now that the dictionary had been completed? Some said: a French grammar; others, a rhetoric, a poetics, a theory of criticism. Read at a sitting before his death, Fénelon's answer was found so full of interest on so many more subjects than those proposed that it was scheduled for publication. Fénelon had just time to revise and make it into a small book of some hundred pages. It takes up grammar and usage, the nature of literary genres, the rules of poetry, the character of tragedy and comedy, the method of history, and the question whether the ancient writers are superior to the moderns.

On all these topics, Fénelon criticizes the conventional view of his time. He is against the excessive "purifying" of the French language that kept excluding words and idioms as "low," unfit for literature and polite conversation. Indeed, he wants to enrich the vocabulary by borrowing from foreign tongues and he encourages writers not to be shy about making new vocables and compounds. Arguments for EMANCIPATION appear throughout the "Letter." Fénelon wants preachers to be simple and spontaneous instead of formal and pompous. Poets are needlessly hampered by the French rules of versification; they should aim, like painters, at passion and truth in place of prettiness or bombast. And this goes for tragedy and comedy, where naturalness should prevail over affectation and thought-clichés.

As to history, the need is for a treatise on the subject, because it is a distinct genre that has not yet been recognized as such. Its importance is double: it is a work of literary art that records cultural change and it is a moralizing influence by its striking examples of virtue and vice. Discussing history leads

easily to the quarrel of the ancients and the moderns which, as we shall see, had flared up twice in the preceding 15 years (348>). Fénelon knew his own mind, but having urged the historian to be impartial, he did not render an explicit verdict for one party or the other. This restraint was further justified by his being at that moment regaining royal favor as president of a national council on Jansenism. His long detachment from court affairs was a qualification: he would be the perfect judge.

By then his long years as an admired writer made him the grand old man of French letters. Natively temperate and charitable, he took care not to reinvigorate the disputants but to calm them down. He does not shuffle but balances the merits of the old and the new. The ancients were the great originators. The moderns in imitating them should be able to surpass them. The best ancients were few in number and none perfect (as had been claimed), but then they were hampered by their imperfect religion and morals. Still, their capacity for the simple and the sublime deserves the highest praise. The moderns, Fénelon implies, have the opportunity to surpass if they adopt the liberal views he offers on usage, style, and the rules of the genres.

*
* *

The life of this extraordinary man takes us to nearly the end of the reign and at the same time to the end of Jansenism: the pope and the national council condemned it without appeal; its partisans died or submitted. Meanwhile another break in continuity had taken place in the court. When Louis was 45 years old—with 32 years of life ahead of him—he experienced a change of heart. He was persuaded to discard Mme de Montespan, whom the Devil had promoted (<291), and he bestowed his favor on Mme de Maintenon, whom God evidently sponsored, for she was pious and used no black arts. Only Providence could have contrived for her an odyssey that defies probability.

Françoise d'Aubigné came of a good Protestant family; her grandfather had been a friend of Henry IV, and she was born in prison during her parents' internment as heretics. Taken as a child to the island of Martinique, then back to France while still young, she became a Catholic in the convent where she was being educated. She was beautiful, of placid temperament, and very poor. At 17 she married Paul Scarron, a comic poet 25 years her senior, a hunchback and a cripple. For him she presided over a salon of the best wits in Paris.

Her next role, as a widow, was to bring up in secrecy the children of Mme de Montespan. When the king acknowledged and ennobled them, Mme Scarron came to live at court and soon received a piece of land at Maintenon, also ennobled for her benefit into a marquisate. From then on her influence steadily increased. Her first aim was to reform the king's morals and reunite him to the queen. Bishop Bossuet aiding, la Montespan was dismissed and

Mme de Maintenon installed in her place. The new marquise remarked that "nothing is more adroit than irreproachable behavior." She was 38 (therefore middle-aged) and in power. Her secret marriage to the king when a widower followed within a few years.

Overnight the court had to change course; the sun now shone through dark glasses. Etiquette remained much the same, but social tactics were burdened with a new apprehension—how to express sufficient piety. For some, it was a vindication of good morals and sincere devotion. For the rest it was an exercise in hypocrisy, another and less merry form of playacting than before. The king himself did not always seem to Mme de Maintenon sincere in his conversion. With a character such as his—a manufactured character, so to speak—whose purpose was to maintain authority by living a role, it is likely that his turnabout was not so much to religion as to religiosity. What is certain is that his new wife nagged him, incessantly disapproving. After a time her entourage joined in this exertion of Christian charity for the sake of his soul.

The work had practical results. The most fateful was the hounding out of France of its best artisans. They were Huguenots (Protestants), shielded from outright persecution by the Edict of Nantes, which Louis' grandfather Henry IV had promulgated almost a century before. Now to please God and Mme de Maintenon it was revoked. Conversion, exile, or death was the choice. As usual, the carrying out of the order was an exercise in horror and injustice. Bureaucrats and busybodies oversaw the operation. Local vendettas led to denunciations, the justice system was perverted. The dragoons were called out and indulged in the inevitable cleansing by massacre.

The refugees settled in England, Holland, and in Prussia, where their industrious habits and respectable lives earned them a good reception and a livelihood. They contributed their expert skill in many trades. They and their descendants—Englishmen and women with French names—soon became prominent in every branch of activity. The same future awaited these dispossessed families in Prussia, where they developed a strong loyalty to the welcoming authorities. They never forgot the benefaction: after the First World War, when the Kaiser lost his throne, the Huguenots of Berlin laid the only wreath on the shrine of the Hohenzollerns.

At Versailles after the conversion, favors as well as policy were dictated by the king's secret wife or one of her coterie. Not all their decisions were bad. She induced Racine to write two plays for the school that she founded for well-born girls that were poor. But it was also she who maneuvered against Fénelon. At first, when the king consulted her on various subjects it was in the presence of his other trusted advisers; and she acted the modest partner who speaks not until spoken to; in the end, she initiated and directed as one in charge.

This relationship suggests a variety of questions about the executive life.

How is it best secured for public policy? Rulers, royal or republican, all have to take advice from one or more among their entourage, but rarely get it absolutely sincere. The adviser almost always has some ulterior interest that deflects judgment. There is only one exception to this generality: the medieval and early modern fool. The post—the institution—of king's fool is a political device based on sound psychology, as well as on ancient religious belief. As he occurs in Shakespeare and elsewhere° the traditional fool is not quite normal; at best, his mind is like a child's, innocent, therefore truthful and sometimes inspired. His sallies are unexpected and amusing. This makeup, native or assumed, is essential to the profession that the fool exercised for centuries at the side of kings. Much of the time he is an entertainer, the jester in cap and bells; but at other times he says things nobody wants to hear and nobody dares to utter. The wise ruler listens

and benefits. But by the monarchical age, rationalism had progressed so far that it drove out the belief in the inspired idiot; he or his intelligent facsimile disappeared. There were women fools too: Queen Mary in 16C England had Jane Cooper, who was well paid and well treated and decently retired on a pension. The last thing Louis XIV wanted near him was a jester telling him and the court home truths. Gravity and a single source of wisdom were the strength of his system. His protecting Molière therefore stands in need of explanation (344>). After the death of Colbert, lacking a minister truly bent on the public good, Louis XIV relied for advice on his wife and his father confessor. He forgot the maxims he had lavished on his heir. Physical ills added their tacit influence to make him more self-regarding than attentive to his people's needs. Finally, his fourth and last war, in which Marlborough repeatedly defeated the best French generals, concentrated Louis' mind on his relation to the Almighty. After one of the worst battles he exclaimed, "Why is God doing this to me?"

* *
* *

One can only guess to what degree Louis was conscious of the motives behind his policy of war. They were certainly mixed and not pure egotism and love of fame. He had been told by Mazarin that he must beware of Spain and the House of Austria. Spain was taken care of by making his grandson its

king, an alliance solidified by Louis' last war. A Bourbon is still king of Spain. The struggle with the other powers was rendered permanent by the proximity of the two non-nations, the Germanies and the Italies. Their weakness made them temptations and therefore danger zones. Seizing even one region would change the balance of power, and its maintenance was the goal.

> A mighty king who, for the space of above 30 yrs amused himself to take and lose towns; beat armies and be beaten; drive princes out of their dominions; fright children from their bread and butter; burn, lay waste, plunder, dragoon, massacre subject and stranger, friend and foe, male and female. . . .
>
> —SWIFT, "ON THE USE OF MADNESS IN A COMMONWEALTH," *TALE OF A TUB* (1704)

Conquests for security upset that balance and war resumed to restore it.

The domestic reasons for war were also strong. Keeping the nobles over-awed required that they should regard the king as their superior in all ways. By tradition they were warriors, lovers of danger, careless of life. He must be as in the past a knight in armor at the head of his vassals. The monarch as impresario of minuets and musicals was all very well, but he must also outshine the party-loving aristocrats at their former game. Now, Louis was not a soldier, much less a military genius; he could be a conqueror only vicariously. He therefore organized campaigns on the same plan as Versailles. He was present at the scene and exposed himself moderately to shot and shell in front of a select group of lords and ladies, well catered for, while their sons and brothers led the mercenary troops against the foe.

A third necessity was to consolidate the nation. War has that effect naturally by creating a common goal, and victory heightens the effect. Since nation is an idea inseparable from continuous territory, annexing provinces to the east, north, and southeast of France would round out the shape of the country and make it so rich, so strong, so clearly top nation that no other could ever threaten it. This is the dream called universal monarchy. Its theory goes back as far as Dante, who wrote the treatise *De Monarchia* to expound it; its frequent recurrence shows the western passion for unity. With Christendom broken up by the Protestant Revolution, the nation-state was the form through which that passion found vent. Charles V also strove for unity, but had he succeeded, his scattered materials could have made only an empire. Henry IV, shortly before his death, had a "Grand Design,"° which may have been national or imperial; it remains ambiguous. By the mid-17C Louis XIV had a clearer idea and a better opportunity. But so had the Hapsburgs in Austria, and 200 years later Germany acted on the same plan.

Whether Louis' success would have lasted if he had acquired what is now Belgium, made the Rhine his frontier, and added Nice and Savoy as they now have been, is doubtful. A popular feeling for national expansion was not fully developed. There was little awareness that fellownationals must have a common language and uniform laws, must know enough to look back with pride

to a common past, and must feel possessive, not rebellious, about their society. It is not possible to glue pieces of territory together and expect national fervor.

Under Louis France itself had not achieved unity. He ruled over five kinds of districts called *pays,* which differed in status and privilege. Indeed, one kind bore the name of "*pays* considered foreign."° Provence was one of these, the reason for the title being a special tariff rate and other regulations. Further subdivisions differentiated regions under written law from those under custom; those that paid the salt tax from others that had bought exemption from it. Colbert had to thread his directives through the interstices of this conglomerate. Had the king really been Louis the Unopposed, as commonly believed, he would have swept away these hindrances by fiat.

As for the elements just cited that make for oneness of feeling, 17C France (and other nations) were wanting. When Racine, the poet and historiographer to the king, went to Uzès in the south, he could not understand nor make himself understood by the natives. In 1789, according to one observer, the Marseillais spoke no French.° The Alpine region of Dauphiné, with its capital Grenoble, which had been added to the crown in the 14C, continued for centuries to consider itself somehow independent—a kind of Texas. When crossing the border its people spoke of "going to France." (I heard the expression as late as the 1920s.) Similarly in England, local dialects that persist create a sort of sub-nationality. And nearly everywhere today these old diversities are resurgent. The French government subsidizes the regional languages and their teaching in the public schools.

The paradox that the nation-state existed before the "nationalist nation" may be explained by the obstacles to communication. But it should be added that a monarch, being both a person and a simple idea, is a stronger unifying force than the abstract nation with elected rulers who are temporary. Hence the significance of the flag, the nation's one concrete symbol. When citizens burn it to make known their opinion and the law takes no notice, something must have happened to the nation-state.

* *

Despite the advantage that a living person has over an entity, Louis lost that personal allegiance as he lost his wars. He had learned that glory costs money, not sheer derring-do: "Victory," he remarked, "lies with the last gold piece." On his deathbed he was conscious also of his other sins of extravagance. When his shrewish wife blamed him for "leaving restitution unmade," he replied that he owed no private one to any one of his subjects, and as for that which he owed to his people, he "trusted in the mercy of God."

The sun king went down without any lingering rays of glowing color.

Rather, the end of the reign recalled on a small scale the circumstances of the beginning: disputes among the powerful and resentment in the populace. Neither sorrow nor respect attended Louis' passing. Some half dozen courtiers went to the funeral at St. Denis, and although on the path of the cortege the people showed no hostility, they did show indifference. It was left to the satirical scribblers to stigmatize the departed in epigrams and quatrains: "Our eyes were too full of tears during his life to leave us any for his death."

The Regency that followed during the minority of Louis' great-grandson, the future Louis XV, took the usual course: relaxation after excessive strain. Saint-Simon and his friends had entertained high hopes of the Regent, the Duc d'Orleans; he was uncommonly able but proved incurably lazy. Morals and manners plummeted into debauchery, corruption, misgovernment, and slovenliness generally (308>).

Yet the impetus that the monarch had given to the arts did not slacken. Styles changed but mastery remained steady. Nor was it visible only at Versailles. Louis failed in his try at universal monarchy, but without trying he conquered large territories outside France for French culture and the French language. As remarked earlier, the pressure of politics on intellect seems irresistible; it takes effect, as in this case, even between enemy nations. To judge the fruits of this peculiar form of empire will take us back to the start of what much later came to be called the *ancien régime*.

CROSS SECTION

The View from London Around 1715

THE HAPPY THOUGHT in the Londoner's mind as 1715 came to a close was: Louis XIV is dead. The endless war had ended with a long-drawn-out treaty the previous year and now, the prime mover being gone, the conflict would surely not be renewed. Forty-six years of it, with three interruptions, was long enough.

The cause had no doubt been dynastic ambition but beneath the claims and counterclaims, both sides—all parties—had the same purpose: to prevent the re-creation of Charles V's empire. France fought in Spain, Italy, the Netherlands, and Germany to capture as much there as could be got, but also to head off the Hapsburgs, who hoped to rule in all four places. The Dutch having gained their independence from the Spanish empire had no desire to lose it to a French one; and being unequal to the struggle by themselves, organized a grand alliance that finally joined in one anti-French coalition: England, Holland, Brandenburg, Portugal, and Savoy.

By provoking this union Louis XIV had managed to bring on the first and second world wars, fought on three continents. The peace treaty allowed his grandson to occupy the Spanish throne, but there was to be no union of the two kingdoms in future. France lost Canada to Great Britain, which for its trouble and expense took Gibraltar from Spain, along with a contract to supply African slaves to South America for 30 years. For the rest, most of the places won or lost by battle were restored to their former owners. The permanent gain for Europe as a whole was the sovereign nation-state, and with it, the "European system" or balance of powers. Empire hereafter meant possessions in other continents.

Associated in each country with this longed-for peace were particular changes in government and social attitudes. In France, the great-grandson of Louis XIV was too young to rule by himself and for eight years was under the tutelage of his great uncle, the Duke of Orleans. This regency, like the Restoration in England (355>), reversed the policies and pieties of which court and town were weary. It was symbolic as well as merciful that the regent's first act was to set free all the prisoners in the Bastille. The new mood not only replaced but condemned the old.

At the same time it welcomed debauchery. The regent set the example. He had great qualities and did not neglect affairs of state but he was lazy and dissolute and unashamed. The grossness of the vice and its public display reminded observers of the time of the Fronde (<286), and to the extent that during the last years of Louis XIV the men and women at court were hypocrites, the adulterers, gamblers, and drunkards, bribe-takers and plunderers of the regency were not a wholly new type.

In this period of frankness, the masked ball at the opera was invented, thanks to a friar who suggested putting a removable floor in the large space to accommodate the revelers. The mask facilitated assignations and the crowd effect smothered self-restraint. Other festivities, such as the public shows and banquets when a new mistress was installed by the regent, made sexual license fashion as well as pleasure. The public knew too the exact price in grants and cash that the latest incumbent had received for her favors. Husbands took part in the bargaining, or tried to. The turnover was rapid, and yet the regent remained popular among women of all ranks. Only the ever-present naysayers spoke out in squibs and epigrams and lampoons either indignant or satirical.

What was perhaps worse was that manners degenerated. From a polished courtier the regent turned into a foul-mouthed ruffian, and in this set the tone. With manners coarsened, feelings become promiscuous too; that is, no longer in proportion with the things that arouse them. Respect for oneself and others, friendship and fair dealing, disappeared, and the fiercer emotions—jealousy, resentment, revenge itself—were diluted in a common acceptance of all human relations as momentary and trivial. Only the force of social example remained unchanged. It is on record that some previously decent men and women, upon being appointed to certain posts, adopted the proper misbehavior so as to be in step with the elect.

An innovation, an idea with a great future, made its appearance at this time. A very young man named Cartouche, trained as a soldier, gained immediate renown for his daring and success as a thief. He was arrested, escaped, and next invented the role of mastermind in crime. He organized bands of fellow professionals, male and female, recruiting even young noblemen who had talent and inclination. At a dinner party, a man who had been robbed on

the way recognized the pair of practitioners among the guests. Cartouche was soon a hero to the populace. Adept at disguise, he was able to hold his own in good society. He headed a delegation to greet the Turkish ambassador and relieved him of the gifts intended for the court. While one band was working in Paris on the foreigners about to invest in the Mississippi scheme (321>), another robbed the mailcoach from Lyon that carried treasure.

His downfall came from treachery by an accomplice. Arrested again—it took 40 men to do it—Cartouche nearly escaped once more. The surprise at his trial was that he was so short. Earlier he had withstood hours of torture without confessing or incriminating his followers. But for some reason he did both later on, though without any chance of escaping the punishment of being broken alive on the wheel. His disciples—several hundred men, women, and teenagers—were executed in the same way or died under torture.

It was understandable that Londoners should have a counterpart of Cartouche in Jonathan Wild (celebrated in novels by both Fielding and Defoe), because the police system was primitive. But Paris was expected to be much better served, thanks to Colbert (338>). What had happened there in 40 years to let crime develop was that the city had grown in area and population and the relaxed manners and morals had loosened the discipline of the bureaus. The English statesman Bolingbroke, an exile in Paris, in a letter to his friends Swift, Pope, and Arbuthnot, speaks in praise of "the divine science, *la bagatelle*." The word means trifle, but with a wide application: it can refer to a modest meal or entertainment, to a loss of small amount, or again to an ephemeral piece of writing or a sexual encounter. Bolingbroke's point is that life should be taken lightly and its little pastimes enjoyed to the full.

*

* *

Closer to home, a concern of the year 1715 in London was a possible invasion of England by a force of French and Scots. Two decades earlier Charles II's brother James II had been deposed, and his adherents were plotting his return. The English call the former the Glorious (and also the bloodless) Revolution. This is another historical misnomer. The change of kings was a coup d'état. A small group of politicians invited to the throne the Dutch head of state William of Orange and his wife, Mary, daughter of the said James. The transfer was for the sake not of making a change in the government but of preventing one. James II had taken steps to reinstate Catholicism and given signs of doing without Parliament. The first of his moves to that end, curiously enough, was through a law of toleration for all religions.

The "revolution" was thus reactionary, not in favor of a new idea but of a change of personnel in the old framework. Nor was it entirely bloodless. One need not be pedantic and cite James's nosebleed at a critical point, but

William had to fight the Stuart forces—Irish and French—in Ireland. His soldiers' harsh suppression of the country, an echo of Cromwell's, is what gave the name of Orangemen to all later supporters of the English interest in the unhappy island.

In 1715 the attempt at restoration in England failed after two skirmishes. Eight years earlier England and Scotland had formed a Union and the clans did not rise for James, despite their long association with France. Yet the English did not feel that their new arrangements were secure. "The '15" was in fact followed by "the [17] '45," which did entail battles. In between, the people continued to fear the Catholic menace at home and abroad. English Catholics were few, but the Protestants were split into two groups that were and have remained social castes, Anglicans and Dissenters. The latter were tolerated but subject to many disabilities, so that every topic was colored and often poisoned by the politics of religion. When shortly before 1715 the brilliant journalist Defoe wrote "The Shortest Way with the Dissenters," recommending that they be totally uprooted, he incurred the wrath of both sides, the dissenters failing to see the irony. He was tried for seditious libel, jailed, and put three times in the pillory. But while in prison his "Hymn to the Pillory" made his position clear and during his public ordeal the London populace drank his health and pelted him with flowers.

King William being a foreigner and from Holland, long the traditional enemy, had to endure attacks on the score of nationality. The sentiment was now conscious and it began to merge the idea of native with that of descent—nation and race, blood and soil. On this point Defoe defended the new king; his poem entitled "The True-Born Englishman" satirizes the notion that such a type exists. For this and other poems and pamphlets and especially for his *Review*, a one-man political journal, weekly at first and later thrice weekly, Defoe has been called the father of modern journalism. It would be more accurate to say political journalism. By 1715 most countries of the West had "journals," "gazettes," or "magazines" that supplied news, miscellaneous comment, or essays on moral and social topics, or all of these together. The press as an institution in several forms was born between 1630 and 1650. It is the pamphlet much reduced in size, issued regularly at short intervals, and with advertising added.

The journalist developed into a social type, exemplified in the London of the years of our concern by Defoe, Addison, Steele, Swift, and a large group of lesser lights. Their common characteristic is allegiance to a political

The Romans first with Julius Caesar came,
Including all the nations of that name,
Gauls, Greeks, and Lombards and by
　　computation
Auxiliaries or slaves of every nation,
[nine other peoples are cited]
From this amphibious ill-born mob began
That vain, ill-natured thing, an Englishman

—DEFOE, "THE TRUE-BORN ENGLISHMAN"
　(1701)

party. The press that attacks the government claims that it is working for liberty and justice, against corruption, and for the general welfare. The press that supports the government claims that it informs the busy or ignorant citizen about the complex activities of the men in power, all single-minded in their devotion to the general good.

These rival advocacies are particularly useful under a mixed government, one with an elected assembly, a party system, and public discussion; under an absolute monarchy, the journalist must be heroic. But under both systems alike, censorship and the repressive use of the courts make journalism an adventure for the hardy. That may be why it has not settled into a profession; like its prosperity, its ethics vary with the degree of its political animus; Defoe and Swift, for example, wrote brilliant polemics for ministers of state, though they followed their conscience and switched parties when they disagreed with their patrons' policies. Defoe endured prison a second time and Swift lost his chance of becoming a bishop because of their opinions.

Defoe's political activism included service as an intelligence gatherer. But Addison and Steele, who made their *Tatler* and *Spectator* famous as classics of English prose and as sources of social history, were political merely by tendency, not of set purpose, much less by employment. The ideal of the news-only journalist came late in the history of the press, and it did not last long (786>).

What the journalists of every type see as their proper task is to form, with the help of rumor and current prejudice, what is called public opinion. Though the noun is in the singular, it is not one set of ideas. When relatively few could read, the influence of the press depended on those few being themselves influential. The ideas of the masses were molded from the pulpit. Public opinion is thus a mob of jostling views that turn into a single one only under the impact of clear events. For the public as well as the journalist, the facts reported must be striking—scandalous or unexpected. For example, around our starting date here, Londoners learned that Thomas Britton, "the small-coal music man" had died. It was unusual that a man who sold small coal and delivered it himself should be an accomplished musician (and also a chemist), who held soirees above his shop, where the best performers, including Handel, were glad to take part.

About the same time there occurred the strange affair of the poltergeist at Epworth. The Reverend Samuel Wesley, rector of that village in the fen country, lived with his large family in an isolated spot. Suddenly, the rectory was the scene of knockings and other unaccountable disturbances. So troublesome and persistent were the phenomena that members of the family wanted to move. But he was stubborn, especially against the Devil, who was obviously trying to dislodge him. The minister had been equally steadfast against his neighbors when they expressed displeasure about his views and

his pastoral care. It now seems probable that the poltergeist was the neighbors resourcefully trying to drive him away.° They did not know (nor did he) that his sons John and Charles, both at Oxford, were brewing there a mixture of religious and social ideas that did not take long to become effervescent.

Equally strange and not so easily explained away was the performance of the Orffyreus Wheel, which occupied for a number of years some of the best minds of the Royal Society and other learned bodies in Europe. Within a casing shaped like a drum, a wheel three feet in diameter and four inches thick revolved when started by hand, then picked up speed, raised weights, and kept going—all this without any external source of power. The inventor, one Johann Bessler, who went by the name of Orffyreus, declined to say how this motion without motor was effected or how he had come to discover the principle. The mystery was a serious matter. Many educated persons were familiar with the new physics and believed perpetual motion impossible. The enemies of Orffyreus assailed him with the passion of the inquisitors against a heretic. He fought back and built three other wheels, larger than the first; the last lifted a weight of 70 pounds. He had a titled patron and never tried to earn money by his exhibitions. The correspondence on the subject is abundant and precise. There it was: experts had examined the sphinxlike machine and had shrunk back discomfited. No solution has ever been found.°

It was remarked earlier that scientific advances more often than not depend on instruments, whether common and ready for use or devised by the researcher. In return, the engineer takes advantage of theory when applicable and at times works side by side with another technician, the architect. These links are evident in the rebirth of civil engineering at the turn of the 17C. Newton's theory of gravitation aroused a desire to measure the earth with more precision. Out of it came the combined telescopic sight and spirit level of Mallet, a French military engineer. The existing instruments for surveying, measuring, and building—a panoply of rulers, compasses, protractors, proportional dividers, angle and level meters, surveying pins, rods and chains, micrometer, callipers, the pantograph, and other "philosophical instruments"—were for the first time made the subject of an illustrated treatise. Their development explains how the notable roads, canals, bridges, aqueducts, waterworks, and harbor defenses of the period—not a few still standing—were built.

In addition, war and preparation for war added to knowledge by the study and building of fortifications. During the dynastic struggles the critical battles were often fought between besiegers and besieged. The fortresses around towns that were the gateway to a region were enormous works of engineering science and Baroque art (333>). They consisted of trenches, walls, bastions, watchtowers, corridors, breastworks, and ditches filled with water. Geometry presided over the design—a succession of vertical angles and horizontal slopes—to magnify the difficulty of approach and entry and

to minimize the effect of head-on gunfire. For cannon of that period did not fire shells and their horizontal shots did not go through earthworks. Siege artillery consisted of mortars and howitzers, pieces that lobbed stones or iron balls over barriers and did damage only where they fell. A fort could best be breached by sapping and blowing up the "works," and this was done whenever conditions permitted.

The leading artists in this architectural genre were the Hollander Coehoorn and the Frenchman

Vauban

The former was an intuitive practitioner, the latter a many-sided genius who developed theory and also directed construction on the spot. He could size up at a glance the features of a site that could be part of his design. He built 160 fortresses, never exactly alike. They were made not only to hold out but also to last. Some of them played a role as late as the war of 1914–18.

As a teenager he enlisted in the army, was wounded eight times, and rose to the double rank of marshal and chief miliary engineer. But he was no glorifier of war. When in charge of operations he did everything he could to reduce casualties and end the fighting. The contrivances of his fortifications had this purpose in view. When the encounter reached a certain stage he judged the situation like a chess player and advised surrender or retreat. For half a century he devoted his wisdom and his strength to the service of Louis XIV, his duties at times bringing him near physical collapse. As he wrote to the minister of war after tramping around works in progress, "in reviewing troops they march past you on their own feet, whereas not a single watch tower will stir an inch at my command."

Vauban also supervised works of peace. His wide-ranging interests led him to study and promote plans for naval strategy, political economy, and national welfare. Saint-Simon, ever-vigilant on that last topic, gave a new, honorific meaning to a hitherto neutral word by calling him *patriote*.° When near his death in the first decade of the 18C, Vauban was busy wrestling with corrupt bureaucrats in charge of the royal tithe.

The man's tireless endeavors present a fourfold paradox that is an emblem of his times: Vauban was tenderhearted, full of sympathy for both individuals and social groups, yet he worked at killing and destroying. He opposed financial extravagance and

> I fear for the state of the monarchy when I see garrisons made up of companies of children or other poor little wretches who have been snatched from their homes and subjected to all kinds of ill-treatment and who are commanded for the most part by officers who are as badly off as they are—lodged like pigs, half-naked and half-dead of hunger.
>
> —VAUBAN TO LOUVOIS, MINISTER OF WAR (1675)°

the weight of taxation, yet his fortifications were the biggest military expense. His genius was lavished on creating enormous structures for defense, yet the king's wars were all offensive and with this in mind Vauban devised an excellent scheme for overcoming strongholds with the least loss of life. Lastly, he himself was always in command outside a fortress, never inside. [The book for laymen to read is *Tristram Shandy* by Laurence Sterne.° Readers keen on technicalities will enjoy the text and plates of *The Fortress in the Age of Vauban and Frederick the Great* by Christopher Duffy.]

*
* *

At a good distance from Europe's leading centers of intellect, in the university of Naples, one of the towering minds of the Modern Era was occupying in 1720 an ill-paid chair of secondary importance and revising a large book. It was a seminal work, but the seeds produced no visible crop. Today, except to some students of the history of history and of the social sciences, the names of the man and his book remain unknown. That man was Giambattista Vico. Like Blake, Vico must be called a prophetic writer in that he said what his fellow geniuses said later on. Only, Blake's poetry can be read and enjoyed by the modern reader, whereas Vico's masterpiece is a closed book. The men of his stature found it open only when they themselves were doing or thinking what he foretold.

The son of a poor Neopolitan bookseller, Vico grew up in dire poverty, he had wretched schooling, and only when industriously self-taught did he enter a circle of learned men and lively thinkers. They were debating advanced views, those of Gassendi, Bayle, Hobbes, Spinoza, and John Locke. The reigning philosophy was that of Descartes, interpreted to give method and logical demonstration authority over all human affairs; the Age of Reason was on the point of declaring itself to be such. Vico began his war of independence by opposing Descartes as dangerously incomplete.

Without knowing anything of Pascal's two esprits (<220)—the Pensées were not yet a classic work—Vico made the same critique of Reason in different terms: man is not all rationality and the other ingredient in his makeup is of equal worth with reasoning; indeed it is of immense importance. The purpose of Vico's objection differed from Pascal's religious concern, though both men took Christianity as the unquestioned truth to start from. What Vico aimed at was a redefinition of man's history and a new philosophy to go with it, so as to form a unified vision of man and the world.

He performed this feat in a complex, ill-written work that he called *La Scienza Nuova*—the New Science.° He had difficulty getting it published, not

on account of its defects but of its merits. (Bad writing, it is easily verified, has never kept scholarship from being published.) Vico saw mankind—nations, civilizations, cultures—as going through progressive stages from bestiality to high civilization and then sinking back into barbarism. To call the first stage bestial was an inkling of evolution and, of course, a heresy.

Vico thus started the tradition of dividing history not by years alone but also by levels of culture that rise, stay fixed, or fall, or possibly rise and rise. From his studies he derived generalities and issued predictions. His most shocking one was that the second barbarism that engulfs civilization after it has reached its summit is worse than the first. The original barbarians possess rude virtues; the later have none left. He listed the marks of the second and how it came about. Crowded city life produces men who are unbelievers, who regard money as the measure of all things, and who lack moral qualities, particularly modesty, duty to the family, and virile courage. Emancipated from ethics generally, they live by mutual spying and deceit.

By this description Vico hoped to warn his contemporaries against what might befall. He had read and assimilated the facts of human action and social decay in Tacitus the historian and Machiavelli the political scientist. But *The New Science* dealt with other large subjects that he as it were invented and that are still of moment: the character of the state, the methods of anthropology and ethnology, the origin and role of social inequality (like Pascal, he had fallen in love with a woman of title), and most provocative, the limits of Providence in shaping human history. Despite the religious and lay predestinarians who are ever present, Vico committed himself to a second heresy, that men make their own history.

Vico died near the midpoint of the 18C, not isolated or desperately poor but without the status and flattering attentions that he deserved. It is plausible to think that the strong sense of history perceptible in whatever he wrote is the reason why recognition came to him at the beginning of the history-wedded 19C. First, some Italian students of public law, then Goethe, Michelet, Auguste Comte, and a few others admitted a debt to Vico for confirming their views. They did not stint their adulation. Hegel and Karl Marx presumably also read him and profited; their works, though not their words,

The free peoples mean to shake off the yoke of their laws and they become subject to monarchs. The monarchs mean to strengthen their own position by debasing their subjects with all the vices of dissoluteness, and they dispose them to endure slavery at the hands of stronger nations. The nations mean to dissolve themselves, and their remnants flee for safety to the wilderness, whence, like the phoenix, they rise again. That which did all this was mind, for men did it with intelligence; it was not fate, for they did it by choice, not chance; for the results of their always so acting are perpetually the same.

—VICO, CONCLUSION, *THE NEW SCIENCE* (1744)

suggest it. A good deal later, anthropologists claimed him as one of their own. Today, one must ask several dozen well-read persons before any of them says he or she has heard of Vico. How many more would have to be asked before a *reader* of *The New Science* or the *Autobiography* was found and verified is a problem in probability theory.

<p style="text-align:center">*
* *</p>

London, unlike other European capitals, looks west as much as it does south and east, perhaps more; and in the early 18C, concern and curiosity alike drew its gaze to the distant west, where the colonies planted a century earlier were thriving. At the same time they were experiencing and causing trouble, for the usual reasons of trade and politics. The colonists wanted from England the manufactured goods they lacked the machinery to make for themselves. They obtained these goods by selling grain, dried fish, and other raw materials to southern Europe and the West Indies, in exchange for wine and other products that England would buy. This was the "triangular" trade. By a less roundabout route, New England bought Caribbean molasses (from sugar cane), distilled it into rum, and with it got slaves out of West Africa to sell to the West Indian sugar growers. When the English decided to tax the molasses for revenue, the price rose for the rum runners, and the political unrest every-simmering in the colonies boiled up once more.

The size of the North American colonial population at that time is estimated at 162,000, but it was not a unified body; the links to the mother country varied from colony to colony. When the original settlement had been by charter—akin to the statutes of a corporation—the colonists felt they lived under a constitution affording permanent privileges, such as an assembly. If established otherwise and subjected to a governor appointed in England, or if a governor was sent to supersede charter rule, the desire for self-government turned into rebelliousness. Add to this the democratic animus of the poor against the landed class that was part of the Puritan tradition (<265), and it is evident that colonial resistance to English rules and rule was inherent and incurable.

It flared up in Bacon's rebellion against "aristocracy" in Virginia and it kept agitating New England until the English "revolution" of 1688 (<309) turned it into violence the next year. Charles II had hoped to rule the colonies by fiat and James II to make them into one unit for the same purpose, sending Sir Edmund Andros to govern it. The Bostonians, however, revolted, put Andros in prison, and restored the charter provisions that Charles had annulled. The struggle for American independence clearly dates from early days. "Virtual representation" of the colonials by members of Parliament wore out its credibility and would have done so sooner if Robert Walpole,

Whig prime minister during the second and third decades of the 18C, had not chosen the colonial policy of salutary neglect.

American sentiment on politics and economic class could seldom be completely radical. The hostile presence of the Indians, the French, and the Spanish had a sobering effect, and colonial troops willingly took part on American soil in the European wars that they called King William's and Queen Anne's—the names show loyalty rather than deny responsibility. The status quo was also buttressed by the churches, although religious attitudes did not remain unchanged. In the last decade of the 17C Massachusetts enacted toleration for all except Catholics; Pennsylvania and Rhode Island enjoyed it without restrictions. And as suggested earlier, the witch trials at Salem in that same decade were manifestations not so much of religious belief as of a curious kind of psychiatric science (<213).

Besides differing in class, wealth, and religion, the 162,000 were divided also by status and origins. The African slaves were property and lived under special laws. Above them were indentured servants—men and women who had obtained passage as immigrants on condition of serving a master for a stated number of years. There were also what might be called "contract wives," women brought over as willing to supply a deficiency and hoping to better their lot.°

The remaining layers of the population belonged to the ranks observed in the mother country, whichever it might be. It is a backward illusion to think of the United States as founded wholly by freedom-loving English yeomen, full of love and tolerance for one another. The emigrants were English, and also Welsh, Dutch, French, and German. A large Scotch-Irish immigration was beginning at the time surveyed here; and already a complaint was heard that newcomers (to Georgia, just then being settled) were of lower character than their predecessors.

The leading cities were Boston and Philadelphia, each of about 12,000 souls, and New York, with only 5,000. Three new ones were founded by the French: D'Etroit, Mobile, and New Orleans; and another by the Spanish: San Antonio with its mission, the

> It was now plainly affirmed, both by some in open Council and by the same in private converse, that the people in New England were all slaves, and the only difference between them and slaves is their not being bought and sold.
>
> —ANONYMOUS, *ON THE REBELLION AGAINST GOVERNOR ANDROS* (1689)

> Those that went over were chiefly single men, who had not the encumbrance of wives and children in England. Such as had left wives in England sent for them; but the single men hoped that the plenty in which they lived might invite modest women without any fortune. The first planters were so far from expecting money with a woman that 'twas a common thing for them to buy a deserving wife at the price of £100.
>
> —ROBERT BEVERLEY (1705)

I am forced to work hard with axe, hoe, and spade. I have not a stick to burn but what I cut down with my own hands. I am forced to dig a garden, raise beans, peas, etc., with the assistance of a sorry wench my wife brought with her from England. Men are generally of all trades and women the like within their sphere, except some who have slaves.

—Tʜᴇ Rᴇᴠᴇʀᴇɴᴅ Jᴏʜɴ Uʀᴍsᴛᴏɴᴇ (1711)

Alamo. But founding cities was not the common goal. The prevailing social type was the frontiersman who must earn a living by facing the wild in all its forms—rugged country, animals, and Indians. The virtue of self-reliance, later eulogized by Emerson, was thus embedded in the national ethos by simple necessity. Later, under the pressure of machine industry and increased population, the ideal eroded and was gradually replaced by its opposite.

Under these harsh conditions, American culture in the high sense was sparse. The output of poetry was negligible, although in the late 17C Benjamin Thomson wrote an epic, *The New England Crisis,* and Anne Bradstreet imitated at length the Franco-English best-selling poet Du Bartas.° She started the tradition of imitating English models that lasted till the end of the 19C. Prose writers on secular subjects, such as the historian of Virginia William Byrd, had the advantage of having fresh and picturesque subjects. In New England the reflections of a lifetime gave unique merit to Judge Samuel Sewall's *Diary.*

In painting, the lack of places where one could train or copy had the fortunate effect of producing primitives, chiefly portraitists, who are now the envy of modernists and the joy of collectors. Music, largely for religious uses, drew on English hymns and other tunes, and for the rest consisted of folk songs, also imported—there was no reason to break the continuity. But out of this material, the musically gifted, largely self-taught, fashioned variations and creations as original in their faults as in their spirit. Sometimes the American composer's dramatic intention succeeds by innovative means that the 20C in the person of Charles Ives would not disown.°

The demands of practical life pointed cultural energies in other directions. Schools had sprung up early, and Harvard College—a sort of high school—was established within a decade and a half of the Pilgrims' landing. More truly collegiate studies came at the turn of the century with the College of William and Mary (honoring the new sovereigns) and Yale, originally the Collegiate School at Saybrook, Connecticut. It was transplanted to New Haven 17 years later, thanks to a benefactor named Elihu Yale, then serving the East India Company in Madras. From there he sent the college goods to sell and books to keep. At all three colleges it was not unusual for students to enter at the age of 13 or 14, a good many of them planning to become churchmen, like their teachers. Society had not yet discovered the need to equip everybody with an academic degree as the ticket of admission to a well-paid job.

While the English colonies in America remained well short of being a nation—a unifying plan by William Penn had no more success than the fiat of James II—another people at the other end of Europe was being coerced into a likeness of the real thing. The Russian czar Peter came to power at the age of 17 in the year when William of Orange became King of England. Both had to assert their authority against resistance, but Peter had the further task of forging a modern state. He had the help of two West Europeans, Lefort, a Swiss, and Gordon, a Scot. But he himself felt his ignorance of the western model and set out to see it for himself. At the turn of the century he went incognito to the Netherlands, worked there in a shipyard; then to France—this time appearing in his own name and style—and finally to England, once more incognito.

He learned fast, and wisely recruited helpers for his scheme of bringing Russia at one jump to a cultural level with the Occident. It proved much more difficult than he had expected. He could, and did, cut off beards and heads and issue edicts. He built a new capital city, Saint Petersburg; he imported foreign books and made French the language of the court; he founded an Academy of Science—but for decades all its members were foreigners, owing to a lack of native candidates. And the country's 500 wealthy families lived as before on vast estates, holding from 100 to 5,000 "souls" (= serfs). Such was the elite soon to be esteemed abroad for its high cultivation, chan-

> By our feats of arms we have emerged into the light of day. Even those who still do not know us, give us respect.
>
> —PETER THE GREAT (1714)

neled through an acquired knowledge of foreign tongues. In the rest of the population, even when emancipated in the 19C, ancestral ways persisted. The men whom Peter took on his tour of the West gave their hosts a fair idea of those ways: they were steadily drunk and uncouth and gave the name Muscovite a connotation it never lost.

Even now, western capitalists who hope to do business on a large scale in Russia are frustrated by habits that antedate the Soviet regime. The acclaimed writer and former exile Solzhenitsyn condemns Peter for the brutality of his reforms, estimating that a million Russians died or were driven out between 1719 and 1727.° The critic goes on to ask whether Russia will survive as a nation. Perhaps it never was one. The question these days can be asked about other states. In Peter's time there is no doubt that the nation as a political form was solid along the Atlantic seaboard of Europe, but weaker as one moved eastward. Though recognized as independent units, Switzerland and Holland (officially the United Provinces) were not yet tight-knit, and the Scandinavian countries had not separated into the present threesome, Sweden, Norway, and Denmark. In the true nation-states there was an excep-

tion to fully national consciousness: the military. During the wars of the 17C French troops fought for the Dutch against France, and German troops for France against the rest of Europe, with a scattering of other nationals shifting sides and sites according to mercenary opportunities.

<div align="center">*
* *</div>

The Londoners who heard of Peter's visit were not limited to that bizarre event for the satisfaction of their curiosity. An extraordinary spectacle across the Channel was keeping the public rooted in suspense as if at a play. It ran for about a year and a half and was also connected with America, if only by a thread. This was the Mississippi Bubble. Its creation and collapse were in large part the work of circumstance. As will be remembered, the regency that followed the death of Louis XIV faced bankruptcy. The state owed about two and one-half times the amount it raised in revenue, a sum that barely covered the expenses of government. The situation provoked an outcry against the tax "farmers." They were made to disgorge their illicit surplus and one was put to death. But the money recovered volatilized on the way to the treasury at the hands of the regent's favorites and his friends' fine ladies. On that typical scene appeared

John Law

He was a Scot of middle age who combined the life of an adventurer with a genius for finance. The son of an esteemed goldsmith and banker in Edinburgh, he was apprenticed to the firm at 14. He worked hard and learned much, but living in London after his majority, he became a gambler and man about town. He was tall, handsome, of alluring address. In a duel over a woman, he killed his man and was convicted of manslaughter but allowed to escape. His travels abroad took him as far as Hungary and Venice. He became an expert on European trade. Years before, he had proposed to the Scottish Parliament a scheme by which a bank would issue notes backed by the value of land and would thus stimulate trade. The scheme was turned down. Submitted next to Louis XIV it met the same response. Returning to France during the regency's critical days, Law quickly won the regent's friendship and trust and proposed his bank scheme once more, with success.

Promptly chartered, Law and Company founded a central bank with branches in several provinces. It issued shares on such terms that they were soon taken up. Trade and industry revived and the notes gained 15 percent in value. Paper money was being for the first time established as common currency and found preferable to metal, because governments had the habit of re-coining and devaluing silver and gold. This success led to the formation of

the Mississippi Company, whose shares were to earn dividends from trade, first with Louisiana and soon after with the Indies. On the strength of Law's reputation, thousands rushed to subscribe and the value of the stock rose 120 percent. Only two public figures held out: Saint-Simon and the Marshal of Villars. The common people risked their savings in hopes of a fortune.

At this high point Law made his great mistake. He let himself be persuaded by the authorities to issue more shares. The country drowned in paper, coins grew scarce, and trade was hobbled. Some 6,000 men were enlisted or coerced into leaving for Louisiana to perk up trade and profits, and an edict forbade anyone's holding more than a small amount of metal currency. This last measure set off a panic. A rush on the bank smothered 15 people to death. M. de Chirac, a physician, frightened nearly out of this world a patient whose pulse he was taking by murmuring to himself, "It's going down, down, down." Law and his family were mobbed; many wanted him hanged. Satirical verses and epigrams went the rounds.

> Here lies the Scot of world-wide fame
> For counting anything you please.
> Thanks to his skillful numbers game,
> France has a terminal disease.
>
> —ANONYMOUS FRENCH SQUIB

Law acknowledged his mistake but was treated generously by the regent—given money for future expenses and allowed to leave for Italy. He returned to England after obtaining a pardon for his homicide and ended his days in Venice poor and dishonored. Since then and as recently as 1996, he has been regarded by some economists as a pioneer in the arts of credit and banking, whose misstep was due to unescapable pressure by ignorant governors.°

The English observers of Law's rise and fall had no call to feel superior. Some half dozen years earlier they had embarked on a scheme devised by the chief minister, Harley, to restore public credit. This was the South Sea Company, financed by shares anyone could buy. The beginnings were favorable, for the plan was sound enough. But when news of Law's early success reached England, the directors of the company over-extended themselves and speculation started. Parliament wrangled over measures to help or hinder; except for half a dozen peers, the only statesman to oppose further development was Robert Walpole.

While legislation was pending, innumerable companies were formed and "went public." Most of their stated purposes were absurd on sight—everything was to return huge profits, from "rebuilding houses throughout England" to trading in hair and teaching the theorbo (a lute with two sets of strings). These enterprises rapidly turned into bubbles and vanished into the same thin air as Law's. But in England there was punishment and some restitution from profiteers. Gibbon the historian gives in his autobiography an

Some in clandestine companies combine,
Erect new stocks to trade beyond the line,
With air and empty names beguile the
 town,
And raise new credits first, then cry them
 down.

—DEFOE

Subscribers here by thousands float
And jostle one another down,
Each paddling in his leaky boat,
And here they fish for gold—and drown.

—SWIFT

account of his grandfather's role as a director of the South Sea Company. He was arrested and fined nearly £100,000. But Parliament left him 10,000, with which he built another fortune and thus afforded his grandson the leisure to write one of the world's masterpieces.

The schemes taken all together had a double result for the advanced nations of the West: banks, credit, insurance (Lloyd's was booming), a national debt, a stock exchange, and speculators were now permanent institutions. Paper money circulated but remained suspect for another 100 years. Said the poet Peacock in the early 1800s: "Experience seems to settle/That paper is not metal." But as early as 1710, Swift's piercing eye had seen the irreversible social and cultural transformation: the new men of importance are "quite different from any that were ever known before the Revolution [of 1688]; consisting of those . . . whose whole fortunes lie in funds and stocks; so that power, which . . . used to follow land, is now gone over into money."°

<div align="center">*
* *</div>

As journalists Swift and Defoe not only wrote for opposite political parties, but were also far apart in status. Defoe with his *Review* was a "contemptible scribbler," popular with the dissenters and the London mob; Swift was an Anglican clergyman, ultimately Dean of St. Patrick's Cathedral in Dublin. He hobnobbed with ministers of state and so forceful were his advice and propaganda that he could boast of having ended the next-to-last European war with his pamphlet *The Conduct of the Allies*.

But as creators of enduring literature the two men stand level. Defoe created a classic type of story all his own: he made actual events into fiction that read like history—*The Journal of the Plague Year*, *The Year of the Great Wind*; and of course *Robinson Crusoe*. The first relates the calamities London endured just before the great fire of 1666 sanitized the city by destroying 400 acres at the center; the second describes what happened in 1709; and the last tells how the solitary sailor hero survived, like Alexander Selkirk marooned on Juan Fernández, off the coast of Chile. These works are not the same as Scott's later invention, the historical novel; they are what is often believed to be a 20C genre called the non-fiction novel.° Defoe also wrote picaresque tales—*Moll Flanders, Colonel Jack,* and others detailing a character's hard life and shady

expedients, all imaginary but undoubt- edly based on facts observed. These stories also have the ring of reportage. Defoe's genius consists in the power to show rather than tell. The flat fact is there before you, and the moral obser- vations sound like the neighbors commenting. This cunning eclipse of the author is achieved by a style that is transparent and brilliantly undistinguished.

I am most entertained by those actions which give me a light into the nature of man.
—DANIEL DEFOE

Remarks of a very different order are called for when we come to

Swift

First one must clear the air of the conventional catchwords, namely that he was a misanthrope and a misogynist obsessed with scatology, and more- over a bigoted politician who never got over his failure to be made a bishop and died mad. Far from being a hater of mankind, Swift deserves to be called a philanthropist of the most practical kind. Throughout his life he went out of his way to help those who approached him for help—men and women, young or old, with or without talent. When in Dublin he put his whole heart- and-mind into defending the Irish people against England's economic oppression. His relations with "Stella," the woman he cared for from his ear- liest youth, were tender and protective; he had taught her when she was a child and both were part of Sir William Temple's household. Swift appreci- ated his patron coolly, but warmed to the personality of Lady Temple, known to fame as Dorothy Osborne, the sprightly letter writer.° The misanthrope, niggardly with his affections and good actions, acts otherwise.

But what of Swift's epitaph, written by himself, which speaks of the "sav- age indignation" that he no longer will have to feel in the hereafter? The word *savage* is true but the key word is *indignation*—the feeling of outrage on seeing injustice. It can be a cheap feeling, indulged right and left to seem virtuous. It is warranted only when the case is clear and the object of one's sympathy deserv- ing. The object for Swift is the individual human being. "All my love is toward individuals—John, Peter, Thomas, and so forth." But men acting as groups— "all nations, professions, and communities," he "hates and detests." And he adds, "not in Timon's manner,"° meaning not taking to the woods as a hermit. Man the animal and his mass behavior is what calls forth Gulliver's recurrent epithet of "odious." The tribal name Yahoo, which he invented, wonderfully expresses human brutishness.

This careful compound of love and hate is not peculiar to Swift. What have religious prophets, poets, philosophers, thoughtful men and women done through the ages but express love toward the lovable and dismay and horror at what history records of Man collectively? Swift had more than the usual rea- sons for his strictures: he passed his whole childhood in wartime. On an imag-

inative mind (as I can testify) the impression is indelible. Then in adulthood Swift lived in a period, first of continuous disarray in government, and next of unabashed political corruption. Close to the powerful, he was privy to the jealousies, betrayals, and injustices of day-to-day politics. He could feel nothing but disgust. To be a lover of humanity en masse requires a sedentary life at a great distance and an exclusive devotion to abstract ideas. The hearty Defoe himself, at the end of Crusoe's adventures, has telling scenes of what happens when a few sailors land on the island. It is paradise lost.

He was perfectly astonished with the historical account I gave him of our affairs during the last century, protesting it was only an heap of conspiracies, rebellions, murders, massacres, revolutions, banishments, the very worst effects that avarice, faction, hypocrisy, perfidiousness, cruelty, rage, madness, hatred, envy, lust, malice, or ambition could produce.

—The King of Brobdingnag
 reported by Gullliver

Under the stress of experience Swift became a satirist, his natural mode of literary expression being irony. Hence *The Tale of a Tub, Gulliver, The Battle of the Books, The Modest Proposal* (that the Irish should raise infants to sell to the English as food), and a stream of short pieces on topical subjects. In these same pieces, including the series on Irish affairs, Swift, dropping irony, is frequently a farsighted political theorist and an astute economist. In still others, he preaches a sincere but temperate religion. The rest of his output discusses manners, language, and literature. He sides with the ancients rather than the moderns. His letters to men and women writers, the quasi-diary called *Journal to Stella,* his epigrams, riddles, and occasional verse show that in his hands topicality is compatible with permanent interest.

The third voyage in *Gulliver*—to Laputa, the Floating Island—deserves special attention for its early depiction of SCIENTISM, the attempt to use scientific method in domains where it does not belong. The Laputans have an Academy where "projectors," stuck on one idea, work for years in vain. They toil to extract sunbeams from cucumbers and seal them in bottles; they want to replace silkworms with spiders and endeavor to make clothes by trigonometry. That Swift was no enemy of progress, science, or invention is shown by his famous maxim that the greatest benefactor of mankind is he who can make two blades of grass grow where one grew before. But make-believe never escaped his lash.

Remains his poetry and the scatology question raised by the Celia poems. In the first place, the use of scatology for social argument is not Swift's invention; it is as old as Aristophanes—and Rabelais came before Swift. Nor was Swift the only writer of his own day to resort to it.° Celia, Chloe, and the others stand for the contemporary beauty verbally adored by the swains and sonneteers. After parodying the conventional praise of the nymph's body, Swift

administers the reader a shock by a reminder of the body's natural functions. In one poem the aids applied to face and physique are detailed to reveal the natural creature. Swift was unmasking both the pastoral myth of the angel in human form and the civilized myth that sexual appeal depends on accoutrements. He wanted his contemporaries to accept men and women in their human shape and skin, womanhood neither distilled nor camouflaged. As to the civilized mode, one suspects from many remarks about cleanliness that Swift was more sensitive than most to the effluvia that his century's minimal hygiene, coupled with elaborate clothes, made usual at social gatherings.

Swift's verse proves him a true poet. His imagination is endlessly fertile and astonishing. His diction is plain, often colloquial, and free of the ready-made in phrasing as in ideas. [The poem to read is his apologia, "On the Death of Dr. Swift."°] The man who early in life had declared his love of "the two noblest of things, which are sweetness and light"° died not of insanity but of what was possibly Alzheimer's disease.°

<p style="text-align:center">*
* *</p>

In poetry Swift was no innovator. He acknowledged a superior to whom he submitted some of his work before publication. This was Alexander Pope. The style that both cultivated had been attempted earlier by minor poets° and brought to perfection by Dryden, who died in the last year of the 17C. The characteristic of the new style was its declarative, matter-of-fact diction. It rejected both the Elizabethans' high evocative rhetoric and the involuted symbolism of the Metaphysicals who came next. Pope and the other 18C poets were not merely content but proud of being sensible. This called for discoursing without raising the voice; their subjects were too important to risk using far-fetched metaphors. Order was further ensured by adopting as the chief medium the ten-syllable iambic line riming in pairs, the heroic couplet. It proved the philosophic couplet par excellence.

When, after 50 years and miles of carefully counted syllables had been written, some poets and critics rebelled, they called those works not poetry but metered prose in snippets of equal length. Thus does the whirligig of taste bring in his revenges. Today, when much that is offered as poetry is not only prose cut up irregularly but bad prose, denying the name of poet to Pope and his "Augustan" followers would be shameful. But what makes the 18C style poetry? Compression of thought and feeling in fluent phrasings that reinforce the clear meaning. Pope recommended the use of words that echo the sense—loud and harsh ones when describing the rough or violent aspects of nature. The belief that the sound of certain words echoes their meaning is a fallacy, but Pope's adopting it shows that he and his peers were not indifferent to the sensuous in poetry. Nor are the sounds they worked with quite the

same as the ones *we* hear in their works. Pronunciation has changed, which makes many of Pope's rimes bewildering. The 18C gentry "drank tay out of chainey coopps and went to the city of Room to spend their goold there"— and so on, according to qualified scholars.°

A clinching point in favor of these poets is that their tone fits perfectly the sober subjects they chose—*An Essay on Criticism* and one *On Man*; *The Rape of the Lock*, a mock epic; *The Dunciad*, an attack on bad poets—these works all by Pope; *The Vanity of Human Wishes* (Johnson); *The Deserted Village* (Goldsmith); *The Seasons* (Thomson); *Grongar Hill* (John Dyer). This last and others of the kind were prized for exact description rather than unexpected thought, and so were the openly informative such as Grainger's *Sugar Cane*. It should also be remembered that all long poems, whatever the period or the style, cannot help containing prosy lines. "To be or not to be, that is the question" does not give the thrill of lyric flight; it simply serves its purpose where it occurs. The Augustans, from Dryden on, were by no means deaf to Shakespeare's other tones. Pope published an edition of the plays in 1725 and took the trouble of adding an anthology of the "beauties" by way of educating readers in the old-fashioned style. But when one of Shakespeare's plays was occasionally staged, it had to be extensively improved by professionals of the theater, and even then the need was felt for additional entertainment, such as performing bears between the acts of *King Lear*.°

Of all English poets Shakespeare must be confessed to be the fairest and fullest subject for criticism, and to afford the most numerous as well as the most conspicuous instances both of beauties and faults of all sorts.

—Alexander Pope (1725)

The living theater was supplied by the prolific pen of Colley Cibber, aided by Addison, Nahum Tate, Susannah Centlivre, and the late Aphra Behn. Cibber producd as well as wrote, and his very readable autobiography gives a colorful account of the stage world of his day. It had fully recovered from not only the Puritans' apprehensions (<189), but also from a strenuous attack during the Restoration. Yet producers and public lacked the wit to appreciate the dramatic talent of young Henry Fielding. His *Tom Thumb the Great, the Tragedy of Tragedies* shows he understood theater. By good fortune, the rejection of his comedies turned his genius elsewhere and he created the modern novel (352; 380>).

* * *

More lasting than the plays that Londoners attended in the first quarter of the 18C, were the operas, native and imported. The genre had begun to be cultivated at the wane of the English school of madrigal composers (<161); their power of dramatic expression leading naturally to works made up of airs

connected by spoken dialogue and prefiguring opera. The form was then reaching its full power with Monteverdi in Venice (<174) and England had his equal (musically speaking) in the quasi operatic creations of Henry Purcell. His *King Arthur* and *Dido and Aeneas* still enchant opera-goers today. Then came, by way of Italy, France, and Germany, opera as we know it, sung throughout, the connecting tissue being recitative. The first English import was the German musician Georg Friedrich Händel, soon followed by the Italian Bononcini. Händel became a fixture, changed his name to George Handel (without umlaut and pronounced *handle*), and for the next 40 years composed prodigiously for state, and church, and the king's pleasure on the river Thames.

This courtly endeavor, the famous *Water Music,* celebrated the coming of the King of Hanover to the throne of England as George I in 1714. But Handel had made himself known a bit earlier by his comic opera *Rinaldo* and next by a *Te Deum* in honor of the treaty that ended the long war (<307). The later works were of the genre known as *opera seria*—serious opera—on subjects taken from mythology, legend, or history: *Orlando, Tamerlano, Giulio Cesare, Radamisto, Agrippina,* and half a dozen more. (But note that *Xerxes* is not about the Persian king.)

The main interest in these productions was the music, particularly the vocal parts, which were given to famous, highly paid divas or castrati. The composer's task was to give dramatic force to the words of an unobtrusive libretto consisting of lyrics and dialogue. The result was a regular seesaw of air and recitative. The pleasure came from the virtuosity of the performers and the composer's rendering of a given passion—love, jealousy, hate, deceit. Plot and action were negligible, sometimes absurd, and character secondary or non-existent. No large ensembles or choruses interfered with this ANALYSIS of feeling; it was the musical parallel of neo-classical tragedy (342>). By contrast, the contemporary French opera was pure Baroque entertainment (341>).

The English poets were virtually unanimous in satirizing the new fad. Few were musicians. They ridiculed the pointless repetition of words and the "irrelevant" coloratura vocalizing by the singers—their Italian names were funny and their salaries outrageous. Besides, the connoisseurs of opera never agreed about the merits of these identically foolish yodelers and fiddlers—all in all, opera was an affront to common sense. The public for serious music is always a small minority—as Handel learned through the financial difficulties that in spite of patrons beset him all his life. This stringency was what led him to composing oratorios, a form that grew slowly out of short religious works for voice: an oratorio is an offstage opera, almost always on a subject at once religious and dramatic. It shares with opera expressive music, instrumental and vocal, and to opera seria it adds the power of choral singing. Handel's

Some say, compared to Bononcini
That Myneer Handel's but a ninny.
Others aver that he to Handel
Is scarcely fit to hold a candle.
Strange all this difference should be
Twist tweedle-dum and tweedle-dee

—JOHN BYROM

masterpiece of the type has become the Christmas offering of first choice in the English-speaking world, *The Messiah*.°

Among those who derided opera was the coterie consisting of Swift, Pope, John Gay, and Dr. Arbuthnot. They were all-purpose critics applying the principle "common sense in every-thing." Under the name Martinus Scriblerus they issued papers ridiculing almanac makers who prophesied, illiterate hack writers, bad poets, and bad preachers. In the mid-1720s Swift suggested to Gay that the morals of the people in Newgate prison hardly differed from those of men and women in high places, and that a good play or opera could be made with an all-criminal cast. Gay set to sketching lyrics and dialogue and enlisted the help of another German musician settled in London, John Pepusch, to fit them to popular songs. The result was *The Beggar's Opera*. An immediate success, it ran for two years. Later it inspired Kurt Weill and Bertolt Brecht's *Dreigroschenoper* (*The Threepenny Opera*), produced exactly 200 years after Gay's.

. . . an established Rule, which is receiv'd as such to this very day, that nothing is capable of being well set to Musick that is not Nonsense. This Maxim was no sooner receiv'd, but we immediately fell to translat-ing the Italian operas; and as there was no great Danger of hurting the Sense of those extraordinary Pieces, our Authors would often make Words of their own, entirely for-eign to the Meaning of the Passages they pre-tended to translate.

—ADDISON, IN *THE SPECTATOR* (1711)

The wider public that preferred Gay to Handel and Bononcini had another novelty at their command: the ballet pantomime. Like opera, it was derived from the masque (<188), being that part of it in which simultaneous song and dance carry the plot forward. At the court of Louis XIV, the Italian Lully—musician, choreographer, stage designer, and impresario—provided opera-ballets (with song) in collaboration with Molière and other poets. These shows would end with a surprise, such as a banquet or a rich gift for all the spectators. But often the singing was omitted and the king took the leading part, dancing, say, as Apollo. This form took the name of ballet-pantomime or ballet *tout court*. An English counterpart, "The Loves of Mars and Venus," dates from 1717 and was solemnly presented as a revival of an ancient Greek and Roman art form: "the first trial of this nature that has been made since the reign of [Emperor] Trajan."°

Lully also composed straight operas. They were spectaculars in the Hollywood sense—opulent in decor and costume, elaborate in machinery for the descent of gods or devils, and musically more varied than the Italian and

English opera seria. It was not long before they included one or two ballets as interludes, usually underlining some part of the action. But the two genres, opera and ballet, kept their separate appeals and publics, both with a prosperous future as forms of art with devotees, innovators, critics, and theorists. The familiar conventions of the ballet—toe dancing, tights, and *tutu* (the short tulle skirt)—appeared gradually, like the steps themselves and the gestures to represent love, rejection, horror—the physical representation of the stuff of neo-classical tragedy, where action is restrained to allow words full play.

*
* *

While these highly conscious endeavors flourished, politics in its usual direct or indirect way affected daily life. Early in the century, a treaty with Portugal introduced the English to port, the wine of Oporto, and by its lower price displaced the French vintages. With this thick fortified drink (ruby or tawny) served with meals came the alternative after-dinner ritual, at home or in the Oxford common room, and the spectacle of the English squire with his foot on a stool, immobilized by gout. Simultaneously, the new French cuisine of the late 17C was making converts among the rich and traveled. They had to be rich if they were to hire a French chef who could adapt French methods to English materials. It is significant that this was the time (1707) when the London firm of Fortnum and Mason, still suppliers of delicacies, was founded. In France, the radical change from cooking to gastronomy consisted in using flavoring and sauces not to hide but to bring out the unique natural taste of each product.° The partaker who knew when this had been achieved could boast of being a gourmet, though the name originally meant only a taster of wine.

Gourmetry and gout raise the specter of illness and medication. Early in the 1700s Lady Mary Wortley Montagu was carrying on a crusade that did not let Londoners forget their health: she had the paradoxical idea that inserting a bit of matter taken from a smallpox patient under the skin of a healthy person would fend off the disease. Inoculation (later, vaccination when cows were used for the purpose) won over a few daring citizens and physicians; they proved her case and George I had his grandchildren inoculated. Cotton Mather in Boston urged the practice, but only Dr. Zabdiel Boylston adopted it; he did not persuade many Americans. The epidemic of 1721 in London was severe. It seemed an unwelcome substitute for the plague, which had struck the year before at Marseille, the last outbreak in Europe till the late 20C.

Less dreaded than the smallpox was the big pox—syphilis, because only some of its consequences were perceived. Still, they were bad enough to call

for a cure, and Dr. Thomas Dover was so confident of his that he became known as Dr. Quicksilver. He prescribed mercury for the pox as well as for other venereal diseases and earned popularity from success and an agreeable eccentricity. It was a family trait: his grandfather had revived, in spite of censure, the Cotsworld Games, competitive sports which a contemporary declared "truly Olympick." They included horse races and these, imitated in other towns, were at last legalized by Queen Anne in the grandson's time.

In mid-career Dr. Dover's odd character launched him into a no less odd adventure. He gave up his practice to join with others in a moneymaking scheme based on privateering. Two ships were outfitted to capture foreign vessels, an occupation close to piracy but licit under the cover of the more or less permanent trade war at sea. Though a landlubber, Dr. Dover found himself on deck and in charge, faced a mutiny, and after three years' roaming, returned to enjoy his share of the spoils and resume doctoring. The feat that sealed his fame was that he rescued and brought home Alexander Selkirk, the man marooned on the island off Chile. Defoe pounced on the facts to fashion his indestructible hero (<322).

The state of medical thought at this time was taking an important turn. Dover had studied under Sydenham, who is credited with reaffirming the paired ideas of Paracelsus (<196) that disease comes from outside the body and that the role of medicine is to help nature to cure itself after repelling the invader. In this view, the old notion about disorder among the humors (<222) was to be discarded. Lady Mary's preventive inoculation (perhaps borrowed from Turkey where her husband was ambassador) certainly implied an external agent for smallpox, and so did the onset of all the venereal afflictions.

These may incidentally have been reduced by the growing adoption of a contraceptive device, which in Dover's day the son of the bishop of Peterborough satirized in a poem entitled *Armour*. Whatever its (disputed) origin, the sheath made of silk or linen got its English name from a Colonel Cundom, of the Guards.° A trio of rakehell poets headed by the Earl of Rochester at once praised the invention. In time, international courtesy required that the English should call it a French letter and the French an English cloak (*capote anglaise*). Mme de Sévigné passed severe judgment upon it in writing to her daughter: "an armor against enjoyment and a spider web against danger."

*
* *

During this crowded period the Occident did not relax its production of fine art, music, and architecture, as we shall see. Simultaneously, a resurgence of religious feeling in England found expression in the "Methodist" movement of the young Wesleys (<312) and in the hymn writing of the prolific Dr.

Watts, author of "O God Our Help in Ages Past." But while the renewal of faith filled the minds of the humble, the educated took a course that led rather to science and SECULARISM. The activities, the arts, the careers sketched in the foregoing pages all imply the ANALYSIS of experience and the SELF-CONSCIOUSNESS of INDIVIDUALISM. In combination these themes characterize the main effort of the entire 18C. Its achievements, which form our next topic, were so potent that today many thinkers condemn them as the source of present intellectual errors and social ills.

The Opulent Eye

WHOEVER WANTS TO FEEL at once the majesty of 17C kingship and the magnificence of Baroque should seek out the room in the Louvre that displays the cycle of paintings by Rubens celebrating the life of Maria de' Medici and her marriage to Henry IV of France. At first sight these panels may repel the modern viewer accustomed to gazing at a few objects at a time—or none; whereas Rubens depicts a multitude: royalty, hangers on, sailors, soldiers, ships, angels, cherubs, animals, weapons, clouds, waves, and stars, all in luscious colors and crowded relations. The scene in each panel seems as improbable as a modern poster advertising holiday travel, but close attention shows everything justified, well ordered, and significant. So it is with monarchical pomp and the Baroque. Their common characteristic is profusion dignifying a central purpose.

For both the art and its political parallel one has to go back to the beginning of the 17C. The monarchical revolution does not begin with Louis XIV, nor the Baroque with Rubens. Toward the end of the 16C, under Louis' grandfather Henry IV and through the work of Caravaggio, the Renaissance spirit passes into the Baroque and the nation-state as a political form begins to look secure.

The name Baroque comes from the Portuguese *barroco,* which designates a pearl of irregular shape. Until relatively recently the word was used to discredit some 150 years of western art. In French, the adjective is still a common way of saying that something is lopsided. It is in our ever-enlightened century that the style has been rehabilitated, its music found pleasing and its monarchism ignored. Nevertheless the link between the two is close: the works are larger than life size, ostentatious, as infinite in detail as royal etiquette and as theatrical in effect, although the drama is static like the daily round at the court. To exemplify the element of size one can do no better than begin with the artist named above,

Peter Paul Rubens

Of Flemish descent, he was born in Germany, where his father was a refugee for his Calvinism. Back in Antwerp after his father's death, young Peter Paul was educated at a time when the painters later known as the Antwerp School were beginning to flourish. The boy early showed his ability to draw, but his mother insisted on making him a page to a countess, in which position he learned to be a courtier, a craft that after leaving pagehood and taking lessons in art, he plied as much as his brush. By the year 1600 he was ready for Italy, where he stayed eight years and where the Venetian colorists made the deepest impression. His own works earned him the favor of the Duke of Mantua. Going with his patron to Florence, he witnessed there the wedding by proxy of the duke's sister-in-law, Maria de' Medici and Henry IV.

Young Rubens was used as an envoy to neighboring courts and received commissions to paint altarpieces and other small works. He had studied the masters of every style—Michelangelo, Raphael, Mantegna, Giulio Romano, and he may have met Caravaggio, whose striking new style in painting he had seen in Rome. The innovator's influence on Rubens equaled the Venetians'. Next he was given a mission so difficult and full of perils as to make of him at the age of 26 a seasoned diplomat. He was to travel to the Spanish court, carrying a load of gifts—gold and silver vases, horses, tapestries, and copies of paintings by Raphael and Titian—all this in order to woo the king into an alliance with Mantua. The danger of being robbed during the slow-moving journey and the difficulty of getting the king and his officials to decide anything made the embassy interminable; but it was worth it to be in Spain during its Golden Age of literature and painting: Calderón, Tirso de Molina; El Greco, Ribera, Murillo, Velasquez and other less familiar names. Rubens had set out in March. He did not get back to Mantua to announce the desired result until the following February. His reward was commissions for several paintings and a grant of 400 ducats. The duke was a collector of portraits; he was also poor at paying what he promised. Patronage would be less bountiful and much more expensive if it entailed actual payments.

After another rewarding stay in Rome, Rubens returned to Antwerp, married, and established a studio; that is, a group of pupils and helpers competent to produce portions of a large composition's "first draft." The master outlined it, gave instructions, and, the routine parts once done, put the finishing touches that made the work a master piece. This cooperation, based on the medieval guild system and abandoned in deference to an increasing INDIVIDUALISM late in the 18C, had the double advantage of teaching the young in an exacting way and of giving employment to older talents short of genius. (Alexandre Dumas adopted the scheme for his historical novels.) Since the 19C, artists of genuine but limited ability let loose on the public their quickly

perishable works, instead of making solid contributions to the more lasting.

Antwerp, together with the rulers of France, Spain, and England, gave the firm of Rubens and Company full employment. These royal commissions diverted Rubens's later career into a double channel. Being in touch with heads of state as artist, he became something like a roving negotiator to avert war: the widowed archduchess Isabella, governor of the Spanish Netherlands, found his connections in Spain and France ideal in her effort to maintain peace. Rubens was entrusted with confidential missions to his powerful friends and was joined by the Duke of Buckingham when England entered the conflict—on the wrong side from the point of view of Rubens as Flemish patriot.

> **A picture of Achilles clothed as a woman, painted by my best pupil and entirely retouched by me—a charming work full of many beautiful young girls. (600 florins)**
>
> —RUBENS LISTING WORKS AVAILABLE TO THE ENGLISH AMBASSADOR (1618)

In Spain he met Velasquez, officially the court painter, though only 29. Their friendly understanding probably led the younger man to make the Italian journey. With Philip IV Rubens had a hard time, but he finally won him over and was asked to paint five portraits of the mulish king, one on horseback. The whole family followed, single file. Tired and eager for home, Rubens was still not let go. The king loaded him with a complicated mission that took him to Paris, Brussels, and London, where Charles I welcomed him. It turned out a long half-year's stay but well spent. Rubens was amazed at the beauty of English men and women and the amount of good art. Along the way he had been ennobled and knighted. Home at last, he began painting for Charles the ceiling canvases of the Banqueting House in Whitehall, the building in front of which the king was executed twenty years later.

Rubens married again—a bourgeoise, although his friends urged union with a lady of the court—any lady. But he feared "the special blemish of the nobility, snobbish pride," which might make his wife "blush to see him handle a paint brush." Commissions poured in and his Helena inspired him again and again as the main beauty of every scene. His royal patron required his services again in a further political tangle that arose in France and lasted eight months, and yet once more for one in Holland. There the artist was insulted. A Flemish duke to whom Rubens had written a dignified letter justifying one of his actions was told that such words could only be used by a person of equal rank; and the noble lord, showing his breeding, published his rebuke. Rubens retired from foreign service and stayed home. The remaining eight years of his life were devoted to two kinds of work, the one typified by *The Ascent of Calvary,* and the other by *The Offering to Venus.* The titles suffice to indicate the kinds. [For an idea of the painter's range, leaf through the color plates in *Rubens* by Charles Scribner III—and even read the text.]

*
* *

Exuberance by design and not from wildness—the spirit of Rubens—is the dominant trait of the Baroque. It was replaced in mid-career by a taste for the sober that acquired the name of classical. Often the two styles mingled, as at Versailles, where the facade is flat and calm and the interior exuberant. The artists of the long century seem to divide, some like Vermeer and Claude Lorraine (*le Lorrain*) preferring quiet interiors or landscapes as subjects, and others such as Bernini and Tiepolo choosing intense activity and crowds drawn, more and more accurately, from history and myth. Still others, Poussin—for example—vary: he too liked quiet landscapes with correct classical architecture as background, but in his *Rape of the Sabine Women* mass violence is required, and the two impulses of the age are fused. Because of this, some critics speak of Baroque classicism, but it seems a needless label when one can see the two styles in opposition, as usual in cultural movements, and occasionally combined.

One of the tireless exhibitors of energy, the long-lived sculptor Bernini, may be the artist who embodied most vividly the spirit of Baroque and thus contributed the most to its later ill-repute. The perfection of his craft left no doubt as to the conceptions that it served, and these were called theatrical, outré, false to nature, by a new generation that preferred suggestiveness to pronouncement. This verdict is a good example of a common critical error: different periods conceive differently and each must be granted its premise before one judges its conclusions, in art or any other form of expression. This fair play does not exclude preferring the products of one age to those of another, but it does avoid blindness.

To enjoy and admire Bernini one must accept the minute care of detail within the hugeness of scale, the roundness of every line as if an angle would hurt the eye, and perhaps hardest of all, the suppliant or suffering poses, eyes turned to heaven, limbs contorted by passion. The magnificent exaggeration tells us that in any given instant everything in heaven and on earth is at stake. So it is in the tragedies of the time: death and dishonor hang over everybody's head from start to finish; there is no relief from tension such as might come from commonplace concerns; life is at the mercy of fortune or of the demigod on the throne who will not grant a second chance. [The book to leaf through and read is *Bernini,* also by Charles Scribner III.]

The architecture of the Baroque period is similarly unforgiving. The facades whether encrusted like Borromini's Church of San Carlo in Rome or classically flat like the east front of the Louvre by Perrault, stun the viewer from a distance, rather than seduce him into coming close. And the profuse detail of the one, like the regular repetitions of the other, convey the same message of grandeur self-assured.

Versailles, the palace—one ought to say, the theater—in view of what has been reported earlier (<288), deserves a few words to itself. It arose on an unlikely spot, the top of a plateau of no great height, and its erection by fits and starts cost many lives. At one time 36,000 men and 6,000 horses were at work. Accidents and "fever" took their toll, this last no doubt from unsanitary conditions that persisted within and without the structure when finished. The back of the palace faced the privies, which were inadequate, and the courtiers' required presence indoors at certain times led to their surreptitious use of columns or corners for urgent relief.

The scale had to be vast not only to match the ideal of sovereignty but also to accommodate the population of the court, its servants and its entertainers. The facade is 650 yards long. The portion that juts out in the middle contains the king's apartments; one of the wings, the chapel and theatre, the other, the living quarters of the most favored. The park in front stretches for miles. It is in two sections, the smaller and nearer being a series of rectilinear gardens dotted with innumerable statues—gods and goddesses, nymphs, tritons, and other classical figures, in addition to pools and fountains that also bear classical names. When turned on, the fountains create the liquid spectacle of jets and cascades known as "the Great Waters of Versailles." At the far end is a canal forming a visual boundary. To supply the system, builders installed a huge conduit and pump that draws water from a stream some distance away. At one time the minister of war, Louvois, proposed that his military engineers divert and split a large river, the Eure, to supply both Versailles and the pleasance at Marly, four miles away. Subduing nature is one element in the Baroque.

Above the park, at a height of some 50 feet, is a spacious terrace. The stairs at all points are monuments in themselves and all the statues are by master hands—Puget, Pradier, Coysevox, and others. The gardens were laid out by another creator, Le Nôtre. Mansart and Hardouin-Mansart shared the design and ornamentation of the palace, including the neighboring pavilion, the Grand Trianon. (The small Trianon belongs to the next reign.)

Inside the huge palace are great halls, galleries, and drawing rooms (*salons*). The Hall of Mirrors is famous; Louis XIV liked mirrors as decoration; he started the practice of putting them over mantelpieces, which makes a room look larger than it is. One of the drawing rooms is *Le Salon de la Guerre,* with appropriate murals expressing his fondness for the sport. It is matched by one for Peace, as promised to his people at coronation (<251). The whole interior of the palace—woodwork, furniture, ceilings, chandeliers—was entrusted to the official painter Lebrun. His taste favored massiveness and gold. The total cost of the edifice and its embellishments over 20 years has been estimated at 214 million francs, a sum hard to translate but certainly implying numbers of billions.

Gorgeous display without stint makes Versailles a part of the Baroque.

But as noted above, the lines are straight, the pools and gardens rectangular, and inside or out what the eye sees, rich and glowing, is massive, not fretted into minute effects. This variation, when pushed to its extreme, appears in the work of Le Nain, who interpreted the workaday world as perfect stillness in subdued tones. Obscured after success in his day, he was not re-discovered till the late 19C. Yet his vision must have been soothing to some contemporaries, for he prospered. There is no law about patronage.

That last word has a plain meaning, which is: money to pay artists. In the Middle Ages and the Renaissance the church was its main source, gradually replaced by princes and rich burghers (<72; 81). These two classes of men still ordered works of fine art for churches and civic buildings, but more and more the commissions were for the palace or the merchant's house—art domesticated. The idea took hold that a house should contain not merely the portraits of its owners but also some beautiful scenes to look at and show off. Humanist popes were popes by election but Humanists by collection. Kings followed suit and by the time of Louis XIV, private individuals as well as rulers felt an obligation—they "owed it to themselves"—to care for art and support its makers. Beautifying the world with the aid of the royal purse is an integral part of monarchism; the democratic state has been of two minds about taking on the burden.

Louis' taste in literature and music was natively good, and in the other arts he used able counselors, among them Colbert, who helped his master sponsor still other cultural things. He added science to the scope of state patronage. He reorganized the Academy of Painting and Sculpture and its annex in Rome. He refurbished the Royal Observatory, and brought in the celebrated astronomer Cassini to head it. He despatched an envoy to collect ancient and modern medals for the king's gallery. He added a colonnade to the Louvre and built huge gates at two of the entrances to Paris. He wanted the city clean, safe, and beautiful. He had the streets lighted and appointed a Lieutenant of Police, whose agents made them secure—the first systematic scheme of the kind.° The sizable library that Mazarin had left was enlarged by purchases of books and manuscripts from all over Europe, while by grants and good rules Colbert brought the manufacture of pottery and of tapestries, notably at the Gobelins, to a high point of perfection. His aim was to make France supreme in the arts and in the crafts of luxury.

Choosing the artists who were supposed to glorify the reign can hardly be a straightforward process, because choice is a cause of strife between cabals. One notable instance illustrates how uneasy the patron-artist relation is, and why. In the late 1630s the French painter Poussin was living and working quietly in Rome. His renown reached Paris, and Louis XIII, possibly at Richelieu's suggestion, invited him to bestow his genius on his native land. The cardinal ordered Sublet de Noyers to conduct the negotiations. Poussin,

valuing his comfort, had the good sense to decline, but he took a year and a half to do it, not wanting to seem ungrateful. Angered, M. de Noyers pointed out that the king "had a long arm," meaning that his influence in Rome could be used to create (unspecified) trouble for the artist. Poussin gave in.

In Paris, very definite trouble awaited him. To begin with, he was ordered to paint allegorical murals: his specialty was small works. True, he did paint subjects from history or mythology, but they were really pretexts for a classical dreamland with a few figures and architectural fragments. Murals would have required large expanses of canvas showing many-sided action. Next, he was to decorate a long gallery in the Louvre, although he had never worked at architectural decorations. He went to work making sketches athletically but not peacefully. It seems the court wanted him to outdo Vouet, the painter favored by the town. Vouet's clique thereupon devised every sort of hindrance and embarrassment to get rid of the interloper from abroad.

After a few months Poussin gave up the struggle, giving the excuse that his wife in Rome was ill and he must return. In the next reign, Colbert summoned Bernini, the all-purpose designer. He came, after making and sending what he had been asked for—plans for altering parts of the Louvre. They did not suit. He arrived in person and made a third and fourth plan before he became convinced that they would not be carried out. He left, disgusted, to rejoin more sympathetic patrons in Rome. When these are of high estate, their habit of unopposed command means tyranny for the artist. What is worse, command is often delegated to a majordomo, who sees his role as supplying art in the same way as he supplies food for his master's kitchens.

In truth, the patronage of art is an insoluble problem. There are no reasonable rules for it. How to distinguish among talents? How far should the artist comply with requests? What measures can be taken to prevent intrigues for the fame and money at stake? In the silence that follows these questions one may hear the words "committee of qualified persons." If so, the rejoinder is: remember the ordeal of Christopher Columbus (<98), which was of the same species as that of any artist. And if reliance is placed on the market as in recent times, the artist must woo the buying public and keep it eager for his goods, a constraint that may be as galling as the arbitrariness of a prince.

*
*　　*

It is generally assumed that the plays and books that entertained courtiers and townsmen in the 17C were all of the classical type, tragic and comic. Racine and Molière, Dryden and Congreve—these cliché-names back up the impression. This is to forget the large output of "heroic romances" that were far more popular than the works that have won a place as classics, still much admired and perhaps little read.

The romances began to be written about the turn of the 16C, when the Baroque of which they are a part began to flourish. Patterned after the handful of ancient Greek and Roman romances, they were a mixture of pastoral and chivalric episodes, something like a prose version of the Italian epics (<146). Many were titled "The Loves of . . ." some kind: Fortunate, Unfortunate, Remarkable, and so on, followed by the name of the hero or heroine. Several were written by members of the nobility and a few by the clergy, but they were soon outnumbered by the works of bourgeois professionals, men and women, who turned out for an eager public reams of amorous-perilous adventure. One of the attractions of the genre was its length, which guaranteed extended pleasure. The most highly prized in the mid-17C were the narratives of Madeleine de Scudéry,° two of which were in 20 volumes each; her trifling ones ranged from four to eight.

Naturally, such productions could not be one story; they were a succession of tales linked, sometimes loosely, sometimes adroitly, with the fortunes of the perdurable hero or heroine. When the true novel came into being 100 years later, the device of the inserted tale hung on; it survived as late as Dickens. In the 17C genre, one finds many plums: stories well told, characters that hold one's interest, whether believable or not, and sensible discourse about morals and philosophy. In the best writers there are scenes of real life and genuine passion. Some, in fact, made use of contemporary scandals, whose participants could be identified under their fictional names. The most readable at this distance are Honoré d'Urfé's *Astrée* and Mlle de Scudéry's *Clélie,* although in her time the most popular was *Le Grand Cyrus.* But to enjoy them now one must be a practiced skipper, for what has denied all these works permanent shelf life is the long stretches between oases.

One suspects that to the first readers those stretches were not dull, and herein lies a cultural generality. What pleases most people in the art of their time is work that deals with the bits and pieces of knowledge and feeling that make up the common stock in everybody's mind. It may also include the memory of past art. A well-crafted mixture of old and up-to-date commonplace feeds and flatters the reader or beholder's sensibility; it is popular as long as that mental mosaic of the time persists. That such success depends on small detail is shown by the fact that contemporaries see differences between writers (or painters or musicians), whose works seem to posterity indistinguishable.

To be sure, the masterpieces also carry with them a cargo of such details, but they are subordinated to a comprehensive vision of the world. In them the timely touches are means, not ends in themselves, and the work that contains them still has force after the inevitable change in customs and conventions. The heroic romances on the continent, like Dryden's heroic dramas in England or Calderón's in Spain, fulfilled the Baroque desire for size and convolution.°

These pieces were also steeped in monarchism. The attention to fine degrees of rank; the gallantry, the period-style of lovemaking; the elaborate flattery and elegant diction of the letters that forward the plot are so many echoes reverberating from the walls of Versailles. But the public for the genre was not confined within those walls. The town, to be in fashion, had to read and talk about the latest of the 20 volumes. So did the residents of towns and courts in Germany, England, and elsewhere, who had learned French to be *au courant* of everything or who read similar fictions in their own language.

Balancing this bulky, melodramatic literature is the compact 17C French tragedy. But one must immediately add that the neo-classic plays were spoken and produced in a Baroque manner. The costumes of the players were unlike anything seen elsewhere in the world. Feathered hats wider than the wearer, dresses draped and bespangled so as to live up to the hats alternated with reconstructions of the antique that aimed at simplicity but faltered on the way. These phantasms moved little and spoke much, against a backdrop and between portals of Berniniesque design: richly carved paneling pricked out with gold and bright colors, massive clouds, sometimes peopled with gods visibly anxious about the outcome of the drama. None of this seemed false, given the sound idea that greatness demands large size. The full-bottomed wig was Baroque, and stage costuming was but a heightening of the norm— as in all theater.

The play itself was about kings and queens and must present their likeness. The tragic subject came from some episode in Roman or Greek history or myth, though no attempt was made to be accurate in language or material detail. Exact local color was not yet one of the merits of literature. What the playwright offered was his poetry and his ANALYSIS of the human emotions. This was done by showing the phases of a conflict between very few characters under tension from the outset of the play. It ended in defeat and death for some and implied a moral or political lesson. Here were no *characters* in the Shakespearean sense and hardly any physical incidents, but human *types* deeply studied.

The poets had to observe excruciating rules. The three unities (<166) were rarely violated, never the code governing rime and meter. These prohibitions suggestive of bureaucracy at work had the force of etiquette. The public knew the rules and enforced them without mercy. The vocabulary too was more and more limited as pedants kept extending the veto of the Précieuses against calling a chair a chair or saying "It is midnight." [For a summary of the constraints, look into *An Essay on French Verse* cited (<164).]

Under such conditions, writing a five-act play was a tour de force. Yet it was repeatedly achieved during the 150-year span of the neo-classic temper, from Corneille to Voltaire.° The masterpieces were few but the laws held firm. How did this literary straitjacket get fashioned? About the time Louis XIV was

born, Pierre Corneille, partly influenced by the heroics of the Spanish stage, produced on a Spanish subject *Le Cid* (<105). But he tamed the form and the language, using the 12-syllable line inherited from Ronsard (<164). The work created a furor for and against. The public relished the chivalric tone, rapid pace, and solid construction and called the piece the first genuine tragedy in French—genuine because it conformed to the ancient rules.

Critics damned the play because it didn't. It was "irregular" in letting the hero survive and enjoy a fair chance of winning the hand of his enemy, the heroine. Richelieu, who fancied himself a playwright, incited a group of academicians to prosecute these crimes. The Academy's verdict found the accusations true but with extenuating circumstances. Corneille defended himself and the public stood by him. He went on to write many more plays, four of them still in the repertory and all obedient to the rules. Thereafter they were sacrosanct, although angry debates on small points kept breaking out.

Corneille's younger contemporary Racine is deemed the peak of perfection in that his language is pure, his action compressed, and his dissection of motives relentless. His subjects being drawn from the ancients (besides two from Bible history), account for the name neo-classical tragedy that has been given to the genre. But the substance itself is Baroque. The five-act structure, the uniform meter, the absence of music and dance make for something altogether different from the supposed Greek models. And the tormented hearts-and-minds, their long arguments and self-analysis, like the rhetorical elegance and the subtle charm of the poetry that flows within the strict boundaries of diction and rime—these suggest the richness of detail and the virtuosity of Bach and Bernini.

These same elements are today what make Racine, for one, hard to follow on the stage. The unprepared listener grasps the sense of the action but—as often in Shakespeare—the involutions of the thought are too fine to seize at the speed of their delivery. Our syntax, moreover, is childlike in comparison. Not that these obstacles were the reason why *Phèdre*, Racine's most powerful tragedy, was hissed off the stage; after which the poet resolved to write no more plays. A noble lord and lady had organized a cabal to help out their protégé, Pradon, who had also done a *Phèdre*. [For a modern approximation of Racine's, read Robert Lowell's translation, *Phaedra.*°]

Louis XIV was not put off by the public's biased verdict. He knew the worth of the poet whom he had made royal historiographer and he did him the further honor of requiring his services as reader—"the best one in France"—at those times when his majesty was troubled by insomnia. That may have happened often if he drank too much of the new black brew called coffee, first made known some half-dozen years before Racine's play by the Turkish ambassador. No doubt Racine, as an accomplished courtier, could at any time of day or night read aloud as if fully awake.

Twelve years after the fall of *Phèdre*, Mme de Maintenon called upon Racine to write a play on a sacred subject for the girls of the school she had founded; acting in it would not expose them to the dangers of plays about love. Racine complied, was asked for another, and thus produced his last two masterpieces, *Esther* and *Athalie*. But this connection with the king's wife ended badly: she also bade him write a memoir on the wretched condition of the people. It fell into the king's hands and all favors were at an end. Much earlier, Racine had written a dazzling comedy, *The Litigants,* which criticized the justice system, but it did not offend, because everybody agreed that the courts were corrupt and immune to reform. The other subject—the misery of the poor—implied that the king was to blame and this could not be tolerated.

Social critic is evidently not a recent role for poets. Nor was Racine the only one in his time (>345). But the vagaries of his career show an artist-intellectual of modern type, rather than the man of reason and self-control associated by convention with the notion of classicism. Although Racine, an orphan, regarded his Jansenist teachers as parents, as a young man he promptly sloughed off their beliefs and attacked them in viciously witty letters. In the theater world he led a fast life punctuated by stormy love affairs. The prefaces to his plays suggest (under wraps) an arrogant awareness of his genius; after the public insult to *Phèdre,* anger and haughty retirement were a characteristic answer. This incident and the onset of middle life brought about a complete spiritual turnaround. He renewed contact with Port-Royal, recanted his scornful words, and accepted his mentors' judgment that by his plays he had been "a poisoner of souls." His friendship with Mme de Maintenon likewise rested on piety shared and a common concern for the state of the nation.

The Louis XIV system—a court run as by a drill sergeant—is no protection against changes of fortune and revulsions of feeling. Behind the facade there unrolls the intimate history that we may read in the letters of Mme de Sévigné and the Memoirs of Saint-Simon. And on reflection, what else does tragedy, the chosen genre of the period, put before us but greatness, reverses, and downfall? The use of select words and faultlessly regular verse to show willful and violent acts ought not to conceal their ugliness: Phèdre is eaten up with lust and Britannicus acts like an infatuated fool. The conflict is with law and reason as much as with other human beings. But for these common flaws and misdeeds to be tragic, they must affect persons of high station. Nowadays this axiom is denied; the democratic mind argues that the death of a salesman is no less tragic than the death of King Lear. In common speech every fatal accident is tragic. This is the language of INDIVIDUALISM—every human being is as important as any other; the premise of politics is applied to aesthetics. If human feelings are basically the same, their portrayal when under

any kind of stress will surely create in the spectator the same emotion and self-knowledge.

This reasoning leaves something out: the acts of a prince or a great soldier affect a whole people, decide the course of history. In the tragic theater, apprehension about consequences makes every moment as thrilling as in the finals of a sports tournament. Compared with this the common man's lot is inconsequential. The non-hero makes no stir—and he is replaceable. Salesmen are plentiful. Besides, proud words and penetrating thoughts are more plausible in the mouths of movers and shakers than in those of the average man. Whether these points are valid or not, to interest courtiers and their prince in the 17C, the mishaps of a merchant would not do. Comedy took care of portraying the lower orders, and by no means always to their disadvantage. The most daring of the critics of king, court, and nobility was

Molière

His name, like Voltaire's, is a mystery. He was born Jean-Baptiste Poquelin and adopted the other cognomen when in his 24th year he decided to be an actor. His father was upholsterer and valet to the king, a good-paying post, and the son followed in it for a time. Then he qualified as a lawyer, having received (the first in his family) an excellent college education. Reading the philosopher Gassendi (346>) made him an Epicurean, but it was amateur theatricals with friends that made him a playwright. To earn a living he formed a troupe, left Paris, and toured the provinces for 12 years, acting and supplying the skits and one-acters for the one-night stands. Some of these reappeared, adapted, in his full-length works.

Back in Paris shortly before Louis assumed full power, Molière acted in a play by Corneille and immediately won the king's support. To Louis' credit it never faltered. One may surmise that given his own solemn playacting the king was glad of a chance to laugh. With that backing Molière and his company were able to use, part of the time, the stage that the Italian players had monopolized. (Competition by Italians in theater, opera, and the other arts continued in France for more than a century.)

Molière and his company's first great success was *Les Précieuses Ridicules,* in which the two marquis are ridiculous as well as the ladies. For the next 15 years Molière put forth his satiric genius in every type of play from farce to high comedy. His targets are familiar: silly young bloods, jealous husbands and henpecked ones, misers, physicians (again and again), lords and ladies, bluestockings, coquettes, shopkeepers, extremists, and hypocrites. Nor was satire his only object. In other plays he created light comedy of the *As You Like It* order; and in his satiric works insinuated opinions critical of the existing order of things. In *Don Juan* he voiced religious doubts and was accused of

atheism, and in two playlets in which he was the central figure he refuted his critics by expounding his theory of comedy.

Molière was not alone in showing that valets and serving maids often have more common sense than their masters. It is the staple of comedy as far back as antiquity. But he endowed his people with life and individuality and gave them lines that verge on social rebellion. His dramatic irony about rank is at its best in the *Bourgeois Gentilhomme*, which ostensibly makes fun of a wealthy merchant who wants to hobnob with the aristocracy. M. Jourdain does get fooled in the riotous pseudo-Turkish ceremonial, but on all other counts it is he who is the forthright and sensible man: he prefers a simple touching folk song to artificial nonsense versified; he sees through the verbiage of the philosophers; he can tell the difference between practical knowledge in teaching and the jargon of theory. At every encounter with convention and affectation he grasps the truth and tells it. As for his desire to rise in the world, though ridiculous, it is universal. A good half of the titled audience that laughed at him must have thought privately of their own more or less recent bourgeois origins.

Molière was passionately in love with an actress in his company and had with her an unhappy marriage. She was flighty and unfaithful. His views on husbands and wives in the two "Schools" that he wrote, one about each side of the predicament, leave the impression that he saw the institution as irrational but inevitable. Love and society are incompatible. The lesson is still clearer in the *Misanthrope*, in which the clever womanly woman is irresistible and the sensible friend a model character, while the "misanthrope" cannot be faulted in his critique of conventional society. All are in the right; the play is a tragic comedy.

In his relations with the king Molière had no cause to be anything but grateful; Louis stood by him against powerful enemies. They thought they had caught him at last when he wrote *Tartuffe*—an insult to religion, they said, choosing to disregard the real subject: hypocrisy. (Incidentally, a late 20C production of the play in France makes Tartuffe a sincere lover of Orgon's wife who chastises himself for this sinful passion; we therefore should pity him.)

It would not do to call Molière a democrat, but his work displays the independence of mind that shocked his friend Boileau the critic. Indeed, a modern biographer sees Molière as an anarchist and atheist. Like Boileau, Fénelon deplored Molière's "low tone" in the comic scenes, especially when the speakers were not low characters. The charge could have gone further:

> He wants to sample all kinds of life—
> There's a god who isn't dumb!
> I'd think him pretty miserable,
> No matter how humans regard him,
> If he stayed up there always stiff and stuffy.
> I'm sure there's nothing stupider
> Than being a prisoner of one's grandeur.
>
> —MOLIERE, MERCURY SPEAKING OF JUPITER
> IN *AMPHITRYON*, PROLOGUE (1668)

Molière's vocabulary, far from following the restrictive tendency of the sensitive souls, is expansive; it makes use of vivid words and idioms spoken by the people.° The 12 years of touring through the provinces afforded Molière a good supply and they occurred to him spontaneously as the right word; he saw no reason not use it. M. Jourdain's preference for the old folk song was also his creator's.

In another way and another genre, La Fontaine embodied the same resistance to orthodoxy. He wrote fables about animals that depicted in the simplest, most concrete terms of the vernacular the thoughts and acts of every social type, including the courtiers and their king. All the ambitions and meannesses, all the vanity, flattery, and servility that flourish in a layered society are reproduced in the dealings La Fontaine attributes to the animals. They enable the vices of the day to be seen from a distance and to be hidden from the slow-witted. Here and there the virtues emerge, but against odds. Thanks to the rapid, colloquial turns of speech and the animal vesture of the satire, the Fables have been imposed on French children as pieces to memorize. Their significance has thus been diluted, as happened also to *Gulliver's Travels* and *Robinson Crusoe*; making a children's book out of a masterwork is to defuse a bomb. [The translation of the fables to read are those by Howard Shapiro, not Marianne Moore's, which give the sense without the conciseness.] In a second series of poems, La Fontaine retold or invented tales of love, classical and modern. These are also in the plain style, but fuller of imagery in order to veil their eroticism. If they carry a moral, it is the Epicurean, that pleasure is the only good, pain the only evil.

Unlike Racine, La Fontaine was no courtier. He was not even at court. He did hold a sinecure as a forester, but did not pay back the favor by obedient attendance. He remained rural, indeed rustic—in dress, manners, and speech. He was incredibly feckless. When his friends urged him to go and offer his book to the king, he grudgingly showed up but forgot to bring the book. He died impenitent.

Others than La Fontaine and Molière were disciples of Epicurus by way of Gassendi and his school of freethinkers. The shift from the Christian stoicism of the previous period (<190) coincided with the victory of monarchism: it needs luxury and there is nothing stoical about luxury. Neither were the ancient Epicureans atheists or voluptuaries, but theirs was a non-interfering god, so that pursuing pleasure in moderation was not evil but wise. The name of libertines given to the 17C Epicureans meant no more than freethinkers— free in opinion, with no suggestion of sensual license. The way in which Gassendi exerted this freedom was to oppose the orthodox view, established by Descartes, that our ideas are innate and hence from God. Nothing is in the mind, said Gassendi, that does not come through the senses; no ideas, feelings, memories are born in-house. This is the root principle of empiricism,

generally credited to Locke (365>), although Gassendi's main work appeared half a century before Locke's.°

In between came the writer who popularized the Epicurean ethics of pleasure,

Saint-Evremond

What he did was simple and obvious, though he himself was an odd character. Banished from France by the young Louis XIV for supporting the disgraced financier Fouquet (<292) and thereafter a lifelong resident of England, Saint-Evremond made many friends although he never learned the language. Charles II and James II liked his company; he corresponded with the Duchess of Mazarin and with titled and learned persons in France and Holland, including William of Orange and Spinoza. He filled his 90-year span with good talk and with writing small essays, not for publication. Given to one friend or another, they were copied and passed from hand to hand until pirated, translated, and—finally—counterfeited: a Paris publisher told one of his hacks, "Write me some more Saint-Evremond."°

His subjects were the popular ones: whether the ancients were superior to the moderns; comparisons between Virgil and the Italian epics; French and English comedy; the merits of theater and the absurdity of opera. Having gained favor with these commonplace topics, he went on to discourse "On the Right Conduct of Life," "Of Pleasures," "Of Loves." His longest piece is a satirical "Conversation Between the Mareschal D'Hocquincourt and Father Cornage." The Father cautions against freethinking, which has the inevitable result of subjecting religion to reason. The Marshal speaks for Saint-Evremond and argues that a rational religion is not atheism.

The attraction of these pieces was their brevity and ease of reading, even when they were obscure here and there from careless writing. Preaching pleasure gets a welcome response and scruples are quieted when one hears that one must be sure to preserve health by cultivating cheerfulness and good temper and enjoying sensual delights in small doses. To Saint-Evremond, friendship was a delight closely tied to good thoughts and good talk. His balanced program went well with the Baroque—better at any rate than Stoicism; there is nothing tight-lipped and resigned to fate in Rubens or Bernini or the music of Bach (388>).

It was widely known that the essayist's Epicurean advice did not

Marshal: A Devil of a philosopher so puzzled my brain about the Parents, the Apple, the Serpent that I was ready to believe nothing at all. Not that I see more reason in it now; on the contrary, I see less than ever.

Father: So much the better, my lord. No Reason! That's the true religion. No Reason! What an extraordinary grace has Heaven bestowed upon you!

—SAINT-EVREMOND (1728)

'Tis fifty years, and perhaps more, that his works have been admired; the Publick has a sort of traditional respect for him, which makes them look upon the least of his fragments as mysteries which people adore in silence without presuming to dive into.

—Charles Cotolendi on Saint-Evremond (n.d.)

come from a pedant in his book room. The exiled author had commanded troops with distinction in important battles; he was an aristocrat, and when people urged him to publish his "works," he expressed surprise that they should so refer to his "triflings." Clearly, Saint-Evremond was the "representative man," par excellence. In any age such a man is influential because his ideas chime in with those of other influential people. He is thereby of historical importance, but gradually he sinks into the third or fourth rank and is read only from curiosity. If the past could really be described as it felt when it was the present, it would show a large gathering of personages like Saint-Evremond, their contemporary admirers sure that here were the classics of the age and unable to believe that a later time would not even recognize the names.

* * *

The labels "ancient" and "modern" and the contrast between their ways in art and literature have been used in debate since Petrarch (<49). But it was not until the end of the 17C that the words fired up two factions that divided the world of letters. We saw just now that Saint-Evremond held forth on what was openly called a quarrel. He was a middle-roader inclining toward the moderns.

The fierceness broke out over a speech by Perrault in the French Academy; an earlier flare-up had occurred in Italy about Tasso's epic (<148). Matching it with Homer's *Iliad* or *Odyssey* was not straight thinking, no matter which side one took, and this first fracas died down. The later and longer set-to seemed better defined: are the present poets and prosaists as a group better than the Greek and Roman? Everybody must choose. The moderns, who said: "We are, because we know more," had the disadvantage of advancing their own merits. The others, now deemed the geniuses of the age, benefited from the modesty of their position: "We are but imitators of the unsurpassable." Poor Perrault, the author of the now classic fairy tales and of the Mother Goose stories, was vilified. Homer having popped up again, though few read and none thought of imitating him, was ably defended by his translator, Madame Dacier. The combatants all took it for granted that the upholders of the ancients did imitate them. Nobody asked where in modern tragedy one could find the manners and thoughts of the ancients, to say nothing of the choruses, the music, and the dances. And just as everybody agreed that Virgil outshone Homer, so the subjects imitated by the moderns came more

often from Roman history, or from the Roman playwright Seneca than from the Greeks—a thin slice of antiquity for a large spread of modern butter.

The moderns won out in the end, carried by a cultural tide rather than by literary arguments, because like a piece of fireworks the controversy kept shooting out branches of all colors. Not that painting could get very far: there were no ancient models. But sculptors and architects fell to and wrangled and once the moderns had staked out their claim, quick minds pointed out that superior work, greater wisdom—in a word, progress—takes place in all things.

This conclusion was far-reaching. With progress admitted, it follows that man and society are perfectible; and if this is possible, schemes for changing the world should be attended to. By the next century programs of reform began to flow in an endless stream. The western mind had turned from backward-looking to future-making. And when the re-orientation became general, society was kept in paradoxical discomfort: cheerful because working to improve life, and suffering guilty SELF-CONSCIOUSNESS because present conditions are so bad. Also endless was the war between the bold and the cautious, who ended up forming political parties under various names, ultimately shortened to the Left and the Right. These in turn are split into factions by the diversity of hopeful plans, though the ancients and the moderns, who are always with us, now seem to agree that the Christian view of the world as irremediably evil is not absolute. Progress is possible, an admission that points to an ever-wider SECULARISM.

<p style="text-align:center">*
* *</p>

Besides essays, Saint-Evremond wrote a few maxims. In its pure form this genre is something new in the mid-17C. What preceded it is the "Table Talk" and the so-called *ana*. This last is the suffix tacked on to a proper name as in *Ménagiana*—the sayings of the writer Ménage or the anecdotes about him. *Anas* were published anonymously and without warrant of truth or accuracy. The similar table talk sampled earlier in dealing with Luther (<16) was a kindred genre. Maxims differ from both in that they are sayings written down by the one who thought them up. They made the *anas* fade away, but table talk survived into the 19C (511>).

The best-known writer of maxims is La Rochefoucauld, a duke, once a hothead of the Fronde (<286), in maturity a saturnine observer of Louis' court. Like neo-classical tragedy, maxims embody the ANALYSIS of human motives. Their art consists, again like tragic verse, in compressing observation into memorable form; they are epigrams without levity. A collection of maxims amounts to a moral philosophy, and in fact the title of La Rochefoucauld's book is *Maxims or Moral Reflections*.

The impression these have left on posterity is that they undermine any faith in goodness and truth. La Rochefoucauld is a cynic who sees in human actions nothing but selfishness, vanity, and envy. Example: "Men could not continue to live in society if they did not deceive one another." But that impression of universal undermining is false. There is no denying that a good number of the maxims question the integrity of the virtues and point out the role of self-interest. But La Rochefoucauld does not enjoy doing it, and he does much else; he is saddened to find human motives not always pure. The proof of his regret is that out of his 500-odd reflections fewer than a third are destructive. A larger number are neutral; they merely describe what happens in life and society. A small but emphatic group deals with the motives and actions of men and women of honor and with the sources of greatness— courage, friendship, gratitude, and true love.

In all three groups love is a frequent subject, for obvious reasons. But the moralist's experience was not that of Versailles alone; he had lived through the war of the factions that preceded, and it is the corrupt politics of that time (about which he wrote a memoir) that inspire his distrust of appearances. Before condemning him as one soured by misfortune, one should remember that this moral skepticism is also Christian—everybody is a sinner, even when doing right. Pascal had said "The ego is hateful," in part because of this universal flaw. In La Rochefoucauld the term for ego is *amour propre*—self-regard, which can underlie all other motives. At several points, the analyst ascribes this duplicity to an unconscious source, which makes for even deeper pessimism since the impulse is uncontrollable.

The fashion in his day was to sketch one's own character in a few pages, and he complied. After a physical description, he paints himself as melancholy, incapable of laughter not only by temperament but from "outward causes that fill his imagination"; that is, life at court. He tries to be "open" to his friends but finds it hard to be other than "reserved." Yet he loves conversation, especially with women; they speak with more precision than men. He has a clear mind and good wit and prefers serious talk about moral questions; but he is often too vehement in discussion. As for gallantry, he has given it up; but he admires grand passions: they show a corresponding greatness of soul.°

A double contradiction appears between some of the maxims and the rest, and between the portrait and those same maxims. It can be accounted for by an inherent weakness of the genre rather than of the writer. Maxims sound universal, whereas they are true only on occasion. If one reads at random in a book of familiar quotations one finds many shrewd sayings and as many others stating the opposite, both true. They are like proverbs: "Look before you leap"; but "He who hesitates is lost." Characters and situations differ so endlessly that no wise thought can fit them all, especially when uttered in capsule form.

One of La Rochefoucauld's neutral remarks opens up a subject of cultural import—his definition of the *honnête homme*. The phrase designates the model character of the 17C. Still a courtier, the type (of either sex) differs from its Renaissance ancestor described in Castiglione's work (<85). There the human being had unlimited interests and capacities. *Honnête* does not mean honest in the modern sense; it means honorable, with a suggestion of adorned with grace, as in the Latin *honestas,* and it implies a group of qualities: well-bred, polished in manners and speech, controlling without visible effort the ego, for in social life it easily offends or encroaches on other egos. The proper man should be trustworthy as well, but what matters first is this absence of rough surface and angular behavior, caused as much by shyness and false modesty as by self-importance and superior worth. La Rochefoucauld gives a lapidary definition hard to translate: the perfect *honnête homme* is "he who does not make a point of anything in regard to himself" (*qui ne se pique de rien*).

It was a social ideal, which found expression in related phrases: *la bonne compagnie, le beau monde, les gens comme il faut*. This ideal was due to the influence of women. They were the arbiters of taste and the judges of comportment, exercising that preciseness that La Rochefoucauld noted in their speech. The salon was a staged play and they were the critics. [The book to read is *The Lady* by Emily James Putnam.] Manners have been called "little morals," both showing the respect due from one human being to another. In truth, one finds that the degree of formality in social intercourse varies in step with other cultural characteristics; it ranges from the etiquette of Versailles (or ancient China) to the casual style of the 20C; it matches the dogmas of the age in politics, psychology, and aesthetics. [The book to read is *Good Behavior* by Harold Nicolson.]

The duke's *Maxims* generalize, but if one imagines likely examples to fit what he says, one finds in the epigrams censure of Louis XIV, his system, and his courtiers. The moralist questions the means by which royal glory and social fame and every kind of power are attained. He despises cunning and intrigue and calls hollow and futile the triumphs of the moment. He is at one with Molière and La Fontaine.

Another critic of the regime, La Bruyère, used a different literary form to chastise the same traits in his contemporaries. His classic *Characters* sketch types and classes of men as they talked and paraded around him. By way of safeguard he first translated a collection of such portraits by the ancient Greek Theophrastus. In substance and effect there is no comparison between the two works, or between La Bruyère's and those of other users of the form.° Theophrastus devotes a page of generalities to the Flatterer, the Impertinent, the Loud Mouth, the Miser, the Shameless, and so on. The whole gallery of figures takes up only 85 pages. La Bruyère transformed the genre. By means of

No matter with what skill the great manage to seem other than they are, they cannot conceal their malignity.

.

One comes across certain wild animals, male and female, scattered over the countryside, who cling to the soil, dig into it, and turn it over with tireless persistence. They have a sort of articulate voice, and when they stand up one sees a human face. They are in fact men. At night they huddle in their lair, where they live on bread and water and roots. They spare other men the trouble of working for a living and thus they ought not to lack the bread they have worked for.

—La Bruyère, *Characters* (1688)

dialogue and action and vivid settings, his 16 chapters fill 750 pages.° His subtitle appropriately announces "the mores of this century."

La Bruyère's exercise of free speech is remarkable. The chapter on the nobility is more daring than Molière's ridicule of the marquis, because the author speaking in his own voice discusses the ways of an entire class. His targets are named in his chapter headings; the list covers all of society: the Great, the Wealthy, the Town, the Court, the Sovereign, Man and the Morals of Our Time, Fashion, Preachers, Freethinkers, Journalists, and a few more who appear scattered among the rest. By the end of this procession one has the feeling that one has read a novel—or more exactly, a novelist's notes for one, with the fullness Henry James adopted when describing his projected works.

La Bruyère's tone is by turns ironic, derisive, straight-faced, and somber. It was fortunate that the Prince of Condé, though difficult to live with, was his steadfast patron, because the readers of *Characters* quickly put actual names to the persons depicted, and like any *roman à clef* the work generated a coalition of powerful enemies. La Bruyère, born a bourgeois but self-ennobled by purchase of an office, needed more than usual support to win election to the Academy—as Molière never could, owing to his disgraceful profession of actor.

The word *novel* applies to *Characters* only so far as it aims at portraying a society. Its dramatis personae are still types, not individuals. The true novel, with its blend of psychology and sociology, comes a good deal later (380>). But in between there is a 17C work that might fairly be called a novella. It is *The Princess of Cleves* by Mme de La Fayette, the companion of La Rochefoucauld during the latter part of his life. She had once written a standard romance (<340) but in her later book the story she tells is that of a love never consummated between a duke and the princess, who is married to a man whom she respects but does not love. The duke woos her impatiently. She tries flight but is prevented by her husband, whom she finally informs of the situation. He shortly dies of jealous despair; the duke presses his suit; the princess remains a widow. It is a study in the growth of a passion, its links to other feelings and to social realities, its anguishing pains and the delicate pleasures of expression and repression.

Although it contains no violence, the work resembles the neo-classic

tragedy in its relentless analysis. The treatment of love often reminds one of La Rochefoucauld's maxims, which is not surprising, since the two writers worked on the text together. It would be too much to say that the heroine's impeccable morals were intended as a reproof to Louis' court. The time of the fiction is the 16C and the plot imaginary. The work appeared (anonymously) five years before the court's enforced conversion to good behavior and it was received with immediate enthusiasm. These three facts together seem significant—of what , it is not easy to say. The work was translated into English while a French critic praised it in Latin, Italian, and his native tongue.

*
* *

One 17C creation that was neither Baroque nor a pretended imitation of the ancients was its prose. Monsieur Jourdain in Molière's *Bourgeois Gentilhomme* is amazed when he is told that he has been speaking prose all his life. The joke is excellent on the stage, but his surprise is well-founded; he is right, as he so often is. What he spoke all his life was *not* prose but speech. Prose is the written form of deliberate expression, a medium that can become an art. It is as artificial as verse. Whereas speech is halting, comes in fragments, repeats, puts qualifiers after the idea, and often leaves it half expressed, prose aims at organized thought in complete units. The qualifiers of each idea often come before or during its exposition, as required by clarity, the sound of the words, or their rhythm.

The modern languages took a much longer time to develop a prose worthy of the name than to find poetic meters that suited their idiom. True, writers who described action produced readable works fairly early; they were guided by the sequence of what happens in the world. But with rare exceptions they failed when they tried to impart what happens among feelings and ideas. In early modern times they were hampered by their virtually native mastery of Latin: it spoiled the vernacular syntax. Thanks to its case endings, Latin leaves the writer free to throw the makings of his sentence into one spot or another without changing the sense. That cannot be done when meaning depends on the right sequence and right linking of words. As late as Milton in his political pamphlets, English prose makes hard reading; sentences are long and cluttered with clause after clause: the mind has to detach and realign, which slows understanding; the prose does not breathe but chokes.

The same was true in French until the time of Pascal. It is generally agreed that it was his *Letters from a Provincial* (<219) that gave the nation a model of modern prose, rapid and rhythmic. Dryden rendered the same service to English prose a little later. Italian and Spanish started from a simpler syntax and reached the same goal sooner. German was kept from it altogether by its retention of case endings and a glutinous syntax. As the young William

James on his travels in the 19C wrote to his parents, the language "is in fact without *any* of the modern improvements."° In technical terms, German did not become ANALYTIC like other modern languages. Few of the great poets and thinkers using German have been masters of both their subject and their prose. [The little book to read is *German Style* (with annotated examples) by Ludwig Lewisohn.]

It is thoughtlessly repeated that writers of fine English prose have learned their art from the King James Version of the Bible, issued in 1611. Nothing can be more easily seen to be false. When English writers sound biblical, they are quoting, consciously or not, isolated turns of phrase; they are not adopting a coherent style found in the Bible. The prose of the 17C Authorized Version is a composite of wordings that go back over 300 years of successive translations of the text. The committee appointed by King James did not start from scratch; it borrowed from Wycliffe and Coverdale and Tyndale—from this last, the ablest, more than from the others. The Preface said that the aim was simply to make a good version better. [The book to read is *Translating For King James* (a participant's notes) edited by Ward Allen.] The result was a language that never was the vernacular of any period.° Often, the turns of phrase, instead of being English equivalents, are word-for-word renderings of Greek or Hebrew idioms; and common sense is flouted in deference to the original: "When they arose early in the morning, behold, they were all dead corpses."°

What did help to shape English prose was Cranmer's Book of Common Prayer (= prayer in common). Its tone and phrasings were heard during the service more often and at greater length than the biblical, and they were in a language spoken outside the church as well as inside. Cranmer labored to make his renderings of the collects and litanies of the Roman missal plain and easily remembered. It was a work of art, as one can see by comparing it with his other writings. Good prose means hard work; as a modern practitioner put it, it is "heavy lifting from a sitting position."°

It should be added that the English prose that suggests the influence of Scripture is of the ornate type, halfway between prose and poetry, and not for common use. An outstanding 17C example is Sir Thomas Browne's *Urn Burial*. Closer to us, Ruskin occasionally employed the style. Indifferent to transparency, reserved for impressiveness, it awaits the opportunity for lofty reflection—the rejoicing over a victory, the solemnity of regretful death— these alone afford sufficient warrant for the orotund periods, the concatenation of awesome images, and the cadences that close gratefully to the ear in a studied succession of polysyllables. Such utterance should have a special name, and a third one should designate the clotted abstractions of the modern trades and specialties. The term *prose*, it should be remembered, comes from *prosa oratio*, which means discourse that goes in a straight line.

The French followed that line, and it is clear why they found it easier to do so than the English. As Catholics they were not subjected to the weekly sermon; they had no Book of Common Prayer, the service being in Latin and entirely spoken by the priest. Only on great occasions such as state funerals was the ornate style required. Fénelon's enemy Bossuet and his fellow prelates used it, but only for religious purposes. All other writers (with one conspicuous exception) cultivated the simple and direct. They were not bound like the poets to use only noble words and euphemisms—*flame* or *chains* for love, *feathered kind* for birds, and the like.

> A piece of writing was shown not long ago to an illustrious personage who smiled and said: "These words must be greatly astonished to find themselves together, for assuredly they had never met before."
>
> —FATHER BOUHOURS (1671)

To achieve lucidity, the spontaneous surge of ideas must be sorted out and the parts fitted into sentences not longer than a normal breath, the connections shown by clear syntax. With correct usage and a minimum of imagery (which might distract the reader) the words seem the natural way to think and to speak. But it is *not* natural. It is a product of extreme SELF-CONSCIOUSNESS, as in Descartes' *Method*. The good sentence is the clockwork put back together again after careful ANALYSIS. The one 17C exception to this achievement is the Duke of Saint-Simon. He is perhaps the only writer of genuine stream-of-consciousness prose in all literature. He violates all the guidelines for clarity and he must be read in French, because translators comb out his sentences and distill his meaning.

But like a 20C novelist, like Proust in some ways, he persuades the reader that his mode of utterance is the natural one, truer than the analytic. Yet the duke was at times a self-conscious worker, as we know from his own lips; and the vast *Memoirs*—41 volumes unpublished till the 19C—are a work of art. Profusion of detail, richness of substance, order in apparent disorder, put it among the masterpieces of the Baroque.

> Shall I add a word about the style—its carelessness, the same words recurring too close together, too many synonyms, especially the long sentences that cause obscurity, and perhaps repetitions of fact. I am aware of these faults. I couldn't avoid them, carried away by the matter and inattentive to the manner of conveying it, not to say explaining it. I haven't been able to cure myself of writing too fast.
>
> —SAINT-SIMON, ON HIS *MEMOIRS* (n.d.)

*
* *

With French becoming by the end of the 17C the second language of the educated European, literature began to follow French models. This influence was particularly strong in Restoration England. Charles II and his friends had been refugees in France for nearly 20 years and his later hangers-on learned

French so as to be *au fait*. The Francophile Restoration mood is well known: relief from Puritan earnestness, easygoing morals; the king, frequently in love, no taskmaster like his patron across the Channel. In the leading genre of the period, comedy of manners, the concerns, conventions, and smart talk parallel those of the court. Vanbrugh, Wycherley, Farquhar, and Congreve made their characters intriguers, extravagant, cynical, unscrupulous, and witty. French plots were copied or adapted—Molière's in particular—but their tone is more Baroque than neo-classical. The language highly spiced: the characters utter worldly wise maxims like La Rochefoucauld, but their similes verge on the obscene. [The account to read is *Comedy and Conscience After the Restoration*, chapters 1–4, by Joseph Wood Krutch.]

In the same period, English tragedy in Dryden's hands abandoned the Elizabethan pattern to follow the French—long tirades in rimed couplets—but again, with more emphatic effects. His subjects—*Aureng-Zebe, The Conquest of Granada*—came not from the ancients but from modern (though distant) historical events. The audience was plausibly treated to high heroics in rutilant language. It was not surprisingly the low point in Shakespeare's reputation. The poets who read him at home admired his power—in spots. But when his plays were produced they were called poor, crude, old-fashioned things. Samuel Pepys, the able secretary of the navy, loved the theater and records in his famous diary the sophisticated judgment of the day.

> Saw *Romeo and Juliet*, a play of itself the worst that ever I heard in my life.—*Midsummer Night's Dream,* which I had never seen before, nor shall ever again, for it is the most insipid, ridiculous play that ever I saw in my life.—*Twelfth Night,* acted well, though it be but a silly play.
>
> —Samuel Pepys (1661–1662)

Other critics were even more contemptuous: Shakespeare and the other Elizabethans "ne'er knew the laws of heroick or dramatick poesy, nor—faith—to write true English neither."° Dryden himself wobbled between fervent regard and near-contempt: Shakespeare "is many times flat, insipid, his comic wit degenerating into clenches [bickerings] and his serious swelling into bombast." He then quotes from *Hamlet* and says: "What a pudder is here kept in raising the expression of trifling thoughts!"

The Restoration produced a good deal of lyric poetry, from which the work of Vaughan and of Traherne stands out, together with the presence of some half dozen women who were more than casual writers. One of them, Aphra Behn, was also a successful playwright. But Dryden easily dominates the scene as poet and prosaist. By his political satires, his translations of Virgil and other ancient Romans, and his bawdy lyrics, he set the tone, diction, and rhythms for the Augustans who came after him (<325). A piece of verse in 10-syllable lines riming in pairs remained for 100 years the passport into liter-

ature that the novel is today. Dryden the critic—in his essays, prefaces, and one masterly dialogue—ranks with the greatest in western literature.

<div align="center">*
* *</div>

In the midst of this display of virtuosity that mingled Baroque and neo-classical tastes, there appeared a little book that had no connection with either style. It was by a tinker named John Bunyan and its title was *The Pilgrim's Progress*. It told in the simplest language how the narrator, Christian, had a dream that made him acutely anxious about his soul. In the dream, he left his family and friends to venture on a journey toward the Heavenly City. It was a dreadful journey: The Slough of Despond, the Valley of the Shadow of Death, Vanity Fair, the Mountain of Error, Giant Despair, and other dangers and deceits tested his resolve. Dialogue with ordinary tempters such as Mr. Money-Love and the Atheist added to the difficulty of the quest.

> Some said, John, print it;
> others said, Not so.
> Some said, It might do good;
> others said, No.
> At last I thought, Since you are
> thus divided,
> I print it will, and so the case decided.
>
> —BUNYAN, TO THE READER OF
> *THE PILGRIM'S PROGRESS* (1678)

It is an allegory, but unlike other works of the kind, it is full of action that creates genuine suspense and depicts believable types. It appealed at once to large numbers of English non-conformists, who did not share the Restoration temper or morals and had no use for its sophisticated, London-centered literature; they could not have understood a Congreve character speaking. Whether taken up for the religious message or as a lively fiction, *The Pilgrim's Progress* remained a popular book for young and old until the end of the 19C. Bernard Shaw admired it as one of the supreme interpretations of human life. A reader of secular mind today would be surprised to find many of Bunyan's opinions congenial. The tinker systematically attacks the ways and what are now called the values of the Establishment. He sees government, the law, manners, morals, and social conventions as devices of the powerful well-to-do for oppressing the poor. They alone are simple, truthful, and charitable. He does not, of course, urge revolution. All he wants is self-reform to save one's soul.

Bunyan was jailed more than once for preaching his radicalism, but he did not write his book in prison, as was once thought. And he wrote other books (and poems) quite unreadable, except one: *Grace Abounding to the Chief of Sinners*. It is an account of his years of torment as one possessed by evil and his delivery from it. Bunyan the Calvinist felt even more tortured than Luther, because in the interval the Bible had become the absolute encyclopedia and it

Ignorance: I know my Lord's will, and I have been a good liver; I pay every man his own; I pray, fast, pay tithes, and give alms.

Christian: But thou camest not in at the Wicket-Gate; thou camest in hither through that same crooked lane, and therefore I fear thou wilt have laid to thy charge that thou art a thief and a robber, instead of gaining admittance into the city.

—BUNYAN, *THE PILGRIM'S PROGRESS* (1678)

was contradictory in its threats and promises.

Christian embodies the INDIVIDUALISM implicit in the Protestant's direct relation to God, with no "good works" possible to help acquire merit and avoid Hell. He gives no thought to anyone but himself. No "family values" keep him from leaving wife and children behind so that *he* may not be damned. But when the book proved a success, Bunyan wrote a sequel of the same length and inferior, in which Christiana and her sons are rescued with the help of Mr. Great Heart.

Bunyan and his book could hardly have gained a moment's attention from the elegant roisterers at the court of Charles II or in the London literary world. The Puritan ethos was no longer matter for hatred, only for ridicule. And the work that had helped to turn hatred into ridicule was Samuel Butler's *Hudibras*. Butler, a farmer's son, was a "domestic" in successive noble houses and popular for his rough-hewn humor. The poem which made him famous is a mock-heroic epic patterned on *Don Quixote*. Hudibras and his squire Ralpho are Puritans who go through ludicrous adventures that show the piety and social ideals of Cromwell's era as hypocrisy and self-seeking. Interspersed are recognizable portraits of prominent figures of Butler's day.

What makes all doctrines plain and clear?
About two hundred poundes a year.
And that which was true before
Proved false again? two hundred more.

—SAMUEL BUTLER, *HUDIBRAS* (1668)

The fun is supposed to come from such things as a fight between the knightly pair and a group of bear baiters and also from the trick riming of the eight-syllable lines—the device familiar in Byron's *Don Juan* and W. S. Gilbert's comic operas. In Butler the versifying is rather crude and rarely witty. But King Charles enjoyed the work and gave Butler a pension. By the end of the 17C both the author and the subject that inspired him had slipped into oblivion. The Restoration mood was giving way to serious thoughts.

The Encyclopedic Century

ENCYCLOPEDIA—"the circle of teachings"—may be taken as the emblem of the 18C. Like the Renaissance, the age was confident that the new knowledge, the fullness of knowledge, was in its grasp and was a means of EMANCIPATION. Confidence came from the visible progress in scientific thought. Science was the application of reason to all questions, no matter what tradition might have handed down. Everything will ultimately be known and "encircled." The goal of exploring nature and mind and broadcasting results was to make Man everywhere of one mind, rational and humane. Language, nation, mores, and religion would cease to create differences, deadly as everybody knew. With a single religion and its universal morals and with French as the international medium of the educated, it would be a world peopled with—or at least managed by—*philosophes*.

Before its realization a good many things had to be got out of the way, the principal one being Christianity—not its ethics of love and brotherhood, but its supernatural history, theology, and church. The Bible must be shown to be a set of fables invented by ignorant or designing people. This was not exactly the purpose of Father Richard Simon, an Oratorian monk of the preceding century, who wrote a *Critical History of the Old Testament* disputing Moses' authorship of the Pentateuch. But he led the way in what is known as the higher criticism of Scripture, the ANALYSIS of its meaning and truth, and not just of the purity of the text. About the same time in Holland, the excommunicated Jew Spinoza, a quiet thinker, went much farther in his interpretation. He had elaborated a philosophy deeply marked by natural science, which was incompatible with a literal belief in the Bible. For Spinoza, God was in all things and all things were alive with His power. Though impersonal and impassive, He deserved man's "intellectual love." This faith was part of an ethics and metaphysics that Spinoza demonstrated geometrically, by more than a hundred propositions deduced in strict order from a few definitions and axioms. The Bible, when closely read, appeared to be a compilation by anonymous scribes and full of contradictions. The moral teachings were

We may therefore say, without having recourse to miracles, which ought to be kept as far as possible for cases of great necessity, that the good constitution of Sarah, and her being exempt from lying-in and nursing, might preserve her beauty even to the age of ninety. Procopius thinks that when she was made capable of conceiving, she recovered her lost beauty. Procopius may say what he likes.

—Bayle on Sarah, sister and wife
 of Abraham

admirable, the historical parts uncertain, and the stories allegorical.

Spinoza was highly regarded by the handful of 17C philosophers and scientists whom he corresponded with. He published little; he lived very modestly as an artisan and declined a chair at Heidelberg. But from a distance he seemed just another freethinker and atheist, though not harmful. Like Simon he had no immediate following. So far, the higher criticism was underground preparation. But shortly a work appeared that exploded the mine and breached the fortress. Its author was Pierre Bayle, also a refugee in Holland. He produced a massive dictionary labeled "historical and critical."° By comparing, juxtaposing, questioning, and describing ironically the familiar parts of the Christian revelation, he left the reader as skeptical as himself—or outraged by the blasphemy.

To avoid censorship Bayle wrote short entries that merely defined the subject: the doctrine was in the appended notes, long and in small print, that encouraged the censor to skip. The Century of Light was thus inaugurated, but also divided. When we regard the philosophes and their *Encyclopédie* as triumphing easily, we are influenced by the now prevailing assent to their views, which helped to make our secular world. But the opposition they met was not crushed; it revived in the 19C and is increasingly vehement today. Its target, the "Enlightenment," is not reason or light but the 18C idea and use of it.

Bayle's *Dictionary* was a work that would attract mainly intellectuals. One is not surprised that Jefferson owned it in five folio volumes. But it took Voltaire to carry its message to the ordinary educated reader, the well-to-do bourgeois, the men and women in high society, and the mixed group in the salons. His message was simple: the Book of Genesis is not wrong on one point: God did create the universe, but nobody knows how, and He set it going according to rules—the laws of science—with which He has no reason to interfere. This is Deism, the religion of reasonable men. Therefore drop the ritual, the prayers and candles—and the fears. At the same time open your eyes to the imposture practiced on you by the church for its sole beneficiaries, the priests and monks, bishops and popes.

To convey this creed, Voltaire used every device and medium at hand; it could be slipped into a political pamphlet, the rebuttal of a personal attack, a five-act tragedy, a short occasional poem, an edition of a classic, or a private letter. Finally, Voltaire condensed the argument in a series of alphabetized

articles—four or five pages long on such topics as Angel, Atheist, Fanaticism, Moses, Miracles, Messiah, Equality, the State, Toleration—in all 73 entries entitled *A Portable Philosophic Dictionary.*° He might have added: Easy to read and Entertaining. It is Bayle in reader's digest form. The prose is transparent, wit is present but subdued; the tone of common sense is irresistible.

Religion as such is not attacked; it is redefined into simplicity. One may well be overawed by the Great Architect and His handiwork—and there an end. All peoples have this same feeling about the Creator, for Man, like Nature, is fundamentally the same the world over. Good morals are untouched; they too are universal. With this underlying unity about ultimate things, there should be no causes of conflict, no religious wars, no crusades, heretics, conversions, inquisitions, burnings at the stake, and massacres.

But the infamous church is only one cause of man's inhumanity to man. The other is bad government. It too must be made rational. And Voltaire here again is gadfly and honeybee in one, partly by accident. While still young and brash he had said something that offended a noble lord and was beaten up by the lord's lackeys. Whereupon Voltaire had the impudence to challenge the lord to a duel. This brought on a second stay in the Bastille (he had had an earlier taste of it) together with an order to leave the country. Voltaire chose exile in England, where he rapidly made friends, learned the language, and studied the institutions. Returning after two years, he wrote his *Letters on the English*— an immediate success and a powerful influence. France became Anglophile; some writers were moved to learn English, translations of English works became more frequent, fashions and manners took an English air.

Before the publication of these *Letters,* the French philosophy of science was Cartesian (<201). There were, according to report, only two Newtonians in Paris. Voltaire followed up his social and political survey with a work on the *Elements of Newton's Physics*, and soon he and others began to explain John Locke's ideas on government. The most enticing was that of toleration. Voltaire did not make the quip to the effect that the English had only one sauce but a hundred religions.° Nor did he write to Helvetius "I wholly disapprove of what you say—and will defend to the death your right to say it"; a 20C woman biographer said it for him.° But the two statements together fairly represent his principle of freedom of speech and religion. The epigram over-simplified the facts: Protestant sects in England were indeed all legal, but unequal in rights and opportunities, and Catholics were more or less persecuted. Still, the English church and state had allowed the Earl of Shaftsbury to print his scandalous view that religion should be optional and atheism considered a possible form of belief. The rationale was that argument brings out the truth, no matter what errors are put forward in what should be in the literal sense a free-for-all. French intellectuals readily saw the advantages of free expression: they remembered Galileo; they knew that Descartes, Gassendi,

Simon, Bayle, and other original minds had been forced to modify or conceal their views for fear of persecution by the Sorbonne.

<p style="text-align:center">*</p>
<p style="text-align:center">* *</p>

Who was this John Locke? He was a physician, a friend of Newton's, who under the Stuarts had not enjoyed much toleration in his native land and had spent some eight years a wanderer in Holland and France. In both countries he had consorted with advanced thinkers. When James II was forced out in 1688, Locke returned home and became the voice of the party that had effected the change. The Declaration of Rights that went with it needed a theorist to make it respectable. Locke was the man to do it, because he had absorbed abroad much of what he ably set forth in his own writings on metaphysics and politics.

For the latter he was indebted to the theorists from Bodin to Hobbes, who had dealt with the origin of human society (<245; 267). The argument that toleration makes a state stronger, not worse off, could be found, for example, in a work by the secluded thinker Spinoza—the only one he published. And the good reasons for representative government had been clearly laid out in Harrington's *Oceana* (<268), to say nothing of the Puritan democrats (<264). In short, Locke earned his fame by a series of well-organized summaries in plain prose of well-ripened ideas. It is not his fault but the result of a not uncommon cultural squint that Locke has been hailed as the discoverer and original expounder of the principle that civil and political rights are lodged in the people.

Since these rights replace the divine rights of monarchy, Locke began by denying the latter. A tract by Sir Robert Filmer gave him the opportunity. Filmer spoke for the sizable English party that was appalled at the violence done to legitimate kingship in 1688. Sharing their religious faith, Filmer derived absolute monarchy from Adam's paternal and universal authority, handed down to all rulers by divine decree. This has been called an absurd idea, but to the multitude who believed like Shakespeare that divinity doth hedge a king, the transmission of power from God to the first man and thence to his anointed descendants is logical; it is a piece of reasoning; and the premise from which it starts is the Bible, revealed truth.

Compared with it, Locke's premise is an assumption about the origin of society. As in Hobbes, it springs from the state of nature—we are dealing once again with those eternal standbys, Reason and Nature (<69). The reasoning goes like this: Man in Nature has every right that his individual power affords—no limits, no prohibitions. But this violent free-for-all proves inconvenient, so he enters into an agreement with his fellows to set up an authority that will restrain violence and settle disputes. That is the social contract or

compact. Once established and generating laws, this arrangement is binding on everybody forever, unless the sovereign—a person or a group—misuses the authority conferred. Such a breach of the contract the members of society may resist, even to the point of overthrowing the governor(s). By this provision Locke justifies those who expelled James II and replaced him with someone—William of Orange—who will abide by the terms of the contract. The significant difference between Locke's reasoning and Filmer's is that Locke's is entirely secular, a telling point when Reason had come to seem more solid than Revelation. There are references to God in Locke's two treatises, but they are pro forma. Again, it seems stronger to base a reasoning on Nature than on faith when advanced opinion is enthralled by the study of Nature. But the starting point is as shaky in the one case as the other: the picture of wild men, accustomed to grabbing each other's food, shelter, and women, spontaneously getting together to make a contract, is as fanciful as the providential descent of authority from Adam to James II.

For Locke and the English who bargained with the new King, William III, the terms of the social contract were the 13 provisions of the Declaration of Rights. But Locke wanted his essay to be theory, higher ground than local needs, good for all places and times. The universal rights came down to three: life, liberty, and property. This last is based on the notion that when a man has "mixed his labor" with some material thing, he has made the product his unconditionally. As for the authority that shall enforce these rights, it cannot be Hobbes's absolute ruler. Power unlimited is too likely to establish a tyranny, as divine monarchs had not done but attempted to do. Locke vests sovereignty in the people. Since they cannot conveniently exercise it, they choose representatives. Of these, some make the law, others are appointed to execute it.

By further reasoning it appeared that the form of government that best embodies these conclusions is the English system called mixed: the king in Parliament (Commons and Lords), the elected Commons being in full control of taxation and the army. No power can be secure without the army; and the Commons have a neat device for retaining that power: each year they pass the Mutiny Act, good for one year only, without which no discipline, no court-martial, would have the force of law. The United States Constitution copied that shrewd provision and reinforced the principle by making the president commander in chief of the army.

> The end of government is the good of mankind, and which is best for mankind, that the people should be always exposed to the boundless will of tyranny or that the rulers should be sometimes liable to be opposed? Upon the forfeiture of their rulers, [power] reverts to the society and the people have a right to act as supreme and place it in a new form or new hands, as they think good.
>
> —JOHN LOCKE, *AN ESSAY CONCERNING THE TRUE ORIGINAL, EXTENT, AND END OF CIVIL GOVERNMENT* (1690)

*
* *

By coincidence, during the time of Voltaire's stay, England welcomed another French observer, the Baron de Montesquieu. He came from the south of France, where he was vice president of the district court, and as such a member of the nobility of the robe. He hardly needed letters of introduction to be well received by Lord Chesterfield and other eminent men, for Montesquieu was the well-known author of a best-seller, *The Persian Letters*. It was the fictional account of a visit to the French court by a Persian. The satire was spicy and double-edged. Both French and Persian attitudes toward religion, rulers, morals, women, and manners were derided equally. The book was a European success. Nobody reading or talking with the witty young judge could guess that 20 years later, at mid-century, after publishing a serious study of Rome's greatness and decay, Montesquieu would produce a large work combining history, political science, and sociology, *L'Esprit des Lois*.

The title suffers when translated *Spirit of the Laws*° (<220). The connotation of spirit here is: intent-and-fitness; and "laws" really mean constitutions—forms of government. The work is a vast survey, so vast that the author tells us at the outset how his courage failed him more than once when trying to organize his materials. His readers everywhere applauded the feat, and the French in particular were confirmed in their Anglomania: six early chapters devoted to liberty describe its embodiment in the English constitution. The separation of powers—legislative, executive, and judicial—ensures freedom and civil rights; the equal weight of those powers keeps government on an even keel.

Montesquieu gives a hint that he may be embellishing the scheme. It was a wise precaution, because the practical working of the government in Chesterfield's England differed markedly from so rational an order. The prime minister (a new title), who was the agent of the executive power vested in the king, had to control Parliament to execute anything, and he often used this power to oppose a king who tried to interfere with legislation. Montesquieu wrote that the independence of the judiciary consisted not in a law but in the jury system. In fact, judges and juries often followed orders from the executive, and Parliament could convict individuals simply by passing a law: the powers were not distinct. In spite of these overlaps, Montesquieu's theory of separation and equipoise caught on as one of the wonders of the world. The American colonists found it most congenial. Montesquieu was the author most often quoted in what they read,° and when they gained their freedom they wrote his theory into their constitution.

The outcome of what has been reviewed here—late 17C critical thought, the events of 1688, and the writings of Locke, Voltaire, and Montesquieu—may be summed up in a few points: divine right is a dogma without basis; gov-

ernment grew out of nature itself, from reasonable motives and for the good of the people; certain fundamental rights cannot be abolished, including property and the right of revolution. A still shorter roundup could be: the political

> It is not for me to inquire whether the English at this time enjoy such liberty or not. It is enough that I should declare it established by their laws. I do not look farther.
>
> —MONTESQUIEU, *L'ESPRIT DES LOIS* (1748)

ideas of the English Puritans aiming at equality and democracy were now in the main stream of thought, minus the religious component.

The elimination of the Christian tradition and Scripture from social theory, and thus from the public debate, left a void that was filled by philosophy popularized. That is how the 18C publicists come to be called philosophes. For them, Gassendi's maxim that all knowledge is drawn through the senses from experience of the outer world was undoubted truth, but this empiricism did not prevent differences—or difficulties. Here again, Locke has been credited with establishing that truth and removing the main objection by the principle of association: sensations felt together form mental pictures of things, that is, ideas, which by the like process form significant connections. The mind has no pre-existing ideas; it creates its own order out of what happens to it. This mode of exploration finds its highest fulfillment in natural science: experiment is experience channeled and closely observed, so as to ascertain more and more permanent connections or "laws" of nature.

Most of these empiricists of the first generation acknowledged God as the Creator. The Great Watchmaker who set the cosmos in motion and then let it run on its own. But He had also endowed Man with the gift of reason, with which he discovers this orderly scheme. The thought then occurred that sensations imply the existence of matter; therefore ideas, feelings, knowledge—life itself—are but the interplay of bits of stuff. Matter in motion acts as cause, and the effect is another part of matter in some other motion. God has no point of entry into the relation; very likely He does not exist. There is in truth no need for Him. Did not the Roman Lucretius write a magnificent poem to teach this lesson? He demonstrated that all things and beings are but the combining, breakup, and recombining of atoms. Atomism is perfect for science, being simple and deterministic. By this route the belief in Predestination returns in full strength.

In the 18C the marriage of science with philosophic materialism had to be performed under wraps for fear of the religious authorities. But it was consummated in the mid-century—notably in the writings of the Baron d'Holbach, Helvétius, and others. And it has ever since been a cause of wide cultural debate, in seesaw fashion: when materialists are up, physics is the "model" and vitalists and idealists are down; when these last two are up, biology is strong and materialists muted (632–3>). In the time of the philosophes a grand battle on this issue took place between the adherents of Newton and

those of Leibniz, who has so far been mentioned here only in passing. He was worth reserving for this representative role.

The controversy started over an unrelated question: which of the two champions had first invented the calculus, the method for determining curves, acceleration, and other relations between quantities that vary at the same time but differently? The point is moot. Newton's symbols proved the more convenient and are the ones now in use, but both men are entitled to the glory of having devised an instrument essential to physical science.

Now, Newton was not a materialist, as may be inferred from his biblical research (<197) and explicit statements.° But his followers made him into one for their own purpose. Leibniz, whose aim was to build a comprehensive system showing how matter and mind fitted together, saw in God's wisdom, goodness, and power the active, continuous cause of the order that science discovers. Leibniz dealt like a scientist with the current problems of space, time, and motion. Objects, he thought, hold together by virtue of the moving particles within. He built an improved calculating machine. He called for an international language of ideas, so framed that one could deduce new truths with it as with numbers. His curiosity and inventiveness knew no bounds.

But by depending on the traditional God to provide a "pre-established harmony" between our ideas and the things they relate to, and also by positing the *monad* as the unit of mind (spirit, soul), Leibniz seemed at odds with the new thought that had sent God into honorable retirement. In fact, the monad was no arbitrary conception. The argument for it was this: by definition mind cannot be analyzed like matter into smaller and smaller bits; it is a whole or it is nothing; the monad is the counterpart of the atom. The 18C anti-materialists should have welcomed the monad. Unfortunately, the Leibnizians were led by an orthodox believer, Christian Wolff, who used old-style theology (and daunting German pedantry) to make his points. The secularists were resolved to keep religion and philosophy apart, so Leibniz was shot down with Wolff regardless of the merits of the monad. Later on, Voltaire in *Candide* let fly a barbed arrow at Leibniz for saying that ours is the best possible world. In Wolff's interpretation, the dictum had turned into the best *conceivable* world. Voltaire had no trouble ridiculing that notion by piling up mishaps and disasters on his innocent hero. The further implication was that if God could not make a better world than the one we know, his goodness or his power must be deficient.

The materialists were not allowed to rest on their laurels. From another quarter had come a troubling argument. Young George Berkeley, later a bishop, but by no means an enemy of science, had a flash of inspiration: what, after all, was meant by matter? We never see it; we see only color and shape, we feel hardness and softness, and so on with taste and smell. Combined in this way or that, these sense impressions signalize an object and we give it a

name. We then imagine—we do not see or feel—a support for all these impressions and we call it matter. As Coleridge put it, matter is like an invisible pincushion that we suppose necessary to hold the various "pins" that are our sensations. [The work to read, short and delightful, is Berkeley's *Commonplace Book,* which details the birth and growth of his thought.]

Berkeley asked: is the pincushion needed? Dr. Johnson—no professional philosopher—hearing of Berkeley's critique of matter, kicked a large stone "with mighty force till he rebounded from it," and said: "I refute it *thus.*"° But Berkeley never denied that things were real, hard as stone and heavy as Dr. Johnson. He pointed out—and he has never been refuted—that matter is a notion added to what the senses actually report. Today, they report to the physicists who own a cyclotron a collection of some 40-odd "particles" whose tracks have to be photographed because their life flashes by in an instant. They do not seem to need the invisible pincushion, being a charge of energy or convertible into one.

Nonetheless, common sense finds the supposed matter useful in daily life, and the scientist—whatever his faith or philosophy—assumes its Johnsonian existence when pursuing his experiments. Out of all these speculations the general public retains the image of the Newtonian world machine. Everything in it is a cog subject to the universal push-pull of cause and effect. So congenial is this picture that in the mid-18C a French soldier named La Mettrie caused a scandal and pleased the materialists with his book *Man a Machine.* Frederick of Prussia rejoiced in it and rewarded him. This application of materialism also rides up and down on the seesaw. In the 19C, after a vitalist interlude, Thomas Huxley declared Man an Automaton (572>). He abandoned the notion, others took it up and in our century once more, man has been portrayed as a chemical, glandular, and electrical machine; and still nearer and more subtly, as one predestined and worked by the instrumentality of cells and genes.

*
* *

The spread of such ideas throughout the Occident during the 18C and the passion with which they were cheered by some and abominated by others, presupposed an eager reading public and a publishing industry in proportion. An ever-increasing number of journals supplied frequent news and fresh speculative ideas on every subject and at every level, from pure science to chitchat. And in this outpouring the monarchical and religious interest was not silent. With the aid of the court, led by the king's mistress, Mme de Pompadour, abbés and bishops, jurists from the Parlement, members of the Sorbonne faculty, and freelance publicists counter-attacked the avant-garde. The name *philosophe,* which has stuck as a badge of honor, many uttered with a scorn imputing shal-

In order to appeal to all classes and characters, Disbelief has in our time adopted a light, pleasant, frivolous style, with the aim of diverting the imagination, seducing the mind, and corrupting the heart. It puts on an air of profundity and sublimity and professes to rise to the first principles of knowledge so as to throw off a yoke it considers shameful to mankind and to the Deity itself. Now it declaims with fury against religious zeal yet preaches toleration for all; now it offers a brew of serious ideas with badinage, of pure moral advice with obscenities, of great truths with great errors, of faith with blasphemy. In a word, it undertakes to reconcile Jesus Christ with Belial.

—BEAUMONT, ARCHBISHOP OF PARIS (1762)

lowness and a hatred powered by the charge of infidelity. Ruder tongues compared the writings of the group to the croaking of frogs and dubbed the authors *cacouacs*. The anger went deep, because not merely opinions but institutions were at stake. Deism meant that the church was superfluous; Reason meant that reverence and obedience, traditional props of government, were in the discard. For the side attacking the status quo, the theme of the hour was EMANCIPATION, which the other side met with the counter-cry "Anathema!"

Opposition to the view of the enlightened was not limited to the ecclesiastics and officialdom generally. It was deeply rooted in the minds and habits of a large part of the European population. To them, warnings and reassurance were addressed from press and pulpit incessantly. But owing to the theological tone and substance of this effort, it did not make for entertaining reading. It tended to deal with separate items and lacked the universality of Reason, Nature, Science, Freedom, and other lofty ABSTRACTIONS monopolized by the avant-garde. It must moreover be said that the orthodox defenders mustered few minds of the first order. The negative position in any dispute needs a double dose of brilliance if it is to arouse enthusiasm, and this was missing. It is significant that in none of the several present-day anthologies of the 18C thinkers, any more than in works on the subject by historians of ideas, does one find the church party well represented. The 18C is made to look all of one mind.

What happened to the Jesuits may have led to this picture of a steamroller at work. They had been for 200 years the best-educated debaters; by the 18C a good many had been charmed away, tacit members of the secular camp. Pope Clement XIII, himself a cultured man, defended the Society rather weakly against this expulsion from several countries, and he established the worship of the sacred heart of Jesus to rally the faithful. Eight years later, his successor, under pressure from heads of state in Catholic Europe, abolished the order, "perceiving that it could no longer produce the abundant fruits and advantages for which it was instituted and approved by so many of my predecessors." And members of other orders, priests, church officials, either shared or tolerated with a smile the increasing infidelity. So true is it that great institutions are undone as much by its presumable guardians as by its enemies (>427f.; 779>).

*
* *

In the heat and smoke of battle, the shades of belief on each side are unclear, causing some participants to be as much confused as enlightened. It therefore seemed desirable to the tacticians that the elements of the new creed should be brought together in one place and made easily accessible. A chance to carry out this purpose was seized, thereby giving birth to the *Encyclopédie*. Its designer, part-author, copy editor, and bodyguard was

... to stop with our Apostolic Authority the circulation of such unreasonable remarks, which are being spread on every side and which are seducing souls ... We declare and state that the Institution the Society of Jesus breathes to the highest point piety and holiness in final aim, which is none other than the defense and the propagation of the Catholic religion.

—CLEMENT XIII, PAPAL BULL,
 JANUARY 9, 1765

Diderot

Not by this achievement alone but for several others, he is the pivotal figure of the entire century. Voltaire outshone him in their day and till nearly the middle of the 20C, but since then the magnitude of Diderot's genius has been felt and his works have been increasingly read—all this without detracting from Voltaire's brilliance, courage, and resourcefulness in the war that the two men waged side by side.

Diderot was the younger and less well-born. He was a country boy, son of a cutler, and he had to make his way in Paris by hack writing, giving lessons in mathematics, and translating English books. A proposal for one of these, *Chambers' Encyclopedia* in three volumes, sparked the undertaking that took 26 years of Diderot's life and taxed to near breaking point his strength of body and spirit. Instead of translating and expanding *Chambers*, the publisher Le Breton and his advisers decided to issue an entirely new work—eight volumes, "by a company of men of letters." It would surpass in every way the dozen or so compendiums available.° Its subtitle tells the scope: *Encyclopedia or Systematic* (Raisonné) *Dictionary of the Arts, Sciences, and Crafts*. Such a range of subjects would afford innumerable opportunities to insinuate the advanced ideas. It is a measure of public opinion at mid-century that Diderot found in France the scores of qualified contributors that he needed. As a warrant of reliability, the well-known mathematician d'Alembert was recruited as co-editor in charge of the articles on his subject and Diderot found in the modest Chevalier de Jaucourt—quite unknown—a tireless researcher and prolific drafter of entries.

Being in so many volumes, the set was expensive to produce and to buy; affluent subscribers must be found. A prospectus stated the aims of the editors

The good of the people must be the great purpose of government. By the laws of nature and of reason, the governors are invested with power to that end. And the greatest good of the people is liberty. It is to the state what health is to the individual.

—*L'ENCYCLOPÉDIE*: ARTICLE ON
 GOVERNMENT

without guile and the money poured in. Evidently, an audience was ready for doctrines counter to tradition and orthodoxy; no truly new thought receives such wide welcome. Soon there were 3,000 subscribers; by volume five there were 4,000. The *Encyclopédie* was the prosperous grandchild of Bayle's *Historical and Critical Dictionary* (<360).

While this engine of war was being assembled, the opposition did not sit still; it was stimulated. The censorship was tightened; a rival reference work was put in hand—the *Dictionnaire de Trévoux,* its name referring to the Jesuit center that was already publishing the vigorous *Journal de Trévoux;*° the court, guided by Mme de Pompadour, roused the faithful to attack the other sinister publication. The Sorbonne and the Parlement, bishops and playwrights, the Academy—enlisted men or volunteers—joined ranks in a campaign of mingled ridicule and fulmination. The old enemies, Jesuits and Jansenists, for once united in denouncing the blasphemous work.

The war lasted a quarter century, with victories and defeats on each side. The publisher was jailed then released and his license canceled. The volumes already out were officially condemned—but not burned as they should have been, for it so happened that the censor, M. de Malesherbes, was a believer in freedom of the press. More than once he warned Diderot that his agents would be coming to seize all manuscripts ready for the printer. They found none. The volumes kept appearing, printed in France, but sometimes bearing the name of a Swiss publisher. What is more, the work expanded under the cascade of copy: by volume 7 the text was only at the letter *G.* Diderot now counted on 17 volumes of text and 11 of plates instead of 2. In the end, Diderot completed 28 volumes. Another editor added 7 for the ultimate version of 1777 in 35 volumes.

Some will find my estimate too low. Still, 40,000 pieces of bread for communion will cost 80,000 livres which, multiplied by 52 Sundays adds up to more than 4 million livres. Why can't we be spared this expense? We are too childish and slaves to custom to see that there are more truly religious ways of worship. Now let me say something about candles. . . .

—*L'ENCYCLOPÉDIE*: ARTICLE ON
 CONSECRATED BREAD

Meantime, the worst blow had been dealt: Le Breton, fearing for his future in publishing, began to take out or alter sentences and paragraphs after Diderot had seen page proofs and passed them for printing. Diderot, who, like Atlas, had borne the whole burden of gathering, coordinating, verifying, editing, and often writing the text, was incensed at the treachery; all he could

do was to keep hammering his publisher with demands for the sheets, hand-written or in print, that had suffered the cuts—in vain. They were not recov-ered until 1933, when a bound volume came out of Russia that plainly was Le Breton's set of suppressed and garbled pages, 318 in number, mostly Diderot's work.°

It was persecution in earnest, but it should not be supposed that the mil-lions of words from *A* to *Z* were all devoted to propaganda. If, for example, one opens the first volume at random, one's eye may fall upon the entry *Asparagus,* a serious essay that took three people to write: a botanist to describe and classify it; Diderot, who tells you at some length how it tastes and how to cook it; and a physician, who offers useful medical remarks. The *Encyclopédie* was and is a reference work as well as a giant pamphlet.

Of the whole, the 11 volumes of plates that Diderot planned and pro-duced are as useful as the rest and in one respect highly original. A large part of them illustrates the tools and processes of manufacture in current use. The cutler's son, who was disappointed when his father's portrait showed the man in his Sunday suit instead of his workman's apron, had a boundless curiosity about trades and crafts and their fundamental role in society. Exhibiting to the world their ways and means marks a date in the history of techne: crafts had hitherto been the secret property of each guild. But by the mid-18C, inventions by outsiders and rapid communication had weakened guild con-trol; Diderot visited the workshops unhindered. Directing his draftsman, he took notes for the explanatory captions. His attitude was in keeping with that of the scientists: free exchange; and with that of the enlightened economists: free trade (382>). On the customs of publishing Diderot had also a word to say. His *Letter on the Trade of Publishing* is a classic statement of the conditions then existing and the EMANCIPATION that should take place for the good of public and author.

<center>*
* *</center>

The vicissitudes of the *Encyclopédie* reveal something more than the hero-ism of Diderot and the cohesion of the *cacouacs.* In spite of the forces of the state arrayed against the writers and the publisher, the fat folios kept coming out and none who collaborated lost his freedom or his life. A repressive gov-ernment in the 20C would have been more efficient. The 4,000 subscribers to the book would have found themselves in labor camps together with the lesser contributors, while the leading ones—Diderot, d'Alembert, Voltaire, Rousseau, Jaucourt, Montesquieu, Turgot, Quesnay, Marmontel, d'Holbach, Vaucanson, Haller, Daubenton, Condorcet—would have been liquidated.

This tells us that the *ancien régime* was beginning to feel the loss of nerve typical of periods of decadence. The aristocrats bought the volumes that

attacked kings and priests and enjoyed a kind of revenge against the monar-
chical system that had tamed them, but did not foresee that their class would
also be tamed, by the guillotine; likewise the abbés and Jesuits who paraded a
liberal theology. One of them was asked if he thought Hell existed. "It does,"
he replied, "but nobody goes there." Among these backsliders some were
close friends of the philosophes and they helped them in emergencies.

Voltaire's career illustrates in great detail the ambivalence of the authori-
ties toward what they knew was open subversion. As we saw, Voltaire was in
trouble early and from the time of his *Letters* praising England (<361), he
never stopped giving offense. Yet while discharging his broadsides he was
Gentleman-in-ordinary of the royal chamber, historiographer to the king,
and secret envoy on wartime missions abroad. But these official positions did
not keep him safe. For a time he had been in Berlin as honored guest and con-
fidant of Frederick the Great, helping him polish his French verse and prose.
Intriguers made the pair quarrel and Voltaire became a wanderer who had to
find asylum in Brussels, Saxe-Gotha, Colmar, Geneva, and finally Ferney, on
the French border, four miles from Geneva, for quick escape.

By then there were standing orders against him and his works—the
Parlement's for his arrest, the Sorbonne's for the public burning of his books,
the Council of State's in general condemnation. Yet his books circulated
freely and he was not a hunted man. His letters reached his friends, among
them—crowning paradox—Mme de Pompadour. Only when Voltaire raised
his voice above normal, as when he defended the Protestant Calas family
against vicious persecution, was he again in danger. Such a hot-and-cold pol-
icy was a trait of the Age of Reason. Kings and noble lords paid Voltaire their
due of flattery; anybody of note, from Boswell to Casanova, felt it imperative
to visit him at Ferney; the place was often referred to as Ferney-Voltaire. He
gave audiences like royalty and the conversations with visitors that were
recorded and published make excellent reading.°

At the end of 20 years as a glorious refugee, Voltaire went unmolested to
Paris to receive at home, at the Academy, at the theater—wherever he was—
the honors reserved for a poet and a hero. He shortly died, a demigod. But to
escape the indignities prepared by church people at his burial, he had to be
smuggled out of Paris at night, embalmed, and propped up in a coach.

During the latter years of the century some of the pressure on the "party
of humanity" had begun to ease. No disaster had struck in the wake of
Reason; the troublesome Jesuit order was expelled from France by the
Parlement, now dominated by Jansenists; the last 10 volumes of the
Encyclopédie came out with the authorities' tacit consent. Diderot at last had
his reward—or at least his well-earned holiday—at a distant resort.

Catherine the Great of Russia, as soon as she had seized her throne and
heard of Diderot's publisher troubles, had invited him to carry on the work

under her protection. He chose to fight it out in Paris, but the invitation remained open and, once a free agent, he set out on a leisurely trip through Holland and Germany, visiting art collections and ending up in St. Petersburg. There he spent five months in comfort and pleasant conversations with the empress. They got on extremely well; he lectured her and when she seemed distrait he took hold of her knee and shook it. Only one unpleasant incident occurred. Some loutish courtiers plotted his discomfiture. They burst in on him in front of the court and one said "Sir, $a+b / z = x$. Therefore God exists. Reply!" According to a report, that has been repeated with variations,° Diderot was struck speechless. This is absurd. He had taught mathematics and written papers that were genuine though not brilliant contributions to the science. And no knowledge of algebra is needed to see through the absurdity. Diderot's silence expressed contempt and the refusal to make a scene.

Diderot's writings other than the articles in the *Encyclopédie* are voluminous and encyclopedic in another sense: he dealt with the philosophy of science, with physiology and psychology, the woman question, the art of acting, and education. He wrote tales and plays and newsletters and two other groups of works of unique merit: dialogues on the physical and moral life of man; and *salons*—the first critical reviewing of exhibitions of paintings.

Diderot ranks as the pivotal figure of the century because his thought evolved, passing from critical effort based on Reason to a conception of man and society in which impulse and instinct are seen as stronger than Reason. The philosophe's love of ABSTRACTION, which yields uniformity, is replaced by a keen sense of concrete diversity. The pivot for Diderot's gradual turn is the *Encyclopédie*. It was toward the end of its production that Diderot began to write the masterpieces embodying his doubts and his new inferences. His darting mind was by nature cross-disciplinary. When he deals with comparative grammar, he brings to bear not only his knowledge of the Latin and Greek poets and of Italian and English syntax, but also of painting and music; he inserts four bars from an opera, and analyzes them in technical terms to show a parallel with five lines of Virgil.°

From his views on art, human life, and the character of experience, Diderot foreshadows Romanticism and at certain points looks as far ahead as Symbolism. This relation to the future explains why his contemporaries gave him a rather narrow place in their regard: he had done good work through the *Encyclopédie,* but was otherwise the incomplete thinker and wayward son. It is only fair to add that his most revelatory works were still in manuscript, but even had they been known it is not likely that his age would have prized them as we do. Diderot was one of history's born conversationalists and his writings repeatedly fall into dialogue. A tale, an essay, a rebuttal will start out sedately in expository form, and soon dash and question mark break up the

line as a living or imaginary interlocutor doubts or denies—it is "interactive prose." In the long dialogues that he never published Diderot gives the floor to people he knew and makes them say what they may have thought about their own subject so that he can utter what he does think.

One of the best is the "Supplement to Bougainville's Voyage." The reference is to a famous circumnavigation of the globe. Diderot's dialogue deals, among other things, with the mores of Tahiti, where sexuality is free and without guilt. The island society, gentler and wiser than the civilized ones, inspires the longings of PRIMITIVISM. But Diderot is no Eutopian. He is tough-minded and has been generally called atheist and materialist. His mature vision does without God, certainly, but he is no militant atheist. As for materialism, I believe in the teeth of the authorities that the term is misapplied.° Diderot's philosophy rests on his study of physiology, amplified by his conferring with physicians. Life, instinct, sexual reproduction, animal behavior, the passions and emotions were his concern. He had no doubt that man is an animal, but animals are not machines, as La Mettrie believed. Diderot thought it likely that "Transformism," the precursor of Evolution, was well-founded. In this again he pivots away from Newton and astrophysics to Buffon and biology (376>). But one looks in vain for his ultimate conclusions about matter and life.

He concluded nothing: he proposed, saying he preferred an explanation that did not require two different principles, matter *and* life. His single entity was "matter that thinks," matter that has "sensibility" (ability to sense). This matter is not the dead matter of the materialist's world machine. When Helvétius in his book on Man ascribed the varieties of human experience to bare matter, Diderot objected: "I am a man and I want causes appropriate to man." Undogmatic, Diderot confessed that he could not understand the passage from matter to thought, though it must exist if one did not suppose an invisible something not in space or time. He added that his system is "open to the same unsurmountable difficulty as Berkeley's argument against the existence of matter."° The body-mind problem has in fact not been solved. If Diderot was not a materialist in the accepted sense, what must he be called? The most fitting term is the one William James chose for himself: radical empiricist° (668>). For both thinkers it has the advantage of reconceiving matter as something close to its present-day aspects—not dead weight, but multiform energy.

He: Everything that lives, man included, seeks its well-being at the expense of whoever withholds it. If I let my little savage grow up without my saying a word to him, he would of his own accord want to be rich, loved by women, and draw to himself all the goods of life.

Myself: If your little savage were left to himself he would strangle his father and sleep with his mother.

—DIDEROT, *RAMEAU'S NEPHEW*
(FIRST PUBL. 1832)

*
* *

The most spectacular discoveries in the Age of Reason were those in electricity. Before and after Franklin's near-suicidal experiment as human lightning rod, many amateurs and professionals worked with the "Leyden jar," which stores static electricity. They recorded the facts of positive and negative charges, measured the output (Coulomb); devised an electric pile (= battery—Volta); and perceived a link between electricity and the action of the nerves (Galvani). Two technical units and the familiar *galvanized* remind us of their names and findings. Very few searchers as yet specialized; all phenomena challenged their minds. Franklin, for example, made contributions to general physics, oceanography, and meteorology. His studies in electricity established the one-fluid theory and the terms *charge*, *negative* and *positive*, and *battery*. He measured and predicted effects and explained the fact of grounding. He added to the understanding of storms and of the Gulf Stream and invented useful things, notably the stove named after him.° Unfortunately, a phenomenon just as elusive as electricity did not fare well at the hands of an investigating committee on which he sat with Lavoisier and others. A Dr. Mesmer had come to Paris from Germany and treated patients by what he called animal magnetism—hypnosis. The committee declared the theory and practice both without merit. By inference Dr. Mesmer was a fraud. His method is in medical use today.

Franklin had come to Paris on a diplomatic mission after the American colonies' declaration of independence and he remained nine years as cultural envoy and negotiator of treaties. He was soon idolized as the embodiment of everything the Enlightenment stood for: reason at work in science, and emancipation from kings and priests. What is more, his simple overseas manners and dress, both "put on," fitted in nicely with the mood of the last quarter of the century (386>); indeed, in his fur hat he was hailed as the Noble Savage.

Another fluid, one that all could see—water—was also being studied in its large effects, the results giving a start to the science of hydrodynamics and yielding improvements in bridge- and shipbuilding. Momentous in its consequences, this renewed interest in water included the effort to hitch it in the form of steam to metal parts and so to form an engine. The first, Newcomen's, worked a pump; next Watt's, more efficient, put man in possession of locomotive as well as stationary power. Steam gave vast importance to certain devices invented some time before: Kay's "flying shuttle" threw the thread across the work in weaving; Hargreaves' "spinning jenny" was a multiple spinning wheel, both devices being intended to increase domestic production. The next invention, Arkwright's water frame, was too large and expensive for home use and it needed power; likewise, Crompton's "mule," which combined the jenny and the frame, ruled out home application: the factory was inescapable.

Practical devices and theoretical understanding gave each other mutual aid. The thermometer belongs to this period, two scales—Fahrenheit's and Réaumur's—being offered to chemists and physicians. After long efforts and the offer of a prize, a clock was built that was accurate enough to measure the time elapsed after travel from a given point—the Greenwich meridian—and thereby to fix a ship's longitude. Like any instrument that measures, John Harrison's chronometer (made of wood) served the needs of pure research; his being denied the prize is one of the scandals in the history of science. [The book to read is *Longitude* by Dava Sobel (Penguin ed.).]

The interest in the earth was fed by numerous expeditions. Bougainville's (<374) was spectacular. Another team braved the Lapland weather to ascertain the size of the earth. An open space near the pole was convenient for measuring a portion of the rotundity and determining the length of one degree. In Sweden, the philosopher Swedenborg, an avowed materialist until his later years, made discoveries in geology and paleontology; and in Lapland again, the botanist Linnaeus searched for exotic plants. On his return he devised the system still used for naming and classifying them. At the other end of the earth, La Condamine sailed the length of the Amazon River, collecting flora and fauna and discovering the rubber plant. Others, like Captain Cook, made voyages to the South Seas, adding archipelagos to the known islands and coming upon New Zealand, whose addition completed the map of the world. Most of these ventures were sponsored by crowned heads or their enlightened ministers, who also maintained botanical and zoological gardens: it was the dawn of "government in science."

Back home, findings were sifted and theories framed. Georges Le Clerc, comte de Buffon, was a naturalist who undertook to gather into one work all that was known about the animal world and, with the aid of Daubenton, to extend the compendium to plants. For his part, Buffon came to believe that the higher vertebrates, including man, were built on a single pattern, the limbs and other organs having related forms. He described the features which by transformation must have led to the anatomy of *Homo sapiens*. Buffon suggests no means for the process. It was bad enough to contradict God's separate creation of all living things, beginning with Man, who was "in His image." To protect himself from the Sorbonne's wrath, the naturalist had to couple his hypothesis with rhetoric to the effect that were we not perfectly sure by revelation that no such interconnections are possible, we should be tempted to believe that. . . .

A censor would find it hard to impugn the disclaimer, but a docile reader might miss the scientist's irony. It was in fact missed by the 19C historians of evolution, but not in its own day. "Transformism" was an idea in the air and, as we saw, firm in Diderot's mind through his contacts with physiologists. By

the end of the century, two complete theories of evolution, one English and one French, were in print for public attention (455>).

Research threw new light also on medicine and the workings of the body. Leeuwenhoek and Stahl discovered the human spermatozoa; physiologists noted the similarities between the human male and female organs of reproduction. Harvey's earlier discovery that the blood circulated and exerted pressure on the vessels inspired in Boerhaave a system of medicine based on hydraulics: if the vessels were too thin or weak, illness developed. In other cases, such as digestive trouble, the cause was chemical. Medical "systems" still ruled practice; Boerhaave's, eloquently conveyed to large classes at Leyden and propagated in seven textbooks throughout Europe, held the stage for 50 years. One advance in preventive care was Jenner's use of cow vaccine, instead of human material, to immunize against smallpox; milder cases and fewer deaths from "vaccinia" resulted.

One study in which system was appropriate found in the 18C its definitive maker, the chemist Lavoisier. He had the right materials and the right method—isolating elements, finding them again in compounds, weighing the proportions in which they combine, and giving them indicative names. This firm foundation for the science was made possible by the separate discoveries of oxygen, hydrogen, and nitrogen (Priestley, Cavendish) and the long-delayed explanation of fire. It had been thought that when something burned a subtle element called phlogiston (flame) was set free. Instead, experiment proved that fire resulted from the combining of oxygen with other substances. [The book to leaf through for illustrations of 18C laboratory work in all fields is *The Album of Science: Leonardo to Lavoisier*, ed. by I. Bernard Cohen.]

Underlying all advances was the progress of mathematics. The work of Halley on comets, of Laplace in cosmology, or (as just noted) of Lavoisier in chemistry depended on numbers. The calculus of Newton and Leibniz was prerequisite to all studies of motion. And in the age that revered Bacon, mathematicians were also physicists who passed readily from mechanics to astronomy and from the theory of fluids to the theory of numbers. D'Alembert, Euler, Laplace were at home in many parts of the single field, "natural philosophy." In one instance, mathematics seemed the inherited craft of a single family, the Bernoulli. Nine of them earned distinction by discoveries in astrophysics, mechanics, botany, and chemistry, and this without incurring reproach for scattering their talents. The clan wound up with an artist of considerable merit as a painter.

It was the encyclopedic yet piecemeal activity of the discoverers that held the interest of the educated public and enabled it to stay up-to-date with science. In many towns—not capitals alone—academies were founded where learned persons mingled with eager ones, titled and bourgeois, to hear papers

on the latest item of discovery or speculation. They offered prizes for answers to disputed questions, the winners gaining instant renown. Echoing these centers were the innumerable salons presided over by ladies, also learned, who steered discussion, invited foreigners, and promoted the gifted young. Less selective, the coffee shops gathered "regulars" of like-minded opinion or avocation.

One of them, the Café Procope in Paris, was made outstanding by Diderot and his friends, while the salons gave lasting fame to such women as Mme du Deffand, Mme d'Epinay, Mme de Tencin, Mme d'Houdetot, Mme Geoffin, Mlle de Lespinasse. Others shone by correspondence of the same caliber as the conversations, nobtably Voltaire's intimate companion, Mme du Châtelet, expert in physics and mathematics; and Diderot's great love, Mlle Volland, whose exchange of letters is a source for the genesis of his ideas.

The variety of topics and the zeal for explanation by measuring the regularities of nature kept strengthening Deism and atheism and weakening the credibility of a Providence concerned with individuals. Western culture was inching toward its present SECULARISM. A shocking event at mid-century supplied a brutal confirmation of disbelief. On the eve of All Saints' Day in 1755, while the faithful were in church, an earthquake shattered Lisbon. Fire and flood from the Tagus river completed its destruction. Tens of thousands perished. Instantly, Voltaire set to work on a long poem that drew the moral: how could a personal God endowed with power and justice ordain such a holocaust? For what conceivable reason kill worshipping men, women, and children in a peculiarly horrible manner? That they were worse sinners than the same number of Parisians or Londoners was a contemptible answer. There *was* no answer, except that the forces of nature acted independently of their creator. [Worth reading is the translation of the main parts of "The Lisbon Earthquake" by Anthony Hecht.]°

*
* *

Voltaire at 60 was the Grand Old Man of letters throughout the western world. He was the Enlightenment personified and the supreme master in all genres. But the touchstone of his eminence was his output of tragedies in verse. They duly followed the pattern set in the preceding age by Corneille and Racine (<342), and though to us lacking the fire of the innovators, they were good imitations, and in one respect were new: Voltaire abandoned the hackneyed Greek and Roman subjects. He went to Tasso's *Jerusalem Delivered,* medieval France, and the Near East. He made Mohammed a hero, and when he tackled Caesar, it was to show by comparison that Shakespeare was only a gifted barbarian who had no notion of tragic art. Voltaire ought to know, hav-

ing read him in English, and now that translations were appearing in French, there was need of a judgment on the foreigner who might lead young poets astray.

Voltaire's output in comedy was inconsequential, like his early attempt at an epic about Henry IV, but his wit and worldly wisdom found vent in numberless occasional poems. The contemporary of his who wrote true comedy in French was Marivaux, and his mode of doing it was unique—so much so that it acquired the name of *Marivaudage*. It consists in showing by innumerable touches—a word, a pause, a gesture—how people in love or on the brink of it are moved by prejudgments, illusions, uncertainty, and blind error, psychological and social. One thinks of Marivaux's dialogue in reading Henry James's plays and later novels. [On Marivaux the book to read is by Oscar A. Haac.]

Marivaux was not a satirist, nor was Voltaire successful when he attempted to ridicule the figure and fate of Joan of Arc. The poem has been held against him as tasteless and given him the 19C reputation of vicious, grinning defiler of all that is fair and noble in humanity. This judgment overlooks the works in prose and notably the tales: not *Candide* alone, but *Zadig, The Princess of Babylon, Micromegas, The Man with Forty Shillings*, and others, in which we find the Voltaire who prized justice, courage, fidelity, and the simple life. In *Candide*, moreover, though the fact has been strangely overlooked, Voltaire no longer believes in progress through light and Reason. The world cannot be cured of greed, fraud, superstition, and violence. The only course for the wise man is to retreat and cultivate his garden.

Needless to say the spirit of *Candide* is not that of the musical that has been made from it,° but neither is Voltaire's advice in *Candide* that of a disillusioned old man. He held the same view of human affairs long before the tale, when he was busy as a writer of histories. The world has forgotten how much he did to inform his age and create in it the sense of history that was to dominate the next century. *The Age of Louis XIV,* the lives of Peter the Great and of Charles XII,° and the vast survey he called an *Essay on the Customs and Manners of Nations* occupied him during many years; and they filled his mind with facts that went against what he as philosophe expounded.

Despite the lack of preliminary studies by other hands, the *Essay* on customs is an attempt at a history of the world seen in cultural perspective—the first of its kind. It takes the reader from the geological setting of prehistory to the Near and Far Eastern civilizations, and thence to medieval and modern times in the West. Here is Voltaire the concrete mind. Gone are the universal reason, single religion, and uniform Man; a close look at the what-happened dispels them. The truth arrived at is that periods of civilization are rare; Voltaire the historian finds only four: ancient Athens, Rome, the Renaissance, and the age of Louis XIV, which carries over into part of his own time.

The idea that cultures rise and fall was not original with Voltaire. As we saw, it was set forth in great detail earlier in the century by Giambattista Vico in his neglected book *The New Science* (<314). Before Vico, the doings of kings had been the staple of historiography, for the good reason that kings were the patrons of historians. National and cultural history date from Vico and Voltaire. But during and apart from the writing of royal histories, historical *scholarship* flourished among certain religious orders such as The Bollandists and the Benedictines of St. Maur. They studied and edited tons of records dating back to early times. Voltaire's work owed much to German and Swiss collections of this sort and their amiable curators. His historical vision influenced his contemporary peers Gibbon, Hume, and Robertson, and spurred Herder, mostly through disagreement, to lay down the principles that inspired 19C historians everywhere (482>).

<div align="center">*
* *</div>

To call *Candide* and similar works tales and not novels is to make a point related to the historical sense. We last looked at the novel in its picaresque stage (<111), when it offers a critique of society and its members by leading a hero through mishaps as he rises on rungs of the social ladder. At the turn of the 17C Lesage enlarged the canvas without changing the method, and Mme de Lafayette made a departure into the study of passion (<352). It was left to the 18C to achieve the full-fledged genre properly called the novel. Furetière had taken a step forward in *Le Roman bourgeois* by describing a class setting, but without much skill. And Marivaux the playwright added subtle psychological interest in *The Jumped-up Peasant* and *The Life of Marianne*.

Little by little these two elements of the true novel, character and social milieu, were centering attention, now one, now the other predominating. England produced the definitive models: Richardson's *Pamela* and Fielding's *Tom Jones*. The richness of introspective and domestic detail in *Pamela*, repeated to the saturation point in the author's other two novels, makes him the founding father of the psychological novel. The species is deep but not broad. *Tom Jones* presents the balanced form; so that if one compares Richardson to a biographer, Fielding must be looked upon as a historian. He virtually tells us so in those wonderful "prefaces" that occur at intervals to explain his work. He calls it an epic, which, as we know, is a poetic history. His apology for Tom's not being a hero makes a related point. He had parodied *Pamela* and, wanting his story to be true to life, he had not made Tom heroic in virtue like her.

Richardson was enthusiastically read in France, especially after Diderot's long essay in his praise. Pamela's high moral tone, her resourcefulness though a simple maidservant in resisting her social superior, her amazingly analytic

self-respect were the cause for many hearts-and-minds to weep at her trials and triumph. The age was heading toward sentimentality (410>). The hardbitten Voltaire himself said that the best plays were those that made one weep the most. And Diderot in his two plays and occasionally elsewhere shows that he enjoyed nothing better than the spectacle of storybook benevolence. It must overcome evil, reconcile enemies, clear up misunderstandings, reunite families. Fielding was not immune: Mr. Allworthy in *Tom Jones* proves it by his very name. But the rest of *Tom Jones* portrays fact and feeling, not sentiment.

Since stage plots with happy endings and sober dialogue were neither tragedies nor comedies, they were called bourgeois dramas, a term that indicates their link with the philosophe temper: the bourgeois was the straightforward man or woman, simple in manners and ethics—altogether respectable; whereas the aristocrat, though called *honnête homme* (<351) was not honest but an intriguer in gaudy array, treacherous and corrupt under the surface. The age that declared men were all born equal and that said kings were lucky warriors and priests confidence men logically found the worthy man in the bourgeois.

The contradictory attitudes that may be read in the works and lives of a Voltaire or Diderot are found in others, of course, and in their crusades as well. It is hard to reconcile in the Enlightenment the assault on kings and conquerors and the enthusiasm for Frederick and Catherine—both dubbed Great, although they ruled Prussia and Russia like dictators. The royal ministers Pombal in Portugal, Aranda in Spain, and later Joseph II of Austria joined with public acclaim this club of "Enlightened Despots."

The first two bestowed favors on Voltaire and Diderot and on others among the academicians of Berlin and St. Petersburg. The same mutual admiration graced some of the German courts ruled by lesser despots who talked French and Reason (390>). The expectation was that these heads of state would carry out reforms of the kind wanted by the avant-garde. It was not an altogether foolish hope: who else could change the structure of governments? No machinery existed for the purpose; and given this difficulty, the more despotic the ruler the greater the likelihood of change—provided he made the *Encyclopédie* his bedside book. The men of the Enlightenment did not promote democracy or contemplate revolution. Voltaire even while prodding others to help him crush *l'infâme,* the infamous church, pointed out the need for religion to keep the masses from killing and looting the propertied classes. Not that the people were stupid or evil, but untaught and brutish. In the event, the failure of plans for education and reform in Russia and Austria confirmed the difficulty and dimmed the luster of enlightened despotism.

Meanwhile a group of economists sought another kind of reform, one that despots might not favor: free trade. In the 17C one Boisguilbert had disputed the dogma of Mercantilism: piling up gold by spurring exports and

deterring imports was short-sighted. It pleased kings but harmed the king-
dom. Prosperity depended on the greatest possible production and exchange,
with only one tax imposed on the producers. In England too a Dutch doctor
named Mandeville had written a popular tale, *The Fable of the Bees,* in which he
argued that consumption and even luxury and waste were good for the coun-
try—his maxim was: private vices=public benefits. In the encyclopedist gen-
eration Quesnay, Turgot, and Dupont de Nemours (later the founder of the
American corporation and dynasty of that name) developed a theory inspired
by Harvey's discovery of the circulation of the blood. It was more than a
rhetorical analogy. Free-moving goods and money would sustain every part
of the body politic. Agriculture was the only source of wealth—industries
only transform a product without adding to it—hence a single tax. As things
were, towns, counties, provinces, and builders of highways all levied tolls and
tariffs that must be abolished. All the good lands must be tilled, and by the lat-
est methods. This faith in the primacy of agriculture seemed rational before
machine industry had shown its fruits, and the name Physiocrat (= Nature
the ruler) was appropriate for these budding economists.

Improvement in agriculture was in fact making great strides in England.
Jethro Tull had invented a drill that directed the seed in planting, avoiding
waste. Lord Townshend had found that certain root crops replenished the
fertility of the soil; and he campaigned for their use; he rose to fame as Turnip
Townshend. The plow was improved and cattle bred more carefully; all of
which reinforced the platitude that the richest and happiest country is the one
that has the largest rural population; the family was blest that had the most
children to work the land and take care of the old folk in their last years. This
picture of the good life went well with the longing that Diderot expressed in
his moments of PRIMITIVISM. It was congenial also to one who had been
Diderot's closest friend and a valued contributor to the *Encyclopédie,* but came
to be feared by the avant-garde as the worst enemy of reason and truth,

Jean-Jacques Rousseau

His books on government, morals, education, and social life did give the
course of ideas a wrench. To understand how, one must erase from the mind
every remark or allusion one has come across about him and his thought. In
academic writings as in journalism, his name and the adjective Rousseauian
are used to characterize opinions that he never held. These statements con-
trary to fact are repeated by rote when certain subjects arise, just as
Shakespeare's phrase "sea change" is set down when the writer thinks of
change. For the record: Rousseau did not invent or idolize the noble savage,
did not urge going "back to nature," did not say that since men are born free
and are now in chains, we must break the chains. He did not base his political

conclusions on the social contract, and when he argued that plays were harmful and the arts and sciences had not improved mankind, he was neither the first nor the last great thinker to hold these views. Finally, his feeling at the end of life that he was the victim of persecution was not paranoid.

What then did he think and say? The catalogue of negatives seems to strip him bare of originality and importance. Let us follow him from his beginnings. Born in Geneva, he came from a family of artisans, his father a watchmaker who taught him "goodness" in a gentle way at odds with the surrounding Calvinism. But the Puritan influence nonetheless went deep. Young Rousseau emigrated to France to make his way and found himself a servant in the house of a provincial lady with intellectual pretensions, Mme de Warens. As her quasi son and actual lover, he learned the manners of society and was converted to Catholicism. He then had a spell of monastic life, and next went to Paris, where Diderot befriended him: they were brother spirits. A prize offered by the Dijon Academy on the question, whether the revival of the arts and sciences had helped to improve manners and morals, stirred their ambition; they conferred about it, Rousseau wrote the essay, taking the negative, and won the prize. He was famous overnight; for it was an arresting paradox to deny the value of what the brightest of the age took pride in and worked to extend. It must be remembered that in the 18C "arts" meant all the arts—mechanical as well as fine, the entire techne of civilized life—as may be seen in Article I section 8 of the United States Constitution.

Diderot may have suggested the resounding "No!" as offering a better chance of winning, but note that it was the Academy, a large group of intellectuals, who raised the doubt. In any case Rousseau never backed away from the position; it was congenial to his Puritan-bred temperament and sincerely held; it led logically to his most influential ideas. But this was not foreseen by those who henceforth made him a literary lion and a potential Encyclopedist. In due course he wrote for the great work all the articles on music; for he was proficient in that fine art, and when the vicissitudes of patronage forced him to earn his living, he did so by copying music. He had married a woman of humble birth and had children to support.

All the while, in every situation, he kept educating himself by voracious reading and searching observation. The ups and downs of his career made him a unique social being: he had waited on table and been an attaché of the French embassy in Venice; he had lived frugally with his family in a Paris back street and been the guest of honor in noble houses; he ended up as an anonymous cottager in a small village. Rousseau was thus the only critic of society to have seen it from every established rank and that of petted genius besides. What he saw in his own person now has to be dug out by teams of Ph.D.s armed with questionnaires.

After the prize piece, Rousseau, then aged 43 and once more a Protestant,

wrote another tract, *On the Origin of Inequality Among Men.* It is here that the myths about his views begin. Voltaire, who had felt annoyed by the first essay, was outraged by the second, declaring that Rousseau wanted us to "walk on all fours" like animals and behave like savages, believing them creatures of perfection.° From these interpretations, plausible but inexact, spring the clichés Noble Savage and Back to Nature. We saw that 16 centuries after Tacitus the noble savage was resurrected as a help to the Evangelicals and that the discovery of America proved this creature a real being; his tribal society shortly inspired the Eutopias. The type reappeared in Gulliver's fourth voyage as the Houyhnhnm, the ever-judicious horse. In short, the myth embodies a permanent ideal, reborn in the Modern Era and satisfying the urge to PRIMITIVISM. It recurs when society faces too much complexity and condemns it as artificial.

Rousseau did inveigh against the characteristics of high civilization, but he did not preach a return to the savage state. He thought it in many ways unattractive—lacking morality, acting by instinct without thought and at one stage without language, and living from hand to mouth. What is preferable when society and property have become established and the inequality of talents is revealed, is that ability should be rewarded for the advantage of the community. This stage, Rousseau says, is the happiest and most lasting in the history of mankind. But he says nothing about returning to it. He does say that when in time wealth and rank no longer correspond to merit, the disparity becomes an injustice and leads to instability. This conclusion, he points out, is easily reached by simply reflecting, reasoning in good Enlightenment fashion. It is not a rabble-rousing argument. Nature and the savage are ABSTRACTIONS like the figures of geometry.

Taken together, these first two essays form a negative critique of things as they are. The later, positive recommendations show that the society to be re-instituted is a revised form of the middle stage just described—the model man is the independent farmer, free of superiors and self-governing. This was cause enough for the philosophes' hatred of their former friend. Rousseau's unforgivable crime was his rejection of the graces and luxuries of civilized existence. Voltaire had sung "The superfluous, that most necessary thing." For the high-bourgeois standard of living Rousseau would substitute the middling peasant's. It was the country *versus* the city—an exasperating idea that, and so was the amazing fact that every new work of Rousseau's was a huge success, whether the subject was politics, the theater, education, religion, or a novel about love.

The best known of the political works, *The Social Contract,* is the one in which occurs, near the beginning, the over-quoted sentence about men born free and everywhere in chains. The journalist mind assumes that the words can only mean "Break the chains." But Rousseau's next sentence, left unquoted, says: "I will now endeavor to show how they [the chains] are legit-

imate." Farther on we come upon the savage once more and learn that although he is free of some faults, he is not a moral being—not immoral, amoral. So he cannot be the material for building a society and running a government. So much for the charge of wanting us "to walk on all fours."

As for the social contract, which critics then and now think ridiculous, it was Locke's starting point a quarter century before Rousseau's birth; yet Locke is praised as sound. The contract is an ancient idea and Rousseau used it as a title that would immediately indicate the subject of his book. In the course of it he says he does not care whether there ever was a contract. He does not need it for his purpose, which is to define his best form of government for men who are free and also moral. Pure democracy, in which all citizens vote on every issue (the New England town meeting) is too good for fallible human beings, and it would be workable only in very small city-states. The next best is representative government, which he calls with great precision: "elective aristocracy."

The people is sovereign in Rousseau as in Locke; the representatives must therefore act for the people's best interests. But human failings—stupidity, selfishness—frequently prevent the "will of all," that is, the majority, from carrying out the "general will," which is the common welfare. All really want it, but blinded in some way they often fail to enact it. The question whether this plan, coupled with a "civic religion" opens the way to dictatorship, as some have argued, would require more quoting and rebutting than is worthwhile here. More important is the neglected fact that when Rousseau was asked to recommend a constitution for Poland and again one for Corsica, he replied not as in the *Contract* by general propositions but in a concrete spirit and with insistence on the need to suit the traditions, customs, and present needs of the people. The Rousseau of the essays based on reasoning alone is often adversely compared with Burke, the practical statesman. An American scholar long ago showed in her *Rousseau and Burke* how false the contrast is and how much the two theorists were at one on principles of government.°

Because school is the place where the mind and feelings are molded, Rousseau defined the proper education for the citizens of a republican state. The *Emile* (the name of his pupil) shows how the native curiosity and other impulses of the child should be made use of to develop intelligence and acquire learning. It is once again "things, not words" (<181). Reading is to be postponed and rules must arise from observation and reflection if they are to be accepted as reasonable. In a word, the program is: the pupil is a child, not a small adult; he or she develops, and the training must be adapted to each phase of the change. Molding in the literal sense is what must not be done. Every subsequent "progressive school," down to John Dewey's in the early 1900s (608>) has applied the intent of Rousseau's precepts.

The book angered all parties—Deist, Atheist, and Catholic—by its section on religion, but pleased many on topics of domestic concern. Rousseau wanted mothers to nurse their children, not farm them out to unknown girls; and fathers should not stay aloof from their offspring. If Emile has a tutor, it is because of the incessant attention the plan requires. Rousseau did not write a manual—and said so; he was giving a new conception of the individual and the growth of his mind. The setting is rural, so that the child learns about living things, the rhythm of the seasons, and the beauty and variety of nature. His daily round is simpler and healthier than in town, free of the conventions and fads that make clever worldlings, prone to dissipation and shallow ambitions. The portrait of Emile makes us think of Fielding's Tom Jones, who also is good-natured and fundamentally honest. Unfortunately Tom's tutors Thwackum and Square were horrors, and if we may take them as only slight exaggerations of the type employed by good families in the 18C, we can gauge the appeal of Rousseau's pedagogy, a distant revival of Montaigne's (<138). Tom was saved by his love for Sophie. Sophie is also the name of Emile's destined spouse—it means wisdom and she embodies it as the helpmate of the citizen-farmer, the man whom Jefferson counted on to make the United States a great nation, the man Tocqueville found when he visited the country.

"Sir, you see before you a man who has brought up his son according to the principles so happily to be found in your *Emile*." Rousseau looked at him hard. "That's too bad, sir, too bad for you and your son. I did not intend to furnish a method; I wanted only to prevent the evils of education as it existed."

—Report of a conversation with M. Angard° (n.d.)

Having grasped Rousseau's aims and seeing what has taken the place of the society he lived in, one must agree with the scholar who concluded that the 18C troublemaker's motto was not back but forward to nature.° In his own day Rousseau witnessed a response to his views besides applause: nursing mothers, ladies on their estates playing at being dairy maids—Marie Antoinette, suitably dressed, did it at court—and a more conscious interest in the countryside, especially after Rousseau published descriptions of his rambles among woods and streams. The conviction grew that time spent in that way repaired the wear and tear of the city. Everybody's paid vacation, now ordained by law, is a remote effect of *The Reveries of a Solitary Saunterer*.

In *Emile* nature had yet another role. The country-bred adolescent begins to ask philosophic questions: how do we come into the world? Who made it? What is the meaning of life? On the subject of procreation, Rousseau urges giving frank answers as soon as the question is asked; it will soon be accompanied by sexual desire, which also needs discussion. As for the larger creation, it cannot be explained in the repellent terms of theology or the remote

abstraction of Deism. Visible nature, its infinite beauties and tremendous power are the living witness to the living God. Religion is a feeling. It combines humility with wonder and sustains the moral law imprinted on the individual conscience.

Rousseau puts religion among the passions, which are the energy behind reason and action. All the passions are good when hitched to the right thoughts, and this linkage, which results from a good upbringing, does not need the apparatus of eternal rewards and punishments or earthly rituals and revelations. Rousseau reminds the reader that two-thirds of mankind are neither Christians nor Jews, nor Mohammedans, from which it follows that God cannot be the exclusive possession of any sect or people; all their ideas as to His demands and His judgments are imaginings. He asks only that we love Him and pursue the good. All else we know nothing about. That there should be quarrels and bloodshed about what we can never know is the grossest impiety.

The *Emile* was condemned by the bishop of Paris not only for teaching men to bypass the church but for implying universal salvation and denying original sin. Rousseau replied that according to the gospel, Christ had died to redeem mankind of sin and that baptism seconded that redemption, after which only individual sins kept one from being saved. In a last work, the *Confessions,* he taught by showing his own faults and misdeeds that he entertained no illusions about human conduct. The gap between moral intention and performance remains a perpetual challenge to the will.

*
* *

The *Encyclopédie* had a great deal to say about music—it would fill three ordinary volumes—and it is all by Rousseau. Hence we may not dismiss him yet. Under Diderot's whip, protesting, he turned out the work in three months. This haste accounts for some of the mistakes that Rameau, the formidable theorist and composer, enjoyed publicizing. It was retaliation for Rousseau's hostility to French music in favor of the Italian, a judgment based chiefly on the ease with which Italian words can be sung as well as set to music. Rameau had made still grander the kind of spectacle created by Lully for Versailles. A recent production of Rameau's *Indes Galantes* gave a taste, but not the full measure, of 18C extravagance in ballet and decor. Only the rich harmony remained. One might label the French style Baroque and the Italian neo-classical. The Italians also offered *opera buffa,* the comic genre, which the French were slow to imitate.

About all this, Parisian opera-goers argued vehemently; Rousseau was not alone in preferring the foreign product to the French, from dislike of pomp and thick musical texture. He made fun of the apparatus, and wanting

Imagine a crate 15 feet wide and long in pro-
portion. On each side are screens roughly
painted to represent chasms or holes in the
sky. Behind is a curtain, always torn. When
people walk behind, it flutters, not unpleas-
antly. Four timbers and a flat board make up
the chariot of the gods. It hangs from a rope
in front of a rag meant to look like a cloud.
But what you cannot imagine is the cries, the
bellowings of the divas, convulsed, faces
aflame, fists tight against their breasts, forc-
ing out groans from their lungs, this being
the only thing the spectators applaud.

—Rousseau, on the Paris Opera (1760)

to show what simplicity in opera could
be he composed *Le Devin du Village* (*The
Village Soothsayer*). It was indeed sim-
ple—a tale of rustic love and fatherly
wisdom, sung to balladlike tunes; no
gods or goddesses shrieking from char-
iots—if we are to trust the partisan
description of the other style. *Le Devin*
proved a success for half a century, but
the charm arising from naive sentiment
has evaporated.

Preceding as well as contemporary
with the Baroque phase of French
music was the double bill, Italian and
German, inaugurated in London, as we
saw, by the operas and oratorios of Handel and Bononcini (<327). In
Germany itself, Baroque reached its summit in the many-sided—one might
say the encyclopedic—work of

Johann Sebastian Bach

He needs his first names, because he belonged to a family numbering 53
musicians over 300 years and because he fathered at least one son—Carl
Philip Emanuel—who outdid him in popularity though not in genius. Johann
Sebastian had a normal career as organist, cantor, and teacher, died in the
middle year of the century, and was not much heard of again until the 1830s.

Since then he has received his due in full measure, though some of his
most fervent admirers make him out exclusively one type of musician.
Because he composed works illustrating the art of fugue and the use of equal
temperament (the tuning system that makes it easy to pass from one tonality
to another) and has also written many fugues, he has been regarded as the
supreme master of so-called absolute music. He knew and practiced no such
specialty. In addition, the number and variety of his works, the size of his
finest ones, his many brilliant pieces that bring out the virtuosity of soloists,
have combined with the self-reproach for his long neglect to induce a wor-
shipful attitude that does him an injustice: he has been made president of the
immortals and deemed infallible in the one genre, whereas his works show a
much more versatile and profound character.

Fortunately, he has had one recent admirer who responded to the works
with both knowledge and sensibility and whose detailed study set the god in a
new light. This was a Renaissance man of our century, Albert Schweitzer, musi-
cian, physician, philosopher, man of letters, and philanthropist. His detailed

study demonstrated that Bach was not merely a master of complexity in musical form, but also a creator of drama in sound. The cantatas, the masses, the three Passions, and most of the smaller works are expressive music and not "absolute," if by absolute is meant an interest in pattern only.

> Its convincing demonstration of the pictorial bent of Bach's mind must necessarily lead to a reconsideration not only of the older view of Bach as a mainly "abstract" musician, but of the aesthetics of music in general.
>
> —ERNEST NEWMAN, ON SCHWEITZER'S *BACH* (1911)

Schweitzer divides composers into poetic and pictorial, and he assigns Bach to the pictorial class. These terms are regrettable for reasons that will find a place later on (495>). But Schweitzer's demonstration of Bach's expressive intentions and results remains unassailable. It should have been plain long ago that the *St. Matthew Passion*, say, or the cantata *Nun Komm' der Heiden Heiland* is not a virtuoso exercise in patterning but the fusion of patterns with dramatic purpose: there is a text, the words describe a scene, the music fits the words and the action. Bach's genius for adapting music to meaning is such that it appears even in works without text or title, we see it, we hear it in Bach's suites, concertos, partitas, and even in works where the opportunity would seem minimal, as for instance in the Chaconne for unaccompanied violin. The drama is there, neither poetic nor "pictorial," but visceral (>639).

Besides the use of equal temperament, the time of Bach and Handel witnessed other innovations. Today's taste for what is too roughly lumped together as Baroque music, felt as soothing after the 19C's orchestral thunders, tends to regard it as fittingly restrained for civilized ears. The truth is that the expressive purposes that moved Bach impelled other composers to want musical instruments improved, notably their range and power increased. They had the organ, which can whisper and raise storms, and Bach for one sought the most powerful available. After all, in the *St. Matthew Passion* he had to evoke the feelings that accompanied the rending of the veil and the earthquake. The feeble clavichord did not carry far; the harpsichord was only a little stronger; but Cristofori in Italy was working at these defects; he built a machine he called *clavicembalo piano e forte*—a keyboard instrument to play "soft and loud." Contrary to all experience, we now call it simply "a soft."

Other ingenious artisans were making progress toward the same end. Stradivarius built violins and other stringed boxes with a power and richness of tone that have not been surpassed. At the same time the oboe was improved for accurate intonation and the transverse flute replaced the recorder, all for loudness' sake. For a different pleasure, Father Castel built a "Color organ" which played fanlike patterns on a screen. At the very end of the century, Tourte bent the violin bow inward and equipped the end with a screw for tightening the horsehair and thus not only increased the volume of sound when rubbing the string, but enlarged the variety of bowings for new effects.

These advances compare favorably with those in spinning and weaving: the modern orchestra and industrial machinery are first cousins whose genesis belongs to the 18C. What Louis XIV heard at Versailles was his father's "grand band" of 24 strings of the violin family. Lully pleaded for the addition of a "small band" of 16, made up of strings, oboes, and bassoons. The Paris Opera raised the total to 21. At other places, ensembles varied greatly; sometimes 10 or 12 bassoons played against the strings in four parts, sometimes trombones, cornets, and keyboard instruments added their color for operatic effect—there was no standard combination. But it was gradually emerging as individual composers tried new blends or solo passages in particular compositions for the expressiveness of tone color. Thus the rustic shawm was introduced into the band as the clarinet.° The prevailing instrumental form being the overture, called *sinfonie,* it needed the best means to express drama. From these pre-orchestral groupings the symphonic forms developed, not the other way around.°

As for the word *orchestra,* its use had an odd beginning. The German opera composer Johann Mattheson, who had helped young Handel early on, published in Hamburg a book with a long title in which *Orchestre* was the striking new word. He explained that it meant the place in front of the opera stage and that he was using it for a new method of instruction. The usual training in music prepared church musicians. Mattheson wanted to cut loose from strictly choral music and polyphony—EMANCIPATION called for in aid of SECULARISM. Through the connotation of *orchestre* he was pointing toward opera and homophony. With these, of course, would come the new instrumentation, which was discarding lutes and theorbos and *trompes marines* (a string instrument despite its name) as unsuitable for an ensemble seeking volume, balance, smoothness, and variety of timbre. For cultural sidelights on the developing orchestra, one may parse Mattheson's title. It suggests a cluster of contemporary facts and attitudes: the French domination of German high culture, the figure of the well-bred cosmopolite and man of taste (*galant homme, goût*), and the Enlightenment shibboleth (*raisonniren*), the art with which one discovers the laws of all things (*universelle*).

The newly revealed *Orchestre,* or *Universelle* and fundamental instructions whereby a *Galant Homme* may obtain a complete conception of the eminent value of lofty MUSIC, *formiren* his *Goût* for it, understand the technical terms, and *raisonniren* skillfully about this excellent science.

—JOHANN MATTHESON, *Das Orchestre* (1713) [THE ITALICIZED WORDS ARE FRENCH OR DERIVED FROM FRENCH.]

*
* *

Mattheson's evocative phrasing leads our thoughts back to the *Encyclopédie,* and thence to Diderot, to look at one more of his decisive contributions: the *Salons.* Beginning in 1760, he visited the annual exhibition of paintings at the Louvre with the novel purpose of reviewing them for others' benefit. He had a good eye, he talked with painters in his usual searching way, learned their jargon and the techniques behind their effects, and produced essays that could be read by amateurs with pleasure and practitioners with profit. Diderot's main demands, as one might expect, were expressiveness and truth to nature. But this truth was far from mere accurate imitation of things. The conception, the scene, the figures, the harmony of shapes and colors, the total emotion aroused must satisfy him before he could admire. For twenty years he discoursed about the works of Boucher, Van Loo, Fragonard, Lancret, Joseph Vernet, Greuze, Chardin, and others. It is a token of his critical acumen that of them all he singles out Chardin as "the greatest magician."

In the period of Diderot's reviewing, the fashionable taste and artistic style acquired the name *rococo.* The very sound of it suggests "not quite serious." Originally it meant decorated with shell (*rocaille*) and it was first applied to screens, tabletops, and furniture generally. It ended by implying delicacy and skillful artifice and finally it connoted clever with a touch of silliness. After the gravity of the age of Louis XIV, lightness of spirit and color, fantasy in thought, profusion of curlicued detail were welcome, together with free imitations of exotic styles, Chinese and other. Rococo was the Enlightenment at play, a relief from Reason, matching the sentimental sallies of Diderot, Richardson, and Rousseau, congenial forms of irresponsibility (410>).

Nevertheless, Rococo in its sweep of cultured Europe produced masterpieces in architecture, painting, sculpture, and interior decoration. What its taste could do in stone was shown in the facade of the Zwinger in Dresden. Its emotional range in painting was demonstrated in the works of Watteau, who brought nostalgia into mythology, and those of Boucher, who made insouciance ubiquitous. Even a religious subject could adopt the style, as in Guenther's *Pieta.*

Rococo had its contrary, equally flourishing. The portraits in pastel by La Tour are a silent rebuke to Boucher's frivolous oils, the busts by Houdon,

What colors, what variety, what wealth of objects and ideas! The man has everything except truth. Where has anybody seen shepherds so elegantly dressed? What occasion has brought together in open country, under a bridge, far from any house, women, men, children, cows, sheep, dogs, bunches of straw, fire and water, pots and pans? What is that well-dressed, voluptuous woman doing? Are those children hers? And this man carrying fire that he's about to heap on her head, is he the husband? What a clutter of disparates! It's obviously absurd. But one can't look away from it. One lusts after it, the extravagance is inimitable. It is magic.

—DIDEROT, ON A PASTORALE BY BOUCHER (1765)

who sculped the century's notables—Voltaire, Rousseau, Diderot, Franklin, Washington—showed them musing soberly. And in England, where Rococo influenced furnishings more than the graphic arts, the outstanding painters Gainsborough, Reynolds, and Raeburn were not inclined to fantasy, except in some accessories when portraying ladies. Before photography only portrait painters could earn a good living and they must cater to their titled customers' mostly downright tastes. This English school should not make us forget that working by their side was a company of watercolorists of the first rank, also bent on being true to life in their depiction of landscapes, houses, and horses.

Apart from both groups stood the first painter who consciously set out to be a critic of society. This was William Hogarth. He took (in his own words) "modern moral subjects similar to representations on the stage." Looking at the aristocrats' relations to the other orders of society, he showed in satirical drawings the rake, the harlot, the idle apprentice, the stages of cruelty. His crowded scenes in connected series form a kind of novel in pictures, the objects when repeated supplying links and suggesting the "progress" (as in a film) of the moral ills he denounced. (*The Rake's Progress* has been made into a ballet by Gavin Gordon and an opera by the collaboration of W. H. Auden and Stravinsky.) Hogarth's works in oils are uninhibited in subject, and like his few portraits were not popular. To find one's class or profession stigmatized in the novels of Fielding or Smollett is something easier to stomach than to see it done with figures and poses and dresses and furnishings that look indecently like those of your friends and possibly like your own.

If it is asked whether the Encyclopedic century was a critical age or a creative one, the fair answer is: it was both of these. Take away its creations and our museums, libraries, and concerts would look stripped, unrecognizable. The 18C *seems* more critical than creative, because it undermined beliefs and institutions that still number many adherents. They naturally resent the crusade that ushered in disbelief and the secular state, brought techne into prominence, and demanded rights for all; whereas there is nothing to resent or regret about Dr. Johnson, Ledoux, or Mozart, whom we have yet to meet.

CROSS SECTION

The View from Weimar
Around 1790

"**THE GERMANIES,**" some 2,000 disparate units that survived the Thirty Years' War, had been reduced by the mid-18C to about 300. Of these, the duchy of Saxe-Weimar was not among the large and influential ones like Hanover, Bavaria, or Saxony. It was a small town with a pleasant countryside of hills and woods. The town still seemed to George Eliot very provincial when she visited it in the mid-19C. Yet during the last 25 years of the 18th it had not only acquired fame as the literary center of Germany, but it had initiated among its neighboring courts a remarkable reversal of their habits and cultural outlook.

For 100 years, as noted before in various connections, the influence of Louis XIV had been overpowering. German princes and princelings spent fortunes on building palaces to which they gave French names, imposed on their courts an absurdly detailed etiquette, entertained themselves with French plays or imitations, and ruled their subjects despotically—absolute monarchs in the literal sense, which Louis XIV neither was nor wanted to be (<284). There were of course degrees in this cultural subjection as in other features to be mentioned; but on the whole these Frenchified Germans were bored. They found relief in drunkenness as regular and compulsory as the protocol, in hunting and gambling, and in love affairs devoid of gallantry. The poverty all around them was extreme, yet the oppressed subjects were forbidden to emigrate. Among the worst victims of this semi-Oriental type of rule were the princes' wives—married for dowry, used to produce offspring, otherwise steadily neglected, virtually imprisoned in a routine without the escapes open to the males. When cruel taxation had exhausted the means of

a small state, it became the possession of a richer one through purchase or kinship. That is how the 2,000 simmered down to 300.

At Weimar, the dowager duchess Anna-Amelia was of a different temper: she looked for pleasure in freedom—from routine, from etiquette, and from protocol, and she delighted in reading, theater, music, and conversation. She invited the poet-philosopher-historian Herder to her court, and he helped her impart the same attitudes to her son Charles Augustus. And when the son needed a tutor who would also be a companion of his own age, she made the momentous choice of bringing to the court a young writer of 26, whose name as the author of a best-seller everybody knew:

Goethe

The young duke found his tutor as eager as himself to carry on studies by roaming the countryside, lunching at a tavern, and talking about things that young men talk about. This was not progressive schooling derived from the *Emile*; it was rather the partnership of like-minded youths hoping each to benefit from the other for success in his chosen task. This comparison may seem odd, since Goethe needed no help as a writer nor could expect any from Charles Augustus. It has been forgotten that in Goethe's extraordinary makeup there was room for political ambition, the desire to rule. Though this can be simply lust for power, in complex natures it is also an aesthetic love of order. So it was in Goethe and he had the requisite gifts, beginning with tact. When he was made privy councillor, the head of the council, Fritsch, was offended by the rash elevation of "Doctor Goethe" and resigned. Goethe stepped into his new role easily and took pains to turn Fritsch into a friend.

From then on, Goethe was (so to speak) the city manager of Weimar. He supervised or directed all activities from the state theater to the conservation of natural resources. Not that Charles Augustus was a do-nothing duke or that Anna-Amelia did not have strong views on policy, nor was the Duchess Louise, though maritally neglected, altogether silent. But Goethe was the executive and innovator who effected the compromises and saw them carried out. At times he was so beset by the mingled troubles and duties that he was tempted to give up. But he persevered and made Weimar both the intellectual center of the Germanies outside Prussia and, indirectly, the leader in civilizing the manners of the other courts.

It should be added to the earlier description that as the figure of Louis XIV receded, the princes turned to a new model, Maria Theresia's court in Vienna, with its even stiffer and stupider etiquette, the core of which remained in force in Austria until the destruction of the empire in 1918. Perhaps the very excesses of the Austrian model helped the new ways of Weimar to take root elsewhere in Germany. Adopting the milder manners

was also fostered by the influx of Rousseau's ideas about domesticity and the love of nature. Their novelty dispelled the eternal boredom. Only Württemburg resisted change until the French Revolution. And Prussia, long since an independent kingdom, needed no example: it was already in the mainstream of western culture. Frederick the Great, poet, philosophe, flutist, host to J. S. Bach, and patron of the arts and sciences, had made Berlin a city of light since his accession a generation before Weimar. Goethe had been "a Fritz partisan" since his own youth in Frankfort.°

In the cultural overturn lurked another element—national feeling. Earlier, princes and peoples thought of themselves as Bavarians, Hanoverians, Saxons, Hessians, and so on. They were Germans only when traveling abroad. At home, consciousness of linguistic unity at last began to develop after a few writers attacked the French literary hegemony and Voltaire in particular. The David who brought down Goliath was Lessing, a critic in Hamburg and also a playwright. His drama reviews pulled Voltaire's talented tragedies to pieces and preached the solid genius of Shakespeare's. Herder, on his side, pointed out the depth and truth to life of popular literature. Rousseau's rejection of the artificial was bearing fruit, and in the process Herder discovered the *Volk,* the people. In this shift of interest, a person was necessarily German, not Hessian or Thuringian or Darmstadter. The birth of the German people's SELF-CONSCIOUSNESS dates from "Weimar."

Perhaps because several of the strongest minds in the German enlightenment had pastors for fathers, but surely because the French Enlightenment seemed divorced from strong moral consciousness, the German resistance to the French cultural domination was grounded in Lutheran morality. The authors who have become the classics of the German nation along with Lessing and Goethe—Schiller, Herder, Novalis, Hegel, Fichte, Tieck, Schleiermacher, and the Schlegels—made a point of earnestness and courage. Kant's design to give equal room and authority to science and to the moral law shows that he felt a need that the philosophes ignored. In the *Sturm und Drang* period (396>) the youthful rebels chose Prometheus as the emblem of their defiance, and in Schiller's early plays, the attack on authority differs from Beaumarchais' in being not self-assured impudence (400>), but daring from righteousness outraged: the hero stands on the same plane as the oppressed.°

This type of rebelliousness prefigures the turnabout that the Germanies began to perform by the mid-century or a little after. From a people universally derided as dreamers and private philosophers, they ultimately became a nation of self-assertive leaders in war, government, education, science, and philosophy itself. Harnessed by Prussia at first, they helped to defeat Napoleon in 1815, learning in the process disciplines that became cultural traits—*practical* order and system and respect for rules that served to promote

national unity and strength. Two hundred years of humiliation as the play-ground of dynastic wars needed to be avenged. By the end of the 19C the rest of Europe began to think of the Germans as born in uniform and helmet and possessed of traits mostly unpleasant and probably racial.

In what may be called Germany's awakening, Weimar's contribution was literary as well as moral, but a question left hanging must be answered first: what was the popular book that qualified Goethe for his administrative post? It was *The Sorrows of Young Werther*. The story is about a young man who loves his friend's betrothed, later wife, and is loved in return—nothing very origi-nal. The account of their feelings recalls the substance of the *Princesse de Clèves* (<352) and the manner of Richardson. Werther, loyal to his friend, respects the marriage vow and commits suicide. The ANALYSIS was apparently so accurate that there ensued a wave of suicides. They and the book have been deplored as the culmination of sentimentality, then rampant also in other countries (410>).

The judgment is not wrong, but it overlooks one thing: part of Werther's complaint is his resentment against social discrimination. The love of etiquette at court had seeped down into the bourgeoisie and subdivided it into levels of rank and title bruising to the ego and revolting to the mind. So ingrained had this punctilio become in Germans high, medium, and low that even the Weimarians could not get rid of it altogether: the poet Schiller's wife was looked down on: her French was not up to standard. She had to go to Switzerland to improve it before she could be accepted as a lady-in-waiting to the duchess. But Werther's self-defeat and similar acts of submission quickly gave place to an energetic revolt of the young, inspired and expressed by two authors of violent dramas: Klinger, whose *Sturm und Drang* gave its name to the whole movement, and Schiller's *Brigands,* which set up the outlaw as the critic of society.

* * *

A year after Goethe arrived in Weimar in 1775, he and his coterie learned that the English colonies in North America had declared their independence. The document proclaiming it opened with the maxims of the Enlightenment. These were not Jefferson's or his associates' alone; they appeared in declara-tions of the several states. What followed was more old-fashioned: a list of con-crete particulars. For a year or more English soldiers and native guerrillas had had bloody encounters, and now all-out war needed an explicit statement of the cause. But despite the ringing preamble of the Declaration, is it a fact that the struggle was the outcome of enlightenment ideas? The utterance did suggest a vast modern nation asserting its right to govern itself on advanced principles unrealizable in the old world. This interpretation was congenial to progressive

Europeans. The truth was different. The American population of 2.2 million was still crude in manners and mode of life. It was not a nation, nor was the fundamental temper of the colonials that of the philosophes. The Americans fought and cheated the Indian tribes on their borders and the southerners lived off the toil of 200,000 African slaves. Despite the admiring regard of the primitivists and the prophecy of Bishop Berkeley half a century earlier, it did not seem as if Europe had much to learn from the people overseas or to fear from their economic competition.

> In happy climes, the seat of innocence,
> Where nature guides and virtue rules,
> Where men shall not impose for truth
> and sense
> The pedantry of courts and schools;
> There shall be sung another golden age,
> The rise of empire and of arts,
> The good and great inspiring epic rage,
> The wisest heads and noblest hearts
> Not such as Europe breeds in her decay. . . .
>
> —BISHOP BERKELEY, "VERSES ON THE PROSPECT OF PLANTING ARTS AND LEARNING IN AMERICA" (1726–52)

Viewed from the colonies themselves the economic concern was one of the motives to independence. Tom Paine, the sympathetic English publicist, said it in so many words. England had spent much on the big war that got rid of the French in America and had been trying to recoup its outlay by taxing and monopolizing colonial trade. Protests and acts of violence had taken place in the colonies for ten years or more before the indignant Declaration. That its preamble read like the doctrines of Locke and Montesquieu only showed that there was an elite that had visited Paris or read imported books. But the list of grievances showed that the armed resistance to the English imposts was not a revolution. The war acquired that name by confusion with later events in Europe.

If anything, the aim of the American War of Independence was reactionary: "Back to the good old days!" Taxpayers, assemblymen, traders, and householders wanted a return to the conditions before the latter-day English policies. The appeal was to the immemorial rights of Englishmen: self-government through representatives and taxation granted by local assemblies, not set arbitrarily by the king. No new Idea entailing a shift in forms of power—the mark of revolutions—was proclaimed. The 28 offenses that King George was accused of had long been familiar in England. The language of the Declaration is that of protest against abuses of power, not of proposals for recasting the government on new principles.

> But oh my friends, the arm of blood
> restrain,
> (No rage intemperate aids the public weal;)
> Nor basely blend, too daring but in vain,
> The Assassin's madness with the patriot's
> zeal.
>
> —JOHN TRUMBULL, "AN ELEGY ON THE TIMES" (1774)

The same is true of what preceded the Declaration—the mass of pamphlets, speeches, letters, resolutions,

reports of conferences, and articles in the press. The question is always what steps to take? Shall we go *as far* as independence? The battle of Concord and Lexington itself, a year before the Declaration, can hardly rank as an outburst of revolutionary ardor. Compare Washington's army with Cromwell's Ironsides and the difference is clear. There was heroism in both wars and Washington's perseverance with an unstable force is of epic caliber. But then the English waged the American war at times halfheartedly. The popular animus was often fierce against those who opposed independence, causing many exiles to Canada;° but again many escaped persecution by pleading illness—"Loyalist fever"—and suffered no harm later on. None of this has the air of revolution.

> **If anything were wanting to this necessary operation of the form of government, religion would have given it a complete effect. The people are Protestants, and of the kind which is the most adverse to all implicit submission of mind and opinion. All Protestantism is a sort of dissent. But the religion in our northern colonies is a refinement on the principle of resistance. It is the dissidence of dissent and the protestantism of the Protestant religion.**
>
> —BURKE, SPEECH ON CONCILIATION WITH AMERICA (MARCH 1775)

The strength of will that won the War of Independence was best described by Burke just before Lexington. He was trying to persuade the House of Commons to conciliate the stubborn Americans. They were not insurgents, he said; they were protesters—and protesting on one single point, the power of granting taxes, on which they thought all other "liberties" depended. The colonies that became independent states contrived only a feeble Confederation and wanted to remain the semi-aristocratic societies they had always been. Even during the war, national spirit was wanting. If one scans the facsimile of the original Declaration one notices that the heading reads: "of the thirteen united States." That small *u* promises no future *U*. Only toward the end of the Seven Years' War, 15 years before, had some demands been heard here and there for union and "democracy." And even these went only as far as extending the vote to those without property. In sum, the American spectacle that Europeans rejoiced at or deprecated at the end of the 18C was not the Democracy in America described by Tocqueville half a century later. Nor was it a model for the French revolutionists of 1789–93.

What remains true is that one intellectual ingredient links in retrospect the two events, the spirit of the *Encyclopédie* and some of its ABSTRACTIONS. The men known as the Founding Fathers of the United States were influenced by these and used them when theory was needed to support the concrete "liberties of Englishmen." It was the same spirit which moved in France the most effective helper of the colonists in their war:

Beaumarchais

Opera-goers who read their program notes recognize the name. It is that of the man who wrote *The Barber of Seville* and *The Marriage of Figaro* before the librettists of Rossini and Mozart gave the two plays another meaning for the musical stage. But the creator of these dazzling comedies was many other things than a playwright. His achievements during a tempestuous career make him an extraordinary man in an age full of extraordinary men. Indeed, it is the multiplicity of his deeds of genius that, combined with his dying during the French Revolution (424>), has eclipsed the renown he enjoyed in his lifetime. Not only France, but Spain, England, and Germany marveled at his adventures.

Without him the American war of independence might have taken another turn (>402). Without him the public opinion that clamored for reform just before the French revolution of 1789 might not have been so determined against all existing institutions short of the king (>402). More than Voltaire and Diderot, and differently from Rousseau, Beaumarchais incarnates the spirit of his age. He represents the bourgeoisie in charge of affairs, the man of letters as spectacular celebrity, the intellectual indispensable to government, the rebel in words giving the public a sense of its rights and its strength. All this, Beaumarchais exemplified in the teeth of opposition, personal and social. He chose the motto: "My life is one long fight." His influence was all the more potent that he was daring in action, not solely a skillful diplomat and publicist.

His rise from humble beginnings is the first of the features that make him a representative man. Son and grandson of clockmakers named Caron, his first occupation was in his father's shop. But the father was a well-read man, full of Encyclopedic ideas. The boy Pierre-Augustin had a scanty formal education, but he was ambitious and taught himself. He had a good singing voice and played the flute and the harp. He wrote well and spoke with eloquence and wit. As an artisan he invented a superior escapement for watches and an improved pedal for the harp. His marriage to an older woman at the age of 25 brought him a small fief that entitled him to become Caron *de* Beaumarchais, and since that footing in nobility seemed to him a little narrow, he bought a royal secretaryship that gave it breadth. He soon mingled with dukes and peers, chatted with Louis XV, and was the musical and literary companion of Mesdames de France, the king's four daughters. There was no longer a Louis XIV or Saint-Simon at court to rebuff and exclude upstarts risen from the vile bourgeoisie (<395).

Beaumarchais found other kinds of enemies. His device for watches was claimed by someone else and it took a committee of experts to award Caron

the priority. An early love affair led to an insult that he could not overlook and in the ensuing duel he wounded his opponent so severely that he died; this plunged Beaumarchais into remorse. His sympathy was always quick and deep, in this case especially, because dueling was a capital offense and his noble opponent refused to say who had caused his grievous wound.

We next find Beaumarchais in another affair of honor. He had two brilliant sisters—wits and poets too—one of whom became engaged to a penniless Spanish grandee named Clavijo. She accompanied him, chaperoned, to Spain, where he was to obtain a sinecure enabling him to marry. Once there he broke the engagement. Beaumarchais rushed to Spain and persuaded the young man to think again, but soon caught him deviously working to slip away once more. Beaumarchais threatened violence and obtained the acknowledgment needed to save his sister's good name. *She* must break an engagement recognized by the suitor or she would never find a husband in any country. On this contemporary imbroglio, soon widely known, Goethe wrote the melodrama *Clavigo*.

Like his later mouthpiece Figaro, Beaumarchais never doubted his own powers. It was not vanity but spontaneous energy, which looked so irresistibly, impudently cheerful that it made him admiring followers and devout enemies. Again and again in deep trouble or danger, he seldom felt cast down; in fact his genius rose to emergencies with redoubled inventiveness and strength.

While occupying the quasi-judicial post of lieutenant for forests and hunts, and under attack as a result of being fair in his decisions, he embarked on a literary career at age 35 with the five-act play *Eugénie*. (Bernard Shaw waited till he was nearly 40 but warned that this was the age limit for beginners.) *Eugénie* belongs to the sentimental, bourgeois genre initiated by Diderot, Sedaine, and others (415>). Beaumarchais appears to have been the first to use the word *drama* to designate a play that is neither a tragedy nor a comedy in the traditional sense. The first three acts of *Eugénie* were very well liked; the last two were hissed, apparently because they sounded like the start of another play. Unabashed, the author cut and pruned and re-presented the piece; it found fair success in France and, adapted by Garrick, a warm reception in England. One passing remark in Beaumarchais' prefatory defense is worth noting: while denouncing the long-established rules of playwriting, he calls them "barbaric, classicist." This is the first use of *classicist* in a derogatory sense.

Beaumarchais' next role was political and of great consequence to two continents, as hinted above. The first, affecting France but astonishing also to the Germans and the English, arose out of the complicated lawsuit known as the Goëzman Affair. It was an unplanned exposure of the state of justice in France, and no doubt in other places. While Beaumarchais was engaged in

suing a count to obtain money due under the will of a third party, he was also engaged in a love affair that got him physically assaulted by a duke. Beaumarchais fought back. For breaking the peace, both combatants were sent to jail by *lettres de cachet*. (Such "letters with seal," by the way, were the only ones issued by the king that did *not* carry his seal.)

Beaumarchais jailed could not visit the judges in his lawsuit, as he must do by custom if he were to have a chance of winning it. In fact, a court councillor had filed a report asserting that the document Beaumarchais relied on was forged; the court had no choice but to declare it null and void and to dismiss the suit with costs, damages, and interest. That councillor was named Goëzman. The court order incited several unknown persons to file claims against Beaumarchais for money supposedly owed; they proved to be false, got up out of pure mischief. But rumors about them dealt the last blow: the talk of the town turned against him: he was a scoundrel finally unmasked.

Before his imprisonment Beaumarchais had taken the duke's attack lightly. On the evening when it happened, which was the day before his arrest, he went, bandaged up, to a friend's house to read the first draft of *The Barber of Seville*. But now, if things stood as they seemed in this his 41st year, he was a ruined man, financially and in repute. Here he was, the only support of his parents and his sisters and nieces—and in prison. For once his spirits failed him; he felt (as he said) shame and self-pity. He appealed to the Lieutenant of Police, who granted him daytime leave under guard so that he might plead with the judges for a hearing at which to argue against Goëzman's report, even though being under guard would be prejudicial. A second appeal set him free after two and a half months of pointless prison.

Beaumarchais was convinced that his opponent La Blache had won in the courts by bribing Goëzman more generously than he himself had. This sounds like the pot calling the kettle black, but the custom was such that even to get a hearing from certain judges—let alone a decision—a gift, several gifts, were required. Judge Goëzman's wife rejoiced in the practice, telling all comers that the family couldn't live decently without this steady income. Advised by his friends, Beaumarchais had given her 100 louis (about 2,400 francs) and a diamond-studded watch of equal value. If he lost the suit, she promised to return the money. She then asked—and was given—15 additional louis for the judge's clerk. Beaumarchais, who had already given him 10, suspected that she meant to pocket the 15. In the end he demanded them back, accusing her of cheating within the framework of the larger cheat. She denied having received the money and set a rumor afloat that he had tried through her to bribe the upright husband and judge. Since Beaumarchais had lost the case, she evidently did mean to keep the 15 after returning the rest, counting on Beaumarchais' making no fuss over the smaller sum.

For his part, Goëzman, feeling caught, first tried the universal remedy—

a *lettre de cachet* to shut up Beaumarchais. It was not forthcoming and fresh rumors about the facts began to circulate. Attack being often the best defense, Goëzman got one of his minions to sign an affidavit stating that Beaumarchais had approached him, money in hand, for a favorable ruling. With this false document ready, Goëzman summoned Beaumarchais. In such a broil, no lawyer would take his case; he must defend himself, and not only in court but before public opinion.

He started telling and publishing his side of the affair. The *Memoirs* about the Goëzmans have become a classic of literary and forensic art. They succeeded because Beaumarchais wove into the factual and legal narrative a large measure of social and political criticism and made the whole entertaining. Dialogue in which he appears by turns cheerful, indignant, witty, and sensible showed up persons and incidents as in a comedy. The public eagerly awaited each installment. Goethe in Frankfort says they were read aloud to large gatherings.

In France, the political effect of the pamphlets and the trial together was heightened by a recent event. The court of justice—the Parlement—had been reorganized by its new president in a dictatorial way—authority curtailed, judges dismissed, others such as Goëzman put in. By adroit allusions to these unpopular acts, Beaumarchais gained numberless supporters. He became the hero of the hour to all but a minority. When a re-trial established the truth of every point in his defense, along with the misdeeds of the Goëzmans, his disgrace was wiped out.

The *Memoirs'* exposure of the Parlement as a politico-judicial institution was not forgotten a dozen years later, when the whole country debated reform on the eve of 1789. But what preoccupied Beaumarchais during that same stretch of time was an equally fateful enterprise. As early as September 1775, while revising *The Barber of Seville,* which had fallen flat, Beaumarchais wrote a long letter to the king (now Louis XVI), telling him that the royal council was ill-informed about the situation of the North American colonists. They were so determined in the pursuit of their cause, said Beaumarchais, that if well armed they would certainly win their freedom. And he added: "Such a nation will be invincible."

Beaumarchais had a double purpose. He relished the idea of a people set free from tyranny. It had been the theme of the opera libretto he had written when Gluck had shown in Paris the new form he was giving to the genre (415>). Gluck had declined composing Beaumarchais' text but had recommended his own pupil, Salieri, who produced a feeble score; it was not worthy of the dramatic and spectacular scenes, in which a high-minded soldier overthrows a despotic king and saves his own wife from the king's evil designs. Freedom and justice in his heart, and aware of how divided English politicians were on the American issue, Beaumarchais wanted France to sup-

ply the means of the colonies' liberation. Its success would at the same time lessen English power in the world. The royal council rejected his proposal for fear of war with England. But Beaumarchais was not to be stopped by one rebuff. He insisted that his knowledge of English opinion was accurate. Louis XV had sent him to London as a secret agent to buy off a blackmailer who threatened Countess du Barry, the king's mistress, with a defamatory book. Beaumarchais not only got 3,000 copies of the book burned on the spot, but turned the author into an informant in the French interest. Now his reports were invaluable.

With a renewed plea Beaumarchais offered a new scheme. Let the government give him a million and he would do the rest—in a word, privatize the pro-American campaign. This time the minister agreed. Beaumarchais became the imaginary firm of Rodrigue, Hortalez, and Company. Its activities were officially forbidden, but it was to supply the Continental Congress with 200 cannon, with mortars, with 25,000 firearms and ammunition in scale, including 200,000 pounds of powder, besides clothing and camping equipment for 25,000 men. All this was to be so secretly collected that the English ambassador and his staff in Paris would not hear of it.

The assignment was grueling by itself; it was made nearly impossible by the usual bureaucratic resistance to action, *plus* the ill-will of one American agent and the suspiciousness of another. Beaumarchais won over the latter, assuring him: "I will serve your country as my own!" That left only the taming of heads of royal factories and arsenals, of admirals in charge of navy yards and of captains for convoys. Everybody questioned and argued and delayed; all had ideas of their own. In the end, Beaumarchais mastered his workforce. He issued orders in the king's name that the king knew nothing about, until admirals and others began to refer without irony to "your fleet, your navy."

The score of ships that played their part at a critical moment in the war of independence were indeed Beaumarchais' in the literal sense: the agent of Congress had promised to send back produce—chiefly tobacco—in exchange for the war supplies. Nothing came from America. Beaumarchais had to borrow the money for his shipments, which on arrival brought him no thanks. At long last, three and a half years after his first move, Beaumarchais received from John Jay, president of the Congress, a letter of thanks and the promise that measures would soon be passed to repay the debt that was owed. Meanwhile, the recipient should know

. . . our affairs are in a more distressed, ruinous, and deplorable condition than they have been since the commencement of the war. From what I have seen, heard, and in part know, I should say that idleness, dissipation, and extravagance have laid fast hold. Speculation and an insatiable thirst for riches; party disputes and personal quarrels are the great business of the day, while ruined finances, depreciated money, and want of credit are but secondary considerations.

—GEORGE WASHINGTON (DECEMBER 1778)

that he had "gained the Esteem of this Infant republic and will receive the merited applause of a new world."

The whole saga was worthy of a real-life Figaro. Its contribution to the success of America's war of liberation was surely as great as that of Washington's aide-de-camp, Marie-Joseph de Lafayette. That brash young man's courage and love of freedom entitle him to his place in all the books, along with the skillful sailors De Grasse and Rochambeau, but the continued omission of Beaumarchais is inexcusable.

Worse yet, when 40 years later Beaumarchais' daughter, who had fallen into poverty, petitioned Congress for the 2.25 million francs still owed her father (Alexander Hamilton's estimate in 1793) Congress replied: "Take one third or nothing."

*

* *

Although in European eyes the North American culture remained backward and contemptible, by the end of the 18C the colonists had made real but uneven progress. At a distance, a simple fact went unperceived: the division between the Americans who were pushing forward and settling the open spaces to the west, and those who on the east coast constituted after 150 years a cultivated establishment.

From the start, religion had been an intellectual force; in the 18C, it exerted a renewed influence on the broadest class. America like England witnessed a resurgence of religious passion, which put forward old ideas: consciousness of sin and recognition of God's mercy; self-reform imperative to ensure grace and salvation. The movement was known in England as Methodism, in America as the Great Awakening. The appeal of the eloquent preachers—John and Charles Wesley in England, George Whitefield in America—produced the mass phenomenon called "revival"; Whitefield was said able to address audibly crowds of 25,000. They sang, they groaned, they chanted and rolled on the ground. The wealthy, the rulers, and the learned were unlikely to enjoy the physics of this renewed faith, of which the political side tended toward democracy.

The surge of feeling about the "infinite concern" benefited another movement, quite different, that of "Mother" Ann Lee and her followers, the Shakers. Starting from Harvard, Massachusetts, it spread first to Connecticut and New York and then to the Midwest. Ann Lee was a factory worker in Manchester, England, whose disgust at industrial life made her a pietist, an immigrant, and a feminist. Her sect believed in the equality of the sexes and in the Return of Christ, who was both male and female, like the Deity. Meantime, the Shakers (so-called to mark their closeness to the Quakers) lived extremely sober lives and developed, untaught, a style of spare domestic

architecture that anticipates the principle of form follows function and is still justly admired.

Jonathan Edwards, who was a minister in New England and a philosopher of the first rank—his complete works are being republished at this moment—rejoiced to see piety regain its place. The two waves of the movement set an American tradition of religious enthusiasm unbroken down to the present. With the microphone and television, the crowds can be even bigger than Whitefield's and the choice now is between the bodily warmth of the camp meeting and the tête-à-tête of the listener in the living room.

For the upper-class Americans of the 18C, the genuine novelty lay not in religion, which was a return, not a departure, but in science and the fine arts. The country suddenly had a group of accomplished painters—Gilbert Stuart, Copley, Peale, Ralph Earl, Benjamin West. The last-named moved to England permanently but continued to exert his influence as mentor of visiting American artists. It is to these men that we owe the likenesses of the contemporary notables, men and women, the historical scenes and landscapes that together give to our imagination the "period look" of the times. It is largely missing for the earlier century, stylized as it is by the primitives.

The other cultural step forward in science, generated before the middle of the century, was the American Philosophical Society, founded in Philadelphia by Benjamin Franklin. "Philosophy" included pure science, medicine, and the mechanical arts. His own inventions and discoveries have been noted earlier (<375). His city could also boast of the astronomer and physicist David Rittenhouse, who contributed to mathematics and made clocks and other instruments for scientific use. While the Declaration of Independence was being written, he petitioned the Pennsylvania Assembly for funds to build an observatory, so that he might serve as Public Astronomical Observer. The proposal was well received, but the war killed it.

What the war favored was the work of Dr. Benjamin Rush, a signer of the Declaration, who taught and practiced also in Philadelphia. Formal training in medicine had begun in the 1760s at the College there, as well as at King's College (shortly to become Columbia) in New York. Ten years later the first textbook in surgery was published. The colonies had some 3,500 physicians, but only one in 10 had a medical degree, earned, like that of Rush himself, in Edinburgh, then the center of medical advance under the leadership of the great William Cullen. At home, Rush fostered medical education, insisted on the importance of chemistry in understanding disease, and published the first textbook on the subject. He worked heroically during the Philadelphia epidemic of yellow fever, although his treatment by bleeding proved disastrous. He redeemed himself by a number of useful observations in the diagnosis of disease and the correlation of symptoms. As head of the hospital for the insane, he applied his conviction that body and mind must be treated together.

In original literary works, the colonies in the 18C were plainly deficient. Of the two earlier poets of merit, Anne Bradstreet and Edward Taylor, the one was neglected, the other is still not in print. The coterie of the 1770s at Yale—Joel Barlow, David Humphreys, Timothy Dwight, and John Trumbull—lacked talents adequate to the grandiose subjects they chose, besides having a misguided idea of poetry. Trumbull's stanza (<397) shows his notion of elevated language. Barlow's *Vision of Columbus* is a versified essay. His theory of the natural growth of society and his predictions about postwar America would have shown their wisdom and originality better in prose.

Playwriting was still weaker in substance and output, though one of the two native works, Royall Tyler's *The Contrast,* an intricately plotted sentimental comedy, "plays" well and is sometimes revived as a curiosity.° Until the 1760s no native professional theater existed—no actors, singers, or dancers, and no playhouses. But the demand that did exist divided society. The perennial objection to the theater—harm to morals—was supported by local laws, and the Confederation Congress passed a resolution that classed under "extravagance and dissipation" gambling, horse-racing, cockfighting, and "all shows and plays."

The dissipated were nonetheless served by an English troupe with David Douglass as actor-manager. He toured the colonies twice with his repertory of English plays by Farquhar, Mrs. Centlivre, Colley Cibber, and George Lillo, interspersed with ballad operas such as Arne's *Love in a Village* and Gay's *Beggar's Opera.* Some of Shakespeare, heavily improved and sometimes offered in thin slices, also figured on the programs. The people of Charleston loved plays and perhaps Boston did too, or why should a law have been passed there in 1750 to prohibit them? It must be added that audiences needed stamina to face an evening in the theater: it consisted of one five-act tragedy or a full-length comedy or ballad-opera, followed by an afterpiece (farce or masque), and further spiced with interludes of vocal and instrumental music that often called forth encores. This ordeal of entertainment, sustained by solid eating and drinking on the spot, began at six o'clock, the patrons' seats being held for them by their servants. In the south whole rows of Black slaves were there from an early hour.

Apart from the struggling professional theater, amateurs at home or youths at school satisfied their fondness for "the play" and their even greater love of music. The Puritans, as we saw (<188), were not inimical to it, and a century after their landing the art thrived in all ways—teaching and composing, church uses, orchestral and domestic performance. Boston itself had more than one music school. The Moravian Brethren in Pennsylvania were steeped in music, they played Bach during his lifetime and began the annual festival in his honor in Bethlehem that still draws crowds.

The war for independence added to the musical offering: frequent per-

formances by military bands, native, French, Irish, English, and German, the Hessian mercenaries showing the highest instrumental competence. Washington urged all his officers to provide music for their troops. The civilian repertory before and after the war was kept up-to-date by the presence of British soldiers and their com-

> I am almost sick of the world and were it not for the Hopes of going to singing-meeting tonight and indulging myself a little in some of the carnal Delights of the Flesh, such as Kissing, Squeezing, etc., etc., I should leave it now.
>
> —WILLIAM BENTLEY, YALE UNDERGRADUATE (1771)

manders, who favored Handel, Haydn, C. P. E. Bach, Purcell, and Arne. The English composers of hymns were well represented, and the publication of manuals and methods, the manufacture of instruments, and the production of original works warrant calling the colonists, before and after independence, a musical people.°

American political and social thought found expression to a comparable extent and with the same display of ability. One thinks at once of *The Federalist*, the book-length collection of papers written by Hamilton and Madison to secure the ratification of the proposed Constitution. It sets forth a complete theory and practice of representative government. Before *The Federalist* a vast amount of political thought filled the colonial press, especially when the conflict with the mother country began to threaten, which was also when the number of periodicals rapidly increased. To these must be added the speeches and resolutions of the assemblies, among them the well-known documents by Thomas Jefferson—his part in drafting the Declaration, his plan for education in Virginia, his charter for the university he founded, to say nothing of his essays on other topics, architectural designs, and domestic inventions.

Unfortunately, the equally decisive thought and writings of Franklin have not found their rightful place in the popular memory. When the Founding Fathers are listed by way of reminder, his name is often missing, just as his scientific discoveries are whittled down to the experiment with lightning. What is remembered is the proverbial wisdom of *Poor Richard's Almanack* and the advice about friends and mistresses in various squibs and in the *Autobiography*. The impression left is of mere shrewdness, in fact of low cunning, recommended not so much for promoting worthy ends as for "getting on."

In France his remembered figure is more true to life (<375). It is that of a philosopher-scientist and a hero in the cause of liberty. A rereading of his many terse, lucid pieces on the grave issues facing the colonies before and during the war would show his statesmanship. He was a partisan neither for his state nor his region but for the colonies as a whole. In political and social argument none of the pettiness suggested by his worldly recipes appears. He perceived the importance of demography; he urged regularizing land grants; he understood that to maintain good relations with the Indians, the attempt

Our North American colonies are to be considered as the *frontier of the British Empire* on that side. The frontier of any dominion being attacked, it becomes not merely "the cause" of the people immediately attacked but properly "the cause" of the whole body. It is therefore invidious to represent "the blood and treasure" spent in this war as spent in "the cause of the colonies" only; and that they are "absurd and ungrateful" if they think we have done nothing unless we "make conquests for them" and reduce Canada to gratify their "vain ambition." If ever there was a national war, this is truly such a one.

—Benjamin Franklin, "The Interest of Great Britain in Her Colonies," quoting and refuting an English opponent (1760)

to educate their youths in British ways was wrong, because it made them suspect to their own people. Franklin wanted union well before the war. For nearly two decades he had used his diplomatic skill in London, explaining America in hopes of changing the policy of exploitation. When he failed, he wrote two pieces of Swiftian irony foretelling Britain's loss of empire. Lastly, he kept France friendly to the new nation, being by virtue of his modest public demeanor, his scientific reputation, and his fur cap the living presence of that New Man, the American.°

As for Hamilton, he too would benefit from a fresh scrutiny, not at the expense of Jefferson, but as a thinker and doer whose part in making the new nation was not limited to writing most of the *Federalist* essays. It is forgotten that Hamilton was a "Continentalist" before he was a "Federalist"; that is, he wrote under the former pseudonym some of the earliest arguments for a strong union before the Constitution was in demand. And when union was established, he saw that promoting manufactures was the only means by which a nation that exports raw materials and imports finished goods can ensure a prosperous stability by a fair balance of trade. That manufacturing creates a new business class and spoils the Jeffersonian ideal of a people thriving as small self-sufficient farmers is true; and for that reason populist sentiment has considered

This is [a project] to raise two, three, or four battalions of Negroes by contributions from the owners in proportion to the number they possess. I have not the least doubt that the Negroes will make excellent soldiers. An essential part of the plan is to give them their freedom with their muskets.

—Alexander Hamilton (March 1779)

Hamilton an enemy of simple happiness and made Jefferson the hero of democracy. In truth, the conflict does not arise simply from rival opinions; it is the result of the evolution of techne at the end of a century of invention. The disparity in standard of living between industrialized nations and those that are not is clear enough today, and its remedy is the same.

*
* *

Germany's EMANCIPATION was not from secondhand French culture alone. The change came about as the sequel of battle and devastation every few years for a total of 43 out of 96. The self-imposed tyranny that was lifting in the 1770s, and with it the retreat of French ideas, made room for native talents. Minds in search of models turned to England and its traditions. We have seen Lessing citing Shakespeare as such a model. The English novelists were read and admired. The curious prose of Sterne gave Jean-Paul Richter a pattern for his own. Visitors to England brought back artistic and political ideas. Georg Lichtenberg, well informed, went to London in search of Hogarth (<392). Haydn found there audiences for which he composed the last 12—the finest—of his symphonies.

It was a one-way traffic: these visits were not returned till the next century, when England discovered cultural Germany. And from Weimar at this earlier time it was probably not clear that English literature was abandoning the heights that the Augustans had occupied and was finding its way through yearnings and hesitations to another peak called Romanticism. The late 18C poets—Joseph and Thomas Warton, Collins, Gray—all took up subjects that showed a desire to range outside the well-trodden field of clear ideas and the declarative tone. Dryden and Pope, Swift and Johnson and their followers had left nothing to do in their perfected style. Among the later generation, Goldsmith and Cowper, who used the old methods, sometimes gave intimations of something new—of melancholy, of mystery, of a new nature itself. There was praise of enthusiasm (formerly deemed a vice of the mind), respect for superstition, and an effort to give up generality in favor of concrete particulars.

Equally indicative were Charles Wesley's religious lyrics, the "medieval" songs that young Chatterton forged (and expiated by his suicide, the age being still too rationalist to forgive being misled), and the poems in Scottish dialect on rural themes by Jean Adams, Lady Anne Lindsay, and Lady Nairn. This poetic medievalism and PRIMITIVISM meant the recognition that un-Enlightenment had merits. A startling novelty put artistic partisanship to the test. This was *Ossian,* a work published by James Macpherson that soon swept Europe in translations. He presented the poem as his rendering into English of an ancient Gaelic epic of which only fragments remained. It caused rapturous admiration and violent controversy. Dr. Johnson denounced it as a fraud—and was right. But the evocations in archaic tones of antique manners in the midst of wild nature filled a need not merely emotional but intellectual: new names, new scenery, new

It is night. I am alone, forlorn on the hill of storms. The wind is heard in the mountain. The torrent pours down the rock. No hut receives me from the rain, forlorn on the hill of winds. Rise O moon from behind the clouds. Stars of the night, arise!

—MACPHERSON, COLMA'S LAMENT, FROM *OSSIAN* (1762)

modes of life were in demand: boredom had done its work of preparing for renovation. *Ossian*, now unreadable, served its therapeutic purpose down to the time of Napoleon, who admired it and encouraged his court composer Lesueur to make it into an opera (461>).

In prose fiction, three distinct genres shared the public's interest. Richardson's and Fielding's followers numbered a good many women, some of whom provided far-flung adventure, others society manners. Of these last, Fanny Burney, daughter of the historian of music, won over London with *Evelina*: 300 copies out of 500 printed established her leadership over such prolific rivals as Charlotte Smith, Mary Robinson, Susannah Gunning, Amelia Opie, and Elizabeth Inchbald. More than a few of their works contain hints of women's resentment of male dominance. The one male novelist of stature, Smollett, bears comparison with Fielding and Defoe for his surveys of the rough texture of life in the 18C.

A second genre owed its start to Horace Walpole, dilettante, connoisseur of painting and architecture, who for his amusement built himself—plump in the middle of the Century of Light—a "Gothic" house filled with "Gothic" curios. This occupation caused him to dream, and one dream supplied the germ of the first Gothic novel, *The Castle of Otranto*. His aim was to frighten by weird events and leave them *without rational explanation*. In due course this folly spawned multitudinous offspring. [The book to read is the *Selected Letters of Horace Walpole* in the Everyman Library Edition.] At the turn of the century Mrs. Radcliffe and Clara Reeve cultivated the genre, which has remained fruitful, largely in women's hands. One work by their younger contemporary Matthew Gregory Lewis added a strand of sexual interest to the fabric: *Ambrosio,* often known as *The Monk* (and the author as Monk Lewis) contains a mysterious bleeding nun, whose role in the story has been described as just short of pornography. But by the operation of relativism it is now purged of all titillating effect, so many have been the subsequent audacities.

The third type of novel goes by the name of sentimental. This quality (or fault), as noted earlier, was endemic in the age of Reason. Voltaire, Diderot, Rousseau, and their congeners displayed it in words and tears, overwhelmed as they were by the idea of goodness, generosity, and innocence. Richardson and Fielding are not free from the affliction; Sterne made it a badge of honor; their imitators increased the dose, and their readers, handkerchief in hand, followed suit. At the end of the century, a novel by Henry Mackenzie, *The Man of Feeling*, portrays with approval a character not occasionally but perpetually sentimental. The fictional type has never died out, and its existence is justified: real life keeps producing many models. [The book to read is *Before Jane Austen* by Harrison Ross Steeves.]

But what is sentimentality? If one asks somebody who ought to know, one is told: an excess of emotion; or again, misplaced emotion. Both answers

miss the point. Who can judge when emotion is too much? People vary not only in the power to feel and to express feeling, but also in their imagination, so that a stolid nature will deem it excessive as soon as love or grief is expressed vividly and strongly. Shakespeare is full of "exaggerated" emotion, but never sentimental. The same remark applies to the other answer. When is feeling misplaced? at the sufferings of the tragic hero? at the death of a pet? at the destruction of a masterpiece? One may argue that any emotion out of the common should be restrained in public, but that is another question, one of social manners that has nothing to do with a feeling's fitness to its occasion. The diagnostic test must be found somewhere else.

Sentimentality is feeling that shuts out action, real or potential. It is self-centered and a species of make-believe. William James gives the example of the woman who sheds tears at the heroine's plight on the stage while her coachman is freezing outside the theater. So far is the sentimentalist from being one whose emotions exceed the legal limit that he may be charged with deficient energy in what he feels; it does not propel him. That is why he finds pleasure in grief and when he is in love never proposes. Sterne accurately entitled his story *A Sentimental Journey*: the tears he shed over the death of the donkey and his preoccupation with the girl at the inn caused him no upset nerves, no faster pulse or quickened breath. He reveled in irresponsible grief and love. This condition explains why the sentimentalist and the cynic are two sides of one nature. In such matters the arts are transparent and the connoisseur can easily tell imitation feeling from the real thing.

<div align="center">*</div>
<div align="center">* *</div>

In the England of the 1780s a literary event of more than local interest was the death of Dr. Johnson, followed not long after by Boswell's account of their friendship. Johnson had been for 30 years the Great Cham° of English letters, a dictator, and also an arbiter of opinion and conduct. He was a poet and biographer of poets, editor of Shakespeare, moral essayist, author of *Rasselas,* a tale comparable in mood to *Candide* and only a little less entertaining, and, pre-eminently, creator of the first and largest dictionary of the English language. When Boswell's work came out, the world could see that Johnson also deserved his fame as a conversationalist.

It is on purpose that the words *Boswell's "Life of Johnson"* have not been used here, although that is the title of the book. It is not truly a biography, not a portrayal but a self-portrait. It begins with a spotty summary of the subject's first 53 years, including many of his letters, after which three-quarters of the total 1,200 pages, covering the final 21 years, consist of reported conversations, with more letters interspersed. [The book to read is *Samuel Johnson* by Joseph Wood Krutch.] Boswell deserves all the praise he has received; his work is a master-

My dear friend, clear your *mind* of cant. You may say to a man, "Sir, I am your most humble servant." You are *not* his most humble servant. You tell a man, "I am sorry you had such bad weather and were so much wet." You don't care sixpence whether he is wet or dry. You *talk* in this manner; it is a mode of talking in Society: but don't *think* foolishly.

—JOHNSON TO BOSWELL (MAY 15, 1783)

piece in a rare genre beyond the power of most biographers. The bulk of the book—the talk—is a delight, because it presents a strong character full of surprises. He is learned but practical, unmistakably of his time but naively religious, conservative but unconventional. His genius lies in common sense, not common*places* like those of Franklin's Poor Richard, but unusual judgments made by clear-eyed observation and couched in lapidary words.

Johnson is said to have made English prose pompous by his example, too easily imitated for too long. Balanced clauses in sentences full of long abstract words impress at first by their majesty but end by lulling the reader to sleep; rhythm and syntax should not be so regular. When early in the next century Macaulay wrote his first essay, he is said to have shocked and pleased like a liberator. This account exaggerates. Johnson, it is true, used "Johnsonese" in his *Rambler* and *Idler* essays. These were short pieces on moral subjects, where both balance for contrast and abstract terms for marking nuances between ideas could be justified. But Johnson did not invent the style, he perfected it in his own way, Gibbon in another. And when Johnson wrote his three volumes of *Lives of the Poets,* he did not use it but wrote rapid narrative in short enough words. One exchange in Boswell has perpetuated the myth about his prose: Johnson utters a terse epigram and immediately translates it into Ramblerese.° It was play of mind and may well have been a joke on himself.

For a fair judgment of the Augustan style as Johnson practiced it, consider the famous letter in which he rebukes Lord Chesterfield for promising and then delaying his patronage of the *Dictionary.°* The prose perfectly fits the respective social positions of writer and recipient. It is dignified, not pompous, and it lucidly delineates the facts and the subtleties of feeling. So much about style. The contents of that letter need a gloss that was not supplied for a couple of centuries: Johnson wrote under a misapprehension. Chesterfield did not commit the offense as charged, and to his great credit he did not put Johnson in the wrong by rebutting the letter. Rather, he showed it to his friends as an example of masterly writing.°

One among the prejudices that Johnson liked to flaunt but did not act upon points to an achievement of cultural importance: he denounced the upstarts—writers and others—who came from Scotland to conquer London. By the 18C the Scottish ministers' insistence on giving all children some schooling for the sake of the faith had at last produced an intellectual class. Edinburgh, Glasgow, St. Andrews, and Aberdeen had flourishing universities and were centers of mental ferment. This supply of intellect overflowed into

London and irritated the Great Cham. Yet when he made the voyage north he was courteous and appreciative. [The book to read is his own *Journey to the Western Isles of Scotland.*]

In higher education, it must be said, Scotland did not have much competition from the south. The two English universities were in the doldrums. Holders of chairs, like the poet Gray, lectured once in a lifetime and any research done was well hidden. Across the Channel, the Sorbonne specialized in condemning books, and it was the town academies that were astir with ideas. Alone on the Continent, the German universities performed, despite enclaves of somnolence, the task of transmitting knowledge; they prepared the many Protestant ministers who fathered the generation of poets and thinkers later known to posterity.

To this period belong two educational novelties that did not reach far in their day but deserve a note in the light of the present confusions about schools. The first is trivial but indicative of the urge to blur distinctions. The Edinburgh Scot John Witherspoon, president of the College of New Jersey (later Princeton University), first used the word *campus* (Latin = *field*) to designate the site of the institution. The word has traveled, and with its meaning inflated. Lower schools in America now use it, France also, and even business firms, especially when there is no field but only a city square. In addition, campus means all colleges and universities—campus rioting, campus crime. The other 18C contribution was the proposal called in our time the look-and-say method of teaching reading. Two French thinkers can lay claim to it.° Both based their inspiration on the fallacy that resurfaced disastrously in our time: adults read whole words in one glance; therefore teach infants to do the same. The 20C application has been a long failure wherever tried and acknowledged only very recently.

To return to Edinburgh, it got the name "Athens of the North" by virtue of possessing, as the century ended, the leading medical school in Europe; a trio of philosophers—Hume, Reid, and Hartley; a pair of distinguished historians—Hume again and Robertson; and the unique Adam Smith, economist and moral philosopher (456>). It is pleasant (or sad, depending on one's bias) to think that the outcome of schooling for religion was a materialist system of medicine and a group of secular skeptics, Hume at their head. He demonstrated in a beautiful dialogue that belief in miracles and the religion based on them is irrational. But he was evenhanded and showed that science had no solid basis in reason either, the fact being that cause and effect are nothing more than the habitual succession of events in time—there is no detectable link between them. To be doubly boxed in by these conclusions agitated Immanuel Kant in Germany and "awakened him" (he said) "from his dogmatic slumber." By the 1780s Kant was well on the way toward reconstruction in philosophy and religion (508>).

*
* *

Although the anti-French crusade began in Germany when the century was about two-thirds over, it did not put an end to the widespread curiosity about cultural events in Paris. Diderot's reviews of the painters' new works, the *Salons* described earlier (<391), were but one type of article that came from France in the *Correspondance Littéraire,* the newsletter that the Baron Grimm, a German settled in Paris and a friend of Diderot's, started for the benefit of the sophisticated courts in his home country. The two men took turns writing lively reports, mostly about things of the mind, but not excluding news of persons—deaths or scandals. The readers abroad passed the sheets from hand to hand as was still common practice everywhere for poems, essays, or whole books in manuscript. This habit explains why the subscription list of the *Correspondance* never numbered more than thirty and yet helped to give Central Europe its cultural tone.

One of the events that Goethe and his Weimar friends doubtless read about was the success of a new comedy by Beaumarchais called *The Marriage of Figaro.*° The author had made his name abroad not by scandal alone (<403–4) but also with a first Figaro play, *The Barber of Seville,* full of satirical shots. In this second, he seemed to be making an all-out attack on the aristocracy. Figaro the valet appeared, in one long speech at least, to embody and denounce the principle of "careers closed to talent." The Count, by "taking the trouble to be born," enjoyed the good things of life that Figaro with all his ability could not attain. At the first performance of the play, it was said, someone in the pit threw an apple core at a duchess in the boxes, and some have seen in the act the first hint of the French Revolution.

But it is doubtful whether Beaumarchais wrote a revolutionary play. Showing up the do-nothing aristocrat was an old device of the theater; Molière had used it. It followed logically from Louis XIV's taming of the warrior-nobleman and there was little risk in doing so. Beaumarchais' theme in *Figaro* is love and intrigue as before—and as in Schiller's *Kabale und Liebe* (*Love and Intrigue*) of the same date. Both plays do depict a social order in which rank and ability no longer correspond, and Schiller's is the more vehement criticism, not being a comedy but a bourgeois drama with republican sentiments. In it the prince sells his subjects as mercenaries to fight in America (as the Hessians had done) so that he may afford jewelry for his mistress. But as in *Figaro,* the target is the deceit and manipulation of people for vicious ends. It recurs in yet another work of the time, Laclos' novel *Les Liaisons dangereuses* (<165). Beaumarchais, then battling to help the Americans, derided in his play the crassness of those who hindered his purpose. But he was their conqueror, not their victim, and we may think that he felt joy more than once when like a Figaro he outwitted the counts who tried to thwart him.

Across the Channel about the same time, the wittiest man ever to sit in Parliament while also managing a theater was striking a blow against that monotonous genre, sentimental comedy. It had been a French import, exploited mainly by a man named Cumberland, aided by several women writers. Their subduer was Richard Brinsley Sheridan. He was the son of one of these women, who doubled as a novelist and was the most gifted of the group. Like Beaumarchais and Schiller, Sheridan acquired from his early struggles a combative attitude toward the world, and in *The Rivals, The School for Scandal,* and *The Critic,* he brought back the vigor of the Restoration dramatists, but without their grossness. Morals had refined and the works of that galaxy of playwrights were in eclipse. Indeed Fanny Burney's heroine Evelina is made to blush at a performance of Congreve's *Love for Love.* The English ethos was edging toward Victorian respectability half a century before Victoria was born.

In the decades here concerned, while the comic playwrights were countering sugar with acid, a new type of opera was replacing the old, not quietly but by a head-on attack. The creator-champion of the new was

Le Chevalier Gluck

This first mention calls for the French form of his title, because the operatic warfare took place chiefly in Paris between his devotees and the partisans of the Italian Niccolò Piccinni, who was made quite unjustly the standard-bearer of the old style. He was anything but a negligible composer. Gluck himself frequently shuttled to Vienna, where he had had his first triumph, and back to Paris, where he was music master to the new queen Marie-Antoinette, wife of the easygoing Louis XVI. She was fond of her teacher, sent him on errands to her home country, and by this patronage made him as many enemies as friends.

In music, his good or evil deed was to break the rules of *opera seria* (<327). These had gone so far in the love of symmetry that in the hands of the Neapolitan School every opera presented three pairs of singers in fixed alternation, each given a fixed type and length of aria. For some people reliable expectations no doubt added to the pleasure of the music, which remained undisturbed by the plot; it was cut to fit the formula.

Instead, Gluck wanted drama. It must be visible on stage and of real human interest. Music should subserve expression at every turn—lyrical, amorous, violent, gloomy, jubilant. And drama called for the presence of more than stated pairs of mismatched lovers—

Versailles, Feb. 13, 1778—Madam My Dearest Mother: . . . I do not know whether Gluck will arrive before the regular mail. By his care I have sent word to my dear mother that my period resumed on the 8th—six days ahead of time.

—MARIE-ANTOINETTE TO THE EMPRESS MARIA THERESIA

there must be crowds. The resulting music would be varied in volume as well as purport—and there would be less of it, thanks to cutting out the pointless repetitions called for by the aria system: *puzza di musica,* said Gluck, it stinks of music.

Such was the new Credo, not implied but written out in prefaces to scores. The works conformed to it. Gluck retained the subjects of neo-classical tragedy, but the music spoke out in all the voices of the passions involved. Gluck's masterpieces—*Orpheus and Eurydice, Alceste,* and the two *Iphigeneias*—in Aulis and in Tauris—carry out the theory that Wagner was to revive under the name of music drama (637>). In the interval, operas in various styles made efforts to recapture the original conception of the genre, which is: expressing through music action as well as feeling, the latter done too sedately in opera seria.

Without detracting from Gluck's merit—he himself credited his librettist Calzabigi with the principle of the new opera—it must be said that the reform was an idea in the air. It seemed obvious to Gluck's other librettist, Du Roullet; and also to Da Ponte, who was Mozart's. The new principle of expressing aptly subjects emancipated from rigid programs was to govern not music only but all the arts. Gluck's demand for a serious drama was implicit in the ridicule that men of letters had leveled at opera as such when the only kind they knew was Handel's (<327). More sweeping was the conviction in many minds that the fine arts dealt with life and must remain lifelike by conforming to actual or truly imagined experience.

As Vico had pointed out early in the century, the purpose of art was not to give pleasure or teach morality but to enlighten about human action (<315). About the same time the Abbé Dubos, whose influence was broad and long-lasting, declared that the function of art was "to excite the passions without dire consequences," again so that we might know their true nature. A few years later, Baumgarten launched the term *aesthetic.* He could not know what ravages it would cause in the years to come. He was simply trying to frame a science of perception and to prove that art required a special use and deliberate training of the senses. As he pointed out, so does the microscope: at first, one who looks through the eyepiece sees nothing but a blur. This jibed

> *La musique doit ainsi que la peinture*
> *Retracer à nos yeux le vrai de la nature*
>
> **Like painting music has a single goal:**
> **To limn the truths of nature as a whole**
>
> —Abbé Dubos (1719)

with Dubos's assertion that Taste is a sixth sense, a faculty denied to many; it is not the mere application of reason: the philistine—he who lacks a sixth sense—was emerging in faint outline.

In England, the young Irishman not yet turned politician, Edmund

Burke, had published an *Inquiry into the Causes of the Sublime and Beautiful,* in which he described in minute psychological and physiological detail the qualities of each and the differences between them: Beauty is smooth and harmonious and agreeable. The sublime is rugged, outsize, and terrifying. The ancients and the men of the Renaissance had not been indifferent to the nature of the several arts and their effects on the soul; but not until the 18C was ANALYSIS carried to such a

When we have before us such objects as excite love and complacency, the body is affected, so far as I could observe, much in the following manner: the head reclines something on one side; the eyelids are more closed than usual and the eyes roll gently with an inclination to the object; the mouth is a little opened, and the breath drawn slowly, with now and then a low sigh; the whole body is composed, and the hands fall idly to the sides.

—BURKE, ON *THE SUBLIME AND BEAUTIFUL* (1756)

point. Theory was in the saddle, spurring the critic to outdo his competitors in seeing deep and drawing hairline distinctions. The 18C, that is, Diderot on Painting, Lessing on the *Laoköon,* and finally Winckelmann on Greece, made detailed art criticism an institution. Its role is part scholarship, part advocacy. Winckelmann's lifelong work was to glorify Greek art and discredit the Roman and thus to revivify Plato's belief that Beauty is divine and to be loved and worshipped. It may be a symbolic coincidence that Winckelmann was the victim of a homosexual murderer.

Every age has a different ancient Greece. Winckelmann's is the one that moved the 19C. By way of Goethe, Byron, Keats, and Lord Elgin, it inspired the universal urge to put a picture of the Parthenon in every schoolroom. It also aroused the Occident to support the Greeks' war of independence against the Turks (514>). Most important, the new Greek ideal helped to evade the old axiom that art imitates nature in the sense of copy. The slippery nature of Nature has bedeviled theorists of government; it also confounds the critics of art. They are forced to say that the object to imitate is *la belle nature,* which suggests that the painter or poet must often tamper with nature to make it beautiful. But what natural model does architecture imitate? If you substitute order and harmony as the requisites, the difficulty does not vanish, it only recedes. But with the lifelike and dramatic also in demand, how well do order and harmony stand the pressure? These uncertainties give rise to the unending battle about music (638>).

*
* *

On May 9, 1781, the Chamberlain of the Archbishop of Salzburg berated an undersized young man of 25 and with a parting kick hustled him out of the palace door. The young man was named

Mozart

He had been the archbishop's musical drudge and treated worse than a domestic, until he rebelled. As everybody with a classical ear now knows, young Wolfgang, taught by his father, was a prodigy. On the date of his expulsion he had composed dozens of works of all kinds, including 11 operas or other pieces for the stage. But up to that point these accomplished works were all imitative in form, though full of originality and Mozartean touches. Still, they are notable only because of the composer's youth. Mozart established his unique voice and style in this very decade of the 1780s, when Gluck's reform had become irreversible. Mozart had no need to do battle about forms or genres, and he was barely affected by Gluck's work.° But it was opera that, beyond any other kind of music, he loved to compose.

When I imagine what an opera should be, fire runs through my veins and I am a-tremble with eagerness to show the French that they must get to know, appreciate, and fear the Germans.

—Mozart, aged 22 (1778)

For the chance to express character in sound Mozart even composed a melodrama, that is, a series of scenes linked by words, some of them spoken through the music. To him the thought of persons in action was not simply a stimulus, it was a stimulant. More than once since his day his music has been admired for its charm, elegance, delicacy—in a word, as Rococo—and at those times some "stronger" master has been taken as "more serious." This is to listen to Mozart with half an ear and half a mind. His depth of feeling and grasp of human predicaments put him among the handful who have made music convey truths. But Mozart does not depart from aristocratic good manners. A critic has pointed out that while hearing Mozart it is often hard to know whether the music is merry or sad. It is thereby the perfect expression of its time: looking at that fin de siècle one cannot decide whether those were delightful years to live in thoughtlessly or the golden moments of a final sunset. It was both.

In opera Mozart's genius lay in making every musical element serve the delineation of character. And this not once for all at the start: each figure in the drama inflects his or her voice in keeping with the situation, the orchestra blending subliminal nuances with those vocally expressed. Nothing is static in the interplay of wills, and each of the operas has its differentiating atmosphere. The miracle in this display of expressive power is that the stream of variousness is held within forms of classic regularity—the Grecian harmony of Winckelmann reproduced in blocks of sound. Part of the unforced symmetry arises from the melodic material, which strikes the ear as abundant and original, but is in fact spare—rarely more than four and eight measures long—and it does not depart from the common 18C vocabulary. It is the

unerring fitness of the melody and the adaptive treatment it undergoes that make one exclaim "Perfection!"

Harmoniousness precludes the sublime which, as Burke made clear, requires roughness and magnitude. But at moments, in *Don Giovanni* and in the last of the operas *The Magic Flute,* Mozart reaches it in his way. It is hard to keep from speculating about the effect the artistic fervor of Romanticism he did not live to see would have had on his style. Certainly nothing in his character held him prisoner to fin de siècle attitudes. One has only to read his letters to find a robust nature, sometimes heartily vulgar, and always prompt to rebel. The Freemason's creed, which he celebrated in *The Magic Flute,* would have prepared him to welcome the revolution of Reason.

Mozart composed in all the current musical genres. He depended for his livelihood on commissions and concerts that he organized himself as a piano virtuoso, and it is an indication of the low status of musicians as a profession that despite continual invitations from kings and lords, Mozart, who was not careful about money, was always in need. The upper orders had not yet caught up with the theorists of art; to these patrons, music outside the church was entertainment. Accordingly, much that Mozart composed was superior potboiling. But among the vast number of symphonies, concertos, sonatas, and other chamber works, many possess the same lyrical-dramatic intent and the same perfection as the operas; and from the symphony in G minor onward, Mozart freely expresses his sense of life, comic and tragic, together with his inventive interest in form.

The symphony is a creation of his time. A prolific school of composers at Mannheim, led by Stamitz, father and son, established the pattern; and Mozart's older contemporary and revered friend Joseph Haydn exploited it in the 104 that he composed to entertain his hosts at Eszterházy. In the Haydn symphonies and string quartets one finds signs of emancipation from the neo-classic—extended melodies, not always symmetrical, yet in balance, and movements that begin in one key and end in another without shocking the ear. In addition, Haydn was fond of folk songs and of scenic effects in his oratorios, *The Creation* and *The Seasons.* The likeness is strong between his art and that of the English poets who strayed beyond the Augustan limits, were moved by the people's ballads, and sang about nature.

But what is free, rich, and new in Haydn lies side by side with merely pleasant, sometimes moving patterns of sound. One cannot put into each of the 104 symphonies the density that Beethoven crammed into 9. Similar ratios—and reflections—about operas emerged after the conception of the art of music changed in these very decades. Some 18C composers turned out operas by the dozen; the record being 160. Haydn's facility has fixed him in a role below that of his genius. Except among chamber-music players, who discover his depth, he gets respect without enthusiasm.

Relevant to the transition is the character of the late 18C orchestra. It makes all possible use of tone color but is still hampered by the mechanical inadequacy of some of the woodwinds, and it has not yet achieved a standard balance between winds and strings. Often the brass is optional and enters in by ones and twos. A very full ensemble numbers about 45. Aside from opera, music remains domestic. It takes a wealthy patron or a court to have a sizable and permanent band. In Paris, it was only a tax farmer, La Poupelinière,° who could match the band at Eszterházy. Few concerts were really public until one departure was made: the bourgeois of Leipzig decided to have a concert hall. They chose the wool-exchange hall—*Gewandhaus*—for their permanent orchestra. Tickets were for subscribers; only five seats were kept open for the intermittent music lover or the visitor from out of town. [The book to browse in is *The Orchestra,* ed. by Joan Peyser.]

<div align="center">*
* *</div>

The public for classical music has never been a majority of the whole population, not even of the educated class. Painting is more accessible and literature still more. And beyond these sources of refined pleasure there are at least two things that create the sense of belonging to an age of civilization at its apex. One is an indefinable ease of living. At the end of the *ancien régime* it was of course limited to the well-to-do and particularly those moving about in the cosmopolitan society of the Occident; for it had organized both manners and material things to make life smooth and agreeable. The outstanding success to that end was Venice, now in full decline, but surviving beautifully (and commercially) as the city of pleasure. Its polyglot company was the most polished, its gambling the most civilized, its courtesans the most entrancing.

It could even boast a small artistic renaissance in the work of Canaletto and Guardi, who abundantly depicted the city. Every youth making the Grand Tour must go through Venice on his return, to gild his cargo of unforgettable memories and purchase a Canaletto or two. Guardi, with his hints of future Impressionism, was less of a souvenir postcard. A glimpse of this Venice by an acute observer will be found in Rousseau's *Confessions,* and a modern scholar's sidelights on both in *Rousseau's Venetian Story* by Madeleine B. Ellis.°

Also a force in making civilization more than an idea in the mind, a feeling, is that important things keep happening, and not disasters alone, but reminders of achievement. During the decades in review this sort of curiosity was well satisfied. The deaths of Rousseau, Diderot, and Voltaire close together could not fail to be noted. And a sailor, Captain Bligh, became famous because of the mutiny on his ship, *The Bounty.* Other marine news: in America a steam engine had been fitted by one John Fitch on a boat that he sailed on

the Delaware River. In France, a certain Dr. Beyer made a machine that uttered the vowels; Cugnot built a steam car and the brothers Montgolfier a balloon which, filled with hot air, lifted their hardy friend Pilâtre Des Rosiers into the blue. The sphere was made of wallpaper (thickened) for that was what the brothers manufactured. The feat was repeated the next year at Lyon by Elisabeth Thible, who soared a mile above the city, singing as she went. Before long a pair of travelers crossed the English Channel in the new vehicle. The first parachute was made, in Paris again, with fatal results.

Meanwhile a French engineer named Vaucanson used his spare time to make automata—robots. His flute player performed agreeably and his duck waddled, swam, picked up grain, and (shall we say?) digested it. More useful, the Argand lamp came into being. It is the long familiar one—the wick that dips into the bowl full of oil is regulated by a little wheel and the flame is enclosed in a glass tube. An attempt was made to light by gas but did not succeed. Steel pens made their appearance, relieving writers of the irritating chore of cutting quills and re-shaping them as they break or wear unevenly.

Also from Paris came a gratifying amount of scandal, proving once more that Age of Reason did not mean the end of human folly. A man calling himself Count Cagliostro was performing miraculous cures. He also foretold the future and obtained messages from the dead. People in high society relied on his services, courted him, assured their friends that he was a supernatural being. He was in fact the son of an Italian innkeeper and a charlatan. One of his schemes is famous as the affair of the queen's necklace.° With a titled adventuress, Countess de la Mothe, he persuaded the erratic Prince Cardinal de Rohan, who was in love with Marie-Antoinette, that if the prince gave the queen a particular diamond necklace worth 1.6 million francs, she would grant him her favors. The necklace passed first through the hands of the plausible pair, who removed the diamonds and sold them in London. Their plot and the cardinal's infatuation got to the ears of the king and prosecution followed. La Mothe was convicted and branded but escaped, as did Cagliostro, who wound up in Rome. There, toward the end of his life, he was condemned to death as a Freemason, but the sentence was commuted to life imprisonment.

London supplied the newsmongers no less steadily. In the central year the city was in the grip of 50,000 rioters. Lord George Gordon, raising the old cry of "No Popery!," marched with a mob to petition for the repeal of a recent act relieving Catholics of some disabilities. The protest swelled into vandalism lasting a whole week. Gordon, not quite sane, was acquitted of treason and ultimately embraced Judaism. Meanwhile, Newgate prison had been destroyed. It was shortly rebuilt and a place found for him there.

By way of compensation there was a new tragic actress, Mrs. Siddons, who was giving connoisseurs of the stage thrills they never forgot. Poets and

When the hand of time shall have brushed off his present Editors and Commentators and the very name of Voltaire and even the memory of the Language in which he has written shall be no more, the *Appalachian* mountains, the banks of the *Ohio,* and the plains of Sciota shall resound with the accents of this Barbarian [Shakespeare]. There is indeed nothing perishable about him.

—MAURICE MORGANN (1777)

essayists are on record as awarding her supremacy among English actresses, and none has challenged her ranking since. Close to her debut, another event—now forgotten—marks a sharp turn in English dramatic criticism. A writer named Maurice Morgann published a long essay to argue for an opinion he had expressed in conversation against general ridicule. Alone against the crowd he had maintained that Shakespeare was unequaled as poet and dramatist, as seer and thinker.° Morgann was the first of the idolaters—and not by rote, like most of his progeny.

Clustered around the well-filled date of 1776 were several other publications of note in intellectual history. On the date itself there appeared the first volume of Gibbon's *Decline and Fall of the Roman Empire* and Adam Smith's *Wealth of Nations.* The others were the Scottish historian Robertson's *History of America,* original and comprehensive and unfortunately cut short by the outbreak of the War of Independence; Jeremy Bentham's *Principles of Legislation,* which one tends to place in the next century because his ideas took effect then; and Hume's *Dialogues on Natural Religion,* the last of the quiet demonstrations by which the Scottish rationalist undermined belief in Christianity and belief in Reason (507>).

On the workaday plane, readers could depend on two new sources of information: *The Times* of London and *The Encyclopedia Britannica,* in three volumes. And the same Londoners, musical or not, might enjoy the first Handel Commemoration in Westminster Abbey. It expressed at once devotion to the master's memory and love of huge vocal and instrumental ensembles—525 at each of the five concerts, the first having been so popular that it had to be repeated.

LAUGHTER. An affection peculiar to mankind, occasioned by something that tickles the fancy. In laughter, the eyebrows are raised about the middle and drawn down toward the nose; the eyes are almost shut; the mouth opens and shows the teeth, the corners of the mouth being drawn back and raised up; the cheeks seem puffed up and almost hide the eyes; the face is usually red and nostrils open, and the eyes wet.

—*ENCYCLOPEDIA BRITANNICA,* 1ST EDITION (1768–71)

In 1788 the treasury of France was empty. Bankruptcy was only a matter of days away. In this emergency the king was persuaded to call for a meeting of the Estates General, an assembly of the three estates—nobles, clergy, and commoners—that had not been convoked in 175 years. Its function had always been advisory, not lawmaking, except for voting new taxes. Now it was

expected both to supply funds and to advise on the reform of the government. To that end it must represent the whole country, hence its members were to be elected by nearly universal suffrage. Simultaneously, opinions on reform were to be sought and gathered in *cahiers*—the equivalent of English "blue books"—drawn up in each region or district. These turned out amazingly alike in their demands. The enlightened ideas had reached into far corners and nearly all advocated a constitutional monarchy, a silent tribute to the ideas of the Anglophiles Voltaire and Montesquieu. Nobody wanted to get rid of the king; everybody wanted to put an end to what was termed *despotism*, the arbitrary, uncontrollable acts of the vast bureaucracy and of the corrupt and clogged judiciary (<402). The very business of electing members of the Estates General showed in what a confused mess the institutions of government were. Some towns belonged to two districts; some districts were in two pieces miles apart. Records were missing; jurisdictions overlapped; special courts and rules and exemptions made nonsense of regular ones; and taxation was a perpetual injustice.

To help make reform thorough and widely accepted, the king had decreed freedom of the press. A torrent of books and pamphlets materialized as if by magic. Clearly, every man, woman, and child in France was a political scientist. They somehow knew their Rousseau and the Encyclopedists: it is remarkable how ideas can spread without overt communication, atmospherically. One voice among the thousands electrified the country, that of a taciturn abbé called Sieyès, who said in a brief manifesto: "the Third Estate [the commoners] is the whole country—a complete nation." Here and there, improvised assemblies met and passed resolutions to similar effect. Constitution-making was the ruling passion.

All this in 1788. The next year, after wrangling over procedure, the Estates General met and wrangled further, forcing the upper estates to merge with the Third and become a National Assembly. Shortly, Dr. Guillotin proposed to it the machine he had improved and that bears his name. The Bastille was stormed and the guard needlessly massacred, riots broke out in several cities, the nobles helped abolish their own privileges, and Sieyès as a member wrote another essay specifying the contents of the later Declaration of the Rights of Man. The reform of the monarchy seemed on the right path, especially after the royal family was brought from Versailles to Paris—a symbol.

The year 1789 had additional meanings outside France. George Washington was elected president of the United States, indeed, the first president of a nation in the history of the world. The first House of Representatives met in New York; the first bourbon whiskey was distilled by a Baptist minister in Kentucky; and Tammany Hall was established as a charitable foundation, whose fate was to become an irreplaceable politico-philanthropic institution.

Everybody knows roughly by hearsay, film, or schoolwork what ensued in France from the events of 1789 and how liberal reforms turned into a new despotism. Some details to remember will find a place later (428–9>). The fragility of the reform temper in the first phase is plain from the mixture of the sentimental and the violent, the brotherhood of all citizens and the hatred toward the many types of "suspect."

One man's vicissitudes illustrate the feverish mood. The valiant friend of America, Beaumarchais, was asked by the mayor of Paris to supervise the dismantling of the now empty Bastille on the once more renamed Place de la Concorde. He went to work with his usual zest, but by 1790 unaccountably became one of these suspects. He was brought to trial and by good luck was spared prison: he would have been killed there with thousands of others two years later. During his trial he had the pleasure of seeing a revival of his opera *Tarare,* revised for the occasion. The hero had originally downed the bad king and taken his place with benevolent intent. Now, in an added scene, one sees the people as hero crowding an altar dedicated to liberty. The tenor and the chorus sing constitutional lyrics. Operas are easier to reform than nation-states.

The Forgotten Troop

THERE ARE MANY REASONS why the words *French Revolution*, all by themselves, evoke at once recognition and appropriate images. The exact date 1789 may not be remembered everywhere as it is in France, but the upheaval occurred "not so very long ago"; it was bloody in a dramatic, personal way. Then it merged with the epic story of Napoleon, still a celebrity.

Many of the issues raised in those 25 years remain a cause of partisan debate, being sources of our political and social system.° The proposition that simply by being born one has certain inherent rights was the idea of that revolution. The germ of it, as we saw, lay in the Protestant Revolution, which asserted the "Christian liberty" of everyone's free and equal access to God (<6). The germ was developed indirectly by the Monarchical Revolution, which lowered the prestige and power of the nobility and tended, despite exceptions, toward making everybody alike subjects of the king within the nation-state. Next, the "Century of Light" launched doctrines, political, social, and economic, that should have caused France to transform its monarchy from so-called absolute to constitutional like England and even more thoroughly. This purpose was widely understood by the population (<423); it inspired the first moves of the Estates General convened at mid-year 1789, and it brought about the nobles' stripping themselves of their privileges. It missed happening by a narrow margin.

Instead of a rough time of steady change, there ensued a chaotic time of regimes and violence lasting a quarter century. The first span, five years long, may be divided into two parts. During the first three and a half, an attempt was made to liberalize the monarchy and modernize the country. In the next one and a half, dictatorship carried on terror at home and war abroad. Then came an interim of relative freedom—five years of successful war that brought Bonaparte to the fore, and then a return to dictation under him as consul and emperor for a decade and a half, war unabating.

The men and ideas that produced this cascade of outcomes are many and cannot be given individual notice here. But one condition of cultural import

can be suggested. The men who came to lead factions or who gained power for a time lacked mature political talent. To govern well requires two distinct kinds of ability: political skill and the administrative mind. Both are very rare, either in combination or separately. The former depends on sensing what can be done, at what moment, and how to move others to want it. Anyone who has served open-eyed on a committee knows how many "good ideas" are proposed by well-meaning members that could not possibly be carried out, because what is proposed consists only of results, with no means in sight for getting from here to there. After serving on a local government body, Bernard Shaw guessed that perhaps 5 percent of mankind possess political ability.

But one can be a true politico and be at the same time incapable of administration. To administer is to keep order in a situation that continually tends toward disorder. In running any organization, both people and things have to be kept straight from day to day. Otherwise, workable ideas will not work. More than talent, genius, is required to set up a national system of administration. Napoleon's success at home and abroad was due to this gift as much as to the art of command in battle.

It is sometimes said that the example of the Americans—a free people—influenced the French revolutionists. Some of their words about the blessings of liberty did at times include references to American independence, but unfortunately no wisdom radiated from the makers of the American Constitution to those making one in France. Only in the war that overtook the French did the American experience come into play in Europe. Lafayette, De Grasse, Rochambeau, Gneisenau, and others had fought in America and seen the inadequacy of the old-line tactics against the sharpshooting Americans and Indians. Europe adopted the flexible line of small columns protected by skirmishers. It needed much less drill, and with lighter artillery increased mobility and speed. [The book to read is *Understanding War* by Peter Paret.]

It is not surprising that the men who filled the three successive French assemblies were not well equipped for their demanding tasks. Many were small-town lawyers like Robespierre, or members of other learned professions; some were artisans, or again small landowners or local officials. A number may have been used to *politicking*, but not to fashioning a constitution or resolving great national issues under the pressure of emergencies. They were certainly articulate. They wrote and delivered endless speeches and debated ad infinitum. The one statesman in their midst, Mirabeau, vainly kept urging them to take action. What is left of French revolutionary eloquence is

At this point don't ask for more time to consider. Grave trouble never grants time.

—Mirabeau, to the Assembly on the "patriotic income tax" proposed by Necker (Sept. 26, 1789)

enormous in bulk and a model of all future campaign oratory—abstract, diffuse strings of generalities aiming at applause for virtuous attitudes and vague on details except when attacking rivals or denouncing "traitors." Again, one exception to verbosity: the lucid and vigorous Danton.

During the first two years of the new order, Mirabeau might have led the way to lasting reforms and averted the series of legal and illegal changes that amounted to coups d'état. He meant to turn the government into a constitutional monarchy and be its leader. Unfortunately, his private financial dealings with the king made his arguments seem venal and his driving energy was an offense. He foresaw the impending rhythm of revolutionary politics: any measure toward stability could be construed as treason to the forward march of liberty and equality. And when the threat of counter-revolution came from foreign kings and princes, the sincerest revolutionists had to compete with the demagogues. This is an historical generality.

Hence the maxim that a revolution devours its children. But that is only a high probability. It is permissible to speculate that with Mirabeau alive and a king and queen endowed with an ounce of political sense, the monarchy could have survived. But again and again wrong choices were made. It was the king who declared war on Austria; it was the king's blunders, often at the queen's urging, that dethroned him; after which a new force came into play: the societies, clubs, and "sections."

The Jacobin Club is remembered for its name, which has come to be used, especially in English, to denote rabble-rousing radicalism. In the revolution the Jacobins were the best-organized party, with "cells" throughout the nation.° The "sections" were the 48 new divisions of Paris, each bearing a symbolic name (of heroes such as William Tell) and ruled by a local assembly, with committees and other members, everyone free to debate. The societies were independent groups promoting a self-appointed mission. An early one was called the Fraternal Society of Both Sexes; another, the Society of Equals; a third, founded by the actress Claire Lacombe, was the earliest to argue for a republic. These groups published newspapers, the most violent and popular being Dr. Marat's *Ami du Peuple*. This "friend of the people" called for a dictator and acted as such toward his worshippers in all groups, including Claire Lacombe.

What the textbooks call the Paris mob was thus an organized and articulate mass of people, not united on every issue, yet enough of one mind to act together at critical moments. The series of riots, revolts, and massacres that bedeviled the lawmakers was their work. They sent delegations again and again to the assembly, lobbying or threatening. They were patriots, defenders of truth and virtue, guardians—no, "saviors" of the revolution.

This political force acquired the nickname of *sans-culotterie* (434>). It was made up of workmen, shopkeepers, teachers, artists, writers, minor civil ser-

vants, with only a sprinkling of the well-to-do. "Lower middle class" does not sufficiently suggest their intellectual pastimes, their desire for education (they were not all literate), their pride of skill, their self-respect and earnestness. They gathered for readings of Rousseau, Volney, and other masters, as well as to make speeches, sing songs, and enjoy moral recitations by young girls—in short, to lead a life of the mind.

It was, besides, a fraternity of activists. When the tocsin sounded from the steeple and the drums beat the *générale,* they marched out to do what the leaders—regular ward politicians—had decided. Some sections were more fiery than others. Hence the lynchings and petty massacres that marked each turn of events and created the "Days" that history remembers. The principles upheld in this way were few and consistent: sovereignty of the people, equality, and what was termed *honorable mediocrity.* This last has no belittling implication; it means a middling station in life—Rousseau and Jefferson's ideal. (The former's *Social Contract* was reissued 32 times in the 10 years after 1789, not counting pocket editions.) This ideal easily lapses into anti-elitism: the *sans-culottes* regarded dogs as aristocratic (because of hunting); true democrats must be content with cats.

Out of this ferment came a vision with a future: the old idea of establishing the good society through communism (<15). It was to be engineered by a terrorist dictatorship. A couple of these theorists perished in the Terror (not theirs) that did take place. Another Communist, named Gracchus Babeuf, also went to the scaffold for attempting a coup based on his "Manifesto of the Plebeians." But his friend Buonarotti, a descendant of Michelangelo's, survived and wrote a tract entitled "Babeuf's Conspiracy for Equality." Its teachings were echoed and re-echoed by leaders of small revolutionist groups throughout the 19C, notably the one led by Blanqui, from whom Lenin is said to have borrowed if not the goal the method.

* \
* *

The direct legacy of the revolution was of course something quite other than communism. That legacy was Nationalism; and coupled with it, Liberalism in the sense of individual rights and representative government. The struggle to implant both of these throughout Europe, and the competition between the two, define the political history of the 19C. The liberal revolution had to forgo Liberalism because of war: the Terror was a by-product of seeing "the fatherland in danger." The foreign enemy was at Verdun, another was at home—the royalist peasants of the Vendée. And the food crisis was acute and permanent. The Committee of Public Safety had to take strong measures: fix prices and hunt down dissidents and black marketeers.

Robespierre, first among equals on that committee, had come a long way

in a short time. As a local judge in his native Arras, he had felt so upset at having to condemn a man to death that he resigned his post. In the first of the Assemblies, he promoted a bill to abolish capital punishment. He changed his mind, but his concern for the poor and oppressed never lagged; price-fixing protected the common man, as well as helped to keep the troops supplied. He led the first efficient police state. His agents in the country directed the vicious purges, of "suspects" and "traitors" and their wives and children. At the front, other agents could remove field commanders, on suspicion or because they ordered a retreat. In Paris, the revolutionary tribunal was in permanent session and thanks to the diligent prosecutor Fouquier-Tinville, in 17 months (as he boasted) some 2,000 heads rolled in the sawdust.

But no tendency in culture, no sentiment—let it be said again—is ever unanimous, not even under extreme force. The word *totalitarian* is acceptable shorthand to mean what the 20C understands by it, but the reality is never total. In the late 1790s a stubborn minority opposed every step of the revolution, their hostility expressed or concealed. Some outwardly conformed; others lived in hiding, sheltered by people who were above suspicion, sincere revolutionists but willing to harbor friends or relatives. The prominent had to flee, in waves, as different opinions prevailed at the center or on the streets. *Emigrés* clustered east of the Rhine and plotted to return at the head of the armies they were trying to muster by pleading with Austria and Prussia. Of those at home some miraculously survived: when the Abbé Sieyès (<423) was asked in later years what he had done during the Terror, he replied: "I lived."° A few found refuge in the United States. Others gave themselves away, weary of being hunted, or were denounced and seized triumphantly, each one a prize for the catcher, who felt he had struck a blow for Liberty.

The roster of victims was distinguished. Lavoisier the chemist was guillotined because he was related to a former tax-gatherer; the learned and dedicated Charlotte Corday, because she had come from Normandy on purpose to stab the fanatical Marat. André Chénier the poet, because of a defiant editorial; Mme Roland, also an intellectual and known as the "Muse of the Girondists," because that entire party was accused and sent to its doom. On the scaffold, she cried, "Oh Liberty, what crimes are committed in thy name!" Louis and Marie-Antoinette, of course, and, killed by neglect or otherwise, their two children, and with the queen, the beautiful Princess de Lamballe, who had refused to leave her mistress; before and after these, many titled men and women, because of their title. One marquise who could have saved herself said: "No. Life is not worth a lie"; by the end, the chief party leaders from Danton to Robespierre inclusive.

The executions were punctuated by striking incidents. The spectacle was better than a play, and the painter David was there, making pencil sketches. When Mme Du Barry, Louis XV's last mistress, found herself on the plat-

form, she screamed, she howled, she had to be dragged and pushed. The bloody-minded spectators were stunned. It dawned on them for the first time that a human being was about to be killed. All the others had been aristos, traitors, enemies of the people—abstract items in a category.

But fear and hatred had been mounting and spreading among the members of the assembly. They heard Robespierre preach the pure society that was to issue from a purified revolution, meaning one still further purged. In his policy of Public Safety they no longer saw their own. Two long days of stormy debate set off organized tumult in the streets. Robespierre and his team were seized and outlawed, and after a further scuffle during which he perhaps attempted suicide and fractured his jaw, another 22 patriots went the way of their predecessors—in a tumbril to the Place de la Revolution.

The relative ease and speed with which the coup d'état was accomplished shows the weakness of the strongest political leadership when it is fresh risen from rebellion: it took much longer to dethrone Louis XVI than to get rid of Robespierre. [For a reminder of the events and fates of the participants, read *The French Revolution* by Charles Downer Hazen. It is so vivid a narrative that its two volumes seem shorter than many a treatment in one. For a more modern view: *The French Revolution* by Albert Goodwin. Carlyle's, in his special idiom, is picturesque and also important as the first account in English that was sympathetic without being partisan. Finally, the monumental *Citizens,* by Simon Schama, is a chronicle rich in fresh and evocative details.]

*
* *

This summary recital should not leave the thought that the revolution did nothing that lasted. It did a great deal—in some ways too much beyond the original purpose of reforming an entire government. It was driven to this excess by its Idea, the faith of the *Encyclopédie* in universal reason, and by the unanimous enthusiasm with which the feelings embodied in the Declaration of the Rights of Man and Citizen were applauded at home and abroad. Young and old in all occupations, and intellectuals especially, exulted in the news of French EMANCIPATION from what was taken to be centuries of servitude. In Wordsworth's recollection, it was a heavenly feeling (<8; 43). The German philosopher Kant viewed it as "the enthronement of reason in public affairs." Others sang and danced.

Goethe, who was by then 40, did not weep with joy but shared the general

When France in wrath her giant limbs
 upreared
And with that oath which sounds air, earth,
 and sea
Stamped her strong foot and said she would
 be free,
Bear witness for me, how I hoped and
 feared.

—COLERIDGE'S MEMORY OF 1789 IN
"FRANCE: AN ODE" (1798)

satisfaction that he says spread throughout Germany. In England the parliamentary leader Charles James Fox declared the fall of the Bastille the greatest event that had ever happened: the British ambassador in Paris judged the revolution "the greatest in history, achieved with the least bloodshed." Those in England who for a dozen years had wanted to reform Parliament counted on events in France to help their cause.

In addition, a movement that resembles the *sans-culotterie,* but more intellectual and better informed, developed in England, fed by the writings of Paine and members of the "Corresponding Societies" that Burke inveighed against. It explains the split among the poets and critics of that time; on one side, the "turncoats" Wordsworth, Coleridge, and Southey, who joined "the forces of reaction"; and on the other, the persecuted Hazlitt, Leigh Hunt, and their friends° (>506). They were reviled for wanting a "bloodbath" French style, though that was far from their intention. English popular sentiment was for recognition of political rights through parliamentary reform, not for a new type of government. Burns's poem on the theme "a man's a man for a' that" echoes the 17C moderate Puritans' demand for fair play and social respect; it does not aim at leveling or communism.

In France, the fervent oneness had not lasted many months; each logical or accidental change alienated individuals or groups. But the tributes received made the assemblies think that they were legislating for the universe, saving the whole world from ignorance and tyranny. The extraordinary thing is that in the long run the revolution did impose its Idea on the world—the Rights of Man, now expanded into "human rights." The doctrine did not spread by itself nor by French efforts alone, and it still has much territory to conquer; but everywhere today men and women cry out and die for it.

The contents of these rights of men always seem clear to those in the struggle; actually, they vary with the arrangements made for their application. The men of 1789 who wrote the first constitution found that they could not give the vote to all: ignorant and illiterate men without property could not be trusted, and only a few cranks thought that women should be. Still, the vote was given to all men who owned the equivalent of three days' wages—a far wider electoral base than the English; and when need arose for a new assembly, France had manhood suffrage. To work the new scheme, the 32 provinces were abolished to make French men and women out of Bretons, Provençals, or Dauphinois. For a new life as brothers their *pays natal* must wear other names and different shapes. At first the shapes were to be squares with other squares inside them. But "nature" prevailed and 83 departments were drawn and named in keeping with geographical features.

This will to make all things new, coupled with financial woes, inspired what would now be called nationalizing the church. Its vast holdings were declared state property and used as backing for paper money. Sold to the

land-hungry peasants (and speculators), they would produce the cash to redeem the notes. Bishops and priests, after taking a loyalty oath, were put on salary like civil servants, after being elected by a vote of the parish and diocese. Soon the too convenient issue of notes outran the proceeds of the land sales and inflation ensued, while the assault on the church alienated a large part of the people. SECULARISM progressed but at the cost of creating "Two Frances" (<297; 630>).

These drawbacks did not halt other reforms. A system of national education was set up—on paper only, for lack of funds. The old and variable measures of length, weight, and volume were unified "scientifically." The new system, now in global use, used as its central unit the meter, from the Greek for *measure*. It was the length of the earth's meridian or great circle divided by 40 million. Weight and volume were defined by corresponding measures of water or length. They increased or decreased in decimals instead of by thirds, quarters, or twelfths as formerly, and so did the unit of money, the franc. The names for all units were neo-classical.

The friendly figure 10 was used again in the "revolutionary calendar": months of 30 days, divided into three "decades" (the word means 10 days, not years), the last day of each being a day of rest. Five days more were needed at the end of the year to make 365 and these too were holidays. They were soon nicknamed "the *sans-culottides*." The new vocables for the 30-day months invoked nature (*Floréal, Prairial*) or suggested seasonal fact by their Greek roots: *Thermidor* = the "gift of heat" that comes from mid-July to mid-August.

The arts received no less attention than science. The existing academies for literature, for painting and sculpture, music (and separately, the opera), were recast into the five specialized units still extant. The royal library was reorganized as the Bibliothèque Nationale, and a new establishment, the Conservatoire, was founded to train musicians of all kinds at public expense. It has proved a model school, abundantly fruitful. This last concern of the revolutionists was linked to their use of festivals to create mass enthusiasm— or perhaps one should rather say to express it, because the pride, hope, and joy excited by the various "Days" when some coup took place aroused collective feelings never before experienced in the towns of France and needing an outlet.

These festivals were for speeches, pageantry, worship, and music. David or one of his studio designed the decor, including giant allegorical statues (made of temporary material), and he organized the event. Meanwhile, some member of the gifted "Paris school" (461>)—Grétry, Gossec, Méhul, Monsigny—composed songs, marches, and secular hymns. These were of equal importance. From the first outbreak, people had sung rebellious or jubilant words to popular tunes or had made up new ones. Later, something had to be done to fill an emotional void by offering occasions for religious

feeling in secular guise, a *sursum corda*—elevate your hearts to an accompaniment of lofty music and ritual. Bred on Deism (<360), the revolutionists tended toward godlessness and at one point thought of promoting a Cult of Reason, with a visible goddess in the shape of a personable actress scantily attired. But Reason did not last long. Under the austere Robespierre it was found that atheism is "the luxury of aristocrats," and a "Worship of the Supreme Being" was installed. It could have, of course, no human embodiment, but it kindled more feeling than the philosophes' nod to an abstract deity.

What part of this worship was inspired by Freemasonry it is hard to say. What is clear is that this fraternal society flourished during the Enlightenment and created a strong bond among thinkers and politicians alike. Freemasons were a particular kind of Deist, fond of ritual and of myths that they took for history. They revered the Great Architect of the cosmos and followed practices they believed inherited from builders—masons—as far back as Egypt. Haydn and Mozart were Masons who composed great music for their order. Many of the American Founding Fathers were Freemasons and as mentioned earlier, the current dollar bill still bears the symbol of the pyramid, earliest and hugest of masonic feats.

In truth, the guild of masons dates back only to the Middle Ages and its emergence as a fraternal order with a political cast and open to all Deists has been assigned to a lodge founded in England in the early 18C. From there it spread rapidly over Europe and made recruits of leaders in all fields of thought and action. On this account some historians have attributed the revolution in France and later upheavals to the Freemasons acting as a body of conspirators.° More likely, the connection works in reverse: men who broke away from the church and who fought for a republic would join the order. It offered a substitute religion that was secular and a politics that was liberal.

The curious blend of politics, nation worship, and music signaled the celebration of Bastille Day, on July 14, 1792. The provincial cities sent large delegations of National Guards to that festival, despite prohibition from the central government, and the capital was crowded with roistering characters at a moment when news from the front was bad. One such group, the 600 from Marseille, had marched 27 days, singing revolutionary songs to make the time pass more quickly. One of these songs, the newest, had come by the grapevine from Strasbourg, where a young lieutenant, Rouget de Lisle, had composed words and music to cheer "The Army of the Rhine." The rousing tune, roared again in Paris by the 600, made it a national anthem and gave it the name of "Marseillaise"—a lucky escape from "Strasbourgeoise."

Manners during revolutions change automatically, as we have seen. In 1789 the temper that produced the motto Liberty, Equality, Fraternity directed such changes, more and more emphatically as time went on. Titles

were abolished, *de* vanished from signatures and salutations; everybody was known or greeted as Citizen So-and-so (forerunner of Comrade in another revolution and century) and *tu* and *toi* instead of *vous* was politically correct. Louis XVI was tried as Citizen Capet, the name of the founder of the line 800 years earlier.

Men's clothes started on their democratic simplification. Though not altogether colorless, they became subdued and gradually dropped such frills as wigs, powder in the hair, ribbons, knee breeches (hence *sans culottes*), garters and silk stockings, silver buckles on shoes, and felt hats. Instead: the *carmagnole,* the blue smock, which gave its name to the revolutionary song and dance, and the red cap, neo-classically derived from the "Phrygian bonnet" of the emancipated slaves in antiquity. Robespierre, fond of neatness in all things, kept to a modest version of the former fashion, but it was safest to look as much as possible like a workman. That is how trousers made their entry as the garment for males, now almost a global uniform, adopted when so desired by women in the West. The show of legs that served the vanity of Louis XIV and his courtiers has been reassigned to the more frankly exhibitionist sex.

* * *

Meanwhile, from late 1792 onward, war was being fought in two directions. For in addition to repelling the German force that had slowly got under way, the revolt in northwest France proved stubborn and menacing. The peasants of Brittany and the Vendée were devout Catholics and royalists and ably led by their noble lords and peasant tacticians. They were crushed at last, and the armies in the east won early victories. As in 17C England, the side animated by a faith triumphed over seasoned professionals. Nor did the French armies lack well-trained officers from the royal service—Bonaparte was one of those. In addition, youngsters in their early twenties, such as Hoche and Marceau, or their early thirties, such as Jourdan and Kléber (445>) rose quickly to command and showed brilliant generalship.

Behind them, close to Robespierre, was Carnot, the administrator par excellence, soon called "The Organizer of Victory." He raised 750,000 men, supplied them, kept up the production of all necessaries, used the visual telegraph to transmit his orders and balloons for reconnaissance, and by staying aloof from the murderous politics of the assembly and its committees, survived. His son, a physicist, and grandson, a president of the Third Republic, kept his name conspicuous in French minds, especially as the last was assassinated (695>). But the founder of the line deserves fame on a par with that of his political colleagues. The task facing him was heroic, because the 14 armies of the revolution were in fact the nation-in-arms, the first perfor-

mance of the kind. Known as a levy *en masse,* it has been the model for the main wars of the 20C.

Common usage makes *nation* and *people* synonymous, but they do not always point to the same entity. A further distinction may be made by calling the old regime a nation-state—a state that governs its people *as if it were* a nation centralized, ruling according to laws, striving for regularity and uniformity

> From now until the enemy has been harried out of the land, all young men will fight. Married men will forge arms and cart supplies, women will make tents and help in hospitals. Nobody will hire substitutes. Civil servants will remain at their posts. Male citizens aged 18 to 25 who are single and childless will march first.
>
> —ACT OF AUGUST 23, 1793, DRAFTED BY CARNOT

over a wide territory. Tocqueville in his study of the old regime shows how closely the structure of France after the revolution resembles that of the old monarchy. But as we saw, inherited divisions and poor communications crippled the old order. The very names of the provinces kept the people from being one nation. It takes a national war to weld the parts together by giving individuals and groups memories of a struggle in common. Needless to add, national*ism* can arise only when a nation in this full sense has come into being. The armies of the revolution and those of Napoleon Bonaparte carried the contagious germ of the nation and its *ism* to the rest of Europe, not solely by example but also by forcing the peoples to resist the invader and giving them a glimpse of that extraordinary conception, Equality.

In arithmetic equality is a simple idea; once grasped, never unsure. In society it is complex and elusive. Thinkers who argue from the state of nature find it easy to say that all are born free and equal (<362); but that is only because in that imagined state there are no standards to measure people by and at birth no talents to compare. The equality of souls in the sight of God also depends on a judgment to which we have no access. From these abstractions, the mind moves next to equality in rights, implying "equality before the law," that is, the same procedures for like cases. These can be made visible up to a point. Beyond it come human decisions—as by a jury and a sentencing judge, where equality is again untestable.

At the third level—equality in social life, business, and politics—the principle is both in force and missing. There are so many facets to the human will and the civilized world that as many good minds have argued for as against the truth, the worth, and the meaning of equality. It was for equality of opportunity that the French revolutionists decreed public instruction. But does schooling provide it? The answer at once shifts to the question of indi-

> The idea that men are created free and equal is both true and misleading: men are created different; they lose their social freedom and their individual autonomy in seeking to become like each other.
>
> —DAVID RIESMAN, *THE LONELY CROWD* (1950)

vidual ability: "human beings are *not* equal: see the test scores." To which the
rejoinder is that schoolwork is only one measure and a vague one. There fol-
lows a list of great figures who were dunces in class. Besides, consider the illit-
erate guide in the Canadian woods: is he not in his domain the superior of
Churchill or Einstein? Finally, if merit is measured by ability and it gives
unequal results, is it iniquitous? The *sans-culottes* discovered this and their rad-
ical wing demanded "equality of enjoyments" (*jouissances*). Today the com-
plaint is that the meritocracy forms an elite; it is aristocracy under another
name; social justice demands equality of conditions. Logically, this should
mean equal wages for all, but these have been rarely argued for.

So difficult is it to define equality and nail down its conditions that in dic-
tatorships where it is proclaimed and enforced in dozens of ways, the needs
of government and daily life re-introduce distinctions; as Philip Guedalla
observed early in the Soviet regime, "some are more equal than others."° The
paradox reminds us that international law has no option but to assume, in the
teeth of the evidence, that all sovereign nations are equal.

There is but one conclusion: human beings are unmeasurable. It follows
that equality is a social assumption independent of fact. It is made for the sake
of civil peace, of approximating justice, and of bolstering self-respect. It pre-
vents servility, lessens arrogant oppression, and reduces envy—just a little.
Equality begins at home, where members of the family enjoy the same privi-
leges and guests receive equal hospitality without taking a test or showing
credentials. Business, government, and the professions assume equality for
identical reasons: all junior clerks, all second lieutenants, earn so much. In other
situations, as in sports and the rearing of children, equivalence based on age,
weight, handicap, or other standard, is computed so as to equalize chances.
That is as far as the principle can stretch.

*

* *

The chief actors in the first act of the great French drama are identified
as soon as named. The same is true as one moves to the next decade and
its prominent figures: Pitt, Nelson, Bonaparte, Wellington, Talleyrand,
Metternich, have kept their names in the books and in common reference.
But looking at the joint list one notices that it is almost entirely political and
military. The men of action have used up the collective memory and deprived
of renown a group of equally remarkable minds. This forgotten troop num-
bers writers, artists, philosophers, scholars, physicians, and men of science. It
would take long and tireless efforts to inoculate the public mind with their
names and deeds; the tight web of culture resists insertions and fame does not
favor the squeezed-in look.

This is not to say that these noteworthy talents were hidden in their own

time or have been neglected by widely read biographers. What they have missed is not praise but its routine repetition, which is fame. Among the people, the glamour of the soldier or war minister outshines every other merit. Accordingly, no description of other specimens in a few pages can reverse the settled impression. All that can be done is to give hints to the inquisitive by a rapid who's who with its usual few details. Other books, not hard to find, will supply facts with which to satisfy curiosity and confirm the presence of a galaxy worth getting to know. It will also serve to date back certain cultural advances to their true beginnings.

Perhaps the most surprising discovery to be made is that of the men who in the quarter century 1790–1815 started medicine on its experimental career. Their main achievements were in physiology. Bichat, Magendie, Chaussier, Leclerc, Dupuytren, Legallois, and half a dozen others made rapid progress in both the normal and pathological workings of the human body. The new chemistry, the use of trial and error, and the new practice of taking notes throughout the course of a disease combined with a team spirit to produce lasting results. Dupuytren's name, linked today with the "contracture" of the palm of the hand, was for a long time associated with a salve for syphilis that enjoyed great popularity. But it is for his experimental work on the role of the brain and the nerves in the functioning of other organs that he deserves notice. He too was a teenager, beginning his studies at sixteen and becoming a prosector two years later. His second career as a brilliant army surgeon points to one of the impulsions that forwarded medical discoveries. [The book to read is *Science and Medicine in France 1790–1855* by John E. Lesch.°] Even before the revolution, hospitals in France and elsewhere were being turned from indiscriminate refuges for the poor and the sick to establishments run on system for the study and cure of diseases. Nursing had become a lay profession and the complexity of the new physiology encouraged physicians to specialize. In the same rational spirit, the insane asylum was transformed from a prison for the hopeless to a place for study and cure. In this reform Pinel was the leader who may be called the first psychiatrist.° One should also give his due to Laënnec, who invented the stethoscope and laid down the bases of chest medicine.

The English physician to note and remember is

Thomas Beddoes

He was the father of the poet Thomas Lovell Beddoes, also a physician, and both of them original minds and strong characters. The elder startled his colleagues and patients by his farsighted innovations. Among those he treated in Clifton near Bristol were Wordsworth, Coleridge, and Southey. Dr. Beddoes was interested in scrofula, the swellings of the lymph glands that

betoken the great 19C disease "consumption" (tuberculosis). He prescribed a good diet and fresh air at even temperatures, and he experimented with the "new airs"—oxygen, hydrogen, and nitrogen. He found the first of these helpful in respiratory complaints, devising for its use the first crude oxygen tent. Having worked with Humphry Davy on nitrous oxide, which proved anesthetic, he suggested that surgeons make use of it. His lifelong concern for the rural poor led him to find modes of treatment adapted to their means. He would tell a farm laborer to put his ailing child to sleep in the barn, where the cattle would heat evenly the large air space, healthier than the fug in the hovel.

Beddoes was a Humanist who studied at Oxford and who, in Germany and at Edinburgh, mastered all the newly booming sciences, especially chemistry. He believed it would govern the future of medicine; he therefore translated for his colleagues a German treatise, and by age 26 was lecturing on the subject at Oxford to large student groups. A quarrel on doctrine, both scientific and political, forced him to resign. For Beddoes approved of the things happening in France, where he had met and talked with Lavoisier.

> Those who decry experiments in medicine do not perhaps perceive that they cut off all hope from those at present incurable; [but] it is a poor project to lay oneself out for the praise of ingenuity by proposing plans which are in no danger of being tried.
>
> —DR. THOMAS BEDDOES (C. 1807)

Beddoes devoted his life to practice and to expanding in published works his own "revolutionary" ideas. He argued for preventive medicine and public health; he taught his patients hygiene, believing as he did that cleanliness, fresh air, and a good diet were more healthful than drugs. He was strongly in favor of girls' education, and was appalled at the catering of girls' schools: "forty fed for two days on one leg of mutton." Women's minds were the equal of men's, and they were "victims of a studied neglect." Boys and girls should be taught together at home and in schools. He also suggested the use of toys designed for early instruction, but made no headway with so absurd an idea. He recommended that the young be taught about sexual matters—physiology and emotions both—and without mincing words.

A minute observer, he concluded that "consumption" was contagious and he told stricken mothers not to breast-feed their babies. The parents, he wrote, should be "the first inspectors of health." He inveighed against the current evening fashions for young women, bare from the bust upward and perspiring in drafty ballrooms. He thought that hypochondria in males was the same as hysteria in females, using the word *hysteria* in the modern technical sense. The close link between illness and "low spirits"—psychosomatic diseases—was plain to him, and he saw mania and melancholy as alternating symptoms of one affliction, now called the manic-depressive syndrome.

What is more, he attributed it and other neuroses to "passions without gratification."

These diagnostic insights brought Beddoes to formulate a theory of the imagination as the faculty that generated the products typical of the human mind: religious fears, delirium, paranoia, inventions, and poetic power. He also took into account in his diagnosis of mental cases the effects of debauchery, the deadening routine of artisans, and brain concussion. He regretted that no serious studies had been made of the nature of sleep. Thomas Beddoes died of emphysema at 48. Coleridge "wept convulsively" on hearing of his death. °

The leaders in pure science during the revolution and the ensuing Empire are not household names any more than Beddoes'. Humphry Davy has been mentioned, and when coal mining was still a leading industry, Davy's lamp, which prevents by a gauze funnel the explosion of methane, was a familiar term. Science owes him much more. His studies in chemistry corrected Lavoisier on several points, including the nature of combustion; Davy explained the chemical working of the Voltaic battery, and as head while still a young man of Dr. Beddoes' Pneumatic Institution, it was Davy's experiments that established the anesthetic properties of nitrous oxide. He also showed the relations of the new gases to long-known acids.

The *Dictionary of Scientific Biography* opens its entry on Laplace (Marquis de) by saying that he was "among the most influential scientists in all history." The grounds for this estimate is the work done in the revolutionary decade that Laplace summed up in his *Celestial Mechanics* and *Theory of Probability*. Earlier, he had dealt with game theory; in 1789 he took part in the preliminaries for the metric system (<432); the 19C used his mathematics to solve problems in electricity and magnetism; and his rigorous methodology had "a part in forming the modern scientific disciplines." In addition, he took the trouble to write on his subject for educated readers, acquainting them with his System of the World.

For the educated man or woman of today, the failure to signalize outstanding genius in the lost group under review is perhaps most grievous in the case of

Georg Christoph Lichtenberg

In the 1790s the German university town of Göttingen harbored a thinker who had become such a "personality" that people of all ranks up to princes and down to students came from the wider world to hear his lectures on physics. From the age of 26 he held a chair at the university, but it was in his living room that he offered knowledge with entertainment. For with captivating charm and a smile always on his lips, he spiced his talk about the lat-

Do not use the word *hypothesis,* even less *theory,* but mode of imagining./He swallowed a lot of knowledge, but it seemed as if most of it had gone down the wrong way./I know from undeniable experience that dreams lead to self-knowledge./Taking off one's hat is an abridgment of one's body, a making smaller./ Every man has his moral backside, which he keeps covered as long as possible by the trousers of decorum./Everyone should study at least enough philosophy and literature to make his sexual experience more delectable./ His beatings showed a sort of sex drive: he beat only his wife.

—LICHTENBERG, *NOTEBOOKS* (n.d.)

est scientific findings with wit and far-flung digressions and asides. Among his discoveries was the principle of thermography that is embodied in the 20C copying machine.

But physics, which for him included fruitful researches in geology, meteorology, astronomy, statistics, chemistry, and mathematics, was far from being his only intellectual interest. Known as a philosopher, a moralist and psychologist, an essayist and a critic of art and literature, he emerged posthumously as one of the most original inditers of maxims. His 16 notebooks° contain thousands of aphorisms, and his letters and the articles he wrote for his popular almanacs contain still more samples of his extraordinary imagination, at once perceptive of hidden realities and questioning of what seems absolutely evident. In physics, for instance, he entertained the ultramodern notion that the wave theory of light and the corpuscular might both be true, and in geometry that Euclid's axioms based on common sense might not be the only right ones. It is not too much to say that Lichtenberg was a Renaissance man—almost the last (<409).

Lichtenberg was part of the spontaneous movement in Germany that sought fresh air, culturally speaking, in England. He made two trips there and although London was "hell" he enjoyed the atmosphere of political freedom. There also he found in Hogarth's engravings a moral and pictorial imagination akin to his own. His book *The Explanation* of these works, Goethe tells us, created a sensation. Lichtenberg praised English common sense as a virtue, in opposition to the German habit of building large abstract systems on a narrow base of observation; these distracted the mind from practical politics (451>). But the French Revolution had taught the people a set of ideas that would not be easily uprooted. Would then—Lichtenberg wondered—the autocrats in power resort to planned barbarism? His metaphysics went beyond mundane advice. Precisely *not* erected into a system it arose out of reflection on things and human behavior and contained the root ideas of 20C speculation, from Pragmatism and Phenomenology to linguistic analysis and logical positivism. Goethe, Kant, Herschel, Volta paid Lichtenberg tribute during his lifetime; and since then, Schopenhauer, Nietzsche, Wittgenstein, and Isaiah Berlin.

Apart from his native and cultivated skepticism, Lichtenberg was for most of his life a cheerful man. He was a hunchback and of amorous disposi-

tion and it is on record that his charming ways enabled him to satisfy his desires without recourse to mercenary means. Two of his loves were deep and lasting, one of them leading to his marriage. Despite domestic happiness with his wife and children, his last decade was darkened by an organic ailment; a year and a half in bed induced a state of continual depression. He doubtless knew its twin sources, for much earlier he had detected the physical role of neurosis, pointed out the large scope of psychosomatic disease, and put a proper value on madness as contributing to genius. He was not the first to do so but he was certainly well qualified for noting it.

Mention was made earlier of Kant's preoccupation in the 1780s with the theoretical basis of natural science (<413). This concern proved so fruit-fully exploited in the next century that it has eclipsed the figure of Kant as ardent disciple of the Enlightenment and sympathizer with the early revolu-tionists. His study of Rousseau com-plemented his philosophe rationalism, and the joint influence inspired his *Plan for Universal Peace.°* With the same hope, a Scottish soldier named John Oswald, who fought in the War of American Independence and was killed in the French Army of the Vendée, was moved to propose a Plan for a Universal Republic, with political democracy and permanent economic equality.

> Enlightenment is humanity's departure from its self-imposed immaturity. This immaturity is self-imposed when its cause is not lack of intelligence but failure of courage to think without someone else's guidance. Dare to know! That is the slogan of Enlightenment.
>
> —KANT (1783)

Another, much younger, idealist who put pen to paper on moral matters during the fin de siècle was a second lieutenant in the French Army named Bonaparte. Although from the petty nobility, as a Corsican he was and felt socially an outsider. He spoke French with an accent at the military schools that he attended and was subjected to ridicule and snobbery. True, he could take comfort in excelling, especially in mathematics, but his first essay at age 16 was appropriately "On Luxury in Military Schools." From then on he pro-duced in 12 years some 40 pieces, a few political and military, called forth by events or his own situation, and the rest ranging from fiction to ethics and social theory. For example: "The Hare, The Hound, and the Huntsman, a Fable"; "On Suicide"; "The Mask of the Prophet, an Arabian Tale"; "New Corsica, a Corsican Tale"; "A Dialogue on Love" (with notes on love and friendship); "Republic or Monarchy?";
an essay on what leads to happiness, for a prize offered by the Academy of Lyon; and *Clisson and Eugénie,* a novel.

This last is known only through a set of notes, but these show narrative skill and grasp of character. Its genesis

> Buonaparte is of a middle size, rather slim, of a tawny complexion, and there is nothing particular in his appearance, except his black eyes, which are extremely brilliant and habit-ually fixed on the ground.
>
> —*THE TIMES* OF LONDON (AUG. 4, 1797)

has been plausibly assigned to his wholehearted love for Désirée-Eugénie Clary to whom he became engaged, although some scholars date it earlier. If the later time is correct, as the heroine's name strongly suggests, the romance in the style of Rousseau's *Nouvelle Héloïse* coincides with critical events in the young soldier's life and embodies some of them. As a Jacobin he had been under house arrest after the fall of Robespierre. Soon released, he was given a brigade to command in the war against the Vendée peasants; he found this inglorious and refused to join his troops. Having thus defied the minister of war, he was discharged from the army. Unemployed, killing time in the Bibliothèque Nationale or at the theater, he was in deep gloom and contemplated suicide. But an emergency, the violent outbreak of October 1795 in Paris, recalled him to the ranks. The demands of his career broke his engagement to Mlle Clary. Six months later he was head of the Army of Italy.

Success there made Bonaparte foremost among generals, and after further prowess, he undertook another adventure, which might be called

With the Brain Trust in Egypt

It is not surprising—but it is shameful—that an unprecedented enterprise by occidentals that was mighty in size and in cultural consequences has remained virtually unknown to the educated in the western world. Most histories and biographies, if they mention it at all, give it a few lines that associate it with Bonaparte's military failure and not with his cultural success. The subject that has been ignored is the expedition of French scholars, scientists, and artists to Egypt in the year 1798. It is a forgotten troop indeed: 167 men of high qualifications, plucked from schools, studios, and laboratories, pursuant to the order of the French government and led by General Bonaparte. The original idea was Talleyrand's.

The government, Bonaparte, and the *savants* (as the group was called by the accompanying Army of the Orient) each had a different purpose in mind. The government (the short-lived Directory) wanted to hold at a distance the young general whose victories in Italy had made him popular. Bonaparte thought that glory beckoned to him as the founder of an empire in the East: if he won India, England would be weakened and he could be a second Alexander. The path was through Egypt. As for the savants, what they wanted was new knowledge and possibly adventure.

Their average age was 25. The oldest, the mathematician Monge, whom Bonaparte had befriended, was twice that age, and he shared with his friend Berthollet, a chemist, the lead in most operations. The youngest, not quite 15, was one of a half dozen students from the Polytechnic School, with as many again of its faculty and 33 of its alumni. The rest were: physicists, chemists, engineers, botanists and zoologists, geologists, physicians and pharmacolo-

gists, architects, painters, poets, musicians (one of them a musicologist), and a master printer on the supporting staff. Of those invited only two scientists and four artists refused, pleading age and family obligations. Many tried to be taken on, though not one among the 167 (or in the army) knew where "in the Orient" the group was bound for. Secrecy until the landing itself was imperative: Nelson with the English fleet patrolled the Mediterranean.

Would the brilliant mathematician Sophie Germain have been of the group had she been old enough? In principle, no women were to form part of the expedition, but some smuggled themselves in, disguised as men, and the troops took on female food servers and nurses. The sailors as usual had the help of young boys for odd jobs.

The organization was splendidly encyclopedic. Besides an amount of supplies and equipment that could have set up a town, the ships carried the scientific instruments used in each of the mechanical arts and the sciences; two whole printing presses with Greek, Arabic, and other fonts, materials for writing, drawing, and painting; and 500 works of reference. In May 1798, Toulon harbor was a forest of masts: 15 ships of the line, a dozen frigates, plus brigs, avisos, tartans—in all 300 vessels, to be joined in Corsica by three other convoys, to transport 38,000 troops and 10,000 civilians. The army numbered more officers than usual, especially generals.

Of the savants, those who were graded as "generals" included authorities such as Dolomieu (the geologist for whom the Dolomite mountains were later named), Fourier (physicist and mathematician), Conté (chemist), Geoffroy Saint-Hilaire (zoologist), Quesnot (astronomer), Larrey and Desgenette (physicians), Lancret (surgeon), Le Père (engineer), Redouté (flower painter), Villoteau (musician). There were two pairs of brothers and one of father and son. No Egyptologist on the outgoing trip, many returning.

The repeated, painful vicissitudes of the journey were many and beyond full recording. For the savants the trip meant roughing it. The soldiers resented them and showed their contempt; the generals did not. The armada escaped Nelson and captured Malta without trouble, Bonaparte showed there his ability to rule and reform. He abolished slavery and overhauled the administration, finances, and educational system. Landing in Egypt—for now all knew their destination—was another thing altogether. Nelson ventured into the safe haven where the French fleet lay and sank several ships with loss of soldiers and sailors but not of savants.

From this moment on, the learned corps was repeatedly exposed to pitched battles and violent native revolts. Possibly worse was the torture of the many long treks through the desert in various directions, with fatigue, thirst, sunstroke, sand blindness, and the jibes of the soldiery as the price of scientific findings and amazing discoveries. Not the least of these, for the historian, is that these men, freshly out of their laboratories and studios and

classrooms, turned themselves overnight into soldiers on the firing line, builders of fortified places, governors of occupied villages, excavators of ruins, and makers of machinery with unfamiliar materials. The savants' courage was equaled only by their versatility. Conté, a chemist and a painter, invented a new kind of pump, made pencils without graphite, improved the gears of water mills, and found a way to reproduce color drawings—this, 10 years before lithography—all of it in response to Egyptian predicaments. Nectoux, a botanist, studied the agriculture and habits of the fellahin, the native peasants. The mathematician Monge worked out the peculiar hydraulics of Moses' Fountain. Le Père, an army engineer, built a stairway and terrace for the palace that Bonaparte appropriated as his headquarters. Fourier shuttled between differential equations and presiding at trials in an improvised, necessary court. Marcel, an Arabist, became the publisher of the journal issued every ten days, which contained the reports of the learned at intervals and, more frequently, news for the troops. The surgeon Larrey took anthropological notes on the mixed population—Egyptian, Turk, Armenian, Greek, Jewish, and Bedouin. When mummies were found he studied embalming. At the onset of bubonic plague and typhoid the astronomers turned meteorologists to help the physicians predict wind and weather. Science conquers all.

So it went. The official program of the expedition was: (1) To study all of Egypt; (2) to spread enlightened ideas and habits; and (3) to furnish the government any information it might require. Duties 1 and 3 were abundantly fulfilled and 2 moderately so. The native population was not at all impressed by the machines and techniques. What they marveled at was that so many foreigners studied Arabic and dashed about the desert for silly reasons. The people of Cairo, the capital numbering 200,000 inhabitants, submitted to having the main streets swept twice a day and the garbage removed. They were shocked by the women's unveiled faces, a little less by having their own appearance sketched in pencil, but horrified when color was applied to the portrait, which made it an aid to witchcraft.

On their side, the westerners were delighted by the sights, the mode of life, and the people, whom after a few months they came to think of as French. This has been a (very un-English) characteristic of the French colonists everywhere. In Egypt they tolerated all but the unsanitary practices, they took native mistresses (one general married a Muslim wife and was converted), and they studied native mores without condescension. Villoteau the musician was at first repelled by the several musics of the different peoples; he came to enjoy and distinguish their merits and share the emotions they were meant to arouse. In the survey of diseases the physician Desgenette told his aides to pay close attention to popular medicine—"superstitions may teach us something useful." Except for this last piece of wisdom, the perfor-

mance and the attitudes of the corps of savants could be called the Enlightenment in action.

Bonaparte was its prime interpreter. He suggested, organized, criticized, and inspired. He set up at once an Institute patterned on the home academies (<432); he was, it will be remembered, a member of its scientific branch. In Egypt, Monge was named its president and Bonaparte vice president, to succeed the president in three months. The members discussed papers written on the spot as data and discoveries were gathered in. When approved, they went past Nelson's watch, together with everybody's letters to the family. Even at leisure in his palace Bonaparte made ideas into entertainment. A small company would be divided into two sides to debate prepared questions in philosophy, government, religion, or ethics.

To give an adequate idea of what this brain trust, the first and largest of its kind, achieved in 20 months is impossible in a few pages or yet a book. The *Description of Egypt* fills 20 volumes of mega-elephant size—approximately 54 inches by 28.° The reason for this format was to make the plates of the Egyptian monuments—one in particular (446>)—illustrative in the utmost detail. Egypt was mapped in 47 plates. Publication, begun after the return to France, was laborious and took a quarter century. The royalties were to benefit the authors, most of whom were then by current standards old men, and not a few were dead. There had been only a handful of casualties during the expedition, the most damaging being the assassination of General Kléber after he had succeeded Bonaparte as chief.

On the joint epitaph of the 167, so to speak, one could inscribe the following items. They gathered all the fauna and flora within reach, found new species, filled gaps in the known ones. Geoffroy Saint-Hilaire was the indefatigable searcher and his collection of fishes and mammals played a decisive part in forming his ideas of evolution and those of Lamarck after him (455>). In chemistry, geology, geography, and mathematics, a number of important advances were made, thanks to new facts supplied by the Egyptian environment. To give but one example, Berthollet proved wrong the notion of affinity in chemistry by studying sodium and magnesium carbonates which are found ready made in Egypt, and he proposed a better hypothesis. The ancient civilization of Egypt was laid open for further study. At first, the explorers reared on Greco-Roman sights found barbaric the Sphinx and the Pyramids, but the Valley of the Kings, the sarcophagi, the mummies—one with a papyrus in her hand—the bas reliefs, the zodiac on the temple ceiling, won their unreserved admiration. They measured, made architectural plans, and inferred history and religion from the vestiges. The unresting pencil of Vivant Denon drew everything and everybody, alive or dead, and the panels of hieroglyphics besides.

When the big block of black granite was found at Rosetta, where the sol-

diers were clearing the ground for defensive earthworks and where that stone had no reason to be, the savants' jubilation was at its height: it bore three texts, one in hieroglyphics, one in demotic (Egyptian cursive for common use), and one in Greek; it promised the decipherment of the Egyptian language. This was done 20 years later by the independent but combined work of two stay-at-homes named Champollion and Thomas Young. In the *Description* volume, the picture of the stone is life size. In the British Museum, where the stone reposes, the caption reads: "Captured by the British Army (1801)," which is literally correct. Adding "from the retreating French army in Egypt" would fit the facts still better.

Egyptian society, government, law, religion, economy, and techne were surveyed as statistically as conditions permitted, a by-product having been to extend social services and amenities in Cairo and elsewhere, notably, 19 hospitals and an ambulance service based on the local common carrier, the camel. For themselves, the savants established baths, a theater and dance hall, and reading rooms, to all of which no doubt the elite of Cairo (men only) had access. Bonaparte had insisted that the native notables were his friends and the populace his people—was he not the most devout worshipper of Allah?

Another survey, literal this time, was also undertaken and completed for the purpose of carrying out an old idea; or rather, to re-create an old reality: a canal at Suez to link the Red Sea with the Mediterranean. All the topographic measurements were made and the placement of trenches, locks, and the like indicated and ready for use. Money was lacking and the project slumbered until a French consul in Cairo reawakened it in the next generation and the canal (on a different plan) was opened in 1869.

Seventy years earlier the concentration of efforts in all directions was a feat without example; the savants worked like maniacs, not against a deadline, but in part because there was no other object in life, and in part to make the most of a unique opportunity. It was also unique that a large group of intellectuals should be let loose in a country much less advanced in art and science, but with a past highly civilized, "monstrous and sublime." Uncommon too that such a group of civilians should without preparation be plunged into war. And soldiering was not the only ordeal. Both in Egypt and in Syria, where Bonaparte made a disastrous side-campaign, the French troops committed atrocities on a large scale and appalled the gentler breed of men who had to witness the carnage. Not until film and television brought these things into the living room did the like occur. Well before *The Description of Egypt* appeared, Europe learned about the country from the several books published and illustrated by members of the corps. Denon's was the first, at once widely translated and in print through 40 editions. Street names in Paris make up a hit-and-miss record of the expedition.

Bonaparte was the gainer too, though his self-portrait as Alexander the

Great was a mirage. He abandoned his Army of the Orient in Egypt, returning home to dispossess the Directory and make himself First Consul, then Consul for life, then Emperor. The title of consul was to quiet fears by suggesting the Roman Republic, and its aura revived a pseudo-classic style in dress and manners. It was not suitable for the imperial regime that ensued. There being no former style to revive, everything Egyptian seemed ideal to fill the gap. It was massive, severe, and adaptable. The lion's foot claws for chair legs and other Egyptian and Near Eastern motifs inspired designers, and the resulting Empire style enjoyed a longer vogue than the Consular. It included the planting of obelisks in cities here and there. For more lasting effects one must look to the work of administrative reform that Bonaparte accomplished during the Consulate: clear-cut and efficient centralization, coupled with a masterly code of laws that was widely imitated abroad and inherited by the American state of Louisiana.

The Spirit Sinister: **Peace is poor reading. So I back Bonaparte for the reason that he will give pleasure to Posterity.**

—HARDY, *THE DYNASTS* (1903)

* * *

Young Bonaparte's writings before his name emerged did nothing to enrich contemporary literature or to lower further its low quality. Throughout the revolution and for another two decades, belles lettres suffered from politics and patriotism. Verse, playwrighting, fiction reproduced current attitudes and platitudes. Virtue in the fraternal citizen, heroism for liberty and the nation yielded nothing but clichés and melodrama. The plot of Beethoven's *Fidelio* is a fair sample: for upholding the truth Florestan has been imprisoned for two years. The governor of the prison, fearing an imminent inspection by a high official, decides to kill and bury the prisoner for fear he might talk. The latter's wife, disguised as a man, interrupts these proceedings and holds the governor at pistol point just as the Minister of State arrives to deal out justice to all parties. The librettist was reworking the French play *Leonore, or Wedded Love* by Bouilly. The titles of others—*The Day of Marathon, or the Triumph of Liberty; The Return of the National Fleet; The Liberator*—suggest tortured repetitions of one idea for propaganda.

To this dearth of genuine literature and original thought there is only a handful of exceptions: one poet, three novelists, two writers of maxims, a psychologist, and a gastronomer. André Chénier, who died on the scaffold at 32, was a true poet. His works, when published for the first time in 1819, were found to herald a rebirth of lyrical and elegiac poetry, together with some of the technical innovations of the Romanticists soon to appear on the scene.

The first of the two writers of fiction, the Comte (often called Marquis) de Sade was in his day considered by turns mad and criminal and spent a good

part of his life in jail and insane asylums. This is one cause of his appeal to our time. Between then and now, his name has served psychiatry to designate the addiction to cruelty for enhancing sexual pleasure: a sadist does not simply enjoy inflicting pain; he is a blender of ecstasies. De Sade repeatedly hired prostitutes (or abducted boys and girls) to take part in orgies of his devising and was then denounced by some of the abused. Getting married did not stop his entertainments; rather, his wife took part in the carnivals. Incarceration, when it came, gave him the leisure to write. His novels—*120 Days of Sodom, Justine, Juliette,* and his other writings—gave promotional descriptions of his practices. These were meant not merely to popularize the varieties of sexual experience but to emancipate everybody from the conventional taboos—and this in the name of scientific truth: an unfinished manuscript, burned by his heirs, bore the title *Nature Revealed.*

As to De Sade's literary art, there is no doubt that he had a gift for graphic narrative and picturesque detail. He had inventiveness, wit, and a modern sort of irony in his matter-of-factness: "When calm had been restored, they buried the two bodies." It is logical that this century's taste for aberrations, which it sees as a norm previously obscured by prejudice, have made of De Sade's doings and writings "an important moment in the history of ideas and of literature."° The 20C German play by Peter Weiss known in English as *Marat-Sade* (also a film) brings together faithfully two figures from the revolutionary period in whom we recognize some of our own celebrities.

De Sade's little-known contemporary Restif de la Bretonne also intended his novels, essays, and diaries to qualify as "nature revealed." He was a peasant from Lower Burgundy named Restif (without the *de* and attachments), who received a good education at a Jansenist grammar-school, and managed in his 72 years to produce 240 volumes—16 of them his autobiography. Ten were devoted to his father's life, 42 to portraying the women of his day, the remainder filled with anecdotes and observations: in all upwards of 1,500 stories, fictional or partly true.

In this effort to tell all, his motive was to complement Rousseau, who had (Restif said) shown forth the man of ideas, the genius. The thoughts and acts of the common man were now in order. If Paul Valéry is to be believed, Restif is superior to Rousseau. But if one is not dazzled by the relentless sociological "research," one will grant Restif only intermittent genius. He was indeed "modern" in his preoccupations—in being pedantic, a fact-grubber subject to paranoid anxiety, a severe critic of cities, and in always thinking of sexual matters. He was vain about his record: he itemized 700 liaisons (12 of them before the age of 15) and a score of illegitimate children before his majority.

He has been compared to Casanova, whose first installment of amorous adventure came out when Restif was at the peak of his own literary production. But the similarity in seduction is numerical only. Casanova had a winning

appearance; Restif was short, thick, dark of face, with a hook nose and brilliant black eyes, not always clean, prone to rage and verbal obscenities—by no means the common man that he wanted to portray. His obsessions included perambulating at night and writing graffiti on walls to mark dates in his life so that he might return on anniversaries and compare his earlier feelings with the present ones. He haunted dance halls and other places favored by transvestites; intruded somehow on a man of title to take down the list and kind of amours the nobleman could remember; spoke at a dinner of lords and ladies presided over by Talleyrand and all wearing masks, and told them how women should dress: tight at the waist to lift the bust and wearing high heels "to sylphidize the leg."

In everything Restif did and wrote he aimed at moral reform. For example, in *The Pornographer* (he is said to have invented the word) he meant the sociology of prostitution and he told how to abate its evils. The book was one of his series of "-graphers" on large issues. A good many of his reforms have been adopted, but not as a result of his exposés. The same is true of his literary style, which has been credited also as a kind of reform. Restif wrote carelessly and often very badly, mixing sentimental rhetoric with a terseness that suggests the prose of Hemingway but is not artful; it soon becomes tedious. What was original was Restif's mode of composition: he set up his text in type direct from his bubbling cauldron of ideas. This touch only heightens the picture of a tireless and eccentric spectator of an age in its decadence. [The book to read is *Paris Nights* by Restif de la Bretonne.]°

> I was walking along the rue Dauphine. [then three lines of sentimental cant] A man was knocked down. People shouted "Stop!" The coachman, a heartless brute—the guilty coachman cracked his detestable whip to get away. The wheel rolled over the wretched man's chest. [three more lines of rant] A gush of blood. The carriage vanished. My former agility is gone. I could not catch up with it [pitiful tale of girl bystander: it's her father]. The man died at midnight.
>
> —RESTIF DE LA BRETONNE, *PARIS NIGHTS* (1794)

After reading Restif, one is willing to believe in the reality of the incredible yet real-life character, Vidocq. He told his own life and Balzac made good use of it in creating his Vautrin, the first criminal mastermind in fiction.° Vidocq is also the prototype of the double agent. He started life as a criminal, served time as a galley slave, organized some less-gifted colleagues into an efficient robber band, and then turned policeman. But this was no crude one-time betrayal for gain or safety. It was the vision of a new calling, which produced a security force largely made up of the best experts, criminals themselves. Vidocq saw to it that they were adept at the *savate*, the street fighting that uses legs and feet and is now enjoying a renaissance in France. His recruits proved as efficient in their new role as they had been in the old. [The book to read is *The Memoirs* (probably ghost-written) in the one-volume English translation.]° When Vidocq

retired, very well off and in high repute, he lost his fortune through another good deed: he staffed a factory with ex-convicts.

A writer of novels and social criticism whose work differs radically from that of the pair just discussed was the daughter of Louis XVI's last minister of finance, the Swiss Jacques Necker. Married early to a Swedish baron, but separated from him for most of her life in letters, she nonetheless wrote and published under her married name and is known as

Germaine de Staël

She began early, with essays on Rousseau, on fiction, and on happiness. Next came the novel *Delphine*, in which the heroine may be called a prototype of the New Woman, superior in mind and willpower and thereby feeling isolated. The theme recurs in *Corinne,* years later, with an added element that must be credited with a share in the enormous influence that Mme de Staël exerted on her contemporaries.° Readers who would have shown their respect for her other works by not going near them, read this second novel and discovered in it that life could be molded by something missing from their 18C life of reason: the sensuous and aesthetic. The story itself is of little moment and the prose not the author's best, but the idea clearly conveyed is that art and the *quality* of art matter in a new way: they modify the inner being and thereby society. The 19th and 20C religion of art originates in this period and Mme de Staël is, with her contemporary Chateaubriand, one of its prime apostles (467>).

In the interval between the two novels she wrote her first trailblazing work: *Literature Considered in Its Relation to Social Institutions*. To start with the Greeks and hew her way through and beyond the Middle Ages was an ambitious task—600 pages barely sufficed. In the doing she had to bypass all poetry. "Literature" amounted to thought and culture and "institutions" meant manners and morals. Her work launched the dogma that "an artist must be of his own time." The touchstones for high culture are: virtue, liberty, glory, happiness, and religion—how they thrive and to what effect. The concluding section, which elicited the greatest applause, was prophetic: liberty, ever-increasing in extent and power, would bring literature to new heights and thus promote what she called the perfectibility of mankind, meaning the growing store and use of knowledge and perceptions.

Consul Bonaparte admired but did not care for Germaine de Staël: she was a politician. The father whom she idolized had made her as a girl his companion in gatherings with the Encyclopedists. She had chatted with Buffon and Quesnay and Turgot, and forever after she thought and spoke like one of the mentors of the world. Her companion, Benjamin Constant, was a member of the Tribunate, the council that debated proposed laws during the

Consulship, and he led the opposition, making speeches that Bonaparte thought written by his mistress. Her salon too brought together troublesome heads. Three years after her big book, which ended on the note of liberty, she was ordered to move 150 miles from Paris.

She chose to go to Weimar instead, but her father's death shortly took her

In a democratic state, one must be continually on guard against the desire for popularity. It leads to aping the behavior of the worst. And soon people come to think that it is of no use—indeed, it is dangerous—to show too plain a superiority over the multitude which one wants to win over.

—DE STAEL, *ON LITERATURE AND SOCIETY* (1800)

to Coppet, the family homestead in Switzerland. There she wrote his life, then traveled in Italy and, returning loaded with artistic experiences, wrote *Corinne.* A stay in France was soon cut short by order of her enemy, now Emperor of the French. It was a second trip to Germany that provided the substance for her second masterwork, two years in preparation: *On Germany.*

Through Swiss connections she had known something of German life and literature; visits to Frankfort, Munich, Berlin, and again to Weimar completed her acquaintance with the varied regions of the country. She interviewed aggressively Goethe and Schiller, Wieland, the Schlegel brothers, and anybody else who might supply facts or enable her to judge attitudes. Her book was a revelation to Europe of a hardly known culture. True, her portrayal of the German people as slow-moving, musical, and pensive; more interested in ideas than in action and in tomes than in salons, was not new. But the names and works of the poets and playwrights, the system of the philosophers, the love of nature, the shades of piety, and the depths of the moral conscience, were new topics presented with amazing vivacity and fullness of detail.

In this way two novel conceptions were introduced to the mind of Europe that modified it permanently. One was that German culture grew out of the chivalric ideal and its literature. In this light, the Middle Ages, far from barbaric, appeared a true civilization. The other novelty was the sharp contrast between "classical" and "romantic," not alone in poetry, but also in feeling and taste. The classical is descended from the pagan Roman past, dominant in southern Europe; the romantic from the knightly and Christian world of the North. This explanation will not stand a second look, since the chivalric literature was created by the troubadours, whose origin and very name are Provençal (<233). But no matter: Mme de Staël fashioned one of the great clichés in the history of ideas. She charged it with productive energy by her praise of two previously reproved human traits: enthusiasm and imagination.

On Germany, the physical book, was nearly obliterated. The French censorship saw no harm in it except here and there and would have passed it with few alterations, but the minister of police, no doubt reading his master's

mind, ordered all 10,000 copies seized and destroyed, manuscripts and proofs likewise if any were found. One escaped and a fresh edition came out in England, with resounding success. Her praise of Shakespeare (with the usual reservations) pleased his scattered English and German boosters, and so did her remarks about the "sterile literature" of the French.

During her last half dozen years, Mme de Staël, hitherto content with sequential liaisons, married a young Italian, visited Austria, Russia, and Sweden; then England, where her interrogations petrified most of the writers she interviewed; traveled again in Italy, and after Waterloo returned to France. There, one year before her death, she married once more, this time into the celebrated De Broglie family. She finished some *Considerations on the French Revolution,* and although partly paralyzed, resumed presiding over a salon.

<p style="text-align:center">*
* *</p>

A pair of moralists who expressed themselves in maxims, Chamfort and Joubert, are not well enough known to be widely enjoyed and appreciated, regrettably. The former, who committed suicide in prison to foil the guillotine, had been a good republican and patriot before his arrest and was known for his sayings in the astringent vein. Even more persistently than Swift or La Rochefoucauld (<349), Chamfort views men acting en masse as hateful or contemptible. As in Swift, it is affection for individuals that prompts the revulsion (<323).

As for Joubert, who survived the Terror to become one of the most sought-after conversationalists of the ensuing two decades, he is less biting than Chamfort but an equally keen observer. His epigrams do not attack but explain and advise. Needless to say, both aphorists are masters of the art of condensing thought and are proportionably difficult to translate.

> Any man aged forty who is not a misanthrope has never loved mankind./A man of integrity is but one species of humanity./The public, the public—how many fools does it take to make a public?/Love as we know it in society is only the exchange of two fantasies and the contact of two surfaces of skin.
>
> —CHAMFORT

> In taking a wife, choose only the one you would choose as a friend if she were a man./If you want to be heard by the public, which is deaf, speak in a lower voice./When one writes with ease one always thinks oneself more talented than one really is./When one of my friends is one-eyed I look at him only in profile.
>
> —JOUBERT

The systematic psychologist of the period was Destutt de Tracy who, with a physician named Cabanis, inspired a small group of thinkers known as Idéologues. The term has none of the modern connotations; it means specialists of the idea, the mind, hence psychologists. Their innovation, related to

the medical advances noted earlier (<437), was to study the diseased mind in order to learn how the healthy think. Because they studied brain and nerve function and the bond between the senses of the thinker and his thought, their findings displeased Napoleon. He needed the support of pope and church and so had to condemn their "materialism." They were not exiled but worked under a cloud. Nor were they totally unnoticed: Stendhal regarded himself as a disciple, and in his novels and other works (476>), applied Destutt's view of the driving forces in human purpose.

The Idéologues, Restif, De Sade, Germaine de Staël, and the two authors of moral maxims all bear witness through their work to the growing scope of SELF-CONSCIOUSNESS. Goethe, also of their time, was alarmed by its spread and wondered how far it would go and do damage to spontaneity in art and human relations. The con-

> A deep analysis of our memories shows why it has been thought necessary to see two essentially different things in *feeling* and *thinking,* also called the *mind* and the *heart.* Actually, this is a superficial conclusion. There is no difference between these two kinds of perception, except a degree more or less of energy and vividness: both are alike *feeling.*
>
> —DESTUTT DE TRACY, *ELEMENTS OF IDEOLOGY* (1817)

scious mind is not continually self-conscious: Socrates had to insist upon his "know thyself." The medieval church, requiring confession of sins, made frequent self-survey unavoidable, and from the Reformation onward a new intensity of religious feeling imposed the question: "is my soul destined for salvation?" The search for an answer could be excruciating and take years, as Luther and Bunyan told the world. But the effort had a definite range and purpose, whereas secular self-consciousness knows no limits and rarely has a stated goal; it is exploration without end and can become paralyzing (785>).

It is in fact the parallel to the scientists' delving into nature, their method of analysis turned upon the inner world. But unlike the scientific, the addiction lacks a test of truth. The laboratory worker's imagination may frame a hundred notions and by experiment settle on one. The lay imagination retains its hundred and utters them, letting them take their chance in the people's minds. The plausible, the picturesque are taken as truths, influence conduct, and generate fears.

Should it be said that the philosopher of gourmet cookery, Brillat-Savarin, also contributed to a harmful self-consciousness? His meditations (as he called them) on the makeup of dishes and the savoring of meals took place during the Revolution and Empire but appeared, published at his own expense, a decade later. That it escaped translation into English for a hundred years says something about English and French *Weltanschauungen.*° The *Physiology of Taste* is not the work of a fanatic; it digresses pleasantly from its proper subject to a variety of others—"Of Corpulence," "Napoleon," "Of

Animals feed, man eats; wise men alone know *how* to eat.

The discovery of a new dish does more for humanity than the discovery of a new star.

Dessert without cheese is like a pretty girl with only one eye.

—Brillat-Savarin, *Meditations* (1825)

Sleep" that reveal a cultivated man who was primarily a jurist. Except for cookery he lived in a time not suited to his nature. During the Terror he had to take refuge in Switzerland and, briefly, in the United States.

The word *physiology* in the title appears significant if we recall the main concern of the new medicine, but the book discusses only the art, not the science of nutrition. The "scientific" title had become common for other uses; Balzac's *Physiology of Marriage* was one among a hundred others on different topics. An earlier period had used *anatomy* in the same sense.

What made Brillat-Savarin's work timely was that it coincided with an epoch in the history of cuisine. Cookery was being regarded as a minor art deserving serious—indeed learned—attention and it was producing a large technical literature. Its authors were practitioners who earned princely salaries in the courts and wealthy bourgeois houses of Europe. When Napoleon put on his crown, the leading authority and performer was Marie-Antoine Carême, who made 196 French soups and 103 of foreign birth. He took notes on every change he made in the preparation of every dish and published virtually a whole library of texts, culminating in *The Imperial Pastryman*. If names affect destinies, his presents a puzzle, for it means Lent.

As for the principle of French cuisine, it is not what many suppose—that every food is but a vehicle for a fancy sauce. As remarked earlier, it is that cooking should bring out the taste peculiar to each, sometimes directly by seasoning, sometimes by contrast with that of the sauce. There are other excellent ways of preparing food, notably the plain French called *cuisine bourgeoise* and the plain English, unjustly derided on the basis of the low standard widely tolerated, which is a social not a culinary deficiency.°

Brillat-Savarin's meditation entitled "Sojourn in America" is six lines of dots. He evidently agreed with Talleyrand, the unfrocked bishop and nobleman, revolutionist, Bonapartist, and royalist—a man for all regimes—who is reported to have said that nobody could imagine how sweet life could be who had not lived during the last years of the monarchy. Allowing for the distorting effect of the violent years that ensued, one can agree with him that the time was a *belle époque*. Ideas were excitingly bold, amours and conversation were perfected arts, manners could be exquisite, and the very awareness that the institutions of government were stalled produced a sense of coasting which is pleasant while it lasts. When decadence is not anxious, it is the best of times, as Dickens perceived and put on record at the opening of *A Tale of Two Cities*. Two years before the calling of the Estates General, the upper

orders had a chance to save the situation and refused. It seems significant that the admirable precept *noblesse oblige* was never uttered until the noblesse had become a thing of the past.°

*
* *

While physiology was progressing by experiment and redirecting psychology, searchers in a cognate domain were advancing a bold hypothesis based on the comparative study of animal forms: evolution. It will be recalled that in the mid-18C Buffon had drawn attention to the structural similarity among mammals and by cautious hints had cast doubt on the biblical account of separate creations (<376). On the eve of the 19th, his direct successor Lamarck proposed an explanation for the natural emergence of species—the use and disuse of organs for adaptation. What is remarkable, across the Channel the botanist and poet Erasmus Darwin, grandfather of the famed Charles, published a two-volume work° also expounding evolution and stressing the perpetual struggle among creatures.

The two theorists quite independently agreed on the central fact of evolution; they differed as to its means; or, more exactly, as to the application of the means. Lamarck posited that environmental conditions caused the animal to change its functions and hence its form. These changes, he believed, were inherited, thus producing in time a different species. The elder Darwin inferred on the part of the creature a will to change and adapt itself to the outer world. The rule of life, said Darwin, was eat or be eaten. Changes of characteristics making new species—evolution—would result either way, the Lamarckian or the Darwinian. When Charles Darwin came to read his grandfather's book, well after the publication of his own, he exclaimed: "whole chapters are laughably like mine."

Many cognate things happened in science during the years that separate the two Darwins (502>). One of the earliest was that geology underwent revision, and it was in a summary of the new view by Lyell that Charles (still ignoring his grandfather's work) found a precis of Lamarck's theory; found, that is, the idea of evolution. It awoke in him the desire to ascertain the means by which it took place (570>). The reason Lyell brought the zoologist Lamarck into geology was to buttress by a parallel his own demonstration that the earth also had evolved.

Now Lyell and his young reader Charles Darwin belong to the 1830s. To see things in proper perspective, one must go back a little and note that the geologist Hutton, disregarding the Bible, had told an unbelieving world how the earth had changed through the ages; how its rocks had risen from the sea, molded by natural forces still at work. He described the cyclical process so exactly that today he is the acknowledged founder of scientific geology. But

the acceptance of his two-volume *Theory of the Earth* took a generation. Lyell shines in the younger Darwin's glory while Hutton, with Lamarck and Erasmus Darwin, remains one of the troop.

It is chronologically in order to add here a word about a pseudo science, because its sequels had lasting and dire consequences. A little before the French Revolution a Swiss pastor named Lavater, published a treatise on physiognomy—the face taken as a clue to character. Two reputable anatomists went to work in hospitals and asylums and shifted the hypothesis from the features of the face to the bumps and hollows of the skull. This they called phrenology (= "brain science"). It became a worldwide superstition, popular in part because it could be turned into a kind of parlor game. At the same time it was the means of a comfortable livelihood for the "professors" consulted by people who took it seriously. Manuals for home use had the citizenry palpating one another's scalps and delivering irreversible verdicts about character and prospects (503>).

Never popular, another kind of science—economics—numbered at this time a forgotten pioneer: Simonde de Sismondi. He was a Swiss, a man of means, and a member of Mme de Staël's circle. To scholars he is known as a voluminous historian of the Italian republics in the Middle Ages and the early literature of southern Europe. But he also wrote four works of political economy that are of more than historical interest. Adam Smith's *Wealth of Nations* had set forth in concrete detail, in the year of the Declaration of Independence, the 18C principles of laissez-faire—the free market as regulator of supply and demand—"liberal economics" is the name of the doctrine. Politically, it dictated that government should scrap mercantilism and no longer interfere with the market mechanism. Sismondi, also a believer in liberty, at first promoted Smith's ideas, relating them to some of his own about population and constitutional government.

But he also urged factual observation in what he was the first to call "the social sciences"; and when the *Encyclopedia Britannica* asked him for an article on political economy, further thought and documentation led him to question the validity of liberal economics. He thus became the first, and for a time the only, heretic among Smith's disciples, the founders of the system. It testifies to his suavity in debate that he retained their friendship and high esteem.

Sismondi had visited England and had been struck by the misery resulting from industrial progress. Why did the seemingly beneficial production of

What is the object of human society? Is it to dazzle the eye with an immense production of useful and elegant things? Is it to cover the sea with ships and the earth with railways? Is it, finally, to give two or three individuals out of each 100,000 the power to dispose of wealth that would suffice to maintain in comfort those 100,000?

—SISMONDI, *STUDIES IN POLITICAL ECONOMY* (1818–36)

goods by machinery bring on "poverty in the midst of plenty"? The answer was: free competition keeps wages low, free enterprise makes for overproduction, which leads to recurrent "crises"—shutdowns or failures entailing unemployment and starvation.

His detailed criticism of the new society includes the observation that it splits labor from capital and makes them enemies, with the power all on one side. The idea of their "bargaining" over wages is absurd. Tyrant and victim describes the relation, yet without cruel intent of the one or knowledge by the other of who his oppressor is. Again, with overproduction the capitalist must seek foreign markets and precipitate national wars, while at home a class struggle goes on without end: "the poor could say that the employer's life is their death, and therefore his death would be their life."° But Sismondi does not urge revolutionary massacre. What is needed is protective legislation.

Sismondi does not oppose machinery; he rejects the idea that the economic situation is the inevitable effect of a law of nature, as the orthodox then affirmed. He saw the evils as the result of social and legal arrangements that could be changed. And he instances the guild system, of which one advantage was prudence in procreation. For the modern worker population Sismondi coined the term *proletariat,* from the class of *proletarii* (from *proles,* Latin for offspring) the lowest class in ancient Rome. To give one more sample of Sismondi's perceptiveness: he pointed out that the combination of capital and labor under existing conditions increased the value of each and produced a *mieux-valeur* [*sic*]. This is close to the *Mehrwert* by which Marx demonstrated that labor was exploited (588>). Sismondi's critique of political economy dates from 1818, the year of Marx's birth.

*
* *

Although the Encyclopedists were in no sense democrats, inequality and its evils had been one of their concerns. The revolution ostensibly cured it by the Declaration of the Rights of Man. But did Man include women as it does in other contexts? (<82) One vehement and articulate woman thought not and she undertook to make it so in the simplest way: she wrote a Declaration of Women's Rights, matching the other, point for point, and in full detail.

Olympe de Gouges was illegitimate, married at 16, and left a widow with a large fortune within a few weeks. This backing heightened the independent temper that caused her discredit through undignified behavior as well as through affairs. She tried to write plays, unsuccessfully, and ended

Men! Are you capable of justice? It is a woman who asks the question. At least you cannot deprive her of that right. Tell me, who has given you the sovereign power to oppress my sex? Your strength? Your talents?

—OLYMPE DE GOUGES, *THE RIGHTS OF WOMAN* (1790)

as a lobbyist for her two causes, women and the monarchy. She proposed for marriage a single form of contract with reciprocal rights, recourse to the law in cases of seduction and paternity, and of course participation in government. This would ensure making all legislation equal for the sexes. She paid with her life for her championship not of women but of the monarchy.

A second agitator of the period was Théroigne de Méricourt, who organized a corps of women as Amazons. They marched in street protests one breast bared in memory of their ancient predecessors, who were supposed to have mutilated themselves so as to draw the bow in battle. Théroigne is said to have led the march of the women of Paris to Versailles that brought Louis XVI to the capital. She recruited for women's political clubs, addressed the assembly, and was regarded by its leaders as one of them. In a demonstration she was attacked by the mob, perhaps by mistake. Her career ended in the insane ward of the Salpêtrière.°

While these two activists were making their presence felt in Paris, a work of theory was being worked out and published in England. Until fairly recently the name of Mary Wollstonecraft elicited no recognition among well-read people, not even when her married name, Mary Godwin, was appended. Godwin himself has been eclipsed; his is one of those names always listed and ever obscure. His wife's claim to renown is the *Vindication of the Rights of Women.*° She had previously written *A Vindication of the Rights of Men* to refute Burke's book on the French Revolution, and even earlier some *Thoughts on the Education of Daughters.* Her feminism antedates the revolution, her marriage to Godwin being itself a feminist act: they agreed not to live together and preserve independence for their respective work.

The feminist *Vindication* was immediately attacked, because it was seen as part of the revolutionary agitation in Britain—all radicals must be put down. The book did owe something to the French Declaration of Rights and to Tom Paine's *Rights of Man,* but it owed much more to the experiences of its author as a self-supporting woman: Mary Wollstonecraft earned her living as a reader and translator from the French for the publisher Joseph Johnson; his firm was a meeting place for the radicals, and there she was treated as an intellectual equal. She also practiced the right to be as sexually free and initiative as men. A semi-autobiographical novel, *Maria,* unfinished at her death, deals with *The Wrongs of Woman,* which are legal, moral, and emotional.

The *Vindication* is less easy to read. Its force lies in outstanding passages within an ill-organized and repetitive discourse, and this may account for its neglect until the end of the 19C, when feminism was resurgent (696>). But even then it did not greatly fuel the fire, because it lacked rhetorical force and advanced no new arguments to make up for diffuseness. The philosophes had not neglected "the woman question." Almost all were for women's education and many women were even then receiving it, as their writings and

political activity amply prove. Diderot wanted a reform of sexual morality and marriage customs for the benefit of both men and women. Rousseau preached tenderness and respect and pointed out how often in history women called to rule had proved superior to any number of princes. Condorcet showed the logic of giving women all rights equally with men. Restif proposed laws to protect the seduced by giving them a claim on the seducer's property. He argued for divorce on demand against a physically abusive husband, a drunkard, a gambler, or one venereally diseased.

These wide-ranging thoughts make up a sizable literature, and it encountered little or no rebuttal—only hostility from traditionalists. The 19C as a whole did not abandon social concern and the ideal of EMANCIPATION for the oppressed. Rather, it made a choice of some among reforms often proposed and postponed the others, particularly what related to women. One reason was the fear of everything that smacked of "French ideas" (even though most were English as well). Another was that this fear, shared by the rest of Europe, brought about a fusion of containment politics with repressive moralism. This peculiar innovation narrowed down not reforms alone but also art, human relations, and human feelings (551>).

*
* *

In the transition period the graphic arts and music largely escaped the propaganda style that afflicted the theater and the novel, but a mere indication of accomplishments will have to suffice; appropriate detail would fill a book. Fortunately, the music of the period has at last been ably surveyed in recent works.°

Claude Ledoux was an architect imbued with social ideals. He designed buildings for workers in a manner suggestive of the work of Le Corbusier in the 20C, simplifying the neo-classical forms into cubes and cylinders of rough texture and massive size. His originality was evident in many ways: in the theater at Besançon he provided seats for the common people—they would cease to be the groundlings. In Paris, he built for its many gates 50 tollhouses in stupendous geometrical forms, the Portes de Paris. Nearly all were destroyed, the one at La Villette surviving as a token of his genius. He summed up his artistic creed in a treatise whose title, *Architecture in Relation to Art, Manners, and Law,* shows again the awareness of culture—art and society as sparring partners.

Pierre L'Enfant, who had fought as a volunteer in the War of Independence, the man whom President Washington commissioned to design the new capital of the nation, was Ledoux's counterpart. He laid out the city on a plan never seen before, which took account of the uneven ground and permitted indefinite extension. Elsewhere, he built houses on the

large scale within and without, notably the Morris mansion in Philadelphia. Spaciousness was then uncommon, as may be seen in Jefferson's Monticello or Alexander Hamilton's Nevis on the Hudson. The government owed L'Enfant a good round sum, which with characteristic congressional thrift was reduced to a pittance (<404); L'Enfant died penniless.

Some of the painters of that generation showed a corresponding originality. The Swiss Füseli, settled in England because his liberal politics did not suit Zurich, was encouraged by Reynolds, made the usual stay in Italy, and then used his perfected technique to depict nudes in strained postures expressing violent feelings, or else to create fantasies by turns erotic and macabre. His friend Blake felt his influence.

Meanwhile in France, Prud'hon disregarded the classic linear stiffness of David's heroic scenes—the reigning style—and cultivated soft, sensual effects, especially in his portraits of women, whom he endowed with a mysterious appeal rather than a revolutionary militancy. His canvases have turned dark from bad pigments; his many works on paper place him among the great draftsmen. One other artist, Fragonard, is thought of as a poetic painter of 18C scenes and fully of that century in style. But his few late works, done during the revolution, call for another characterization—stark and suggestive of the much later Expressionists (650>).

Two women cultivated the art of portrait painting with conspicuous success: Angelica Kauffmann and Elisabeth Vigée-Lebrun. The first of these also made wall paintings for the elegant English houses designed by Robert Adam. A close friend of Reynolds's, she helped him in founding the Royal Academy of Art and was one of its first members. Much in his late manner, she depicted representatives of the upper classes. Elisabeth Vigée-Lebrun filled the same role, specializing in portraits of women: Marie-Antoinette sat for 25 likenesses. The other 600 (by the artist's own count), she made as she traveled across Europe from palace to palace and expensive town houses. Two of her works show us how Mme de Staël and Byron looked. In effect, this duo of painters were the photographers of the age and as such deserve the credit we give to a Brady or Nadar for pictorial sociology (586>). And the same must be said of the sculptor Nollekens, who made busts of Garrick and Sterne, Pitt and George III, Benjamin West, and Charles James Fox. He belongs with Houdon, whose gallery ranges from Voltaire to George Washington (<391).

Two other sculptors—Canova and Thorvaldsen—were neo-classicists, but with a drive toward life-likeness. Canova was in fact accused of using life masks to give his faces a live aspect. He made a full-length semi-nude statue of Napoleon's sister that she and others regarded as a portrait, despite the mythological label of *Venus Victorious*. Thorvaldsen has lost renown latterly,

but he was in his day the perfect reproducer of the human figure. He is now said to be "cold"; but if the painter David, who is not noticeably warm, is admired for what he aimed at and did, the same indulgence must be granted his two contemporaries. All the while, the American school of painters (<405) was producing masterpieces only lately appreciated.

An identical chiaroscuro effect has kept the musicians of the revolution and the Napoleonic Empire mere names in books. Their pieces for the revolutionary festivals are unknown—it was they who inaugurated outdoor classical music—and their operas and instrumental works are never played. Yet at least three of the revolutionary works, half a dozen of the operas, several overtures, some religious and some chamber music match in quality and in technical importance other works familiar to concert-goers. All it would take to bring Gossec, Méhul, Le Sueur, Boieldieu and one or two others into the charmed circle would be to play their music.

As for the composers of popular music, the revolution saw in its first half year the printing of 116 songs, followed four and five years later by 590 and 701 more. The output dropped to 137 in the half year of the coup d'état; the total: 2,438 in five years. From these a capable mezzo-soprano of our time° has made a selection and shaped it into a semi-staged program that has met with success in various European countries. Among the classical masters of the period, Spontini and Cherubini are perhaps better known than their peers—but not enough. The eager listener today is limited to single recordings; live performances are met by chance.

What did this Paris School (so-called though full of foreigners) accomplish? They sought expressiveness and in their modest way enlarged the means to achieve it: to rich gifts of expressive melody they added chromaticism, dissonance, rhythmic irregularity, and inventive orchestration. They originated the use of pauses—silence—for dramatic effect and placed performers in groups distant from each other for contrast and dialogue, the spatial element, often attributed to certain composers of the electronic age. It was in fact used in the medieval church and later by composers in Venice.

Centering in the Conservatoire, where a number of these composers taught, musical life in Paris was intense. Napoleon favored opera and was a reliable patron; his ballet master Gardel was a true creator of new forms, and Le Sueur, the imperial composer, was a theorist who held original ideas that influenced his best pupil, Berlioz. The whole group received Beethoven's unmixed admiration.

Even in this rapid run-through, it is easy to detect signs of the desires and techniques of Romanticism. The feelings, thoughts, and modes of expression summed up under that period name were already fully conscious in England and Germany during the interregnum when the southern countries were held

It was Beethoven who absorbed the full impact of the French revolutionary [composers]—a fact not always recognized in all its significance by his biographers. After Beethoven we see Weber and—to a lesser degree—Schubert and Mendelssohn accept certain French influences.

—BORIS SCHWARZ, *FRENCH INSTRUMENTAL MUSIC: 1789–1830* (1987)

back by war and censorship. A whole generation there suffered a cultural lag and caught up with the rest of Europe only after another outbreak of fighting for liberty (493>).

In England, the move away from neo-classicism had taken place before the last decade of the century (<409). A striking illustration of it is given in the *Discourses on Painting* by Reynolds. He was the grand old man of the brush and president of the Royal Academy of Art. In 1790 he had for a decade given an annual lecture to its students. In the first ones all his advice supported the established rules and prescribed the ideal of neo-classical balance, serenity, and generality. By 1788 and to the end, he says that there are really no rules: "nature," inspiration, genius are the only guides to making the work live and move the beholder.°

As a further twist in the time warp, it should be noted that the early English Romantic poets—Wordsworth, Coleridge, Blake, and Southey—also belonged, for a time, to the forgotten troop. In 1783, Blake in "To the Muses" ends by saying of contemporary poetry: "The sounds are forced, the notes are few." Some dozen years later, Wordsworth and Coleridge's *Lyrical Ballads* appeared, with a preface-manifesto defining the new art; it exists. But for the public it does not. More than a decade will be needed for recognition and enjoyment. The same delay affected the first generation of Romantics elsewhere. Full appreciation came only after the nations had laid down their arms in 1815.

PART III

From Faust, Part I, to "Nude Descending a Staircase No. 2"

The Work of Mind-and-Heart

CROSS SECTION:
The View from Paris Around 1830

The Mother of Parliaments

Things Ride Mankind

CROSS SECTION:
The View from Chicago Around 1895

A Summit of Energies

The Cubist Decade

The Work of
Mind-and-Heart

AFTER WATERLOO HAD BEEN FOUGHT and Napoleon was at England's mercy, France was occupied by the Allies and the Bourbons were restored to the throne, the Treaty of Vienna was signed, and the victorious powers formed a defensive alliance. The task then facing Europe was twofold: containment of revolution and reconstruction in culture. Each of these dominant concerns had its opponents. Containment was to be achieved by the Russian tsar's Holy or the powers' Quadruple Alliance. But force of arms could serve only against new uprisings after the fact. Some other force was needed as preventive restraint. We shall see later what it was and how it worked (550>).

Meantime, the flood of emotions stirred, the hopes and ideas raised between 1789 and 1815—ideas that were fought for, suppressed, misdirected, or misunderstood during the quarter century—were to be reviewed, adapted to the times, shaped into some kind of order. The outburst against

Captain Sartorius of the Slaney frigate arrived yesterday, confirming all the antecedent accounts of Buonaparte's surrender and his safe conveyance to England. He is, therefore, what we may call, here.

—THE TIMES, LONDON (JULY 25, 1815)

abstract reason and the search for order make up one continuous effort, which has acquired the historical name of Romanticism. What began as a cluster of movements became the spirit of an age. As a result, the name has seemed to some critics unusable because it was attached to disparate sets of facts and tendencies. There is first the galaxy of artists—poets, painters, musicians, and theorists of art and society—an outpouring of genius hard to match in any period for variety and numbers. Then there is the many-sided religious revival that made 18C Deism and atheism look like dry, shallow ways to confront the mystery of the world. Next, Romanticism included political and economic ideas either new or developed forms of earlier views. Finally, there are Romanticist philosophies, morals, and attitudes, scientific innova-

tions, and the rediscovery of certain past periods, thanks to the characteristic discipline of History.

Such are the reasons why Romanticism was not a movement in the ordinary sense of a program adopted by a group, but a state of consciousness exhibiting the divisions found in every age. Hence all attempts to define Romanticism are bound to fail. The critics ask: "What about this element?"— or: "What of the thought of So-and-so?" A respected American historian of ideas° found 18 different Romanticisms, which has suggested dropping the name altogether. That is impossible; the term is there, embedded in history and in a billion books and minds, where it will continue to lead an active life. Like Puritan, it must be retained and—to repeat—shown to be a Zeitgeist and not an ideology. The spirit was inclusive: the liberal Victor Hugo, his reactionary compatriot Joseph de Maistre, the radical Hazlit, his enemies Coleridge and Southey—all are, were, and must be called Romanticists—and not in different degrees but equally. One unifying thought was the altered conception of Man—necessarily altered by the extraordinary experience of a doctrinaire revolution, the spectacle of the self-made master of Europe, and a series of wars waged by nations instead of dynasties.

In the 1820s the Romanticist Stendhal drew a helpful distinction. He said that a Romanticist work was "one meant to give pleasure to us living today, whereas a classicist one was designed to give pleasure to our grandfathers." This does not define Romanticism, but it points to the state of mind and feeling of three generations. Because the 18C—the grandfathers—put their faith in Reason, some have described this difference as "a revolt against reason," a caricature that has tended to vitiate scholarship and criticism ever since. The term *Reason* is ambiguous and ought to be replaced by Intellect. Romanticism said: "Intellect is not enough—which does not exclude intelligence, reason-*ing*. Reason was an 18C passion; the Romanticist passion was for the work of mind-and-heart.

As soon as it is seen that Romanticism was a phenomenon like the Renaissance, the need for a definition disappears. The two periods are alike in their sweep and their wealth of talents, in their inner oppositions and their overarching unity. In that earlier age some were Platonists, others Aristotelians; some had faith, others did without or pretended to have it. Some thought "good letters" the superior art, others that painting was supreme. And a solid clerical phalanx still held to the ideas of the medieval Scholastics, whom the new thought despised (<56). Likewise, the dominant Romanticism faced the ever-present old guard.

Romanticism being relatively near to us, its internal divisions loom larger, more radical than those of the Renaissance. And if one asks why in the face of such divisions, one speaks of unity at all, the answer for all periods is that the ultimate unifying force of an age is its predicaments: the urgent demands, the

obstacles to social peace or progress, the need for new art that Stendhal pointed out—things that alert minds cannot ignore: every living thinker or artist works to fulfill these calls or deny them in some way. The ways differ but converge on the challenge.

There were Romanticists who wanted a king and others a parliament, some were Catholic, others Protestant; some were drawn by the Middle Ages, others by the Orient; some relished poetic prose, others abhorred it. Still others, such as Victor Hugo, passed during a long life from royalism to socialism and from orthodox Catholicism to a creedless but fervent faith like Rousseau's. In poetry, diction varied from the symbolic to the colloquial, as painting did from exuberance to matter-of-fact. The Baroque musical dramas of Bach were revived from long obscurity (<388), while grand opera flourished within conventions of its own.

One obstacle to a dispassionate understanding of Romanticism is the word itself. *Puritan* connotes one thing; *romantic,* a hundred. This is no figure of speech. In a work of my youth, published over fifty years ago, I added to a discussion of the period a sampling of usage in print, ranging from scholarship to advertising—90 small paragraphs, annotated to show from the context what the writer meant by romantic(ism).° No two meanings agreed. Nor were they related in the usual way of many-faceted words. The extremes included: formless and formalistic, erotic and ascetic, unreal and realistic. One statement, about Mazzini, managed in nearby sentences on his role in unifying Italy to qualify it as romantic but not romantic.° This quasi permanent state of affairs calls for a

Digression on a Word

The use of *romantic* in English goes back to the 17C when it was used to denote imagination and inventiveness in storytelling and, soon after, to characterize scenery and paintings. It served as a synonym to *harmonious, picturesque.* At the core of the epithet, obviously, is a proper name: *Rome, Roman.* From the start, the image is many-sided. Centuries after the fall of the empire, the vernacular spoken along the Mediterranean was no longer vulgar Latin but a variable dialect called *roman.* From it came French, Spanish, Italian, and other *romance* languages, still called by that name in academic departments. After a time, *roman* was applied to tales written in that dialect as spoken in southern France.

These tales were often about love and adventure, as contrasted with epic narratives or satires. In French today the word for novel is still *roman,* while in English a *romance* is one kind of novel and by further extension one kind of love affair. On this account *romantic* gets used to denote the blissful state and character of the participants. The next step comes when the affair, the

"Romantic" in my lexicon means unreal, glossed over with a false attractiveness to entrap those who will not see through the gloss to the truth beneath. Advertizing is wholly dependent on romance. So is the position of women in society.

—Carolyn Heilbrun (1986)

romance, has ended unhappily. *Romantic* at that point takes on a clutch of new meanings: illusory, foolish, unreal, incapable of learning from experience, downright stupid—quite as if the previous situation had had no real existence and value while it lasted. Clichés such as "romantic scheme," "incurable romantic" come into circulation and the supposed contrary *realistic* develops into the highest term of praise for a plan, opinion, or action. Yet the contemptuous word retains some of its glamour—indeed, it means glamorous when the travel agent promises "romantic nights" on board ship. Nor do all married couples despise the romance of their youth.

In the last years of the 18C in Germany and England, *Romantic* generated the -ist form to designate those dissatisfied with the neo-classic style and enthusiastic about new forms in art and thought. None of the motley meanings of *romantic* gives any help in understanding that outlook. It is obvious that an age that left scores of masterpieces in every art and original ideas still current cannot have been populated exclusively by men and women weak in judgment and continually lovelorn and subject to illusion. The one link between the temper of the period and the original meaning of the word is that Romanticism validated passion and risk. The two are inevitably connected; but as we shall see, they neither exclude reason, nor overlook the real. On the contrary, the spirit of adventure in Romanticism aims at enlarging experience by exploring the real.

Before coming to particulars, it may be helpful to bring two other words that have the same root as *romantic* and that lead in still other directions. *Romanesque* is the name given to the architecture that departed from the ancient Roman style and preceded the Gothic. In French today *romanesque* refers not to architecture but to the novel—*roman*. It means *novel-like, as in a novel*, and applies to an experience or mode of behavior. All these things being so, clarity might be secured by giving *romantic* and *romanticist* different roles, thus keeping the loose, promiscuous implications of the degraded word apart from the achievements of the first half of the 19C. But this suggestion breaks down where the shorter adjective naturally suits sentence rhythm, or when, in speaking, the -ist noun used as adjective sounds clumsy or affected. A better safeguard is to know Romanticist work at firsthand.

Of course, *classic* and *classical* are also ambiguous, though less so. In Germany, Poland, and Russia, the Romanticists were the first poets and novelists of European reputation. On this account they were soon dubbed the country's classic or classical writers: Goethe and Schiller, Pushkin and Mickiewicz are classical in their respective homelands. But they are not clas-

sicists or neo-classical. Schiller created further confusion by calling all literature since the ancient Greeks and Romans *sentimental*. What he meant was that ancient poetry was spontaneous, direct in its vision, free from any models, and he called it *naive*. Ever after, he pointed out, poets have had to study their own feelings (sentiments) in addition to life itself and the ancients' works besides. Schiller's *sentimental* means modern SELF-CONSCIOUSNESS.

* * *

The span of years when Romanticism was the spirit of the age is roughly the last decade of the 18C and the first half of the 19C. Those 60 years witnessed the work and struggles of three generations, but this work is not chronologically parallel in every country. Germany and England were first in line: the artists and writers born in the 1770s brought out their innovations in the 1790s and early 1800s (Wordsworth, Coleridge, Constable). At that time France, Italy, Spain, and East Central Europe seemed culturally stagnant under the Revolution and Napoleon (<447). The second generation, born around 1800, showed its powers beginning in the 1820s (Pushkin, Lamartine, Delacroix, Emerson), and was the last contingent fully to share the prevailing temper. The next was a broken wave. The talented born around 1810 partake of the original source (Wagner, Liszt, Gautier, Melville), but in their mid-career the world changed and they re-oriented themselves and their beliefs (558>).

Since Romanticism produced much more than art, and the arts were superabundant, the whole panorama cannot fit into a single chapter; it will take three. The present one deals with the revised conception of man and the representation of this new man in the several arts by the pioneers. "The View from Paris Around 1830" will continue the story of artistic production down to the mid-century, coupled with that of philosophy. The theories and institutions of society and the march of science will occupy the chapter after next, "The Mother of Parliaments." To re-enact in the imagination the three-dimensional reality requires thinking in counterpoint to these three linear narratives.

By the end of the story it should appear that the present age is not simply "the heir of the Enlightenment" as many complain or boast; it is also the heir of the age that corrected the Enlightenment's errors and, while adding errors of its own, deepened and amplified all the categories of art and thought. [The small book to read is *Classic, Romantic, and Modern* by Jacques Barzun.]

Behind the first unmistakable Romanticist works stands the thought of four men who by date and upbringing belong to the 18C but were at odds with it: Rousseau, Burke, Kant, and Goethe. Rousseau alive and dead was studied in depth by poets and artists as well as political scientists. What his readers learned from him was that human beings are moved by passion.

What wiser and what juster and what more really merciful law than that man shall not be able to receive into his head what he will not receive into his heart also?

—NEWMAN (1841)

Thought or "reason" is the instrument of desires. It is not their opponent always at war; it chooses ends and the means to fulfill them. To say this is to say that heart-and-mind or mind-and-heart is the single engine of moral, social, and scientific progress. So said Destutt de Tracy (<453). Hume, considered a pure 18C rationalist mind, held exactly the same view. But not having made the point vivid, he is never accused of throwing away reason and giving the loose to impulse. Had the western languages had for mind-and-heart a single word such as the Chinese *hsin* (<202), much futile debate might have been spared.

Man, then, is conceived by Romanticism as a creature that feels and can think. His every thought is charged with some emotion. When this opinion is new in the culture the need is felt to study the ways of mind-and-heart as one force, while giving form to its less conscious stirrings. We may see in the Romanticist image of the *Doppelgänger* a symbol of the two levels that thought traverses (473>). This close attention to the inner life explains the "egotism" and "subjectivity" of Romanticist writers. The poetry of the period is predominantly lyrical—it speaks in the first person to report on its findings within the self. From this search other discoveries follow. The Imagination emerges as a leading faculty, because it conceives things in the round, as they look and feel, not simply as they are conceived in words. Enthusiasm turns from being a dangerous form of folly to the prerequisite of all great deeds. As Goethe's Faust says at the start of his adventure, "In the beginning was not the Word, but the Act." The Word—an abstraction—comes after. Wordsworth, confirming Rousseau, sees in "the feeling Intellect"° the human urge to sympathize with all living things, which reason alone could not arouse.

He who is possessed by these ideas and can communicate his discoveries is the Genius. For the Romanticists and since, the name stands for productive power. One now *is,* a genius, not as formerly "has a genius for"—some activity or other. The genius is an uncommon type of human being and the outward sign that he deserves the title is the scope of his imagination, matched by means adequate to its concrete and lasting expression.

Energy is the only life, and is from the Body; and Reason is the bound or outward circumference of Energy.

—BLAKE (1793)

Inborn like genius, but not limited to the few, religious feeling was validated anew by many Romanticists; and its outgrowth, organized religion, enjoyed a renaissance as one of the indispensable works of mind-and-heart. In every country of Europe, the teachings of the ancestral creeds replaced the abstract propositions of Deism. But it was thanks to a modified orthodoxy,

which relied first on the religious impulse and then in varying degrees on two other emotions characteristic of the time: the love of nature and the respect for history. In Rousseau's *Emile,* the eloquent profession of faith offers Nature—the works of God—as the proof of His existence and attributes. The concrete beauty of nature speaks directly to the receptive mind. And from the same source comes, as we saw, the cult of nature—the love of trees and flowers, gardening for pleasure, bird-watching and camping, and the belief that one must leave the unnatural city at least once a year and restore in the countryside something essential to life.

At the same time nature moves us enjoyably; Byron in his journeyings says: "Mountains are a feeling." The 18C feared them as horribly ugly obstacles to travel and pitied those who resided nearby. For the Romanticists, the vastness of the universe created awe and instilled the sense of man's contradictory nature, powerful and weak, great and wretched, as in Pascal (<219). To find a resting place for one's impulse of love and submission one seeks God through nature or in nature. Spinoza had shown the way (<359). Condemned as an atheist for 150 years, he was now rehabilitated as a "God-intoxicated man"; for he saw the divine as pervading all things and the believer as possessed by "the intellectual love of God." Pantheism was one form of Romanticist faith.

> Call it not vain, they do not err,
> Who say that when the poet dies
> Mute Nature mourns her worshipper,
> And celebrates his obsequies.
>
> —WALTER SCOTT, *THE LAY OF THE LAST MINSTREL* (1805)

The other path, that of history, was taken by the Oxford Movement that revivified the Church of England. Inspired by Newman (later a Catholic and a cardinal), the Tractarians (so-called from their propaganda by means of scores of tracts on single topics) went to the early Christian church fathers to recover beliefs and practices that would restore fervor and concreteness to worship. Asserting that the continuity of tradition made Anglicans catholic with a small *c,* the reformers created the High church segment of the established Church. Their contemporaries in strength of belief, the Methodists, had founded their sect earlier to fulfill the comparable desires of the lower middle classes. They were the first "enthusiasts." In America, a decade of revelations to Joseph Smith led him to found in 1830 the Church of the Latter-Day Saints or Mormons.

Meantime in France an extraordinary work had appeared called *The Genius of Christianity.* The title was an argument in itself. By applying *genius* in the double sense of message and mastery to an institution that was also a revealed religion, the author testified to the greatness of the one and the spiritual truth of the other. That author was the Vicomte René de Chateaubriand, a writer on politics, a historian, a novelist, temporarily a statesman, and ulti-

On the face of it, it seems to me a rather remarkable thing to have found a way, by means of a single hammer stroke, to awaken in one instant in a thousand hearts the same emotion. Considered moreover as harmonious sound, a bell unquestionably possesses a beauty of the first order, that which artists call *grandeur*.

—CHATEAUBRIAND, "OF CHURCH BELLS,"
 THE GENIUS OF CHRISTIANITY (1802)

mately the greatest French memorialist since the Duke of Saint-Simon (<355).

In his thick book about Christianity Chateaubriand unites into an apologia every topic in any way touched by religious feeling: daily life, nature, the inner self, society, government, history, and the arts. The appeal is to every interest, with a strong bias in favor of the aesthetic and visionary. After a résumé of the Christian story and the fitness of the sacraments in the course of life, one finds in the work a succession of brief comments and suggestive links that form a coherent and delightful pilgrimage through such subjects as: astronomy, the Deluge, the earth and living creatures, and birds' nests. Then come patriotism, the conscience, immortality, and Judgment Day. Skipping, one lights on Poetry, and the epics of Dante, Tasso, and Milton; a comparison of Virgil and Racine; Heloïse and Abelard. And later on: history in modern literature, the pagan gods, the saints, angels, and Satan's crew; and still further some contrivances in the fine arts; Hell, Purgatory, and Heaven. Thus is fulfilled the promise of the subtitle: "The Poetic and Moral Beauties of the Christian Religion." The book had an enormous vogue; Chateaubriand had to dash all over France to stop printers who were busy pirating it. This success coincided neatly with Bonaparte's making the Roman Catholic once more the established church. The charm of Chateaubriand's scattered vignettes is gone, but the essence of his argument has continued persuasive; in each generation converts are made by the church's appeal to artistic sensibility.

*

* *

First included in *The Genius of Christianity,* though intended as part of a series of tales, *René* also captured a moment in the rise of Romanticism. It is the story of a youth reared in solitude with a sister who finds that her love for him is a guilty passion. She enters a convent. Horrified, he flees to America, where he unburdens his soul by recounting his life to an Indian chief. They share the cult of nature, and the youth delves into what he calls *le vague des passions,* that is, the troubled state when the passions are strong but unfocused. This mood—also called *mal du siècle*—was apparently widespread, for René had many echoes. Sainte-Beuve said: *René, c'est moi* and Berlioz records a kindred feeling in his *Memoirs.* The melody which opens his *Symphonie Fantastique* and which he composed in adolescence, is undoubtedly another expression of the same emotional uncertainty characteristic of puberty. In Germany

somewhat earlier, this aimlessness had been desperate and violent (<393). All these symptoms remind us that many artists of the period matured very early, not a surprising effect of the unsettled world in which they grew up.

Such conditions predisposed to religion. The pastor Schleiermacher in Germany led the Protestant revival, basing his call for faith on "the autonomy of the religious feeling"—a given in Man, as Rousseau said. The idea of God does not arise from thought or will, but from the inborn sense of dependence, man's weakness felt in the moments of SELF-CONSCIOUSNESS. Granting this premise, one can argue the rationality and utility of particular beliefs, and as in the 16C, Protestantism in the 19th argued the merit of being free of superstition and blind submissiveness. The Romanticist pattern could not be clearer: feeling first, reason giving it form and direction, life the adventure propelled by faith.

In general, the new wave of believers took their creed as consistent with the modern scientific assumption that God has no reason to disturb the laws of nature. But the poets—believers or not—had reasons for respecting superstition. For one thing it offered splendid opportunities for fiction, yielding such masterpieces as Burns's *Tam O'Shanter* and Scott's *Wandering Willie's Tale*. For another, superstition could be regarded as the poetic imagery of the people. In *Faust* two powerful scenes depict Satanic rites that give vent to the dark forces in us and in nature. Superstitions have

> Superstition is the poetry of life. Both invent imaginary beings. Both sense the strangest connections between real, tangible elements—an interplay of sympathies and antipathies. Superstition does no harm to the poet, because he can turn his half-delusions to advantage in a variety of ways.
>
> —GOETHE (1823)

meanings that the Enlightenment forgot or ignored. For example, the German legend of the *Doppelgänger,* the exact double visible at times behind the galloping horseman, represents the second man within us, who can be moral or devilish. Such embodied wisdom was forgotten again until the 1890s, when psychology and anthropology recovered it under the name of myth. And once more it was welcomed and used by poets and storytellers.

What links myth with literature is the Romanticist faculty par excellence, the Imagination. As we saw, the faculty regained respect, but the word remains ambiguous. Coleridge pointed out that it is not mere fancy; little effort is needed to put together in thought bits and pieces of experience—say, a talking animal. To imagine is not to fashion charming make-believe. But it takes imagination to write a fable in which the talking animal satirizes with insight and wit some feature of society. Out of the known or knowable, Imagination connects the remote, reinterprets the familiar, or discovers hidden realities. Being a means of discovery, it must be called "Imagination of the real." Scientific hypotheses perform that same office; they are products of imagination.

This view of the matter explains why to the Romanticists the arts no longer figured as a refined pleasure of the senses, an ornament of civilized existence, but as one form of the deepest possible reflection on life. Shelley, defending his art, declares poets to be the "unacknowledged legislators of the world." The arts convey truths; they are imagination crystallized; and as they transport the soul they reshape the perceptions and possibly the life of the beholder. To perform this feat requires genius, because it is not a mechanical act. To be sure, all art makes use of conventions, but to obey traditional rules and follow set patterns will not achieve that fusion of idea and form which is properly creation. It was Romanticist discussion that made the word *creation* regularly apply to works of art. As mentioned earlier, Shelley thought that Tasso in the 16C had been the first to use it, but that cannot be shown. Note that 19C creation by genius is something rather different from late 20C *creativity* (787>).

These Romanticist words, recharged with meaning, helped to establish the religion of art. That faith served alike those who could and those who could not partake of the revived creeds. To call the passion for art a religion is not a figure of speech or a way of praise. Since the beginning of the 19C, art has been defined again and again by its devotees as "the highest spiritual expression of man." The dictum leaves no room for anything higher and this highest level is that which, for other human beings, is occupied by religion. To 19C worshippers the arts form a treasury of revelations, a body of scriptures; the makers of this spiritual testament are prophets and seers. And to this day the fortunate among them are treated as demigods.

<center>*</center>
<center>* *</center>

As prophets, from the earliest days of the religion, they castigated the society in which they lived. It was sunk in the mire of commerce and industry, activities that blunted the senses, narrowed the mind, killed the imagination. With these tenets the campaign against the middle class had begun. In the coruscating preface to *Mademoiselle de Maupin,* Gautier denounced the materialist view of life that prevails because of trade, sole concern of the bourgeois.

The mark of this contemptible creature is his incapacity to understand and enjoy art—except the academic or sentimental kind. What is more he does not know that genuine art is not a vehicle for moral lessons. It serves its own ends and none outside itself—except to enchant the fit beholder. This is the doctrine of "art for art's sake," usually believed to be a new idea of the 1890s (>617). The philistine was born simultaneously with the start of the

> A novel is not a pair of hand-sewn shoes, a sonnet a patent syringe, or a drama a railroad line, for all of those—not these—are the things that civilize mankind.
>
> —GAUTIER, *MADEMOISELLE DE MAUPIN*

artists' hounding of the bourgeoisie, the class that gave them birth and from which came their best patrons and admirers.

Admiration, it must be said, is not a uniform trait in all periods. A strongly critical one like the Enlightenment disdains the enthusiastic kind, because it suggests gaping at things not understood. Admiring fervor returned with the Romanticists, especially the young, for whom it was a test of imagination. One admires a genius because one has the imagination to see that there is no *mechanism* in him or his work, nothing that can be analyzed and rationalized. Shading upward from admiration is an equally strong passion, caused by the power of love. Its importance might have been deduced from the erotic meaning of *romance,* but its character goes beyond that meaning. Romance is simple, naive, all on one plane of dazzled awareness. Nineteenth-century love repudiated also its 18C conception: a courtly minuet in which both parties knew the steps and found pleasure not only in the goal but also—perhaps more—in the game. Nor was the crude course of the hunter and the hunted acceptable. As with the art of music, the Romanticists insisted that in love the pleasure of the senses was not enough. High significance, the deepest motions of the spirit were of the essence. A book has been written about some famous liaisons of the period under the title *The Love Affair as a Work of Art,°* but its 20C biographical and psychological treatment tends to blur the 19C aspect of things. The Romanticist love affair combines passion with imagination and desire with risk. Passion means suffering and the lover feels that he is possessed. The dark side of nature, the Dionysiac element (Satanic in *Faust*), propels him. But he is also uplifted by celestial emotion on beholding the beauty of the beloved, not solely the physical beauty, but that which derives from harmony achieved between one's nature and one's spirit—what the Germans called the beautiful soul (*schöne Seele*). In that exaltation, the Romanticist further recognized the impetus that produces art.

Goethe in *Faust* called this spur the Eternal feminine. Love begets devotion to the particular being; each seeks to find in the beloved another self, different but equal, especially in emotional and artistic sensibility. The conception had practical results. After Rousseau's *Nouvelle Heloïse,* which Shelley read so assiduously, there was no question among advanced thinkers but that women's education must be as complete as men's and of the same quality. Passing from theory to event, it appears that the artists of the time found many "muses" to inspire them, gifted, heroic, and honored. To name but a few: Caroline Schlegel, Queen Louisa of Prussia, Rachel von Varnhagen, Princess Lieven, Jeanne Récamier, and not the least animating, Germaine de Staël (<450). It hardly needs saying that such unions were subject to the usual vicissitudes. Social conditions and individual faults had their well-known effects, and the high romances did not abolish other types of love.

Stendhal, who was nothing if not critical, wrote a treatise *On Love,* based on

the psychology of Destutt (<452) and firsthand observations in more than one country. He distinguishes four species—the physical; the tasteful (the 18C game of dallying); love from vanity (the man or woman flattered by the lover's beauty or status); and love from passion. The last, says Stendhal, is the source of the highest happiness; it is very rare in France, it thrives in Italy. Here again the imagination creates. It "crystallizes" (his term) one's feelings of wonder and admiration and projects them on the beloved. This is the love of Heloïse and Abelard and of many Romanticists, including Stendhal himself.

In society this passion requires equality between the lovers, because the happiness comes from being and talking together far more than from sexual pleasure. Stendhal credits women with all the talents that men can ever have and wants for both an identical education, though women will probably use their abilities with a difference. In any case, the man capable of passion-love does not act the overlord; he is diffident in that relation; he is possessed by it as he is by high art.

In muted counterpoint to the doctrine of passion-love between beautiful souls there ran one of frank fleshliness. Gautier's *Maupin* novel makes the rounds of carnality, hetero- and homosexual, and adds transvestism, all in the mood of gaiety. In the year of its appearance, Karl Gutzkow published *Wally*, in which his heroine "marries symbolically" the man she loves by standing naked before him on the eve of her marriage to another. And both Schlegel in *Lucinda* and Mundt in *Madonna* glorify the adventures of free sexuality.

> I have had proof this evening that when music is perfect, it sets the heart in exactly the same condition as that produced by the presence of the beloved; which is to say music gives the most intense happiness available on this earth.
>
> —STENDHAL, *ON LOVE* (1822)

In keeping with his claim that he is writing a "physiology of love," Stendhal affirms that the two experiences of the most concentrated awareness—love and art—are due to the same excitement of nerves and brain. He adds that passion-love serves to keep alive the youthful feelings of sympathy and generosity that soon dry up as human beings learn the ways of the world. He does not deal with Eros in isolation; his discourse brings in history and biography, contemporary politics, and varieties of law and national character—further proof that Romanticist love is no pastime for empty heads-and-hearts.

In Stendhal's day the book had no influence. Its form and style were too strange. Three small editions sufficed for 15 years. He himself said that he wrote for 100 readers. He nonetheless expressed beliefs and attitudes widely applicable to his age. His remark about human sympathy and generosity is a case in point: in social outlook the 19C may well be called the century of love. Both individuals and groups bestirred themselves to protect systematically the poor and the weak from the rigors of life. This was especially true in

England. John Howard had started prison reform in the 1780s; the Earl of Shaftesbury pushed legislation to save women and children from long hours of labor; workers themselves formed benevolent societies to help one another in bad times; Bentham's followers humanized the criminal law; church groups set up refuges for "fallen" women; orphan asylums were taken away from heartless profiteers; cruelty to animals began to be seen as heinous; and the administering of the Poor Law was re-organized; Clara Barton founded the Red Cross; Father Damien gave his life to caring for the lepers on Hawaii; the missionary at home and abroad was half a preacher and half a social worker. Not all the schemes were well designed, but by mid-century they were there, in action. And novelists from Dickens onward used their medium to arouse the public conscience about some social evil. The Continent gradually followed suit.

True, the promoters of this neighborly love were not all moved to it by a Stendhalian passion combining love and music; their motives often had a political or religious component; but the aim was deliberate and new. That it arose from a general shift in ideas about human beings appears from the change in manners, steadily more gentle and restrained. Half a century earlier, when Fielding, ill and crippled, was leaving England for the warmer climate of Portugal, the sailors who saw him come on board shouted insults and jeered at his helplessness. And as Fielding himself showed in his novels, the manners of the gentry were often gross and those of the commonplace nobility coarse. Slowly developing, the ideal of the lady and the gentleman was taking hold; it was an ideal distilled from the best aristocratic and upper middle-class behavior. Meantime, the abstract idea of rights had awakened an impulse to make law and convention the vehicles of fairness and respect to all (<431).

<center>*
 * *</center>

Stendhal's 400 pages contain perhaps 100 anecdotes, illustrative of love and lovers; their names often given in full. He did not do this to titillate the reader or create scandal, but to produce "an exact scientific study." He was always in search of the *petit fait vrai,* the small true fact. Contrary to common opinion, his fellow Romanticists were equally keen about the factual. They knew not only that they were living in a changed world that must be charted, but also that much "enlightened" knowledge had been made useless by generalizing. This new world must be described in concrete detail. Thus Wordsworth in the preface to *Lyrical*

> During my life I have seen Frenchmen, Italians, Russians, and so on. Thanks to Montesquieu I even know that one can be a Persian; but I must say that as for Man, I have never come across him anywhere.
>
> —DE MAISTRE (1795)

Ballads quotes and condemns an 18C sonnet for its string of abstractions and he demands that poetry use the common speech of common men to record their thoughts and feelings. Later poets—Vigny, Musset, Pushkin, Shelley, Leopardi—agreed. Plain diction and ordinary life had become the materials of literature; Victor Hugo said that even the ugly could be used in art. Note that in Wordsworth the ballads are not love stories like the olden tales of the Scottish Border; they are patterned after the street ballads that relate commonplace incidents in rough meter and crude detail.

To Generalize is to be an Idiot. To Particularize is the Alone Distinction of Merit.

—BLAKE (C. 1808)

Fact, detail, the ordinary is the badge of truth—of one kind of truth. Balzac fills his novels with the particulars of banking, country medical practice, the way clerks live, the manufacture of gold braid, and endless other matters of fact. Scott, especially in his Scottish series, is an accurate historian of common and lordly life in his native land at a given moment. Manzoni, Dumas, Stendhal, Eugène Sue, and a crowd of other practitioners of the historical novel that Scott invented rely on the force of the circumstantial to make what they invent seem also true. In Victor Hugo's *Notre Dame* the chapter on the beggars' quarter makes one think of Zola: it is sheer Naturalism (623>).

Pushkin gave Russian poetry a new directness, especially in his verse tales, by a diction that conveyed common details in a conversational tone. Yet it is unmistakably poetry, not prose cut up and printed in uneven lines. In painting, from Géricault taking as a subject a recent shipwreck, to Goya depicting the ravages of war when the armies of Napoleon and Wellington fought over Spain and Portugal, and further to Delacroix showing the victims of the Turkish massacres in Greece, the preoccupation with lifelikeness encourages the portrayal of contemporary incidents. In England meanwhile, John Constable had shown that color in nature was far brighter over a wide range than prevailing practice allowed. His demonstration was simple: he took a violin as brownish green from old varnish as a standard painting of the day and held it close to the grass. His patron Sir George Beaumont was convinced. Independently, the young watercolorist Bonington used color gradations for seaside scenery that caused Delacroix to change his palette radically. The painters' term *local color* soon came into literary use to mean the accurate portrayal of manners and costume as a means of conveying reality. With a like intent, the young sculptor Antoine Barye studied the large animals of the Paris zoo (where he was ultimately appointed professor)° and after overcoming the resistance of the Beaux-Arts school, was commissioned to make the groups of bronze wild beasts, life-size, that embellish several of the gardens of the city. Simultaneously in America, Audubon was sailing down the

Mississippi on the lookout for birds to draw and paint, achieving his purpose with the completion in 1838 of his 435 plates of life-size depiction.

These creations prove one neglected truth about the Romanticists in art: they were Realists. But "as everybody knows," Realism arose about 1850 in reaction against Romanticism. This critics' cliché need cause no confusion if the works of the first half of the century are described accurately as above. It is then seen that Romanticism contains in itself the practice characteristic of the three movements that followed it: Realism, Symbolism, and Naturalism. The difference between the later tendencies and Romanticism is that each specialized in one of the techniques developed by their common ancestor. That the descendents worked in a different mood for a different purpose has blurred the relation.

To put it another way, the arts after neo-classicism went through four phases, the first comprehensive and the next three exclusive, each developing in full one tendency of the original movement. Consider again the *Lyrical Ballads*. Part of the work was characterized on the previous page: common subjects, common words—the realistic part. Next come lyrics about love or nature, still in simple language and true to life, but not re-creating the commonplace atmosphere that came to be seen as the sign of the truly real. The third part is Coleridge's *Rime of the Ancient Mariner*, a narrative in which strange, "unreal" events symbolize the truths of the moral world—a Symbolist poem.

In the next generation and in France, not only Hugo and Musset and Vigny but Gérard de Nerval present the same inclusiveness. He translates Goethe's *Faust* in its various styles ranging from vulgar to lofty; in *Chimères* he writes "romantic" sonnets; he collects the folk poetry of his native province; and in *Vers Dorés* (Golden Verses), he writes lines in which every noun is a symbol pointing to a hidden spiritual realm. He is so much a Symbolist poet that the sonnet "El Desdichado" is still argued over for its possible meanings, and the prose poem *Aurélia* likewise.

In Blake, setting the allegories aside, it is symbolism that gives significance to most of the *Songs of Innocence and Experience*. In Hölderlin, in Novalis, in Kleist, descriptions of nature and feeling have the same purpose. The last named, who was so deeply persuaded of the ambiguity of all experience, has been regarded as a forerunner of Rilke and even of Kafka and Pirandello. Ambiguity, when used on purpose, is the device of symbol par excellence. Akin to ambiguity and symbol, the fantasy that pervades the work of Jean-Paul Richter (132>) seems a response to Ackermann's suggestion that poetry should find some of its materials in dreams. It was Jean-Paul, so popular that he was generally referred to in that shortened form (or else as *Der Einzige* the Unique) that Carlyle chose to discuss him first when he introduced German literature to the English. By contrast, Heine like Byron used his satirical bent

to make poetry out of little scenes of daily life in colloquial language, with an occasional foray into legend and history.

As for the surcharged realism later called Naturalism (623>), the germs of it may be found in certain poems by Gautier and by Hugo° and in the work of Petrus Borel, who was not afraid of entitling some of his fiction *Immoral Tales*. That these ventures belong to the Romanticist years does not mean that later comers were imitators or exploiters of perfected styles. The meaning is rather that when the ground is cleared as it was by revolution and rebuilding is called for, every kind of thing is attempted, but not everything is pursued; and much turns out wasted effort, all three outcomes being the usual result of EMANCIPATION.

In the domain of Form, the Romanticist emancipation entailed no waste. The freedom enjoyed by the arts today was their achievement. When Hugo boasted that he had stuck the Jacobins' red cap on the dictionary, Wordsworth had already given the same signal: no words forbidden because they were not noble (<477). To make the ugly acceptable, Hugo declared that "Whatever is in nature is in art."° And poets everywhere made free with every meter, rhythm, stanza, and longer form, in their several languages. Hugo, again, went quite far in permitting himself "irregularities" that scholars credit with having shown the way to the late 20C poets.°

A by-product of openness was the rehabilitation of earlier ages of literature—the medieval in Germany; Chaucer, the Elizabethans, and the Anglo-Saxon *Beowulf* in England; Ronsard and the Pléiade in France (<163), with Villon and Rabelais thrown in for good measure. Balzac was so enamored of the latter that, as noted before, he wrote some excellent pastiches in an approximate 16C idiom, the *Contes Drôlatiques* (Droll Stories).

Prose also underwent reform. One has only to compare the style of Voltaire with that of Chateaubriand. The former is entirely lucid, flexible, and smooth and it says what Voltaire wants it to say, but it is all *saying*. Chateaubriand's is equally clear and as fully under control, but it kindles the imagination and stirs the senses to *seeing*. The gain is in unsuspected thoughts and feelings. The Romanticist Stendhal and a few others rejected this departure from their own matter-of-factness. Stendhal made a point of reading a page or two in Napoleon's terse Civil Code before sitting down to write his novels. Chateaubriand went farther along his own path. In one of his works° some have seen an anticipation of Rimbaud in the *Illuminations*. And in the *Memoirs* the verbal compounds, the discontinuities, and other syntactic devices have struck critics as prefiguring elements of the modern prose of Gide, Proust, Joyce, and the Surrealists. Such likenesses do not prove direct influence; similar inventions arise out of the general state of the art. But recalling these innovations makes it clear that the period was formative precisely because it was not uniform.

*
* *

With their searching imagination in literature and art, it could be expected that the Romanticists' intellectual tastes would be anything but exclusive. They found the Middle Ages a civilization worthy of respect; they relished folk art, music, and literature; they studied Oriental philosophy; they welcomed the diversity of national customs and character, even those outside the 18C cosmopolitan circuit; they surveyed dialects and languages with enthusiasm. This was a genuine multiculturalism, the wholehearted acceptance of the remote, the exotic, the folkish, and the forgotten. Victor Hugo delved into all the histories and literatures he could get access to and forged out of their figures and incidents the panoramic *Légende des Siècles*. When he came across the Malay verse form called *pantoum,* he wrote one. Gérard de Nerval collected French regional songs in dialect and translated them. Liszt, who as a virtuosos pianist crisscrossed Europe repeatedly, noted down the local forms of popular music and composed pieces in the genre: his catalogue of songs reads like a gazetteer. He rehabilitated native Hungarian music and brought out that of the Gypsies (properly Romani), hitherto unknown. It is from his efforts that all the Zigeuner art music of the Viennese composers has come.

These interests have persisted and some are now scholarly disciplines. But taking them together, critics of Romanticism have not hesitated to call them "escapes." And as everybody knows, escapism is a federal crime. Perhaps a more sensible way of judging Romanticist curiosity along multiple lines is to see it as a release from parochialism. The preceding age aimed at reality only in the form of general truths and, worse, it limited civilization to four periods in six countries. True, Voltaire in his large history of manners and customs (<379) had made an effort to contradict this, his own formula about the past; but it remained his inner conviction and that of the Encyclopedists, Diderot alone excepted.

It was the creed of the Complacent Cosmopolite, productive of much that was new and good but limited by its program. When Hume, for example, wrote an essay on national characters, he showed a knowledge of history without the intimate sense of it. To him, the French were the new Romans; the English were the Greeks. The 19C was imbued with the *feel* of the past. It came, first, from the flood of personal memoirs and large-scale histories that described in a multitude of ways the experience of the quarter century that followed 1789. No such amount of detail, passionate and tendentious, true and false, had ever poured from the presses in so short a time. Next, that literature gave rise to the idea of collecting all the extant documents indicative of the national past. In France, England, and Germany owners of archives were solicited, attics of public buildings were ransacked, and large series of

volumes began to be compiled at government expense. Political debate made increasing use of history as precedent for action or model for the future.° Reading history became a common 19C pastime, soon making the historical a natural way to approach any subject. Even now when the habit is obsolescent, the physician takes the patient's history before diagnosis and the businessman in his annual report offers the past as harbinger of a rosy future.

My son should read much history and meditate upon it; it is the only true philosophy.

—NAPOLEON, POLITICAL TESTAMENT
(APRIL 1821)

In view of this eagerness and these materials, what the 20C historian G. M. Trevelyan, echoing Carlyle, meant by saying that "Scott taught Europe history" was that the novelist's Scottish and medieval stories accustomed the public to seeing the past as a vast, colorful panorama in motion, filled by living men and women who were busy at common tasks. Kings and queens making treaties or speeches from the throne were history also, but far from being all of it. In a mood of self-irony Scott dedicated his first "researched" novel, *Ivanhoe,* to the Reverend Doctor Dryasdust. The earlier Scottish novels were written out of an abundant memory the reverse of bookish. In retrospect, the French historian Albert Sorel opined that one should "read and absorb" Balzac before writing history. The sense of "how things go" presupposes that people and their habits, speech, and costume vary wonderfully from place to place and time to time. Change is seen to come in curious ways from the interaction of leader and led, coupled with accident and coincidence. History reads like a novel and a novel is a history—almost.

Scott's "Waverley" series began to appear anonymously one year before Napoleon's exit from Europe. Their popularity spread and persisted. In Germany five different translations were published, one of which made the fortune of Schumann's father. Scott's ecumenical conception of history had in fact been put forward in Germany a decade earlier by Herder. His *Ideas Concerning the History of Mankind,*° describes a totality made up of peoples that are diverse because of their different pasts. Each people or *Volk* is shown to be the creator and preserver of the group culture. Through contact with others it becomes aware of its identity. Underlying the theory was fact: the revolutionary and Napoleonic armies had redrawn the mental map of Europe. In place of the 18C horizontal world of dynasties and cosmopolite upper classes, the West now consisted of vertical units—nations, not wholly separate but unlike. So far, no mutual hostility was implied; Europe was a bouquet of variegated flowers; Romanticist pride in the nation was *cultural* nationalism. It is significant in this regard that the novels Scott wrote about his country changed the English attitude toward it from contempt to sympathetic curiosity. George IV went north and wore kilts to pay his respects to the country and its literary portrayer and give him a knighthood.

This new genre, the historical novel, brought with it the historical heroes, and it is interesting to note how they grew in Scott's mind. From an early age, stimulated by the Border ballads in Bishop Percy's collection he turned himself into a living source of knowledge about the clan feuds and the wars with the English. He also read ancient French romances and then German ones and translated Goethe's *Goetz von Berlichingen* (<14). The first fruits of this preparation were the six verse tales that made his reputation as a poet. *The Lay of the Last Minstrel* and the others are imaginary plots full of action and accurate local color. They are no longer what one expects of either verse or fiction, but they are worth leafing through for the handful of beautiful songs.

Scott went on to publish editions of local lore and of English authors and to write history and biographiy in between the creation of his vast double set of novels.° Nor should the *Journal* of his final, heroic years be overlooked. The novels are seldom read today and that is a great loss; they contain characters and scenes of such power that, once read, they remain indelible. In their own day they were compared to Shakespeare's most dramatic moments and the judgment was not outré. But one must know where to turn for them and be patient through the preliminaries. [The book to consult is *Walter Scott* by Edgar Johnson.]

<p style="text-align:center">*
* *</p>

Given the task of reconstruction, the Romanticists could not do without the ideal of the hero. They filled it with diversified but not incompatible contents. They may have known that by etymology the word is related to *servant* and *protector*. To begin with, they revered the genius, conceived chiefly as the artist who is a seer. Goethe sketched the model first in Wilhelm Meister, then with finality in Faust: he is the seeker. In the old legend of Dr. Faustus (<112), two-thirds of his demands on the Devil are material—food and cash—but the last is "to fly among the stars," and that is also what the 19C desired, figuratively. The Faustian adventure that so gripped the Romanticists aims at discovery as such; the cosmos and human consciousness are infinite and there can be no end to their exploration. Shakespeare appealed to men of this temper precisely because his plays propound no thesis. Conclusions about life or character are temporary and reversible. Goethe wrote an essay entitled: "Shakespeare and No Ending."

It was the will to take heroic risks that settled the place of Napoleon in the imagination of artists and peoples.

I feel a kind of religious sentiment as I dare to write the first sentence of a history of Napoleon. It deals with the greatest man since Caesar. His superiority lay entirely in his way of finding new ideas with incredible speed, of judging them with complete rationality, and of carrying them out with a willpower that never had an equal.

—STENDHAL ON NAPOLEON (1816)

Hazlitt wrote his life, making him the symbol of the revolution; Scott also, but with grudging admiration. Stendhal, who had served in his army during the retreat from Russia, devoted a book to his character. Byron mourned his loss after having alternated praise and condemnation. Goethe said he could not hate such an enemy. Beethoven dedicated his third symphony to the hero Bonaparte (the title *Eroica* has stuck) and canceled the tribute only when the soldier turned upstart emperor. Lamartine, Manzoni, Hugo, among others, wrote extolling or pensive poems. Berlioz was inspired by Bonaparte's crossing the Alps with his army to sketch a work of which the extant *Triumphal Symphony* and *Te Deum* contain portions. Painters innumerable portrayed him, and out of their imagination put on canvas scenes from his decisive battles. He had been everywhere doing great things. The questing hero is the representative of mankind on the march.

Hegel in his *Philosophy of History* describes the figure under the name of "world-historical character"—the man who at a given moment embodies the scattered volitions of his age and is mysteriously empowered to carry them out. This incremental force drawn from the masses explains how periodically a mere man comes to look superhuman: he is able to change the face of society when all previous efforts have met unshakable resistance. Hegel was well placed for making this portrait from life: he was in a cellar at Jena while Napoleon was fighting to victory above ground. Although when he was finally brought down all Europe cried "*Ouf!*" as he had predicted, the relief erased no memories. For the majority of thinkers and artists he remained the genius in whom they recognized and celebrated not themselves as individuals, but their drive to achievement. Almost all deplored the dark side of the hero, the foibles, the mistakes some called crimes, and the destructiveness. But the other facet stayed bright. Here was no ordinary conqueror for booty, but a man who fashioned a new Europe. The areas of his influence, the efficiency of his administration, his code of laws, his active role in art and science, his lapidary judgments of men and society, even his ambition, ruthless but lofty, bespoke the heroic character.

The mixed and scattered impressions were confirmed by the fallen emperor's reflections, gathered and

I wish to award the sum of six thousand francs as encouragement to the person who will advance our knowledge of electricity. It is my aim to urge physicists to concentrate on that branch of physics, which in my opinion is the road to great discoveries.

On a fountain with figures of naiads spouting water from their breasts: "Get rid of those wet nurses: the naiads were virgins." (1811)

That woman [Mme de Staël] teaches thinking to those who never thought of thinking or who have forgotten how to do it. (c. 1800)

—Bonaparte (1802)

Napoleon understood the spirit of the times. As a German I have been his greatest enemy, but actual conditions have reconciled me to him. He understood art and science and despised ignorance.

—Beethoven (c. 1820)

published by his companions on Saint Helena. Some enemies found their hatred dissipating.

In Central Europe the benefits of a network of good roads, of improved harbors, and especially of the reduction of states from 300 to 36 that he effected (<393) did not go unappreciated. It completed the extinction of feudal vestiges and his cavalier handling of kings and princes sustained his character of champion of the people. The world at large seems still to side with him, not Wellington, since everywhere Waterloo has become a synonym for defeat, not victory.

That downfall had a meaning beyond the political. It added an aspect to the ideal of Napoleon as hero. Life is tragic and all heroes succumb to fate. The foreknowledge that this is so is a reminder of the Romanticist conception of man as great and weak, the weakness often being the doing of evil. Some natures feel this fatality from the start of their career and one such, often seen as the archetypal Romanticist, gave through both fiction and his own life, vivid expression to this awareness. He was the youthful poet

Byron

By word and deed, he made as lasting an impression as Napoleon; Byronism is a phase in the history of the western mind. It is made up of daring, rebelliousness, melancholy, self-reproach, and the imagination of disaster. The heroes of Byron's tales and plays are, like himself, greatness and failure personified. His leap to fame overnight with the publication in 1812 of the first two cantos of *Childe Harold* was no accident. For ten years the English had been fearing invasion. Across the Channel Bonaparte had an Army of England equipped with balloons, and in the west country rumors were frequent that he had landed at night to reconnoiter. Anxiety and hatred were the staple of talk and journalism. Suddenly here was in fluent verse a tale of pensive, leisurely travel in southern Europe. The hero's name suggested a young knight errant (*childe*), who took delight in art and nature and made the reader feel his own flexible emotions at each site. To the beleaguered English this moving vista seemed a window opened to fresh air and sunny skies. One may call its enjoyment an instance of escape, but it was an escape by a prisoner of war; nor was it liberation to a never-never land, but to parts of Europe that everybody knew existed and many had visited.

Childe Harold was the first sketch of the Byronic hero. The full-fledged character appears in slightly varied forms in the verse tales that quickly followed—*The Corsair, The Giaour, The Bride of Abydos*, and three others that were avidly read from one end of Europe to the other. One feature that made the leading figure in each melodramatic plot congenial was his being or becoming an outlaw. Students, intellectuals, artists—rebels by reflex action—had

had a taste of the liberalized institutions set up by Bonaparte wherever he went. As time went on and the repressive regimes in power after the peace of 1815 appeared to have erased the rights of man (<431), those restless spirits felt represented in the strong, brooding, vindictive Byronic brigand-adventurer who is ruthless toward his foes and, although passionate toward women, not subdued to their will either. Women readers responded no less admiringly. To them the dark sense of overhanging evil and obsessive guilt added the last touch to complete the seductive affinity. Byronic heroes soon filled poems and novels and have continued to fascinate—witness Emily Brontë's Heathcliff in *Wuthering Heights,* the Regency novels of Georgette Heyer, and one profitable line of popular romance and film.

But as pointed out above, the Romanticist has more than one idea in his head, and Byron's works bear out the generality. His love lyrics, his political verse, the *Ode to Venice, The Lament of Tasso,* and that enchanting vision, *The Dream,* show as many different impulses of his mind. And yet another is the one preferred today: the poet Byron began and ended as satirist. He began by assailing "English Bards and Scotch Reviewers" and ended with *Don Juan.* This masterpiece, written simultaneously with two kindred satires,° describes life as it can be, comic or sordid, and riots in wit and irony. The sharp drop from high sentiment or tense drama into comment that ridicules the situation or the self is a Romanticist device, powered in *Don Juan* by the virtuoso two-syllable rimes.° The epic was left unfinished, Byron thinking that to help the Greeks win their independence (514>) was more important. He died of fever at Missolonghi, aged 36.

In biographies, Byron's mismarriage and love relations with women have monopolized attention. Lives keep appearing; he belongs to the class of inexhaustible subjects with Mary Queen of Scots and Napoleon. This "romantic" curiosity has neglected Byron's friendships with men and practical activities generally. In these relations he was the epitome of calmness and good judgment, just as he proved a good organizer in Greece and statesmanlike when he argued in the House of Lords. He spoke there against the harsh punishment of the "Luddites," the workers who destroyed the machines that put them out of work. Lastly, there is Byron the critic and fact-seeker like Stendhal, and first-rate letter-writer. Byron preferred Pope to Shakespeare and said he did not give a lump of sugar for his own poetry, but the historical details in it were reliable. [The book to read is *The Letters of Byron,* chosen to give an outline of his life and opinions, ed. by Jacques Barzun.]

* * *

At the beginning of the present account of Romanticism, Rousseau's *Emile* was cited as having moved many 19C minds with its exposition of reli-

gious faith. The rest of the book was equally potent on the subject of education. To Rousseau, rearing a child in the proper way would make the "man and citizen" necessary to the success of a republic. It would be a state of free and responsible human beings, free not of the civilizing arts and sciences, but of the artificialities and inequalities of the *ancien régime*. The subsequent destruction of that regime made a scheme of education all the more urgent to those engaged in Reconstruction, and to that political purpose was added the characteristic love impulse of the new age—sympathy and generosity toward the individual as such. That resolve was doubly strong when the individual was the child. In the 1820s and 1830s three thinkers almost simultaneously proposed a new type of schooling. The most inspired, Friedrich Froebel, follows Rousseau in the now universal belief that true education is an unfolding of the person, the development of native gifts through the free but guided activity of the self. His own unhappy childhood, the very opposite of this ideal, made him innovate as well as try to reform.

Under a hostile stepmother and a neglectful father, and without playmates, Froebel grew into a moody, maladjusted man, incapable of consistent effort, at once rebellious and domineering, and generally unloved. He had a hard time learning to read and, being considered stupid, was apprenticed to a woodcutter. An intense love of nature was his refuge from humiliation. What saved him from suicidal despair was a brother who opened to him the pleasures of intellect and enabled him, after study at Göttingen, to become assistant to Pestalozzi, the other theorist of Romanticist education. Froebel first established a school for his five orphaned nephews with the program of "educating men to be free." Denying original sin, he asserted that all social evils come from bad education and that after mother care, the all-important need of the growing child is self-expression. In his writings Froebel mixed irrelevant and fanciful ideas which together with his character hampered all his efforts.

Then, at the age of 55, having failed at everything, he invented the kindergarten. It was designed for the very poor and it made him feel that he had found his true vocation. To this new institution he gave the memorable name of *Kleinkinderbeschäftigungsanstalt*. Not till three years later did he coin, by chance, the word *Kindergarten*. It had struck the nature lover that the child was a plant meant to grow freely. Froebel's creation was quickly imitated. The role of the mother was made important, songs were written, and toys "suggestive of the unity of the world" were called gifts as they were handed to the children. Paper cutting, molding clay, weaving, and games of "finger play" became part of the curriculum. All seems harmless, but opposition was strong and the school failed. Froebel managed to find a patron in the Baroness von Marenholtz-Bülow. She lectured about his invention at home and abroad, and in London won over Dickens as a supporter. By mid-century,

when Froebel had died and while the kindergarten was prohibited in Russia as subversive, it made headway in the United States. It appeared first in Watertown, Wisconsin, then in Boston, thanks to the ever-active Elizabeth Peabody.° Twenty years after this first acceptance it reached New York.

Pestalozzi, whom Froebel had briefly assisted and regarded as his mentor, was also a fervent disciple of Rousseau, so that both men drew on a common source rather than the one from the other. By theorizing in print first, Pestalozzi gained a lasting reputation throughout the West. His practical work began in 1798, after the French Army destroyed a town on Lake Lucerne and left orphans to be cared for—many more than Froebel's five nephews. Pestalozzi fed and housed them and made them the material for testing his doctrine. It was the one that must be called perennial (<181)—things instead of words; or in the master's phrasing: "living souls instead of dead characters, deeds of faith and love instead of abstruse creeds, substance instead of shadow."

Expelled by the returning French, Pestalozzi opened a school elsewhere and endured the usual opposition, but within half a dozen years had succeeded well enough to arouse wonder and approval. Natural development, mind-and-heart expanding with age as a single faculty; spontaneity and direct use of the senses to observe, the teacher a guide instead of a force-feeder of facts—these familiar notions were (as always) felt to be a long-awaited EMANCIPATION. It recurs and in time defeats itself (>793). Independently of Froebel and Pestalozzi, the Bavarian novelist mentioned earlier, the "Unique Jean-Paul," wrote a long book to modify what he considered in Rousseau and his followers the too negative role of the teacher. A positive teacher must go beyond practicalities and aim at an ideal goal.

> Education can neither consist entirely of mere unfolding—for everything that keeps living unfolds—nor of developing all the powers, because we can never act upon all of them at once.
>
> The child is not to be educated for the present—this will happen without our help unceasingly—but for the remote future and in opposition to the immediate one.
>
> —Jean-Paul Richter, *Levana* (1806)

Thirty years after Richter and across the ocean, a young lawyer who was state senator in Massachusetts was invited to become secretary of the newly established Board of Education. He had never thought about the subject, but he took the chance, sold his law books, and, chided by his friends, gave up the lease on his office. This was Horace Mann. In politics he had been wedded to principle, and his thoughts about education when he got around to them were a compound of the political and moral. His concern was not to reform but to promote. Like Jefferson legislating earlier for the state of Virginia, Mann thought of education and the republic as intimately linked. This was Rousseau again, but probably a spontaneous conviction. Knowledge must be widespread, free, and common to all, in order to make self-respecting, inde-

pendent characters. Without them no constitution, no rights, no system of justice can endure. Mann was struck by American diversity in origins and traditions secular and religious. The public school should foster a sense of community by sharing what he called a "public philosophy," as yet unformulated, but obviously to be based on civics, ethics, and history.

From these premises Mann derived and expounded in his twelve reports a program of liberal education ranging from good books to vocal music, laying stress on the three R's, and topped by instruction in human physiology (in our jargon, health education). To carry out the second half of the precept *mens sana in corpore sano,* the schoolhouse must be airy, clean, and full of light. Though Mann attained his ends and has a secure place in the history of American education, he has been blamed in our time for limiting his demands: why not free higher education and why not *public* education exclusively? This second criticism may come to be considered again. In any event, Mann's conception should be judged in the light of the social and political conditions of the 1840s. Children were counted on to help the farmer, who saw little good in book-learning, and public money for schools was not popular with legislators. Mann's arguments for the free public school, inseparable from the existence of political rights and duties under a republic, also remind us that governments in the world of 1840 were not all republics, that constitutions were few, and that the rights proclaimed in France in 1789 were thought by many in Europe and elsewhere to have been abolished for good.

CROSS SECTION

The View from Paris
Around 1830

IF ROMANTICIST Mind-and-Heart has been properly sketched and illus-
trated, it should have left a summary impression something like this: in
Romanticism thought and feeling are fused; its bent is toward exploration and
discovery at whatever risk of error or failure; the religious emotion is innate
and demands expression. Spirit is a reality but where it is placed varies and is
secondary: the divine may be reached through nature or art. The individual
self is a source of knowledge on which one must act; for one is embarked—
engagé, as the 20C Existentialists say. To act, enthusiasm must overcome indif-
ference or despair; impulse must be guided by imagination and reason. The
search is for truths, which reside in particulars, not in generalities; the world
is bigger and more complex than any set of abstractions, and it includes the
past, which is never fully done with. Meditating on past and present leads to
the estimate of man as great and wretched. But heroes are real and indispens-
able. They rise out of the people, whose own mind-and-heart provides the
makings of high culture. The errors of heroes and peoples are the price of
knowledge, religion, and art, life itself being a heroic tragedy.

It was with these conscious or unconscious perceptions that the
Romanticist period pursued the task of reconstruction after the quarter cen-
tury of struggle and doubt. By 1830 the ground had been leveled flat. As
Musset said: "Everything that was no longer exists; everything that is to be
does not yet exist." As it happened, strong original minds were not lacking;
their thoughts and deeds in politics, economics, and science have been noted
from their inception to the point where we now take up their parallels in high
culture.

Paris in the 1820s and 1830s became conspicuously the meeting place of artists and writers native and foreign. The latter date brought to the fore the leaders of the second generation of Romanticists. But first, Paris itself claims a moment's attention. Supposing one sailed over it in a balloon, one would see none of the landmarks now well known even to people who have never been there—no Eiffel Tower, no Place de la Concorde, only an expanse of mud crossed by ditches and without any obelisk in the middle. The Champs-Elysées too was but a broad dirt road leading merely to some masonry stumps—the unfinished Arc de Triomphe.

Through the heart of the city the Seine ran turbid and was crowded with barges, laundry boats, and floating baths moored to uneven banks not yet faced with stone. Spanning the stream were fourteen bridges—about half the present number—and some still had houses or shops along their roadway. One would find the Louvre almost complete and in it some works of art, some artists who lodged there, and some rooms used for government storage. Opposite, in the Tuileries gardens was the spacious palace (now destroyed) where the restored Bourbon King Charles X resided. Next to it, the rue de Rivoli would take one, as now, to the rue Royale, which gave as yet no sight of the templelike church of the Madeleine at the end—only the foundations had been laid. Land speculators (among them Balzac) would shortly be rivals for the surrounding lots; they expected the building to be a railroad station. The first line, Paris to Saint-Germain, was about to be opened. Nor was the massive opera yet thought of. As for that other monument, the column at the Place Vendôme, cast from the cannon captured in the years of war, it stood tall, but instead of Napoleon on top there was a huge fleur-de-lis.

Venturing into the side streets would be risky. Many were narrow, some dead ends, most of them unpaved and without sidewalks. Not a few had the ancestral gutter in the middle for the slops daily emptied from the houses on each side. In a word, a good part of the capital was still the original, unplanned, overcrowded town. Stendhal, who had seen Milan and found it clean, always cursed the sticky black mud of Paris and its lack of trees. The walls around the town kept it small. They were not moved outward until the mid-1840s, after which the surrounding villages were able to join the metropolis. Before that date it was an outing into the country when Chopin and Vigny went to Montmartre to visit Berlioz.

Even so, Paris could show some signs of progress. After long neglect, buildings were being scrubbed and paving realigned along main arteries. New residential districts had opened up: Victor Hugo went to live in one near the Etoile. In the 12,000 lampposts gas began to replace the smoky, stenchy oil; and two innovations were making a timid beginning: the use of John McAdam's recent invention for surfacing roads and public transportation in the form of the omnibus.° The population had reached 786,000—an increase

of nearly 50 percent in 30 years—and the city was more and more in need of the modern style of abode, the tall apartment house. The rooms were poorly laid out in it, but by and large it marked a great advance: the social classes mingled there as on the streets or in the 14 theaters. On the ground floor there might be a shop whose owner also resided there with his family, servant, and apprentice. The first floor above was for people of wealth, the next higher for the "comfortable"—say a retired couple or a general on pension. Clerks or artisans (not factory hands) lived yet higher up, while in the garret a milliner's girl and a starving poet might halve their misery by huddling together.

For the Parisians that made up the so-called *Tout Paris* (not all of Paris, but the culture-makers and their hangers-on), three events made 1830 memorable. The first, in February, was the "battle of *Hernani*," waged by the Jeunes-France (or bright youth) against the old guard. The young poet Théophile Gautier, wearing a red waistcoat as a sort of rallying flag, directed his band of crusaders at the première of Victor Hugo's play *Hernani* to make sure that it was not hissed off the stage. Everybody had heard the word *romantique* which, coupled with Jeunes-France, meant the overthrow of rules in poetry and of proper language on the stage. The enormities that night were palpable: the riming lines did not come out even with the sense; it ran over to the next line, and this displaced the pause that ought to come regularly at the middle. Elegant singsong gave place to rhythmic stumbling. Worse was the verbal indecency: common words jostled noble ones. At one point a character said: "It is midnight," instead of some roundabout phrase. And like a bombshell one heard the syllables *mouchoir*—handkerchief.

Well before that crisis the staid audience was hissing (done in France by whistling), stamping its feet, and shouting murder—all this to a ground bass of applause by the young literati, also armed with expletives. From the first gallery a contingent had come prepared with fishhooks on a string with which to lift the wigs of the bourgeois below, thereby enlarging the sense of *perruque* (wig) to mean an intellectual or artistic diehard. The young troops won the day; a second performance confirmed the victory. Note in passing that Hernani is a bandit who wins the love of a titled lady, herself sought after by both a nobleman and a king. This Byronic hero, who makes a high-minded sacrifice at the end, was brother to all the young rebels-in-art in the audience; the play felt like an allegory acted out.

The next liberating event came at the end of July. The efforts of the two successive Bourbon kings to bring back the forms and powers of the *ancien régime* had been a crescendo culminating in press censorship to stifle protests of many kinds. It finally provoked an explosion. Three days of fighting got rid of Charles X, King of France, and installed his cousin Louis-Philippe as king of the French, a distinction that hints at accountability. The uprising, backed by a banker and other solid citizens, cheered by the journalists, and manned

by students and artisans, was signaled by the singing of the revolutionary "Marseillaise" (hitherto forbidden) and the flutter of the bright tricolor flag in place of the all-white. It waves at the center of Delacroix's painting, *Liberty Leading the People,* which is not entirely poster art: next to the striding woman who is Liberty is the lifelike street urchin brandishing a gun amid the tumbled debris of the fighting. It left 2,212 dead and 5,451 wounded. For the 4,054 barricades the rebels had torn up 8,125,000 cobblestones.° The loose paving and narrow streets were a godsend.

On the first day of the outbreak, one of the young enthusiasts had been writing music, locked in at the Institut with other competitors for the Rome Prize. As he came out at noon and saw a group merely talking on the street corner, he hailed them and setting the example led them in singing the "Marseillaise." His name was

Berlioz

He was to provide the third epoch-making event of the year, but that was in December, four months off. At the moment he was a 26-year-old student who had come from his native village near the Alps six years earlier to study medicine. His father was a doctor, and the well-to-do, well-respected family hoped that the boy's early talent for playing and composing music would remain an avocation. But once in Paris, going to the opera and hearing Gluck's scores (<416) blotted out medicine. The venerable Le Sueur had taken the 20-year-old as a pupil, and when trouble arose with the family over the neglect of medicine, the late emperor's official composer pleaded that they should not hinder a great career to come.

Berlioz next attended the Conservatoire and, while enduring further periods of strain with his parents—allowance cut off, often restored—followed the set curriculum, which led each year to the Rome Prize contest. Now that some of Berlioz's pieces that failed three times to win the prize are played in concert halls the world over, it is easy to gauge the originality that baffled his judges. At last in 1830 the prize was his. In the meantime he had composed three overtures, two cantatas, a requiem mass, part of an opera, *plus* a symphony in five movements that he wanted to hear before leaving for his two years in Rome. He called it *Symphonie Fantastique.*

He had made friends among instrumentalists at the opera and elsewhere who were willing to play for him. Having also begun to write music criticism, he had discovered the power of the press. It was a time, Sainte-Beuve tells us, when a newspaper, with its small circulation, made of its readers virtually one family; everybody knew all that was happening. With this in mind, Berlioz wrote program notes for his symphony, linking the movements with verbiage to form a story. It had an air of autobiography and aroused curiosity accord-

ingly. Actually, the symphony is not a narrative; music cannot tell a story. The five movements express moods—love-longing in the first, pastoral in the third—and action in the rest: the waltz, the march, the witches' dance.

> Expression is by no means the sole aim of dramatic music; it would be foolish and pedantic to disdain the purely sensuous pleasure of melody, harmony, rhythm, and instrumentation, independently of their power to depict the passions.
>
> —BERLIOZ (C. 1835)

What made a story line seem plausible was the purely musical device of a leading theme that blends or contrasts with the music of each section. This innovation provided a model for the genre later called Symphonic Poem, which has enabled composers to write works entitled *Tasso* or *Dante*, *Don Quixote* or *Ein Heldenleben*. These "stories" are taken in stride, but Berlioz's combination of music and program note has had the unfortunate result of creating the myth of "program music"; that is, the notion that some music is "pure," self-standing, and some "literary" and requiring printed words to be understood and enjoyed. The proof that this difference is imaginary will be spelled out on a later page, when a parallel dogma ordaining "pureness" in all the arts infected the mind of critics and aesthetes (639>). Here it is only necessary to say that Berlioz's first symphony was and is pure music, since musical sounds organized intelligibly cannot be anything else. Whether a piece is associated with something else by means of a label does not change its character, and that association can always be ignored.

At the same time, the confusion arising from the words *pure* and *program* calls attention to an important fact in the history of music. The symphonies of Beethoven, beginning with the *Eroica,* were found hard to follow by their first listeners. To assist understanding, musical minds that did grasp the form wrote comments for the bewildered, and since the music was dramatic in purpose and effect, the obvious way to help was to suggest a story, with persons and events—as in opera, with which people were familiar. The "plot" suggested for a symphony need not fit closely—a hint about certain passages would prime the imagination. One of Beethoven's early admirers was E.T.A. Hoffmann,° a conductor and composer, whose fantastic tales (Offenbach's opera *Tales of Hoffmann* draws on them) have obscured his merit as an opera composer. It was he who led the way in programmatizing the Beethoven symphonies. Then Schumann, Liszt, Berlioz, Wagner, and a host of others filled their writings on music with these supposititious dramas, until by the last third of the century the public was fully prepared to hear a piece of instrumental music that carried associations indicated in a title or by the composer's telling about the idea, book, place, or occasion of its making. Being sensible, listeners today do not wonder whether Debussy in composing *From Dawn to Noontime on the Sea* had an hour-by-hour timetable in front of him. Yet in another part of their mind they still harbor a suspicion of program music.

That spectacular event of December 1830 makes such good copy for writers of program notes that they repeat it ad nauseam.

When Berlioz said that he took music where Beethoven had left it, he meant that the art of continuous expressiveness in instrumental music, initiated by Beethoven (who called it "poetizing"), was the Romanticist contribution to music. Berlioz saw it as his mission to further it by amplifying the means. He broke through the convention of "four-squareness" in melody, the rigidity of rhythms, and the predictability of harmonic formulas. He not only extended the use of timbre for tone color, he made it an element of structure and of contrapuntal effect—all this without abandoning the resources already exploited by his revered masters—Gluck and Spontini, Weber, and Beethoven. That the Berlioz style was his own could not be mistaken. Nothing like the sound of the witches' rampage in the *Fantastique* or, in the [Childe] *Harold in Italy,* the brigands' roistering had ever been heard on earth. [For a technical analysis, the book to read is *The Berlioz Style* by Brian Primmer.]

Not that the new music was all fireworks. In his "Note on Romanticism," the poet William Ernest Henley depicts "the heroic boys of 1830" as frenzied in "their hatred of restraint" and determination "to return to truth and nature." The plausible remark confuses two things. Great periods of art do raise the temperature of the place where the artists congregate and argue and compete. But this "frenzy," like the excitement caused by such events as *Hernani* and the *Symphonie Fantastique,* does not change the permanent conditions of artistic creation: hours of solitary, painstaking work, much acquired knowledge, long reflection and revision, which together increase mastery.

It was then that I began my Thirty Years' War against the professors, the routineers, and the deaf.

—BERLIOZ (1855)

In the ten years following his first masterpiece, Berlioz produced five more: *Harold in Italy,* the *Requiem,* the opera *Benvenuto Cellini,* the dramatic symphony *Romeo and Juliet* (which impressed Wagner, aged 26 and newly in Paris), and the *Funeral and Triumphal* symphony, of Napoleonic inspiration. The remaining 30 years of his life he devoted to conducting his works (and Beethoven's) throughout Europe. He taught the musical world the substance and the poetics of Romanticist music.° In parallel with this effort carried on without manager or subsidy, he wrote music criticism for the leading Paris newspaper and contrived to produce five more works of the first magnitude, including the epic music drama *Les Troyens.* He died on the eve of the Franco-Prussian War and was thus spared its madness and hardships.

That Berlioz did not form a school in the sense of recognizable followers was a result of his uniqueness as well as of the breadth of his teaching. His melodic invention—the greatest since Mozart, according to Van Dieren—

was not imitable. "With his rhythms," says Robert Craft, "Berlioz enters the 20C," which suggests that the emancipation he afforded was more extensive than the innovations his contemporaries took advantage of; for example, his use of space to modify sound. But in his scores and his *Treatise on Instrumentation and Orchestration* student composers found more than a practical guide. They found an aesthetics of music, not a system to follow, but a conception to exploit. Similarly, apart from some themes and harmonies borrowed by other composers (notably Wagner), it was not these that proved formative, but rather the Berlioz mode of creating out of the musical elements what might be called figures of rhetoric, expressive turns and tropes that enticed others to coin their own. So true is it that in any art style is the ultimate communicative force.

> Berlioz not only showed his contemporaries the way in which music could most profitably develop, but he also summed up everything it had already achieved. He restored to melody the freedom of movement it had lost. His tonal changes exploited all the possibilities Beethoven had envisaged. His harmonic progressions showed how the grammar of music could be refashioned. It was a tremendous *technical* achievement.
>
> —BRIAN PRIMMER, *THE BERLIOZ STYLE* (1973)

*
* *

In the decades before and after the outstanding year 1830 the majority of Parisians saw or heard about many things that doubtless interested them more than any artistic event. Insurrections broke out in many places: Spain, Portugal, Naples, the Papal states, Poland, the American South;° Belgium revolted against the Netherlands and shortly became an independent state. There was rioting in Germany, and in England's second city, Bristol, violent clashes took place over the pending Reform Bill. And while the new French government of Louis-Philippe conquered Algeria as a colony and was organizing the Foreign Legion, it was embroiled for two years with the striking silk workers of Lyon.

In the capital, the cholera, which had crept across Europe from the Far East, began its devastation. It could strike in a dramatic, a Romanticist manner: people at the opera ball suddenly cried out, collapsed, and died. The immediate cause was dehydration. The treatment devised by a Scottish physician—drinking a glass of salt water—was known only locally. In Paris, in spite of all nostrums, the popular prime minister Casimir Périer died of the disease; in Berlin it struck down Hegel. [The book to read is *King Cholera* by Norman Longmate.] At the same time, the Parisians were enjoying one of their bouts of Anglomania. The ways of the English Regency had given the model to imitate. Like all regencies it was a time of easy morals and conspicuous consumption. Entertainment was at a premium: George IV and his court needed

it. They started more horse race "meetings" and they raised boxing to a high place among fashionable spectacles. At Brighton a gorgeous pavilion and a pier were built to provide a variety of pastimes, including sea-bathing. Seaside resorts became common, while the inland town of Bath attracted social butterflies, valetudinarians, and gamblers. [The description to read is that in chapter 25 of Dickens's *Pickwick Papers*.]

And then there was the Dandy. This picturesque invention was due to Bryan Brummell, by no means a lord—he was the son of an upper servant—who, as the Regent's friend, imposed an original standard for male fashion and behavior. The figure is often confused with that of the 18C Fop; it is in fact the opposite. Far from showy, the dandy dresses very plainly, but he dresses to perfection: not a line or crease or a hair out of place. He does not dazzle the company with his wit, but speaks little and soberly; animation might disarrange the folds of his neckcloth. But in this austere mood of ambulant fashion-plate he permits himself from time to time a repartee that wounds and is worth repeating. [The book to read is *The Dandy From Brummel to Beerbohm*, by Ellen Moers.]

The dandy soon begot analogues in France—the Count d'Orsay and the fine poet Musset in particular. The only English writer to adopt the pose was the novelist Bulwer-Lytton. For an artist it serves to provoke, indeed, to defy bourgeois manners. In Brummell's version it is hard to keep up, but when merged with earlier elements—aristocratic ease and high bourgeois sincerity—it helped form the ideal of the gentleman, as imperturbable as the beau, but more gracious. [The book to read is *Good Behavior* by Harold Nicolson.]

Of the other English fads, the French took up horse racing and founded the Jockey Club; the young bloods went about in the light carriage called after the mountain goat *cabriolet* (whence *cab*), and if really *au fait,* they tacked on to the equipage a young boy, sometimes Black, called for obscure reasons a "tiger." As for their dress, they improved on the dandy, flaunting bright colorful coats, short and tight, pointed collars sticking into the chin, trousers pulled tight by a strap underfoot, and tall hats of high polish. The authorities call this costume "the second original dress period of the century."° One true advance was that in view of this rigorous garb, children were no longer dressed like small adults.

Less faddish entertainment was also available and popular. Italian operas were being composed and produced in abundance thanks to a trio of geniuses—Bellini, Rossini, and Donizetti. They made Stendhal swoon with delight, as he had begun to do somewhat earlier on hearing their forerunner Cimarosa. Together they inspired him to write a large *Life of Rossini* that re-creates the atmosphere generated by the whole school. What was entrancing about the Italian operas was their inexhaustible fount of melody, more lyrical than dramatic, but varied, full of verve, and easy to remember. It was adapted

to character and situation, but without stressing the somber side. Bellini's *Romeo and Juliet,* for example, is musical comedy in place of Shakespeare. Donizetti was moving toward a tragic style when in the mid-1840s his mind began to give way. Levity of plot and make-believe in treatment have consigned to oblivion much of this beautiful music. The names of some of Rossini's operas survive thanks to their overtures, which in this period were becoming another independent genre.

Berlioz's symphony had been played in the concert hall of the Conservatoire. Somebody sitting somewhere else, say at the opera, might have argued that the really great musical event of 1830 was Auber's new opera in Brussels. By depicting the tragic story of the 17C rebel in Naples, Masaniello, it was the spark that set off the insurrection which freed Belgium from the Dutch—and no wonder: in the last act of the opera Vesuvius erupts. This uncommon artistic success was followed the next year by the premiere in Paris of *Robert le Diable* by Meyerbeer. In retrospect it has been called the first *grand* grand opera, because everything about it was large (five acts) and lavish (all velvet and gold). The new work appealed by its seriousness, often factitious, but then taken at face value; it proved a model for composers and librettists until Wagner broke the spell (637>). Emphatic arias and dramatic recitatives gave singers opportunities for a way of performing that could give the impression of tragedy.

This sense of the real thing was guaranteed—so to speak—by the new accessories—furniture, carpets, doors, pillars, cloisters, tombstones were all solid—real (as were later goats and waterfalls), all forbidding disbelief. Trapdoors allowed dramatis personae to emerge or disappear in clouds of steam, and the new gas lighting enabled the time of day to vary at will. On the first night of *Robert the Devil* a piece of cloud fell on the ballerina and the trapdoor swallowed down the tenor, but they resumed unhurt and the evening ended to great applause.° Opera in all its forms and styles dominated the century with its offshoot, the ballet, as another sumptuous genre, both independent and adjunct to opera. The breathtaking Maria Taglioni (516>) inaugurated the full-sized spectacle the year after *Robert the Devil.* The scale of concerts generally was large too. A recital might bring together virtuoso pianists and diva vocalists in more than a dozen alternating numbers. One reviewer noted that by midnight part of the audience was seen to be leaving. It is true that in the hall music lovers mingled with lovers of keyboard acrobatics, but all had an insatiable gust for ballads, romances, solos for various instruments, and especially for arias from well-known operas, rendered by the divas, and "brilliant" variations on those tunes, hammered by the pianist. Liszt thrived for a time on this demand but grew weary and turned to more solid works. Chopin decided early not to compete with Liszt or Thalberg, who were the rival champions on the piano. Two other stars shone on other platforms: Paganini and Bériot, both violinists. Singers of great renown came

from abroad, the soprano Maria (Garcia) Malibran being the most acclaimed before and after her death at 28. Musset wrote one of the world's great elegies about her as the archetypal artist who gives her life to art and although applauded by the masses is truly prized only by the few.

Added to the bonanza of popular novelties were the new dances. The waltz had begun the procession; now other countries outside the Occident were drawn on and the repertory of the rustics as well. The polka, the mazurka from Poland, the seguidilla from Spain, the galop, and other rural brawls were adopted or adapted to dainty shoes and polished floors. In every country the citizenry were tripping it to the tunes of another nation. Chopin did not disdain using these rhythms of his native land for enchanting concert pieces, and a host of lesser musicians exploited the vogue by composing in every one of the species for ballroom use.

Of the waltz it must be said that it effected a radical change in manners; indeed, it marks a date in the history of sexuality. All dancing has this carnal component, but for centuries its full enjoyment was the privilege of the rural lower classes alone. City people deemed it their duty to civilization to limit themselves to figure dances, the entire company moving gracefully in set patterns. The steps were reduced to measured walking, with curtsying at intervals and touching hands only for turns or shifts of partners.

Judge of my surprise to see poor dear Mrs. Hornem with her arms half round the loins of a huge hussar-like gentleman I never set eyes on before and his more than half round her waist, turning round and round and round to a d- - - -d see-saw, upside down sort of tune. I asked what all this meant: "Can't you see they are valtzing—or waltzing?" (I forget which). Now that I know what it is, I like it.— Horace Hornem, Country gentleman.

—Byron, "To the Publisher" of "The Waltz" (1812)

The waltz, originating in Germany, changed all that. As mentioned before, it had long been a pastime for artisans in their guilds and when transplanted brought with it the traditional tune of "Ach, du lieber Augustin." What words and music did was to break up forever the elegant dance of groups into couples and to turn the diffident romp into a whirl. The shock of seeing (and being) the sexes paired in a close clutch and moving in 3/4 time at a dizzy speed was severe and prolonged. Resignation to the indecency (on the usual ground of "there is nothing to do; it has come to stay") took over a decade. Byron wrote a short satirical poem "The Waltz" in 1812; Berlioz in 1830 was free to make the second movement of his *Symphonie Fantastique* a waltz. [Read Byron and listen to Berlioz.]

Except for the enterprise of one devotee, the violinist Baillot, chamber music was little appreciated in Paris. Goethe, who much enjoyed it, described the pleasure as that of hearing the conversation of four civilized people. If the genre struck others the same way, its aura was perhaps too suggestive of 18C

salons. Besides, the Beethoven quartets were not known; the late ones had bewildered the hearers when attempted.

<center>*
 * *</center>

One important incident of the year 1830 did not stir up *Tout-Paris*, naturally enough, because it happened within the walls of the Academy of Sciences. But the news reached Goethe in Weimar and, though he was usually unmoved, he showed excitement. In those days he was being pleasantly pestered by a young poet named Eckermann, who recorded their conversations. This is the core of the one that took place on August 2 of that year:

"Tell me," cried Goethe as I entered. "What do you think of the great event? The volcano has broken out, everything is in flames, and it's no longer something going on behind closed doors."

"A dreadful affair," I replied, knowing the revolution of 1830 had just broken out . . . "the reigning family will be driven into exile."

"We do not seem to understand each other, my dear fellow," rejoined Goethe. "I am not speaking of those people. . . . I am speaking of the open break that has occurred in the Academy between Cuvier and Geoffroy Saint-Hilaire over a matter of the highest importance to science . . . you cannot imagine what I felt on hearing the news of the sitting of July 19."

The scientific controversy was over the hypothesis proposed by Lamarck about the transformation of species—Evolution (<455). Saint-Hilaire, with his researches in Egypt behind him (<445), had contradicted the leading anatomist—the man who said he could reconstruct a whole animal from a single bone. Goethe's interest was not merely that of a foreign intellectual with a taste for science: he was a scientist. His work on the metamorphosis of plants had been accepted by botanists and his discovery of the intermaxillary bone by anatomists. He offered some useful views in geology, and although his protracted studies of color had not displaced Newton's, he had every right to consider himself an experimenter on a par with those who gave all their time to the pursuit.

The idea of evolution inevitably appealed to him, chiming as it did with the Romanticist view that everything is alive and in motion—a dynamic universe, as modern jargon has it. Biology was accordingly the "period science" rather than physics. As in the 18C, expeditions kept being launched to all parts of the earth to study living forms, including "races of men." Young Charles Darwin, fresh out of Cambridge and not cut out for the church, sailed in 1831 on one of these catchall ventures (503>). Humboldt, roaming with Bonpland in Central America, collected 60,000 plants, of which a tenth were unknown in Europe. On his return he helped to form the idea of "science" as a unitary enterprise by writing for the general reader an attractively

"You know, all is development—the principle is perpetually going on. First, there was nothing; then there was something; then—I forget the next—I think there were shells; then fishes; then we came—let me see—did we come next? Never mind, we came at last and the next change will be something very superior to us, something with wings."

—LADY CONSTANCE IN DISRAELI'S
 TANCRED (1847)

serious book, *The Cosmos*. By contrast, such novelties of the decade as Ross's ascertaining the magnetic north or Lobachevsky's non-Euclidian geometry, in which the angles of a triangle do not equal 180 degrees, did not call forth general interest. They were harder to understand than evolution, which had also the news value of contradicting Genesis. In 1844, not quite a generation before Darwin's *Origin of Species,* an anonymous work created a scandal among the devout. It was called *The Natural History of the Vestiges of Creation*. It gave cosmic scope to the idea of evolution and titillated free spirits such as those Disraeli satirizes in his novel *Tancred*.

Biological evolution was made plausible by progress—visible—and by the popularity of history. From the 1820s onward, accounts of the past tended to be written as growth, the development of some idea or institution. Burke had shown that society is organic, since it consists of a living chain that, perishing as individuals, is ever renewed as the human race. Organicism, biology, history, evolution—all professed to explain the present or any given entity by finding out its antecedents. Informative as it is, it can be a dangerous method. When a thing is made out to be but the sum of its past states, the conclusion is as reductive as ANALYSIS; it mistakes a group of elements for a going concern and it implicitly denies novelty. This tempting error has been labeled the "genetic fallacy."

*
*　　*

Studies of development in all things logically included the history of languages. The 18C had given a great deal of thought to the origin of language and the forms of grammar, both important to worshippers of reason. The early 19C moved from these topics to the concrete facts of language and their variations from place to place. This research brought out regularities that were dubbed "laws," such as the sequence of vowel change in Germanic languages, established by the brothers Grimm, and also likenesses among large groups of dialects, Germanic and Romance, as well as definable subgroups (Celtic, Semitic). When the languages of the Orient, traced back to Sanskrit, were compared with the western group, likenesses were found that warranted seeing one line of descent. The "Indo-European" languages were thereafter the family of greatest interest to the western scholars who called themselves philologists—lovers of words.

As speech implies a human being, so languages imply whole peoples; philology began to talk about Celts, Latins, Semites, Hindus, and as many other tribes or nations as the written records might suggest. These records being by nature haphazard and hard to verify, they generated a battle of scholars that kept hundreds of 19C writers out of other mischief, but generated one of their own. The source of the Indo-European tongues was assigned to a supposed original form called Aryan. From this original language a people was in turn deduced, and since the word *aryas* means noble, the imagined people was taken to be of the highest caliber.

The sequel is easy to guess: the notion of distinct races bearing exclusive traits was launched on its juggernaut road. That old standby, the *Germania* of Tacitus was exhumed once more to define the Germanic "race." For other peoples Caesar's *Wars in Gaul* were made to serve, and so were all ancient writings that contained any "ethnic" information. In the polemics of an earlier day the claim had been made that the nobility everywhere in Europe came from the Germanic conquerors of Rome (<295). Philology revived the supposition and out of it came the belief in a superior type, the Germanic or Nordic, who also appeared under other aliases; the early 19C scholar John Pinkerton, for example, was a grammatical "Saxonist."

It was taken for granted that the characteristics, both physical and moral, that an ancient author had noted remained unchanged during the centuries and were uniform within the tribe. The Germans were tall, blond, blue-eyed. In the ancient Oriental record there was evidence that the *aryas* people had similar looks. Therefore the people living in the North of Europe in the 19C were the remote, unspoiled offspring of the Aryans. Defying evolutionary thought, it was descent *without* modification. It was also uncritical history, crude ethnology, and brash philology mixed to suit national pride. Not altogether by chance (as we saw, <456), the study of human traits had taken the physical turn called phrenology—bumps and valleys in the skull might denote "amativeness," which was love in the erotic sense, or "philoprogenitiveness," which was love of one's children. Faith in the system was not another superstition of the illiterate; good minds trusted and acted on the results. When Darwin applied for the post of naturalist on the *Beagle,* Captain Fitzroy palpated his head and, being also a physiognomist, took a long look at his dubious nose. We may laugh at phrenology now, but its direct heir, the now discarded "skull anthropology" of the 19C, with its implication about superior and inferior "races" was the work of some leading men of science (578>).

*
* *

The East, near, middle, and far, has always been a magnet to the West. The crusaders to Jerusalem brought back civilized ways; the Renaissance sent

out missionaries and imported goods; the 17th and 18C knew enough of eastern literature to use it in pastiches of travelers' reports as a means of undermining Christian theology and monarchical theory. The Romanticists—Byron, Lamartine, Chateaubriand, Kinglake—went east in person and wrote about the entirely different outlook on life of those who live beyond the eastern edge of Christendom. Concurrently, scholars of the first rank—Bopp and Brockhaus in Germany, Burnouf in Paris, William Jones in England—men who had mastered Persian or Sanskrit, or Hindi, were by their lectures and publications giving prominence to texts that were read by poets and philosophers. Around 1800, Goethe was moved by them to write his "Oriental" poems. Ultimately, the corpus was edited for the public by Max Müller as *The Sacred Books of the East* and published in England by the East India Company.

These ancient scriptures, such as the *Rig Veda*, confirmed the travelers' accounts of a world in which Time, having little urgency, does not lead the mind to take movement and change as matters of prime interest. Hence a cosmos in which events have meaning but little force and repeat eternally. Effort is futile; individuals are unimportant specks within the unchanging All in All. To this vision of life, certain Romanticists in their despondent mood gave their assent. Schopenhauer was one (556>). More remarkable, a group of thoroughly active young thinkers managed to adapt the Oriental scheme to their optimistic ends. These were the New England Transcendentalists, the first galaxy of artistic genius in North America.

From Paris and other European centers in 1830 the United States were not a prepossessing sight. Visitors who had been well received and were in general complimentary to their local hosts were censorious about the rest of the country. The revolutionaries of 1789 in France had considered the Americans of 1776 freedom fighters of their own temper—mistakenly, but that image had vanished with the century. In the next, from Captain Basil Hall to Charles Dickens and Mrs. Trollope (>517), the picture is that of a people without manners or discrimination and boastful besides. With one exception to be noted, the other critics—those who stayed away—interpreted the new nation as the land where equality was maintained at the expense of intellect and the arts, both virtually non-existent. In their place, energetic go-getting and beaming self-satisfaction fulfilled everyone's aspirations. The election of the common-man President Jackson in 1828 had eliminated any remnants of the cultivated outlook acquired by the Founding Fathers from the French and English Enlightenment.

Crude though the portrait was, it is true that the American intellectual class that did exist in the 1830s looked less and less to England and France for ideas. It was Germany that fed them. Even when they read Coleridge and Carlyle, the leaders of advanced thought in England, they were receiving a dose of German ideas (<409). Chief among American Germanists was professor George

Ticknor of Harvard. He, George Bancroft (later the first national historian), and a few others had gone to German universities and carried home the message of Herder and Goethe, Kant and Schiller in all its poetical and philosophical strength. Ticknor in turn imparted it to young Emerson and his classmates.

The virgin soil of the New World was without Middle Ages waiting to be rediscovered, and the people had no firsthand memories of Bourbons and Napoleons. So what dominated the minds of the young American geniuses was the religious emotion, the love of nature, the spirituality of art, the value

> Far or forgot to me is near,
> Shadow and sunlight are the same;
> The vanished gods to me appear,
> And one to me are shame and fame.
>
> —EMERSON, "BRAHMA" (1830/1857)

of INDIVIDUALISM, and the hope of creating a national culture based on the uniqueness of the American experience. On all points Emerson is representative. Trained for the Unitarian ministry, the least demanding of Christian sects, he gave it up under the influence of Montaigne, who led him to ponder the lessons of nature and to vivify his own poetic version of Eastern thought. The impassive divinity diffused through the cosmos afforded him not resignation as in the *Vishnu Purana* that he read, but a cheerful serenity.

In the mid-1830s Emerson gave a Phi Beta Kappa address that influenced many minds by summoning the native thinker and artist, whom he called "the American Scholar,"° to cut loose from European models. Oliver Wendell Holmes (Sr.) hailed it as "our intellectual Declaration of Independence." Settled in Cambridge or Concord, Massachusetts, a group of congenial spirits formed the first self-conscious American "School." It included Thoreau, Hawthorne, Holmes, Orestes Brownson, Margaret Fuller, Theodore Parker, Jones Very, Bronson Alcott, and Elizabeth Peabody. Emerson alienated some of his other friends when he declared the church dead and all forms of ministry an anachronism. But he remained a preacher: his essays, which were first lectures, are lay sermons on the topics that naturally arose out of his philosophy; and his success as a speaker—the source of his livelihood—suggests that people outside the Boston area responded favorably to his original creed. The realm of spirit defined by the new German philosophy and already numbering American converts merged easily with the eastern cosmology in Emerson's conception of an "Oversoul."

The strength of its appeal in another individual guise is shown in the career of Emerson's neighbor and companion Thoreau. He found publishers for his writings and was tolerated by the town of Concord, most notably by the tax collector, whose demands he kept ignoring. If one wonders how building a native American culture is compatible with Brahma (to use a shorthand term for the Transcendentalism), what suggests itself is that Brahma mainly served the same purpose as the European artists' repudiation of the

bourgeois world. The artist lives in an ideal realm and from there bestows culture on society. An American critic has made a cognate point; both Emerson and Thoreau (and later Whitman) exhibit what he calls "the imperial self."° That self, confident in its INDIVIDUALISM, tells others to shuffle off communal ties and enjoy a self-made universe in all its purity.

This lesson proved congenial to many Americans, especially in Thoreau's variation. To this day *Walden* is a name to conjure with; it means fleeing the daily grind, living at the heart of nature, free to breathe and contemplate. Self-reliant PRIMITIVISM is the intended message, but not the truth about Thoreau's escape: he took civilization with him: clothes, nails, seed, and lumber, none of which he had made. Like Crusoe he survived thanks to essential fruits of social effort; indeed, Thoreau required direct help from friends to put the roof on his hut, nor did he give up going back to Concord during the two-year demonstration. These and other inconsistencies pass unnoticed in the bliss one shares with the narrator. The vacationer camping out, the hunter and woodsman, the Boy or Girl Scout feels it a birthright to live a facsimile of the Pilgrim-and-pioneer existence.

Going much farther than Emerson, Thoreau has encouraged in every generation the urge to Civil Disobedience. His tract with that title is the most engaging and incoherent discourse ever written on government.° Good and bad reasons and self-contradictions wind up in an astonishing sober statement of compliance with the legitimate demands of the state. The essay is effective because its meanderings correspond to the feelings of rebellion that the young generally feel on the threshold of the big world and that artists of all ages tend to share. And Thoreau was a poet. His travel books and journals ought to be read as prose poems strung on a philosophic narrative thread. Similarly, the descriptive parts are more often allegories than writings about nature in the manner of Gilbert White or John Muir.

What the Transcendalists, unlike the Romanticists abroad, rarely showed was a cultural interest in The People. For one thing, their historical sense was dim—as it must be when Brahma rules: past, present, and future are all one. Hawthorne did recall the past, but it did not make him happy. And without historical perspective The People lacks grandeur—its name evokes only one's contemporaries, dull and misguided, instead of the patient, anonymous makers of one's treasured inheritance. And in New England no daily physical reminders of inheritance were present—no ancestral mansions, ancient churches, scarred ruins, battlegrounds fought over again and again. Goethe, the exceptional European who thought well of America, congratulated the country on this very deficiency.

Outside New England the same happy insouciance prevailed. Washington Irving in New York echoed conscientiously the manner and the concerns of English writers, his local subjects being legend for humor's sake.

To the south, Poe used his genius as poet and critic to disown "the man in the crowd" and chastise the would-be literati who wrote imitative verse and prose. Not a Transcendentalist, he felt the double attraction of death-haunted mystery and ratiocinative science, inventing for their expression the detective and the horror story, and relying for stimulus rather more on French literature than on English.

Of course, the French public of the late 1830s had a chance to set its mind straight on the new nation by consulting Tocqueville's *Democracy in America,* but although its title might lure readers anxious about the revolutionary threat in Europe, its title would leave artists and intellectuals uninterested and secure in their prejudices. To both groups, it must be remembered, the word *democracy* did not mean representative institutions and the rule of law; it meant a form of government untried since ancient Greece and the rule of the illiterate mob.

> America, you're better off than
> Our continent, the old.
> You have no castles which are fallen,
> No basalt to behold.
> You're not disturbed within your inmost
> being
> Right up till today's daily life
> By useless remembering
> And unrewarding strife.
> Use well the present and good luck to you
> And when your children begin to write
> poetry
> Let them guard well in all they do
> Against Knight-robber-and-ghost story.
>
> —GOETHE (WEIMAR, 1821)

*

* *

It might seem as if a few strong heads in the northeastern United States had disposed of the country's strong attachment to religion quickly in almost noiseless fashion. Many people around them in fact remained steadfast, and so did the rest of the country. But among intellectuals the knowledge of German literature and thought brought with it a substitute religion. It had its roots in Kant's wrestling with Hume's problems and it is known as German Idealism. To avoid confusion the word should be spelled *Idea*(l)ism. Hume's poser was this: if reasoning shows that what we call cause-and-effect is merely our habit of seeing one thing come after another—yet not invariably—what becomes of our vaunted sciences? The mind learns everything from experience, uncertain and not alike for all; any hope of system is therefore illusory.

Kant did not question the analysis; instead, he redefined experience. He made a "critique of pure reason," by which he distinguished two realms. One is that of things as they are and the other of things as they appear to the human mind. We can never know things as they are, and when we perceive things in experience our minds have had a formative part in the way they appear. We see them in time and in space, in separateness that allows them to

be counted, and so on. One of these contributions of the mind is the relation of cause and effect, not illusory, but as real as time, space, and number. Men of science can sleep in peace again, confident that their investigations reveal a true connection. Common sense too is reassured.

Hume's demonstration was the logical end of Empiricism—the mind shaped by things "out there." Kant posited a mind that acts like a waffle iron on batter. The difference explains the name Idealism: the philosopher, instead of going from thing to idea, goes from idea to thing. Kant's reversal and its varied modifications convinced a vast following on both sides of the Atlantic; Idealism was the dominant western philosophy down to the 1890s (668>), especially in the form that Hegel developed from it after the first generation of Kantians.

In Hegel's system the Ideal and the Real are two aspects of one Being, which is the Absolute. The Real manifests itself as experience or history; the Ideal is spirit in all things and the equivalent of soul in human beings. At death the spirit-soul returns to its fount in the Absolute, the equivalent of God. This worldview was bound to attract minds that could no longer believe the Christian account of reality and yet, moved by religious feeling, wanted a scheme that affirmed soul and immortality. The scheme was made still more persuasive by Hegel's keen sense of the world's concrete diversities. All things and beings are in restless motion and hostile confusion. His most readable work, the *Philosophy of History,* resolves these conflicts by a novel "logic": the battle of ideas ends by pitting two antagonistic "theses" against each other: the thesis confronts the antithesis and out of the struggle comes the synthesis, preserving the best elements of each. Thus history evolves, the Idea is not static but progresses, and Hegel asserts that its forward march is that of ever-enlarging freedom. Karl Marx, to establish his own view of history and the goal ahead, borrowed Hegel's logic wholesale (549>). For Hegel, living after the French Revolution and Napoleon, freedom had visibly been granted to western Man.

How in the light of these facts Hegel has been made the apostle of tyranny by the state and the advocate of German aggression can be explained only by the effect of two world wars, coupled with the vice of literalism. Hegel did express himself in favor of a strong state. What intelligent German who remembered 200 years of helplessness would want a weak one? In Hegel's day, the state created by the Prussian awakening (<395) was less than 20 years old and must not be allowed to droop again. If one were to ignore historical conditions such as these, one could describe the makers of the United States Constitution as also advocates of a strong state. Hegel said the state was more important than the individual, yet as early as 1821 he demanded representative institutions; and 10 years later, when near death, he wrote in praise of the

pending Reform Bill in England. So clear was his position that well past the middle of the century he was regarded as a revolutionary.°

A thinker who deviated from both Kant and Hegel needs a word, because he has recently regained the attention of philosophers. This was Schelling, who called his system *Natur-philosophie*. It made the Idea less abstract by affirming the independent objectiveness of the natural world. Its essence is energy and so is human consciousness. Schelling's definition of art as organic form influenced Coleridge, and the depiction of "the human condition" as a source of anxiety anticipated the Existentialists.

In metaphysics the only 19C rival of German Idealism was the system of Auguste Comte. To him, metaphysics was an error to discard. Primitive societies were animistic, seeing live agents inside every natural event. Then medieval thought explained things by making abstract words into causes, powers literally meta-physical = behind physics.° Modern science at last dealt directly with fact. This is Positivism. Comte defined and placed the several sciences in ascending order from mathematics and astronomy up to biology and sociology, each drawing materials from the one below and adding its own complexity. He coined the word *sociology* for a new science that should complete the total survey of the real world, leaving nothing outside the grasp of scientific method.

Positivism found adherents among the empiricists dismayed by Hume (<508) and among scientists who saw no need of any philosophic backing for their work, and who would certainly not be lured by the involuted language of Kant and Hegel. In England, the young Stuart Mill was drawn to the Positive philosophy and publicized it, and Harriet Martineau, a prolific writer on moral and social issues, gave in one tome an abridgment of Comte's four volumes. English Positivists formed a dedicated group that lasted until the 1890s but never threatened the supremacy of Idealism, English version. Being a Positivist after all required little effort of thought and offered no occasion for elaborate argument. To a scientist or a businessman who lacked the speculative turn of mind, Comte's doctrine, which had its longest influence in South America, was *not* abstruse and one's metaphysical neighbors could be left to their illusions.

Meanwhile in France a routine accident impelled Comte to build upon his down-to-earth system a quasi religious superstructure: he fell in love. He had started his career as a mathematician, became secretary to Saint-Simon (522>), and made an unhappy marriage. After his great work, he met Clotilde de Vaux, who was married to a convict. She kept Comte a mere passionate friend, and this emotional awakening made Comte a feminist° and the founder of a creed of which Clotilde was the patron saint and himself the high priest. Worshipped beside them were certain chosen heroes and benefactors

of humanity. No transcendence irradiates the Positive religion; every aspect of it remains mundane, but its catechism, including the reading of some 100 great books, was meant to satisfy a need not met by the strictly positive.

Comte's religion made few converts anywhere, but his plain system was ecumenical; it survived longest as the favored philosophy in the Argentine. Though his name is rarely mentioned, his simple view of science is implicit in the public mind the world over.

<p align="center">*
* *</p>

A death that occurred in 1830 went unnoticed in Paris and received hardly any attention in England, yet it has significance as marking the end of the greatest literary and political critic of the age,

Hazlitt

He could have figured as one of the Forgotten Troop (<436), because his name is not a household word. But he is not so much forgotten as half-known, his mode of thought is out of favor and his range is too broad to let him be classified. Unlike his friend Charles Lamb, he does not invite that coziness which generates a "Friends of ———" Society with a quasi scholarly newsletter.

Hazlitt was first a painter and a metaphysician, then a drama critic, a political commentator, an autobiographer, and a master of the familiar essay. In all genres he excels; in every line he wrote he was Criticism personified. He ranks moreover among the distinctive English stylists. As Stevenson said with the perspective of half a century: "We are all clever fellows, but we cannot write like Hazlitt." One reason that he is not linked as a critic with Coleridge, De Quincey, and Landor is that he was their political enemy, hated and abused in their periodicals. *The Quarterly* said that he wrote Cockney English, or again called him "pimply-faced," though he had a clear, smooth complexion. His crime was that he had not abjured the French Revolution like the Coleridge coterie, nor had he joined the nation in making a bogeyman of Napoleon. Like Scott, he wrote a four-volume life of the emperor, but taking the other side.

It is easier to describe what Hazlitt does in his critical essays than to convey the impression they make. Perhaps one's strongest feeling is that the ideas are not conclusions "recollected in tranquillity" but worked out in front of you. Those long enveloping sentences feel hot from the forge. In his *Characters of Shakespeare's Plays,* in his *Lectures on the English Poets,* in his essay "On Genius and Common Sense," indeed, in whatever his mind lights on, Hazlitt finds the deep source of the matter and traces its implications and ramifications; he sees how the event, the impulse, or the vision took shape; he

relates what is there to other parts of the same work, to the work of others, to the author's life, to life in general, to his own life. It is not analysis, it is judgment encompassing its object, leaving it whole and illuminated.

As remarked earlier, criticism of this order is out of favor today because it follows no system, lacks a jargon, and affords pleasure when read. How can it be "rigorous"? It is "impressionistic." These and other strictures must be understood as part of the competition between art and science. To be up-to-date and acceptable nowadays, any mental activity must use principles couched in special abstract terms and forming a system (>730). What is poured into the mold other than impressions drawn from the work is not stated. But one has only to read Hazlitt without preconceptions as to what he ought to do to see that he is both rigorous and exhaustive. His practice is to describe and define and to describe again, adding a line, a touch, developing the complete image. You see a drafts man, a painter at work. He persists and insists that you shall see the way he perceives—not that he is trying to persuade you of an idea, only to make you as good a reader as he is. And that means one who not merely knows more than the careless or unguided but enjoys more.

> If we have a taste for some one precise style or manner, we may keep it to ourselves and let others have theirs. If we are more catholic in our notions and want variety of excellence and beauty, it is spread abroad for us to profusion in the variety of books. Those who would proscribe whatever falls short of imaginary perfection do so, not from a higher capacity of taste or range of intellect than others, but to destroy, to "crib and cabin in" all enjoyments and opinions but their own.
>
> —HAZLITT, "ON CRITICISM" (1821)

In his familiar essays Hazlitt gives pleasure and wisdom like Montaigne. He speaks of himself as a witness in the same way and he quotes almost as much. But he does so in English and he sticks rather more closely to his announced subjects: "On People With One Idea"; "On the Indian Jugglers"; "On Living to Oneself"; "Why Distant Objects Please"; "On the Feeling of Immortality in Youth"; "Whether Actors Ought to Sit in the Boxes." His subjects divide between the unexpected and those born of common experience. [A good group to begin with is the small collection entitled *Winterslow,* ed. by his grandson W. C. Hazlitt.]

The reader who is captivated will want to go on in two directions: to *The Liber Amoris* and to *The Spirit of the Times.* This last consists of bio-critical essays on the leading political figures of the day. The characterizations are verbally sharp, but never caricatures. For example, describing Lord Eldon, the Lord Chancellor, Hazlitt says: "He has a fine oiliness in his disposition which smooths the waves of passion as they rise." The most remarkable portrait is the one of Burke. Here is the man whose ideas had given strength to counter-revolutionary thought in England, who was the embodiment of Conservatism, a party that but for him would have ruled in mere dumb resistance,

My favorite guide to reading would be the critical writings of William Hazlitt and Samuel Johnson and Emerson, who are the critics in the English language who have most influenced me. I don't know anything better than *The Characters of Shakespeare's Plays* by Hazlitt.

—Harold Bloom (1998)°

with nothing to say for itself—here, in short, was Hazlitt's quintessential enemy. Yet so balanced is the judgment at work that the essay turns out the finest of eulogies. Hazlitt makes clear the wrongness (as he thinks) of Burke's ideas of freedom, of government, of religion, and of the English Parliament. But Burke's genius as a thinker and writer and the worth of his character are represented in glowing lights and delicate shades. It is a perfect exhibition of critical genius.

The Liber Amoris, "the book of love," relates the curious behavior of a young woman Hazlitt fell in love with and his baffled response to it. The telling, again, is immediate, yet detached; it stands halfway between a case study and a novel, like the *Adolphe,* of Benjamin Constant, in which the narrator dissects his love-subjection to Germaine de Staël (<450). One more work, the *Conversations with Northcote,* show Hazlitt matching opinions with a painter,

We might consider whether Hazlitt could have performed this function [of mediator] so well if his mind had not been central to Romanticism. His thought moves with the advancing storm center of Romanticist creativity. Its great issues meet, intersect and interpenetrate, converging toward resolution or conflict.

—John Kinnaird (1978)

as he was qualified to do by his early practice of the art and lifelong passion for it. [The book to read on Hazlitt in all his aspects is *William Hazlitt* by John Kinnaird.]

Hazlitt as philosopher is not without originality and will receive a moment's attention later on, when German Idealism and its variants are shown losing their hold at the end of the 19C (668>). As for being philosophical in the ordinary sense, Hazlitt qualifies for the label: after years of quasi persecution and disappointments, on his deathbed and no doubt thinking of his intimacy with art and literature, his last words were: "Well, I've had a happy life."

*
* *

Northcote was of an older generation, and there is no sign that Hazlitt paid attention to the artists of his own time. Two of them, Turner and the much younger Delacroix, were the great pioneers showing the way for decades to come. But in 1830 they occupied the ambiguous position of the strangely talented who fail to please current taste. It took a long vehement book by Ruskin to gain Turner his rightful place; and Delacroix owes his more to other painters down to Picasso than to the majority of critics. This is

understandable when we see that their innovations were many and radical. Turner's transmutation of actual scenes into sunbursts of pigment, grand designs of light and color, startled their viewers looking for hard outlines and human figures. Violent contrast was one of his devices. Ruskin once found him sticking a piece of black paper on a spot of the work in hand—"nothing else was black enough." By an odd coincidence, Balzac, who never saw these works, wrote a novella called "The Unknown Masterpiece," in which a mystical painter creates a new type of work, made of light and color alone (644>)

It is light and color and color and light that defines Romanticism in paint. In 1834, Delacroix went on a government mission to Morocco and was struck by the difference between its sunshine and what goes by that name in Paris. Bonington had already modified Delacroix's palette. The sand, the skies, the animals, the white burnous, and the bronze complexions of North Africa changed it again and gave him the means to project on canvas what Turner also intended, which is drama. That period characteristic also animates Victor Hugo's monochrome fantasies and "abstract" works on paper.

> What made the drapery glisten so?
> Not a man but Delacroix.
>
> —YEATS, "A NATIVITY," LAST POEMS (1936–39)

Both Turner and Delacroix left an enormous number of works—oils, etchings, drawings, watercolors. Delacroix in addition decorated the walls of the two palaces where the Chamber of Deputies and the Senate of France hold their sittings. Abundance is another period characteristic. The quantity of prose and poetry, of essays, fiction, histories, and lives, the amount of music for church, stage, and concert hall are astounding. So is the harvest of masterpieces compared to the wastage. One may say this was to be expected from so many cohorts of geniuses, but a great many died young. The enabling condition of the plethora was what one may term the "cultural courage" of Romanticism. Its makers were not afraid of failure—nor of being foolish. They did not exercise caution to look acceptable, dignified, "mature" or "realistic."

Aside from the heap of silly ventures and spoiled efforts, Romanticism failed to produce lasting work in two domains: architecture and the theater. When the "romantic" tendency was only a mood, in the mid-18C, its exponents had pitched on Gothic ruins for their satisfaction—and never got away from them. The power of Gothic, reinforced by study of the Middle Ages, was too strong. The gifted Pugin in England adapted Gothic elements to practical needs—the Gothic Revival style—and he shared the design of the new Houses of Parliament after the destructive fire of 1834. But in other hands than his, the idea generated only imitation. In France, Viollet-le-Duc was so entranced by Gothic that he spent his talented energy clamoring for restorations and carrying out a good many, now disapproved yet preservative.

Time and the revolutionists had damaged many beautiful churches. In Berlin, Schinkel also built in Gothic Revival style but did not on that account give up the neo-classical. It is a great pity that Ledoux (<459) had no successor.

One creation of the period that doubtless had a limiting effect on architecture was the new image of Greece. The 18C had seen Greece mainly through the works of Rome; Virgil was generally preferred to Homer. Now in the 1820s support for the Greeks, rebels against the Turks, brought ancient Greece closer to the Occident. Sympathy not only led Byron to the land itself (<486) but rallied spirits all over Europe. Pan-Hellenic societies sprang up all over Europe. Poets wrote odes (Berlioz set one to music); studies made the two ancient civilizations distinct, especially after Lord Elgin saved and shipped to England the sculptured frieze of the Parthenon, where the Turks were housing gunpowder. The "new Greece" now figured as the cradle of western civilization and the home of perfect art. Athens had been entirely populated by artists; Greek tragedy contained the ultimate wisdom on human life; Socrates was the wisest man who ever lived. He had been put to death by a vote of those consummate artists, but never mind. Read Plato and forgive. The 19C cult of Greece, the Greek temple which is a bank on Main Street, and the picture of the Parthenon in the classroom date from this moment of enthusiasm.

German poets and thinkers often combined attachment to their native traditions with a longing for the Southland. Goethe, who had visited Italy and written a famous poem of longing about the lemons in bloom, was a conspicuous example. He tried in several works to recapture the classical equipoise that the scholar Winckelmann had been the first to eulogize (<417). Now in 1832, Goethe had just died and *Faust, Part II* at last published. This sequel to the poem that made the spirit of Romanticism into a world character invokes it again in a symbolic scene that shows Goethe's wish to mingle romantic with classical: Faust marries Helen of Troy and their offspring is Euphorion = well-being. The poet let the world understand that he was thinking of Byron. This episode in Faust's odyssey through the world of affairs is important because in an earlier moment of classical fervor Goethe had called Romanticism sickness and Classicism health. Critics hostile to 19C culture as a whole are fond of quoting this contrast as final, although Goethe himself retracted it before *Faust II*, which *is* his last word. The play ought to end with Faust's death, because he asks for more time, the present moment being so fine. His bargain with the Devil stipulated that on making that wish Satan would seize Faust's soul. But Faust is saved by the reason for which he asks for time: it is not self-centered enjoyment; it is that he has not finished supervising a work of engineering for the public benefit.

The second *Faust* drives the hero through the worldly world after his adventure through nature and the self. Lifelike or not in the play, the symbolic

events involve current issues that Goethe was concerned about. A modern student has suggested that the work is a kind of tract on sound economic policy. Its merit is its many-sidedness, but whatever it may mean, it is not a stageable drama, nor (so to speak) permanently dramatic. It shares this negative with a large number of Romanticist plays. Byron's six tragedies; Vigny's, Balzac's, and the elder Dumas's dramas in prose; Lamb's and Coleridge's efforts are not without interest but are without theatrical force. The deficiency afflicted the entire age, yet with interesting exceptions. Hugo's verse dramas still show the impress of his genius when read, but it is the plays which he wrote "in freedom," from current conventions (*Théâtre en Liberté*), and thus were never staged in his day, that are now put on and admired. Their appeal lies in the strangeness of outlook and discontinuity in dialogue, both suggestive of the 20C Theatre of the Absurd (754>).

The same qualities inform the work of Georg Büchner, the German rebel of the 1830s who died at 24, leaving two plays and the fragment of theatrical Naturalism that Alban Berg seized on to make his opera *Wozzeck.*° Of Büchner's other plays, *Danton's Death* depicts with tremendous force the drama of a defeat that is virtually willed by the victim. It should be staged as it was by Max Reinhardt: a play of mass action and multiple conflicts. As for Büchner's comedy *Leonce and Lena,* it resembles the purposeful incoherence of the Hugo pieces and the same flouting of common sense that is the point of Musset's several *Comédies et Proverbes.* These too are relished now on the French stage. To these Romanticist anticipations of Naturalism and the promptings of the unconscious, one is tempted to add Pushkin's so-called tabloid plays as yet another Romanticist manifestation of theatrical power. But since Pushkin is not to be seen staged in the West, it may be risky to make the connection.

A related exception was the ballet. It is drama in pantomime and subject to the same demands of clarity in action and progress toward climax and denoument. The late 18C was fond of ballets built on myth and familiar ancient history, both easily depicted and imagined from fairly conventional bodily movement and groupings. The 19C took on for its three-act spectacles more difficult themes, less generalized, and based on some of the little-known subjects favored by the Romanticist poets and composers. In 1827, Eugène Scribe, a prolific young playwright, wrote a complex libretto, *The Sleepwalker, or The Advent of a New Land,* which the choreographer Jean Aumer enriched with symbolic nuances. Five years later, *La Sylphide* electrified the audience with its innovations, per-

> After *La Sylphide,* the opera house was invaded by gnomes, mermaids, salamanders, nixes, peris, will o' the wisps—weird, mysterious beings that lend themselves wonderfully to the fancy-rich authority of the choreographer. The thick buskin of Greek drama gave place to the satin slipper.
>
> —GAUTIER, *LE BALLET ROMANTIQUE* (1858)

formed by Maria Taglioni (<499), whose slim figure, hairdress, and blending of *pointes* (rising on toes) with other steps set the standards of 19C style. From then on, ballet writing became a specialized profession. Gautier's *Giselle* is but one of a huge output on a wide variety of subjects, not a few of its best examples being still produced, plain or distorted for modern taste.

The likely reasons why there are not more masterpieces among Romanticist plays are several. With the drama of revolutionary lives and a hero such as Napoleon present to everybody's mind, the would-be playwrights were at a disadvantage when it came to inventing situations and characters. The dramatic sense was not at all blunted—it came out in their poems and novels, and as we saw, in painting and music. In all of these the beholder's imagination was effectively moved without recourse to embodied action.

A further, mighty obstacle was

Shakespeare

We left him a successful 16C playwright who satisfied the public high and low, was admired and loved by the more learned and superior craftsman Ben Jonson, but criticized by him and others for hasty production and "want of art." In the next two centuries Shakespeare's presence was noted as a maker of pretty poor stuff (Pepys) and then of pieces worth cutting and doctoring because of their good parts (Garrick), while poets found the plays full of great poetry—in patches—and of faults beyond belief (Dryden, Dr. Johnson). Finally, one voice in England proclaimed him a deathless dramatist and portrayer of character (Morgann) (<422).

But before Morgann, Germany had started Shakespeare on his second wind of reputation. Lessing first prized him as a rebuke to Voltairian tragedy; Herder, Schiller, Goethe, Tieck, and the Schlegels, by dint of praising, commenting, and translating, erected the towering figure. The Shakespeare that we revere is a German creation. Then came the devoted propaganda of Coleridge, Lamb, and Hazlitt in the first and second decades of the 19C, after German opinion had spoken and been heard.

The upshot was: Shakespeare's art was equal to his genius; his judgment in characterization and dramatic fitness was impeccable; his knowledge of life and human beings was not equaled by any other poet or playwright. Next to these powers his faults counted for nothing; and many of these were not his faults but ours or those of his time. Carlyle near the end of the campaign summed it up when he called Shakespeare "the greatest of poets hitherto."

Thus was "the bard" born. Bardolatry in turn produced the Shakespeare of school and commerce. Charles Lamb and his sister Mary had written the attractive *Prose Tales from Shakespeare*. The painstaking Dr. Thomas Bowdler fumigated the plays, ridding them of all that might offend a chaste ear and

making them suitable for reading aloud by the family after dinner, each taking a part. Bowdler's *Family Shakespeare* filled a void in an age when mechanized pastimes were unknown, and his benefaction contributed the verb *bowdlerize* to the language.

The rescue of Shakespeare from the role of "pure child of nature" uttering "native woodnotes wild" was necessary and long overdue. Until it was done, less than half Shakespeare was visible, just as he appears in the painting by Ingres called *The Apotheosis of Homer*. Ingres was a classicist. Again, the refutation in France and Italy of the "Gothic barbarian" charge amounted to a vindication of the new in art. Stendhal's *Racine et Shakespeare* came out just after an English Shakespeare company had been hissed off the stage in Paris. When another troupe arrived five years later, in 1827, the Jeunes-France went wild and carried with them a good many of their elders.

It was at last seen that Shakespeare was the first poet to put on the stage rounded characters instead of types, characters whom we know better than it is possible to know anyone in life, including oneself. These figures Shakespeare presents in striking actions and situations that are modern instead of antique—nation, monarchy, Christianity make them so. Besides, for life's predicaments and the feelings they arouse, Shakespeare coins definitive phrasings by the hundred; this in addition to stretches of poetry verbally and emotionally miraculous.

After the critic, the actor, and the schoolmaster had made the name sacrosanct, an industry arose outside the academy and the theater and the Shakespeare establishment became impregnable. It was henceforth embarrassing to criticize the bard, unless one enjoyed defiance as such. An amusing incident of the 1830s in America illustrates the orthodox attitude. Frances Trollope, mother of the two novelists,° emigrated to Cincinnati to restore the family fortunes by opening a dry goods store. During her stay she spent an evening in the company of one of the city notables, "a serious gentleman," as she reports in her lively *Domestic Manners of the Americans*, and they compared views about Byron and other poets.

"And Shakespeare, sir?"

"Shakespeare, madam, is obscene, and thank God we are sufficiently advanced to have found it out."°

The man was perhaps a bit succinct in his estimate, but it showed that he had read the plays and understood a good many passages; whereas her contemptuous indignation is that of the blind worshipper. Better critics than either Mrs. Trollope or her host have, again and again, quietly set down in diaries and letters, in essays and reviews, the tenable objections to Shakespeare's mind and art: the dull passages, including the puns, often obscene and prolonged; the inflated sentiments, the ludicrous images, the insoluble syntax, the contradictory details, the theatrically awkward turns, and

the sheer excess where terseness or silence would be best. Several adept at stagecraft like Gide, condemn whole plays; Yeats saw only "beautiful fragments"; others, like John Crowe Ransom, find Shakespeare "the most inaccurate of poets." Goethe himself in his long eulogistic commentary has an aside on "the comics in *Romeo and Juliet*," who are "unbearable." Over the years, many devotees such as Lamb and Thomas Hardy have said that the plays are really for reading only; then the blemishes can be looked upon as it were in soft focus.

These strictures are confirmed by the fact that actors and producers since his day have found it necessary to cut and transpose his scenes with a liberal hand. The public never hears all he wrote. Only about half of the 37 plays are ever staged; and although the producers do not, as in the 18C, use performing bears to pull in the crowd, they do add acrobats, change the place and time of the action, impose modern dress and telephones, and reinterpret the plot in flat contradiction to its plain meaning. In short, these 16C pieces are quality yardage for anybody to tailor according to whim.

None of the defects that have disturbed previous and later critics affected the enthusiasts of the 1830s. They were not blind or deaf, but like every generation they knew when they had found the perennial "elements that are wanted"—ideas, forms, names to serve the combative purposes of the moment. As *Faust* had made concrete the Romanticist vision and faith, so the Shakespeare play—no matter which—sanctioned the tone and ingredients of Romanticist art. By ranging from common prose and actual vulgarity to sublime lyric flights and from philosophic despair to imperious violence, Shakespearean drama fulfilled the Romanticist ambition to embrace and express whatever is.

The Mother of Parliaments

IN SPITE OF ALL its contradictory acts, the French Revolution of 1789 must be called the Liberal Revolution. The word *liberal,* it is true, acquired its political and economic meanings well after the five high-fevered years were over, but as pointed out on earlier occasions, a revolutionary Idea endures, and this one received its central definition in an actual law within two years of the first outbreak. It stated that "No other interests exist but the particular interest of each individual and the general interest of all. Nobody shall be permitted to gather citizens around intermediate interests and thus cut them off by the spirit of association from the public interest."°

This explicit language against guilds or other groups and their special wants decrees that the nation shall be dedicated to INDIVIDUALISM—everyone free to act as he sees fit in all ways that do not infringe the rights of others, whether taken separately or as the whole nation. The entire 19C fought with words or guns over this proposition and part of the 20th is still doing so (777>). The demand for the vote, for charters and constitutions, and for reforms in existing governments had in view this simple scheme, which was to be worked by elected representatives of the people. It promised to each and all a fair field on which to compete for an endless variety of further benefits.

The demand for this new power, vocal throughout Europe, beset the victorious restored monarchs of 1815 and generated a common policy of containment, orchestrated by Prince Metternich, chief minister of Austria. It was hard going for a full generation. The upsurge of angry claims and the armed uprisings were continual. Students, professors, and other educated bourgeois, sometimes helped by artisans and occasionally by bankers and manufacturers, agitated for the vote, brandished a charter, or shouted for a republic. *Los liberales* was first used in Spain in the 1820s to designate the "freedom fighters" opposing the monarchy and wanting to maintain the "Charter of 1812" that Napoleon had bestowed. A little later the young Alfred Tennyson, still

unknown as a poet, enlisted in another bout of this typical "Spanish Civil War," but thought better of it and backtracked while still in southern France. In neighboring Portugal, the same demands led to armed conflict also and the same triumph of monarchy.

In the Germanies the universities and student fraternities were the centers of resistance to the Metternich system. Celebrating the tercentenary of Luther's 95 Theses proved a fit occasion to agitate against "reaction" in the name of "liberty." Two years later, Karl Sand, a student at Jena, expressed the same defiance by assassinating the illiberal playwright Kotzebue. It was a Thirty Years' War, intermittent like the first, but breaking out over a wider territory: France, Greece, Poland, Russia, northern Italy, Naples, the papal states, and Belgium, kept tsar, emperors, and kings on the qui vive. Little changed except that Belgium won independence as a state. In England, the riots of 1831–32 in favor of the pending bill to reform Parliament came close to being a nationwide revolt; in the United States, the election of President Jackson was a decisive victory for "the people" as against the "aristocracy" established by the Founding Fathers; in Canada, eight years of unrest and armed conflict ended by uniting the provinces and securing political rights. In South America, the struggles for independence from Spain, which went back to the 18C, became general in the early 1800s and finally succeeded in a dozen states. Brazil likewise cut loose from Portugal. The desire for EMANCIPATION was universal.

Significantly, England, even though as keen for suppression as the rest of Europe, gave military help to the rebellious Spanish and Portuguese—in vain—but it did ensure the freedom of the South American colonies by supporting the United States in the Monroe Doctrine, which warned the European powers against interfering in the affairs of the Western Hemisphere.

To the men of the Enlightenment the English form of government had been the bulwark of liberty; or rather, the House of Commons was seen as playing that role. Rousseau had himself asserted that for large countries pure democracy was not workable and that representative government must serve as substitute. It now became the common aspiration of all rebels to install such a system in their own lands. In every language the word *parliament* meant all that went with it.

Democratic hindsight should not prompt the thought that Metternich's policy of suppression was doomed from the start and that the monarchists were plain evil doers. To the question who wants another 25 years of war and revolution? the reasonable answer was nobody. The universal need was stability and peace, and there seemed no other recourse but Legitimacy; that is, the appeal to long-established forms and rulers. It was the common-sense position. The greatest political thinker of the late 18C, Edmund Burke, had demonstrated that stable governments depend not on force but on habit—

the ingrained, far from stupid obedience to the laws and ways of the country as they have been and are.

It follows that to replace by fiat one set of forms with another, thought up by some improver, no matter how intelligent, ends in disaster. To expect such a scheme to prosper is unreasonable because habits do not form overnight. Change is inevitable and often desirable, but it serves a good purpose only when gradual—evolution, not revolution, yields betterment, if only because at any time a people is composed of several generations. They do not see things all the same way; and even the youngest, some of whom may favor radical change on the large scale, lack the habits needed to make novelty work. Those who favor revolution do not even agree on its details, as events since 1789 amply proved, and this double lack: habitual consent and agreement on change accounts for the never-settled state. Hence the value— indeed the necessity—of Legitimacy, which is another name for the habit of consent. It should be added that at the end of his life Burke, without adhering to the "ideas of 1789," conceded that there are moments in history when political evolution is for one reason or another impossible—the dam bursts and the land is submerged in the flood until a new legitimacy builds up.

What Legitimacy would also restore was the "concert of Europe," or as it is also termed, the balance of power. France under Danton and Bonaparte had broken the concert, upset the balance, changed the use of war from a balancing device to a predatory scourge. Any liberated people whose policy would be set by the vote of an assembly would act in the same way. Wars may be necessary, but they are justified only if they are limited wars and not the rush of a nation in arms bent on re-creating a polyglot empire in the place of nation-states. [The book to read is *A World Restored: Europe After Napoleon* by Henry A. Kissinger.]

*
* *

Burke himself came to recognize that by 1790 history had turned a wide corner politically and socially. The observer must say the same about culture. The Renaissance, with its worship of the ancients, had given all its fruits. Three centuries of Classicism, and Neo-classicism remained as touchstones for critics and brickbats for die-hards; but the enormous body of masterpieces created in the three centuries was now bound for the museums and libraries. In the great quarrel the Moderns had won. And thanks to the example of science and engineering, the word *modern* itself had taken on a new force. It no longer meant simply a fresh addition to what we possess from the past; rather, it dismisses each yesterday with something like contempt. The typical 19C voice prates continually of evolution, improvement, progress in all things. The speaker is born a future-ist. This new temper made it hard for

the principle of Legitimacy to play its role in government and explains why it had to be sustained, paradoxically, by force.

But if this great breach made by the revolution and Romanticism is so wide, did it not interrupt the continuity of the themes supposedly persistent through 500 years? To ask is to forget that themes do not designate only contents or results; they also tag hopes and wants. Themes remain as desires shift. The 19C wanting self-governing parliaments sounds the dominant theme of EMANCIPATION. The ever-enlarging scope of science extends that of ANALYSIS to other parts of life, carrying SECULARISM with it. All three tend to enlarge the great cloud of ABSTRACTION. Liberty, Equality, Nation, Progress, Evolution are abstract ideas that may be filled with manifold contents. In the same vein the century refers more and more to Art, Science, Politics as entities that do or fail to do their duty, and likewise Labor, Capital, the People. This is convenient if the concrete world is close behind the word and pictured. Otherwise, discussions of policy become a war of words.

This is what occurred during the 1830s and 1840s among those who fought for "freedom," especially in Central Europe and Italy. Did freedom consist in winning political rights or in becoming an independent nation? Similarly, in France and England, the demand for extending the vote, the support for the broader Charter (to reform Parliament), took it for granted that political power would bring economic relief. These overlapping goals moved the several dissident groups—English Chartists, German *Burschenshaften*, *Carbonari* and Young Italy, French underground Republicans—until the cacophonous and murderous débacle of 1848–51 (547>).

Meanwhile a contrapuntal chorus made plain in its social critique that clamoring for the vote was aimed at the wrong target. Changing political arrangements would not cure the evils of the new industrial order. The machine had changed everything. Wielded by a few ruthless owners, it was dissolving the social bond and crushing the individual, now helplessly isolated. Worse still, the substitution of wheels and gears for the hand of man robbed the "operative" of the natural rhythm and fulfillment of Work. Nor did the abundant production of goods bring about widespread prosperity. "Poverty in the midst of plenty," the recurrent fact that bothered Sismondi, was the defining phrase of the age.

The first and most influential among these critics of industry were the disciples of the Comte de Saint-Simon, a distant relative of the 17C duke (<294; 355). Under the name of *New Christianity*, Saint-Simon depicted a society in which an orderly distribution of tasks and goods would be ensured by the rule of bankers and scientists, these callings making them expert planners and calculators and their role being central in any society that uses machines. The doctrine turned into a movement when the count's disciples, being good Romanticists, perceived that expertise and calculation were not enough. Only

when feeling propels thought does it become active and communicable. Therefore the artists must be enlisted to make the ideal society attractive and the

The Golden Age, which a blind tradition has hitherto placed in the past, is ahead of us.

—SAINT-SIMON (1825)

new life congenial. A quasi religious ritual was designed which clothed the rigor of science and of money in mythic fashion through songs and festivals. For a sample, Parisians were treated to demonstrations by the disciples, who caroled as they paraded along the boulevards in their light blue troubadour costume.

This appeal for help from the arts is a familiar revolutionary ploy. It flatters and it awakens the social conscience in minds otherwise indifferent to politics. Among those who in the 1830s responded to the call with enthusiasm were the already famous young virtuoso Liszt and the vibrant character whose loves, friendships, and feminist fiction made her a force in many domains, George Sand. Liszt attended meetings, composed suitable songs, and wrote an eloquent article on the unsatisfactory situation of the artist in bourgeois society. Liszt and Sand became friends—not lovers—and shared for a time the Saint-Simonian ideal. But this program was not alone in the field. Remolding society was a desire haunting many different types of intellectual. It harked back to Babeuf and his expounder Buonarotti (<428), who rank as the first conscious and deliberate socialists on the Continent. In the 19C the urge to complete the political revolution by the social was a widespread desire. Thus the Abbé Lamennais, an intense believer, had the vision of a Christian social community that enticed Liszt (again) to join his prayerful coterie at La Chênaie, where he composed more music for the cause.

Sand, who had meanwhile been swept off her feet by Michel de Bourges, the republican who preached revolution by blood and iron, also cultivated the abbé, scaring him by her erotic aura. Still full of revolt about the place of women and of love, she then drifted into the orbit of Pierre Leroux. He was an inventor on a small scale, who began his public career by writing for *Le Globe*, the Saint-Simonian journal that traveled all over Europe—Goethe read it and John Stuart Mill wrote for it. But Leroux struck off on his own and preached the gradual elimination of property, the equality of women (with the right to love, married or not), and immortality through reincarnation—all this topped off with the rehabilitation of Satan. Mme Sand was Leroux's steadfast disciple and though she let some of these tenets lapse, she remained an avowed socialist all her life.

Yet another theorist was Charles Fourier, not to be confused with his almost exact contemporary, Jean, a mathematician of outstanding achievement. The former's plan for a regenerated society was the most detailed. It sought to equalize labor and rewards, and by classifying tasks, talents, and impulses, adapt the work assigned to the individual's temperament: emotional

satisfaction was prerequisite to a consenting population and a stable society. It should be added that Auguste Comte, as Saint-Simon's former secretary, owed a good deal of his system to this early association, including the idea that myth and ritual are needed for social cohesion.

The French proposals of the early 19C have been lumped together as one tendency and dubbed Utopian Socialism. The fact is that their theorizing shortly led to practice—to actual colonies living more or less according to plan. America was the predestined place where this could happen. There was room, land was cheap, and best of all, there was a tradition not so much of tolerating as of ignoring singularity when it applied to a whole group. Long before these new Eutopians, there had been a dozen or more "peculiar" communities, beginning in 1694 in Pennsylvania with the "Society of Women in the Wilderness." Those founded two centuries later numbered upward of 80 and were scattered from Maine to Texas. The best known were inspired by Fourier, thanks to his influence on the minds of the New England Romanticists. Emerson, Hawthorne, Margaret Fuller, and C. A. Dana were leading Fourierists, while in New York Albert Brisbane, Horace Greeley, and Henry James, Sr., were also strong adherents and propagandists. The New Englanders formed at Brook Farm and again at Fruitlands the "phalanx" specified by the master mind, though without following his intricate particulars. Brook Farm is the setting of Hawthorne's *Blithedale Romance,* which is really a tragedy.

The several dozen other plantations followed diverse schemes, all playing variations on the idea often used as their chosen name: Harmony. The one at New Harmony in Illinois deserves special note. It was the creation of Robert Owen, a Scottish cotton manufacturer, who had made a success at home of the model town he created around his factory at New Lanark. It gave the workers good housing, schools, recreations, and a good livelihood. Its American duplicate flourished as long as he was in charge. In England and Ireland, Owen spread his reasoned-out doctrine by lecturing and writing and he gathered a very large following. They founded no communities but set up "cooperatives," as he recommended, the consumer-members reaping the benefit of wholesale prices and shared profits.

On one point all the would-be social engineers agreed: the reigning school of political economists was fundamentally wrong. Adam Smith, Ricardo, Malthus, Nassau Senior, J. B. Say, Bastiat, J. S. Mill, proclaimed that they had found the eternal laws of economic life; present conditions were dictated by the nature of things; one must submit to them as one does to gravitation; from which followed the dogma "laissez-faire," already taught in the 18C by the Physiocrats, restated with full historical evidence and some caveats by Adam Smith, and now proved deductively by the laws of economics.

What was in fact the proof? By nature the individual pursues his self-interest. In a money economy he seeks the lowest price when he buys and the highest when he sells. Prices are not arbitrary but go up and down according to supply and demand. For example, the price for sale or rent of a piece of land depends on the value of its yield in produce compared with the yield and price of neighboring pieces. "Economic man" makes strict comparisons.

As for wages, they come out of a "fixed fund," the size of which is regulated by the condition of the market for capital (money and equipment) and the supply and demand for labor. If the supply of labor is abundant, the wages are lower. The manufacturer *cannot* pay higher wages than the rate imposed by all these ratios working together. Robert Owen up in Scotland might do wild things for his people, but if everybody did the same, the whole of English trade would collapse. He ignored "Classical Economics."

It is a mistake to suppose that its creators and proponents were hypocrites moved by the desire to justify their friends, the captains of industry, while callously disregarding the sufferings of the workers. The science disregarded equally the sufferings of the factory owner who failed when overproduction periodically caused a string of failures. An economist such as the Reverend Thomas Malthus was deeply concerned about the working poor. Their numbers were increasing at an unusual rate. Economically, they ought not to have so many children; it enlarged the supply of labor and they were making themselves poor. One could surmise that the working people had little other pleasure than that of the bed. Malthus would not deny it, though he had nothing to recommend but sexual abstinence; he took bitter comfort in the thought of wars and plagues that mowed down the living, because he calculated that the food supply could only be increased by small amounts in the ratio of 1-2-3-4—while people increased as 2-4-8-16. His worry has not been dispelled; demographers continue to speculate about the rapid increase of people as hygiene and medication recklessly prolong life.

Most of the American "anti-economics" communities lasted but a few years. One reason was that, unlike the Shakers, Amish, Moravian Brothers, and Mennonites, who survived despite pressures from outside, the Fourierists and others lacked a religious bond of equal strength. The 19C revival of faith (<471) was not dogmatic enough to exert the same binding force; and the myths freshly made up were flimsy make-believe. This looseness of dogma, in turn, is explained by the second divisive cause: INDIVIDUALISM dominant. If one thinks of the New England Transcendentalists one by one and then tries to imagine life at Brook Farm, the spectacle makes one smile. Here was a cluster of talents who exalted the independent thinker and the self-reliant character and showed little regard for the mass of common people building a new country all around them. Their hero in life and fiction

was the genius, the single pioneer, the solitary wanderer like Thoreau, the lone woodsman Natty Bumppo in Fenimore Cooper's novels. By what magic could these be harmoniously drilled into a Fourierist phalanx?

Questioning, often denying, Progress, another type of critic added his testimony on the rightness of Eutopias, at least in principle. A planned society must be the remedy for the worsening conditions of life. Both the working poor and the luckless manufacturer caught in "overproduction," later renamed "business cycle," were victims of the inflexible laws of political economy. Everybody was morally degraded by the decline of true work, by the flood of poor-quality goods (known as "cheap and nasty"), and by the new mode of thinking and feeling—always *quantity*: price, cost, output, growth: it was the tyranny of numbers over generous feelings, peace of mind, moral conscience, and religious faith.

The chief deliverer of this message was Carlyle. A preacher by temperament, who devised a singular but effective sermonizing style, he acted as England's director of conscience for half a century. Other denouncers of industry, utilitarianism, and progress came from the church, the literary world, and the ranks of the Tory party. Mostly landowners, its members had a keen eye for the flaws of the manufacturers' regime, their rivals for wealth and power. Influenced also by the propaganda of the seventh Earl of Shaftesbury, they passed laws limiting hours of labor and the exploitation of women and children. These were the earliest in the huge code regulating machine industry that receives additions daily, hourly, from all the nations of the West. But Carlyle put little faith in legislation. It cured only the symptoms of the evil. Parliament was a "talk shop" from which little good could come as long as wrangling went on between two seesawing forces. Things must be taken in hand by a leader and made to go in one direction, the right direction. Such a leader, whom he calls hero, the people must recognize and worship.

> One age, he is hag-ridden, bewitched; the next, priestridden, befooled; in all ages, bedevilled. And now the Genius of Mechanism smothers him worse than any Nightmare did. In Earth and in Heaven he can see nothing but Mechanism; he has fear for nothing else, hope in nothing else.
>
> —Carlyle on Man in *Sartor Resartus* (1831)

Because these words have acquired fearsome associations in our century, Carlyle's intentions need explicating. First, his hero is not bound to be "the man on horseback." In the six lectures *On Heroes and Hero Worship,* the historical examples range from the pagan hero-gods such as Odin to the founders of religions (Mohammed) to the great poets (Dante, Shakespeare), and to "men of letters," by which Carlyle means intellectuals: Rousseau, Dr. Johnson. In short, the hero is anyone who by standing out from the crowd exerts an influence on what happens. There are military heroes, of course— Cromwell, Napoleon—but Carlyle says in so many words that it is the thinker

and writer who is the needed hero now, the leader through ideas and words. And he "may be expected to continue as the main fount of heroism for all future ages." Similarly, worship is not superstitious groveling but whole-hearted admiration. It is not an age that rewards popular entertainers above all other talents that can cavil at hero worship.

In a later preachment entitled *Past and Present* Carlyle gives an example of what he means. Using a 12C chronicle, he shows how a community of monks at St. Edmundsbury fell into moral and financial disorder and was restored to proper monastic ways and solvency by Abbot Samson. He is a modest but steadfast man, not especially popular, who is appointed head. He did not know until then that he was a born leader and he has to improvise the policies for recovery. They are strict but not dictatorial: he reasons with his people; sometimes he has to compromise. The only absolute command is Work—faithful, exact, productive performance. Everything good flows from this center, which is the justification for man's life and the way of guarding his soul from evil.

So much for the lesson of the past according to Carlyle. The present by contrast is chaos: no leadership and therefore no clear direction, wasted efforts, pointless conflicts, behavior led by greed, because utility is gauged solely by material measures. Selfishness overrules all other considerations. Had not Bentham said that to those it made happy "pushpin (bowling) is as good as poetry"? The "happiness of the greatest number" as a guide to policy was a leveling down. All these falsities produced the common distress in the present inhuman state miscalled civilization. So far Carlyle. Scattered in other corners of England, a dozen or so of anti-capitalist writers, each independently, were urging some form of socialized society. William Thompson (a feminist), J. F. Bray, Charles Hall, Thomas Hodgskin, Mary Hennell, are among those now reckoned the first socialists with programs not looking to establish small communities but to undo the work of the economists and redirect society toward justice for all.

John Stuart Mill was a special case. He had given brief attention to Saint-Simon and to Auguste Comte (<509), had in fact written for *Le Globe*, but had drawn back, foreseeing that in Comte's system life would be "like that of a beleaguered town." It was in revising his *Principles of Political Economy* that Mill broke with the liberal school by asserting that the distribution of the national product could be redirected at will and that it should be so ordered for the general welfare. That final phrase, perpetually redefined, was a forecast. For all these disparate schemes—the Eutopias that failed sooner or later, the complaints of Carlyle and his acolytes, England's Socialist Five and their counterparts abroad (549>)—remained for a century the views of a minority, often noisy but unable to arrest Progress and quash public optimism about it. Yet it was their underlying idea—essential socialism—that ultimately tri-

umphed, taking the twin form of Communism and the Welfare State, either under the dictatorship of a party and its leader or under the rule of a democratic parliament and bureaucracy.

The interval of a century was filled with various voluntary movements: Christian socialisms that put remedial responsibility on the church, Catholic, Lutheran, or Anglican; Lassalle's socialist "corporate state" (for Germany) to direct enterprise for economic justice; there also, Lassalle's growing party of militants bent on setting up a workers' state—socialism in one nation, the most advanced. The poet Heine, an exile in France, seeing his country astir with these desires, in addition to its pent-up passion for nationhood, warned Europe against that double menace to civilization: Germany and Communism°—all this before Marx was much heard of.

<div align="center">*</div>
<div align="center">* *</div>

In the forefront with Progress, was the Liberals' demand for parliaments and a wider franchise. They promised that nothing fanciful like changing social habits and hierarchies was to result, but giving political power to all educated and propertied individuals would guarantee free speech and a free press, and out of free public opinion would come peace and prosperity. England was leading the way. This middle-class conception of the desirable government had the support of many artisans and other workers, which brought on demonstrations and riots in the hope of full democracy ahead.

One would suppose that an institution as old and long-admired as the British Parliament would be well understood and easy to copy. It has not proved so. The reputed Mother of Parliaments on whom the gaze of the world has centered for over two and a half centuries has borne no equally handsome or really healthy children. All have needed therapy; more than one has died ingloriously, and of the survivors some lead a visibly malarial existence. This generality applies to Europe. The United States is a happy exception, owed to a direct inheritance of the life-giving tradition. In the non-western world elected legislatures are either make-believe institutions or bodies in recurrent disarray.

Instability and ineffectiveness have been due for the most part to the elaborate written constitutions that set up these assemblies. The document usually tries to protect the legislature from the executive power, following (as was thought) the English precedent that let the king reign but not rule. What was not understood was that technically England is not ruled by the House of Commons, but by "the king in Parliament" meaning the House of Lords as well as the Commons. This phrase in turn denotes a network of customs that govern what each of the three parts may or may not do. For example, to make the House of Lords pass the Reform Bill of 1832, the king was requested to create enough Liberal peers to overcome the resistant majority in that

house—and he would have complied, against his private opinion. This characteristic sort of thrust-and-yield when the time is ripe was and is incomprehensible outside the British Isles.

It cannot be written into any charter, nor would it be desirable to do so if it could be done, because conditions change and custom, if it is appropriate, can be more smoothly modified than a constitution. England is thus the only country that can boast at any time of having an up-to-date constitution; all others (including the American) grow obsolete in some of their fundamental arrangements and risk those parliamentary "crises" that punctuate the modern history of nations. France, Italy, and Germany have gone through five constitutions each since achieving an elected assembly; and Spain a dizzying number, like the Balkan states.

This knack of judging when and how things must change without upsetting the apple cart was painfully acquired by the English over the centuries. They were long reputed the ungovernable people. But fatigue caught up at last and a well-rooted anti-intellectualism helped to keep changes unsystematic and under wraps. Forms, titles, decor remain while different actions occur beneath them; visual stability maintains confidence. It was the knack of rising above principle, the reward of shrewd inconsistency. That state of being, it should be noted, is not contradiction, which makes an institution work against itself. What is not consistent is nonetheless functional and will probably be brought into line later. There are times, to be sure, when one change at a time is not enough; a broader scrubbing up is in order. This occurred in the English constitution in the second third of the 19C when those Whigs who were called Radicals and later formed the Liberal party ousted the Tories at the end of 20 years of stubborn anti-revolutionary suppression. A representative Radical Whig, who merits acquaintance also as a polemicist and humorist of genius was

Sydney Smith

He came on the scene when England had been debating reforms for fifty years and had adopted none. Although a mere vicar stuck away in a country parish, Smith sprang into a leadership role when he published anonymously the *Peter Plymley Letters* on the mooted subject of "Catholic Emancipation"— the lifting of the barriers that kept Catholics out of Parliament, the universities, the professions, and offices under the crown. His was a new voice and a new type of voice. He wrote in a way calculated to persuade both the ordinary mind and the professional politician, and the firm anti-Catholic besides. Smith prevailed because he understood the objector's feelings and met his resistance on the practical plane. Smith's discourse was conversational, often humorous; it dramatized ideas by describing situations and it could be elo-

How very odd, dear Lady Holland, to ask me to dine with you on Sunday the 9th, when I am coming to stay with you from the 5th to the 12th. It is like giving a gentleman an assignation for Wednesday when you are going to marry him on the preceding Sunday—an attempt to combine the stimulus of gallantry with the security of connubial relations.

—Sydney Smith (1811)

quent at the right pitch and the right places. Here was a pamphleteer propounding what is just, humane, and tolerant without himself ignoring these virtues by writing like a fanatic.

Sydney Smith soon became the intimate of the leading lights—men and women—of the Whig party. They found the short, stout cleric an ideal dinner guest, full of wit and good humor and good sense, astute in his judgment of men and politics, replete with knowledge of past and present. The vigorous intellect of this fresh recruit was a tonic and his fearlessness was heartening. He would take on a "persecuting bishop" in print and though unable to convince him of anything, would not incur his enmity, meanwhile edifying the bystanders. To list Sydney Smith's campaigns is to define the temper of Liberalism and to reveal contemporary attitudes, social and cultural. Next after Catholic Emancipation, which was finally achieved in 1829, came the reform of the ways in which England chose its members of Parliament: no more boroughs in some lord's pocket, because it was a mound of grass with no voters left; representatives given to towns that had none— Birmingham, Manchester, Leeds, and others; and an electorate enlarged to include those who owned or rented a middling amount of property. Roughly, one family in six numbered a voter. [For an impression of the English voters in action soon after the Reform Bill, read the account of the Eatanswill election in Dickens's *Pickwick Papers,* chapter 13.]

In one of his four speeches on the bill, Smith answered the objection that if it were passed, agitators would not let the people alone but ask for more and more: "If the winds would let the waves alone, there would be no storms. If gentlemen would let ladies alone, there would be no unhappy marriages and deserted damsels. And so we must proceed to make laws for a people who we are sure will not be let alone." Smith's Johnsonian mind could always find the lapidary phrase to make a point clear: Apropos of the self-serving practice of judges, he wrote: "It is surely better to be a day longer on the circuit than to murder rapidly in ermine." At the same time he knew that reform does not come about from good sense alone. "The talk of not acting from fear is mere parliamentary cant. From what motive but fear, I should like to know, have all the improvements in our constitution proceeded? If I say, Give this people what they ask because it is just, do you think I should get ten people to listen to me? The only way to make the mass of mankind see the beauty of justice is by showing them in pretty plain terms the consequence of injustice."

Although he spoke well, in a warm, encouraging voice and without thunder or antics, he preferred engaging his opponent in print. He founded with a few friends the *Edinburgh Review,* a quarterly that immediately became a power in politics and letters as the organ of Whig opinion. It was an entirely new form of magazine, no longer a house organ for publishers and written by hacks, but the forum of independent critics. Its articles were by present standards extremely long, virtually monographs. The "hook" on which a piece hung might be a new poem or novel or history or somebody's travels, but the work and the author might be disposed of in a paragraph while the author's *subject* was treated in full as the reviewer thought it should be.

Macaulay's famous essays were first published in the *Edinburgh* and eagerly awaited. A beginning writer was "made" if his work appeared in the "buff-and-blue"; the articles were unsigned, but readers could tell them apart. Besides Macaulay, the mainstays of the review were Smith, Hazlitt, Horner, and its editor Francis Jeffrey. It was these whom Byron satirized in his early poem *English Bards and Scotch Reviewers.* To Jeffrey, Smith once wrote a letter indicative of his own temper: "I exhort you to restrain the violent tendency of your nature for analysis and to cultivate synthetical propensities. What is virtue? What's the use of truth? What's the use of honor? What's a guinea but a damned yellow circle? The whole effort of your mind is to destroy. Because others build slightly and eagerly, you employ yourself in kicking down their houses and contract a sort of aversion for the difficult task of building well yourself."°

> I never read a book before reviewing it; it prejudices a man so.
>
> —SYDNEY SMITH, ON THE CRITIC'S TASK

One anomalous law that Smith labored to get repealed was that which denied counsel to those charged with a felony. He took up the agitation and riddled the "most absurd argument advanced in the honorable House, that the practice of employing counsel would be such an expense to the prisoner—as if anything was so expensive as being hanged! 'You are going to be hanged tomorrow, it is true, but consider what a sum you have saved!'" To allow prisoners counsel in cases of high treason had taken seven sessions of debate: "Mankind are much like the children they beget—they always make faces at what is to do them good; and it is necessary sometimes to hold the nose and force the medicine down the throat."

Equally cruel and unjust were the game laws that protected the landlord and his wild fowl: "An unqualified man who kills a pheasant shall pay five pound, but the squire says he shall be shot—and accordingly places a spring-gun in the path of the poacher. The more human and mitigated squire mangles him with traps; and the supra-fine country gentleman only detains him in machines which prevent his escape but do not lacerate their captive. Of the

gross illegality of such proceedings there can be no reasonable doubt. There is an end of law if every man is to measure out his punishment for his own wrong."

Incensed like Blake, Sydney Smith cried out against the practices of the chimney-sweeping trade: "An excellent dinner is the most pleasing occurrence and a great triumph of civilized life. It is not only the descending morsel and the enveloping sauce, but [the setting and the company]. In the midst of all this, who knows that the kitchen chimney caught fire and that a poor little wretch of six or seven years old was sent up amid the flames to put it out? Boys are made chimney sweepers at the age of five or six. *Little boys for small flues* is a common phrase in the cards left at the door by itinerant chimney sweepers. Girls are occasionally employed." Smith concludes with irony: "It was quite right to throw out the bill for prohibiting the sweeping of chimneys by boys—because humanity is a modern invention. Such a measure could not be carried into execution without great injury to property and greatly increased risk of fire."

There are matters of moment to Liberals that cannot be made into bills for Parliament to vote on. One that caused Smith concern was the education of women. "If it were improved, the education of men would be improved also," because "the formation of character for the first seven or eight years of life seems to depend almost entirely on them." Besides, a country should employ as many "understandings" as possible, which should include "the capacities that women possess—wit, genius, and every other attribute of mind of which men make so eminent a use." At present, "half the talent in the universe runs to waste." As for the feeling that "educating women is something ludicrous," consider that "a century ago, who would have believed that country gentlemen could be brought to read and spell with ease and accuracy, which we now so frequently remark? Nothing is so stupid as to take the actual for the possible."

Not that Smith had any respect for the public (= private preparatory) schools of England or its two universities. All of them disgraced the ideal and the practice of education. The schools spent years teaching resistant young minds to write Latin verses; a compliant graduate, says Smith, "will have written 10,000—more than in the *Aeneid*—and will never write another." The older boys, left idle, were so unruly that a master was entitled to a "pebble fund"—compensation for the risk of being pelted. As for the universities, their teaching was sparse and narrow. Sending a youth there ensured only "instruction in vice and waste of money."

In religion and morals, the vicar showed the same penetrating mind as in politics and social affairs. His faith as an Anglican was sincere and strongly held, but not proselytizing. He ridiculed the Methodists, the Puseyites (Tractarians <471), and the "Clapham Sect" of intense evangelicals; but he would have fought against their persecution. In all these ways, he reminds one

of Swift, and like him too, he gave solicitous care to his parishioners—their health and housing, their disputes and other human predicaments. The wisdom of his moral outlook appears notably in his dislike of the Society for the Suppression of Vice. "It is hardly possible that a society for the suppression of vice can ever be kept within the bounds of good sense and moderation. The loudest and noisiest suppressors will always carry it against the more prudent part of the community; the most violent will be considered as the most moral." And as to the brand-new situations that the invention of the railroad placed people in, his usual logic finally prevailed: "The very fact of locking the doors will be a frequent source of accidents. Mankind, whatever the directors [of the Great Western] may think of that process, is impatient of combustion and will try to get out through the windows. And why stop at locking doors? Why not strait-waistcoats? Why is not the accidental traveller strapped down?"

Sydney Smith was not exclusively a political animal. His literary judgments were acute. He praised Scott's masterpiece *The Heart of Midlothian* when everybody was damning it; he was almost alone in his low estimate of Samuel Rogers as a poet; he did not care much for novels of contemporary life, but Dickens's *Nicholas Nickleby* won him over; the ethics of Mme de Staël's *Delphine* (<450) reminded him of Restoration comedy; and he was the first to acclaim Ruskin's defense of Turner's art in *Modern Painters*.

Being represented as common sense incarnate, Smith has been denied imagination. But humor of the highest kind such as Smith's is pure imagination. Reviewing travels in South America, Smith describes the sloth always hanging beneath a branch: "he passes his life in suspense, like a young clergyman distantly related to a bishop." The printer of the *Edinburgh* is always tardy: he shall be fired "and compelled to sell indecent prints *in the open air* for a livelihood." Macaulay monopolizes conversation—yes, but "he has occasional flashes of silence that make it quite delightful." It was Macaulay's judgment that Smith was "the greatest master of ridicule that has appeared in England since Swift." Although he kept the company exploding with laughter, Smith like many humorists was frequently plagued with melancholy. And again like such minds he incurred blame for showing the ludicrous side of serious matters. He understood how this judgment came about: people go by outward signs and "the outward sign of a dull man and a wise man are the same, and so are the outward signs of a frivolous and a witty man." The genius he accounted for in similar terms that fit his own case: "He is *eight* men, not one man; he has as much wit as if he had no sense and as much sense as if he had no wit; his conduct is as judicious as if he were the dullest of human beings and his imagination as brilliant as if he were utterly ruined."

During the first half of his life Sydney Smith had to struggle with poverty and disappointment. He was poor and had a large family to support. No sooner was he a favorite in London than he was forced by a new law (of which

he approved) to reside in his parish, deprived of all intellectual conversation. His irrepressible fun was the strong will's victory over the dumps, just as his energetic pastoral care was the victory of the moral conscience over tempting self-pity—again a likeness with Swift exiled in Ireland. Smith was finally rewarded by his political friends with the post of Canon of St. Paul's in London, and he ended his days in financial ease and in the midst of his cherished and cherishing friends. One of them said what might well serve as an epitaph: "You have been making fun of me, Sydney, for 20 years, and I do not think you have said a single thing I should have wished you not to say." [For his life, the book to read is *The Smith of Smiths* by Hesketh Pearson; and for extracts from his writings and correspondence it is *Selected Writings of Sydney Smith*, ed. by W. H. Auden.]

*
* *

Requiring that people who vote should own some property was for most of the 19C a matter of course—and of logic: to use a share of the political power responsibly, one must own a share of the commonwealth, as a stockholder does when he votes for the company's board of directors. According to the thought-cliché, the restriction was due to the selfishness of the "rising bourgeoisie" (<243)—manufacturers and bankers—who wanted to keep all the power to themselves. But as indicated earlier, that all-purpose explanation is a myth. The 19C success of the so-called Industrial Revolution did put money into the hands of a new group of people—clever mechanics, good men of business, lucky speculators—and as always it was not a class but individuals who rose as others fell. In France, when the lower middle class complained of not having the vote because they lacked the property qualification, the prime minister Guizot told them: "Get rich!" The assumption was that affluence betokened ability. It also guaranteed that the newly enfranchised would not use their votes to the detriment of property rights. For the steadily poor, it was the time before compulsory public education and the penny paper, and it is hard to imagine now the degree of ignorance and narrowness of these illiterates kept out of public affairs. They exemplify the very point of EMANCIPATION anywhere, at any time: it is not to give power to those who have earned the right to it, but to lift the helpless to a level where they are free to learn how to use the right.

Those who oppose that freedom argue that as illiterates, as slaves, as children, they cannot manage the household, which is true though illiberal. The political history of the West has been a running battle between the "realistic" deniers of one freedom after another and the generous ones who gambled on another truth, that capacity is native to all and depends only on fair conditions for its development.

In England, the parallel situation was modified after the Reform Bill of 1832 had opened the door a crack to the voteless. The "bourgeois" who were "risen," thanks to their business or industrial skill and were now represented in Parliament, had to contend there with the gentry and aristocrats—the Tory party—who, as shown earlier (<526), were bent on passing labor laws unwelcome to factory owners. Both sides succeeded in their hostile intentions, and it turned out that when the Tories lost their old protective tariff on grain, the benefit went not exclusively to bourgeois merchants and employers but to the whole population.

What should not pass unnoticed is that the start of social legislation, beginning with the new Poor Law and going on to the control of labor conditions, required two devices that must be called epoch-making, not to say ominous: inspectors and statistics. The modern individual has been emancipated from subjection to rank and has exchanged it for "inspection" over the whole range of life's activities. This control takes the form of permit, license, and stated limitations, as well as actual inspection. At the same time, state agencies and private researchers gather totals by kind and publish numbers. Most often the purpose is to show why there is cause to foster or restrain an activity. The concerned citizen develops the habit of living by statistics. He may be said to live a Stat Life (795>). These developments were unavoidable. The nature of industry in its strange new meaning—no longer: steady application to the task, but steady submission to the machine—made regulation imperative; and the ingress of techne into everything that serves human needs, from food, clothing, and shelter to locomotion, medicine, and entertainment, has required counting and control without end to save life itself.

*

*　　*

A further reason for the difficult times suffered by imitation parliaments was that for ages the mother type, with all its anomalies, did not represent people but interests—land, trade, the church, the universities. These interests might split into factions, but as issues changed so did the alignment of parliamentary spokesmen. When the scheme of "one man, one vote" was substituted, the foundation shifted unperceived under the system. INDIVIDUALISM replaced a handful of interests by "public opinion"—vague, wavering, unformed, unpredictable, the views (as Bagehot put it) of the bald-headed man in the omnibus. To corral millions of such private notions into fairly defined interests required new means. Direct bribery would no longer serve to unite as it had done in the past. Appeals to self-interest, coupled with indirect bribery, required political parties, public programs, and strict voting discipline. And for steady policy there must be only two parties and a clear winner.

The English two-party system owes some of its solidity to another tradi-

tional arrangement never imitated: the aisle across the meeting hall. After the houses of Parliament burned down in 1834, they were rebuilt on the same plan, which divides the members into two groups facing each other. The vis-à-vis begets speeches conversational in tone. One can hardly "orate" at an opponent who looks at you across a narrow space; whereas the semi-circular, theaterlike layout of all other parliaments, besides creating the Left, the Right and shadings in between, encourages the high-flown and the abstract.

Even in campaigning, the English address the crowd quite as if talking informally to one person. That does not exclude rabble-rousing or the palpable bribery of promising benefits. Both are standard practice in all democracies that hold real elections. But to call it "appealing to the emotions instead of the reason" is a stupid cliché. All appeals are to ideas. No candidate says: "Let me awaken your angry feelings." He must stir up the feeling by giving it something to attach it to. Electioneering ideas are *familiar ideas ready-charged* with strong emotion: Die rather than yield; For God and Country; no more immigrants, soak the rich, more well-paid jobs, my opponent is a crook—these are ideas as truly as the Ten Commandments. And strange new ideas such as ecology or abortion can acquire the same sort of familiarity and emotional force.

But as industrial society has grown more complex, individual opinion has grown more diverse and confused, and parties have multiplied. Rarely does one party obtain a solid majority. Coalitions form and fail and re-form, hold up action or promptly reverse it, making for incoherent governance. The people become distrustful, discontented—and bored. After the age-long struggle for the vote, democratic countries show an extraordinary attitude toward it: they boast of their form of government and express nothing but contempt for politicians—the men and women they have themselves chosen. Worse, of those who have the vote, fewer than half use it. Lastly, exerting influence on the people's representatives, "lobbies" re-create on a large scale the former role of organized interests (780>).

A little before 1870, a double survey of the London underworld had been carried out independently by Dr. William Acton and by Henry Mayhew. The former studied prostitution. London was the reputed world center of that trade, or rather the showpiece for numbers and variety that Venice once had been. De Quincey gave an unforgettable picture of the world in which he met the endearing "Ann the Outcast" who saved his life.° Three decades later, Dr. Acton concluded from his interviews that prostitution was for a good many women a temporary expedient; that others took it up from liking; and that the number of hopeless cases should make the existing charitable organizations multiply their work and their facilities.

Mayhew's four volumes on *London Labour and the London Poor* are better known, and abridgments have been reprinted in our time.° The work deals

with many diverse groups under the two categories of the title, giving sharp, detailed descriptions (often in the subject's actual words) of the lives led by each type of man or woman. It partly overlaps Acton's domain and it includes the deliberately homeless and the criminal. Both writers maintain their detachment; it is the substance itself that creates by turns sympathy or disgust, impatience or despair.

Still, life in cities had brought some material improvements: life expectancy had risen; huddling in tenements was preferable to living in filthy, weather-beaten hovels on the farm in decline; and sheer numbers in close proximity had put ideas into the vacant mind. It was of course with these darker images in mind that 19C social thinkers kept expressing their fear of "democracy." They meant not a system of government but the masses, the "great unwashed." They remembered the Paris mobs of the two French revolutions. Not until after 1870 did the free school turn the mob into the crowd.

> The young [among] the poorly paid English labourers, the product of long centuries of oppression and neglect, look forward to the moment of their abandonment of field labour for the more lucrative work on railways or in the mine. I well remember the little group in a Yorkshire village who would frequently walk a couple of miles to watch the express dash through the small station in the darkness.
>
> —E. N. BENNETT, *PROBLEMS OF VILLAGE LIFE* (1910)

Visitors to the United States who published their experiences on returning to Europe gave a less alarming view of government by the people, yet never expressed enthusiasm like the later visitors to Soviet Russia. Actually, only one report about the United States was thorough and reliable: Tocqueville's *Democracy in America*. The first volume, the one full of detail, appeared in the mid-1830s after a concentrated study of not quite 18 months. It was descriptive and dispassionate. It showed the many admirable human traits that come with self-government and equality: the firm, upstanding character who shows servility to none; the ease of mind about local affairs, since they are discussed and acted openly, all concerned being present; in addition, a sense of freedom from the past and its compelling errors and injustices; a legitimate feeling of power used at will in setting up voluntary, uncontrolled associations for group benefits or good works.

Tocqueville's minute account of the Constitution and the federal government, local institutions, the press, and prevailing ideas and attitudes about each element in the structure amply proved that the United States was not ruled by the least capable. Rather, everybody could be and generally was a responsible citizen, able to take part in policy making, whether poor and illiterate or not. The picture was a vindication of Rousseau and Jefferson and the spirit of the Enlightenment. That image has become so congenial to Americans that quoting Tocqueville has the force of Scripture. American presidents never leave the White House without quoting him. The official

mission that Tocqueville had been entrusted with at his own request—he was a judge 24 years old—was to study the prison system. His separate report on the subject contributed to a more favorable view of America. Widely read, it proved useful to several European countries then engaged in reforms. But side by side with the evident good in democracy, Tocqueville's first volume contained observations and predictions that gave pause even to sympathetic readers. The great danger was the tyranny of the majority. No protection against it was provided—or could be, given the principle of one man, one vote. And that tyranny was not legal only but social also—pressure from the neighbors, tacit or expressed. As for equality, it breeds envy among those neighbors and resentment of any sign of superiority. The effect is to bring down the quality of every performance to the average level and sometimes below it. With his unusual gift of prophecy, Tocqueville gave a description of "the American poet" that sounds like the specifications for Walt Whitman and his themes; but he found no works of American literature outstanding—it was a little early for the New England school—and no aspect of the civilization would evoke the word *elegance*. Summing up the genuine achievements and prosperity of the American people and asking to what they should be mainly attributed, Tocqueville answers: "To the superiority of their women."

> I know of no country in which there is so little independence of mind and real freedom of discussion as in America. The majority raises formidable barriers around the liberty of opinion; within these barriers an author may write what he pleases, but woe to him if he goes beyond them.
>
> —TOCQUEVILLE, *DEMOCRACY IN AMERICA* (1835)

Tocqueville's second volume is a masterwork of a different sort, not an armory of facts and explanations, but a set of inferences from chosen data to suggest the future of political institutions in the West. Tocqueville thinks the onward march of democracy irresistible, and he means by democracy both representative institutions and the power of the masses. He did not like the prospect but did not rail against it; he merely totted up the losses as he had done the benefits.

Another work on the United States, contemporary with *Democracy in America,* has been regrettably ignored. Tocqueville did not come over alone, but with his friend and fellow magistrate Gustave de Beaumont. They decided to observe together but to write separately, and it turned out that their surveys overlapped very little. Beaumont was mainly concerned with manners and mores. He produced three long essays on "The Social and Political Condition of Negro Slaves and Freedmen"; "Religious Movements in the United States"; and "The Early State and Present Condition of the Indian Tribes of North America." Unfortunately, Beaumont chose for the wider dissemination of his findings the medium of a novel entitled *Marie.* It is

the tale of a young Frenchman who marries a southern girl "of mixed blood." The book has never been translated; as a novel it is negligible in spite of some strong scenes. But the essays and many of the chapters of the tale are pure social criticism of the highest order. Beaumont recounts a race riot and a visit to the utopian Oneida colony; he offers a discussion of the fine arts and a forecast of the dangers inherent in Negro slavery and the mistreatment of the Indians. He lacked his companion's genius for synthesis but he was an equally perceptive reporter.

Few pleasures are either very refined or very coarse, and highly polished manners are as uncommon as great brutality of tastes. Neither men of great learning nor extremely ignorant communities are to be met with; genius becomes more rare, information more diffused. There is less perfection but more abundance in all the productions of the arts.

—TOCQUEVILLE, ON THE EFFECTS OF FUTURE DEMOCRATIZATION (1840)

Tocqueville's conclusions in the second part of his work led him to the subject of his next study, the *ancien régime* and the revolution of 1789. In it he concluded that bureaucratic centralization under the three Louis had already destroyed the internal balance of powers and prepared the way for a state in which all are subject to a single authority, unprotected by the old-established liberties of each class. Powerless as individuals, they were launched into competition with one another. Self-interest being thus made strictly individual, isolated, it reduces public opinion to "a sort of intellectual dust, scattered on every side, unable to cohere."

*
* *

While ideas of democracy, plans of social justice, reform legislation, and the remaining strength of Suppression were changing the culture of Europe, another force was silently adding its influence in the same direction. At first, machinery affected only those who organized its use and the men and women who worked in factories. But by 1830 a different type of machine came into being that changed the life and the minds of all peoples. The memory of it is nearly gone, but it was the completest change in human experience since the nomadic tribes became rooted in one spot to grow grain and raise cattle; it was in effect a reversal of that settling down. Locomotion by the force of steam, the railroad, uprooted mankind and made of it individual nomads again. This and other cultural consequences were quickly felt from the little stretch of land where the first public railway journey was made.

That *locus classicus* was the 30 miles between Manchester and Liverpool, and the date was September 15, 1830. On that inaugural trip the backers of the engineer George Stephenson rode with government officials and their guests, including the Duke of Wellington and William Huskisson, well-known

economist and president of the Board of Trade. Thirty-three cars carried them in eight trains drawn by as many locomotives. The whirlwind ride at 20 to 25 miles an hour took them across country and over a large bog, Chat Moss, that everybody said was impassable and would sink the cars and the enterprise. But Stephenson found a way to float his rails on it and the cortège did not even hesitate at the supposed obstacle.

But about halfway, at a stop to refill the engines with water, the first railroad accident occurred. Amid exclamations of wonder and delight, the crowd poured out of the leading train on one track, while another passed slowly on the other. Huskisson, standing at the open door of the Duke of Wellington's carriage and conversing, was confused by the cry of "Get in! Get in!" He tried to get around the door, was knocked down by the engine and fatally injured, though conveyed to medical help in 25 minutes.

The accident is charged with a special meaning: from then on, human beings have had to sharpen their reflexes under the threat of moving objects. It has been a continual re-education of the nervous system as ever new warnings by sight and sound command the body to halt, or step in the safe direction. The eye must gauge speed, the ear guess the nearness of the unseen. And besides sheer survival, the daily business of life calls for taking in and responding to an ever-enlarging array of lights, beeps, buzzes, and insistent rings.

Multiform danger on the track had to be guarded against from the start. Employing a man on a horse to wave a flag ahead of the train had a comic implication and did not last long. But for a quarter-century the risk of accident was ever-present and multiform. One of the early catastrophes occurred on the Paris-Versailles line a dozen years after the English inaugural journey. It was doubly shocking, doubly fatal, because the passengers had been locked in "for safety." When the axle of the leading of two locomotives broke and the momentum piled up the second and the cars behind, fire broke out and made a funeral pyre of the injured and the dead—upward of 50. The locking-in, which persisted for many years on the Continent and about which Sydney Smith had pungent things to say while it lasted in England (<533), testifies to the mental disturbance caused by mankind's hurtling through space in a box.

As a mechanical invention, the railroad consists not merely of a steam engine mounted on a cart and dragging another. Equally important are the flanged wheel, which gives automatic direction by following the rail, and the roadbed, which holds the rails firm and equidistant under tremendous periodic stresses. Startled and unobservant, Tennyson early got the impression that train wheels run in grooves, which accounts for the line in his poem about the world running forever "in the ringing grooves of change."° Not long before the inaugural trip, De Quincey had written one of his finest essays, that on "The English Mail Coach." It celebrated the improved roads and solid carriages, the superior horses and expert coachmen that together

provided the swiftest postal service on record and thrilled the passengers—especially the four on top—by racing along at nine miles an hour.°

The mail also required a network of inns with horses ready to relay the exhausted arrivals, but that organization was simple compared with what the railroad soon had to install. First, enclosing the tracks to keep off people and cattle; then, a mode of signaling to make possible "single-track working," that is, having trains go in each direction on one track. Fortunately, the electric telegraph was ready to hand, thanks to S.F.B. Morse and his code. The system needed men to send and to convey these wire messages—despatchers—and also station masters, signalmen, track inspectors, brakemen, and conductors, in addition to the engine's fireman and driver. Putting up barriers and lanterns at grade crossings, installing signal-and-switch towers at short intervals, improving these and their successive adjuncts: the air brake, electric track circuiting, steel-car construction, automatic stopping of engines, central despatching, and numerous other means took seventy-five years and many deaths, but made the railroad a nearly perfect human achievement.

Railroad workers soon constituted a vast army, with officers and a manual of rules. They performed their tasks under constant pressure and a severe discipline, while being also subject to the penalties of the law for infractions that led to accident or death. This too was a transformation of the character of Work. Earlier, the factory had meant regimentation, but it was plain, simple, relatively static—nothing like the life-and-death decisions required of the railroader, for whom avoiding injury was intrinsically more difficult. The railroad developed an aristocracy of labor marked by physical strength, skill, and judgment of entirely new kinds. As for increasing passenger safety by means of new rules or devices, it was considered at first no duty of the government. In England, where progress was steadiest, the task was taken on by a group of brilliant engineers (often from the army) who studied each accident and published recommendations to the competing companies; they were not conclusions enforceable by law. Since then, plane travel has been dealt with in the same Liberal fashion.

Rule 331. If from the failure of telegraph lines or other cause, a Signalman is unable to communicate with the next block station in advance [i.e., farther ahead], he must stop every train approaching in his direction. Should no cause for detaining the train be known, it may then be permitted to proceed with a Caution signal or a Caution card. [One of 64 possible situations requiring stoppage and caution.]

—*RULE BOOK OF THE PENNSYLVANIA LINES* (1901)

For a good while, the men and women who traveled on the railway kept being amazed by it and also appalled. They wrote descriptions and prophecies and polemics. Wordsworth inveighed against the disfigurement of tranquil valleys; Vigny versified the magic change of mankind from shepherd to flying

The Loco Motive machine was to be upon the railway at such a place at 12 o'clock. So of course we were at our post in 3 carriages and some horsemen at the hour appointed. I had the satisfaction, for I can't call it *pleasure,* of taking a trip of five miles in it at 20 miles an hour. As Accuracy was my great object I held my watch in my hand at starting and all the time, and as it has a second hand, I knew I could not be deceived.

During the five miles, the machine was occasionally made to put itself out or *go it*; and then we went at the rate of 23 miles an hour, and just with the same ease as to motion or absence of friction. But the quickest motion is to me *frightful*; it is really flying, and it is impossible to divest yourself of the notion of instant death. It gave me a headache which has not left me. Altogether I am extremely glad to have seen this miracle, but having done so I am quite satisfied with my *first* achievement being my *last.*

—Thomas Creevey° (1829)

adventurer on untold missions; Lamartine saw in the ease of travel the growth of mutual understanding across frontiers and the prospect of international peace. Dickens, with his quick sense of disaster, turned the traveler's sensations into a nightmarish vision that he reproduced in fiction more than once. The common people fell into an inevitable cliché: "Believe it or not, I took the eight o'clock train to X, getting there at 12; did my business, took the 2 o'clock back, and was home by 6." We know this, because Flaubert ridiculed it with scores of other platitudes in his *Dictionary of Accepted Ideas.*° To the philosophical mind, the new marvel caused only the sad reflection that moving from place to place added nothing to intellectual or spiritual worth. One was the same fool or knave at either end of the journey. And the "business" done more quickly only added to the dominion of materialism. The businessman naturally ignored this jaundiced estimate and built railroads as fast as capital could be raised to do it. The 1840s in England suffered the "railway mania"—dozens of lines projected, too many built; hence failures, lawsuits, much countryside spoiled, towns angry at being passed by, the coal and iron trades booming, rival designers steadily improving engines, rails, ballast, cars, brakes, signals, and operations.

For a country such as the United States, the railroad was the means of rapidly developing the open spaces and their natural resources. In spite of recent revisionist opinion, the Middle and Far West would not have become populated and prosperous so quickly with the sole aid of canals and the pony express. Russia's hinterland remained backward for lack of railroad builders with greedy intentions. In Africa and the Far East, the Westerners' railroads gave the start to the New Imperialism by pushing trade inland from the treaty ports and the old outposts dating back to the 15th and 16C (<103). The railroad did not begin or complete the making of "one world" in habit and outlook, but it gave the infiltration by the West of other parts of the globe its strongest push.

Alone among the products of the industrial age, the railroad generated a

special kind of admiration, indeed of affection blended with poetry—the so-called romance of the railroad. It is associated with the sound of the train whistle at night and the fleeting squares of light as the express rushes north; and during the day, with the first sight of the engine down the track, its hissing white plumes as it slows to a stop, the exchange of mysterious words and *billets doux* between driver and stationmaster, and the majestic departure of such a bulk of iron and human freight—without us. These and kindred impressions, recorded innumerable times, have inspired poems down to our day.° The train is a presence in literature throughout the 19C in a way that the plane has not been in the 20th. Zola's *Human Beast,* Hardy's "The Journeying Boy," and Anna Karenina's choice of suicide on the track are but a few examples out of many.

Tolstoy, incidentally, thought the railroad an invention of the devil; descriptions of Russian trains in his day tend to confirm his surmise. Crowding in the stage coach meant four bodies with cramped limbs; but the railroad introduced another kind of oppressiveness by the size of the masses it gathered and delivered. The well-known painting by Frith, *The Railway Station,* gives an idea of the new promiscuity. And as Daumier showed in *his* painting, *The Third-Class Carriage* was the equivalent of steerage on ships or a late 20C jet plane. But between, say, 1890 and 1940, first-class railroad travel afforded not only speed in comfort but a unique cluster of pleasures, from excellent meals cooked on the train and served in style to roomy and private overnight quarters, and from punctuality throughout the trip to the perfect base for seeing the country in its three-dimensional aspect. Today, "the train" evokes only charmless convenience in Europe and overlong discomfort in the United States. Nor is the uprooting of one's being a sensation any longer felt; people are no longer vegetables attached to the soil but self-packing objects always between destinations. Motion is the normal state. [The book to read is *The Railway Revolution* by L.T.C. Rolt.]

The railway in its prime gave the art of architecture a new direction by its need for a type of building unheard of before, the urban railway station. The ways in which iron, steel, and glass were used did not come from textbooks or the Beaux-Arts school in Paris; they were invented by the engineers who had also found new ways to design bridges for the long spans and heavy loads of rail traffic. In all these works, they were functionalists; that is, content to show rather than conceal structure. Among these innovators, Isambard Kingdom Brunel was the pre-eminent genius who should rank among artists as he does among engineers. The latest in skyscrapers and, earlier, the Crystal Palace where the Great Exhibition of 1851 dazzled the world, owe their magnitude and their metal-bound glassiness to the railway and the unfettered genius of its builders. [The book to leaf through and read is *The Railroad Station* by Carroll L. V. Meeks.]

Three other cultural by-products date from early in railway history. One

is the ticket, which burst on the world in 1838 and is now the universal proof of entitlement—ID, theater admission, key to the hotel room, and credit card. The second is artificial time. Before the railroad and universal moving about, each town or village had its own reckoning, more or less accurately based on the overhead sun indicating noon. Fifty miles away to the east noon was earlier, and later to the west. This pluralism was incompatible with a railroad schedule. Instead, wide territories must be made to share a single arbitrary time, false and unnatural everywhere but along one meridian. The resistance to this ABSTRACTION was unexpectedly strong. In the United States it took a crusader who argued the cause from state to state to achieve a common time.°

A third, more readily acceptable innovation, was the new taste for whiskey as a drink, first for the hoi polloi and ultimately for the gentry. It was brought into gin-soaked England by the Irish navvies who dug the earth (by hand) for the "cuttings" and wheelbarrowed it aloft for the embankments. Their nickname, since then a byword for grueling work, is the diminutive of "navigator," so-called because originally recruited to build canals but diverted to the swifter carrier.

<p style="text-align:center">*
* *</p>

Trial and error in making steam engines and locomotives spurred the pure scientists in their research; the time of the railway mania was also that of Kelvin, Joule, and Mayer, who established the equivalence of work and heat. The motion of molecules in gases under pressure was measured and so was the speed of light. Whether light was propagated by corpuscles or by waves was argued, for the spectroscope showed discontinuous bands for colors. Since no one believed in action at a distance, the invisible "ether" was posited as the medium in which all waves, corpuscles, and other stresses and strains took place to produce visible phenomena. The scale might be that of the heavens or of the test tube, the great push-pull of Mechanism ruled, as the recent mathematics of Laplace and Lagrange had foretold (<439).

So engrossing were such investigations that the amateur who also pursued other interests disappeared; seeing which, William Whewell of Cambridge decided that a more exact name was needed than "natural philosopher." He proposed *scientist* and nobody objected.° What was not noticed was that in a field where equally rapid advances were being made, electricity, a sort of counterpoint was developing that would in future disrupt the mechanical scheme. The endlessly fertile mind of Faraday created the electromagnet and the electromotor, showed that chemical action yielded current, and current created heat and magnetism. Talents of the same caliber—Ampère, Oersted, Ohm, Henry (in the United States)—contributed essential discoveries to a science whose practical application was also in the

future, but which at this time helped to confirm the gratifying generality that all forms of energy are conserved. What is more, these energies can be converted into one another. True, the result of a conversion was not as usable as the original output; the steam that has driven the locomotive dissipates once its work is done, and the molecules that form the white condensed water vapor that one sees are not "available"; but none are destroyed. This is entropy—a turning away from use—recorded in the second law of thermodynamics, which in its generality foretells the end of the universe.

In biology, meanwhile, besides continued thought about evolution (<455), the progress of organic chemistry at the hands of Liebig and Pasteur, the identifying of the cell by Schwann, and pioneer work on nerves and brain by others all validated Lavoisier's notion that the living body burns like a candle, which in turn means that life can be reduced to the laws of mechanics. Out of these interchanges and parities, the synthetic mind of Helmholtz framed a general view of the universe as a concert of atoms linked by central forces.

<div align="center">*</div>
<div align="center">* *</div>

At the same time as some Romanticist composers fashioned the period's favorite musical entertainment by uniting song with historical plots and real furniture on stage—in short, grand opera—other Romanticists created the full orchestra. It may be defined as a band of some 100 instruments in balance; that is, distributed by kinds in fixed ratios to ensure that any desired volume of sound does not obscure distinct tone colors. This grouping constituted an instrument by itself, the counterpart of the organ with its own tone colors obtained from its many stops and registers. This full orchestra and the so-called Romantic organ were alike products of the new industry. Improvement in the clarity and volume obtainable from strings came late in the 18C with the Tourte bow (<389), and some headway was made with the tubes of the woodwinds, but it was not until the device of keys and the invention of valves that winds and brass became accurate and acquired the independence that made the orchestra truly multicolored and capable of expressiveness in all its sections.

The keys enabled the player to open and shut holes that he could not reach with his fingers when these holes were correctly spaced for just intonation. Flute, clarinet, oboe, bassoon, and English horn—could now sound perfectly in tune and perform passages formerly unplayable. Similarly, the valve provided exact tone and wider range for the French horn, trumpet, and other brass. Throughout the winds, metal replaced wood (*wood*wind recalls an almost obsolete fact), and new brass instruments evolved out of imperfect but desirable old ones—the tuba out of the ophicleide, itself a parvenu "serpent." Adolphe Sax, the inventor of the saxophone and the saxhorn (a kind of bugle), was at once improver like Edison and manufacturer like McCormick.

In the same decades, at the hands of Erard in France, Broadwood in England, and (last) Steinway in Germany, the piano likewise underwent mechanization. Armed with steel wires and pegs, an improved pedal assembly, and a highly refined "action," it began its career as the first machine disseminator of music at large. Anything and everything could be arranged for piano. The creation of its ugly stepchild, the upright, reduced its price and made it usable in small quarters—it was to be found in log cabins of the American West. From this popularity the false impression grew that the piano was a kind of domestic orchestra on which any transcribed piece could be played and remained the same as the original. The young were made to learn the piano rather than other instruments; the genteel lady in "reduced circumstances" turned piano teacher, and the piano tuner became a regular visitor.

Lastly, orchestral composers tended to use the keyboard as incubator and testing ground for their ideas, instead of thinking orchestrally from the start. That the piano is percussive and monochrome and can hardly sustain a note should have served as a warning, but the custom prevailed of composing a work and then "orchestrating" it. The word should rather be "instrumenting it," since it is the choice of instruments at any point that gives both character and color to the passage. The result was a great deal of excellent music whose qualities are compromised by clumsy or routine instrumentation. Liszt is the outstanding example of a creator on the piano who had to hire others to orchestrate for him, until by sheer will he taught himself an instrumental style of his own.

The enhanced organ owed its advent to one very young man in particular, Aristide Cavaillé-Coll. The 19C profited from several other inventor-builders, but he was the early innovator, himself early in being a capable artisan at the age of 11, when he was already working in his father's organ-building shop. Still young, he solved two long-baffling mechanical difficulties having to do with wind pressure and the smooth changing of stops. He went from his native Montpellier to Paris, aged 22, to give his talents wider scope, and by a happy chance had at once the opportunity to compete (in three days) for the building of a new cathedral organ of 84 stops at St. Denis, near Paris. The young man got the commission, which started him on a long career of innovation, for he believed in adapting each instrument

All vertical rollers shall be made of iron, their pivots lathe-turned and their bearings of brass; each part shall be carefully filed and polished. All wooden pipes shall be varnished inside and out to improve their tone and their durability. All metal pipes shall be made of tin and the thickness of the metal in each pipe shall be gauged with the utmost care, using instruments to measure precisely without guess work. The metal in each pipe will then have a thickness proportional to the length and diameter of the pipe, giving uniformity of tone throughout the keyboard.

—A. Cavaillé-Coll, Specifications for the St. Denis organ (1833)

to its individual place and use. Cavaillé-Coll organs, the authorities tell us, were instrumental (literally in this case) in shaping the works of both the schools of French music for the organ.°

The recent interest in playing old music with the instruments of its own day has shown the difference it makes not merely in dynamics but in meaning. The absence of certain timbres and the presence of others affect the force and the atmosphere of the passage and dispose of the idea that a note is a note whether played on the kettledrum or the ocarina. Also of our time, the retreat from the 19C orchestra and the popularity of chamber music, partly due to economic reasons, have arisen from the feeling that Romanticist passion is passé. Lyrical love outpourings, the pangs of melancholy, the storms of revolt against fate, the realism of "nature painting"—all these no longer correspond to our anxieties and resentments. Just as there is today no poetry expressing public emotion, but only the private individual's testimony, so the full orchestra, with its antecedents in the collective zeal of the French Revolution and its equipment born of the industrial, belongs to the museum; or rather, serves as one for the repertoire that made it a creation unique in the world: Beethoven, Berlioz, Schubert, Schumann, Mendelssohn, Liszt, Brahms, Tchaikovsky, and their descendants down to Strauss, Debussy, Bruckner, Mahler, Sibelius, and Shostakovich.

<center>*
 * *</center>

The year 1848 has come to live in the official mind of western nations as significant of many diverse things. Its 150th anniversary was elaborately celebrated in France, with echoes elsewhere on the Continent. The distant date was taken as marking the victory of Liberalism, the rebirth of democratic institutions, and the spontaneous awakening of working-class solidarity. Long memories would also recall the abolition of slavery in the French overseas possessions and, aimed at the same goal, the first issue of William Lloyd Garrison's *Liberator* in Boston, while in Seneca Falls, N.Y., a convention of women issued a "Declaration of Rights and Sentiments" demanding the vote.

And there are concrete events to remember. Early in 1848 an armed revolt broke out in Paris that toppled after 18 years the constitutional but conservative monarchy of Louis-Philippe and his prime minister, Guizot. He was not a reactionary: he had battled the restored Bourbons and was a respected historian; but as an austere Protestant who remembered that his father had been guillotined during the self-purges of the revolutionists, he stood for order, which in his day he interpreted as let-things-alone. Unrest had been visibly growing for half a dozen years. Widespread economic depression afflicted Europe—it was the time of the Irish famine, England

had suffered through the "Hungry Forties." In France, bad times for industry and bad harvests caused severe distress. Reform groups organized "banquets" for discussions that were really demonstrations against the government, while underground republican groups enlarged their network and propaganda.° The Paris press kept up an effective critique in word and picture. Every week, Daumier's deadly lithographs caricatured the king and his adherents, giving his face the shape of a pear and showing up the doings and clichés of the middle-middle class as tawdry and dull.

After a few days' fighting and the king's abdication, the Second French Republic was set up (the first dated back to 1792), the poet-orator Lamartine taking the lead in the assembly against Louis Blanc, the leader of the Socialist parties. Blanc forced the recognition of "the right to work," and as relief for the unemployed established "national workshops." They provided "made work" of doubtful use, but took care of some 100,000. But hostility developed between Liberals and Socialists, bourgeois and workingmen—those who would be satisfied by purely political changes and those demanding economic reforms for the working class. Four months of mutual provocation ended in a second armed outbreak, the bloodiest street fighting Paris had ever seen. The workers were cut down, and the victors, by providing the new constitution with a strong executive, laid the ground for their own destruction in the near future (587f.>).

Abroad, the events of those six months in France fired up enthusiasm in the many groups that had for three decades plotted against Metternich's system of Suppression. Revolts occurred at many points in central Europe. Hungary rose up against Austria; in Italy Mazzini and his followers set up a Roman republic. The Irish rebelled; the Belgians fought back French insurgents on the frontier. Polish exiles left Paris in droves to stir up revolt at home. Shortly, the Continent was the theater of local wars in which the demand for a Liberal constitution and a national state were confused. [The book to read is *1848: The Story of a Year* by Raymond Postgate.]

The conflict was savage, victories impermanent, like the several rebel regimes that emerged in Italy, Hungary, and elsewhere. Massacres, executions, forced exile, betrayals, concessions never meant to be lived up to, a halt to cultural activities, created a flood of refugees bound for London—including Metternich, who fled from Vienna in a laundry cart. Suppression was at an end, but the kings and princes were still fighting for their prerogative. In Dresden the young Richard Wagner

How comes it that trade is too often disguised cheating? Law, chicanery? Medicine, experimental manslaughter? Literature, froth? Politics, a lie? And society, one huge war?

—G. LUDLOW IN *POLITICS FOR THE PEOPLE*, A CHRISTIAN SOCIALIST WEEKLY
(MAY 13, 1848)

barely escaped being shot, as were some of his fellow musicians. In Paris, both trade and art had come to a standstill and the press was muzzled. Berlioz among a good many others had no recourse but to cross the Channel to find a livelihood.

In London, during the early spring of 1848 the Chartists (= bearers of a charter signed by the thousands) bore down on Parliament in a huge parade. The main points of their petition demanded male suffrage, the secret ballot, no property qualification, and a salary for members of Parliament. Special constables were recruited to prevent rioting, one of them being Napoleon's nephew, Louis Napoleon Bonaparte, of whom the world was soon to hear. The demonstration and petition had no results and Chartism faded away. Similarly in Germany, an assembly that had gathered at Frankfort to give all the Germans a national state and a Liberal constitution worked hard to reach consensus, but the effort came to nothing. The delegates were able but without political experience; their constitution provided for too many situations and too many interests; it resembled a philosophical system rather than an outline for action.

At the same time, a young German philosopher exiled in London, whom Heine had met in Paris and thought brilliant, was also working at a plan for a future society. This was Dr. Karl Marx, a disciple of Hegel and already a marked man in both Germany and France for his revolutionary temper. With the son of a Manchester manufacturer named Engels, Marx was writing a manifesto for the Communist League. It combined an analysis of industrial society with a review of European history and a list of ten legislative reforms (income and inheritance tax, and the like) with a call upon workers everywhere to unite in overthrowing the existing order.

Taken all together, the ferment and bloodshed of 1848–50, lengthened to 1852 in France, carry one message: merely Liberal demands, that is to say political and parliamentary, had failed. They had not overcome the monarchies and they had not satisfied the aroused peoples. This again was due to lack of experience rather than of intelligence. Lamartine had said long before, apropos of poetry, "it will be philosophical, political, and social, like the times that humanity is about to go through." And in the republican assembly of 1848, Victor Hugo thundered: "Replace political policies with social ones"; in other words, provide for the well-being of every individual, for equality has become the rule. The Romanticist liter-

Look at what is happening within the working classes. Can you not see that their passions, from being political, have become social? Can you not see that ideas are gradually spreading among them which are not only going to overthrow certain laws, but society itself, knocking it off the foundations on which it rests today?

—TOCQUEVILLE, SPEECH TO THE ASSEMBLY (JAN. 27, 1848)

ary generations had all been "committed"—*engagés*—and most of their spokes-
men had written poems and prose for the Liberal cause and social justice. All
the makers of Socialist eutopias, all the critics of mechanical progress, all the
dissenters from classical economics said the same thing. That transition from
purely political thought to social was to be the task of the next 100 years.
Meantime it wore the guise of an enigma to be solved.

Things Ride Mankind

"MID-VICTORIAN" is a term commonly used to condemn attitudes regarded as ridiculously pompous and dangerously repressive. It denotes the substitution of moralism for morals, which it is thought blighted the entire period called Victorian. But that was a span of 64 years and no moral or other outlook can last so long unchanged. The image as a whole is historically false. To begin with, moralism set in some 20 years before Victoria was born. It was a response to disorder ensuing from the French Revolution and its sequels in France, and particularly obnoxious in the English regency under the prince who became George IV. Byron noted the early signs of "cant moral, cant political, cant religious." In fact, it was the force that exiled him. Its origins go back to Methodism, and in the early 19C its impulse to do good inspired the Evangelicals of the Church of England to agitate for such causes as the abolition of slavery.

Moralism had an even wider purpose. By repressing in each individual the actions, words, and even thoughts that run athwart the conventions, it represses what might disturb the existing state of things. Everyone is a policeman set over himself—and as a living unit of social pressure, over his neighbor. Moralism served in parallel with overtly political Suppression. The goal aimed at is Respectability. The equivalent in French—*la considération avant tout*—makes clear the role of others: how they consider us helps to keep us worthy of respect. To this invisible coercer is added another: the class above and below one's own. There is a point of difference between this balance of forces, internal and external, and the democratic social pressure (783>); the latter is not necessarily matched within the individual by self-control. That difference explains why the Victorian period produced so many strongly marked characters, fearless in promoting original views and often eccentric in habit and deportment. Self-control

Shopkeepers and retailers of various goods will do well to remember that people are respectable in their own sphere only, and that when they attempt to step out of it they *cease to be so.*

—ANON., *HINTS ON ETIQUETTE* (1836)

at least develops a self. And the multiple achievements of the Victorian Age testify to the abundance of such men and women. The French phrase also tells us that Victorian moralism was not limited to Great Britain. The entire Continent lived under its sway and so did the United States. It must be added that in England and elsewhere the aristocracy, though diminished in power, could flout the conventions if they chose, and the lowest class enjoyed the same independence: for both it was a case of having nothing to lose.

This freedom was most often exercised in sexual matters, for it was sexuality that moralism needed most to repress. It is the strongest of the instincts; it makes men and women want to break through all restraints. Others' feelings and their rights, the judgment of family and friends, regard for one's safety are no barriers to erotic passion at its peak (575>); and since passion in its general form of libido is at the heart of every kind of fierce ambition, political or artistic, in either it may mean revolt. So close is sexuality to politics that nearly all revolutions and social utopias begin by decreeing free love and then turn puritanical when the leaders see that license undermines authority.

It is therefore a mistake to think that "the Victorians" in their pursuit of a purified life became blind to sexual realities. To ignore does not mean to be ignorant of; on the contrary, the effort heightens awareness. Hence the verbal absurdities of 19C moralism that were devised to conceal facts and drive away wrong thoughts. The body and its parts must not be mentioned; even a piano was debarred from having legs. The parallels today are the words used to conceal bodily and mental infirmities and spare their victims; it has been held that "hard of hearing" is an offensive phrase.°

The 19C apprehension of lust also explains the theoretical character of the respectable woman; that is, not the living person, but the specified model. She must not be a temptress, which for the Bible-reading majority was the role that by nature and precedent she was expected to play. It is an error to suppose that the "angel in the house" denounced today has been the ideal for centuries. Although the medieval poets of chivalry exalted their lady, they were not self-deceived. Only in the late 18C, when Sentimentalism infiltrated the Enlightenment, did woman begin to be fragile by definition; and then, for shelter, the 19C added ignorance of large parts of life. Pure and ethereal, she was to be an object permanently sacred to the male, not just in poetry or while being courted.

The corresponding male image was that of a strong but coarse creature of instinct, who showed no emotion, never wept, and who if left alone with a woman for ten minutes would infallibly molest her sexually. Unless close relatives, therefore, men and women must never meet alone. This etiquette and what it presupposes need only to be stated to show that it could never have been observed to the letter by any society of human beings. It was contra-

dicted in its own day by other theoretical and practical schemes; for example, the notion that the young girl must be properly trained in certain accomplishments to entice the male into marriage—music, sketching, household management. The 19C was the golden age of manuals for girls and matrons. Mrs. Beeton wrote a classic of the genre, and in books for the perfect education of girls, much more than music and sketching was recommended—the sciences of nature and physical exercise. Accordingly, there was no outcry but, rather, recognition when Dickens in *David Copperfield* marries his hero first to Dora, who is close to ideal helplessness—she doesn't know that oysters have to be opened—and after the author has shown the drawbacks of a sweet, pure, animated doll, disposes of her and installs in her place the solid, competent Agnes. In a later novel, Dickens makes the young Bella say: "I want to be something much worthier than the doll in the doll's house." These last words became the title of Ibsen's famous play about the New Woman 15 years later.

The historical record and Victorian literature alike show women of ability with strong minds, not a few of whom wielded the power in the house. Had all been Doras, as the abstraction "Victorian woman" takes for granted, there would have been no next generation of able men, and the age would have been barren of accomplishment by either sex. Among the rural and urban workers, who got along very well without Respectability, men and women toiled side by side in field, factory, or shop, with no thought or wish for the ideal feminine role.

These wage earners also contradicted the notion of the perpetually aroused male victimizing the helpless maiden. The Victorians of the class above adopted and established the late 18C meaning of *gentleman*. Earlier, the term implied birth. Now a gentleman was whoever behaved like one—in speech and dress to start with, but also in manners, civility, and above all in deference to women. There is more to say about the vigorous sexuality of Victorian times; here the last item to note about 19C moral coercion is the family. Its choke hold on the individual was widely effective, though the paternal (or maternal) tyranny was not always as extreme as represented in Samuel Butler's *Way of All Flesh* (633>).

Good behavior in the streets was another by-product of respectability, seconded by the policeman on the beat. Nineteenth-century London was safe as it had not been before, lagging behind Paris and other capitals. Sir Robert Peel's creation of 20 years earlier, named after him the "bobby," had been slowly accepted after objections in defense of the Englishman's immemorial liberties. Unarmed and of civil manners, the disciplined men in blue swinging idle truncheons were the living image of Respectability. English became a synonym of law-abiding. This was a gratifying discovery, made clear to all after the opening of the Great Exhibition in 1851. The six million people, native and foreign, who

thronged the Crystal Palace did not loot or riot but conducted themselves like ladies and gentlemen at a soirée. The same was true of the popular open-air resorts, Vauxhall, Ranelagh, and half a dozen others—except after midnight, when these places were tacitly reserved for assignations, though not for violence. Wanting tranquillity after long unrest, Europeans obtained it in good measure by what might be called home remedies.

<center>*

* *</center>

When Emerson wrote: "Things are in the saddle and ride mankind,"° he covered in one sentence the feature of his time that many perceived and others dumbly responded to. Like Carlyle, with whom he exchanged ideas, Emerson saw mechanism governing the mind after machinery had coerced the body. A people or nation was now judged by the annual output of coal and iron, the total tonnage of ships, the number and variety of inventions designed to multiply goods—all expected to increase in quantity each year. Classical economics was a mechanism too, and by the common measure of things, the makers and dealers were said to be "worth" so much. Worthiness was not so readily ascertained.

Besides this revulsion against things and numbers, the complaint against mechanism in the 19C and ours has included the direct effect of machinery on the spirit. This is not imaginary, and it is rarely seen to be not a single but a double effect. The obvious part is that the machine makes us its captive servants—by its rhythm, by its convenience, by the cost of stopping it or the drawbacks of not using it. As captives we come to resemble it in our pace, rigidity, and uniform expectations. But there is in mechanism a subtler influence. The machine is an agent of ABSTRACTION. It is itself an abstraction in that it does one particular task (or at most two or three) and yields identical products. There is no fringe of fancy, no happy error or sudden innovation as in the handworker's performance. That is why machine-made things rarely draw our glance more than the few times when they are new and handy. They induce no subsequent reverie, no speculation, and no love. The robot is a repulsive caricature of Man. When the domestic or public landscape is filled with objects deprived of any aura, it is as if the world of living things had been reduced by abstraction to something emphatically not alive.

It is of course true that the first stone axe or pump handle was a machine and looked just like another axe or handle—but not quite, the irregularity kept it individual; besides, most pre-industrial tools were made of wood, which has a life of its own. One cherishes a Boule cabinet in preference to a filing cabinet. It is not that metal is without appeal to the senses or that geometrical forms are unaesthetic—Art Deco showed how pleasing they could be; the oppression of mechanism begins when every horizon is crowded with

the means that abstract from life and reduce it to functions. What this complaint overlooks, of course, is that the enthusiasm for progress as measured by production was not wholly blind or selfish. It carried the humanitarian hope that the ancient spectre of penury and famine would be exorcised by the abundance flowing from the mills and dispatched everywhere by rail and steam. The machine moreover relieved man of some back-breaking toil.

Hence that booming 19C institution, the world's fair. In early modern times, fairs were markets held on regular dates when lack of roads made it hard to distribute goods. In the 17C Rome and Paris held the first fairs for a single kind of goods—fine art. Then in the mid-18C the Royal Society of Arts, Manufactures and Commerce in London was founded, and it shortly organized a fair of the now familiar kind—artifacts displayed so as to be coveted and copied. The French Revolution followed suit in 1791, with competition stimulated by prizes. From the year 1844 in Paris and 1851 in London, large industrial fairs have been held at short intervals down to the present day, when sight-seeing tourism has been added to the lure.

That of 1851 in London deserved to be called great in more than one respect. Victoria's consort, the German prince Albert, eager to make his new people value him, took on the project. An able organizer, he was also gifted with a sense of scale. The Crystal Palace erected in Hyde Park proved an architectural triumph. Sir James Parton built of prefabricated parts a structure of iron rods enclosing clear glass. A vaulted transept rose high in the center of the long gallery that extended (symbolically) 1,851 feet and afforded a total floor space of 800,000 square feet. Spread out over it were eight miles of tables displaying the works of 1,300 exhibitors. The striking United States contributions were Colt's "repeating pistol" and a smoothly working set of false teeth. Queen Victoria believed like others in the primacy of Things, and at the opening on May 1 declared it "the greatest day in our history." In New York City the following year a copy-cat exhibition in a "crystal palace" opened on the present site of the Public Library.

*

* *

Who can arbitrate between the Machinists and their adversaries? In the second half of the century nobody denied that material betterment was a worthy goal; but many, unable to cheer progress, had to be content with decrying the loss of moral and intellectual elevation that progress seemed to entail. The imaginative philosophies and poetical passions of Romanticism, its cultural nationalism and generous social schemes had come to be replaced by something called *Realpolitik* in one domain and Realism in all the others. The *Real* in the German word denotes *things*—a *Realgymnasium* is a largely vocational school. Applied to politics, the term means the policy of seeking material

advantage instead of furthering principle. In this view Nationalism is for territory not culture. Social reform is for feeding the masses and it must come or there will be violence—the class war. Until then, compete and get rich.

It might be said that such conduct has always been the way of states, classes, and individuals. But the atmosphere one breathes is different when the vulgar way becomes the ideal. It turns the thoughtful into cynics or pessimists. In the Germany of the 1840s a group known as *Die Freien* asserted their desperate freedom by the declaration: "God is dead"; all is permitted. One of their number, Max Stirner, developed a system under the title of *The Ego and His Own*° that made it a duty for the individual to fulfill all his wants by any means at hand; there is no reason not to; EMANCIPATION has no natural limits.

Other types of anarchism thrived in France and elsewhere. Proudhon, famous for his paradox "Property Is Theft," preached the replacement of the central state by small, spontaneous self-governing units. Blanqui, ready for violence (<428), adopted the slogan "Neither a God nor a Master." Out of Russia, two wandering agitators and writers—Bakunin, the total anarchist and ferocious enemy of Karl Marx, and the more liberal (at first) Alexander Herzen, made converts to the Proudhonian idea that the state must be destroyed by the spontaneous action of the working class and replaced by self-governing cooperative groups. These might be federated if they choose. Within Russia, the new generation, according to Turgenev's novel *Fathers and Sons,* is typified by the hero, Bazarov, the systematic nihilist.

The term implies living without doctrine, seeing no point in action. Such despondents found their mood philosophically accounted for by Schopenhauer. Born in the same year as Byron, he belonged to the Romanticist generation. He had helped bring into notice the sacred books of the East that underlay his well-worked-out philosophy in *The World as Will and Idea*. But it had been rejected for almost half a century; now its vision was found to be the answer to the riddle of existence. The world is will in the sense of desire: human life is a perpetual striving for satisfaction—in vain. Desire follows upon desire and in so doing creates images of truth, love, happiness, justice, or other alluring wants that can never be satisfied. It is all a vast illusion. The Hindus call it Maya and personify it as a goddess. There is but one exception to the fate of desire—art. This is a scrap of solid western Romanticism: art is not illusion nor always vanishing. The desire it arouses *is* fulfilled by its object. Thus the cult of art serves as refuge to the bystanders alienated by Progress. From his coffin corner, Schopenhauer also issued several volumes of essays and aphorisms in highly readable prose, salted with sarcasm, that treat of the disagreeables of ordinary life and how they are dealt with by the wise.

What of the art that is supposed to appease desire? In the shift from

Romanticism, the cult of poetry sub-
sided into the love of prose; that is, of
the novel. Its program acquired the
name of Realism and made it a vogue
word. The *real*-portion of the word is
intended to mean factually true, obvi-
ous in everyday experience. It was sug-
gested on an earlier page that in a pre-

Not long ago I read in a London newspage,
concerning some report of a miserable state
of things among a certain class of workfolk,
that "this realistic description is absolutely
truthful," where by *realistic* the writer simply
meant painful or revolting.

—GEORGE GISSING (1895)

cise critical sense all artists are realists: what they depict in words or paint is to
them an object of consciousness; a dream, a ghost, an illusion is as real as a
beer barrel or a toothache. "Realism," "realistic," as used in talking about lit-
erature, therefore have a crabbed sense, and that sense became so rapidly cor-
rupted that it is unfit for use by anybody who likes to be precise.

The novel was bound to become the dominant genre of the 19C, in part
because it apes the stance of history. It is written to sound as if its incidents
had happened. Moreover, by describing human predicaments in a social set-
ting, it combines psychology and sociology and discourses freely about its
own invented people and events for the purpose it shares with history—
explanation by ANALYSIS.

Flaubert's *Madame Bovary* is often taken as the original model of Realism
in fiction, although the ism was made a literary slogan earlier by Champfleury
and exemplified by his fellow theorist Duranty. Both had been impressed as
early as 1848 by the declaration of the painter Courbet (566>), who
announced that he would paint nothing but "the modern and the vulgar,"
meaning the commonplace. Flaubert detested the label Realist—or any
other—but his apprenticeship is enlightening as to the intention of the term.
Born in the second decade of the century, he imbibed Romanticist ideas and
ideals from which he never really departed. The subject he chose for his first
novel was Saint Anthony tempted in the desert. When the long work was fin-
ished, Flaubert read it to his closest friends, who damned it without pity,
unanimously. The color, the imagery, the luscious rolling sentences, the
events themselves were found unconvincing—false and boring. Flaubert was
crushed. *Saint Anthony* was burned, a martyr to Realism. Flaubert must find
another subject and do the opposite of what he had done.

The opposite was *Madame Bovary*, the story of a provincial woman mar-
ried to a dull man and leading a dreary life. She has vague aspirations toward
lively society and romance in love. As a girl she had read Walter Scott and she
pines for adventure. She takes the plunge into successive love affairs with two
men who are differently mediocre and finds herself caught in financial dis-
grace and passional despair that must end in suicide. Though somewhat
expurgated for serial publication, the book was taken to court as immoral,
though one would have thought Emma Bovary duly punished for her trans-

gressions. Not that Flaubert killed her on that account; it was society that offered no escape. The book—that is, author and printer—was not condemned. But in killing Emma, Flaubert had killed part of himself, as he implied when he said: "*Emma, c'est moi.*" Her aspirations, in clearer and stronger form, were his and were thwarted, made to look foolish, by the temper of his times.

He took revenge in his second novel, *L'Education Sentimentale,* which means the education of the feelings, without any connotation of sentimentality. Set in Paris during the uprisings of 1848, it takes a hero, again, full of vague longings and weak principles through events and among people that exhibit nothing but cynicism, vice, pessimism, and listlessness. [The translation to read is that by Perdita Burlingame.] Flaubert thus vented his hatred of "the bourgeois," whom he defined as "one whose every thought is low." This floating target was already Gautier's a quarter century earlier; it was now every artist's; the bourgeois ethos was regularly blamed for the lack of public hope.

As the Realists professed to take a sober view of all things after what they considered the misplaced enthusiasms of Romanticism, so in discussions of aesthetics the word *Classicism* recurred in rebuke to the artistic freedom—the freedoms—taken by the Romanticists. This Neo-Neo-Classicism could obviously not reinstate the forms and feelings and social attitudes that existed at the court of Louis XIV or the standards by which the 18C judged art and literature. The Neos could only try to recapture the spirit of obedience and apply a curb to the imagination.

In many who shared this tendency, it was by instinct rather than reasoning and implicit rather than expressed. Brahms, for example, whom Berlioz had greeted as an accomplished young musician, did not theorize; he simply came to think that his technical training was incomplete and he took lessons in counterpoint. In the same reflex way he chose to write symphonies like Beethoven's instead of symphonic poems like Liszt. Hanslick, the leading music critic of Central Europe, did theorize and write aesthetics. He had welcomed the Berliozian influence in that part of Europe when it began to be felt in the 1840s, but now concluded that it had gone too far in Wagner and Liszt, whom he attacked in the name of Beauty in Music.°

In the fine arts one finds the painter of murals, Puvis de Chavannes, bending his genius to the allegorical genre so as to satisfy the need of quiet harmonious beauty in the place of drama. One may regard the English painters of the pre-Raphaelite Brotherhood as performing the same retreat from the present (567>). In all these moves it is clear that the retreat was as much from the ugly world of industry and commerce as from the energies of Romanticist art. It too had disliked the world's ways, but it had braved them head on and offered its own massiveness as a countervailing force.

In tune with Puvis in France, the most conscious artists other than nov-

elists were the poets called Parnassians. Their fighting periodical was called *Le Parnasse contemporain*; the title by itself suggests their program: stay on the heights with Apollo and the Muses, scorn the vulgar below. Their leading talent, Leconte de Lisle, was not a writer of manifestos. His poetic output consisted of long, beautifully wrought poems in strict form that celebrated scenes and stories from the ancient world. He made a point, like a number of other European writers, of spelling Greek names "correctly," for aesthetic distance, no doubt: Sokrates, Kleopatra—and not as the modern languages had adapted them. Leconte also chose subjects from the Near and Far East, labeling these poems "barbaric," that being the name the ancient Greeks gave to all aliens. These exotic scenes were not offered in the Romanticist tone of happy discovery; they were "murals" in words, exact in detail, and well-designed to foster serenity in the reader. As in Schopenhauer, the Oriental universe is a cure for agitation. Only in one sonnet did Leconte break out of his reserve to affirm that never would he exhibit his mind-and-heart to entertain a world dominated by "mountebanks and prostitutes." The Parnassians' counterpart in Italy was Carducci, who from his college days yearned for a return to the poise of classical antiquity and gave that need of refuge expression in his mature work.

The contemporary poet who at once reveled in that world and made verbal music out of it while condemning it as Satanic was Baudelaire. He made it his specialty to describe and raise disgust not alone at the grossness and vices of mankind, but at the very conditions of life. The title of his famous book, *Flowers of Evil*, is an ironic labeling of the *fruits* of evil that the poet finds in both the inner and the outer worlds. So perverse do human beings seem to Baudelaire that some have seen in him the influence of De Sade. In a few poems, for contrast and as it were relaxation, he praises sensuous beauty and the mind calmed by achieving order; but Realism prevails and behind his objectivity he despises what he believes he sees. That, in turn, is the reason he asks for "something new, even if there be none in the world." [The book to read is *The Horror of Life* by Roger L. Willliams.] Gautier like Flaubert, but without any crisis, doused his Romanticist fervor. He said he could no longer love, from too much ANALYSIS. He wrote poems that are, as he explicitly wanted, formally fine and cold; the collection is significantly called *Ceramics and Cameos*.

Flaubert's two other novels show that he had had enough of Realism. His imagination wanted free play. He had been to the Near East and had found the Arab world a delight to the senses. He chose to re-create ancient Carthage as the scene of a melodramatic tale about a femme fatale, Salammbô. Then, undeterred by his early discomfiture, he returned to his hermit in the desert and produced his final masterpiece, *The Temptation of Saint Anthony*. Both works allowed him to make his pages glow with color, myth, exotic details,

and strange words. When he was attacked for setting down improbable things, he referred for his facts to ancient sources about animals, geography, and gems that cure diseases. This circuit with Saint Anthony first and last tells us what literary Realism was: the search for the thoroughly commonplace and its minute delineation. Without help from theory it had been the technique of Defoe, Fielding, Smollett, and of the Romanticists from Scott and Balzac to Stendhal and Manzoni, although as remarked earlier it was not the Romanticists' single technique in any one work. George Sand herself, at the end of her career, toned down her exuberance to depict the rural life she knew so well. [The book to read is *The Realists* by C. P. Snow.]

> "Very good story," he said, "but it's not what I call Realism. You don't say when it happened or where or the time of year, or what color your aunt's second cousin's hair was, nor what the room was like, nor what happened afterwards."
>
> —J. J. Farjeon, *Number Seventeen* (1928)

The contrast between Flaubert and Balzac gives the best idea of the passage from one set of thoughts and feelings to its successor. The bulk of Balzac's 35 volumes is devoted, like Flaubert's first two novels, to a critique of society by exact depiction. In Balzac's mind, his observations were as trustworthy as science. In a first scheme he gave the name "Study" to each of three groups of stories. In a preface he stated that as Geoffroy Saint-Hilaire the zoologist (<501) had mapped the ways of the animal species, so he Balzac was mapping the human species in their native habitat. The later title *Comédie humaine*, paralleling Dante's *Divine Comedy*, points to the modern aspect of the work, Time as against eternity. "A generation," said Balzac, "is a drama in which four or five thousand play the leading parts. My book is that drama." It contains in fact over 2,000 characters and the grouping is regional—"Scenes of Parisian Life"—of Provincial—of Private—and so on. The unity of culture is shown by the reappearance of certain characters in more than one of these Scenes.

The amount of sheer information that the plan of his work enabled Balzac to impart shows him to be a Realist in purpose and execution—multitudinous accurate detail. But the scope also allowed him to have his say about the current state of affairs. He found it deplorable: money was everything. He wanted a monarchical government seconded by a pious and pastoral church and guided by an aristocracy of talents. It would disdain the present corruption: "The national budget is not a safe-deposit box; it is a spray can."

Flaubert might have seen and thought comparable things but he would have shown, not said them. Nor would he have ventured, as Realist, to treat of subjects such as Balzac treats in "A Passion in the Desert," which links a tiger with a woman in a way that anticipates one of Izak Dinesen's African sketches; or in "The Girl with the Golden Eyes," a mysterious character suggestive of

Henry James with hints of lesbian lean-
ings; or "The Unknown Masterpiece"
(644>). To repeat the generality:
Romanticism includes Realism as one
of its perspectives and techniques.

We do not get away from him; he is behind us
when he is not before. So far as we do move,
we move round him; every road comes back
to him.

—HENRY JAMES ON BALZAC (1905)

Because Flaubert adopted the
Realist's astringent technique and found it difficult, he has come to be
regarded as a hero of literature. His friends have told us how he wrestled with
words to make each the only possible one, sweating over one page a day and
testing every sentence aloud in his *gueuloir* (roaring den). It is assumed that the
result must be flawless French. That is an error. Flaubert's prose is often
slovenly in grammar and syntax, like that—curiously enough—of most nov-
elists. The criticism is heard over and over about the masters; yet it may be
this careless ease that lends their work verisimilitude. At any rate, what
Flaubert aimed at and achieved was perfect accuracy in description, using
technical terms if need be; spare and undistinguished dialogue; no repetition
of words close together, because it draws attention; and of course no elo-
quence.

But again, Flaubert paid himself back for this torture in a satire he left
unfinished. Bouvard and Pécuchet (names meant to depress) are retired
clerks who talk in clichés and copy out longhand commonplace things they
cull from print—they have forgotten why. And as an appendix to what was to
be a dully lugubrious novel, there is a list of current bourgeois platitudes, *The
Dictionary of Accepted Ideas.*° The summit of Realism must be total dullness, and
George Gissing near the end of the century makes the point. In a novel of his
own, one of his characters is writing a novel and striving for prose and events
so dull that nobody will be able to keep reading.°

*
* *

The preeminence of the novel did not at once prevent poets from gain-
ing the attention of a broad public; the retreat into little magazines comes
later. England, France, and the United States had each a national poet, a
bard—Tennyson, Victor Hugo, and Longfellow. They filled the imagination
with lyrics and tales and gave counsel in verse on public concerns. Of these
Victor Hugo was the only one surviving from the 1830 generation of
Romanticists, and as political exile from the Second Empire his message in a
volume of dazzling philippics was an indictment of that regime. Beside it
came *La Légende des Siècles*—a vast panorama of human history forming a kind
of discontinuous epic, and an equally epic novel *Les Misérables.*° In all these
works, no lyric abandon but grim preoccupation with social fact.

Tennyson, especially as poet laureate, performed the same service. *Maud*

(579>) expressed anger and despair at selfish, unpoetic mankind. *In Memoriam* tried to answer religious doubt after the shocks from science. *The Idylls of the King* allegorized the moral failings of the modern world. Only in a few discursive poems are man and his life contemplated cheerfully, with some hopes for the future outlined. The younger poet of equal range, Browning, was the more sanguine of the two, but apart from a few bouncing lyrics, he dealt in Realism like a novelist. His dramatic monologues depict cynicism and crime, and *The Ring and the Book* is a historical novel in verse. What is more, Browning's verbal technique was to force commonplace words into cragged lines, often producing instead of the intended Realism a series of puzzles that generated the Browning societies—groups of readers determined to help each other find out the obscured meanings.

In the United States, Longfellow was Tennyson's twin in popularity. His work in that role has unfortunately drowned out his private voice; he should be read for such poems as the three sonnets prefixed to his translation of Dante's *Divine Comedy* and for a few fine meditations such as "My Lost Youth." His versions of foreign lyrics and tales are often well done. In a different way, his contemporary Emerson also warrants going back to, now that the dry prosaic type of poem is not only in vogue but dominant. But of the American writers before 1848 it is Poe whose outlook, doctrine, and genius left the deepest mark on western literature, thanks to Baudelaire, who served as his interpreter. A deliberate misfit in the United States and an acute critic of its literature, Poe delved into European works of all kinds for help to frame what would now be called his aesthetic. The product was nonetheless original. In "The Philosophy of Composition" he launched an idea that had a future: he pointed out that in any long poem only brief passages here and there are poetry; the rest are connecting tissue versified. True poetry, moreover, is not made out of ideas and it must be word music. Out of these axioms came the theory and practice of "pure poetry" dear to the Symbolists at the end of the century. Mallarmé's sonnet "On the Tomb of Edgar Poe" acknowledges the debt.

In addition, Poe devised and defined the short story. The form concentrates the strictly necessary details so as to leave but one impression—of character, or situation, or atmosphere. The result can rank as "pure" too, in comparison with the sprawl of the novel. Early in the 20C the short form seemed about to displace the long from the first rank in popularity, at the same time as yet another of Poe's inventions was becoming an object of worldwide addiction: the detective story (739>). In his fiction, Poe's predilections are Romanticist: the supernatural, the macabre, the erotic, the etherealized. Except for crime and detection, he eschewed the drabness of Realism and proved an isolated forerunner of Symbolism.

*
* *

In 19C England, the novel was both a source of entertainment and a medium of reform. The railway journey doubled the demand for it and installed the bookshop on the platform. Filling that appetite gave many intelligent women who were denied the professions a chance to earn a decent living. The output, by male, female, or genius, was abundant.° Dickens began with entertainment, went on to social reform, and ended with more somber works that combined criticism of life with study of character. At no time was his art restricted by the dogmas of Realism. He too loathed moneygrubbing and its side effects on the mind-and-heart, as he showed in *Hard Times,* and he knew how to describe the back alleys. But he also reveled in the color and diversity of life, to render which he made language perform miracles. He has passages of rhetoric and its parody, others of pure stream of consciousness; then too he erupts in coruscating images; he makes malaprops reveal the speaker's point of view; and he coins innumerable phrases that capture a familiar emotion and its cause. He is the most inventive manhandler of the language after Shakespeare. No alert reader will tolerate the foolish comment that Dickens's people are not characters but caricatures. Santayana long ago showed that the saying betrayed poor observation of the common scene; and were the judgment true, Dostoevsky would not have named Dickens as an influence on his own creations.

Both George Eliot and Thackeray came closer to the soberness of Realist narrative, but her moral and social dissertations and his satirical whispers to the reader make them compromisers with the creed. The same holds true for the Brontë sisters and Mrs. Gaskell. In all of these the photographic impulse is strong and well seconded by the ability to convey its discoveries. But for its perfect employment one must go to the indefatigable Trollope and the sad, impassive Hardy. The one other master of the novel worked outside all categories but his own. Meredith had a system of ideas to embody in story form and for this a prose of his own making. It is this medium, no doubt, and this purpose behind the scenes that today keep him out of favor. The prose moves forward by crimped metaphors that have been compared to small Imagist poems. They are indeed occasionally difficult, but not enough to make readers turn academic and band together in painful exegesis as they did for Browning and now do for Joyce. What Meredith has to offer for reflection and literary pleasure is not to be found in any other writer.

His philosophy affirms confidence in nature's workings, and his ideal of society is the civility achieved when the natural man or woman submits to the policing of the comic spirit. This spirit reigns in a quarter equally far from Moralism and from Realism. It calls for high intelligence and quick wits in the

service of self-criticism, not harsh or loud but uncompromising; it is acute SELF-CONSCIOUSNESS with a smile. Perhaps the best showing of the comic spirit's performance occurs in *The Egoist*. No other representation of male self-love and arrogance undone comes close to this one, which is all the more edifying that the hero who is to be toppled is no fool, except along one line. He has charm enough to beguile, and then by impercipience to lose, one of the most enchanting of heroines. Meredith favors women over men, and his novels are full of attractive creatures who outshine—and civilize—the misguided sex.

Readers of *The Egoist* will remember the character of Dr. Middleton, the heroine's father, who is already civilized. He is a portrait of Thomas Love Peacock, Meredith's first father-in-law, and he calls for special notice, not as such but for his own unique genius. Peacock was a satirist in verse and prose who has to this day a choice group of devoted readers. His novels, so-called, are a blend of the tale and the dialogue, ornamented with poems and bathed in humor that suggests Rabelais and Swift. These short works' nearest kin are the fictions of Oliver Wendell Holmes, Sr. (585>). Because Peacock's narratives also bring in points of classical scholarship, arguments about music and food and drink, and loving descriptions of Welsh scenery, they are not to everybody's taste; but that by their very eccentricity they represent part of the 19C English mind in superb literary form cannot be denied. [The venturesome reader might well begin with *Nightmare Abbey*.]

The novel is the one type of literature that a good many people read continually, every day, like the paper or the Bible. That is why it is educational and can be reformist. It teaches readers of all classes what happens outside their own ambit. City dwellers know nothing of the little village world with its repetitious ways; and small-town folk cannot imagine the diversities of the metropolis. The novel supplies the want. With the novel, such English authors as Harriet Martineau, Charles Reade, Mrs. Oliphant, Charles and Henry Kingsley, and Mrs. Humphry Ward had a forum where current questions about the social system or the state of the church could be broached through the emotional troubles of likable individuals with names and identities. Thus spread the awareness of a "problem." As early as 1845, Disraeli's *Sybil or, The Two Nations* had pointed to the gulf between rich and poor and had stimulated factory reform. As for the tons of run-of-the-mill fiction for the trade, it is possible that its teachings did some harm. Novels of high society by remote observers and romances about angelic girls and prince charmings could certainly turn weak heads. But the socializing effect and the soothing influence of the genre have been on the whole anodyne, and in the stressful climate of Mechanism even necessary.

For the bright youth, one type of novel served another need: it is the *Bildungsroman,* as the Germans call it after Goethe's early model, *Wilhelm*

Meister. In all its imitations it is the story of the talented youth who stumbles about before finding his true beliefs and his place in the world. The story of Pierre in Tolstoy's *War and Peace* is the example that stands out among the dozens produced in the later 19C. In today's jargon, "the identity crisis" continues to furnish text and sermon for rearguard novelists.

Germany alone cultivated a quiet genre of Realism in miniature, the novella. Its triumphs have not traveled abroad, although the names of Gottfried Keller, Brentano, Grillparzer, and Storm awaken vague recognition, especially Storm's, whose *Immensee* has often been drafted to help teach intermediate German in college. The novella has been called by the writers themselves Poetic Realism, because compact and laconic, the form unites a poetic vision of the world and stark events that clash with it. The technique is strict: concrete details and no comment.

A last offshoot of the novel, science fiction, was created in 1863 by Jules Verne. He is remembered today as the author of *Round the World in Eighty Days* because it was made into a film, but he wrote equally stirring tales about going to the moon, traveling under the sea, and using power at a distance by means of rays. He lived long enough to learn that he had a wide-ranging disciple in H. G. Wells, but whether he actually did so is not clear.

The balance sheet of the 19C theater is short and simple. Once the vogue of the Romanticist historical play in the manner of Hugo subsided in the 1840s, stage needs were supplied by melodrama. It could be crude like the plays made out of *Uncle Tom's Cabin,*° or it could be dressed up as the serious mirroring of life in the "well-made play."° Its best exponents were the prolific Scribe and the competent Dumas *fils* in France, well imitated abroad. In England, Shakespeare was put on when in despair of anything better, usually much cut to make the play a proper star vehicle. [The book to read is *Melodrama* by Wilson Disher, with illustrations.]

It was Shakespeare, as suggested earlier, who inspired and discomfited the best poets of the time: Tennyson, Browning, Swinburne all wrote long verse tragedies. Like Byron's attempts, all they lacked was stagecraft—they were "closet drama"—Byron said "water closet" of his own plays, which was unjust. All these works are worth reading—once. Comedy in England found no successor to Sheridan, but France had Feydeau and one or two others, some of whose farces—for example *The Italian Straw Hat*—have been revived with success and even supplied a film.

Submerged among those who worked to formula was Henry Becque. His natural sense of theater, allied to his strong yet subtle mind, produced the stunning comedy *La Parisienne* and two other plays and much drama criticism. Now he is seen as the founder of the Naturalistic theater; he was discouraged from writing more by rejections and cabals. A comparable resistance held back Ibsen and Bjørnson for a time, and in self-defense they organized in

1859 the "Norwegian Society for Theater, Music, and Language." But any recognition that Ibsen had created a new type of drama had to wait 30 years. In the sixties, he was rather admired as the author of a poem on the death of Abraham Lincoln.°

*
* *

If in the mid-19C one was a reader of Schopenhauer and looked to the art of painting for the lasting satisfaction of restless desire, one had to go to the past or the Neo-Classicists for it (<558). The Realist school did not beget serenity. The new master Courbet offered to contemplation strictly workaday sights. His elder, Daumier, had done the same in his few paintings, but with Romanticist passion had cast a glow on the squalid. It could be argued that in any case the subject of a painting is of no importance; the eye should take in "the art" and nothing else. But that is later sophistication unheard of for most of the century. Response, as always during the preceding 400 years, was to the work's power or charm felt through the subject and its treatment—dramatic, psychological, allegorical, or other. Courbet's paintings have vitality as well as commonplace truth. The scene in which he portrays himself with his country neighbors, *Good Morning, M. Courbet,* is cheerful; and his *Atelier,* where he paints a nude amid a group of fellow artists and writers, was meant to shock: as a painter he had by convention the right to look at the unclothed model; as visitors, they have none to stand around and watch. So determined was Courbet to tilt at convention that he painted a female nude in an outstretched pose that modern magazines of superior pornography reserve for their centerfold; he entitled it *The Origin of Life.*

More moving were his "Stone-breakers," weary drudges on the road, and *The Burial at Ornans,* another village scene that has the requisite grimness of Realism. Only when Courbet painted nature—forest glades, running deer, or the sea—did the doctrine relax its hold. These works are exact too, but if they were meant as "criticism of life," they succeed in a very distant way. They rank with the landscapes that members of the open-air Barbizon School, now elderly, were still painting: Corot with his delicate woods, Millet with his peasants, had been conscious precursors of Realism in its concern with the plain fact and with mute suffering. It is not surprising that Courbet had political convictions that led him to side with the Commune in its rising against the government after the fall of the Second Empire (588>). He helped to bring down the column on the Place Vendôme, reminder of the Napoleonic legend, and his photo was taken standing by it. This nearly cost him his life; he ended it an exile in Switzerland. [The book to look at and read is *Courbet* by Sarah Faunce.]

Pictorial Realism made adherents in Central Europe and Switzerland but

not in numbers to be termed a school. In England it never took hold as such, but the cult of detailed truthfulness did bring together a group of high talents, who banded together as the Pre-Raphaelite Brotherhood (<558). Their name is ambiguous: they did not mean to station themselves before Raphael, as one might think, but before those who followed him—the -*ites*. The preferred subjects of the P.R.B., as it came to be known, were myth and legend, particularly the Christian. Beauty of body and spirit was their way of criticizing life—the life of industry and *Realpolitik*. Dante Rossetti, Holman Hunt, Millais, Burne-Jones, and in Central Europe Moritz von Schwind were so far Realists that they lavished laborious care on precise representation—no dramatic distortion in the manner of Delacroix (whom they admired) tempted them, nor anything stylized like Blake (whom they brought out of obscurity), nor again the fluid light of Turner. The subdued colors of the Pre-Raphaelite paintings, the ornamentation, the symmetry, and especially the repose suggest Plato's faith that the true reality does not inhere in the crude objects we move among, but in the ideal world of forms and essences. It is worth noting that Ruskin, who had persuaded the world of Turner's genius, gave the young Pre-Raphaelites his support, moral and material. To him, good painting was the sole test—let the artist choose his subject—short of the obscene: being in charge of Turner's studio after his death, Ruskin found a large collection of erotic drawings, which he conscientiously destroyed.

Realism in painting obviously had a shorter life than in literature. Even before Courbet left the scene, Manet was leading painters away from the flatly tangible, and soon the shimmering lights of Impressionism would puzzle and attract. It was a new way to overcome the physically harsh world: go up to the railway station and reduce its bulk and grime to the sparkling colors of Monet's *Gare St. Lazare* (644>). All the while, of course, there flourished the "chromo, the lithograph in color, cheap in price and hack-produced, which was representational in deadly fashion. The word has remained as shorthand to damn a painting so lifeless in imitation that it amounts to a falsehood. The art of sculpture, by contrast with manifestations of Realism, remained faithful to its traditional models, from myth, history, and religion to straightforward portraiture.

As for music, the only "things" in it are on the operatic stage, and there the 19C audiences of resolute realists were given full satisfaction. Scenery and props and unexpected effects were provided in their native substance to the farthest extent manageable (<499). Other types of music, vocal and instrumental, expressed realities of another kind and were appreciated by audiences looking for different sensations; which is not to say that among the operas of Meyerbeer, Verdi, Gounod, and the young Richard Wagner there are not masterpieces of the art of sound.

*
* *

A close second to the novel in educational power was the mass of historical writing that the 19C turned out and the public absorbed. Here was the real without a doubt. The genre had settled its scope and style in the previous period (<379), but the general eagerness for it was brand new. Scott's novels, we are assured, whetted the taste (<482) and curiosity bore on past and recent in equal measure. The evolutionists, well before Darwin, taught that knowing yesterday explained today and could be used to justify or condemn current positions in politics. Most of the histories of the French Revolution and Napoleon proved a thesis. The large works of Michelet in France and Bancroft in the United States unfolded the rise of the nation and its achievements. German and Italian historians, for lack of a nation, glorified the folk. The progress of liberty was another organizing principle. Macaulay's *History of England,* and Froude's, Motley's *Rise of the Dutch Republic* are classics of the type. The German Mommsen's vast panorama depicts the loss of liberty in ancient Rome and Caesar's statesmanship in the crisis.

Macaulay has since been blamed for begetting a school of "Whig historians," Whig meaning Liberal in the 19C sense. They are accused of falsifying our past by showing it as Progress. This objection takes it for granted that some interpretation will be the true view, and if so, final. Any writer of history aims at stating the truth, but that is only ancillary to the central role of the discipline, which is to present patterns and permit the welter of facts to be reconceived. On the grand scale, Macaulay encompasses the years of the Stuarts' overthrow in 1688 and the beginnings of Parliament's independence during the later wars with Louis XIV. If one is well versed in the facts one may question the historian's estimate of persons or deplore events that he celebrates, but these disagreements leave a vast edifice standing and not to be seen anywhere else. In short, Macaulay offers more than a point of view. He was a master of narrative, of portraiture, and of synthesis. His famous Third Chapter is a model of social and cultural history, and his separate biographical essays show their subjects as living and thinking beings.

The dissenter who says "it was not like that" is in the situation of friends passing judgment on another friend: "He did this, which means that." "No, it doesn't, because he also did that, which means this." The dispute cannot end unless each side responds to the challenge: "Tell me what your standard of action is." At that point, barring fac-

On another occasion I was with far more eminent men, the two most learned men in the world. I need hardly tell you their names—they were Mommsen and Harnack. On each occasion the question arose: who was the greatest historian the world had ever produced. On each occasion the name first mentioned and the name finally agreed upon was that of Macaulay.

—Lord Acton° (n.d.)

tual errors that both sides will acknowledge in good faith, each will retire probably unconverted. Such is the reason for saying that a reader of history must be a reader of histor*ies*—several on the same topic—and a judge at leisure on the points in conflict.

Topping interpretation is the larger question: is the past recoverable? Some thinkers maintain that history cannot be known; the past has disappeared and its debris are not adequate to resurrecting it. This metaphysical issue may be left to those it torments because they trust their logic at the expense of their memory. The 19C German historian Ranke trusted his and put that intuition in words that have become famous as a sort of Hippocratic Oath in four words for the historical profession: *wie es eigentlich gewesen*—"as it really happened."

The phrase states what the candid historian believes he is telling when he consults his sources and writes down his findings. Part of his confidence comes from another intuition, which is that the intelligent propagandist *knows* that his version of events is not what really happened; he is distorting for a purpose. The difference does not certify the honest man's every word, but it does show that just as the memories of one's own past can be verified by letters, diaries, and the testimony of others, so by the same method, rooted in memory, the past can be in large measure described and known.

Reliableness in history is linked with one more subject, easily confused, particularly by historians themselves when uttering the pretension that history is a science (654; 655>). It commits them to minute accuracy: they think no piece of work valid, much less "definitive," if every statement in it could not be defended in a court of law. So strong is the fetish that at one time young professionals were virtually forbidden to write about subjects covering more than a few years of the past in a region correspondingly narrowed— what a derisive critic called "biennial history."° Otherwise, it was impossible to make sure of every last detail.

Out of this decree came the most illogical of thought-clichés: "If I find this error on a small point, how can I trust the author on the big ones?" On this principle Froude was for years maligned as "inaccurate" by Freeman. This impeccable colleague was found after his death to have been even more lavish of small errors than Froude.° In the physical sciences, to be sure, it is at times imperative that every decimal be right. At other moments, ranges of figures or simple orders of magnitude suffice. But in the popular conception of science small and large are of equal moment and the superstition has been transferred to history, where a rational Theory of Error would legislate just

His inaccuracies are neither specious nor misleading. There are qualities that outweigh occasional and trivial inaccuracy and Parton has them while the other biographers of Mr. Jefferson have not; and the worth of the book should be assessed accordingly.

—ALBERT JAY NOCK, *JEFFERSON* (1926)

the opposite: attend most carefully to the big points and judge the impor-
tance of details by their consequence. Albert Jay Nock dealt with the issue in
his *Jefferson,*° with a finality that should silence the pedants.

The zeal to produce only cautiously curtailed works assumes that, as in
science, the historian's work will form part of a coherent structure—the final
report "on what really happened." The monograph to settle a particular ques-
tion is indeed useful and admirable, and the great historians depend on many
such for their large works. But these single-point studies do not, as they stand,
fit in with others to form an edifice. Again, the would-be scientists gave
themselves another commandment: history must not be literary; that is,
agreeable to read. Macaulay was the horrid example. His style is sinewy, dra-
matic, its rhythms suggest the public speaker's voice, the portraits are life-
like—the whole is literature as the author intended it to be; he struggled with
the arrangement of parts like a novelist.° Most 19C historians can be read
with pleasure; those who came after and were afraid to write well encouraged
worse writing in their disciples and these ended by seeing the public for his-
tory turn away, leaving the glib popularizer a free field.

*

* *

The 19C historians who were not Whiggish and not fond of heroes were
likely to be pessimists and fatalists—Guizot, for example. They must have
known in handling their sources that each piece of paper was the work of a
human hand and mind, but the feeling of an irresistible push embodied in the
great anonymous mass of peoples and nations drove these writers to the phi-
losophy that sees fate in geography, climate, race, or some other material fact.
The individual has no true choice in what he does and mankind is a cast of
puppets.

This assumption current science seemed to be proving. The philosopher
Ludwig Büchner, writing in the 1840s, put the dogma in striking fashion: *Ohne
Phosphor Kein Gedanke* = without phosphorus, no thinking possible. The false
inference followed: thought is nothing but phosphorus. The "nothing but" in
any form is REDUCTIONISM. Not all scientists were avowed materialists, but
nearly all assumed the primacy of matter, which is why the appearance of
Darwin's *Origin of Species* in 1859 produced at once acclamation and conster-
nation. Up to that time, evolution had been explained as the result of some
action on the part of the creature, and this meant an intrusion of the will, even
if unconscious, in the workings of nature. Now Darwin proposed a purely
mechanistic operation. It made the old idea of evolution fit under physics by
means of the idea of Natural Selection—not wholly new but well neglected.
Ten years earlier, the philosopher Spencer had coined the phrase "Survival of
the Fittest," but the suggestion needed the support of the heap of facts that

Darwin had observed during his voyage on the *Beagle* and since. He and Alfred Russel Wallace independently adopted the same hypothesis a few months apart, which, in view of Spencer and the forgotten forerunners, indicates that the notion was in the air. It was made most congenial by the renewed vigor of materialism generally—things in the saddle first and last.

Thinkers of opposite mind (including notable scientific figures) rejected Darwin's hypothesis with vigorous arguments from many standpoints, especially the religious. Thus began a controversy lasting half a century and known as the warfare of science and religion. As for the public, it could no longer take the casual view of evolution as "interesting" or merely plausible. The crowd was gradually convinced that Darwin had proved it. The popular view was: Man is descended from the apes. It lent itself to jokes, cartoons, and epigrams by skeptics. Disraeli said that as between Man an ape or an angel, he was "on the side of the angels." Gobineau said: "not descended from the apes, but rapidly getting there."

> Life and the Universe show spontaneity:
> Down with ridiculous notions of Deity!
> Churches and creeds are all lost in the mists;
> Truth must be sought with the Positivists.
>
> Wise are their teachers beyond all comparison,
> Comte, Huxley, Tyndall, Morley, and Harrison.
> Who will venture to enter the lists
> With such a squadron of Positivists?
>
> There was an ape in the days that were earlier;
> Centuries passed and his hair became curlier;
> Centuries more gave a thumb to his wrist—
> Then he was Man and a Positivist.
>
> —MORTIMER COLLINS (1860)

Everybody could see that Natural Selection was another link in the stout chain of Things uniting physical science, materialism, Realism, and Positivism.

Nothing said or written has, to this day, succeeded in erasing the confusion between Evolution and Natural Selection. Likewise, scientists are still convinced that *Origin of Species* assigns natural selection as *the* cause of evolution, whereas the sixth and last edition of the book reinstates two others: Lamarck's use and disuse and environmental influences. Darwin later wrote a large book illustrating the further role of *sexual* selection. This cloudy state of affairs has even thickened. Here is not the place to trace out the lines of thought that lead from Darwin to the quite different *Darwinism* and on to the conflicting beliefs that are now held by the authorities in various centers of research and publication. Nobody questions evolution—there seems no reason to, but what is taught about its character and its mechanism is by no means consistent; yet the diversity of views is rarely confided to the student or educated reader.° [One small book to read is *Darwin Retried* by Norman Macbeth.]

In its own time, the vogue of natural selection among intellectuals affected other concerns than religion. Applied to politics it bred the doctrine

that nations and other social groups struggle endlessly in order that the fittest shall survive. So attractive was this "principle" that it got the name of Social Darwinism. Thomas Huxley, "Darwin's bulldog," finally felt bound to disown the notion. In the same Oxford auditorium where 30 years before he had ridiculed and routed Bishop Wilberforce for invoking moral and Scriptural considerations, Huxley now preached the distinction between evolution and ethics: human groups are bound by moral laws.

But this backtracking did not change the minds of struggle-for-lifers any more than Huxley's recanting his article on man as an automaton influenced the materialists. The public was only the more bewildered and disturbed, as Tennyson had been very early by the Spencerian spectacle of nature no longer Wordsworthian, but "red in tooth and claw." Tennyson was the national poet; and Spencer the international philosopher. If these leaders of opinion portrayed a universe in which mankind is moved by blind forces, then their prediction that all was for the best gave doubtful comfort—how did they know? What should one believe? The physicists had calculated exactly when the sun would go out. These thoughts alone were enough to darken life.

The Rock of Ages itself was crumbling, for science, history, and ANALYSIS had reinvigorated the Higher Criticism (<359). In German hands, the Bible was being parsed and it yielded many reasons for doubting. David Strauss had secularized the life of Jesus and George Eliot had translated his book into English; the French had a version by an even worse desecrator, an unfrocked priest celebrated as a scholar and man of letters, Ernest Renan. He was sure that science would make all other works of the mind obsolete: philosophy, theology, literature would disappear.° Faith was folly. An Anglican bishop from Africa had told an ecclesiastical court that was trying him for "errors" that one of his Zulu converts, after learning his catechism, asked: "Do you believe all that?" And a handful of other Anglican clergymen wrote a collection of *Essays and Reviews* that conscientiously undermined Christian beliefs. They too were tried but not defrocked. Apart from the dying remnant of Oxford "Puseyites" (<532), only the Catholics, with Newman their superb writer and apologist, seemed unshaken.

When the Victorians are lumped together as complacent hypocrites and prudes, it is forgotten what dismay and self-searching was occasioned by this debate on religion and science. The agony that a believer who was also a man of science could undergo may be read in Edmund Gosse's memoir *Father and Son*. The wider battle of ideas was carried on in periodicals and also in the Metaphysical Society, a group not of professional philosophers but of leaders of social and religious thought who read and discussed papers at each other without convincing anyone. Their views and characters were well dramatized by W. H. Mallock in his fictional (and amusing) *New Republic.*°

These imperative choices for thinking men and women formed the substance of Matthew Arnold's work as critic and interpreter of the chaotic scene.° He himself was a sufferer. His father, with never a doubt, had created at Rugby the model English "public school" on the principle that moral conduct according to the Decalogue was the core of the good life and should therefore be the center of education. His son could have no such confidence. To him religion was but "morality touched with emotion," and if moral rules derived from religious revelation, neither had a solid base.

According to Arnold, the behavior of the English social classes was touched neither by spiritual nor by intellectual forces; the upper orders were barbarians, the middle classes philistines. Those farther down—he called them the Populace—could not be blamed for anything they did. Instead of a society there was anarchy. The only cure Arnold could think of was culture, which he defined as the best that has been thought and said in the world. The prescription embraced the Greco-Roman and the Hebrew (biblical) traditions, amplified by the literature of the West in modern times—in other words, the humanities or liberal arts.

Another critic of the anarchic temper was of a different cast. James Fitzjames Stephen (later to be Virginia Wolf's uncle) was a learned judge and political theorist who in the early 1870s published *Liberty, Equality, Fraternity*, a rejoinder to Mill's essay *On Liberty*. Stephen was a Liberal and a firm upholder of free speech and action, but he opposed Mill's principle that the ideal of liberty forbids interfering with any individual act that is "self-regarding"—for example, drunkenness. Stephen argued that very few acts are entirely self-regarding and that the strength of the social bond depends on a general agreement about what is acceptable in behavior—an agreement that must be enforced. His experience in court and as codifier in India of laws that prohibited such (self-regarding) customs as widows' throwing themselves on their husbands' funeral pyre confirmed his study of English law, which showed libert*ies* concretely defined as they grew.

In countering the abstractions of Mill and Bentham, Stephen used words which, although perfectly true, shocked the loving temper of the age, made him seem *il*liberal, and account for his remaining misknown. For example, he says that through the criminal law, "men rightfully, deliberately, and in cold blood, kill, enslave, or otherwise torment their fellow-citizens." The reader cannot refute the statement but would rather not have it thrust upon him. Again, Stephen favored government by consent of the governed, but he pointed out that all governments depend on force and the threat of force—the greater the force and the surer the threat, the better for peace and justice.°

These stark truths did not make him an ogre on the bench; he was an energetic defender of the weak and wretched when they were mistreated, and

he had the respect and even the friendship of his opponents, thanks to the civil habits of Victorian debate. Today he must be counted as a harbinger of Liberalism's Great Switch (688>).

It must be added that since Arnold, the indefinite cure by culture has been expounded by many minds, from Woodrow Wilson to Robert Hutchins, and on practical—not fanciful—grounds. It is part of the resistance to SCI-ENTISM. In Arnold's day, Oxford and Cambridge were far from founts of culture in his sense. Most undergraduates caroused, and the queen opined that education ruined the health of the aristocracy. The Workingmen's Institutes did much good by giving the able in the underclass an opportunity to better their lot, but the training was mainly technical or scientific, for obvious practical reasons. At the universities, so feeble was the teaching and faint the research that Parliament ordered a review leading to reforms. It is from this mid-century overhaul that Oxford and Cambridge acquired the aura their names still exhale.°

But this academic renovation hardly fulfilled Arnold's hopes. As an inspector of secondary schools he recommended an adaptation of the French lycée; but the improvement of the old English "grammar schools" and of the ones set up after the Education Act of 1870 was slow, and he did not live to see any rising tide of culture. Arnold died full of the melancholy that moves one so deeply in his poem "Dover Beach," which ends by urging a desperate remedy, one that has often been echoed since: let us two forlorn lovers be true to one another. [The book to read is *Victorian England: Portrait of an Age* by G. M. Young.] Moments when despair is redeemed by love do not occur on demand and would not satisfy persons who, resentful of materialism, on the one hand, and an outworn creed on the other, feel confined and bored. They are ready for adventure into the unknown, provided it respects intuition, hope, and the improbable.

> . . . the world which seems
> To be before us like a land of dreams,
> So various, so beautiful, so new,
> Hath really neither joy, nor love, nor light.
>
> —ARNOLD, "DOVER BEACH" (1867)

This is what happened in the middle of the century. A craze swept over Europe and America for communicating with spirits by table-turning. A game for some, for others it was a solemn enterprise; many drew comfort from ghostly seances. Mediums sincere and fraudulent emerged from dark corners, bringing messages or apparitions from the dead. The leader of the profession was Daniel Dunglas Home (pronounced Hume), who supplied answers and evidences from the other world and performed superhuman feats, such as floating out of one window and back again through the adjoining one. It was not only the credulous bourgeois who believed in these proofs of the supernatural. The poet Elizabeth Barrett was a believer in Home's "powers," and thereby enraged her husband, Robert Browning. He subli-

mated his fury in a graphic poem, "Mr. Sludge, the Medium."° Victor Hugo, exiled on his Channel Island, spent a good many evenings at table-turning before deciding that it was foolishness.° Berlioz satirized the practice in his music column on hearing what inanities were being attributed to Mozart and Beethoven. The physicist Tyndall took care of the phenomena rather unphilosophically by clamping one of the table legs between his own. But other men of science credited some of the "manifestations" and thoughtful curiosity ultimately led to founding a Society for Psychical Research that would conduct systematic inquiry (664>). The paradox of spiritism is that starting out as an antidote to the tyranny of matter—things—it ends up proving spirit by producing things to see, hear, and feel.

<center>*
 * *</center>

The Darwinian discussions about animals and descent brought up topics not commonplace before and thereby encouraged a preoccupation connected with both love and moralism. After the date of *Origin of Species,* one hears of a physician—Dr. Allbutt—who held radical views on sexual matters and who imparted them to selected groups of listeners. George Eliot was one and Herbert Spencer very likely another. The subject was the physiology of reproduction. Lady Amberley, then aged 24, and her husband, who were to be Bertrand Russell's parents, were attending other lectures on physiology given by a woman doctor named Garrett. Scattered hints elsewhere warrant thinking that exchanges of opinion and information about birth control were also taking place.

As indicated earlier (<552), Victorian awareness of the sexual instinct was ever-present. Now it seemed to be finding expression under the aegis of science, thus opening the educated mind to its actual workings. The London *Times* taught the public a more general lesson on the same subject apropos of the Northumberland Street case of 1861. A respectable major had been lured into the office of a man who had lent money to the major's beautiful mistress and had tried to kill him so as to win the woman. The major, though badly hurt, killed his attacker instead. The *Times* offered what amounts to an apology of the *crime passionnel.*

The silence was broken also on a higher plane. In the late 1860s young Swinburne published *Poems and Ballads,* in which a dozen and a half pieces

At the bottom of the whole story lies one powerful, absorbing, and uncontrollable passion. A sight has met the eye, a sense is awakened, a new and fatal discovery is made; the powers of fascination have thrown their spell, and a soul that was free a moment ago is captive and enthralled. No human mind has an immunity from the danger of such attacks; everyone is exposed, whatever be the texture of his mind, coarse or refined; he is exposed as being a man.

—THE LONDON *TIMES* (AUGUST 8, 1861)°

praised the sexual act and its vagaries too. The author was "an unclean imp from the pit," but he was read. In France a little earlier, Baudelaire had caused a similar outcry with poems in his *Fleurs du Mal* that took as subjects physical disgust and sexual perversion. They were condemned at law, even though their tone was not cheerful like Swinburne's. To the same decade belong two other works by masters: Wagner's *Tristan and Isolde*, in which the adulterous love driven by the potion inspires the *Liebestod* music which simulates the sexual act; and Meredith's narrative in sonnets, *Modern Love,* in which, with fleeting physical details, the intellectual type of mismating is dissected.

One part of the community had no need of such awakenings. Artists and literary men had by and large not put on Respectability; they had no need of it, not being in business, politics, or the professions; their work made its way by and for itself—or it did not. But to be at ease and in good company while producing it, they created in the 19C an institution tailored to their wants: Bohemia. It afforded cheap living, enforced no moral code, allowed modes of dress as singular as desired, and required no sustained solvency. It was first established in the "Latin Quarter" on the left bank of the river in Paris [see the two operas on this *Bohème*];° it had branches (spontaneously) in other capitals; and it has remained a refuge for the gifted young and the anti-social of any age. There too the artist failures, often headed for drink or drug addiction, are fraternally looked after. Economic support comes not alone from the working girl who lives with the poet and feeds him, but also from the local shopkeeper or restaurant owner, patrons of the arts who should have a commemorative plaque on their premises.

Toward the indiscretions of artists prominently before the public or figures from politics or the professions, the Victorians' attitude was ambiguous. Like the valiant major in Northumberland Street, Samuel Butler had a mistress, but not for love and not to live with—as a mere convenience, though she was evidently an intelligent woman whom he treated generously and with respect. He himself qualified as respectable, being discreet and his books hardly known. Dickens offers another illustration on the positive side. He had wedded the wrong sister and endured a painful marriage for many years. He then fell in love with a young actress and rumors of adultery circulated that were in fact untrue. Thereupon, against all advice, Dickens felt compelled to explain his domestic situation and deny the rumor by publishing a statement in his own paper and in others by a press release. (He was angry when *Punch* thought the news outside its purview.) The press criticized and the public was stunned but did not withdraw its admiration or esteem. Later, the young woman did become his mistress—without his advertising the news—but both felt guilty ever after. Marian Evans (George Eliot) was not ostracized by all good people for "living in sin" with another well-known writer, G. H. Lewes.

Although Dickens's hold on his public and George Eliot's on hers were undamaged, the career of the most promising liberal politician, Sir Charles Dilke, was ruined when his mistress's husband sued for divorce. The facts disclosed were in truth unsavory and he made a poor witness in his own defense. Meanwhile, Gladstone, the recurrent prime minister, came close to disaster when he was seen talking with prostitutes on his way home from Parliament late at night. He was able to prove that he did not pursue the accost except to find out if he could help redeem the woman from her sexual bondage. This motley of arrangements and outcomes sounds remote from the Romanticist loves of Byron, Liszt, George Sand, Musset, and Metternich.° It is rash to draw broad comparisons from scattered instances, but there is about the latter-day cases a suggestion of the low spirits, a resigned acceptance of the second best, that belong to the mood of Realism.

A last word must go to a subject which, even though not concealed today, is as obsessive now as it was in the 1800s. The Victorian output of pornography was abundant as at present, at both times a by-product of frustration; the word is in order, for sexual activity, however free, does not necessarily bring sexual satisfaction (790>). As to literary skill and inventiveness, some of the Victorian fantasies in print attained heights that the paperback and the Web have yet to scale. [The book to read is *The Other Victorians* by Steven Marcus.]

<div align="center">*</div>
<div align="center">* *</div>

When Darwin and Huxley talked about "favored races," meaning the surviving fittest, they were referring to the varieties of any animal species. But another group of scientists and publicists, using the same words, meant specifically varieties of men. The 19C was the heyday of physical anthropology, which divided mankind into three or more races. It was taken for an exact science in spite of its conflicting statements, and it was also the playground of historians, social theorists, and politicians, who surfeited the public with tomes, monographs, pamphlets, and magazine articles. The words Celt, Caucasian, Aryan, Saxon, Semite, Teuton, Nordic, Latin, Negro, Hamitic, Alpine, Mediterranean mingled with "cephalic index"—"*dolicho-*," "*brachy-*," and "*meso*-cephalic"—and other technicalities of the laboratory.

Mention has been made of what came before: the explorations of the 18C, which supplied data about distant tribes physically distinct; the early 19C linguists' launching of the Aryan language and "race"; the anatomists' phrenology (<456; 503). All these merged in or with the skull. For it was the skull, its bumps forgotten, that the mid-century anthropologists took as the diagnostic sign of the races. Yet in another quarter there persisted the historians' loose system going back to Tacitus about the different traits of the Germans, Romans, and Celts, and their innumerable subdivisions with sepa-

rate names. And in addition there was the biblical division into Semite, Hamitic, and Japhetic, which overlapped one more, the visual: red, yellow, black, and white.

Using the latter scheme loosely, the Comte de Gobineau published in the 1850s a two-volume work on *The Inequality of Races*. It dealt more with cultures than with races, being an early cry of alarm about the fate of the West's high civilization: it would perish by the admixture of the yellow and black races' folkways. Not widely read until much later, when the book by its title chimed in with the floating hostility of groups and nations, it then gave the word *race* increased prominence. Gobineau himself talked race but behaved always unlike a racist, as if on the individual plane his conclusions did not apply—a notable case of theory without practice.°

All these fragments of thought and meaning attached differently by different intellectuals to the notion of race obtained their scientific coloring from the skull anthropologists. They measured the dry specimen lengthwise and across, divided the latter measure by the former and multiplied by 100 to obtain their index. The three Greek prefixes cited above mean long, broad, and middle, and by the range within which an index falls, an individual is classified. The line separating one range from another is of course arbitrary, and some zealous workers found more races than others by subdividing groups.

The principal scientist engaged in this measuring and speculation was Paul Broca in Paris. Noted as a surgeon and an authority on anatomy, his contribution to physiology (among others reviewed in a recent book)° was the localization of the speech function in the brain: Broca's convolution. That he spent so much time on the outside of the skull (so to speak) testifies to the power of ideas in the air. He acknowledged that the cephalic index was not a natural feature and hence that the races derived from it were likewise an artifice.

The next step was to find concentrations of each type of skull in the population. This game was facilitated, unexpectedly, by the building of railroads. The land taken for them often included disused cemeteries, and the exhumed skulls went to those most eager to exploit them. The former inhabitants of the locality were then found to belong, all, or most, or few, to the long- or the broad-headed race. The final step was to link the index with other characteristics by ascertaining the traits of the skulls' owners when alive. (Measuring skulls in the living was uncertain owing to hair and tissue.) To find these traits, history and geography were consulted. It appeared that long skulls clustered in northern parts, had blue eyes, blond hair, and tall stature; southerly people had broad skulls, with brown eyes and hair and were short. Broca's terms and digits soon formed the underpinning of a new "science" named anthroposociology. In it blond hair and blue eyes meant Nordic, which meant Aryan, which meant superior.

Rudolf Virchow, famous as a physician, public man, and anthropologist,

noticed what apparently nobody else had seen, that the Germans were not all tall, blue-eyed blonds. He conducted a vast survey of German schoolchildren which showed over a third of them to be short and brown in coloring. It should have put an end to anatomical chauvinism, but it did not. The fantasy went on: in the superior long skull resided a brain that was self-reliant, enterprising, a likely planter of colonies and founder of empires. His German ancestors were truly noble—read Tacitus (<9). By contrast, the broad skull denoted a subject race. Living under regimentation by a strong state (the Roman empire) had affected its character permanently. A broad skull would most likely be a proletarian and a socialist.

Not all who argued about race for 60 years believed the same solemn fictions, but almost educated westerners believed in the root idea that race equals character and uttered some fiction of their own. There were Celtists who exalted the race's imagination. Many in England had attacks of Saxonism. In southern Europe, "Latin" leagues were founded to fend off the Teutonic barbarism. In Central Europe, Pan-Germanism and Pan-Slavism (mostly religious) opposed each other and all others. History and literature were ransacked for evidence of former eminence and "purity of stock." There were a few critics such as Alfred Fouillée, who reaffirmed the unity of the human race and the autonomy of ideas. They were rare. Until the end of the century, the best men of letters kept explaining art, temperament, or destiny by some casual or extended reference to race. [The book to read is *Race: A Study in Superstition* by Jacques Barzun.]

> Masses of men will be exterminating one another for one degree more or less in their cephalic index.
>
> —ALFRED FOUILLÉE (1893)

*
* *

The contentions about race, which often meant nation, expressed various kinds of aggressive feelings, triumphant or balked. There was pride in industrial power and in the New Imperialism making inroads into China and Africa. In Europe, after eight wars, with and against different partners, Russia and the Turks had been defeated and Italy and Germany at last unified. The first of these wars, the Crimean, brought to light such incompetence in the organization of the English army, at home and in the field, that it could not be concealed. The suicidal Charge of the Light Brigade caused by a blunder got celebrated in Tennyson's poem and the paradox of a corrupt and ignorant officer corps being versified and as it were honored by the poet laureate heightened the longing for the soldier's selfless courage. Tennyson had expressed it earlier in his monodrama *Maud,* which contains his finest love lyrics. The hero is a despondent critic of society who sees his true love lost to wealth. The worldly, exploitive, "realistic" society, says Tennyson, needs cau-

Why do they prate of the blessings of
 peace?
We have made them a curse.
Lust of gain in the spirit of Cain,
Is it better or worse?
When the poor are hustled and hovelled
 together like swine . . .
And chalk and alum and plaster are sold to
 the poor for bread.

—TENNYSON, *MAUD: A MONODRAMA* (1855)

terizing by the fire of war. In the war that came, more soldiers in the Crimea died of disease and insanitary hospitals than by gunfire. Nor did the war accomplish much. Its one great benefit to England and, by extension, to the world, was the emergence of a true heroine,

Florence Nightingale

Her story has so often been told—and so well told°—that here it is necessary only to give a reminder of it in outline. She felt the stirrings of her vocation as a teenager, and then had a long struggle with her family before she was able to take the first steps. It was reasonable for people of high standing to prevent their daughter from becoming a nurse. The occupation was not unjustly associated with drunkenness and loose morals. Florence's strong will prevailed. After a tryout in Germany when aged 33, she was at last able to show what she could do. She set new practices and new standards for nursing in a small private hospital in London. Her demonstration attracted notice in the medical world and an intelligent minister of war, Sidney Herbert, enlisted her help in the Crimean theater.

What she found defies description, but with scant resources and few assistants she installed sanitation and system, and developed new treatments, making ward rounds daily, even if it meant being 20 hours on her feet. The stricken soldiers—upward of 5,000 at one time—soon regarded her as a saint, an angel sent to save their lives.

Back home she refused further official work, but kept up her influence with the aid of the large sum that had been raised in her honor. Her genius was obviously not limited to the practice of nursing. The activities with which she filled her long life show that she was one of the great administrators of history. The art always implies political sagacity, and so true was this in her case that for years the British government kept consulting her on many delicate subjects, including India, where she had never been. Her glory is to have turned a menial and despised livelihood into an honorable profession.

England's ally in the Crimean War was Napoleon III, the destroyer of the Second Republic of 1848. He had done so by getting elected as its president, on the strength of being "the nephew of my uncle," and once in office had first made himself "Prince president for life" and then Emperor. (The son of Napoleon I, who should have been II, died young and never ruled.) The steps to the throne entailed the coercion, imprisonment, and exile of opponents,

after some street fighting. The illegalities were covered by plebiscite, the vote of the entire nation. With this device Napoleon III showed the way to those 20C dictators who can say their rule is democratic because it was sanctioned by a popular vote.

During the republicans' last stand in Paris there was in the city a young Englishman of extraordinary character, who should be known for his later accomplishments, as well as for his bystander's view on the new Caesarism. This youth of 25 was

Walter Bagehot

The first thing to know about him is how to pronounce his name. It is *Badjet*. And the next is that his singular genius derives from his double vision. In any conflict of persons or of ideas he was always able to see that neither side was perverse or stupid, but had reasons for militancy; and he entered not only into these reasons but also into the feelings attached. This is a rare talent, especially when it does not lead to shilly-shallying in the double-viewer's own course of action. Bagehot could always state the reasons for *his* choices with the utmost clarity.

In 1851, he was in Paris as the special correspondent of an English periodical and he told its readers that after the disorder of the Republic's last days a strong executive was unavoidable: trade had stopped, life and property were insecure, Paris and the big cities could not stand it any longer. But while justifying the move toward dictatorship, Bagehot was expressing his private preference by helping the last republicans to build their barricades. Ten years later, reviewing the course of events in France, Bagehot concluded (before the empire's collapse) that Caesarism is a remedy for the short term and a calamity when prolonged. As things turned out, the Second French Empire saw an increase in manufacture and trade and a beginning of social welfare. But a dangerous foreign policy was required by the regime's shaky foundation, and this need of vainglory finally brought it down. The new upper crust at the court and in town was showy rather than elegant and intellect was at a discount. The atmosphere is well captured in the excellent comic operas of Offenbach—parodies of the classics in the mood of rather vulgar gaiety.

Bagehot's due fame has been hampered by his dying too soon—at 51— and even more by the variety of his writings. In each of his domains he is highly prized, but versatility looks like a division, not an addition of powers. He was a political journalist, succeeding as editor of *The Economist* his father-in-law, who had founded it. For 17 years Bagehot commented on the political and economic affairs of the week. One outcome of this close study was a pair of classic works: *Lombard Street*, which is a description of the British financial

system; and *The English Constitution* [it is the book to read], which describes in short compass the social and psychological reasons for the successful working of the induplicable English Parliament.

These works alone would justify ranking Bagehot among the original thinkers of the 19C. But every one of the 12 volumes of his writings offers additional proof: the essays on past and present English statesmen show the consummate political historian; another collection of articles on particular situations in trade and finance show the economist; the dozen more on literary figures and topics reveal a literary critic, while his reflections on philosophy and religion throw a light on his time not to be had from any other source. To G. M. Young, the master historian of the Victorian age, Bagehot was "the wisest of his generation."

Bagehot's ability to make ideas live appears on every page he wrote. A student in an American business school once found in its library a slim volume entitled *The Love Letters of Walter Bagehot*. It proved to be, once more, the carrier of a double message: sprightly missives to the author's fiancée interspersed with comments on the current state of certain firms and the stock exchange that would be sure to interest the fiancée's father. Both recipients were doubtless entertained. Bagehot's prose is rapid and enveloping, somewhat in the manner of Bernard Shaw; it leaves no uncertainties as it voices also what the opponent or the reader is no

> I get tired of either sense or nonsense if I am kept very continuously to either and like my mind to undulate between the two as it likes best.
>
> —BAGEHOT TO HIS FIANCÉE (FEB. 1, 1858)

doubt thinking. It is humorous and sad, because Bagehot, though an expert in business and politics, never feels his mind-and-heart fulfilled by them. When he says: "Unfortunately mysticism is true," he means that it is too bad for the man always after the main chance; for himself, Realism is not enough. Bagehot's gift of double-mindedness appears strikingly in his short work *Physics and Politics,* which William James called a "golden little book." It undertakes to apply Darwin to politics, but Bagehot is no Social Darwinist (<571). He begins indeed by showing "Natural Selection" in the early stages of the march of civilization—the better organized, more cooperative groups conquer the less unified. But then more and more other qualities, initiatives, and ideas—liberty, free discussion, written law, habits of calm reflection, of tolerance and generosity—conduce to survival, because they make for an ever higher degree of cohesion. These virtues are the strength of the national state, whose power a less developed people cannot successfully withstand. In such a struggle, conquest makes at least possible the enlargement of civilization.

But the New Imperialism of the 19C worked neither all for civilizing nor all for mercenary ends. It civilized by side effect. Missionaries did not merely bring "moral pocket handkerchiefs," as Dickens scoffed; they were often

doctors of the body as well as disturbers of the soul. Colonial officials introduced goods, means of transport, and control of nature; they kept the peace and abolished inhuman rites. Still, it was the application of force, not freedom, which is extremely difficult to restore, and after its installation, to manage. At the same time, the second 19C expansion of Europe took thousands of its natives to the other continents, bringing about a continuous mixing of cultures on a larger scale than before. Language, customs, diet, art, the conception of man and of life—all were modified. Within Europe itself, more people were incited to travel abroad, and this to such an extent that Thomas Cook immortalized his name by inventing the guided tour and bringing to birth that feral creature, the tourist. Lastly, the wide world beckoned directly or by marital connection to a special group, whose public presence changed an eccentricity into a vocation,

The Women Travelers

They were mainly British. Travelers includes explorers and travel writers, and they are too numerous to chronicle individually. A sampling list must suffice, with the suggestion of a sampling book to read. The roll of honor and interest combined, pushing the date down to the early years of this century, runs as follows: Lady Atkinson, Gertrude Bell, Lady Florence Dixie, Lady Eastlake, Amelia Edwards, The Hon. Impulsia Gushington, Harriet Martineau, Fanny Park, Ida Pfeiffer, Janet Ross, Isabel Savory, Lady Sheil, and Mrs. R. H. Tyacke. [The book to read is *Unsuitable for Ladies: An Anthology*, ed. by Jane Robinson. For nautical readers, a supplement is *Seafaring Women* by Linda Grant.]

*
*　　*

In North America, the imperialist urge manifested itself in the conquest by the United States of vast territories to the south and west. A short war with Mexico added California and the area between it and the Rio Grande boundary, which had been in dispute. Then the United States annexed the large state of Texas, recently seceded from Mexico. These acquisitions upset the balance of power between the states where slavery existed and those where it was prohibited. After two compromises and the rise of a strong Abolitionist movement, civil war broke out in 1861, splitting the nation into a free north and a slaveholding south.

The war attracted a number of European observers, in part because it was the first to take full advantage of modern industry, not only for the making of weapons and equipment but also in the use of the railroad for transporting both matériel and men. Ten years earlier in Germany, an attempt had

been made to collect troops in one place and move them quickly by rail to another. It failed disastrously, from lack of experience in mustering the rolling stock and doing the complicated despatching. Another novelty, at least in the United States, was the tactical use of balloons. Two plans of the previous 25 years had been turned down by the military. The first Army Balloon Corps was added to McClellan's army at the very beginning of the war.

Peace and Reconstruction made an end of slavery in western society (<547). But in the United States the constitutional amendments that emancipated the Blacks were enforced only for a brief time; the southern states managed to deny their former slaves civil and political rights, equality in education and other advantages, and socially decent treatment (592>). This gross breach of the law laid up for the future the troubles that have darkened the years beginning almost exactly a century after the Civil War ended.

As usual the war called forth ability of all kinds and it made plain the genius of Lincoln. Though often reviled during the struggle, he soon after took his place among the great leaders of history. It is only recently that note has been taken of his genius as a writer. Earlier opinion held that suddenly, as a result of the enlargement of his soul by his responsibilities, Lincoln was visited with inspiration in two or three pieces now famous. It has been easy to show, once the truth was glimpsed, that from early manhood he handled words in a manner unsurpassed for compression and lucidity, rhythm and force.°

Whitman, also a Civil War hero, achieved force in *Leaves of Grass* by the opposite means. His vision of America is conveyed by piling up, seemingly helter-skelter, details either of the landscape or of the social scene or of the traits and habits he assumes are common to every man or woman in the country. His conception of his main subject (death being a second one) was perhaps influenced by the character in one of George Sand's novel who is a "people's poet"; the fitness of Whitman's method was foretold by Tocqueville. Of the other American poets writing on public themes, James Russell Lowell needs mention here because he is rarely thought of, although he produced classic works. *The Biglow Papers,* first series, about the Mexican War, and the second about the war between the states, are masterly satires of current opinion in the rural speech of New England. A third poem, "A Fable for Critics," is in standard English and gives a good idea of the literary scene, while distributing prizes and bad marks with a free hand. One more product of the Civil War, a piece of reporting entitled "My Hunt After 'the

> As all the citizens of a democracy are nearly equal and alike, the poet cannot dwell on any one of them; but the nation itself invites the exercise of his powers. It allows the poet to include them all in the same imagery and make a general survey of the people itself.
>
> —Tocqueville, *Democracy in America* (1840)

Captain'" (586>) provides an opportunity to introduce its author, a figure of importance on several counts:

Oliver Wendell Holmes

He is the man of thought and science, the poet and humorist, not his son, the justice of the Supreme Court. The elder Holmes distinguished himself early by a medical discovery that made him wonder whether he would "ever again have so good an opportunity of being useful." It was indeed of immense benefit: he proved the contagiousness of puerperal fever, which killed many women soon after childbirth. By neglecting sanitary measures, the attending physician carried it from one mother to the next. Holmes had to fight the whole system—doctors and nurses and hospital managers—to obtain recognition of the fact. In Vienna, Semmelweis would meet the same hostility on the same issue a little later. It was the dawn of Hygiene, the goddess incarnated in Florence Nightingale, struggling with old habits, and promoted by the intolerable "new dirt" of industry.

Holmes made other contributions° while teaching generations of Harvard medical students and pursuing at the same time a writing career in prose and verse. His facility for *vers de societe*, the knack of suiting an occasion with riming lines, has concealed a body of excellent poems that are a little less than serious and a little more than light; for example, his sonnet on writer's itch, "Cacoëthes Scribendi." The mastery displayed in "The Wonderful One-Hoss-Shay" has been noted by the critics as if unique, but it extends to many other poems. They are satire blended with sympathy but nonetheless acute. Similarly, "The Chambered Nautilus" and "The Last Leaf" are by no means Holmes's only moving pieces in the serious mood.

In prose, *The Autocrat of the Breakfast Table,* which dramatizes lives and opinions with an art that conceals art, deserves a place not far from the novels of Thomas Love Peacock (<132). The sequels to *The Autocrat* are less sustained, but even the last of them, *Over the Teacups*, contains original reflections. What a vigilant reader will find is that Holmes, liberated by his medical training, was always pushing as far as he dared against the fencing-in of Respectability. In morals, religion, established authority, love between the young, he keeps saying—and hinting when the subject is delicate—that "there is more to it than you know or will admit." One character in *The Autocrat,* a wounded spirit who lives a mysterious existence in an upper room, seems intended to show up the strained placidity of those around the downstairs table. If this is true, the silly sentimental verses with which Holmes interlards his chapters begin to look like tokens of concession to conventional feeling. Dull as they are, their workmanship equals that of the verses where he satirizes freely.

"My Hunt After 'the Captain'" is the story of Holmes's adventures when he went looking for his son, the future justice, reported wounded in battle but lost sight of by the army and possibly dying. A different kind of medical concern inspired the three novels beginning with *Elsie Venner* in 1861. Its interest, like that of the other two, is not as literature, but as one of the very first "studies" of abnormal psychology in fiction; Elsie is a schizophrenic. A present-day psychiatrist has found in these novels more than one anticipation of his science and of Freud himself. If in Holmes's Boston there had lived a Boswell to record the doctor's table talk we might have a counterpart of that other doctor, who is popular for that alone. According to the alert Henry James, Sr., Holmes's display of "superior intelligence" went with "genuine modesty."

The son has monopolized the father's three names and with them reputation. There is no need to lower it for one Holmes in order to raise it for the other. The justice had an enormous and beneficial influence on the law and deserves well of his country on constitutional issues. But he can show nothing to justify attributing to him the same power in philosophy or literary art. He adopted early the shallow materialism that marked the mid-century, and with it a routine cynicism that often spoils the pleasure of reading his vigorous correspondence. No two temperaments could be imagined more opposite than the father and the son.

*

* *

Thanks to an invention that quickly turned into an industry, the American Civil War qualifies once again as a "first" by the new mode used to record it systematically. Mathew Brady roamed the fields with his large box and took more than 3,500 photographs. The practical form of the invention was some 20 years old. Around 1830, after much trial and error, the brothers Niepce in France were able to put to use Josiah Wedgwood's earlier discovery that silver nitrate turns black in sunlight. They devised means of "fixing" on paper, glass, or metal the substance once exposed. The image itself comes from the camera obscura, an instrument long used by artists, which consists of a box—or a room—with one very small aperture to let in light. The scene outside appears upside down on the wall opposite for the artist to draw or imitate. Hence the name camera (room in Latin) for all the boxes successively armed with lens, timer, flash, light meter, and lately digital computer. The picture too has evolved, its first exploiter in partnership with Niepce being Daguerre, whose portraits on copper (daguerreotypes) are still family treasures after being the popular novelty of the 1840s.

Photography was a marvel that inspired professionals to use it in all departments of life and lured amateurs to capture and store their fugitive experiences in the home or on their travels. Flaubert and his friend Maxime

du Camp made a long voyage to the Near East and up the Nile, from which du Camp brought back the makings of a volume. It was a novelty widely admired; the machine-made coffee-table book could celebrate today its sesquicentennial. But in one quarter photography was seen at first with a lackluster eye. It is the French painter Paul Delaroche who is credited with saying: "It will kill painting." More than one artist must have said or thought so. In the event, it was mainly portrait painting that was hurt, in addition to the trade of engraving, which had long served the public by supplying reproductions of works of art. With the portrait in oils went the strong and varied faces that even obscure artists knew how to transmit down to the middle of the 19C and that one sees on the walls of universities and public buildings. The photographic studio tended more and more to fashion a countenance that was smooth, rounded, characterless, airbrushed into a one-face-fits-all likeness, flattering and democratic. There have been fine and truthful portraits in paint since the camera, but they are rare.

By way of compensation, photographs of scenes and people not posed for good looks have won a place as works of art. Effects of lighting and composition, and the skill shown in exposing, developing, and printing the work qualify at least as high artisanship. And the subjects chosen, especially when in series, have influenced opinion by "exposing" society, much like that extension of Realism, the Naturalistic novel (625>). The picture in motion and geared to sound was a cultural offshoot of the turn of the century that does not now call for explanation.

*
* *

While the United States was fighting a civil war to determine whether it would survive as one nation, Napoleon III was losing prestige at home and had what he thought "the great idea of his reign." Mexico had undergone an anti-clerical revolution; Napoleon sent an army to put it down and to impose the Austrian prince Maximilian as Emperor of Mexico. The expedition was a failure, and Maximilian faced a firing squad, as one can see in Manet's painting. Napoleon had already tried to refresh his popularity in France by concessions called "the Liberal Empire." Now, after the Mexican fiasco. he had to deal with the moves, including little wars, that Bismarck was making to unify the Germans into a nation at long last. The French, never able to tolerate that desire and fearing the outcome, made representations clumsily, and war followed in 1870. Ill-prepared, the French were quickly defeated, after which came a four-month siege of Paris. In the interval, the Prussians sitting in Louis XIV's Versailles proclaimed the resurrection of the German empire, while out of the débacle (about which Zola wrote a stirring novel), emerged a third French republic. It seemed in a good way to succeed, when the artisans

and casual laborers of Paris, fearing a conservative government, took up arms and captured the city. They killed indiscriminately, took hostages, murdered some of them, and so terrified the rest of the nation that the second siege of Paris could only end in savage mutual bloodshed.

April 15. The organized corps of Pétroleuses [women fighters] were a savage crew deluging what public buildings they could with petroleum and setting light to them. They fought at the barricades showing superhuman courage. On the Rue de la Paix, the first to mount it was a woman.

May 12. The edict has at last gone forth that all between 19 and 40 who will not fight shall be shot. There were 60 executions in the Rue St. Honoré.

—COL. J. C. STANLEY ON THE PARIS COMMUNE° (1871)

All Europe, including many liberals and socialists disavowed the Commune, which was the name chosen by the insurgents to show their organic bond as citizens of the municipality. But Karl Marx in London, seeing the chance for a political stroke, and perhaps also the value of that name, issued a pamphlet that represented the insurrection as a foretaste of the class war to come—the proletariat aroused and about to establish Communism. This was a piece of big-lie propaganda. The Commun*ards* were neither the proletariat nor Commun*ists*. The "municipal republics" they wanted set up in the rest of France were the opposite of the central dictatorship of Marx's program. But Marx had rightly judged that the event had given worldwide notoriety to workingmen in arms. The image could be a vivid myth for the Idea of the next revolution.

Marx, with the continual help of Engels, worked on two planes. On the political, theory and consistency gave way to opportunism, as in the instance just cited. On the theoretical he wrote elaborate treatises arguing points of history, philosophy, and economics against all previous and current authorities. Shortly before the pamphlet on the Commune, he had finished the first part of a central treatise, *Das Kapital*. It is one of those famous works, like Montesquieu's *Esprit des Lois* and Spengler's *Decline of the West*, that every intellectual thinks he has read. Its style and organization are demanding; the Russian censor in the 1860s decided to let it into the country because very few could work their way through it. When Marxism became a subject of research and of college courses to be taught, more academics mastered the contents than socialist politicians and militants had ever done.

Capital professed to show scientifically how the worker was exploited. His labor adds value to the material he works on and this addition is worth more than the value of his wages. (Sismondi had said the same <457.) This "surplus value" is taken by the capitalist. Since Marx, the "labor theory of value" has been discarded by the economists and the reasoning is no longer valid, but the error, when restated for propaganda, is a simple and powerful argument. About history, Marx's thesis is (in his words) "Hegel turned on his

head." Instead of a battle between ideas—thesis and antithesis—out of which comes a synthesis, the clash is between purely material forces: "dialectical materialism." Marx's view here is that of the Realist, for whom only tangibles exist. The rest—art, thought, law, religion—constitute only a superstructure of no effect by itself. History moves forward by the shifting relation of things, and in its present phase will bring about proletarian Communism inevitably. Its final stage, after the dictatorship of the proletariat, will be the "withering away of the state," a happy anarchy. It is curious to note this hope or expectation, characteristic of the 19C: Herbert Spencer predicted it as confidently as Marx.

Yet although for Marx thought is ineffectual, he kept on having thoughts and putting them to work. He saw the revolution as taking place in Germany, the most advanced industrial nation, having the most numerous proletariat. The prediction was logical, because in the Marxist system it is not from the individual's will to gain economic power that one class replaces another, but from its "relation to the means of production." And what the revolution aims at is not the destruction of the state but possessing it for Communist ends.

Marx believed these formulas and principles to be science, as did Lenin after him, who fought diluters of the creed and brought the teachings up to date. As noted earlier, both men, and Engels too, appear in the American *Dictionary of Scientific Biography,* where Marx is credited with a simple contribution, that of having aided the understanding of science by seeing it as a social product. Sociologist is in fact the status that Marx retains after his history, economics, and prophecy have lost persuasiveness. Bernard Shaw justly granted him another merit: like Darwin he gathered fifty years of critical thought about the system that kept the majority poor and he made the world listen in earnest. As a onetime Hegelian Marx indulged liberally in ABSTRACTION, but first and last his vision of history and of reality is that *things* drive mankind.

CROSS SECTION

The View from Chicago
Around 1895

THE DECADE that followed the Franco-Prussian War witnessed a good many changes in outlook and manners—long beards came off, women grew more self-assertive, social conventions were questioned one after another, and the innovations in techne and in social theory were of the kind that promises lasting developments. Many young artists who were to impress the world received their first exposure to the public. Sporadic agitation for many causes began to form actual movements. The 1870s and 1880s are crowded with cultural starts.

But the noisy world of boom-and-bust business and raucous politics was not diverted from its habits. To the observers on the sidelines it seemed cruder than ever in its goals and practices. In the United States, Mark Twain and his friend Charles Dudley Warner described the scene in a jointly written novel as *The Gilded Age*. It is a lurid tale of deceit, fraud, political corruption, seduction, and murder. The subtitle of the book is "A Tale of Today." Shortly, Henry Adams published his novel *Democracy* (anonymously) with the same intention, castigating the Grant administration in particular. Both fictions portray a senator of fluctuating ethics as the emblem of the moral weakness of representative government. Both Adams and Mark Twain remained pessimists to the end of their days and recurrently in their writings, while Ambrose Bierce on the West Coast, besides producing a series of stunning war stories, wrote prose and verse in which human beings and institutions are portrayed as hypocrites and frauds. His *Devil's Dictionary* had rightly been called at first *The Cynic's Word Book*.

Looking back from the 1930s, Lewis Mumford drew a picture of the

period as one barren of art and full of random agitation. He called it the Brown Decades.° The financial panic of 1873 afflicted the entire capitalist world. Unemployment, strikes violently put down, boycotts (a new word and thing), farmers ruined by the fall of consumption, railroad gouging, oil and steel trusts and cartels provoked popular hatred; political assassinations darkened the horizon (695>).

In the United States, a wave of "Jim Crow" enactments formally denied the Black population their civil rights; in 1896 the Supreme Court decided in *Plessy v. Ferguson* that providing "equal but separate accommodations for the white and colored races" satisfied the constitutional requirement of equality among citizens. This reversed the movement that was beginning to give recognition and status to Black talent. Frederick Douglass was valued as an eloquent speaker and as editor of the *National Era,* and he held the posts of marshal of the District of Columbia and ambassador to Haiti. Mississippi sent John Roy Lynch to Congress, and he served as vice chairman at the Republican National Convention of 1884. But these exceptions did not multiply.

Whether it meant repression or reform, the time inspired crusades against drink and other things classed as vice: free love, contraception, and abortion. The Women's Christian Temperance Union formed local centers, and the outcry against Demon Rum erupted into guerrilla warfare when Carry Nation went about, hatchet in hand, vandalizing saloons. She financed her vocation by selling "souvenir hatchets." In England, Parliament enacted rules to reduce the open hours in pubs, the poor man's clubhouse. Was it to combat alcoholism or social unrest?

In the United States, Anthony Comstock had no doubt that he was appointed to dam up sexuality in all its manifestations. At the age of 28, in 1873, he founded the Society for the Suppression of Vice and persuaded Congress to pass the Comstock Law that made it a crime to send through the mails information or devices in aid of contraception. He had a stalwart enemy in Victoria Woodhull, a declared champion of free love, a believer in spirit return, and an expounder of the social benefits, under given circumstances, of abortion. She did not prevail. Comstock went on to rid New York of the evil presence of Mme Restell, a fashionable abortionist, and finally drove her to suicide.° He decreed that small replicas of the Statue of Liberty showed too much breast. He protected New York theater-goers from the infection of Shaw's early plays and also the readers at the Public Library, which he compelled to lock up *Man and Superman.* His reign lasted till the First World War.

Some of the new religious sects were explicitly anti-modern and repressive. So was the decree of the Vatican Council of 1870 that held the pope infallible in matters of faith and morals. Six years before the Council, Pius IX had drawn up a long list of "modern errors," which good Catholics must now

take as condemned by God Himself. Of the new religions, Christian Science, denying the reality of matter, disallowed medicine; Jehovah's Witnesses isolated its members in various ways from the present world, which was shortly to be destroyed; and the Salvation Army, militant against drunkenness and other profane failings, at least waged war with a warm heart and rousing music.

The population that endured these protective measures was assailed on another front: a crowd of political and economic reformers, who had every reason to claim public attention. Panics, unemployment, violence such as the anarchist bombing and hangings in Chicago (linked with the demand for the eight-hour day), the Pullman strike of 1894, the blowing up of the warship *Maine* in the Spanish-American War; the widespread feeling that entrepreneurs were "robber barons" and the government of cities a "machine" run by greedy bosses; that financiers opposed for their own benefit the coinage of silver that would help the common man—all these made for permanent anger and turmoil. Agitation was kept up by the barnstorming of the powerful orator William Jennings Bryan and to complete the unsettling of minds, Robert Ingersoll carried on his crusade against all religious beliefs.

> We want to feel the Sunshine,
> We want to smell the flowers;
> We are sure that God has willed it,
> And we want to have eight hours.
>
> *Chorus*: Eight hours for work,
> eight hours for rest,
> eight hours for what we will.
>
> —SUNG IN CHICAGO AND ELSEWHERE (1885)

These conflicts in society and the emotions moved a thoughtful journalist to write a work that condemned the status quo by indirection. Edward Bellamy's *Looking Backward* of 1887 depicted society as it would be in the year 2000. The scene is Boston, and peace and prosperity reign there and elsewhere in America thanks to state socialism, though not under that name. Money is unknown; there are credit cards, which entitle anyone to a large variety of goods in the national stores. One's share has limits, but it is ample for all but the insanely extravagant, because the elimination of waste caused by competition makes for plenty.

Hence no anxiety among the poor, no hostility toward the rich; the distinction has disappeared. But everybody must work four hours a day until the age of 45. The rest is leisure, for which the usual high-minded occupations are provided. This Eutopia was an immediate best-seller, the utopian assumption being swallowed—again as usual—that the sole cause of social strife is the starving of the simpler material needs and that they can be fulfilled by simple planning.

The practical reformers had no unified program. The closest to the grass roots was Jacob Coxey's. A compassionate businessman from Ohio, he wanted the government to issue money and relieve unemployment by public

works. He planned a peaceful march to Washington—a "living petition," but "Coxey's army" numbered only 500 when it reached the capital. Coxey was stopped from speaking and arrested; after which some 1,200 more arrived from other states. Still, the movement publicized the need, and in the 20C the march has become a frequent and effective instrument of protest here and in Europe. In our more responsive time, 500 or 1,200 have sometimes been enough to reverse policies, at least locally.

In the 1870s the spectacle of immense wealth cohabiting with poverty struck the self-taught San Francisco printer and journalist Henry George and incited him to study the question. After two or three essays he wrote the classic *Progress and Poverty*. It points out that land values rise automatically wherever business activity (progress) takes place, and it creates poverty among those who own nothing but their labor. Wealth comes from rent, and since it is unearned, it should be taxed for the general good, making all other taxes unnecessary. George did not know that his analysis and conclusion were first set forth by the 18C physiocrats and variously restated by James and John Stuart Mill and Karl Marx. Most of his readers did not know it either; the Single Tax movement grew and made him a public figure. He lectured here and in England and Ireland, and ran two vigorous but unsuccessful campaigns for mayor of New York. In the first of these he shared with Theodore Roosevelt the reform ticket. His influence abroad was lasting. Bernard Shaw and his Fabian friends thought him the equal of Marx, if not superior in practical sense, and *Progress and Poverty* guided land reforms in Austria-Hungary. A Henry George Society still meets and sponsors discussion and publication in New York.

> Henry George once remarked how strange it was that human beings were smart enough to build [the] Brooklyn Bridge, but not smart enough to keep a lot of condemned wire from going into it.
>
> —ALBERT JAY NOCK (1933)

An economist of a different kind, Thorstein Veblen dissected business and industry from the shelter of Chicago and other universities, according as the difficulties caused by his wayward behavior propelled him from one to the next. But his thought was straight and rigorous through a dozen works, beginning with *The Theory of the Leisure Class*. It made his name at the turn of the century, though written in a style that parodied academic prose—long words and involved sentences. "Theory" meant the ways of the class and the use of their means. The rich judged all of life in terms of price and were condemnable from an economic point of view since they reveled in waste. Veblen's phrase "conspicuous consumption" entered the language to label the habit of buying expensive things to impress the neighbors. Later, cars, yachts, furniture, and home appliances that serve this purpose came to be known as "status symbols." Earlier, at the princely courts, extravagance for ostentation had to be content with jewels and silks, banquets and gardens.

Progress in conspicuous consumption has been made possible by industry's multiplication of expensive objects.

But it must be added that by the end of the 19C the leisure class had disappeared. Rich or poor, nobody in the present world has leisure or would know what to do with it, except perhaps the homeless. The English weekend dates from about 1880, but everybody is now busy at all times, even on holidays—this too a side-effect of things in abundance. By dealing once more in his other works with the actions of social groups, Veblen founded "institutional economics," a new branch of the subject, which challenged the primacy of the classical school and ensured him the rank of initiator among economists.

Among the mixed company of reformers who kept in the public eye during the double decade and whom Theodore Roosevelt called "muckrakers" (after the man in *Pilgrim's Progress* who with his eye looking down at the mud did not see the crown above his head), were two women whose work had notable influence. One was Helen Hunt Jackson, a classmate of the poet Emily Dickinson. "H.H.," as she was generally known, felt deeply about the cruel treatment of the Indians and after success as a novelist, she wrote *A Century of Dishonor* as an indictment of the national policy. This led to her being made a special commissioner to investigate the conditions afflicting certain tribes, after which she drew on her experience for another novel, *Ramona*, a further popular success. The plight of the Indians was not over, but the problem had been stated and was not buried again.

Ida M. Tarbell is perhaps better remembered than Helen Jackson, because in the Marxist 1930s her name was recalled with that of her fellow muckraker Lincoln Steffens as critics of capitalism. Both were contributors to *McClure's Magazine*, which S. S. McClure, an Irish immigrant, founded to crusade against big business and other perceived enemies of individual rights (Arthur Conan Doyle invested in the venture). After seeing that her youthful hope of a career in biology was barred by the male monopoly, Ida Tarbell made herself a scholar in literature and history by studying at the Sorbonne and the Bibliothèque Nationale. On her return, at McClure's suggestion, she wrote biographies of Napoleon and Lincoln and went on to investigate John D. Rockefeller's spectacular rise from clerk to tycoon. Five years of research produced *The History of the Standard Oil Company*, the most thorough description of contemporary methods in business.

> When I contemplate him [Andrew Carnegie] as the representative of a particular class of millionaires, I am forced to say, with all personal respect, and without holding him in the least responsible for his unfortunate circumstances, that he is an anti-Christian phenomenon, a social monstrosity, and a grave political peril.
>
> —THE REVEREND HUGH PRICE HUGHES (1890)

The problem of our age is the proper admin-
istration of wealth, that the ties of brother-
hood may still bind together the rich and
poor. There [is] one mode of using great for-
tunes, the true antidote to the temporary
unequal distribution of wealth. Under its
sway the surplus wealth of the few will
become, in the best sense, the property of the
many, because administered for the common
good.

—Andrew Carnegie, *The Gospel of
 Wealth* (1900)

This exposé and others by the
McClure forces gradually persuaded
lawmakers to begin regulating financial
operations and seeing to it that trusts
were prosecuted under the Sherman
Act of 1890. President Roosevelt him-
self conceded the necessity of limiting
property rights. But the other side also
claimed to represent INDIVIDUALISM.
Andrew Carnegie argued that through
competition it accumulated wealth
which, properly used, would do more
for the common good than if it were
divided among the people. He set up public libraries, founded institutions to
improve education and promote world peace. Rockefeller from his earliest
employment regularly gave some 15 percent of his income for public uses. He
and others gave large sums to found universities and colleges, which the ordi-
nary wage earner could not do. But the reformers were not appeased. Quite
logically, Ida Tarbell ended up espousing the then modest version of the wel-
fare state. It was the start of the Great Switch (688>). She had not supported
the suffrage movement, because she thought that voting and passing laws had
little influence when unsupported by popular feeling; she could see how the
Blacks, now legally "free," were treated.

The most hurried sketch of political thought in that effervescent time
would be incomplete if no word was said about Mr. Dooley. His remarks in
Irish brogue began to edify readers through a column of the mid-1890s in the
Chicago Post. Mr. Dooley is a Chicago saloonkeeper who chats with his friend
Hennessy and other characters in Archey Road about every aspect of the
world and a few things besides. These lifelike encounters were the creation of
Finley Peter Dunne, whose political understanding and gift of satirical phras-
ing put him on a level with all the other American and English writers who
made the 1890s an age of sagacity and wit. The man who noted the advent of
canned goods by a passing mention of "a taste of solder in the peaches" is
nothing less than a literary genius.° His seven volumes of Mr. Dooley's table
talk furnish the proof of this judgment and constitute a panorama of the time.
There is hardly a subject—from Roosevelt's charging up San Juan Hill in the
Spanish war° to nationalism at the Olympics (just then revived after 1,700
years), from "Reading Books" to "The Supreme Court"—that the saloon-
keeper does not enliven with pregnant observations applicable to like cases in
any year. [The collection to start with is the first, dated 1898: *Mr. Dooley in
Peace and in War*.] It is a disgrace to American scholarship that he is not stud-
ied, and thus republished and enjoyed on a par with Mark Twain and

Ambrose Bierce. The dialect in which Mr. Dooley dialogues with his crony is no more an obstacle than the several types of back-country speech in *Huckleberry Finn*.

Finley Peter Dunne is only one of the names on a list of great native sons whose neglect is a reproach to the American mind, that is to say the academics and the critics (780; 798>). A second is George Perkins Marsh, who in the 1890s submitted to the Secretary of Agriculture a report on irrigating the western lands. He had been asked to study the question because he had recently re-issued his *Man in Nature* under the more arresting title of *Earth as Modified by Human Action*. Marsh was the first ecologist.° For over 30 years he observed and reflected and publi-

On John D. Rockefeller: He is a kind iv Society f'r th' Prevention of Croolty to Money. If he finds a man misusin' his money, he takes it away fr'm him and adopts it.

On the Paris Exposition of 1900: I was determin' to probe into th' wunders iv science. Where did I bring up, say you? In th' front seat iv a play house with me eye glued on a lady iv th' sultan's hare-em tryin' to twist out iv hersel'.

On the Negro Problem: I freed th' slave, Hennessy, but faith, I think 'twas like turnin' him out iv th' pa-antry into th' cellar.
—You can't do ennythin' more f'r thim than make him free.
—Ye can't, Hennessy, only whin ye tell 'em they're free, they kno-ow we're only stringin' them.

—MR. DOOLEY (1898)

cized the need to be vigilant about the earth and how to replenish it. Under that nature-lover, President Roosevelt, conservation began—and Gifford Pinchot got the credit. At the present time, when Earth Day comes around one hears not a word about George Perkins Marsh.

His pioneering in ecology should be enough to clinch his fame, but he had additional interests and powers. He was the first diplomatic envoy to Italy and served there with more than common skill during the American Civil War and for the ensuing 20 years. Previously, his post had been Turkey, because of his fluency in foreign languages, which were in fact his second life-long preoccupation. His scholarship was deep and wide; he wrote a grammar of Old Icelandic, and his *Lectures on the English Language* is full of fresh findings and original ideas—virtually a cultural history. It qualified him to be one of the earliest of Murray's collaborators in the *OED*—the dictionary that details the history of every discoverable English word.

*
* *

By definition, the reality known as "the state of the art" in industry or techne lags behind the "state of the mind" of innumerable inventors. There, innovative things are fermenting endlessly, many of them making no headway, either because, as in the fine arts, they meet with incomprehension, or because they are not quite fit for use. The story of the zipper is an epic of per-

severance. It is yesterday's novelty, now perfected, that is the boasted "state of the art." In the period traversed at this point, this mixture of novelty proposed and novelty accepted included: the telephone; the phonograph and the player piano; the lightbulb (very crude) and the typewriter (likewise); the lightweight (so-called safety) bicycle; a rudimentary internal combustion engine; man-made fiber not quite rayon; the pesticide DDT; Tiffany stained glass; Eastman's box camera; the cash register; and that unnatural wonder, Ivory soap. [One book to read among others is *The Bicycle* by R. John Way.]

But perfection was not altogether missing. Two engineering marvels received international acclaim: Roebling's Brooklyn Bridge (<594), which used his twisted-wire cable for suspension, and James Eads's bridge across the Mississippi at St. Louis. The latter's elegance belied its strength, which was demonstrated at the inaugural by having a clutch of locomotives steam slowly on the two tracks to the center of the cantilevered structure, firm under the 700 tons.° These two works made the use of steel henceforth imperative. The then recent collapse of the bridge across the Firth of Tay in Scotland had proved the danger of relying on wrought iron. But steel was a scarce commodity for another 10 years.

As for the making of everyday things, it was entering a new phase with the paper bag and the cardboard box, both mass produced. They led the procession of objects now made to be thrown away after use. The box and the bag were due to the discovery that other materials than rags—straw, bark, esparto grass, wood pulp—could be turned into paper, thereby cheapening newspapers, magazines, and books. Still other intellectual and social consequences of the paper deluge it is better not to contemplate. Instead, it is comforting to think that about the same time Levi Strauss began to make blue jeans, complete with copper rivets. Other beginnings are well enough indicated, at least for Americans, by naming firms that date from these same decades and are still producing: Borden, Heinz, Pillsbury, Coors, Anheuser-Busch, Edison, Gillette, Lipton, Nestlé, De Beers, Montgomery Ward, J. Walker Thomson, and—until quite recently—the ubiquitous Woolworth. Again a period piece, the Blue Train sleepers began running between Calais, Nice, and Rome and soon begot the Orient Express, which afforded a luxurious, unbroken journey from Paris to Constantinople. The corresponding one across the United States followed after the completion of the Union Pacific in 1869, but the run soon lapsed for all time into the irrational and inconvenient changeover at Chicago.

To close the account of what might be called the burgeoning time of novelty before the flowering of the 1890s, one may rapidly run through a list of news and events that the dwellers in that city doubtless took note of. After the fire that in two days of October 1871 engulfed one-third of its area and made 100,000 homeless, the clearing of the ground proved an unsought opportu-

nity for modernizing. From abroad came word that Henry Morton Stanley had found Dr. Livingstone in Central Africa and made a certain remark; the rich grocer Schliemann, whose plans for excavation had been thought mad, was bringing to light the remains of ancient Troy; in another journalistic coup, Pulitzer sent the bold and beautiful Nellie Bly (Elisabeth Seaman) around the world with the mission to better Jules Verne's (imaginary) record of 80 days (<565). She beat him by eight days, a measure of the progress in transportation between 1872 and 1890. A photograph was taken of a galloping horse, showing that he had all four feet off the ground; Carlo Collodi published *Pinocchio* and Robert his *Rules of Order*; Oscar Wilde visited the United States and proved a good mixer with all classes of people. Alfred Nobel's dynamite, and Dr. Allbutt's clinical thermometer came into general use; white workers jealous of Chinese coolies precipitated a race riot in Los Angeles; in New York the Tweed Ring's pocketing of millions of public money was exposed, eliciting from the boss the answer "What of it?"; out west the Jesse James gang made the train holdup a classic performance; at sea the *Mary Céleste* was found floating undamaged, with breakfast on the captain's table and nobody aboard.

All this valuable information was of course disseminated by newspapers. Everywhere they kept increasing their circulation. The well-paid advertising made possible a nominal price for the issue itself, and the features already noted of scandal and whipped-up excitement over things big and little brought about the lowest form of competition. In 1896, Pulitzer's *New York World* was running a one-panel cartoon called The Yellow Kid. Hearst persuaded the cartoonist Richard Outcault to extend the Kid into a strip for the *New York Journal*. The angry squabble over rights that went on in public for months is said to have given rise to the epithet Yellow Journalism. It certainly was in use a year or so later, when the *World* and the *Journal* raucously campaigned for "action" in Cuba and pushed country and government into the Spanish-American War. Unlike later students, those then in college clamored for it. At Harvard, William James, who addressed the bloodthirsty crowd, vainly urged: "Don't howl with the pack!"

*
* *

Not since the "Hungry Forties" had a decade earned a nickname when the 1890s came to be called the Naughty Nineties. Next, it was associated in England with the color yellow, because of *The Yellow Dwarf, The Yellow Book,* and it finally came to rest as the Mauve Decade. Mauve superseded Brown (<591) as fitter to evoke Aestheticism (621>). Naughty replaced the gloom of the Gilded Age by approving enjoyment and buoyant spirits. In retrospect, the time seems far more complex than a batch of adjectives can suggest. If "the Nineties" are to be thought of as a cultural unit, the term should stand

not for one but for two decades, stretching from 1885 to 1905. This would be both indicative and convenient, because the important innovations of those years cannot be pinned down to single events, ideas, or works with a date attached. The full-size turnaround required the energy of men and ideas from diverse activities strung across time and space during those 20 years. Accordingly, the view from Chicago (or anywhere else) around 1895 does not reach into every corner; a further swing of inspection will be needed to complete the survey (615>).

As host to the world in 1893, Chicago looked with pride at the contents of its Columbian Exposition. It housed the products of 46 foreign nations and was visited by more than 25 million people. In size and architectural display its 150 buildings made it a much grander show than the Centennial held at Philadelphia in 1876. At Chicago, the occasion was the 400th anniversary of Europe's discovery of America; what was really shown off was the difference between 1492 and the present: metal and machinery had virtually eliminated wood and manpower.

Again unlike previous world's fairs, the Columbian paid attention to ideas as well as things. It had a Building of Manufactures and Liberal Arts. It held conferences of experts on religion, peace, women's demands, and the problems of youth. As to the fruits of science and techne that it put on view, it was so rich and well organized that Henry Adams said it was an education in itself. What mesmerized the visitor on arriving was the electric glow of the huge portal. Illumination was the feature at many points within, especially at Electricity House. So much light, not from the sun, was a new phenomenon, and the fair as a whole got the name of White City. True, faulty insulation of the wiring caused a few fires, but they were soon forgotten in the joy of defeating darkness.

Two years earlier, when electric lights and bells had been installed in the White House, President Harrison's large family were frightened and would not touch the switches or press the buttons for fear of shock; the current was turned on for the evening and disconnected in the morning.° But the habit of accepting the new as always preferable to the old spread fast, not only because by now the factory product was not shoddy—it really worked as promised—but also because (so it was assumed) behind innovation was the push of forward-marching science. It is from this time that one dates another category of marketable product, the antique. Putting science ahead of industry in the program was more prophecy than fact. Up to that time nearly every device had been the work of inventors and engineers building on previous working devices. It was only

Science finds, Industry applies, Man conforms. Science discovers, genius invents, industry applies, and Man adapts himself to or is molded by new things.

—*GUIDE TO THE COLUMBIAN EXPOSITION*
 (1893)

in the year 1890 that Sir Alfred Mond, a chemist of German descent, urged upon a group of businessmen the advantages of what is now known as R&D—research and development: pure scientists hired by industry to find processes that engineers can embody in machines and appliances.

Invention in the Nineties kept pace with desire, and world's fairs in rapid succession showed its fruits to the multitudes. There had been a large one in 1889 in Paris, where the Eiffel Tower proved that a metal structure 300 meters high would stand up and that by searching far and wide enough steel for it was available. It was not long before Louis Sullivan, a Chicago architect (648>), made use of a similar metal rib cage as the skeleton of an office build-ing, the model skyscraper. Its principle is that of the medieval cathedrals: the walls do not support but fill in. Sullivan laid down the rule: "Form follows function." He meant that a building must clearly show the structure that serves its purpose. He deplored the neo-classical, highly ornamented style of the Columbian Exposition, which was bound to be widely imitated: "It would set back architecture for fifty years."

The lag was much shorter, even though the fine arts do not make their way in the world as fast as the mechanical. In Paris, when it was decided not to take down the Eiffel Tower with the rest of the fair, some hundred artists and writers signed a protest saying that M. Eiffel's ugly folly was a blot on the beauty of the city. But techne won out; the Tower still stood at the next Paris fair of 1900 and was shortly put to use as a post for wireless telegraphy. Going Chicago one better, ideas were the sole object of the fair at St. Louis in 1904.

Next to fairs as a recurrent event, another old practice expanded and became a mighty institution: advertising. Its rapid development was in fact a necessity when the leviathan of the age spewed forth continually new prod-ucts, many of them for the ordinary citizen and not expensive. Advertising had long existed as simple publicity—at first a few lines announcing a lost article or the opening of a shop. Then the paragraph, descriptive and boast-ful. The Nineties saw the rise of the craft as we know it: the arresting display in type and picture with repetitious slogans and extravagant claims: Post Toasties, the first breakfast cereal, would cure appendicitis; contraptions with wires implying electric power would relieve lumbago and housemaid's knee. Bottled liquids and Pink Pills for Pale People worked miracles.° Bicycles, cars, bathtubs, stoves and carpet sweepers, cameras and fire escapes, shoes and hats, corsets and locomotives received public encomiums from the makers, often backed up by ecstatic users, and starkly illustrated in black-and-white line cuts. The object was shown in association with human figures seductively posed and faces radiating happiness.

McClure's and other magazines grew thicker by as much as 100 pages of advertising in one issue. Flyers littered the streets; "sandwich men," so-called

from the tall placards strapped to their chest and back, paraded along the main avenues; the billboard was erected and the brick wall of the apartment house painted for the benefit of tradesman and public. Those were the extension of the political and theatrical poster to every other kind of production. [The book to look through is *Scrapbook of Early Advertising Art* by Floyd Clymer.] The choice of goods on the market kept enlarging and, oddly enough, required that people be perpetually reminded to buy bread or soap or candy or sales would decline. The text and design of these early appeals was crude, but the principles have proved eternal. The Nineties could even boast the first professional writer of advertising copy, an anonymous hero.

How advertising turned into a force acting on the public mind so successfully that it now serves to propel every kind of purpose, dogma, political and private ambition, health measures, and private or public institutions is a long chapter of cultural history that has yet to be written.° Its changing substance and tone will be instructive. For example, when Ivory Soap declared itself "99 and 44/100 percent pure," it banked on the fact that the public had learned enough science to know that perfect purity is not attainable and that the precise measurement implied in the fraction testified to the superior quality of the article. The overcrowding of the modern mind with names, phrases, and pictures is another effect of this uncontrolled haranguing which, among yet other cultural effects, diverts literary talents and dilutes the new styles in painting.

A bird's-eye view of the goods and appliances that the Nineties, when taken as a double decade, offered the public makes it clear that nearly all our modern conveniences date from the turn of the century. Here is a gradually gathered list that only approaches completeness. Obviously, some of the items needed improvement before finding a market:

for the home: central heating; the bathtub of modern size and shape with hot and cold running water; the safety razor; the chlorinated water supply; stainless-steel implements; the electric toaster, iron, oven, sewing machine, and dishwasher;

for the office: the electric elevator; the dial phone; wireless telegraphy; the punched-card sorting system; the portable typewriter; the coffee-vending machine;

for health: Salvarsan for syphilis; various antitoxins; radium treatment for breast cancer; heart surgery; the beginning of organ transplant (in animals); appendectomy; the psychiatric clinic; the baby incubator; contact lenses; toothpaste in a tube;

for recreation: motion pictures, musical comedy; the gramophone; ice dancing; volleyball and basketball; the Ferris wheel; the jukebox; the newspaper headline; the cabaret song relayed by phone (in Paris); the screen kiss; and the striptease;

for food and drink: breakfast cereals; milk delivered in bottles; packaged

produce (prunes); Coca-Cola; margarine; the ice cream cone; chop suey; canned fruit; the gin cocktail; the refrigerator; and the thermos flask;

for instruction: public libraries; the correspondence course; the syndicated article (McClure's invention); the questionnaire method; the language course on gramophone; the publisher's blurb;

for shopping: the full-range department store; the chain store; the escalator; the shopping center (Cleveland, Ohio, 1893: a four-tiered, glass-covered arcade with 112 luxury shops); the coin telephone; the traveler's check;

for law and order: fingerprinting; telephone tapping; the automatic pistol; and the electric chair;

for transportation and other needs: the automobile and the aeroplane; the city subway (underground) train; the pneumatic tire; wireless telegraphy; vocal and orchestral recording; color photography; the roll film; rayon and other artificial textiles; celluloid; chewing gum; book matches; rubber heels; the zip fastener;

prophetic firsts: the hunger strike; women's football club; woman stockbroker; the acronym SCAPA = Society for Checking the Abuses of Public Advertising.

In short, those were the years when Comfort was replaced by Convenience. The home appliance and the packaged product are additions to the panoply of life and they relieve it of chores, but they do not simplify it; they are often a burden. The appliance must be fed and cared for, repaired and "upgraded." It demands a new skill, rigid habits, and vigilance—and despair ensues when it fails. Emerson had observed the drawback of any such possession: "If I keep a cow, that cow milks me." A device fulfills one need at the expense, possibly, of several others. New means of communication diminish privacy and wastefully multiply human contacts, robbing one of time. It is a sidelight on this last consequence that the leading writers of the 19C produced, without typewriters and telephones, bodies of work that astonish us by their volume, and this often in a span of years much shorter than our average lifetime. The modern situation has been described in detail by a Swedish scholar who explains "the decline of service in a service economy" and gives the mathematical model for the relation between increased mechanization and loss of free time. [His book, brief and non-technical until the last chapter is: *The Harried Leisure Class* by Steffan Linder.]

Besides, designers of domestic products often lack imagination or think only of visual appeal, or consult economy in manufacturing, and for these reasons neglect points of discomfort in the device. This is so general a drawback to living among machines that the term *user-friendly* has had to be coined to lure the purchaser, who frequently finds the reassurance in the printed leaflet rather than the object itself. The one clearly good result of labor-saving by home appliances has been the EMANCIPATION of the servant class.

Long ago, John Stuart Mill pointed out that mechanizing man's work had

changed but not lightened his toil. But it has not been noticed that mechaniz-
ing the home has laid another load on the laborer's back: it has made simple
poverty impossible. No household today can remain without the conve-
niences, beginning with the telephone and other utilities (as they are called),
and going on to the car, radio, and television. Needed for holding one's job or
socially imposed by the neighbors and one's children, they are part of an
oppressive "standard of living." For some families this means moonlighting
or perpetual debt; for others, who refuse the struggle, it is *abject* poverty
instead of the tolerable life that an earlier age might have afforded.

The implication is not to side with the inhabitants of *Erewhon*, who
decreed that all machines must be abolished. Certain side effects have been
admirable. For example, turning night into day at the flick of a switch has bet-
tered the conditions of study and white-collar work and has relieved small
children of many fears. Electricity transformed the factory from a smoky hell
into something of a showplace. For the machine is one of the works of man,
not an alien intruder; it is born of handwork and imagination, like art, and its
material shape may achieve beauty fused with utility. This perception has rein-
forced Sullivan's aesthetics of Functionalism (<601; 605>).

* * *

On his visit to these shores in 1882, Oscar Wilde did nothing to convert
the country to the religion of art. In any case, the American temper was too
earnest and headlong in another direction. Critical thought, when it was not
bitter as in Mark Twain and Ambrose Bierce, was bent on reform. As we saw,
it was big business, incipient colonialism, corrupt politics, and the condition
of the poor, the young, and the Blacks that disturbed the men and women
with a moral conscience. But another group—artists, thinkers, scholars—
often felt isolated in a country whose main interest lay in settling land and
building railroads. When able to do so, such "outsiders" lived abroad. It was
almost a tradition. In the 1860s W. W. Story, a lawyer turned sculptor, had
lived in Italy and gathered around him a shifting circle of like-minded dilet-
tantes; Stuart Merrill lived most of his life in France and is considered one of
the French Symbolist poets (620>); scholars felt they must spend time in
Germany; in mid-career Henry James made England his permanent home;
his brother William had a European education. Of those who stayed in the
United States, most painters were students and disciples of European
schools, who modified their chosen style to suit American subjects. These
were usually the large and wild aspects of the continent, but presented as
enticing or mysterious rather than rugged and threatening. Such were the
works of Cole, Church, and Asher Durand. One painter, Albert Ryder, stood
apart. His treatment of subjects signified a retreat into an unknown world

that contains neither landscape grandeur nor workaday plainness. His conception of *The Race Track*, for example, suggests a tantalizing dream akin to the visions of the Symbolists, though Ryder was unaware of them or their works.

Another who went against the stream was the architect Richardson. To counter the routine imitation of European historical styles, he designed purposely heavy-looking buildings of fine proportions, with strongly marked windows. Then he simplified the externals, especially for private houses; but his liking for large indoor spaces was for some time unpractical from lack of central heating. Progress toward bareness in architecture was hastened by the development of the skyscraper: its size makes moldings around windows, cornices at each floor, or any other decoration look ridiculous, and the doctrine of Functionalism forbids it in any case.

That American artists felt their native land to be still wild both in topography and in manners may seem a paradox when it is remembered that the year 1890 is said to mark the closing of the western frontier. But the several "Oklahoma Openings" by which parts of that territory were auctioned off began in 1889 and continued through 1906, so that there was still frontier life behind the closed frontier. Throughout the Great Plains (as the classic work of that name by Walter Prescott Webb makes clear), farming or ranching life was dependent on barbed wire and the Colt revolver. The Indians pushed out of their homelands had not yet been subdued, and the settlers' police forces were often distant and uncertain. Seeing or hearing about these facts gave the sense of an unfinished country.

East of the Mississippi, the situation was different. For many, the attractions of the city were irresistible. Hamlin Garland depicted their effect on a village girl in *Rose of Dutcher's Coolley,* and a pioneer statistical study listed the advantages of urban life: better educational facilities; a higher standard of living aided by conveniences; more lively intellectual contacts; and more varied amusements, including music and the arts. Especially in the Northeast, long settled and closer to Europe, a growing body of people were reversing the current and enhancing the existing means of thought and culture. Museums were founded or consolidated in Boston, New York, and Washington; choral societies and orchestras were established in several more cities. Universities replaced colleges—and not merely in name, as happened recklessly in the 1950s, but in earnest, by the creation of graduate schools. Columbia, Chicago, Johns Hopkins, Cornell, led the procession; and several newly founded state universities in the Middle West began to fulfill local demands, both intellectual and agricultural or industrial.

The notion of making the university serve the public came to John W. Burgess when, at the age of 17, a Union soldier in the Civil War (though his family owned slaves), he reflected that minds better trained than the political

leaders on each side of the struggle would have found means of averting it. After graduating from Amherst, he went to Germany to observe the system of higher education, then to the Ecole des sciences politiques in Paris. On his return he organized at Columbia College the Graduate Faculty of Political Science, the first in the country and the nucleus of the university, the designation assumed a few years later. The next demand came from the scientific interest. The president of Harvard, Charles W. Eliot, a chemist, transformed the college into a university by adding one school after another—the Lawrence Scientific School and the Medical School being his special care—and by making the Divinity School non-denominational. He won his fight to establish the elective system that allowed students to make up their own program of study. But he insisted on laboratory work, and the new degree of Bachelor of Science, which helped to kill Latin, was instituted.°

Further, in helping Daniel Coit Gilman on his career, Eliot indirectly helped to set up the Sheffield Scientific School at Yale and the rise to eminence of the Johns Hopkins University. There, inspired by the German example, Gilman invented the American Ph.D. and created the first research medical school, headed by such luminaries as Osler and Halsted. Earlier, Andrew D. White had dreamed of a university that would admit any qualified student regardless of means, sex, or color and would be "an asylum for science." After struggles in which Ezra Cornell supported him and provided money, White combined a land-grant school of agriculture in upstate New York with a full-size university and became its president. In retirement he wrote a widely read work indicative of his own philosophy, the *History of the Warfare of Science and Theology in Christendom*. Also after conflict with his faculty, Woodrow Wilson made Princeton a modern university of the first rank.°

Meanwhile at Chicago, William Rainey Harper organized with Rockefeller backing the University of Chicago. Being a biblical scholar, Harper did not specially favor science, but he insisted on a "senior college"—the upper two years—where research methods would be taught. It is this combination of science and research with a spreading policy of "come one, come all" that makes the 1890s the starting point of modern American higher education, dedicated to science and public service. Its sheltering of the fine arts came later (746>).

Then begins also the sad story of the humanities, the endemic "plight of the liberal arts." In earlier days they had lived on excellent terms with science—what there was of it, usually a professor of physics and astronomy and one of chemistry or "natural history." Those sciences had nothing illiberal about them; all types of knowledge were born equal. But in the 1880s and 1890s the increasing squadron of specialized sciences invaded the academy banners flying and claiming a monopoly of certified knowledge. It would be wrong to suppose that the scientists went out of their way to maim or kill the humanists. The latter's wounds were self-inflicted. In the hope of rivaling sci-

ence, of becoming sciences, the humanities gave up their birthright. By teaching college students the methods of minute scholarship, they denatured the contents and obscured the virtues of liberal studies.

"Research" was the deceptive word that made humanists devote their efforts exclusively to digging out facts *about* their subject without ever getting back into it. Nicholas Murray Butler, another university builder of the period (746>), used to relate a telling example. When he was an undergraduate taking a course in the Greek dramatists, the professor opened his first lecture on Euripides by saying: "This is the most interesting play of our author: it contains nearly every irregularity in Greek grammar." It is this fallacy of misplaced significance that continues to deprive the humanities in college of their attractiveness and their practical value. The curriculum may have a large offering of "liberal arts courses," but they are worthless as education if they are not taught humanistically. But again, the science faculty is not responsible for the folly of their colleagues across campus. The humanist's fear and envy of science in the 1890s was groundless. Huxley had truthfully pointed out that science appealed to the young mind and developed it for all intellectual purposes, because it was observation and organized common sense—nothing there to frighten or repel the liberal arts major. Science has become something other than common sense, but that is another story (750>).

*

* *

Populism, the state of mind that moved members of the comfortable classes to take thought and action for "the needs of the people," did not overlook intellectual matters. Andrew Carnegie decided to pepper the country with public libraries; others set up workingmen's institutes, as Thomas Cooper had done in New York as early as 1859. And one other, peculiarly American organization flourished in the Nineties that supplemented the work of the academy. This was the Chautauqua Movement, named after the lake in New York state, where the Episcopal Methodist church established the main center of the enterprise. Others arose in scattered fashion across the country, often serving rural areas by sending out troupes of lecturers and entertainers. Starting out as a camp meeting for religious studies and discussion, these assemblies became occasions for music and drama and general education. The Institution also offered correspondence courses, published a review for 35 years, and held a summer session at which notables lectured. William James accepted an invitation and dutifully addressed the thousands. But by the end of the week he was suffocated by the atmosphere—earnest, blameless people piously eager to learn. He longed, as he put it characteristically, for "the flash of a pistol, a dagger, or a devilish eye."

One more agency at work on American culture was Elbert Hubbard's

group of Roycrofters in East Aurora, N.Y., who worked with their hands and published *The Philistine*. Reference books treat this institution harshly, because Hubbard used it to make money and the product was not of high quality, especially when compared with the Kelmscott Press, which the poet and socialist reformer William Morris had set up in England and which Hubbard professed to emulate. Morris's aim was to reinvigorate the arts and crafts in a world of shoddy factory products. By the Nineties the movement had succeeded: the market offered manufactured objects of good materials and attractive design and at a lower price than the handmade. Over here, Hubbard's propaganda at least helped to create the taste for good things, although what the country bought in large numbers as the Morris chair with adjustable back was nothing of the kind. Hubbard also issued pamphlets—some 170 in all—entitled *Journeys to the Home of the Great,* which fostered admiration and respect for human achievement. That he and his Roycrofters must be classed as purveyors of popular culture does not justify scornful descriptions of the effort; and if it was profitable, so are pop art and thought everywhere today without blame. He must be accounted a pioneer.

*
* *

In the wake of political and economic reform, care for the person, the individual life, grew intense. As we saw, the Columbian Exposition sponsored conferences on the young. Shortly, societies for their protection were formed in Germany, France, and Belgium. In 1899, a Festival of Youth drew a large crowd in the Bois de Boulogne. A specialized literature flourished abundantly: there must be "child savers" argued one author. Another viewed juvenile offenses as "the spirit of youth on the city streets." Ellen Key, the Swedish feminist, declared on the eve of the new century that it would be "the century of the child," and in her book of that title the first chapter heading is: "The Right of the Child to Choose His Parents."

Many parents and other persons sharing their concern set about reforming the school. As always, it was "ossified," "stultifying," and therefore cruel. The child must be freed from dull teachers and rote learning; his naturally inquisitive mind redirected from words to things (<181). John Dewey and his friends at the University of Chicago started a school that would effect the EMANCIPATION from all these errors—the progressive school. The pupil could choose his line of studies, would not recite memorized facts but discuss them, and would progress at his own pace. The teacher would be a mere guide (now called a facilitator), who would present knowledge as the solution of problems.

Dewey fell into this last fallacy by assuming that thinking always follows "the deliberate method of science." What is deliberate in science is verification. Discoveries, as shown by their individual histories, are made not step by

step according to Dewey's formula,° but by spurts of illumination, as in art or philosophy—or everyday life; the Eureka ("I have found it") of Archimedes in his bath is typical. In modern times, the famous case of Kekulé has been not at all unusual: working on the carbon compound benzene, the chemist, asleep and dreaming, "saw" the "benzene ring" that represents the configuration of the molecule. It was an important advance, because it established that the properties of a substance depend on its structure. [The book to read is *Science and Hypothesis* by Henri Poincaré.]° The "problem approach" in teaching has done as much harm to students as the look-and-say routine to young pupils learning to read.

In any case, infants could not be expected to solve problems in five steps or choose their own studies; and as kindergartens were spreading fast and psychologists recommended early schooling, programs for tots were needed. One of the most approved was devised by Maria Montessori, an Italian physician who was first interested in teaching the retarded. She was a disciple of Edouard Seguin and Jean Itard, pioneers in the treatment of idiots, deaf mutes, and other disabled children. Dr. Montessori studied further in Paris and London and was made professor at the University of Rome. She resigned to open her Casa dei Bambini—House for Tots. *McClure's Magazine* publicized her work for years before she brought out *The Montessori Method* in 1912.

It is based on the same premise of INDIVIDUALISM as the progressive school and is an excellent preparation for it. The infant is "self-active" and can therefore be made self-teaching. Objects devised for the purpose incite the joint development of the senses, the muscles, and the mind. (One is reminded of Dr. Beddoes' educational toys, <438.) Suitable games sustain interest; the child is on his own for hours, uninterrupted by adults, and the result is concentration and self-discipline. By the age of six he or she has a "unique personality," fashioned by his or her own efforts. "The child," says the Method, is "building a man or woman," the scheme obviously an elaboration of Rousseau's principles. Praised and well patronized until the First World War, the Montessori schools suffered eclipse when behavioral psychology decreed that intelligence was physically predetermined and showed fixed levels at every phase of the child's growth. This made early experiences unimportant. When that dogma lost authority in the 1950s, Montessori schools reappeared here and abroad. Meantime, Dr. Montessori had become a mystic who viewed the child as a redeemer of mankind.

On the next stage in life—adolescence—it was the American psychologist G. Stanley Hall who gathered the facts and drew up the guidelines. He too agreed with Rousseau about the late emergence of intellect in a kind of second birth—adolescence—which is often accompanied by storm and stress. Like the two preceding stages, it can be rightly dealt with only if one knows that all three recapitulate human evolution: from birth to 6 or 7 the child is a

little animal—"simian"—who needs the "negative education" given simply by controlling the environment. From 8 to 11 we have the savage, selfish and tribal in his conduct. Physical exercise is indicated; drill rather than book work and anti-social behavior tolerated as outlet, to prevent its later emergence. Lastly, the adolescent needs a broad survey of knowledge and ideas and should be informed about sexuality, which nature presses on his attention. At this stage, coeducation should cease; it puts obstacles to learning for both girls and boys.

In the United States, a long stretch of schoolwork lay ahead: more than one state was setting up the public high school, after which propaganda drove many to college. The free and compulsory high school was unheard of except in the United States. There it was much favored by labor for the delay it imposed on becoming a worker competing in the market. For very clear reasons, Stanley Hall thought the high school should be a "people's college" in itself, not a place of preparation for the "unregenerate colleges" that others so much admired. In this belief he regenerated Clark University as its president in 1888, and invited as visiting professors the leaders of the new science of psychology (659>). He incurred odium when he welcomed Dr. Freud of Vienna in 1909 (641>).

*
* *

Stanley Hall's opposition to coeducation in the high school did not spring from any anti-feminism, and even had it done so, the current that was propelling women's interests—higher education in particular—would have swamped his "scientific" conclusions. Not a few women's colleges were being founded, Bryn Mawr, Barnard, and Radcliffe enlarging the northeastern group of Vassar, Smith, and Wellesley, senior by 20 years. The earliest went back in date to the 1830s. In all respects, women's EMANCIPATION in this country was ahead of the European effort. The Seneca Falls Convention for Women's Rights of 1848 had had no counterpart elsewhere.

From the beginning, the settlement of the American continent had drawn heavily on women's strength of body and mind, and their contribution gave them an authority in the home that was marveled at abroad and that they never lost. But they wanted more—the vote and access to the professions—and it was in the 1870s that the struggle became unceasing. By the 1890s the professional world was beginning to open up and the demand

Men tell us 'tis fit that wives should submit
To their husbands submissively, weakly;
That whatever they say, their wives should obey,
Unquestioning, stupidly, meekly;
But I don't and I can't and I won't and I shan't.
No! I will speak my mind if I die for it.

—"LET US ALL SPEAK OUR MINDS" (1848)

for the vote was no longer shocking. Women had obtained it in Wyoming as early as 1869 and Colorado followed suit in 1893, Utah and Idaho in 1896. It is hard to speak of independent American women in the 1890s without evoking the figure of Lizzie Borden who, in 1892, was charged with the murder of her parents. Clearly she was not one to act "weakly, meekly." She was acquitted (rightly, as the most thorough study concludes)° and thereafter proved herself a woman of character and dignity in the teeth of local prejudice.

Perhaps because of the gains already achieved, one finds in American literature at the end of the century nothing like the array of English genius promoting women's rights. The best American writers had always portrayed women that were clearheaded, self-reliant in conduct, and in speech often scornful of men. Women's part in conquering the West everybody fully acknowledged. As the century closed, any reader of Henry James, William Dean Howells, or John William De Forest, knew what restrictions were still to be lifted, mainly in the higher reaches of society. To the general understanding, Oliver Wendell Holmes contributed his knowledge of psychiatric cases in three novels (<586) and Theodore Dreiser that of the strong-willed, talented, self-made woman in *Sister Carrie.*

Literary theory hardly troubled the American reader of these books. The battle between schools going on abroad interested chiefly the men of letters and critics. The news and ideas that crossed the ocean were more entertaining. There was *Trilby,* a novel by George du Maurier that swept the world. Like Sister Carrie, Trilby is an acclaimed singer, but not at all self-made. A sinister character named Svengali, Hungarian and a musician, had got hold of her, an artist's model (originally a laundress), and by hypnosis made her a concert artist. Her love for a young English painter in Paris and the Bohemian life there supply the charm of the story. When Svengali dies suddenly, Trilby's voice fails too. There is no happy ending. What the name Trilby now evokes is a soft felt hat creased in the middle.

The English musical comedy *Floradora* was another import that won instant success, and as a new form of entertainment it gradually ousted the simpler vaudeville from the stage. In Paris, a little before the 1900 Exposition, the theatrical sensation of the hour was *Cyrano de Bergerac,* whose acclaim reverberated throughout the West. The five-act drama in verse was by a 29-year-old poet named Edmond Rostand. The play pivots (so to speak) on the hero's nose, which is outsize and which did adorn the real 17C writer, Bergerac. The plot is slight and the romance of no interest. Nevertheless, the explosion of enthusiasm at the premiere was unprecedented; it was like a sports event today. The author was pelted with ladies' gloves and fans. People wept and embraced and would not leave the theater, as if they were one family at their own party. The emotion released is indicative of a pre-existing state of feeling. Cyrano is the heroic individualist, ugly and crossed in love, but

lashing out fearlessly against those in power, against the rich, the liars, and the blockheads. He is the universal underdog, but endowed with the glamour of swordplay and the art of rhetoric.°

This last is the strong element in the play's appeal. The spectator who understands French is gripped by the virtuosity of the language. The verse technique is pure Victor Hugo, handled with the liveliest fancy, just short of imagination. The fancy is the only element that has proved translatable into other languages; reproducing the click and sparkle of the French is not possible. That has not stopped the work from being performed everywhere without letup. Some actors have specialized in the role; for example, Shago Shimada, who for the last 25 years has portrayed "Shirano Benjuro" for the Japanese. Films and television productions continue to be made; the hero-victim is ever popular.

When Cyrano burst upon the world, the same fine craftsmanship and brilliant polish had for some years enchanted audiences in the comic operas of Gilbert and Sullivan. Gilbert's sure-handed plotting and picturesque figures were rendered memorable by efficient dialogue and superb versifying in the manner of Byron's *Don Juan*—all this perfectly matched by Sullivan's melodies, which often parody well-known passages in great operas, from Handel's to Verdi's. In addition, several of these little "G. and S." masterpieces were topical in their satire. *Trial by Jury* makes fun of English law; *Pinafore* of the English navy; *Iolanthe* of the House of Lords; *Princess Ida* of women in male occupations; and *Patience* of preciosity in the arts.

Of this last-named opera, conventional criticism says that the hero-poet Bunthorne was patterned after Oscar Wilde. The dates suffice to disprove it. The opera was produced in 1881, therefore conceived, written, and composed earlier. Wilde's first volume of poems appeared in 1882, when he was 28. He was not enough known in London to be an object of humor on the stage. A satirist addressing a theater audience can ridicule only what many average people have heard of more than once. This is a generality. Molière's *Précieuses* (<344) lived a generation before him. Gilbert's Bunthorne is not Wilde but a Pre-Raphaelite, as is confirmed by several lines in the play, such as holding a lily in his "medieval hand"—a backward-looking aesthetic, not Wilde's modern one.

In the same year as *Cyrano,* a show as widely reported was the celebration of Queen Victoria's 60th year on the throne. She seemed to have occupied it forever, but she was only 77. The variety of events and the extent of change in her time gave the Methuselah impression. She had survived accidents, republican disfavor, and popular protests; she had filled the other thrones of Europe with her offspring and relatives; she was Empress of India and titular head of nations and peoples multi-ethnic, infidel, and pagan. On her possessions the sun never set—a thought that her English subjects curiously found

advantageous. They cheered enthusias-
tically her Diamond Jubilee, believing
for the moment that they owed
England's world supremacy to her, or
again to their own superior breed.

The other nations of the West,
particularly Germany and the United
States, both rising to power, might
share the feeling of respect due an old
and upright monarch but could not
partake of the self-congratulations or
testify to the excellence of the British
Empire. One voice in Britain, that of a
man reared in India and who knew the

On Queen Victoria's Diamond Jubilee: **Glory
be, whin I look back fr'm this day iv gin'ral
rejoicin' an' see what changes has taken
place an' how much better off th' wurrld is,
I'm proud iv meself. War and pestilence have
occurred in me time, but I count thim light
compared with th' binifits that have fallen to
th' race since I come on th' earth.**

**—What ar-re ye talkin' abut? cried Mr.
Hennessy. What have ye had to do with all
these things?**

**—Well, said Mr. Dooley, I had as much to do
with thim as th' queen.**

—*MR. DOOLEY IN PEACE AND IN WAR* (1898)

United States, was raised amid the hurrahs to sound a warning. Rudyard
Kipling's "Recessional" told his fellow Englishmen that they should remem-
ber the just God watching their actions. "Lest they forget," he conjured the
vision of "their pomp of yesterday" becoming that of "Nineveh and Tyre,"
that is to say extinct.

Kipling is too often regarded as a jingo imperialist. On more than one
occasion he was a severe judge of his country, and when the United States
acquired its first colonies in the Spanish-American War, he again defined
imperialism—"the White Man's Burden"—in ethical terms: "By all ye leave
or do, the sullen, silent peoples shall weigh your gods and you." Kipling was
evidently aware of portents of change, of some risen wind that could over-
turn and destroy. His uttering that perception while the queen was being glo-
rified was apt. The Victorian institutions and their counterparts outside
England no longer commanded allegiance or respect. The thoughtful knew
that a certain view of life must be given up, but not by revolution in the heroic
mood—that had bred its own evils. The ethos could be overturned in the lit-
eral sense—turned upside down—by ridicule, by doing in all things the exact
opposite. Gilbert and Sullivan's topsy-turvydom was to be enacted in social
thought and real life.

A Summit of Energies

THE SUGGESTION that two decades, and not one, be called the Nineties (<599) arises from the rush of new ideas and behavior that took place between 1885 and 1905. Change did not then stop; on the contrary: but it was another and quite different impulse that irrupted early in the 20C and animated the Cubist Decade that followed. If one could write a page on a dozen levels simultaneously as in a musical score, an account of those 30 years would form one story. To be fair to the actors in it, one would recall (as will be done here) the fruitful germs that came to light during the preparatory 1870s.

The turn of the century was a turning indeed; not an ordinary turning *point,* but rather a turntable on which a whole crowd of things facing one way revolved till they faced the opposite way. The image falsifies only a little: things did not turn in unison. Besides, the new was not, as it sometimes is, all of one kind or showing a family likeness. In art, science, and politics, and social outlook the period offered two opposite ways of being new and two ways of judging it, exultant or desperate. The daring were sanguine, the reticent found new retreats in new forms of PRIMITIVISM. In either case, the clear intent was EMANCIPATION. The forward march proceeded in several columns fighting as they went.

To play with the image of the turn once more: the turning, as said before, was often upside down. Oscar Wilde's *Importance of Being Earnest* is the perfect display of this intellectual gymnastics, beginning with the punning title: the importance to the hero of being named Ernest is not that he has the moral quality praised by the Victorians, but that the young woman he loves fancies the name. In the play all the pieties of the previous age are turned on their heads; for example, having lost *both* parents is reproved as sheer carelessness. Smoking is approved because a man must have some occupation. The farce is a serious criticism of the ideas it is respectable to utter.

Earlier, Samuel Butler (<553) had done the same puncturing of thought-clichés. Tennyson's "'Tis better to have loved and lost than never to have

loved at all," Butler rewrote as: "'Tis better to have loved and lost than never to have lost at all." He and his witty friend Miss Savage exchanged such revisions of conventional sentiments, calling the game "quoting from memory." Wilde's epigrams, which state the opposite of what one expects, do not do so merely as a trick; they dismiss affectations and condemn thoughtless states of mind. "I live constantly in the fear of not being misunderstood," says Wilde, meaning: the public should be baffled by new art, not reduce it to something it already understands. Shaw's plays work out in life situations a similar reversal of judgment. In *Mrs. Warren's Profession,* running an efficient brothel is shown to be in her circumstances, the only way open to her of earning a decent living and educating her daughter—in short, of being "respectable." Overturning one social judgment thus condemns more than one accepted part of the system. When Ibsen at long last was tolerated on the stage in this period, his plays supported the new thesis that the most admired virtues and revered institutions were obstacles to the good life: marriage, always telling the truth, respect for authority, propriety at all costs. All ideals in the abstract are causes of disaster to individuals and ultimately to society.

In Ibsen these teachings were not, as in Shaw, coupled with high comedy, which for some spectators lessens the gravity of the issue; Ibsen adapted the 19C melodrama to his purpose, putting live characters in conflicts made memorable by violence. Under the influence of these new ideas, the theatre was reviving after a long coma: besides Wilde and Shaw, Pinero, Galsworthy, Henry Arthur Jones in England, Strindberg in Sweden, Brieux in France, Hauptmann and Sudermann in Germany, Schnitzler in Austria, Pirandello in Italy were giving the public cause for scandal and thereby inculcating the new ethos.

An interesting paradox accompanies this course of education: Wilde and other writers in their capacity of critics insisted that art had no duty to teach morality (617>). But here they all were doing just that by denouncing the old morality as no longer serving moral ends. Obviously the dictum about art should have said: "no duty to teach conventional morals." What then did the new code command? The answer was not simple. Art itself, not this or that message, was to be the guide of conduct—art by its truth, harmony, and grace molded the spirit; aesthetics was a form of ethics. In other words, evil is ugly and detestable.

Such a rule means that rules carved in stone for the whole world are as inadequate and misleading as local conventions. Life's complexities must be artfully, not mechanically, handled. As Shaw pointed out: "Do not do unto others as you want them to do unto you; they may not have the same tastes." What art teaches at this point is Fitness. Time, place, persons create a unique situation that the moral being deals with as one seeking the most harmonious

result. This chimed in, as we shall see, with the philosophy of verified result (the true meaning of Pragmatism) that contemporary thinkers were elaborating (665>).

This use of an artistic criterion to judge moral problems extends to art as a whole the 19C tenet that literature is a criticism of life; it reaffirms the 19C devotion to art, whose mission was to combat "bourgeois ideas." The adjective is unfair but the phrase is clear. To profess this "religion" came to be called aestheticism. The aesthete was a new social type by reason of attitudes and ways of speech that were deliberate poses, means of propaganda for the purpose of destroying Respectability. Not all the writers, painters, and musicians of the time assumed the manner, nor did they all believe in "art for art's sake." This axiom borrowed from Gautier after half a century was always more of a fighting slogan than a first principle. To the philistine it gave the command: "appreciate the artistry in art; not just the entertainment or moral lesson." To the artist it enjoined "no compromise with the taste of the multitude. Do not write or paint to sell." And for many others, artists and lovers of art, as we shall see, it held yet another meaning (620>).

Why should this attitude have been common enough to find multiplied expression in a period of steady improvement in the means of life? Perhaps poetic minds are never satisfied; perhaps improvement always raises expectations higher than its own level. Perhaps the very busy-ness of the changing world was felt as hostile by the contemplative seekers of beauty and perfection. The three explanations singly or together probably account for the various individual judgments that led toward a common conclusion. What is certain is that part of the Nineties' desire to create also went with a program of active retreat.

<div align="center">*</div>
<div align="center">* *</div>

What the retreat was from, earlier pages have described: the industrial world. It had long caused stress and strain, and the accumulated complaints were summed up in the charge that business, imperialism, labor unrest, and war were destroying civilization. The facts were reinforced by the superstition that fin de siècle—the end of years numbered in 18 hundreds—somehow indicated all things coming to an end. Events, it is true, were suggestive. The Third French Republic was shaky and threatened by "the man on horseback" (military dictatorship). England felt its industrial and commercial supremacy slipping away and labor threatening.° Germany, while glorying in its freshly won imperial might, was rent by a struggle between the state and the Catholic population—Virchow called it a *Kulturkampf* (war of cultures)—and by the violent action of socialists and workingmen inside Parliament and outside.

Italy and Spain were no less disunited over similar issues of religion and governance. In Norway nationalism was brewing the revolt that within 10 years would make the country split off from Sweden. When a French newspaper in 1895 opened a survey on the question "Are We Decadent?," it cited the "crises" in parliamentary government, rebellion in the colonies, the falling birthrate, and the strange turn in the arts.

Near that date, a book called *Degeneration,* by a German physician named Max Nordau,° had gone through several editions in central Europe and been translated into the other languages. It professed to show that every well-known artist of recent years was a neurotic, an alcoholic and drug addict, or had died insane. His scope may be gauged from the headings of his central chapters: The Pre-Raphaelites; Symbolism; Tolstoyism; The Richard Wagner Cult; Parnassians and Diabolists; Decadents and Aesthetes; Ibsenism; Friedrich Nietzsche; Zola and His School. The list sounds like the description of a course in late 19C thought and culture; after which the last two chapters: Prognosis and Therapeutics suggest the confidence of a psychiatrist who can take on half a century of intellect and sanitize it. Nordau's clinical facts were well set out; his conclusion was that the arts indicated social decay and furthered it. Hence their influence must be resisted by all healthy minds. The call went unheeded. Not only did the popularity of the arts increase, but their moral and social message became more and more hostile toward society and persuaded the literate that Europe *was* decadent. The pope wrote a Latin ode bewailing the fact.

> A noble age, begetter of good arts, is dying. Whoever cares to may celebrate in song the conveniences and laws of nature that have been brought to light. For my part, the misdeeds of this declining century affect me much more forcefully. They make me grieve and feel wrathful. What shame, what towering examples of disgrace do I descry when I look back!
>
> —POPE LEO XIII (JANUARY 1901)

To such a conviction, responses vary with temperament. In the bad days of Realism (<559) Baudelaire had recommended drugs—"artificial heavens." In the generation after him, the extraordinary youth Arthur Rimbaud, who wrote all his poems between the ages of 15 and 20, chose violence—at least in words. He would destroy everything if he could. He began by roughing up the language and the form of verse (622>). Later he disowned his works as "rinsings," by which he meant at once dishwater and things watered down from others' work—he may have been thinking of his use of Coleridge's *Ancient Mariner* in his own *Bateau ivre.* In his other poems (two in free verse, others in prose), his aim was "to disorganize the senses" so as to erase the associations that possess our minds. Perception of the world must begin again from a clean slate. When adult, Rimbaud the anarchist and anti-rationalist left western Europe for the Near East; he lived and died there as a miscellaneous trader, with apparently no intellectual interests or companionship.

*
* *

Rimbaud is the first of those I have elsewhere called the French Abolitionists, bent on complete cultural destruction. A contemporary of Rimbaud's who emerged later and had the same goal was Isidore Ducasse. Under the pseudonym of Comte de Lautréamont, he wrote a series of prose fragments called *Songs of Maldoror*. They tell of the young author's hatred of Man and God and his worship of the Ocean, alone pure and life-giving, particularly of monstrous and repulsive creatures. The stream of nightmarish visions is often poetic-erotic; the imagery resembles that of the Symbolist poets (620>), but the denunciation of the cultural past and present is lucid. The pseudo comte voices the aristocrat's disdain for the common life and its habitat, the stance also implied in Villiers de l'Isle-Adam's dictum when describing the conditions of an ideal state: "Living? Our servants will do that for us."°

The most explicit Abolitionist is also the one who tried to embody the doctrine in his day-to-day behavior: Alfred Jarry. His best-known work is the play *Ubu roi* (*King Ubu*), in which the main character serves a double purpose; he is to be laughed at with contempt as stupid, arrogant, and incapable; and he also throws back on the world these same feelings. Jarry dressed in outlandish garments like Ubu, spoke in a high falsetto—like Ubu—and acted erratically and offensively. He pretended to be a good shot and would without reason point a revolver at a bystander, one of whom he once wounded with a blank. Jarry would repeat with variations one of Ubu's speeches: "We won't have destroyed anything unless we destroy the ruins too." Jarry died of alcoholism.

> Everything in Jarry, that strange humbug, smelled of affectation—his face whited with flour, his mechanical speech without intonation, the syllables evenly spaced, and the words made up or distorted.
>
> —ANDRÉ GIDE (1926)

The work and its author find admirers today; a New York acting group for avant-garde plays is named the Ubu Theatre. Others take the play less seriously and enjoy the humor that still others see as intended rather than realized. Jarry made up the name Ubu from that of a teacher, one Ebé, whom he had hated and ridiculed in school, and the adolescent fun is prolonged in Jarry's sequels and commentaries on the play.° The scene is Poland, "because that means Nowhere," presumably an allusion to the country's frequent annexation and loss of identity. Ubu invents swearwords and talks in a manner supposedly Rabelaisian. In the text, the word *finance* is spelled *phynance* and reference is made to the science of *pataphysics*. The verb *merdre*, from the scatological noun *merde*, was regarded, when the play was produced, as a bold invention weighted with satirical force. And so were the speeches that seem to say something but carry no discoverable sense.

The reception of *Ubu roi* and the legend rapidly formed around Jarry's antics have given him and his hero a place as the carrier of a central message for his time: Destruction. The Abolitionists were surrounded by writers who held the same estimate of the contemporary world but relied on its destroying itself. These were the Decadents. They took the name for themselves and *Décadence* as the title of one of their innumerable little magazines. The designation made them neither sad nor angry; there was even something chic— late Roman Empire—about being the last and the doomed.

But side by side with them, writers of a different order chose another means of assuaging the pain they felt. They turned their back on ordinary existence and through their poems created an ideal one to live in, a realm of beauty attainable only by fit spirits. Their art was not descriptive; the ideal was conveyed in symbols to keep it secret and sacred. This Symbolist school of poets—Mallarmé, Verlaine, Laforgue, Tailhade, Moréas (who gave the group its name) was the pre-eminent one of the early Nineties. For them and their admirers among the public, art for art's sake really signified art for life's sake—art is what helps us to live; without it existence would be unendurable. This had been Schopenhauer's credo. It has remained, barring the interruption of the Cubist Decade (643>), the comfort of sensitive persons unwilling or ill-equipped to wage the battle of life.

The form and coloring that this conviction took at the turn of the century, not in France alone but in artistic circles throughout Europe, found its English expression in the writings of Walter Pater, a modest Oxford don, who pondered the masterpieces of painting and literature to extract from them some magic to enhance life. He found it in the resolve to make each moment carry a unique sensation of the most exalted kind, "to burn," as he put it, "with a pure gem-like flame." The hero of his one novel, *Marius the Epicurean,* does so and may be taken as the prophet of the Nineties religion. It deserves that name not alone because it considers art the highest spiritual expression of man, but also because the world that it rejects is in fact "the world" in the Christian sense of pleasures of the flesh, wealth and self-seeking—all the vanities. The artist and his disciples do cultivate the senses, but not in a carnal way.

Pater was not the man to make a stir with his philosophy of life. Fortunately, he had taught the perfect bearer of the gospel: Oscar Wilde. He personified the ideal Epicurean; he was the living embodiment of the new social type, the aesthete. But he was much more and he is due recognition for what he did beyond playing that role and being the victim of a famous prosecution. His true worth has been blanketed by the figure of the *poseur* and the homosexual. As playwright he wrote the most brilliant farce in the English language, *The Importance of Being Earnest* (<615), as well as other plays that helped break down the Victorian prejudice against the woman who takes a

lover, while the man remains "respectable." He wrote delightful fairy tales for grown-ups (originally for his two children) and a few fine poems, of which one—"The Ballad of Reading Gaol"—is masterly. As a maker of epigrams he deserves a place next to the best of the French; and as a critic he belongs in the first rank, both for the three long essays that define aestheticism and for his reviews of current books, which contain maxims worth remembering about life and literature. His apologia *De Profundis* is a moving chapter among autobiographies, and his article "The Future of Socialism" shows again the well-balanced mind, as much at home in the worldly world as in the world of art.

From this sketchy recital it may be seen that if Wilde, like Bernard Shaw, resorted to acting a part, it was in the interest of the causes they espoused; they made up each a personage whom the responsible critic must see through in order to judge rightly the solid and varied accomplishments that lie behind. Now, as to Wilde's representation of the aesthete: the name by etymology refers to sense impressions. The aesthete is expert at recording and judging sensations. He perceives more in the universe and makes finer distinctions than the common creature. In works of art, which are bound to be difficult if they are genuinely art, he sees everything where the rest see nothing. Two things follow: art needs a critic to interpret it for public appreciation and the critic must be as gifted as the artist to see deeply and justly into the work. Hence a piece of true criticism is a work of art. The Nineties were a time especially rich in critics, and the position that criticism acquired then, on the strength of Wilde's aesthetic reasoning, has not been disputed since. A hundred years later, it is true, critics have evolved: there are a dozen different species that determine exactly what the artist did that he knew nothing about and what inner or outer forces drove his mind. The latest practitioners, called Deconstructionists, have finally got the upper hand and disposed of the maker altogether in favor of his public, Tom, Dick, and Harry, all adept at "creativity" (788>).

<p style="text-align:center">*
* *</p>

In the original aesthetic outlook the only criterion for judging art was perfection of form, which was deemed the essence of beauty. All other features are irrelevant. This exclusion makes art "autonomous." Being independent of subject matter, including ideas, social, moral, or religious, each work is a complete world. This contradicts some 3,000 years of artistic theory and practice, but it has the advantage of detaching the work from this world and enabling the beholder to feel himself in another, by definition perfect and beautiful. These assumptions form the basis of the talk about "pure art." The concept owes something to Poe (<562), whom Baudelaire interpreted for the

Europeans, and also to Pater, who said that all the arts were tending toward the condition of music, which was supposed by these predominantly non-musical poets to be form pure of contents, nothing but inner relations. Purity is another evocative term implying EMANCIPATION from things as they are.

The Nineties' theorizing about the graphic arts was reaching the same position. Roger Fry, Clive Bell, and others asserted that painting consists of line and color and nothing else; sculpture presents volume and line. The relations of these elements are the points of interest and signs of mastery. The apparent subject is a mere excuse or pretext for design. A work therefore has no meaning expressible in words. It is philistinism to look at it as if it represented any thing or idea (646>). Whistler's famous picture of his mother sitting in a chair is nothing but what its title says: "Arrangement in black and gray No. 3." Those words hint of an influence on the doctrine that its promoters may not have been conscious of. Like the would-be purist in art, the scientist takes a concrete experience and by an act of ABSTRACTION brings out a principle that may have no resemblance to the visible world. Thus the ideal of form in art resembles the idea of mass in physics: externals disregarded to reach essence. This entire system—if it deserves the name—helps to explain a large part of 20C art that would otherwise be incomprehensible (723>).

Poets and prosaists, whether Abolitionist, Decadent, or Symbolist, found that to create works adequate to their vision the language must be re-created. Symbolist diction needs words that suggest rather than denote. Mallarmé called it "giving a purer meaning to the words of the tribe." At the same time, abolitionist purposes require grammar and syntax to be defied. Decadent feeling looks for vocables of the rich and rare kind that imply the sensual indulgence of Sardanapalus about to die amid his treasures and his women. To "disorganize the senses" as Rimbaud wished, images are juxtaposed without links and come from contrary parts of experience. Successive lines have no apparent connection. The strange words that Laurent Tailhade threw into his lines disconcerted in another way, so that little glossaries were compiled for the relief of the bewildered. Mallarmé resorted to yet another device for this general brainwashing. He looked up in Littré's dictionary on historical principles some long-forgotten meaning of common words and used these in that sense.° From all these deviations, poetry—and by contagion prose literature and the other arts—become objects of study that start as riddles.

The period thus contains the models and methods of all modern poetry since: free verse,° language distortion, calculated obscurity. One apparent exception is the poetry of our day that combines free verse with ordinary colloquial prosiness, as in the works of William Carlos Williams, in children's poetry, and the contributions that newspapers print; but even this mode was prefigured a century ago in the works of the English poet John Davidson. To the extent that this last poetic style also disregards regularity, the forward

march of literature since Rimbaud has been a vast collective EMANCIPATION. One can understand and sympathize with the motive that led to linguistic tampering. If the goal was to shut out the external world of the daily press, one must get rid not only of its clichés but also of its mind, which consists of plain words, short sentences, and unchanging adjectives that explain all things with equal ease.

What is singular about the philosophy of aestheticism is the combination of the striving for purity and the Pateresque program of making life a series of strong sensations. Plato, who was the first worshipper of Form, made no such mistake: his love was mathematics, not the aesthete's revel in images of physical beauty and elaborate decoration, delicate colors, sounds, and textures—such as are found in the prose of Pater and Wilde, the poems of Verlaine, and notably in Huysmans' novel about Des Esseintes, who makes a cult of collecting fragrances. Mallarmé himself was not above writing advertisements for perfume. The prevailing tone of the artistic Nineties is voluptuousness, subtle, to be sure—mauve rather than purple—but still physical and far from mathematical pleasure.

The paradox was inevitable and in its way touching. Artists, whatever they may say, are by nature uncommonly alive to sense impressions, every art calling for keenness in one or more of the senses; their practitioners' one aim in life is to give their conceptions material being. The musician, far from dealing in pure forms, molds tons of air. "Abstract art" is a contradiction in terms (723>). The social motive for the aesthetes' retreat into art being clear, there remains the question, what motive made purity a second necessity? Mallarmé gives the answer in his superb sonnet, written in clear language and entitled "Brise Marine" (Sea Breeze). The first line reads: "The flesh is sad and I have read all the books." The last six words tell us that the whole weight of past literature bears down on him and adds to his pre-existing sorrow. Exactly 100 years earlier Faust had said the same thing, also in the first line of his soliloquy—all the books are dust, not life. Each of the two utterances records the end of a cultural age, 1790 and 1890.

<center>*
 * *</center>

Naturalism is the period's other, broader movement, and as its name indicates, it is the exact opposite of Symbolism. With a few exceptions, Naturalism finds expression in the novel, where persons and objects are described in ordinary words and the reader, far from being transported to an ideal realm of beauty, is thrust among the sordid places and vulgar predicaments of the present. It was shown earlier how Ibsen, Shaw, and other playwrights performed that same task. The novelists had a larger canvas to fill with horrors and could deal with subjects not easily stageable. Like the plays,

the novels said: "Look; it is not as you think." The effect was to destroy the conventions of the respectable by showing how they and the other half of society actually lived. One may ask how this differed from Realism. In two ways: the Naturalists pretended no aloofness from the scenes they described. Without preaching, they compelled the reader to be appalled and indignant, so deeply that sometimes the shock brought reform. For example, the exposure of meat packing in Chicago by Upton Sinclair in his novel *The Jungle* led President Roosevelt to investigate and install the Pure Food and Drug Administration. The master producer and theorist of the genre, Zola, declared the Naturalistic novel scientific by virtue of its method—or at any rate *his* method, which was to collect news items and official statistics, as well as social and medical studies before framing plot and character. All these provided the "nature" to be reconstructed in Naturalist fiction. He systematized Balzac's claim that his works amounted to a social zoology (<560).

The transition between these two novelists a generation apart was effected by the Goncourt brothers, Jules and Edmond. They began as dilettantes interested in 18C manners and ladies, in Japanese art, and other aesthetic curiosities. Writing on these subjects, they became good cultural historians and when they turned to novel writing they presented their works as "documentary" and reliable. One was about a servant (their own), who leads a double life, blameless and debauched; others of their "studies" were about the vicissitudes of a circus and about the troubles of a hospital nurse. These stories are no longer read, partly because they are written in short impressionistic scenes that must be fitted together by the reader, and because of their contorted style, which the authors called *prose d'art*.

Their connection with Naturalism (the document) and with Symbolism (a special language) shows the weak point in Zola's theory. When challenged by critics who denied that a novel could be scientific, Zola redefined Naturalism as "Nature seen through a temperament." Scientists too have their little ways, but these do not appear in the product. In the novel it turned out that temperaments were liable to alteration. The Naturalist Huysmans turned Symbolist; the Gissing of *New Grub Street* shortly before his death was planning a historical romance; and young André Gide, who absorbed the Symbolist atmosphere as he came of age, abandoned it for direct discourse when he came to write novels.

Zola's backtracking did not change the tone and animus of the Naturalistic novel as produced by many different temperaments: Zola, Mirbeau, Huysmans (the early works) in France; George Moore, Gissing, Arnold Bennett, the later Hardy in England; Frank Norris, Hamlin Garland, Upton Sinclair in the United States; Douglas Brown in Scotland; Maxim Gorky in Russia. In the best Naturalist novels—certainly in Zola's—the reforming purpose imparts great energy to the world it portrays: it is not

Realism; because one feels the zest for life in the worst characters and the worst circumstances. *Germinal,* which deals with a strike in the coal mining region, is a particularly good example because of the passions aroused. But even in the average apartment house of *Pot-Bouille* (*Restless House*) or the drunkard's milieu in *L'Assommoir* or the prostitute's in *Nana,* the reader is not exposed to the listless mood of Flaubert's *Bovary* or *The Education of the Feelings* (<561). When Naturalism pointed to social decadence, it was to the sound of drums and trumpets.

A shelf full of novels, however fine, could not expose all imaginable evils—or cure them—but among other revelations it threw its glaring light on the secrets of sexuality, which in a sense is nature itself; and as novels reach a wider public than plays, the outbreak of truth-telling provoked a storm. It galvanized Dr. Nordau (<618). For now the facts were shouted from every quarter. Hardy's *Tess of the d'Urbervilles* and *Jude the Obscure* showed that an irregular sexual union did not blight a woman's character—Tess was "a pure woman faithfully presented." The relations of Jude and Sue showed both the urgency of the instinct and the revulsion it can cause. Grant Allen's *The Woman Who Did* by its title alone caused a furor; innocent as readers might appear, they understood. It was the shock that did the good work. George Moore's *Esther Waters* and H. G. Wells's *Ann Veronica* put sexuality back as a force among other social forces, the interaction always a danger and a cause of disaster under the present convention of systematic blindness. The scandalous topic could no longer be ignored and to chart this unruly power meant discussing marriage and the family. Bagehot's friend R. H. Hutton had long ago remarked: "The dark places of the earth are the happy Christian homes."

The structure of constraint and deceit about sex and domestic life did not prevail only in England. In his best work, the satire *Penguin Island,* Anatole France delivers a little lecture on sexuality and convention. Maupassant's short stories dealt with both these topics. Abroad, Tolstoy had recorded in *The Devil* an episode of sexual obsession—his own. Sologub in *The Petty Demon* combined sexual and symbolic themes; and in central Europe, plays and novels on the subject poured forth once secrecy had been breached: Wedekind's *Spring's Awakening,* Sudermann's *Magda,* Strindberg's *Miss Julie,* and other studies in the aberrations of love. The body of work by Arthur Schnitzler, the Viennese playwright now unjustly neglected, explored the varieties of sexual relations in a civilized capital, from *Liebelei,* the "unimportant affair" that ends badly, to *Reigen,* the successive encounters that interlink upper, lower, and middle class, admirably filmed as *La Ronde.*

Worse to think about was the itinerary of venereal disease that Ibsen retraced in *Ghosts* and Brieux in *Damaged Goods.* And next, a hint that homosexuality was to be accepted as an irreducible fact appeared in a novel, quickly suppressed.° Swinburne's and Edward Carpenter's poems had been similarly

allusive, but poetry is easily misread. Aubrey Beardsley's striking black-and-white illustrations to various texts ranged over the whole of sexuality, including the hermaphrodite.° And Wilde's two trials were public enough to propel a question that in the mid-1920s Gide's *Corydon* and Radclyffe Hall's *Well of Loneliness* kept alive by shocking until it became the openly discussed topic that it is at present.

The riddling and ruining of the previous ethos by men of letters was no routine exercise in bourgeois-baiting; it was a strenuous effort of the moral conscience, which included a positive aim: to do justice to women in every respect—sexual, social, and political. The same conscience moved a number of sociologists and physicians, their works buttressing the literary positions. Paolo Mantegazza compiled three volumes on *The Sexual Relations of Mankind*; René Guyon half a dozen on the *Legitimacy,* the *Ethics,* and the state's attitude toward the sexual act; Patrick Geddes described *The Evolution of Sex*; Otto Weininger wrote *Sex and Character*; Iwan Bloch described *The Sexual Life of Our Time and Its Relation to Modern Civilization,* and Havelock Ellis's seven volumes of *Studies in the Psychology of Sex* gave the first account of the subject through case reports and commentary. The abnormal manifestations had been studied earlier by Krafft-Ebing.° At the same time, well before Freud, physicians were noting the presence of sexuality in infants, the last domain where "purity" interpreted as absence of sexual feeling could take refuge.° In the United States a lone pioneer, Dr. Denslow Lewis, met with great resistance from his colleagues when he tried to publish his paper on *The Gynecologic Consideration of the Sexual Act.*° One of his relevant facts was that the age of consent in several states of the Union was nine years.°

*
* *

After all this it should be clear that the sexual revolution—if that is its right name—took place *then* and not now. The mid-20C amplified and extended the EMANCIPATION that the Nineties fought for and began to practice. An emblem of the changed attitude: in 1900, FitzGerald's translation of the *Rubaiyat of Omar Kayyam* reappeared after 40 years of obscurity and graced the coffee table, appropriately bound in limp leather. In short, *The Joy of Sex* is a late-20C book title, but proclaiming the fact dates from the Nineties.

Women's emancipation ran parallel to the sexual and interacted with it. Free love was a slogan and a vogue; divorce became more frequent and less reproved; Parliament took up marriage with deceased wife's sister and talked about it with unusual freedom. The Commons had already passed the Women's Property Act that abolished the husband's grip on his wife's fortune. Oxford and Cambridge each founded a college for women, after several years of offering extension classes and degrees by examinations. The queen

herself approved. And public schooling for the whole nation was beginning to make literacy commonplace for both sexes. Robert Lowe M.P. had said on voting for the measure: "We must educate our masters." Well-to-do families had not waited for this democratic move to give their daughters good instruction in history and general literature. After the male playwrights' and novelists' converging critiques, it was possible for Shaw to put the New Woman on the stage (in *The Philanderer*) and begin to take for granted the vast difference from the old in manners and rights.

The liberation from sexual taboos and the rise of the freedom to live and to love on the same terms as man had been preceded by a large-scale activity and influence, now forgotten. Women in the 1870s and 1880s dominated the field of English fiction for educated readers. In the first of those decades nine of these professional writers published a total of 554 novels—an average of 61 apiece.° The dozens of other producers satisfied an inexhaustible hunger for romance, for history dressed up, and increasingly for "problems," religious, social, and sexual. Leslie Stephen, Virginia Woolf's father-to-be, predicted that it would not be long before women held a monopoly of novel-writing. What did happen was that fifty years after his prediction, instead of scores of women authors, England would boast hundreds. George Eliot's *Middlemarch* and Meredith's *Egoist* (<564) are of course in a class apart. But *The True History of Joshua Davidson, Christian Communist* by Mrs. Lynn Linton proved extremely popular in the 1870s. Among some 40 authors whose names send a faint echo, any reader of today who has spent time in summer hotels where old books linger will come across Rhoda Broughton, Amelia Edwards, Miss Braddon, Mrs. Oliphant, the witty "John Oliver Hobbes," and perhaps Marie Corelli, and the passionate "Ouida" (Louise de la Ramée), in whose well-printed and violently illustrated works a great deal of talent and social thought are buried. Hidden away with them are a couple of satires by men: Laurence Oliphant's *Piccadilly,* which demythifies high society, and *Gink's Baby* by Edward Jenkins, which makes savage fun out of Parliament, the law courts, and the religious sects. Trollope was helping on the good work too, notably in that fine satire *The Way We Live Now,* but was undervalued as being neither a genius nor a truly popular writer.

Fewer than their novelist sisters, but steady producers too, women poets published epics and long stories in verse, love lyrics and poems about nature. These filled the keepsake albums and were praised sincerely but mistakenly by male reviewers; they had perhaps not enough material for comparison. Emily Brontë and Christina Rossetti stand out as poets, not poetesses, but their output was small and obscured by the familiar voices of the old-established Tennyson and his peers. Meredith, as poets like James Thomson, the author of "The City of Dreadful Night," were hardly prized. An atheist and political radical, Thomson was as disreputable as Swinburne.

In making their case for Eros and an open world for women, the argumentative artists of the Nineties seemed once more to forget their own dogma that art has nothing to do with morals. They had in mind the old morals; and they forgot at the same time that getting rid of one code of behavior inevitably tends to install its opposite. In the course of training the public to use a new set of standards for judging art and life, this host of critics of life accustomed the crowd to bear up under shock—indeed to expect it, particularly from the arts. The lesson took so well that shock from art is now required.

For the ordinary citizen who yielded to the temptings of change, throwing off the compulsions and habits of the preceding age felt like going from a house of discomfort into the open air. And the image was close to the reality. Attention to the individual included his bodily health. It was then that hygiene, public health, the flush toilet, and clean water supply joined town planning in the drive to reform everything and inspired at the same time new tastes, activities, manners, and institutions. As Paris couture gained world dominance, the rigidities of dress were relaxed. The designer Paul Poiret liberated thousands by decreeing that the well-dressed woman need not wear a corset. The bicycle and lawn tennis had already begun to loosen the limbs and their coverings. The outdoor life beckoned. New games of throwing or kicking a ball helped to give a new meaning to the word *sport*; it was soon an institution for both amateurs and professionals. An English soldier founded the Boy Scouts; schools added gymnastics to the program. Skiing, imported from Scandinavia, was transformed from makeshift wintertime travel into an all-year pleasure industry.

The machine—railroad, motor, bicycle, plane, motion picture—lured the senses into a new addiction: speed. Trains could now run at 100 miles an hour. But speed in an enclosed space quickly loses its thrill. The car, then mostly an open affair, makes the wind jet passing the ears give a sense of heroic recklessness. In 1901 the poet Wilfrid Scawen Blunt wrote in his diary: "Going at 15 miles an hour. It is certainly an exhilarating experience." He would have been even more exhilarated nine years later had he crossed the Channel in the cockpit of Blériot's airplane—or he could have taken up the new sport of hang gliding from hilltops.

Offsetting these cheerful doings was the increase in mental illness and the spreading use of drugs. Something in industrial civilization seemed to be too much for the steadily alert mind to bear. In a long essay, *Civilization, Its Cause and Cure*, Edward Carpenter gave a clear account of the affliction and specified as remedy a simple PRIMITIVISM. At the Paris hospital La Salpêtrière, Charcot and Janet dealt with a stream of patients suffering from hysteria, the name that covered depression, anxiety, causeless excitement, motor disturbances, and "simulated diseases"—those that have no discover-

able basis in the body. Some few of the troubled had multiple personalities. One hears an echo of the strange fact in Stevenson's tale about Dr. Jekyll and Mr. Hyde.

An increasing recourse to drugs suggested a like maladjustment. Addiction, mainly in the upper classes, was viewed with sympathy. It was not a criminal offense to buy or sell morphine. Freud for a time prescribed cocaine to some of his excitable patients, and we know that Sherlock Holmes, when he was bored, injected himself with a 7 percent solution. Soon after their accession, the tsar and tsarina in St. Petersburg were taking a mixture of marijuana and hyoscine by way of relief from official cares. More thorough-going, a man named Aleistair Crowley preached the joys of the drug experi-ence combined with black magic.° Thus the late Timothy Leary was not the first in his line. Nor have acolytes disappeared: a new edition of Crowley's *Magick* appeared in 1997.°

<center>*
 * *</center>

The contrast between the enthusiasm of the innumerable reformers and the belief that civilization was at once decadent and too harsh for the thoughtful to live in and stay sane was matched by the contrast between the regard for individual well-being and the violence in many forms that threat-ened life. The turn of the century treated itself to four big wars and a handful of lesser conflicts, all marked by atrocities and massacres not needed for vic-tory, but continuing proof that the perpetrators were indeed human. After years of meddling in Cuban uprisings, the United States fought Spain and acquired its first colonies. England, after long involvement in South African conflicts, fought the Dutch Boers, incidentally learning from the medical review of their own recruits in what poor physical condition were the English lower-class males. The Boer War also showed up English generalship and ended in a treaty praised as liberal because it left the Boers in charge of south-ernmost Africa; but it also left there *apartheid*—discrimination against Indians and Blacks that required later bloodshed before it was abolished. Japan fought China, mainly over possession of Korea, and thus laid the ground for many-sided conflicts later on. Japan then fought Russia over Korea and Manchuria. The Russian defeat demonstrated the nation's incompetence and persuaded the West that it now faced a "Yellow Peril."

The Chinese meanwhile had been harassing the foreigners in their midst who held territories and concessions and were always seeking more. A nationalist group, called Boxers from their symbol of the clenched fist, mur-dered some 250 westerners and finally drove the European diplomats in Peking into their embassy compound, while killing missionaries and traders in the provinces. A force of Europeans and Americans, led in part by a

German general, was sent to relieve the besieged and followed up their success by massacres elsewhere. A huge indemnity was levied, of which the United States devoted its portion to fellowships that enabled Chinese students to attend American colleges.

So much for professional violence. The amateur kind was expended on kings, heads of state, and other political figures (695>). A bomb in a Barcelona theater made a point that presumably could not be made in any other way, and our time has faithfully applied the technique. In those pioneer days it was "the Anarchists" or "the Nihilists" who were blamed, causing perpetual confusion in the use of the terms. The true anarchist is a gentle trusting soul who argues for a world without government—a type Marx would turn into after the necessary dictatorship (<589). But in the Nineties there were impatient anarchists, who wanted immediate results and relied on Alfred Nobel's recent invention, dynamite, to gain their ends. It was from remorse at this misuse of his product that Nobel established his prizes. As for the Nihilists, they too are often mislabeled. The genuine kind believe in nothing and do nothing about it. Disillusion, cynicism demonstrate that every action, even getting up in the morning, is futile. The type is depicted in two Russian novels and in Dickens's *Our Mutual Friend.*°

The general restlessness apparently affected criminals too. It drove cat burglars and safecrackers for the first time out of their private enclaves in cities and spread them all over town, upsetting police routines and increasing their own opportunities. Some of their exploits apparently excited the public in a new way: it began to welcome fiction glorifying the gentleman burglar. Raffles and Arsène Lupin were Robin Hood redux in evening dress. The creator of Raffles was the brother-in-law of Conan Doyle, whose Sherlock Holmes, equally in demand, has outlived the upper-class thief and remains a leading indicator of that past time.

Like another piece of make-believe, but grimmer, the incredibly long-drawn-out Dreyfus Affair aroused passion and prejudice throughout the world. In France the chain of misdeeds—treason, coercion, perjury, forgery, suicide, and manifest injustice—re-created the cleavage of "the two Frances," always recurring at critical moments. The nearest had been "1789"; the next was to come with the German occupation in 1940. The battle about Captain Dreyfus's innocence while he was in prison for life on Devil's Island posed for the intellectuals on both sides the dilemma: the individual or the state? Zola's decisive appeal to public opinion was argued in rational detail, not in ringing tones, as suggexted by the defiant title *J'accuse* supplied by Clemenceau, and INDIVIDUALISM finally triumphed.

Since the Nineties the Left and the Right have fought battles under these mutually oblique names in other countries, the issues seemingly unlike on the

surface but linked underneath to the choice between expansive change and restrictive status quo, between Liberal and Conservative, with fitful surges of Radical, which sometimes means change by force of arms. It was during "the Affair" that the word *intellectual* became a noun with its present connotation of professional of the mind holding social and political views. It bears the relation to thinker that aesthete does to artist: it denotes a large group of people articulate for a cause and often militant, without being themselves artists or thinkers. [The book to read is *Nineteenth-Century Opinion,* an anthology of extracts, 1877–1901, ed. Michael Goodwin.]

*

*　　*

Moral and social attitudes are one thing; the works of art that come out of them are another; and the theorizing that accompanies the art is a third. The interconnections among the three are interesting and may add to one's understanding, but they rarely help to determine the quality of the art or the pleasure it can give. One can enjoy and admire a neo-classical tragedy while rejecting its monarchical tendency, and one can read Rimbaud, Mallarmé, and Laforgue without suffering the horrors that they felt or wanting to destroy the world. One can do the same with science—admire the results and distrust the assumptions. That is what happened in this all-questioning period. First a short list of results: elegant experiments by Michelson and Morley in the late 1880s had shown that the ether, the substance imagined as the carrier of light waves throughout the universe, had no existence.° It was a blow to the mechanics of Newton that took it for granted there could be "no action at a distance"; everything happens by push or pull.

From another quarter it appeared that the Clerk Maxwell equations for electromagnetic events did not fit certain phenomena that came out of advances in chemistry. In the 1870s the table of the elements drawn up by Mendeleyev showed that they clustered in groups with similar properties. And there were gaps in the series that suggested the existence of others as yet undiscovered but with predictable characteristics. Two young chemists working in the Nineties with Becquerel and Bémont, Pierre and Marie Curie, extracted from pitchblende some stuff that wasted away into nothing, though it produced heat and electrical effects. The phenomenon was called radiation. One emerging fact after another led to Max Planck's Quantum Theory, which states that radiation is not continuous but occurs in separate small units. They cannot be dealt with individually, but only by calculating the "half-life" of the whole. Incidentally, a "quantum leap" is not the great pole vault that jargon assumes from the impressive sound of the words: it happens inside the atom without being detectable. Undetected in a different way, Willard Gibbs, work-

ing at Yale on thermodynamics, laid the foundations of the new science of physical chemistry, but recognition of its value and his methods was much delayed.

These discoveries put in doubt, not the vast amount of knowledge about nature amassed since the late Middle Ages, but the assumptions beneath the physics and chemistry elaborated in the 19C. Nor was it the mechanical view alone being upset; the idea of a "law of nature," akin to a statute law invariably enforced, seemed no longer a sound metaphor. As early as the 1870s it was pointed out that natural laws were only observed regularities measured carefully but not absolutely. Next, an American theorist, J. B. Stallo, showed in detail the inconsistency among the ideas used in different parts of physics. To be sure, science has never been troubled or hampered by shaky foundations, but in the spring-cleaning mood of the Nineties, all such rifts in Positivism (<509) added something to the discomfort, and the laity was puzzled. [The book to leaf through is *Album of Science: The 19th Century* by L. Pierce Williams.]°

The multiplication table is in need of review and reform.

—STRINDBERG, *THE BLUE NOTEBOOK*

Henry Adams, who kept abreast of ideas in many fields, was dismayed especially by what was happening to Evolution: not that it was being rejected, but how it produced new species was the object of debate. Mendel's work on the color of sweet peas had been rescued from obscurity after 30 years and a new science, genetics, based upon that work, established the notion of dominant and recessive characteristics. It suggested to Weismann that the "conflict for survival" took place within the plasm. Without theorizing, Bateson and others pointed out that species were more stable than Darwinists liked to think. Du Bois-Reymond believed his experiments showed that characteristics acquired in life could be inherited, as Lamarck had said and the Darwinists (but not Darwin) denied. De Vries was struck by the occurrence of "sports," familiar in animal husbandry—offspring quite different from the progenitors. He called these "mutations" and considered them more important than Darwin's small random variations.

Forty years ago, our friends always explained things and had the cosmos down to a point, *teste* Darwin and Charles Lyell. Now they say they don't believe there is any explanation, or that you can choose between half a dozen, all correct. The Germans are all balled up. Every generalization that we settled forty years ago is abandoned. The one most completely thrown over is our gentle Darwin's Survival, which has no longer a leg to stand on.

—HENRY ADAMS (1903)

On this view Evolution might be discontinuous. Abstractly, it looked like quantum radiation. Hans Driesch, working on embryonic cells and finding that position affected their role, became a vitalist, together with other scientists and philosophers, notably J. S. Haldane,° who was qualified in both domains. Philosophically, it seemed as

if there were a general impatience with Matter, which had loomed so large and pressed down so heavily on 19C thought. The data suggested discarding it along with the rest of Victoriana. This sweeping out was undertaken in the most interesting, though at the time fruitless, way by

Samuel Butler

Like William James, the young Butler thought that he might make a career as a painter. Both did creditable work for their studio masters and each left a couple of good portraits; but they decided alike that the vital spark was missing, and both wound up as psychologists and philosophers, although Butler never sought or held such professional titles.

When *Origin of Species* came out, Butler was immediately convinced that evolution was the best hypothesis for replacing the biblical account of man's creation. On that point Darwin's book only confirmed an idea already well discussed (<455; 501; 571); but on the other point, the main one, of struggle and survival as the means by which evolution works, Butler had strong doubts. He put them to Darwin, was not properly answered, grew angry, and unwisely protested in a way that fastened on him the reputation of a crank. It doomed him to leading his intellectual life on the outskirts of literature, publishing his books at his own expense, and emerging posthumously in the early 20C as the author of a novel, *The Way of All Flesh*. Its timely concurrence with the new ethos made his name.

Much earlier, in the 1870s, he had published anonymously the satirical utopia *Erehwon* ("Nowhere" spelled backward), in which we find him already attacking the two idols of the century: Progress and Respectability. He calls churches "musical banks" where one keeps an account of merit and demerit to be cashed in as happiness or damnation hereafter. Sin, to the Erehwonians, is being sick or poor, not matters for pity or charity but punishable crimes. As for Progress, Erehwon has machines and keeps perfecting them until the thought occurs that they will soon develop consciousness, win their independence and, being stronger, enslave mankind. It is therefore decided to destroy them—even watches. A few specimens, made harmless, are kept in a museum.

The tale rapidly found readers as long as they could attribute it to one or another well-known Victorian; the book stopped selling when the unknown Butler's name was revealed. This snub was not the best treatment for a man whose character had been bruised by his rearing; *The Way of All Flesh* shows how (<553). It made Butler critical of all things established, and when he attacked he expected debate but got only silence or reproof. The Darwin affair reproduced the experience of home. Yet it is to this one-sided guerrilla war that we owe the remarkable works that fill 20 volumes in the Shrewsbury edition.

The late Samuel Butler [was] in his own department, the greatest English writer of the latter half of the 19C. It drives one almost to despair of English literature when one sees so extraordinary a study of English life as Butler's *Way of All Flesh* making so little impression that, when some years later, I produce plays in which Butler's extraordinarily fresh, free, and future-piercing suggestions have an obvious share, I am met with nothing but cacklings about Ibsen and Nietzsche. Really, the English do not deserve to have great men.

—SHAW, PREFACE TO *MAJOR BARBARA* (1907)

The cloud that hid Butler from his contemporaries has since then been pierced only here and there to let through the light. What suited the temper of the Nineties and 1920s is pretty well known: *The Way of All Flesh, Erehwon,* and extracts from the *Notebooks.* Four works of original philosophizing—*Life and Habit, Unconscious Memory, Evolution Old and New,* and *Luck or Cunning*—are as if they did not exist. Their titles broadly indicate the contents but do not suggest the variety of insights about life and the mind. To combine their arguments would yield something like this: the objection to Darwin's evolution by survival alone is that it relies entirely on Luck; it "banishes mind from the universe," while experience shows mind acting for results that it foresees. Mind is seconded by habit, which starts conscious and becomes unconscious. This composite cunning was the agency that Erasmus Darwin had proposed in his work on evolution (<455) and Butler espouses it, with a list of zoological facts hard to explain by Darwinian Luck. Butler also pointed out that to account for the origin of new species one must account for the origin of variation from the old, which nobody so far knew or had said anything about. These considerations place Butler among the vitalists of his own day and he did receive from Bateson, the geneticist and namer of the science of genetics, a fair tribute at the 50th anniversary celebration of Darwin's book.°

Butler as thinker was in tune with the pragmatist generation (666>). In his comments on the conduct of life he always asks to what result a view will tend, and his guide in ethics is common sense of the Johnsonian kind (<411). This choice is not inconsistent with the fact that whatever his mind turned to inspired in him unusual ideas and projects. He disliked the plushy language in which Homer was translated, so he brushed up his Greek and translated the *Iliad* and the *Odyssey* into colloquial English prose. He liked Shakespeare's sonnets and wanted to elucidate the story they told, if any. He memorized all 154 and concluded to his satisfaction that a small group of them had traditionally been misplaced. After rearrangement, he could follow the straightforward narrative and deal with the autobiographical lines and the puzzling dedication by surmising that Mr. W. H. was not some noble lord but someone called Hughes or Hews, probably a fellow actor. Oscar Wilde had independently reached on the same evidence the same conclusion, detailed in his story *The Portrait of Mr. W. H.* Neither account has received scholarly attention.

Butler liked to spend his holdiays in Italy and what he enjoyed there sup-

plied the material for a pair of travel books, one of which, *Alps and Sanctuaries,* is a gem. But more was to come of his wanderings: exploring Sicily led him to the belief, based in part on geographical features, that it was the goal of Odysseus' journey and, from internal evidence, that the tale had been written by a woman, the princess Nausicaa described in the *Odyssey*. Classical scholars paid no attention; Butler was confirmed in his contempt for holders of chairs who have no curiosity and will not argue against a thesis that is based on reasons lucidly set forth. Only lately has a scholar deigned to discuss this work of Butler's and accorded it respect.° Two volumes of entertaining essays, an admiring life of his grandfather, headmaster of the famed Shrewsbury School, and the *Notebooks* complete Butler's contribution to English literature. The Notes were appreciated after the First World War, because their tone often jibes with the serious frivolity of the period.

"God is love." I dare say. But what a mischievous devil Love is!

To be written: "Tracts for Children," warning them against the virtues of their elders.

"The Complete Drunkard." He would not give money to sober people; he said they would only eat it and send their children to school with it.

It is not he who gains the exact point in dispute who scores most in controversy, but he who has shown the most forbearance and better temper.

—SAMUEL BUTLER, *NOTEBOOKS* (n.d.)°

It was fortunate that Butler did not have to make a living by his pen. As a young man having his way to make, he went to New Zealand, was very successful as a sheep farmer, and returned home with a competence. Later in life it was reduced, partly through a fraud practiced by a friend. What gave Butler most satisfaction in his self-restricted bachelor existence was Handel's music. He detested 19C composers and relished that of his idol so much that he took lessons in counterpoint and (with a friend) composed the words and music of two small cantatas, one of them farcical. Could a man do more to bewilder the public?

*
* *

While pure science was in temporary confusion, medicine was making assured strides. The work of Claude Bernard and Pasteur at mid-century had finally imposed on the ancient art the latest ways of laboratory research, and discoveries followed one another in rapid succession. In his comprehensive study of digestion, Bernard established the functions of the pancreas and the liver, including the formation of blood sugar, and he also made clear the workings of the vasomotor system—the opening and narrowing of the blood vessels—by showing the equilibrium between opposite impulses from nerves

that he was the first to discover. After Pasteur's proof that microorganisms existed and could do amazing things, such as turn milk sour (whence pasteurization—killing the germ with heat), a host of searchers found in one or another shape of bacterium the cause of tuberculosis, diphtheria, anthrax, typhoid fever, leprosy, influenza, gonorrhea, and syphilis, and the parasite of malaria. It was also discovered that ultraviolet rays are germicidal. Out of this fund of knowledge came the anti-toxin or serum therapy. Meanwhile, Hahnemann's principle of homeopathy, that a small dose of a drug whose effect resembled the disease would incite nature to cure it, had been applied by physicians for half a century. Now the parallel with serum therapy had the result of increasing the number of homeopathic physicians and patients. Surgery did not lag behind. Appendectomy enjoyed a vogue and President Cleveland's physician, Dr. Keen, declared: "the abdominal cavity has become the playground of the surgeon."° Add for the record: the systematic practice of osteopathy; Luther Burbank's plant manipulation that yielded as a starter the superior potato; and the founding of the authoritative journal *Science*.

But once more in counterpoint, an interest that had been confined to the classicists in universities was given a different status by the publication in 1890 of the first volume of *The Golden Bough* by James Frazer. The very title suggests a realm alien to science: the work was a study of myths. Originating in all parts of the world, these tales fashioned by early man in many cultures had been gathered by observant missionaries and others in their voluntary exile from Europe. Concurrently, the work of early cultural anthropologists such as Tylor and Lewis Morgan in the 1860s and 1870s had familiarized the public with the ways of the tribal mind. Noting some striking similarities among geographically distant myths, Frazer had begun to classify them and compare details. It seemed obvious that myth-making was a primitive form of science—man explaining the universe, making order among the facts of experience by means of overarching ideas, and embodying these in characters whose acts evoke the truth.

For 200 years myths had been dismissed as ignorant superstitions; now they were seen as expressions of important thought. That they were richly symbolic comforted both the Symbolist poets and the critics of materialism in science, while the rehabilitation of the primitive mind encouraged the renouncers of civilization. The western mind was experiencing one of its periodic attacks of PRIMITIVISM. Rimbaud, Robert Louis Stevenson, Gauguin, Lafcadio Hearn fled Europe permanently. Others such as Henry Adams and John La Farge went on trips to the Near or Far East for temporary relief; and the ordinary tourist was steadily lured by the travel agent's promise of "old world," "unspoiled" places, where the roar of the modern city did not penetrate. Edward Carpenter's essay (<628) goes into great detail about the needs of body and mind for surcease from citification.

The advent of myth, joined to the earthly twins, fatigue and boredom, contributed to the outbreak of Wagnerism. It was an ism and not just the vogue of a particular composer and his works, such as happened for Mahler in the late 20C. Wagner's operas had been before the public for thirty years and were appreciated at their just value by connoisseurs. What occurred around 1895 was a vast extension of his public, thanks to an organized propaganda built on the subject, the message, and the musical system of *The Ring of the Nibelungen*. Music lovers had always been a minority among intellectuals; and the rest had generally ridiculed opera (<327). For the first time now literary people *en masse* took to music—to Wagner's music. They were told that to bridge the gap between their tone-deaf past and this new art form, they must study. Articles, handbooks, lectures were there to help, besides Wagner's prose works in eight volumes. Shaw wrote *The Perfect Wagnerite*; in Paris Mallarmé in a sonnet called Wagner a god, and a *Revue Wagnérienne* was started to confound the resistant and to keep the devotees of the cult abreast of interpretation.

What was there to interpret? A musical system and an array of provocative Wagnerian theories. The master (so ran the thesis) had composed works that made obsolete all previous operas and the genre itself; the new *music dramas* re-created the art of ancient Greek tragedy. Not looking back only, this was the "music of the future" promised to the world as far back as the 1860s. That future was now. In addition, the text of *The Ring* was a great poem, written by Wagner himself and needing interpretation, because it was a social allegory that described how and why the existing order of things was doomed. Total destruction is brought on by love of gold. This catastrophe pleased the Abolitionists and confirmed the Decadents and such of the Primitivists as had not yet fled. It was also rumored that young Wagner had been a revolutionary in Dresden and had barely escaped death in the upheaval of 1848. This endeared him to social reformers.

But what clinched this verbal agitation was the fresh aspect of the operas themselves. No more Realism coupled with tiresome historical subjects such as Meyerbeer and Verdi and their kind, French or Italian, kept using. Instead, a blessedly unfamiliar legend—several legends if one went to see *Tristan, Lohengrin, Tannhäuser,* and *Parsifal*. In *The Ring,* against fantastic scenery, the characters, sporting barbaric names and primitive costumes, declaimed impressively rather than sang separate little tunes that could be whistled on the way out. Having grasped the role of the brief series of notes called leitmotiv and memorized what character or idea each stood for, the listener could follow the extremely detailed story while bathed in the endlessly repetitive melodious flow. As Thomas Mann remarked, Wagner by his system taught his listeners music. And indeed many of the literate found themselves genuinely enjoying it, or at least Wagner's brand. That reliable witness

Sherlock Holmes drags his philistine roommate to "Wagner night at Covent Garden" and does not record any protest from Dr. Watson.

One thing more raised Wagner high in the esteem of those men of letters, painters, sculptors, architects, and critics, who perhaps had never before attended a concert. That was the spectacle of an artist who had conquered stupid resistance from stuffy bourgeois and academics and had died wealthy and revered in his own country. Accounts of him pictured a lord receiving tribute in his castle and a demigod worshipped at Bayreuth. He was the emblem of vindication for every artist—and he stood in nobody's way, since he was dead.

Considering the service Wagner rendered not to music and musicians alone, but also to culture at large, one is reminded of what Darwin did for science and Marx for political science. Drawing on the pioneer work of half a century, each produced work which, right or wrong, publicized to the whole world the importance of the object they were concerned with—evolution, the distribution of wealth in society, and dramatic music.

While Wagnerism was conquering the Occident, another musical ism claiming to be new was being touted in Italy: *Verismo*, or truthful-ism. Its aim was to portray "real life" instead of either historical melodrama or Wagnerian myth. Mascagni's *Cavalleria rusticana* dealt with rural passions; Leoncavallo and Puccini each dramatized *La Bohème,* which is the life of the impoverished artist, and so did Charpentier with *Louise,* the artist's "free-lover." In Puccini's *Madama Butterfly,* the down-to-earth outlook is no doubt conveyed by the hero's being asked "Will you have a whiskey-and-soda?"; but in *Tosca* the story is dated 1800, while the plot is an old-style melodrama with only one touch of the contemporary: the heroine's aria "Vissi d'arte" (I lived by and for art) is Nineties aestheticism. More consistent, Alfred Bruneau systematically took his subjects from Zola's Naturalistic novels. But in all of them only the subject was new. Form and musical substance followed, with some added freedoms, the vivid example that Bizet's *Carmen* (at first unsuccessful) had set in the mid-1870s and that independently Verdi had given in his late masterpieces *Otello* and *Falstaff.*

Liking Wagner's music was to be "advanced," but so was talking against it in the name of a contrary movement with the motto: genuine music is *absolute*. Denouncing dramatic music, "program music," words with music or uttered about it, was the dogma of pure art applied to sound. Its adherents, like those who followed Pater in thinking that all the arts tend toward music as pure form (<621), could not help deploring the cult of Wagner. True, it had shown up the fripperies of Italian and French 19C opera—no musical soul could now take them seriously—but in their place stood this massive mongrel, which was anything but pure form and pure music. The absolute kind required the true connoisseur to stop regarding as art the works that pretend

to arouse emotion or convey drama, that is to say, all music since the ancient Greeks, and stick to fugues, canons, or other forms that are composed expressly to exclude any interest other than the fulfilling of the pattern. This last qualification is needed, because there are such pieces—fugues and so on—that are arousing and dramatic (<388). Purity in music, painting, and poetry came down to the appreciation of technique. Had that view been logically held to, the show-off pieces of note-spinning for solo instruments would be art, whereas the works of Chopin and Liszt would be flawed because impure.

One source of the fallacious doctrine is the ambiguous word *program*. When it is taken to mean that a piece of music relates again in sounds a scene or story, then a program is certainly objectionable and contrary to the nature of music. Inarticulate sounds cannot tell a story or depict a scene, and no composer has ever tried to make it do so; it is an impossibility.° There is in fact no "program music" to throw stones at with righteous anger. But in the sense of a plan or outline, all music is programmatic. Those admired pure forms are a program for the composer to follow, an outline to fill out. Unless he does so as sheer exercise, his mind-and-heart as it thinks and feels will leave its imprint on the work—hence the difference between a dull fugue, perfectly "correct," and an exciting one.

That being so, the composer can also follow the outlines of a second program, such as the words of a song: he makes the music fit form *and* atmosphere. The songs of all times and places convey joy, love, or grief. Music for church services also follows a second, outside pattern, and oratorios and operas obviously do the same. Even dance music, beyond its pattern, suggests wild gaiety or stateliness. A march is for a wedding or a funeral, and it is not the same march. So-called program music is evocative in no other way than a song or a march. It does not unfold a tale—it cannot—but it matches the character, mood, atmosphere of this or that episode without interfering with the established forms and rules of composition. Music is pure sound at all times and places, even at the opera. What is remarkable about western music is that by its chosen scales, modified through equal temperament, and by developing complex forms and complex instruments, it has raised the expressive power of music to heights and depths unattained in other cultures.

But the power of expressing a mood, of suiting an occasion, of fitting the words of a song or the course of a ritual must not be confused with imitative effects such as the greatest composers have indulged in from time to time. Bach's *St. Matthew Passion* has pas-

The fallacy that the essense of music is vague namable expressiveness, instead of definite unnamable impressiveness, is only carried out by making the expressiveness mechanical and independent of any impressiveness whatever.

—EDMUND GURNEY, "WAGNER AND WAGNERISM" (1883)

sages where we are to imagine the earthquake and the tearing of the veil; Beethoven's *Pastoral* symphony presents analogues of a storm, a brook, and a bird. Such imitations rely more often on rhythm or tone color than on notes, and they are not "expression" in the important sense. If not, it leaves the question, How can a concourse of sounds correspond to an emotion? That last word is not the right one. For example, in Haydn's *Creation* there is a strong modulation to C major on the words "Let there be light." The notes as such have nothing to do with light. But the change of key—and to *that* key— produces a visceral sensation (for want of a better word), a sensation of discovery, of openness, release, relief—it has no name; it is not one of the emotions. The same sensation could in fact match several different emotions: surprise, joy, escape, triumph—and thus could fit different situations. This is proved again and again when composers transfer a piece written for one opera to another. The soldiers' march in Gounod's *Faust* was composed for *Ivan the Terrible*. Much of Moussorgsky's *Boris Godunov* was composed for other subjects. Such is the nature of the link between pure sounds and things outside.

The composer who sets words or conveys drama knows from his own visceral responses what he should do at any point with melody, harmony, and rhythm to move the listener appropriately. And when in the absence of stated ideas a fugue or a chaconne moves us as if it had a plot, it is because the composer has followed some visceral sequence of his own—wordless and imageless—while carrying out the demands of the form.

That the universal practice of classic composers refutes the believers in absolute music should not obscure the reason why the latter took up their cause. Like other artists they wanted to clear the ground for their own conceptions and specifically to clear the air of talk about Beethoven's titanic thoughts, of Hoffmann idolizing Mozart; of Schumann explaining Berlioz; of Liszt and his mistress programmatizing his symphonic "poems"; of wordy librettos to read before the curtain goes up—of all talk whatsoever. Another irritant was that the symphonic composers of the 19C had also been men of letters, who found literary works as suggestive of musical ideas as the texts of church service and the biblical narratives had been earlier. The music linked to these secular scriptures, works by Shakespeare and Goethe, Byron, Scott, or Victor Hugo, was a reminder of the cultural burden of the past. The cry of absolute music, of pure art, was a detergent. As it turned out, pure music was more argued for than produced. Composers continued to record in the titles of their works the inspiration they drew from life and literature, and a good many did not scruple to add "programmatic" comments to facilitate appreciation.

If a generality is to be gathered from this debate on detaching art from life and enjoying under the name of Form the skeleton of a piece of work, it

is that the human mind is not pure. It is full of ingrained responses and acquired associations that cannot be got rid of or set aside. They form what psychologists call the apperceptive mass. A study made long ago of the ways in which good listeners "take" a piece of music when neither title nor composer is given showed that, in amateurs and professionals alike, all sorts of so-called extraneous factors entered into the experience.° To be an inert receiver would in fact amount to a mental disease.

That purism should arise in the Nineties is understandable; let it be said again: it was a practical means of retreat. But it is yet another paradox that the same period and often the same minds made use of symbols and welcomed the rehabilitation of myth, both of which imply a human mind that adds something to what it perceives. In doing so it finds in the object not only meaning but often multiple meanings. Soon a certain Dr. Freud, who had studied in Paris with the men who treated the psychotic, was developing in Vienna a theory of the unconscious that assigned to myths and dreams a significant role in all the workings of the mind.

The Cubist Decade

THE CULTURAL EFFERVESCENCE of the double decade I have called for short the Nineties did not stop as the century turned. The energies deployed continued to innovate and attack the leftovers of the high 19C culture. But a marked change occurred about the years 1905–1908, which makes it convenient to call that prewar period the Cubist Decade. Naming it after a style of painting seems justified by the parallels that will appear between one new art and the rest and with still other cultural starts of the time.

The first of the differences from the recent past was that the energy expended by the Nineties in putting the world at a distance, in negation, turned affirmative. The doers and the spectators appear exhilarated instead of wounded. There was no more talk of decadence, even though outward events remained as chaotic and deplorable as they had been before. The fresh vigor came with a generation of men and women born in the late 1870s and early 1880s, who grew up in the doleful time, appreciated its anti-worldly art and thought, but felt either that the Symbolist or Decadent ideas and techniques were played out, or that there were other ways not of resisting but of combating the evils of society.

To appreciate this change of attitude, it is useful to go back to the Impressionists and Post-Impressionists and see how their vision of the world veered into its opposite. The first, shocking exhibition of works by those whom the annual Salon rejected in 1874—Manet, Monet, Pissarro, Sisley, Degas, Renoir, and Berthe Morisot—earned them the nickname by which the movement and the style

I had the greatest difficulty in getting a new foothold on reality and in giving up the theories of that school. (I mean the ones formed by Mallarmé's followers), which tended to present reality as an accidental contingency and wanted the work of art to escape from its grip.

—ANDRÉ GIDE (1918)

We were not part of a negative movement of destruction against the past: We were out to construct something new; we were in the van of the builders of a new society which should be free, rational, civilized, pursuing truth and beauty. It was all tremendously exhilarating.

—LEONARD WOOLF, SOWING (1961)

are known: a critic denied that those canvases were serious paintings; they evaded reality; they were mere *impressions,*° as one of Monet's works was modestly titled.

It was Manet's *Gare St. Lazare* that by its subject—a railway station—proved how outrageous this sort of painting was—figures and objects in a colored haze, composition indefinite, execution sketchy. Yet some people pretended to like it; for others it was a new affliction, ridiculed as *monomanetmania.* Three years after Manet's vaporous vision, Monet painted 11 views of the same Gare St. Lazare that represent the changes of light within the glass-topped smoke-filled structure. The seven artists who were not hung (soon joined by the American Mary Cassatt) were proclaiming the EMANCIPATION of one art from the narrow confines of Realism, and they thrust on the eye a new realness, just as "perceived" as any other. When finally acknowledged, this feat of re-education inspired Wilde's later dictum that "nature imitates art."

The Impressionist painters worked on the principle that the play of light was the true reality; objects are not the solid things with a definite outline and color that we take them to be; nor are shadows uniformly dark. They contain the color complementary to that of the object that casts the shadow. The artists made use of the phenomenon of optical merging, by which two pure colors put close together—say, yellow and blue—will be seen as if blended into green and much brighter than if actually mixed. This technique gives the characteristic luminosity of Impressionist work. Lastly, light is perpetually changing, so that a painting ought to be made instantly—a snapshot—or as near to that as possible. It was on this premise that Monet painted the series of Rouen cathedral in 20 "takes"—gray, blue, pink, and so on. [Still worth reading, George Moore's *Modern Painting* gives in a series of short articles a contemporary's view of the transition from Corot to Monet.]

> The mission of art is not to copy nature but to express it. The radiation of light is what gives the appearance of a particular body; so I have not drawn outlines; I have spread over the contours a cloud of warm and delicate tints in such a way that you cannot put your finger on the spot where the contours merge with the background. Nearby it all looks woolly and imprecise, but from two paces away everything grows clear and one feels that the air surrounds the whole.
>
> —BALZAC'S HERO IN *THE UNKNOWN MASTERPIECE* (1832)

There was a scientific basis for the new technique; Chevreul and Helmholtz had settled the facts about color a generation earlier, but the Impressionists did not read science; their eyesight and the works of Delacroix justified their technique. He had painted colored shadows, and as he once explained to the son of George Sand, this optical effect is fundamental to painting.

More than one painter as far back as the 15C Venetians had shown

inklings of the same perception. Nearer to the 1900s, Turner in his last period had painted bursts of light in bright clashing colors. These precedents could be urged in defense of the new effects, but Delacroix's direct and acknowledged influence is what confirms the connection stated earlier, that Impressionism, like Symbolism, is the final working out of Romanticism (<479).

You can stuff the most violent colors into your painting, just give them a reflection that unites them and you will never be loud. Is nature sober in coloring? Isn't it flooded with fierce contrasts that in no way destroy its harmony? Some people try to eliminate this in their painting; it can be done but there's a slight drawback, which is that *painting* is eliminated too.

—DELACROIX, *REMINISCENCES* (n.d.)

It took about eight years for the Impressionists to gain some recognition. They were stoutly defended by Zola and other Naturalist writers, who saw the kinship with their own work in the exact re-creation of "nature" and the choice of subjects from common life. It could have been argued just as truly that these painters were, like the Symbolists, evading the real world by blurring its harshness. Since more than one Impressionist master lived and worked well into the 20C, the Post-Impressionist techniques of the Nineties must be seen as so many dissonant lines moving against a style that continued to dominate the scene for 60 years after its birth. Accidentally as usual, it was not Impressionism or its rebellious offshoots that around 1900 were called *Art Nouveau—the new art*. It was a vogue which in its gentle way also left Realism behind in favor of sinuous threads of color and flowerlike designs, such as those of the ironwork over the entrances to the Paris Metro. Mucha in France and Tiffany in America are two of its prized performers, but it offered no new technique and had no long future.

The painter who first used, then abandoned the Impressionists' technique was a man of their own generation, Paul Cézanne. He was considered such a failure that Zola made him a pathetic character in a novel. On his part Cézanne thought that color and drawing are a single element, so that to neglect drawing—line and outline—was to end in formlessness. My aim, he said, "has been to make Impressionism into something solid and lasting, like the art one sees in museums." In place of the momentary aspect, he reinstated emphatic composition by the contrast of blocks of colors and of definite volumes. From Cézanne onward, the younger painters variously diverged from the Impressionist haze. The object, which threatened to fade like a phantom, reappeared in Cézanne, but not in the shape it bore in, say, the Realism of Courbet—not closely imitated from nature, such as had been the rule since the Renaissance discovery of perspective, yet strongly indicative of its natural form.

In Cézanne's time, there were Neo-Impressionists, such as Seurat, who also claimed Delacroix as their forebear and who gave outline to figures while keeping the Impressionist sparkle by the division of color into small patches

(not dots)—brilliance by optical merging. Another was Signac, who supplied a complete theory of the genre. His book is doubly significant, because it marks the beginning of extensive verbalizing about artistic innovations for the benefit of the public. Theory was actually wanted; instead of one period style as in the past, several styles co-existed and the amateur asked: "What am I to look for?" while the critic wondered: "Is it art? If so, which of the disparate kinds?" Theory answered these questions more or less rationally. Meantime galleries needed arguments or principles to cite in publicity for their artists' renown and sales. Balzac estimated in 1840 that there were 2,000 painters in Paris; a century later, all the cultural centers of Europe and America had contingents at least as large. Every artist who hoped to exhibit or obtain an agent must give an account of his aims and justify his special brand of vision and method.

While Cézanne was working at volumes and gradations of planes, Gauguin was painting clearly outlined areas that look flat because the paint is thin and evenly distributed, and Van Gogh was developing his original mode of thick slashes of violent color that give the canvas a rough surface and an extraordinary glow. Both Gauguin and Van Gogh depicted recognizable objects but the interest lay in the treatment. The same concern was handled in yet another way by the painters who called themselves Nabis (*prophets* in Hebrew) and who were described as *Fauves* (*wild beasts* in French). The acknowledged leader of another group, Matisse, loosened the link between painting and "the illusion of reality" by distorting form for aesthetic or decorative effect. In Gauguin and Van Gogh color is used for contrast or brilliancy, not representation; in a portrait two aspects of the face turned three-quarters may be orange and green. The onlooker gradually learned not to expect the literal on canvas. Some of these deviations from the actual were inspired by interest in Oriental art, especially the Japanese. And out of the variably Real came more books, notably those of Roger Fry and Clive Bell (<622) that reconciled all presentations, declaring that the art consisted in nothing but color and line on a flat surface. Whistler's "arrangements" might show a bridge or a seated woman: never mind that; how well were the portions arranged? The question kept the eyes busy and ideas at bay.

In sculpture, volumes are of course integral to the art, but in Epstein and in some works of Rodin, both contemporary with these painters, the surfaces are roughly indented and suggest the texture of a Van Gogh. Rodin's conceptions also diverge from pure representation. When for a public site he made a figure of Balzac with a massive head and bust rising out of a sort of barrel, it caused protest and was rejected.

*
* *

The radical break with Impressionism and its three or four sequels came in 1908 with the first works by Picasso and Braque that were dubbed Cubist. As usual the appellation was crude and the outcry ferocious. For connoisseurs who had finally embraced the Impressionists and Post-Impressionists, the leap forward from Cézanne, though really not tremendous, was alarming. A respected critic who had battled for the Impressionists ended up in the 1930s weary and damning the works of the previous quarter century under the caption "Painting Gone Mad."°

What was infuriating was that the Cubists—not the original pair alone but soon a group of young and well-trained artists: Gleizes, Delaunay, Metzinger, Ozenfant, Severini, Léger, Lyonel Feininger, Russolo, Juan Gris—were painting, exhibiting, and arguing for Cubism as the only art fit for the times. Their affront to the beholder was to offer as something worth looking at a geometrical construction of dully colored planes that defied harmoniousness as well as the exercise of imagination. A poet, Guillaume Apollinaire, undertook the task of explaining the paradox in a series of articles, and shortly two of the painters, Gleizes and Metzinger, joined in writing a pair of books, *Cubism* and *On Cubism and How to Understand It*. The authors showed that a Cubist painting was the product of an ANALYSIS of forms. In choosing to neglect appearance altogether and to present essence, Cubism was a return to classical principles. The dramatic and psychological intentions of Romanticism had been worked out to the full. There was no use in repeating what had been done.

The analysis of forms had already concerned Cézanne. Some of his landscapes at L'Estaque have a pre-Cubist look; and the sculptured masks from the Congo that Picasso admired show the facial planes angular and juxtaposed. The Cubists, moreover, took "form" to mean the whole object, not its front view only; they put on canvas in one image the successive facets that someone walking around the object might see. Perhaps the clearest demonstration of the principle was given by Marcel Duchamp while he was still a Cubist. His two versions of a *Nude Descending a Staircase* present the figure in outlines at once successive and simultaneous, thereby suggesting movement down the steps. That this way of taking reality was not restricted to painters but was somehow in the air is shown by the remark of the Symbolist critic Rémy de Gourment, a decade before Cubism: "Believe it or not, I can see all the facets of a cube at the same time."

The idea—the feeling—of simultaneity governed the efforts of talents in other arts, which justifies the appellation of Cubist for the whole movement. Sculptors analyzed the shapes of things and of the human body and arrived also at geometric solids whose coordinated planes suggest motion. Duchamp-Villon's *Horse* in the garden of the Museum of Modern Art is not a

quadruped, but the animal's coiled power. Brancusi's bird, like Archipenko's human figures, is related to motion in the same way through the streamlined surfaces, flat or round without detailed modeling. These works and the Cubist paintings exerted a lasting influence on the design of furniture, appliances, and textiles. The style known as Art Deco was so called because the first group of such designers planned an exhibition of their *Arts Décoratifs* for the year 1915. War postponed it a full decade (725>). A year before the war, the now famous Armory Show of 1913 in New York City aroused widespread discussion, no longer wholly hostile, as it had been on scattered occasions earlier. Ex-President Roosevelt reviewed the show and was extremely polite through several paragraphs before deciding that the painters latest in date belonged to the "lunatic fringe."° The Armory pictures went to Boston and Philadelphia and were seen by an estimated 150,000 people.

The architects, as everybody knows, also went in for flat and bare surfaces. They had a head start on the Cubists, having been stimulated by the railroad station, the availability of steel, and the need for high office towers on expensive city space. Louis Sullivan had solved the problem in Chicago in the 1890s. In the Cubist Decade the makings of what became the International Style might be seen in the buildings of Tony Garner, Behrens, or Auguste Perret. The last-named was especially influential in furthering the use of concrete, then a new material, and he was distinguished from his peers by his belief that entirely bare surfaces everywhere in sight would become boring. He found ways to break flatness without diminishing the sober functional look, for example, in the Théâtre des Champs Elysées.

<div align="center">*
* *</div>

If simultaneity was the ruling idea, the poet could no longer be content to set down his own single voice as in the past; he must orchestrate and represent on the page the many voices that he heard or could imagine in the cacophony of the times. This program was defined in 1912 by H. M. Barzun° and carried out by him and others in a variety of works. They break up the linear page of print, either to compose above one another a polyphony of lines—simultaneous songs or other utterances; or, again, transform the familiar stanza spacially for a visual representation of the theme. From these derive the Choric and the Concrete poetry of later years.° One of the best known of such early works is Apollinaire's collection of *Calligrammes*.° Using more traditional means for the same intention, the Unanimists interpreted simultaneity as the powerful common voice of the liberated masses, not diversified yet requiring expression in some new form. Jules Romains' free-verse poems and novels embody this vision as does Verhaeren's *Villes Tentaculaires* (*Octopus Cities*).

It has been said that Cubism and kindred arts were influenced by science. That is the wrong way to put it, because none of those artists read much if any contemporary science. But in trying to go below the surface of things and bring out structure in place of appearance, Cubism does independently parallel the early 20C physics: the atom is "more real" than the visible chunk of matter, and so on down to the farthest reach of ANALYSIS.

In his latest works (1911) Picasso has achieved the logical destruction of matter, not, however by dissolution but rather by a kind of parcelling out of its various divisions and a constructive scattering of these divisions. The problem of purely artistic form is the real problem of his life.

—WASSILY KANDINSKY, *CONCERNING THE SPIRITUAL IN ART* (1914)

Rather than science it was techne that affected the Cubist eye: motor-car speed and aviation, which respectively force images into each other and flatten what is rounded. There is no record of Cubist fliers, but photographs showed the earth in the geometric way now familiar to the air traveler. Obviously, the influence of motion pictures in changing visual reality belongs here also. The figures in the "movies" do not move, but seen in rapid succession give the illusion of motion—the stroboscopic effect. The mad results of speeding up the film strip, juxtaposing pieces of it for impossible actions, and using a soft focus or other distortion emancipated the mind; it was no longer crassly resistant to artful mis-Representation.

Soon, the genius of David Griffith invented a series of devices that laid the foundations of the new art of film. A failed actor and playwright, Griffith was employed for five years to direct short movies for a firm called Biograph. In the 400 that he made, he created the close-up, the long shot, the fade out and fade in, the framing to vary the scene from the usual rectangle, and cross-cutting to suggest simultaneous actions. The modern viewer accustomed to these and other effects has no notion how much they distort normal sight and how strongly they affected the first viewers.

In those same years, the work and the propaganda of Stieglitz and his associate Steichen established photography as a graphic art separate from painting and of equal interest to those with eyes to see. At the gallery known by its street number "291," Stieglitz held exhibitions, gave lectures, and like Griffith kept inventing new ways of making the camera do what he wanted. He was the first to produce scenes in snow, rain, and at night. Again, a medium wordlessly opened the mind to what it had never perceived. Incidentally, a law of the 1890s preceded Steichen in declaring that a photographer was not a mechanic; he was a professional man and must pay a fee for a license. Stieglitz was an activist. Before the Armory Show he exhibited paintings by Cézanne, Matisse, Lautrec, Rousseau, Picasso, and Severini and sculptures by Rodin and Brancusi—to an almost entirely hostile and mocking public. But there were modern American painters, also hung at the gallery,

who found the shows an encouragement: John Marin, Hartley, Dove, Maurer, and Max Weber among them.

Like the Impressionists, the Cubists took their subjects from the life around them—no more history, mythology, or allegory and, in portraits, very little if any psychology. This workaday outlook was reinforced by Braque's invention of collage—"pastings" on the canvas of bits and pieces from ordinary objects, such as a newspaper headline, to highlight a still life. This touch of the actual disappeared in the evolution of Cubism through several phases. By the 1920s, it has been maintained, the Cubist works of Gleizes and Delaunay led to the so-called abstract art that now prevails almost universally° (723>). As remarked earlier, it is not the painting or sculpture that is abstract—it can be seen and touched; it is what is left after other elements have been abstracted. Since "abstraction art" would be clumsy, a better term would be "analytic," or even better, "residual art."

The elimination of the recognizable, especially of the individual face in a Cubist portrait, bears a subtle relation to the wave of Populism which, as noted earlier, flowed over Europe and America at the turn of the century. The emerging masses swamped the individual. He still existed, of course, but anonymously, an atom among thousands of similars. To portray the particular, of which Blake had made such a point—that detailed uniqueness the Romanticists had cultivated with passion—looked like trifling in view of the numbers, the millions of human beings now so important, but indistinguishable alike in status and habits.

While France witnessed these departures from Impressionism, several other alterations of it occurred in other countries. The German artists of the "Blue Rider" group headed by Franz Marc and Wassily Kandinsky modified representation to render symbolically the spiritual element in life and in objects. Those of "The Bridge" with Emil Nolde represented human beings as borne down by outer forces. The Scandinavian Edvard Munch showed them weirdly frightened or maddened and the Viennese Kokoschka, denatured under torture. Art faced the evils of its time: recording the sense of wrong has sometimes been called Expressionism, but the name is more properly applied to the theater. The common element in the styles just listed is distortion of form without abstracting from a self. In Italy, the message and manner were different. The Futurists there applied the Cubist technique in celebration of speed, machinery, and a buoyant Abolitionism° (<619). Russolo's "Dynamism of an Automobile" is intended to suggest the rush of air as felt in headlong motion, without any car or person visible.

From the summary of this ebullient period in the arts, two generalities emerge. One is that the most reasonable date for the term *Modernism* is not 1880 or 1890 but the years just described, *after* Symbolism and Impressionism had achieved renown and *before* the large public of the 1920s came to know

what had been done in the years just preceding war in 1914. That the break implied by tacking on *ism* to *modern* was widely felt only then is shown by a simple fact: the denigration of Romanticism and ridicule of the Victorians reached the newspaper public after the war was over. Lytton Strachey and Irving Babbitt are cheerleaders of the Twenties.

A second conclusion is implicit in the first: the arts of our time have all derived their techniques from the Cubist Decade, but in developing them variously, the sensibility of the artist, his attitude toward the world, and his feeling about himself have progressively changed from Constructivism—the apt name taken by some painters before 1914—to Destructivism. The cognate word *Deconstruction* lately made commonplace can be stretched to cover the same rooted purpose and is especially apt because it means "taking to pieces what has been built" and not simply "knocking it down."

One other energy was arrested during death's interregnum and hardly resumed full strength: the general culture, and not its avant-garde products alone, had been international in spirit. Before 1914 the critics and scholars of Central Europe were particularly free of national bias. They wrote about past and present art with such zeal and sympathy as to diffuse an atmosphere akin to that of the cosmopolitan 18C. It contributed to the mood of joy in creation and appreciation that made later comers look back on those years as a *belle époque*. Artists traveled freely—no passports or visas—many to Paris, where they might stay for a time, because the excitement there was the hottest; and, when back in Berlin, Vienna, Prague, or St. Petersburg, they merged their newfound inspirations with local influences and independent innovations. [The book to read is *The World of Yesterday* by Stefan Zweig.]

*

* *

The word *Populism* has come up in various contexts as one of the characteristics of the turn of the century. Only in America was it a conscious movement bearing that name. In Europe it was an outlook that influenced political and cultural action. Its meaning could be defined as the strongly felt presence of "the people," their needs and rights, their behavior and ideas. In the Nineties all this was the substance of the Naturalist's novels and the cause of the aesthetes' flight to a finer world. No fewer than three outstanding books appeared on crowd psychology.° Systematic study was devoted all over the western world to society's role in shaping the individual. Lester Ward, C. H. Cooley, and George Mead in America and Tönnies, Hobhouse, Pareto, and Max Weber in Europe laid solid bases for social psychology. The methods came from the newly defined and independent science of sociology.

Emile Durkheim, its founder, posited as a fundamental unit akin to the atom "the social fact." It has no connection with psychology, which regards

Organized crowds have always played an important part in the life of peoples, but this part has never been of such moment as at present.

—LEBON, *The Psychology of Crowds* (1895)

A social fact is any way of behaving, regular or not, that is capable of exerting an external constraint on an individual; or again, any way of behaving that is general throughout a given society, provided the behavior exists independently of its individual manifestations.

—DURKHEIM, *The Rules of Sociological Method* (1895)

the individual mind, or with politics, or the law, which can change arbitrarily. Suicide is a social fact, and Durkheim chose it for his first large-scale study. It can be measured by counting and be related to other social facts so as to yield correlations and predictions—the "laws" of a particular society; that is, their statistical norms. If this premise is true it implies a determinism and makes the study a science.

The 20C developed Durkheim's discipline into endless specialties. Today, through newspapers, the public is treated to a daily dose of "studies" that indicate with numbers how, under stated conditions, individuals in groups behave. Legislation is often guided by such reports, crime statistics being an example, despite the fact that statisticians keep questioning the accuracy of the data. A whole community, *Middletown*, has been twice analyzed in great detail,° and the universal pastime of polling is an offshoot of sociology. There is moreover a sociology of every activity—science, art, play, sexuality; of crime it is called criminology.

Concurrently, with the proliferating social sciences, the writing of history underwent review and reform, again in keeping with the populist temper. When Lord Acton, dean of the profession and editor of the *Cambridge Modern History*, told his juniors: "Take up a problem not a period", he was directing them to a social situation in place of a series of events. In France, a group headed by Lucien Febvre had a similar idea: no more events but "collective mentalities." They published the *Annales d'Histoire Economique et Sociale*, and the name *Annales* came to mean a doctrine and technique that converted the majority of historians everywhere. The substance and character of historiography were radically altered; narrative, individual figures, and literary art were banished from the definition and the practice. In Germany, Dilthey redefined the history of ideas into something close to the history of social myth and Lamprecht demanded a history that would make use of the latest findings in psychology and sociology (656>).

These goals for history have been pursued down to the present, the late Fernand Braudel and his colleague Robert Mandrou being considered the masters of the reformed genre. Regarded by some as making history a science at last, and by others as achieving a synthesis of the "sciences of man," it rests on the exhaustive study of the commonplace facts that the course of life leaves in city halls, police stations, business firms, and private attics—wher-

ever paper accumulates. There, the theory maintains, the real life of the people is to be seen. In such histories narrative gives way to description. Topic dominates continuity in time; the historian turns into a sociologist working on the past. He studies violence or the cost of living, religious habits or the forms of business enterprise at a certain place and date. Thus: *Poverty in Habsburg Spain* or *Madness, Anxiety, and Healing in 17th Century England.* When stouthearted, he attempts to treat all of these and their like in a set of chapters covering a considerable span; for example the single-topical *Centuries of Childhood°* and the comprehensive *France: 1848–1945°* in two volumes, the first subtitled "Ambition, Love, and Politics;" chapter headings include: "The Rich," "Children," "Notaries," "The Genius in Politics."

By opening up those large repositories of inconspicuous facts formerly underused, these historians have done pioneer work; and their painstaking labors are worthy of respect. Earlier historians did not disdain such topics, but they only sampled the sources as they wove their compact findings into narratives of events and individual action. Now individuals were deemed unimportant. Neither great men nor medium-size ones had influence; only the crowd had power, and what it affected was not events, which matter little, but the broad conditions of life. This motionless history defied a tradition of 2,500 years.

A second result was that the general public no longer read history as it had in the 19C. Some professional historians continued to write monographs on persons and events, but the Macaulays and Prescotts and Michelets and Mommsens were missing; their descendants were busy collecting scraps for the history of friendship,° or the history of private life,° or that of envy.° The general public read the popularizers. Their work can be excellent, but more often it is a catchy recital without the life-giving ingredient of vision.

One must deplore the replacement of history by attempts at retrospective sociology, not because it lacks interest as such—though it can be tediously anecdotal—but because it fails in spite of all the digging. With fine honesty the practitioners keep telling us that the data are incomplete, inadequate. The result, as an English historian has pointed out, is that in Braudel's survey of *The Mediterranean World*, the mass of details tells us no more than we knew before from the earlier "literary" accounts.° A further drawback is that the topics treated—marriage, violence, friendship—are not definable subjects; they are ventures in ABSTRACTION; like sociology, they mix under one name actions and situations existentially very different.

But what of Toynbee and Spengler, contemporaries of the *Annales* groups, and others before them who professed to explain in large works the *meaning* of history? These attempts are classed as philosophy of history, because they find a system and a purpose in the chaos of events. This is done by assigning one continuous force or a predestined goal as the motive power

which in the end will bring mankind to some attractive or disastrous end. Divine Providence, the march of Freedom, or the class struggle is shown to be the engine at work beneath the welter. By grouping historical instances that show a steady progression, the thesis is proved.

The merit of these ambitious works lies in their by-products, the descriptive parts, which are often good history, original and convincing. It is when the author forces well-known events and persons into a set of boxes that the scheme breaks down; for example, when Toynbee has to make the Thirty Years' War a "small war" to satisfy his set pattern. What vitiates all the systems is the fallacy of the single cause. To begin with, cause in history cannot be ascertained any better than motive in its human agents. Both must be represented as probable, and it is wiser to speak of *conditions* rather than causes and of *influences* rather than a force making for change, because what brings it about is the human will, which is distributed among all the living.

This is to say that a historian who contemplates the infinite diversity of human character, the range of human desires and powers, the multiplicity of social and political institutions, the endless schemes proposed for improving life, the numberless faiths, codes, and customs passionately adhered to, fiercely hated, and in unceasing warfare, the vast universe of art with its expressions in a galaxy of styles and languages—all these existing to an accompaniment of sacrifice, injustice, and suffering, persecution imposed or willingly endured—such a historian is persuaded that these challenges to the concrete imagination cannot be merged and reduced to a formula. History is not an agency nor does it harbor a hidden power; the word *history* is an ABSTRACTION for the totality of human deeds, and to make their clashing outcomes the fulfillment of some concealed purpose is to make human beings into puppets.

For the same reason, history cannot be a science; it is the very opposite, in that its interest resides in the particulars. As James Fitzjames Stephen pointed out in the 19C, if a science of history were possible, it would consist of a few "laws" that could be written on half a page. To invent an example, the first law of historico-dynamics might read: "Everything sticks and nothing holds." It would cover every instance of the observed fact that no purpose or idea makes its way without hitches, setbacks, and temporary stasis; and no movement, institution, or culture goes on forever.

Not a science and not a philosophy, history is bereft in an age like ours, which wants at least theory when science is not attainable. Can a case still be made for Cinderella? One line of advocacy might be that even if history were simply a story recited in various versions, it would be worth having as a vast mural full of action and color. But as pointed out earlier (<xiv), when presented by a thinking historian, history does more: it shows patterns that recur

with a difference, dramas in which one follows exposition, complication, and denouement, while continuity in aims suggests THEMES. In all these ways knowledge of man is enhanced. History moreover includes energetic lives, no two alike, that show creatures as characters.

These elements need no theory to earn respect. And a further possibility exists. At times in the present work, the narrator threw in the remark: "This is a generality." The dictum meant that a conclusion just reached applied mutatis mutandis to other broad ranges of fact. These fruits of reflection, like history itself, are interesting as well as useful; here is a round dozen to show how scanning the last five centuries in the West impresses on the mind certain types of order:

—An age (a shorter span within an era) is unified by one or two pressing needs, not by the proposed remedies, which are many and thus divide.

—A movement in thought or art produces its best work during the uphill fight to oust the enemy; that is, the previous thought or art. Victory brings on imitation and ultimately Boredom.

—"An Age of ——" (fill in: Reason, Faith, Science, Absolutism, Democracy, Anxiety, Communication) is always a misnomer because insufficient, except perhaps "An Age of Troubles," which fits every age in varying degrees.

—All historical labels are nicknames—Puritan, Gothic, Rationalist, Romantic, Symbolist, Expressionist, Modernist—and therefore falsify. But "renaming more accurately" would be effort wasted. Coming from diverse minds, it would re-introduce confusion. All names given by history must be accepted and opened up, not defined in one sentence or divided into sub-species.

—The historian does not isolate causes, which defy sorting out even in the natural world; he describes conditions that he judges relevant, adding occasionally an estimate of their relative strength.

—Neither of these propositions is true by itself: "Ideas are the product of society." "Social change is the product of ideas."

—The denial just stated applies also to heredity and environment; great men and the masses of mankind; economic forces and conscious purpose; and any other pair of commonly invoked coordinate factors. The exact course of their respective action cannot be understood and consequently cannot be stated.

—A class is not a homogeneous group of people marching in step but a sort of labeled platform populated by a continuous stream of individuals coming from above and from below. Once settled, they acquire the common traits.

—The potent writings that helped to reshape minds and institutions in the West have done so through a formula or two, not always consistent with the text. Partisans and scholars start to read the book with care *after* it has done its work.

—In art, influence does take place and when strongest is least literal. When it is literal it must be called plagiarism and the fact should not be concealed by the eminence of the thief.

—In biography, systematic explanation by unconscious motives defeats the purpose of portraying an individual character. It turns him or her into a case, which then belongs to one of the types in the literature of psychology.

—Progress does occur from point to point along a given line for a given time. It does not occur along the whole cultural front, though it may appear to by throwing into shadow the resistant portion. The sciences are no exception.

To these dogmatically stated rules, some modifications or contrary cases will no doubt occur to the student and the reader. That is one use of the rules: to sharpen the sense of difference in similarity. The other is to guide reflection on the facts met with in any account of a past or present scene. Testing a generality makes for precision in remembrance, which is knowing history. To be remembered also is that these twelve are not exhaustive; others might be framed, and few or none may fit times and places other than those which suggested them.

*

* *

Lamprecht told his colleagues at St. Louis that "the progressive and therefore aggressive point of view is the socio-psychological." We have seen the outcome of the socio part; the psychological has had a comparable impact, not so much on history as on biography, which is reserved for later discussion (792>). What is in point here is the recasting of anthropology. Once again one sees a discipline enlarging its scope. The 19C concentrated on the individual subject—the dimensions of his skull, with a glance at the color of hair and eyes and height. In the most intent practitioners, these indices were enough to determine race, politics, degree of ambition, and ultimate fate (<578). The populist temper abandoned the single specimen to that fate and turned to the tribe. At the hands of Malinowski and Franz Boas, anthropology became the sociology of primitive groups. The researcher went to live with them and noted down every feature of their life. To this entire set of habits and beliefs the anthropologist gave the name of culture and, as explained earlier, the term has degenerated into near-absurdity. The find-

ings excited general curiosity and, used piecemeal, fed arguments about morals and government in modern societies. In other words, PRIMITIVISM found fresh materials to work with.

Why is the word *culture* one of the most contested in the language? The truth is that none of us quite understands what we mean by it.
—JOHN CASEY° (1994)

In further parallel, the scholarship developed in the 19C as philology laid claim in the early 20th to being a social science and took the new name of linguistics. This change was also a by-product of populist feeling. Philology had studied literary texts and charted the course of changes and regularities within families of related languages back to a hypothetical Aryan tongue (<503). At the turn of the century *The English Grammar* of Henry Sweet (Shaw's model for Higgins in *Pygmalion*) pointed the way to a new rigor by being purely historical and descriptive instead of prescriptive; that is, it did not recommend certain forms and condemn others. The word *correct* lost its meaning. Usage was all. Sweet also reclassified the parts of speech to get rid of the grouping and terminology derived from Latin. English—and any other language—must be examined like a distinct natural phenomenon; and the place to do so was no longer printed books but the speechways of the common people, the least educated.

At the same time in Switzerland, Ferdinand de Saussure was lecturing on what he called General Linguistics,° by which he meant the structure of language as such. He defined it as a system of signs that are arbitrary and that carry meaning not by their sound but by their difference from each other. Thus language is pure form. (Compare "pure art" above, <640). A language is never complete or perfect in any individual, only in the mass of speakers. It must therefore be studied not only for its changes through time, but also for its state at any time. This novel idea, Saussure likened to the work of the sociologist and thus made good linguistics' claim to being a social science. The various types and uses of Structuralism as well as the idea of stylistics derive from Saussure.

The cultural consequences of replacing philology by linguistics have been many and far-reaching. Since the real language is what the people speak—the linguist's sole concern—the written language must be dismissed as artificial. Since there is no right or wrong way of speaking no judgment is to be passed on usage. Correctness is the vicious idol of snobs. Since the doctrine interprets changes in speech as the "life of the language," any criticism of usage, such as deploring confusions in meaning or losses of useful distinctions is so much violence done to the well-being of the mother tongue. Complaints are bound to fail, anyway; they only prove the critic an enemy of Populism. As a leading linguist put it in a famous essay: "No native speaker can make a mistake."° On the contrary, his "mistake" may contribute to that vigorous life which the linguist studies like a biologist.

The effect of linguistics on education was severe. Grammar books doubled in size, rich in diagrams and definitions, owing to the abandonment of the old parts of speech and the standard terms for their interrelations; for example, not "subject of a sentence" but "head word." Words themselves were assigned multiple labels according to meaning and function:° *there* was not only an adverb; it could be a pronoun when used to refer to a previously mentioned place: "I will be there." In short, the principle that teaching begins with simplification was flouted in favor of strict science. Worse still, linguists differed in the grammatical names and categories that they sought to impose. One outcome has been the need for remedial classes in college.

In the pursuit of science, some linguists sought for the fundamental unit out of which language is made. They found it in the "phoneme," the single sound which, compounded with others, makes up a word. Unfortunately, it was not long before there were six definitions of the particle. And in Saussure's system, sound is not the unit, it is only the vehicle of the sign, the abstract item that signifies what is meant.

The loss of grammar and the dogma that anything said is to be treated with the respect due to life itself have had the further cultural effect of encouraging the natural carelessness of talk; it even made it an asset: a new president of the United States in 1988 gained in popularity when he was found halting in speech and loose in grammar.° In the same spirit, the linguists attack anybody who speaks up for saving threatened meanings and especially distinctions among words. This rebuke is paradoxical, since as scientists they should remain neutral toward all influences acting on language. That it is a social institution for exchanging thoughts and at its best when its terms remain clear, as in the sciences and other technical fields, does not seem to be part of the linguistic creed, nor that language has aesthetic powers and uses that also depend on conservation.

The linguists' exclusion of the written word from their purview as if it had no influence on speech is again a touch of Populism and bad science. The western peoples read printed matter by the ton and pick up their clichés from a hundred written sources generated by business, government, newspapers and magazines, advertising, and directions about the use of appliances and medication. There are even people who read books and absorb for use new expressions made up by authors. And readers and authors being part of the people, their concern with the efficacy and the beauty of the language gives them a right to speak up at least equal to the right of the careless. Many among "the people" do not, in fact, adopt the linguists' attitude; they want to be correct and buy dictionaries. There they find the notations "standard" and "substandard," "colloq." and sometimes "vulg." If these distinctions exist, it seems as if a native speaker could make a mistake, such as uttering something "vulg." at a wedding or a funeral. In truth, right has nothing to do with the

matter. If it had, one might complain that, as stated in linguistics, it is too narrow: native speakers who cannot make a mistake ought to share their privilege with children and foreigners, none of whom should ever be set straight.

As for the life of the language, that phrase is not science, but metaphor. Language is not alive; only those who use it have life, and when they stop speaking it, their language, if written, remains whole, readable and usable like classical Latin and Greek. To decide whether the living users should be encouraged to preserve or to tamper, one must judge by results. Establishing a standard spelling abolished the old democratic right to follow one's fancy, and the result is that we can still read with relative ease the literature of the last 500 years. During that same time the vocabulary has suffered losses and changes, the increase in distinctions being much to the good; while the losses and confusions, many due to ignorance in a world of illiterates, were not then cheered along by specialists. The present order of things is not likely to keep the written word readable for another five centuries. But, it is only fair to add that the laxity now favored and fostered came in parallel with the poets' games with vocabulary and syntax in the Nineties, a recreation soon taken up by the writers of prose, and pursued in the 20C by advertisers, journalists, and corporate managers.

When the new historians spoke of "collective mentalities," they meant the temper or states of mind prevailing in certain periods and differing from those before and after. Psychology was a word in vogue; the study of the subject formerly known as "the human understanding" had been making strides like the other social sciences and had earned its ology. Its program was to replace the generalities of former thinkers by detailed observation and measurement.

In the preparatory 1870s, William James, trained as physiologist and physician, had set up at Harvard the first psychological laboratory. It was soon followed by Wilhelm Wundt's in Leipzig,° and others elsewhere. By having willing subjects detect differences in sensation between weights or colors and the like, certain regularities were noted. Ernst Weber found that a proportional increase in the stimulus was needed to perceive change: if after lifting 40 grams 41 are needed for feeling any difference, 80 grams requires not 81 but 82. It was termed *Weber's Law.*

But the law (and others like it) seemed to apply only within a moderate range. Beyond it, human variety set in and the conclusion was drawn that sensory and other perceptions could not be explained by analysis and counting. Wundt posited an inner psychic force that integrates simple elements. Observation and introspection remained the instruments of modern psychology; observing rats in traps and mazes being a favorite and giving currency to "rat race" as a useful metaphor for modern occupations. In the early experimental period, Pavlov was accounted a contributor to psychology

when he engineered the conditioned reflex in dogs. But this was an incidental result of his study of digestion. Pavlov directed a physiological laboratory in St. Petersburg and always "renounced the untenable pretensions of psychology." Dogs differed, so they gave no clue to the human mind's working; a sudden emergency such as fire de-conditioned them. When they were forced to differentiate between smaller and smaller differences in stimulus, they bit the apparatus; humans similarly worked on may have been tempted to bite the experimenter—it is not recorded.

When, in 1890, William James's *Principles of Psychology* appeared, the two volumes were at once recognized as epoch-making. The work summed up in critical fashion all the solid findings since Locke on the mind and Berkeley on vision. It disposed of still current theories such as "mind-stuff" and pure Associationism and replaced them with James's own contributions. The scope and analytic power of the *Psychology* have made it more than a hallowed classic. Leading authorities in our time keep referring to its insights and its unexhausted suggestiveness. It is moreover so full of the stuff of life that lay readers have found it engrossing.

The most notable and influential chapter was James's redefinition of the mind. It is "first of all a stream. Chain or train does not express it; it flows." James headed his detailed description "The Stream of Thought" to make it clear that he was refuting the former account in which separate "ideas" derived from as many sensations somehow got combined. In an abridgment of *The Principles* that he published two years later, the phrase "stream of consciousness" conveyed still more vividly the fact of flowing and established itself as the final designation in psychology, literature, and common speech.

> Mr. James, I mean Mr. William James, the humorist who writes on psychology, not his brother, the psychologist who writes novels.
>
> —ANON., *PAGES FROM A PRIVATE DIARY* (1899)˚

James showed that relations among ideas come in the stream also, along with whatever they relate; Hazlitt had an inkling of this reality at the height of the Associationist doctrine. And James, like Destutt (<453), re-affirmed that feelings are attached to the fluctuating waves of thought, some of them often entirely devoid of images: a feeling of *if*, a feeling of *but*, are familiar and not picturable. Ideas, James went on, are not so much lumps in the stream as "cuts" that we make in it for our various purposes—the mind is purposive. When instead of daydreaming the purpose is firmly pursued, that is properly thinking.

In his treatment of a score of other functions of the mind, James evinced no desire to make a system. His scientific bent and empiricist philosophy (668>) both opposed such a course. But his contemporaries did not refrain. Half a dozen systems flourished and were debated among doctrinaire adherents. The British hung on to their Associationist scheme—ideas cling

together because they originate at the same time or place—but they modified it in the light of new findings. The Germans were structuralists—sensations follow a predetermined order. Some Americans stressed personal and organismic factors; others called themselves Behaviorist, because all thoughts result from the body's actions. The Scot MacDougal was "hormic," that is, a believer in intention and purpose; and two Germans, Kohler and Koffka, devised the *Gestalt* theory, according to which the whole being responds to whole situations for the sake of adjustments. This made them severe critics of the linguists who believed that speech and ideas were installed as a separate appliance in the mind. Debaters who wanted to pin a label on James and his disciples called them functionalist, which leaves the door open to revisions of theory.

Finally, an Austrian School was in being that adopted the name Psychoanalytic. Unlike the others, it had its start in the study of mental illness, like the theories of the French *Idéologues* in Napoleon's time: studying the diseased mind reveals how the healthy works. It is worth remarking further that from 1912 to 1950, no new school of thought about the mind made its appearance, and since then the novelties have been only variations. The Cubist Decade remains the fountainhead in every department of culture.

The head-and-heart of the Vienna School was of course Freud, who kept building theory brilliantly and with great speed on experience gathered during and since his work with Charcot, Janet, and Breuer. His acolytes Jung, Adler, and Ferenczi are still recognizable names. These and later disciples diverged from the master, but all agreed on the governing power of the Unconscious and made its existence as familiar and important as that of the appendix or (now) the genes.

Despite its public prominence and its role in all the "depth psychologies," knowledge of the Unconscious did not begin with Freud. In the encyclopedic work that covers the history of the subject, one reaches Freud on page 418 out of 900.° What comes before Freud is a sizable number of Romanticist thinkers and notably Schopenhauer, who saw life ruled by two instincts—self-preservation and the sexual drive, the latter producing the contents of consciousness. After him, Eduard von Hartmann collected a large store of supporting evidence for his assigning much of culture to unconscious motivation. Others suggested analyses of dreams and the death wish. William James was well aware of the part played in the mind's operations by what was called in his day the subliminal, and he was ready for Freud's message when he heard it at Clark University in Massachusetts, where Stanley Hall brought the two men together in 1909.

They continued talking, in German, as they walked to the train station, James carrying Freud's suitcase and suffering an angina attack, but tactfully concealing it from Freud, who noticed it all the same. Their later references

to each other show mutual respect, though James thought Freud attributed too wide a scope in human motives to the sexual drive. James's pluralistic mind resisted any form of the single cause. He might have accepted the libido in its broad meaning and the death wish too, had he lived to read Freud's later expositions. Other physicians had the same objection; and the public, which heard mostly rumors from Vienna, was also incredulous—shocked, in spite of the recent discussions in public of sexual matters (<625).

Freud's mentors in Paris had concluded that certain mental disturbances were rooted in sexual maladjustment, and so had Dr. Beddoes in the early 19C (<438). When Freud made the Unconscious an agent in the mind at large he was basing his belief on work with patients ill-adjusted to the social world. His genius lay in discerning within their uninhibited talk elements that his powerful imagination formed into a system. His knowledge of myth, religion, and literature, when applied to his ANALYSIS, gave an unusual flavor to the persuasive written lectures that he published as an introduction to his psychology. But the system was first of all for therapy.

Earlier workers had used self-searching and unbosoming as relief from anxieties, and the Catholics' periodic confession strongly suggests the formalizing of a natural urge. Perhaps there is also a link between the old notion of the guiding genius—angel or devil—and a sense of compulsion from within. Freud made all such traditions and speculations seem obsolete by the clarity and completeness of his arguments. In this respect, he resembles Marx and Wagner in their role as great borrowers and great formulators. But Freud's doctrine was not final. Jung veered into the realm of myth, finding there archetypes—the shapers of the mind both in the *persona* or individual and in the "collective unconscious" that he posited. It is Jung's scheme and language that have won over the artists and critics and have led to methods of literary ANALYSIS by noting recurrent images, symbols, and mythic patterns. As for the Freudian interpretation of authors and historical characters, it finds no warrant in the master's work. The amount of evidence drawn from documents, compared with that of a live psychoanalysis is patently insufficient.

The second main dissident, Alfred Adler, has been unjustly overshadowed by the other pair. He was alone in contending that society exerts a shaping influence on the mind. In the sequel he has been vindicated by more than one psychoanalyst, from Karen Horney to Abraham Maslow. And the "inferiority complex" that Adler postulated is at least as much bandied about in popular psychology as its rival named after Oedipus. [The book to read is *In Freud's Shadow* by Paul E. Stepansky.]

When in the late 1920s emancipation from the 19C ethos was well-advanced, the primacy of sexuality in Freud was at last found titillating, especially in common talk; reticence was old fogeyish and bluntness the mark of a free spirit. But those who used the jargon without reading the sources did not

notice the ambiguity in the word *libido*. No doubt in many contexts Freud is speaking of the sexual drive, but elsewhere he has in mind the Latin meaning of *desire, eagerness, longing,* which includes the sexual but covers Urge at large, the dionysiac impetus that moves human beings to want, do, and achieve. *Libido* corresponds to Schopenhauer's Will, Bergson's *élan vital*, Nietzsche's "will to power," and other thinkers' "life force." The terms differ in their precise application and are not identical with Freud's understanding of the Id, but all imply the same engine at the core of the creature. Freud's use of *libido* about himself shows that it can apply to entirely non-sexual situations (701>). And when four years of war supplied fresh matter for reflection, he added the death wish to whatever propels the psyche.

In two respects psychoanalysis differs from a number of its rivals in psychology. Freud offered it as a physiological science fulfilling the same demands of material verification as any other; to him, Id, Ego, and Superego were organs functioning like the nerves and the brain; his works described the mechanics of their operation. He never acknowledged that some of his answers to queries beg the question or that the terms he created may help understanding but are not the equivalent of formulas in physics.

In the second place, Freud had little to say about the workings of the artistic mind or the character of human societies. The Leonardo and Dostoevsky essays do not assess their art. There was no reason to expect that they should, but in those two domains his ideas have been exploited so freely that his system is commonly considered to have explained biography, literature, and human relations. Of artists he says only that they want money, fame, and sexual gratification; of societies he says in one of his best books° that it would be risky to psychoanalyze a culture. And far from encouraging the overthrow of social restraints he sees repression as the prerequisite of civilization.

> It is impossible to ignore the extent to which civilization is built up on renunciation of instinctual gratification, the degree to which the existence of civilization presupposes the non-gratification (suppression, repression, or something else?) of powerful instinctual energies.
>
> —FREUD (1930)

*

* *

During the time when psychoanalysis was deemed wild and incredible— interpreters of dreams were charlatans—other notions and systems, equally hard for sensible people to believe, were flourishing. Since the 1870s and the weakening of the established religions, it had been a time of cults. The critique of scientific materialism had opened a breach, and people with spiritual longings who could find fulfillment neither in the old churches nor in the arts yielded to the lure of sects. Their richly abstract verbiage gave access to The

Gross and unclean living, indulgence in animal passions and appetites thicken and coarsen the astral body, while a temperate and a pure life, control of the lower nature, and high unselfish thoughts attract to it the finest and rarest sorts of astral materials.

—ANNIE BESANT, "THE CONDITIONS OF LIFE AFTER DEATH" (1896)

One or The All, with peace of mind and pride in owning The Truth as side effects. Mary Baker Eddy had led the procession in the preparatory period with Christian Science, which defied the materialism of medicine. Next came Madame Blavatsky's Theosophy, a blend of religion and Oriental metaphysics that brought relief from the burdens of western INDIVIDUALISM; it contained enough imaginative substance to capture Yeats's strong mind. This appeal of the East gave currency also to Vivekânanda's Esoteric Buddhism. The recovery of myths and the interest in psychology generated several types of "New Thought" that drew on autosuggestion and other modes of guiding consciousness to the Light and enhancing happiness. This movement of ideas has gone on into the present, reinforced by cultish innovations within Christianity; biblical criticism had confused its message, giving license to new prophets who have redefined moral duties and promised salvation, sometimes through mass suicide. The important thing is to believe again.

Not quite a cult, because unorganized, the believers in mediums and spirit return kept in existence the methods and manifestations traditional since the mid-19C (<574). But now, the rise to consciousness of the Unconscious had the unexpected result of arousing genuinely scientific interest in psychical phenomena, from the revelations of mediums to thought transference, the behavior of ghosts, and the misbehavior of poltergeists. The Society for Psychical Research had been conducting investigations in the field since the early 1880s, but its activities did not draw much attention until a connection was made between the familiar showings of the supernatural and the work of unconscious suggestion. A book by the Swiss psychologist Flournoy, based on five years' study of a medium, made known the "mythopoetic function" and its "romances of the unconscious." This scientific enterprise had a martyr.

What are the obstacles to the Yogî? Disease, mental laziness, false perception, non-attaining concentration and falling away from the state when obtained.

—SWAMI VIVEKÂNANDA, *RÂJA YOGA* (1897)

Edmund Gurney (<639), the gifted critic and vigilant secretary of the Society, committed suicide—a mystery to his friends. Evidence subsequently found suggests that his act resulted from his discovery that a report of psychic phenomena that he had validated and published was fraudulent.°

Scientific and popular preoccupation with the mind naturally had the effect of increasing western SELF-CONSCIOUSNESS, and in amateur introspection one of the first discoveries is that motives are not simple or single. It

may seem odd to associate this now obvious statement with political economy; the warrant for it is the change in the name and principle of that social science about the time when the others also revised their outlook. The adjective *political* in use from the beginnings of the discipline meant that the whole state was affected by the production and trade of goods and the government must regulate them (<292). By the latter third of the 19C, the ideas of utility and equilibrium altered this relation, while EMANCIPATION from governmental controls suggested that dropping *political* and coining *economics* met the need for accuracy.

In the original view of motive, "economic man" was a standardized automaton: he bought in the cheapest market and sold in the dearest. In the revised view, he still does this but the decision to buy, which contributes to the demand and influences value and price, is governed by the "marginal utility" *to him* of the article. The automaton now had a mind; individual psychology had entered the market. The buyer takes thought about the amount of use or pleasure that he would derive from the last unit of these benefits embodied in the product: one buys three clocks to furnish a new house; a fourth one would be nice but is the enjoyment worth the outlay? The last clock's value is at the very edge, the margin, of the desire. A fifth clock is not even considered. When all similar utilities—the customer's about buying, the manufacturer's about producing, the retailer's about stocking, and so on—are calculated, the economy should be in equilibrium. Jevons, Marshall, and Walras were the thinkers who theorized to this effect and established economics as a self-standing *social* science. Historians of the subject still call this turn-of-the-century model part of "classical economics," but a cultural historian must point out the difference just indicated. With the advent of the welfare state government has re-entered the scene and *political* economy has resumed its place, even though it has not recovered its proper name (778>).

<center>*
* *</center>

One can sympathize with Freud's insistence on the materialistic basis of his system; he did not want the medical world to class him as a quack. But the timing of his claim was unfortunate. As will be recalled, biological thought had begun to stray from materialism into vitalism, the mechanics of evolution were under fire, and philosophy was generalizing these and other tendencies in a fashion that denied matter or idea as the sole underlying reality. If the scientist found that he must regard light now as waves and now as corpuscles, it implied inconsistent behavior in matter and contradiction in thought. That pair of dilemmas posed the question of truth and how it is made sure. The theory that gave a radical answer was named Pragmatism. The Greek-rooted word was chosen by Charles Saunders Peirce, who first suggested the method

as a way of ascertaining the meaning of important words: the meaning was the sum total of the practical effects the word implied. This definition William James developed into a theory of truth, which he supported by arguments and applications in *Pragmatism: A New Name for Some Old Ways of Thinking*. The name that Peirce chose and James adopted is regrettable, because it has a bad historical past and a worse present. There is little hope of disinfecting it, but clarity here requires a

Digression on a Word

Over the centuries *pragmatic* has meant: *busy, meddlesome* (busybody), *opinionated, connected with state business, according to common practice, giving factual reasons*, and—nowadays—*devoid of principle*—surely a poor record for one word. The Greek root *pragma* means *the thing done, to be done, rightly done*, and more simply *fact*. Headlines such as one reads today: "Election Raises Pragmatist to Power," "From Revolutionist to Pragmatist," suggest a politician not expected to steer a straight course; he has made his way by compromise and the abandonment of stated aims. There was an excellent word for this flexibility: *opportunism*—until the press hit upon a more high-sounding term.

In its philosophical meaning, Pragmatism occasioned a vehement debate in the Cubist Decade; or rather, the meaning that James intended was mistaken for something else, which was furiously attacked. With such a past, there is little hope that the ism will ever regain its intended sense and an acceptable connotation. The case is as bad as that of Romanticism and worse than that of Puritanism. James's pragmatic theory of truth answers the question: how do we go about determining whether a statement is true? The obvious reply is: when it describes the fact exactly. This is the "copy-theory" of truth, which as James pointed out, has a radical flaw. One notes down a piece of experience and the notation is offered as true. How can this be tested? The answer cannot be: by looking again at the thing reported. That would catch a gross error or a lie; but barring these, to look again and repeat the statement may be to echo an illusion. One should be able to somehow go behind the appearance and obtain something else to compare with the possibly false impression—and that is impossible.

James says: do not look back to the origin of the statement but forward to its consequences. What practical effects will occur from believing and acting on the proposition? The method also holds true of objects. A true conception of an object is the sum of the observations that follow from handling and using it. Act in keeping with a hypothesis and the outcome will prove or disprove it. In this view, a theory or

> To talk of reliance is a poor external way of speaking. Speak rather of that which relies because it works and is.
>
> —Emerson (1840)

system must fulfill our expectations and must also fit in with our previous knowledge, already tested by use. If there is a clash, which is to be discarded? Testing by concrete results is the only answer. Neither past certainty nor reliance on authority can validate truths.

When James called Pragmatism an old way of thinking, he was recalling the dictum repeated throughout history in various wordings, of which the most familiar is: "By their fruits ye shall know them." He was also saying that the pragmatic test by results is what everybody, scientist or layman, actually does, since there is nothing else obtainable to match with a statement offered as truth.

Yet during the controversy about Pragmatism, its opponents tried to discredit the principle by boiling down: "Truth is what will be steadily borne out by subsequent experience" to: "Truth is what you can get away with." European critics, seizing upon James's birthplace, said that his thesis was typically American, "a theory for engineers"—minds limited to action and deaf to ideas.

Except for a very few, the professional philosophers in the debate did not shine by the relevance or courtesy of their arguments. They ignored the answers to objections and did not examine the abundant applications of the method that James made in his book, showing how it resolved the perennial questions of determinism, design in nature, matter and spirit, and the like. To them, Truth with a capital T had a disembodied, goddesslike nature that called for a worshipful attitude and that resided in statements in an absolute way. To call for acting on a statement degraded something noble. James's conception of truth as a pointer to utility, always tentative and incomplete, was heresy.

More than one European critic forgot science, which pursues truth by testing what follows from a hypothesis and how it fits in with previous truths, all this done with rigor and integrity. Verification means to *make* true; it is a process, an instrument for reaching desirable goals, rather than a static feature in certain propositions. The height of imbecility on the part of academic philosophers was reached when one of them wrote a rejection of Pragmatism on the ground that he had tried it and found it would not work. Instrumentalism would have been a better name and it was used by a few among James's supporters, but it died with them.

Although mention of James usually triggers the thought of Pragmatism, it is not for bringing out the merits of that age-old way of finding truths that he is a towering figure among western thinkers. First as a psychologist and then as a metaphysician he re-oriented the seekers in the field.

People picture pragmatism as something that must necessarily be simple and capable of being summed up in a formula. I ceaselessly repeat that on the contrary pragmatism is one of the most subtle and *nuancées* doctrines that have ever appeared in philosophy.

—BERGSON (1909)

Describing how truths are made was but one part of that achievement. A second consists of James's Radical Empircism. By this phrase is meant his premise that experience is the sole ground of reality; it is not divided into mind and matter, soul and body, idea and sensation.

To open the way to this conception, James published a paper entitled "Does Consciousness Exist?" The question is not a joke. James does not deny, of course, that human beings are conscious, both of themselves and of the world; what he denies is the existence of an entity called Consciousness that stands apart and watches the contents of experience go by. What we feel and know, says James, arises from one part of experience entering into relation with another part, just as happens when we think about ourselves and examine our actions and ideas, or when we distinguish the separate qualities of an object, or indeed when we divide the flow of experience into objects—all these activities occurring *within* the flow and serving needs, practical and intellectual. These two needs do not differ in kind, for experience includes curiosity and truth-seeking which, as pragmatic theory shows, is related to use in life.

Radical Empiricism is a philosophy; Pragmatism a method, each independent of the other. If Pragmatism states the facts correctly, everybody is a pragmatist without knowing it. To follow James, the Radical Empiricist is a choice; one must come to see how the familiar notions of common sense and philosophy find their place in his comprehensive view of experience. For James the universe is pluralistic and open; it is not a ready-made order but one in the making as the sciences and the arts go deeper and deeper into the physical and psychic (plural) realities. Without blurring this distinction between method and worldview, those who may be called the Pragmatist generation belong to it by their fresh recognition, variously expressed, of the primacy of experience—in politics, social thought, aesthetics, and religion.°

The influences that converged on that generation were various; Bergson, Duguit, Ernst Mach, Vaihinger, Croce, Simmel, Dilthey, F. C. S. Schiller, Dewey, Nietzsche, Frazer, Durkheim, Shaw, Ortega y Gasset, Pareto, Norman Angell, the Fabians, came from different traditions and retained from them disparate elements in their handling of diverse subjects. One can read about a *Pragmatic Revolution in Politics.*° One should read in the works of Alfred Sidgwick the inadequacy of formal logic and the ways of sound argument in actual debate.° It is a lesson, once more, on the worth of experience, the lesson applied throughout

In attributing to William James the inauguration of a new stage in philosophy, we should be neglecting other influences of his time. But admitting this, there remains a certain fitness in contrasting his essay "Does Consciousness Exist?" with Descartes' *Discourse on Method.* James clears the stage of the old paraphernalia, or rather he entirely alters its lighting.

—WHITEHEAD (1925)

the undoing of Victorian ethos. What was wrong with that ethos was its calculated denial—useful in its day—of certain facts of experience. "Taken" in a new way, experience shattered the ethos. Spontaneous pragmatists, the men of the Nineties (as we saw) had an easy time showing that the consequences in life of the old ideals proved them false and that exact opposites might be true. Hence the "change of lighting" that Whitehead attributes to James.

His contribution to the understanding of beliefs (in contrast with truth) is well known but not always rightly represented. In *The Varieties of Religious Experience* he studied the many forms and directions that the human impulse of faith can take and the links between these forms and other mental traits. He warned against the reductive view that explains mysticism as frustrated sexuality or Puritan self-torment as chronic dyspepsia. Before the *Varieties*, James had coined the phrase Will to Believe in the course of showing that belief—an unverified idea—is legitimate and valuable in situations where testing is not possible. He gives the example of the mountaineer who must leap across a chasm if he is to save himself; the belief that he can do it adds to his chance of success; disbelief probably means failure; disbelief is in fact a belief. Life continually presents options of this type, in which the confident outstrip the hesitant.

By the same reasoning, religious faith sustains and is to that extent validated. Critics have twisted this qualified statement to mean "believe anything you like and it's the truth." James carefully defined when and where his principle holds; as one logician put it, "What James really advocates is the use of working hypotheses, though they may often be hypotheses which can never be verified."° James later modified the *will* to the *right* to believe, neither meaning the same as "wishful thinking." The breadth of James's worldview and of its influence has been matched by its permanence. He is quoted apropos of innumerable subjects, and he periodically reappears in retrospective estimates expressing wonder at the extent of his powers.°

It is this maintained contact with the facts of life that makes James's vivid, beautiful prose so easy to read and so difficult to understand. One feels its richness and ignores its kind of precision. Here is an abstract philosopher who makes concrete connections and applications, but a man for whom concrete situations sprout into philosophy.

—LEO STEIN (1948)

*
* *

A thinker, no less radical than James, but whose work, finished by 1890, became widely known only in the 1900s, made the starting point of his speculations the contrast in Greek religion between Apollo and Dionysus: the static order of reason *versus* the dynamic working of impulse. That thinker was

Nietzsche and Georg Brandes was his prophet. Thanks to him a philosophy difficult to extract from the aphorisms in which it is couched began to be seen more or less whole. There is no Nietzscheanism, not for lack of admirers and interpreters, but because the work is a series of critiques and visions. They are clear and coherent, but not framed into a system. That fact makes a point: for Nietzsche as for James, experience is not yet complete; it contains novelty, especially as regards the nature of man, who is at present inadequate and unfinished.

The word *superman,* the phrase Will to Power, and the statement "God is dead" are the tags that Nietzsche stands for in the casually educated mind, and as they are understood in that precinct all three are misleading. Nietzsche is no crude atheist; he evinces respect for Jesus and he is no materialist. Spirit, inherent in mind, is creative, and the superman is the self-development of man into a creature a state above and beyond what he is now. The God that is dead is the one who presides over Christianity, a doctrine designed for the weak and the poor in spirit. By glorifying the helpless it multiplies the number of victims afraid and resentful of life.

In health man feels within him the will to power, a drive to action and achievement, including the self-mastery that will characterize the superman and establish a new ethos. The present conception of what is evil will be replaced by other standards of right and wrong, contrary to both the Christian and the worldly virtues and vices of western civilization. In ethics and the search for truth Nietzsche is a Pragmatist.

> In place of fundamental truths I put fundamental probabilities—provisionally assumed *guides* by which one lives and thinks.
>
> —NIETZSCHE (1882)

Like Ibsen, Nietzsche despises current ideals; like the Pragmatists he wants challenges to conventions judged by results, and these measured by the enhancement of life. Like the aesthetes he cannot bear the public mind fed on newspapers and the "thoughtful" journals. The intellectuals who "love art" and hold "advanced ideas" are as sheeplike as the masses; he calls them "culture philistines." Individuality, courage, and imagination, the zeal to enlarge and diversify individuality instead of regularizing it, are all wanting. Only by defiance and attack can a livable world, with an expressive art to match, be created. Some of Nietzsche's metaphors, like the phrases already cited, make him easy to misunderstand; "blonde beast of prey," "beyond good and evil," and bellicose imagery suggest a brutish warrior and "superman," a tyrannical overlord. Coupled with his condemnation of pity and Christian charity and his contempt for the behavior of good people, what Nietzsche seems to desiderate looks like barbarism rather than superhumanity. But his regrettable phrasings are more conspicuous than frequent, and in the bulk of his writings he appears in his true guise as psychologist, social critic, and interpreter of art.

This is not to say that a livable society could be founded on his brand of INDIVIDUALISM. But his design is a new man and civilization, not a utopia. His psychology is sound: compassion easily becomes a selfish pleasure fostering self-righteousness (787>). It requires a constant supply of the poor and the weak, instead of encouraging the healthful and self-reliant.

Nietzsche's assault on the character of both the mass man and the intellectual conformist was launched in the 1870s and 1880s, a time when the booming of industry, the ruthlessness of capitalist enterprise, and the ravages of renewed imperialism were at their height, filling the air with rejoicing and self-congratulation, in Germany particularly. The three wars by which Bismarck made an empire corresponded in no way to Nietzsche's military figures of speech; he was disgusted by the vainglorious mood after the defeats of Denmark, Austria, and France; the country's attitude was the reverse of aristocratic.

Besides being a philosopher and a classical scholar, Nietzsche was a more than ordinary amateur composer: He wrote two symphonic works in the Berlioz genre, and when he heard Bizet's *Carmen* he hailed it as a model of "Mediterranean art." The epithet was bestowed with Wagner's "Northern" music in mind. Nietzsche had fallen early under the spell of Wagnerism—the ideas and the music, both, and was soon a friend and defender of the master. Then had come disenchantment, and in a pair of essays he assailed the doctrine and the works; he saw in them an expression of what he was denouncing in culture at large: the massive, the long-winded, and the theatrical. Art like man's soul should be aristocratic, the signs of which are: directness and the brevity that comes from concentrated energy and rapid perception. *Carmen* met these specifications, in sharp contrast with the slow ruminating pace not only of the Wagnerian system but also of German scholarship and philosophy. Nietzsche's prose, which ranks with Goethe's and Schopenhauer's for clarity and elegance, fulfills these demands neglected by the German tradition.

Nietzsche was naturally immune to the contagion of populism. His model aristocrat Zarathustra is such because he is truly and solely himself and aloof from collective enthusiasms. It was the mistake of Hitler and his intellectual aides to include Nietzsche among the early prophets of their social and racial dogmas. They soon found that he did not suit the role—quite the opposite—and within a short time he was quietly cast aside. [The book to read is *What Nietzsche Means* by George Allen Morgan.]

There is more than one way of showing up the civilization one lives in. The most usual is to contrast the moral and mental vices of the upper classes with the sturdy virtues of those they dominate. That was Rousseau's and Jefferson's way. They chose as the ideal citizen the sober artisan and the contented farmer. Tolstoy went one level lower and glorified the *moujik,* the Russian peasant. These choices were not made in the abstract. Each grew out

of familiar dealings with the desirable type. In Tolstoy this PRIMITIVISM came after equal familiarity with rank and power—they were his birthright—and after the production of literary masterpieces acclaimed by the whole world.

These novels and other fictions Tolstoy came to disown, sweeping out in the same gesture the entire artistic output of the West. He set out to demonstrate how artificial is the experience of life reproduced in novels and plays, how narrow their subject matter, which would be unintelligible to any human being not brought up in capital cities and corrupted by absurd customs and concocted interests. His description of a modern opera is a superb piece of satire, the plot and the production possibly made up, since nobody has been able to identify the work. [The essay to read is his diatribe *What Is Art?*.°]

To Tolstoy the natural man he respects is simpleminded in the good sense and ignorant in the eyes of the world. Such a man knows how to do his work and is faithful to his duty. He is humble and a Christian, but not as the Orthodox church understands the believer. The words of Jesus suffice. Tolstoy proved his integrity by ending his days living like a peasant among his former serfs, without comforts, good clothes, hygiene, or fine food. For the teaching that he undertook in their behalf he wrote four *Reading Books*, which are masterpieces of storytelling in the folk tradition.

News of this saintlike withdrawal from society and intellect spread abroad and generated a cult. People came to pay homage to this latter-day early Christian, from curiosity or to confirm their resolve to imitate him. His pacifism and creed of non-resistance influenced still others, adding to the number of previous agitators for peace. For it was then that the first moves were made to promote the arbitration of international disputes, coupled with hopes of an organization for peace. In 1898 the tsar called a conference to meet the next year at the Hague. Twenty-six nations sent delegates who discussed disarmament and codification of the laws of war. It was agreed—on paper—to ban the dropping of bombs from balloons, poison gas, and dum-dum (soft-nosed) bullets. War prisoners were to be humanely treated and conflicts resolved by arbitration. A permanent court was set up to direct it, but recourse to it was not compulsory, nor any limitation of armaments.

The tsar's motive was thought to be the lack of money to compete with other nations in military strength. Still, his move was not futile; a second Hague conference, instigated by President Roosevelt, was held eight years later. It improved the machinery for arbitration and produced signed conventions governing the rules of war, the rights of neutrals, and the permissible actions for collecting international debts. Between the two conferences, Peace Societies were formed in many countries and agitation continued up to 1914. William James, knowing that the aggressive instinct needed an outlet, wrote "The Moral Equivalent of War," which suggested the conscription of

youth for hard work in the midst of nature or in community service, a foreshadowing of the mid-20C Peace Corps.

The Four Years' War later made pacifism equivalent to treason, although some writers—Romain Rolland, for one—kept up the propaganda for peace from the haven of neutral Switzerland. It was there also that Lenin and his little band of orthodox Marxists plotted and kept up in *Iskra* (*The Spark*) an endless philosophical polemic against other Socialists and other philosophers, against scientists or anybody else who deviated from historical materialism. Compared with the new tendencies in thought and science, they were doctrinaire reactionaries and the chances were slim that their ideas had any future.

> The war against war is going to be no holiday excursion or camping party. "Peace" in military mouths today is a synonym for "war expected." Every up-to-date dictionary should say that "peace" and "war" mean the same thing, now *in posse*, now *in actu*. But a permanently successful peace-economy cannot be a simple pleasure-economy. We must make new energies and hardihood continue.
>
> —JAMES ON "THE MORAL EQUIVALENT OF WAR" (1910)

* * *

The Cubist Decade brought forth novelty in literature, but without the shock that the painters inflicted. The outward form of play and novel seemed undisturbed. But the substance in the innovators was radically new, though obscured at first by the flood of regular novels. The Russian writers were being assimilated as translations kept appearing in quick succession, and their presentation of character influenced and paralleled a transfer of interest from the body to the mind and its wild vagaries—again a shift in keeping with the current anti-materialism. Individual action in Russian literature, especially in Dostoevsky and Chekhov, is often unaccountable, against reason and self-interest, and though at times tied to religious belief or ancestral habits, more detached from social conditions than occidental writers were accustomed to make out. The inner life is stronger than the outer norms. This new vision made the Naturalist novel seem jejune and imparted a sense of mystery and terror to the novel.

In an entirely different tone but with the same depth, Henry James in his final works concentrated on involutions of feeling and idea that make for tense drama. He gives only the barest indications of the circumstances, the occupations, and even the actions of his figures, but the reader who learns how to read him is made witness to unforgettable scenes. After 150 years the novel was abandoning its role as fictive history and social criticism, retaining psychology as its field of study. In his Notebooks, moreover, James defined the ways of making the novel a work of art, limiting dialogue and external

description and devoting attention to form—balance and symmetry in handling the main matter. To him this consisted in the decisions people make that affect others as, face-to-face, they work out their conflicting desires. Public and critic excused themselves from reading him by saying that his style had grown too difficult. What escaped their notice was that his subtle trailing after emotions and their qualifying adverbs is punctuated by colloquial phrases that maintain the connection with the workaday world—and the Naturalist technique.

In a different way, Conrad combined violent action in exotic places or on the sea with persistent inquiry into the strange thoughts and motives of the rather ordinary people that he portrayed. Striking events and picturesque settings gave his works the popularity denied to James, whose last three novels hardly found readers. Conrad benefited from the impression that he was simply a writer of sea stories and revolutionary politics. A theory of this change in direction had appeared much earlier, when J. K. Huysmans broke with the Naturalist leader Zola and wrote novels about eccentricities of character unrelated to social conditions, the first of which, *A Rebours* (*Against the Grain*), was prefaced with a long justifying essay.

Nobody understood the soul less than the Naturalists, who meant to study it. They saw life as all of a piece and accepted it only as conditioned by plausible factors. I have now learned by experience that the unbelievable is not always, in this world, an exception.

—Huysmans, Preface to *A Rebours* (*Against the Grain*) (1884)

The unreformed novel remained less original. The leading producers, such as Anatole France, Romain Rolland, Paul Bourget, and their counterparts in every country, did not neglect character as a source of interest, but they were happier criticizing ideas. They were really writing long essays with dialogue and furnishings to make the pill palatable. Only Maurice Barrès and Pierre Loti sounded a new note in their "novels of egotism," which—long after Stendhal's invention of the style—recited faraway wanderings and uncommon sensations and desires that fed the love of self and singularity. Still, the objections to the Naturalist novel kept being repeated. Long after Huysmans, Virginia Woolf was pleading the same cause in *Mr. Bennett and Mrs. Brown*. Bennett was the widely read and respected author of "studies" of English life at every level. Mrs. Brown was the imaginary figure whom, according to Virginia Woolf, Arnold Bennett would depict almost entirely by externals, from ancestry to class, clothes, and domestic life, her mind and feelings not ignored, but superficially treated.

Psychology was clearly the chosen preoccupation of the new century, both as a professional study and as the main fare of literature, pure or mixed with the old social details. The purest form was to come when the author reproduced a character's stream-of-consciousness. One French writer of the

older generation, Edouard Dujardin, had in one brief novella inserted what he called an "interior monologue." Earlier, Dickens in one or two short passages had shown the stream spoken aloud by a character. Dujardin's contrivance went unnoticed and Dickens's unremembered. Of course, the device is artificial; it is managed by the author to make a point. The images of an actual stream are too fluid and fleeting for anybody to take notes on them and Joyce's later expedient in *Finnegans Wake* ends in self-defeat (720>). All this introspection differed essentially from the Nineties' revulsion from material reality and creation of another world. Indeed, it was the opposite. The artists in the early 20C did not retreat from any conceivable reality; they were exploring with zest any territory not yet conquered.

> Strip the novel of all the elements that do not specifically belong to it: External events, accidents, traumas belong to film. Let the novel hand them over. Even the description of the characters does not belong to the genre. The *pure* novel—and in art purity alone matters—should not concern itself with it.
>
> —GIDE, *THE COUNTERFEITERS* (1926)

<center>*</center>
<center>* *</center>

In the Cubist decade the stage did not yet dare to present as leading characters the madly incomprehensible. On the contrary, when Strindberg, Shaw, Ibsen, Galsworthy, Pirandello replaced the routine motives of melodrama (<565) they used figures of unusual intelligence and lucidity and set them to deal with the questionings of the self-conscious mind, Pirandello stressing the ambiguity at the bottom of self and behavior. [The book to read is *The Playwright as Thinker* by Eric Bentley.] Concurrently, staging underwent a change at the hands of Max Reinhardt, Gordon Craig, and Stanislavsky. The first produced spectacles on a grand scale with the aid of new mechanical devices; the second designed settings that ignored Realism in favor of pictorial and architectural beauty, not for use in the action, but able to enhance it; the last laid down rules that were later famed as "the Method" to be described in a moment. The producers of effects were slowly taking precedence over the dramatist and his actors.

Of these, the ones still reigning were of the old school, notably Sarah Bernhardt, whose golden voice prolonged the life of the 19C repertory; and Eleanora Duse, a more subtle interpreter who faintly foreshadowed the new style—"she seemed not to be acting at all"—and thus suited the contemporary theater of ideas. It was in fact sheer intellectualism that animated Stanislavsky. His system for training actors for a modern play, say, one of Chekhov's, was to make them master the "psychology" of the figure they impersonated. To do so required studying the character's milieu; that is, the rest of the play and the world outside, of which the play was a slice. For this

purpose the assembled performers and Stanislavsky read and reread and discussed the play for months. Then at rehearsals he bullied them individually, his death blow being a repetitious: "I do not believe you." He himself had done research in an ever-widening circle, so that on the boards he was virtually conducting a Ph.D. seminar. In time, he came to disavow acting "with a stuffed head and empty heart."

There was a hint of "the method" in Shaw's printed plays, where each of the principal characters is introduced by a few lines about age, circumstance, and prevailing attitude, but it is nothing to compare with the brainwashing that Stanislavsky's system entailed. The uniqueness of the individual that it implied—once more a by-product of the intense psychological temper—found expression in the poets. In Germany, Stefan George made disciples who, without being poets themselves, formed a cult on that same core idea of the induplicable ego. D'Annunzio in Italy shared the conviction, and not only wrote but behaved so as to make it conspicuous. The more highly prized poetry of Rilke dissected the self's experience to find in it myths, but so expressed that their bearing must be deciphered to yield the sense beneath the sensuousness.

It has been said that Richard Strauss's librettist, Hugo von Hofmannstahl, gave promise in his early poems of being the greatest lyricist in German since Mörike. But during a nervous breakdown he became convinced of the futility of words and chose the subsidiary role for which he is known by all opera-goers. The genre obviously requires plain, singable speech, which he did provide; yet he managed through fine-grained lines and curious motives to endow his plots with a delicacy not frequent in what is hopefully called the lyric theater.

The decade ended just in time to salute the new Yeats. The surface qualities of word music and fluid responsiveness to sensation that had characterized his poetry since his beginnings in the mid-1880s had disappeared from the collection *Responsibilities* that appeared in 1914. The poems in it are written in tight-packed lines, and the hard-edged words treat of social and moral themes in no bucolic spirit. But again in the decade, a greater surprise was the appearance of a new poet who was old in years and practice. In the late 1890s Thomas Hardy, because of the harsh criticism that greeted his sexual themes (<625), gave up the novel and brought out a first group of Wessex poems, some of which had been composed 30 years before. Then came his verse epic in three parts on the Napoleonic wars, *The Dynasts*. New collections of lyrics early and late kept appearing and winning immediate acclaim. Seven well-filled gatherings, the last appearing shortly after his death in 1928, established the fame of a major poet. Their enthusiastic reception owes something to his verbal innovations, strange but clear and in keeping with the genius of English, and to the impassive recital of compressed dramas that end in death

or despair. Sometimes the cause is accidental and victims are doomed by their incapacity to see or act; at other times, perverse ideas or feelings ensure catastrophe. Hence the titles: *Life's Little Ironies, Satires of Circumstance, Time's Laughingstocks*. No other English poet has made rural lives and ways so gripping or so free of sentimentality. That his mood is often stoically hopeless shows a sensibility formed when scientific determinism ruled thoughtful minds; yet reading him does not leave one depressed but exhilarated, which in poetry is the sign of the tragic spirit.

*
* *

The span that opened with Cubism ended in a great burst of music and dance: the Russian Ballet and a new school of post-Wagnerian composers. The Russian dancers, choreographers, designers, and their chief musician Stravinsky astonished Paris in 1910 with the performance of *Firebird*, soon followed by *Petrushka* and *Le Sacre du Printemps*—the rites celebrating the advent of spring. The mythic themes of the first and third works and that of the circus in the other were congenial and the productions dazzling. Ultra-bright colors in the decors by Bakst, the amazing feats of the principal dancers, Nijinsky and Pavlova, the brand-new choreography of Fokine, the flawless productions by Diaghilev, and the unaccustomed sonorities and rhythms of Stravinsky aroused enthusiasm and fury. The *Sacre* provoked as much anger as the first Cubist works; its premiere caused a riot in Auguste Perret's newly opened modernist Théâtre des Champs Elysées. People stood on their seats to yell insults and pummel their neighbors of opposite opinion.

The Parisians—and the rest of Europe—greeted very differently the performances of a self-exiled American woman who also had something new to show them. Isadora Duncan incarnated the natural dance of free movement and varied rhythm in opposition to the artifices of classical ballet. The slight shock of seeing a solo dancer, barefoot and thinly veiled, was altogether pleasurable and so were Isadora's "interpretations" of music by Beethoven and Wagner. Others danced; she re-created.° She became an idol sung by poets, and her advocacy of free love formed a cult. She founded schools of dance in several countries and her disciples firmly established the modern dance.° Jaques-Dalcroze devised "eurhythmics," a method by which children learned to move their limbs and bodies naturally while responding to music appreciatively.

Part of this energetic PRIMITIVISM inaugurated by Stravinsky (and matched by Duncan) was no doubt due to his emphatic rhythms and discords, which acted on the nerves directly. They had the further effect of making the composers who were disturbingly new in the late 1890s appear by contrast rational and delightful. It was a varied group, whose sensibilities con-

verged in the resolve to swear off Wagnerism and be expressive without repeating 19C lyricism and drama. To name Debussy, Delius, Chabrier, Hugo Wolf, Skriabin, Erik Satie, Dukas, and Busoni is to name but the most conspicuous innovators. But they form only one half of the musical contingent; masterly adapters and extenders of 19C techniques still flourished in tandem with the modernists: Bruckner, Mahler, Elgar, Vaughan Williams, Strauss, Sibelius, and Puccini with his Verismo compatriots (<638) composed works that have not lost their power.

The moderns led by Debussy came to be known as Impressionists, because they composed by detached touches of harmony and tone color like the pointillists, avoiding long melodies, counterpoint, and rhythmic or other kinds of emphasis, and thus turning their backs on 19C methods. They were in fact dealing with a predicament inherited from that period, the gradual undoing of tonality by chromaticism, which is the use of notes outside the prevailing key. This difficulty went back a long way: when Cherubini heard Beethoven's *Fidelio*, he complained that he could not tell in what key the overture was. Debussy also sought to change the familiar atmosphere of music by the use of unusual scales. The line of influence here is unusually roundabout. He owes this inspiration to the "Russian Five," who belong to the 1870s, and particularly to Borodin and Moussorgsky, who acknowledged their debt to Berlioz and his use of modes. Debussy went further. By his chords used as dabs not dictated by melodic line he defied one kind of logic to establish another. It was so effective and pliable a technique that looking back on the double decade, a later composer and music historian finds it applied, robustly, in the prewar works of Stravinsky and Schoenberg. [His book, recommended for reading, is *Music Ho!* by Constant Lambert.]

Schoenberg, as is well known, worried about tonality almost from the beginning of his career, and one may suppose that to put his ideas in order he published a treatise on harmony in 1911. His contemporary, Kandinsky, cites it as another contribution to modernism, though it contains no mention of the system that ultimately became a technique adopted for a time by composers everywhere. It made Schoenberg the rescuer of music. Before his treatise he had in fact taken the first step in his Opus 11, No. 1, of 1909, a piano piece that is atonal, or as he preferred to say, pantonal—it has no central key. In the same year *Five Orchestral Pieces* followed this program, disorienting academic and custom-trained ears. This EMANCIPATION from tonality as the organizing principle of western music corresponds to the radical departures made contemporaneously in the other arts.

Within those same years, America made two contributions to classical music, one of which is likely to be overlooked: the marches of John Philip Sousa. Far from being commonplace military music, the sizable group of his best are remarkable for melody and counterpoint and can stand comparison

with any other composer's in a genre that was not disdained by the greatest masters. The second, an epoch-making innovation, was Ragtime and the Blues composed and played by Black musicians, first in New Orleans, then in Chicago. Their work was the flowering of mixed traditions and it remained local until its eruption full force in the rightly named Jazz Age (738>).

While this new American music was rapidly developing in the South and Midwest, the Northeast was being educated to European modernism by a mixed group of Wagnerites and Nietzscheans, admirers of Ibsen, Shaw, and the Cubists—James Huneker, Barrett Wendell, Brander Matthews, John Sloan, Alfred Stieglitz, Stephen Crane, and the writers for *The Smart Set*, "a journal of ideas," edited by H. L. Mencken and George Jean Nathan.

To sum up, the gestation of modernism went through three phases: a preparatory period, roughly from 1870 to 1885, during which old modes are questioned or tentatively flouted; the Nineties (1885 to 1905) when the 19C ethos and its limitations on art are turned upside down, while the common world is shunned by a growing brood of aesthetes; third and last, the Cubist Decade (1905–14), when the young generation, stimulated by the inventions that transform visible reality and working in parallel with the scientific notions that negate common sense, gives the arts fundamentally altered goals and forms. At the same time, the great wave of Populism, also rising in the 1870s, inspires a redefinition of history and the social sciences. All that the 20C has contributed and created since is refinement by ANALYSIS or criticism by pastiche and parody. But these manifestations came to public notice only after the wide hiatus of the Four Years' War.

PART IV

From "The Great Illusion"
to "Western Civ Has Got to Go"

The Great Illusion

The Artist Prophet and Jester

Embracing the Absurd

Demotic Life and Times

The Great Illusion

THE BLOW that hurled the modern world on its course of self-destruction was the Great War of 1914–18. It was called great on account of its size rather than for any notable merit. When its sequel broke out in 1940, the earlier conflict was renamed First World War in deference to the second. This was an error, since the European wars of the 18C were also world wars, promiscuously fought in India and North America and on the five seas. But these, not being wars of peoples, did not threaten civilization or close an era.

The 15 years that preceded the catastrophe have since been called *la belle époque* and also "the banquet years."° This nostalgic remembrance dwelt on the high artistic achievements of the Cubist Decade and on the outstanding minds that promoted social reform and forced a political turnaround that has shaped the present conception of the state throughout the West. A third form of energy was also at work: the practice and cult of violence. Many contemporaries blinded themselves to its significance in the enthusiasm for the abundance of original art and intellect; but many others, with fear or zeal, thought of nothing else.

Before dealing with the kinds and causes of bloodshed, the constructive effort in politics must be sketched so as to show to what degrees it bears on present-day forms of government. In England during the decade before the war, the quartet who stirred the reading public into thinking were Wells, Chesterton, Belloc, and Shaw. Wells was for a time a Fabian Socialist (686>) but left the group when he thought their proposals unworkable, although he had his doubts also about democratic Liberalism. His forte was not politics but the state of society, which he discussed in novels he managed to make popular. They are in fact tales, as defined earlier: plausible characters but not memorable, contrived yet lifelike situations, and outcomes that clearly show the social predicament and sometimes resolve it by a mixture of common sense and original prophetic suggestions. His essays attack more directly. Largely self-taught and with a tincture of modern conceptions, Wells took up science fiction where Jules Verne left off. These tales, long or short, still make excellent reading;

indeed, they make most of his successors' works in the genre sound crude in narrative and unimaginative apart from the technical fantasies.

Chesterton disagreed with Shaw's Socialism and Wells's reformism and agreed with Belloc on the social and spiritual teachings of the Catholic church to which he was converted in mid-career. His own program for ending the evils of capitalist plutocracy was Distributism—the wide ownership of property. It would restore independence to the individual and create a true democratic electorate, instead of a populace manipulated by a venal press that can govern the governors (<599).

The Nineties had seen the advent of the cheap daily paper, in which raucous propaganda, crime, and scandal were the main fare, but not the only attraction. Starting when Alfred Harmsworth, later Lord Northcliffe, began publishing a sheet called *Answers to Correspondents* (earlier *Tit-Bits*) in the late 1880s, the newspaper became the sort of popular encyclopedia that it is still. Daily features about sports, fashions, and theater; advice about health, business, and finance, card games and cookery, in addition to a puzzle, a comic strip, and the day's installment of a long-winded romance—all this amid wads of advertising—turned the traditional four to eight pages of strictly political news, major accidents, and obituaries into the sole source of mass enlightenment. Radio and television have only annexed the program at the expense of genuine news—and lengthened the menu: six soap operas and fifty ads instead of one continued story and 20 pages of ads.

Newspapers of the new type had no room for the views of the pair whom Shaw dubbed "the ChesterBelloc" or for Wells's or for his own. Serious views required other modes of publishing, such as tracts. These tended to reach only the already converted. A new form of journalism was called for. *G.K.'s Weekly*, written almost entirely by Chesterton and his brother, was the type of journal that countered the press lords' "organs" and their giant circulations. *The Saturday Review, The New Age, The New Statesman, The Spectator* in England, *The Nation, The New Republic* in the United States, and their analogues in other countries fed the educated curiosity about new ideas, particularly about *la question sociale*, "the submerged tenth," but also about the new books. It was a modified return to the 18C *Tatler, Spectator, Rambler*, and other periodicals written by one or a small group of like-minded thinkers. The most unified and best organized were the Fabians. And among them the most untiring and resourceful propagandist was

The main business of the Press, supposedly is news. If news is what happened yesterday, the newspapers print an awful lot of phoney news. News is what the Press produces. Most of the world's "news" is manufactured by the Press itself: interviews with important men, reports on grave situations, political surveys, "informed speculation," etc. A large part of the Press has in effect abandoned the pretence of dealing exclusively with facts.

—T. S. Mathews° (1959)

Shaw

Although today the frequent production of his plays ensures familiarity with his name and a few of his ideas, the range of his genius and his place in the evolution of western culture has been obscured by the usual postmortem cloud that overtakes great figures.

His extraordinary life, begun as a shabby-genteel Dubliner without patrons or prospects, who by sheer will made his influence felt in half a dozen domains and was for half a century a world figure in literature and social thought, is kept before the public by new editions of his works and large and small biographies. His enormous output of plays, preface-essays, political tracts, music and drama criticism, and his correspondence—a quarter of a million letters, most of them also small essays on the subject he was master of—make him a 20C Voltaire carrying the message of a Rousseau in his propaganda for radical change in government, morals, aesthetics, and religion. He was a formidable debater and prose polemist.

> It is not easy to dispute with a man for 20 years without sometimes feeling that he hits unfair blows or employs discreditable ingenuities. I can testify that I have never read a reply by Bernard Shaw that did not leave me in a better temper or frame of mind; which did not seem to come out of an inexhaustible fountain of fair-mindedness and intellectual geniality.
>
> —G. K. CHESTERTON ON SHAW (1936)

That his plays are more than comedies of ideas and contain an evolving metaphysics is hardly suspected, least of all by his most voluminous biographers. Nor are the plays and their long prefaces generally seen in their right relation to each other. A misconception lingers that the plays are witty discussions, whereas they are full of emotion, of hope and pathos, arising from the clash of convictions—true dramas in the tradition of Aristophanes and Molière. Nor does the play simply dramatize the gist of its preface. That introductory essay supplies the complex background of those passionate positions; each preface is a study in cultural history. Shaw's mind was formed by the 19C poets, historians, and philosophical writers, and his grasp of implications and knowledge of secondary figures are those of a scholar in the field. In the play that follows the preface it is current desires, needs, and errors drawn from life itself that are at issue and that led Shaw to retrace their origins.

A comparison of Shaw's plays with, say, Galsworthy's will show that Shaw is the more objective of the two. Like Bagehot, he had a double vision, even and especially in his crusades. He promoted the teachings of Ibsen, Wagner, and Socialism, but pointed out the limits of their applicability. When Shaw wrote about Shakespeare, he allowed himself to be misunderstood by blaming the bard for his pessimism and lack of doctrine. But he knew the plays better than most critics; he denounced the actor-managers who cut and

altered the text to make a "vehicle" for themselves, and he campaigned for a national theater to give the repertoire decent productions.

Shaw was a conscious pragmatist, like every true artist. What counts in a work of art is its effect, however obtained; obedience to previous canons of form or limits of any kind will only yield academic exercises. Pragmatism is the natural bent of Shaw's heroes and heroines, just as his own made him a Fabian Socialist. He acknowledged Marx's influence as denouncer of capitalism, but his method and his economics were wrong. The label Fabian chosen by the group—not a nickname for once—comes from the name of the Roman general who wore down the enemy by skirmishes and delaying tactics instead of head-on combat. Gradual change, suited to the English temper and form of government and beginning with municipal ownership of utilities, could bring about Socialism and install it solidly. Each step should be taken only after a survey of conditions by experts in economics and statistics such as the famous pair Sidney and Beatrice Webb, Shaw's closest associates in the company. In the event, the Labour Party was formed out of Fabians and other Socialist groups which, by Fabianizing, made England a welfare state—old-age pensions, national insurance, free medical care, and taxation of wealth through income and inheritance taxes. [The book to read is *This Little Band of Prophets* by Anne Fremantle.]

Above and beyond Shaw's political propaganda and his arguments in favor of vegetarianism, anti-vivisection, and more healthful clothing; on top of his universal criticism of doctors, schools, prisons, parents, politicians, actors, bishops, musicians, conductors, philistines, and the king's censor of plays; and even more central than writing and directing his plays, what preoccupied Shaw was philosophy and religion. He did not belong to any church nor was he an independent Christian. But he kept redefining in modern terms many of Christ's teachings and the churches' dogmas, especially the Catholic: "There is a soul hidden in every dogma." The word *Catholic* meant to him what an up-to-date religion should be—universal; a common faith is a necessity for any society that wants internal peace and decent government. He invoked Jesus in condemning punishment as now administered by law; he declared every birth an immaculate conception. The communion of saints was to him what others have called the Great Conversation among all thinkers and artists, who with everybody else own a place in the world that is "the temple of the holy spirit." As a member of the pragmatist generation Shaw was an anti-materialist and an anti-idealist; reality is not split in two, with one element pushing the other around. The life force is a single animating element, matter and spirit being its aspects or manifestations. Hence Shaw fought the Darwinists and supported Samuel Butler (<634). Man is self-evolving, as in Nietzsche (<670), led forward and upward by the "masters of reality"—artists, statesmen, founders of religion. The superiority of

Shaw's superman will lie in the spontaneous self which makes for right action without a struggle.

So far, the work of redefining myth and dogma so as to satisfy a modern man's need of faith was relatively easy: the character of the ultimate reality was harder to conceive, because the pragmatic turn from abstract and conventional ideals to effective action and solid results in human affairs does not generate future goals, and these cannot help being also abstract ideals until they materialize—or turn conventional. That danger is ever present. Faithful to his religious interpretation of life, Shaw in play after play represents this predicament as a fight between God and the Devil. A man or woman is in heaven or hell, depending on the part chosen in ordinary concerns; it shows one's spiritual state. The great speech in the Hell scene of *Man and Superman* contrasts a page-long calendar of petty motives with true ethical impulses, showing the difference between those who assist the life force to create the superman and those who are a drag upon it by being hostile or inert. The superman, as mentioned before, will act rightly, ethically, not by struggling with selfish and carnal desires, but naturally, thus making ethical calculation unnecessary. And the life force will gradually eliminate that other drag, its union with matter. This is the outcome of the five plays that make up *Back to Methuselah.*

Your friends are not religious: they are only pew-renters. They are not moral: they are only conventional. They are not virtuous: they are only cowardly. They are not even vicious: they are only "frail." They are not artistic: they are only lascivious. They are not prosperous: they are only rich; not courageous: only quarrelsome; not masterful, only domineering. . . .

—DON JUAN TO THE DEVIL IN
 SHAW'S *MAN AND SUPERMAN* (1904)

This Eutopia did not weather events. At the nadir of the war years, Shaw despaired of man's ability to overcome his brutish instincts and his propensity to lie and mouthe empty ideals. Shaw put his increasing pessimism in *Heartbreak House,* which appeared in 1920 and shows the end of a world (or *the* world?) with a bang, not a whimper. His last plays all dealt with the same theme of cosmic and human illusion and aimlessness. His estimate was confirmed by seeing the Labour government act on Fabian lines and leave society unchanged. Shaw ended in the mood he had blamed in Shakespeare, both borne down by the chaotic spectacle of man's actions.

In his last years, Shaw extolled Russian Communism, like Bertrand Russell, the Webbs, and millions of other intellectuals. But in Shaw, one suspects a different spirit within the motive. His approval of government by murder and massacre looks like a desperate gambler's last throw. It contradicts not only a lifetime of clear pragmatic thought, since protracted violence means practical failure, but also the plays written at the same time as the advocacy: *The Apple Cart, On the Rocks,* and *Geneva,* the first pair arguing against

The conception of the general strike, engendered by the practice of violent strikes, implies the conception of an irrevocable overthrow. There is something terrifying in this, which will appear more and more terrifying as violence takes a greater place in the minds of the proletariat. But by undertaking this serious, formidable, and sublime work, Socialists will raise themselves above our frivolous society and become worthy of showing a new path to the world.

—Georges Sorel (1908)

persecuting dissent, even though democracy is in danger; the third, ridiculing Hitler and Mussolini, whose methods paralleled Stalin's. The playwright kept to the faith that the wearied propagandist abjured.

Shaw was not the only disillusioned Socialist. A decade before him the French engineer Georges Sorel, seeing the meager results of the Socialists' entry into parliaments and cabinets, proposed direct action. In his book *Reflections on Violence*, he urged the industrial unions to form a single body which, by means of a general strike and its sequel—a final combat with the police—would overthrow the capitalist system. To weld together this new force required a myth; that is, an ideal image of the future happy state. The young journalist Mussolini was much struck by this program and did not forget its salient features.

* * *

What Shaw and all the other publicists who agitated the social question helped to precipitate was the onset of the Great Switch. It was the pressure of Socialist ideas, and mainly the Reformed groups in parliaments and the Fabian outside, that brought it about. By Great Switch I mean the reversal of Liberalism into its opposite. It began quietly in the 1880s in Germany after Bismarck "stole the Socialists' thunder"—as observers put it—by enacting old-age pensions and other social legislation. By the turn of the century Liberal opinion generally had come to see the necessity on all counts, economic, social, and political, to pass laws in aid of the many—old or sick or unemployed—who could no longer provide for themselves. Ten years into the century, the Lloyd George budget started England on the road to the Welfare State.

Liberalism triumphed on the principle that the best government is that which governs least; now for all the western nations political wisdom has recast this ideal of liberty into liberality. The shift has thrown the vocabulary into disorder. In the United States, where Liberals are people who favor regulation, entitlements, and every kind of protection, the Republican party, who call themselves Conservatives, campaign for less government like the old Liberals reared on Adam Smith; they oppose as many social programs as they dare. In France, traditionally a much-governed country, *liberal* retains its economic meaning of free markets, and is only part of the name of one small

semi-conservative party; Left and Right suffice to separate the main tendencies. In England also, the new Liberal party numbers very few. Conservative and Labor designate the parties that elsewhere are known as Conservatives in opposition to Social Democrats. The political reality, the actual character of the state, does not correspond to any of these labels. It is on the contrary a thorough mixture of purposes and former isms that earlier would have seemed incompatible. Nowadays, a sensible voter should call himself a Liberal Conservative Socialist, regardless of the election returns. Changes of party mean only a little more or a little less of each tendency, depending on the matter under consideration. [The book to read on the arguments, briefly and beautifully dramatized long ago about shades of political opinion, is *A Modern Symposium* by G. Lowes Dickinson.]

<p style="text-align:center">*
* *</p>

The West that brought on itself the war of 1914 was a larger society than the one that was split four centuries earlier by the Protestant Revolution. The later Europe included Russia and Turkey, and the world at war included Africa, Australia, New Zealand, the South Pacific, and Japan. Two-thirds of the way through, the United States joined the Occident. The seas were doubled in size by the submarine, and the air was added as a spacious new theater of war. Who can deny the reality of progress?

Much has been said about the causes of the Great War, and all the chief actors in the feverish August days—nations and individuals both—have been accused of making it inevitable. No conclusion has been agreed upon, because no action can be held to have been decisive by itself. The most that can be charged against any officials is that the Austrian Minister Konrad von Hoetzendorf wanted a war and that Sir Edward Grey in the Foreign Office vacillated before announcing that Britain would side with France. All the other diplomats and heads of state worked hard to avert the catastrophe. And no man could have engineered it alone. Likewise, no single "cause," overt or underlying, propelled the multitudes into shedding their blood. A cluster of long-standing conditions, of cultural traits and intellectual defects, of purposes varying in force, brought the diverse minds to their collective act of will.

The *occasion* is not in dispute: it was the assassination by a young Serb, in June of the fatal year, of the heir to the throne of Austria-Hungary, Archduke Franz Ferdinand and his wife, Sophie. The name Sarajevo, the site of the murders, evoked that event until recently, when the same name raised another picture of carnage. The background of both occurrences was the same: in 1914 the peoples of the Balkan region had been in turmoil for decades and at grips with one another in two wars since 1912. [Read Bernard Shaw's play *Arms and*

the Man.] Long under Turkish rule, the Balkan population was mixed in ancestry, language, and religion, each an obstacle to forming stable nations, especially when the neighboring Russia, Austria, and enfeebled Turkey kept fomenting the unrest for their own ends. These intrigues, complicated by alliances among the other European powers, precipitated war one month after the killing of the archduke.

It has accordingly been said that nationalism was the root cause of the Great War. That passion was indeed one of the impelling ideas, but it was rather the *failure* of nationalism in Central and Eastern Europe: the long delay before Germany, Austria, Italy, and Russia became nations bred in that region the perpetually nervous and grasping state of mind. The evidence is intricate but nonetheless clear. Austria-Hungary was an ill-glued empire, in which Hungary and some Slavic parts—Bosnia prominent then as now—wanted more independence. The archduke was in favor of a three-cornered union in which the Slavs would no longer be mere possessions. It was late in the day to hope for the fusion that the full-fledged nations had achieved when the occidental monarchs made their revolution (<239). In a Europe with parliaments and free-thinking intellectuals, separatist and irredentist (= land peopled by fellow nationals beyond a frontier and therefore "unredeemed") feeling could not be stilled. The appeal to some past greatness, to "a unique language," to "a great hero of the 9C sung in the national epic," to religion—all this together with the demand for a parliament in the place of puppet kings, energized small groups that could only be repressed by intermittent violence. The tyranny that the weak exercise on the strong undid all compromises.

Serbia will someday set Europe by the ears and bring about a universal war on the Continent. I cannot tell you how exasperated people are getting here at the continual worry which that little country causes to Austria under encouragement from Russia. It will be lucky if Europe succeeds in avoiding war as a result of the present crisis.

—SIR FAIRFAX CARTWRIGHT, AMBASSADOR
 TO AUSTRIA, TO THE FOREIGN OFFICE
 (JAN. 31, 1913)

As for the other two new-fledged nations, their old aggressive attitudes hung on. In the middle of the Balkan troubles of 1912–13, Italy made war on Turkey to wrest in North Africa the infertile strip of Tripoli, a sop to Italian national egotism and no strengthening of Italian unity (691). Germany, no longer guided by Bismarck's diplomatic genius, stumbled into the several "crises" that dotted the 15 years before the Great War. The particulars of each came under the general aim of "a place in the sun." (In the next war Hitler called it *Lebensraum*—room to live.) The German kaiser Wilhelm II turned up here and there to make blustering remarks that enabled the French and English during the war to represent all the Germans as Huns led by a new Attila. In fact, after the Sarajevo crisis the kaiser did all he could to hold back Austria and avert war.

The confrontations were about possessions, whether in Europe, like Austria's, or elsewhere on the globe, like those of Germany, England, and France. Italy's in Africa were so trifling that the hunger for more was a lasting motive. In view of this ardent bickering the hunt for a single cause of the war shifts ground and points to Imperialism, later renamed Colonialism. It certainly was a prominent condition, but it does not explain the line-up on each side of the conflict. The crisis of 1898 over a spot in Africa was between England and France, soon to be allies; England and Russia were traditional enemies over portions of the Middle East, but in 1914 allies against Germany. This triple alliance opposed a dual one between Germany and Austria, which Italy joined, only to break away from it after war started.

Both sides had plenty of reasons for arming to the teeth. England built dreadnoughts and superdreadnoughts as Germany watched the seesaw between armor and firepower and widened the Kiel Canal for access to the North Sea. France lengthened military service to three years. Everywhere "The Next War" filled news articles and common talk. The phrase was in the title of a book by a German general,° and the provocative utterances of the kaiser helped to keep the tension high.

What must be said further about the 20C colonial empires is not that nations found them financially worth fighting for on the contrary, they were an expense; only some individuals profited. But Imperialism created endless opportunities for enhancing or wounding prestige. Hence the boast about possessing lands so fortunate that the sun never sets on them. In short, not alone imperialism as economic greed, but "national honor"—Jingoism as a state of mind—was another of the conditions that led to war.

To cite but one example, when Germany and France were trying to settle a crisis relating to commercial rights in Morocco, the "peace-minded" prime minister Lloyd George made a speech in London in which he complained of being ignored in the negotiations. The German government protested violently that England had no interest in Morocco, so it must be hatred of Germany that inspired the speech. The German rebuke was so strong that England made more than token preparations for war. The year was 1911.

In every country before 1914 there were groups organized ostensibly in defense of the national interest, but actually aggressive in that they all harped on some particular "menace" that had to be put down. In France, these patriot leagues were anti-German and wanted revenge for the humiliating defeat of 1870 and the loss of Alsace-Lorraine. In Germany, England was the target; in England, German progress in empire and industry was felt to be more than competition: direct aggression. As a prominent journalist wrote in the first sentence of the first article of a series: "Germany is deliberately preparing to destroy the British Empire." And until 1904, when France and England reached an understanding precisely with "the German menace" in mind, the

two countries eyed each other with suspicion. They had nearly come to blows over Egypt and the Sudan; the French had been the incurably warlike people under two Napoleons. England was "perfidious Albion," a scavenger nation that picked up its possessions by fomenting wars on the continent and entering them at the last minute on the winning side. History thus read with a squint played a formative role on minds kept steadily insecure.

The meaning of the Balkan troubles was clear enough, but opinion was fiercely divided over two other and bigger wars, though these were seen from a distance. The English had with difficulty put down the Boers of South Africa; the Americans had easily wiped out the Spanish overseas empire, both wars at the turn of the century (<629). The English, as we saw, had made a generous peace that consolidated the bigoted Boer regime; the United States had become an expansionist power with colonies outside its borders. The Boer War's contributions to the dawning century should not be lightly passed over: the use of dum-dum (expanding) bullets, the color khaki to make military uniforms blend with the scenery, and a novel institution: the concentration camp.

Also outside Europe, a quasi war, the Boxer Rebellion already referred to (<629), focused attention: that the relief of the beleaguered diplomats came from an international force under the command of a German general showed that a common enemy fosters cooperation, but it hardly lasts beyond the crisis.

Violent events of this kind, simultaneous or in rapid succession, made the conscious mind reel: anger, shame, pride, confusion, relief, then a return to apprehension nurtured by the press. Newspapers were more widely read than ever as public schooling kept increasing the number of working-class readers. Replacing the pulpit as the medium of information about current events, print was more authoritative than voice, and its message came out daily, not once a week on Sunday. And instead of being coupled with a predictable sermon, the news (true or not) sounded fresh and was served up with excitement added. The power of the press was demonstrated when it prodded the United States into that gratifying war with Spain.

*

*　　*

The educated public that read the weeklies was likely to find in some of them justification for war as such, or at least debate about it. It was a live issue because writers of various nationalities and grades of intellect were Social Darwinists (<572); they believed that the theory of Natural Selection applied to nations as well as to animal species: struggle brought out the fittest. In the light of this belief the Yellow Peril became a "fact" after Japan defeated Russia. The American Homer Lea, a hunchback who was a general in the Chinese army, had warned in *The Valor of Ignorance* against Japanese aggression

and pointed out in *The Day of the Saxon* the duty of concerted policies against the menace from the East. He was not alone in arguing that the West must be ready for conflict and never flinch from it. War might be costly in lives and money, but the reward was an improved "race," a stronger, finer, more capable people. The term *struggle-for-lifer* was adopted as is into the French language and its equivalent elsewhere. The American president Theodore Roosevelt generalized the notion as "the strenuous life" and defined foreign policy as walking softly and carrying a big stick.

This argument drew additional plausibility from the analogy with economic competition: the stronger firm conquers and swallows the weaker, proving itself more efficient. The world benefits from better goods at cheaper prices. Opponents of this simple vision—a small minority—pointed out that the economic benefits were anything but likely: the bigger firm charges monopoly prices. And as for war between peoples, it is the fittest, youngest, and most selfless individuals who get killed. Victory is ruinous and defeat profitable, as (for example) it had been to France in the Franco-German War of 1870 and to Spain after 1898. The French reacted with energy and quickly paid off the large indemnity; Spanish industry boomed. The French defeat did Germany more harm than good, economically and morally, as Nietzsche had pointed out: rampant vulgarity and "materialism" characterized the fledgling Second Reich.

Yet another line of thought converged with Social Darwinism to reinforce the war spirit. Scholars who called themselves anthropo-sociologists did not hesitate to assert that the "Mediterranean race," with its brown eyes and round skull, was not disposed toward individual self-reliance and risk-taking. Its nature was to favor socialism—protection by the state; whereas the Nordic type was the pioneer, the individual endowed with courage and originality, who single-handed achieves great things. On him alone all progress depends. The political implications of this pseudo science were that England,

> War is one of the conditions of progress, the sting that prevents a country from going to sleep.
>
> —ERNEST RENAN (1876)

> War is the storm that purifies the air and destroys the trees, leaving the sturdy oak standing.
>
> —BARON KARL VON STENGEL (1901)

> Natural entities are controlled by the same laws that govern life—plant or animal or national. These laws, so universal, so unalterable in causation, are only valuable as knowledge of and obedience to them is true or false. To thwart, to deny, to violate them is folly.
>
> —HOMER LEA (1895)

> I am pleased with the spirit of those who are now advocating war for its own sake as a tonic. Let those who believe in it repair to Salisbury Plain and blaze away at one another until the survivors (if any) feel that their characters are up to the mark.
>
> —BERNARD SHAW (JAN. 1, 1914)

Holland, Germany, Scandinavia, and the United States were bound to prosper and lead the world, while the Mediterranean countries ("the Latin nations") would be left trailing farther and farther behind.

That fortunate adventurer in South Africa, Cecil Rhodes, believed this prediction so literally that to help prepare the future rulers of the world he endowed by his will of 1903 the scholarships that bear his name. They were intended for English, German, and American students of high character and ability, who would acquire at Oxford the attitudes and traditions that made Englishmen movers and shakers. Those wonderful colleges had something to teach fellow Nordics and would bind them in brotherly love. When the war came, the Germans suddenly lost their racial merit and their scholarships.

Another proposal for improving the world, professing to be purely scientific readily fostered the polemics on race. It originated in the concern with mental disease and defects. Francis Galton and Karl Pearson used certain statistics about hereditary ills and set afloat the program of Eugenics. The incidence of genius and of feeble-mindedness seemed to indicate that an advanced civilization ought to take steps that would produce more of the former and none of the latter. The defective should be forbidden to marry and the healthy and bright encouraged to mate.

Much was published on heredity and argued about the program's feasibility. When someone suggested that Shaw ought to have offspring with Isadora Duncan, he is said to have replied: "It might have my body and her brains." Karl Pearson was the first professor of eugenics (and perhaps the last); he taught many but did not create a lasting band of followers. Dalton's example inspired a number of books about genius, often with the aim of comparing countries, measured in numbers of great artists and thinkers.

What is false in this dogma is the belief that a nation is a race, a group sharing a common biological descent. Equating nation with race defies the most elementary knowledge of history. From time immemorial, Europe and America have been playgrounds of miscegenation. Celts, Picts, Iberians, Etruscans, Romans, Latins, Huns, Slavs, Tartars, Gypsies, Arabs, Jews, Hittites, Berbers, Goths, Franks, Angles, Jutes, Saxons, Vikings, Normans, and a host of lesser tribes once thought distinct mingled in and around the Roman empire, a vast mongrel population. The Celts swept from Britain to Asia Minor; the Scots came from Ireland, Germanic tribes covered the Occident, Arabs and North Africans held southern parts of it—and so on. Later, the conglomerates called nations mingled likewise through voluntary migration, exile, and the violent or willing crossbreeding of wars fought by multinational mercenary armies. Napoleon's troops at the last were drawn from all Europe. Since his time, easy travel has added its tribute to the tutti frutti of genetic diversity. To say Anglo-Saxon or Latin about any modern

people is as absurd as it would be to call Winston Churchill a Jute or a Norman—or an American because of his mother.

If nations are of mixed "race," groups of nations are still more mixed and the names for such groups are meaningless. "Nordic" says nothing about "blood" or character. And the supposed fate attached to the name never stopped anybody from trying to prevent its taking place. As we saw, against the Pan-German League bent on uniting all German-speaking peoples, there was the Pan-Slavic League with a matching goal, and an Alliance of Latin Nations bringing up the rear. Apparently, round skulls were not altogether lacking in get-up-and-go.

But in the basis of these groupings one detects the principle that Hitler exploited in his Third Reich. A nation is forged into unity by successive wars and the passage of time. When this result has not been achieved, some other means must be found. Pseudo science and determinism suggested faith in race as a substitute; it is inborn, a "natural" unifier, and it is present in each citizen; if it can be made conscious it bridges over religious, political, and class divisions. Of course, assigning race in this arbitrary fashion also serves separatism by fostering the cozy atmosphere of the subrace or clan. In the Germany that sought perfect oneness and no less in the present opposite tendency to secede into ever smaller groups based on "roots," the West has been witnessing a confused mêlée among four of its traditional drives to unity: nation, class, race, and "culture" in the voguish sense deprecated earlier (<xv).

<p style="text-align:center">*
* *</p>

Although fiercely debated, the Great Switch legislation was not seen as the beginning of a profound change, social or political. Two writers, Chesterton and Belloc, did express alarm at the coming of *The Servile State,*° but they were not heeded in the tumult of violent ideas and events. The men and women called Anarchists or Nihilists (actually early terrorists) publicized their views by assassination. Heads of state and prime ministers were an endangered species. The outstanding cases of the former were the presidents of France and of the United States: Sadi Carnot and McKinley, the Empress of Austria and the King of Italy—all within five years. Next came some Russian officials, claimants to Balkan thrones, and then Franz Ferdinand and his archduchess. [Read Oscar Wilde's melodrama *Vera or The Nihilists.*°]

A different sort of terrorism, lacking a philosophy but expressing the revolt of misery, broke out in Paris just before the war. It was the work of the first motorized criminal gang. Twenty youths, 17 boys and 3 girls, managed in 18 months to rob banks, raid gunsmiths for weapons, and kill 8 people. When caught they were found to be pale and underfed. Four had died during their

rampage. (It is worth noting that the Paris *Grand Guignol* theater specialized just then in the thrilling novelty of short plays of no interest except for horrible violence and visible gore.)

Other youngsters, better dressed and better fed, favored violence for a different purpose. They were French students and intellectuals bent on overthrowing the republic and installing a dictator or else restoring the monarchy, and in either case rabidly anti-Semitic. These anti-Dreyfus, anti-Republicans were inspired and sometimes led in their street demonstrations by older men, respected thinkers, whose books expressed total disaffection from the contemporary culture. Such men were to be found not only in France but in Italy and Germany.

In England, seeing Parliament remain deaf to the demand for the vote, the New Woman turned activist. She was patronizingly dubbed suffragette but gave a performance that had nothing ladylike about it. Led by Mrs. Pankhurst, these young women yelled themselves hoarse in parades, stormed the House of Commons, chained their wrists to the doorknobs of public buildings, or set fire to them, wrestled with policemen in Trafalgar Square, went on hunger strikes when jailed; and one young heroine, carried away by zeal for martyrdom, went to a racetrack and stood in front of the onrushing horses. At the same time in the United States the parallel movement for the vote was making peaceful progress. President Taft's wife expressed approval; parades and petitions were accustoming the public to the strange idea.

> *Mrs. Banger:* "**What women need is the right to military service. Give me a well-mounted regiment of women with sabres, opposed to a regiment of men with votes. We shall see who goes down before the other. This question must be solved by blood and iron, as was well said by Bismarck, whom I have reason to believe was a woman in disguise.**"
>
> —SHAW, *PRESS CUTTINGS* (1909)

Although, as we saw, crime for gain spread throughout cities, it was still professional, not violent or vindictive—no street muggings. The police generally knew their opponents, both sides played a kind of game. Sentences were short and prison harsh. Killing had a clear motive.

During the very month of tense exchanges that ended in war, Paris and other capitals waited with the usual relish the outcome of a murder trial in Paris. A well-known figure, Joseph Caillaux, had been the one statesman in France working for a good understanding with Germany; he had defused a grave crisis by yielding unimportant holdings in Africa. A newspaper violently opposed to his policy began to cast discredit on him as a man by publishing (stolen) love letters of his to his wife, who was his mistress at the time they were written. Without his knowledge, Mme Caillaux went to the newspaper office, spoke with the editor-in-chief demanding that the publication stop, and when he refused drew from her handbag a revolver and shot him

dead. [The book to read is *Death of an Editor* by Peter Shankland.] Incidentally, the editor she killed, Gaston Calmette, had been helping Proust to get his novel published.

Mme Caillaux was acquitted, but the jury had a hard time. The episode had no precedent and the means used by partisans for carrying on political debate were unexampled. Perhaps the jury thought that the new journalism was a provocation to violence. Certainly, what went on day after day outside the courtroom did not promote calm deliberations. Mobs paraded and yelled insults at counsel entering or leaving the courtroom and cried "Murderer!" whenever Caillaux himself appeared. The rioters were from those parties opposed to the Republic, notably the Action Française, and were called on that account "the king's henchmen." They were not riffraff but young bourgeois intellectuals moved by the same animus that was expressed across the Rhine by the forerunners of National Socialism.°

*

* *

In view of later events, the state of mind that prevailed in Russia in this pre-war period has relevance here. For decades the intelligentsia had variously argued and plotted against the autocratic regime of the Romanovs. Assassinations, executions, and forced labor in the salt mines of Siberia had not quelled the spirit of revolt; it was encouraged by the production of novels and plays which, owing to a tradition due to the censorship of political writings, were not simply literature but propaganda. In 1881, heedlessly, the tsar who had freed the serfs and entertained some reformist ideas was murdered. More executions and more activism followed. By the 1890s the mood of defiance and hope of freedom ruled many minds. It found clearest expression in the novels and plays of Maxim Gorky, making him the leader of rebel opinion. By 1905, after Russia's defeat by Japan, this intellectual and popular discontent made a rising seem opportune. After an effective general strike, for a whole year violence and concessions by the government alternated. Workers fought soldiers and organized soviets (action committees). A Duma (parliament) was set up and led by the Liberals. The provinces did not hang back. And then the tide turned. With army support, the tsar was declared an autocrat (sole ruler) and given control over all legislation by the Duma. Punitive expeditions into the provinces completed the work with the usual savagery.

All hopes were dashed. Passiveness and eroticism succeeded energy and dissent. Gorky ceased to be a hero. Leonid Andreyev, also in novel and plays, became the voice of lassitude and despair, the obsession with death and existential Angst in the face of a cold universe. [Read *The Seven That Were Hanged*.]

Andreyev was borne down not merely by the loneliness of Man in the cosmos but also by that of men in cities. Russia was beginning to be industrialized,

I curse everything that you have given. I curse the day on which I was born. I curse the day on which I shall die. I curse the whole of my life. I fling everything back in your face, senseless Fate. With my last breath I will shout in your stupid ears: "Be accursed, be accursed!"

—ANDREYEV, *THE LIFE OF MAN* (1906)

with the usual accompaniment of crowding and individual anonymity. It is significant that in the West, social observers had begun to criticize the modern city and to offer plans to make it livable. Patrick Geddes in Britain is well known, but Camillo Sitte and several others in Central Europe pioneered the new art which is also a social science.°

With all the preaching and practicing of bloodshed between 1890 and 1914, how can it be that in retrospect the period was seen as an ideal time deserving to be called *la belle époque*? An answer has been given on a previous page (<651). Here it is enough to say that the intellectual and artistic elites, and to a certain extent high society, lived in their world of creation, criticism, and delight in the new. They were aware of the crises, no doubt, but after one or two had gone by gave little thought to what they might still cause. At any rate, those engaged in high art and science took little notice. It was popular literature that pictured the state of affairs. Erskine Childers in *The Riddle of the Sands* warned of German designs; Conan Doyle made Sherlock Holmes uncover foreign plots to steal secret plans; and the inexhaustible E. Phillips Oppenheim in his spy fiction made excellent use of the material furnished by the news while giving the model of a genre popular ever after.

The cosmopolitan spirit held fast, sustained by a great deal of travel between capitals. Biographies show how often the artists and writers whose names we remember were away from home and visiting their counterparts in Paris, Vienna, Berlin, London, Prague, Buda-Pest, or St. Petersburg. [The book to read is *Buda-Pest 1900* by John Lukacs.°] They must see at first hand the extraordinary things being created, exhibited, and found wonderful or detestable. Acquaintances begun by correspondence developed into friendships. Periodicals were numerous and prompt reporters of the new. The Germans were particularly noted for their international outlook and quick receptivity. [The book to read is again *The World of Yesterday* by Stefan Zweig.]

In the United States the cultural gap was shrinking (<679). The West as a whole rejoiced in the vibrant common culture, continually cross-fertilized and thriving high above national and other material interests. Exceptions to this unpolitical frame of mind were few, for it was not easy to combine a throbbing, demanding aesthetic life with any kind of political cause. To many artists public affairs seemed unworthy of their attention. Their contempt for politicians, mass movements, and journalism equaled their scorn for business at large. They looked down not merely on the source of their own families' wealth but also on the prosperous "academic" artist, and more harshly still on publishers, art dealers, or musical impresarios.

This haughty ignorance of social and political facts enables us to understand why the cultivated classes reacted as they did when war came: several hundred intellectuals in Germany signed a manifesto denouncing "the other side" as if betrayed by a friend and brother. It was immediately answered, with a like rhetoric, by several hundred of the French. The enemy's purpose must be wicked since *we* are innocent.

As for the masses, when they heard the newsboys shout: "War Declared!" they felt as if concussed. Their thoughts ran wild in all directions. It could not be, yet it was. The word *war* had been uttered a million times earlier, in fear or in hope and raised whatever images the speaker had at command; but the immediate prospect of battle was like an explosion in the soul. The next instant, emotions varied—appall for some, joy for others; relief at the end of suspense, positive zest for action, negative resolve to die rather than yield; all this projected against a kaleidoscopic background of faces—son, brother, husband, friend. Every country but England had compulsory military service; all men between 18 and varying dates of middle age had received an identity booklet that specified where to report in case of war—no additional summons needed. It was a saving of time for that instrument of policy known by the antiseptic name of Mobilization.

Mingled with concern for the self and those held dear went a sudden spasm of brotherly love for all fellow citizens, high and low. Danger, glory made them into a compact totality of equals at grips with heaven knows what evils. It was exhilarating and righteous besides. The overarching thought was a great simplifier; everybody understands war and bows to its single objective. Long dormant motives burst into life: heroism—risking one's life unselfishly to defend the homeland, its women and children; manliness—to do superhuman deeds under fire; to put down wanton aggressors who were committing atrocities. In England and France it was also noble to defend democratic institutions against "Prussian militarism" and humble the kaiser with his ridiculous upturned mustache and spiked helmet.

Altogether it spelled liberation from the humdrum of existence, with all its petty cunning for selfish ends. A new life opened, free of corrupt motives and vulgar self-indulgence. Proponents of war as good in itself were being vindicated. Thematically, the first industrial world war combined PRIMITIVISM—the cure for civilization that Carpenter had called for (<636)—with an EMANCIPATION that nobody could oppose.

In the event, this last desire was fulfilled in many ways. Class barriers lost rigidity; conventions were relaxed. The soldier was cut loose from his nine-to-five at the office or six-to-four in the factory, as well as from home and its constraints. Watchful neighbors having scattered, each spouse, now separated, gained sexual freedom if it was wanted, or at least escape from a bad marriage. Hostile feelings against fellowman, employer, or state authority

found release in being legitimately turned against the anonymous foe. These freedoms, soon taken for granted, furthered the feminist movement. Women were indispensable to "war work" and not solely as nurses and entertainers of the troops, but as chauffeurs, bureaucrats, factory hands, and "farmerettes." They showed that they could perform as well as men—often more conscientiously—in the reserved precincts of the male. It was impossible after the war to deny them the vote by arguing their incapacity.

One is an idealist only if one finds beauty in self-sacrifice; and one is all the greater idealist if one sacrifices oneself for a motive that is chivalric and arbitrary. The acme of idealism is sacrifice for no motive at all.

—PAUL SOUDAY IN *LE TEMPS* (MAY 11, 1917)

Besides these by-products of wartime, the ever-changing conditions of the conflict gave rise to ideas and attitudes that unhinged the public mind and left it maimed and disoriented. It scrambled the continuities of western culture. The artists' mutual understanding across frontiers vanished in an instant. The same thing happened to the Socialist movement, which had often been thought an automatic brake on war in Europe; people *knew* the working class put solidarity first; branches of the party in the several countries would not fight but fraternize. This did not come near happening. In England, a few leaders withdrew from politics by way of protest; in France, the man who might have acted according to prediction, Jean Jaurès, was assassinated two days before the declaration of war. After August 1914 socialists had to sing *L'Internationale* like hypocrites, if at all.

But the intellectual rift was worse than the political; the cultivated classes had no excuse. By definition—their own boastful definition—intellectuals were independent thinkers, always abreast of the latest truths in art, science, and social thought. In France they had become conscious of their strength as groups on each side of the Dreyfus Affair (<630; 696); now they seemed incapable of judgment. Overnight, en masse like so many sheep, they turned into rabid superpatriots.

The most remarkable feature of this turncoat response was not its being the same in all the belligerent countries—so much could have been foretold from the common features of western culture. What is truly astonishing is the unanimity, unheard of on any other subject but the war and the enemy. Looking over the roster of great names in literature, painting, music, philosophy, science, and social science, one cannot think of more than half a dozen or so who did not spout all the catchphrases of abuse and vainglory. It would fill pages with repetitious, distressing quotations if a full survey of the participants in this aberration were attempted here. [The book to read is *Redemption by War: The Intellectuals and 1914* by Ronald N. Stromberg.] A handful of examples will show what the few dissenters were expected to say and what courage it took to refuse or say the opposite.

First, war glorified by poets. Robert Graves: Never was such antiqueness of romance/Such tasty honey oozing from the heart. Rupert Brooke: Now God be thanked who matched us with this hour. Claudel, Apollinaire, Ezra Pound, Isadora Duncan, and others extolled the fighting as divine. H. G. Wells in his best-seller *Mr. Britling Sees It Through* has the war bring about a return to religion. Lesser talents wrote hate songs that were set to music by Richard Strauss and Mahler, while Debussy, Alban Berg, and Stravinsky made patriotic boasts. Freud wrote of "giving all his libido" to Austria-Hungary. The historians and social scientists—Lamprecht, Meinecke, Max Weber, Lavisse, Aulard, Durkheim, Tawney—all found in the materials of their field good arguments in praise of war or reasons to excoriate the enemy. Arnold Toynbee wrote volumes of atrocity propaganda, for which he later hoped to atone by writing his *Study of History* in 10 volumes. Bergson and other philosophers sang the same tune.

And everywhere the clergy were the most rabid glorifiers of the struggle and inciters to hatred. The Brotherhood of Man and the Thou Shalt Not Kill were no longer preachable. Only

> Carry on the war to win the peace—there's a formula that should certainly fulfill the wish of Benedict XV.
>
> —MONSIGNOR CABRIERES, AUG. 28, 1917

the pope, Benedict XV, could be a pacifist, and in spite of his plea for peace addressed to all belligerents in 1915 and later, his bishops in various countries spoke out for total war. They enlisted God: "He is certainly on our side, because our goals are sinless and our hearts are pure." The most moderate said: "Kill but do not hate." One English preacher spoke of "the wrath of the Lamb" and another speculated that although Jesus would not have become a combatant, he would have enlisted in the Medical Corps. [The book to read is *Society at War* by Caroline Playne.]

This unprecedented cultural phenomenon requires an explanation. Nothing close to it happened during the Napoleonic wars. Many intellectuals then were able to stay cool over the heads of the nations-in-arms. The 20C fury recalled the wars of religion or the English and American civil wars. In 1914 religion was no longer a prime aggressive impulse, and the "religion of art" was not the creed of an organized force. In the 19C, it is true, one or another thinker found himself sharing the national animus in wartime; for example Tolstoy on two occasions, though he was a pacifist, and Dostoevsky during the Russo-Turkish War of 1877. But not before 1914 was the flush of blood lust seen on the whole intellectual class. What made the cultural elite give up its ideals, its habits, and its friendships?

The "purifying" of human motives by war has been mentioned; it could boast precedents more acceptable than the declarations of generals and revolutionists. As we saw, Tennyson in the mid-19C had written a novel in verse, *Maud*, in which social-political corruption is shown as swept away by the war

spirit. A little later Ruskin gave a lecture to young soldiers in which he asserted that war had two faces, noble and ignoble. When war was just, when it was fought by dedication and not compulsion, and fought according to the rules of chivalry, it was not only admirable but it could lead to the creation of fine art, equally noble. It is a remarkable piece of reasoning, parts of which could be quoted as a denunciation of the nation-in-arms and of the "military-industrial complex" later castigated by President Eisenhower. But in 1914 nobody thought of Ruskin's and Tennyson's literary works. "Redemption by war" was a spontaneous popular impression, soon seen to be fallacious. War profiteers, cowards looking for safe posts, the black market in rationed goods, and a relaxation of sexual conventions showed that war was overrated as a moral detergent. [The book to read is *The Sexual History of the World War* by Magnus Hirschfeld, "Translated from the German and Intended for Circulation Among Mature Educated Persons Only."]

The next explanation is: normal patriotism reinvigorated by the old, deep-lying instinct of aggression that can turn into a vocation and become the badge of nobility, as it did in the Middle Ages and for centuries after. It could be said too that peaceful patriotism had been exacerbated into violent isms—nationalism, imperialism, monarchism, militarism, jingoism, anarchism, nihilism—by the prewar years of crisis and confrontation. And yet one must think again. It is true that some intellectuals had been doctrinaire, "integral nationalists," but the majority were not and their about-face owed something to their rediscovery of the importance of justice in public affairs. The Dreyfus case had stirred them earlier because he was an individual persecuted by the state—he resembled the artist punished by society. With the war the pattern was revised and applied to nations: "little Belgium" invaded by "a barbarian horde," innocent women and children massacred, atrocities (cutting off children's hands and women's breasts) committed "on principle." This last charge was made by all the governments and all probably had some factual basis as in every war, but with the also usual exaggeration of numbers. These notions formed the material of the incessant propaganda, required for "psychological warfare," a new mode of aggression and an art form. It was perfected not solely by journalists, as might have been expected, but by novelists, poets, and critics, graphic artists and photographers.

Yet another motive, though perhaps less conscious, animated these culture-makers: for the first time in their lives they had become important, useful, *wanted*. No doubt society before the war gave them much attention, in praise or dispraise, and "the arts" were extolled as—among other things— the mark of a great nation. But much of this worship was paid at the feet of the dead—past artists and their works. The living had to be content with the approval of their peers. The fine cosmopolitan exchanges did form a genuine self-approving elite, but did not afford each artist the ecumenical recognition

he aspired to. And these workers as a class did not feel a part of the buzzing, booming confusion of the "real" world. While despising that world, creators of the new felt that this compliment was returned. War let these unacknowledged leaders rejoin society, cheered them as soldiers, praised and paid them for their ability to fight—or write communiqués, draw posters, censor correspondence, and do research in history for the "war effort." They were practical men at last.

The misfortune was that the military and civil authorities did not coordinate their plans. They allowed many artists, especially the young, to perish in the trenches, or at best to waste time and talent in other places: the violinist Jacques Thibaut had no way to practice during his years at the front, while the Cubist Albert Gleizes, on kitchen duty, peeled potatoes at Toul. The many who died, like the young writer Dixon Scott, are but names one comes across in old periodicals, memoirs, or privately printed anthologies.

*

* *

If both sides were right, what did each fear and contend in its propaganda for home and foreign consumption? The head of the central powers, the Germans, must defend their recently won unity and their greatness in science, industry, and world trade. The ancestral foes, France and England, were jealous and would undo Bismarck's work, redivide the empire to destroy their competitor; while to the east, Russia, a barbarian state, would seize territories to add to its conglomerate empire. For Austria-Hungary the issue was dynastic survival by "containment" of the Slavic menace from Russia through the Balkans. Everybody had a flawless case in addition to self-defense. So armed in spirit, the belligerents could not dream of anything but total victory— hence the interminable, death-dealing years.

In the western camp, as noted earlier, peaceful democracy was the palladium that must be saved from imperial militarism. The presence of Russia on this side of the struggle made the argument a little shaky; a better one was the proof of German lawlessness in its violation of the treaty that had guaranteed the neutrality of Belgium for nearly a century. When the Germans marched through the "gallant little country" calling the treaty "a scrap of paper," the true character of the Huns began to be perceived. England had planned to do the same, but that was a military secret. As the years showed, all-out war knows nothing of neutrality and little of international law. Huge masses of men in collision means a pitiless, unprofessional war of attrition, fought not on fields but in trenches or foxholes and anywhere else as needed.

None of this had been foreseen. The nation-in-arms initiated by the French revolutionists in 1792 was too far back to remember and 44 years had elapsed since the previous European war, in 1870, which had been between

armies in motion. In August 1914 the populations expected to hear about marches, sieges, and pitched battles. Professional soldiers, reinforced by levies as needed, and carrying out planned campaigns, would decide the issue. Many in France were sure that "We'll be in Berlin in three months." The general staffs, at least among the Allies, were not far from the same predictions. They expected the cavalry to take part—soldiers in August 1914 filled ditches around Paris with branches and twigs to hinder the horses—and uniforms were still showy: the trousers of the French had been dyed red in Germany; rifles and bayonets and field guns were of tried and tested patterns. German industrial advances upset all this "preparedness."

Among other unexpected facts some were entirely novel and not all of German origin: poison gas, air raids over capitals, submarines sinking ships regardless of flag or cargo, thus starving neutral states; the use of church towers as observation posts and their consequent destruction, the issuing of forged currency to cripple enemy finance, and propaganda organized like large-scale advertising. In short, the deployment of the entire population and economy in support of "the front."

Strategy failed on both sides. When the Germans' Schlieffen Plan to defeat France quickly by passing through neutral Belgium could not be properly followed up, because the Prussians to the east complained of being overrun by the Russian army and re-enforcements were taken from the west, no plan but a series of improvisations followed, ending in mutual stalemate along miles of disputed lines. This front was quickly a devastated area, strung with barbed wire and seamed with man-high dugouts, the trenches. The combatants, self-trained for the ordeal, lived in squalor—mud, water, vermin—in preparation for sorties designed to capture the opposing trench by annihilating its occupants. This over-the-top endeavor was prepared by bombardment—a barrage of shells—to reduce the opposition. Casualties were in proportion to the enlarged scale of everything: 5,000 men, perhaps, on a normal day when, as Erich-Maria Remarque recorded in his famous novel years later, the communiqué read: "On the West Front, Nothing New."

. . . men staggered wearily over duckboard tracks. Wounded men falling headlong into the shell holes were in danger of drowning. Mules slipped from the tracks and were often drowned in the giant shell holes alongside. Guns sank till they became useless; rifles caked and would not fire; even food was tainted with the inevitable mud.

—Col. G. L. McEntee, *Military History of the World War*

In the modern people-to-people fighting, men are expendable like powder and shells; they are important but less so than men and women in factories making that ammunition. Still more important are the material resources out of which to make it, the money to pay the bill, and the inventive talent to create better or novel weapons. The Great War produced the tank and the "French 75," a small,

mobile cannon; the wide-ranging submarine; the blimp and the gas mask; various types of planes; the armed dirigible (zeppelin); and finally the large-bore gun, "Big Bertha," that could fire a shell over Paris from 75 miles away. I remember its inauguration and effects, worse than the air raids by the noisy *Tauben* ("doves"), because the big gun fired at any moment of the day, whereas the night raids by planes were concentrated in a short time and preceded by a warning. Taking refuge in a cellar at night was for us children a kind of fun—at first.

Also by the end of the war, boys of 16 were filling the gaps in the insatiable trenches. The use for the first time of troops from the African and Asian colonies had not sufficed, but it marked the entry of Third World settlers into the European nations. The hope never ceased that a sudden push on a broad front—an "offensive"—would dislodge enough of the enemy to cause a rout and end the war. The German effort at Verdun in 1916 wiped out some 700,000 lives in four months and brought no decision; the same year at the Somme, the British losses were 60,000 in one day.

Neither did the war at sea. The battle of Jutland in the same year showed the Germans superior to the Grand Fleet in tactics and marksmanship, but overborne by the size and number of the English capital ships. The loss of English tonnage was twice the German. Later, Germany's so-called unrestricted submarine warfare destroyed merchant shipping liberally, with the result of bringing the United States into the war. The fresh troops and supplies refueled the offensive that put an end to the German and the Turkish Empires, broke the Austrian into small pieces, and left the restless Balkans at the mercy of statesmen and journalists who must draw a new map of the West.

It was an impossible task, made so largely by the existence of secret treaties that had been negotiated between the heads of the powers to apportion their future spoils. They swapped provinces undisturbed by notions of ethnic or other rights. It was the old dynastic mode. When revealed after the war, these treaties caused the revulsion that created the demand for open diplomacy, thereby putting an end to the importance of ambassadors and leading to the "summit" meetings of heads of state, with the press in attendance, the calculated leaks, and the dubious results. The selfish, vengeful provisions of the treaty of peace in 1919 made the new map unstable. The demand that Germany give material reparations and the attempt to keep her forever weak were based on an outmoded conception of both victory and the character of Central Europe (711>). John Maynard Keynes gained instant prominence by his exposure of *The Economic Consequences of the Peace*.

Long before the book, before the war itself, the futility and the danger of war for profit had been demonstrated. Fair warning had been given to all thinking people in the West by an English journalist named Norman Angell.

In 1909 he had written a pamphlet entitled *Europe's Optical Illusion*. His thesis was simple: modern war between great powers means a dead loss for both victor and vanquished. The pamphlet attracted wide attention, which led Angell to expand it into a fully documented work retitled *The Great Illusion— A Study of the Relation of Military Power in Nations to Their Economic and Social Advantage*. In it he quoted the words of leaders on all sides who entertained the great illusion. He showed that the existing ways of international finance put the wealth of one nation at the mercy of another. Hostilities would ensure their common loss. Colonies were no asset but a subsidized expense; annexing them or some part of a defeated country, or occupying it to levy tribute was yet more wasteful. Besides, the cost of an up-to-date war would be ruinous. All the resources of all the participants would be drained dry. No nation and no individual would benefit from victory. A large-scale war in 20C Europe would be suicide disguised as self-interest.

The argument was so clear, temperate, and convincing that all who gave their minds to it believed it. But it is one thing to believe that one's previous idea is wrong and another to act on the newly revealed right. Habit, social pressures, a streak of fatalism conspire to keep action in the groove already dug. *The Great Illusion* was not heeded but enacted.

*
 * *

From the earliest days of the struggle each belligerent also carried on an internal war of ideas, coupled with popular persecution. To begin with, "enemy art" must be banned from the stage, the museum, and the concert hall. More than this, it must be shown through scholarly books that enemy thinkers had long ago created the viciously aggressive character of the enemy nation. History backed up the charge: to the Allies, the Germans had always been barbarian raiders; they had destroyed Roman civilization and overrun the helpless Occident, their eternal motto: "Might Makes Right." Hegel, Fichte, Nietzsche had glorified either the conquering state or the conquering superman, in Nietzsche's words applicable to both, "the blond beast of prey" (<670).

The Germans had a corresponding case, in some respects more tenable: the French, though long since decadent, were pursing their obsessive aim to dominate Central Europe. In their palmy days, it had been their playground; invasion after invasion had ravaged the small helpless states, kept them poor, underpopulated, and divided—made them the laughing stock of the rest of the world. Slowly, from Frederick the Great to Bismarck, nationhood had developed and had triumphed at Versailles in 1871. This legitimate union of German peoples into a German national state had created in France a breed

of monarchists, nationalists, imperialists, anti-Semites, *revanchards*—all rabid militarists who believed that breaking up Germany one more time was essential to both the well-being of France and the success of their several factions at home.

England had naturally joined in. The age-old policy of meddling in continental affairs, always against the strongest, most advanced nation, was aimed at dominating the world by sea power and trade. The German character, noble, courageous, sincere (and pioneering in science and techne) had good reason to despise the decadent French and the English nation of shopkeepers, as Napoleon called them. In this joint betrayal of their best traditions—to say nothing of the nuances of truth—the leaders of opinion on both sides were rehearsing (so to speak) what happened less than a dozen years later, when writers, artists, and academics attacked or defended the renewed aggressiveness of Fascist, Communist, or National-Socialist regimes.

Two conspicuous exceptions to the frenzy were the French novelist and musicologist Romain Rolland and the playwright and social thinker Bernard Shaw. In late 1914, Rolland published a short book entitled *Au-dessus de la Mêlée* (*Above the Struggle*), in which he tried to show the oneness of western culture and the folly of all the recriminations. He was at once reviled, called traitor and spy, and his prewar fame revoked as an aberration. It does not detract from his midwar courage and clear-sightedness to point out that he was in neutral and multinational Switzerland when he wrote his book, but the fact helps to make clear the force of the contagion to which the brains of Europe succumbed—the likes of Bergson, Arnold Bennett, and Thomas Mann, but not, be it noted, Richard Strauss, who refused to sign the German Manifesto (<699), saying it was not an artist's proper role to make declarations about politics and war. He was consistent and made no protest in the sequel war, 15 years later, incurring much blame.

Similarly in 1914, the dean of French letters, Anatole France, shocked his friends and the public by remaining mute—and sullen when questioned. He would not join the chorus. At last, beset from all sides, he wrote some propaganda pieces about the homeland, but so saccharine that only the naive could think them sincere. In England alone a few politicians, including the future Labour prime minister Ramsay MacDonald, resigned from office and went into semi-retirement. [The book to read is Shaw's *Common Sense About the War*, which adroitly takes to pieces the thought-clichés of the embattled mind.]

Seltzer Water. consult your gazeteer under "Seltz"—what do you find? "Prussian village, 40 kilometers from Mainz-on-Ems, known for its mineral water." After that I dare you to splash seltzer into your apéritifs.

—*PARIS-MIDI*, JULY 30, 1917

*
*　*

To pass from individual expression to collective attitudes leaves the same impression of idealism out of control and corrupted by the belief that to uphold it required falsehood and hatred. To be sure, the unceasing anxiety of millions about the fate of the nation and of their relatives and friends at the front acted as a permanent bar to sober reflection. After that first shock and indignant dismay, various ways developed of coping with the facts and the emotional strain. For the facts included not only what was known or supposed about the fighting itself but also what happened at home, plain to see: family life broken as badly as by divorce; careers, occupations ended and livelihood reduced to a meager government allowance; social distinctions and manners diluted or erased—even clothing and speech altered to fit new human relations, loss of bourgeois pride and comforts—in short, an unexpected tide of egalitarianism.

It required, among other things, that nobody but the physically disabled should be exempt from fighting in the trenches. This ensured that the fittest in the realms of art, science, intellect, and eminence generally would be reduced in numbers proportionately with the rest. The same exposure applied to works of art, architecture, libraries, and the like: the war supposedly fought on each side to defend the cultural heritage of each "truly civilized" nation took little care of the objects and the persons in whom and in which that heritage was embodied. It is hard to see how it could have been done, given the temper of the time and the means at hand. By the next world war a lesson had been learned and valuable works and workers were rather better protected. [The book to leaf through is *L'Europe Blessée* (in English despite its title) by Henry Lafarge.] The animus too had changed and few spoke or acted against the classics of enemy art. Only a philosopher or historian here and there produced a tract to prove that Carlyle and the indispensable Hegel had been the instigators of Fascism.

To describe the ways in which civilians adjusted themselves to the shifting stresses and strains of 1914–18 would mean a nation-by-nation survey of different groups in each country—a book in itself. Only a few suggestive facts can be cited as representing typical behavior within and across the frontiers.

One shield against the spectacle of death was the renewed resort to spiritism. Conan Doyle was far from being the only notable convert;° many men and women—often atheists or agnostics—were driven by the urge to talk with their dead, and fortune-tellers enjoyed a surge of popularity and profit. Other stricken souls became atheists from that same spectacle. At the front, finality had another effect: the lure of danger, after months in the trenches, took a peculiar turn into the lure of death. "Come and die," cried Rupert Brooke, "it will be such fun." It was in observing this new fascination

that Freud surmised the presence of a death wish in human beings. A small scattering of ethical or Christian minds turned "conscientious objectors," a category provided only for English subjects and entailing imprisonment. Bertrand Russell and Lytton Strachey are the remembered examplars. On the Continent, the only equivalent mode of refusing combat was to ask for service as stretcher bearer or ambulance driver.

Apprehension as a steady state fed the spy mania. That spies were a subtle menace was true, though often their reports were not believed or not used in time by their employers. And as it happens, the two publicized executions for the crime were mistakes. Edith Cavell was only a nurse who helped soldiers to escape and Mata Hari (later the heroine of a musical) merely acted out her private romance of spying without doing any. Persons (or things) with names that were or were thought Germanic were denounced. Many natives and foreigners were interned, others lost their employment, were separated from their spouse, and in the best outcome, merely ostracized. (Americans of German descent had the same experience after 1917.) In Europe during the early August days, shops with foreign names were likely to find their windows broken and their business at an end—for example in France, the chain of dairies called Maggi, a Swiss firm.

In England as well as France, changing names became a safety measure or a proof of loyalty. The novelist we know as Ford Madox Ford was born Ford Madox Hueffer, the son of a German musician long resident in England. The royal family, Hanoverian to start with and more recently of Saxe-Coburg-Gotha, turned into the House of Windsor, while its Battenberg relatives by a happy transposition flourished as the Mountbattens. Unfortunately, anyone who owned a little dog of the dachshund breed (badger-hound),

> We have looted and persecuted, reviled and insulted and assaulted. We have meanly robbed poor women of their little savings; we have seized a man for going across London to snatch a caress from his wife, and we have punished him as we punish only the most savage hooligans. Editors of newspapers have printed dastardly letters demanding that German prisoners of war, when they die, shall not be buried as soldiers who have fought for their country, but thrown on the dungheap to "rot like dogs."
>
> —SHAW ON THE CIVILIANS' ANTI-GERMAN FURY (1917)

and was thus an object of suspicion, had no choice but to get rid of the dog; its distinctive silhouette made a change of name unavailing.

Any remark not fully orthodox might bring on the accusation. That fine scholar and prose writer, G. Lowes Dickinson, was driven from King's College, Cambridge, by his outraged fellows. How Shaw escaped lynching is a miracle as well as a tribute to his polemical skill. The paranoia lasted as long as the war— and no wonder: the very form the fighting had taken was a piece of madness, so that caught between the revolt of reason and the fear of defeat, the only outlet was to talk nonsense and vent frustration on others at random. The reign of

I have seen the fingerprints of the Hidden Hand in the Foreign Office, in Downing Street, in Finance, in Ireland, and in the sea affair by the transfer of the management of the Navy from the Sea Lords to a Germanized Foreign Office.

—Arnold White, *The Hidden Hand* (1917)

the Absurd, now a literary genre, begins in the Great War.

Those who well before 1918 saw through the great illusion or discovered the futility of mutual decimation but kept quiet, combined their loathing with resignation. Others contrariwise found a new fighting resolve, not based on hope of glorious success, but for the sake of a quick ending: see it through as fast as possible for a return to peace and sanity. The politicians in power shared the intention to speed the conclusion, with the added motive of coming out, at peacetime, ahead of the opposition party and of fellow leaders. Both purposes explain the continual dissension within governments and the frequent changes of method and of generals. Except in spots, now and then, the conduct of the war in every nation was crippled by rivalries and misconceptions, chaotic, inefficient.

The task was in truth formidable. The nation-in-arms is virtually a communist state: the people must be paid wages and fed and protected and regimented behind the lines as much as at the front. Minds must be kept loyal and at the right pitch of hate, so that successive drafts of fighters are accepted without murmurings. Letters and newspapers must be censored while the propaganda mill grinds on. As for decisions about strategy and overall command, they must please many masters: dissenters in the cabinet, the heads of the allied states, and public opinion. Hence failures must be disguised or concealed.

It is significant that the mind control broke down soonest and oftenest in the trenches, where fine words could not compete with physical and moral sensations. Fraternizing with the enemy occurred early in the war and continued. At Christmas, at Easter, on other occasions, truces took place; under identical conditions human beings develop fellow feeling. In 1917, after two and a half years of misery, and repeated, obviously futile attacks against an impregnable position, mutiny broke out on the French front. It was put down and the fact kept secret. (In 1998 the French prime minister spoke of those mutineers as worthy of respect and commemoration and the press agreed; the English likewise exonerated their participants.) Eighty-one years earlier, the Germans, just then holding the advantage, made peace overtures. They were rejected. Then came the news of America's declaration of war against Germany, which gave the conflict renewed impetus.

Varying estimates have been made of the losses that must be credited to the great illusion. Some say 10 million lives were snuffed out in the 52 months and double that number wounded. Others propose higher or lower figures. The exercise is pointless, because *loss* is a far wider category than death alone. The maimed, the tubercular, the incurables, the shell-shocked, the sorrowing,

the driven mad, the suicides, the broken spirits, the destroyed careers, the budding geniuses plowed under, the missing births were losses, and they are incommensurable. The postwar survey, *Economic and Social History of the World War*, made in the early 1920s under the editorship of Professor James Shotwell, is a shelful of volumes and is thus unreadable. It was still incomplete by the beginning of the second war. Simply looking at the subtitles broadens one's idea of the magnitude of each item in the moral and material bankruptcy.

The Armistice, moreover, did not halt the toll. It was escorted by an outbreak of typhus in Central Europe and a worldwide epidemic called Spanish flu, virulent and in most cases fatal. Then, as Herbert Hoover told the world in his famous report as commissioner in charge of relief in Europe, the postwar state of large sections of the Continent was one of starvation, homelessness, and disease. One cannot pour all human and material resources into a fiery cauldron year after year and expect to resume normal life at the end of the prodigal enterprise.

Nor did fighting end with the Armistice of 1918, still celebrated as the close of the Great War. Little wars continued sporadically—in Russia against the Bolshevik regime, and also in Poland, Czechoslovakia, Hungary, Rumania, Greece, Turkey, and northern Italy. Except for Russia, which wanted peace at any price, these other peoples had not had the benefit of long years of attrition on their soil and they were apparently content to lose more lives for doubtful gains.

The reckless expenditure of lives was bound to make a postwar world deficient in talents as well as deprived of needful links to the prewar culture. What proved equally devastating in the sequel was the policy of the Allies toward Germany. They acted on the fallacy about finance that Norman Angell had exposed and created in Central Europe a festering wound. To cite but one instance of their exactions, by January 1921—some 18 months after the signing of the treaty—Germany had delivered 20 billion marks' worth of goods. The Allies said the lot was worth only 8 billion. By way of punishment they occupied additional industrial centers at German expense and imposed special duties against German imports into the Allied countries.

The balance of trade against Germany steadily increased while the country was expected to produce in cash and in products such as coal variable amounts each year to reach a total of 32 billion. Inflation set in, coal delivery lagged, and France occupied its source, the Ruhr. While there it fomented a movement to make the Rhineland a separate state. It failed. But meantime, the wealthiest German capitalists, indifferent to the fate of the republic, invested abroad, worsening further the plight of the German people. The Allies, it is true, were trying to pay off their debts to the United States, which was pressing: one way or another, the great illusion was the script the allied

players kept rehearsing through one act after another. Two decades later, when Hitler came to power by a straightforward vote of the German people, the players were surprised at the denouement.

It was not long after the end of the Great War that farseeing observers predicted the likelihood of another and it became plain that western civilization had brought itself into a condition from which full recovery was unlikely. The devastation, both material and moral, had gone so deep that it turned the creative energies from their course, first into frivolity, and then into the channel of self-destruction.

The Artist Prophet and Jester

ONE NOTABLE DEATH that occurred in the Great War has gone unsung,
indeed unrecorded: the death of the philistine. That omission is no doubt due
to his not having been called a hero, ever, although he was one of a special
kind. Surely it took courage of the best mulish sort to make the same protest,
generation after generation, on seeing each new school of 19C art and litera-
ture produced and derided, then accepted, and at last exalted and lodged at
public expense in museums, libraries, and concert halls.

Philistines were still alive and kicking late in the Cubist Decade (<647);
they disappeared into the trenches with everybody else. By 1920 any that sur-
vived had been miraculously transformed, not into aesthetes but into trim-
mers and cowards. To this new breed anything offered as art merited auto-
matic respect and grave scrutiny. If a new work or style was not easy to like, if
it was painful to behold, revolting, even, it was nonetheless "interesting." Half
a century later *unless* the reviewer finds it "unsettling," "disturbing," "cruel,"
"perverse," it is written off as "academic," not merely *un*interesting but con-
temptible.

The stupid bourgeois had through the alchemy of war come out the
docile consumer of the mid- and late 20C. He takes the existence of a mind-
twisting avant-garde as much for granted as the earth's being round; it has the
status of a holy synod. To say this is not to overdo metaphor. Art has been
defined over and over as Man's highest spiritual expression, and in one
respect superior to religion in that it is the only activity that does not lead to
killing; it is in fact the redeemer of an otherwise evil affliction, human life.
The artist is moreover a prophet in the biblical sense. Long since called "a
criticism of life," his work denounces the sins of the contemporary world.
This view of the arts, fervently held by their leading practitioners, has come
to be accepted by a sizable part of the public, for many of whom it provides a
pastime or a livelihood. The pillars of society—business, the church, govern-
ment—have concurred. It would seem appropriate to date *popular*
Modernism from the time of this final victory won by the religion of art in the

early 1920s. The message first uttered in the early 1800s, "art for art's sake," finally conveyed to the literate its true sense: "art for life's sake" (<617).

This dating of ecumenical Modernism gets rid of the confusion among the two or three others without affecting the traditional use of *Modern* (no *-ist*) for the era since 1500.° At that time, as we saw (<224), the phrase *Middle Ages* was not in use and *modern* meant "common" in the sense of new, voguish. (The low Latin *modernus* was rooted in *modo* = recently.) It took a long time for new and common to become new and uncommon. Here again, the early 19C is the pivotal moment. Modern was used in a complimentary way by the pioneering Gautier in the 1830s; *modernité* by Chateaubriand in the 1840s;° and Baudelaire in the 1850s found it an accepted critical term. A small indication: the French bibliographer Octave Uzanne edited *Le Livre* for many years; in 1890 he renamed it *Le Livre Moderne*. Thanks to this changed view of modernity, art joined science in spreading the 20C dogma that latest is best. Modernist Man looks forward, a born future-ist, thus reversing the old presumption about ancestral wisdom and the value of prudent conservation. It follows that whatever is old is obsolete, wrong, dull, or all three.

Such was the deep conviction of some talented young in the 1920s. Unlike the reconstructed philistine, they did not need to subdue the flesh in order to partake of the new and shocking. They had survived the beastliness of the war, the war caused by their stupid or wicked elders. The new life must be free of all the old errors and full of new pleasures. Gaiety was the main item on the agenda, a taking hold of life with both hands, feeling tolerant toward human vagaries (including one's own), and under stress, showing nonchalance. This last trait is no doubt what Hemingway had in mind when he defined courage as grace under pressure—an odd notion, since physical courage can be ungraceful, ugly, desperate. But applied to moral resistance, the maxim fits the temper here characterized. Given the relaxed situation of the early postwar, this rejection of the past, coupled with ways of compensating oneself for the recent horrors, was EMANCIPATION with the least effort.

*
* *

Despite the break in beliefs and feelings, the pause between the Great War and the next saw the progress of three movements that were already prominent in the period called for convenience the Nineties. These late 19C beginnings were revolts too, which is why their continuation fell in with the postwar temper. The 1920s might have completed these earlier purposes if the second war had not taken place and postponed fulfillment till the 1950s and 1960s. The three were: sexual emancipation, women's rights, and the welfare state (<688).

Because these were changes in moral, social, and political habits and the

1920s and 1930s are remembered chiefly for art and frivolity, the fact that this period took the second step toward the mores and the politics of the 20C fin de siècle has been forgotten. The final, mid-20C phase of 1890 emancipations has been regarded as so many beginnings. Since the artistic and the other manifestations cannot be described simultaneously, the former as the more conspicuous then and now shall occupy us first.

Early in the 1920s the young intellectuals were turning excited attention to half a dozen works of literature that deserve to be called defining. Their authors belonged to an older generation and the works, gestated during the war, dealt with the experience that every living soul had recently undergone. T. S. Eliot's *Waste Land* epitomized by both title and contents the thoughts and feelings of the survivors. The note of desolation is struck in the first line: "April is the cruellest month." From Chaucer to Shakespeare and from Shakespeare to Browning and Whitman April had been sung as the gentlest, most welcoming month. Now all that April stands for, particularly the generative force, arouses antipathy; life is abhorrent.

The Waste Land goes on to record a hodgepodge of facts, ideas, superstitions, and interests born or vivified during the ordeal. In Eliot's first group of poems "wasteland" is foreshadowed; it is the name for the earth and the soul; for what coexists without meaning; art and its nightingales; fragments of cabaret song; Buddhist nihilism; sublime longings ending in vulgar, senseless riming jokes; sexuality acknowledged in the mood of revulsion—the disparate images and tones affirm the blurring of all distinctions, the incoherence of the world. By itself, *The Waste Land* was the crystallization of a moment in European culture. There had been none such since Goethe's *Faust* and Byron's *Childe Harold* (<485).

Very different but likewise emblematic, Joyce's *Ulysses* made a saga out of the contrast between the critical consciousness and the inescapable demands of life. The tale begins with a glimpse of the poet, the artist, whose powers keep him a spectator, an alien in the uncaring world. The rest of the odyssey is framed by the next scene and the final soliloquy, both expressions of the physical: in the first Bloom is at stool and thinking evacuations; the last shows Molly thinking sexual organs and intercourse. In between, the spectator trails through that other wasteland called a city. Sordid back streets and busy thoroughfares form the boundaries of modern life. Bald description, satire through parody, calculated ramblings permit nuances within disgust, and even at times a sad sort of sympathy. The literary innovation borrowed from an obscure French author, the "interior monologue,"° parallels the "free association" method of curing neurotics.

Two other outstanding works, new in the early 1920s though finished during the war years, embodied its experience by showing former codes of conduct and belief as obsolete and society in decay. These were Shaw's

Heartbreak House and Proust's *Remembrance of Things Past*. This last title, attractive as it is for readers of the Scott-Moncrieff translation, misses the point: the original says "in search of lost time," with a play on words suggestive of "forgotten days" and "time wasted." The story stresses the evanescence of all things and in particular of the social and artistic world that the narrator tries to reconstruct in memory. It is interesting—and was largely unnoticed till an American scholar made the survey°—that the recollection includes with respectful attention a good deal of the contemporary science, both directly and by way of metaphor.

The length of Proust's novel is a logical consequence of his way of remembering. It too is associative: the famous crumb of tea cake and other similar details made the now overstated point that the mind is at bottom non-rational. That is also the lesson of the interior monologue, of which Proust makes indirect use. Instead of the non-logical "stream," he created the meandering sentence (in French: *phrase à tiroirs*). One clause after another is forced into the preceding, the lengthening group somehow harnessed together in a single syntactical unit. It is hard to read and often to understand. It is antiprose, as the first critics of the work noticed. For as we saw earlier (<353), prose is a highly artificial genre that requires the taming of speechways to attain clarity, and in Proust one is pulled down, below speech, into the wayward flitting of thoughts and images.

The counterargument is that without the wanderings no impression of search, of difficulty and doubt, would have been rendered. One has only to read Proust's easy, delightful first novel in one volume, *Jean Santeuil*, to see that lucid and rapid discourse was inappropriate to the later work. The pastness of the past—let alone its rediscovery—called for the way he wrote. That this memory-seeking prose has given the loose to a large amount of bad writing in every literary language is true but not the originator's fault.

Much has been written to the effect that Proust intended a devastating exposure of the upper bourgeoisie and the relics of the nobility in France, making their tastes and their vices look so repulsive that, as in Marx, this upper crust would be blown to bits. This is to mistake portrayal for propaganda. A reading of Balzac's *Comédie Humaine* will show that *his* subject was the tastes and vices of the aristocracy and upper bourgeoisie of his time, and if their descendants were still around for Proust to observe a century later, the chances are that new money and old titles alike survive in spite of revolutions and wars. The question is, with how much authority? What Proust recorded was the passing of an elite, swamped—as Balzac feared—by the fully risen tide of democracy. After 1920, as mentioned earlier, another wave of populism, mightier than the first (<595; 651) swept over western culture. It arose from the communal experience of war and was accelerated by the Russian revolution. The people became the sole object of interest and concern. Art,

literature, social theory, manners, and morals reshaped the common feelings and set the tone of the altered society.

Shaw's *Heartbreak House* gives a more concentrated view of the maelstrom of emotions after the war; a play is always more tightly woven than a novel. As usual, Shaw's mode of edifying is that of high comedy. The people who live in Heartbreak House or visit there are, like Proust's, the idle well-to-do, and two or three contrasting types, including a burglar and the mad Captain who owns but cannot run the dwelling he calls his ship: it is adrift. He can only comment on the frivolity of the crew as they make love, quarrel, brag about their prowess, and remain ignorant of the conditions that govern their conflicting beliefs and actions. All but young Ellie, who ages rapidly out of innocence into experience, are as unhappy as they are worthless. The businessman in their midst, like the burglar, knows more of the truths of life, but the motives the pair live by are narrow and destructive of others and themselves. The Captain's acquired wisdom comes out in bursts and sometimes stuns the person addressed; at other times it is dismissed as his madness. In either case it does no good. Maxims in times of danger are useless, experience is incommunicable. The knotted strands of life, desire, assumptions, and moral codes cannot be unsnarled; they can only be cut, which is what happens when an air raid occurs, with a silencing fortissimo like the finale of a Beethoven symphony. The two thieves—burglar and businessman—are killed, the survivors exhilarated: they hope for another bombing the next day. The allegory is plain: the West has brought on itself the housecleaning its foul habits deserved; whoever looks about him and reflects should welcome it.

One other great figure voiced the same perception, also allegorically, the last of the great poets, Yeats. He had been one of the pensive Symbolists and mystics of the 1890s. He remained a mystic, but age and political responsibilities had turned him into a prophet too, hardening and condensing his language in phrases some of which, such as "the center cannot hold," have become clichés descriptive of "our condition."

*
* *

Whether or not the younger talents admired any of these older figures, they were driven in other directions by the cult of the new. It was an imperative so ingrained that it was not discussed: the 19C had seen to it. But in that century, the new was a departure by a number of geniuses who soon generated a school of able exploiters. In the 1920s, originality produced the spectacle of many overlapping styles at once. The apparent gain was an actual loss: it not only deprived the age of what might have been its characteristic style, it also subjected each competing group to the accidents of vogue. By the end of the 20C it was commonly said that the lifespan of a style is three months. For

The great geniuses of the past still rule over us from their graves; they still stalk or scurry about in the present, tripping up the living, mysteriously congesting the traffic, confusing values in art and manners, a brilliant cohort of mortals determined not to die, in possession of the land.

—WYNDHAM LEWIS (1915)

such creators the ancient maxim is reversed: life is long and art is short.

Why did Modernism not get a single style that would define the ism concretely? The answer is not rebellious egotism alone. The burden of the whole past, down to the turn of the 19C—all the masterpieces, great and small—exerted a pressure of paralyzing effect. Everything had been done. Substance and techniques had given all that was in them.

The impetus born of the Renaissance was exhausted, and the new start made in the years just before 1914 had been cut short; its creators themselves were unable or unwilling to pick up where they left off. These facts made the younger talents feel caught in the jaws of history; they must be original, but their heritage stood in the way and the means of making a new start were denied by the break in culture. They were at a new starting point without the benefit of an uncluttered ground, a clean slate.

The age demanded that we sing
and cut away our tongue.
The age demanded that we flow
and hammered in the bung.
The age demanded that we dance
and jammed us into iron pants.
And in the end the age was handed
the sort of shit that it demanded.

—ERNEST HEMINGWAY° (1925)

In retrospect, the scattering of their efforts may be grouped into a small number of tendencies: One, to take past and present and make fun of everything in it by parody, pastiche, ridicule, and desecration, to signify rejection. Two, return to the bare elements of the art and, excluding ideas and ulterior purpose, play variations on these elements simply to show their sensuous power and the pleasure afforded by bare technique. Three, remain serious but find ways to get rid of the past by destroying the very idea of art itself.

The enormous sum of talents exerted to carry out the individual programs under these categories fills one with admiration for the undertakers' pertinacity and with sympathy for their historical plight. All alike were doing the work proper to the artist—mirror life as they saw it, respond to its pressure by criticism overt or implied. And clearly also, their different paths converged on the negatives: ridicule, denial, anti-art, and sensory simplicity mean that culture and society are in the decadent phase, when it is everybody's duty to do his share of ground clearing. It is a manifestation of PRIMITIVISM on the large scale.

It was in the midst of war, that a small group of young people inaugurated the first of these modern techniques of destruction by seeming madly irre-

sponsible on purpose. They were in Zurich in 1916, protected by Swiss neutrality but not "above the struggle" emotionally. They chose for their movement of revolt the label "Dada," which is French baby talk for hobby-horse. In usage the connotation is double: obsession and mischief. Giving this tag to a new literature signified that it mocked and threw over the set forms and rational language of all previous poetry and prose, together with the conventions of print.

I don't even want to know that any man lived before me.

—ON THE COVER OF DADA NO. 3 (1917)

Every word was wrong; every word was Romantic, banal, probably used by the so-called poets of the 19C. He tried again: ochreous residue, heart's dregs—that was sufficiently unlike Tennyson, but it wouldn't do. *Heart* was one of the bad old words. But why write about autumn at all—another prohibited word. It all shows how second-rate I am, he concluded.

—GERALD BULLETT, *THE JURY* (1935)

The Dada manifestos were accompanied by poems and prose that made their way across frontiers, so that by 1920, Dadaism, led by Tristan Tzara, was one of the new schools that critics treated with respect. Its productions were classed as "amusing," but that did not make them any less "important"—destruction by derision is a recognized mode. Its novelty lay in the nihilism of the joke. It was not aimed at particular targets in orderly language; it attacked everything by dislocating everything. There lay the importance of Dada and its analogues in the graphic arts (722>). They gave a new model of total demolition, a fresh impetus to the prewar Abolitionism of Jarry, Lautréamont, and Marinetti (<619). The point was easy to grasp—a child could understand it.

In that same year, 1916, James Joyce was also in Zurich, studying music with Busoni and intending to be a singer. But he was even then leaning toward literature. His fellow student, the American composer Otto Luening, recalls in his autobiography how fond Joyce was of producing verbal glosses on musical works.° Whether Dada's way with words in print had anything to do with Joyce's later taking apart and regluing of syllables remains conjecture. If it is only a coincidence, the parallel shows the spirit of the times at work dismantling linguistic and literary habits. Apollinaire had prayed for a new language, Mallarmé for a new visual layout of ideas; H. M. Barzun for an orchestration of voices (<648). Time and the war translated their desires into an explosion of the dictionary. The prewar Futurist Marinetti brought his creed up to date in *Freedom for Words,*° listing among 10 principles: war on intellect, ending syntax and common spelling, creating the ugly, machinelike living, simultaneous perception, and "the maximum of disorder." Many kinds of poems and novels resulted from this form of freedom, and to this day one comes across contemporary writers who exploit typography as a means of expression.° What remains firmly established for all is the right to disregard not only the reader's beliefs but also his understanding.

Surrealism is pure psychic automatism by means of which is expressed the real functioning of thought—thought dictated without any control over it from reason or from considerations of a moral or esthetic kind.

—ANDRÉ BRETON (1934)

This right acquired a recognized basis when Surrealism came into being under the leadership of André Breton. The Dadaists claimed that they were its progenitors by virtue of their yielding to impulse; the Surrealists had the advantage of being "scientific" about it: they were versed in the nature and workings of the Unconscious and relied on dreams and the well-known phenomenon of automatic writing as the proper groundwork of poetry and fiction. Here was an offshoot of the recently publicized psychoanalysis, which seemed to justify abandoning the rational, the coherent, the readily intelligible in literature. Were they not largely absent from everyday life, business, government? Let the ubiquitous Haphazard speak.

This attitude suggests another turn in the theme of INDIVIDUALISM. Each artist cultivates his own garden, psychically speaking, and the reader or beholder uses his own fund of psychic images to interpret what is before him. The critical theory of the 1890s that each work of art is "an autonomous world" validates the practice. From another point of view, such works are also "pure art," because, coming out of the unconscious, they ignore all the meanings of the world. In the domain of spirit and psyche, communication is at a low ebb, its value negligible; it depends after all on conventions, and these are outworn. Non-sense rules the world.

DADA SONG

An elevator's song
That had dada in its heart
And overtaxed its motor
That had dada in its heart

The elevator
Was carrying a king
Heavy breakable autonomous
He cut off his big right arm
Sent it to the pope in Rome

Which is why
The elevator
No longer had dada in its heart

Eat some chocolate
Wash your brain
dada
dada
Drink some water

The result is paradoxical but of decisive effect. The artist condemns society by picturing not its follies but its madness. He is the jester whose absurd remarks tell the king what is wrong with his realm. The 20C writer is under no obligation of clear discourse—the language of Dada, like the blur of *Finnegans Wake* and the stutterings of Gertrude Stein, is by its nature anti-social; like Mallarmé he himself despises his audience; but claims its attention as the one being who pictures the world as it is. At the same time, the work of art being pure and autonomous, not subject to any rules, it affirms the artist's unconditional EMANCIPATION.

Dada, Surrealism, and their sequels had as a by-product a democratic en-

largement of the terms *art* and *artist*. Relying on the unconscious simplifies things: the unconscious is by definition neither learned nor thoughtful and everybody has one; and its deliverances in free associations or automatic writing are exempt from revision, else they would lose their genuineness. Thus the individual artist, not responsible in any direction, is really above criticism. It is a return to the ancient Greek conception of the "genius"—for example Socrates' *daemon*—as a spirit that lives within and guides the creature without his control.

Of course, the best disciples of Surrealism did more than tap the underground lake of associations driven by instinct, and as a result of their giving their material a tendency *Surrealist* acquired a narrower meaning, now the only one in common use: anything that causes dismay by violating ordinary experience. And since it seems that the unconscious is a reservoir of horrors, exploring it makes the cruel, the perverse, the obscene—the "sick"—more and more taken for granted as natural and normal. The untoward that is reported by the press it dubs "surrealistic," and this factual source encourages writers to outdo one another in creating scenes of outrage. Science fiction and film as well as novels keep teasing the mind with the unspeakable and possibly incite young and old to reenact the deeds in real life. The progress made since the Gothic shudders of the late 18C is manifest (<410).

<p style="text-align:center">*
* *</p>

When back from the trenches, the painters and musicians of the older generation felt disoriented. The path traced so long ago, in the zeros and teens of the century, had petered out. It was impossible to paint, sculp, or compose in the old way; equally impossible to start from scratch like a beginner. And since the latest young generation had been deprived of the normal tutelage by and resistance to their immediate elders, those newcomers who were unmoved by Dada were at a loss how to proceed.

As it turned out, these elders tended to leapfrog backward over one or more centuries and draw stimulus from forgotten works. Apollinaire, who returned wounded from the southeastern front, modified his technique and ended up writing poems to his new love in the versification of the mid-19C. Stravinsky, the star that led the musically advanced before 1914, found themes to inspire him in Pergolesi.

> Today every composer's overcoat has its corresponding hook in the cloakroom of the past.
>
> —CONSTANT LAMBERT (1934)

Fernand Léger and Picasso abandoned their ways of analysis-cum-synthesis and dealt in representation and rotundities that negated their previous geometries. For a time it was believed that a sober neo-classicism was under way.

But the winning gamble, the ultramodernist note was struck by Duchamp, also an elder. His temper had been contrary even before the war, from dissatisfaction with himself and his peers. The brilliance of his *Nude Descending a Staircase* remained a glow in the distance but not a beacon. His far-reaching influence on his contemporaries and successors has come from another signal light: his painting a mustache on a reproduction of the Mona Lisa. This coupling of two powerful symbols disposed of the Renaissance and its sequels; it was the counterpart of Dada. Construction was at an end and its opposite had begun.

To mix images one might say that the mustache opened a door, gave a password, flashed a permanent green light that allowed anything well done with pencil or chisel to qualify as art—or rather, to qualify as fulfilling the collective aim of anti-art. [The reproductions to look at are in *The World of Marcel Duchamp* by Calvin Tomkins.] A new term, "free form," summarizes the various techniques used in this EMANCIPATION. The creative eye found ways to discern in ordinary objects the "free form" of others, as Arp did in his mustache-hat and mustache-watch. Incompatibles when fused spark ambiguous meanings—witness the "free-formers" in words—and Ambiguity contributes to disarray.

These departures served the further purpose of bewildering by the titles put on the works. They could be cryptic, visibly irrelevant, or obscene. Everything kept on "amusing" the beholder through the years to come. The stuffed goat with a tire around its middle entertained at the Tate Gallery in London; the ladder against the wall inviting a walk-through at the Whitney in New York; the 22 small television screens around the room just oscillating in South America; the man's suit of gray felt on a hanger in Munich—Duchamp again had blazed the trail with a green vest, also on a hanger. These jokes were serious and must be taken so. Helping to destroy a culture is, in fact, no joke if one is bursting with talent and technical skill and must bend them to a sort of REDUCTIONISM, instead of giving their expansiveness free rein. Other artists found less demanding and more direct means of contributing to the common effort. Found Art (jetsam from the beach), Junk Art (the discarded refrigerator door), Disposable Art (objects, magnified, or made of flimsy materials; bridges and buildings draped in cloth)—all these told the world that art as an institution with a moral or social purpose was dead.

The same message could be read in aleatory art (based on random points generated by dice or a computer); mobile art, including "sculptures" in the form of small useless machines in purposeless motion, or the pair of shoes that step back and forth; the canvases that show simple or complex geometrical lines (a whole series "exploring the square"), these last opening the way to drawings or photographs of bacteria, snowflakes, or internal organs. The

point is: just design, in two dimensions or three, with or without color. Pattern is all—almost any pattern pleases.

On seeing that painters and sculptors were no longer representing persons or objects but preferred forms bare of suggestiveness, critics began to speak of Abstract Art. This usage took it for granted that those forms were abstracted; that is, derived from some existing thing in nature. It is an unfortunate label, convenient as shorthand perhaps, but a critical misnomer on several counts. First, it blots out the fact that all art is concrete, made of matter and non-existent apart from it, even literature, oral and written. If anyone thinks that music escapes this condition, let him calculate the mass of the air set vibrating in definite shapes during a two-hour concert. Next, the arts that "represent" do so by abstracting too. No portrait, landscape, or bust duplicates in full what its model offers to view. Lastly, not all the Modernists derived their visual or plastic forms from some part of nature, something seen and then stripped down to a skeletal look. Nor can the term properly apply to some abstract idea that the work supposedly conveys. Sir Joshua Reynolds called one of his paintings *The Age of Innocence,* but what we see on the canvas is the figure of a little girl. These distinctions are important because of the genuine ABSTRACTION that science and techne have interwoven with the immediate and palpable in modern life. *That* type of abstraction, as shown earlier, deserves the name: it pulls away from direct experience, for example, a musical performance live last year and heard, subtly weakened, on tape today.

Duchamp's world of forms was soon supplemented by Dali's, sprung explicitly from Surrealism. This artist too felt the need to raise a flag by painting Mona Lisa's upper lip, endowing it with a facsimile of his own German-Kaiser bracketlike mustache. For the rest, his representation of things is as they occur—or might occur—in dreams and preferably in nightmares. The watch bent over the edge of the table cannot be expected, in its uncomfortable pose, to keep good time. But the technique itself is of the very old-fashioned "photographic" kind, much imitated by other Surrealists, who can thus indulge their evident abilities. Their landscapes, nudes, and still lifes, including the justly famous can of tomato soup,° are academic art of the best worst kind and thus make the point that even that despised style is scheduled for perdition.

The imaginative painter's eye and hand found yet another way to enlighten the beholder: make line, color, and texture the sole interest. Prewar critics had said that this trinity was the only part to admire in any work (<622; 646), but they had not supposed that it would exclude other elements. Now the program was taken literally. Large panels of "vibrating" colors in graded or contrasted shades, or dots, lines, planes, checkerboards, or unpatterned

splotches (some randomly dripped on the canvas) arrested attention even though they are in essence very still life. (The parallel in music will be noted later, 727>.) The mind and the senses must be led back to their naive condition to bring high culture back to its first elements.

Finally, the most intense artistic minds took the most direct path. They represented on canvas or in stone, wood, or metal human beings in dehumanized form—body parts twisted, amputated, emaciated, background and accessories revolting, coloring and texture mortuary. At one exhibition in New York the artist produced the ultimate model by painting his body green and lying nude in an open coffin. Since then an English painter has chosen as his medium excrement. They have a good pretext for their offerings in the physical and moral destruction of war. No imagining of disfigured faces and torn bodies and ruined landscapes could rival what firepower does, and it would be but a slight exaggeration to call Picasso's *Guernica* a "realistic" picture. From physical degradation made visible one can infer what the latest moderns feel in their existence and recognize in these anti-human portraitures. [The book to read is *The Dehumanization of Art* by Ortega y Gasset.]

Given the several ways of modernist art it is logical to conclude that the production of things to see and read is not a rare or special gift. It is populistically distributed to all or nearly all. For one thing, some of the genres such as Found Art do not require long study or much practice. For another, the unimportance of subject matter eliminates the need for psychological or other truth in the work. In other words, the demand for genius has died out. Accordingly, there has sprouted throughout the western world a great number of museums, galleries, workshops, sidewalk shows, and government or business programs to exhibit, sell, or send abroad as propaganda the increasing mass of works. This flowering has taken place not only in capital cities but also in modest towns and villages. These new art centers have been seconded by schools, hospitals, and other sources of wall space so as to accommodate children's art, art by the physically or mentally disabled, art by convicts, art by chimpanzees. Art proves also suitable for therapy and for tranquilizing the unruly in prisons and asylums.

In the genres that call for more premeditation than the rest, the beholder often found that appreciation required some familiarity with the great tradition. Pastiche and parody cannot avoid being Allusive Art and it loses its point if the target is unfamiliar. Other tendencies likewise contained echoes of the past, the modernist mind being haunted by it willy-nilly. Picasso, for example, seemed obsessed with Delacroix's *Women of Algiers*. Fifteen times he patterned a work of his own on the Romanticist painting, each more "scribbled over" than the last, but all recognizable. The series might be entitled *The Victory of Duty Over Admiration,* the duty being to erase the past. For another

kind of allusiveness, read Balzac's play of 1847, *Mercadet*, and note the recurring line "waiting for Godeau," a character who is expected to solve everybody's troubles and who never appears.

<div align="center">*
* *</div>

Architecture and music must be modern too, in their own way. Architects and craftsmen in the decorative arts did not reject their immediate forerunners, possibly because they dealt in objects of public and domestic utility. The former had to house thousands of office workers on a narrow plot and built tall towers; the latter graced the period by the brilliant profusion of the Exposition des Arts Décoratifs of 1925, postponed 10 years by the war. The show made Art Deco a historical term. The glass of Lalique, the textiles of Rodier, the tapestries of Lurçat, together with the new forms of chairs and lamps and tables imprinted the mind's eye indelibly. They reshaped not merely the public's expectations as to household furniture, but gave the idea of design a distinct status while creating a new profession (726>). Its members serve the world of commerce and dictate shapes for everything from perfume bottles and computers to vacuum cleaners and bathroom fixtures. This breed of artists arose with Art Nouveau in the Nineties, but Art Deco moved away from fluidity and toward the sterner lines of machinery. Louis Sullivan's doctrine of Functionalism—form follows function—continued to rule modernist architecture. The doctrine, though fallacious, was productive of much beauty. Function in any artifact is rarely single, and the designer's favoring one function usually means neglect of another: the motor car looks like a turtle to be "aerodynamic"—speed in the wind—but it is anti-functional for the user to get in and out of. So true is this conflict of aims that a new descriptive term has emerged: makers of quite functional devices have had to modify them so as to pacify the customers who want them "user-friendly."

Art Deco objects and furniture, smooth in sweeping lines, sharp angles, and low to the ground, were preceded by the radical architecture of the Nineties, also influenced by machine industry (<554). Its postwar flowering descriptively called International was ever more geometrical and bare of ornament; it gave the modernist city block the silhouette of shoe boxes on end. The mass effect was awe-inspiring even when any or all of the separate buildings were undistinguished. [The book to look through is *The International Style* by Henry Russell Hitchcock and Philip Johnson.] One architect only, the Belgian Auguste Perret, the prewar pioneer of construction in glass and concrete (<677), continued to invent ways to give surfaces diversity by Art Deco decorations and receding or protruding planes. Most other buildings relied

on window placement and the feeble effect of modest molding or timid entablatures at the second-story level. Above, the walls rose flat and gray like so many punched cards.

At the same time, what may be called techne architecture had become a genre of its own and was receiving enthusiastic praise for such masterpieces as the liner *Normandie*,° the George Washington Bridge in New York, and later the Gateway Arch over the Mississippi at St. Louis. It was characteristic of its novelty that the New York bridge was "saved" by artistic influence from having its metal towers encased in stone panels, as originally planned. Concurrently, people with Art Deco furniture sported an actual valve or gear of polished metal on their mantelpiece.

To justify his monotony in concrete, Le Corbusier, high priest of the genre, said that a house was a machine for living. He built large blocks of workers' houses and a lock-keeper's gate on the Rhine in the same functional (and one would think, suicidal) style. When after the second war the reaction came, helped by the development of new materials and new ways of handling the old, it rejoined the other arts in their defiance of expectation. Churches took on rounded animal forms and museums double-boiler outlines. The latest conception of a luxurious mansion suggests huge rocks in a heap. All proclaim the liberated fancy.

To call a house a machine and make it feel as if it were, by movable partitions, large expanses of glass, and other factorylike features, yields, once again, convenience at the expense of comfort. Such a house is REDUCTIVISM, down from the neolithic coziness of the cave, later refined into the hearth and home. Together, free form and mechanizing add to the aggressive conviction that anything may be done.

To believe that these several characteristics of the modernist arts molded only the souls of the elites is to overlook the fact of "cultural seepage"— through advertising, which always borrows from art and intellect; through the highly organized entertainment industry, which translates the new into the popular; and through a new, self-conscious activity that some have called the distinctive feature of the age: design. Owing much to the Decorative Arts Exhibition of 1925, it had its start early in the Depression years, when a French army captain named Raymond Loewy came to the United States and, with a portfolio under his arm, aggressively argued with manufacturers that their products were ugly, clumsy, and possibly dangerous. He made sketches and got orders to redesign a variety of articles from dictating machines to locomotives. Of the last he made the first streamlined model. Soon other draftsmen, who had encroached on his lucrative practice, were streamlining everything in sight. Loewy also introduced color, and on the plea that certain products, such as perfume, looked so much like one another that advertising was useless, he annexed packaging for his stable of designers. The skill of the new profession has been

applied without limit and has resulted in making the outside of what we buy even more desirable than the thing within. [The book to read is Loewy's account of his odyssey: *Industrial Design*.]

The arts of Modernism have done one more thing; they have played a part in the general relaxation of conduct so widely complained of since the mid-century. The attack on authority, the ridicule of anything established, the distortions of language and objects, the indifference to clear meaning, the violence to the human form, the return to the primitive elements of sensation, the growing list of genres called Anti-, of which the root principle is "Expect nothing," have made Modernism at once the mirror of disintegration and an incitement to extending it. And all this was going on long before the moral, sexual, and political rebellions that shook the western world in the 1960s.

*
* *

Except for a small group, the musicians did not immediately find ways to do for their art what Dada and the architects accomplished. This exceptional vanguard was linked to the Futurists and called themselves *Bruiteurs*—noise-makers. Theirs was both the true music of the city and the return to the elemental fact that concussing various materials will create sound. Hence a lifelike polyphony of clangors, interspersed with the chromatic portamenti of sirens and the two notes of fire engines. This innovation was recently recalled in anniversary celebrations in Italy and in France; the Futurist effort had anticipated the harmony of shell-fire at the front. After the war, a somewhat modified inspiration produced Antheil's *Ballet Mécanique*, and in our time John Cage and others have reverted to the eloquence of pure noise.

> When George Antheil adds to his score sixteen pianos, an electric buzzer or two, an aeroplane propeller, and a pneumatic drill he is, after all, providing little more than the average background to a telephone conversation.
>
> —CONSTANT LAMBERT, "THE MECHANICAL STIMULUS"° (1934)

Cage denatured the sound of the piano by physical means, presented works consisting of blows on pieces of wood, and in the notable *4' 33"* featured silence carefully measured. These works purpose to teach respect for the elements of the art. During the silence all kinds of sound occur in the hall; this revelation helps to loosen up the auditor's rigid notions of what music should be, whereas in the composer's ear all sounds are equal. These events inspire the reflection that a good deal of 20C art has been instructional, the artist-pedagogue flogging the dead philistine, as in Magritte's painting of a large briar type with the caption "This is not a pipe"—as of course it isn't.

From the prewar decade the musicians of the 1920s inherited the strong

belief that the system of tonality was literally played out. The extreme use of chromaticism (using notes outside the chosen scale) had destroyed the value of scale itself as carrier of significance. Recourse to polytonality (two or more scales simultaneously) then to atonality (disregard of the sense of scale) ushered in for music the common modernist state of complete EMANCIPATION. The orchestra also tended to lose its preeminence as an instrument, and small groupings of its constituents were favored, with special emphasis on percussion, which echoed the cacophony of life. But Varèse's subtle and complex *Ionisation* showed that music could not, like words and paint, do without system. Notes by themselves lack the connotations that even a syllable may evoke or the emotional tone that a line or dab of color arouses. After a good deal of composing atonally, Schoenberg devised the system called serial (he preferred the term *pantonality*), which attracted the majority of musicians while repelling most audiences.

The public tried hard; the philistine did not come out of his grave; on the contrary, he kept there his aesthetic distance. The reason for the prevailing demur was that "serial composition" by means of the "12-note row" appeals to the mind rather than the ear. It liberated dissonance and demanded of the listener a perceptiveness nothing had trained him for. What the system required was to decide at the outset the only allowable notes to be used in the piece, all combinations and permutations being usable. It was a challenge: "see what you can do within these constraints." The scheme was circumscribed creation. Boulez among others declared that he was bent on "destroying everything" and he earned critical approval for his "dismantling of music and total reconstruction under new laws."°

After use by Schoenberg, Boulez, Pousseur, Stockhausen, and others, some serialists came to employ mathematics to ascertain the possibilities. It turned out surprisingly that wider ranges of sounds were available than had been expected. Seeing this, some used computers to make the choices at random—"aleatory music," as in the poetry similarly engineered and like painting by dripping pigments. Other composers left the choices to the performer, and one at least declared that the result was something not to be called music but only vibrations. Traditional scoring by conventional signs on the staff sometimes gave way to curving lines—arabesques in different colors—general indications for a semi-improvising performer. The practice of the jazz musicians was instanced as a justifying precedent.

The work is made collectively at the moment of its being composed-performed, and henceforth merged in a single creative, quasi magical art. I try to put you, the performer, in tune with the currents that go through me, so that you may be joined to the inexhaustible fount that floods us with vibrations and thereby transmit not a music, but the vibrations that come from a higher region of direct action.

—KARLHEINZ STOCKHAUSEN (1969)

Technique, ingenuity, chance, and the irresistible lure of SCIENTISM displaced the tonally ordered intention of expressiveness. These aspects of the new music resemble Joyce's words made out of other words, the architects' "sculptured" houses, the painters' elaborate geometries, and the sculptors' search for new materials and ready-made items to assemble for "installations." Artists in the 1920s began to speak of their "research," its "problems" and difficulties hinting at heroic effort. Like Stravinsky referring to one of his works, they confided to the public: "This has been labored over very patiently."

Serial composition does not favor the lyric voice—melody—but the genius of Alban Berg, by using a modified form of the system, did create two operas—*Wozzeck* and *Lulu*°—that won over the choosy devotees of that genre. Though not melodic in the bel canto Italian sense, the music of these works unmistakably conveys whatever Berg intended. For the application of the pure system one must listen to the works of Webern. Characteristically, they are brief; his entire output fits on two small disks.

At one point in the second half of the century it seemed as if an advance in techne comparable to that which created the 19C orchestra (<546) would inspire composers in new directions. This was the synthesizer, a device by which any note, rhythm, or tone color can be produced in any volume desired and immediately recorded on tape. It is as if every instrument had unlimited range and power without the help of human lungs and fingers. The machine had a forerunner in the 1930s when Leon Theremin demonstrated how radio oscillations could be controlled by hand to produce "electro-acoustic" music. But his invention found no takers.

Twenty years later, more than one classically trained musician greeted the synthesizer warmly for its flexibility and ease of control. They have used it for effects by themselves or in combination with the familiar instruments. This "electronic music," like the percussive genre, enabled the composer to echo the violence and harshness of life. But the modernist sensibility is disinclined to vastness. Just as poets attempted no large-scale works of public import, cultivating only the personal voice, so composers preferred the small ensemble, often unusual in its instrumental makeup. Small works had the advantage of being more likely to be performed. The large orchestras had a set repertoire, and to be played by one of them entailed prohibitive expense, from the printing of parts to the extra rehearsing of difficult scores. And as in the theater, unionized labor created hurdles along the path between artist and public.

One other musical innovation also bore this restrained character: the solo-voice works composed and sung on a 43-tone scale by Harry Partch. They required a few specially built instruments, and the unfamiliarity of both the apparatus and the music kept these cantatas from receiving much notice for a long time. [The book to read is *Genesis of a Music* by Partch himself.]

Appreciation is beginning to be shown at the very end of the century, and one much-played composer, György Ligeti, has acknowledged Partch's influence. But the music of Bernard Van Dieren, again sui generis, is still awaiting the serious attention it deserves.

*

* *

Any contemporary observer of the cultural scene since the Great War knows that it does not appear to him or her in its fullness and that judgments about any part of it are uncommonly liable to error. The neglect of Partch and Van Dieren illustrates the incompleteness; the clash of opinion about a crowd of composers, including Varèse, Stockhausen, Cowell, Carter, Luening, Babbitt, Boulez, Sessions, Wuorinen, and Ussachevsky, and about electronic music shows the danger. It applies to modernists in every other art. A conscientious critic faces a barrage of views that are tenable—and contradictory; he cannot entertain them all; yet not to choose is to prove wrong.

As for spotting general characteristics, the task is difficult too. A critical term first used about Modernism tells us why: its arts have been promoted and accepted as "experimental."° The word stands for endless efforts to be different; it is one of the many misnomers of our time. An experiment is conducted under rigorous conditions; it follows a method, relies on others' most recent research, and is subject to review by peers. The artist's effort is entirely individual and uncontrolled. It is barely trial and error, since there exist no standards by which error can be gauged and a better trial made. What Modernism achieved is no less worthy for the lack of an honorific drawn from the laboratory. It would be better described—and this for more than one reason—as *suggestive* art. (The French slang phrase "launching a balloon" springs to mind.) *Suggestive* would cover the part that was pastiche and parody, the part that appealed by scandal, the part that embodied the obscure hints of the unconscious, and—perhaps clearest of all—the combination of parts that detach emotion from past art. Still, the word *experimental* proved a great convenience as a mind-opener. It made the public, inured to science, take the improbable with composure; it kept the lid down on the coffin of the philistine.

The worker is one rather given to observing, thinking, and doing. It's not easy for him to talk about and explain his work, but as he and his work have been placed in false position many times, I suppose he owes it to himself to say something.

—John Marin (c. 1910)

But the artists' suggestive efforts did not promote the mission of Modernism unaided. More than ever before, the creators harangued the crowd. Theories proliferated; books, periodicals, interviews, catalogues of exhibitions, and program notes explained and justified and made tech-

nique pre-eminent. The inarticulate artist was at a disadvantage and made weak gestures to follow the fashion. If the articulate felt a similar inadequacy when wanting to impress otherwise than by the work itself, they concealed it in recurrent clichés. Their art was the result of "concentrated study of spatial and linear interrelations"; or as "the determination of spaces by their relation to surface and line." The blurbs rang the changes on space, line, color, volume, and material or (in the other arts) brought in *nature, sensation, feeling, research, rigor,* and *control.* Much of this was no doubt sincere but added nothing to the beholder's previous knowledge that painters and sculptors are concerned with space, line, and volume, and others with the things they boasted of. When the titles of compositions did not joke or provoke, they expressed the same wish to appear learned, difficult, and scientific: *Investigation No. 12, Structure for Two Pianos, Study in Curves and Squares*—this last rather superfluous. The ancient maxim about art concealing art had lost currency.

Critics and artists who favored the serious, hard-work posture, as against the jokes and mockings that were prominent in the 1920s and 1930s and that are still found spicing new works, have at times called these "the sophomoric element" in Modernism. The allegation rests partly on the fact that many of the artists were very young and also on the quality of the jokes.

> Dada was born of a revolt that was shared by all adolescents.
>
> —TRISTAN TZARA (1926)

The rimes and contents of the Dadaists' works were not witty, their ridicule was not sharply aimed or worded with brilliance or originality. Painting the mustache on Mona Lisa can hardly be deemed an inspiration that thrills and makes one go back to it with renewed delight. The same is true of that photograph by Man Ray, rightly regarded as a master, which shows the back of a seated nude woman, decorated with cutouts that imitate the *f*-shaped holes of a violin. One feels likewise about the titles Erik Satie gave his compositions: *Three Pieces Shaped Like Pears, Dried Up Embryos, Things Seen Without Spectacles.*° When Duchamp in later years signed a copy of the Mona Lisa untouched, he wrote on it "Shaved." These sallies from artists now in the pantheon call for a few words more.

The term *sophomoric* means wisdom expressed foolishly—or folly wisely. If taken merely as dismissive it would not fit the case, for the results of Dada and its continuing animus show that the jesting was not silly but effective. Yet sophomoric does apply when one reflects that the mustache and the dorsal violin were intended to be *un*inspired, adolescent—not a joke but a jape. The ridicule mocks itself as well as its object. Modernist works of derision did not provoke laughter and were not meant to. They were mock-funny, which means serious, and those called "amusing" are designed to leave one hardly

smiling but moved to reflection. This is also one's blunted response to the new style of caricature: Paul Klee's or Ronald Searle's differ in this way from the old practice from Daumier to Max Beerbohm.

This muted elation is what the people of the period urged upon one another and boasted of possessing but misnamed "the sense of humor." It was not the ability to see life as comedy, which needs no special recommendation. It was the readiness to laugh at oneself when among others, a feat that rarely sparks explosive laughter; it is only SELF-CONSCIOUSNESS made into the habit of self-depreciation. It requires no self-reform, but has its use in forestalling criticism. Such apologies and confessions should not be classed as hypocrisy. Their popularity corresponded to the postwar increase in democratic feeling, which demands that one continually show awareness of one's limitations. Far from feeling at ease or superior, one reassures others by acknowledging that one is "only human" or "human after all." At the same time, through its connection with the mocking arts, the modernist sense of humor (it needs a better name) guarantees that one is adept at seeing through everything.

<p style="text-align:center">*</p>
<p style="text-align:center">* *</p>

Although the philistine left no descendants, it should not be imagined that the great drive to emancipate the arts was entirely unopposed. The resisters and denouncers of Modernism were highly qualified critics, cultivated men and women, impeccable intellectuals. And they took a higher ground than that of simply rejecting some products of the artistic avant-garde as repetitious, sophomoric, and obscure not from profundity of thought but from mere slovenliness. This opposition attacked the entire mass of culture-makers with a capital *C*—writers, thinkers, and talkers, as well as artists. A widely read book published in 1928, *The Treason of the Clerks*, gave a compact statement of the charge. ("Clerks" was the inclusive term, as in Coleridge's "clerisy.") The betrayal consisted in abandoning Reason and the duty to devote it to universal ends. The truths of the spirit were eternal and imposed limits that must not be transgressed. The author, Julien Benda, argued that a philosophy such as Bergson's gave free rein to the will, and thus to the willfulness characteristic of the modernist temper.

Many works before and after Benda's made the related points with kindred arguments. Massis' *Defence of the Occident*, Irving Babbitt's *Rousseau and Romanticism*, and the Shelburne Essays of Paul Elmer More (these last two authors Americans) took the reader back a hundred years to find the germs of the decline in store for western civilization: it was Romanticism, with its abandonment of rules, overstepping of limits, and ridicule of conventions— in short, the general EMANCIPATION—now victorious.

Anti-Romanticism was not a new critical position, especially in France,° and it had (for some) a political and religious corollary. That side of the movement was much to the fore in the heyday of Mussolini. T. S. Eliot was not alone in defining himself as classicist, Anglican, and monarchist. Only, outside England this last pair of allegiances meant one or another religious faith and some form of dictatorship. In the United States the literary group known as the Southern Agrarians were content to be "reactionaries," in the sense of resisting looseness in art, morals, and politics.°

The world of the articulate was thus divided into two camps, each of which saw a different set of menaces working their evil on civilization—a new barbarism or a reactionary oppression. A third group, the Marxists, favored "social realism," which was plain representation in all the arts so as to convey to the people a simple message in support of the socialized state. This last conception of art has vanished; the other two have faded away from the center of discussion and there is talk of Postmodernism. The reasons given for this new label are often elusive. One fact stands out in the graphic arts: representation is once more acceptable, clear common speech in poetry also, and "serial" composition is no longer obligatory. As for the political discontent that incited to flirting with dictatorship, it has had to find other outlets. What arouses partisan passion at the end of the century is the split on moral and religious issues. The outlook that calls itself Liberal faces everywhere one or more parties of the right who demand, like Benda, a return to the fixities.

<div align="center">*</div>
<div align="center">* *</div>

While the public between the wars watched with amusement or distaste the avant-gardes discharging their arrows at past literature and present society, prewar writers who had survived and were still productive enjoyed ever wider appreciation. Shaw, Wells, Conrad, Yeats, Hardy came fully into their own. Kipling's reputation entered a new phase. He was prized for his prewar masterpiece *Kim* and had moved on from stories about India and poems about the British empire to tales for children—the *Jungle Books*—and next, to atmospheric stories about rural England, ghost stories, social satire, and tales about ships' engines and imaginable air transport across oceans. This chimed in with some artists and designers' reverence for machinery, but one critic complained that Kipling began by depicting human situations, then wild animals, and was ending with steam boilers and propeller shafts. The rejoinder might be that it takes art to make the behavior of animals and machines hold the attention of adult readers.

Another group—André Gide, Romain Rolland, Galsworthy, Arnold Bennett, Norman Douglas, Theodore Dreiser, Thomas Mann—were the acknowledged leaders of western fiction; and the rising generation—Cocteau,

Virginia Woolf, Kafka, Maurois, Sinclair Lewis, Scott Fitzgerald, and Ernest Hemingway—seemed the avant-garde, more solid than the Surrealists. A few more—E. M. Forster, Chekhov, and Proust—were in fact published authors before the war but recognized only afterward.

One underlying idea, one subject inspires this large output of fiction: the horrors of the narrow fate enforced by bourgeois life and institutions. From Mann's *Buddenbrooks,* which depicts a family's disintegration, to Galsworthy's *Forsyte Saga,* Sinclair Lewis' *Babbitt,* and Proust's and Gide's extended novels, each set in a different country, the same conflict is shown in which the life of the spirit is stifled or destroyed. Society is hostile to the artist, and the family shrinks ordinary men and women to a fraction of their human capacity. The American novelists of the period had an ally in H. L. Mencken, who inveighed against what he called "the booboisie" and the democracy it controlled. The attack sounds as if the Nineties had never broken through the earlier Victorian narrowness and a new EMANCIPATION was called for.

Side by side with the authors of these attacks on "the system," writers back from the trenches turned their experience into a myriad of war novels, which is to say anti-war novels. A good many combined the spectacle of those horrors, or the return from them to civilian life, with scenes of sexual freedom—again, a repetition of the Nineties. This literary crusade was induced by wartime emotions and occasions, which concentrated the thoughts of many on sexual satisfaction, denying it by separating men from women, encouraging it by the opportunities the separation created. It was not long before it became obligatory in the novel to introduce at some point the overt sexual scene. D. H. Lawrence's widely banned *Lady Chatterley's Lover* was in effect a discourse on method, in which the words used (though in dialect) reinstated a kind of basic English. It raised the legal issue of obscenity, still with us. In poetry, instead of the dreams and sighs of late Victorian verse, one found the breasts and thighs of the uninhibited image-maker. In due course, but more guardedly, there followed the celebration of homosexual love.°

Thanks to courageous women such as Margaret Sanger and Marie Stopes, knowledge of contraception made headway in the 1920s, and social thought was broadened by a growing list of instructors in sexual fulfillment. Lovemaking as an art and the techniques to be mastered for adequate, not to say professional, performance became a concern of the wider public. Sexology was welcomed to the circle of ologies, while the popularization of Freud led to the belief that repressing the sexual instinct was dangerous. A change in manners favored this EMANCIPATION. Informality had become the fashion and it simplified encounters; for etiquette is a barrier, the casual style an invitation. The soft collar, the short skirt, the slip-on shoe accompanied a new feeling of camaraderie between the sexes that encouraged meeting and dashing about in sports cars, also a convenience for the pastime known as

"necking." The bobbed hair and flat chest, bobby socks and sensible shoes distinguished the "flapper" of the Jazz Age from her predecessor the damsel. [For visual evidence, look at the drawings of John Held, Jr., and then read *The Jazz Age* by Percy Marks.] Not that the "pals together" behavior of young women diminished sexual attraction; it was felt and discussed by the pals, though modestly known as "It"—"she or he has It." Whether the boyish look was an unconscious response to the fact that the bond created by life in the trenches made men prefer the male figure and deportment is matter for speculation. Military life tends to stimulate affection between males and may permanently divert it.

The charged atmosphere and discussion in the press incited to premarital lovemaking, to "experimentation," and gave warrant to it for the sake of "emotional maturity." An American judge named Lindsay promoted "companionate marriage," a trial period of cohabitation governed by stated rules; it is by now frequent without rules or memory of the judge. Bertrand Russell, A. P. Herbert, and others agitated for the reform of divorce laws, and nearly everywhere the previous requirement of adultery as the sole ground gave way to the claim of incompatibility. Those who resisted this great drive to acknowledge copulation as a human right and a subject of constant public interest waged a losing battle. Books were prosecuted here and there for obscenity or excluded from public libraries, but the label "banned in Boston" proved helpful to sales elsewhere. When in 1927, Judge Woolsey ruled *Ulysses* fit to circulate in "Puritan America," the aim of the Nineties rebellion was fulfilled. Writers and artists everywhere had made common cause against the last-ditch defenses of Respectability, which Somerset Maugham redefined as "the cloak under which fools conceal their stupidity."°

<center>*</center>
<center>* *</center>

Gaiety, we saw, was in order after the anxious years of bloodshed and sorrow. The desire was met by entertainments that appealed to the mind at the same time as they were lighthearted. The word *sophisticated* came into use to describe the happy mixture. The stage was booming and well supplied with clever plays. Somerset Maugham, A. A. Milne, Noel Coward, Ferenc Molnár, Philip Barry among others cultivated the drawing-room comedy. Revues displaced vaudeville with higher-grade humor, as in the brilliant works of Lorenz Hart and Richard Rodgers, Beatrice Lillie's clever skits, and Balieff's *Chauve-Souris*. Musical comedies also flourished, the lyrics, music, and dance superior to early models and the productions elaborate.

Light verse and the humorous essay acquired the status of literature and appeared in book form as well as in magazines—*Punch, Judge, Life, La Vie Parisienne.* Max Beerbohm, Robert Benchley, A. P. Herbert, Dorothy Parker,

Stephen Leacock were intellectual satirists who caused laughter rather than wounds, and so were such caricaturists as Gluyas Williams, Caran d'Ache,° and Beerbohm again. It is from this period that nonsense in prose or verse came to be seen as an important part of literature, Shakespeare's songs being cited as proof. Lewis Carroll's poems and his *Alice* stories were works of art to be respected, children's books were designed in that vein to appeal also to adults—witness Milne's *Winnie the Pooh* or H. G. Wells's *Tommy*. The limerick meanwhile, first addressed to children by Edward Lear, had been modernized before the war by turning the last of the five lines from a repetition of the first to a fresh idea for shock or surprise. The vogue inspired poets and novelists to contribute their fantasies, predominantly off-color, in that capsule form. Norman Douglas published a classic collection of limericks in 1928.

After the supremacy of *Vanity Fair* as the magazine of sophistication, *The New Yorker* recruited a galaxy of talents of a like cleverness as essayists and draftsmen, while Mencken's *American Mercury* of a nearby date used irony and sarcasm in chronicling the deeds and beliefs of the middle class. In England, *Life and Letters, The New Statesman, The Criterion,* and *Punch* were arbiters of taste, precisely in life and letters.

With the same purpose earnest playwrights dramatized social and moral issues. At the Abbey Theatre in Dublin, a center of the Irish literary Renaissance, Yeats, Synge, Sean O'Casey produced lasting works. Sadler's Wells in London, the Vieux Colombier in Paris, the Freie Bühne in Berlin, and in New York the Theater Guild and the Provincetown Playhouse helped to launch young playwrights. At the Guild or elsewhere on Broadway the somber Eugene O'Neill headed a group that included Maxwell Anderson, Sherwood, Behrman, Sidney Howard, and Thornton Wilder. Later, Clare Boothe and Lillian Hellman proved their equals.

For these works a host of fine actors were available, the last to be classically trained in voice and movement before The Method devised by Stanislavsky to elicit spontaneity and naturalness (>675). Those older actors frequently deviated into the standard Shakespeare repertory, and one company in New York gave a memorable *Hamlet* in modern dress, with a telephone on the king's desk for the line: "Come, Gertrude, let's call up our wisest friends."

By then the movies had captivated a still larger public and created an unheard-of habit: going out for entertainment once a week. It was the halfway step to the daily, hourly television enchantment. In the 1920s, thanks to Griffith (<649), motion pictures had developed means of its own, adaptable to every kind of sight or story. The early one-reel slapstick farce and simple serial tale in almost identical installments gave way to comedy, drama, and "spectaculars." The choice afforded openings to a variety of acting talents who became specialized heroes and heroines, their lives and loves chronicled

in picture magazines. Charlie Chaplin reigned as the incomparable satirist through farce; Mary Pickford and Douglas Fairbanks were worshipped as embodiments of romance and adventure; the horse-and-gun Western was manned by half a dozen grim-faced interpreters; and abroad the sinister type of tale, such as *The Cabinet of Dr. Caligari,* thrilled the masses. There also, with *The Blue Angel,* came one of the first would-be significant films, based on a serious novel by Henrich Mann, *Professor Unrat.*

Yet another form of entertainment, which competed with film and novel, was the short story without pretension to literature. Magazines, weekly and monthly, proliferated, were cheaper than books, and offered a menu instead of a single dish. Each year, the *Best Stories* appeared in book form to fill the bottomless chasm. From that half-century's output there survive but a few performances of lasting merit, some with the finest characteristics of the novel, for example, the short stories of Katherine Mansfield and those of Chekhov, then newly translated from the Russian. Others than Kipling wrote tales that deserve a place in literature: Arthur Machen's fantasies, Conan Doyle's medical and other strange adventures; M. R. James's and Algernon Blackwood's ghost stories. Lastly, the recital of true crimes and famous trials, which Henry James was fond of reading, was elevated into an established form of narrative by such masters as Edmund Pearson and William Roughead.

Sharing popularity with the foregoing were two types of biography. Lytton Strachey, a member of the Bloomsbury group, gave the model of the "debunking life" in short compass. The chapters of *Eminent Victorians* repeated the Nineties' attack through ridicule, seasoned in this case with garbled facts and a few falsehoods. At the same time, André Maurois invented the biography enlivened by fictional detail and dialogue, but not pretending to be other than it was. There flourished as well several modes of exploiting the careers of the dead, to belittle or explain them away, for instance the "psychographs" of Gamaliel Bradford. These works were complemented by a spate of autobiographies, many written early in the subject's life and retailing the miseries of his childhood and schooling. Likewise biographical was E. C. (Edmund Clerihew) Bentley's creation, the clerihew.° It consists of four lines of free verse purporting to relate an incident in the life of a famous character. Like the limerick, it has aroused the talent for nonsense in such writers as Paul Horgan and W. H. Auden.° Altogether, the 1920s and 1930s were fond of seeing the highbrow mind at play, whether in Dada or in the nonsense writers. It was relaxing and "humanizing."

But fun could be energetic too. When Josephine Baker, the Black American dancer, came to Paris in 1928, she aroused a frenzy of enthusiasm with her *danse sauvage* (= not "savage" but "wild and primitive"). Paris was ready; it was already dancing in steps that some thought primitive indeed—

the one-step, two-step, and fox-trot. The wildness was provided by that new music, also from America, jazz. It was loud, pulsing, insistent, full of syncopations and cross-rhythms; it left one deaf and dizzy when it stopped. One felt intoxicated by it, even without the other import from overseas, the Bronx cocktail (pronounced *bronze* in France), a blend of orange juice and gin, an odd mixture, medicinal in taste and hardly fit to go with food. It was superseded, but jazz was not a vogue; it had come to stay. Even then it numbered famous performers, though it had not yet developed its theorists and historians or raised the creators of its successive forms to the same Pantheon as the classical composers. Jazz continued to be music for use, for the feet, while gradually appealing to devotees and musicologists as concert offerings.

On the stage "modern dance" had another meaning. After Isadora (<677), it was a new art, freely evolving, and original performers from various countries found an international audience. Mary Wigman, La Argentina, Jeanne Ronsay, Harald Kreutzberg, José Limon, each innovated and some founded schools. And from India Shankar (the elder) dazzled the West with his troupe, whose dances and rhythms were a revelation in music and ritual.

Independently in Germany, a music also for use (*Gebrauchsmusik*) was the program of Paul Hindemith and others. It aimed at reinstating music in the home for a steady diet there as well as outdoors; the disused older practice should end the 19C isolation of music in a hall visited at intervals. The movement led nowhere, but its aim foreshadows the later taste for the chamber group, Baroque music, and the habit, akin to chewing gum, of turning on background music—at home, in elevators and taxis, or while telephoning.

Meanwhile in Paris near the end of the war there had gathered around the writers Erik Satie and Cocteau a group of young composers, "The six," notably Auric, Poulenc, and Honegger, soon joined by Milhaud, who produced an abundance of usable works, a good many of which were marked by the light touch of the period. In the same vein, the German Carl Orff made a cantata, now very popular, of the roistering songs of medieval monks— *Carmina Burana.*° In the United States, Charles Ives composed in an original idiom many songs, marches, and dances, as well as five symphonies. To Antheil's *Ballet Mécanique* already cited should be added Walton's *Façade*, poems by Edith Sitwell set for voice and small orchestra; Constant Lambert's stunning *Rio Grande*, and some similarly rollicking works by Randall Thompson, Percy Grainger, and Virgil Thomson. These same composers were also attracted to staid topics, but it is fair to say that by and large it is their works of either populist or comedic intent that have become familiar. Heaven-storming was cut off by the wall of war.

*
* *

Engaging the mind so as to entertain it adroitly without raising social issues drew in the 1920s an increasing public to a genre that has since then risen in esteem and popularity until it is now the subject of university courses and dissertations. That genre is crime fiction, first known as the detective story, or again as mysteries or thrillers. These are really subspecies that differ widely and need not take up space here; aficionados are aware of the differences and others would not recognize features cited in general terms. The important point is that crime stories are not novels but tales. The distinction, it will be recalled (<111; 352), is that between narratives in which, to put it briefly, psychology and sociology are the main concern and stories that depict plausible but captivating lifelike incidents that involve only familiar social types. Novels analyze individual characters and their social setting. Tales relate adventures that take for granted motives and settings.

The detective tale in its ideal form has a regular pattern, like Greek tragedy.° A dead body is found, doubtless murdered; the police fumble the investigation. Accompanied by his admiring friend and biographer, the gifted amateur appears and solves the case by reasoning backward from clues to criminal. The unfolding must observe certain restrictions—no supernatural agencies or poison unknown to science, no physical impossibilities or even improbabilities; and since the main interest consists in the process of discovery amid the confusion of facts and human purposes, there must be neither psychological delving nor a full-blown love affair.

> The detective's friend acts in the dual capacity of very average reader and of Greek chorus; he comments freely on what he does not understand.
>
> —E. M. WRONG (1926)

In the first postwar period the taste for "mysteries" was considered infra dig; readers would apologize for their addiction. Some famous literary critics went out of their way to castigate them as lowbrow.° This was contrary to fact; detective stories were written by and for highbrows. In that Golden Age of the genre, the English women writers led the field: Sayers, Marsh, Allingham, Heyer, and Christie were unsurpassed in invention and technique, affording the pleasure of literary art—plotting, wit, and narrative skill, in the service of invention, which must be ever fresh. President Wilson and Bertrand Russell were voracious consumers and more recently, J. L. Borges and Pablo Neruda.

Later observers psychologized and said that reading the tales purged the lust for mayhem. This showed complete ignorance, since the genre does not dwell on the physical act of murder and the corpse is usually disposed in

> Aurelius Smith did not look much like a detective, yet there was something calculatingly cool about each trivial motion he made. As he sat at tea with his secretary his slender fingers dropped a slice of lemon into his cup with the deliberate motion of science.
>
> —R. T. M. SCOTT, "BOMBAY DUCK" (1929)

the first few pages. What the stories satisfied was fascination with method—an aspect of SCIENTISM—coupled with the pleasure of seeing crime put down; in other words, Reason and Right. If the four-year spectacle of mass slaughter had anything to do with the popularity of these tales, it must have acted by contraries, for crime fiction stacked the cards against the killer and concentrated on justice and the rare mind endowed with "ratiocinative powers."

Commit a crime and it seems as if a coat of snow fell on the ground, such as reveal in the woods the trace of every partridge and fox and squirrel and mole. You cannot wipe out the foot-track, you cannot draw up the ladder, so as to leave no clew.

—Emerson, "Compensation"

The taste for interpreting clues was not new in the 1920s. In the mid–18C Voltaire had written a tale called *Zadig* after its hero, an "oriental" who serves his king by useful detective feats. Somewhat later, Beaumarchais wrote a short skit of the same kind in a contemporary setting. In neither of these is murder involved; it is pure reconstruction of events by inference. In the early 19C an American named Leggett applied the technique to a shooting;° and next, Edgar Poe,° creator of the short story as a form, put the stamp of his genius on four tales in which investigation is the motive power. Between Poe and Agatha Christie the crime tale was cultivated along two paths. The French developed the *roman policier,* long on melodrama and short on thinking. English writers preferred the short story, which in Conan Doyle found a master.° Not only did he possess the ingenuity needed to sustain the detective interest, but he created a pair of characters that are among the best known on earth. Sherlock Holmes and Dr. Watson rank with Don Quixote and Sancho Panza, and it is hard to think of a third partnership of equal renown. Indeed, in a fundamental sense they are the same pair, bent on a similar quest but in a different costume, 300 years apart.

So vivid are the two moderns that they have become the object of a worldwide cult coupled with a make-believe scholarship: the members of the dozens of Sherlock Holmes societies pretend that Holmes and his friend were historical persons whose lives are recorded in minutest details in the 60 stories. Since these were not written to be consistent or complete, inferences from the data are the subject of endless argument, much of it carried on with the subdued humor that is itself an engaging aspect of Doyle's narratives. This manifestation of modern pedantry does not differ from that shown in the single-author societies and collectors' bibliographical concerns. But the Holmes-and-Watson "findings" show how easy it is to draw plausible conclusions from verbal hints when the truth is in fact unknowable.

After Holmes, as one student said, the deluge. [The book to browse in is *Catalogue of Crime*, ed. by J. Barzun and W. H. Taylor.] In the end it was the long

story that prevailed—too long at first and spoiled by red herrings, then reduced to novelette length, and latterly reinflated to tome proportions. The reason for these variations is the rapid exhaustion of intrinsic devices and external sources of interest. Thus the exploits of the gifted amateur gave place to the "police procedural," side by side with the "private eye"; and again, to the lawyer, doctor, insurance inspector, or other professional who, more modestly but as effectively as Holmes, assists the regular force. In Holmes's day it was appropriate to look down on Scotland Yard, because not long before his time several detectives had been convicted of breach of duty and corruption.°

Out of the interest in crime fiction came two cognate genres: the spy story and the recital of true crime, already mentioned (<739). All these species of tale offer a common substance that has been little noted: they are faithful records of tastes and fashions. It has been well said that one goes back to the Sherlock Holmes adventures because in them "it is always 1895"—the London of hansom cabs, opium dens, and Jean de Reske at Covent Garden. Holmes himself is a man of science and a Ninetyish aesthete at the same time. Similarly, Dashiell Hammett and Raymond Chandler in America, like their progeny on the West Coast, have echoed the catchwords and vogues, even the tastes in jazz, film, and artwork of their decade, and certainly the obsession with sexuality. This cultural journalism adds verisimilitude to plots that are not the fruit of observation but contrivance. Unfortunately, of recent years this topical varnish has thickened and tended to obscure the central purpose of the genre. The hero or heroine forgets to display investigative ability while showing off extensive knowledge of music and the decorative arts.

For the best critical discussion of the form and merits of the detective tale, one should go to the writings of

Dorothy Sayers

She started in life with a gift and a passion for words. Born in Oxford, she was the only child of a clergyman and musician and a woman of modest education but energetic, highly intelligent, and proud of an ancestress who was a cousin of William Hazlitt's. Unfortunately for mother and daughter, four years after the child's birth, the family moved to a vicarage in Cambridgeshire, remote but handsomely endowed. There, the wife grew increasingly bored with her husband, and the child was reared with hardly any young friends or other society. She amused herself by voracious reading, writing stories and poems, imagining what the outer world was like and pondering the details of the Christian faith, which she read as a story. At the same time, she was a tomboy, full of life like her mother and practical in everyday matters. These

traits shaped her subsequent career: innocence, energy, a down-to-earth attitude that did not limit imagination, and a peculiarly intimate feeling for what has been called the Christian epic.

She went to Somerville College at Oxford, where she became a fine scholar (read her next-to-last tale, *Gaudy Night*), and was one of the first batch of women to receive a full Oxford degree instead of a certificate; or rather, two degrees in one ceremony—Bachelor and Master of Arts. So far, her life had been smooth and pleasant: now she must earn a living. She served as secretary to a man who ran a service associated with a school in France. They had a sort of love affair—in words—that was the first of her misfortunes in that domain. She had a plain face and unattractive shape, coupled with strong sexual appetites. After two more episodes, which left her with an illegitimate son who turned out handsome and intelligent, she found late in life a congenial husband, though his latter days darkened hers by becoming ill, alcoholic, and of uncharacteristic bad temper.

So much for the unedifying yet anguishing odyssey that Sayers had to endure while developing her literary gifts. As a young woman, a job as copywriter in the largest London advertising agency proved useful (read *Murder Must Advertise*) and enjoyable too: there was good writing even in ads. In all she wrote she aimed at the simple and direct.

Like Henry James, who gave a full-blown theory of the novel, Sayers laid down that of the detective tale, using her scholarship by turns seriously and with humor. Interviewed on the subject, she once manifested her forthright ways of speech: "imbeciles and magazine editors" would ask her to discuss crime fiction "from the woman's point of view. To such demands one can only say 'Go away and don't be silly.' You might as well ask what is the female angle on the equilateral triangle." On aesthetics at large she wrote an extraordinary little book, *The Mind of the Maker*. Its thesis is that the ordinary experience of making anything—creating art or applying workmanship to any object—corresponds to the meanings symbolized by the Trinity. First comes the creative Idea, which foresees the whole work as finished. This is the Father. Next the creative Energy, which engages in a vigorous struggle with matter and overcomes one obstacle after another. This is the Son. Third is the creative Power of the work, its influence on the world through its effect on the soul of the user-beholder. This is the Holy Spirit. All three are indispensable to completeness as they unite in the work.

The demonstration had a double purpose, critical and religious. While analyzing human creation it showed that God's work as revealed in Christian theology followed the same pattern and man is indeed made in God's image. Before this highly original book, Sayers had lectured and written plays on religious themes for festivals held in Canterbury cathedral and other churches. For these she did research in medieval history, literature, and language and

her activity brought her national attention as an intellectual evangelist. When the BBC commissioned her to present in dramatic form six programs depicting the life and death of Jesus, she wrote a script that combined simplicity in word and idea with emotion free of sentimentality. And like naturally religious persons in the Catholic tradition, she enjoyed being humorous about the objects of her faith.

St. Supercilia's unworthy father brutally commanded her to accept the hand of a man who, though virtuous, sensible, and of good estate, knew only six languages and was weak in mathematics. At this the outraged saint raised her eyebrows so high that they lifted her off her feet and out through a top-storey window, whence she was seen floating away in a northerly direction.

—DOROTHY SAYERS, *PANTHEON PAPERS*

She continued without letup what she considered her mission to show the role and validity of belief, using reason and example in the manner that makes *The Mind of the Maker* a work of permanent interest, comparable to C. S. Lewis's. But Sayers was not an absolutist. In this world belief in God she thought indispensable to answering unavoidable cosmic questions and as a fixed point by which to settle earthly ones, but to demand or enforce a particular conception of the Deity would ensure only division and oppression. She was explicitly a pragmatic relativist; more than once, in various contexts, she writes: "The first thing a principle does is to kill somebody."

The research she had done in the history and literature of the Middle Ages had persuaded her that she could translate Dante. Competent in Greek, Latin, and French, she now learned Italian and rendered Dante in the terza rima verse scheme of the original. Her youthful scribblings had trained her to think metrically and she chose the simplest, briefest language to give due place to Dante's wit, sarcasm, and humor, little or none of which appeared in previous efforts; all were solemn in deference to the theme.

She died suddenly at the age of 64 before quite finishing. But a friend supplied the lack and the translation appeared in the Penguin Classics, to mixed reviews, some enthusiastic. Much praise came from C. S. Lewis. Her version has two merits: it makes for an easily readable and dramatically effective work, like Samuel Butler's prose translation of the *Iliad* and the *Odyssey*; and her interpretation of Dante is tenable if one remembers that he wrote a pamphleteering poem in which, as a wandering exile, he damned his political and personal enemies, extolled friends, and put forth dogmas by no means all orthodox.

What will remain of Dorothy Sayers' work as a whole is a matter for conjecture. The attitudes and prose style of crime fiction have changed, though several of her tales keep being reprinted. *The Mind of the Maker* has the survival value of an original idea perfectly developed and expressed. In the rest of her religious writings Sayers was ahead of time. The present preoccupation with the Bible, Jesus, and Creation should lead back to her views. If the colloquial

Dante finds no lasting favor, the scholarly Introduction and Notes must remain important for students.

Sayers' conclusion that principle kills had been borne in upon her by the onset and the conduct of the Great War. National honor, naval supremacy, colonies for show rather than benefit, regions that must be conquered to "redeem people of our race," and "No peace, no surrender" had been goals pursued so stubbornly that Europe had turned itself into a vast burnt offering—a holocaust—without seeing that the two sides were cooperating to that end on identical principles. Some now said that it might happen again. If so, life was not worth living. Stefan Zweig and his wife, refugees in Brazil, committed suicide together in 1942.

> We believe that the chief trouble among nations today is fear—the fear of death and especially the fear of life. This is what depresses men's spirits and paralyzes constructive effort. We believe that this fear can only be driven out by a strong awareness of the value of life. Our aim is to give to the people of this country a constructive purpose worth living for and worth dying for.
>
> —Dorothy Sayers: Prospectus for a series of books to be edited by her (1940)

During the stalemate phase of the first war, Oswald Spengler, a German schoolteacher of mathematics, revised and completed a large work, begun some years earlier, and which came out at the right time when the two volumes appeared in 1918 and 1922. *The Decline of the West* provoked, as is usual with large intellectual demonstrations, responses of all kinds—instant or reasoned denial, agreement from persuasion or from previous conviction, and haggling because of disputable facts and generalities. The net effect was that for many who did not share the contemporary gaiety and resented the futility of the war, Spengler's thesis was proved. All the news confirmed it: a severe depression and unemployment; small wars all over Europe after a peace treaty that did not respect national feelings; a wobbly republic in Germany which could not pay reparations, nor the Allies their crushing debts; dictatorship under Mussolini in Italy; continued displacement and starvation of refugees; global and local epidemics; and the lasting spectacle in the mind's eye of devastated regions and broken bodies.

If that was the handiwork of western civilization, its demise was not only sure but also not to be regretted. Some of the thoughtful not possessed by love of the arts or pleasure-seeking predicted Armaggedon in another war. Others began to believe that "light comes from the East": Soviet Russia holds the only livable future.

Embracing the Absurd

THE AMERICAN EXPEDITIONARY FORCE that went to Europe in June 1917 not only enabled the Allies to defeat the Central Powers, it laid tribute on the old world for the benefit of the new by absorbing and bringing back Culture. The soldiers who served in France gathered from the Occident new impressions and ideas that made some of them want to return to Europe and gather more. The so-called American expatriates of the late 1920s were young. Favored by the high value of the dollar in lowered foreign currencies, they were able to stay over there until the Great Depression of the 1930s forced them home. Their sojourn amounted to a traveling fellowship of which the effect was to close the cultural lag of about ten years that had generally obtained between European and American art and intellect. In the 1920s the presence in Paris of such figures as Picasso, Joyce, and Pound and of Gertrude Stein, who provided a meeting place where aspiring artists and writers would find their elders and one another, stirred the kettle of ideas to their joint advantage. [The book to read, despite its invidious title, is *The Crazy Years* by William Wiser.]

When these young men left for their culture quest, the United States was in a mood of fierce isolationism and "anti-red" apprehension that made departure only the more attractive. But when they returned the academy was receptive to the image and ideas of Europe carried home by native sons. The ground had been prepared for this welcome. The American school system was at the height of its dedication and efficiency. The grammar school had assimilated millions of motley immigrants; the free public high school was a daring venture that was the envy of industrialized nations; its curriculum was liberal (in modern speech: elitist)—Latin, the English poets, American and English history, a modern foreign language, mathematics and science every year—and no marshmallow subjects. With some variations, the school world, in which discipline applied to work and behavior alike, had been saturated during the war with references to Europe, whether at sales of "liberty bonds" or programs to encourage giving to troops, refugees, and Belgian children.

The idea of the Continent was a live idea, and when some of its art and literature—and strange foods—began to filter in, minds were eager, not resistant.

This was still more evident in higher education. The big universities such as Columbia under Nicholas Murray Butler, the self-appointed traveling representative of American scholarship to Europe, and Harvard under Lawrence Lowell, had in recent years opened their doors to a larger group than ever before. Second-generation Americans showed their deep thirst for all the learning that their parents had missed and that the upper classes had presumably kept to themselves. The new-risen took to it with ease, while the upper classes apparently did not want to hoard it.

Some of the demobilized soldiers made their way to college to resume an interrupted education or went there to start one, and this injection of maturer minds also gave those years on campus an unusual vibrancy. It held over until the return of the exiles, when because of their economic plight something unprecedented took place: the academy took in the artist, for shelter and for use in teaching. This was a wholly American departure. Scholarship and art had nowhere before hobnobbed in one faculty. In the 1890s Romain Rolland had not found it easy to have his dissertation in musicology accepted for a doctorate by the University of Paris; it was an extreme concession. In postwar America, beginning with one or two tame specimens, the university gradually acquired whole departments of music, fine arts, and drama; the English department admitted critics and novelists, and soon the campus boasted of resident poets and string quartets, theater troupes, and an arts center.

The isolationism of the rest of the country had a plausible motive. Although President Wilson, contrary to legend, had maneuvered ably at Versailles against the vulture-minded victors,° he failed to get the United States to join the League of Nations, and European intrigues and conflicts persisted in a disheartening way. The treaty (in several parts) was not a settlement, as the one at Vienna in 1815 had been after Napoleon, and its unwisdom laid the ground for the next mêlée of peoples twenty years later. [The small book to read is *Between the Wars* by D. C. Somervell.]

In the interim, the Soviet regime took firm hold on the Russias, Turkey modernized itself under Kemal Pasha (Ataturk), Italy yielded to Mussolini's dictatorship and Spain to Primo de Rivera's, Japan invaded Mongolia, the small countries of Central Europe succumbed to armed Communism or struggled against it, and Germany, starving, weakened and beset by inflation, failed to solidify its republican institutions. When the Weimar regime could not pay the reparations imposed by the Allies (<711), the punitive occupation that followed solidified antagonism toward the victors and gave Hitler his toehold. The books by historians and journalists that blamed Germany alone for starting the war did not lessen resentment. Meantime, the United States, unable to collect the war debts incurred by the Allies, recouped its losses by

enabling Germany to recover economically, thus in the end adding material means to the will of revenge.

Throughout the Occident and America, Communism was making converts. Disillusioned by the Great War and the peace, intellectuals saw in "the Russian experiment" a fresh start with clean hands—Lenin and Trotsky, those great leaders, had denounced the war, got out of it, and had successfully fought off the armies of Imperialism and Capitalism. Writers and artists believed the promise of the Soviet apologists that workers of the mind were to be supported by the state equally with those of the hand; the Russian culture-makers no longer faced the western catch-as-catch-can of art patronage, nor did the proletariat fear unemployment. For the western reader Marx was abridged and popularized again, Communist party "cells" were formed under managers trained in Moscow, and recruits took to the discipline with the aid of mental or sexual lures according to taste. Many sympathizers, called fellow travelers, remained outside the party and gave it strength in public opinion. When the Great Depression, set off by the worldwide collapse of the stock market in late 1929, ruined industries and banks and threw millions out of work, Marx's prophecy that capitalism was doomed by its own internal vice was proved, and the ranks of Communists of all degrees of participation swelled everywhere. Marxism pushed aside every other current of thought, including the Catholic neo-Thomism, which had made notable adherents a little earlier.

A reporter who went to Russia wrote back that "he had seen the future— and it worked." Former populists and socialists took the new ism as the fulfillment of their old dream. Young writers and other artists collaborated in Marxist theater and music, published Marxist novels, painted Marxist murals. Marxist colleges were founded, and in uncommitted institutions Marxism was lectured on and discussed: one could not be "educated" if ignorant of the doctrine that was "the wave of the future." As one skeptic remarked, "The Communist Manifesto is assigned reading in every course except Hygiene." Fascism and soon National Socialism, which had won some partisans at their beginnings in the 1920s and 1930s, lost them, and together became the enemy for the right-thinking to combat. The world looked like the arena of the eternal crusade between Good and Evil. In the second of those two decades, war in Spain between the young Republic and the soldiers of General Franco aiming at dictatorship became the battleground on which the two "Fascist" powers tested their arms against the Liberal and Leftist (Socialist) forces. These last were joined by many writers and artists from England and America, with the eventual loss of young talents; of the native Spanish killed in the struggle, the loss of the poet Lorca was the most deplored.

Disillusionment followed when it was found that on orders from Moscow Communist fighters ostensibly on the Liberal side helped to eliminate some of its leaders as enemies of their own. The power shining in the

East that had enjoyed so much support among men of ideas did not lose it on this account, and only some recanted after the revelation of extensive domestic murder and massacre under Stalin. Then, in less than half a dozen years the Union of Soviet Socialist Republics became the noble ally of the Occident in its war against German and Italian Fascism, although for a couple of years Hitler and Stalin had contracted a marriage of convenience.

Their nations are more permanently associated in history by their use of massacre as state policy. What distinguishes from other mass killings the two egregious examples of the 20C, the Russian of the kulaks (enriched farmers) and the German of Jews, Gypsies, and others marked for destruction by their beliefs, is that they were deliberate and systematic, and in the German, abetted by science. In neither instance was it the soldiers' frenzy in victory or the populace avenging against their neighbors some old grievance. There is no excuse for massacre in any case, but history set a kind of standard that these acts of national policy violated. It was left to the 20C to perform deeds resembling the Roman extermination of Carthage, though even in that instance there was understandable occasion in the two previous wars between the powers, in one of which Hannibal had invaded Italy and inflicted a humiliating defeat on the Romans.

The modern attempts at genocide were ignobly intellectual: the kulaks' existence contradicted the theory of Communism, and the German victims were "racially harmful" to the nation. Granted the mix of other objectives— for the Germans a scapegoat, for the Russians, money and land, and for both a unifying effect—the blot remains that a pair of ideas, long matured and held as true by millions outside the scene of their application, should have produced a special kind of sophisticated crime.

Undeclared war is condemned by international law, but not without precedent. Thanks to the Japanese attack on Pearl Harbor, the United States once more became involved in the European struggle that began as a "phony war" in 1939—phony because declared but inactive. President Roosevelt's subdued help to England early on; the occupation of France by Germany; De Gaulle's leadership of the Free French; the Resistance in the *maquis* (the bush); the Vichy regime of Marshal Pétain, formerly the hero of the Great War, who now complied with German demands, hoping to emerge at last as head of an arch-Conservative regime; and the six years of bloodshed in all parts of the world—these scenes of the echo-war have not yet faded from all memories. What is not sufficiently known is the role played by Pierre Laval, twice co-leader of the reactionary Vichy government. To preserve the integrity of France, he battled with the German head of the Occupation, Abetz, to keep workers from being sent to German factories and Jews to death camps. He held on to food and other supplies and kept the basic services of the nation from disarray—all this not absolutely but to the extent that

his superior ability managed to extort concessions from the enemy. His too was a resistance. He was shot as a traitor in 1945 but his record more justly classes him as a patriot in a post of double danger. [The book to read is *Laval, Patriot or Traitor?* by René de Chambrun.]

By 1945, when Hitler, defeated, had committed suicide and Japan, atom-bombed, had surrendered and was under American occupation, the war had set western economies afloat again and at the same time had solidly estab-lished the welfare state. Its beginnings, it will be remembered, go back, first, to Germany in the 1880s; then to England and the budget of 1911; conclu-sively to the 1930s, when President Roosevelt with his brain trust of Great Switch Liberals (<688) set up the agencies to administer a full program. Throughout the West nowadays no other type of government is dreamed of; the only debate between opposed parties is whether the government shall be fatter or leaner and it appears that sustained dieting is something bureaucra-cies find as hard as individuals (779>).

<p align="center">*</p>
<p align="center">*　　*</p>

To sum up, the crowded quarter century preceding the renewal of world-class war showed two contrasting moods—lighthearted, some survivors of the Great Illusion revelled among artistic and intellectual novelties and agreed on the resolve "Never Again" to fight for king and country or *la patrie*. Francis Buchman's Oxford Group united many young and old in global benevolence coupled with this pervasive pacifism. Simultaneously, events piled up that provoked the death-struggle, farther flung and at the outset not at all jaunty as the first had been, and gravity returned. But these are only two sides of the pyramid. The third has been touched on: it was the coming to general awareness of the intellectual and scientific achievements of Modernism. The philosophers were glum, the men of science bright-eyed; they had a new view of the cosmos that altered the aspect of science, whereas the psychologists, novelists, and poets made the human mind more self-con-scious than ever, convinced as they were that thought and action are driven.

Einstein and Freud were the principal names attached to the new tidings; but as we saw, the work of these two embodied half a century of previous dis-covery and cogitation. Poincaré was on the verge of stating Relativity; James, the French psychiatrists, and their predecessors took account of the Unconscious and the role of sexuality. This link with the past does not deprive the later pair of their glory; it only means that the bombshell effect of their ideas in the 1920s was such only for the lay public. And for it the news was not merely astonishing: feelings and attitudes rapidly adapted to the changed vision of the outer and inner worlds, with the usual distortions that follow the diffusion of ideas.

"Surely, we ought to be a little more upset than we are over this great universe that has just died so suddenly."

"What universe?"

"Why, yesterday's universe, Newton's universe. Hitherto, the various cosmic systems have fitted inside our skulls. This new one refuses to do so. From the point of view of the man in the street, it is absurd. That is what is really great about it."

—Anatole France to Nicholas Ségur
(c. 1920)

Einstein's Relativity posited the speed of light as the ultimate yardstick, a time-space continuum and a multi-dimensional world, in which the observer is part of the determination of fact. When the curving of light rays around the sun gave proof of the system and other paradoxes emerged, such as the habit of no longer regarding anything physical as absolute except the speed of light, they put an end to the comfortable notion that science is common sense organized. Newton was now a classic on the shelf, still valid up to a certain point, inapplicable beyond it.

The new science was no longer within the grasp of the intelligent amateur. Both its concepts and its mathematics required a specially molded mind, for whom the concepts needed no names but could be read in numerical formulas. This made the scientist still more wonderful but set him as a breed apart.

What was the citizen to make of assertions that one infinite is larger than another and that a magnitude can be added to another without changing the sum? Or that "an electron is merely the pattern of its aspects in its environment so far as those are relevant to the electro-magnetic field"?° Or worse, perhaps, that man must be regarded as a mere collection of occurrences; obeying the *must* is quite difficult. The net result was that modernist physics deprived human beings of any object of cosmic contemplation. The actual order of the heavens and the workings of nature on earth were alike unimaginable—no poet could make an epic out of them, as Lucretius and Milton had done, or address a lyric to the moon. One could still gaze at the Milky Way, but it was *vieux jeu*; whatever notion crossed the mind at the sight was obsolete, any emotion a primitive fantasy. None of the new terms coined at the scientific mint were evocative. *Electron, photon,* and later: *quark, charm,* which popularizers keep idiotically calling "building blocks" of the universe, carry no suggestion of being blocks. Even "particle" (all 40-odd) is a misnomer, since its instant-flash existence leaves but a dot on a sensitive plate; it never flies into one's eye and makes it water.

What happened in physics has had comparable effects in the other familiar sciences and on the new ones that have arisen to link them in the hope of an ultimately unified account of all that is. Curiously, just as ordinary man was being left incommunicado, some of the language used in scientific descriptions became anthropomorphic in the way once forbidden. It used to be said that *force* was wrong because it suggested man's right arm at work; *energy* was

the right neutral word. Now, as we saw, it is official to speak of a weak force and a strong force. Similarly, in the life sciences one hears of a substance conveying "information" to another—"Neuron talks to chip and chip to nerve cell"—and of a "code" regulating these exchanges. All this has an unreality which is once again a bar to contemplation.

The rapid advances due to coordinated research over the wide world continually add deeper findings, subtler relations than those announced yesterday, and the impression grows that science is the task of peeling an infinite onion. In that process, science as it moves leaves behind it a shadow: superstition. This is unavoidable. If ten years ago the facts were such and such and now they are different—perhaps the reverse—then everybody has for a decade been laboring under a superstition. The one comfort is that it was not devised without much care on the part of many people. This unrolling tape of what is reliable is a guarantee of watchfulness, although at any one moment the truths of science are not the same for all those who work at it, let alone the laity.

Perhaps only in medicine does acting on its assurances at a given time prove hurtful, many of its findings being based on the post hoc fallacy: this outcome after that treatment; after which another study finds otherwise. There is no other way open, but error need not be fatal and yet damaging. During the early years of this century Dr. Metchnikov, who was Tolstoy's physician and had a European reputation, laid down the rule that the products of digestion must be eliminated early if poisons were not to percolate into the system and cause "auto-intoxication." Headache, nausea, and bad complexion were attributed to this self-poisoning and were particularly harmful to the young. The result was that several generations of small children were tormented by their enlightened parents into behaving according to rule, until it was shown that no poisons filtered out.

In purely mechanical matters, the danger is less, although in early days radiation caused deaths, both to workers who put radium paint on watch dials to make the numbers visible in the dark and to patients overdosed with X-rays in dentistry and the radium treatment of tumors. The counterpart of this unhappy experience is the current apprehension of lead and asbestos. They endanger those who work where they are breathed in, of course, but do they harm where they do not pollute the air? As things stand, despite the conscientious work of the many trained minds, the reports of "science" on a wide range of subjects are contradictory, equally publicized, and the laity cannot decide what to believe: global warming, radon in the soil, agent orange, additives to food, genetic tampering—an intelligent opinion about them cannot be formed. And when there is evidence that business and politics affect more than one "scientific" pronouncement, gone is the confidence in science felt and voiced in the 19C.

Meanwhile, the development of the atom bomb and its use against Japan

Is Science to Be Man's Servant or His Idol?

—Headline over a review of two books
in *Science* (1962)

raised the ethical question: should scientists work at projects for destruction? In several countries "Concerned Scientists" joined to establish the entirely new principle that science is not above all moral considerations. Shortly thereafter, advances in genetics posed the same ethical query about seemingly beneficial deeds, such as aiding the infertile, modifying plant and animal species, and finally "cloning," which would duplicate a human being to the last detail, as a mechanical copier does a document.

Between the end of one war and the next, techne fashioned impressive new machines. In aviation, the dirigible (the zeppelin), though brought to a huge size with many advantages for travel, had a short life: it was vulnerable to wind and storm. The airplane, rapidly improved for war use, was standardized at two wings instead of the original four, one pair above the other; and beginnings were made to replace propellers by jet propulsion through turbines. During the second war Germany developed rocket engineering to a point that made possible in a few years man's first excursion outside the earth's atmosphere. The Russian artificial satellite *Sputnik* (= "co-traveler"), put in orbit in 1957, blazed a path that led Americans to achieve the first stroll on the moon. Outer space is now everybody's playground, cluttered with wandering appliances and mobile homes under classical names like Apollo. These accomplishments have revived—quite irrationally—the idea that other worlds may be inhabited and have given science fiction impetus and materials. (H. G. Wells had already imagined *The War of the Worlds* in 1898.) Broadcasting, first by radio, then with television, enabled people to indulge their tastes for things to hear and see. They have done so with remarkable unanimity throughout the world. Speed in communication and means of detecting facts at a distance, such as radar, multiplied at a similar rate, culminating today in the various devices attached like the tentacles of an octopus to the computer, which despite its name is not in essence a calculating machine. It is not likely that any turn of fashion would deprive science and techne of the overriding power and influence they have obtained.

*

* *

The political mistakes that were made on all sides before Europe slipped into war again are so well remembered that words such as *appeasement, fifth column, collaborator, Munich* are still used as shorthand in the press. On the mood of that stretch of time in England, its fads, its films and plays, its novels and music, there exists a record of prime merit and interest, which is a masterpiece in its genre. That is the diary in nine compact volumes covering 15 years called *Ego* and written by

James Agate

Having served in France during the war years and stayed there a while longer, the young man from Lancashire became bilingual and well versed in French culture, so that he keeps recurring in his work to its contemporary aspects. An early novel based on his experiences proved to him that fiction was not his forte. He tried another form of writing and by his 30th year he was a widely read drama and film critic.

Among his colleagues he was the most learned about the history of the stage and literature at large. His reviews were terse, decisive, and extremely readable. And he was also a character whose tastes, avocations, and friendships made him a conspicuous figure on the London scene.

He was an excellent musician and steady concert-goer, he loved good food and the best champagne, he played golf with scientific assiduity, and he took part in the staid racing of show horses. When in 1932 he decided to start a diary, he resolved to depict his life entire, which meant giving a place not solely to his daily thoughts and occupations but also to his talk and correspondence with others, including his brothers and sister, no less singular than himself. The resulting narrative, with fragments of hilarious mock-fiction, ranks with Pepys's diary for vividness of characterization and fullness of historical detail.

> This then is the situation in 1926. A large part of the London Theatre is given up to plays about dope-fiends and jazz maniacs; other large tracts are abandoned to the inanities of musical comedy. Roughly speaking, three-fourths of the London stage is closed to persons possessed by the slightest particle of intellect or the least feeling for the drama. Picture theatres are springing up all over the place, attracting by their cheapness, superior comfort and the greater intellectual content of their programmes.
>
> —JAMES AGATE

Agate (he pronounced it to rime with *Hay gate*, but many acquaintances said *Ay-git*) found his tastes expensive, was always short of money, and took on every kind of literary job. He worked with speed but scrupulous care, keeping count of the hundreds of thousands of words that he turned into print each year. He wrote a good short life of the French actress Rachel; and published his best reviews in *At Half-Past Eight, Red Letter Nights,* and *A Short View of the English Stage: 1900–1926*; he edited classics on the same subject and his correspondence, never collected and perhaps largely lost by this time, was voluminous.

He was helped in these labors by a succession of secretaries, of whom Alan Dent, himself a fine mind and excellent critic, lasted the longest; his role in *Ego* adds much to its conversational brilliance. Agate helped to give a start to Kenneth Tynan, among other writers and musicians, and was a strong force behind young talents and new undertakings in music and letters. But his common sense of the Johnsonian type kept him from being an all-out

It was a dire day when Hitchcock or some-body discovered that a woman screaming emits the same sound as a train entering a tunnel. Fusion became the rage, what began as woman ended as tunnel, and why she was screaming or who was in the train ceased to matter.

—JAMES AGATE IN *EGO* (1935)

Modernist; he did not rave like others over the plays of Christopher Fry, finding his imagery affected. He detested the music of Bartók. On account of such judgments Agate was put down by some as a semi-philistine. His interest in the points of pacer horses seemed confirmation; and although himself a fluent Shakespearean, when he said that soldiers on leave should be given musical comedy and not *Macbeth*, his low brow raised the high brows of the righteous even higher.

The same perceptiveness made Agate aware of portents that the self-centered avant-garde failed to take in. As Rebecca West said in reviewing one of the *Ego*s: "The sense of doom beats behind the frivolity like a majestic theme in the bass." His friends expected in 1940 that he would suspend *Ego*: when he said no, they expostulated: "It means that you regard your diary as more important than the war."—"Well, isn't it? The war is vital, not important. Because I am suddenly stricken with cancer, must cancer become my whole world? Except insofar as I am a coward, it does not fill my whole mind."

It is of course because Agate's mind-and-heart was in touch with the feelings and thoughts of both the unassuming and the intellectual that he was a good critic of plays and had a broad taste in music and an intimate knowledge of both. He resembles Shaw in this range and in the freedom to express his liking for the less than sublime: love of what is fine should not make one finicky. That Agate was a stylist is evident from all his mature writings; his voice is his own, his talent natural; he could not have written his millions of words if he had had to struggle with them. How long it will take before *Ego 1* to *9* comes back into readers' hands is beyond guessing. It is a pity the diary is not in cipher, like Pepys's, for then it would benefit from the irrelevant interest that so often promotes great work—witness Stendhal's. [Still on library shelves is one volume, *The Later Ego*, which combines nos. *8* and *9,* ed. by J. Barzun.°]

* * *

Absurd was the term used by Anatole France when he heard of Einstein's universe, and the word began to be used more and more often about the workings of the postwar state and society. During those years also, a philosophy both technical and popular made the Absurd a definition of human existence, thereby generating a "theater of the absurd" and visiting kindred changes on other literary genres. What precisely does the word suggest? Etymologically, it implies "not to be listened to"; usage adds: illogical, plainly not true, contemptibly wrong, contrary to common sense and laughably so.

But little laughter is heard from those philosophers or from people who find themselves in an "absurd predicament" caused by the ways of contemporary society. Absurd in that context means cross-purposes, self-defeating arrangements. Societies have always been flawed by patches of self-contradiction. It is hard to imagine a huge group of people fashioning at various times a great many institutions and producing a fully consistent pattern of aims and actions. Unless the disparities go deep—for example, slave states and free states in a federation—the culture glides over local and temporary absurdities—until they grow too numerous or too glaring.

The philosophic absurd betokens something of a different order: a state of mind about the conditions of life as such. That native state, according to the belief, is Angst, anguish. In its first statement by the Danish theologian Søren Kierkegaard, it was a religious anxiety. He was revolted by Hegel's conception of the universe, in which Reason coincided neatly with Reality and man could feel cheerful at being part of so well ordered a divine absolute. Men's souls came out of it and would return to it after witnessing reason turn into fact. Kierkegaard saw instead an unbridgeable chasm between God and man with his troubled world, which called for a wholly individual and humble worship.

The 20C has translated this intuition into the atheist vision of Existentialism. Man is simply here; he has to make what he can of a universe that is not even hostile but strange and uncertain. Man is never given a purpose or mission; he must devise them for himself, knowing that their fulfillment has no external justification or reward—altogether an absurd situation. The feeling-thought at the root of this metaphysics is an assessment of the present century. The madness, the futility of the two wars, Man's incapacity to direct civilization along any precise course, and especially the gap between the actions of men and their stubbornly professed ideals show that they have no given destiny.

This account does not explain how and why an Existentialist takes up his creed from among the several varieties. Their unifying principle is that a modern philosophy must start with things as they are perceived, existence as we live it, and not from any prior idea. Given that premise, one may suppose that after the first and second wars of the century, it was not so much the permanent condition of human life, or the varied conditions in which most of mankind live, as the spontaneous estimate thinkers put on their own life that gave the tone to their speculations. Thus the guilt, anxiety, indifference, and strangeness that beset them as human beings who suffered from the plight of western culture found a place in their systems.

That this is a tenable interpretation of the existentialist Absurd appears from the ideas put forward simultaneously by certain psychologists and sociologists. They diagnosed people and the world as mad. The Scottish psychia-

You are a pain in the neck
To stop you giving me a pain in the neck
I protect my neck by tightening my neck
 muscles
Which gives me the pain in the neck that
 you are.
—Ronald Laing, *Knots* (1970)

trist Ronald D. Laing made his name with the paradox that madness was the sane response to an insane world; and he illustrated the absurdity of his patients' madness by fashioning little verses that show the typical modern mind going round in circles.

Other writers, students of Marx and Freud and loosely known as the Frankfort School, argued for combining the liberal side of Marxism with the erotic ingredient of psychoanalysis to effect a new EMANCIPATION of mankind from intolerable physical, social, and economic oppression. In the United States, a parallel demand under the arresting title of *Life Against Death* gave its author, Norman O. Brown, an influence comparable to that of Herbert Marcuse, the representative in America of the Frankfort School. Together with Timothy Leary, the advocate of drugging as the means of enhancing the free life, these mentors have been classed among those responsible for the outbreak of the world's youth in 1968.

The novelists and playwrights were not behindhand. In order to reject "realism," which they saw as a false front—in fact, by now an almost sentimental rendering of reality—they created the various types of the literary Absurd: the theater of that name—originally and significantly "the theater of cruelty"—associated with Antonin Artaud, Beckett, Harold Pinter, Ionesco, and others, and the theory and illustration of the same new ethics in the novels of Albert Camus and a number of other talents. The pattern that emerges from the endeavor as a whole is that absurdity, anti-reason, is the formula that explains social and individual life and the indicated pattern for the arts. It is a curious match with the pattern of science, where common sense no longer has any place in the results to be expected from investigating nature.

However fitting for the times, the existentialist complaint seems puny. It laments because man must make his own goals within a universe that stays aloof. Both are questionable assumptions. It can be argued that man and nature are one: nature is conscious of itself in and through man. And what man has made of the world, intellectually and materially, is his mission—chosen by him, it is true, but so universal that it is tantamount to fated, obligatory. Besides, how strange and unfriendly is nature? It has of course no intentions, friendly or unfriendly; it does not even exist as an entity; it is a man-made construct from his experience and for his purposes. But once taken as such "it" feeds him, it yields in a thousand ways to his handling, and it is beautiful. The sight of it often gives pure mindless joy. To dismiss as mistaken all these links with the cosmos that men have celebrated in worship and song is to forget that if the

mind mistakes, it is because it "takes," and that the current submission to the absurd is a taking within life, not outside it; hence not competent to damn it permanently.

From the conjunction of science with philosophy and literary theory in anti-reason, one is reminded of the youths writing in Zurich in 1916, the Dadaists. They too were practicing the Absurd, though without the name or the theory. And so were the later Surrealists, especially the painters and sculptors (<723.). The conclusion to be drawn is commonplace: these artists and thinkers, moved by the same opinion of their surroundings, did more than "reflect" or "mirror" it in their work, they reproduced the actual features of that environment—but with a difference: the works of the Absurd set off no spark of positive electricity, no rebellion against the absurdity of the Absurd. On the contrary, it is accepted as inherent in life.

In contrast, earlier philosophies used life as the very source of sanity; it was the measure of rightness, not vulnerable to corruption. The distinction was implicit between Life and *our* life at the moment; and the new thought, the new art showed what Life demanded. Even the Stoics, who did not dance with joy at the idea of being alive, left life and the cosmos their validity. The Absurd marks a failure of nerve.

It is true that some French Existentialists, notably Gabriel Marcel, have been able to reconcile their philosophy with the Catholic faith, which tells us to be resigned rather than to rebel. But the mainstream, represented by Sartre and Beauvoir, adopted Marxism and were its faithful propagandists. It was hardly an original countermove to absurdity; in fact, it is a contradiction. To follow Marx is to believe that the steps ahead are determined by the phase of history—its present material conditions—not the free choice of men's will. And the goal of Marxist history is a utopian existence without laws and presumably without Angst.

The passage from the original speculation to the mind of the public and the pages of newspapers took place rapidly after the mid-century point, the end of the second war. With an atmosphere saturated with the reports of scientific truths contrary to sense; poems and plays and paintings "expressive of our time," yet riddles without a key; critical theories from which we learn that surface meanings are a cloak and only hidden ones matter; or else that there being no intention in the author, there are no ascertainable meanings in the work; lastly, laws and rules that entangle one in fantastic predicaments (grist to Kafka's mill)—so many daily encounters with the absurd made it part of the regular furnishings of the mind. The absurd has always maintained a spacious home in daily life; whoever should doubt it need only consult Erasmus in *The Praise of Folly*. But the 20C has gone the 16th one better in making the absurd a sign of rightness, of surefire appeal. Any doctrine or program that claims the

merit of going against common sense has presumption in its favor—a major discovery is at hand. Where earlier the proponent was declared a charlatan, now he is the bearer of the desirable new and enlightened.

A repertory of such doctrines and programs would be lengthy. Here are a few samples of the absurd in practice. Western nations spend billions on public schooling for all, urged along by the public cry for Excellence. At the same time the society pounces on any show of superiority as elitism. The same nations deplore violence and sexual promiscuity among the young, but pornography and violence in films and books, shops and clubs, on television and the Internet, and in the lyrics of pop music cannot be suppressed, in the interests of "the free market of ideas." Under that rubric, speech (at least in the United States) has enlarged its meaning to include action: one may burn the flag with impunity; it is a statement of opinion. The legalism would seem to authorize assassination.

> Democratic civilization is the first in history to blame itself because another power is trying to destroy it.
>
> —Jean-François Revel (1970)

Before the second war ended, groups in the West began to agitate for means to protect the approaching peace. Schemes for an Atlantic Union and a strengthened League of Nations were well supported and did issue in the North Atlantic Treaty Organization and the United Nations, which include a number of agencies for good works in education, labor relations, and the like. Independently, English and other publicists revived the demand for an international language that would aid mutual understanding. It was an old idea, first proposed in the 17C, worked out in the 18th, and doubly fruitful in the 1880s, when Esperanto and Volapük were devised. Early in the 20C a leading mathematician, Giuseppe Peano, created Interlingua, largely for scientific purposes and based like the others on European roots and a simplified grammar.

After 1945 this idiom was put forward again but the victory went to a new scheme, entirely different from the others, Basic English. It was the work of C. K. Ogden, promoted by his friend and collaborator the respected literary critic I. A. Richards. They rightly presumed that English was already international and strove to reduce it to essentials for beginners' sakes. The result was in fact a reductio ad absurdum. The Basic vocabulary was far from truly simple; it disallowed many common words in favor of phrases with *make* or *have* that are difficult to put together, let alone remember. No faithful user of the method could build on his Basic by reading newspapers or listening to English speakers. It is even doubtful whether anybody who mastered the rules could say very much of interest to another proficient; and one who knew English and wanted to address a fluent Basicist might find it hard not to stray outside the limits of 850 words: 600 nouns and 18 verbs. He would find *soup* permissible, but for *potato* he would have to concoct: *plant with thick*

brown cover that is bursting from the earth. Headwaiters would have to add mind reading to their polyglot virtuosity. It is curious that a prodigal handler of real words such as Winston Churchill praised this constipated idiom.

> **Basic English is a carefully wrought plan for transactions of practical business and interchange of ideas, a medium of understanding to many races and an aid to the building of a new structure for preserving peace.**
>
> —WINSTON CHURCHILL AT HARVARD (1943)

The present addiction to using initials instead of names and to giving institutions long titles that yield a pseudo-word acronym is the childish-absurd. It taxes the memory, creates ambiguity as identical letter groups multiply, and makes it difficult to understand both the local newspaper of a town not our own and the periodical literature of a foreign country. All this wastes time, and when the practice invades biography to refer to persons, it insults the subject and reader alike.

Enough has been said about the serious-absurd in the arts (<722), except for its side effect, the now standard practice for making the classic plays and operas acceptable. To most directors, modernizing means inventing travesties that will surprise and shock by a change of setting or purport. They offer a Tartuffe who is no self-seeking hypocrite but a sincere lover driven to subterfuge by passion; or again, a Don Giovanni in a wheelchair throughout the opera, because his boast of sexual conquests really conceals impotence.

That the words and the music of these (and other) works contradict the "interpretation" no longer bothers anyone. With this revisionist effort goes the habit of underlining the meaning of the piece by untoward action—much kneeling and lying and rolling on the floor and long, close embraces to make sure the audience sees that the lovers are sexually intent. Shouting instead of speaking the lines completes the stage-absurd at its most emphatic.

When we come to modern theorizing, the drive to defeat common sense takes another turn and divides opinion, some rejecting a doctrine because its aim is to make us forget in a fantastic way the diversity and concreteness of things, others finding the far-fetched

> **If I am still here at that point, what I'd really love to do is [Shaw's] *Back to Methuselah*. I would like to rip it to shreds and really go at it.**
>
> —THE ARTISTIC DIRECTOR OF THE SHAW FESTIVAL IN CANADA° (1995)

system congenial because it replaces experience by verbal abstractions, often amusing. Three names—Lévi-Strauss, McLuhan, Kuhn—although not usually associated, nevertheless were at one through their parallel systems and found enthusiastic believers because of these common characteristics.

The first was an anthropologist, who in his study of primitive peoples introduced the idea of Structure. This is a formal pattern made up of indicative items, such as whether food is eaten cooked or raw. Peoples' diversities recede in favor of classification. Structuralism was readily extended to other subjects; it had a great vogue among linguists, helping to make grammar

unteachable in school; and to literary critics it supplied new criteria and a way to refresh their vocabulary.

For Marshall McLuhan, theorist of behavior, the catchy formula "the medium is the message" meant that techne, which is systematic and coercive, overwhelms language and meaning. Words, in fact, are obsolete; the visual, which is patterns, now rules thought, form obliterates contents. Released from "linear" habits, the modern mind, suitably dislocated, embraces wholes in new structured relations. And so the Renaissance, with the painter's linear perspective, and Gutenberg, with his mischievous invention of printing, are got rid of.°

Thomas Kuhn was a physicist and historian of science who proposed to general acclaim by his peers the idea of "paradigm shift." The paradigm is the new conception in science that periodically occurs and being a pattern rather than single truths causes a change in all the fields of research. It is able to affect the entire domain at once, because the older minds offer no adequate defense against the new organic structure.

From the Look of Things to the Structure of Appearance:

By looking at their representation you learn something about their internal structure [but when looking at what is fed into a computer] we are seeing something analogous to the computational processes which go on in the brain.

—Jonathan Miller on some effects in painting (1990)

In these three movements SCIENTISM is of course evident, and more particularly the long-established scientific use of models, the bare outline of a state of affairs. By matching it with data from fresh experiments, hypotheses can be verified and thus new generalities fitted into the pre-existing scheme. To leave behind the facts of experience and reach the smallest number of mathematical statements about patterns is indeed the scientist's business. Is it the business of anybody else? Lévi-Strauss's Structuralism and the formulas of McLuhan and Kuhn have been questioned on this philosophic ground, as well as on the evidence of particulars. Without much inquiry one can see that despite McLuhan, the use of words has not decreased; techne is the parent of television, where talk shows thrive, a verbal flood, and of e-mail, which is a form of print. Structuralism in language and criticism has been supplanted by other doctrines, and *pace* Kuhn, a number of specialist historians have denied that the overturns in scientific thought suggest to them the flapjack in the pan.

*
* *

In the realm of ethics, the most blatant absurdity of the day is wrapped up in the bogey word *Relativism*. Its current misapplication is a serious error,

because it affects one's understanding of physical and social science and derails any reasoning about the morals of the day. Nine times out of ten, the outcry against Relativism is mechanical, not to say absentminded. Everybody is supposed to know what the term means; it has become a cliché that stands for the cause of every laxity; corrupt or scandalous conduct is supposed the product of a relativist outlook. When linked with Liberal politics, it implies complacent irresponsibility.

The Relativist denies (so runs the charge) that there is a fixed Right and Wrong, better and worse. This makes for a readiness to follow fashion in behavior—"anything goes," "everybody does it." Relativism and conscience are diametrical opposites. What in all this is the meaning of *relative*? It means flexible, adaptable, a sliding scale that gives a different reading in similar situations. Morality says: "Do not lie." The relativist says: "In view of this or that fact, I shall lie without hesitation or remorse"—to head off a criminal, to spare anxiety, or any other good reason. The anti-relativist then infers that the same person will cheat, steal, and so on up the ladder of immorality, always justified "relatively" to some particular; or—even more likely—with no excuse, because Relativism turns habitual and supports no idea but that of self-indulgence.

Another count in the indictment is that Relativists make no distinctions among moral codes, religions, or cultures. All these, relatively to their place and time, their history, their means of subsistence are equal in value: as 5 is to 10, so 10 is to 20—multiply and you get 100 = 100. This grievance has in view the stance of the historian and the anthropologist, who in their descriptions apply a local and time-related standard, not an invariable external one. They believe that to understand one must sympathize. To illustrate: the anthropologist asserts that the man who can count up to five in a tribe ignorant of numbers is a mathematical genius. The historian who finds a 16C ruler granting toleration to all Christian sects calls him a pioneer moralist and humanitarian. The denouncer of Relativism infers from these relative judgments that the five-digit man and Einstein are equals and the tolerant ruler on a par with the framers of the United States Constitution. This is a gross error in logic. The relative *judgment* implies no ultimate *estimation* or preference.

It is here we begin to see the Absurd concealed in the misuse of the term. Western civilization justly boasts of having developed the idea and the machinery of Pluralism. It accommodates in one polity contradictory religions, moral codes, and political doctrines, all equal in status. Nothing is said about their respective merit or value, let alone their being equal, which would be meaningless. From this social and cultural tolerance those who assail Relativism do not dissent; they benefit from it; they never mention it. Now, the opposite of the Relative is the Absolute, and the Absolute means one principle only, a single standard of thought and behavior. One must therefore

ask the anti-relativist: "Whose Absolute are we to adopt and impose?" The plural state is full of them, down to the several sects of any one religion. How far a society can allow diversity under Pluralism is a real issue. The rival claims of two large language groups can split a nation badly—witness Belgium and Canada. But blaming Relativism whenever diversity creates disorder beclouds a type of situation that must be settled politically. Meantime, the absurdity remains of espousing Pluralism and groaning about the absence of an absolute that would cure moral ills.

> World is crazier and more of it than we
> think
> Incorrigibly plural. I peel and portion
> A tangerine and spit the pips and feel
> The drunkenness of things being various.
>
> —LOUIS MACNEICE, "SNOW" (1970)

Reflection shows further that anybody who thinks at all uses the relative standard continually; it is the operation the mind goes through in all judgments. To compare two lengths, one relates each to a yardstick. A judge or jury relates the facts of the case to the law. Under an absolute code the same relativing procedure would still be needed to judge offense and punishment. No standard works like an automatic machine, nor can a civilized society do without variable standards that call for relativist application: the law is the law, but the judge sentences the first offender less heavily than the second or third. Unequal treatment within typical situations is the rule of intelligent action: the child's meal or medical dose is related to his age and size.

But are there not at least a few fundamental principles of conduct that the whole world acknowledges as binding and not subject to change? Apparently not. Not even "Thou shalt not kill." At the start of the admirable common law, in the 11C, *wergeld* was the rule; that is, paying for murder done; *murther* originally denotes a fine (<228). Among the Eskimos, in the past also, a murderer was asked to leave, he did so and was received without a word by the neighboring tribe. In the most advanced countries self-defense allows killing. So does war, which qualifies as remote self-defense. The Christian clergy in the Great War read the Sixth Commandment in that relative way (<701). The absolutely uniform human conscience does not seem to exist.

It is true that for civil peace and comfort most societies reprove and punish killing and all kinds of injury to the person, lying and breaking promises in serious matters, and cheating and stealing—if property is part of the system. But the particular laws vary infinitely and stand in contradiction from time to time. In the one realm of property, the western businessman's moral conscience in the year 1880 differed radically from that of his descendant in 1980. The same disparity occurs from place to place: what is (criminal) bigamy in the Occident is the first step in gaining status in parts of Africa. When the anti-relativist deplores the present state of morals he is judging it relatively to a previous state, which he believes was fixed and eternal.

Perhaps to clear the mind of the stubborn cliché, one should speak of *Relationism*. One would then notice that science is Relationism first and last. The whole effort is to establish relations between phenomena, ultimately between pairs of well-defined sense impressions, by the medium of a material or numerical yardstick. This done, all proportions can be derived for practical uses. Form in art—fitness in anything—consists in a subtle or vivid relation between parts that cannot be arrived at by means of an absolute formula. In society tact is the great art that makes for civility, for civilization, and tact is nothing but the subtlest relationism in action.

<div align="center">

*

* *

</div>

The century's second big war, like the first, left small fires burning in many places and only two powers apparently strong enough to influence the course of the world, the United States and Russia. Unable to come to terms, they confronted each other for 40 years in a Cold War; that is, a war by proxy. But because the close of the war against Germany and Japan was followed by the collapse of the colonial empires, and out of them the creation of a collection of small states—they really should not be called nations—the degree of importance given to these states and wars grew in magnitude, representing as they did the antagonism between the two main powers. Ever since—and in spite of the Soviet collapse—the western populations have felt daily concern about the struggles in eastern and southeastern Europe, the Middle and Far East, South America, and all parts of Africa.

The repeated splitting apart of the liberated colonies, Communist seizures of power, followed by counter-dictatorships with a revolving-door effect (and changes in more and more geographical names) have put the large and peaceful at the mercy of the small and aggressive. In many regions, Fundamentalisms animate without unifying. To maintain some order in strategic areas, the older nations have taken on the task of policing—piecemeal—because in many corners some "liberation army" is raiding and massacring in order to cut up still further the nationette recently carved out of a larger unit. The boast that speed in communication and the desire everywhere for western entertainments and conveniences have at last created one world is offset by the amoebic division among peoples.

Very different was the drive toward a new freedom which, in the United States, changed human relations throughout the society. After many long years, the sense of outrage set off in the southern states a revolt against things as they were. The Black population staged protests of various forms to obtain the rights that the Civil War had enshrined in the Constitution a century earlier and evil custom had denied. Thanks to the self-controlled crowd action led by individuals who were intelligent, courageous, eloquent, and temperate,

the uprising was not a bloody fray. The country as a whole judged it morally and legally justified, and it now celebrates by a national holiday the outstanding figure who guided the movement to substantial success: the prophetically named Reverend Martin Luther King.

The sequel has not been all that was hoped for; prejudice dissolves slowly. In addition, steps were taken that have magnified the idea of race and made it of decisive importance almost everywhere in the culture. Not the lawmakers, who passed in 1964 a wise act compelling equity, but afterward, certain public and private agencies imposed rules that ensured a preferential right to work or to qualify for posts on the basis of status as "a minority." That absurd term included women, and this new privilege increased mutual hostility among individuals and groups. In Europe, the same confused policy has damaged the relations between natives and immigrants. Here and abroad the state has lost the virtue of being impartial and thus the moral authority to make impartiality the law for all.

It was during one of the wars by which the United States intended the containment of Communist power in the Far East, the Vietnam War of the 1960s, that there occurred a widespread revolt of youth. The former French power in Indochina had been allowed to collapse and the American forces fighting in the jungle were not making headway against the guerrillas from the North. In the States, conscription was being evaded by the alert in colleges and universities. With help and money from various sources, born leaders among students turned the disaffection first against their alma maters and soon into denunciation and sabotage of "the system."

Violent confrontations began in California in 1965 and spread east, where by 1968 it was paralyzing college life. Reaching Europe, it nearly toppled the government of De Gaulle in France, affected England and Germany, the rest of the Continent sporadically, and deeply disturbed the Japanese universities, otherwise bastions of discipline. The troubles continued in various forms until the mid-1970s, having marked upon the mind of a generation a pattern that still affects policy in government and the academic world.

Starting with anti-war feeling like the English pacifism of the 1920s—"make love, not war"—the young Americans picked up the anti-capitalist animus of the Marxist 1930s, and merged these emotions with either PRIMITIVISM or NIHILISM, depending on temperaments. Some of the rebels formed communes in which they lived like early Christian or 19C utopian groups—brother-and-sisterhoods with property and workload in common; others hid in basements to make bombs and blow up businesses by way of advertising their views. The European students, much more numerous in their non-resident universities and with a tradition of rioting that goes back to the 12C, made their anger politically effective and obtained from government concessions that enhanced their livelihood and have kept them a threat.

The programs naturally differed according to country or city. During one demonstration in Chicago that was brutally repressed, a leaflet was issued listing eight immediate desiderata, among them: the abolition of money and "everyone an artist."° Some artists might well think that this state of affairs had been their own long since. A later protest, at one of the leading universities in California, is to be remembered for the encouraging presence of a clergyman active in national politics and for the slogan he and the crowd chanted during the demonstration: "Western Civ. Has Got to Go!" The civ. in question was a course in the core curriculum, but it was not being denounced for academic reasons. Its title expressed an ecumenical emotion that is still voiced at large and systematically in many a college classroom.

American students in 1968 had one genuine grievance that hardly appeared in their speeches and posters: their neglect by the faculty and abandonment to teaching assistants. The absentee professoriate was the fruit of a double pull: the federal government's pressing into war service experts not in science only, but in all fields from foreign languages to naval history; and the foundations' large bribes to the universities for allowing the best members of their faculties to man the social and other projects devised by the ex-professors in charge of making grants. These managers also created on campus specialized centers and institutes that drew to the foundation the loyalty and financial dependence that the teaching faculty formerly owed to their own institution and students.

When the rebellious were still in their colleges and universities, their way of protest was to occupy a building, especially the president's office, and vandalize ad lib, not excluding the destruction of research notes and equipment. On their side, administrative officers behaved with that final degree of caution which is cowardice. They complied a with summons to discuss "non-negotiable issues," swallowed all insults—one president on a platform before the student body allowed a pot of paint to be poured on his head—and countered no student advocacy with their own. In the few cases where they called the police to protect employees and strangers, they were universally blamed. In the midst of the excitement some professors were heard to say that they had never felt so alive; conflict invigorates, as the intellectuals learned in 1914 (<701). In England, the tumult was briefer, thanks to the Cambridge vice-chancellor, who got in touch with his counterparts and drafted a joint statement pledging that they would confer, and if need be, reform, but not tolerate resort to physical means.°

To assess this unusual movement, which shook the West seriously and yet without overturning regimes, is risky. Some of the loudest and ablest of the student leaders turned into obscure business or professional men; others went successfully into regular politics. But with the exception of one man in Europe,° neither group has bred a statesman. What their diffuse influence has done is to make usual a truculent attitude toward professors. The latter's

authority, whether conferred by scholarship or the title itself, is now held in check by practices reminiscent of the Middle Ages (<229). Students now give their teachers good or bad marks annually and these are used in determining salary and promotion. In some institutions students take part in planning the subject and readings of the course and are free to argue about their grades. The rebel feeling of the 1960s helped put authority always on the defensive (the word itself is taboo)—all decisions must follow consultation. Such is the logic of EMANCIPATION.

<p style="text-align:center">*
* *</p>

Two of the themes that have earned their small capitals in these pages, ABSTRACTION and ANALYSIS, have been attached to material facts for obvious reasons and in a literal sense. But there are modern habits and occurrences that are less visible, including the frequent combination of the two themes in one event. The occasion or result may carry a flavor of the absurd.

One may posit as a generality that "the machine abstracts." It puts a middleman—a middle-thing—between experience and perception, it yields only a derived and artificial experience. For example, the voice on the telephone or in the movie theater is not the human voice; it is the distorted residue required to make out what is said. To call this and all other transformations by machine Abstraction is warranted by the fact that machines are designed to capture or modify one part of reality in order to gain some advantage. The loss of other parts seems a fair exchange. In canned foods, their lasting power is secured by destroying subtle tastes and sometimes by creating an altogether different product, drawn from the original in the way that a Cubist painter deals with a face or figure.

It is a function of the cyber world, so-called, to go a step further and offer the client a wide choice of manufactured experience—everything from reproductions of famous paintings to lifelike female figures that act out seduction in looks and gestures. It is a measure of the taste for the abstract that in the eyes of European viewers these digital courtesans outshine real women; "virtual reality" is now stronger than the concrete; machine-made love conquers all.

This is not to say that the practice of abstracting from the real did not exist before the machine, or that human life could be carried on without the use of abstraction; it begins in infancy. Names abstract: *mother, father, tree, chair, five, six* are abstractions that also abridge in a crude way the reality of the individual things—toys do the same in a physical way, and so does cooking food. A high civilization multiplies these devices and develops super-abstractions that are the product of ANALYSIS. Analysis, as we saw early on, breaks wholes into parts for a better grasp of the qualities and behavior of the object. This

increase in understanding also depletes, since analysis omits the feature that makes the whole interesting or valuable. One tends to think that the clock and its parts are the same, but until assembled the parts are not a clock: they cannot be wound; they have been abstracted physically; they are scrap metal until properly reunited in space.

Analysis that entails abstraction is also done mentally for the sake of counting. When a sociologist wants to know how many children, on average, are born to the families in the state, he must frame a set of abstractions after analyzing the visible reality: is a family only a married pair or any fertile couple? What of adopted children? How to deal with stillbirths? If sampling rather than counting is used, there enter new abstractions that define the sample by analyzing the population for certain features. The desired result turns out to be something like 3.2 children per family, which is surely a superabstraction.

The hundreds of statistics, the "indexes" and "ratings" applicable to innumerable activities are all analytic abstractions that bear an arbitrary but—it is hoped—useful relation to things as they are. The figures are definite, their worth often indefinite; so indefinite, indeed, that the three critiques continually made of statistical reports are: the analysis included a part that does not belong; the statistical method was faulty; and no account was taken of an interfering factor. Frequently forgotten is the fact that a perfectly computed correlation does not imply a causal relation between the paired events. At best, statistics—the stat life, as it figures in these pages—puts before us a plausible reproduction at a remove from reality.

It is quite far removed when one considers a further step in certain abstractions, the reliance on "indicators." These are the signs chosen to represent something hard to get at direct. Going by signs has been commonplace from early times too: pimples indicate measles; the art of medicine relies with great success on symptoms. But abstract pimples, so to speak, are more chancy. Do answers to a questionnaire about a prospective employee's tastes and habits indicate future performance? The correlation that charms the personnel officer may be self-serving. The answers given may be largely false, and even if honest, even if correct, what *is* the connection? This is the essence of the case against opinion polls.

It is not unfair to say that the present culture conducts its business largely like the inhabitants of Swift's island of Laputa, who hovered in the air over the solid earth beneath. Direct judgment of human beings is mistrusted. Ours is a credentials society, in which estimates of ability and character are roundabout. Sizing up someone face-to-face has come to be frowned upon: "Don't be judgmental." Yet the appraisal is not without indicators; its chief defect is that it is hard to defend, whereas a score expressed in numbers cuts off argument regardless of its validity.

In the scholarly disciplines likewise, analysis furnishes the materials and abstraction the mode of expressing results—the terminology of the field of study. It often makes the reports and the textbooks so empty of concrete words that the reader must translate strings of vocables ending in *-tion* into pictures of life until his imagination retreats exhausted.

Like workers in science, economists make use of models that consist of figures about things made and sold, rates over time, and so on. Refined measurements of abstract interconnections lead to models entirely in mathematical formulas—the branch of study called econometrics. Experience during the last decade or so has not been kind to economists. Their warnings and predictions have been falsified by what people as producers, consumers, and investors have chosen to do. This unruly behavior adds to the tangled argument between Keynesians and their decriers about desirable policies. Some call for measures in support of the supply side of the economy; others want government to keep up demand, if need be by deficit spending. But both groups in fact agree on the mechanics that Keynes described in his epochmaking *General Theory of Employment, Interest, and Money.*

Attempts have been made to use numbers similarly in history—to "measure" violence, for example, as if it were a homogeneous substance. The effort has not had much success. An older form of abstraction, which is also a structuralism, is the philosophy of history. It was described earlier (<653) and shown to be misleading principally through its assertion of a single cause. Events are roughly handled to form recurring patterns that together form the structure of history. The hope of strengthening such a scheme by importing scientific ideas into it was made early in this century by Henry Adams. He tried to fit his knowledge of medieval and modern history and his experience of life, which was that of a man subjected to forces that he could neither resist nor fully understand, into a system of recurrences. But instead of a single named cause and an identical pattern, he posited Energy at large as the driving force of history and cited a principle of thermodynamics to explain the course of civilization. The principle states that energy, though never lost, becomes less and less organized and usable—the log burns and gives heat but once. In modern culture and society, Adams saw increasing multiplicity and diversity as this loss of energy. He added a "law of phase," which he borrowed from Willard Gibbs and which he apparently misunderstood, to determine moments when the energy is frittered away more massively than usual, this taking place at an accelerating rate. Adams predicted that 1917 was such a moment. Recurrent bursts would eventually produce the disarray and death of civilization.

An attempt to "structure events"—a voguish abstract phrase for "put order in things"—need not produce absurdity. Order in facts, ideas, intentions is necessary. Without patterns, memory is swamped. And for present action

and control, contemporary facts must be put in order, even at the cost of doing injustice to exceptions. The result warrants what may be called "the sociological intent." What is absurd is the habit of believing the order to be the truth and the facts negligible. Almost as bad is to import the cast of thought and the jargon where they are not needed; for instance, to say, "everybody tends to maximize their values," instead of: seeks pleasure and tries to avoid pain—if that is indeed the thought behind the vague abstraction. In any context the word *values* is surely the emptiest in current use. To sum up, analysis and abstraction are not demons to exorcise, but like the machine, to be mastered, not obeyed. To live amid lax words and dim thoughts more or less translatable into concreteness depletes energy and deadens the joy of life. The man in the street who says "Precipitation probability is twenty percent" is less alive than if he said and felt "small chance of rain."

<p style="text-align:center">*
* *</p>

For the thoughtful who take part—at a distance, it may be, and by solitary reflection—in the fiercest battle of the day, the deep division over the idea of the state, and the place of religion, there is a document that should be read to concentrate thought and guide choices. It is a section some 20 pages long in Dostoevsky's *Brothers Karamazov*. The piece is somewhat formally presented by one of the brothers, Ivan, as a poem that he wants to recite to the youngest, Alyosha; it bears a title: "The Grand Inquisitor." Ivan immediately adds that it is not verse and not written down; he will speak it if Alyosha will listen. What it is may be called a fantasy fiction, an allegory. Ivan is a rationalist and atheist disaffected from both heaven and earth; he might pass for an Existentialist disgusted with life. Alyosha is all candor, goodness, and simple faith—and eager to hear his brother's "poem."

The scene is Seville at the height of the Spanish Inquisition, on the day after an auto-da-fé in which 100 heretics were burned. Christ appears. He is immediately recognized by everybody. The people fall to their knees and worship. They beg that a young girl being brought out of church in her coffin be revived. He speaks and she sits up, smiling. At His word an old man regains his sight; Christ is no phantom or delusion. In the midst of the wonders, the old, very old Cardinal-Inquisitor appears. He too recognizes the stranger and orders his guards to arrest Him and put him in prison. The crowd, automatically overawed, offer no protest but fall on their knees and worship the Cardinal.

That night the Inquisitor goes to Christ in his cell and berates him for what He has done—not only in reappearing, but in His original cruelty to Man. The accusation is detailed and constitutes a little treatise on political science and the Christian faith. The Inquisitor harks back to the three temptations with which

the Devil tried to make Christ one of his own: first offering bread to Him who was starving in the desert; then urging that He throw Himself down from a height to show Himself miraculously saved; lastly displaying the empires of the earth, to tempt Him with power. In rejecting all these, says the Inquisitor, Christ reaffirmed through his own person Man's gift of freedom; human conscience chooses without compulsion or limitation.

But, says the Inquisitor, man is weak, confused, sinful, incapable of bearing such a burden. Seeing this heartless imposition, some wise men among the mass of mankind have taken the burden on themselves of giving the rest what they need to be at ease; the agency is the hierarchy of the church. It provides bread. Man needs it but does not live by bread alone; the weak and wayward conscience needs certainties; it wants miracle, mystery, and authority. These also the church supplies. Man's final desire is unity, the peace of knowing that all think and feel alike. And this boon is on the way to realization, thanks to thought-control and the irresistible appeal of the other gifts, especially bread.

Throughout the harangue, Christ has been silent and gently smiling. But the Inquisitor is not through. Not only has Christ harmed God's creatures by making them free, He has imposed on the wise—the 100,000 on earth who run the great deception—an intolerable burden. They live in sadness, deprived of their freedom in keeping up the show—"correcting His work"—not from love of power but out of pity for Man.

Now and then during the indictment Alyosha protests against the meaning Ivan puts on the gospel and the church. Ivan loves his brother and does not argue with him but quietly continues. Although the smiling Christ says not a word, the drama built up among these four is intense. How it is resolved need not be set down, for it is the dilemma that relates to our concern. [The résumé should tempt to reading the masterpiece, which is in part II, book V, chapter V of *The Brothers Karamazov*. Separate editions of *The Grand Inquisitor* are also available.]°

Dostoevsky was once an Ivan and became a matured Alyosha, yet his view of man did not change as radically. He chose freedom but gave approval to the policies of Pobietonostsev, the head of the Holy Synod—not a Grand Inquisitor, to be sure, but an autocrat governing an orthodox hierarchy resembling the Catholic. In the novel, the illegitimate half-brother of the Karamazovs, Smerdiakov, has traits such as Dostoevsky attributes to most men in Ivan's allegory: weak, credulous, sinful, and also full of vanity, resentment, and half-baked knowledge acquired by reading beyond one's intelligence. It seems as if Dostoevsky, like the critics of modern society from Baudelaire to Ortega y Gasset, lumped together all classes into the figure of the Mass Man, contemptible regardless of birth or education.

That Russia was the country where the Inquisitor's scheme of bread and mystery was attempted under the name of Communism would not have surprised Ivan's creator. The tradition of ruthless authority and total unity went back to Peter the Great (<319); the emancipation of the serfs and the beginnings of industry were too recent to have developed different habits, and the rebel intelligentsia, lacking political skill, had been repeatedly put down. Bread ensured obedience to the Soviets as in the Spanish allegory, but the Inquisitor's 200,000 were not matched in efficiency and the regime broke down over bread, not ideas.

The late 20C welfare states of the West are not Communist Russia or Seville in the 16C, but some of the aims and devices are not unlike. The desire for security on the part of the population is the same, coupled though it is with a desire for freedom. This combination, as the Inquisitor implies, is self-contradictory and probably unworkable. Coming at the end of the Occident's long struggle to emancipate all men from ancestral bonds and natural constraints, the question makes it opportune to survey western institutions as they now work or fail. But before this risky stock-taking, the elements of tone and temper, of manners and morals must be sketched where they are to be found, which is in the behavior of the individual.

Demotic Life and Times

THE FOURTH OR SOCIAL REVOLUTION that was set off—but far from completed—by the events of 1917–18 in Russia changed the governments of many regions of the world. A large number of peoples became Communist, and the official names they assumed often suggested that they were new democracies added to those of the West. The leaders of the time paid lip service to "the rule of the people." But the elections and assemblies of those upstart regimes were make-believe. And one must add that even the western countries had no right to the designation. *Democracy* means rule by the entire people—the town meeting in which all debate and vote. There were none such. The right name, when it was deserved, should have been *representative government*. By a further slippage, *democratic* had come to be used in praise of miscellaneous things—a restaurant with "democratic prices" or a person whose manners were "very democratic." For clear thought about the ethos of that period in decline we shall say *demotic*, which means "of the people."

Making this distinction is not a piece of pedantry. Toward the end of that era of the West, individuals and society alike thought and acted in ways quite *un*democratic in both the strict sense and the loose—for instance, staging protests in the streets against a lawful decision or demanding after a poll that the legislative body vote in accordance with its results.

In attempting a sketch of a culture at its close, the elements to look for may be classed under the headings of style and society, style meaning the choices made by individuals, and society meaning the ways of institutions. Although not clear-cut, the difference is that between what is personal or private and what is public or official. The aims and desires of the two overlap but generally conflict—a small civil war, for it is of course individuals who decide and carry out the official demands that are challenged or resisted by other individuals.

*
* *

The strongest tendency of the later 20C was Separatism. It affected all earlier forms of unity. The fact was noticed early in this book apropos of culture (<xiv). The ideal of Pluralism had disintegrated and Separatism took its place; as one partisan of the new goal put it: "Salad bowl is better than melting pot." The melting pot had not eliminated all diversities; it had created a common core.

At the outset, separatism might have seemed a mood that would pass. But if one surveyed the Occident and the world as well, one could see that the greatest political creation of the West, the nation-state, was stricken. In Great Britain the former kingdoms of Scotland and Wales won autonomous parliaments; in France the Bretons, Basques, and Alsacians cried out for regional power; Corsica wanted independence and a language of its own. Italy harbored a League that would cut off the North from the South, and Venice produced a small party wanting their city a separate state. Northern Ireland, Algeria, Lebanon carried on unstoppable civil wars.

The Spanish Basques fought for years to break away from Spain, and Catalonia kept on showing disaffection as in the past. Belgium was rent by a language difference that is also geographical and that pitted the two halves against each other on most issues. Germany, recently reunited, was not re-welded. The former Soviet Union lay helpless in many parts, and in the one still called Russia, insurrection led to war in Chechnya and Dargestan. Turkey and Iraq had to fight the Kurd separatists. The Afghans were up in arms. Mexico faced the rebellious Zapatistas, while Quebec periodically demanded freedom from Canada. The Balkan would-be nations continued their ethnic and religious massacres for the sake of separateness.

In the United States there were mostly tokens of the malaise. A small group that wanted Texas to regain its status of independent republic had to be quelled by force; and there were armed parties and religious bodies that spoke and behaved as if entirely independent of the existing order. There were also threats within smaller units: Martha's Vineyard talked of secession from Massachusetts and Staten Island from New York. It is symptomatic that a group calling itself the Nation of Islam used the word *nation* without protest from other groups or from the authorities. Would this denomination have passed without comment at any earlier time in American history? Puerto Rico, a territory, was of two minds: some of the people wanted statehood, others nationhood. Several Amerind peoples also called themselves nations and were at last recovering their just due under old treaties, but their demands were for sharing rights, not secession. Efforts to make English the official language of the United States regularly failed.

Other forces worked to denationalize. Immigrants from far-off emancipated colonies brought into Europe alien languages and customs. They huddled separately in slum enclaves—a Turkish settlement here, an Algerian

suburb there. France had an African village, complete with medicine men and ritual chants and dances. This 20C "colonizing" of the West could muster only the power of the weak. Unemployed or in menial jobs, these foreigners were victims, and being united mainly by religion appealed to sentiment for help from the welfare state. When molested by their equally poor white neighbors or expected to conform to western habits, these clans were defended by their host government, from compassion and fear that a demand for conformity would be "racist." And in some of these districts the national police would not venture. The same motive of respect led to the official encouragement of plans to revive local dialects. Europe was experiencing again the grand confusion of peoples that had occurred in the Late Roman Empire and tapered off in the Middle Ages.

Separatism was rampant all over the globe. No sooner was India free of British rule than Pakistan broke away, and no sooner was the new nation separate than Bangladesh freed itself from it. The old Ceylon, a huge island renamed Sri Lanka, carried on a civil war for more than 20 years, and in the Himalayas, India again fought Pakistan over Kashmir. The East Timorese nearly destroyed Indonesia. Wherever one looked—at Ireland, the Middle East, South America, Southeast Asia, all of Africa, the Caribbean, and the whole ocean speckled with islands, one would find a nation or would-be nation at war to win or prevent independence. In the Indian Ocean, 300 miles east of the tip of Madagascar, are the Comoros—four islands whose total area is 830 square miles and whose population was then 493,000. Released from French ownership they became the Federal Islamic Republic of the Comoros. It could not last: the people of the smallest island, the Anjouans, wrangled for a dozen years with the central government and finally declared their separateness. Delegates from neighboring countries joined in celebrating EMANCIPATION triumphant. That the nation-state was ceasing to be the desirable form of political society was clear in spite of the growing number of fragments that assumed the name—close to 200 by the end of the 20C.

Disuniting in another way was the European Union, made up of 15 of the most productive countries. It had gradually won the power to intervene in national affairs. The ruling body in Brussels could regulate important economic transactions, nullify judicial decisions, enforce the acceptance of immigrants, and set the central bank interest rate for 11 of its members. Scholars wrote monographs on sovereignty, asking themselves and the public "What Makes a Nation?"° A large part of the answer to that question is: common historical memories. When the nation's history is poorly taught in schools, ignored by the young, and proudly rejected by qualified elders, awareness of tradition consists only in wanting to destroy it. True, the word *history* continues to be freely used, but in ways and places where it does not belong. Garbled and fictionalized versions in films and "docudramas" disgrace the

word, while the fancy for objects dug up or dredged from the sea, which the press hails as "a piece of history," complete the quietus of the historical sense.

In the light of the facts, it was absurd for contemporaries to say that the ubiquitous armed conflicts were expressions of nationalism. They were the diametrical opposite; like the artists' anti-art, the time was creating the anti-nation. To become a separate state, not really independent, but on the contrary dependent on money and protection from one of the big powers, was a step backward. The end of the half millennium destroyed what the beginning had so painfully accomplished: put an end to feudal wars by welding together neighboring regions, assimilated foreign enclaves, set up strong kings over large territories, and done everything to foster loyalty to something larger than the eye could see. A common language, a core of historical memories with heroes and villains, compulsory public schooling and military service finally made the 19C nation-state the carrier of civilization.

Now all these elements were decaying and could not be restored. It must have struck keen observers as a pathetic move when the French government in 1996 organized a celebration to mark the anniversary of "the Baptism of Clovis," the 5C Frankish chieftain who turned Christian and ordered his tribe to do the same. The celebration was to remind the modern nation of its ancient unity, as if Clovis had made France. No such thing existed in the 5C. And in the 20th, disunity was marked by the immediate protest against the celebration by all the parties of the Left, more than half the nation.

* * *

The main merit of the nation-state was that over its large territory violence had been reduced; nobles first and citizens later were subjected to one law uniformly recognized and applied. In the last years of the era of nations, violence returned; crime was endemic in the West. Assault in the home, the office, and on city streets was commonplace and particularly vicious. That children—infants—were frequently victims of parental rage, incest, or killing was a puzzling fact that cast doubt on the reality of traits such as love of offspring, part of the myth of "human nature."° Prisons were full and new ones continually being built to receive causeless killers, offenders against the drug laws, and the personnel of organized crime. Even so, the number of prosecutions and convictions was a small fraction of the reported offenses. The prisons themselves, far from exerting the full force of the law, were scenes of perpetual violence. Humane sentiment had made them less rigorous, almost comfortable, while prisoners' rights multiplied. The inmates formed gangs that governed, overawing the guards and abusing their fellow prisoners sexually and in other ways; riots and escapes were frequent.

A baffling fact was that the public schools were also a regular setting for

violent acts. Armed guards patrolled the corridors to keep the peace among the pupils; teachers were assaulted to the point where the danger became an expected risk of the profession. In a large state, some 50,000 incidents could occur in one year.° From their early teens, pupils carried guns, assaulted each other, and on occasion committed little massacres by shooting into a group at random with a rapid-fire weapon.

> It's very exciting to violate the law, though it can also lead to a kind of madness.
>
> —ICE-T, INTERNATIONALLY RENOWNED RAPPER (1998)

As we shall see, certain recurring situations having to do with rights and the agencies that administer them produced fits of rage that could turn dangerous. The feeling of being hemmed in by rules matched that of being hemmed in by people—there were too many of both.° INDIVIDUALISM had undergone an unexpected turn: under the welfare ethos the individual came in conflict with his alter ego—his equal in rights—throughout the day. To the competition of talent in business or the professions was added endless confrontation within the private sphere, often over things at once trivial and important: the suburban community dictated the color of your front door.

> If you are oppressed, wake up about four in the morning and most places you can usually be free some of the time if you wake up before other people.
>
> —WILLIAM STAFFORD, "FREEDOM" (1970)

It was the eutopian imagination at work making corrective rules as the path to the good life. The welfare ideal did not merely see to it that the poor should be able to survive, but that everybody should be safe and at ease in a hundred ways. Besides providing health care, pensions ("social security"), and workmen's compensation for accidents, it undertook to protect every employee by workplace regulations and every consumer by laws against harm from foods, drugs, and the multiform dangers that industry creates. All appliances were subject to design control and inspection. The citizen must moreover be protected from actions by others that are not visibly hostile or inherently criminal, those, for example, that can be committed by the imaginative in trade, investment, and banking.

At the same time, it was also held that the state had the duty of supporting art and science, medical research, and the integrity of the environment, while it must also make sure that all children were not simply literate but educated up to and through college—rules, rules, definitions, classifications, and exceptions = indignation—and litigation. The welfare state cannot avoid becoming the judiciary state.

The cost of welfare in money was huge and in mental effort exorbitant. As a kind of afterthought there was the old-fashioned role of government that had to be attended to: military defense, policing the land, building roads, dispensing ordinary justice, delivering the mail, and running the political and

executive institutions themselves. The task of distributing benefits was alone overwhelming. High taxes were unavoidable, and so was waste. Add to it corruption, also inevitable when inspectors are afoot, and it should have been no surprise to the contemporaries that the program fell short of its aim. There was still poverty, derelicts on the street, unattended illness, and complaints of "not enough" from every welfared group in turn—workers, farmers, businessmen, doctors, artists, scientists, teachers, prisoners, and the homeless.

<div align="center">*</div>
<div align="center">* *</div>

In a culture based as it was on the machine, a welfare state was inescapable. The array of safeguards against danger would be a sufficient justification of the system. A second, also arising from the machine, was mass production. The population must have the means of buying without letup; and the phrase "social security" must include security for the producers of the abundance as well. Only buying by everybody all the time kept the great machine running. This obvious truth does not mean that the motives behind welfare were all of the material order; humane feelings mingled with the practical and with certain historical memories. Nobody wanted to return to the 19C economic free-for-all with its periodic "starvation in the midst of plenty" (<456). This time around the middle classes would have sided with the workers in protest and revolt. The society *was* demotic.

Hence advertising with its peculiar status of approved deceit and temptation. Since techne kept driving production, new appetites as well as old must be kept at a high level, and in effect rich and poor must be made to live with the sense of continual deprivation; there were always new *necessities*. Seeing this endless prodding and spending, often entailing perpetual indebtedness, thoughtful people inveighed against "the consumer society." It seemed animal-like in its concentration on filling physical wants. The consumer could have retorted that he was helpless; the standard of living was an official agent of oppression.

It was remarked earlier about the 20C that the art of administration had not been thought about since Napoleon. As the welfare state needed a new bureau for every added program, the lack of men and women properly trained for the diverse operations was crippling. It is true that many manuals were published about *management*, the running of big firms. But those books dispensed only platitudes concealed in a would-be military jargon that changed every year without altering the substance. The only works deserving of attention were the rare first-person accounts of things accomplished. [An interested reader can learn about good 20C business management from *The Art of Being an Executive* by Louis B. Lundborg.]

Owing to sheer size, corporations, hospitals, and universities suffered the

same difficulties as the government bureaucracies. They were in fact all alike. Those appointed to man them improvised their procedures, and as legislation augmented, laid down rules that filled hundreds of pages, an impenetrable jungle for citizens and officials both. One reads of a new ordinance of 1999 issued by a large city to control demolition for low-cost housing; the news report casually mentions that it comes on top of 56 others. Achieving some ordinary purpose was difficult and carrying through a large undertaking impossible without help. The prosperous tribe of consultants, strong minds who had mastered one set of intricacies, enabled entrepreneurs armed with patience to attain their ends.

The common man all the while remained a working member of all the institutions that his needs and rights compelled him to approach. His very existence generated forms that he had to fill out; he was an unpaid clerk who wrote his name and address three times on one page. When he had to thread his way among the gears of an institution, he began a collaboration with an indefinite number of its representatives, amiable or grudging, but all armed with computers, who helped or delayed his rescue from entanglement. As in the years before the French Revolution, demotic society had become labyrinthine. It was easy to forget that the aims of demotic society had been devised by the combined intellect of 15 generations of men and women who stood out of the mass by their capacity and courage. It would have been reasonable to infer that simply to carry on their work demanded, not indeed an equal amount of collective genius, but as high a degree of common sense and alertness. The point at which good intentions exceeded the power to fulfill them marked for the culture the onset of decadence. [The book to read is *The Death of Common Sense* by Philip K. Howard.]

*
* *

The welfare duty hampered and distorted the functioning of "political democracy." In the genuinely elected governments of the West, the system had drifted away from the original plan and mode of operation. To begin with, the voter turnout had shrunk; national elections were not infrequently won by the votes of fewer than half the electorate; the people were no longer proud to have the franchise. This indifference was due to distrust of politicians and contempt for politics, although these are the very organs of representative government. *Politics* was a pejorative word; an endeavor or institution that was branded as politicized lost it virtue.

In legislatures, instead of power to enact the policies approved by the popular majority, the leadership must walk the tight-rope of coalition. There were too many parties—a dozen was not unusual—and where proportional representation was in force this evil was compounded. Voters bent on a sin-

gle goal formed parties, elected a few candidates who joined coalitions by contributing votes to a frail majority in exchange for supporting the dwarf party's solitary plank. The effect on the quality of legislation is easy to imagine, and as the welfare state must pass laws by the bushel, the consequences were on the large scale.

The United States, though not a parliamentary government, was nonetheless in the same position. Its two parties were façades for factions with incompatible aims, so that the party platform was coalition work and the president in office had to conciliate not two but several subparties in Congress if his program was to succeed. In that body (as in its counterparts abroad) powerful committees were coached on issues by hardworking staffs, a sizable corps of unelected talent with ideas of their own; the most cogent debates might take place in this legislative underground. When a bill such as the budget took up several thousand pages, the single representative was a mere spectator nursing his independent mind. And all the while he and other members were subjected to expert propaganda from lobbies, interest groups organized on every kind of basis—oil, pigs, or old age.

It is plain that the representative system had slid from one assumption to another. Originally, the national interest was to be determined by each member individually, and his view determined his party allegiance and his vote. But now a committee chairman weighed the arguments of the lobbyists and bargained with other chairmen to secure in advance the vote of the chamber. True, group interests had always been influential; but when lobbies became part of the machinery, the aim was to seek a balance of many competing groups instead of ascertaining the needs of the nation's large constituencies—land, commerce, finance, empire, and the poor. In demotic times, parliamentary debates, such as they were, no longer interested the public; the press ignored them.

In the United States this change was solidified by the high cost of running for office. To be elected took millions of dollars. The economic and ideological interests provided those millions, often divided among rival candidates so as to forward the cause no matter who won. Campaigning largely bypassed issues and dealt in attacks on character. Candidates were coached by experts in what they should say; the public was informed in 30-second television "bites." Lastly, the root idea of a parliament was fundamentally distorted by the practice of polling. Anybody could conduct a poll and announce what the people wanted. Candidates and representatives would then try to reconcile the popular verdict with the claims of their financial backers and the urgings of the lobbyists.

Bogged down in their efforts to keep welfare up-to-date, the democracies had lost the power to keep the governing machinery up to the same date. Reforms were much discussed; many were virtually unquestioned and statesmen talked of "re-inventing government." All that happened was bill after bill

put before the legislatures and soon or slowly allowed to die. Such a failure of will, which is to say the wish without the act, is characteristic of institutions in decadence.

<div align="center">*
*　　*</div>

In all the foregoing the 20C demotic individual has appeared in his public guise, as citizen—an immigrant, freedom fighter, or criminal; a listless voter, a victim of impotent law and order, and a receiver of benefits at the hands of government and business bureaucrats not adequate to their role. The one reference to the individual as a private person was the mention that he felt a lack of room to breathe, oppressed by the rule book and by the mass of adversaries in the allocation of conflicting rights. He must now be observed in the sphere of action that was presumably his own—in his tastes and habits, which together may be called his style.

His overriding taste was for the Unconditioned Life. After 500 years of steady EMANCIPATION this preference might have been expected; it was bred in the occidental character. For the large groups that until the mid-century had been disregarded and mistreated as inferiors, acquiring the common privileges and an increasing measure of respect naturally stimulated the desire for more. But the unconditioned life was something different from enjoying rights and decent treatment from one's fellows. It was to act as if nothing stood in the way of every wish. Such an attitude expects no rebuffs and overlooks those it provokes. When the longing for the limitless arises in a mind out of the common it may be called Faustian. It then may lead to new knowledge and spiritual discoveries; but in the ordinary soul the urge is for small satisfactions. Under its sway, the men and women of the period made choices that amounted to a style in the usual meaning of the word: the demotic style was the Unfitting.

It was the outgrowth of the casual style which, as we saw, had its beginning after the Great War (<734). Casualness took many forms, and to wear jeans that were torn and stained was casual, but only at the start. When one could go to a shop and buy the jeans ready-made with spots and patches, cut short and unraveled at the edges, a new intention was evident. When young women put on an old sweater, pearls, and evening pumps together, when young men went about in suits of which the sleeves covered their hands and the legs of the trousers were trod underfoot, they made known a rejection of elegance, a denial of feminine allure, and a sympathy for the "disadvantaged." Such clothes were not cheap; their style was anti-propriety, anti-bourgeois; it implied siding with the poor, whose clothes are hand-me-downs in bad condition. To appear unkempt, undressed, and for perfection unwashed, is the key signature of the whole age. As in earlier times the striving was to look and

act like "quality," whether aristocrat or upper bourgeois, now the effort was to look like one marching along the bottom line of society. The hitherto usual motive behind self-adornment—vanity—had the advantage of concealing physical blemishes, thereby showing regard for the onlookers' sensibilities. The reverse, the self purposely uncared for, expressed at once demotic anti-snobbery and demotic egotism.

The Unfitting appealed to the young but was not their monopoly. A sample of the casual style among adults had been to sport a business suit at the opera; this expanded into the open collar and no tie or jerseys and T-shirts almost anywhere, even in church. Airport crowds offered a typical fashion show. Where office workers were still required by their employer's rules to wear business suits, "free Friday" relaxed them to usher in the weekend. In schools, extreme unfitness caused a reversal. Dress codes were enforced despite protests and strikes, so as to put an end to the distraction caused by the bizarre and sometimes indecent garb that the pupils had devised, unchecked by their parents. It turned out that discipline in classes and hallways improved, further evidence that the unfitting was an aspect of the unconditioned life.

Clothing was but the most obvious sign of the demotic style. Other choices expressed the same taste, for example, getting married underground in a subway station or around a pool, in swimming suits. And since unfitness meant freedom, other conventions should be defied, notably those classed as manners. The word was seldom used and the practice highly variable. Business firms and airlines thanked their customers effusively, but civility between persons was scant, especially in cities.

Deference toward women had decreased and was sometimes resented by feminists as condescending. Nor were the elderly entitled to more courtesy than other equals. The curious use of first names soon after acquaintance was a convention that showed the demotic paradox about convention itself.

The need to hurry, real or imagined, had created fast food, available at all hours, and it begot eating and drinking everywhere at any time. Shops, public offices, libraries, and museums had to post "No Eating or Drinking"

In the Pasadena, California, City Council, a member was censured for cursing and screaming invective during the session. The American Civil Liberties Union defended him by attacking the Council's courtesy code as "silly," "goofy," "embarrassing," and "a laughing-stock." In the triumphant press release, the ACLU called [the Council's defeat] "a victory for all of Pasadena."

—Judith Martin (1996)

The Italian parliament has passed a bill decriminalizing some 100 offenses, such as insulting a public official, drunken behavior in public, begging aggressively, and desecrating the flag.

—News item, June 17, 1999

signs to protect their premises from accidents and the disposal of refuse. The consumer society consumed, and up to a point one can sympathize with the impulse. In a heedless, uncivil world the driven needed to look after their wants as soon as they arose, to pay themselves back, as it were, by self-coddling. The indulgence was after all but the extension of the habit of EMANCI-PATION. So many curbs and hindrances to desire had been removed—the legal and conventional by new laws and new conventions, the natural ones by techne with the aid of science—that the practice of permissiveness sprang in fact from the workings of welfare, coupled with the power of doing innumerable things by pushing a button.

Pleasure first and fast in a society that oppressed only unintentionally was bound to make instinctive rebels. At work, criticism or reproof was felt to be intolerable; there is a human right to make mistakes. Observers spoke of the decline of authority, but how could

> Having grown up in the 1960s, I've never seen a protest I didn't like. I might not always have agreed with the shouted objectives or postered profanities, but it seemed such an American thing to do.
>
> —LETTER IN *THE NEW YORK TIMES* (1991)

it survive in a company of equals? Distrust attached to anything that retained a shadow of authoritativeness—old people, old ideas, old conceptions of what a leader or a teacher was meant to do. In the same spirit, the period cultivated the anti-hero. A positive hero would have raised a *compelling* example. There was indeed talk of "role models," but the celebrities chosen supplied very few. Champions in sports did beget emulation in the athletic young, but only entertainers caught the imagination of the masses. Unfortunately, success on stage or screen went with disorderly lives, chronicled from day to day with discouraging comments by the experimental moralists themselves: drugs, prison, sexual promiscuity, suicide punctuated their performances—as happened also to some sports figures.

Anyhow, the demotic individual was supposed to fashion a "lifestyle" for himself; that new word implied it. Yet one found very few eccentrics. Compared with the 19C contingent that defied Victoria's menacing eye, the showing of their descendants was poor. Most of their eccentrics were

> I didn't know how to study, but I liked the lifestyle. You could dress any way you wanted. I was wearing pajamas and a sport coat to school and pajamas and loafers to formal events. College was terrible. I didn't get it at all, but it got me out of the house.
>
> —BILL MURRAY, ACTOR (1999)

criminals; the laity conformed, not least in their supposedly custom-made lifestyles; from which it would seem that emancipation is attainable from everything except one's peers.

*
* *

Visitors tend to be conscious of the time they have available and are more likely to be concerned with whether the experience will be entertaining as well as educational.

—Richard Foster, "Defining Museums for the 21st Century" (1998)

"Art Galleries: Church or Funfair? Museums in a Democracy."

—Julian Spalding, director of the Manchester (England) City Gallery (1989)

"This library will surprise you," said the dean. "The coffee bar is as far from the image of the old [library] as you can get. We're thinking of the library as a social space as well as a study space."

—At a college in the Northeast (1998)

Passing from tastes and habits to fancies, the historian of the late 20C notes the love of the conglomerate. Originally used for business, the word denotes here the wish to mix pleasures, activities, and other goods so as to find them available in one place. The purpose in itself was not new; the country general store, the city grocery or department store were traditional, for convenience. But something else made the museum of art sell jewelry and offer the public motion pictures, lecture series, and string quartets. More than one great library had some of these, and teas and soirées besides; universities provided their alumni with guided tours of picturesque regions of the world, and to their own townspeople a whole range of artistic events. Bookshops owned by chains provided a corner with tables for coffee and toys for children and their mothers to play with, while the clerk scanned Clio on line for the elusive book. In the refurbishing of a railroad station it was felt desirable to make room for a chapel in case anyone bored with waiting wished to worship or be married. It is not enough to suggest economic need for some of these conglomerates. They did not create but respond to a want. In most combinations there is an element of pleasant surprise due to a touch of the Unfitting. Multisatisfaction, multimedia hinted of multiself, gave a feeling of opulence, and brightened one's mood at the expense of blurring distinctions.

There was also the mental conglomerate, better known as muddled thinking. It was evident in the "as" habit: gesture as language; hockey as theater; clothing as animated sculpture; landscapes as living art. Straight thinking could have pointed out that language replaced gesture and by being radically different proved more effective. Gesture may have *meaning* and communicate it, but Language is language and nothing else is. Similarly, hockey is occasionally drama, which means conflict, but theater is coherent and significant drama, prearranged—and so on.

When White photographed frost on a window he saw galaxies; when he posed a branch against a certain kind of light, he caused it to stand for a whole system of mystic thought. His pictures were worlds complete in themselves; even though they captured something from the outside, they did not refer to it again but made it into something else.

—David Travis (1994)

The conglomerate that best fulfilled the ideal of the time was the course offering of the large colleges

and universities. It had ceased to be a curriculum, of which the dictionary definition is: "a fixed series of courses required for graduation." Qualified judges called the catalogue listings a smorgasbord and not a balanced meal. And large parts of it were hardly nourishing. The number of subjects had kept increasing, in the belief that any human occupation, interest, hobby, or predicament could furnish the substance of an academic course. It must

"Fifty-some majors, thirty-some concentrations, and hundreds of electives."

—THE DEAN OF AN IVY-LEAGUE COLLEGE TO ARRIVING STUDENTS.

A university that offers a doctorate in sensuality, including courses in "niceness and meanness" and "mutual pleasurable stimulation of the human nervous system" was [well described] in 1992 as "an academy of carnal knowledge."

—*NEW YORK TIMES* (1996)

therefore be available to young and old in higher learning. From photography to playing the trombone and from marriage counseling to hotel management, a multitude of respectable vocations had a program that led to a degree. On many a campus one might meet a student who disliked reading and had "gone visual," or be introduced to an assistant professor of family living.

These hundreds of electives were designed to appeal to students who wanted unconditioned choice. To produce the large array was not difficult, given the favoring tendencies in the outer world. The liberal arts were subdivided by SPECIALISM into bits and pieces of scholarly interest, but of little benefit to young minds that lacked previous knowledge of the larger field. And the concern with social EMANCIPATION, seconded by SEPARATISM, generated whole departments, each devoted to teaching the accomplishments of one ethnic or sexual group in isolation. But not all groups were eligible for such attention.

*
*　　*

Being suspicious of conventions, demotic equals were often at a loss in their daily encounters: shall one act diffident or clamant of one's rights? Does occupation confer a status that one is entitled to show off? Where in the scheme of things do I belong? Who am I, anyway? Such questions made up the "identity crisis" studied by psychiatrists whose patients had not "found themselves." Others struggled with "lack of self-esteem"; still others confessed to painful wanderings before being rescued by an act of conversion— religious, often cultist, or assisted by therapy. The number of sufferers in the population was admitted to be large, a continuing problem for the family, the employer, and the social services.

Finding oneself was a misnomer: a self is not found but made; and the anti-hero, anti-history bias was an obstacle to making it, because a starting point from the past was missing; it had to be made from scratch. The situation was

There is always that other strange second man in me, calm, observant, critical, unmoved, blasé—odious! He is a shadow that walks with me, a sort of canker of doubt and dissection; it's very seldom that I forget his loathsome presence.

—Lord Leighton (1857)˚

the point. The anti-hero comes upon someone whose face causes him immediate aversion: it is his own mirrored in a plate-glass window. Self-consciousness had been deepening with every advance in psychology and by the delving of poets, novelists, and other experts in Analysis. The self-torture dif-

... publicity over achievement, revelation over restraint, honesty over decency, victimhood over personal responsibility, confrontation over civility, psychology over morality.

—Maureen Dowd (1995)

akin to that of a displaced person in distress. No one is on record as exclaiming with Erasmus or Wordsworth "Oh, what a joy to be alive!" (<8). Instead, in numberless novels a character was shown possessed by self-hatred, which soon culminated in a hatred of life. One incident was repeatedly used to make fered from Luther's and Bunyan's: theirs was concentrated on the soul and the purity of their faith. The modern self-harassment was diffused over every impulse to action.

Self-contempt was redoubled by knowing that performance was of slight value compared to Image. That inclusive word could be defined as a set of indicators that suggest, but do not indicate, the thing sought. Judgment of people by signs was not a new habit; it is almost inevitable and it is fair enough when the signs are an outgrowth of personality. But the period required the contrived; one made one's way by image-building-and-tending. This duty was not limited to persons: businesses, political parties, schools, museums, churches—any institution that had a public—must present the type of image favored at the

—Guilty about what?

—Guilty at being ourselves, guilty at not being ourselves. I don't know: guilty at feeling guilty, guilty because we don't feel guilty. Above all, we want to confess—to anybody, about anything.

—Cecil Jenkins, *Message from Sirius* (1961)

moment. The craft of public relations was there to help manufacture the façades, and the onlookers confessed that "Perception is all." Or not quite all, if one looks into another corner of the demotic mind. There, disgust at playacting, a surviving sense of the real, a spurt of true independence caused in the sensitive a subdued conflict that bred guilt.

* \
* *

After so dispiriting a catalogue, a reminder is in order. No period style affects the entire population. A majority remains untouched by what is most visible in the age, yet without changing the style that it declines to follow. The

counterpoint does not affect what is steadily in the news and talked about as important and lively and desirable. Older tastes and desires persist but are neglected, or so taken for granted that they might as well not exist. Style, like celebrities, is what is well known for being well known.° Of course, the majority that keeps aloof is not cut off; it rejects the style but is aware of its ideas and attitudes and may share one or another of them. Among demotics, three stood out: Compassion, Irreverence, and Creativity.

Compassion was the sign of the right-minded, truly human person; *compassionate* was the highest compliment one could pay to the living or the dead. All victims deserve pity and help, and as victims outnumbered everybody else (so to speak), since any person might well turn victim overnight, there were plenty of opportunities for compassion. Glorifying it was not lip-service. The whole population was readily moved to help the distressed at home or abroad. Besides the well-known Red Cross and Peace Corps, dozens of organizations roamed the world, teaching, curing, saving women from prostitution and children from sweatshops and starvation, rescuing the unjustly jailed, housing and feeding refugees, denouncing tyranny, and raising money for these and all other charitable purposes. The 20C was continuing the 19C tradition, but detached from sectarianism and, since governments took part, vastly expanding the amount and variety of aid supplied.

At home, fire, flood, and earthquake brought the victims instant help, individual and organized. The physically disabled, the retarded, the excluded in any way had public opinion behind them to secure compensatory treatment. A victim's claim to appropriate assistance was a logical extension of the doctrine of Human Rights, which had been enshrined in an international charter and not limited by any definition. Rights were continually being extended. Group propaganda and lawsuits by individuals did the work. Prisoners obtained most of the rights of the law-abiding; animals, babies, embryos were on the list for similar protection. In 1999 the state of New York made breast-feeding in public a civil right. This ceaseless endeavor to aid and permit was a spectacle unknown to any previous civilization.

The second idea, irreverence, was the monopoly of the clever and bold, free of compassion. They saw through everything and spoke out with an amused smile. Their skill was always mentioned in obituaries and in articles introducing those freshly in the news. It was rarely noticed that when nothing is revered, irreverence ceases to indicate critical thought.

But the most endearing idea in the demotic mind was surely that creativity dwells or lurks in every human being. In retrospect it seems not so much a mistake as a mislabeling. It is a fact that nearly all human beings feel the urge, and a great many have the ability, to make something with their hands or think a new thought. The knack of drawing, singing, riming, making similes,

and recording emotions in prose is widely distributed. But the activity ought not to be called creative. In truth, the products of this creativity were rarely called *creations*, the name reserved for the works of genius.

Still, the misnomer was nonetheless harmful to the person and to society. Individuals of ordinary talent or glibness were encouraged to become professionals and thereby doomed to disappointment; and too many others, with just enough ability to get by, contributed to the lowering of standards and the surfeit of art (790>). The error was to suppose that art is made by innate skill combined with acquired technique. These will turn out only conscientiously imitative art. Creation requires an uncommon mind and strong will serving an original view of life and the world. [The book to read is *Journalism Versus Art* by Max Eastman.]

Particularly in industrial society the gifted and the sensitive long for the artist's life; they exaggerate its autonomy and freedom from routine. But perhaps there were substitutes for it in white-collar fraud and the obsession with entertainment, including immersion in sexual imagery. The fraud, like the violence, was new in frequency and it too seemed mindless, although in both cases the act must have satisfied some budding thought and required a choice of means to carry it out. At any rate, white-collar crime called for intellect: in every country one found bevies of top executives and leading politicians behind bars and others under indictment. They had no need of money or prestige; what they needed and found—one may surmise—was adventure and a field for the use of imagination in outwitting the system. Fraud was the sport of capable minds and lofty souls who wanted to rise above commerce and make-believe. It was creativity in a rich medium; and codes of professional ethics had to be written and rewritten to cover new offenses. Simpler kinds of cheating were popular among university students, the merits and morals of the custom argued in the campus newspaper; while their well-to-do parents practiced shoplifting and as guests in motels appropriated any desirable object not firmly bolted down.

These occupations showed a desire for activity which, for the energetic, entertainment failed to provide. Whether sports event or soap opera or rock concert, entertainment in its main 20C forms was seated and passive. The amount supplied was unexampled—Imperial Rome did not match it. In both places it became the people's chief object in life, because for the millions Work had lost its power to satisfy the spirit. Yielding no finished object, taking place only abstractly on paper and in words over a wire, it starved the feeling of accomplishment. It was drudgery without reward, boredom unrelieved; the factory assembly line had more reality, although it too could bring on the comparable "blue-collar blues." By contrast, the most routine entertainment had color and shape, and by depicting violence and sexuality it stirred the deadened senses.

Children, who are easily bored and restless, stared for hours at the television screen for the parallel reason that school denied them the sense of progress toward knowledge.

The atmosphere of sexuality likewise gave the illusion of real life. And the word *atmosphere* suggests only the enveloping presence: its force was invasive. The air was thick with pictures of half-naked bodies in seductive poses. Advertising, film, and popular magazines depended on these to make sure of catching and holding public attention.°

The sexual act itself was imitated wherever it could be managed, onstage or onscreen; some performers went so far as to commit indecent acts in front of their live audience. There was a cult of nudity, in serious plays and on public beaches, quite as if in those settings naked bodies were not the reverse of aphrodisiac. Pornography, protected by the rules of free speech, was abundant but of low quality compared with the classics from Petronius onward; even the 19C models were better literature. Closely allied were the writings of innumerable doctors and psychologists, seconded by columnists in magazines and newspapers, who offered advice on coital technique, or methods for luring the opposite sex, or encouragement to the old not to give up. The preoccupation with the subject began about the age of 12 and was in proportion to the incitement.°

The greatest damage from the sexual emancipation occurred in the public schools, where sexual talk and behavior, being tolerated, distracted from work. The resulting early pregnancies caused disasters of all kinds. But so great was the thrall of the sexual that school authorities dealt with the problem by means of courses, free contraceptives, and handbooks giving a full view of the subject, its variants and aberrations. Quite as deplorable was the effect of so much SELF-CONSCIOUSNESS throughout society. By a hastily worded convention linked with the ideal of female independence from the male, all unwanted "advances" (as they used to be called) were stigmatized as "sexual harassment."° A single gesture and even staring° might bring on the charge, the consequences of which ranged from penalties at law to compulsory "sensitivity training."

The sexual reality was often halfhearted and disappointing, much obses-

> "I mean," says the other, "this is what we live for." That is, "catastrophe, chaos." Or, as he adds, "you can't always count on the occasional earthquake to jump-start your heart."
>
> —INTERVIEW, *THE NEW YORK TIMES* (1996)

> Beer ads featuring animals having sex were ordered removed from Harlem stores by the brewer after complaints. But the campaign will continue elsewhere, posted everywhere the beer is sold. It features rhinos and giant turtles mating; the caption: "Research Says Sex Sells Beer."
>
> —NEWS ITEM, FEBRUARY 20, 1999°

> Every sixteen-year-old is a pornographer, Miss Piranesi. We had to know what was open to us.
>
> —HORTENSE CALISHER, *QUEENIE* (1971)

The sexualization of the masses by optical stimulation goes hand in hand with a diminution of the tension between individual partners. The wish-dream figures of mass sexuality lose all quality when they are reduced to private ownership. Like Rose-Marie they draw fabulous salaries for their ability to sexualize the atmosphere at a distance; they practice anticipation and destruction, offer a shabby substitute for experience.

—Erich Kuby, *Rose-Marie* (1960)

sion but little passion—what D. H. Lawrence had called "sex in the head." Men and women did not benefit from the boasted "revolution" as they had expected; it did give some people the free play they wanted, but it pushed many more into courses unsuited to their nature and capacities.

It did not install the Mohammedan paradise on earth, although everything in sight suggested that it had. Pornography is a form of utopian literature and, like the advertising of Desire, it set a standard that brought on paralysis. When an erectifying drug was put on the market, the millions who rushed to obtain it numbered the healthy young as well as the ailing old, and women at once demanded its feminine equivalent. It was apparently not known that desire must be dammed up to be self-renewing.

*
* *

Persons who could detach their minds from the current obsessions and turned to the arts found in them the self-destructive characteristics detailed on earlier pages. The sheer amount to be seen and heard debased it. An explicit dead end was reached when, in the last year of the century, Warhol's *Brillo Box* sculpture, which is an exact reproduction of what stands on the grocer's shelf, was said to face the beholder with "the important question, What makes the difference between a work of art and something not a work of art when there is no perceptual difference between them?"° That matchless pair of destroyers, Duchamp and Picasso, had done what they set out to do.

If one moved on to literature, violence and sexuality were there too, full of imaginative refinements and seasoned perversities, often laced with pseudo-technical pedantry such as Henry Miller's notorious: "Tania, I make your ovaries incandescent."° Black humor was one of the favorite spicings substituted for energy; another is known to psychiatrists as *le goût de la boue*— the love of dirt. Black humor—no connection with Black people—resembled the old heartless practical joke; it enacted in words a predicament that ended in cruel horror. The victim might be shown as destroyed by his enemy or fate or—the 20C touch—a stranger. The taste for it helps to

Decadence was brought about by the easy way of producing works and laziness in doing it, by the surfeit of fine art and the love of the bizarre.

—Voltaire (1748)

understand the rehabilitation of De Sade (<448), and it may have concealed a wish to protect oneself from disasters to come—the method of Mithridates, who fed on poison so as to withstand poisoning. One cannot laugh at black humor; the face merely contracts into an unprepossessing rictus.

The featuring of filth was likewise the extreme of a past interest, that shown in the Naturalist novel. In the later period it had the reinforcement of the two great demotic wars, whose veterans knew mud and blood at first hand. Television, when it came, brought both into the living room. In the interval, poetry and fiction did their part to provide what an Italian critic, referring to the Beat movement, praised as "vulgarity, crudeness, and sordidness."° Before the Beats, Joyce had frequently meant to disgust: he preferred "the snot-green sea" to Byron's blue Ocean. By the end of the era, performers and their groups knew how to choose names based on the tastes that would attract: Garbage, Johnny Rotten, Sex Pistols, Grateful Dead, and the like.

If one happens to remember Conrad's definition of art a century earlier—"a single-minded effort to render the highest kind of justice to the visible universe"—one wonders whether 20C writers no longer wanted to render justice, and if they did, whether the universe had radically changed its visible aspect. The critical mind inclines toward a complex judgment: the artist remained a faithful portrayer, but over the century his work has done its share to make the visible universe deteriorate. Unfortunately, in this bewildering of the senses, such as Rimbaud had called for (<618), both the artistic and the ordinary person were left without a guide. Criticism had given up its main duty of reasoned review and was busy praising and promoting rather than putting order in the welter. Even when the language of the commentators was not obscure on purpose, it only added to confusion by vagueness or paradox.

> The logistics of the gaze infiltrate the work. They suggest inwardness and events beyond the frame. The shocked mien in Untitled [two nudes] implies an unseen transgressor. In another canvas two stares lead in opposite directions . . . an eerie condition of de-centering.
>
> —A CRITIC ON ROTHKO (1999)

> His paintings are reflections of solitude. His drawings are whispers—like chalk drawings on a slate. He tests our established rules.
>
> —ONE ARTIST ABOUT ANOTHER

> Forms that have a catalytic force growing from an ambiguous but strongly felt fountainhead in nature, frequently with double meanings and feelings, have a hold on me.
>
> —A SCULPTOR ON HIS WORK

> Music could be defined as a system of proportions in the service of a spiritual impulse.
>
> —GEORGE CRUMB (n.d.)

> Art is what you can get away with.
>
> —ANDY WARHOL (1987)

*
* *

So much exposure to the puzzling, the shocking, the bizarre (called surrealist), the repellent, the intrusively (sexually) intimate, the disturbing and the disturbed was bound to cause a perpetual inquisitiveness about human motives. The upshot was the pastime of psychologizing. It became common after the dissemination of Freudian ideas, when a new form of superstition—popular psychology—using and misusing technical terms, began to fill the conversation, the routine novel, and the press. By accounting for conduct or point of view, psychologizing ended discussion—no need to think of an argument to meet whatever was advanced; the imputed motive explained it away. It was another form of name-calling; the person was classified and labeled with finality. Psychologizing was particularly destructive in biography. The subject was reduced to a case, which brought him or her down to the common level of all other cases of the kind; the anti-hero was the final aspect of the eminent. But demotic inquisitiveness did not stop there. The interest in the personal led writers to interview the subject's surviving contemporaries and fill the life with the full harvest of gossip. Eager readers of biographies spoke like everybody else of human dignity but forgot that it is tied to a due measure of privacy.

> How pleasant it is to respect people! When I read books I am not concerned with how the authors loved or played cards. I see only their marvelous works.
>
> —CHEKHOV, *NOTEBOOKS* (n.d.)

Bringing into one view these elements of the demotic style shows how reasonable was the search for ease and latitude. The excess of demands had to be shifted from oneself to others. The claims did not rest on one's outstanding performance but on stated rights that all shared. Hence the collective energy, successful as it might be in affording the multitude a living full of conveniences, added little to the fund of civilization and left a host of people in various states of discontent and unhappiness. The grounds for this conception of the self in relation to the world have been detailed as the story of the West unfolded. In that light they evoke sympathy, at the same time as they help to explain the disorientation of the culture at its close.

For it must be remembered that although the habits and desires that formed the demotic style were lodged in individuals, it is they—and the most able and active among them—who made the rules and led the institutions all lived by. Some of these public agencies have been shown earlier to be disintegrating, working against their best intentions, and unable to change. A brief look at a few more, particularly those that are not official or organized—language, for example—will enable the observer to judge whether the culture as a whole should be called decadent.

The demotic languages were decadent because verbal inflation and misusage interfered with vigor, precision, and clarity. Correctness had ceased to

be recognized; it was, on the contrary, denounced. The resulting obstacles to good prose were: a vocabulary full of technical terms and their jargon imitations, an excess of voguish metaphors, and the preference for long abstract words denoting general ideas, in place of short concrete ones pointing to acts and objects. An idiomatic writer sounded simpleminded. All the western tongues were similarly afflicted.

It was said earlier that the great 19C invention, the public school, had lost the power to make children literate. Methods useless for that purpose, absurd teacher training, the dislike of hard work, the love of gadgetry, and the efforts to copy and to change the outer world ruined education throughout the West. These schemes and notions of American origin were taken up abroad as they arose.° [The book to read is *The Transformation of the School* by Lawrence Cremin.] During the last phase of school decay in the United States, the family was invoked in blame and for help. Parents, so ran the charge, were not "involved" in their children's schoolwork, did not know teachers or programs, and were hostile when their offspring were disciplined. They should become part of the institution, which could not work without them, and certainly not against.

In this admission of failure, what was in fact "the family"? The attacks on that institution in the 1890s, followed by disruptive wars and new ideas

> In general, it can be said that the school attempts to reproduce actual community life on a democratic basis, to establish social habits and attitudes, and in particular the habit of scientific thinking.
>
> —REPORT ON A PROGRESSIVE SCHOOL (1919)

> Here's how an eighth-grade social studies teacher begins her explanation of "Current History in the Middle School": "There is a common misconception that a history course is a study of the past."
>
> —SIMON SCHAMA (1998)

> I saw a tug boat pulling a barge. I learned what a ferry boat looks like. I liked the time when the ferry boat made a big squeak. I think the trip was fun. I don't think the trip was worthwhile because I had seen it all before.
>
> —KATHY H. IN THE FOURTH GRADE (1972)

> From laying our own rail system for steam engines, to studying the houses of Frank Lloyd Wright, to designing amusement park rides—that's how the physics curriculum flows in my classroom.
>
> —TEACHER IN MACUNGIE, PENNSYLVANIA (1999)

about sexual relations, had changed it to the point where "family values" was a phrase that divided the population into believers and heretics, and the believers not always model practitioners. The traditional form of union had not disappeared, but the variants (celebrated by the soap opera) were becoming traditional themselves: families in which both parents were employed; families in which one or both parents, employed outside, worked at home; single-parent families, the parent being employed or not; "second families" with children from previous marriages; families for months or years in mid-

divorce; families rearing grandchildren; unmarried couples with or without children; homosexual couples with a child, adopted or not. Out of these situations arose two novelties: the day care center and the semi-orphan.

Adapting schedules, abilities, and emotions to rearing children and furnishing the help requested by the school was a dismaying task, even when the hindrances of poverty and lack of literacy in the common tongue were not present. The upshot was that an increasing number of children found at home no encouragement to schooling, no instruction in simple manners, no inkling of the moral sense. Some of the waifs bred in that way were those who took to drugs, became thieves before their teens, and committed the conscienceless crimes falsely called mindless. They formed gangs, boys and girls together, with able leaders and strict rules. It was *they*, not prime ministers, who reinvented government. And when they joined to it so-called Satanism, they rediscovered ritual if not religion. The larger group that executed graffiti on city walls were in line with the makers of disposable art, bent on destroying the medium as well as the culture.

<p style="text-align:center">*</p>
<p style="text-align:center">* *</p>

In the 1890s, sports then in their infancy had been praised for developing the high moral outlook called sportsmanship. In less than a hundred years, sports had lost their honor, though not their glamour. Competition had enormously increased skill, and better nutrition, physical strength. Participants and spectators numbered by the millions;° but amateurism was in decline and corruption was rife. Professionals cheated for money or by taking body-enhancing drugs; champions committed rape and other violent crimes. When contests pitted together two national teams, one crowd of fans mobbed the other; riots, wounds, and deaths were the sportsmanship of the day. At the same time, without sports, colleges and universities would have lost their standing and alumni money. Sports were the last refuge of patriotism. On such occasions as the French victory of 1998 in soccer, the whole people's enthusiasm led the leaders of opposite political parties to fraternize and declare that the event had reunited the nation. Soon after, it was discovered that the governors of the Olympic Games, also reborn in the Nineties, had taken bribes from the countries wanting to be hosts.

The other professions, called liberal, had similarly lost enough of their self-respect to be deprived of the prestige they once enjoyed. Doctors, once idolized, were accused of indifference to their patients and of money-grubbing as well as malpractice. Professors were no longer regarded as the indispensable experts they had been from the time of the brain trusts through the Second World War. They had injected "political correctness" into the

academy and made themselves ridiculous by the antics it entailed. Scholarship was the pretentious garbed in the unintelligible. Lawyers ceased to be divided into two kinds, the worthy and the contemptible. "Let's kill all the lawyers," dug out of context from Shakespeare,° became a cliché. This animus was due to the large increase in litigation under the many protective rules of the welfare ethos; lawyers thrived on suits against corporations for product liability, the jury verdicts being often exorbitant.

Journalism, which not everybody called a profession, did not escape the common revulsion. The press had abandoned the ideal of impartiality; every newsman editorialized and colored the truth, while also responding to the supposed demotic need that news be "human." Instead of the former "lead" summarizing the facts, a novel-like opening described the scene, then quoted the predictable comments of a person chosen at random to typify the situation. Often, a string of experts also expressed an opinion before important points were disclosed. It was a suspense story. A new professional, the "investigative reporter" invaded privacy, abetted the theft of confidential documents, and claimed immunity for "the public's right to know."

> Scotty managed to get hold of the full text of each of the principal nations' proposals, which the [*New York*] *Times* duly published—to the statesmen's consternation and the journalists' admiration—day by day.
>
> —OBITUARY OF JAMES B. RESTON° (1995)

It was not unusual for someone to learn of his promotion or dismissal by reading the paper a week ahead of the official announcement. To public figures the reporter was the dog of uncertain temper, pacified by fresh news. As for broadcast news, it was meager, repetitious, and limited to what could be photographed; natural and other disasters were its best raison d'être.

Journalists themselves were dissatisfied with the state of their craft and continually criticized their fellows' performance in journals and discussion groups.° On the Continent associations and in England a semi-official body tried to limit the excesses of which most newspeople disapproved but which the zeal to make a scoop kept unstoppable. Meanwhile, the physical production of the newspaper remained a stunning feat. Many pages, millions of words and figures, fitted headlines and pictures, advertising as ordered, and on Sundays thick supplements bundled in the right order—all this in fair prose and with few glaring errors was a miracle accomplished daily in the dark hours.

One more thing to recall about "the media" is that they spread abroad the latest findings that made up the Stat Life (<535; 652). Through both news stories and advertising, everyone was sooner or later made aware of the needs of health and the dangers of life, together with the norms set by the average in behavior. The Stat Life was an abstract police force working from within.

I WANT YOU

To Stop Smoking / Wear Your Seat Belt
Eat Your Vegetables / Stay Out of the Sun
Lose Weight / Buckle Your Kids in the
Back Seat / Talk About Race
Use a Condom / Volunteer
Eat Less Red Meat

—AROUND A PICTURE OF UNCLE SAM
POINTING HIS FINGER AT THE READER
(1997)

*
* *

For the growing contingent of per-
sons hooked to computers, it was the
Internet that promised a future full of
continuous miracles. It dazzled even
those who stayed away from it. One
thing it proved was the power of techne
and its good health. But not every use
of that new Delphic Oracle made
things easier than before. The library,
for one, presented the researcher some new obstacles. To specify them would
call for details of interest only to the profession; two obvious points must suf-
fice here. In large libraries, the number of computer terminals never equaled
that of the users who formerly could work simultaneously at the card cata-
logue lining the walls. In small libraries, when the solitary computer was in use
or "down," the collection of books was for the time being incommunicado to
others. °

With science, techne was the sole institution untouched by any falling off;
that is, *in results*. That qualifier is required, because science and techne were
not exempt from severe social and philosophical criticism. ° Quite apart from
instances of falsified data, science and techne had lost their sanctity. A body
of thoughtful opinion made the joint enterprise responsible for the worst of
contemporary ills. Too much of the rational and the mechanical was deemed
destructive of the spiritual in man. Then too the ever presence of numbers, of
technical terms and ideas, of dependence on system and formula—fallible or
not—bred a prison-like atmosphere. The absence of variety, of empty time,
of things *unprocessed* quenched the simple love of life. Again, the renewed
religious longings remained unsatisfied. The churches, internally divided,
vainly tried to unite with others; theology, intellectually strong earlier in the
century, was enfeebled and could not move the culture from its secular-
scientific base.

Added to the unease was the fear of physical destruction by nuclear
weapons and of psychic disarray by the manipulation of genes. Cloning was
only the apex of disturbing procedures. But no complaints stifled the zest and
ingenuity of researchers and engineers. It is true that the time of vast original
conceptions that cause a readjustment of accepted ideas was over. The one
important novelty was an addition that modified little despite its dramatic
name. Chaos, the new branch of physics, dealt with irregularities such as the
weather or motion within a waterfall. Instead of defining parts, Chaos found
patterns in wholes, thus going counter to the standard method of ANALYSIS

and avoiding its REDUCTIVISM. It raised, but did not settle, doubts about the law of thermodynamics that records how matter and energy perpetually disintegrate. But Chaos did not affect the knowledge-is-power men, who could boast of having justified every claim made by their sponsors from Bacon to T. H. Huxley.

As for techne, the wonders of the space program sufficed to prove its imagination and versatility. One picturesque measure of its progress could be seen in June 1993, when the Space Center in Florida unrolled into the air a spool of 1,640 feet of copper wire to generate electricity in a tube at the end. It made one think of Franklin, turned as it were on his head.

Outer space was the theater for such techne spectacles; cyberspace was the scene of human inquisitiveness, fashion, garrulity, and greed. What the world-wide Web did to the demotic character is hard to define. It made still more general the nerveless mode of existence—sitting and staring—and thus further isolated the individual. It enlarged the realm of ABSTRACTION; to command the virtual reduces the taste for the concrete. At the same time, the contents of the Internet were the same old items in multiplied confusion. That a user had "the whole world of knowledge at his disposal" was one of those absurdities like the belief that ultimately computers would think—it will be time to say so when a computer makes an ironic answer. "The whole world of knowledge" could be at one's disposal only if one already knew a great deal and wanted further *information* to turn into knowledge after gauging its value. The Internet dispensed error and misinformation with the same impartiality as other data, the best transferred from books in libraries.

The last 20C report on the working of the "world-wide web" was that its popularity was causing traffic jams on the roads to access and that the unregulated freedom to contribute to it words, numbers, ideas, pictures, and foolishness was creating chaos—in other words, duplicating the world in electronic form. The remaining advantage of the real world was that its contents were scattered over a wide territory and one need not be aware of more than one's mind had room for.

> Just as the strength of the Internet is chaos, so the strength of our liberty depends upon the chaos and cacophony of the unfettered speech the First Amendment protects.
>
> —JUDGE STEWART DALZELL (1996)

*
* *

The thought occurs that in the high tide of demotics—the second half of the century—it was hard to find a figure of the intellectual world to put side by side with those singled out earlier. One must go back to the first half for a thinker of comparable range and power: the obvious one is Ortega y Gasset,

the author of *The Revolt of the Masses* and numerous other philosophical studies that are also contributions to cultural history. [The book to begin with is *The Modern Theme*.] Ortega y Gasset died at mid-century, but in his treatment of the arts, education, psychology, and social theory, this aptest observer of his period delineated the leading features of the next. That he was not much cited or quoted after his death does not amount to a settled judgment upon him. [The book to read is: *Ortega y Gasset: A Pragmatic Philosophy of Life* by John T. Graham.] Sooner or later he will have to be heard as a witness—and not alone. To know the whole century adequately, historians will have to listen to the words of several others who also belong to its formative time. To cite only three Americans: John Jay Chapman, Albert Jay Nock, and Leo Stein.°

*
* *

From this summary survey of individual style and social institutions, it is plain that the demotic culture in decadence did not suffer from inertia. It was active in proportion to its predicaments; paralysis in one domain—and incompetence in many°—excited lively efforts to overcome them. Many shrewd minds, accurately noting the condition of stasis, urged plausible remedies; nobody pretended that apart from science and techne advance was taking place. But some hesitation was shown about applying the word *Decadence* to the whole West and the whole era, as our distance from it now enables us to do without tremor.°

That reluctance was natural but—again—it did not preclude insight or courage. A document from that time, undated and anonymous, shows the demotic mind and character at its best and fittingly concludes our account. It is entitled

Let Us End with a Prologue

"The careful historian, before he ventures to predict the course of history, murmurs to himself '*Schedel*.' It is not a magic word, but the name of a learned German who, in 1493—note the date—compiled and published the *Nüremberg Chronicle*. It announced that the sixth of the seven ages of mankind was drawing to a close, and it included several blank pages for recording anything of interest that might still occur during the final days. As we know, what occurred was the opening of the New World and all innovations that followed from it—hardly a close. With this risk in mind, I mean to set down what appears to me possible, plausible, likely, as our own era reaches an end.

Our Age

Some of the descriptive labels: Age of *Uncertainty*; Age of *Science*; Age
of *Nihilism*; Age of *Massacres*; Age of the *Masses*; Age of *Globalism*;
Age of *Dictatorships*; Age of *Design*; Age of *Defeat*; Age of *Communication*;
Age of the *Common Man*; Age of *Cinema and Democracy*; Age of the
Child; Age of *Anxiety*; Age of *Anger*; Age of *Absurd Expectations*

"Some writers have called our time the end of the European age. True in
one sense, the phrase is misleading in another: it overlooks the
Europeanization of the globe. Techno-science and democracy are far from
ruling everywhere, and in certain places they are fiercely opposed; but
together they grip people's imagination and inflame their desires. The whole
world wants, not freedom, but EMANCIPATION and enjoyment. And the West
is the corner of the globe whose peoples, borrowing freely from all others,
have shown the way of achieving the one and given the means of possessing
the other. [A book to browse in is *Pandemonium* by Humphrey Jennings.] The
shape and coloring of the next era is beyond anyone's power to define; if it
were guessable it would not be new. But on the character of the interval
between us and the real tomorrow, speculation is possible. Within the histo-
rian lives a confederate who is an incurable pattern-maker and willing to risk
the penalties against fortune-telling.

"Let the transitional state be described in the past tense, like a chronicler
looking back from the year 2300. As the wise ancient Disraeli remarked, "We
cannot be wrong, because we have studied the past and we are famous for dis-
covering the future when it has taken place."

The population was divided roughly into two groups; they did not like
the word *classes*. The first, less numerous, was made up of the men and women
who possessed the virtually inborn ability to handle the products of techne
and master the methods of physical science, especially mathematics—it was
to them what Latin had been to the medieval clergy. This modern elite had
the geometrical mind (<216) that singled them out for the life of research and
engineering. The Lord Bacon had predicted that once the ways and biases of
science were enthroned, this type of mind would be found relatively com-
mon. Dials, toggles, buzzers, gauges, icons on screens, light-emitting diodes,
symbols and formulas to save time and thought—these were for this group
of people the source of emotional satisfaction, the means of rule over others,
the substance of shoptalk, the very joy and justification of life.

"The mind was shaped and the fancy filled by these intricacies as had
been done in an earlier era by theology, poetry, and the fine arts. The New
Man saw the world as a storehouse of items retrievable through a keyboard,

and whoever added to the sum was in high repute. He, and more and more often She, might be an inventor or a theorist, for the interest in hypotheses about the creation of the cosmos and the origin of life persisted, intensified, from the previous era. The sense of being close to a final formulation lasted for over 200 years.

"It is from this class—no, group—that the governors and heads of institutions were recruited. The parallel with the Middle Ages is plain—clerics in one case, cybernists in the other. The latter took pride in the fact that in ancient Greek *cybernetes* means helmsman, governor. It validated their position as rulers over the masses, which by then could neither read nor count. But these less capable citizens were by no means barbarians, yet any schooling would have been wasted on them; that had been proved in the late 20C. Some now argue that the schooling was at fault, not the pupils; but when the teachers themselves declared children unteachable, the Deschooling Society movement rapidly converted everybody to its view.

"What saved the masses from brutishness was the survival (though in odd shapes) of a good deal of literature and history from the 500 years of western culture, mingled with a sizable infusion of the eastern. Some among the untutored group taught themselves to read, compiled digests, and by adapting great stories and diluting great ideas provided the common people with a culture over and above the televised fare. It was already well mixed and stirred by the 21C. Public readings, recitals of new poems based on ancient ones, simple plays, and public debates about the eternal questions (which bored the upper class), furnished the minds and souls of the ordinary citizen. This compost of longings, images, and information resembles that which the medieval monks, poets, and troubadours fashioned out of the Greco-Roman heritage. Religious belief in the two ages alike varied from piety, deep or conventional, to mysticism.

"As for social organization, the people were automatically divided into interest groups by their residence and occupation, or again by some personal privilege granted for a social purpose. The nation no longer existed, superseded by regions, much smaller, but sensibly determined by economic instead of linguistic and historical unity. Their business affairs were in the hands of corporation executives whose view of their role resembled that of their medieval ancestors. Not the accumulation of territories but of companies and control over markets were their one aim in life, sanctified by efficiency. The pretext was rarely borne out, but the game prospered and the character of the players followed another medieval prototype: constant nervousness punctuated by violent and arbitrary acts against persons and firms. Dismissals, resignations, wholesale firings of workers and staffs were daily events. There being no visible bloodshed, wounds and distress were veiled. The comprehensive welfare system, improved since its inception, repaired the damage. Its decisions being

all made by computer on the basis of each citizen's set of identity numbers, there could be few tenable grievances. Those due to typing errors would be corrected—in time. There was thus no place for the citizen-voter and the perpetual clash of opinions that had paralyzed representative governments.

"The goal of equality was not only preserved but the feeling of it enhanced. Faith in science excluded dissent on important matters; the method brings everyone to a single state of mind. On the workaday plane, the dictates of numerical studies guided the consumer and the parent, the old and the sick. The great era had ended—by coincidence, no doubt—as it had begun, with a new world disease, transmitted (also like the old) through sexual contact. But intense medical research in due course achieved cure and prevention, and the chief killer ailment was once more heart disease, most often linked to obesity. The control of nature apparently stops short of self-control. But Stat Life, ensured by the many specialized government agencies, inspired successful programs and propaganda in many domains of the secure society. The moral anarchy complained of in the early days of the Interim rather suddenly gave way to a strict policing of everybody by everybody else. In time it became less exacting, and although fraud, corruption, sexual promiscuity, and tyranny at home or in the office did not disappear, these vices, having to be concealed, attracted only the bold or reckless. And even they agreed that the veil is a sign not of hypocrisy but of respect for human dignity.

"As for peace and war, the former was the distinguishing mark of the West from the rest of the world. The numerous regions of the Occident and America formed a loose confederation obeying rules from Brussels and Washington in concert; they were prosperous, law-abiding, overwhelming in offensive weaponry, and they had decided to let outside peoples and their factions eliminate one another until exhaustion introduced peaceableness into their plans.

"After a time, estimated at a little over a century, the western mind was set upon by a blight: it was Boredom. The attack was so severe that the over-entertained people, led by a handful of restless men and women from the upper orders, demanded Reform and finally imposed it in the usual way, by repeating one idea. These radicals had begun to study the old neglected literary and photographic texts and maintained that they were the record of a fuller life. They urged looking with a fresh eye at the monuments still standing about; they reopened the collections of works or art that had long seemed so uniformly dull that nobody went near them. They distinguished styles and the different ages of their emergence—in short, they found a past and used it to create a new present. Fortunately, they were bad imitators (except for a few pedants), and their twisted view of their sources laid the foundation of our nascent—or perhaps one should say, renascent—culture. It has resurrected enthusiasm in the young and talented, who keep exclaiming what a joy it is to be alive."

*
* *

It need hardly be pointed out that the anonymous author's extravaganza did not represent any body of contemporary opinion, only his own. Nor can it be ascertained when and on what grounds his vision of the future occurred to him. But the preceding survey of demotic life and times can be chronologically situated and described as

A View from New York Around 1995

Reference Notes

NOTE: *Readers who look up the marginal quotations will notice that some have been condensed without the usual three dots to show omissions; this was done to save space, restricted as it was by the page design. In some quotations given in translations not my own, I have changed a word here or there for clearer meaning. Most quotations have been left without reference, either because their source is noted in part and easily found, or because they represent widespread views, and to name the writer as if he were the originator would be misleading and in some cases unfair. Latinists will recognize in this the principle stated by another historian, Tacitus: neminem nominabo, genus hominum significasse contentus—"I name no one; it is enough to point out the kind."*

The abbreviations P., L., and N.Y. in the references to place of publication stand for Paris, London, and New York.

For help in verifying these references, I am indebted to my diligent copy editor, Shelly Perron; to Sally Kim at HarperCollins Publishers; and to the equally resourceful James Nielsen of the library staff of the University of Texas at San Antonio.

Prologue

Page

xiv *James* repr. in *Memories and Studies*, N.Y., 1911, p. 318.

 department *New York Times*, August 8, 1995.

 bus culture *New York Times*, September 17, 1995.

 brewing See Samuel Huntington, *The Clash of Civilizations and the Remaking of World Order*, N.Y., 1996.

 coffee table E.D. Hirsch, *Cultural Literacy: What Every American Needs to Know*, Boston, 1987.

xv *to learn* John Cowper Powys, *The Meaning of Culture*, N.Y., 1929, Preface.

xvii *town crier* One did survive: Ralph Smith, of Mariemont, Ohio, near Cincinnati; he died on August 14, 1995, as noted in the *New York Times*.

xviii *Birrell* *Obiter Dicta*, L., 1884, essay on Carlyle.

 Shakespeare The remark is typical of the would-be practical mind—hence no need to name the author. See in the head note above the Tacitus principle.

The West Torn Apart

4 *techne* The word is short and exact; *technology* is neither.

10 *greatest number* Otto Jespersen's doubts about Luther's influence on German would deny the importance of the written word.

11 *Erasmus* Quoted in J.A. Froude, *Life and Letters of Erasmus*, L., 1906, p. 49.

15 *recent date* May 1, 1991.

16 *the legend* On the psychoanalytic view in Erik Erikson's *Young Man Luther*, see Roland H. Bainton's "Psychology and History" in *Religion and Life*, Winter 1971.

Preserved Smith A fuller version, entitled *Life of Luther* in the Bohn series, 2nd ed., L., 1872, is a retranslation, corrected and amplified with useful notes, of Michelet's 19C French translation.

The New Life

21 *discontents* See Sigmund Freud, *Civilization and Its Discontents*, N.Y., 1930.

25 *heavenly body The City of God*, ch. XX.

soul-substance See Josiah Royce, *The Spirit of Modern Philosophy*, Boston, 1893.

27 *human time* See R.C. Churchill, *The English Sunday*, L., 1954.

28 *suicide* Jim Jones led The People's Temple to their death in 1978. Since then David Koresch and his Branch Davidians also perished, and several sections of the Solar Temple aim at the same goal. Millennial cults likewise expecting The End exist in the hundreds throughout the West.

30 *The Mind of the Maker* N.Y., 1941, See the chapter "Scalene Trinities," pp. 149 ff.

38 *of capitalism* See Max Weber, *The Protestant Ethic and the Spirit of Capitalism*, trans. Talcott Parsons, with an Introduction by R.H. Tawney, N.Y., 1958, Chapter V.

may be done "Appeal to the Council of Trent," quoted from his *Eirenikon* in *The Renaissance Reader*, ed. by J.B. Ross and M.M. McLaughlin, N.Y., 1953, p. 666.

39 *William James* "On the Perception of Reality" in *Principles of Psychology*, N.Y., 1890, v. I, p. 321.

40 *being waged* e.g. the resurgent protest in the United States against the teaching of Evolution in the public schools.

42 *Burckhardt: Judgments on History* Notes posthumously published, trans. by Hans Zohn, Boston, 1958, pp. 98,105.

The Good Letters

43 *humanism* A survey of several hundred writers, made in the 1950s by Warren Allen Smith, elicited responses that he classified under seven definitions, including *ancient, classical, communistic*. See *Free Inquiry*, v.1, no.1, and *New York Times*, Oct. 15 and Nov. 8, 1980.

45 *bilingual* On bilingual education in the public schools of the United States, see Jorge Amselle, *The Failure of Bilingual Education*, N.Y., 1996, pp. 111 ff.

46 *footnote* Now a convention under fire. See *New York Times*, August 1996, *passim*.

47 *of the 13th* Besides Henry Adams's *Mont St. Michel and Chartres*, see J.J. Walsh, *The Thirteenth, Greatest of Centuries*, N.Y., 1907.

48 *Middle Ages* Originally published in English in 1923. A new translation by Rodney J. Paxton and Ulrich Mammitzsch under the literal title *The Autumn of the Middle Ages* appeared in 1996 (Chicago Press).

49 *changed emphasis* John Herman Randall in *The Making of the Modern Mind*, N.Y., 1926/1976, p. 118.

50 *admire the view* Revisionists have doubted the climb up Mont Ventoux, but it remains part of the cultural past by its role as a common reference on the love of nature.

53 *Fall of Adam* See the evidence in Norman Douglas, *Old Calabria*, L., 1915 (N.Y., 1956), ch. 21.

54 *Seminal Emission* See the article of that title in *The Bible Review*, February. 1992, pp. 35 ff.

56 *forerunners* See Charles Edward Trinkaus, Jr., "Lorenzo Valla on Free Will," in Ernst Cassirer, ed., *The Renaissance Philosophy of Man*, Chicago, 1948, pp. 147 ff.

61 *Petrarch's handwriting* Actually, italic was based on the current cursive used by the humanists.

62 *of the language* Caxton thus belongs with Dante, Amyot, and Luther, but is rarely given the credit.

63 *and alone* Saint Jerome is said to have been the first to read with his eyes only, no sound or lip movement when reading by himself.

64 *their zoos* For an elephant's painful and picturesque journey by land and sea from Lisbon to Rome, see Silvio A. Bedini, *The Pope's Elephant*, L., 1997.

The Artist Is Born

66 *Cellini* *Two Treatises*, trans. by C.R. Ashbee, L., 1888; N.Y., 1967, pp. 122–23.

67 *a book to read* in the selection made by Edward McCurdy: *Leonardo da Vinci's Notebooks*, N.Y., 1923.

69 *look "natural"* During this period of "good painting" in the West, the Byzantine artists also began to make their works more "natural." See Charles Diehl, *Choses et Gens de Byzance*, P., 1926, pp.146 ff.

70 *and Profane Love* The title is traditional, not Titian's.

 lifelike See H. Pirenne, *Optics: the Illusions of Perspective, Painting, and Photography*, L., 1970.

72 *Notebooks* See note to p. 67 above.

73 *and color* The treatise is by Piero della Francesca, written 1480–90.

74 *about it arose* See J.B. Bury, *The Idea of Progress*, L., 1920, p. 35*n*.

75 *stored in books* See preceding note.

 H. Ruhemann N.Y., 1948.

79 *representatives* Ralph Roeder, *The Man of the Renaissance: four lawgivers*, Cleveland, 1933.

80 *Diary of 1580–8* in English in *Montaigne's Complete Works*, trans. by Donald M. Frame, Stanford, 1948.

81 *Beaumarchais' play* See a modern translation by J. Barzun in *Phaedra and Figaro*, N.Y., 1961 (Racine's *Phèdre* was translated by Robert Lowell).

84 *Drummer Boy* charcoal and pastel at The Century Association, New York.

87 *of women* An exhaustive and highly readable survey entitled *"The Landmarks of Classic Feminism From Plato to the Seneca Falls Convention of 1848"* was written by Harrison and Edna Steeves in the 1960s. It remains unpublished. The typescript entrusted by the authors to my care and gratefully used in this book is now in the Columbia University Rare Book Library. See also M.P. Hunnay, *Tudor Women as Patrons, Translators, and Writers of Religious Works*, Kent State, Ohio, 1985.

Cross Section: The View from Madrid

94 *life and honor* His message is traditional. What he actually wrote to his mother on Feb. 23, 1525 was: "The only thing left to me is honor, and my life is saved."

98 *Caribbean island* Which one is still argued over. See *New York Times*, Oct. 12, 1985; and Samuel Eliot Morison, *Christopher Columbus, Mariner*, Boston, 1942; in paperback, N.Y., 1985.

 implausible ones The list includes the Phoenicians, Romans, and Chinese; St. Brendan in the 6C; Herjohfson and Leif Ericson; the Welsh prince Madoc; the brothers Zeno and the Pole Jan Korno; some English fishermen and Portuguese sailors a decade before Columbus; and in his time, the Venetians; a French claim stated that the Gauls had been first.

99 *deception* See Morison, note to p. 98 above.

100 *anniversary year* There was no celebration of Columbus in the United States until 1792. Young Washington Irving was soon a glorifier, while Charles Francis Adams and Justin Winsor the historian were early detractors.

 and the Gospel The phrase, used in his lectures, is William R. Shepherd's, professor of history at Columbia University in the 1920s.

101 *80 years ago* A.H. Lybyer, "The Ottoman Turks and the Routes of Oriental Trade," *English Historical Review*, October 1915, pp. 577 ff.

102 *corrupted politics* See Woodruff D. Smith, "Complications of the Commonplace: Tea, Sugar, and Imperialism," *Journal of Interdisciplinary History*, Autumn 1992, pp. 259 ff.

 poetry and prose On various names and meanings of *tobacco*, see Isaac Taylor, *Words and Places*, L., 1864/1921, p. 360.

103 *Oliver Warner* A British Council Publication, L., 1958. See also James Anthony Froude, *English Seamen of the Sixteenth Century*, N.Y., 1898.

 at her nose *Comedy of Errors*, III, ii (1592).

104 *America unlikely* Vespucci is named Alberigo in documents of his time, which has suggested that it was America that gave its name to him in the form *Amerigo*. See Sir William Fraser, *Hic et Ubique*, L., 1893, p. 103.

108 *1789 revolution* See J. Barzun, *The French Race: Theories of its Origins and Their Social and Political Implications*, N.Y., 1932.

110 *of his age* J.B. Trend, *The Civilization of Spain*, L., 1944, p. 101.

112 *hallucinations* See Piero Camporesi, *Food and Fantasy in Early Modern Europe*, N.Y., 1989.

and the dance Among users of the legend besides Marlowe and Goethe: Delacroix, Berlioz, Bonington, Schumann, Liszt, Gounod, Boïto, and Busoni.

114 *demand for surnames* Quoted in J.P. Hughes, *Is Thy Name Wart?*, L., 1965, p. 17. See also C.M. Matthews, *English Surnames*, N.Y., 1967.

115 *their validity* J.H. Brennan, *Nostradamus: Visions of the Future*, N.Y., 1992.

The Eutopians

117 *our own day* See John Rawls, *A Theory of Justice*, rev. ed., Cambridge, Mass., 1999.

121 *with speeches* See Edward E. Lowinsky, "Music in the Culture of the Renaissance," *Journal of the History of Ideas*, Oct. 1954, pp. 509 ff.; see also the exhaustive study of one city: Frank A. D'Accone, *The Civic Muse: music and musicians in Siena during the Middle Ages and the Renaissance*, Chicago, 1997.

124 *Long live Gonzalo* *The Tempest*, II, i.

125 *Counter-Renaissance* See the work of that title by Hiram Haydn, N.Y., 1950.

133 *Albert Jay Nock* Illustrated, N.Y., 1934.

134 *be mistaken* Letter to the General Assembly of the Scottish Church, Sept. 1643.

140 *reference to it* *The Tempest*, I, ii.

142 *gentlemanly pursuit* See Alfred Harbage, *As They Liked It*, N.Y., 1947.

 tabulated See *The Shakespeare Allusion Book*, by successive editors, London, 1909/1932, 2v.

143 *one of Shakespeare's* In *Twelfth Night* (V, i) it is the "whirligig of time"; E.E. Kellett coined from it *The Whirligig of Taste*, L., 1929.

Epic & Comic Lyric & Music Critic & Public

153 *tip of Africa* Encouragingly renamed Cape of Good Hope by King John II of Portugal.

 to the colonists See J.B. Trend, *The Civilization of Spain*, L., 1944.

154 *no musician* The judgment is by Saint-Saëns, an intimate.

 period as a whole See Cecil Gray, *The History of Music*, L., 1928/1947.

155 *in favor* See Ernest H. Wilkins, "A General Survey of Renaissance Petrarchism," *Comparative Literature*, Fall 1950.

158 *pluck the strings* The word *jongleur* now means *juggler* but, derived from the Latin *jocum*, it was long used for any person playing, including playing jokes.

159 *dated 1470* See Joan Peyser, ed., *The Orchestra*, N.Y., 1986.

 recent times See Harold Rosenberg, *The Tradition of the New*, N.Y., 1959.

161 *on a shutter* Six more lines add nothing to the sentiment. See Thomas Percy, *Reliques of Ancient English Poetry*, new ed., L., 1847, v.2, p. 134.

162 *Pasquier* in *Recherches de la France*, 1560, Bk VII, ch. vii.

166 *Spingarn* *A History of Literary Criticism in the Renaissance*, 2nd ed., 1954. See also Marvin T. Herrick, *The Fusion of Horatian and Aristotelian Literary Criticism*, 1531–1555, Urbana, Ill., 1946.

Cross Section: The View from Venice

170 *Nicolson* See *Diplomacy*, L., 1939, p. 51.

171 *was frequent* Galileo died on Jan. 8, 1642; Newton was born on Dec. 25, 1642, which would be Jan. 5, 1643 on the Continent. England adopted the Occidental calendar in 1752; Russia in 1918.

174 *inherently absurd* See his small book *What Is Art?*, first published in English in 1898. It is coupled with *The Kingdom of God* in the N.Y. edition of 1899 (Thomas Crowell).

175 *Gascony* See Geoffrey F. Hall and Joan Sanders, *D'Artagnan the Ultimate Musketeer*, Boston, 1964.

182 *important points* See "The Significance of John Amos Comenius at the Present Time," Introduction to *Comenius on Education*, Teachers College Classics No. 33, N.Y., 1967.

183 *gastronomy* The word was not used until the 19C, but the reality is attested by the facts in Jean-Francois Revel, *Culture and Cuisine*, N.Y., 1982, ch. 6.

184 *reappearance in 1997* A new design of blue jeans called Flip Fly: news item Dec. 7, 1997.

185 *memoirs of the day* For example the five volumes of *Historiettes* by Tallemant des Réaux (c. 1655–1660).

186 *theological bar* For the details, see note to p. 87.

The Invisible College

191 *dates from 1840* Proposed by William Whewell, of Trinity College, Cambridge, in *The Philosophy of the Inductive Sciences*, L., 1840, it was adopted without opposition.

192 *of the moderns* See Neil C. Van Dusen, *Telesio, the First of the Moderns*, N.Y., 1932.

 not 1600 Published for the Board of Education and the Science Museum by His Majesty's Stationery Office, L., 1939.

196 *it didn't* To sort out Galileo's ideas from conventional notions, see James Brophy and Henry Paolucci, *The Achievement of Galileo*, N.Y., 1962.

200 *market at work* See P.J. Davis and Reuben Hersh, *Descartes' Dream*, Boston, 1986. and Alain Laurant, *Du Bon Usage de Descartes*, P., 1996.

202 *heart-and-mind* See Wm. Theodore De Bary, *Message of the Mind*, N.Y., 1989, General Introduction.

206 *as a debit* See A.C.L. Day, *The Economics of Money*, L., 1959, pp. 150–151.

210 *Skeptical Chemist* Not *only* a chemist, Boyle framed the familiar "Boyle's Law" on the behavior of gases.

211 *dated 1670* See Saul Jarcho, "Seventeenth-Century Medical Journalism," *Journal of the American Medical Association*, April 3, 1972, p. 32.

215 *on love* For its authenticity, see Morris Bishop, *Pascal, the Life of Genuis*, N.Y., 1936.

218 *Scientific Biography* N.Y., 1970, 15v.

222 *Democritus Junior* The name implies "cheerful philosopher." Democritus Senior was an ancient Greek sage reputed to be always laughing at the follies of mankind.

a cathedral The poet was Frederick Mortimer Clapp, in conversation.

Bergen Evans The title page adds: In consultation with George W. Mohr, M.D.

222 *at John Hopkins* See Dale Keiger, "Touched with Fire," *Johns Hopkins Magazine*, Nov. 1993, pp. 38 ff.

An Interlude

225 *the late 17C* See Nathan Edelman, "Early Uses of medium aevum, moyen âge, middle ages." *Romanic Review*, Fall 1938, pp. 327 ff. See also George Gordon, "Medium Aevum and Middle Age," Society for Pure English , *Tract 19*, 1925.

dark is vague; the period has also been called muddy, rusty, leaden, monkish, and Gothic. See preceding note, *Tract* 19, p. 15.

individual freedom In France, the histories of Guizot—of France and of Europe—led the way for the later theorists of race; in England, "Saxonism" began earlier, see note to p. 108.

226 *in detail* See Ferdinand Lot, *The End of the Ancient World*, N.Y., 1931; R.W. Southern, *The Making of the Middle Ages*; Marc Bloch, *Feudal Society*, Chicago, 1961, 2v.; Carolly Erickson, *The Records of Medieval Europe*, an anthology, N.Y., 1971.

for the post See Marc Bloch in preceding footnote, v.2, p. 343.

impetuous and violent Ibid, pp. 410 ff.

227 *Agincourt* Quoted in Patrick Devlin, *The Judge*, Chicago, 1981, p. 170 *n2*, quoting John Keegan, *The Face of Battle*, L., 1979, p. 112.

Coleridge's poem Kubla Khan, or *A Vision in a Dream*, 1797.

habits of thought See George L. Burr "The Year 1000 and the Antecedents of the Crusades." *American Historical Review*, April 1901, pp. 429 ff.

228 *the professions* See Jacques Le Goff, *Les Intellectuels au Moyen Age*, P., 195

229 *with impunity* For the student life and university administration, see Pearl Kibre, *The Nations in the Mediaeval Universities*, Cambridge, Mass., 1945.

Carmina Burana Settings of medieval lyrics, mostly joyful, found in the Benediktbeuren monastery in Bavaria. See Helen Waddell, *The Wandering Scholars* (discussion and translations of songs), N.Y., Anchor Books, 1955; and Anthony Bonner, *Songs of the Troubadours* (with musical examples), N.Y., 1972.

232 *fabliaux* See below last note for this page.

and importance See H.S. Bennett, *Chaucer and the Fifteenth Century*, N.Y., 2nd ed., 1954, pp. 8 ff.

no of She was born in Domrémy, therefore not "of Arc." The confusion arose with her legend.

needs interpreting See R. Howard Bloch, *The Scandal of the Fabliaux*, Chicago, 1986.

Monarchs' Revolution

244 *of the robe* For example, Montesquieu inherited from his father the judgeship that the latter had bought.

to start with His rise owed much to his sister Arabella's being the mistress of the Duke of York, later James II.

fraudulent See Jean de Bonnefon, *Les Curiosités héraldiques*, P., 1912.

245 *vile bourgeoisie* See p. 295 for exact meaning of this phrase.

246 *On the Republic* See Julian H. Franklin, *Jean Bodin and the Sixteenth Century Revolution in the Methodology of Law and History*, N.Y., 1963.

247 *theories of race* For an example of its innocent genesis in medieval history, see Books XXX and XXXI of Montesquieu's *Esprit des Lois* (1748).

249 *We not I* The custom began with the Roman Emperors, who are thought to have had in mind the large number of countries of which they were the highest authority, making as it were a collection of emperors.

250 *voice of God* See George Boas, *Vox Populi, Essays in the History of an Idea*, Baltimore, 1969.

limited monarchy See Paul Doolin, "The Kingdom of France in the Last Three Centuries of the Ancien Régime Was a Limited Monarchy." Paper given at the American Historical Association Meeting in N.Y. City, Dec. 1940.

251 *has two bodies* See Ernst H. Kantorovich, *The King's Two Bodies*, Princeton, 1981.

people perform See Diderot's description in *Rameau's Nephew* of the "little dance" (figurative) that everybody, high and low, must go through repeatedly in front of royalty.

253 *of the earth* This account, shortened, is drawn from *Chéruel, Dictionnaire Historique des Institutions, Moeurs et Coutumes de la France*, P., 1885, v.2, 1117 ff.

259 *Vettori* The letter is dated Dec. 10, 1513.

Puritans as Democrats

262 *and Music* by Percy Scholes, N.Y., 1962.

266 *of his own* See William Haller, *The Rise of Puritanism: The Way to the New Jerusalem as Set Forth in the Pulpit and Press from Thomas Cartwright to John Lilburne and John Milton, 1570–1643*, N.Y., 1938/1965.

267 *social justice* See John Rawls, *A Theory of Justice*, rev. ed., Cambridge, Mass., 1999.

268 *his Politics* See his work of that title, Book III, ch. 10, and Book IV, ch. 12.

272 *our century* See in its *Bulletin* for Dec. 1991, the conclusion of volume I of a five-year study of Fundamentalism conducted by the American Academy of Arts and Sciences; and also William H. McNeill, "Fundamentalism and the World of the 1990s," *Bulletin* for Dec. 1993.

277 *sense of longing* Quoted in Charles Harding Firth, *Oliver Cromwell and the Rule of the Puritans in England*, L., 1900, repr. L., 1953, p. 381.

278 *independent sects* The adjective here stands for the small dissident groups who favored toleration, not those known as the Independents, who were against it. See "Orthodoxy in England and New England, 1640–1650" in *Proceedings of the American Philosophical Society*, 1991, p. 401.

279 *William Penn* His deserved reputation as the establisher of tolerance in Pennsylvania has obscured his stormy political career, spent mostly in England. See Joseph Illick, *William Penn the Politician*, N.Y., 1965.

279 *alleged misdeeds* *The Apologia of Robert Keayne, the Self-Portrait of a Puritan Merchant*, ed., Bernard Baylin, N.Y., 1964. Superb editing has made a difficult text intelligible in half the number of pages that the probate court had to deal with.

Reign of Etiquette

285 *untenable position* Press conference, *New York Times*, June 29, 1958.

Business of Kings See Gabriel Boissy, ed., *Pensées choisies des rois de France*, P., 1920, p. 197; see also pp. 144–45 *nn*.

289 *surgery* This practice was inaugurated when president Eisenhower's ileitis was diagnosed.

291 *the king's use* See Gabriel Hanotaux, *Etudes Historiques*, P., 1886, pp. 262 ff.

293 *political debate* See *Le Monde* passim after the French elections of 1997.

294 *were asked* On this and related details, see Chéruel, *Histoire de l'Administration monarchique en France*; James E. King, *Science and Rationalism in the Government of Louis XIV*, N.Y., 1972; Paul Beik, *A Judgment of the Old Regime* (Columbia University dissertation, 1943); and Lionel Rothberg, *Opposition to Louis XIV*, Princeton, 1965.

early 20C See the work by James E. King in preceding note.

this century See records in the Columbia University Rare Book and Manuscript Library.

Charlemagne See note to *fraudulent* on p. 244.

295 *a monarchy* See J. Barzun, *The French Race, Theories of Its Origins and Their Social and Political Implications*, N.Y., 1932.

302 *and elsewhere* See Barbara Swain, *Fools and Folly During the Middle Ages and The Renaissance*, N.Y., 1932.

303 *Grand Design* See Edwin D. Mead, ed., *The Great Design of Henry IV from the Memoirs of the Duke of Sully*, with "The United States of Europe" by Edward Everett Hale, Boston, 1909.

304 *considered foreign* The others were: *pays* of the state; *pays* formerly self-taxing (*élection*); *pays* of custom law; *pays* of written law; self-ransomed for paying one tax only (*rédimé*).

no French So said the Abbé Grégoire, which may be too broad a generalization. These non-speakers must have sung the French words of the Marseillaise as they marched to Paris to celebrate the 14th of July.

Cross Section: The View from London

312 *drive him away* See Trevor H. Hall, *New Light on Old Ghosts*, L., 1965. In *Poltergeists*, N.Y., 1959, Sacheverell Sitwell prints the diaries and letters of the Wesley family about the manifestations: pp. 157 ff.

ever been found See Rupert T. Gold, *Oddities*, L., 1928, ch. 5, for pictures of the machine and reports of the tests.

313 *patriote* Earlier it meant only *native, compatriot*.

Vauban quotation and all details on fortification are from Christopher

Duffy, *The Fortress in the Age of Vauban and Frederick the Great, 1660–1789*, L., 1985, pp. 72 ff.

314 *Laurence Sterne* Uncle Toby's obsession with the siege of Namur is entertaining and instructive.

New Science Translated from the 3rd ed., 1744, by T.G. Bergin and M.H. Fisch, Ithaca, N.Y., 1948. See also Vico's *Autobiography*, trans. by M. H. Fisch and T.G. Bergin, N.Y., 1944.

317 *their lot* See Robert Beverley "The Historical and Present State of Virginia," L., 1705, quoted in *The Annals of America*, Chicago, 1968, v. 1, pp. 326, 329.

318 *Du Bartas* This Huguenot poet, who fought under Henry IV, wrote *The Week of Creation*, a religious work which, translated by Joshua Sylvester, went through 30 editions in a few years.

not disown See Wilfred Mellers, *Music in a New Found Land*, N.Y., 1965.

13 or 14 The high school had not been invented and *college* was not *university*, but the site of passage from *pupil* to *student*.

319 *between 1719 and 1727* Alexander Isaevich Solzhenitsyn, *The Russian Question at the End of the Twentieth Century*, N.Y., 1994.

321 *Anonymous French squib* My translation is virtually word for word.

governors See Tim Congdon, "John Law and the Invention of Paper Money," *Journal of the Royal Society of Arts*, January, 1991.

322 *into money* Swift's *Examiner No. 13*, Nov. 2, 1710, pp. 916 ff.

non-fiction novel This term has been made ambiguous by its application to novels closely based on contemporary facts. My original use of it in *The Atlantic Monthly* (July 1946) and again in *The Energies of Art* (1956, p. 125) was to designate novels such as Kafka's, André Gide's and C.P. Snow's, in which the atmosphere of fiction is absent and that of a factual report is present, though the story is entirely invented.

323 *letter writer* For her letters to her future husband, see Edward Abbott Parry, *Letters From Dorothy Osborne to Sir William Temple (1652–1654)*, Wayfarer's Library, L, n.d.

Timon's manner The allusion is to an ancient Greek story and possibly to Shakepeare's *Timon of Athens*.

324 *resort to it* See Jae Nunn Lee, *Swift and Scatological Satire*, Albuquerque, N.M., 1971.

325 *of Dr. Swift* See the commentary in *Master Poems of the English Language*, ed., Oscar Williams, N.Y., 1966.

sweetness and light The phrase, often attributed to Matthew Arnold, occurs early in Swift's *Battle of the Books*.

Alzheimer's disease For diagnoses other than madness, see Milton Vogt, *Swift and the Twentieth Century*, Detroit, 1964.

minor poets Waller and Denham. See Edmund Gosse, *From Shakespeare to Pope*, L., 1885.

326 *qualified scholars* See Ernest Weekley, *Something About Words*, L., 1936.

of King Lear See Hazelton Spencer, *Shakespeare Improved*, Cambridge, Mass., 1927.

328 *The Messiah* now called *Messiah*, without *the*, by misguided persons who want
to reproduce Handel's unidiomatic notation on the score.

Trajan See Linoln Kirstein, *Four Centuries of Ballet*, N.Y., 1970/84, p. 94.

329 *each product* See note to p. 183.

330 *of the Guards* The name is possibly the anglicized form of *Condom*, a
cathedral town and county seat in southwestern France. Bossuet was bishop
of Condom.

Opulent Eye

338 *of the kind* See Philip John Stead, *The Police of Paris*, L., 1957.

340 *Scudéry* The full title is *Artamène ou le Grand Cyrus*, P., 1650, 12,000 pp.

convolution For Calderón in translation, see (besides a fragment by Shelley),
Kathleen Raine and R.M. Nadal, *Life's a Dream*, N.Y., 1968. In Eric Bentley's
series of translations called *The Classic Theatre* (Anchor Books, N.Y., var. dates,
there is a volume of Spanish plays that includes Calderón.

341 *Corneille to Voltaire* See preceding note for translations in the volumes of *The
Classic Theatre*.

342 *Phaedra* in *Phaedra and Figaro*, respectively translated by Robert Lowell and
Jacques Barzun, N.Y., 1961.

346 *the people* for a full survey of Molière's language see F. Génin, *Lexique . . . de
la langue de Molière*, P., 1846,

347 *Locke's* The comparable works are dated 1643 and 1690, Gassendi's the
earlier. For a modern revaluation of his influence, see his entry in the
Dictionary of Scientific Biography.

Saint-Evremond His friend Des Maizeaux persuaded him to allow publication
of the works, translated into English, in three volumes, L., 1728. The *Letters of
Saint-Evremond*, also in English, were published with an engaging introduction
by John Hayward, L., 1930.

350 *of soul* There is no adequate version of the *Maxims* in English, because the
conciseness is hard to reproduce, but for the sense the translation by Louis
Kronenberger (N.Y., 1959) may generally be relied on.

351 *of the form* For comparison, see Richard Aldington, *A Book of Characters*, L.,
n.d.

352 *750 pages* The French text in the edition by A. Chassang, *Oeuvres Complètes*,
P., 1876, 2 v., has a useful discussion of La Bruyère's method and his language.

354 *modern improvements* William James to his parents, May 27, 1867, in *The Letters
of William James*, L., 1920, v. I, p. 87.

of any period See George P. Marsh, *Lectures on the English Language*, N.Y., 1880,
p. 263.

dead corpses it occurs twice, in 2 Kings 19.35 and Isaiah 37.36.

sitting position The definition is Russell Baker's in the *New York Times*, Feb. 17,
1996.

356 *English neither* Thomas Rymer.

Encyclopedic Century

360 *historical and critical* Originally planned as a repertory of the errors in Moréri; Bayle's was published in *two* folio volumes, 1697.

361 *Philosophic Dictionary* This is not the work in two or more volumes that have been put together by later editors from miscellaneous pieces by Voltaire related to philosophy and religion.

a hundred religions The saying is attributed to Marquis Caraccioli, the ambassador from Naples, and he did not say a hundred—only sixty.

for him E. Beatrice Hall, writing as S.G. Tallentyre in *The Friends of Voltaire*, L., 1906, p. 199 and, slightly modified in *Voltaire in His Letters*, L., 1919, p. 65. See Burdette Kinne in *Modern Language Notes* for November 1943.

364 *Spirit of the Laws* The first, widely read, translation into English by Henry Reeve is marred by mistakes. Revision by Phillips Bradley appeared in N.Y. in 1945, and a new version by George Lawrence, L., 1969. This last is an improvement but still improvable.

what they read See Bernard Faÿ, *The Revolutionary Spirit in France and America*, N.Y., 1927.

366 *explicit statements* particularly in his four letters to Dr. Bentley; see Derek Gjertsen, *The Newton Handbook*, L., 1986, pp. 176, 218–9, 348, and 461–4.

367 *refute it thus* Boswell's *Life of Johnson*, August 5, 1763.

369 *available* The most popular was Moréri's in one volume (1674/1691), which Bayle accused of Catholic bias.

370 *Journal de Trévoux* originally *Mémoires de Trévoux*. The change of title suggests a more miscellaneous audience to be reached and persuaded.

371 *Diderot's work* See D.H. Gordon and N.L. Torrey, *The Censoring of Diderot's Encyclopédie and the Re-established Text*, N.Y., 1947.

372 *excellent reading* See Louis Biancolli, ed., *The Book of Great Conversations*, N.Y., 1948.

373 *with variations* As late as the 1980s, an American university press issued a book in which this *canard* was made much of.

lines of Virgil In his *Letter on the Deaf and Dumb* (1759) about art and esthetics.

374 *misapplied* See J. Barzun "Why Diderot?" in Stanley Burnshaw, *Varieties of Literary Experience*, N.Y., 1962.

of matter See the "Conversation Between D'Alembert and Diderot," in J. Barzun and Ralph Bowen, *Rameau's Nephew and Other Works*, N.Y. (Anchor Books), 1956.

radical empiricist The term is defined and the principle applied in James's *Essays in Radical Empiricism*, L., 1912.

375 *named after him* For a concise summary of Franklin's scientific work, see Samuel Devons, "Franklin as Experimental Philosopher" in *American Journal of Physics*, Dec. 1977.

377 *Bernoulli* Sometimes spelled Bernoulli.

378 *Anthony Hecht Poem Upon the Lisbon Disaster* (bilingual text), Lincoln, Mass. 1977.

379 *made from it* Lyrics by Richard Wilbur, music by Leonard Bernstein.

379 *Charles XII* King of Sweden, famous as soldier, defeated by Peter the Great in 1718 and killed while invading Norway.

384 *of perfection* See George R. Havens, *Voltaire's Marginalia on the Pages of Rousseau*, Columbus, Ohio, 1933.

385 *government* See Mary Osborn, *Rousseau and Burke*, N.Y., L., 1940.

386 *M. Angard* in M.J. Gaberel, *Rousseau et les Genevois*, Geneva, 1858, pp. 143–44.

 forward to nature This is the persuasive theme of Ernest Hunter Wright's *The Meaning of Rousseau*, L., 1929.

390 *the clarinet* For further details, see Joan Peyser, ed., *The Orchestra: Origins and Transformations*, N.Y., 1986.

 other way around Ibid.

Cross Section: The View from Weimar

395 *in Frankfort* See his account in the autobiography *Poetry and Truth*, Bk II, paragraph 4.

 the oppressed See especially *The Brigands*, his early play urging rebellion against all existing institutions and all "the fathers."

398 *Canada* See the details of persecution in Colin Nicolson, "McIntosh, Otis, and Adams Are Our Demagogues," in *Proceedings of the Massachusetts Historical Society* for *1996*, Boston, 1998, pp. 73 ff.

406 *a curiosity* by amateurs on the Columbia University campus in 1928. For a comprehensive survey, see Kenneth Silverman, *A Cultural History of the American Revolution*, N.Y., 1987.

407 *musical people* See Wilfrid Mellers, *Music in a New Found Land*, N.Y., 1965.

408 *New Man, the American* The phrase was coined by J. Hector St. John, pseud. of M.G.J. de Crèvecoeur, about the Americanized European, in his book *Letters From an American Farmer*, L., 1782.

411 *Great Cham* The despotic ruler of Tartary; the title is a form of *Khan*; the nickname was given Johnson by Smollett.

412 *Ramblerese* Johnson said first: "It has not enough wit to keep it sweet," and at once rephrased it: "It has not vitality enough to keep it from putrefaction." The remark referred to the Duke of Buckingham's comedy, *The Rehearsal*. The anecdote is in Boswell, May 30, 1984.

 masterly writing For the mutual misunderstanding, see J.H. Sledd and G.J. Kolb, *Dr. Johnson's Dictionary*, Chicago, 1955, ch. 3.

413 *claim to it* Abbé Redonvilliers of the French Academy: *De la manière d'apprendre les langues*, P., 1768; and Nicolas Adam, *Vraie manière d' apprendre une langue quelconque*, P., 1787.

414 *of Figaro* It is more properly Figaro's *wedding* that is the pivot of the play.

418 *Gluck's work* It is limited to parts of *Idomeneo, Rè di Creta*, an operia seria, 1780.

420 *La Poupelinière* Wealthy tax farmer, pupil of Rameau, and patron of musicians, who first introduced horns, clarinets, and the harp into his private orchestra.

 Madeleine B. Ellis Baltimore, 1966.

421 *queen's necklace* Dumas' novel, *The Queen's Necklace* gives in the opening chapters a good portrait of Cagliostro.

422 *and thinker* New editions appeared in 1820 and 1825, and it was reprinted in *The Oxford Library of Prose and Poetry*, ed., W.A. Gill, Oxford, 1912.

Forgotten Troop

425 *social system* On some of the debated points, see J.R. Censer, ed., *The French Revolution and Intellectural History*, Chicago, 1989.

427 *the nation* See Crane Brinton, *The Jacobins*, N.Y., 1930.

429 *I lived* The usual translation "I survived" does not express what the original implies: he did not say "J'ai survécu"; *living* was by itself an extraordinary feat.

427 *their friends* See F.J. C. Hernshaw, ed., *The Social and Political Ideas of Some Representative Thinkers of the Revolutionary Era*, L., 1931.

433 *conspirators* See Bernard Faÿ, *La Franc-Maçonnerie et la révolution intellectuelle du XVIIIè siècle*, P., 1942.

436 *than others* Guedalla coined the phrase in "A Russian Fairy Tale" (*The Missing Muse*, L., 1927). Much later, Orwell popularized the idea, but it is likely that he arrived at it independently.

437 *John E. Lesch* See also David M. Vess, *Medical Revolution in France 1789–96*, Gainesville, Florida, 1975.

 psychiatrist On this and related subjects, see the pioneering papers of Dora Weiner in various learned journals.

439 *of his death* His life and work are detailed in John Edmonds Stock, *Memoirs of the Life of Thomas Beddoes, M.D.*, L., 1811, a remarkable book of 500 pp., all in one chapter. For a summary, see J. Barzun, "Thomas Beddoes, or Medicine and Social Conscience," *Journal of the American Medical Association*, April 3, 1972, pp. 50 ff.

440 *Notebooks* For a selection of Lichtenberg's Aphorisms and Letters, with a detailed account of his life, see F.H. Mautner and Henry Hatfield, eds., *The Lichtenberg Reader*, Boston, 1959; and for the complete writings in German, *Werke*, with an Afterword by Carl Brinitzer, Hamburg, 1967.

441 *Universal Peace* See Theodore Caplow, *Peace Games*, Middletown, Conn., 1989.

445 *54 inches by 28* The present account is almost entirely based on Robert Solé, *Les Savants de Bonaparte*, P., 1998. See also Christopher J. Herold, *Bonaparte in Egypt*, N.Y., 1962.

448 *and of literature* So says the *Encyclopedia Britannica*, 15th ed. (micropedia) under his name.

449 *de la Bretonne Les Nuits de Paris or the Nocturnal Spectator*, N.Y., 1964. See also Alex Karmel, *My Revolution*, a semi-fictional autobiography based on Restif's "Journals," 1789–94; N.Y., 1970. For a recent study of De Sade, see Francine du Plessix Gray, *At Home With the Marquis de Sade*, N.Y., 1998.

 in fiction He appears in half a dozen of Balzac's novels as Jacques Collin—his "real" name, made up by Balzac—then as Vautrin in *La Dernière incarnation de Vautrin*, 1845.

English translation Bohn edition, 1854. The French is in 4 volumes, 1828.

450 *her contemporaries* See Christopher J. Herold, *Mistress to an Age: a Life of Mme de Staël*, L., 1959.

453 *Weltanschauungen The Physiology of Taste: Transcendental Meditations on Gastronmony*, N.Y., 1948, a very poor translation.

454 *deficiency* For a reasoned and entertaining account of English dishes, see Rupert Croft-Cooke, *English Cooking: A New Approach*, L., 1960.

455 *of the past* The phrase occurs in the *Réflections* of the Duc de Lévis dated 1808. The duke lay claim to descent from the oldest noble family in France, an ancestor having presumably taken part in the first crusade. The idea of *noblesse oblige* thus took a long time to germinate.

 two-volume work *Zoonomia*, L., 1794, translated into German, 1796–97.

457 *their life* Quoted in Mao-han Tuan, *Simonde de Sismondi as an Economist*, N.Y., 1927, p. 38.

458 *Salpêtrière* The present account of these two women relies on the work by H.R. and Edna Steeves cited in note to p. 37 and on Simon Schama's *Citizens*, see p. 426. See also Gwyn A. Williams, *Artisans and Sans-Culottes*, N.Y., 1969.

 Rights of Women A paperback reprint of the 2nd ed., L., 1792, was published by Dover Books, Mineola, N.Y., 1996.

454 *recent works* See Boris Schwartz, *French Instrumental Music Between the Revolutions, 1789–1830*, N.Y., 1987; and Jean Mongrédien, *La musique en France des Lumières au Romantisme*, P., 1906.

461 *our time* Hélène Delavault.

462 *the beholder* Blake's marginalia on the *Discourses* overlook this shift and are to that extent unjust to Reynolds.

The Work of Mind-and-Heart

466 *of ideas* the late Arthur Lovejoy, of Johns Hopkins University.

467 *romantic(ism)* In *Classic, Romantic, and Modern*, Boston, 1943/1961.

 not romantic *Ibid.*, p. 158.

475 *Work of Art* Dan Hofstadter, *The Love Affair as a Work of Art*, N.Y., 1996.

478 *professor* at the Jardin des Plantes— the botanical garden, but in part a zoo where Barye could study the animals he wanted to sculp.

480 *and by Hugo* For example "L'Egout de Rome" in *Les Châtiments*, Bk VII (1852).

 is in art Preface to his first play *Cromwell*, a ringing manifesto for artistic freedom (1827).

 20C poets See P. Thieme, "Notes on Victor Hugo's Versification," in *Studies in Honor of A. Marshall Elliot*, Baltimore, 1911, v.I.

 one of his works His monumental and posthumous autobiography, *Mémoires d'Outre-Tombe* (1849–50).

482 *for the future* See J. Barzun "Romantic Historiography as a Political Force in France," *Journal of the History of Ideas*, June 1941.

 History of Mankind See the edition in English, abridged and introduced by Frank E. Manuel, Chicago, 1968.

483 *set of novels* Scottish and medieval.

485 *reconnoiter* See Thomas Hardy's short stories and reminiscences, passim.

486 *kindred satires* *The Vision of Judgment* and *Beppo* (1818–1820).

 two-syllable rimes The precursor of W.S. Gilbert in the operas that he created with Arthur Sullivan.

488 *Peabody* She was the model, unconsciously on Henry James's part, for Miss Birdseye in *The Bostonians*.

Cross Section: The View from Paris

492 *the omnibus* The first company failed. See L.A.G. Strong, *The Rolling Road*, L., 1956, pp. 93 ff.

494 *cobblestones* For a summary of the official report, see *Le Romantisme*, Bibliothèque Nationale *Catalogue*, P., 1930, pp. 174 ff.

495 *Hoffmann* originally E.T.W. (for Wolfgang). He changed W. to A. in honor of Mozart, whose second given name was Amadeus.

496 *Romanticist music* See Katherine Kolb Reeve, *The Poetics of the Orchestra in the Writings of Berlioz*, Yale dissertation, 1978.

497 *American South* Nat Turner's rebellion to free the slaves, one of several about that time in the southern American states and the West Indies.

498 *of the century* See Angus Holder, *Elegant Modes in the Nineteenth Century*, L., 1935.

499 *great applause* For a picturesque description of the preparation and premiere of *Robert the Devil*, see Mark Edward Perugini, *The Omnibus Box*, L., 1946, Ch. IV. See also: William L. Crosten, *French Grand Opera, an Art and a Business*, N.Y., 1948.

505 *American Scholar* The quarterly review that bears this title is an organ of the Phi Beta Kappa Society and aims at furthering Emerson's conception of culture.

506 *imperial self* The phrase is Quentin Anderson's. See his book of the same title, subtitled *an Essay in American Literary and Cultural History*, N.Y., 1971.

 on government For a critique, see J. Barzun, "Thoreau the Thorough Impressionist," *American Scholar*, Spring 1987.

 narrative thread Ibid., pp. 255 ff.

509 *revolutionary* See A. Véra, *Introduction à la philosophie de Hegel*, P., 1844, pp. 4 ff.

 behind physics The derivation of the word has been questioned by some who say it arose when copyists placed his philosophy *after* (*meta*) his *Physics*. A wit accordingly redefined metaphysics as "an author's instructions mistaken by his bookbinder."

 a feminist A similar liaison had the same effect on John Stuart Mill. See his *Autobiography*, ed., Mortimer J. Adler, N.Y., 1924.

512 *Harold Bloom* Said at the Shakespeare Conference, Bowie State University, Dec. 5, 1998.

 John Kinnaird See his *William Hazlitt, Critic of Power*, N.Y., 1978; and for the details of his life, P.P. Howe, *William Hazlitt*, L., 1922 (Penguin ed. 1949).

515 *Wozzeck* The original name is Woyzeck, corrupted by mistake. See *The Plays of Georg Büchner*, trans. Geoffrey Dunlop, N.Y., 1928.

517 *two novelists* Anthony and his elder brother Thomas Adolphus, author of novels and other works now forgotten.

 found it out Frances Trollope, *Domestic Manners of the Americans*, Cincinnati (1828), N.Y., 1904, p. 91.

The Mother of Parliaments

519 *public interest* From the law named after *Le Chapelier*, passed June 14, 1791.

528 *and Communism* See François Pejtö, *Heine: a Biography*, L., 1966.

531 *well yourself* For several of these quotations and others of equal interest, see Lady Holland and Mrs. Austin, *Memoir and Letters of Sydney Smith*, new ed., L., 1869; and Stuart J. Reid, *A Sketch of the Life and Times of Sydney Smith*, N.Y., 1885.

536 *saved his life* In his *Confessions of an Opium-Eater* (1821).

 in our time See Peter Quennell, ed., *London's Underworld, Selections from the Fourth Volume of London Labour and the London Poor by Henry Mayhew*, L., n.d.

540 *grooves of change* In "Locksley Hall" (1842).

541 *nine miles an hour* The sense of speed is relative to what habit has made "normal" and also to the degree of bodily comfort or exposure to the elements.

542 *Thomas Creevey* The now famous diarist, an M.P. who had opposed railways, was given a short ride on Nov. 4, 1829– a trial run for notables ahead of the formal opening of Sept. 15, 1830.

 Accepted Ideas See the translation by J. Barzun, *New Directions*, N.Y., 1968.

543 *to our day* See J. Barzun, "The Imagination of the Real," in *Art, Politics, and Will*, ed., Quentin Anderson et al, N.Y., 1977.

544 *common time* Starting out as the principal of a girls' school in the Northeast, Charles F. Dowd wrote and lectured about his idea till his retirement; See his *System of national time and its application, etc.*, Albany, 1870; and a biography: *Charles F. Dowd . . . a Narrative of His Services*, by Charles N. Dowd, N.Y., 1930.

 nobody objected In his *Philosophy of the Inductive Sciences*, L., 1940.

546 *for the organ* See Michael Murray, *French Masters of the Organ*, New Haven, 1998.

548 *propaganda* The efficiency and extent of this movement has only recently been shown. See Jeanne Gilmore, *La République clandestine: 1818–1848*, P., 1997.

Things Ride Mankind

552 *offensive phrase* News item, August 25, 1999.

554 *ride mankind* Ode Inscribed to W.H. Channing (c. 1848).

556 *and His Own* Max Stirner (meaning *the impudent?*) was the pseudonym of Kaspar Schmidt (1806–56).

558 *Beauty in Music* For Hanslick's precise ideas and actual role, see Geoffrey Payzant, "Tones Already Fading: Hanslick on Music and Time." Paper read at Time Symposium 14, University of Toronto, Feb. 3–9, 1992. See also a published version in *Journal of Musicological Research*, 1989, pp. 133 ff.

561 *Accepted Ideas* See second note to p. 542.
keep reading New Grub Street, L., 1891.
Les Misérables See Victor H. Brombert, *Victor Hugo and the Visionary Novel*, Cambridge, Mass., 1984.

563 *was abundant* See Harley Granville Barker, ed., *The Eighteen-Seventies*, N.Y., 1929.

565 *Tom's Cabin* The numerous adaptations of her novel, staged simultaneously in several countries is said to have opened the age of Sensation Drama. See M. Willson Disher, *Melodrama*, N.Y., 1954, pp. 2–4.
well-made play See examples in the Bentley series, note to p. 340 above.

566 *Abraham Lincoln* translated by W.H. Schofield, *American-Scandinavian Review*, 1918, pp. 104–06.

568 *Lord Acton* Quoted in James W. Thompson, *A History of Historical Writing*, N.Y., 1942, v.2, p. 300.

569 *biennial history* Frederic Harrison in *The Meaning of History*, N.Y., 1894.
than Froude See W.H. Dunn, *James Anthony Froude*, Oxford, 1961, 2v.
Jefferson Washington, D.C., 1926, Appendix.

570 *a novelist* See in G.O. Trevelyan's *Life and Letters of Macaulay*, the diary for Dec. 1838, Nov. 1841-July 1843, July 1848.

571 *educated reader* See also Norman Macbeth, *Darwinism*, San Francisco, 1985; and for a scientist's detailed account, Søren Løvtrup, *Darwinism*, L., 1987.

572 *would disappear* Renan wrote his *Future of Science* in 1848 but did not publish it until 1890.
New Republic Subtitled: *Culture, Faith, and Philosophy in an English Country House*, L., 1877.
chaotic scene For the definitive work on Matthew Arnold's ideas, see Lionel Trilling, *Matthew Arnold*, N.Y., 1939/1977.

573 *peace and justice* For a full treatment of Stephen's ideas, see James A. Colaiaco, *James Fitzjames Stephen*, N.Y., 1983.

574 *still exhale* See Michael Sanderson, ed., *The Universities in the Nineteenth Century*, L., 1975.

575 *foolishness* See Gustave Simon, *Chez Victor Hugo: Les tables tournantes de Jersey*, P., 1855/1923.
London Times For the attitude of the press in general, see Richard D. Altick, *Deadly Encounters*, Philadelphia, 1986.

576 *this Bohème* By Leoncavallo and Puccini.

577 *Metternich* See *The Private Letters of Princess Lieven to Prince Metternich: 1820–1856*, L., 1937.

578 *without practice* See J. Barzun, *Race: A Study in Superstition*, N.Y., 1937/1965.
recent book Francis Schiller, *Paul Broca, Founder of French Anthropology, Explorer of the Brain*, Berkeley, Calif., 1979.

580 *so well told* by Cecil Woodham-Smith, *Florence Nightingale*, L., 1950/1983, and Elspeth Huxley, *Florence Nightingale*, L., 1975.

584 *rhythm and force* This is demonstrated in J. Barzun, "Lincoln the Writer," in *Essays on Writing, Editing, and Publishing*, Chicago, 1971/1986.

585 *contributions* See his *Medical Essays*, Boston, 1861/1881.

588 *Paris Commune* Quoted in Lady St. Helier, *Memories of Fifty Years*, L., 1909, pp. 102 ff.

Cross Section: The View from Chicago

592 *Brown Decades* They are stated after the title: 1865–1895. Publ. N.Y., 1931.

Woodhull See Barbara Goldsmith, *Other Powers*, N.Y., 1998, and Mary Gabriel, *Notorious Victoria*, Chapel Hill, 1998.

to suicide See Allan Keller, *Scandalous Lady, the Life and Times of Madame Restell*, N.Y., 1981.

596 *literary genius* See his life written by Elmer Ellis, *Mr. Dooley's America: a Life of Finley Peter Dunne*, N.Y., 1941.

Spanish War Sticklers insist it was Kettle Hill, not San Juan, a less attractive vision. But as with William the Conqueror's landing place, Hastings or Senlac, the world has enshrined the better-sounding name.

597 *first ecologist* See his *Man and Nature* edited by David Lowenthal, Cambridge, Mass., 1965, and the same editor's *George Perkins Marsh: Versatile Vermonter*, N.Y., 1958.

598 *700 tons* See Quinta Scott, *The Eads Bridge*, Columbia, Missouri, 1979.

600 *in the morning* The account of its installation by the White House factotum, Irwin Hood Hoover is in his *Forty-two Years in the White House*, L., 1935.

601 *worked miracles* See James Harvey Young, "The Paradise of Quacks," *N.Y. State Journal of Medicine*, Feb. 1993, pp. 127 ff.; and "Sex Fraud," *Pharmacy in History*, 1993, No. 2, pp. 65 ff.

602 *to be written* See Sir Charles Higham, *Advertising*, L., 1925; J.S. Wright and D.S. Warner, eds., *Speaking of Advertising*, N.Y., 1963; and Edd Applegate, *Personalities and Products: A Historical Perspective on Advertising in America*, Westport, Conn., 1998. For a brilliant sidelight, read H.G. Well's novel, *Tono Bungay* (1909).

606 *instituted* See the comment by Dean Briggs quoted on p. 45.

of the first rank See Hardin Craig, *Woodrow Wilson at Princeton*, Norman, Okla., 1960.

609 *Dewey's formula* See John Dewey, *How We Think*, Boston, 1909.

Poincaré For a critical survey of the varied methods of science, see R.M. Blake, C.J. Ducasse, and E.H. Madden, *Theories of Scientific Method: The Renaissance Through the Nineteenth Century*, Seattle, 1960; and Jacques Hadamard, *ThePsychology of Invention in the Mathematical Field*, Princeton, 1943; other works by Abraham A. Moles (Geneva, 1957) and W.I.B. Beveridge (L., 1955) make the same point of diversity in method and inspiration. On *Vitalism* see L. Richmond Wheeler, L., 1939.

611 *study concludes* See Edward D. Radin, *Lizzie Borden, the Untold Story*, N.Y., 1961.

612 *of rhetoric* For the historical Cyrano, thinker and satirist, see Erica Harth, *Cyrano de Bergerac and the Polemics of Modernity*, N.Y., 1970.

Summit of Energies

617 *labor threatening* See Helen Merrell Lynd, *England in the Eighteen Eighties*, L., 1945.

618 *Nordau* pseudonym of Max Simon Südfeld (1849–1923).

619 *do that for us* *Axel*, P., 1890; trans. by June Guicharnaud, Englewood Cliffs, N.J., 1970. See also his novel *L'Eve future*, P., 1886, in which Edison is a character and techne refashions daily life.

 on the play See Maurice Saillet ed., *Tout Ubu*, P., 1962.

622 *in that sense* See Charles Chassé, *Les Clefs de Mallarmé*, P., 1954.

 free verse The early practitioner and best theorist was Gustave Kahn. See the Preface to his *Premiers Poèmes*, P., 1897 and the developed treatment of the subject *Le Vers libre*, P., 1912. The belief that Walt Whitman was a formative influence has been shown to be baseless. See P. Mansell Jones, *The Background of Modern French Poetry*, Cambridge, Mass., 1968, pp. 159 ff.

625 *quickly suppressed The Hazard of the Die.* See S. Beach Chester, *Anomalies of the English Law*, Boston, 1912, p. 135.

626 *hermaphrodite* To be even-handed, his heterosexual *Lysistrata* drawings were also suppressed.

 Krafft-Ebing His *Psysopathia Sexualis,* first translated into English in 1892 (Philadelphia), was sold only to physicians until the 1920s.

 take refuge For a survey of reports by medical men, see Stephen Kern, *Freud and the Emergence of Child Psychology: 1880–1910*, Columbia University Dissertation, 1970.

 Sexual Act published, Chicago, 1900, after its rejection by the *Journal of the American Medical Association;* repr. Weston, Mass. 1970.

 nine years Ibid., p. 21.

627 *61 apiece* See H. Granville Barker, ed., *The Eighteen Seventies*, N.Y., 1929; and also: (Anon.) *Women Novelists of Queen Victoria's Reign: a Book of Appreciations*, L., 1891.

629 *black magic* For this annotated edition, see *Magick: Liber Aba*, York Beach, Maine, 1997.

630 *Mutual Friend* in the character of Eugene Wrayburn.

631 *no existence* But a physicist writing in *Physics Today* questions the assertion. See *New York Times*, Feb. 2, 1999.

632 *Pierce Williams* Regrettably, it omits Mendeleef's Periodic Table.

 J. S. Haldane Not to be confused with his younger relative J.B.S. Haldane.

634 *Darwin's book* See *Darwin and Modern Science: Essays in Commemoration of . . . The 50th Anniversary of the Publication of the Origin of Species*, Cambridge, Eng., 1909.

635 *respect* David Greene, Introduction to *The Authoress of the Odyssey by Samuel Butler*, Chicago, 1967.

 Notebooks Additional notes were published in *Life and Letters*, Oct. 1931.

636 *Surgeon* Dr. W.W. Keen in *The Progress of the Century, a Symposium*, N.Y., 1901, p. 254.

639 *impossibility* Berlioz was the first to say so in his program to the *Symphonie*

Fantastique of 1830. See also "Is Music Unspeakable?" *American Scholar*, Spring 1996.

641 *the experience* See P. E. Vernon's report, originally published in *The Musical Times* (London), repr. in *Pleasures of Music*, ed., J. Barzun, N.Y., 1951, Chicago, 1977.

Cubist Decade

644 *impressions* Louis Leroy in *Charivari*, Apr. 25, 1874.

647 *Gone Mad* by Camille Mauclair, L., 1931; it is the English translation of a series of articles in *Le Figaro*.

648 *lunatic fringe* Roosevelt's review appeared in *The Outlook*, Mar. 22, 1913.

H.M. Barzun in "Voix, rythmes, et chants simultanés" in *Poème et Drame*, P., 1913; see also *Simultanéisme/Simultaneita*, Quaderni del Novecento Francese 10, Rome, 1987; and Léon Somville, *Les Devanciers de Surréalisme*, Geneva, 1971.

later years For a collection of such poems, see John Hollander, *Types of Shape*, N.Y., 1979; Emmett Williams, *An Anthology of Concrete Poetry*, N.Y., 1967, and S. McCaffery and B.P. Nichol, *Sound Poetry*, Toronto, 1978.

Calligrammes P., 1918.

650 *universally* See Daniel Robbins, "From Cubism to Abstract Art," *Baltimore Museum of Art News*, Spring 1962, pp. 9 ff.

Abolitionism See F.T. Marinetti, *Les Mots en Liberté*, Milan, 1919.

651 *crowd psychology* by Gustave Lebon; Gabriel Tarde; Scipio Sighele. Lebon's *The Crowd* was reissued with an introduction by Robert K. Merton, N.Y., 1960.

652 *in great detail* First by Robert and Helen Lynd in *Middletown*, a study in American culture, N.Y., 1929, and again in two other volumes, 1930 and 1937; finally in successive volumes under the editorship of Theodore Caplow in the 1980s.

653 *France 1848–1945* by Theodore Zeldin, Oxford, 1973, 2v.; *Centuries of Childhood* is by Philippe Ariès, trans. by Robert Baldick, N.Y., 1965.

2,500 years On the features and arguments about the new of history see J. Barzun, *Clio and the Doctors*, Chicago, 1974; and Gertrude Himmelfarb, *The New History and The Old*, Cambridge, Mass., 1987.

of friendship Anne Vincent-Briffault, *L'Exercice de l'Amitié*, P., 1995.

of private life A series of volumes under the editorship of Philippe Ariès, P., 1985–87 and Cambridge, Mass., 1987 ff.

of envy Helmut Schoeck, Vienna, 1996 and P., 1998; see also *A History of Rudeness* by Mark Caldwell, N.Y., 1999.

literary accounts See *Encounter*, April 1973.

657 *John Casey* in the London *Sunday Times* for Mar. 1, 1994.

General Linguistics The *Course on General Linguistics* was publ.: La Salle, Ill., 1986/1994. For a contrasting cultural view, see Roman Jakobson, *Essais de Linguistique Générale*, P., 1963.

a mistake Allen Walker Read in 1964.

658 *and function* For the most thorough application of the principle, see Ferdinand Brunot, *La Pensée et la Langue*, P., 1936.

 in grammar Noted by William Safire in his column "On Language," Mar. 6, 1988.

659 *in Leipzig* The sequence in dates was established by Robert S. Harper in the *Harvard Alumni Bulletin*, 1949, pp. 169 ff.

660 *Private Diary* Anonymous; attributed to H.C. Beeching, L., 1898.

661 *out of 900* Henri F. Ellenberg, *The Discovery of the Unconscious*, N.Y., 1970.

663 *best books* *Civilization and Its Discontents* (1930).

664 *fraudulent* See Trevor H. Hall, *The Strange Case of Edward Gurney*, L., 1964.

668 *and religion* For this movement of ideas, see J. Barzun, *A Stroll with With William James*, N.Y., 1983, Chicago, 1986.

 in Politics See W.Y. Elliott, *The Pragmatic Revolt in Politics*, N.Y., 1928; Hans Joas, *Pragmatism and Social Theory*, Chicago, 1993; and Louis Menand, "The Return of Pragmatism," *American Heritage*, Oct. 1997.

668 *actual debate* See first: *The Use of Words in Reasoning*, L., 1901; then *The Process of Argument*, L., 1893, and *The Progress of Disputes*, L., 1910.

669 *be verified* See Edwin Leavitt Clarke, *The Art of Straight Thinking*, N.Y., 1929, p. 217*n*.

 powers See Sigmund Koch and David E. Leary, *A Century of Psychology as Science*, N.Y. 1985.

671 *Berlioz genre* See Charles Andler *Nietzsche et Sa Pensée*, P., 1920 and *La Jeuness de Nietzsche*, P., 1921, p. 280.

672 *What is Art?* See note to p. 174.

677 *re-created* Sir Frederick Ashton in the *New York Times*, June 26, 1981; and also Anna Kisselgoff, *New York Times*, July 1, 1981.

 modern dance See Fredrika Blair, *Isadora*, N.Y., 1986.

Great Illusion

683 *banquet years* See book of that title by Roger Shattuck, N.Y., 1955/58. See also Sisley Huddleston, *Paris Salons, Cafes, Studios*, Phila., 1928.

684 *Matthews* *The Sugar Pill: an Essay on Newspapers*, N.Y., 1959. For a partisan but equally skeptical view, see Hilaire Belloc, *The Free Press*, L., 1918.

691 *German general* Friedrich von Bernhardi, *Germany and the Next War*, N.Y., 1914 (1912).

695 *Servile State* By Hilaire Belloc, L., 1927/1948.

 The Nihilists The place and date of the events are given as Moscow, 1800, but they would still be plausible in 1900.

697 *National Socialism* See Fritz Stern, *The Politics of Cultural Despair*, Berkeley, Cal., 1961.

698 *a social science* See George R. and Christiane C. Collins, *Camillo Sitte and the Birth of Modern City Planning*, N.Y., 1965.

John Lukacs See also Mary Gluck, "Endre Ady: an East European Response to the Cultural Crisis of the "Fin de Siècle," Columbia University Dissertation, 1977; and Carl E. Schorske, *Fin de Siècle Vienna: Politics and Culture*, L., 1979.

708 *notable convert* Doyle's interest antedated the war and was in his eyes compatible with the scientific attitude. See Owen Dudley Edwards, *The Quest for Sherlock Holmes*, Edingurgh, 1983.

Artist Prophet and Jester

714 *era since 1500* Several recent works on the meaning of modern Modernism are worth attention, notably Robert Crunden, *American Salons: Encounters with European Modernism*, N.Y., 1992, and his anthology *The Superfluous Men*, Austin, Texas, 1977; Christopher Faille, *These Last Four Centuries*, N.Y., 1988; William R. Everdell, *The First Moderns*, Chicago, 1997; and Noel Annan, *Our Age*, N.Y., 1990.

in the 40s In his *Mémoires d'Outre-tombe*, publ. 1849 but completed by 1843.

715 *interior monologue* The novella is Edouard Dajardin's *We'll to the Woods No More*; in the original French, 1887–88; in English translation by Stuart Gilbert, N.Y., 1938. Joyce read the book in 1901.

716 *made the survey* Charles Scribner, Jr. "Scientific Imagery in Proust," *Proceedings of the American Philosophical Society*, v. 134, no. 3, 1990.

718 *Hemingway* in *Der Querschnitt*, Feb. 1925.

719 *musical works* See Otto Luening on the group in his autobiography, *The Odyssey of an American Composer*, N.Y., 1980.

Freedom For Words Les Mots en liberté futuristes, Milan, 1919. See also Marjorie Perloff, *The Futurist Moment*, Chicago, 1986; and Léon Somville, *Les Devanciers du Surréalisme*, Geneva, 1971.

723 *tomato soup* by the late Andy Warhol.

726 *Normandie* unconscionably scuttled in New York harbor at the beginning of the second world war.

727 *Mechanical Stimulus* in *Music Ho!*, L., 1934, p. 239.

728 *new laws* Antoine Golea in *Musical Quarterly*, Jan. 1965.

729 *and Lulu* unfinished but performable and filmed.

730 *experimental* Blake used it once, without echo for over a century.

731 *Without Spectacles* See Nigel Wilkins, ed., The Writings of Erik Satie, L., 1980.

733 *in France* Baron Seillière made it the subject of several works, see also Hugo Friedrich, *Das Anti-romantische Denken in Modernen Frankreich*, Munich, 1935.

and politics The American poet John Crowe Ransom declared that he was in manners aristocratic, in art traditional, and in religion ritualistic.

734 *homosexual love* Notably in Gide's *Corydon* (1920) and Radclyff Hall's *Well of Loneliness* (1928).

735 *their stupidity* See *A Writer's Notebook*, L., 1949.

736 *Caran d'Ache* pseudonym of Emanuel Poire, which he made up by turning the Russian word for *pencil* into a French-sounding name.

the clerihew created in his *Biography for Beginners*, L., 1905. His *Clerihews Complete*, L., 1951.

W.H. Auden See his *Academic Graffiti* (which includes the earlier collection in *Homage to Clio*), N.Y., 1971; and *The Clerihews of Paul Horgan*, Middletown, Conn., 1984, which has a technical description in verse.

738 *Carmina Burana* See p. 229.

739 *Greek tragedy* The demonstration is given in Dorothy Sayers' essay, "Aristotle on Detective Fiction," *Unpopular Opinions*, N.Y., 1947, pp. 222 ff.

as lowbrow notably Edmund Wilson and Robert Graves. Wilson recanted after reading Doyle's *Hound of the Baskervilles*.

740 *a shooting* William Leggett, "The Rifle," in *Sketches by a Country Schoolmaster*, N.Y., 1829, reprinted in Mary Russell Mitford, ed., *Stories of American Life*, L., 1830. Beaumarchais, *Gaîté faite à Londres*, trans. in J. Barzun, ed., *The Delights of Detection*, N.Y., 1961.

Edgar Poe as he was known to his contemporaries and in Europe to this day. The form *Edgar Allan Poe* was imposed by his posthumous editors.

found a master See note to p. 708 above for a study of Doyle's work in the genre.

741 *corruption* See George Dilnot, *The Trial of the Detectives*, L., 1928.

742 *detective tale* in the Introduction to *The Omnibus of Crime*, N.Y., 1929.

The Absurd

746 *victors* See Klaus Schwabe, *Woodrow Wilson, Revolutionary Germany, and Peace-Making: 1918–1919*, Chapel Hill, 1985.

750 *magnetic field* Whitehead's formulation in *Science and the Modern World* [Boston] 1925, N.Y., 1954, p. 191. See also "features of a conceptual scheme" (Polykarp Kusch), and such discussions as Bernard d'Espagnat, "The Quantum Theory and Reality," *Scientific American*, Nov. 1979, pp. 158 ff.; and Murray Gell-Mann, "Is the World Really Made of Quarks, Leptons, and Bosons?" *Bulletin of the American Academy of Arts and Sciences*, April 1976.

754 *J. Barzun* Crown Publishers, N.Y., 1951.

756 *Knots* Pantheon Books, N.Y., 1970, p. 30.

751 *Canada* Interview in the *Toronto Star*, May 20, 1995.

760 *got rid of* See Marshall McLuhan, *Understanding Media*, N.Y., 1963.

765 *physical means* The vice chancellor was Sir Eric Ashby. See his book, written with Mary Anderson, *The Rise of the Student Estate in Britain*, Cambridge, Mass., 1970.

one man in Europe Daniel Cohen-Bendit.

770 *also available* For a Russian commentary, see Vasily Rosanov, *Dostoevsky and the Legend of the Grand Inquisitor*, trans. by Spencer E. Roberts, Ithaca, N.Y., 1972.

Demotic Life and Times

775 *Makes a Nation?* See *New York Times*, Dec. 5, 1992, and article by Sophie Gerhardi on the "cracks" in the nations of Europe, *Le Monde*, May 16, 1996.

776 *"human nature"* Its cultural diversity is so great that its unity seems hardly

more than physical. See Laura Bohannan's case study, "Miching Mallecho, *From the Third Program*, ed., John Morris, L., 1956.

in one year　Reported in Texas for 1998.

777　*too many of both*　Hence Sartre's "Hell is other people," which was anticipated by Oscar Wilde in *An Ideal Husband*, Act III, where Lord Goring says "Other people are quite dreadful. The only possible society is oneself."

786　*Lord Leighton*　in Mrs. Russell Barrington, *The Life, Letters, and Work of Frederic Leighton*, N.Y., 1906, 2v., v.I, p. 18.

787　*for being well-known*　The phrase is that of Daniel Boorstin, famed historian and former Director of the Library of Congress.

789　*public attention*　An early study of American iconography shows how, from comics to pinups, the eye is given the pleasure of unreality: Geoffrey Wagner, *Parade of Pleasure*, N.Y., 1955.

the incitement　Possibly a hoax, notice came in the mail in 1999 of a symposium on "The New Sexual Frontier: Safe Sex With Your Pets; the Courage to Break Through the Human-Animal Frontier." College and school students were urged to send in "topics" and to attend.

"sexual harassment"　a misnomer when applied to one or a few incidents.

even staring　"If you become aware that someone is staring at you, do not tolerate his behavior . . . talk to the police." Posted in the library of a leading midwestern university (1995).

790　*between them*　For other critical predicaments, see Arthur Danto, *After the End of Art*, N.Y., 1987.

incandescent　See "The Last Pages of *Sexus*" in *The New Olympia No. 3*, 1962, pp. 44 ff.

791　*sordidness*　See Fernanda Pivano, *C'era una volta un beat*, Rome, 1976; and *Album Americano*, Milan, 1997. See also Henri Raczymon, De l'ordure en littérature," *Le Monde*, Oct. 3, 1998.

793　*as they arose*　See Liliane Lurçat, *L'Echec et le désintérêt scolaire* (P., 1976) and *Le Temps prisonnier*, P., 1995; and the frequent articles of Max Beloff in the British press.

794　*by the millions*　See Richard D. Mandell, *Sport: a Cultural History*, N.Y., 1984; and E.E. Snyder and E.A. Spreitzer, *Social Aspects of Sports*, 2nd ed., Englewood Cliffs, N.J., 1983.

795　*from Shakespeare*　2 Henry VI, iv, 2. Jack Cade and other rebels want "all in common" and "no money," which requires that not only lawyers should be killed, but anyone who can read and write.

James B. Reston　Obituary in the *Proceedings of the American Philosophical Society* for June 1998.

discussion groups　Notably the Media Studies Forum, seconded by the *Columbia Journalism Review*.

796　*to others*　In different ways the classic principles of librarianship were frequently flouted. For those principles, see William E. Henry, *Upon Libraries and Librarianship*, Freeport, N.Y., 1931/1967.

criticism　These critics were respectively: Celia Greene (1976); George Perec (1991); and Susan Haack (1999).

798 *and Leo Stein* To sample their contributions, see the J.J. Chapman anthology, *Unbought Spirit*, ed., Richard Stone (Urbana, Ill., 1998); Albert J. Nock, *The State of the Union, Essays in Social Criticism*, ed., Charles H. Hamilton, Indianapolis, 1991; and Leo Stein, *Appreciations: Painting, Poetry and Prose*, N.Y., 1947.

in many See Victor Bugliosi, *Outrage*, N.Y., 1996, pp. 32–36.

without tremor For a comparative judgment, see Joseph R. Strayer, "The Fourth and The Fourteenth Centuries," Presidential Address at the American Historical Association meeting, 1971; publ. *American Historical Review*, v.77, no. 1, 1972.

Index of Persons

NOTE. Numbers in boldface type indicate the pages of the main treatment and of substantial additions to it. Cross references to the names will be found in the Index of Subjects beginning on page 853. For turning the entire book into type several times and finally on to disk, I am indebted to the skill, accuracy, and intelligence of Treva Kelly.

Index of Subjects

NOTE. For the reader's convenience, some of the entries on large subjects have as heading the name, adjective, and derivative noun that go together, e.g. Liberal(s)(ism). The phrasing of each subentry then links up with one or another of the three forms.

On every subject treated in this book, my obligation for advice and correction has been extensive. I hereby give unmeasured thanks to Henry Graff, John Lukacs, Joan Peyser, Charles Scribner III, and Carl Schorske.

Abolitionism(ists), U.S., of slavery 551; of machinery 604, 633, French 619–20, 622, 719; and Wagner 637

abstraction (theme), method of 193; 196, 201, 203, 213–4, 218, 245, 255, 373, 384, 398, 522, 544, 554, 589, **766–7**; in science 216, 622; Lichtenberg on 440; *Faust* on 470; in criticism 511, 760; in idealism 616; in art 622, contradictory 623; in Cubism **649**, 723; structure in historiography 653, 768, in linguistics 657–8, **759–60**, in anthropology **759–60**, in history of science **760**; in common talk 769, and virtual reality 797

Absurd, the, 12; theatre of 515, 754–5, 756; in science 607, 750; in criticism 621, 651; in war 710, in world 720, 757–8; philosophy of **754 ff.**; sign of rightness **757–8**; in rule-making **779**

academic, term of contempt 78

academy(ies), def. 57; Florentine 57, Pico attends 59; Tasso writes for 149; Swedish, of Science 207, 281–2; of art and science 210–1; English Royal, of Science **210–1**; 17C French, Spanish, German, American 211, 405; on Orffyreus's wheel 312; Russian 319; of Painting and Sculpture (France) 338; numerous 18C 377–8; Dijon and Rousseau 383; French Revolutionary 432; English Royal of Arts 460, 555; French, of Science 501

acting, **675–6**; and staging 675; and Stanislavsky **675–6**, 736; outré 759; see also titles of plays

Adamo Caduto, 53

Adiaphorist(s), 28, 31

administration 39; of empire 97; Cromwell and 277; of monarchy 292, 301–2; difficult art 426; Bonaparte a master of 447; badly needed **778–9**

advertising, early 206, 684; 599, 601–2, 603; by Mallarmé 623; late 20C 684; cultural use of 726; by public relations **785**; for image 137, 289, 785; of Desire 790

Aeneid, The, 152; travestied 165

aesthetics, see criticism

Africa, epic 49; railways in 542

Age of Louis XIV, The, 379

Ajuan island, see Comoros

Albigenses, 5

alchemy 58, 65, 191, 207, 221, 282; Erasmus on 206

algebra, Descartes and 202; Pacioli treatise 206; origin of 206–7

allegory(ies) Luther on 20, 30; *Faery Queene* 154; for masque or music 156; *Pilgrim's Progress* 357; in Blake 479; in Thoreau 506; in Shaw 717

Alps and Sanctuaries, 635

A Man for All Seasons, 118

ambassadors, see diplomacy

America(s), Spanish 93, 97, 100; discovery of